ARTS & HUMANITIES
Through the Eras

ARTS & HUMANITIES
Through the Eras

Ancient Greece
and Rome
1200 B.C.E.–476 C.E.

James Allan Evans, Editor

THOMSON

GALE

Detroit • New York • San Francisco • San Diego • New Haven, Conn. • Waterville, Maine • London • Munich

THOMSON
GALE

Arts and Humanities Through The Eras: Ancient Greece and Rome (1200 B.C.E.–476 C.E.)

James Allan Evans

Project Editor
Rebecca Parks

Editorial
Danielle Behr, Andrew Claps, Pamela A. Dear, Jason Everett, Dwayne Hayes, Rachel J. Kain, Ralph G. Zerbonia

Editorial Support Services
Mark Springer

Data Capture
Elizabeth Pilette

Indexing Services
Barbara Koch

Imaging and Multimedia
Randy Bassett, Mary K. Grimes, Lezlie Light, Michael Logusz, Christine O'Bryan, Kelly A. Quin

Rights and Acquisitions
Margaret Chamberlain, Shalice Shah-Caldwell

Product Design
Michelle DiMercurio

Composition and Electronic Prepress
Evi Seoud

Manufacturing
Wendy Blurton

LIBRARY OF CONGRESS CATALOGING-IN-PUBLICATION DATA

Arts and humanities through the eras.
 p. cm.
 Includes bibliographical references and index.
 ISBN 0-7876-5695-X (set hardcover : alk. paper) —
 ISBN 0-7876-5696-8 (Renaissance Europe : alk. paper) —
 ISBN 0-7876-5697-6 (Age of Baroque : alk. paper) —
 ISBN 0-7876-5698-4 (Ancient Egypt : alk. paper) —
 ISBN 0-7876-5699-2 (Ancient Greece : alk. paper) —
 ISBN 0-7876-5700-X (Medieval Europe : alk. paper)
 1. Arts—History. 2. Civilization—History.

NX440.A787 2004
700'.9—dc22
 2004010243

This title is also available as an e-book.
ISBN 0-7876-9384-7 (set)
Contact your Thomson Gale sales representative for ordering information.

Printed in the United States of America
10 9 8 7 6 5 4 3

CONTENTS

ABOUT THE BOOK

SEEING HISTORY FROM A DIFFERENT ANGLE. An education in history involves more than facts concerning the rise and fall of kings, the conquest of lands, and the major battles fought between nations. While these events are pivotal to the study of any time period, the cultural aspects are of equal value in understanding the development of societies. Various forms of literature, the philosophical ideas developed, and even the type of clothes worn in a particular era provide important clues about the values of a society, and when these arts and humanities are studied in conjunction with political and historical events a more complete picture of that society is revealed. This inter-disciplinary approach to studying history is at the heart of the *Arts and Humanities Through the Eras* project. Patterned in its organization after the successful *American Decades*, *American Eras*, and *World Eras* products, this reference work aims to expose the reader to an in-depth perspective on a particular era in history through the study of nine different arts and humanities topics:

- Architecture and Design
- Dance
- Fashion
- Literature
- Music
- Philosophy
- Religion
- Theater
- Visual Arts

Although treated in separate chapters, the connections between these topics are highlighted both in the text and through the use of "See Also" references to give the reader a broad perspective on the culture of the time period. Readers can learn about the impact of religion on literature; explore the close relationships between dance, music, and theater; and see parallel movements in architecture and visual arts. The development of each of these fields is discussed within the context of important historical events so that the reader can see history from a different angle. This angle is unique to this reference work. Most history books about a particular time period only give a passing glance to the arts and humanities in an effort to give the broadest historical treatment possible. Those reference books that do cover the arts and humanities tend to cover only one of them, generally across multiple time periods, making it difficult to draw connections between disciplines and limiting the perspective of the discipline's impact on a specific era. In *Arts and Humanities Through the Eras* each of the nine disciplines is given substantial treatment in individual chapters, and the focus on one era ensures that the analysis will be thorough.

AUDIENCE AND ORGANIZATION. *Arts and Humanities Through the Eras* is designed to meet the needs of both the beginning and the advanced history student. The material is written by subject experts and covers a vast array of concepts and masterworks, yet these concepts are built "from the ground up" so that a reader with little or no background in history can follow them. Technical terms and other definitions appear both in the

text and in the glossary, and the background of historical events is also provided. The organization of the volume facilitates learning at all levels by presenting information in a variety of ways. Each chapter is organized according to the following structure:

- Chronology covering the important events in that discipline during that era

- Brief overview of the development of that discipline at the time

- Topics that highlight the movements, schools of thought, and masterworks that characterize the discipline during that era

- Biographies of significant people in that discipline

- Documentary sources contemporary to the time period

This structure facilitates comparative analysis, both between disciplines and also between volumes of *Arts and Humanities Through the Eras*, each of which covers a different era. In addition, readers can access additional research opportunities by looking at the "Further References" and "Media and Online Sources" that appear at the back of the volume. While every effort was made to include only those online sources that are connected to institutions such as museums and universities, the web-sites are subject to change and may become obsolete in the future.

PRIMARY DOCUMENTS AND ILLUSTRATIONS. In an effort to provide the most in-depth perspective possible, *Arts and Humanities Through the Eras* also includes numerous primary documents from the time period, offering a first-hand account of the culture from the people who lived in it. Letters, poems, essays, epitaphs, and songs are just some of the multitude of document types included in this volume, all of which illuminate some aspect of the discipline being discussed. The text is further enhanced by 150 illustrations, maps, and line drawings that bring a visual dimension to the learning experience.

CONTACT INFORMATION. The editors welcome your comments and suggestions for enhancing and improving *Arts and Humanities Through the Eras*. Please mail comments or suggestions to:

The Editor
Arts and Humanities Through the Eras
Thomson Gale
27500 Drake Rd.
Farmington Hills, MI 48331-3535
Phone: (800) 347-4253

CONTRIBUTORS

James Allan Evans, Editor, received the Ph.D. in classics from Yale University in 1957 with a specialty in Greek and Roman social and economic history. He was a Thomas Day Seymour fellow at the American School of Classical Studies in Athens, Greece, in 1954–1955, and taught at Wilfrid Laurier University, the University of Texas at Austin, and McMaster University in Hamilton, Ontario, where he was a professor of ancient history. In 1972 he accepted a professorship at the University of British Columbia, Vancouver, and taught there until his retirement as professor emeritus in 1996. Since retiring he has been a visiting professor of history at the University of Washington, Seattle, a visiting special lecturer at Simon Fraser University in Burnaby, Canada, and a Whitehead Visiting Professor at the American School of Classical Studies in Athens. He is the author of *A Social and Economic History of an Egyptian Temple in Greco-Roman Egypt* (Yale Classical Studies, 17, 1961), *Procopius* (Twayne, 1972), *Herodotus* (Twayne, 1982), *Herodotus, Explorer of the Past: Three Essays* (Princeton, 1991), *The Age of Justinian: The Circumstances of Imperial Power* (Routledge, 1996), and *The Empress Theodora: Partner of Justinian* (University of Texas Press, 2002). He was also editor of the series *Studies in Medieval and Renaissance History* (AMS Press) from 1977 to 1996. In 1992 he was elected a fellow of the Royal Society of Canada. He is presently writing a book on the intrigues and the power play of the Byzantine court in the period of Justinian.

Lisa Rengo George received the Ph.D. in classics from Bryn Mawr College in 1997, and has been an assistant professor of classics in the Department of Languages and Literatures at Arizona State University since 1999. She was a visiting assistant professor of classics at Skidmore College from 1994–1998. At Arizona State, she is the founder and co-director of the undergraduate certificate program in classical studies, and she teaches courses in ancient Greek and Latin language and on classical mythology, culture, and literature. She is a recipient of a Whiting Fellowship and an award from the Women's Classical Caucus of the American Philological Association. Professor George's research interests range from Greek and Roman drama and Homer to Xenophon and gender studies in antiquity. Her publications include the forthcoming book *Prostitutes in Plautus*; articles on Plautus and Aeschylus; and chapters on ancient Greece and Rome in *Mythologies of the World* (New York, 2001).

John T. Kirby, Advisor, is professor of classics at Purdue University, where he has chaired the programs in classical studies and in comparative literature. His books include *The Rhetoric of Cicero's Pro Cluentio* (J. C. Gieben 1990), *The Comparative Reader* (Chancery Press, 1998), *Secret of the Muses Retold* (University of Chicago Press, 2000), *Classical Greek Civilization* (Gale Group, 2001), and *The Roman Republic and Empire* (Gale Group, 2001). His websites include the popular CORAX site (www.corax.us), a hypersite that offers a comprehensive online classics curriculum. His awards and honors include a Morehead Scholarship, an NEH Fellowship, and teaching awards at the departmental, university, state, regional, and national levels.

William H. Peck was educated at Ohio State University and Wayne State University. For many years he was the curator of ancient art at the Detroit Institute of Arts where he was responsible for Greek, Roman, and Etruscan art as well as the art of Egypt and the Ancient

Near East. He has taught art history at the Cranbrook Academy of Art, the University of Michigan, and Wayne State University. He is currently teaching at the College for Creative Studies in Detroit. His books include *Drawings from Ancient Egypt* (Thames and Hudson, 1978), *The Detroit Institute of Arts: A Brief History* (Detroit Institute of Arts), and *Splendors of Ancient Egypt* (Detroit Institute of Arts). He has published scholarly and popular articles on Greek and Roman sculpture as well as Egyptian art and archaeology. He has many years of archaeological experience resulting in a direct familiarity with ancient architectural techniques. His travels in Europe, North Africa, and the Near East have given him the opportunity to study firsthand the major monuments of architectural history. He has been responsible for a number of exhibitions at the Detroit Institute of Arts and has also lectured on art and archaeology throughout the United States and Canada.

Nancy Sultan received the Ph.D. in comparative literature from Harvard University in 1991. She joined the faculty at Illinois Wesleyan in 1993, where she is professor and director of Greek and Roman studies, and chair of the Department of Modern and Classical Languages and Literatures. Her scholarly interests are in the areas of Hellenic cultural studies, oral poetics, ethnomusicology, and gender studies. Relevant publications include a book, *Exile and the Poetics of Loss in Greek Tradition* (Rowman and Littlefield, 1999), and several articles on Greek musical traditions: "Private Speech, Public Pain: The Power of Women's Laments in Greek Poetry & Tragedy," in *Rediscovering the Muses: Women's Musical Traditions*, ed. K. Marshall (Northeastern, 1992), "Women in 'Akritic' Song: The Hero's 'Other' Voice," in *The Journal of Modern Greek Studies* (1991), and "New Light on the Function of 'Borrowed Notes' in Ancient Greek Music: A Look at Islamic Parallels," in the *Journal of Musicology* (1988).

ERA OVERVIEW

THE BEGINNINGS. The history of Greece and Rome spans more than 2,000 years, from the Minoan and Mycenaean civilizations of prehistory to the beginnings of the Byzantine Empire which carried on the language and culture of Greece, though now within an environment permeated by Christianity. The history falls into periods that are more or less well-defined. There was the Bronze Age: the era of the Minoan civilization on the island of Crete and the Mycenaean civilization on the mainland. Then, for reasons modern historians do not understand, there followed an age of upheaval and invasion affecting the whole eastern Mediterranean. Raiders who came to loot and burn reached even Egypt, where Egyptian sources recorded their attacks and called them "Peoples of the Sea." In Greece, the years following 1200 B.C.E. are marked by destruction and migrations. Refugees from Greece made their way to the western coast of Asia Minor and the offshore islands where they founded settlements which grew into flourishing cities.

COLLAPSE AND RECOVERY. What followed the collapse of the Mycenaean civilization was a period known as the "Dark Ages," for little is known about it except what the archaeological remains reveal. Yet it was a period when the characteristic political structure of Greece developed: the *polis*, or city-state, an urban center with a defensible citadel called an acropolis—the name means merely "the city on the hill"—which was surrounded by the territory of the city-state. A large *polis* such as Athens grew by amalgamating a number of small states until all of the region known as Attica became the territory of Athens. Another development was the invention of the

Greek alphabet which used letters borrowed from Phoenicia, and still another was the beginnings of literature, as story-tellers and oral bards spun tales about the gods, and about the men and women who lived in the Mycenaean period, which now belonged to the misty past.

THE ARCHAIC PERIOD. The "Dark Ages" slipped easily into the archaic period which ended in turn as the sixth century B.C.E. gave way to the fifth. Poets now wrote down their poetry and thinkers began to speculate about the nature of the universe. The twelve Ionian cities that had been founded on the west coast of Asia Minor and the Dodecanese Islands became brilliant centers of Greek culture. In one of them, Miletus, Greek philosophy was born with thinkers such as Thales, Anaximandros, and Anaximenes, and in another, Ephesos, the temple to Artemis, built in the Ionic style, was the largest temple in the Greek world. Towards the end of the period, the Greek cities of the eastern Aegean region fell under the rule, first of the Lydian Empire centered at Sardis, and second of the Persians, who overthrew the last Lydian king, Croesus, in 546 B.C.E. Persian power was advancing, and the historical event that marked the close of the archaic age and ushered in the classical period was the invasion of Greece by the Persian Empire in 490–479 B.C.E. and its defeat.

THE CLASSICAL PERIOD. The coalition of Greeks that turned back the Persian offensive was led by Sparta, but it was the Athenian fleet that made victory possible, and Athens entered the classical period with new confidence. Athens' government was democratic, and its culture aroused the admiration even of its enemies. And

Athens did have many enemies, for it dominated the Aegean Sea with its fleet and, guided by the policies of an imperialist statesman named Pericles, transformed an alliance created for defense against renewed Persian aggression into an empire that paid it tribute. The tribute financed a building program that made Athens the most beautiful city in Greece. The last two decades of the fifth century B.C.E. were consumed by a war between imperial Athens and an alliance led by Sparta, and Athens lost. The brief golden age was over, although the classical period continued until Alexander the Great changed the face of the Greek world with a series of military campaigns that radically expanded Greece's territory.

THE HELLENISTIC AGE. Alexander's conquests ushered in the Hellenistic world. Alexander's generals carved out kingdoms for themselves and welcomed Greek immigrants. Royal capitals such as Antioch, Pergamum, and Alexandria rivaled Athens as centers of culture. In Alexandria, the kings of Egypt built a great library and made it a think-tank for Greek intellectuals. But in the west, Rome was expanding. Its chief rival, Carthage, had been humbled by the end of the third century B.C.E. and in the following years, the Romans moved into the eastern Mediterranean. The last Hellenistic kingdom to fall to Rome was Egypt, and in 30 B.C.E. Cleopatra, the last monarch descended from one of Alexander's generals, committed suicide.

THE ROMAN REPUBLIC. Rome's history falls into two eras: the republican period, when it grew from a small city near the mouth of the Tiber River to dominate the Mediterranean, and the imperial period, when emperors ruled a vast region stretching from Britain in the west to Syria and Iraq in the east. The Roman republic was founded traditionally in 509 B.C.E. when a dynasty of Etruscan kings was expelled, and their place taken by elected magistrates called consuls. The republic expanded, first dominating Latium, the Latin-speaking area around Rome, and then extending its rule into Italy and beyond Italy into the lands bordering the Mediterranean. As Rome extended its rule, it extended its citizenship until finally in 212 C.E., long after republican government had given way to emperors, everyone in the Roman Empire became citizens of Rome.

THE ROMAN IMPERIAL PERIOD. As the empire expanded, the incompetence of the narrow ruling class that dominated republican government brought about its downfall, and in 30 B.C.E., Octavian, the adoptive son of Julius Caesar, made himself master of Rome and set about establishing a new government structure. It preserved the trappings of the republic, but put power firmly in the hands of the *imperator*, or commander-in-chief. Octavian took the title "Augustus" which would be conferred on his successors too, and the empire enjoyed more than two centuries of prosperity before the tide changed against it. Yet the last emperor in the west abdicated only in 476 C.E., and in the east, an emperor continued to rule in Constantinople until the Turks captured the city in 1453.

CHRONOLOGY OF WORLD EVENTS

By James Allan Evans, Michael S. Allen, and Patricia D. Rankine

c. 2000 B.C.E. Greek-speaking people migrate into Greece.

c. 1900 B.C.E. –c. 1700 B.C.E. During the Proto-Palatial period of Minoan Civilization on Crete, great palaces are built at a number of sites, principally Cnossos, Mallia, and Phaestos.

c. 1700 B.C.E. –c. 1450 B.C.E. This is the Neo-Palatial period on Crete when Minoan civilization reaches its height, and it ends with another destruction of the palaces.

c. 1600 B.C.E. A new dynasty at Mycenae on mainland Greece begins to bury their dead in shaft graves with rich offerings, and Mycenae gives its name to the civilization which now develops on mainland Greece.

c. 1450 B.C.E. The palace at Cnossos on Crete is reinhabited by Greek-speaking people.

c. 1450 B.C.E. –c. 1200 B.C.E. The Mycenaean civilization is at its height; its trading ships ply the eastern Mediterranean and reach Sicily and Italy.

c. 1250 B.C.E. The Mycenaean Greeks attack Troy and destroy it.

c. 1200 B.C.E. –c. 1150 B.C.E. The Mycenaean palaces fall victim to raids by the "Peoples of the Sea."

c. 1150 B.C.E. –c. 1000 B.C.E. New migrants appear in Greece.

Greece emerges from this period with Dorians in control of the eastern Peloponnesos, Crete, and the southwest portion of Asia Minor, including Rhodes; the Ionians in control of Attica, the island of Euboea and the western central coastline of Asia Minor including the offshore island; and the Aeolians in control of Lesbos and a portion of the northern Asia Minor coastline.

950 B.C.E. –700 B.C.E. Vases are decorated with geometric patterns with circles, straight lines, meanders, and we find abstract representation in sculpture. This is known as the Geometric Period.

c. 900 B.C.E. Sparta is founded when four villages of Dorian Greeks in the Eurotas valley, Limnai, Mesoa, Kynosura, and Pitane unite to form a single settlement. The original inhabitants of the region are made helots, that is, serfs.

814 B.C.E. The Phoenician city of Tyre founds Carthage in modern Tunisia.

c. 800 B.C.E. –c. 550 B.C.E. The Indian Aryans continue their expansion on the Asian subcontinent, settling westward along the Gangetic

plain. During this period the first of the *Upanishads,* the chief mystical and philosophical scriptures of Hinduism, are composed.

798 B.C.E.
–782 B.C.E. The kingdom of Israel, led by Joash, wars with the Aramaean armies of Ben Hadad II, recovering territories formerly lost to Hazael of Damascus; Judah, including its capital at Jerusalem, subsequently falls to Joash as well, losing its independence.

776 B.C.E. The Olympic Games are founded, and we have a record of the victors from this date up to 217 C.E.

770 B.C.E. The Chou relocate their capital to Loyang, marking the beginning of the Eastern Chou Dynasty.

753 B.C.E. According to traditional sources, the city of Rome is founded by Romulus, the son of a princess of Alba Longa and the god Mars.

c. 750 B.C.E.
–550 B.C.E. The Greeks expand throughout the Mediterranean in this period, founding colonies in Sicily, southern Italy, southern France, eastern Spain, Libya, the north Aegean, and the Black Sea region.

743 B.C.E. Tiglath-pileser III of Assyria launches his first major campaign against neighboring states to the west, besieging the Urartean allies at Arpad.

c. 740 B.C.E.
–c. 720 B.C.E. Sparta under king Theopompus conquers Messenia, almost doubling her size and reducing the Messenians to helots.

731 B.C.E. Revolution breaks out in Babylon; Tiglath-pileser III returns from his western campaign in order to put it down.

722 B.C.E. Samaria falls to Assyria; Shalmaneser V is succeeded by his son, Sargon II, at whose orders thousands of Israelites are taken as captives into Mesopotamia.

c. 720 B.C.E. In China the Hung Kou (Great Ditch) is constructed, connecting a tributary of the Huai to the Yellow River.

709 B.C.E. Sargon II of Assyria sends Merodach-baladan into exile, declaring himself king in his place.

c. 700 B.C.E. After a lengthy and indecisive siege of Jerusalem, Hezekiah agrees to pay tribute to Sennacherib; Sidon and Tyre likewise submit to vassalage under Assyria.

Celtic peoples begin to settle in Spain.

c. 681 B.C.E. Esarhaddon, Sennacherib's son and heir, puts down a rebellion instigated by one of his brothers, who had murdered their father. Esarhaddon becomes king of Assyria.

668 B.C.E. Assurbanipal succeeds Esarhaddon as king of Assyria; a patron of Assyrian and Babylonian culture, he compiles a vast library of tablets chronicling literature, history, science, and religion.

663 B.C.E. Assyria captures Thebes, defeating Tanu-atamun and putting an end to Ethiopian power in Egypt. Psammetichus I becomes Pharaoh of the new dynasty; looking back to Old Kingdom Egypt for his model, he initiates what is known as the Saite Revival, a renaissance in religion, art, and literature.

c. 660 B.C.E.
–c. 640 B.C.E. The Messenians attempt to throw off their Spartan overlords with help from neighboring Achaea, Elis, and Argos. Sparta represses the revolt only with difficulty and thereafter develops into a militaristic state in order to maintain her domination of her helots.

657 B.C.E. Cypselus makes himself "tyrant" (dictator) of Corinth, driving out the aristocratic clan of the Bacchiads that had controlled the government of Corinth. The tyranny of Cypselus and his descendants lasts until 580 B.C.E.

642 B.C.E. According to tradition, Ancus Martius becomes king of Rome; during his reign he constructs a bridge over the Tiber River.

c. 624 B.C.E. Draco draws up the first written law code of Athens.

c. 616 B.C.E. Tarquinius Priscus, the first in a line of Etruscan rulers, becomes king in Rome; the Cloaca Maxima (a canal through Rome), the Temple of Jupiter Capitolinus, and the Circus Maximus (an arena for chariot racing) are all built under his reign.

611 B.C.E. Nabopolassar leads his armies against Harran, where Assuruballit II had been trying to muster his Assyrian forces; however, with his Median allies absent, Nabopolassar is unable to capture the Assyrian fortress.

609 B.C.E. The remaining Assyrian armies, allied with Egypt, attempt to recapture Harran, but without success. Neko II succeeds Psammetichus I in Egypt and leads his armies north to aid Assyria.

608 B.C.E. On his march north, Neko II meets Josiah of Judah at Megiddo. Josiah is killed and Judah conquered, but the Egyptian army is prevented from reaching their Assyrian allies in time to save them from defeat.

597 B.C.E. The Babylonian armies besiege Jerusalem. When it falls, after nearly three months, thousands of Israelites are taken captive to Babylon.

594 B.C.E. Solon is appointed sole archon to make necessary economic and constitutional reforms, and lays the foundations for the later Athenian democracy.

586 B.C.E. Jerusalem falls to Nebuchadnezzar, who razes the city and takes away captive to Babylon a second wave of Jews. This defeat marks the end of Judah as a nation.

578 B.C.E. Rome, under the reign of Servius Tullius, –534 B.C.E. enters the Latin League.

560 B.C.E. Pisistratus makes his first of three attempts to make himself tyrant of Athens.

559 B.C.E. Cyrus the Great ascends to power in Anshan, in what will later be known as Persia.

c. 551 B.C.E. Confucius is born.

c. 550 B.C.E. Celtic tribes begin to settle throughout Ireland, Scotland, and England.

Lao-tzu, traditionally the author of the *Tao Te Ching* and founder of Taoism, flourishes in China.

547 B.C.E. Cyrus II of the Achaemenid royal house of the Persians, who were vassals of the Medes, overthrows the king of the Medes, Astyaages, and unites the Medes and Persians under his rule.

547 B.C.E. Cyrus, king of Persia, overthrows Croesus, –546 B.C.E. king of Lydia, and absorbs the Greek cities on the coastline of Asia Minor into his empire.

546 B.C.E. Pisistratus finally succeeds in making himself tyrant of Athens and when he dies in 527 B.C.E. his son Hippias takes over as tyrant.

539 B.C.E. Cyrus the Great takes the city of Babylon, and the Jews in exile are released from their captivity.

534 B.C.E. Pisistratus establishes the great festival of the City Dionysia in Athens. Thespis from the deme—that is, the village—of Icaria wins first prize in the tragedy contest.

533 B.C.E. Cyrus the Great enters India, exacting tribute from cities in the Indus River Valley. He establishes, according to Herodotus, what will become the twentieth of the Persian satrapies, or provinces, in Gandhara.

520 B.C.E. The Jewish Temple at Jerusalem is rebuilt –515 B.C.E. at the insistence of the prophet Haggai.

510 B.C.E. A new temple of Apollo is completed at Delphi, with a help of a generous donation from the Athenian family of the Alcmaeonidae, who thus gain the favor of Delphi.

Roman tradition dates the exile of Tarquinius *Superbus* ("Tarquin the Proud"), the last king of Rome, to this year. Two elected consuls replace the king as the chief magistrates of the Roman state.

Sparta, at the urging of the Delphic oracle, forces the tyrant Hippias out of Athens.

509 B.C.E. The Roman republic is founded, according to traditional histories; Lucius Junius Brutus and Lucius Tarquinius Collatinus (Lucretia's husband) are made consuls. The Temple of Jupiter Optimus Maximus is constructed on the Capitoline Hill.

509 B.C.E.
–507 B.C.E. Under the leadership of Cleisthenes, who belongs to the family of the Alcmaeonidae, Athens establishes a form of democratic government based on equality before the law.

508 B.C.E. A contest in dithyrambic song and dance is established at the City Dionysia in Athens as distinct from tragedy, which had now developed into a dramatic presentation.

c. 500 B.C.E. The Bantu peoples of Africa begin their migrations.

Iron is introduced in China.

The Nok culture of West Africa begins to flourish.

A revolt against Persian rule breaks out in Ionia, led by Aristagoras of Miletus, and Athens and Eretria send help to the rebels.

496 B.C.E. The Roman dictator Postumius defeats the Latins at the battle of Lake Regillus. The Latin armies had been led by Lars Porsenna, allied with Tarquinius Superbus, the exiled king of Rome.

494 B.C.E. The Ionian rebel fleet is crushed by the Persian navy at the Battle of Lade, and the embers of the revolt are quickly extinguished.

490 B.C.E. The Athenians, with the help of their little neighbor Plataea, defeat a Persian expeditionary force led by Datis and Artaphrenes at the Battle of Marathon.

480 B.C.E. Xerxes I of Persia is defeated by the Greek navy at Salamis.

The Celtic tribes that had earlier spread through the British Isles in small numbers now begin to arrive en masse.

479 B.C.E. The Persian army led by Mardonius is defeated at the Battle of Plataea and in the same year, the Persian fleet is wiped out at the Battle of Mycale.

477 B.C.E. The Delian League is formed under the leadership of Athens to counter any future Persian expansionism.

472 B.C.E. The tragic poet Aeschylus produces *The Persians,* which is the earliest tragedy that has survived.

c. 450 B.C.E. Rome gets her first written law code, the Law of the Twelve Tables.

449 B.C.E. Hostilities with Persia cease, but Athens forces the Delian League allies to continue paying their annual tribute to the League treasury which Athens now uses to finance the Periclean building program.

447 B.C.E. Work begins on the Temple of Athena *Parthenos* (the Parthenon) on the Acropolis of Athens.

445 B.C.E. Athens concludes a Thirty-Years Peace with Sparta which recognizes Spartan hegemony in the Peloponnesos, and Athens and Sparta each pledge not to interfere in the other's sphere of influence.

444 B.C.E. Chinese mathematicians accurately calculate the length of the year at 365¼ days.

443 B.C.E.
–429 B.C.E. After the ostracism—exile for a ten-year term—of his last serious political opponent, Thucydides the son of Melesias, Pericles holds unchallenged power in Athens, being elected year after year to the committee of ten generals. His imperialist policy puts Athens on a collision course with Sparta.

437 B.C.E. Construction of the monumental entrance to the Athenian Acropolis (the "Propylaea") begins and it is completed five years later.

432 B.C.E. The Parthenon is completed and dedicated in Athens.

431 B.C.E. The Peloponnesian War breaks out between Athens and the Spartan alliance.

Euripides' tragedy, the *Medea,* is staged in Athens.

430 B.C.E. Plague breaks out in Athens, and within four years a third of the population, including Pericles, dies.

427 B.C.E. The philosopher Plato is born.

425 B.C.E. The Athenian comic poet Aristophanes produces his *Acharnians,* an anti-war comedy which is the earliest of his surviving plays.

421 B.C.E. The Fifty-Year Peace known as the "Peace of Nicias" after the Athenian who negotiated it, is concluded between Athens and Sparta, restoring the *status quo ante.*

Building begins on the temple on the Athenian Acropolis known as the Erechtheum.

415 B.C.E. Athens embarks on a great expedition to Sicily which is utterly destroyed two years later.

413 B.C.E. –404 B.C.E. In the last phase of the Peloponnesian War, Sparta occupies Decelea on Athenian territory and uses it as a base to lay waste Athenian territory and to encourage slaves to run away.

Persia supplies Sparta with subsidies to build a fleet to challenge the Athenian navy.

411 B.C.E. Athens introduces an oligarchic government to replace its democracy, but the Athenian navy refuses to accept the new constitution and the democracy is restored within the year.

c. 410 B.C.E. Celtic tribes later known to the Romans as Gauls begin their southward migration across the Alps.

409 B.C.E. In Sicily, the Carthaginians launch an offensive and destroy the cities of Selinus and Himera.

406 B.C.E. Athens wins her last victory of the war over the Spartan fleet at the Arginusae islands, but she puts the commanders of

her fleet to death for failing to rescue shipwrecked crews.

The tragic poets Sophocles and Euripides both die in this year.

405 B.C.E. In Sicily, the Carthaginians conquer Acragas, modern Agrigento, and advance on Syracuse. The Greek cities unite under the tyrant of Syracuse, Dionysius I, and resist the Carthaginian advance.

The Spartan fleet under Lysander captures the Athenian fleet at Aegospotami (Goat's River).

404 B.C.E. Athens capitulates and Sparta takes over the Athenian Empire except for the Greek cities on the coastline of Asia Minor which are returned to Persia.

Sparta controls the cities in her empire by setting up pro-Spartan oligarchic governments in them, which were supported by garrisons under Spartan governors called *harmosts.*

403 B.C.E. Thrasybulus restores democracy in Athens with the acquiescence of the Spartan king Pausanias.

401 B.C.E. On the death of the king of Persia, Darius II, his son Artaxerxes II succeeds to the throne but his younger brother Cyrus rebels, recruits an army including ten thousand Greek mercenaries under a Spartan commander, Clearchus, and advances into the heart of Mesopotamia as far as Cunaxa, where Cyrus is killed in battle with Artaxerxes. The Greek mercenary force retreats north to the Black Sea coast under the leadership of the Athenian Xenophon.

399 B.C.E. Socrates is condemned to death on a charge of corrupting the Athenian youth and introducing new gods.

399 B.C.E. –394 B.C.E. Sparta renews war against Persia to free the Ionian cities but with limited success.

396 B.C.E. In Italy, Rome, after a war of ten years, conquers and destroys the city of Veii, further up the Tiber River from Rome,

Arts and Humanities Through the Eras: Ancient Greece and Rome (1200 B.C.E.–476 C.E.)

xix

which had blocked Rome's northward expansion.

395 B.C.E.
–387 B.C.E.
A coalition of Athens, Corinth, Thebes, and Argos, subsidized by Persia, fights Sparta and, in 394, a Spartan fleet is defeated off the island of Cnidus by a Persian fleet led by the Athenian Conon who then sails to Athens and rebuilds the fortifications which had been destroyed at the end of the Peloponnesian War.

In the same year, Sparta defeats an anti-Spartan coalition at Coronea and, faced with signs that Athenian power is reviving, Persia and Sparta settle their differences.

390 B.C.E.
The Romans are defeated by Gallic invaders, led by the Brennus, at the battle of Allia. The city of Rome is subsequently besieged, and only the Capitol does not fall. Following the conquest of the Gauls, the Latins and the Hernici end their alliance with Rome.

387 B.C.E.
In Italy, Rome is sacked by a tribe of Gauls (Celts) who besiege the Capitol and withdraw with much booty only after receiving ransom.

Athens and Sparta sign a peace mediated by the Persian king—hence it is called the "King's Peace" or the "Peace of Antalcidas" after the Spartan admiral who was the chief negotiator. Persia keeps control of the Greek cities in Asia Minor but guarantees the freedom of the rest of the Greek cities.

386 B.C.E.
Plato founds the Academy in Athens where he is to teach for the rest of his life.

382 B.C.E.
In a surprise attack, Sparta occupies the Cadmeia, that is, the acropolis of Thebes, and places a garrison there.

c. 380 B.C.E.
In Rome, after the sack by the Gauls, a fortification wall—the so-called Servian wall—is erected around the Seven Hills which make up the core of the city.

379 B.C.E.
A troop of young Thebans surprises the Spartan garrison on the Cadmeia and

overpowers it, and war between Thebes and Sparta follows.

Thebes, led by Pelopidas and Epaminondas, aims at uniting all Boeotia under her leadership.

377 B.C.E.
Athens establishes a new naval alliance of sixty autonomous members designed to resist Spartan imperialism.

371 B.C.E.
Sparta and Athens sign a general peace, but Thebes will not sign for the terms of the peace would force her to undo the unification of Boeotia. Sparta therefore orders King Cleombrotus who had an army in Boeotia to attack Thebes, and the Theban army under Epaminondas inflicts a disastrous defeat on the Spartans at the battle of Leuctra.

371 B.C.E.
–362 B.C.E.
Thebes, under the leadership of Pelopidas and Epaminondas, is the chief military power in Greece.

A Theban army frees Messenia from Spartan control, thereby depriving Sparta of half its territory.

367 B.C.E.
The young Aristotle comes to Athens and becomes a pupil of the philosopher Plato. He remains a member of Plato's Academy for twenty years until Plato's death.

362 B.C.E.
Thebes defeats a Spartan-Athenian alliance at the Battle of Mantineia, but the Theban statesman and military genius Epaminondas is killed in the battle.

359 B.C.E.
Philip II becomes king of Macedon on his brother's death.

358 B.C.E.
In Italy, the Samnites, a warlike Italic people in south-central Italy, expand their territory to the western coast of Italy and form a league.

356 B.C.E.
To defend against the Huns, China constructs its first wall along its borders; along with others to be built later, it will serve as part of the Great Wall.

347 B.C.E.
Plato dies and is succeeded as head of the Academy by Speusippus, the son of Plato's sister.

343 B.C.E.
–341 B.C.E. In Italy, war—the so-called First Samnite War—breaks out between Rome and the Samnites, an Italic people in south-central Italy, sparked by an alliance which Rome made with Capua. The war ends with a compromise peace.

342 B.C.E. Aristotle goes to Macedon as tutor to the young Alexander the Great, son of king Philip II of Macedon.

340 B.C.E.
–338 B.C.E. The Latin League, a coalition of cities in Latium allied to Rome, attempts to end the alliance and Rome, with Samnite help, crushes their separatist revolt, dissolves the Latin League and instead makes separate alliances with the individual Latin cities.

339 B.C.E.
–329 B.C.E. Chuang-tzu, a major interpreter of Taoism and celebrated literary stylist, flourishes in China.

338 B.C.E. At Chaeronea in Greece, Philip of Macedon defeats the combined armies of Athens and Thebes. Thebes is punished severely; Athens gets lighter terms.

337 B.C.E. The League of Corinth is formed under Philip of Macedon's patronage. The League names Philip leader and supreme general, guarantees autonomy to all cities, and resolves to make war on Persia to avenge the Persian invasion of Greece in 480 B.C.E.

336 B.C.E. Philip is assassinated, and his son Alexander the Great becomes king.

335 B.C.E. Thebes revolts from Macedon on hearing of Philip's death, and is vanquished by Alexander, who enslaves the citizens of Thebes and destroys the city, sparing only the house of the poet Pindar.

Aristotle returns to Athens and founds the Lyceum where he spends the next eighteen years teaching, writing, and doing research.

334 B.C.E. Alexander launches his campaign against the Persian Empire, defeating the Persian satraps of Asia Minor at the Granicus River in May, and following up his victory by capturing the Greek cities along the Asia Minor coast, and then striking east through Caria, and Phrygia to Cilicia. He replaces the Persian satraps with Macedonian officers to rule the conquered territory.

333 B.C.E. Alexander defeats the Persian king Darius III Codomannus at the Battle of Issus. Refusing an offer of peace from Darius, he proceeds with the conquest of Syria.

332 B.C.E. Alexander takes the Phoenician city of Tyre after a seven-month siege, and then thrusts down the Mediterranean coast to Egypt where he passes the winter. While there, he visits the shrine of Zeus Ammon at the Siwa Oasis, where the high priest greets him as the son of Zeus.

331 B.C.E. Antipater, whom Alexander had left behind as his deputy in Macedonia, suppresses a revolt of Sparta in Greece.

Alexander defeats Darius III at the Battle of Gaugamela, and forces him to flee the battlefield.

The satrap of Babylon, Mazaeus, surrenders and joins Alexander, who seizes the Persian treasure in Babylon and Susa.

Alexander the Great founds the city of Alexandria in Egypt.

330 B.C.E. Alexander captures and burns the Persian ceremonial capital of Persepolis, thus marking the completion of the panhellenic campaign to avenge Xerxes' invasion of Greece in 480 B.C.E.

330 B.C.E.
–329 B.C.E. Alexander pursues Darius who is taken prisoner by the satrap Bessus, and catches up to him too late to prevent his murder by Bessus, who now assumes the title of king.

Alexander proclaims himself the successor to the Achaemenid royal line of Persia.

One of Alexander's generals, Philotas, is implicated, probably wrongly, in a supposed conspiracy against Alexander and is executed; as a precaution, Alexander also

orders the death of Philotas' father, Parmenio, who had served under Alexander's father, Philip of Macedon.

329 B.C.E. Alexander conquers eastern Iran.

Bessus is captured and executed.

328 B.C.E. Alexander campaigns in Sogdiana where he meets and marries Roxane, the daughter of a Sogdian baron.

Alexander introduces Persian court ceremonial, including *proskynesis*, that is, kowtowing before the king, which the Macedonians and Greeks in his retinue oppose.

327 B.C.E. The so-called "Pages Conspiracy" is suppressed and Alexander's court historian, Callisthenes, the nephew of Aristotle, is put to death.

Alexander pushes on through modern Afghanistan towards India.

327 B.C.E. –325 B.C.E. Alexander the Great invades India.

326 B.C.E. In Italy, a second war breaks out between Rome and the Samnites.

Alexander defeats the Indian rajah Porus at the Hydaspes River in northern India, and then pushes on until a mutiny on the Hyphasis River forces him to turn back. He fights his way down the mouth of the Indus River where he builds a fleet, and embarking part of his army on it, sends it back along the coast to the mouth of the Tigris and Euphrates rivers while he himself leads the bulk of his army through the desert regions of Gedrosia and Carmania to Persepolis.

324 B.C.E. At Susa, Alexander pushes ahead with a plan to create a mixed Macedonian-Persian elite by marrying eighty of his officers to Asian women and arranging the marriages of ten thousand of his soldiers to Asians— he himself marries the daughter of Darius III.

After a mutiny at Opis, Alexander reorganizes the empire, giving Persians and Macedonians equal rights.

Currency is standardized throughout the empire, thus laying the basis for the great expansion of the economy in the Hellenistic world.

323 B.C.E. Alexander dies at Babylon on the eve of setting out on a new expedition. Perdiccas, to whom Alexander gave his signet ring on his deathbed, becomes regent and guardian of the kings: Alexander's half brother, Arrhidaeus, and Alexander's son, as yet unborn—Roxane is pregnant when Alexander dies.

Alexander's generals—the so-called *Diadochoi* (Successors)—carve out domains for themselves: Antipater, who was left to rule Macedonia in Alexander's absence, takes Macedonia and Greece, Antigonus the One-Eyed takes Phrygia and Lycia, Ptolemy Egypt and Lysimachus Thrace, while Eumenes, Alexander's secretary, throws his support behind Perdiccas.

On learning of Alexander's death, Greece tries to throw off the Macedonian yoke in the so-called Lamian War, but the insurrection is crushed by Antipater. The Athenian democracy is suppressed, the anti-Macedonian leaders are killed, and Demosthenes commits suicide to avoid capture.

321 B.C.E. In the Second Samnite War, Rome suffers a humiliating reverse at the Caudine Forks but does not accept defeat.

The *Via Appia* (Appian Way) is constructed south from Rome as a supply-line for the Roman army.

320 B.C.E. In the spring, Perdiccas marches with an army against Egypt to dislodge Ptolemy, but is killed by his own troops as he attempts to cross the Nile Delta.

The *Diadochoi* hold a conference at Triparadeisos ("Three Parks") in Syria.

Antipater replaces Perdiccas as guardian of the kings, Ptolemy is left in Egypt, Antigonus the One-Eyed, with Antipater's son Cassander on his staff, is put in command of the Macedonian forces in Asia with the assignment of eliminating Eumenes, and Seleucus gets the satrapy of Babylon.

317 B.C.E. Alexander the Great's mother Olympias invades Macedon with an army from Epirus to defend Alexander IV, the son of Alexander and Roxane, and executes Philip Arrhidaeus, his wife Eurydice, and about a hundred of their supporters.

Cassander invades Macedon to dislodge Olympias.

317 B.C.E. –307 B.C.E. Cassander appoints the Aristotelian philosopher, Demetrius of Phalerum, to rule Athens as his deputy. When he is driven out by Demetrius Poliorcetes, he goes to Egypt where he advises Ptolemy on the establishment of the Great Library of Alexandria.

316 B.C.E. Eumenes is forced back into the eastern satrapies, fights an indecisive battle at Paraetacene, and in its aftermath, is betrayed to Antigonus and executed.

316 B.C.E. –301 B.C.E. Antigonus the One-Eyed, now in control of Asia after the death of Eumenes, and his son, Demetrius Poliorcetes (Besieger of Cities), make a bid to take over Alexander's empire.

312 B.C.E. Ptolemy of Egypt, to counter the ambitions of Antigonus the One-Eyed, reinstalls Seleucus as satrap of Babylon.

The Seleucid dynasty counts this date as Year One of the Seleucid era which continues to be used in the Middle East long after the dynasty falls.

307 B.C.E. Demetrius, son of Antigonus the One-Eyed, attempts to capture Rhodes—the siege gives him his sobriquet "Poliorcetes" (Besieger of Cities) because of the siege engines that he and his engineers designed to breach the Rhodian defenses.

To commemorate their victory, the Rhodians build the Colossus of Rhodes, one of the Seven Wonders of the Ancient World.

304 B.C.E. Rome emerges victorious from the long, hard-fought Second Samnite War, and annexes Campania, the region between Rome and Naples, thus preventing further expansion of the Samnite League.

301 B.C.E. Lysimachus, Cassander and Seleucus eliminate Antigonus the One-Eyed at the Battle of Ipsos, though Demetrius Poliorcetes escapes. Four Hellenistic kingdoms result: Macedon under Cassander, Thrace and Asia Minor under Lysimachus, Egypt and Palestine under Ptolemy, and the Persian heartlands and northern Syria under Seleucus.

298 B.C.E. In Italy, the Third Samnite War breaks out. Rome faces a coalition of Samnites, Etruscans, Celts, Sabines, Lucanians, and Umbrians.

297 B.C.E. In Macedon, Cassander dies, and his death is followed by disorder as Pyrrhus of Epirus, Demetrius Poliorcetes, as well as Cassander's own sons make bids for the throne of Macedon.

295 B.C.E. In Italy, Rome wins a victory over a coalition of Etruscans and the Celts at the Battle of Sentinum, and the Etruscans make a separate peace with Rome.

290 B.C.E. Rome makes peace with the Samnites who are now required to serve in Rome's army.

286 B.C.E. In Greece, Lysimachus adds Macedon to his kingdom.

285 B.C.E. –282 B.C.E. Rome secures control of central Italy by defeating the Celtic tribe of the Senones.

282 B.C.E. War breaks out between Rome and the Greek city of Tarentum, modern Taranto, when Rome encroaches on Tarentum's sphere of influence.

281 B.C.E. In Asia Minor, Seleucus defeats Lysimachus at the Battle of Corupedion and takes over his realm, including Macedon.

Arts and Humanities Through the Eras: Ancient Greece and Rome (1200 B.C.E.–476 C.E.)

xxiii

280 B.C.E. Tarentum brings Pyrrhus, king of Epirus, with an army of mercenaries into Italy where he defeats the Romans at the battle of Heraclea.

Seleucus is assassinated by Ptolemy the Thunderbolt, a renegade son of king Ptolemy I of Egypt. Ptolemy becomes king of Macedon while Seleucus' son Antiochus inherits his father's realm in Asia.

279 B.C.E. A horde of Celts, otherwise known as Gauls, invade Macedon, defeating and killing Ptolemy the Thunderbolt, thus leaving Macedon without a king. The Celtic horde pushes down into Greece, bypassing Thermopylae and making for Delphi, but are stopped by the guerilla resistance of the Aetolian League in northwest Greece.

In Italy, Pyrrhus of Epirus inflicts a second defeat on the Romans at Ausculum, where his heavy casualties give rise to the aphorism "Pyrrhic Victory," a victory that is as costly as a defeat. The Roman senate refuses Pyrrhus' offer of peace.

278 B.C.E. –275 B.C.E. Pyrrhus campaigns against the Carthaginians in Sicily in the employ of the Greek cities. He forces the Carthaginians back into their fortress at Lilybaeum, modern Marsala, but cannot take it, and his ambition to create a Sicilian kingdom for himself is thwarted by the Greek cities.

278 B.C.E. A horde of Celts is brought into Asia Minor by Nicomedes of Bithynia who hopes to use them against Seleucus' heir, Antiochus I, so as to secure the independence of the Bithynian kingdom in northwest Asia Minor. The Celts (or Gauls) soon become a menace to Greek Ionia.

275 B.C.E. King Antiochus I, the son of Seleucus, defeats the Celts in the "Battle of the Elephants," so-called because Antiochus used an elephant corps in his army, but then Antiochus shifts his attention to war with King Ptolemy II of Egypt, and the credit for keeping the Celtic raids in check goes to Philetaerus, a eunuch whom Lysimachus left in charge of his treasure in the citadel of Pergamum, but after Lysimachus' death begins to act independently.

Pyrrhus returns to Italy with a depleted army and is defeated by the Romans at Beneventum, after which he returns to Greece.

274 B.C.E. Antigonus Gonatas, son of Demetrius Poliorcetes, on the strength of a defeat which he inflicts on the Celts at the Dardanelles, occupies the vacant throne of Macedon where the Antigonid dynasty will rule until the last king, Perseus, is dethroned by the Romans in 167 B.C.E.

272 B.C.E. Tarentum surrenders to Rome and the Greek cities of southern Italy become allies of Rome.

264 B.C.E. The First Punic War begins, pitting Carthage against Rome. The two powers fight for control of colonies on the island of Sicily.

263 B.C.E. In Asia Minor, Eumenes I, the nephew and successor of Philetaerus, inherits the rule of Pergamum, nominally as a governor of King Ptolemy II of Egypt.

260 B.C.E. –253 B.C.E. Antiochus II regains much of the territories in Asia Minor lost by Antiochus I, during the Second Syrian War against Ptolemy II of Egypt. Pergamum remains independent.

260 B.C.E. Rome wins a naval battle over the Carthaginian fleet off Mylae in northeast Sicily, using a grappling-iron called the *corvus* which allowed the Romans to use boarding tactics effectively against the Carthaginian ships.

256 B.C.E. The Romans win another naval victory off Cape Ecnomus in southern Sicily, and then make a landing in Africa and defeat the Carthaginians.

Xanthippus, a mercenary soldier from Sparta, reorganizes the Carthaginian army and defeats the Romans at the Battle of Tunis the next year and forces its surrender.

The Chou dynasty in China ends. The Chou is the longest dynasty in Chinese history, lasting for 771 years.

251 B.C.E. Aratus of Sicyon adds Sicyon to the Achaean Confederacy. He is an aggressive general of the Confederacy and later adds such city-states as Megalapolis (235) and Argos (229).

250 B.C.E. A newly-built Roman fleet is victorious at Panormus, modern Palermo, but is defeated next year at Drepanum, modern Trapani.

In Bactria (eastern Iran), Greeks whose ancestors had been settled there by Alexander the Great acclaim their general Diodotus as king. The kingdom lasts more than a century, though in its final years it splits into two kingdoms under rival kings.

246 B.C.E. The Third Syrian War is fought between
–241 B.C.E. Ptolemy III (Euergetes) of Egypt and the Seleucid king Seleucus II, who had replaced Antiochus II.

241 B.C.E. Attalus I succeeds Eumenes I of Pergamum. For refusing tribute to the Galatians, he is given the name Soter ("Savior"). Under Attalus, Pergamum becomes an important power and is pivotal to Roman politics in Greece and Asia Minor.

Hamilcar Barca is defeated by the Romans at the Aegates Islands. The First Punic War ends.

238 B.C.E. Carthaginian mercenaries on Sardinia who are in revolt appeal for assistance to Rome, which forces Carthage to cede her the island.

237 B.C.E. Carthage, under the leadership of Hamilcar Barca, begins to expand her empire in Spain. Hamilcar Barca, accompanied by his ten-year-old son, Hannibal, conquers southern and eastern Spain. The new Punic outposts in the region challenge Roman hegemony.

232 B.C.E. Ashoka, the Buddhist monarch of the Maurya empire in India, dies.

227 B.C.E. Rome unites Sardinia with Corsica to form her second province.

226 B.C.E. Hasdrubal, the successor of his father-in-law of Hamilcar Barca as Carthaginian commander in Spain, makes a treaty with Rome agreeing not to expand north of the Ebro River, but Rome follows this by making an alliance with Saguntum south of the Ebro.

223 B.C.E. Antiochus III (the Great) begins his rule over the Seleucid kingdom. He expands the dynasty to Armenia, and he regains Parthia and Bactria.

221 B.C.E. Hasdrubal is murdered, and Hamilcar Barca's eldest son Hannibal becomes Carthaginian commander in Spain.

219 B.C.E. Hannibal captures Saguntum, an ally of Rome. Rome demands that Carthage relinquish Saguntum and surrender Hannibal to them, and when Carthage refuses, declares war.

218 B.C.E. The Second Punic War begins. Hannibal crosses the Pyrenees mountains, marches through southern France and over the Alps into Italy with 50,000 men, 9,000 cavalry, and 37 war-elephants. In the autumn he defeats the consul Publius Cornelius Scipio at the Ticinus River in the foothills of the Alps. The other consul joins Scipio and both are defeated at the Trebia River in December.

217 B.C.E. Hannibal defeats the consul Gaius Flaminius at Lake Trasimene. Quintus Fabius Maximus is appointed dictator for a six-month term and avoids battle with Hannibal.

216 B.C.E. At Cannae, Hannibal inflicts a disastrous defeat on the Romans, led by the consuls of the year, after which Rome adopts more cautious tactics, avoiding battle with Hannibal.

215 B.C.E. In the aftermath of Rome's defeat at Cannae, King Philip V of Macedon makes an alliance with Hannibal, and to stymie Philip, Rome makes an alliance with the

Aetolian League and initiates the First Macedonian War between Rome and Macedon.

In Sicily, Rome's old ally King Hiero of Syracuse dies, and under his successor Syracuse goes over to Carthage.

Led by the consul Marcellus, Rome lays siege to Syracuse, which defends itself with war engines designed by Archimedes who is living in Syracuse.

214 B.C.E. The First Macedonian War begins with Philip V's attack on Messene.

Construction of the Great Wall of China begins when smaller, pre-existing frontier walls are linked together and strengthened. The purpose of the wall is to keep out the Hsiung-nu, nomads from the north of China (Mongolia).

212 B.C.E. Syracuse is captured and, in the sack that follows, Archimedes is killed.

Carthage abandons Sicily.

207 B.C.E. Hannibal's brother Hasdrubal brings reinforcements for Hannibal across the Alps, but is defeated and killed at the Metaurus River in northeast Italy.

206 B.C.E. The Romans under the young Publius Cornelius Scipio win control of Spain.

Hannibal's youngest brother Mago takes the Carthaginian fleet from Spain to Genoa to urge the Celts and Ligurians in northern Italy to rise against Rome.

205 B.C.E. Scipio returns from Spain and is elected consul.

Philip V of Macedon and Rome make peace, the so-called "Peace of Phoenice," Rome having withdrawn her troops from Greece two years before.

204 B.C.E. Scipio leads an army to Africa, forcing Carthage to seek peace. Peace negotiations lead to Hannibal's recall from Italy.

202 B.C.E. Peace negotiations having broken down, there is a decisive battle between the Romans led by Scipio and the Carthaginians led by Hannibal at Zama, where the Carthaginians are beaten. Rome imposes a huge indemnity as part of the peace terms.

201 B.C.E. The Second Punic War ends. Carthage signs a treaty with Rome, surrendering its navy and its territories in Spain.

200 B.C.E. King Antiochus III defeats the army of King Ptolemy V of Egypt at the Battle of Panion and annexes southern Syria and Palestine which had hitherto belonged to Egypt. Jerusalem now falls under Seleucid rule.

Rome, having received appeals from Pergamum, Rhodes, and Athens against Philip V's expansionism, sends a army and navy to Greece, thus beginning the Second Macedonian War.

Volcanic islands in the South Pacific are settled by seafaring peoples emigrating from Southeast Asia.

The Hopewell culture begins to emerge in central North America in what will become the states of Ohio and Illinois; this society is characterized by mound-building.

197 B.C.E. A Roman army under Titus Quinctius Flamininus advances into Thessaly and at the battle of Cynoscephalae defeats Philip V, who is made to retreat to his own kingdom, pay an indemnity and surrender all his fleet except for six ships.

196 B.C.E. At the Isthmian Games, Flamininus proclaims that all the Greek cities should be free, and two years later Roman troops leave Greece.

192 B.C.E. War breaks out with the Seleucid king Antiochus III, who is decisively defeated two years later at Magnesia south of Pergamum in Asia Minor.

188 B.C.E. The Peace of Apamea imposes stiff terms on Antiochus III, thus starting the decline of the Seleucid empire, and Rome is now mistress of the eastern Mediterranean.

c. 185 B.C.E. The Sungas replace the Mauryas as the ruling empire in India. Pusyamitra becomes the first Sunga ruler and returns India from Buddhism to orthodox Hindu.

175 B.C.E. Antiochus IV *Epiphanes* ("God made Manifest") becomes king of the Seleucid empire and attempts to halt its decline. His effort to have himself recognized as divine and receive sacrifice as a god leads to a rebellion of conservative Jews in Judaea, known as the "Maccabean Revolt" after its leader, Judas Maccabaeus.

171 B.C.E. The Third Macedonian War begins between Rome and Perseus, son of Philip V, king of Macedon.

168 B.C.E. After some initial setbacks, Lucius Aemilius Paulus defeats Perseus at the Battle of Pydna. Perseus is taken as a prisoner to Rome and the kingdom of Macedonia is dissolved. Polybius of Megalopolis is one of one thousand hostages from the Achaean League brought to Rome, and while there he composes his *Universal History* in 39 books.

164 B.C.E. The Maccabees reconsecrate the temple in Jerusalem. The event is from this date commemorated as Hanukkah.

Antiochus IV dies.

149 B.C.E. A third war breaks out between Rome and Carthage.

149 B.C.E.
–148 B.C.E. An anti-Roman revolt breaks out in Macedon and after it is suppressed, Macedon becomes a Roman province in 146 B.C.E.

146 B.C.E. A Roman army under Publius Scipio Aemilianus captures Carthage and destroys it.

Rome suppresses a revolt of the Achaean League in Greece and destroys the city of Corinth. The territories of the Achaean League are annexed, and Rome makes Greece into a Roman province named Achaea.

141 B.C.E. A period of Jewish independence in Judaea begins. Simon Maccabaeus becomes high priest after the murder of his brother Jonathan.

Han Wu-ti is emperor in China. He is an innovator in education, economics, and defense. He introduces a public granary to China and makes innovations to the cavalry.

136 B.C.E.
–132 B.C.E. A slave revolt breaks out in Sicily led by a Syrian slave, Eunus, who is captured after Enna and Tauromenium, two centers of the revolt, fall to Rome. An estimated twenty thousand slaves are crucified.

133 B.C.E. Attalus III, the last king of Pergamum, dies and bequeaths his kingdom to Rome. Tiberius Sempronius Gracchus is elected as tribune (an annual office) and attempts a land reform to settle poor Roman citizens on small farms, and the royal treasure of Pergamum is used to pay the costs of this measure. While attempting to secure his election to a second term as tribune, which his opponents claimed was unconstitutional, Gracchus is killed.

130 B.C.E. An anti-Roman revolt is suppressed in Pergamum which its last king had bequeathed to Rome, and Pergamum is organized as the Roman province of Asia.

129 B.C.E. The death of Antiochus VII marks the end of Seleucid power in the eastern region. The Parthians are left as the major power east of Babylon.

123 B.C.E.
–122 B.C.E. Gaius Gracchus, Tiberius' younger brother, renews the land reform started by Tiberius, but loses voter support when he attempts to extend citizenship to Rome's allies. When Gracchus' party occupies the Aventine Hill, the senate declares martial law, Gracchus' supporters are slain, and Gracchus has his slave kill him.

112 B.C.E.
–105 B.C.E. The Jugurthine War in Numidia brings the incompetence of the senatorial government in Rome into sharp focus. Jugurtha is finally defeated by Marius in 106 B.C.E. and next year surrenders to Lucius Cornelius Sulla.

113 B.C.E.
–101 B.C.E. The Cimbri and Teutones migrate from Jutland into Gaul (modern France) and three times defeat the Roman armies they encounter. There is panic in Rome, and

Marius returns from Africa, is elected consul and is re-elected to successive consulships until 100 B.C.E. He reforms the Roman army so that it is no longer recruited from property owners but rather from the landless proletariat who expect to be settled on small farms when they are demobilized.

102 B.C.E. Marius with his reformed army defeats the Teutones at Aquae Sextiae (modern Aix-en-Provence) in southern France.

c. 100 B.C.E. The Belgae, a Gallic people, arrive in Britain.

The city of Teotihuacán, twenty-five miles from modern Mexico City, emerges as a major commercial center; it is the home of the Pyramid of the Moon and Pyramid of the Sun, the latter being the largest building in pre-Columbian America.

91 B.C.E. A tribune, Marcus Livius Drusus, proposes reviving the Gracchan land reform and extending Roman citizenship to Rome's Italian allies, but is assassinated.

91 B.C.E. Drusus' assassination triggers a revolt of
–89 B.C.E. Rome's Italian allies, who were eager for citizen rights and are now bitterly disappointed. They form an independent federation of their own, and the civil war that results ends only when Rome concedes them citizenship.

88 B.C.E. Mithridates VI attacks the Roman province of Asia, and urges the Greeks to rebel against the hated Roman officials and taxation agents. Eighty thousand Romans in Asia Minor are killed in the massacre that results. The Roman senate places Sulla in charge of the war against Mithridates, but the popular assembly transfers the command to Marius. Sulla marches with his army on Rome, drives out Marius' supporters, reestablishes the rule of the senate and then leaves to conduct the war against Mithridates.

87 B.C.E. Once Sulla is gone, Marius with his supporters returns to Rome, massacres his political opponents, and is elected consul for the seventh time.

87 B.C.E. In Greece, Sulla besieges and captures
–86 B.C.E. Athens, which had supported Mithridates, and after the capture many Greek works of art are shipped to Rome.

Plato's Academy closes down.

86 B.C.E. Marius dies shortly after taking up his seventh consulship.

Sulla defeats Mithridates' army at Chaeronea in Greece, and again next year at Orchomenos.

83 B.C.E. Sulla returns to Italy and destroys the Marian supporters and their allies, the Samnites and Lucanians, next year at the Battle of the Colline Gate, one of Rome's city gates.

82 B.C.E. Sulla, assuming the office of dictator,
–79 B.C.E. draws up a list of enemies to be killed, including ninety senators and two thousand six hundred equestrians, and then reforms the constitution, placing control of the Roman government in the hands of the senate which is dominated by a tight group of old Roman families.

c. 80 B.C.E. Invaders from Central Asia begin to spread throughout the Indus River valley. Chinese silk increasingly becomes a major luxury import to wealthy provinces such as Roman Egypt.

79 B.C.E. Sulla resigns the dictatorship voluntarily and dies a year later.

78 B.C.E. On Sulla's death, one of the consuls of the year, Marcus Aemilius Lepidus attempts to undo Sulla's constitutional reforms, and when he turns to armed rebellion, the senate grants one of Sulla's young officers, Gnaeus Pompeius (Pompey), extraordinary powers to suppress him.

77 B.C.E. Pompey persuades the senate to grant him
–71 B.C.E. a special command to suppress an insurrection in Spain led by one of Marius' former officers, Quintus Sertorius, which Pompey accomplishes after Sertorius is betrayed and assassinated.

74 B.C.E. War with Mithridates VI, king of Pontus, having broken out again, a former supporter of Sulla, Lucius Licinius Lucullus, is sent to suppress it and is initially very successful.

73 B.C.E. A gladiator, Spartacus leads an uprising of
–71 B.C.E. slaves in Italy. The revolt is suppressed by Marcus Licinius Crassus, and the remnants of the slave army are wiped out by Pompey who encounters them as he returns to Italy from Spain.

70 B.C.E. Pompey and Crassus, both successful commanders with armies to support them, demand the consulship and once they are elected consuls, they dismantle Sulla's constitutional reforms.

The Roman poet Vergil is born in the village of Andes near Mantua in the province of Cisalpine Gaul.

68 B.C.E. Pompey is given an extraordinary command to repress piracy in the eastern Mediterranean which he does efficiently within six months.

66 B.C.E. Pompey is sent to replace Lucullus, de-
–63 B.C.E. feats Mithridates, conquers most of Asia Minor and advances down the Mediterranean coast as far as the border of Egypt. He takes Jerusalem and enters the Holy of Holies of the Jewish Temple, thereby earning the hatred of the Jews.

63 B.C.E. Marcus Tullius Cicero, famous as a statesman, orator, and author of works on philosophy and politics, is one of the two consuls of the year, and during his consulship, suppresses a conspiracy led by Lucius Sergius Catilina.

60 B.C.E. Pompey, Crassus, and Julius Caesar form the so-called "First Triumvirate," an unofficial three-man coalition to further their several political goals.

59 B.C.E. With the support of the First Triumvirate, Julius Caesar is elected consul with a diehard senatorial, Bibulus, as his colleague. Caesar carries out Pompey's political agenda and is himself granted rule of the provinces of Cisalpine Gaul (Italy north of the Rubicon River), Narbonese Gaul (southern France), and Illyricum (modern Croatia and Serbia) for a five-year term.

58 B.C.E. Caesar conquers all of Gaul (modern
–51 B.C.E. France) and crosses the English Channel twice to make probe into Britain.

56 B.C.E. Julius Caesar, Pompey, and Crassus renew their political coalition, agreeing that Pompey and Crassus will both be consuls for the next year and then be given provincial governorships, while Caesar would rule Gaul for an additional five years. Pompey marries Caesar's daughter Julia to cement the alliance.

55 B.C.E. Pompey and Crassus hold the consulship, and then Pompey is made governor (proconsul) of Spain for a five-year term, and Crassus of Syria, where he plans to win military laurels by attacking the Parthians. Pompey remains in Rome and governs Spain with legates who act as his representative.

Britain faces a Roman invasion under Caesar.

52 B.C.E. Because of the gang warfare in Rome, Pompey is elected consul with no colleague to keep law and order, and at the end of his term, he is granted the governorship of Spain for five more years.

51 B.C.E. Uxellodunum becomes the last town in Gaul to succumb to Caesar. The Roman wars against Gaul end.

49 B.C.E. The Roman senate, having refused to accept Caesar's request to be allowed to stand for the consulship *in absentia*, thus allowing him to avoid prosecution for illegal acts during his consulship, decrees that Caesar must resign his command, and commissions Pompey to defend the republic. Caesar crosses the Rubicon River separating the province of Cisalpine Gaul from Italy, and heads for Rome, while Pompey evacuates Italy for Greece. Rather than follow Pompey, Caesar goes to Spain and smashes Pompey's armies there within six months.

48 B.C.E. Caesar defeats Pompey at the Battle of Pharsalus in Greece. Pompey flees to Egypt where he is put to death by the boy king Ptolemy XIII on the advice of his ministers who thought that thus they would win Caesar's favor.

Caesar comes to Egypt in pursuit of Pompey, where he makes the young princess Cleopatra his mistress and becomes embroiled in a war with Ptolemy XIII and the Alexandrians.

47 B.C.E. Cleopatra gives birth to a son by Julius Caesar: Ptolemy Caesar, commonly known as "Caesarion" (Little Caesar).

Having established Cleopatra on the throne of Egypt, Julius Caesar goes to Asia Minor, defeats Pharnaces, the son of Mithridates VI and a supporter of Pompey, at Zela (Zila in north-central Turkey) and sends dispatch to Roman senate reading, *Veni, vidi, vici* ("I came, I saw, I conquered").

Caesar lands in Africa to suppress Pompey's supporters who had rallied there for a last-ditch effort to "save the republic."

46 B.C.E. Caesar smashes the Pompeian resistance in Africa at the Battle of Thapsus.

Caesar returns to Italy, becomes dictator for ten years, introduces a number of reforms including the Julian Calendar which fixes the year at 365 days with an extra day every four years, and in November leaves for Spain to suppress resistance led by Pompey's sons.

45 B.C.E. At Munda southeast of Seville in Spain, Caesar defeats the last resistance of the Pompeians.

44 B.C.E. Julius Caesar is assassinated by a cabal of senators led by Marcus Junius Brutus and Gaius Cassius Longinus.

Octavian, the great-nephew of Julius Caesar whom Caesar had adopted and made his heir in his will, arrives in Rome to take up his inheritance.

Burebistas of Dacia is assassinated; his empire is divided into several kingdoms.

43 B.C.E. The Roman poet Ovid is born at Sulmo, about ninety miles from Rome.

The "Second Triumvirate" of Mark Antony, Octavian, and Lepidus is set up, and the proscriptions begin the next day—a list of political enemies, including Marcus Tullius Cicero, is drawn up, and they are liquidated.

42 B.C.E. Brutus and Cassius, Caesar's assassins, are defeated in two separate battles at Philippi in northern Greece.

41 B.C.E. At Tarsus in Asia Minor, Cleopatra, queen of Egypt, meets Mark Antony, who accepts her invitation to spend the winter with her at Alexandria.

37 B.C.E. Herod the Great, with Roman support,
–34 B.C.E. rules Judaea. Herod promotes the spread of Hellenism throughout the province, which spawns opposition among his subjects, particularly the Pharisees.

36 B.C.E. Sextus Pompeius, Pompey's last surviving son, is defeated in the naval battle of Naulochus and is driven from southern Italy and Sicily.

Octavian demotes Lepidus after he makes a power grab.

c. 35 B.C.E. A system of writing is introduced in Guatemala in Central America.

31 B.C.E. Octavian defeats Mark Antony and Cleopatra at the Battle of Actium.

30 B.C.E. Octavian enters Alexandria as a conqueror. Antony has already committed suicide, and Cleopatra takes poison to avoid being taken in triumph to Rome.

29 B.C.E. Octavian returns to Rome and holds a triple triumph.

27 B.C.E. Octavian, the heir of Julius Caesar, reaches an agreement with the Roman senate to share power with it. Octavian continues to hold the office of consul each year, but he can claim to have restored the republic, and the senate bestows on him the title "Augustus"—the "Revered One—which all subsequent emperors take.

23 B.C.E. Augustus resigns from the consulship in mid-year—thereafter he is consul only twice more. Instead, he is granted tribunician power (*tribunicia potestas*) which gives him the powers that a tribune in the republic once wielded, including a blanket right of veto.

16 B.C.E. –13 B.C.E. The Provinces of Spain and Gaul are reorganized under the Roman emperor Augustus. The emperor subdivides Hispania Ulterior into Baetica (Andalusia) and Lusitania.

14 C.E. The emperor Augustus dies and is succeeded by his stepson, Tiberius.

9 C.E. –23 C.E. Wang Mang rules China. As with his predecessors, the issues that affect his reign are economic (the resistance of wealthy landowners that leads to famine) and military (continued struggles against the Hsiung-nu in the north).

c. 30 C.E. –c. 33 C.E. The crucifixion of the Jewish leader Jesus of Nazareth occurs.

37 C.E. Tiberius dies and is succeeded by Gaius Caligula whose ancestry can be traced back to Augustus Caesar through Augustus' daughter, Julia.

41 C.E. Gaius Caligula is assassinated by the praetorian guard which puts Caligula's uncle, Claudius, on the throne.

c. 45 C.E. St. Paul begins his missionary work to bring Christianity to non-Jewish communities throughout Europe.

54 C.E. Claudius dies, according to rumor poisoned by his fourth wife, Julia Agrippina, who engineers the accession of Nero, her son by a previous marriage, shoving aside Claudius' own son, Britannicus.

64 C.E. A great fire destroys half of Rome. Nero seizes the opportunity to build his palace known as the *Domus Aurea* (Golden House) on the area cleared by the fire.

St. Paul is executed in Rome. The persecution of members of the Christian sect under the Roman Empire begins.

66 C.E. The "Zealot" party (Jewish nationalists) lead a revolt in Judaea against Rome.

68 C.E. Vindex, the governor of Gallia Lugdunensis, revolts and puts forward Servius Sulpicius Galba, governor of Hispania Tarraconensis, as his candidate to replace Nero. Vindex's revolt is suppressed but the senate and the praetorian guard in Rome accept Galba as emperor. Nero flees and commits suicide.

68 C.E. –69 C.E. After three men, Galba, Otho, and Vitellius, succeed each other quickly, Vespasian, general in charge of suppressing the revolt in Judaea, wins the throne. It becomes painfully clear to all that the Roman army can make and unmake emperors.

69 B.C.E. Natives besiege the German town of Colonia Ulpia Traiana (Xanten); Mainz also revolts.

70 C.E. Vespasian's son, Titus, who has taken over command of the Roman army in Judaea, captures Jerusalem and destroys the Temple. The booty from Jerusalem is brought to Rome and placed in the new Forum of Peace which Vespasian constructs.

78 C.E. As a governor of Britain, the Roman general Gnaeus Iulius Agricola advances into Scotland.

The Saka era begins in India. Many scholars favor this date for the beginning of the reign of Kaniska, the Buddhist king responsible for having protected the Kushans from Chinese sovereignty.

79 C.E. Vespasian dies and his son Titus, who had already been made co-emperor, succeeds him.

Mt. Vesuvius, near the Bay of Naples in central Italy, erupts and buries Pompeii, Herculaneum, and Oplontis under lava and ash.

81 C.E. On the death of Titus, his younger brother Domitian becomes emperor.

96 C.E. Domitian is assassinated by members of his own household, including his wife

Domitia. The Roman senate chooses as his successor an elderly senator named Marcus Cocceius Nerva.

97 C.E. Faced with the threat of revolt by the praetorian guard, Nerva adopts the governor of Upper Germany, Trajan (Marcus Ulpius Traianus), and makes him co-emperor.

98 C.E. Trajan succeeds Nerva as emperor.

c. 100 C.E. Traders from Indonesia sail along the coast of Africa, possibly leaving settlers on Madagascar.

The Funan, a Hindu people that first emerge in Southeast Asia, occupy the Mekong Delta region of present-day Vietnam, as well as portions of Cambodia and Thailand. They trade with both India and China.

The Anasazi people begin to develop their culture in the deserts of southwest North America. They make baskets, grow corn, and build adobe structures.

105 C.E. –106 C.E. Trajan makes a second campaign into Dacia and annexes Dacia as a Roman province.

117 C.E. Trajan dies and on his deathbed adopts Hadrian.

122 C.E. –128 C.E. Hadrian's Wall, a frontier rampart running from Wallsend-on-Tyne to Bowness-on-Solway, is built to protect Roman Britain from incursions from the north.

138 C.E. Hadrian dies having adopted Antoninus Pius as his successor, who in turn adopts Marcus Aurelius and Lucius Verus at Hadrian's insistence.

Evidence of the presence of Moors (or Muslims) appears in Dacia; they occupy the city of Racari.

c. 150 C.E. –c. 200 C.E. The Goths migrate to the region north of the Black Sea; previous migrations brought them from southern Scandinavia to the area around the Vistula River.

161 C.E. Antoninus Pius dies after a long, peaceful reign and is succeeded by Marcus Aure-

lius and Lucius Verus who is co-emperor until 169 C.E.

165 C.E. –166 C.E. Seleucia is destroyed by Gaius Avidius Cassius of Rome. The fall of the city ends a major commercial center in Babylonia; Mesopotamia becomes a Roman protectorate.

166 C.E. Pestilence, brought back to Rome by the troops of Lucius Verus who had been campaigning in the east, sweeps the empire.

German tribes cross the Danube frontier and penetrate the empire as far as northern Italy.

180 C.E. Marcus Aurelius dies in camp at Vienna while campaigning on the Danube frontier against barbarian tribes known as the Marcomanni and the Quadi and is succeeded by his eighteen-year old son, Commodus.

184 C.E. The Romans are forced to cede the frontier in Scotland. The Roman frontier in Britain now extends only to Hadrian's Wall.

The rebellion of the Yellow Turbans begins against the Han dynasty in China. The peasant revolt is quelled within six years by Ts'ao Ts'ao.

193 C.E. After Commodus' assassination, there is a period of civil war, ending with Septimius Severus seizing power.

The siege of Byzantium begins, lasting about two years. The city supported general Pescennius Niger's revolt against the Roman ruler Septimius Severus.

211 C.E. Severus dies while campaigning in Britain, and is succeeded by his sons, Caracalla (co-emperor since 198) and Geta (co-emperor since 209). In 210, Caracalla murders Geta.

212 C.E. The emperor Caracalla extends Roman citizenship to all Roman provincials.

226 C.E. The Sassanians overthrow the Parthian dynasty in Iran. The Parthian empire had covered a great expanse, extending during

one period from Iberia (east of the Black Sea) to the Persian Gulf.

235 C.E. The Severan dynasty comes to an end with the murder of the emperor Alexander Severus, and fifty years of military anarchy follow.

248 C.E. The Goths invade the Balkan city of Moesia and murder the Roman emperor Gaius Messius Quintus Decius (251); they later sack Nicaea and Nicomedia and raid the Ionian cities.

249 C.E. In order to extirpate Christianity, the emperor Decius issues an edict ordering all citizens to sacrifice to the gods and get a certificate proving they had done so. The order lapses after Decius' death in 251 C.E.

c. 250 C.E. The Mayan classical period begins in Mexico and Central America; the dedication of monuments for astrology and mathematics distinguishes this era.

254 C.E. Barbarian attacks in Upper Germany result in the withdrawal of many Roman troops.

257 C.E. The Franks, a coalition of Germanic tribes, invade Lower Germany.

284 C.E. Diocletian becomes emperor and reforms the government of the empire, appointing Maximian as co-Augustus, ruling the western empire while Diocletian himself ruled in the east, and then appointing as Caesars Galerius (in the east) and Constantius Chlorus (in the west).

287 C.E. Marcus Aurelius Mausaeus Carausius, a former Roman admiral, takes Britain and northern Gaul and declares himself emperor.

c. 301 C.E. Christianity becomes the state religion of Armenia, making it the oldest Christian civilization.

303 C.E. Diocletian issues an edict authorizing general persecution of the Christians, which continues to be carried out vigorously in the east by Diocletian's successor, Galerius, but less vigorously in the west.

305 C.E. Diocletian and Maximian retire, and Galerius becomes senior Augustus in place of Diocletian and Constantius Chlorus junior Augustus in the west.

306 C.E. Constantius Chlorus dies at York in Roman Britain and his troops proclaim his son Constantine emperor in his father's place.

311 C.E. Galerius, Augustus in the east, calls off the persecution of the Christians and dies shortly thereafter.

312 C.E. Constantine defeats Maxentius, the son of Maximian who had seized control of Italy, at the Milvian Bridge outside Rome. On the eve of the battle he converts to Christianity, and once in control of Rome, he builds his first Christian church, the basilica of St. John Lateran.

313 C.E. Constantine and Licinius, now emperors in the east, agree to allow the Christians freedom of religion (the so-called "Edict of Milan").

 The Edict of Toleration of Christian Worship is passed in Trier, Germany.

317 C.E. The Eastern Chin dynasty begins in China. The rule will eventually succumb to ongoing attacks from the north.

320 C.E. Candra Gupta I rules in India. He controls the center of the country by the time of his death, establishing a power base from the Ganges to the coast of Bengal.

 St. Pachomius establishes the first cenobitic community in Egypt.

324 C.E. Constantine unites the empire by defeating Licinius, the Augustus of the east.

 Byzantium becomes the foundation site of Constantinople, the Roman capital on the Danubian frontier.

330 C.E. Constantine dedicates his new capital, Constantinople, present-day Istanbul.

337 C.E. Constantine dies and is succeeded by his three sons, Constantine II (337–340), Constans (337–350) and Constantius II (337–361).

354 C.E. Aurelius Augustinus (St. Augustine) is born; he becomes one of the most important authors of the early Catholic Church. His works include *Confessions* (circa 400), *De doctrina Christiana* (On the Christian Doctrine, 397–428), *De trinitate* (On the Trinity, 400–416), and *De civitate Dei* (On the City of God, 413–426).

331 C.E. –363 C.E. The reign of the last pagan emperor, Julian who is killed while making a disastrous expedition against the Persian Empire.

370 C.E. The Huns expel the Ostrogoths from Ukraine. The Ostrogoths are a division of the Goths, who earlier migrated from Scandinavia to the region south of the Vistula River.

378 C.E. A Roman army, led by the emperor Valens, is destroyed by the Goths at Adrianople in Thrace.

382 C.E. The emperor Theodosius I settles Goths within the empire as federate troops; they are not assimilated into the Roman army but serve under their own chieftains as allies (*foederati*) of the Roman Empire.

395 C.E. On the death of the emperor Theodosius, the empire is divided between his two sons, with Honorius ruling in the west and his elder brother, Arcadius, ruling in the east.

c. 400 C.E. The first settlers, sailing from the Polynesian islands, arrive in Hawaii.

Pelagius, the British Christian writer, is active during this period. He spends some years in Rome, but the political unrest there leads him to Africa and Palestine; Pelagius's exhortation to Demetrias is called the first British literature.

The Olmec civilization in Central America ends.

406 C.E. –407 C.E. The Germanic Vandals occupy the Rhine region after the Huns drive them westward; the nomadic Alans of Russia are also driven to Gaul by the Huns. This ex-

pulsion marks the end of Roman rule in Gaul.

410 C.E. The city of Rome is captured and sacked by a horde of Visigoths led by Alaric.

Britain is abandoned by the Roman Empire. The Saxons and other Germanic peoples become more prevalent; Celtic culture also spreads.

Alaric dies.

429 C.E. The Vandals enter North Africa and over the next ten years take over the Roman provinces there.

441 C.E. –443 C.E. Attila leads the Huns against the Eastern Roman Empire; they destroy such cities as Naissus in Moesia.

451 C.E. The Huns are defeated in Gaul by a Roman force, along with the Visigoths, at the Catalaunian plains.

The Council of Chalcedon establishes the doctrine of diophysitism, the idea that Christ is both human and divine; the council declares any other doctrine heresy.

The Persians defeat the Armenians at the Battle of Avarayr. The Zoroastrian faith replaces Christianity as the official religion in this region.

476 C.E. Odoacer the German deposes Romulus Augustulus in Rome; the Ostrogoths soon establish an empire in Italy. Gaiseric, the king of Vandals and the Alans, who had captured Rome eleven years earlier, dies the following year.

The last Roman emperor in the west, Romulus Augustulus, is deposed.

490 C.E. The Ostrogoths under their king, Theodoric, invade Italy and establish the Ostrogothic kingdom which lasts until 554.

527 C.E. –565 C.E. The emperor Justinian reigns in Constantinople and directs a campaign to recover North Africa, Italy, and part of Spain for the empire.

chapter one

1

ARCHITECTURE AND DESIGN

William H. Peck

IMPORTANT EVENTS
in Architecture and Design

c. 3000 B.C.E. The beginning of the Hellenic civilization in the Greek mainland includes the construction of some early structures for domestic and public use.

c. 2000 B.C.E. The first attempts at more carefully designed architecture take place in Greece.

c. 2000 B.C.E. –c. 1600 B.C.E. The inhabitants of Crete are influenced through their contacts with other peoples of the eastern Mediterranean to attempt larger and more complete buildings.

c. 2000 B.C.E. –c. 1450 B.C.E. The Minoan Palace Culture in Crete flourishes; this architecture is known for its arrangement of buildings around a central court, varying levels connected by small staircases, and monumental entrances.

c. 1600 B.C.E. –c. 1200 B.C.E. The development of the Mycenaean Palace Culture spreads through parts of mainland Greece. This architecture is influenced by the Minoan Palace Culture but has more logical ground-plans and are built as fortifications.

c. 1450 B.C.E. The palaces of Crete are destroyed, probably by invaders from mainland Greece.

c. 1300 B.C.E. –c. 1250 B.C.E. The "Treasury of Atreus" at Mycenae is constructed. It is an almost perfectly preserved example of the "tholos" tomb type.

c. 1250 B.C.E. The Lion Gate at Mycenae, one of the few Mycenaean monuments that would have been visible to later Greek travelers, is built.

c. 1100 B.C.E. At this date or a little earlier a wholesale destruction of palaces and citadels takes place. About four centuries of confusion and poverty ensue, later called by some scholars the "Dark Ages" of Greece.

c. 800 B.C.E. –c. 700 B.C.E. Early Greek temples are first constructed using pre-Doric designs.

c. 580 B.C.E. The Temple of Artemis at Corfu and the Temple of Hera at Olympia are constructed. These temples are the oldest known examples of archaic Doric architecture.

c. 550 B.C.E. The Temple of Apollo at Corinth and the Basilica at Paestum are completed. They are the best known surviving examples of purely Doric-style temples.

c. 490 B.C.E. The Temple of Aphaia at Aegina is completed. It is the first temple to meld the Doric and Ionic styles.

c. 447 B.C.E. –c. 432 B.C.E. The Parthenon at Athens is constructed. It is the best surviving example of a Doric temple with Ionic elements.

c. 437 B.C.E. –c. 432 B.C.E. The Propylaea at Athens is constructed. It is one of the only surviving monumental entrance structures.

c. 421 B.C.E. –c. 405 B.C.E. The Erechtheum at Athens is constructed. It is the only temple of importance to be constructed fully in the Ionic style.

c. 350 B.C.E. Construction begins on the theater at Epidaurus, one of the best preserved Greek theaters.

c. 170 B.C.E. Construction of the Temple of Olympian Zeus at Athens is begun and will not end until the second century C.E. It is one of the most balanced examples of Doric architecture to incorporate the Corinthian style.

c. 150 B.C.E. The Stoa of Attalus, a public meeting place with shops in the Agora at Athens, is constructed around this date. It is a typical example of a building designed for practical use and commerce.

c. 100 B.C.E. The Temple of Fortuna Virilis is constructed in Rome, incorporating Greek and Etruscan design elements.

c. 40 B.C.E. The Tower of the Winds at Athens is constructed. It is the first truly Roman structure built in Greece.

c. 27 B.C.E. The Pantheon in Rome is begun by Agrippa but it is not completed until the reign of the emperor Hadrian in the second century.

c. 16 B.C.E. –c. 13 B.C.E. The Pont du Gard aqueduct is constructed. It is admired for its functionality in carrying water as well as its architectural properties such as its proportionate arches and varied heights.

The Maison Carrée at Nîmes is constructed. It is the best surviving example of the blending of the Greek and Etruscan designs used in Augustan architecture.

c. 64 C.E. Nero's Golden House is completed. It combines every architectural technique known at the time, including a revolutionary revolving dome.

c. 70 C.E. The Colosseum in Rome is completed, an unprecedented four-story structure. It was created using pioneering architectural tools such as arches, columns, and mechanical elements such as pulleys and elevators.

c. 79 C.E. The destruction of Pompeii by the eruption of Vesuvius preserves Roman architecture for future generations.

c. 81 C.E. The Arch of Titus at Rome is completed. It is the best surviving example of a gateway arch.

c. 111 C.E. –c. 114 C.E. The construction of Trajan's Forum, the largest of the imperial forums, occurs during this time.

c. 113 C.E. Trajan's Column in his forum at Rome is dedicated. This marks the first column to serve as a burial place as well as a remembrance marker.

c. 125 C.E. –c. 128 C.E. The Pantheon at Rome is constructed. It is a good surviving example of the Roman use of concrete to create domes and rotundas.

c. 135 C.E. Hadrian's villa at Tivoli is completed. It is a rare architectural complex that incorporated landscape into the design of various buildings.

c. 211 C.E. –c. 217 C.E. The Baths of Caracalla at Rome are constructed, one of the best surviving large bathhouses. It shows the extravagance that architectural designs began to include such as swimming pools, baths, and game rooms.

c. 300 C.E. The Palace of Diocletian at Spalato is constructed, taking cues of architectural decadence from Persian designs.

c. 306 C.E. –c. 313 C.E. The Basilica of Maxentius at Rome is constructed. It is one of the most important monuments in classical antiquity and one of the first Christian structures in Rome.

c. 310 C.E. The Basilica of Constantine at Trier in northern Gaul is completed. It is the last of the great civilian basilicas constructed before the style was adopted fully by religious structures.

c. 312 C.E. –c. 315 C.E. The Arch of Constantine at Rome is constructed, marking the regular use of the Roman Corinthian style as well. The arch is also the best surviving example of a triumphal arch.

c. 532 C.E. –c. 537 C.E. The Hagia Sophia at Constantinople is constructed. It is the greatest example of Byzantine architecture.

OVERVIEW
of Architecture and Design

THE HERITAGE OF CLASSICAL ARCHITECTURE. The architecture of Greece, Etruria, and Rome is one of the most important parts of the Western world's heritage from the time of antiquity. Forms and traditions that were developed in ancient Greece and its colonies, with the addition of the influence of Etruscan traditions, were augmented by the innovations of Roman architects and engineers. These have inspired and molded the architectural forms of Europe and the United States as well as all of the cultures touched by them. The traditions of classical architecture have persisted well into the twentieth century, only to be replaced in part by the advent of modern materials and building techniques. The models for banks, railroad stations, and other public buildings were for many years the temples of the Greeks and the bath complexes of the Romans.

SOURCES AND EVIDENCE. The sources of knowledge available to modern scholars for a study of the architecture of the Greeks, Etruscans, and Romans consist mainly of four types. The most obvious type of evidence are the ancient buildings still preserved in whole or in part, although there are very few structures that fit this category. Examples include the Pantheon in Rome and the Maison Carrée in Nîmes, France. The second body of material comes from the excavation of ancient sites and the remains of destroyed buildings. This evidence provides the additional possibility of reconstructing something of the appearance of monuments no longer preserved, and it also provides much of the modern knowledge about domestic architecture, the construction of houses and dwellings. For the third source one may turn to the writings of a limited number of ancient Greek and Roman authors who have preserved some descriptions of the appearance of buildings as well as the methods of construction or the architectural theories employed. To these three sources can be added the representation of monuments and buildings on coins and other works of art. These can provide some idea of the appearance of structures that disappeared long ago.

BUILDING MATERIALS. The materials employed by ancient architects were generally simple and somewhat limited by the technology of the time. In the earliest periods unbaked mud brick and plaster were employed, with the addition of wood for roofing material. The development of stone architecture was slow at first, dependant on the metal technology necessary to facilitate quarrying and dressing the material. The employment of stone was first restricted to important structures, mainly cult temples. The principal building technique consisted of a horizontal member supported on two vertical uprights. Even the uses of this simple form were limited by the technical ability to place stone elements at great height. As knowledge of the bearing strength of stone became better understood, buildings could assume larger proportions. At the same time the decoration of buildings progressed as the artistic qualities of architecture were developed and modified. Complex architectural elements employing the use of arches and vaulting and the advanced utilization of brick and concrete were relatively late innovations made mainly during the period of the Roman Empire. These advances allowed for larger structures capable of enclosing vast spaces.

MINOAN AND MYCENAEAN CULTURE. The earliest record of designed structures in Greece come from the remains of the palaces on the island of Crete, built by the Minoan civilization between 1700 B.C.E. and 1200 B.C.E. It is necessary to mention them if only because they represent a significant architectural tradition of distant memory in the Aegean area, representing a level of development to which the later Greek architects would later return. The multileveled complexes of these palaces with upper floors supported by columns and walls decorated with fresco painting reached a level of utilitarian design and sophistication not matched in the ancient world. The Minoans were followed by the Mycenaean civilization of the Greek mainland that made significant advances during its last phase (c. 1400–1100 B.C.E.). Massive stone architecture for citadels, temples, and tombs became typical, but this tradition was not continued during the so-called "Dark Age" of Greece (c. 1200–800 B.C.E.). Much of the knowledge of architectural achievement and technical advances was lost and had to be reinvented after a period of almost 400 years.

GREEK ARCHITECTURE. The early beginnings of traditional Greek architecture can only be demonstrated by very slim evidence. This includes the excavated remains of a building termed a *megaron* at the site of Themon in Aetolia in Greece dating to around 1000 B.C.E. Terra-cotta models of similar buildings from two centuries later provide additional evidence for the impor-

tance of the form. The *megaron* consisted of a single room or hall with an open end and a porch supported by two columns. Buildings of this type were probably more an official meeting hall than a religious building but the arrangement anticipates the general layout of later formal temple design. At the end of the seventh century B.C.E. the two most important arrangements or "orders" of Greek architecture had begun to evolve. The Doric and the Ionic orders take their names from the two dialects of Greek generally spoken on the mainland and in Asia Minor. As architectural styles the Doric developed earlier but the two orders were used concurrently throughout Greece and the colonies. The ground plan of temples from this time was still a simple arrangement consisting of a long room with a porch supported by columns. Some decoration in relief sculpture was added and statues of cult deities were in evidence. By 600 B.C.E. the emerging form of the Greek temple can be demonstrated in the remains of the Temple of Hera at Olympia. This temple also provides clear evidence of the transition from wood architecture to stone. By the early sixth century, around 570, the formal elements of arrangement and decoration had been standardized. The result, as exemplified by the Temple of Zeus, also at Olympia, was an example of impressive and logical design. After the destruction of the Acropolis in Athens by the Persians early in the fifth century, the Parthenon was erected from 447 to 439. Dedicated to Athena, it stands as the epitome of classical architecture and the culmination of a development of architectural design which transformed simple utilitarian structures into artistically realized and awe-inspiring monuments. The architecture of the Hellenistic Period (330–146 B.C.E.) employed variations and elaborations on the developed forms of the classical architecture of the fifth and fourth centuries but maintained standards of proportion and design while striving for more dramatic and impressive effect.

ETRUSCAN ARCHITECTURE. Etruscan architecture began to develop at about the same time as early Greek architecture. The Etruscans, mainly in north-west Italy, were in contact with the Greeks and were a formative influence on the Romans. The evidence for the architecture of the Etruscans consists mainly of the remains of their temples and tombs. The tomb was often an underground chamber or chambers sometimes marked by a tumulus or mound. The typical temple form contained a chamber with a deep porch, usually elevated on a platform with steps leading to it. Much of the preserved decoration from Etruscan temples was made of molded and painted terra cotta rather than the carved stone favored by the Greeks. Etruscan forms such as the raised temple and the circular tumulus were an influence on the architecture of the following Roman period.

CLASSICAL AND BYZANTINE ARCHITECTURE. In many respects the Romans continued in the traditions of the Greek architects but they were also influenced by the Etruscans. The singular innovations of the Romans were the more general use of the arch and the development of the vault and the dome. These forms were made possible by the employment of building techniques that employed concrete, a material taken for granted in modern times, but one only exploited widely toward the end of the Roman Republic. The theaters, arenas, bridges, baths and aqueducts of the Romans represent an era of engineering advancement almost unparalled in the history of the world. The advancements in engineering and construction techniques made during the late Roman Republic and the early empire were carried on after Christianity became the official state religion of the Roman Empire. This was evident mainly in the use of the basilica form—originally a secular administrative building type—for church architectural design, but also in the use of vaulted and domed techniques for the construction of church forms which became increasingly more elaborate. When the emperor Constantine transferred the capital to Constantinople the state fostered this development of monumental structures dedicated to the new religion.

CONCLUSION. The architecture of the classical world began simply, to satisfy basic human needs. It was based on practical considerations and restricted by limited technical skills. Its evolution in the Greek homeland and colonies can be traced for over 700 years in the development of a style that is still inspirational today. The complexity of architectural production under the Romans remains one of the great building achievements of history culminating in the religious architecture of the Byzantine Empire. This development of architectural form covered a span of about 1,500 years, a period in which much of the lasting vocabulary of Western architectural design was invented and perfected.

TOPICS
in Architecture and Design

SURVIVING SOURCES

LOSS OF EVIDENCE. The architecture of ancient Greece and Rome never completely disappeared. Many

examples of buildings or the remains of them have always been visible or have been easily rediscovered, particularly in the Greek mainland and in Italy. However, the remains of classical antiquity can be found throughout the lands of the Mediterranean, the Aegean, North Africa, and the Middle East. Such remains were not always respected and preserved. It is all too obvious that ancient buildings were reused for different purposes than for those for which they were originally intended, often necessitating structural or decorative changes. As an example, in Syracuse, in Sicily, it is possible to see the original columns of a temple imbedded in the wall of the later church that utilized the original site. Marble and sandstone could very easily be reused, and limestone was often burned for the lime it contained. Decorative columns were taken away and pressed into service in later churches and mosques. Metal fittings and other decorative elements were regularly stripped from buildings to be melted down. Many dedication inscriptions in metal lettering have disappeared as a result of this practice.

REDISCOVERY IN THE RENAISSANCE. In the late fourteenth century artists and architects, principally in the cities of Italy including Rome and Florence, began to take a new interest in the art and architecture that surrounded them. It was an important part of the general reawakening or "rebirth" of interest in classical antiquity at the time that included all aspects of ancient learning. Scholars, artists, and architects began to investigate the ancient remains, study and copy the preserved decorations, and analyze the proportions of the monuments. The result of this newly developed field of study was an attempt to imitate the art and architecture of antiquity, regarded as a perfected art worthy to serve as models for their time. The writing of Vitruvius was taken very seriously as the guide to proper application of the rules of ancient architecture, disregarding the fact that his work was limited by his own time and experience to a short time in ancient Roman history. However, the revived interest in classical architecture was mainly limited to Roman rather than Greek examples because of the nature of the remains available. This was not a simple copying of Roman buildings but an attempt to understand the elements, systems of proportion, and decorative devices, in order to use them in ways suitable to their own time. Architects such as Filippo Brunelleschi (1377–1446) and Michelozzo Michelozzi (c. 1396–1472) were among the leaders and innovators in the newly developed style, but it was with artist-architects like Bramante, Michelangelo, and Palladio that it reached its highest expressions.

THE CLASSICAL REVIVAL. The Renaissance architecture of Italy had considerable influence on the later developments in France and England, but a revived interest in ancient architecture was also kindled by the discovery and excavation of ancient remains such as the buried city of Pompeii in the mid-eighteenth century. The ancient monuments of Athens were also studied and published, as were the structures of Palmyra, a city in the Syrian desert. The Panthéon in Paris, designed by Jacques Germain Soufflot (1709–1780), modeled on the ancient Roman building in Rome, is a good example of this revived interest. Many products of this reuse of ancient principals and ideas exist throughout Europe. One outstanding example is the Brandenburg Gate in Berlin, designed by Karl Gotfried Langhans (1733–1808) and built at the end of the eighteenth century. It was clearly modeled after a structure in Athens, although some details have been changed. For the classical revival in America, one of the outstanding names is that of Thomas Jefferson. He believed that Roman architecture was best suited for the important buildings of the new American republic, and he applied his direct knowledge of ancient remains and his theories to a number of projects including the Virginia State Capitol. Greek forms were also employed by other architects in the young country, as in the design of the Bank of the United States in Philadelphia. The architect, William Strickland (1787–1854), used the Parthenon in Athens for his model and inspiration. The ideals of classical architecture have persisted, almost to the present day. Many important buildings have been designed with the models of ancient Greece and Rome in mind. This is such an integral part of the development of American architecture that it almost goes unnoticed today because the forms are so familiar to us.

EXISTING BUILDINGS. The architectural remains of the Greek and Roman world survive in varied stages of preservation in a number of places around the Mediterranean basin. Some Roman examples, such as the Maison Carrée at Nîmes in France, dedicated early in the first century, or the Pantheon in Rome, a construction largely of the second century, still stand much as they were built in antiquity. These attest to the methods used in their construction but also to the respect shown them when they were later utilized as Christian churches. By contrast, major monuments such as the Parthenon on the Acropolis at Athens were not so well treated and are evidence to that neglect. The Parthenon had been used as a church, a mosque, and then for the storage of gunpowder. It was partly destroyed when an explosion of an ammunition cache blasted out much of one side of the structure in 1687. Except for that accident, it might be

one of the best-preserved Greek temples in the modern world. Not many examples of Greek and Roman architecture have survived even this well, although there are many lesser-known remains outside of Greece and Italy that add to modern knowledge.

SURVIVING GREEK ARCHITECTURE. The ancient buildings of Greece are justly famous and include some examples, such as the Parthenon, with the complex of buildings on the Athenian Acropolis, and the temple called the Theseum, also in Athens, that give modern scholars some idea of the appearance of the ancient buildings. Throughout the country are the remains of structures in various stages of preservation. With some monuments, such at the great temple at Olympia, the appearance of the building has only been determined by excavation of the site, extensive study, and reconstruction on paper. With others, where only a few columns might remain upright, the plan of the structure can still be determined from the remains of stone foundations. The most significant examples of Greek architecture away from the Greek mainland are to be found in southern Italy, Sicily, and the western coast of Turkey (East Greece). To study the evolution of early Greek architecture the temples at Paestum, south of Naples, and at various sites on the island of Sicily, including Selinute and Agrigento, provide essential supplementary evidence. By chance of preservation, these more nearly complete or re-constructible examples exist in what were the colonies of the Greek city-states. When the Greeks colonized southern Italy and Sicily they brought their architects and artists and imported their own traditions of art and design. For most constructions they simply used local materials. By contrast, the great temple of Diana at Ephesus, in what is now western Turkey, survived as only the foundation platform; still providing enough evidence for some idea of the appearance of what must have been one of the great buildings of antiquity.

SURVIVING ETRUSCAN AND ROMAN ARCHITECTURE. The preserved architecture of the Etruscans is limited to tombs, of which thousands have been found. Etruscan tombs were generally underground structures containing several chambers or rooms. Some of the architectural detail incorporated in the decoration suggests that the tombs were meant to imitate temple and house architecture but few examples of domestic and religious structures have actually been preserved. There are town walls composed of roughly hewn stone which can be dated to the time of the Etruscans but the actual style of buildings can only be reconstructed from the evidence obtained from excavations. In contrast, the evidence for the evolution of Roman architecture during the Republic and the empire is extensive and a variety of structures are preserved in whole or in part. In addition to famous structures such as the Pantheon and Maison Carrée, there are many monuments in the city of Rome and in the Italian peninsula that give a vivid picture of the variety of Roman building. These include temples and tombs, palaces and theaters, and an assortment of public structures including aqueducts, bridges, bath complexes, markets, administrative buildings and the like. Probably the most familiar examples are the amphitheaters and ceremonial arches, exemplified by the Colosseum and the Arch of Constantine in Rome. However, the cities of Ostia, the seaport of Rome, and the two cities of Pompeii and Herculaneum, preserved by the eruption of Mt. Vesuvius, also provide considerable evidence of town planning, layout, and development. Other evidence exists outside of Italy as well. As the Roman Empire grew, the colonies sustained building projects that have left many partly or completely preserved examples. To mention only a few areas, in the colonies of North Africa, whole ancient cities have been preserved, only to be recovered by excavation. In such places the remains of civic centers, religious and political monuments, and domestic complexes have been found. Throughout Europe, notably in France and Spain, amphitheaters, bridges, and aqueducts attest to the skill of Roman architects and engineers.

LITERARY AND OTHER EVIDENCE. For Greek architecture and construction methods there is considerable inscriptional evidence preserved. In this material architects are named; contracts for quarrying, transportation of material, and actual construction are itemized and the wages of various class of workmen are detailed. Modern scholars are also fortunate that professional Roman architect Vitruvius Pollio, writing in the time of the emperor Augustus, left an extensive and detailed discussion of the techniques of ancient architecture that has been preserved. He was a practicing architect and military engineer with a knowledge that was both theoretical and practical. In his work *De Architectura* (On Architecture) he discussed numerous subjects, ranging from the types and characteristics of building material employed during the early empire, to the placement of buildings in respect to the natural environment. His viewpoint was one that looked back at classical Greek architecture as a model to imitate but he also left valuable information about the nature of Etruscan buildings. What he wrote about methods of construction and materials, as well as the rules of proportion employed in architectural design, is very valuable to an understanding of ancient architecture. Pliny the Elder (Gaius Plinius Secundus) also wrote about the

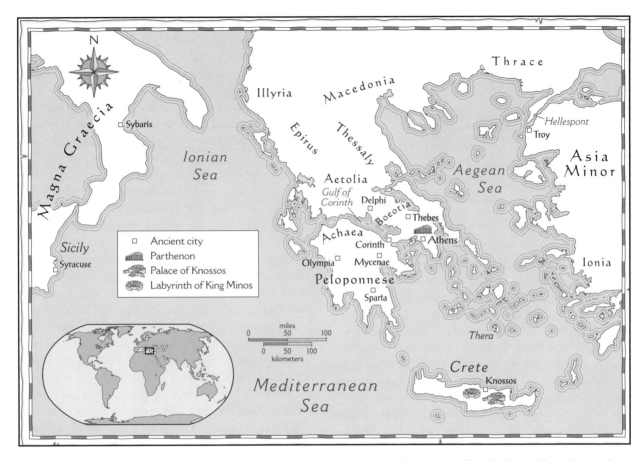

Map showing Ancient Greece and Crete, the cities of Delphi, Thebes, Athens, Corinth, Mycenae, Olympia, Sparta, Troy, Knossos, important monuments, the Parthenon, Palace of Knossos, Labyrinth of King Minos. **XNR PRODUCTIONS, INC. THE GALE GROUP. REPRODUCED BY PERMISSION.**

use of metals and stone in architecture in his encyclopedic *Natural History.* In addition, many ancient authors or travelers described the buildings they saw. Probably the most important of these was the Greek traveler, Pausanias. He left invaluable descriptions of what impressed him when he visited the important cities of Greece in the second century C.E. In addition to inscriptions and literary descriptions, there are countless examples of the representation of buildings or parts of them on coins, in wall painting, pottery decoration, and even terra cotta models. These often depict structures or monuments that no longer exist and convey supplementary information that can be used to fill out our knowledge of ancient architecture.

SOURCES

J. J. Pollitt, *The Art of Greece, 1400–31 B.C.: Sources and Documents* (Englewood Cliffs, N.J.: Prentice-Hall, 1965).

———, *The Art of Rome, 753 B. C.–337 A.D.: Sources and Documents* (Englewood Cliffs, N.J.: Prentice-Hall, 1965).

Vitruvius, *The Ten Books on Architecture.* Trans. Morris Hickey Morgan (Cambridge, Mass.: Harvard University Press, 1914).

MINOAN AND MYCENAEAN ARCHITECTURE

CULTURAL BACKGROUND. Before the flowering of the classic Greek architectural style in the mainland there were two important periods of development in building that had come before. The Minoan (c. 2600–1100 B.C.E.) and Mycenaean (c. 2800–1100 B.C.E.) civilizations flourished in the island of Crete and in mainland Greece for close to 2,000 years. Many of their accomplishments in art and architecture were unknown to the Greeks of the seventh and sixth centuries B.C.E. but some memory of their accomplishments was preserved in mythology and epic poetry such as the *Iliad* and the *Odyssey* of Homer, and some archeological traces of their structures survived. The Minoans are known to modern

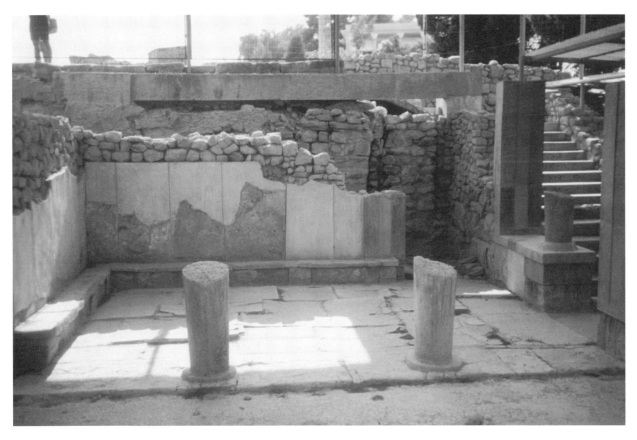

A light well in the Minoan palace at Phaestus in Crete. COURTESY OF JAMES ALLAN EVANS.

scholars by the modern name given to them derived from the mythical king Minos who was said in mythology to have a great palace at Knossos in Crete. They were an island people and seafarers who traded widely in the eastern Mediterranean and came into contact with the cultures of Egypt and the Near East. Undoubtedly they knew something of the monumental buildings erected by the peoples of Mesopotamia and the Nile Valley and may have been influenced by them. Fortresses and temples, however, were not an important part of their building concerns. The island location of the culture provided some defense against invaders and marauders so the art of fortification and fortress building was not especially developed. The idea of building shrines or temples to the gods had also not developed to any great extent. Hence the most important examples of Minoan architecture were the result of a highly developed style of complex palace design. What is known of the remains of the palace architecture of the Minoans, as evidenced by palaces such as the one at Knossos, have been revealed by excavation and reconstruction.

MINOAN ARCHITECTURE: KNOSSOS. In Crete the bare remains of the ground plans of simple houses from

the late prehistoric period have been uncovered, but it was not until the excavation of the palace of Minos at Knossos by Sir Arthur Evans that the complexity and something of the development of Minoan architecture was known. The palace—most likely built between 1600 and 1500 B.C.E.—is essentially a governmental administrative center and a royal residence combined. Arranged around a large central courtyard were dozens of rooms, chambers, small courts, halls, and storerooms. The maze-like arrangement of these elements may have even been the inspiration for the myth of the fabled labyrinth. The building was unusual in that it was several stories high with the upper floors supported by columns. The shape of these architectural elements has been debated but there is considerable evidence to show that the columns were tapered in a manner that was the reverse of the normal shape in later Greek architecture; they were larger at the top and gradually smaller at the bottom. Staircases and light wells provided access and air circulation for this complex building. The walls of the palace were decorated with fresco painting (painting done on the wet plaster) as well as modeled plaster reliefs. Both the complexity of the structure, built over a long period with many changes and additions, and the colorful decoration attest to a

View across the courtyard of the Minoan palace at Phaestus in Crete. COURTESY OF JAMES ALLAN EVANS.

highly developed civilization with considerable wealth and material resources at its command.

OTHER MINOAN ARCHITECTURE. Although the Minoan civilization is best known today from the partly reconstructed ruins of the palace at Knossos, many other remains of this culture exist on the island of Crete. The principal evidence is to be found at Phaestus, Mallia, and Hagia Triada. The final stage of the palace structure at Phaestus in the south of the island is characterized by a more regular plan. Although not symmetrical in its layout it appears to adhere to an almost rectangular grid. One of the important features of the palace is an open court, or peristyle, with columns around it. This seems to anticipate one of the main features of the typical Greek house of a thousand years later but it is probably only an example of a design solution for interior space that might have developed anywhere. The palace at Mallia, on the north coast east of Knossos, is distinguished by a large court with many small rooms leading from it in a confusing arrangement that appears not to have been carefully planned in advance. There is some thought that the maze of rooms supported an upper story where the arrangement of space may have been more formal. Due

to the terrain, the small palace (or villa) at Haiga Triada on the south coast was laid out without a central courtyard in an "L"-shaped plan. This suggests that architects of the Minoan period were adaptable to the local situation in their design for large administration buildings and domestic quarters.

MYCENAEAN ARCHITECTURE. The Mycenean peoples—named after Mycenea, the most prominent city on mainland Greece at this time—ushered in a new attitude toward architecture and building. The Mycenaeans were a dominating culture and soon expanded from the mainland of Greece into the Greek isles, overcoming the Minoans of Crete by 1400 B.C.E. and, being a mainland culture, began building compact citadels and fortresses protected by massive walls instead of large sprawling palace complexes. The citadels at Mycenae and at Tiryns have many common features, including an orderly and compact ground plan, encircling fortress walls, and rooms that were used for administrative purposes as well as residential. The interior walls were of stone with upper parts in sun-dried brick. Interior supporting columns were of wood, floors of plaster or gypsum, and ornamentation in plaster as well as some

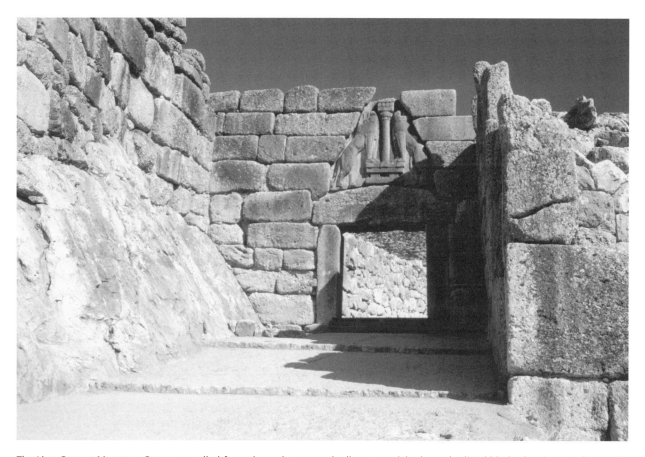

The Lion Gate at Mycenae, Greece, so-called from the sculpture on the limestone slab above the lintel block, showing two lions with their feet resting on an altar. © CHRIS HELLIER/CORBIS.

carved stone. The "megaron" form, basically a long hall used for assembly, is an important element in Mycenaean architecture. It is this general form that is thought by some to be the basis that later Greek temple design took as a starting point. The other major architectural achievement of the Mycenaeans was the Tholos tomb. Originally these were thought to be treasuries or storehouses for valuables, but they are now generally believed to be the tombs of Mycenaean rulers. The tholos tomb was a circular, underground, stone structure with an interior rising to a point. The stone construction was accomplished with the corbelled system where each higher row of stones overlaps or projects farther into space. When a corbelled dome or arch is trimmed or cut to a curve, it is virtually impossible to determine that it is not based on a true arch. The "Treasury of Atreus" at Mycenea (1300–1250 B.C.E.) is a prime example of the tholos type of tomb. It was approached by a straight passage of about 35 meters cut into the hillside. The main entrance doorway was decorated with half columns in green stone with other facing elements in red stone. These were carved with decorations of spi-

rals, chevrons, rosettes, and other geometric designs. The massive size of some of the stones, particularly one of the lintels, which has been estimated at over 100 tons, indicates a level of experience and an organizational ability that made it possible to shape, move, and handle extraordinary construction elements. This ability to work in large stone, also seen in the construction of the citadels, is thought by some scholars to be related to the work of the contemporary Hittites in Asia Minor (modern Turkey). At Pylos in the southwest the remains of a palace has been found. It is a complex, somewhat resembling Minoan architecture, with courts, rooms, stairways and storage areas. There was an original megaron but it is not central to the plan. Two phases of construction can be seen with an expansion that became the more important part of the building. In the latter phase there is a larger and more formal megaron with a central hearth and four columns that once supported a four-sided balcony. This large audience hall was decorated with fresco paintings and mosaic floor in a lavish manner that indicates the wealth and power of the rulers of Pylos.

THE RUINS OF MYCENAE

INTRODUCTION: In the second century C.E. the Greek traveler Pausanias, who can only be described as an antiquarian—a person who studies ancient remains—left an account of the sights he saw and tried to give historical explanations for them. His descriptions of the monuments of Greece are an invaluable source and reference. He often describes the way a temple area was decorated and he gives the names of the artists who were responsible for the sculpture, as well as the architects. His historical explanations of events are sometimes a little fanciful, but they were based on the knowledge of history available to him in his time. As an example, his description of the citadel of Mycenae and its gate decorated with lions illustrates the fact that the remains of a period in Greek history of over a thousand years earlier were still visible and were still identified with the people who made them.

It was jealousy which caused the Argives to destroy Mycenae. For at the time of the Persian invasion the Argives made no move, but the Mycenaeans sent eighty men to Thermopylae who shared in the achievement of the Lacedaemonians. This eagerness for distinction brought ruin upon them by exasperating the Argives. There still remain, however, parts of the city wall, including the gate, upon which stand lions. These, too, are said to be the work of the Cyclopes, who made for Proetus the wall at Tiryns. In the ruins of Mycenae is a fountain called Persea; there are also underground chambers of Atreus and his children, in which were stored their treasures. There is the grave of Atreus, along with the graves of such as returned with Agamemnon from Troy, and were murdered by Aegisthus after he had given them a banquet. As for the tomb of Cassandra, it is claimed by the Lacedaemonians who dwell around Amyclae. Agamemnon has his tomb, and so has Eurymedon the charioteer, while another is shared by Teledamus and Pelops, twin sons, they say, of Cassandra, whom while yet babies Aegisthus slew after their parents.

SOURCE: Pausanias, *Description of Greece.* Trans. W. H. S. Jones (New York: G. P. Putnam's Sons, 1918): 331.

THE DARK AGES. The centers of Mycenaean strength were destroyed from around the beginning of the eleventh century B.C.E. as the Dorians began to invade Greece. Like any invading culture, the Dorians brought their own cultural styles, and the Mycenaean and Minoan influences began to be suppressed. Many historians have termed this the "dark ages" of Greek history, for the Dorians did little to advance any of the cultural aspects of the society, and architecture, which would take on mainly Doric traditions by the eighth and seventh centuries B.C.E., remained mainly in the Mycenaean style during this time. By the time that the Greek culture began to construct its famous temples and structures of the fifth and fourth centuries B.C.E., many of the architectural designs of the Mycenaeans and Minoans had been lost, but many were the basic elements for what is considered by many scholars to be classical Greek architecture.

SOURCES

Reynold Higgins, *Minoan and Mycenaean Art.* Rev. ed. (Oxford: Oxford University Press, 1981).

A. W. Lawrence, *Greek Architecture.* Rev. R. A. Tomlinson (New York: Penguin Books, 1983): 35–70.

SEE ALSO *Religion: The Early Greeks on Mainland Greece*

GREEK ARCHITECTURE

GREEK BUILDING TECHNIQUES. Almost all major Greek architecture employed the simple "post and lintel" system. In this method of building, two or more uprights—columns, piers, or walls—support horizontal members of a length limited by the strength of stone able to support its own weight. The "post" is the upright structural part and the "lintel" is the bridging element meant to span openings or support the roofing of the building. The Greeks became proficient in this style of construction as they developed methods of quarrying stone and the transportation and the handling of large stone masses. Ingenious devices were invented for the lifting and hoisting of building materials. From inscriptional evidence we know that the pulley, a device now taken for granted, was used with wooden lifting structures. These primitive cranes had two, three, or four legs, depending on the situation and the weight demands. Systems were developed for lifting stone that employed rope rigging to lift while levers and crowbars were used for placement. These devices seem self-evident today, but in their time they represented technological advances over the ancient technique of moving stone to a height on sleds and ramps. Timbers were used to support and form the structure of the roofing that was usually covered with tile. In domestic architecture, dwellings, shops, and other utilitarian buildings, construction was much simpler. It

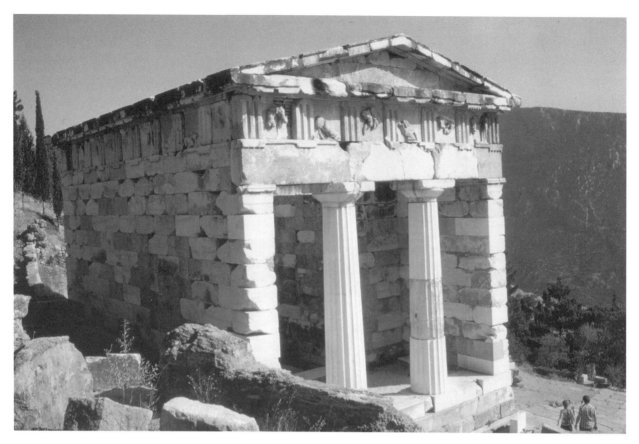

The Treasury (Storehouse) of the Athenians at Delphi, Greece, built after the victory of the Athenians over the Persians at Marathon in 490 B.C.E. **PHOTOGRAPH BY HECTOR WILLIAMS. © HECTOR WILLIAMS.**

usually consisted of walls of fired or unfired brick laid on rough stone foundations. The tools employed for most architectural work were simple, yet they represent the state of technology of the period. Architects and engineers used cords for measuring, with squares, plumb bobs, and levels to maintain the accuracy of the construction. Masons employed hammers, axes, files, and chisels to work the stone. Iron tools were adequate to shape marble and limestone.

EARLIEST TEMPLES. The history of Greek architecture is essentially the history of the development of the Greek temple. In the Bronze Age and the periods of Minoan and Mycenaean strength in Crete and mainland Greece, the temple was not the principal place of worship of the gods. A dwelling place or cult center for the deity was not defined by an elaborate structure so the importance that was to be placed on temple building signaled a new and different attitude to worship. One important consideration must still be remembered. The temple in Greek culture was not a building to accommodate groups of worshipers. It was the house of the god or goddess with a statue of the deity and perhaps

some additional rooms that functioned as treasuries, but the rites and sacrifices made to the god were carried out on an altar in front of the temple. The earliest examples of temples of the Greek age can only be deduced from archaeological evidence. There are pottery models of single-room structures with peaked roofs dating to the eighth century B.C.E. that give some indication of early temple design. The idea of surrounding a temple structure with one or more rows of columns seems to have been a purely Greek invention. In other ancient cultures, particularly in Egypt, columns were mainly used on the interior of temples, sometimes in great profusion. In Greek architecture the exposed column was one of the most characteristic elements. Probably the earliest rectangular temple with a colonnade surrounding it for which there is evidence is the temple to the goddess Hera on the island of Samos. It has been dated to the late eighth century B.C.E. At this stage the columns were of wood set on bases of stone. The temple was rebuilt in the seventh century B.C.E., made slightly larger, and modifications were made that brought it closer to the

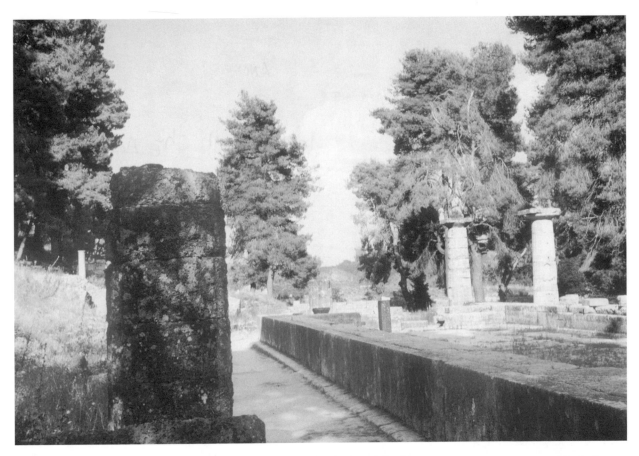

Ruins of the Temple of Hera at Olympia, Greece, dating from the beginning of the 6th century B.C.E. **COURTESY OF JAMES ALLAN EVANS.**

eventual proportion and design of temples of the classic age.

EARLY DORIC STYLE. About 580 B.C.E. a Doric-style temple was built to the goddess Artemis on the island of Corfu, just off the northwest coast of mainland Greece. Although it has been completely dismantled, enough of the limestone blocks have been found to furnish evidence to suggest its size—about 77 feet wide and about twice that in length. Enough of the pediment—the triangular space at the end under the double-pitched roof—was recovered to show that it had been decorated with carving in relief, representing a gorgon and a battle between gods and giants. This is the one of the earliest examples of pedimental sculpture that can be determined. Around the same time a temple was built to the goddess Hera at Olympia. Only the super-structure has been preserved but it was possible to deduce that it had sixteen columns on the side and six at the ends, the corner columns counted twice. The columns had no separate base but rested on the top step of the platform. Columns of the type called Doric were fluted—carved with a series of shallow vertical chan-

nels—and tapered toward the top. The capital, or top of the column, consisted of a curved pad-like part with a square block above. The plan of the temple at Olympia includes a pronaos, cella, and the first known example of the opisthodomus. The cella was the central hall or sanctuary of the temple, and the pronaos was the small anteroom in front of it. The opistho-domus is a small porch at the back of the cella. There were two rows of columns inside to support the roof and evidence that there had been engaged columns as well, attached to the sidewalls. This temple originally had columns in wood that were only gradually replaced in stone. As a result they are of several different periods and styles from the sixth century B.C.E. to Roman times. In the second century C.E. Pausanias noted one wooden column still standing which had not been replaced. The walls of this temple were of sun-dried brick laid on a stone foundation. The architrave or base for the roof structure that bridged the columns was apparently of wood, and the roof itself was covered in terra cotta tiles. A large limestone base was found inside the cella, probably for the cult statue of the goddess or a

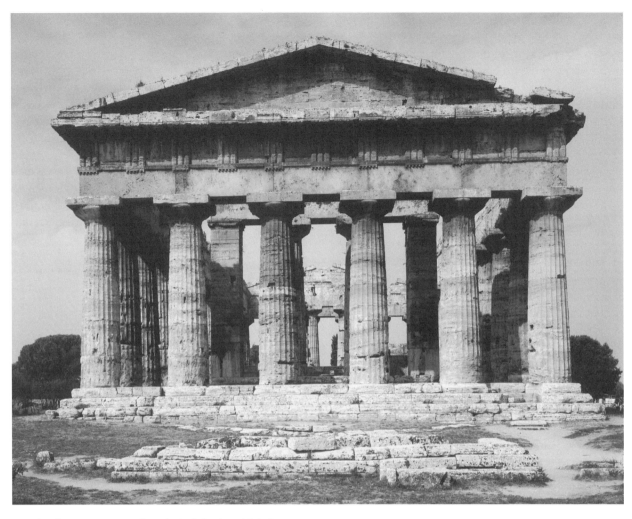

Temple of Hera at Paestum in Italy. Built in the mid-sixth century B.C.E. **THE ART ARCHIVE/DAGLI ORTI.**

double statue of Hera and Zeus. This early temple is important not only for its layout and proportions but also for the evidence it gives of temples originally built with wooden elements being replaced by more durable stone construction. In the Doric order the frieze—the horizontal band above the architrave—was decorated with a pattern of alternating *triglyphs* and *metopes*. The triglyph is a single block with its face carved to resemble three vertical bars; the metope is a rectangular slab that may be plain but may also be decorated with painting or relief sculpture. It is thought by some that the design of the triglyph was a memory of the beam-ends in wooden architecture, but this explanation is not accepted by all architectural historians. The temple of Apollo at Corinth, dated to about 540 B.C.E., is the only example of a sixth-century mainland temple with some columns still standing. Each column is a monolith—carved from a single block—standing about 21 feet high, made of a porous limestone originally finished with a coat of stucco. There were six columns on the end and fifteen on each side, making the length two and a half times the width. The platform under the colonnades rose in a slight convex curve. This is the earliest example known where this adjustment was made to correct the optical illusion that makes the base line appear to be curved. The interior of this temple was divided into two chambers back to back, each entered from its own porch. Other preserved examples of sixth-century Doric architecture can be found in the Greek colonies of Sicily and southern Italy. To fully appreciate the early development of the Doric style it is necessary to examine some of these. Three well-preserved temples at Paestum, south of Naples, include one to Hera from the mid-sixth century. It has long been known as the "Basilica" and is still referred to by that name in some publications. All of the peripteral colonnade is still standing and the architrave is still in place, but the walls are completely gone. There were nine

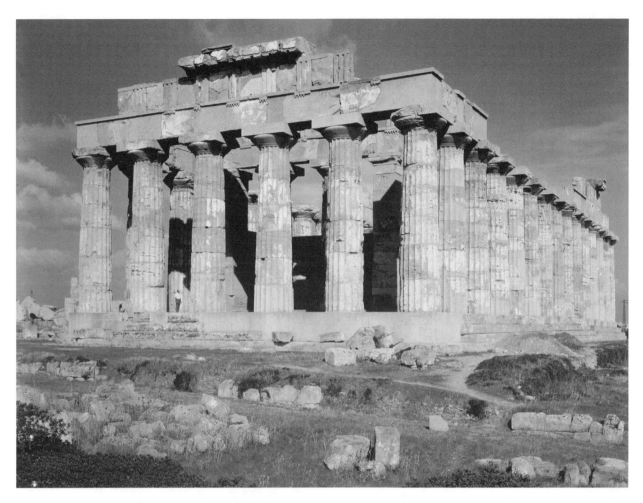

Temple E, probably dedicated to Hera, in Selinunte, Sicily. Begun early sixth century B.C.E. **THE ART ARCHIVE/DALGI ORTI.**

columns at each end and eighteen on a side. This is somewhat unusual with an uneven number on the façade dividing it in half. The cella contained a central row of columns that were the same size as the colonnade. A feature of this early stage in the development of the Doric order is that the columns in this temple were radically tapered from bottom to top so they gave a springy or elastic appearance to the structure.

EARLY IONIC ARCHITECTURE. The Doric and Ionic architectural orders have a number of differences but the main one is the placement, shape, and proportion of the columns. The Doric column sits directly on the platform of the temple; the Ionic has a base, usually composed of several elements that may even contain carved decoration. As compared to the simpler Doric capital the Ionic capital has a pair volutes—spiral- or scroll-shaped ornaments—that may suggest construction in other materials than stone and also reflect the influence of cultures from western Asia or Egypt. The Ionic column is generally thinner in proportion to its height than the Doric,

and Ionic temples generally only have two steps where the Doric has three. Two temples built about the same time in the mid-sixth century are examples of the early Ionic-style and are also among the first large-scale temple buildings in Greek architecture. One of these was a second temple dedicated to Hera on the island of Samos and the other to Artemis at Ephesus in east Greece—now the west coast of Turkey. The temple at Ephesus was partially paid for by King Croesus of Lydia, whose wealth became proverbial—"rich as Croesus." At Ephesus the temple to Artemis had a double colonnade with 21 columns on a side measuring almost 360 feet. This massive building was built of marble with a wooden roof covered with terra cotta tiles. Some of the lower column drums were decorated with relief carving. The temple to Hera at Samos also had a double colonnade and faced east, as was the normal orientation of Greek temples. The temple to Artemis, by contrast, faced west. This may have been influenced by an earlier shrine on the site at Ephesus. A later temple on the Samos site, begun around

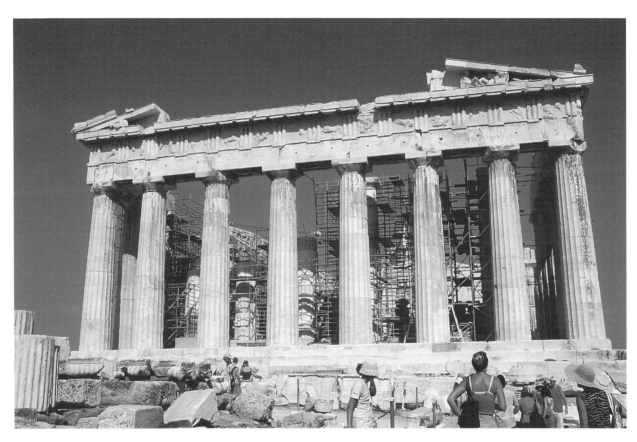

Exterior view of Parthenon on Athenian Acropolis from the east. **PHOTOGRAPH BY HECTOR WILLIAMS. © HECTOR WILLIAMS.**

530 B.C.E., was the largest Greek temple of which modern scholars have knowledge. It measured 179 by 365 feet and had columns that were 63 feet high. The columns themselves were of limestone, but their capitals and bases were of marble, probably to conserve the valuable marble.

FIFTH CENTURY TEMPLES. In the fifth century B.C.E., the refinement of the relationship of architectural elements and proportions were effectively resolved resulting in the "classic" look of Greek temple architecture. The ideal relationship of the numbers of columns—ends to side—was resolved at six to thirteen. Marble came into prominence as the major building stone, replacing limestone where it was available. An important example of the developing refinement from sixth into fifth-century B.C.E. architecture is the one dedicated to the goddess Aphaia on the island of Aegina, southwest of Athens. A good deal of it has survived, including some of the pedimental sculpture, enabling reliable restoration to be realized. Its position on a hilltop is a reminder that the site of a Greek temple was often chosen for its commanding height and view of the sea or surrounding landscape. The temple had six by twelve columns, not yet the ideal relationship of six to thirteen

to come. The interior of the cella in this temple had two rows of smaller columns that supported a second, smaller, row above. This two-story interior colonnade was not unique and can be found in some other temples. Its purpose was to help support the roof construction. Since it was not thought proper for interior columns to be taller than those on the exterior the solution was to have two superimposed levels of smaller columns to reach the height between floor and roof. This arrangement can also be seen in the temple of Hera (once thought to be dedicated to Poseidon) at Paestum in southern Italy. This temple, probably the best example of a Greek-style temple preserved, was also built between the beginning and the middle of the fifth century. The exterior decoration of the temple at Aegina included marble roof tiles on the edge of the roof, water spouts in the shape of lions' heads, antefixes shaped like palmettes, and a considerable amount of colored detail. Although there is some debate about the amount of decorative color used in Greek architecture, many examples of painted surfaces have been found preserved, giving considerable support to the idea that these structures were not the stark light color of marble or limestone, as they exist today.

a PRIMARY SOURCE *document*

PAUSANIAS DESCRIBES THE PARTHENON

INTRODUCTION: Often it is the description written by a traveler in ancient times that gives us a real impression of how the monuments looked in their own time. When Pausanias, the Greek traveler and historian, visited Athens in the second century C.E. and climbed to the top of the Acropolis, he saw the Parthenon in what must have been near its original condition. As was usual with his writing, he tried to identify the subjects of the decoration and explain their historical or mythological significance.

As you enter the temple that they name the Parthenon, all the sculptures you see on what is called the pediment refer to the birth of Athena, those on the rear pediment represent the contest for the land between Athena and Poseidon. The statue itself is made of ivory and gold. On the middle of her helmet is placed a likeness of the Sphinx—the tale of the Sphinx I will give when I come to my description of Boeotia—and on either side of the helmet are griffins in relief. These griffins, Aristeas of Proconnesus says in his poem, fight for the gold with the Arimaspi beyond the Issedones. The gold which the griffins guard, he says, comes out of the earth; the Arimaspi are men all born with one eye; griffins are beasts like lions, but with the beak and wings of an eagle. I will say no more about the griffins. The statue of Athena is upright, with a tunic reaching to the feet, and on her breast the head of Medusa is worked in ivory. She holds a statue of Victory about four cubits high, and in the other hand a spear; at her feet lies a shield and near the spear is a serpent. This serpent would be Erichthonius. On the pedestal is the birth of Pandora in relief. Hesiod and others have sung how this Pandora was the first woman; before Pandora was born there was as yet no womankind. The only portrait statue I remember seeing here is one of the emperor Hadrian, and at the entrance one of Iphicrates, who accomplished many remarkable achievements.

SOURCE: Pausanias, *Description of Greece*. Trans. W. H. S. Jones (New York: G. P. Putnam's Sons, 1918): 23, 25.

THE ACROPOLIS. The buildings on the Acropolis—literally "high city"—at Athens had a long history extending back into Mycenaean times. The oldest temple of the goddess Athena on the site can be traced back at least to the seventh century B.C.E. Originally a fortified stronghold, the limestone plateau high above the city remained the center of worship for the patron goddess with her main altar after its military importance had diminished. At the beginning of the fifth century B.C.E. the Athenians began a building project to replace the old temple and construct a new propylon—entrance gate—to the sanctuary. This plan was interrupted by the Persian invasion and the destruction and sack of the Acropolis in 480 B.C.E. It was not until after the mid-century that the plans for a new temple for the city goddess were carried out. Modern scholars know this new temple as the Parthenon, so named because it was dedicated to a special aspect of the goddess as Athena Parthenos—Athena the maiden or Athena the virgin. Her cult center eventually contained several important buildings in addition to the main temple. These are the Propylaea or entryway to the Acropolis, the temple of Athena Nike or Victory, and the Erechtheum, a building intended to organize several cults in one structure.

THE PARTHENON. Under the leadership of Pericles the old building plan of the 480s was revived at the mid-century. The architects of the new temple to Athena were Ictinus and Callicrates. The cult image for the temple was the work of Phidias, who probably also created the decorative program for the whole building and is traditionally thought to have been the overall director of the works. The temple was begun in 447 and dedicated in 438 but the sculptural decoration was not completely finished until 432. The building was used in later times as a Byzantine church, a Catholic church, and a Muslim mosque. In 1678 an explosion of gunpowder stored in the cella destroyed much of the center of the temple that had been in a good state of preservation up to that time. In the period 1801–1803 the English collector, Lord Elgin, received permission from the Turkish officials to remove some of the sculpture—the so-called *Elgin Marbles* now in the British Museum (and the source of controversy with the present Greek government). These included some of the pedimental figures and most of the relief frieze that are considered among the most important examples of fifth-century B.C.E. Greek art. The building itself was constructed of Pentelic marble on a limestone foundation that partly covered that of the earlier temple. Some of the column drums from the ruined temple were found in good condition and used in the new one, dictating the size of the columns—34 and one-fourth feet high—but not the overall proportion. The Parthenon has eight columns on the ends and seventeen on the sides because it is somewhat wider in pro-

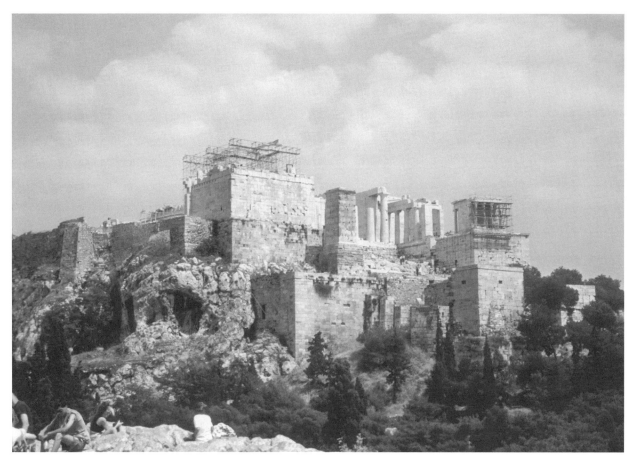

A view of the Acropolis of Athens from the southwest showing the Propylaea (monumental entrance). **COURTESY OF JAMES ALLAN EVANS.**

portion than had been the rule. It is possible that this extra width was planned to accommodate the interior view of the extraordinary colossal gold and ivory statue of Athena in the cella. The plan included the peripteral colonnade, front and rear porches with six columns, and a chamber behind the cella that may have served as the treasury. The cella had a two-story colonnade on the sides and back, presumably for viewing the Athena statue. By the mid-fifth century Greek architects had achieved a level of design with a refinement and a harmony of proportion that has seldom been equaled. This was done over time by trial and error, taking advantage of technological advances in building and by considerable experimentation with the visual effects of size, shape, and relationships. Visual refinements were made to correct optical illusions. Thus the main horizontal elements in the facade of the building—the platform *stylobate* and the superstructure *entablature*—were gently curved downward from the center. The columns and walls lean slightly inward. The columns taper toward the top in a slight curve *entasis* and even the depth of the column

fluting is less deep at the top. The Doric column of the fifth century B.C.E. has been greatly refined from its predecessor of a hundred years before, and its curved profile is much more subtle. Many scholars have seen this as an incorporation of Ionic aspects into the Doric style. Much has been said about the ideal mathematical proportions that were developed by Greek architects in order to define the visual relationships of building parts. In the Parthenon a number of examples of this principal at work can be seen. The ration of width to length of the temple is 9:4; the space between the columns to their diameter has the same relationship, 9:4, and this can be seen in other aspects of the building as well. The use of simple repeated ratios and geometric relationships imposed a visual order and harmony and resulted in an architectural masterpiece.

THE PROPYLAEA. The Propylaea was the grand ceremonial gateway and entrance to the precinct of the Acropolis. It replaced an earlier structure as the Parthenon had replaced an earlier temple. It was the work of the architect Mnesicles, and it was begun in 437

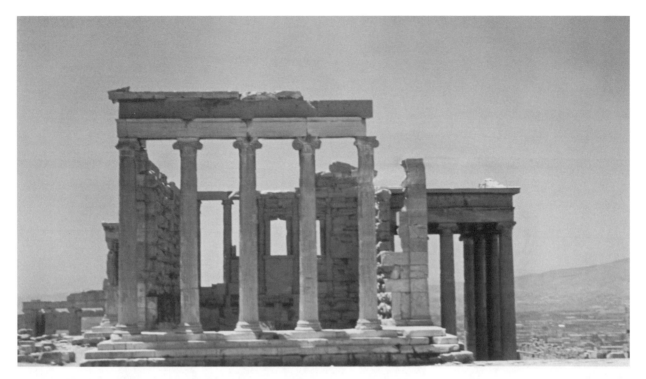

The Erechtheum in Athens; the view from the east. COURTESY OF JAMES ALLAN EVANS.

B.C.E., after the construction of the Parthenon was finished and work on it was halted in 432 B.C.E. The Propylaea was entirely of marble and took five years to build but was never completely finished according to plan. In addition to the grand gateway with a wide central passage it had porches with six columns on the outer side and inside and was to have two large rooms flanking the doorway. One of these rooms was described by Pausanias as a "picture galley" but it has also been suggested that this was a formal dining room. The building was built entirely of costly marble and on such a large scale that some of the ceiling beams had to span a distance of eighteen feet. As a consequence of this size, these have been estimated as weighing over eleven tons. This ability to handle large weight at a height indicates a well-developed system of construction techniques.

THE TEMPLE OF NIKE AND THE ERECHTHEUM. High to the right of the Propylaea a small temple was begun about five years after work on the ceremonial gateway was suspended. This compact structure was dedicated to Athena Nike—goddess of victory. It was designed in the Ionic style with four slender columns at each end. The cella was entered between two piers or square pillars which were connected to the side walls by bronze lattice screens. A carved frieze representing the Greeks battling the Persians decorated all four sides of the entablature, an element more typical in the Ionic

than in the Doric style. The pediment above had carved figures, as can be determined by attachments, and a sculpted parapet on three sides was added later. Another important building on the Acropolis in the Ionic style is the Erechtheum. It takes its name from Erechtheus, a legendary king of Athens, whose palace may have been thought to have once stood on that location. Begun in 421 and finished in 405, it is probably the most unusual structure in the precinct because of its irregular plan. This was perhaps the result of a need to bring together several shrines or cult places. There were three inner chambers and three porches or porticoes of different sizes and on different levels. On the south side the porch had six caryatids—architectural supports in the shape of human figures—supporting the entablature instead of columns. These famous female statues have been removed to the protection of a museum and replaced with copies. One of the important lessons to be learned from the Erechtheum is the fact that Greek architects were able to adapt to the needs of an unusual situation.

THE TEMPLE OF OLYMPIAN ZEUS. To the southeast of the Acropolis in Athens a large temple dedicated to Olympian Zeus was begun around 520 B.C.E., but it was left unfinished and only the platform was used in its completion at a much later time. Under Antiochus IV, king of Syria, work was resumed on the tem-

The Temple of Olympian Zeus in Athens, begun in the sixth century B.C.E. but finished by the emperor Hadrian (117–138 C.E.). COURTESY OF JAMES ALLAN EVANS.

ple in the second century B.C.E. but it was not finally finished until 131 C.E. in the time of the Roman emperor Hadrian. It is thought that it was originally planned in the Doric style but when it was completed it was with elements of the Corinthian order including elaborate floral Corinthian capitals. The original plan included a double row of columns in the peripteral colonnade with a third row at each end. This was probably influenced by other early temples on a large scale like that of Hera at Ephesus. The Temple of Olympian Zeus was one of the largest in Athens, measuring 135 by 353.5 feet with columns that were 57 feet high. Its completion hundreds of years after it was started was probably a result of the emperor Hadrian's admiration for Greek culture.

THE GREEK THEATER. Although the temple form is the most important architectural type in Greek history, there are a number of other kinds of structures to consider. In addition to the temple there were many other types of public buildings, monuments, altars, and tombs that should be mentioned. The theater was perhaps the second most typical expression of Greek archi-

tectural design. All festivals, athletic contests, and dramatic presentations were held out of doors. Originally even the Assembly of the citizens of Athens was held in the open air on the sloping rocky outcrop known as the Pnyx. This allowed the participants to see and hear the speakers who were at a lower level. It follows that the performances held in honor of the god Dionysus would be held in a hollow where the audience could be seated on the sloping hillside. In the history of the Greek drama most theaters were constructed where they could take advantage of the natural hillside. The beginnings of the drama were in choral dances so the most important area of the theater was the circular *orchestra* which literally means "dancing place." The body of the auditorium or *theatron* consisted of a semicircular arrangement of gently sloping stone rows of seats. As the idea of the dramatic theater developed and the number of actors was increased, it became necessary to provide a stage with a backing of some sort. This was called the *skene* and it provided a sounding board to help project the voices of the actors as well as to provide some rudimentary scenery. The idea of the theater as a special building

Hellenistic theater at Kourion in Cyprus. COURTESY OF JAMES ALLAN EVANS.

seems to have developed at the end of the sixth century and the beginning of the fifth century B.C.E., but one of the earliest still in evidence is the theater of Dionysus on the southern slope of the Acropolis. It was later changed or modified when it went through a number of re-buildings during the fourth century and the Roman Imperial period. One of the best-preserved examples of a theater is at Epidaurus on the east coast of southern Greece. According to Pausanias, the architect of this theater was Polykleitos the Younger. It was constructed around 350 when the essential elements of theater design had been formalized. The auditorium, which has a shape slightly more than a semicircle, is cut into the hill-side. The stone seats are divided into wedge-shaped blocks or sections with a horizontal passageway separating the lower from the upper part, which is steeper and has higher seats. The design of the seats even provides some leg space beneath to allow the spectators to make room for people passing in front of them. The lowest seats were for special attendees and had backs and arm rests. In some theaters these seats for dignitaries were almost throne-like with elaborately carved decoration. There was presumably an altar in the center of the or-

chestra, as evidenced by a stone base found in place. The stage building must have been a tall one, again to judge from the remaining foundations. This theater could accommodate an estimated twelve to fifteen thousand people, seated in relative comfort and with apparent ease of entrance and exit. The design of Greek theaters changed somewhat to accommodate other types of dramatic presentations when they were developed but the basic parts remained the same and were standard throughout the Greek world.

BUILDINGS WITH A SPECIAL PURPOSE. One of the most important buildings in the daily life of the Greeks was the *stoa*, a one or two-storied structure with a long colonnade that could include shops and serve also as an informal meeting place. The stoa of Attalus in the Agora (open marketplace) at Athens has been reconstructed from the archaeological evidence and serves as a good example of the type. Such colonnaded buildings provided protection from the elements for the public in their daily activities and as a result they were to be found in religious complexes as well as marketplaces. Other public buildings were specifically designed as meeting places for the civic councils, assembly halls for a particular cult, and

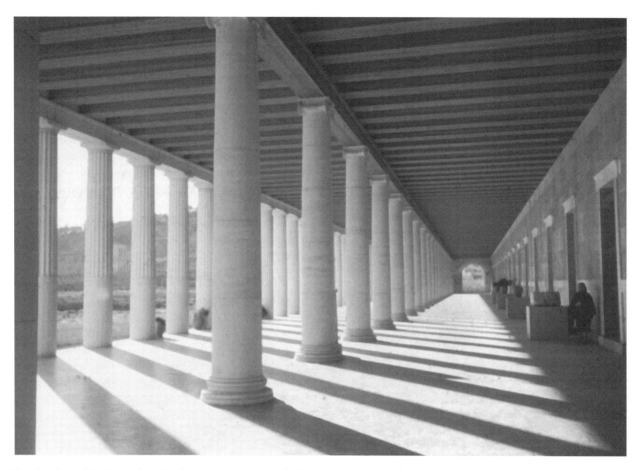

Interior view of the Stoa of Attalus in the ancient agora of Athens, Greece. Originally built as a gift of King Attalus II of Pergamum (159–138 B.C.E.). **PHOTOGRAPH BY HECTOR WILLIAMS. © HECTOR WILLIAMS.**

even informal spaces for social clubs. Functional buildings included fountain houses where people would go to fill their water jars. These are often illustrated in Greek vase painting. One special type of building was the clock tower. The only surviving example is the so-called "Tower of the Winds" preserved in Athens. Built in the first century B.C.E., it is an octagonal (eight-sided) building with carved reliefs depicting personifications of the winds at the top of each side. In addition to space for a water clock and reservoir there were sundials mounted on the sides and a wind vane was mounted on the top.

HOUSES AND CITY PLANNING. The typical Greek house answered the need for an enclosed space offering privacy and protection. The normal plan of the living space centered on an open court with a peristyle or verandas. A number of examples have been excavated, and they generally follow the same arrangement that consisted of an entrance hall with a small room to one side, a central courtyard with rooms of various sizes fronting on it. These houses were generally of one story and laid out in a square plan, with mud brick walls on a stone or rubble foundation. The floors in special areas, such as the dining room, could be decorated with mosaics. The dining room was also often provided with platforms for the reclining diners. Bathrooms were sometimes paved and provided with terra-cotta tubs, but other sanitary facilities have seldom been found in excavation. The doors of houses were of wood and from representations in vase painting modern scholars know that they were decorated with metal studs. The regular arrangement of dwellings in an orderly city plan became popular in the early fifth century B.C.E. Greek cities were laid out with provision for public meeting and trading places (the agora or public square), and cult centers and sanctuaries where the temples and shrines were located. The cities were typically surrounded by a protective wall, with towers, moats, and defensible gates. Such fortifications were the result of the need to guard against attack and to assure a sense of security.

SOURCES

A. H. Lawrence, *Greek Architecture*. Rev. R. A. Tomlinson (New York: Penguin Books, 1983).

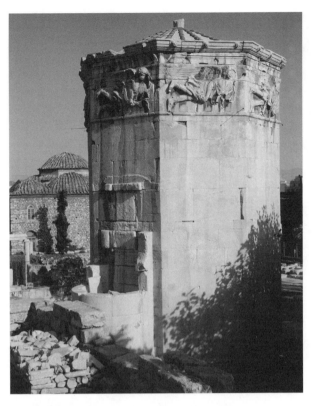

The *Horologion*, known as the "Tower of the Winds," in Athens, Greece, which served as sundial, water-clock, and weather-vane (built 2nd–1st century B.C.E.). **THE ART ARCHIVE/ DAGLI ORTI.**

G. M. A. Richter, *Greek Art* (London: Phaidon Press, 1967): 7–44.

SEE ALSO *Fashion: Garments in Classical Greece; Religion: The Gods of Olympus; Religion: Worshipping the Gods: Sacrifices and Temples*

ETRUSCAN ARCHITECTURE

BACKGROUND. The study of Etruscan architecture is principally the study of tomb design because the greatest body of evidence preserved consists of subterranean tombs. The examination of architectural types such as temples and other public structures cannot be based on standing buildings, as is possible with the Greek or Roman material. It is necessary to rely on archaeological finds, which consist mainly of foundations and the remains of building parts. However, the descriptions of ancient authors, particularly Vitruvius, supplement modern knowledge. His *De Architectura* (On Architecture) is a particularly useful reference because, among other topics, he describes his understanding of the basic rules for the design and construction of Etruscan

temples and their sites. It always has to be remembered that Vitruvius wrote in the late first century B.C.E. and had a desire to explain and employ classical styles in the work of his own time. He was a practicing architect and had a practical knowledge of materials, working techniques, and other areas of knowledge—such as site planning—that were part of the necessary education of the architect. His motives and the time in which he wrote, at the beginning of the reign of August Caesar, influenced his attitudes. Since he was one of the few ancient authors whose writing on architecture was preserved, he was very much respected in the Renaissance. Architects of that time turned to his work for the clearest explanation of ancient styles and techniques available to them.

MATERIALS AND TECHNIQUES. In the earliest beginnings, Etruscan architecture employed the crude wattle and daub technique, a method of construction employing bundled sticks with an overlay of mud. It is clear, from the evidence of tomb decoration that imitates living structures, that timber work was employed by the early sixth century B.C.E. in the construction of houses. From other evidence it can be seen that the Etruscans employed tufa blocks and ashlar masonry in foundations, buildings, and walls. "Tufa" is a porous volcanic rock common in Italy, and "ashlar" describes large, squared stones. Mud brick and half-timber construction on stone foundations was also practiced, a technique that used wood for framing and unbaked brick to fill the spaces between the frames. Mud brick and wood were the main materials of temple wall construction throughout most of Etruscan history. The lack of plentiful physical evidence available for an understanding of temple architecture can be attributed in part to the perishable nature of the material employed.

THE ETRUSCAN TEMPLE. Our principal knowledge of Etruscan temple architecture comes from Vitruvius who described in great detail their layout and construction as he understood them. In addition to the scant archaeological evidence and the literary sources for temple planning and construction, there are also imitations of temples found in tombs and on tomb facades and miniature copies used as votive gifts. The Etruscan-style temple, also called the Italo-Etruscan temple, had a form of its own that resisted the growing influence of Greek architecture. The Etruscan temple was more open in plan than the Greek, in part influenced by the need for observation of natural phenomena such as the flight of birds in divination. The material of the Etruscan temple never changed in the way that Greek construction did where wooden ele-

ments were later superseded by stone. The materials in Etruria remained wood on a stone foundation with considerable use of terracotta for decorative elements and roof tiling. One of the standard ground plans seems to have been a simple structure with a cella divided into three parts which has been interpreted as a provision for the worship of a triad of gods (Jupiter, Juno, and Minerva). There are also examples of ground plans preserved that have one or two rooms, depending on the number of deities worshipped in a particular locality. The main body of the temple opened on a porch supported by columns. The temple usually was raised on a podium or platform approached by a flight of stairs. The raised platform and stairs remained a characteristic of later Roman temple architecture in contrast to the Greek preference for closer visual relationship with the ground plane.

ETRUSCAN TOMBS. The earliest Etruscan burials were essentially of two types: pit burial containing an urn with the ashes of the deceased, or a trench burial for the remains. Around 700 B.C.E. more developed tombs began to appear. These were also of two general types. One of these was a chamber-tomb type somewhat similar in design to the tholos tombs of the Mycenaeans, with a domed or "bee-hive" shape constructed of corbelled masonry. The shape varied and could be round or square. Side rooms provided space for the remains of other family members or personal belongings. This type of tomb could accommodate the sarcophagi of the deceased as well as some tomb furniture and personal possessions. The mound, or tumulus, that covered this type became a characteristic element of the landscape and made the location of the tomb clearly visible. Around the year 400 B.C.E. cremations of the dead became a more regular practice and the architecture of tombs gradually underwent a change. Instead of the constructed stone chamber covered with a mound, the tomb was cut into the rock or tufa hillside. Imitations of wooden architectural elements were carved on the façade and in the interior of the tombs. Instead of space for sarcophagi, shelves for cinerary urns were provided to accommodate the cremated remains of several family members. The wall decoration of tombs of both types included relief carving and painting. The subject matter of Etruscan tomb painting included the funerary banquet as well as scenes from Greek mythology.

CITY PLANNING AND DOMESTIC ARCHITECTURE. Etruscan towns and cities were situated to take advantage of water supply and defensive positions, as were most early communities in the ancient world. Access to the sea was important but most settlements were far enough inland to offer some protection against sea raiders. City walls for defense did not seem an important part of town planning if the choice of the site offered enough security. An ancient tradition credits the Etruscans with the invention of the type of city plan where streets intersect at right angles forming a north-south east-west grid. Although this system of city planning became very popular with the Romans, there is not yet enough evidence to prove that it was an Etruscan innovation in the Italian mainland. Etruscan houses of the early seventh century B.C.E. tended to be oval in plan and were placed to take advantage of the terrain, not according to a grid plan. These houses were of the wattle and daub type of construction with a thatched roof. Rectangular houses begin to appear around the middle of the seventh century. These were built on a stone foundation with wooden framing and unbaked mud brick. Gradually house plans developed from a broad layout with an entrance vestibule and a few rooms to one with a long entrance corridor leading to a courtyard surrounded by several rooms. This type of house with an interior courtyard was carried on in later Roman dwellings with an atrium, a larger and more formal central court.

SOURCES

Axel Boëthius and J. B. Ward-Perkins, *Etruscan and Roman Architecture* (Baltimore, Md.: Penguin Books, 1970).

Friedhelm Prayon, "Architecture," in *Etruscan Life and Afterlife: A Handbook of Etruscan Studies.* Ed. Larissa Bonfante (Detroit: Wayne State University Press, 1986): 174–201.

ROMAN ARCHITECTURE

BACKGROUND. Roman architecture is essentially a hybrid composed of elements inherited from the Etruscans combined with the outside influences of the Greeks. As an example, the native Etruscan building traditions can be recognized in the early substructures of the Capitoline Temple in Rome. With archaeological evidence of this kind supplemented by ancient descriptions this temple can be identified as the type described by Vitruvius as typically Etruscan, consisting basically of a wide structure with a deep porch supported by columns. By contrast, the Temple of Apollo at Pompeii, probably built in the late second century B.C.E., is a typical example of a temple that exhibits Greek influence in its plan. Etruscan and early Roman art and architecture were very much influenced by the advances made by the Greeks, particularly by the structures built in the Greek

CITY
Planning Was Not Invented
Only by the Greeks

It seems that there was an almost universal need among peoples throughout history to impose some order on their communities by the use of an overall plan where the local terrain allowed. This orderly design of towns and cities can be seen in many parts of the ancient world in cultures as distinct as ancient China and Egypt. Leopold Arnaud, a distinguished professor of architecture, in an essay titled "Social Organization and the City Plan" explained that it would be wrong to credit only the Greeks with the invention of city planning. He said that the idea of a rectangular pattern for town planning is very ancient. The origins of the system might have developed from the method of plowing a field or laying out a military camp but it was a practical arrangement and the idea could have developed independently in many different places.

In Egypt, during the Old Kingdom (2175–2134 B.C.E.), the streets of the City of the Dead at the foot of the Great Pyramid at Giza were laid out on a grid pattern with streets intersecting at right angles. This probably imitated and resembled the arrangement used in cities for the living. There are other examples of city planning in Egypt recovered by archaeological excavation that show this pattern to have continued throughout Egyptian history.

The plan attributed to the Greeks did not develop until late in their history during the time of Alexander the Great and his successors in the Hellenistic Period (Late fourth through late first centuries B.C.E.). This does not mean to suggest that the Greeks learned city planning from the Egyptians but simply that the same kind of organization was seen to be practical in both cultures.

The Roman town plan was similar to that developed by the Greeks and may owe some debt to them. In a Roman community the two main thoroughfares were called the *cardo*, which ran north and south, and the *decumanus*, east and west. Other streets ran parallel to the *cardo* and *decumanus* creating a regular system of city blocks.

Large cities like Rome and Athens, however, were not planned according to any organized scheme. They had simply grown and expanded from small settlements over a long history. Attempts were made at various times in both cities to bring some order to their plans but without overall success in either case.

colonies in southern Italy and Sicily. However, the contributions made by Rome to the development of architectural design were eventually of a different character. The development of new materials and techniques made possible revolutionary advances in the creation of monumental structures and especially in the treatment of interior architectural spaces. Greek building, whether in wood or stone, relied heavily on the post and lintel system—uprights supporting a cross bar—resulting in a style that created a strong horizontal sense of stability and solidity. The exterior of a Greek temple generally presented a carefully planned and orderly arrangement of its parts as seen from all views but the interior space was a less important consideration. With the development of concrete as a building material from the second century B.C.E. Roman architects and engineers were free to experiment with building on a colossal scale, enclosing large interior spaces and creating an architectural style that was basically new and extremely inventive.

ROMAN BUILDING TECHNIQUES. Building in stone as practiced by the Greeks required skilled stonecutters and masons, the help of engineers and riggers to carry out the actual construction, and little more. Some carpentry was necessary for the wood beams to carry the roof, and tile setters were needed to finish its covering.

By contrast, the newly developed techniques of the Romans required a larger range of specialists for the greatly expanded building program. Since concrete is initially a liquid, its use requires the cooperation of skilled carpenters to build scaffolds and forms, in addition to masons for some of the stone elements such as foundations and door frames, brick and tile layers for parts of the construction and the roof, plumbers for drainage systems, plasterers and painters for finished work, and artists/decorators for wall paintings and mosaic floors. In ancient Rome the need for this variety of skills resulted in the development of specialized working groups or guilds that could provide the necessary training and the continuity of experience. The initial use of concrete by the Romans may have grown out of a type of packed mud construction, but it more probably developed from the use of clay to bond courses of brick or stone. Once the discovery was made that rubble fragments of stone could be bonded together by pouring a liquid mortar over them, the natural next step was to build forms of wood that would retain the mortar until it hardened. Basically, Roman mortar was comprised of lime, and the best lime mortar used volcanic ash as an aggregate. Casting structural elements from concrete rather than carving them out of stone gave Roman architects the freedom

a PRIMARY SOURCE *document*

THE EDUCATION OF THE ARCHITECT

INTRODUCTION: The only Roman technical work on the art and science of ancient architecture was written by Vitruvius Polio, who lived during the reign of the emperor Augustus. In *The Ten Books on Architecture*, he gives detailed treatments of such subjects as town planning, styles of architecture, building materials, and methods of construction. Since he was a practicing architect in addition to being a learned man, the information he left is especially valuable, not only for the study of Greek and Roman architecture but for the descriptions he provides of the Etruscan architecture that no longer exists. Vitruvius' work has also been described as a practical guide to becoming a Roman architect. In this section he lists what sort of education an architect should have.

1. The architect should be equipped with knowledge of many branches of study and varied kinds of learning, for it is by his judgment that all work done by the other arts is put to test. This knowledge is the child of practice and theory. Practice is the continuous and regular exercise of employment where manual work is done with any necessary material according to the design of a drawing. Theory, on the other hand, is the ability to demonstrate and explain the productions of dexterity on the principles of proportion.

2. It follows, therefore, that architects who have aimed at acquiring manual skill without scholarship have never been able to reach a position of authority to correspond to their pains, while those who relied only upon theories and scholarship were obviously hunting the shadow, not the substance. But those who have a thorough knowledge of both, like men armed at all points, have the sooner attained their object and carried authority with them.

3. In all matters, but particularly in architecture, there are these two points: —the thing signified, and that which gives it its significance. That which is signified is the subject of which we may be speaking; and that which gives significance is a demonstration on scientific principles. It appears, then, that one who professes himself an architect should be well versed in both directions. He ought, therefore, to be both naturally gifted and amenable to instruction. Neither natural ability without instruction nor instruction without natural ability can make the perfect artist. Let him be educated, skillful with the pencil, instructed in geometry, know much history, have followed the philosophers with attention, understand music, have some knowledge of medicine, know the opinions of the jurists, and be acquainted with astronomy and the theory of the heavens.

4. The reasons for all this are as follows. An architect should be an educated man so as to leave a more lasting remembrance in his treatises. Secondly, he must have a knowledge of drawing so that he can readily make sketches to show the appearance of the work which he proposes. Geometry, also, is of much assistance in architecture, and in particular it teaches us the use of the rule and compasses, by which especially we acquire readiness in making plans for buildings in their grounds, and rightly apply the square, the level, and the plummet. By means of optics, again, the light in buildings can be drawn from fixed quarters of the sky. It is true that it is by arithmetic that the total cost of buildings is calculated and measurements are computed, but difficult questions involving symmetry are solved by means of geometrical theories and methods.

5. A wide knowledge of history is requisite because, among the ornamental parts of an architect's design for a work, there are many the underlying idea of whose employment he should be able to explain to inquirers.

SOURCE: Vitruvius, *The Ten Books on Architecture*. Trans. Morris Hicky Morgan (Cambridge, Mass.: Harvard University Press, 1914): 5–6.

to create more complex shapes, achieve greater heights, and span wider spaces. Although the arch, vault, and dome were known in other ancient cultures, it was not until the Romans developed the use of cast concrete that their full potential was realized and exploited.

EARLY ROMAN ARCHITECTURE. The Romans retained many ideas about building from their Etruscan predecessors, but they also absorbed some of the ideas of the Greeks that were passed on to them by the Etruscans. Houses for the cults of the gods were obviously important in both cultures. The designs of those cult places or temples in Greece and Etruria varied, but the first Roman temples were modeled more on Etruscan prototypes. Unlike the Greek temples that had a noble solidity about them, the Etruscan and early Roman temples suggested an openness as well as a sense of mystery. The early temple to Jupiter in Rome, the *Capitolium*, of the late sixth century B.C.E. was certainly built in the Etruscan style but on a grand scale, to judge from the foundations and some of the blocks that still survive. In following the Etruscan pattern it rested on a high platform or podium, had a broad porch supported by pillars, and a cella divided into three cult chambers. It was approached only from the front up a broad stairway that

Arts and Humanities Through the Eras: Ancient Greece and Rome (1200 B.C.E.–476 C.E.)

27

a PRIMARY SOURCE *document*

THE EMPEROR AUGUSTUS CHANGES THE FACE OF ROME

INTRODUCTION: The Etruscans built a great deal of their structures from perishable mud brick, including not only private dwellings but also temples and other public buildings. As Roman civilization developed and Rome became a great power in the Mediterranean world, it was only natural that important structures be constructed of more lasting and attractive materials. Not only was marble more durable, but it was also more beautiful. In his life of the emperor Augustus, Suetonius, the Roman historian, credits the emperor with leaving his mark on Rome.

He [Augustus] so improved the city, which had previously lacked the trappings which befitted the dignity of its empire and had been subject to floods and fires, that his boast to have "left in marble that which he found made of brick" was quite justified. And he made it safe for posterity, at least to the degree that it is possible for human reason to have foresight in such matters.

He built many public works, among which the following are conspicuous: his forum with the temple of Mars *Ultor*, the temple of Apollo on the Palatine, the temple of Jupiter *Tonans* on the Capitoline. The reason for constructing his forum was the greatness of the population and the number of judicial cases; these made a third forum necessary ...

SOURCE: Suetonius, *The Divine Augustus*, in *The Art of Rome, c. 753 B.C.–337 A.D., Sources and Documents*. Ed. J. J. Pollitt (Englewood Cliffs, N.J.: Prentice-Hall, Inc., 1966): 104.

suggested the change from ordinary life to the precinct of a god or gods. Later Roman temples would retain these characteristics—the design emphasis on the front porch and the raised podium, reached by an imposing flight of stairs.

ROMAN TOWN PLANNING. Where it was possible, Roman towns and cities were laid out on a system of streets intersecting at right angles, a type of layout also used for Roman military camps. It is thought that this system may have been inherited from Etruscan town planning, but some Greek cities had also used a grid and it is difficult to prove the exact derivation of the Roman plan. In the Roman system the main north-south street was called the *cardo* and the main east-west street the *decumanus*. These two streets were always wider than others and acted as the axes of the plan. Near their crossing in the center of a town were located the forum, the major temples, the main ceremonial and administrative buildings, and other structures central to the life of the community such as the major bathing establishments. In urban town planning some elements were standard and necessary to Roman life. The most obvious necessity was a type of dwelling which in Roman usage could range from a humble structure to a great palace. The provision of clean water for consumption and bathing was probably the next most important consideration—hence the emphasis on developing methods of transporting water over great distances such as the Roman aqueduct. The need for structures devoted to religion and the worship of the gods engendered a large variety of temple designs. The commemoration of military victories or the glorification of emperors and commanders was satisfied by the erection of monuments, columns, and arches, and the entertainment of the people was provided for by a well-developed system of theaters and arenas. The final necessary architectural form was the tomb structures for the burial of the dead.

THE ROMAN HOUSE. In the nearly 200 years of the Roman Republic—from 200 to 27 B.C.E.—a number of standard architectural forms developed. One of these, most typically associated with Roman architectural style, was the house form. Like its Greek predecessors, the Roman house looked in on itself. The exterior fronting on a street was not decorated and had only the main entrance door and possibly a few windows, although they were not a prominent feature of the design. The ground plan was often symmetrical and balanced. Beyond the entrance vestibule was the *atrium*: the central court with an opening in the roof, usually with a pool in the center where rainwater would collect. Around the atrium were the living rooms and bedrooms. Passing through the atrium one entered the *tablinum*, a formal room for entertaining visitors. Next to the tablinum was the *triclinium*—the dining room. In a more elaborate house there might be a further peristyle or open court and even an interior garden with more rooms leading off from it. This basic plan could be made more complex depending on the wealth, rank, and position of the owner. Country villas of the Republican Period, such as the Villa of the Papyri at Pompeii of the first century B.C.E. were already extremely elaborate and costly. The basic house plan with atrium and peristyle became the basis to which were added subsidiary wings and separate buildings, gardens, and pools, depending on the size of the household

and the number of family members, servants, and slaves. By contrast to the standard plans, in commercial centers such as Ostia, the port of Rome, there are still preserved examples of apartment houses. These buildings were four or five stories high and arranged in blocks. The ground floor was regularly occupied by shops, and the individual apartments were often provided with a private staircase. The city of Ostia provides an excellent example of city planning intended to accommodate a large population in a limited space while still furnishing the necessary services for a comfortable existence.

PALACES AND VILLAS. During the time of the Roman Empire the power and wealth of the emperor was often expressed by the construction of an elaborate palace. After the great fire of 64 C.E. which destroyed a considerable section of central Rome, the emperor Nero had a sumptuous palace—the *Domus Aurea* or "Golden House"—built for himself modeled on the lines of a sprawling country villa complete with gardens and an artificial lake. Although much of it was later destroyed, there is enough preserved (supplemented by the descriptions left by Roman historians) to give some idea of its design and decoration. One of the surviving parts consists of a large octagonal room with a domed ceiling and smaller rooms radiating from it. The design of the room is radical enough for a villa or a palace but when these remains are taken together with ancient descriptions that describe walls covered with gold and ivory it is possible to imagine the rich impression such a palace would have presented and why it was called the "Golden House." The villa constructed by the emperor Hadrian at Tivoli around 135 C.E. was more a collection of buildings and accessory parts than a country house with a unified plan. It contained two principal living areas, bathing establishments, at least three theaters, and a stadium, reflecting pools, gardens, and other structures, some of which cannot be easily explained. Because Hadrian was a great traveler he named parts of his "villa" after places he had visited such as the "Canopus" after a city in Egypt. Many of the architectural advances that had been made by the Romans in the use of concrete and vaulting were incorporated in parts of Hadrian's villa. A strong contrast to Hadrian's villa, and even to the Golden House of Nero, is the palace plan of the emperor Diocletian at Spalato (Split in the former Yugoslavia), built in the early fourth century C.E. This palace complex was surrounded by a wall with towers and gates. Inside it was laid out like a military camp with two main streets. In addition to residential quarters and rooms for formal audiences, the palace contained a temple (probably dedicated to Jupiter) and a

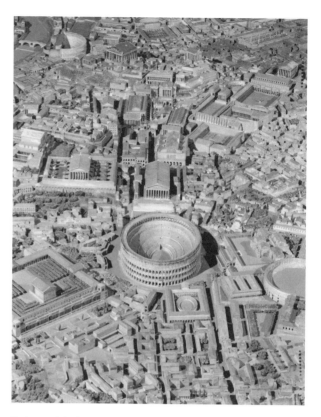

Scale model of ancient Rome in the Museo della Civilta. In the center, the Colosseum is shown, and above it, the Temple of Venus and Roma designed by the emperor Hadrian. © ARALDO DE LUCA/CORBIS. REPRODUCED BY PERMISSION.

tomb prepared in advance for Diocletian. Piazza Armerina in a valley in central Sicily is the site of another palatial villa that may be contemporary with the palace at Spalato, but the owner has not been conclusively identified. In many ways its plan resembles that of Hadrian's villa because it is a loosely organized assemblage of colonnaded courts, audience halls, and residential areas. Two aspects of the villa make it unusually interesting. It is situated in a remote area in the center of the island, suggesting a retreat or vacation place. The well-preserved floors are covered with decorative mosaics of exceptional appeal. There are hunting scenes with the capture of exotic animals, probably for the arena, scenes of the chariot race in the circus, and even images of lightly clad female athletes at their exercise. A distinguished person, who is probably the owner of the villa, is represented with his attendants. The quality of these mosaic "paintings" has led some to argue that the villa at Pizza Armerina was also an imperial residence.

AQUEDUCTS. As the power of Rome increased and urban centers grew in size, one of the most important

Arts and Humanities Through the Eras: Ancient Greece and Rome (1200 B.C.E.–476 C.E.)

29

a PRIMARY SOURCE document

NERO BUILDS A "GOLDEN HOUSE"

INTRODUCTION: Nero's reputation in popular history characterizes him as the emperor who "fiddled while Rome burned." The great fire of Rome certainly gave him the opportunity to construct a palace in one of the areas devastated by the fire, but it was also a section of the city occupying considerable space where ordinary Romans had lived. Nero spared himself no luxury. Where crowded tenements had housed a large population, he designed for himself a spacious dwelling with gardens and pools for his own pleasure. Some of this building still exists. Other parts of it were destroyed and later structures built over it. The Roman historian, Suetonius, tells the story.

It had a vestibule, in which stood a colossal statue of Nero himself, 120 feet high; the area it covered was so great that it had a mile-long portico with three colonnades; it also had a pool which resembled the sea and was surrounded by buildings which were to give the impression of cities; besides this there were rural areas varied with plowed fields, vineyards, pastures, and woodlands, and filled with all types of domestic animals and wild beasts. All the structures of the other parts of the palace were overlaid with gold and were highlighted with gems and mother-of-pearl; there were dining rooms whose ceilings were equipped with rotating ivory panels and with pipes so that flowers could be strewn and unguents sprayed on those below; the foremost of the dining rooms was a rotunda, which rotated day and night like the heavens; there were baths through which flowed sea water and medicinal spring water. When the palace was completed in the mode which has been described, he dedicated it and expressed his approval only by noting that he was "at last beginning to live like a human being."

SOURCE: Suetonius, *Nero*, in *The Art of Rome, c. 753 B.C.–337 A.D., Sources and Documents*. Ed. J. J. Pollitt (Englewood Cliffs, N.J.: Prentice-Hall, Inc., 1966): 143.

general considerations for the public good was the importance of a supply of fresh water. Roman engineers became especially adept at constructing the stone conduits, often many miles in length, which brought water from springs high in hilly terrain into the cities. Since they were exceptionally well built, remains of these remarkable structures can still be found, not only in the vicinity of Rome itself, but also in locations that were once a part of the widespread empire, as at Segovia in Spain or in Tunisia in North Africa. One Tunisian aqueduct ran from Zaghouan, the site of an important spring in the south of the country, for 45 miles to reach ancient Carthage on the seacoast. It was constructed so well that many sections of it still stand. The more familiar and probably more typical example of aqueduct construction is the one represented by a section called the Pont du Gard that bridges the Gardon river at Nîmes in France. Constructed between 20 and 16 B.C.E., the complete aqueduct ran for 31 miles with a downward grade calculated at 1 in 3000. The part that bridged the river is one of the most visible examples of Roman aqueduct building—standing almost 300 yards long and 160 feet high. The structure is in three levels with arches of smaller size in the top course to carry the water conduit. One of the chief ancient sources on the construction and maintenance of Roman aqueducts is a work by Sextus Julius Frontinus, an administrator and tactician, who wrote a treatise on the water supply of Rome in the first century C.E.

TEMPLES. The typical Roman temple, mainly derived from an Etruscan prototype, is well exemplified by the so-called temple of Fortuna Virilis on the Tiber in Rome. Built in the latter half of the second century B.C.E., it has a façade of four Ionic columns in Greek style plus two on each side of the porch, known as the *prodomus*. The columns on the sides of the cella—the main hall or sanctuary—are not free standing but are "engaged"—they appear to project from the wall and are actually parts of it. This use of engaged columns is a characteristic that can be seen in many Roman temples. A good comparison is the Maison Carrée at Nîmes, one of the best preserved examples of temple architecture from the time of the emperor Augustus in the late first century B.C.E. It is larger than the temple of Fortuna Virilis, with six columns at the front and back and eleven on a side, eight of which are engaged. The capitals are of a more elaborate Corinthian style—fluted columns with flowered capitals—but otherwise a comparison of these two temples shows that it is really only the size of the building that is different. The basic elements of raised podium, steps, and deep porch are the same. By contrast, near the temple of Fortuna Virilis in Rome is a round temple that is much more Greek in spirit. The podium is stepped all round and not just in front. The twenty Corinthian columns make a circular colonnade surrounding a circular cella. This building is difficult to date but it demonstrates the fact that temples in Greek style could coexist with those in a more Italian tradition and that temples with a special purpose

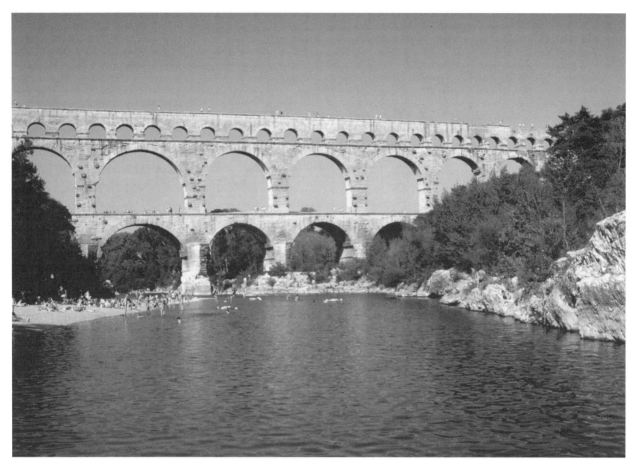

Pont du Gard, an aqueduct at Nimes, France, built before the fifth century C.E. It was the highest bridge structure in the Roman world. **NATIONAL AUDUBON SOCIETY COLLECTION/PHOTO RESEARCHERS, INC. REPRODUCED BY PERMISSION.**

could assume special shapes. A further example of the variety possible in Roman temple plans is the Pantheon in Rome, one of the best-preserved buildings from classical antiquity. The translation of the name signifies that this structure was meant as a temple to all the gods. Its preservation is due to the fact that it was converted into a Christian church by the seventh century C.E. The Pantheon is unusual because it has rectangular porch with a round interior, a traditional temple façade with an innovative inner space. Much of the structure can be dated to the time of the emperor Hadrian in the early second century C.E. but there has been considerable discussion as to the dating of the whole temple. The sixteen Corinthian columns that support the porch are granite shafts 38 feet high, an engineering accomplishment in its own right. The proportion of the "rotunda" is mathematically harmonious because the height of the interior is the same as the diameter of the interior. The construction of the main part of the building relies on an elaborate system of relieving arches within the walls to help distribute the weight vertically. In addition, the concrete of each ascending level of the walls was purposely made with progressively lighter materials. The architects and engineers of the Pantheon worked together to produce what is not only one of the best preserved, but also one of the most beautiful buildings from Roman times.

BASILICAS AND BATHS. Two types of construction that best exemplify the Roman architectural achievements of inventive use of concrete as a material and the enclosure of large spaces are the basilica and the bathing establishment. Both of these types were places of public assembly. A basilica can be defined simply as a large hall used for civic and administrative purposes capable of accommodating large crowds. The Roman bath was also often a large and complex structure built on a grand scale. The Basilica of Maxentius in Rome, built in the fourth century C.E. is a good example of the size and complexity a civic building could attain. In size it was larger than a football field—213 by 328 feet—with a large central space covered by enormous vaults. On

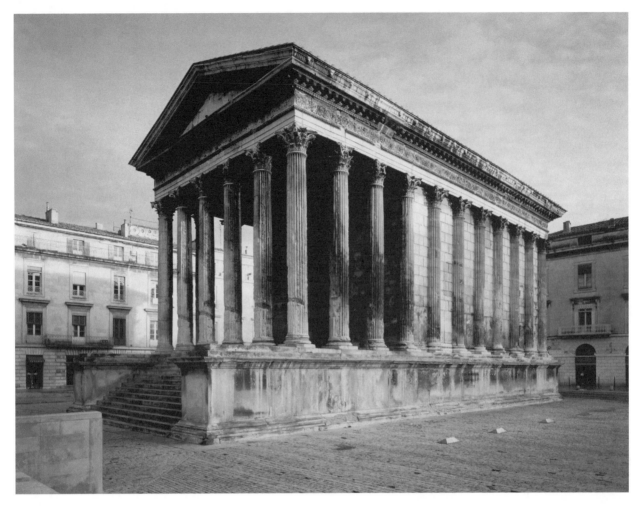

The Maison Carrée in Nîmes, France. ARCHIVO ICONOGRAFICO, S.A./CORBIS.

either side of this were three large bays. This reflects the plan of the later basilica form used in Christian churches made up of a high central aisle with two lower side aisles. The building was finished by the emperor Constantine so the structure is sometimes referred to with his name rather than that of Maxentius. One side of this basilica still stands as a vivid example of the size and scale of late Roman architecture. Compared to the basilica the Roman bathing establishment could be far more complex. Early in the third century C.E. the emperor Caracalla completed an enormous public bath that had been begun by his father, Septimius Severus. The Baths of Caracalla were meant as a form of imperial propaganda, built for the public good at great expense, reflecting the emperor's desire to appear as a concerned ruler. Whatever Caracalla's motives, the ruins of his baths survive as another example of construction on a grand scale, with the main building alone measuring over 800 feet wide. There were three essential parts of any Roman public bath: the *frigidarium*,

the *tepidarium,* and the *caldarium,* a series of rooms that got progressively hotter. The standard method of heating baths employed a system of *hypocausts,* conduits for steam or hot water beneath the floor. In the Baths of Caracalla, as in many large bathing establishments, in addition to the changing rooms and rooms for washing there were also areas for exercise and games, swimming pools, gardens, libraries, and other social areas. The visit to the baths was an important part of a Roman's social life and it was well provided for here. The scale of Caracalla's baths can only be compared in modern times to grand structures such as large train stations and public libraries.

THEATERS AND ARENAS. The Roman theater was significantly different in its construction from the type developed by the Greeks. Although Greek and Roman theaters appear to be very similar, all they really had in common was that they both had areas for the dancers or actors and provided seating for the spectators. The

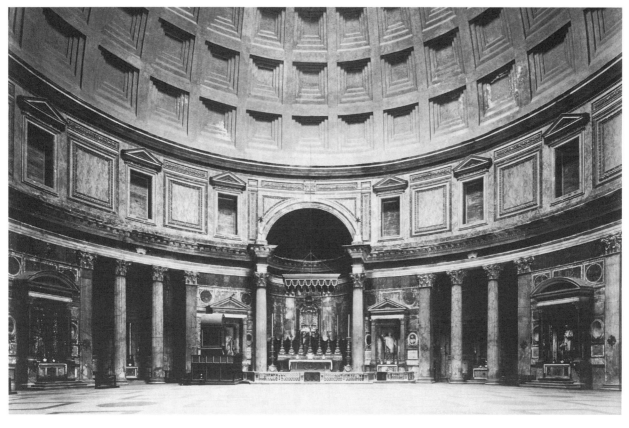

Interior of the Pantheon, Rome, completed 125–128 C.E. © MICHAEL MASLAN HISTORIC PHOTOGRAPHS/CORBIS. REPRODUCED BY PERMISSION.

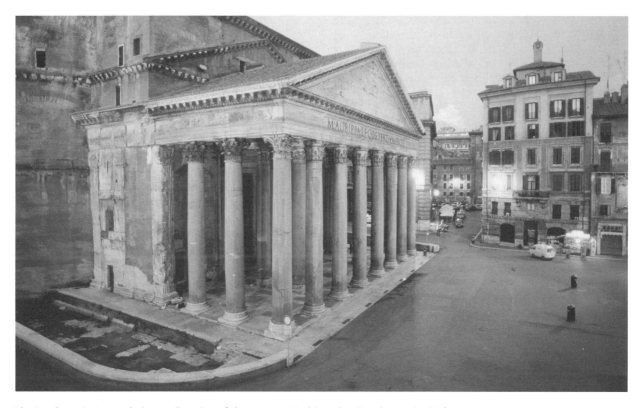

The Pantheon in Rome, dating to the reign of the emperor Hadrian, showing the portico in front. © VINCE STREANO/CORBIS.

Arts and Humanities Through the Eras: Ancient Greece and Rome (1200 B.C.E.–476 C.E.)

33

a PRIMARY SOURCE *document*

BATHING ESTABLISHMENTS ON A GRAND SCALE

INTRODUCTION: The Roman baths were far more than the word "bath" suggests. The elaborate structures provided in every Roman city for bathing were also social centers—places of recreation and sport. Almost as important, they provided an opportunity for the ruler or an important official to make a show of generosity for the populace. If the emperor wanted to express his interest and concern for his subjects he could do so by building important public buildings such as markets and baths. After the Roman engineers and architects had developed methods of spanning large interior spaces it was only natural that such techniques would be used in grand building plans as part of imperial propaganda. The Baths of Caracalla, which even in ruins is one of the most imposing buildings in Rome, stands as evidence of this. In the *Historia Augusta*, a collection of imperial biographies written during the reigns of Diocletian and Constantine, the possible method of the construction of the baths is discussed.

Among the public works which he left in Rome were the remarkable baths which bear his name; within these baths is the *cella soliaris* which architects declare it is impossible to duplicate in the same manner in which it was built. Four latticework grates made of bronze or copper are said to have been raised as supporting arches, and the entire vault rested on these; yet its size is so great that men who have expert knowledge in the field of mechanics deny that it could have been built in this way. He also left behind a portico named after his father and containing a record of his father's achievements, both his triumphs and his wars. ... He also built a new street which runs next to his baths, that is the *Thermae Antoninianae*; you would not easily find a more beautiful street among all those in Rome. He brought the rites of Isis to Rome and constructed magnificent temples for this goddess everywhere.

SOURCE: *Historia Augusta, Antoninus Caracalla,* in *The Art of Rome, c. 753 B.C.–337 A.D., Sources and Documents.* Ed. J. J. Pollitt (Englewood Cliffs, N.J.: Prentice-Hall, Inc., 1966): 196.

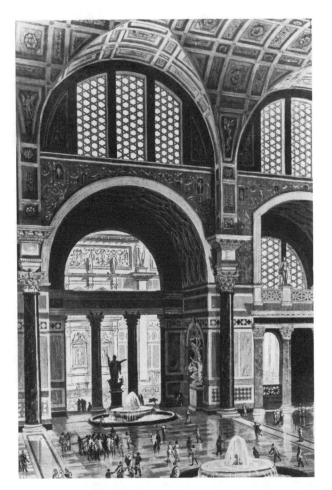

Imaginative drawing of the interior of the Thermae (Baths) of Caracalla, the most splendid of the imperial baths at Rome, built 212–217 C.E. with huge, vaulted rooms and an intricate heating system. © UPI/CORBIS-BETTMANN. REPRODUCED BY PERMISSION.

auditorium of the Greek theater was more than a half circle in plan where the Roman type was almost always a semicircle. The orchestra in the Greek theater was the focus of much of the action but the stage with an elaborate permanent backdrop of complex design—the *scaena*—was the place where the Roman drama was acted. The theater at Aspendus in Asia Minor (modern Turkey), built in the second century C.E. is a prime example of the developed and elaborate nature of the Roman type. The auditorium has a diameter of over 300 feet and the elevated stage is over twenty feet deep. It is estimated that this building could accommodate over 7,000 people. Such construction on a large scale attests to the importance of the theater in Roman life. In many respects the amphitheater for gladiatorial and other games was just as important. One of the most visible and imposing monuments in Rome is the Flavian Amphitheater, better known as the Colosseum, but it is only the best known example of a type that was built in many parts of the empire. The Colosseum was begun by Vespasian and finished by his sons Titus and Domitian between 70 and 80 C.E. It occupied the site of Nero's Golden House and gave back to the people a

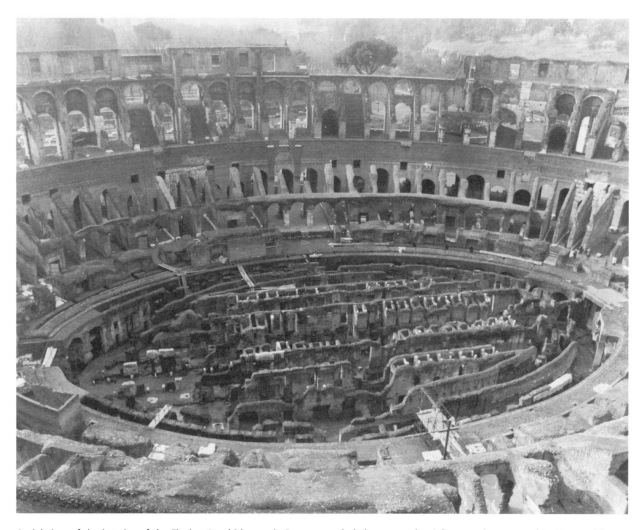

Aerial view of the interior of the Flavian Amphitheater in Rome, popularly known as the Colosseum, inaugurated in 80 C.E. with a festival lasting 100 days. AP/WIDE WORLD PHOTOS. REPRODUCED BY PERMISSION.

part of the city he had occupied for himself. The Colosseum was a masterpiece of construction supported on an interlocking structure of passages, stairways, and ramps, all necessary and carefully planned for the movement of forty-five to fifty thousand spectators. Below the arena level was a subterranean maze of corridors, storerooms, and cages to accommodate prisoners and wild animals. The exterior decoration reflected the debt to Greek practice by using columns of the Doric order on the ground floor, Ionic on the second, Corinthian on the third, and engaged Corinthian pilasters for the fourth tier. There was also a system of awnings to provide some shade from the bright Roman sun. Amphitheaters similar to the Colosseum were built throughout the empire—at Pompeii and Verona in Italy, Nîmes and Arles in France, and El Djem in southern Tunisia, to name just a few. The arena in El Djem, which held only about 30,000 spectators, is one of the best-preserved examples partly because it is now in a sparsely populated part of the country. Preserved Roman theaters and amphitheaters stand today as vivid reminders of the popular entertainments enjoyed by the Roman people and provided for them by the emperors. As examples of a highly developed engineering and architectural tradition they nevertheless call to mind the dramatic and comic literature of the Roman stage as well as the often bloody spectacles of the arena.

MONUMENTS. The Romans were especially fond of commemorating their achievements in war by the celebration of a "triumph"—a victory procession voted by the Senate—and the erection of a monumental triumphal arch. A typical example is the Arch of Titus at the east end of the Roman Forum. It celebrates his victory in the Jewish war of 70 C.E. and the two large relief carvings on the interior illustrate the victory procession. On one Titus is shown in his chariot

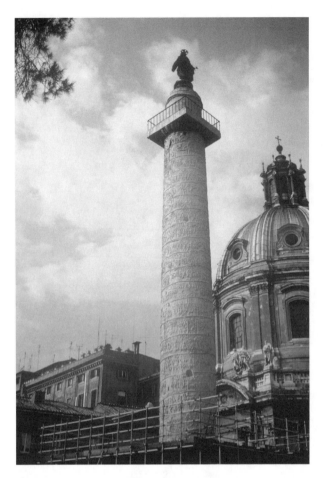

Column of Trajan in Rome. COURTESY OF JAMES ALLAN EVANS.

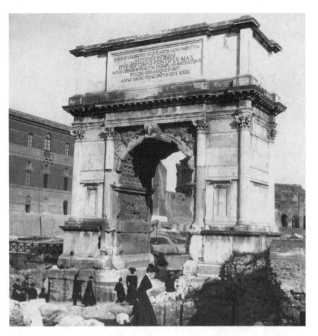

Arch of Titus in the Roman Forum, erected in 81 C.E. to commemorate the victory of the emperors Vespasian and Titus in the Judaen War (70 C.E.). FRANCIS G. MAYOR/CORBIS.

accompanied by the goddess Roma and a winged victory. On the other the victorious soldiers carry the booty from the Temple at Jerusalem, including a giant menorah, the seven-branched candlestick. An example of a monumental arch commemorating an event that was not a military triumph is the arch erected by Trajan at Benevento south of Rome. On this arch, dated 14–17 C.E. Trajan is shown distributing food to the poor of the city. The arch is also decorated with images of victories and the seasons, and also with some later additions that include the young Hadrian, stressing his relationship to Trajan. Not all arches commemorate a special event. Some mark the entrance to a city, to a forum, a market, or even the end of a bridge, and some serve only as civic decoration. A type of monument comparable to the "triumphal" arch is the commemorative column. The Column of Trajan in the forum he constructed memorializes his two wars against the Dacians in a band of relief carving that slowly spirals to the top of its 125 feet. Constructed of drums carved from marble that weigh an estimated forty tons, the shaft con-

tains a spiral staircase of 185 steps as well as a tomb chamber for the ashes of the emperor. It is a documentary in stone with a mixture of stock scenes of the emperor addressing his troops and carefully detailed views of the Roman army at war where even the insignia of the various units have been faithfully reproduced. Its aim was to emphasize the nobility of the emperor and the character of the Roman army. The Column of Trajan is one of the most successful examples of narrative in Roman art even though the higher parts are almost impossible to appreciate. Commemorative arches and columns such as this one and the later Column of Marcus Aurelius reveal a great deal about the Roman desire to commemorate important events and military campaigns. They acted as decoration and focus to the cityscape and served as visible reminders of the might of the Roman Empire.

BURIAL OF THE DEAD. Like the Etruscans before them, the Romans practiced both cremation and inhumation. The purpose of the tomb was twofold: to protect the remains and commemorate the dead. Tombs could take a variety of forms as different as a simple square box, a cylindrical structure resembling a tumulus, a tower, and even a pyramid depending on the social position of the deceased and the local custom. In one case the tomb of a baker was designed to look like an oven; in another, the tomb of Cestius on

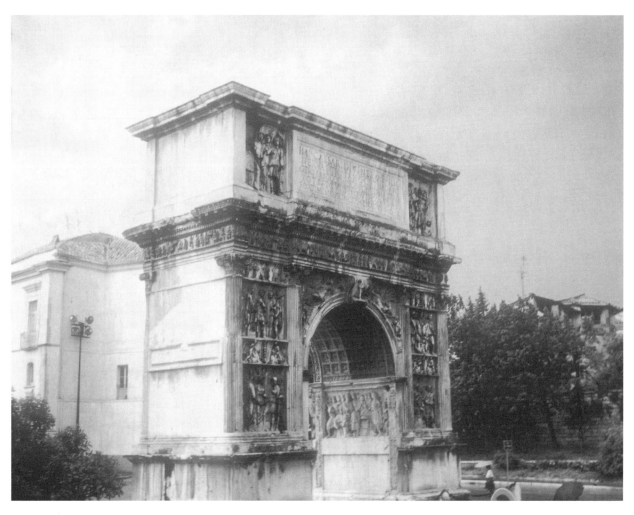

Arch of Trajan at Benevento, Italy, marking the terminus of the Via Traiana. **COURTESY OF JAMES ALLAN EVANS.**

the Appian way, the shape is pyramidal for reasons that have not been explained. The tomb of the emperor Augustus was a cylindrical monument, 280 feet in diameter, built in the Campus Martius just outside of Rome. It was constructed of several layers with a circular colonnade at the second stage. The emperor's intention was to make his tomb a monument to the Julian family, and he had the ashes of other members of the family collected to be entombed with him. A little more than a hundred years later Hadrian also had his tomb designed as a large cylindrical building, perhaps in imitation of Augustus. The tomb of Augustus had been filled with the remains of Nerva, the last to be deposited in it. Trajan's ashes, in a break with tradition, were entombed in his column, so Hadrian was actually building a mausoleum for the continued use of the imperial family and it was used as such until the burial of Caracalla. Hadrian's tomb is now known as the Castel Sant' Angelo and by the sixth century it was used as a fortress. Its decorative

elements were lost long ago and in one account sculpture was hurled from its heights as missals. This was the fate shared by many of the monuments of Rome. Buildings were robbed of their stone to be reused in new construction. The Pantheon was converted into a Christian church and towers were added to it which have since been removed. The Arch of Titus was incorporated into the wall of a medieval fortress, and the Roman Forum became an area where animals were sent to graze.

SOURCES

Axel Boëthius and J. B. Ward-Perkins, *Etruscan and Roman Architecture* (Baltimore, Md.: Penguin Books, 1970).

Richard Brilliant, *Roman Art from the Republic to Constantine* (London: Phaidon, 1974).

Nancy H. Ramage and Andrew Ramage, *Roman Art: Romulus to Constantine* (New York: Harry N. Abrams, 1991).

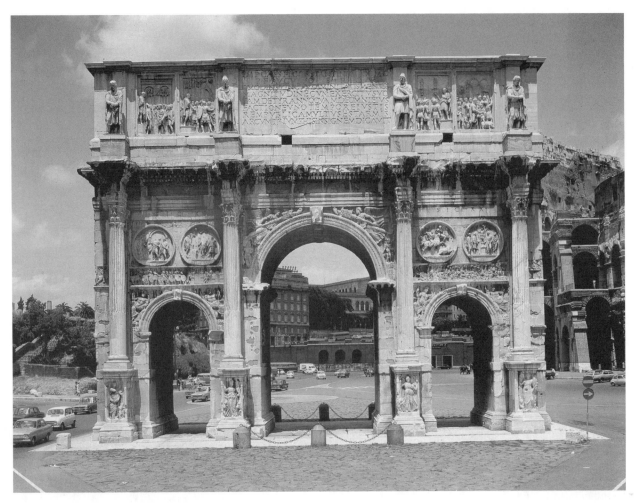

Arch of Constantine in Rome, built by the Roman senate to commemorate Constantine's victory at the Battle of the Milvian Bridge in 311 C.E. TRAVELSITE/DAGLI ORTI.

THE LATE ANTIQUE

THE ARCH OF CONSTANTINE. With the accession of Constantine in the early fourth century C.E. architecture entered a stage of transition from traditional Roman forms to those used in Christian Byzantine buildings, a period given the convenient designation of "Late Antique." The Arch of Constantine, from this time, is one of the most visible monuments in Rome. It is situated near the Colosseum, and in some aspects it is a prime example of a continued respect for tradition. Its general design, with three arched entrances, is very like the Arch of Septimius Severus at the west end of the forum, built about a hundred years earlier. The main difference between the two monuments is that the sculptural decoration of Constantine's arch is in several different styles. Some of the reliefs represent him and are in the style of his time, others have been reused from the time of Hadrian and others. It is almost as if a con-

venient model was used and available decorations were pressed into service without regard for their stylistic relationships. Side by side, the realistic representations of the time of Hadrian and the more stylized figures of the period in which the arch was built can be seen.

THE BASILICA FORM. The term "basilica" simply designates a hall used for assemblies and meetings. In Roman use this usually meant a civic building with administrative purposes. The Basilica of Maxentius in the Roman Forum was an example of the type carried to its most elaborate design with side bays and vaulted ceilings. The more typical form was of a much simpler design. As an example, at Trier on the Moselle River in northern Gaul the emperor Constantine completed a vast palace complex begun by his father. This included residences, a large bath establishment, a circus, warehouses, and other structures. One of the most significant buildings for the history of architecture, included in it

is the audience hall or basilica, much of it still preserved. It was a simple plan—a large rectangular hall 95 by 190 feet with a semicircular *apse*—a curved recess usually at the end of a building as it is here. Before entry to the main hall was a transverse crossing, fore-hall, or *narthex*, and a portico or vestibule. To add some width without resorting to vaulting over aisles on both sides of the nave, as the central hall was known, the ceilings of the side aisles were lower. This gave an opportunity to include windows in the side walls of the nave, helping to light the interior. As the Christian church developed from the secular Roman form for civic use, the architectural parts served to focus the attention of the worshipper on the ceremony. This was accomplished with the single direction of the tunnel-like space ending in the apse aided by the rhythmic repetition of the columns on either side. Examples of this form can be found in the plan for the old St. Peter's Basilica in Rome or in fifth century C.E. churches such as Santa Maria Maggiore and Santa Sabina, also in Rome. The great space-enclosing forms exemplified in structures like the Roman baths were not completely forgotten. The Church of Hagia Sophia in Constantinople, built under Justinian in the mid-sixth century, preserves the basic basilica plan, but on a scale and with the use of an elaborate system of domes that it is almost unrecognizable as such. What Hagia Sophia shows us is the continuation of Roman values in an architectural tradition that produced monumental results, but it was in the service of the Christian faith and not the Roman state.

SOURCES

John Beckwith, *Early Medieval Art* (New York: Praeger, 1969).

Axel Boëthius and J. B. Ward-Perkins, *Etruscan and Roman Architecture* (Baltimore, Md.: Penguin Books, 1970).

Richard Brilliant, *Roman Art from the Republic to Constantine* (London: Phaidon, 1974).

David Talbot Rice, *Byzantine Art* (Baltimore: Penguin Books, Ltd., 1968).

D. S. Robertson, *A Handbook of Greek and Roman Architecture* (London: Cambridge University Press, 1964).

EARLY CHRISTIAN AND BYZANTINE ARCHITECTURE

THE EARLY CHRISTIAN BASILICA. When the emperor Constantine recognized Christianity as the official state religion early in the fourth century, Christians were able to practice their faith openly. Whereas before they had met in secret in the catacombs and in other non-public places, they were now free to act as an organized and recognized cult. The first Christian meeting places were private houses and it was only when the religious ritual became more formalized that a special building was needed. It was probably to divorce themselves from the old religions that the forms of the "pagan" Greek and Roman temples were not utilized for Christian worship. The long rectangular form of the civil basilica was easily adapted for this use, although some changes had to be made. The basilica was basically a meeting house where large groups could be accommodated to conduct business and carry on other civil functions, although some changes had to be made to the form for its new religious purpose. The normal civic basilica had its entrance on one side, and this was altered to accommodate the interior orientation and direction necessary in the church. One of the best examples of an early Christian basilica was the original Church of St. Peter in Rome. It was erected by order of the emperor Constantine on the site of the Circus of Nero where the apostle Peter was martyred. Its construction was begun in 324 C.E. but it was destroyed at the end of the fifteenth century to make room for a later church. There is considerable evidence in drawings and plans to indicate its design. Its general layout included an atrium, a large open courtyard that the participants passed through to enter the body of the church. Although the main meeting hall followed the general plan of the civil basilica, the addition of the atrium recalled the form of the private houses originally used for worship. In the Church of St. Peter a large central aisle known as the nave was flanked on each side by two parallel side aisles. Only the largest churches had five aisles; it was more typical to have a large central nave with only two side aisles. The focus of the religious ritual was at the altar at the far end from the entrance, exactly like the arrangement in most Christian churches even today. While the exterior and interior walls and columns were of stone, the roof over the nave and side aisles was of wood. This was a pattern followed in most early Christian churches of the basilica type, disregarding the use of stone or brick vaulting in favor of economical and easily constructed wooden roofing. The form that had been designed as a meeting place to accommodate large crowds for the conduct of business and government affairs used throughout the Roman world had evolved into the standard for a place of Christian worship. The pattern established by the first Church of St. Peter was followed in many early churches. A typical example is the Church of Santa Sabina in Rome, begun in 425. Its arrangement follows the basilica pattern with the addition of a half dome over the apse, the semicircular niche at the end of the

Arts and Humanities Through the Eras: Ancient Greece and Rome (1200 B.C.E.–476 C.E.)

39

nave. In it, as in many early churches, the columns supporting the side walls of the nave were taken from earlier buildings. In some cases the reuse of such building elements was done without any concern for their style or order. Mosaics were used extensively for decoration on the façade, in the interior on the side walls and in the apse. These enlivened the interior with color and reflected light but they also served as informative and devotional illustrations of scripture.

THE DEVELOPMENT OF THE BYZANTINE CHURCH. The city known in antiquity as Byzantium was re-founded by Constantine as the "New Rome" in 333 C.E. At the breakup of the Roman Empire by the successors of Constantine in 335 it became the capital of the Eastern Roman Empire with the new name of Constantinople. The development of church architectural style in the east, while serving the same purposes as in the west, took on somewhat different form. There are a number of reasons suggested to explain the difference, including the scarcity of wood for the roofing, resulting in a return to the arches and vaulting developed by Roman architects. Although this may be part of the explanation, it is more likely that the church architecture in the east—Byzantium—was the result of a combination of local traditions of construction and the influence of Eastern (Persian) architecture. While Roman architects had been comfortable with the design of round buildings such as the Parthenon that could be roofed with a dome, Byzantine architects were faced the problem of a circular dome resting on a square or rectangular building. This problem could be solved in two ways: by the use of *squinches* or by *pendentives.* The squinch uses an octagonal arrangement formed by bridging the corners with a lintel or an arch. The pendentive uses a second dome form from which sections have been removed leaving a circular base supported by four triangular sections resting on four piers. Hagia Sophia in Istanbul, which essentially follows the layout of a basilica, is an example of the use of domes supported by pendentives. One variation of a plan popular in the east was a central arrangement in a circular or octagonal building, as can be seen in the Church of San Vitale in northwest Italy, constructed between 526 and 547. The central arrangement or circular form never became popular in the west except for baptisteries and other special purposes. The separate architectural traditions of east and west continued into modern times and are still evident in the differences between modern churches of the Greek Orthodox rite and those of the more Western tradition.

SOURCES

John Beckwith, *Early Medieval Art* (London: Thames and Hudson, 1964).

Jean Lasuss, *The Early Christian and Byzantine World* (London: Paul Hamlin, 1967).

David Talbot Rice, *Byzantine Art* (Harmondsworth, England: Pelican Books, 1968).

SEE ALSO *Religion: The Rise of Christianity*

SIGNIFICANT PEOPLE
in Architecture and Design

HADRIAN

76 C.E.–138 C.E.

Emperor

PATRON OF MONUMENTS. Publius Aelius Hadrianus (Hadrian) was emperor from 117 to 38 C.E. He became the ward of the emperor Trajan at his father's death. He held a number of important military and civic posts including the governorship of Syria until Trajan's death in 117. Trajan had designated Hadrian as his successor on his deathbed. An important aspect of Hadrian's reign was his extensive travel throughout the Roman Empire, literally from one end (Britain) to the other (Syria). His reasons for years of travel combined the need for inspection tours and a desire to show himself as the ruler to the far-flung provinces. His importance to the architectural history of Rome includes the completion of the Pantheon in Rome, the temple of Olympian Zeus in Athens, his imposing tomb in Rome (the Castel San Angelo), and his imperial villa at Tivoli.

SOURCES

Michael Grant, "Hadrian," in *The Roman Emperors* (New York: Charles Scribner's Sons, 1985).

J. J. Pollitt, *The Art of Greece 1400–31 B.C.* (Englewood Cliffs, N.J.: Prentice-Hall, 1965): ix–x.

PAUSANIAS

Middle to late second century C.E.–Late second century C.E.

Antiquarian
Traveler

GREEK TRAVELER. Traveler and antiquarian Pausanias left an extensive account of the parts of Greece he

visited in his book *Descriptions of Greece*, including detailed descriptions of numerous monuments and buildings. The book also discussed the history of the site described as well as some of the local customs, systems of worship, and local myths. His accounts read very much like a modern guidebook. He was very interested in sanctuaries, tombs, and statues and wrote lengthy sections on Attica, Megara, Argolis, Laconia, Messenia, Elis, Olympia, Achaia, Arcadia, Boeotia, Phocis, and Delphi. He also took care in describing scenes of notable battles, and historic and artistic monuments. He was selective about what he described and omitted, calling attention to what he found important in the realms of architecture, culture, and art. Often Pausanias is the only surviving source for the original appearance of a temple or a sanctuary, at least as it appeared in his time. Little else is known about the man except that he probably was a native of Lydia and the time he lived and wrote can only be inferred from internal evidence in his text.

SOURCES

Pausanias, *Guide to Greece.* 2 vols. Trans. by Peter Levi (New York: Viking/Penguin, 1984).

J. J. Pollitt, *The Art of Greece 1400–31 B.C.* (Englewood Cliffs, N.J.: Prentice-Hall, 1965): ix–x.

PLUTARCH

c. 50 C.E.–c. 120 C.E.

Priest
Antiquarian
Biographer

GREEK BIOGRAPHER. Plutarch was a man from a distinguished Greek family with considerable influence in governing circles. For the last thirty years of his life he was a priest in a temple at Delphi. He was also a prolific writer who used his works to influence greater cooperation between Greece and Rome. His body of writings includes philosophical, rhetorical, and antiquarian works, but he is best known for his *Lives* of famous men. He arranged the biographies in parallel pairs: for example, he portrays the Greek and Roman orators Demosthenes and Cicero side-by-side for contrast and comparison. Some of the biographies are particularly informative about architectural projects. Plutarch's life of Pericles is a prime source for detailed information on his building projects on the Acropolis at Athens. It includes lists of the types of craftsmen employed, the names of the architects of the various buildings, and even the fact that the sculptor Phidias was the general overseer of the

work. His accounts add life to the historical record through the medium of biography.

SOURCES

N. G. L. Hammond and H. H. Scullard, *The Oxford Classical Dictionary* (Oxford: Oxford University Press, 1989): 848–849.

SUETONIUS

c. 69 C.E.–c. 140 C.E.

Scholar
Civil servant

CAESAR BIOGRAPHER. Gaius Suetonius Tranquillus had a distinguished career in the Roman imperial civil service and was most likely secretary to the emperor Hadrian. He was a scholarly man, recognized for his qualities by Pliny the Younger and others. His *Lives of the Caesars* is a history consisting of twelve biographies from Julius Caesar to Domitian, but it is also a valuable source for information about the buildings erected during their reigns. His work is particularly useful as a source of information on architecture that no longer exists.

SOURCES

N. G. L. Hammond and H. H. Scullard, *The Oxford Classical Dictionary* (Oxford: Oxford University Press, 1989): 1020.

VITRUVIUS

fl. first century B.C.E.

Architect
Military engineer

WROTE ARCHITECTURAL HANDBOOK. Vitruvius was a Roman architect and engineer who lived and worked during the early part of the reign of the emperor Augustus. Aside from his architectural achievements, his major work was a treatise titled *De architectura* (On Architecture). This was based on his own experience as well as on works written by other (mainly Greek) architects. The contents of this handbook includes chapters on town planning, architecture in general and the qualifications of the architect, building materials, temples, civic buildings, domestic buildings, pavements and plaster work, water supplies, measurement and geometry, and machines. His work is especially valuable because it reflects his practical experience and for the careful analysis he provided of the

architectural orders and the standards of proportion. His description of "Tuscan" temple design contributes to modern knowledge of the appearance of lost Etruscan architecture. The sections on materials and construction methods are particularly useful to an understanding of ancient building techniques. Besides his written work and buildings attributed to his design, little else is known of Vitruvius.

SOURCES

N. G. L. Hammond and H. H. Scullard, *The Oxford Classical Dictionary* (Oxford: Oxford University Press, 1989): 1130.

DOCUMENTARY SOURCES
in Architecture and Design

Pausanias, *Description of Greece* (second century C.E.)—Pausanias traveled extensively in the Mediterranean world and was a keen observer of the places he visited. In his account of his travels through Greece he gives a brief sketch of the history and the layout of the important cities, but it is his detailed description of many of the important architectural monuments—temples, shrines, treasuries, and other public buildings—that has proved to be one of the most valuable sources for the history of Greek architecture. His travels in Greece included most of the major cities such as Athens, Olympia, and Delphi.

Pliny the Elder (Gaius Plinius Secundus), *Natural History* (first century C.E.)—Pliny's compendium of facts included a discussion of building materials and construction as well as the techniques of the artists and decorators of major architectural works.

Suetonius (Gaius Paulinus Suetonius), *History of the Caesars* (second century C.E.)—Suetonius' account of the lives of the twelve Caesars from Julius Caesar to Domitian contains descriptive material about the buildings and monuments of Rome. Often he describes works which no longer exist or gives a description of them—if they are in ruins—as they existed in his time.

Vitruvius (Vitruvius Pollio), *On Architecture* (end of the first century B.C.E.–beginning of the first century C.E.)—Virtruvius' work on architecture is the single extant source written by a professional architect of the time that has survived to modern times. In it he deals with virtually every aspect of the craft as it was then understood, including architectural history, style, site design, and construction. His section on the education of the architect is especially interesting because it outlines the various areas of knowledge and expertise for which an architect was responsible.

chapter two

DANCE

James Allan Evans

IMPORTANT EVENTS
in Dance

c. 1500 B.C.E. A small steatite (black soapstone) vase found at Hagia Traiada on Crete dated from this time period shows a harvest dance carved in relief.

c. 1300 B.C.E. A small earthenware figurine found at Palaikastro on Crete from this time period shows women dancing in a circle around a lyre-player.

544 B.C.E. The "Festival of the Naked Boys" is organized in Sparta where Spartan youths as well as older men dance naked in the marketplace and sing hymns in honor of the dead who fell at the Battle of Thyrea, fought with Sparta's northern neighbor, Argos.

534 B.C.E. The Festival of the City Dionysia is established in Athens by the tyrant Pisistratus in which Thespis wins first prize for his "tragedy"—a dithyramb (choral song) where he impersonates the main character himself.

508 B.C.E. At the City Dionysia, a separate contest for dithyrambic song and dance is established.

501 B.C.E. A day of comedy is added to the three days of tragedy at the festival of the City Dionysia in Athens. The characteristic dance of comedy, the *kordax*, is considered vulgar if danced offstage.

486 B.C.E. Comedy is produced for the City Dionysia in the same way as tragedy: the chief magistrate of the state called the "archon" assigns a "choregus" to each comedy production, who defrays the cost and oversees the training of the 24 dancers in the chorus.

423 B.C.E. Aristophanes in his comedy *The Clouds* attacks the new experiments in song and dance that are being introduced to the Athenian stage at this time.

364 B.C.E. Rome is smitten by plague, and to placate divine wrath, the Romans introduce Etruscan dancers who put on performances of dancing in the Etruscan style, without singing or miming of the song.

334 B.C.E. The playwright Lysicrates erects his choregic monument which still stands in Athens to commemorate the victory of his chorus in a dithyrambic contest of 335–334 B.C.E.

c. 300 B.C.E. A guild of Dionysiac artists—actors, musicians, and dancers—is formed in Athens.

279 B.C.E. Soon after this date, the guild of Dionysiac artists of Athens have their rights to unhindered travel in Greece confirmed by the Amphictionic League, a league of states centered at Delphi which supervises the governance of the temple-state of Delphi.

240 B.C.E. Lucius Livius Andronicus of Tarentum produces his first dramatic presentation in Rome, which includes songs accompanied by interpretative dance.

c. 200 B.C.E. Dancing becomes a social accomplishment in Rome, and upper-class parents begin to send their sons and daughters to dancing school.

c. 150 B.C.E. In Rome, general Scipio Aemilianus Africanus attempts to close down the dancing schools.

c. 22 B.C.E. The famous pantomime Pylades, a protegé and probably an ex-slave of the emperor Augustus, introduces a new type of pantomime dance into Rome.

2 C.E. The *Sebasta*, games of the Greek type, are founded at Naples to rival the great festivals of Greece such as the Olympic, Pythian, Nemean, and Isthmian Games. Sometime shortly after the emperor Augustus' death in 14 C.E. contests in pantomime dancing are added to the Games, along with other contests in the arts of the theater.

23 C.E. The emperor Tiberius bans all pantomimes from Rome because of the disturbances that pantomime perfor-

mances cause in the theaters. They are not allowed to return to Rome until Gaius Caligula becomes emperor in 37 C.E.

162 C.E. The emperor Lucius Verus brings back
–165 C.E. to Rome the famous pantomime dancer Apolaustus, known as "Memphius," from his military campaigns in the east.

c. 525 C.E. Theodora, a former pantomime dancer in Constantinople, marries Justinian. They will become emperor and empress of the Roman Empire in 527.

Arts and Humanities Through the Eras: Ancient Greece and Rome (1200 B.C.E.–476 C.E.)

45

OVERVIEW
of Dance

THE REALM OF TERPSICHORE. Dance belonged to what the Greeks called *mousike*, the arts of the Nine Muses, the daughters of Zeus. Four of them—Polyhymnia, Calliope, Euterpe, and Erato—gave poets inspiration; Melpomene presided over the theater of tragedy, and Thalia, the theater of laughter; Urania marked the movements of the stars and planets; and Clio preserved the memories and myths of the past. Chief of them all, however, was Terpsichore, sovereign of the dance. Dance had a place in festivals, religious rituals, productions in the theater, entertainment at banquets, education of the young, and military training. The sway of Terpsichore extended over all movements of the body, including acrobatics, and in particular, gestures of the hands and arms—what the Greeks called *kheironomia*. Modern knowledge of ancient dance comes from widely scattered sources: paintings on vases, inscriptions carved on stone, and references in Greek and Latin writings. Most of the information comes from the period of the Roman Empire, when many of the ancient dances, if they were still danced, were much changed. The names of a number of ancient Greek and Roman dances, and the traditions attached to them, are known, but there are informational gaps in this knowledge. One example is the *Gymnopaideia* ("Dance of the Naked Boys") which was danced every year in the marketplace of ancient Sparta. There is record that the dancers were naked, yet this information also shows that men as well as boys took part in the dance, leaving open to interpretation both the meaning of the dance as well as the title. Another example is the *geranos* ("Crane Dance") which was performed on the sacred island of Delos. While it is clear from records that this was a dance closely tied to religion, there is no indication what, if anything, the dance had to do with cranes or birds of any sort. The most well known example is that of the "tragic chorus" which danced and sang in Greek tragedies. While much is not known of the origins of many Greek dances and traditions, their influence in numerous different realms, from religion to literature to fashion, is evident.

ORIGINS. The purpose of dance in Greek and Roman society is similar to the role that dance played in almost every early culture in which dance was tied directly to the rites of religion. Dancing commemorated the changing of the seasons, life and death, social solidarity, and the connection between humanity and the unseen powers that affected human existence. If a tribe depended on hunting wild beasts for its food, the hunters might dress in animal skins and dance for the success of the hunt. Since religious ritual was intensely conservative, dances where the dancers impersonated animals continued to be performed long after the society depended for its food more on its harvests than it did in the hunt. Following the domestication of plants and animals, another type of dance came into being: the community danced on threshing floors after the harvest, thus expressing not merely its pleasure that the crops were gathered in, but also the hope that next year's crops would be bountiful. Dances performed in spring festivals where the dancers made great leaps into the air were intended to encourage the fertility of the fields. Then, too, there were dances to celebrate weddings, war dances intended to keep warriors in peak physical condition, and some dances that served as a release from the pressures and restrictions of the workaday world. Once dance moved into the theater, it evolved into spectacle. In the Roman Empire, dance competed with gladiatorial games and chariot races for audiences' interest, and famous dancers went on tour, playing in provincial theaters found in towns of any size in the Roman Empire.

THE CONTRIBUTION OF CRETE. The earliest description of a dance comes from Homer's description of the shield of Achilles in the *Iliad*, on which the blacksmith god Hephaestus portrayed two dance scenes. One is a dance of the grape-harvesters as they pick the grapes for the vintage. The other is a dance that specifically recalls Minoan Crete, a prehistoric civilization found on an island off of mainland Greece. The dance was performed on a dancing floor similar to the one that belonged to Ariadne, daughter of Minos of Crete. Homer's reference to dance in the *Iliad* indicates that the Greeks recognized Crete's contribution to dance, which included the *hyporchema*, a lively dance of song, pantomime, and instrumental music played on the lyre or the *aulos*. The *geranos*—the "Crane Dance"—also came from Crete. According to legend, the dance was brought to the sacred island of Delos by the Athenian hero Theseus on his way back from Cnossus where he had killed the Minotaur, a half-man, half-bull monster that was kept in a maze-like building called the "Labyrinth." The *geranos* continued to be danced on Delos at a festival held every July.

THE DANCE AS RELIGIOUS RITE. It would not be incorrect to state that all Greek dance had a connection with religion, for dances took place at festivals which were held in honor of one god or another. There were some dances, however, that were vital to specific religious rites. The Great Mother goddess, Cybele, whose center of worship was in Phrygia in western Asia Minor on the fringe of the Greek world, was attended by eunuch priests called Corybantes who performed ecstatic dances as part of her ritual. Better known, however, is the dance of the maenads, where female devotees of the wine-god Dionysus danced wild dances or *orgia* in paroxysms of temporary madness, during which they might capture wild animals and tear them limb from limb. They are frequently shown on Greek vases as attendants of Dionysus. In many Greek states, congregations of women assembled in mid-winter every other year, journeying up even snow-covered mountainsides to dance their "orgies" in honor of Dionysus.

THE MANY VARIETIES OF GREEK DANCE. Apart from the maenads, Greek literature mentions many varieties of dance. There was the Pyrrhic dance, a war dance that imitated combat between warriors. It was the national dance of Sparta, a militaristic state, but similar dances took place elsewhere in the ancient world, including a very early dance in Rome begun, according to tradition, by Rome's founder, Romulus. The *Herakeio* was a dance of women in honor of the goddess Hera, and the *epilinios* was a dance performed while treading grapes during the harvest in honor of Dionysus, the god of wine. The dance performed by the chorus in the production of a Greek tragedy was the *emmeleia*. It was a dignified dance, whereas the dance of Greek comedy, the *kordax*, was not. The satyr plays staged at the close of a day of three tragedies during a festival included the *sikinnis*, in which the dancers were costumed as satyrs. The *partheneia* ("dance of virgins"), was a chorus of ten or eleven girls who were eligible for marriage, whereas the *himenaios* was a wedding dance, danced by the bride with her mother and some friends. The *hormos* was a dance of men and women who formed a chain, and the young man who led the chain displayed his skill at dance and, incidentally, his abilities as a warrior. The *hyporchema* which came from Crete, was a combination of pantomime and dance, and it was performed by boys and girls who sang to musical accompaniment as they danced.

THE DITHYRAMB. The dithyramb was a choral song and dance performed in honor of Dionysus. According to Aristotle's essay, *The Art of Poetry*, Greek tragedy began with the dithyramb because the chorus told a story

from myth with song and dance. About 600 B.C.E. a famous artist of the dithyramb, Arion, whose patron was the tyrant or dictator of Corinth, Periander, gave it a definite form. Its development into tragedy began in Athens when the festival known as the "City Dionysia" was founded, and a leader of the dithyramb, Thespis, took a solo part. Tragedy, however, did not displace dithyrambs at the City Dionysia, for in 508 B.C.E. dithyrambs were given their own place in the festival. They were staged at other festivals as well; in fact, the theater of Dionysus in Athens was used more often for dithyrambs than it was for tragedy and comedy.

DANCE AS A PROFESSION. Most professional dancers remained nameless in ancient Greece. They were for the most part slaves, owned by the master of a troupe. In the *Banquet* of Xenophon, which describes a banquet attended by Socrates in 421 B.C.E., the owner of a troupe from Syracuse in Sicily provides dancers to entertain the banqueters. It would have been considered disgraceful for an Athenian citizen to own a troupe of dancers, but this master was an alien, and hence not bound by Athenian conventions. There was also interpretative dancing by professionals in Greece although little is known about it. One story relates the performance by the tragic actor Neoptolemus of the myth of Cinyras, the king of Cyprus who founded the cult of Aphrodite there and unwittingly committed incest with his own daughter who gave birth to Adonis. Presumably it was a performance of song and dance, a forerunner of the Roman pantomime.

PANTOMIME. Pantomime is supposed to have been introduced into Rome in 22 B.C.E. by the artist Pylades and his rival Bathyllus. Mime performances and songs were performed on the Roman stage earlier than 22 B.C.E., but Pylades and Bathyllus introduced a new kind of interpretative dance that became wildly popular. Pylades and the pantomime artists after him danced while an assistant recited the story, and a small orchestra provided the music. Emperors had their favorite pantomimes: Augustus backed Pylades while his minister of public relations, Maecenas, was Bathyllus' patron; Gaius Caligula (r. 37–41 C.E.) doted on Mnestor, and Lucius Verus (r. 161–180 C.E.) was an aficionado of Memphius, who supposedly taught the philosophy of Pythagoras with his dance. Unlike mimes, pantomime artists were usually men who impersonated characters by using masks, and a swift change of mask allowed them to switch quickly from one character to another whenever the script demanded it. They were, however, masks with closed mouths, not the open-mouthed masks of theatrical dramas. There were also dances in mimes, which were skits involving unmasked actors who were occasionally

women. Galeria Copiola, for instance, was remembered because she performed her first dance on stage in 82 B.C.E. and her last in 9 C.E., at the age of 104. By the time of the later Roman Empire, pantomime and mime were intermingled, and women danced roles on stage taken from mythology. The empress Theodora, the wife of the emperor Justinian (r. 527–565 C.E.) was a pantomime actress before she met her future husband. The skit for which she was best known told the myth of the rape of Leda by the god Zeus disguised as a swan. Theodora's choreography was simple, for though she was a talented comedienne, she was not a skillful dancer. She took off all her clothes except for the girdle around her groin that the law required, and reclined on stage while an attendant sprinkled her with grain. A gaggle of geese then waddled on stage and ate the grain off of her body. Although the Roman Empire was largely Christianized by Theodora's day, the Christian church's disapproval of the theater failed to eradicate the staging of ancient myths.

TOPICS
in Dance

DANCE IN PREHISTORIC GREECE

MINOAN CRETE. The Bronze-Age civilizations of Greece bear labels applied to them in modern times. The Minoan civilization on Crete, which flourished from 2000 to shortly before 1400 B.C.E., was a non-Greek culture with an indecipherable language likely linked to contemporary societies in Asia Minor. The Mycenaean civilization on mainland Greece developed a few centuries after the Minoan civilization began and ended at about the same time. Its name comes from the first site of its discovery: Mycenae, the legendary capital of Agamemnon who led the Greek coalition in the Trojan War. Since the initial archeological discoveries, at Mycenae in the 1870s and on Crete at the so-called Palace of Minos at Knossos at the start of the twentieth century, archaeologists and historians have discovered a great deal of information about these Bronze-Age cultures. For instance, at a Minoan site in eastern Crete, Palaikastro, archeologists discovered a primitive figurine made of earthenware, portraying women dancing in a circle in the center of which stood a man playing a lyre. Found with the figurine were six clay birds. The figurine dates to after 1400 B.C.E. when Greek-speaking immigrants from mainland Greece had already invaded the island,

and it is the earliest portrayal that has survived of a musician playing the lyre, surrounded by dancers in a circle. Harvesting was a time for dance on Crete; as evidenced by the so-called "Harvester Vase"—a small vase of black soapstone showing a procession of harvesters, which was discovered at Hagia Triadha on Crete. The "Harvester Vase" gives scholars a glimpse of a harvest dance performed on Crete around 1500 B.C.E. The vase shows harvesters striding along, four abreast, singing and lifting their knees high with every step. They carry long objects over their shoulders that have been identified as flails or winnows, tools used to separate grain. The lead harvester is a man who shakes a *sistrum*, a kind of rattle used in Egyptian religious ceremonies, and appears to be singing heartily. Another Cretan dance ceremony is shown on a gold seal-ring, discovered in tombs dating to the fifteenth century B.C.E. at Vapheio close to Sparta in Greece. The seal-ring depicts a woman dancing under a tree wearing the fashionable court dress worn by ladies in the Palace of Minos on Crete. To her right a youth leaps to pluck either fruit or a flower from the tree. While visual references are clues to dance in ancient Cretan civilization, the best evidence of the tradition of dance comes not from archaeology, but from Greek literature centuries later.

THE EVIDENCE OF LITERATURE. One of the first literary texts dealing with the Cretan tradition of dance after the collapse of the Bronze-Age civilization came from the poets of the island of Lesbos. One poem, from seventh century B.C.E., attributed to either Sappho or Alcaeus, reads "Once upon a time the girls of Crete / were wont to dance in harmony like this / their soft foot beats circling the fair altar. ..." Other examples of the reputed Cretan dance rituals came from the Homeric epics the *Iliad* and the *Odyssey*. The *Iliad* tells how the blacksmith god Hephaestus made new armor for the hero Achilles so that he could rejoin the battle after his best friend, Patroclus, was killed while wearing Achilles' armor. The shield that Hephaestus made showed scenes from the everyday life of early Greece, at peace or war, and among them were two dance scenes. One portrayed a dance as the grapes were harvested from the vineyard, which is reminiscent of the "Harvester Vase." The other depicted a dance on a dancing floor that Homer explicitly likens to one which the legendary craftsman Daedalus built at Knossos for Ariadne, the daughter of King Minos of Crete. The *Odyssey* tells how the hero Odysseus in his wanderings reached the island of Phaeacia. Phaeacia, ruled by a generous king and a wise queen, is thought to be based on folk memories of the world of ancient Crete, though the *Odyssey* was written at least six

a PRIMARY SOURCE *document*

THE MINOANS WERE FAMOUS DANCERS

INTRODUCTION: Homer's *Iliad* reflects the tradition that the Minoans in Bronze Age Crete were famous dancers. The passage quoted here describes how the blacksmith god, Hephaestus, made new armor for Achilles, for Achilles had loaned his armor to his friend Patroclus who was killed by the Trojan hero Hector. The shield that Hephaestus fashioned was a work of art. On it he depicted scenes from Greek life, including two dance scenes, one of which specifically recalls the dances that were once held at the Palace of Minos in Knossos. The first scene is of a vintage dance where youths, both men and women, dance as they harvest the grapes, while in their midst a boy plays the lyre and sings the Linus-song, which is a dirge that marked not joy but sadness. Perhaps here it was a lament for the passing of the summer and the advent of winter. The second dance scene, which is described below, showed boys with daggers and girls wearing garlands on their heads. Both are dressed in their best clothes—the men have rubbed theirs with olive oil to make them gleam—and they perform an intricate dance, first forming a circle and dancing a round dance, and then reforming into two ranks which moved to meet each other. In the middle of the circle were two gymnasts or tumblers, who performed somersaults and made great leaps into the air. This sort of acrobatic dance was considered a Cretan specialty. Homer makes the point that this was like the dances that were danced at Knossos in

Crete, on the dancing floor of Ariadne, who in Greek mythology, was the daughter of King Minos of Crete. Homer is recalling the tradition that Minoan Crete, where a pre-Greek civilization reached its height in 1700–1450 B.C.E., was famous for dancing.

Also did the glorious lame god depict a dancing floor like unto that which once upon a time, Daedalus fashioned for Ariadne of the lovely tresses in broad Knossos. On it were youths dancing, and maidens whom it would cost many oxen to wed, their hands holding one another's wrists. The maidens were clad in fine linen, and the youths had well-woven doublets faintly glistening with olive oil. Fair garlands the maidens wore, and the youths had daggers of gold hanging from silver baldrics. And now they would dance round in a circle, light and deftly on their feet, as when a potter sits by his potter's wheel which fits neatly between his hands and tries it out, to see whether it spins smoothly; and then they would form into lines and move quickly to meet each other. A large crowd stood joyously round about the lovely dancing-floor, [and among them a god-like minstrel was making music on his lyre], and in the midst of the dancers, leading their dance steps were two acrobats swooping and doing somersaults.

SOURCE: Homer, *The Iliad*, ix, 689–709. Trans. Andrew Lang, Walter Leaf, and Ernest Myers (London: Macmillan, 1911). Text revised by James Allan Evans.

centuries after the peak of the Minoan civilization. King Alcinous of Phaeacia had five sons and they all need clean clothes to wear at dances. Alcinous' daughter, Nausicaa, took the laundry to the seashore where she met Odysseus and directed him to her father's palace. There he attended a banquet where the Phaeacians displayed their special skill at dancing. The dancing floor was swept clean, the minstrel took his place in the center of the floor with his lyre, and the young dancers performed in a circle around him. Then two dancers showed off their expertise at dancing with a ball. The one threw the ball into the air; the other leaped up and caught it before his feet touched the ground. Then they danced, the one throwing the ball to the other, who caught it and threw it back. From this example, it appears that ancient Cretan dance covered a broad range of movement: juggling, turning somersaults, and making gestures with arms and hands. It was all part of *mousike*, the arts sacred to the muses of dance, music, and poetry.

THE GERANOS DANCE. One dance that originated on Crete was the *geranos*. Many scholars originally trans-

lated *geranos* as the Greek word for "crane," creating speculation that the *geranos* was a dance where performers imitated the flight of cranes, or costumed themselves as cranes. Animal and bird dances of this variety were well known in Greek culture. However, from portrayals of the geranos that have been discovered on pottery, it is clear that the dancers did not costume themselves as cranes. One attempt to explain the title of the dance suggests that the dance merely simulated the migratory flight of the cranes. A more widely accepted theory suggests that the word *geranos* was mistranslated as "crane." Rather it is derived from a word meaning "to wind" in Indo-European, the ancient language from which most modern European languages were derived. This idea of winding is backed up by visual representations of the geranos that show dancers with joined hands forming a row that wound back and forth, sometimes even reversing direction, as if it was making its way through a maze. Many scholars began to speculate that the geranos was a "winding dance," meant to represent a snake, and was done in rituals to honor a great serpent such as a python. There is archaeological evidence for

THESEUS DANCES THE GERANOS

INTRODUCTION: The lifetime of Plutarch of Chaeronea stretched from the forties of the first century C.E. into the reign of Hadrian (117–138 C.E.) He is best known for his *Parallel Lives* which matched biographies of eminent Greeks with eminent Romans. He devoted one biography to the hero Theseus, and in the excerpt below, he describes how the dance called the "Crane" came to Crete. Dicearchus, whom Plutarch cites as a source, was a pupil of Aristotle.

On his way back from Crete, Theseus touched at Delos. There, when he had sacrificed to Apollo and dedicated in his temple the statue of Aphrodite which he had received from Ariadne, he and the Athenian youths with him executed a dance, which they say is still performed by the people of Delos, and which consists of a series of serpentine figures danced in regular time and representing the winding passages of the Labyrinth. The Delians call this kind of dance the Crane, according to Dicaearchus, and Theseus danced it round the altar known as the Keraton, which is made of horns all taken from the left side of the head. They also say that Theseus founded games at Delos and that he began there the practice of giving a palm to the victors.

SOURCE: Plutarch, "Theseus," in *The Rise and Fall of Athens; Nine Greek Lives by Plutarch.* Trans. Ian Scott-Kilvert (Harmondsworth, England: Penguin Books, 1960): 27.

rituals involving snakes in Minoan Crete, and Greek mythology relates that Apollo killed a sacred python which was worshipped at Delphi when he took over the shrine and made it his own.

MYTHICAL ORIGIN. Another possible origin for the geranos comes from Greek mythology. According to one myth, King Minos of Crete forced Athens to send him tribute every year of seven youths and maidens who would be fed to the Minotaur, a half-human and half-bull monster who was kept in the Labyrinth, a maze of winding paths and corridors, at Knossos. Whether the Labyrinth was a building, or an open-air area, or even a dancing floor, as one scholar suggested, is not clear. The hero Theseus, the son of the king of Athens, insisted on going to Knossos as one of the seven youths to be sacrificed to the Minotaur, and once there, he killed the Minotaur and escaped the twists and turns of the

Labyrinth by following a cord which the daughter of Minos, Ariadne, had given him. On his way back to Athens, Theseus stopped at the sacred island of Delos, where he and the rest of the young Athenian youths who had escaped with him danced the geranos. This scene from the myth is depicted on the François Vase, a famous vase painted in black-figure style, named after the excavator who discovered it in an Etruscan grave in Italy in the early part of the nineteenth century. On one side of the vase, under the rim, Theseus and his companions are shown disembarking from the boat, and forming a row of dancers, hands joined, alternating by gender. The dancers then wound back and forth to commemorate the twists and turns that they faced in the Labyrinth. Records exist showing the geranos was performed yearly on the island of Delos around a horned altar, similar to those found in the Palace of Minos on Crete, lending even more credence to the theory that the geranos was Cretan in origin.

THE GERANOS IN THE CLASSICAL PERIOD. Regardless of the origin of the geranos, it continued to be danced on the sacred island of Delos into the Hellenistic and Roman periods. The dancers were both male and female and they formed a sort of chorus line with a leader at each end who were known as *geranoulkoi* ("ones that pull the crane"). Some inscriptions from Delos survive which furnish other evidence about the dance. It was usually performed during a festival held in the month which the Greeks called *Hekatombaion*—equivalent to July on the modern calendar—and it was danced at night by the light of lamps and torches. The inscriptions show payments for torches, wicks for lamps, and olive oil to fuel the lamps. They also show that the dancers were paid ten drachmas each, not a small sum when a stonemason might make between one and two drachmas a day. The inscriptions also state that the dancers were supplied with branches, which were tokens of victory, and ropes or cords which the dancers carried, props that point back to the Labyrinth myth. Because the geranos was danced at night, it was most likely part of rituals that were performed to honor the deities of the Underworld, the *chthonic* ("earth") deities. Some scholars believed this is further proof that the geranos was a ritual snake dance, for snakes were creatures of the Underworld. The geranos survived into the early Roman period of Greek history, but was no longer performed after the first century B.C.E.

OTHER ANCIENT DANCES. There were other dances as well that the Greeks thought originated from Crete. One was the *hyporchema*, a lively choral hymn sung to the god Apollo which included interpretative

dancing. The *paean* was also attributed to Crete; it was a hymn of supplication to Apollo similar to the hyporchema. When festivals and sacrifices to Apollo were held on the sacred island of Delos, choirs of boys danced and sang both the hyporchema and the paean to the accompaniment of the *aulos*, a woodwind instrument similar to an oboe, and the lyre. The *nomoi*, poems telling the adventures of heroes or gods, which also had a Cretan origin, were sung to the music of the lyre or the double-*aulos*. In early Greece, the nomoi were only accompanied by a series of gestures, but later versions included dance steps as well. Dances that involved men bearing their arms—originally war dances—were widespread in the Greek world, but the traditional war dance of Sparta, known as the *pyrrhike* or "Pyrrhic Dance," had a Cretan origin. A Spartan myth surrounding the founder of the Spartan constitution, Lycurgus, told of Lycurgus's desire for dances that befitted a society of warriors and so he persuaded a musician and choreographer named Thaletas to come from Crete and instruct the Spartans in song and dance. Thaletas of Crete was an historical figure: he was a musician and teacher of dance who was known to have practiced his profession in Sparta in the seventh century B.C.E. He may have given new shape to pyrrhic dance in Sparta, but records show that Sparta had the pyrrhike warrior dance long before Thaletas arrived there. Because of their widespread influence, the Cretans deserved the reputation for dancing that they had among the ancient Greeks. Long after the Minoan civilization on Crete receded into the shadows of mythology, the tradition of their ancient dances continued.

THE PAEAN AND THE HYPORCHEMA. The paean was named for a ritual shout of worshipers invoking the god Apollo: "ie ie paian." It was a rhythmic cry accompanied by a dance: three short syllables followed by a long, or in musical notation, three quarter notes followed by a half note. This rhythmic beat came to be known as the "paean." The paean was sung to drive out pestilence or celebrate victory, though it probably began as a hymn to Apollo. Paeans were also sung and danced to Artemis and Ares, and also to Poseidon in his capacity as "Earth-Shaker," the god of the earthquake. Fragments survive of more than 22 paeans written by Pindar, providing scholars with evidence that these dances and songs were part of religious rituals. Sometimes confused with the paean, the hyporchema also played an important role in religious ceremonies. The choir singing the hyporchema was divided into two sections: one sang without dancing, or if it danced, it used a simple dance-step, whereas the other did not sing, but instead danced an interpretative dance adapted to the text of the song. It used a

rhythm similar to the paean, though the hyporchema seems to have been the livelier of the two. Sometimes the term "hyporchema" simply means a lively dance when mentioned in literature.

ANIMAL DANCES. Another type of dance with prehistoric roots was the animal dance, where the dancers wore animal masks, or even impersonated wild animals without wearing masks. One animal dance was performed at Brauron outside Athens at a shrine to Artemis. During the Brauronia festival held every four years, girls between the ages of five and ten danced a dance of little bears. The founding legend for the Brauronia told that a band of Athenian youths killed a bear at Brauron, thus provoking the anger of Artemis who sent a plague; the Brauronia with its choral dances of young girls expiated the sacrilege. Another animal dance focused on bulls. A Greek vase in the British Museum depicts in black silhouette three dancers who wear bull masks, the tails of bulls, and hoof-like coverings on their hands. This scene is reminiscent of the legend of the Minotaur who was kept by King Minos in the Labyrinth at Knossos on Crete. Further proof of bull dances comes from the Palace of Minos where a fresco depicts acrobats, both male and female, leaping over the back of a charging bull in graceful somersaults. The Greeks would have considered acrobatic stunts like this a form of dance, and on Crete, the tradition of acrobatic dancing lived on into later periods. Greek literature makes mention of owl dances—the owl was sacred to Athena—and a wine jug in the British Museum shows two dancers costumed as birds dancing as a piper plays the *aulos*. Another piece of archaeological evidence for animal dances comes from the sanctuary of the goddess known as *Despoina* at Lycosura, in the mountainous region of Arcadia. *Despoina* is not a proper name; it means "Mistress," or "Lady" and probably this goddess was a manifestation of the ancient goddess called the "Mistress of the Wild Animals," who was honored with animal dances. A broken piece of marble carved in low relief on the colossal statue of Desponia at Lycosura shows ornamental motifs such as eagles, thunderbolts, and girls riding on dolphins. Also included is a group of female dancers wearing animal masks. Several wear masks portraying rams' heads; at least one wears a horse's head. More evidence comes from finds near an altar on the slope above the temple of Despoina. Some exploratory digging turned up a large number of earthenware figurines of dancers wearing animal heads that were buried there. Lycosura was visited in the second century C.E. by the Greek traveler Pausanias who described what was left of it in his day, and noted that it was the oldest of all the cities on earth, leading scholars

to believe that the worship of the "Mistress" with her animal dances was an ancient rite that was still recognized in later Greek periods.

SOURCES

I. R. Arnold, "Local Festivals of Delos," *American Journal of Archaeology* 37 (1933): 452–458.

A. Burns, "The Chorus of Ariadne," *Classical Journal* 70 (1974–1975): 1–12.

Claude Calame, *Choruses of Young Women in Ancient Greece.* Trans. Derek Collins and Janice Orion (Lanham, Md.: Rowman and Littlefield, 1997): 53–58.

Lillian B. Lawler, "The Dance in Ancient Crete," in Vol. 1 of *Studies Presented to David M. Robinson* (St. Louis, Mo.: Washington University Press, 1951): 23–51.

———, "The Dancing Figures from Palaikastro: A New Interpretation," *American Journal of Archaeology* 44 (1940): 106–107.

———, "The Geranos Dance–A New Interpretation," *Transactions of the American Philological Association* 77 (1946): 112–130.

S. H. Lonsdale, "A Dancing Floor for Ariadne (Iliad 18.590–592): Aspects of Ritual Movement in Homer and Minoan Religion," in *The Ages of Homer: A Tribute to Emily Townsend Vermeule.* Eds. J. B. Carter and S. B. Morris (Austin: University of Texas Press, 1995): 273–284.

Steven Lonsdale, *Animals and the Origin of Dances* (London, England: Thames and Hudson, 1981).

———, *Dance and Ritual Play in Greek Religion* (Baltimore Md.: Johns Hopkins University Press, 1993).

L. Mueller, "The Simile of the Cranes and Pygmies: A Study of Homeric Metaphor," *Harvard Studies in Classical Philology* 93 (1990): 59–101.

P. Perlman, "Acting the She-Bear for Artemis," *Arethusa* 2 (1989): 111–133.

C. Sourvinou-Inwood, "Ancient Rites and Modern Constructs: On the Braduronian Bears Again," *Bulletin of the Institute of Classical Studies* 37 (1990): 1–14.

WAR DANCES

THE PYRRHIKE. The most famous war dance in ancient Greece was the *pyrrhike* which became the national dance of Sparta, and persisted there long after Greece became a province of the Roman Empire and similar war dances had died out in other cities. The Greeks had several stories that accounted for the name of the pyrrhic dance. One said that it was invented by a Spartan called Pyrrhicus, though an alternative version claimed that Pyrrhicus was a Cretan. Another story connected the dance with the son of the hero Achilles, who bore two names: Pyrrhus as well as Neoptolemus. After Achilles was killed in battle at Troy, Pyrrhus came to Troy to take his father's place, and his greatest exploit was killing Eurypylus, leader of a force of Hittites that had come to help the Trojans. After he slew Eurypylus, he performed an exultant victory dance, and from his dance the pyrrhike took its name. The pyrrhike and many other war dances were common among the peoples in the Greek world, as well as in neighboring countries between the tenth and seventh centuries B.C.E. Dancing had a practical purpose in the warfare of early Greece when warriors often fought in single combat, and nimble feet made the difference between a warrior dodging the spear that his foe hurled at him, and being impaled by it. In Homer's *Iliad*, the Trojan prince Hector tells the Greek hero Ajax that he is not frightened by him, for he knows the steps of the "deadly dance of Ares," the god of war. By the mid-seventh century B.C.E., however, the complexion of war had changed. Battles became contests between two battle lines of heavily-armed infantrymen called "hoplites," and a good hoplite did not dodge or dance; rather, he stood firmly in his place in the battle line and shoved the enemy that faced him with his shield and thrust at him with his spear. Dance ceased to be an important part of military training, except in Sparta, which maintained its militaristic traditions long after it ceased to be a military power. By the end of the second century C.E. the pyrrhike was performed only in Sparta, where boys were still trained to dance it from the age of five. Yet the pyrrhike remained the dance most often portrayed in war sculptures and vase paintings.

ACCESSORY TO MILITARY TRAINING. Spartan education, which was intended only for the warrior elite that controlled the state, aimed to produce superb soldiers, physically fit and skilled at handling arms. *Hoplomachia* (weapons training) between men was an important part of a warrior's education, and it resembled a type of dance. When the philosopher Plato discussed the pyrrhic dance in the *Laws*, he described it as part of the hoplomachia. However, as pyrrhic dance developed in Sparta, youths who were being hardened for battle would first have their training session where they practiced their skill with the weapons of war, and then when it was over, they danced. A piper played the *aulos*, which had a timbre not unlike bagpipes, and the young warriors formed a line and danced to a quick, light dance step. While they danced, they sang songs which were composed by musicians who worked in Sparta in the seventh century B.C.E. such as Thaletas, who was credited with organizing the Gymnopaidiai (a

a PRIMARY SOURCE *document*

DANCING IN PLATO'S IDEAL STATE

INTRODUCTION: In Plato's old age, he returned to the subject of his most famous work, the *Republic,* and tried once again to outline what the government and society of an ideal state should be. The result is the *Laws,* Plato's last attempt to frame a utopia. It is to be a city-state named Magnesia, of precisely 5,040 citizens, plus slaves and some resident aliens whose sojourn in Magnesia will be limited to twenty years. The education of the citizens is important. Plato deals with the type of literature to which youth should be exposed, the kind of music they should hear and what sort of physical training they should have. The topic of physical training brings him to dancing, which he divides into two classes, the reputable and the disreputable, and reputable dancing can in turn be divided into two classes, war dances, and dances of peace. The following passage deals with war dances, that is, pyrrhic dances.

So let's accept what we've said so far as an adequate statement of what wrestling can do for a man. The proper term for most of the other movements that can be executed by the body as a whole is "dancing." Two varieties, the decent and the disreputable, have to be distinguished. The first is a representation of the movements of graceful people, and the aim is to create an effect of grandeur; the second imitates the movements of unsightly people and tries to present them in an unattractive light. Both have two subdivisions. The first subdivision of the decent kind represents handsome, courageous soldiers locked in the violent struggles of war; the second portrays a man of temperate character enjoying moderate pleasures in a state of prosperity, and the natural name for this is "dance of peace." The dance of war differs fundamentally from the

dance of peace, and the correct name for it will be the "Pyrrhic." It depicts the motions executed to avoid blows and shots of all kinds (dodging, retreating, jumping into the air, crouching); and it also tried to represent the opposite kind of motion, the more aggressive postures adopted when shooting arrows and discharging javelins and delivering various kinds of blows. In these dances, which portray fine physiques and noble characters, the correct posture is maintained if the body is kept erect in a state of vigorous tension, with the limbs extended nearly straight. A posture with the opposite characteristics we reject as *not* correct. As for the dance of peace, the point we have to watch in every chorus performer is this: how successfully—or how disastrously—does he keep up the fine style of dancing to be expected from men who've been brought up under good laws? This means we'd better distinguish the dubious style of dancing from the style we may accept without question. So can we define the two? Where should the line be drawn between them? "Bacchic" dances and the like, which (the dancers allege) are a "representation" of drunken persons they call Nymphs and Pans and Sileni and Satyrs, and which are performed during "purifications" and "initiations," are something of a problem; taken as a group they cannot be termed either "dances of peace" or "dances of war," and indeed they resist all attempts to label them. The best procedure, I think, is to treat them as separate from "war-dances" and "dances of peace," and put them in a category of their own which a statesman may ignore as outside his province. That will entitle us to leave them on one side and get back to dances of peace and war, both of which undeniably deserve our attention.

SOURCE: Plato, "Dancing," in *The Laws.* Trans. Trevor J. Saunders (London: Penguin, 1970): 307–308.

Spartan festival). Hence, the pyrrhic dance was most likely not part of the weapons training, but was done to enhance the nimbleness of the warriors.

CHANGED TO PANTOMIME. Another literary source for information about the development of the pyrrhic dance came from an author named Athenaeus who wrote a discursive work at the end of the second century C.E. called *Learned Men at a Banquet.* In it, Athenaeus imagines banqueters displaying their knowledge on a host of subjects, including dance. According to the *Learned Men at a Banquet,* the Spartans, who had a penchant for war, still trained armor-clad boys from the age of five in the pyrrhic dance in the second century C.E. The dance, however, was no longer truly a war dance by this time. Athenaeus described it as a kind of Dionysiac pan-

tomime—the dancers performed an interpretative dance that related various myths of the god Dionysus, including his expedition to India and his return to his native state of Thebes. By the time that Athenaeus lived, pyrrhic dances were staged for Roman tourists, and in fact, pyrrhic dancers sometimes performed at Rome to amuse the crowd in the public games as a prelude to the deadlier entertainments offered by gladiatorial games and wild beast fights. Julius Caesar staged pyrrhic dancing at Rome, and so did the emperors Caligula, Nero, and Hadrian. The North African rhetorician and philosopher, Apuleius of Madauros (c.123–c. 190 C.E.), whose novel, the *Metamorphoses,* or the *Golden Ass,* is the only Latin novel to survive in its entirety, described a typical dance entertainment staged in the amphitheater at

Young Athenian males performing the pyrrhic dance. A marble relief from Athens, 4th century B.C.E. THE ART ARCHIVE/ACROPOLIS MUSEUM ATHENS/DAGLI ORTI.

Corinth in his own day. First there was a pyrrhic dance, performed by boys and girls, beautifully costumed, then there was a pantomime—a ballet on the "Judgement of Paris" in which the young Trojan prince Paris judges a beauty contest of goddesses—and finally, the *pièce de resistance*, a convicted murderess torn apart by wild beasts.

THE GYMNOPAIDIAI. Another famous war dance of Sparta was one performed for the *Gymnopaidiai*, which scholars first translated as "Festival of the Naked Youths." The central feature of the festival, usually held in the heat of the Spartan midsummer in honor of the god Apollo, was a dance contest in which contestants danced naked. The contest was not just restricted to young boys, however, but was divided into three groups that were graded according to age: retired warriors too old for active service, warriors of military age, and youths still too young to serve in the army. Many scholars have

come to believe that the word *Gymnopaidiai* should be translated as the "Festival of Unarmed Dancing," for instead of wearing armor, as did the dancers of the pyrrhike, the dancers of the Gymnopaidiai wore nothing at all. The dancers pantomimed scenes from wrestling and boxing matches, but at all times, their feet moved in time to the music. As they danced, they sang songs by Thaletas and by another musician, Alcman, who plied his trade in Sparta about the same time.

ARMED DANCES OUTSIDE SPARTA. The pyrrhike may have been the national dance of Sparta where it was part of the regular exercise of warriors keeping themselves in good physical condition for battle, but it was found elsewhere in the Greek world as well. In Sparta, the pyrrhic dance was sacred to the divine twins, Castor and Polydeuces, whom the Romans knew as Pollux. In Athens, the pyrrhic dance honored the warrior goddess

a PRIMARY SOURCE *document*

WAR DANCES OF THE GREEKS

INTRODUCTION: Xenophon (ca. 430–ca. 354 B.C.E.) was a disciple of Socrates who—against Socrates' advice—joined a force of soldiers of fortune who were recruited by the younger brother of King Artaxerxes II of Persia, Cyrus, who plotted to overthrow Artaxerxes and make himself king. But in the decisive battle fought at Cunaxa in Mesopotamia, Cyrus was killed and his Asian supporters melted away, leaving the force of Greek mercenary soldiers to find their way home. To make matters worse, the Persians invited the Greek officers to a parley and killed them, thinking that the Greek troops would be helpless without their leaders. But the troops chose new officers, one of them Xenophon himself and they made their way north to the Black Sea, and from there the survivors disbanded to find new employers. When they reached Paphlagonia in Asia Minor, the ruler of Paphlagonia sent envoys to the Greek officers, who gave them a dinner, and the various ethnic groups in the little Greek army entertained them with war dances, with the dancers bearing arms. The Paphlagonian visitors were surprised that all the dancers wore armor as they danced, whereupon a dancing girl was brought on, who performed the "Pyrrhic" dance, a Spartan war dance named in honor of the hero Achilles' son, Pyrrhus, otherwise known as Neoptolemus. The Paphlagonians were even more impressed. They wondered if the Greek women fought in battle side by side with the men, and the Greeks replied in jest that it was their women who had routed the king of Persia, Artaxerxes II. Xenophon describes the scene in a vivid passage in his *Anabasis* (*The March into the Interior*), which tells the story of how the ten thousand mercenary soldiers that Prince Cyrus recruited from among the Greeks and their neighbors—for not all the recruits were Greeks—marched into the interior of the Middle East and returned again.

After we had poured wine on the ground to honor the gods, and had sung a hymn, first two Thracians stood up and began to dance in full armor to the sound of the pipe, making nimble leaps high into the air as they wielded their sabers. Finally one of them struck the other, and everyone thought the man was mortally wounded. His fall was artfully done, I suppose. The other man stripped him of his armor as the Paphlagonians howled, and made his exit, singing a Thracian war song known as the "Sitacles." The other Thracians bore the fallen dancer away, as if he were dead. But he had been not at all hurt. Next some Aenianians and Magnesians got to their feet and danced the dance called the *Karpaia*, wearing their armor. The dance was like this: One man is driving his oxen as he sows a field, his arms laid at his side, and he casts frequent glances around him like a person who is afraid. A robber approaches, and when the sower sees him, he grabs his arms and goes to meet him and fights to save his team of oxen. These soldiers did this to the rhythm of the reed pipe. And at last the robber ties up the man and takes off the oxen. But sometimes the owner of the oxen trusses up the robber. When that happens, he yokes him beside his oxen with his hands tied behind his back and drives off. Then a Mysian came on with a light leather shield in each hand. And at one moment he danced, pantomiming a battle against two opponents. Then he wielded his shields as if he were fighting a single opponent. Then he would whirl around and do somersaults, still holding his shields. So it was a fine sight to see. Finally he danced the "Persian dance"—clashing his shields together, he would crouch down and then leap up. He did all this keeping time to the music of the pipe. Then the Mantineans and some others from region of Arcadia came forward, wearing the finest armor they had, and they performed a drill to a tune with a marching tempo played on the pipe, and they sang a warrior hymn. And they danced in the same way as they did in the processions with which they honored the gods. And as the Paphlagonians looked on, they thought it odd that all the dances were performed wearing arms. A Mysian who saw that they were amazed, retorted by persuading one of the Arcadians who had acquired a dancing girl to dress her in the finest costume he could, fit her with a light shield and bring her on to give a graceful performance of the "Pyrrhic" dance. Thereupon there was a roar of applause, and the Paphlagonians asked if the Greek women also fought side by side with their men. The Greeks answered that these were the very women who had routed the king from his camp.

SOURCE: Xenophon, *Anabasis*. Book 6 (Cambridge, Mass.: Harvard University Press, 1998): 466–470. Translated by James Allan Evans.

Athena, the patron goddess of Athens. It was part of the ceremony of the annual Panathenaic festival that was held in honor of Athena, as well as the Great Panathenaic festival when non-Athenians were allowed to compete in the athletic events. The dancers were called *pyrrhicists* and they were chosen from among the *ephebes* (youths over eighteen years of age). Several relief sculptures have survived that portray the Athenian pyrrhic dance. One shows youths, naked except for helmets, shields, and swords, dancing a light dance-step; another shows them in a chorus line, presenting their shields. Their training for the festival was financed in the same way as dramatic productions; a well-to-do citizen was chosen as *choregus* ("leader of the chorus") and he paid the costs and had

a PRIMARY SOURCE *document*

CURETES AND CORYBANTES

INTRODUCTION: The Curetes and the Corybantes had one thing in common: both danced wild ritual dances, but they should not be confused. According to legend, the dance of the Curetes was taught them by the Rhea, a Mother Goddess who belonged to the generation of the Titans, and it was first danced to protect Rhea's infant son, Zeus. When Zeus was born his mother spirited him to a cave on Mt. Dicte on Crete to save him from his father Cronus who would have swallowed him as he had swallowed his other children to prevent their birth, and around his hiding place, the Curetes danced their frenzied dance with great leaps and clashing weapons. In the classical period, the Curetes were a Cretan tribe who performed a ritual dance on the sacred island of Delos, an ancient dance similar to the one which the Roman priests known as the Salii performed. The Corybantes were priests of the great Mother Goddess Cybele, whose center of worship was Pessinus in Phrygia in western Asia Minor, where the most sacred object in her cult center was a black stone which embodied the divinity of the goddess. The cult of Cybele and her young lover Attis, a god of vegetation, was brought to Rome in 205–204 B.C.E., and a temple was built to her on the Palatine Hill, one of Rome's seven hills, but until the reign of the emperor Claudius (41–54 C.E.) she was confined to her temple and served only by eunuch priests who were immigrants from the east, for her rites and the ecstatic dancing of her devotees shocked the Romans. In the following passage, Lucretius, writing in the first century C.E., describes a procession of Corybantes, whom he claims the Greeks called "Phrygian Curetes," and compares them to the Cretan Curetes, understandably, for both performed wild dances in the service of a Mother Goddess. Since Lucretius wrote in Latin, he gives the gods their Latin names: Cronus is Saturn and Zeus is Jove or Jupiter.

Various nations hail her [Cybele] with time-honored ceremony as our Lady of Ida. To bear her company they appoint a Phrygian retinue, because they claim that crops were first created within the bounds of Phrygia and spread thence throughout the whole earth. They give her eunuchs as attendant priests, to signify that those who have defied their mother's will and shown ingratitude to their father must be counted unworthy to bring forth living children into the sunlit world. A thunder of drums attends her, tight-stretched and pounded by palms, and a clash of hollow cymbals; hoarse-throated horns bray their deep warning, and the pierced flute thrills every heart with Phrygian strains. Weapons are carried before her, symbolic of rabid frenzy, to chasten the thankless and profane hearts of the rabble with dread of her divinity. So, when first she is escorted into some great city and mutely enriches mortals with wordless benediction, hay strew her path all along the route with a lavish largesse if copper and silver and shadow the Mother and her retinue with a snow of roses. Next an armed band, whom the Greeks call Phrygian Curetes, joust together and join in rhythmic dances, merry with blood and nodding their heads to set their terrifying crests aflutter. They call to mind those Curetes of Dicte, who once upon a time in Crete, as the story goes, drowned the wailing of the infant Jove by dancing with swift feet, an armed band of boys around a boy, and rhythmically clashing bronze on bronze, lest Saturn should seize and crush him in his jaws and deal his mother's heart a wound that would not heal.

SOURCE: Lucretius, "Movements and Shapes of Atoms," in *On the Nature of the Universe.* Trans. Ronald Latham (Harmondsworth, England: Penguin Books, 1951): 78–79.

general oversight of the production. Crete was another source of war dances, the best known of which was the dance of the Curetes. It had a legendary origin: when the mother goddess Rhea gave birth to the infant Zeus, she hid him in Crete in a cave on Mt. Dicte to save him from his father Cronus, and the Curetes performed their dance, which Rhea had taught them, to camouflage his hiding place. They whirled about their shields and banged them with their swords as they made great leaps into the air. This performance was a primitive ritual connected with the cult of Zeus on Crete, which was quite unlike the cult of Zeus on mainland Greece, for the Cretans believed that their Zeus died and was reborn with the seasons. The dance of the Curetes marked his rebirth. In the ancient world, the Greeks and Roman saw a connection between the dance of the Curetes and the frenzied dance performed by the Corybantes, the priests of the Great Mother, Cybele, the ancient goddess of Phrygia in western Asia Minor, and there may be this much connection: both rituals went back to an ancient fertility religion. The dance of the Curetes, however, was not a dance of priests like the dance of the Corybantes, but of warriors, though neither dance seems to have had much in common with the pyrrhic dance.

SOURCES

E. K. Borthwick, "Trojan Leap and Pyrrhic Dance," *Journal of Hellenic Studies* 87 (1967): 18–23.

———, "P. Oxy. 2738: Athena and the Pyrrhic Dance," *Hermes* 98 (1970): 318–331.

———, "Two Notes on Athena as Protectress," *Hermes* 97 (1969): 385–391.

Paul Cartledge, *The Spartans* (Woodstock, N.Y.: Overlook Press, 2003).

Nigel Kennell, *The Gymnasium of Virtue, Education and Culture in Ancient Sparta* (Chapel Hill, N.C.: University of North Carolina Press, 1995): 67–69.

D. G. Kyle, *Athletics in Ancient Athens* (Leiden, Netherlands: Mnemosyne Supplement 95, 1987).

Kurt Latte, *De saltationibus graecorum* (Giessen, West Germany: Töpelmann, 1913): 27–63.

J.P. Poursat, "Les représentations de danse armée dans la céramique attique," *Bulletin de Correspondence Hellenique* 91 (1967): 550–615.

Noel Robertson, *Festivals and Legends: The Formation of Greek Cities in the Light of Public Ritual (Phoenix Supplement 31)* (Toronto, Canada: University of Toronto Press, 1992): 146–165.

Fritz Weege, *Der Tanz in der Antike* (Halle/Saale, West Germany: Max Noemeyer Verlag, 1926): 38–56.

E. L. Wheeler, "*Hoplomachia* and Greek Dances in Arms," *Greek, Roman and Byzantine Studies* 23 (1982): 223–233.

WOMEN'S CHORUSES

THREE CATEGORIES. Women's choruses can be divided into three categories: girls before the age of puberty; unmarried girls, called variously *parthenoi* or *korai* or *nymphai*; and married women. The most evidence survives on the *parthenoi*, a Greek word that many scholars have translated as "virgins," yet literary evidence points to this word meaning "women who have not yet given birth." The size of the parthenoi chorus might vary, but most were composed of ten members. A parthenoi chorus was often portrayed on Greek vases; one vase, found in the marketplace of ancient Athens and dating to the beginning of the seventh century B.C.E., shows ten young women, all dressed in white, holding hands, their heads turned upwards as if they were singing and dancing. Another vase, a mixing-bowl for wine—the Greeks drank their wine mixed with water—which was made in Athens in the mid-fifth century B.C.E., shows ten young women holding hands and an eleventh woman playing a pipe. Similar choruses of young men existed between 800 and 350 B.C.E., but Greek artists preferred to portray choruses of women in most forms of art.

PARTHENEIA. *Partheneia* were the songs and dances maidens performed in their choruses. One of the first poets of choral lyrics, Alcman, was famous for the partheneion that he wrote for Spartan girls in the second half of the seventh century B.C.E. A papyrus copy of this partheneion was found in the nineteenth century C.E., and many scholars have used this as a starting point for knowledge of the parthenoi. The lyrics of the partheneion indicate that it was danced to and sung by a chorus of ten girls who were related to each other, and included a *Agido* ("leader of the music") and a *Hagesichora* ("leader of the dance"). According to literary records, it was most often performed at sunrise in competition with another chorus. There is no clue as to what the dance was like, nor how intricate the dance steps may have been, except that the meter that he used in his poetry was generally simple.

THE CARYATIS. The Caryatis was another type of dance, the origins of which are found in Caryae in Spartan territory. The goddess Artemis had a statue and a sanctuary there at which the young girls of the area (known as "caryatids") performed a traditional dance every year in honor of the goddess. Much of the knowledge of this dance comes from a description written by Pausanias, a Greek traveler of the second century C.E. whose guidebook for Greece is the classical archaeologist's Bible, but additional information comes from various art forms, including a statue group of three caryatids that was excavated from Delphi in the nineteenth century C.E. The dance was a spirited jig, with many whirls and pirouettes. In the statue discovered at Delphi, one caryatid is shown with a tambourine, another with castanets. Their usual dress was a light knee-length *chiton* ("tunic") and on their heads they wore a *kalathos*—a vase-shaped basket wreathed with leaves from palms or rose bushes. The dance was so famous that the dancers were immortalized not only in art but also in architecture. The term "caryatid" is a description of a column that has been sculpted to resemble a Caryatis dancer—the most famous examples are to be found in the "Porch of the Maidens" attached to the temple known as the Erechtheion on the Athenian acropolis. Many column capitals (tops of columns) took on the description of "kalathos" because they so resembled the headdress of the Caryatis dancers.

SOURCES

Claude Calame, *Choruses of Young Women in Ancient Greece: Their Morphology, Religious Role and Social Function.* Trans. Derek Collins and Janice Orion (Lanham, England: Rowman and Littlefield, 1997): 149–156.

J. Pouilloux and G. Roux, "Les danseuses de Delphes et la base dite de Pankrates," in *Énigmes à Delphes* (Paris: E. Boccard, 1963): 123–149.

THE DITHYRAMB

BEGINNINGS. Among the scraps of poetry that have survived by the seventh-century B.C.E. lyric poet

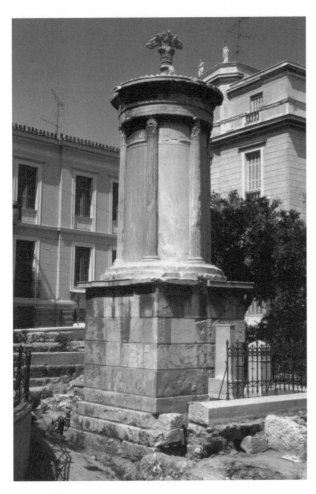

Monument erected by Lysicrates in Athens to commemorate the victory of a chorus of boys in the dithyramb contest of 334 B.C.E. for which he was choregus. PHOTOGRAPH BY HECTOR WILLIAMS. © HECTOR WILLIAMS.

Archilochus of Paros, one describes the poet's ability to start the *dithyramb* ("graceful round of song") of the lord Dionysus, when wine has loosened his mind. This is the first time that the word *dithyramb* appears in surviving Greek literature, though scholars are certain that Archilochus was not the first Greek to use it. The dithyramb was a song and dance in honor of Dionysus at festivals where much wine was drunk. The Greeks themselves did not know how the dithyramb developed. Several Greek states claimed it as their invention, yet it most likely developed among the Dorians who lived in the Peloponnesos south of the Isthmus of Corinth.

CONTRIBUTION OF ARION. In Herodotus's *Histories* (c. 425 B.C.E.) there is an account of the creation of the dithyramb. During the years 627–587 B.C.E., the city of Corinth was ruled by a tyrant called Periander, and at his court was Arion, the most distinguished musician of his day. It was he who Herodotus credits with the cre-

ation of the dithyramb. He also wrote that Arion coined the term *dithyramb* and instructed choirs in Corinth how to perform it. There were choruses of song and dance in honor of gods and heroes before Arion created dithyrambs; in Corinth's neighbor to the west, Sicyon, there were "tragic choruses" performed every year in honor of Sicyon's legendary king, Adrastus, and they were very ancient. Modern scholars suspect that the word *dithyramb* itself was not Greek, and an ancient form of the dithyramb may have predated the immigration of Greek-speaking people into Greece. Under Arion's direction, however, the dithyramb was probably given form and structure—henceforth it would be sung by a regular choir, and it would tell a story. The dithyrambs performed before Arion were most likely an undisciplined performance of song and dance where the dancers improvised folksongs about the heroes of old. Arion added music that he composed, and choreography, and probably it was he who established the traditional size of the dithyrambic chorus at fifty dancers. Hence, Arion is most often credited by modern scholars as the inventor of the classical Greek dithyramb.

NEW DIRECTION. Thespis was the leader of a dithyrambic chorus in the Athenian village of Icaria, and during the early 530s B.C.E., he made an innovation in the production of the dithyramb which had far-reaching consequences. When his choir performed at the local festival in Dionysus' honor, he took a solo part. Before Thespis, the choir sang a story from the Heroic Age of Greek mythology, and danced to the accompaniment of a piper. Thespis, however, stepped forward and assumed the role of the hero, singing antiphonally with his choir in a kind of musical dialogue, all the while gesturing with his hands to add to the drama of the tale. Then, in 534 B.C.E., the tyrant of Athens, Pisistratus, established the great festival of the City Dionysia. The villages outside the city of Athens had celebrated festivals honoring Dionysus long before this time, but now the city of Athens itself had a festival that overshadowed them. During the festival a contest was held in which dithyrambs were performed, usually with a dancing chorus responding to a soloist who also sang and danced. Thespis's innovation made dithyrambs very popular during these festivals, but it also created an offshoot, tragic plays, which in the generation after Thespis threatened to overtake the dithyramb's popularity.

CONTINUED DEVELOPMENT. The evolution of the dithyramb continued in the late sixth century B.C.E. Around 525 B.C.E., after the death of the tyrant Pisistratus, a lyricist named Lasus came to Athens to enjoy the patronage of Pisistratus' younger son, Hipparchus.

Following Arion's example, he standardized the number of choristers in the dithyrambic chorus in Athens at fifty, and they sang to the accompaniment of several pipers playing the *aulos*, not just one. It was thanks to Lasus that a separate contest for dithyrambs was established in Athens at the festival of the City Dionysia in 508 B.C.E. The first winner of the contest was Hypodicus of Chalcis, and while his works have been lost, his background has become important to scholars. Hypodicus was not a native of Athens but the neighboring state of Chalcis on the island of Euboea, proving that dithyrambic poets were not merely a phenomenon of mainland Greece and that these poets traveled from state to state, practicing their profession.

ATHENIAN PRODUCERS. The date of the first dithyrambic contest at the festival of the City Dionysia is significant. Athens had driven out the tyrant Hippias and adopted a democratic constitution which established ten new "tribes," political groups into which all citizens were divided according to a complicated formula that made certain that every tribe contained citizens from the three regions of Attica: the city of Athens itself, the interior of Attica where people lived in country villages, and the coastal region. At the City Dionysia festival, every tribe was expected to present two dithyrambs: one performed by boys and the other by men. The citizen who produced these dithyrambs in each tribe was a well-to-do man who was chosen as *choregus* (leader of the chorus), and his duty was to pay the poet who wrote the dithyramb and the music for it, the choreographer who taught the chorus their dance steps, and the musician who played the double-reed instrument called the *aulos*, as well as outfitting the fifty singers and dancers who performed the dithyramb. It was no light expense, but the choregus whose choir won received as a prize a tripod, which was a kettle on three legs, the equivalent of a cup given nowadays to a winning football or hockey team, and he would build a monument to display it. There was a street in Athens called the "Street of the Tripods" which once was lined with choregic monuments that displayed tripods won for dithyrambs, tragedies, or comedies, each set up by the proud choregus whose production had won the prize. The name of the street survives to the present day, but all the choregic monuments are lost, save one built by a choregus named Lysicrates in 334 B.C.E. when his chorus won the prize for the best dithyramb.

THE DITHYRAMBIC DANCE. Dithyrambs were popular in Athens and soon they were staged in other festivals as well as the City Dionysia. The performance of the dithyrambs, however, seemed to be similar regardless of the location. The dithyrambic choir entered the theater with a solemn march, and then sang as they moved around the orchestra, now dancing in a circle counterclockwise and then reversing and dancing clockwise. The music and the poetry were most likely more important than the dance. The performers accompanied their song with gestures that must have been something like the stylized gestures of the dances of India. Having finished their song, the dithyrambic choir moved out of the theater to a dance step, possibly a march. As the fifth century B.C.E. wore on, the dithyramb evolved towards a less austere and more emotional performance. A fragment of a dithyramb by the poet Pindar, better known for his "Victory Odes," describes a frenzied dance, accompanied by tambourines and castanets, which belonged to the rites of the god Dionysus. The dancers toss their heads and shout, and a dancer representing Zeus shakes his thunderbolt. The type of music also changed; the dignified, simple Phrygian mode was replaced by elaborate flourishes and trills. A dithyrambist named Cinesias who lived in the later fifth century and early fourth century B.C.E. was responsible for some of these changes. What is known of him comes mostly from his critics who did not like his innovations, but scholars see that the dance of the dithyrambs under his direction became a great deal more lively. The comic poet Aristophanes, who was no admirer of Cinesias' innovations, poked fun at Cinesias' pyrrhic dances. In his comedy, *The Clouds*, Aristophanes jibes that clouds have a particular fondness for writers of dithyrambs, such as Cinesias, because their feet never touch the ground and they are always prating about clouds. Aristophanes was apparently referring to a dithyrambic dance that had a great deal of leaping and vaulting, and, on the basis of Aristophanes' remarks, some scholars have speculated that Cinesias must have actually introduced pyrrhic dances or something similar into his dithyrambs.

LATER HISTORY. The majority of information that survives on dithyrambs comes from Athens, but it is clear from fragments of evidence that dithyrambs spread to many parts of mainland Greece. They took place at Delphi, where the theater overlooking the temple of Apollo is largely intact except for the stage building, and at the festival of Apollo at Delos. At Epidaurus, the cult center of the medicine god Asclepius, dithyrambs were performed in the athletic and dramatic festival that was held there every four years. By the second century B.C.E. however, the dithyrambs had given way to more tragic and comedic performances, and few records of their performances exist.

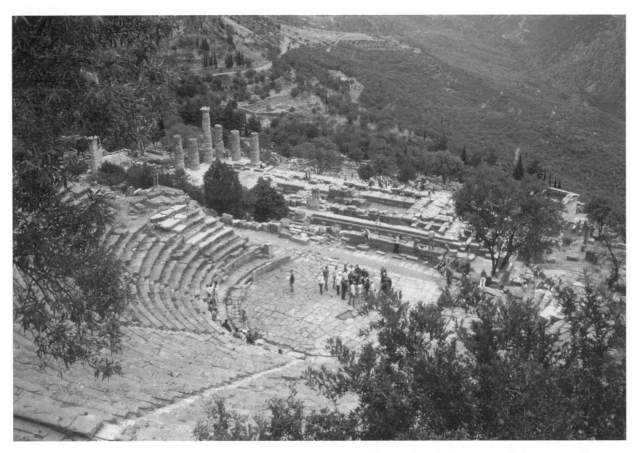

View of the theater in Delphi, Greece, where dithyrambs were performed. **PHOTOGRAPH BY HECTOR WILLIAMS. © HECTOR WILLIAMS.**

SOURCES

Christopher G. Brown, "Dithryamb," in *Encyclopedia of Greece and the Hellenic Tradition*. Ed. Graham Speake (London, England: Fitzroy Dearborn): 499–501.

Lillian B. Lawler, *The Dance of the Ancient Greek Theatre* (Iowa City: University of Iowa Press, 1964): 1–21.

A. W. Pickard-Cambridge, *Dithyramb, Tragedy and Comedy*. 2nd ed. Rev. by T. B. L. Webster (Oxford, England: Oxford University Press, 1962).

G. A. Privitera, "Archiloco e il ditirambo letterario presimonideo," *Maia* 9 (1957): 95–100.

———, "Il ditirambo fino al V secolo" in *Storia e civiltà dei Greco*. Ed. Ranuccio Bianchi Bandinelli (Milan: Bompiani, 1977–1979): 311–325.

FOLK DANCES.

DANCES OF EVERYDAY LIFE. "Anyone who cannot sing and dance in a chorus is uneducated," stated Plato in the *Laws*, which is a blunt reminder that dance was part of Greek education. Dances played a large role in everyday life. They belonged to folk tradition, and they often had a religious or semi-religious basis. Mourners danced at funerals. They can be seen on vase-paintings, in long rows with hands placed on top of their heads in a gesture of grief. There were also wedding dances. There was no wedding ceremony as there is in the Christian church, but after the families of the bride and groom had worked out the details of the marriage agreement, a chorus of young men and women escorted the bride and groom to the groom's house with dance and song. There were usually two choirs—one of men and the other of women—and since the dance was performed by torchlight, it presumably took place after nightfall. Dances marked the change of seasons, particularly spring with its flowers and the return of the birds, for the Greeks did not understand the migration of birds and their reappearance each spring must have seemed almost magical. There was a folk dance called the "Flowers," where the dancers divided into two groups, and as they performed, one group chanted, "Where are my roses? Where are my violets? Where is my lovely parsley?" and the other group replied, "Here are your roses. Here are your violets. Here is your lovely parsley." There were also folk dances like farandoles, where men and women danced together,

hand in hand, forming a chain. A young man led the chain, performing dance movements suitable for a virile young male, and following him was a girl performing modest dance steps proper for a decent young woman. When banquets were given, there might be dancing entertainment, and already in the fifth century B.C.E. a well-to-do man who gave a banquet might hire professional dancers. In early Greece, however, dancing was still amateur, and it was the guests themselves who danced.

FOLK DANCING IN SPARTA IN HONOR OF OR-THIA. In the fifth century B.C.E., Sparta was a militaristic state which valued prowess on the battlefield above all else. Compared to contemporary Athens, it was a smaller, less advanced community. Yet two centuries earlier, it was a center of dance and music, which attracted famous musicians and choreographers such as Alcman, Terpander, and Thaletas. Folk dances, however, were no concern of these professionals, and consequently we are ill-informed about them. For one type of folk dance, where the dancers wore masks, there is only archaeological evidence. About 700 B.C.E., a primitive temple was built in Sparta by the banks of the river Eurotas and dedicated to the goddess Orthia—or to Artemis Orthia, for by the classical period, Artemis had half-assimilated Orthia, though Orthia's ancient cult remained largely unchanged. A hundred years or so after the temple was built, it was destroyed by a flood of the river, which sealed the temple ruins under a thick layer of sand. The temple was rebuilt about 550 B.C.E. and then a second disaster, a raid by a barbarian tribe called the Heruls in 267 C.E., once again sealed in its remains below a layer of rubble. In the late third century C.E., after the sanctuary was restored, a small semi-circular theater was built to seat tourists who came to Sparta to witness Spartan youths being flogged, sometimes to death, which was part of the ritual of Orthia's cult. The result of these vicissitudes was that the votive offerings made to Orthia, and other remains having to do with the ceremonies at the sanctuary as well, got some protection from the depredations of time, and were preserved for archaeologists to discover in the twentieth century C.E. The finds show that there were ancient folk dances by masked dancers at the shrine of Orthia—ritual dances to begin with, but then evolving into simple folk dances as time erased the reasons for the rituals. Pipes for playing dance tunes, made of animal bones, were found, inscribed with dedications to Orthia, but the most distinctive feature of the deposits was a series of masks made of terracotta. They are reproductions of masks made of wood which were actually used in dances, but wood rots in the damp

earth, and the Spartans preferred to dedicate masks made of more durable material. The dedications started at the end of the seventh century B.C.E., but the great bulk of them belong to the next century. The masks are fearsome things, which makes it likely that the dances performed in Orthia's sanctuary were originally apotropaic—that is, they were danced to drive away the malevolent unseen powers that send plague or crop failure. The masks must have become eventually like Halloween masks, which once upon a time protected against the spirits that prowled the earth on All Hallows Eve, but lost their ritual meaning as time went on. It is uncertain how long these dances continued in honor of Orthia, as ancient literary sources yield no information about them.

THE DANCE OF HIPPOCLEIDES. Before dancing became professionalized, the performance of solo folk dances was an accomplishment of the well-bred young Greek, and a man who disgraced himself on the dance floor besmirched his character. Damon of Athens, a music teacher of the fifth century B.C.E. who counted Socrates among his pupils, asserted that song and dance arose from the movements of the soul: noble dances gave proof of noble souls and ignoble souls were reflected in vulgar dances. The historian Herodotus, who published his *History* about 425 B.C.E., relates a story which demonstrates how dance revealed an ignoble character of a man, and also illustrates the sort of dancing entertainment one might have found in the banquet halls of leading men in archaic Greece, when wine flowed freely and guests made merry. The story focused on Cleisthenes, tyrant in the early sixth century B.C.E. of Sicyon, Corinth's western neighbor. He desired to find a suitable husband for his daughter, Agariste, so he made a proclamation at the Olympic Games that any young man who thought himself worthy to be his son-in-law should come to Sicyon to enjoy his hospitality for a year and after he had observed all of them carefully he would choose one to be his daughter's husband. A small battalion of suitors arrived at Sicyon, and Cleisthenes watched them closely, noting their athletic ability and general decorum. The young aristocrat Hippocleides of Athens headed his preferred list. When the time came to announce the winner, Cleisthenes first entertained all the suitors at a banquet, and after the banquet was over, the suitors competed in *mousike*—song, dancing, and poetry—as well as public speaking. Hippocleides excelled, surpassing all the other suitors, and he would have won Agariste except that he got drunk. When it was his turn to dance, he ordered the pipe-player to play the *emmeleia*, a type of dance that choreographers used for Greek tragedy; but Cleisthenes lived before the age of tragedy,

and the emmeleia was probably not a graceful or sophisticated dance during this period. Cleisthenes was not pleased by Hippocleides, but he said nothing. Then Hippocleides had a table brought in, stood on it, and performed a few Spartan jigs followed by Athenian ones. Jigs, much like emmeleia, were considered low-class dances at the time, yet Cleisthenes still said nothing. Then Hippocleides stood on his head and gestured with his legs, in mocking of an acrobatic dance, a sign of great disrespect, for it would have normally been performed by someone much below the station of Hippocleides. At this point Cleisthenes could contain himself no longer, exclaiming, "Hippocleides! You have danced away your bride!" Hippocleides replied, "What does Hippocleides care?" which did nothing to change Cleisthenes' estimate of his character. Much learned effort has gone into attempts to identify the dances that Hippocleides performed. The Spartan jig may have been something like the *Gymnopaideia*, which Spartan boys and men performed naked, in which case Hippocleides stripped to dance it. As for the Athenian dance that came next, it may have been the *kordax*, the dance associated with Old Comedy in Athens, with high kicks, somersaults, and twists. Hippocleides' retort to Cleisthenes, "What does Hippocleides care?" became a proverb, meaning "So what?", and the general verdict of Greece was that Hippocleides was a foolish young man whose drunken dance cost him a good marriage, although he was undoubtedly admired for his dedication to the dance.

THE FOLK FESTIVALS HONORING VICTORIOUS ATHLETES. Greek athletes who won victories in the great athletic contests of Greece—the Olympian, Pythian, Nemean, or Isthmian Games—received only wreaths to wear on their heads as prizes, but when they returned home, they could expect a great deal more. Sometimes a section of the circuit wall was temporarily demolished to allow them to enter the city without having to go through the city gates. They might receive meals at public expense in the town hall for the rest of their lives, which was a great honor. If they themselves were well-to-do or came from a prominent family, they could commission a poet to produce a victory ode. It could be a lucrative commission, particularly if the victors belonged to one of the great ruling families in Greek Sicily. The sound and spectacle of a public performance by a great poet is something that a modern reader of classical literature can capture only by relying on his imagination, for the music that accompanied it is largely lost and early Greek authors took dance for granted and only rarely mentioned it. Sometimes a note in passing by an ancient writer allows modern readers to conjure up a picture of

what the spectacle must have been like in these folk festivals where the citizens of the victorious athlete's hometown gathered to celebrate his victory. Famous poets such as Pindar, Simonides, and Bacchylides appeared in theaters, magnificently costumed, playing a *kithara*, the ancestor of the guitar though it is usually translated as "lyre," and surrounded by dancers. The opening lines of the victory ode which Pindar wrote for Hieron of Aetna in Sicily, whose chariot was victorious in the chariot-race in the Pythian Games held at Delphi, gives an example of a typical poetic opening:

> O lyre of gold, Apollo's prized possession, shared by the Muses with their violet crowns, you the dancers heed as they start the revelry; your notes direct the singers when to lead the dance whenever the quivering strings give forth the first notes of the prelude.

With these words, Pindar cued the dancers to begin as he swept his hand over the strings of his *kithara* and produced the opening notes of his ode. For the fee that a poet charged for a victory ode—in Pindar's case they were high—the poet not only wrote the poetry, he also choreographed the dance, trained the dancers, and wrote the music. Like all such poetry, it was written for a special occasion, to be presented before a specific audience. Pindar's victory ode for Hiero—called his *First Pythian*—was performed before a large, patriotic audience in Hiero's hometown of Aetna, and then performed again on other occasions, as long as the citizens of Aetna were willing to listen to praise of Hiero.

SOURCES

J. B. Carter, "Masks and Poetry in Early Sparta," in *Early Greek Cult Practice*. Eds. Robin Hägg, Nanno Marinatos, and G. C. Nordquist (Stockholm, Sweden: Svenska Institutet i Athens, 1988): 89–98.

Paul Cartledge, "The Mirage of Lykourgan Sparta: Some Reflections," in *Spartan Reflections* (Berkeley: University of California Press, 2001): 169–184.

Guy Dickens, "The Terracotta Masks," in *The Sanctuary of Artemis Orthia at Sparta. Excavated and described by members of the British School at Athens, 1906–1910.* Ed. R. M. Dawkins (London, England: Society for the Promotion of Hellenic Studies, 1929): 163–186.

Lillian B. Lawler, *The Dance in Ancient Greece* (London, England: Adam and Charles Black, 1964): 116–126.

William H. Race, *Pindar* (Boston: Twayne, 1986).

Albert Schachter, "Pindar," in *Encyclopedia of Greece and the Hellenic Tradition*. Ed. Graham Speake (London, England: Fitzroy Dearborn, 2000): 1322–1323.

DANCE IN THE THEATER

DIONYSIAN FESTIVALS. In Athens, there were three days of tragedies and satyr plays, and one day of comedy produced at the great festivals of the City Dionysia in March and the Lenaean Festival in January. In addition there were the festivals of Rural Dionysia, held in honor of Dionysus outside Athens in the towns and villages of the countryside each December. The rural festival in Piraeus, the port town of Athens, was particularly famous. The difference was, however, that whereas new plays were presented at the festivals in Athens, the Rural Dionysia festivals generally had older more familiar plays. Tragedy, comedy, and satyr plays each had its own dances. The main dance associated with tragedy was the *emmeleia*, a term which covered a number of dance patterns and postures. The dance of the satyr plays was the *sikinnis*, performed by men costumed as satyrs, with pointed ears, snub noses and the tails of goats or horses. The dance of comedy was the *kordax*, noted for its obscene gestures. The kordax was acceptable in the theater, but in everyday life no decent person danced it unless he was drunk. Evidence for these dances of the theater comes partly from careful study of the plays that have survived, from art and sculpture, and from references in literature, many of them scattered through writings belonging to the period of the Roman Empire, when the staple of the theater was the pantomime.

TRAGEDY AND THE CONTRIBUTION OF AESCHYLUS. The tragic poet Aeschylus was a great innovator in drama production in the first half of the fifth century B.C.E. He was one of the first playwrights to produce his own material. He was also the first playwright to use two speaking actors, and when Sophocles introduced a third actor, he followed suit. He may not have been the first to use painted scenery, but his scene painter was the first to experiment with perspective. Moreover he took great care to work out appropriate dances for the chorus in his tragedies. Other tragic poets, it seems, used professional choreographers. Aeschylus did his own choreography, and did it so well that he was remembered as the first choreographer to train his dancers in *schemata*—the poses, postures, and gestures appropriate to the words and music that they sang. Though seven tragedies of Aeschylus have survived and the words that his choruses sang can be studied, little about the melodies or the dances that accompanied the words is known.

THEORIES. Writing in the fourth century B.C.E., the philosopher, musical theorist, and an alumnus of Aristotle's Lyceum Aristoxenus of Tarentum wrote that there were three important elements to choral lyric: poetry,

song, and dancing. All three of these aspects shared a common rhythm, which meant that the meter a tragic poet used for the odes sung by the chorus should identify something about the dancing which accompanied the music and the poetry. For instance, if the poet used a marching rhythm for the entrance of the chorus into the orchestra of the theater, the chorus most likely marched in step; if he used a more lyrical measure, the

a PRIMARY SOURCE *document*

THE IMPORTANCE OF GESTURE

INTRODUCTION: Quintilian was a famous teacher of oratory in Rome of the first century C.E. who was appointed to a salaried professorship of rhetoric by the emperor Vespasian (69–79 C.E.). After he retired, he wrote a book on oratory, the *Institutio Oratoria*, which covered everything an orator should know, and among the topics was the proper use of gestures. Quintilian was discussing oratory, not dancing in the theater, but nonetheless the gestures that an orator used to communicate his meaning were, for the most part, the same gestures that a dancer in the theater might use, and hence Quintilian is an important witness to the science of *kheironomia*. The following quotation is an excerpt from a much longer passage on useful gestures for the orator.

The following short gestures are also employed: the hand may be slightly hollowed as it is when persons are making a vow, and then moved slightly to and fro, the shoulders swaying gently in unison: this is adapted to passages where we speak with restraint and almost with timidity. Wonder is best expressed as follows: the hand turns slightly upwards and the fingers are brought in to the palm, one after the other, beginning with the little finger; the hand is then opened and turned round by a reversal of this motion. There are various methods of expressing interrogation, but as a rule, we do so by a turn of the hand, the arrangement of the fingers being indifferent. If the tip of the first finger touches the middle of the right-hand edge of the thumbnail, the other fingers being relaxed, we shall have a elegant gesture well suited to express approval, to state facts and to mark off the points we are making. There is another similar gesture with three fingers folded which the Greeks nowadays use a great deal, now with the right hand and now with the left, to round off their arguments point by point. A rather gentle movement of the hand expresses a promise or assent, a swifter movement urges action and sometimes expresses commendation. There is also the well-known gesture if rapidly opening and closing the hand to press home what we are saying, but it is a common gesture rather than an artistic one.

SOURCE: Quintilian, "Delivery Gesture and Dress," in *The Institutio Oratoria of Quintilian*. Vol. IV. Trans. H. E. Butler (Cambridge, Mass.: Harvard University Press; London: William Heinemann, 1922): 297–299.

chorus danced into the theater. There were tragedies, too, where the chorus was already in the theater when the action began, and in that case, presumably the fifteen choristers filed into the orchestra and took their positions quietly before the play started. By examining the meter of the poetry, scholars can make an educated guess as to whether the choreography was lively or sedate. If a *kommos* ("dirge") was sung, the chorus presumably made gestures of mourning, for the literal meaning of the word *kommos* is "beating," as in "beating the breast," which was a gesture of grief. By and large, however, the *schemata*, the poses of the dancers and the figures of the dance, is unknown. One aspect of dance that only survived in Greek art work was called the *kheironomia*—the art of gesture with the hands. Numerous vases and sculptures show dancers making common gestures such as the hand bent upwards—the hand is outstretched and the fingers are bent backwards, away from the palm. The hand itself could be held in many positions such as the palm down, palm turned towards the dancer's body, and hand before the dancer's face, and each position signified a different meaning. The Greeks and Romans both considered gesture a significant instrument of communication, one that orators, for instance, had to master, and hence it was also an important element of dance. Telestes, a dancer whom Aeschylus used, was so great a master of communicating with his arms and hands that he could dance the whole of Aeschylus' tragedy, *Seven Against Thebes*, making the meaning clear by his gestures and dance figures. *Kheironomia* can still be seen in Oriental dances, such as the ritual dances of Cambodia, but overall it has fallen out of the Western dance tradition.

THE CHORUS BEFORE AESCHYLUS. Aeschylus put tragic dance on a new footing by inventing new *schemata* ("choreography") for the dance company, including the twists, kicks, and other poses that the dancers performed, but dance was an important part of tragedy before the fifth century B.C.E. as well. The dithyramb from which tragedy developed had choruses of fifty choristers, and presumably the tragedy with which Thespis won first prize at the City Dionysia of 534 B.C.E. had a chorus of that number. At some point the chorus was reduced to fifteen choristers; it was most likely reduced to twelve first and then later increased by three, although the reasons for this are unknown. Early poets such as Thespis, Pratinas, Cratinus, and Phrynichus were all dancing instructors as well as tragedians. By the first decades of the fifth century B.C.E. there was already a small corps of trained dancers available for theater productions—semiprofessionals, but some of them immensely talented. There were both artistic and economic reasons for re-

ducing the size of the tragic chorus. The choregus—the citizen who paid the costs of production—must have preferred a chorus of fifteen to one of fifty because it was less expensive, and the tragic poet preferred it because fifteen well-trained dancers could perform the complicated choreography which he arranged better than amateurs, no matter how talented they were. Before Aeschylus, dance appeared relatively undisciplined. This can be seen in Aristophanes' comedy, the *Wasps*, where the old man Philocleon gets drunk and performs the old dances of Thespis and Phrynichus. They are dances with leaps and whirls and high kicks. This is nothing prim and proper about them. Students of ancient dance have found this evidence troubling, for it seems to indicate that early tragedy, as it developed from the dithyramb, was accompanied by dances that were much less orderly and decorous than they were after Aeschylus' reforms. Scholars typically have not valued the evidence from Aristophanes' work, for he was a writer of comedies and therefore may have exaggerated the old-fashioned dances of early tragedy for comic effect. Yet there would be no point to Aristophanes' joke if the early tragedies before Aeschylus were not remembered for their lively dances, which were perhaps amateurish but very vigorous. Due to this supposition, polished, well-choreographed dances of Greek tragedy in the classical period do not precede Aeschylus.

THE DANCE OF COMEDY. Comedy and satyr plays both have their origins in the revels that were danced and sung in honor of the Dionysus, the god of wine. The word "comedy" must be connected with the Greek word *komos*, meaning a "band of merry-makers"—revelers who sang and jested as they danced through the streets. Where and how comedy took form as a theatrical presentation is much disputed, but in Athens it became an official part of the City Dionysia in 486 B.C.E. and it soon developed its own conventions. What is known about "Old Comedy" is based largely on nine of the eleven surviving plays of Aristophanes which were produced during the Peloponnesian War (431–404 B.C.E.). His last two plays, produced after the war was over, belong to "Middle Comedy"—a term which was coined in the Hellenistic period after the death of Alexander the Great in 323 B.C.E. to label the transition between "Old Comedy" and the situation comedies of the "New Comedy," where the chorus provided interludes of dance and song between the acts, but played no role in the play itself. The size of the chorus grew smaller; at a performance in Delphi in 276 B.C.E. it was made up of just seven choristers, and a century later, a comedy performed on the island of Delos had only four.

THE STRUCTURE OF OLD COMEDY. "Old Comedy" plays had a six-part structure. First there was the prologue where the protagonist outlined the plot, usually centered around an extravagant and impractical solution to some current problem. Next came the *parodos*, or entry of a chorus of 24 imaginatively costumed dancers. Then came the *agon*, the contest or debate, where the protagonist defended his brilliant solution against objections from opponents and always won. Then came the *parabasis* ("digression") where the chorus addressed the audience directly with song and dance, and vented the spleen of the comic poet against various prominent citizens. The song and dance of the parabasis contained one long sentence called the *pnigos* ("choker") because it was to be uttered all in one breath, and the actors whose breath control allowed them to perform it perfectly could expect numerous applauses. A number of farcical scenes followed, separated by song and dance performed by the chorus. Finally the merry *exodus*, a scene of rejoicing usually leading up to a banquet or wedding, was staged. The chorus exited dancing. A good example of the use of dance in comedy can be seen in the final scene of Aristophanes' *Ecclesiazusae* (The Women in the Assembly). Praxagora, the leader of a coup of women who promulgate a new constitution, witnesses her husband Blepyrus entering with a group of dancing girls, on his way to a banquet to celebrate the new constitution. The chorus leader orders the dancing girls to dance, and Blepyrus to lead off with a fine old Cretan-style jig, and chorus, dancing girls, and Blepyrus all exit to the beat of the music.

THE KORDAX. In the parabasis of Aristophanes' *Clouds*, produced in 423 B.C.E., the leader of the chorus told the audience that this was a modest play: there would be no *kordax* dance in it. The label *kordax* did not refer to all the dances in comedy, but to a particular dance, which was performed solo—at least in the sense that the dancers performed it independently, not as members of a chorus line coordinating their movements. It was a suggestive dance, like the "bumps" and "grinds" of dancers in modern-day burlesque theater. The kordax-dancer rotated his buttocks and abdomen, sometimes bending forward at the hips. The dancer might also hop, as if his feet were tied together, or leap into the air, or simply wiggle suggestively. Leaps and whirls of all kinds were part of a kordax performance, and it was performed to the music of the *aulos* which must have had a timbre rather like the bagpipes. Proper people did not dance the kordax. The philosopher Plato thought it should be banned from the ideal state which he described in his *Laws*.

THE SATYRS' DANCES. The dance that was characteristic of the satyr play was the *sikinnis*—a dance which was sometimes used in comedy as well. The originator of the satyr play was a dramatist named Pratinas of Phlius, who presented plays in Athens at the start of the fifth century B.C.E. It was a lively dance, with much horseplay, rapid movements, and expressive gestures, many of them obscene. Two satyr plays have survived, including one by Euripides that includes a sikinnis. Euripides' *Cyclops* is a burlesque of the tale of Odysseus in the cave of the Cyclops that is told in the *Odyssey* of Homer. In *Cyclops*, old Silenus comes on stage, and having introduced the play, summons the chorus of satyrs. He refers to their entrance as a *sikinnis* and so presumably they dance on stage. The satyrs have been captured by the Cyclops, Polyphemus, and made to tend his flocks, and when they enter, dancing, they drag on sheep and goats, though whether these animals are real or imaginary is impossible to judge. However, the chorus of satyrs in *Cyclops* only plays a secondary role, and the text gives little hint as to what the choreography was like. The role of Odysseus, however, has several solos accompanied by interpretative dance that gave splendid scope to the actor who played the role to display his talents.

SOURCES

E. K. Borthwick, "The Dances of Philocleon and the Sons of Carcinus in Aristophanes' *Wasps*," *Classical Quarterly* 18 (1968): 44–51.

J. F. Davidson, "The Circle and the Tragic Chorus," *Greece and Rome* 33 (1986): 38–46.

C. W. Dearden, *The Stage of Aristophanes* (London, England: Athlone Press, 1976).

Eleanor Dickey, "Satyr Play," in *Encyclopedia of Greece and the Hellenic Tradition*. Ed. Graham Speake (London, England: Fitzroy Dearborn, 2000): 1495–1497.

B. Gredley, "Dance and Greek Drama," in *Themes in Drama*. Vol. III (Cambridge: Cambridge University Press, 1981): 25–29.

Richard Green and Eric Handley, *Images of the Greek Theatre* (London, England: British Museum Press; Austin: University of Texas Press, 1995).

H. D. F. Kitto, "The Dance in Greek Tragedy," *Journal of Hellenic Studies* 75 (1955): 36–41.

Lillian B. Lawler, *The Dance of the Ancient Greek Theatre* (Iowa City: University of Iowa Press, 1964).

Diana F. Sutton, *The Greek Satyr Play* (Meisenheim, Germany: Hain, 1980).

Oliver Taplin, *Greek Tragedy in Action* (London, England: Methuen; Berkeley: University of California Press, 1978).

DIONYSIAN DANCE

ECSTATIC DANCE. Dance and song were a part of every religious festival, but in some, dance was an instrument with which the dancer could achieve a closer communion with divinity by entering into a state of rapture. The violent whirls and leaps of the dance brought the dancer into a state of ecstasy. The goddess Cybele, known as the Great Mother, whose cult center was in Phrygia in western Asia Minor, was attended by eunuch priests called Corybantes, devotees of the goddess who castrated themselves with flint knives after dancing to the accompaniment of cymbals and castanets until they attained a state of utter rapture. Among the twelve Olympian gods and goddesses of Greece, the nearest counterpart of Cybele was Demeter, who presided over the fertility of the earth, and the dances performed in her honor were generally full of lively movements. In the ancient festival of the Thesmophoria, which the women of Athens held over a period of three days, one dance that was performed was the *oklasma*. During the oklasma a dancer crouched down, with her knees on the earth, and then swiftly leaped up as high as she could from her crouching position, trying to reach the perfect image of the god to achieve rapture. It was the god of wine, Dionysus, who presided over the ecstatic dances that are best known. Dionysus was accompanied by a *thiasos*—a company that parades through the streets singing and dancing—and the thiasos of Dionysus was made up of maenads (frenzied women) and satyrs. Dionysus and his thiasos were frequent subjects for Athenian vase painters working in the black-figure and red-figure techniques.

DEFINING THE MAENADS. The maenads were female devotees of Dionysus who went up into the mountains and there engaged in a frenzied, ecstatic dance in honor of the god of wine. Sometimes they caught wild animals and tore them limb from limb with their bare hands and ate the animals' raw flesh. The myth of Dionysus relates that he was born in Thebes, the chief city in Boeotia, the region of Greece northwest of the city-state of Athens. His father was Zeus and his mother was Semele, daughter of King Cadmus of Thebes, who was destroyed by Hera's jealous hatred. Once Dionysus was fully grown, he made a campaign into India that lasted two years and then returned in triumph to introduce his new religion. For historians of religion, there is much about the Dionysiac cult that is hard to understand. Dionysus was a latecomer to Greek religion, as the myths about him seem to suggest, for he was not originally one of the Twelve Olympian Gods, and when he was added to the list, he displaced Hestia, the goddess of the hearth.

He was worshipped in the Mycenaean period, for his name appears on the Linear B tablets found in the so-called "Palace of Nestor" at Pylos, which was destroyed in 1200 B.C.E. Apparently dance was an important part of his cult. On Keos a prehistoric temple has been found, which was erected in the fifteenth century B.C.E., and continued in use for a thousand years. In it were the remains of twenty terracotta statues, all of them women, shown with their breasts bared and their hands resting on their hips, resembling Dionysian dancers. An inscription on a votive offering found in the excavation and dating to early classical times identifies Dionysus as the lord of this sanctuary. The terracotta dancers indicate that dance was an important part of the rites practiced in reverence to Dionysus, and scholars have suggested that these dancers were also priestesses of the cult of Dionysus.

MAENADS IN THE CLASSICAL WORLD. Diodorus of Sicily, a Greek historian who wrote in the mid-first century B.C.E., noted that in Boeotia and other parts of Greece, as well as in Thrace, which stretched into modern Bulgaria and Romania, sacrifices were held every second year in Dionysus' honor to commemorate his triumphal return from India. Consequently, in many Greek cities, every other year, bands of women gathered for rites that honored Dionysus. Diodorus called these bands of women *baccheia* and the rites they performed *orgia* ("frenzied dances"). These women of the baccheia included not only unmarried girls but also respected married women. The baccheia danced to the music of the tambourine and the reed pipe known as the *aulos*, and as they danced they flung their heads back and raised the cry "euhoi" that sounded like "ev-hi." Evidence from literature and from temple inscriptions show that biennial festivals of this sort took place in a number of cities, such as Delphi, Thebes—which claimed to be Dionysus' birthplace—Rhodes, and Pergamum, as well as Mytilene on the island of Lesbos. As part of the festival, which always took place in midwinter, women would climb a nearby mountain and there, during the night, they would dance an *oreibasia*—a dance or procession in the mountains. The rite involved real hardship and sometimes danger. Plutarch, a writer in the second century C.E., reported that at Delphi, for instance, a group of women were cut off by a snowstorm at the top of Mt. Parnassus and a rescue party had to be sent out to bring them down the slopes.

THE EVIDENCE OF EURIPIDES' BACCHAE. The most graphic description that exists of the maenads comes from Euripides' play, the *Bacchae* or the *Bacchants*, as the title is sometimes translated. It was written at the end of Euripides' life, while he spent the years 408–406 B.C.E.

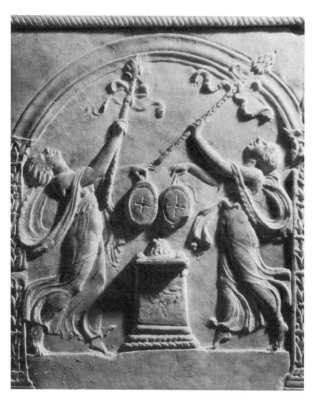

Roman relief of maenads or bacchantes dancing around a votive altar, from the 3rd century C.E. **THE ART ARCHIVE/MUSEO NAZIONALE TERME ROME/DAGLI ORTI.**

in Macedon, and the play was not produced in Athens until after his death. The plot tells how Dionysus returned to his birthplace, Thebes, and there his new religion encountered resistance as it did at a number of places in Greece. Dionysus brought with him a thiasos of maenads from Phrygia in Asia Minor, who formed the chorus of the play, and they danced into the theater orchestra to the music of the aulos and the tambourine. The Dionysiac rite is taking hold of the city. Pentheus, king of Thebes, who had been away, arrives back home to find maenads dancing on Mt. Cithaeron, and in the middle of each group, a wine bowl added to the general intoxication. Pentheus' own mother Agavé has joined the maenads. Pentheus vows to put an end to this madness. A herdsman arrives to describe the wild dance of the maenads that he and his fellow herdsmen have witnessed on the slopes of Mt. Cithaeron. Pentheus is persuaded by a stranger who is the god Dionysus in disguise to go to see the maenads himself, and when the maenads discover him, they tear him to pieces. In the final scene, Pentheus' mother Agavé enters, frenzied and blood-stained, bearing Pentheus' head, which she imagines is a lion's cub. She has killed her own son in her madness, and as her mind clears, she is overcome with horror. Dionysus has brought tragedy on the royal house of Thebes.

Arts and Humanities Through the Eras: Ancient Greece and Rome (1200 B.C.E.–476 C.E.)

67

a PRIMARY SOURCE *document*

THE ECSTASY OF THE MAENADS

INTRODUCTION: According to Diodorus of Sicily, an historian who wrote a *Universal History* in Greek in the reign of the emperor Augustus (27 B.C.E.–14 C.E.), the god Dionysus made an expedition to India and after two years, he returned with a great deal of booty, and he was, so the story goes, the first Greek to celebrate a triumph seated on an elephant. To commemorate his return, the Greeks who lived in the region of Boeotia, where Dionysus was born, and other Greeks as well, made sacrifices to him every second year, and in some of the Greek cities, both married and unmarried women would go up into the mountainsides and act the role of maenads, women who were Dionysus' companions. We see them in Greek art, dancing rapturous dances and carrying the *thyrsos*: a wand wreathed with ivy and vine-leaves and with a pine cone on top. The classic description of the madness of the maenads is found in Euripides' *Bacchae*, which tells the myth of how Dionysus returned to Thebes in Boeotia where he was born and the mother of the king Pentheus and her sisters joined his throng of maenads. Pentheus, however, resisted the new cult, and when a herdsman pasturing his cattle on the mountainside brought him a report of how the maenads, including his own mother, Agavé, were dancing madly on Mt. Cithaeron, he determined to go and see them himself. They discover him and tear him apart, and in the final scene, Agavé comes on stage bearing the bloody head of her son whom she and her sisters, Autonoe and Ino, had torn apart, thinking he was a lion's cub. The excerpt quoted below is from the speech of the messenger who reports the madness of the maenads to Pentheus.

Our herds of pasturing cattle had just begun to ascend the steep to the ridge, at the hour when the sun shoots forth his rays to warm the earth. I saw three bands of women dancers; Autonoe was leader of the first choir, your mother Agavé of the second, and Ino of the third. They all lay in the sleep of exhaustion. Some were reclining with their backs against branches of fir, others had flung themselves at random on the ground on leaves of oak. …

Then your mother rose up in the midst of the bacchants and called upon them to bestir their limbs from sleep when she heard the lowing of the horned cattle. The women then cast the heavy sleep from their eyes and sprang upright, a sight of wondrous comeliness. There were young women and old women and maids yet unmarried. First they let their hair fly loose about their shoulders and tucked up their fawnskins, those whose fastenings had become unloosed, and girt the speckled skins about them with serpents that licked their cheek. Others held gazelles in their arms, or the untamed whelps of wolves, feeding them with white milk. These were young mothers who had left their infants behind and still had their breasts swollen with milk. Then they put on ivy wreaths and crowns of oak and flowering morning glory. One took her thyrsus and struck it against a rock, and there sprang from it a liquid stream of water. Another struck her thyrsus upon the ground and the god sent up a fountain of wine for her. Those that had a desire for snowy milk scraped the earth with the tips of their fingers, and had rich store of milk. From the wands of ivy there dripped sweet streams of honey. If you had been there to see, you would have approached with prayers the god whom you now revile. …

[*The herdsman then told how he and his comrades tried to capture the maenads, and then found themselves in danger.*]

We fled and escaped a rending at the bacchants' hands. But, with naked, unarmed, hands, the women attacked the heifers that were grazing on the grass. You could see one holding wide the legs of a well-fed calf which bellowed and bellowed. Others rent heifers apart. You could see the ribs and cloven hooves tossed here and there, and pieces smeared with gore hanging from the firs, dripping blood.

SOURCE: Euripides, *The Bacchants*, in *Ten Plays by Euripides*. Trans. Moses Hadas and John McLean (New York: Bantam Books, 1981): 296–297.

THE DANCE OF THE MAENADS IN HISTORICAL TIMES. Euripides' *Bacchae* has haunted the study of the maenads' dance, and the speech of the herdsman that describes it is a classic account. It appears, however, that in most places where the biennial festival of Dionysus was celebrated, the rites of the maenads were not spontaneous explosions of dancing. They cannot be compared with the outbursts of dancing madness that affected communities in Europe from the fourteenth to the seventeenth century, when people danced until they dropped. Nor was it the same as the tarantella, the whirling dance for couples from south Italy, danced to six/eight time, which was thought to be a cure for a nervous disorder known as tarantism. Rather the orgia seem to have been carefully regulated, and they were restricted to certain groups. The women who danced in the orgia played the role of maenads briefly and then returned to their everyday existence, which for many of them must have been humdrum. The maenads' dance in Euripides' *Bacchae*, culminating in the tearing apart of a victim, is mad and primitive, and Dionysus is a ruthless god, but to judge from the number of repre-

sentations in Greek art it was a dance that haunted the Greek imagination.

SOURCES

J. Bremmer, "Greek Maenadism Reconsidered," *Zeitschrift für Papyrologie und Epigrafik* 55 (1984): 267–286.

E. R. Dodds, "Appendix I: Maenadism," in *The Greeks and the Irrational* (Berkeley: University of California Press, 1951): 270–282.

Lillian B. Lawler, "The Ancient Greek Dance: The Maenads," *American Journal of Archaeology* 31 (1927): 91–92.

———, "The Maenads," *Memoirs of the American Academy in Rome* 6 (1927): 96–100.

S. McNally, "The Maenad in Early Greek Art," *Arethusa* 11 (1978): 101–135.

PROFESSIONAL DANCERS

DEFINING PROFESSIONALS. The dividing line between the amateur and the professional dancer in ancient Greek society is not an easy one to draw. The first tragedian, Thespis, was not only a dancer but he also taught dance, and so did all the early tragic poets. Sophocles received instruction from Lamprus, a famous teacher of dance and music who was also well-known for his abstention from wine, which was unusual among the practitioners of *mousike*—music, dance, and poetry. Even the tragic poet Aeschylus, who did his own choreography, used the services of a dancing master. Yet even though choristers and dancing masters might be paid, they were considered non-professional. The fifty men who sang and danced the dithyrambs in Athens did not dance full-time, meaning they had other occupations that represented their primary work and so were not considered professional dancers. Dancers who entertained at banquets fell into a very different social category. Professional dancers and musicians were available for hire, and typically had a low social status. By the late sixth century B.C.E., contemporary literature tells of professional *auletrides* ("flute-girls"), except that their instrument was not the demure flute but a reed instrument which was the ancestor of the oboe. There were training schools for auletrides, but it was not their skill with the aulos that was their greatest attraction to audiences. They were also courtesans and prostitutes; by the fourth century B.C.E., the word *auletris* was almost a synonym for a cheap prostitute. Hiring dancers for entertainment at the lavish banquets given by wealthy hosts was a common occurrence in the Greco-Roman world. The Roman writer Pliny the Younger, who lived under the emperors Domitian (r. 81–96 C.E.) and Trajan (r. 98–117 C.E.), wrote to a friend, chiding him for failing to come to a banquet that Pliny had given, and listing the delights he had missed, among them dancing girls from Cadiz in Spain. Xenophon, Socrates' disciple, described a symposium that Socrates attended where the entertainment was provided by a troupe of dancers and musicians headed by a Syracusan dancing-master who hired them out. Both the musicians and dancers described in the accounts of Pliny and Xenophon were most likely slaves. Among the entertainments that they offered was a sword dance performed by a female acrobat, and a mime telling the myth of Dionysus and Ariadne, danced by a girl and a handsome boy. Both of these dancers would not only perform for their dance master, but would also share his bed. The life of professional dancers was harsh and, except for a lucky few, they were at the bottom of the social scale.

THE DIONYSIAC GUILDS. Sometime very early in the third century B.C.E., the actors, dancers, and musicians in Athens formed a *synodos* ("guild"). It may not have been the first such association, for there is some reason to think that the earliest actors' guild was formed in Hellenistic Egypt, where it was imposed on the actors by the government. In any case, the Athenian guild was the first in mainland Greece, and it was soon followed by the Isthmian guild centered in Corinth, and by others, until there were six in all, including one for the Greek cities in southern Italy and Sicily. They engaged in an astonishing range of activities: they exchanged gifts and honors with cities and kings, they secured tax-exemptions and front row seats in the theater for their members, and organized festivals. Travel in the Hellenistic world was insecure, for the numerous poor had turned to robbery, and the roads were infested with highwaymen and the sea-lanes with pirates. Hence the guilds negotiated the right to *asylia*—the right of safe passage from city to city. The rights of the Athenian guild were recognized officially after 274 B.C.E. by the Amphictionic League, an inter-state organization based at Delphi which was the association closest to a "United Nations" that Hellenistic Greece knew. The Dionysiac troupes of professional artists moved from place to place, and even small towns built stone theaters. In addition to theaters, they built *odeons*—music halls with roofs so that a rainstorm need not interrupt a performance. Pericles built one in Athens during the fifth century B.C.E.; it was a square building with its roof supported by a forest of columns, but later odeons look like small theaters with roofs that must have been made of wood. Their interiors were too dark for productions of tragedy and comedy, but lamps could provide enough lighting for music and dance. The music hall at Pompeii in southern Italy,

a PRIMARY SOURCE *document*

A DANCER ENTERTAINS AT A BANQUET IN ATHENS

INTRODUCTION: The *Symposium* by Xenophon describes a banquet attended by Socrates which took place just after the athletic festival of the Great Panathenaea of 421 B.C.E., which the wealthy Athenian Callias gave for his boyfriend and his father, to celebrate the boy's victory in the wrestling match. Xenophon wrote his *Symposium* some forty years after it was held, and so it is not likely that it is a completely accurate account, though he claims to have attended the banquet himself. However, his account is of the entertainment offered by a troupe of musicians and dancers belonging to an unnamed master from Syracuse in Sicily. The performers were probably slaves, and their master probably a *pornoboskos*, or pimp, who hired out the performers for entertainment and sexual favors when his customers demanded it.

When the tables had been taken away and the guests had poured a libation and sung a hymn, a man from Syracuse came in to provide some merry-making. He had with him a girl skilled at playing the pipes, and a dancing girl, one of those who could perform amazing acrobatic stunts, as well as a very handsome boy who was a gifted player of the *kithara* and a brilliant dancer. The Syracusan master of the troupe made money showing them off. Now the girl pipe-player played a piece to the guests, and the boy played his *kithara* and everyone agreed that both had given a satisfactory performance

The conversation in the room then continues until Socrates points out that the dancing girl is ready to perform.

Thereupon the girl who played the pipes began to play a tune, and a boy who attended the dancer handed her hoops up to the number of twelve. The dancer took them and as she danced, she threw them spinning round into the air, making note of just how high she had to throw them so as to catch them in regular rhythm.

As Socrates watched the performance, he remarked that it showed that women were in no way inferior to men, and hence any of the banqueters who had wives should not hesitate to educate them. Socrates was asked immediately why, then, he did not practice what he preached on his own wife, Xanthippe, who was notoriously bad-tempered, and Socrates replied that horsemen practiced their skill on spirited horses, not on docile ones. Then the banqueters turned their attention back to the acrobatic dancer.

Next there was a hoop brought in and set in the middle of a circle of upright swords. Then the dancer turned somersaults over these swords into the hoop and then out in the opposite direction. The onlookers were worried that she might suffer some mishap, but she carried out this performance, boldly, suffering no harm.

SOURCE: Xenophon, *Symposium*. 2.1-11. Translated by James Allan Evans.

which was built just after 80 B.C.E., has the design of a small Roman theater, with a low, narrow stage, and the groove in the stage where the curtain wound down can still be seen.

THE POPULARITY OF THE DIONYSIAC ARTISTS. The first century and a half after the death of Alexander the Great (323 B.C.E.–14 C.E.), the city of Rome had a large population of under-employed or unemployed, and Augustus knew how important it was to keep the mob happy. There is a story reported of Augustus which told that in 17 B.C.E., when some citizens were irritated at the strict morality laws which Augustus promulgated, he allowed the officials in charge of the festivals to spend three times the amount on them authorized by the treasury, and permitted the popular dancer Pylades to return to Rome, even though he earlier had been banished for sedition. He did chide Pylades for his noisy rivalry with the dancer Bathyllus, however, to which Pylades replied that if the people spent their time with dancers it was Augustus who gained. Pylades recognized the value

of dance in diverting the attention of the mob from the failings of the government.

SOURCES

James N. Davidson, *Courtesans and Fishcakes: The Consuming Passions of Classical Athens* (New York: St. Martin's Press, 1998).

Brigitte LeGuen, *Les Associations de Technites dionysiaques à l'époque hellénistique.* Vol. I, *Corpus documentaire;* Vol. 2, *Synthèse (Études d'Archéologie Classique, XI–XII)* (Nancy, France: Association pour la Diffusion de la Recherche sur l'Antiquité, 2001).

G. M. Sifakis, "Organization of Festivals and the Dionysiac Guilds," *Classical Quarterly* 15 (1965): 206–214.

DANCE IN ROME

THE INFLUENCE OF ETRURIA. The city of Rome in 364 B.C.E. was suffering from a plague. Believing the plague to be the result of the anger of the gods, the Ro-

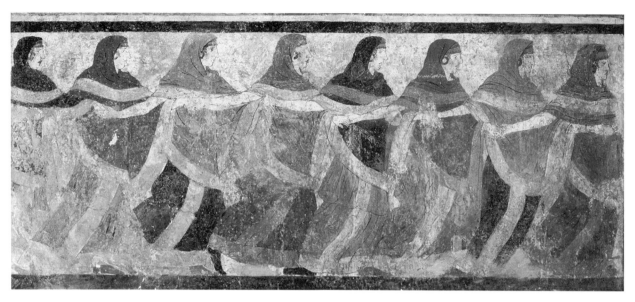

Wall painting from a tomb at Ruvo di Puglia, Italy, showing a funeral dance. © MIMMO JODICE/CORBIS. REPRODUCED BY PERMISSION.

mans brought in Etruscan dancers in an effort to appease the gods and gain some relief from the plague's devastation. The Etruscans danced to the music of the *aulos*, the precursor to the oboe, without any songs or gestures, but their graceful movements entranced the Romans, who began to imitate them. There is much about the Etruscans which is still a mystery—the riddle of their language has not yet been solved—but in the ancient world, they were known for their love of luxury, to which the paintings found in their tombs of the magnificence of their festivals and banquets can attest. In one tomb, the *Tomba dei Cacciatori* (Tomb of the Huntsmen), men dance in the open air, most of them nude except for a loincloth. They are shown separated from each other by trees or shrubs, dancing wildly to the music of the double-aulos. In another tomb, the *Tomba delle leonesse* (Tomb of the Lionesses), a naked man is shown dancing opposite a scantily-clad woman. On opposite walls of the *Tomba del Triclinio* (Tomb of the Dining Couch), there are two groups of five dancers each, alternating in gender. In one corner, a musician plays the double-aulos, and in the other, a man plays the lyre. Another tomb shows a man apparently dancing in armor to the music of the aulos. Like the Greeks, the Etruscans knew the *pyrrhike* ("war dance") or something like it.

ROMAN ATTITUDES TOWARDS DANCE. Roman character had a strong ascetic streak. The Etruscans may have introduced Romans to the dance, but it retained the reputation of a foreign import for years after. Plato may have said that a man who did not know how to dance was uneducated, but Plato was a Greek, and his Roman contemporaries would have thought the senti-

ment ridiculous. The art of the dance did eventually come to Rome along with the rest of Greek culture, but for the Romans, dancing always remained entertainment. It was never part of a Roman's formal education. By the end of the third century B.C.E., upper-class Romans did start to send their children to dancing-masters for lessons, and in the first half of the second century B.C.E., while Greece itself was falling under Roman domination, Greek dancers, most of them probably brought to Rome as slaves and then freed, set up dancing-schools. From the Roman perspective, the creation of dancing schools gave dance a status far beyond that of mere entertainment, and its possibilities for the corruption of character led to a backlash against this art form. In the middle of the second century B.C.E., Scipio Aemilianus, a Roman aristocrat who generally admired Greek culture, moved to close the schools down, but his success was short-term at best. Yet Scipio's view of dance persisted in Roman culture into the first century B.C.E.: it was permissible for Romans to know how to dance, but knowing how to dance expertly was a symptom of depravity.

NATIVE DANCES OF ROME. Nonetheless there were dances native to early Rome. One called the *bellicrepa* was supposedly instituted by Rome's founder, Romulus, and was a dance in armor performed by warriors drawn up in battle ranks. The cult of the god Mars *Ultor* ("Avenger") involved dances by armed men, and on a number of surviving medals and gems, as well as one bronze statuette, there are representations of Mars dancing. There were also ancient priestly brotherhoods with

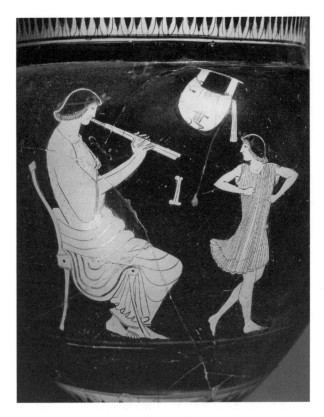

"The Dancing School," detail of red-figure vase, 5th-century B.C.E., Greece. Teacher is playing the double-*aulos*; a kithara hangs on the wall in the background. THE ART ARCHIVE/MUSEO PROVINCIALE SIGISMONDO/CASTROMEDIANO LECCE/DAGLI ORTI.

a PRIMARY SOURCE *document*

DEATH OF A ROMAN IMPRESARIO

INTRODUCTION: Excavations which took place under St. Peter's basilica in the Vatican in the 1950s have turned up an ancient cemetery which was once on the Vatican hill before the emperor Constantine built a church there over the tomb of St. Peter. Numerous mausoleums, burial urns and inscriptions marking the graves of the dead have been found there, among them the one quoted below. Aurelius Nemesius was evidently the master of a troupe of pantomime dancers. The date of the inscription is uncertain but sometime in the third century C.E. is likely.

To Aurelius Nemesius, spouse most dear and well-deserving, who lived 53 years 9 months 11 days, who won the highest praise for his art served as master of chorus, dance and pantomime. To him his wife Aurelia Eutychiane has dedicated and erected [this stone].

SOURCE: "Tombstone of an Impressario," in *The Empire*. Vol. 2 of *Roman Civilization: Selected Readings*. Ed. Naphtali Lewis and Meyer Reinhold (New York: Columbia University Press, 1990): 145.

ritual dancers. The best-known are the Salians, priests of Mars *Gradivus* ("Marches Forth to War") who, according to tradition, were established by Romulus' successor as king of Rome, Numa. They wore helmets and breastplates over embroidered tunics, and they carried swords and the sacred shields of Mars. To the music of trumpets they paraded through the city of Rome, making stops at places hallowed by religion, and there performing the Salian dance. They shuffled from left to right, then from right to left, and all the while they beat the earth with their feet and made leaps into the air as they beat their shields. The Roman historian Livy mentions another ancient dance performed to propitiate Juno in 207 B.C.E., during the long and difficult Second Carthaginian War. Twenty-seven young girls made their way to the forum while singing a hymn, and there they took hold of a rope and danced with it through the streets on their way to the temple of Juno. Ancient rope dances were also found in Greece; a fragment of a Mycenaean fresco shows men wearing donkey-headed masks in procession carrying a rope.

INTRODUCTION OF PANTOMIME. The historian Zosimus, who wrote in Greek in the reign of the em-

peror Theodosius II (408–450 C.E.) on the decline of Rome from the time of the first emperor Augustus (r. 27 B.C.E.–14 C.E.) to his own day, has little to say about Augustus, but he does note an important development in dance that occurred during Augustus' reign.

> In those days the pantomime dance was introduced, which did not exist earlier. Pylades and Bathyllus were the first to introduce it, though there are other reasons too for the many evils that have survived up to the present day.

Zosimus was still a pagan writing at a time when the pagan religion had become a small minority in a largely Christian empire, but he reflected the old-fashioned belief that the decline of Rome was caused by moral decay, and dancing was a symptom of decay. The old Roman attitude towards dance died hard. Pliny the Younger, a writer of elegant letters in the later first century C.E., commented in one of his letters on the death of an eighty-year old woman, Ummidia Quadratilla, who owned a troupe of pantomime dancers, and enjoyed their performances more than was proper for a woman of her social station. She did not allow her grandson to see them—to that extent she remained faithful to the old

a PRIMARY SOURCE *document*

LUCIAN OF SAMOSATA ARGUES THE VIRTUES OF THE PANTOMIME DANCE

INTRODUCTION: Lucian of Samosata in Syria who lived in the second century C.E. wrote essays and dialogues often from the viewpoint of a satirist, but his dialogue on dancing is a serious vindication of the pantomime. He imagines that a fan of pantomimes is talking with a Cynic philosopher who scoffs at them, but is eventually won over. The dialogue was probably written in Antioch in the years 162–165 C.E. when the emperor Lucius Verus, until his death in 168 the colleague of Marcus Aurelius, and an aficonado of pantomimes, was in Antioch ostensibly leading a campaign but actually enjoying the delights of the city. In this passage, Lucian compares the pantomime to contemporary productions of tragedy.

As far as tragedy is concerned, let us form our first opinion of its character from its outward appearance. What a repulsive and at the same time frightful spectacle is a man tricked out to disproportionate stature, mounted upon high clogs, wearing a mask that reaches up above his head, with a mouth that is set in a vast yawn as if he meant to swallow up the spectators! I forebear to speak of pads for the breasts and pads for the paunch to make himself look obese so that his body will not be too slender in proportion to his height. Then, inside the costume is the actor himself shouting his lines, bending forwards and backwards, sometimes even singing the poetry, and—this is really shameful— making a song out of his misfortunes.

[*Lucian gives some examples of ridiculous tragic performances, and then contrasts them with pantomime.*]

On the other hand, there is no need for me to say that the dancer is seemly and becoming, for it is clear to everyone who is not blind. The mask itself is very attractive and suitable to the theme of the dramatic presentation. Its mouth is not wide open like the masks of tragedy and comedy, but closed, for the pantomime artist has many actors to take the speaking parts for him. In the past, to be sure, the pantomime artists did both sing and dance. But when their panting as they danced interfered with their singing, it seemed better that others should sing for them.

SOURCE: Lucian, "The Dance," in *Lucian*. Vol. 5. Trans. A. M. Harmon (Cambridge, Mass.: Harvard University Press, 1936): 239–243. Text modified by James Allan Evans.

Roman view that dance corrupted the youth. Since Quadratilla was enormously wealthy, she could afford to have her pantomime troupe put on private performances for her own entertainment, but by that time Rome had permanent theaters built of stone—the first of them opened in 55 B.C.E., long after many towns in Italy had them—and it was pantomime dance rather than tragedy and comedy that filled them.

ANTECEDENTS OF PANTOMIME. Before pantomime was invented, there was mime. In Greece, a mime was a short dramatic skit that could be sung and danced on stage. The banquet which Socrates attended after the Great Panathenaic festival of 421 B.C.E., which Xenophon described in his *Symposium*, was entertained by a mime in which two dancers performed the story of Dionysus and Ariadne. Ariadne, daughter of King Minos of Crete, helped Theseus escape the Minotaur and accompanied him on his homeward voyage as far as the island of Naxos where he deserted her, and Dionysus arrived to make her his bride. This mime seems to have had at least some of the features of the later pantomime. The subject was a tale from mythology, which was the stock-in-trade of pantomime. Mimes came to Rome in the third century B.C.E., where they became very popular, and they covered a wide range of subjects. Women regularly appeared in them as *mimae* ("mime actresses") as well as men. One popular feature of the festival known as the *Floralia* (Flower Festival) was a mime in which mimae appeared naked. The masses loved mimes, and Roman emperors favored them. The emperor Domitian (r. 82–96 C.E.) catered to the bloodthirsty taste of the Roman public by ordering a genuine crucifixion inserted into a mime. Troupes of mime artists, some owned by impresarios who were mime performers themselves, toured the towns and cities of the empire, and played in the local theaters at festivals which well-to-do local citizens financed to advertise their public spirit. By the time of the late Roman Empire, it was hard to distinguish between mime and pantomime, and the Christian church frowned on both of them. In 22 B.C.E., however, two pantomine artists, Pylades and Bathyllus, invented the Roman pantomime, and whatever its antecedents, it was recognized as something new.

DESCRIBING PANTOMIME. Pantomime created a new kind of dance performance by marrying three arts: song, music, and mime. Song and dance had been part of Roman theatrical productions ever since the first playwright, Livius Andronicus, produced plays in Rome. Livius Andronicus had lost his voice singing, and his audience allowed him to mime the songs while a boy sang

a PRIMARY SOURCE *document*

THE PANTOMIME DANCER, PYLADES

INTRODUCTION: Macrobius, the author of the *Saturnalia* from which this excerpt is taken, lived at the end of the fourth century C.E., and we know little about him, except that he was not a native of Italy—he may have come from Africa. However he was deeply attached to the traditions and literature of ancient Rome at a time when they were under threat. In his *Saturnalia*, he imagines the leaders of Roman society of his day, many of them still pagans or at least sympathetic to paganism, gathered for the festival of the Saturnalia in December, and their conversation ranges over various antiquarian topics, such as dancing, indigestion, and drunkenness, among others. In the passage quoted below, Macrobius looks back four centuries before his own day to Pylades, the dancer who, along with Bathyllus, revolutionized the pantomime in the reign of the emperor Augustus (27 B.C.E.–14 C.E.).

Having once begun to talk about the stage, I must not omit to mention Pylades, a famous actor in the time of Augustus, and his pupil Hylas, who proceeded under his instruction to become his equal and his rival. On the question of the respective merits of these two actors popular opinion was divided. Hylas one day was performing a dramatic dance the closing theme of which was *The Great Agamemnon*, and by his gestures he represented his subject as a man of mighty stature. This was more than Pylades could stand, and from his seat in the pit he shouted, "You are making him merely tall, not great." The populace then made Pylades perform the same dance himself, and, when he came to the point at which he had

found fault with the other's performance, he gave the representation of a man deep in thought, on the ground that nothing became a great commander better than to take thought for all.

On another occasion, when Hylas was dancing *Oedipus*, Pylades criticized him for moving with more assurance than a blind man could have shown, by calling out: "You are using your eyes."

Once, when Pylades had come on to dance *Hercules the Madman*, some of the spectators thought that he was not keeping to action suited to the stage. Whereupon he took off his mask and turned on his critics with the words: "Fools, my dancing is intended to represent a madman." It was in this play too, the *Hercules Furens*, that he shot arrows at the spectators. And when, in the course of playing the same part in a command performance at a banquet given by Augustus, he bent his bow and discharged arrows, the Emperor showed no annoyance at receiving the same treatment from the actor as had the populace of Rome.

He was said to have introduced a new and elegant style of dancing in place of the clumsy fashion popular in the time of our ancestors, and when asked by Augustus what contribution he had made to the art of dancing, he replied, in the words of Homer,

The sound of flutes and pipes, and the voices of men.—*Iliad 10.13.*

SOURCE: Macrobius, *The Saturnalia*. Trans. Percival Vaughan Davies (New York and London, England: Columbia University Press, 1969): 183–184.

for him. In pantomime, song was provided by a choir, not a solo performer. The piercing notes of the double-aulos had provided the music in the past, but Pylades added more instruments. Pantomime musicians soon developed into an orchestra, with musicians playing the aulos, the panpipes, cymbals, *kithara* (a kind of lyre), the lyre, and the trumpet. The conductor of the choir marked out the beat with a *scabellum* ("iron shoe")—a clapper with a sound-box which could be worked with the foot. While the choir sang and the orchestra played, the pantomime artist mimed the plot of the drama. He used masks, but unlike the masks used by a tragic or comic actor which had a gaping mouth to allow the actor's voice to project, the pantomime masks had closed mouths, for the *pantomimus* ("pantomime actor") did not speak. Behind him stood an assistant who might be an actor with a speaking part, but he also gave the pan-

tomimus help when needed—when the pantomimus switched roles, he changed masks, and a little assistance was sometimes necessary. The favorite plots of pantomimes were taken from mythology and the audiences were familiar with them.

THE GREAT PLAYERS. Two great pantomimi were associated with the invention of the new pantomime: Pylades, an ex-slave of the emperor Augustus, and Bathyllus, an ex-slave of Augustus' minister of public relations, Maecenas, who also supported a stable of writers. They may have cooperated in the introduction of this new entertainment around 22 B.C.E. The performances of Bathyllus were more joyous and light-hearted performances than those of Pylades, and his dances were livelier. Pylades created the tragic pantomime: a spectacle with choir, full orchestra, scenery, and even a second pantomimus when the plot demanded it. Both Pylades and

Bathyllus had enthusiastic supporters who sometimes fought pitched battles in the streets. The emperor Augustus even banished Pylades from Rome for a period but relented and allowed him to return in 17 B.C.E. at a time when the emperor's popularity was sagging. For the Roman masses, the recall of Pylades made up for other measures that were unpopular.

THE STARS. The rivalry between the stars of the pantomime was intense. Pylades quarreled not only with Bathyllus, but also with a pupil of his, Hylas, whose talent on stage challenged his master's. Pylades became wealthy. He owned his own troupe of pantomimes and in 2 B.C.E. he financed a festival himself, though by that time he was too old to perform, and sat in the audience. The emperor Nero, who had ambitions as a pantomime dancer himself, killed a *pantomimus* named Paris because he thought him a rival. The names of great pantomime dancers lived on, for later dancers assumed them, hoping to inherit some of their fame. There was a Paris in Nero's reign, another in the reign of Domitian (81–96 C.E.) and another in the reign of Lucius Verus (161–169 C.E.), co-emperor with Marcus Aurelius. Five pantomime dancers with the name of Pylades can be traced, and six with the name of Apolaustus. By the time of the fourth century C.E., women were dancing in pantomimes. They had always played in mimes, and the distinction between the two was breaking down. In the sixth century C.E. the empress Theodora (527–548) was a pantomime dancer in her youth in Constantinople, which was by then a Christian city, and respectable women could not attend the theater. Yet once Theodora became empress, she did not forget her old friends in the theater. They were welcome as her guests in the imperial palace, and she arranged good marriages for their daughters.

SOURCES

Mario Bonaria, "Dinastie di Pantomimi Latini," *Maia* 11 (1959): 224–242.

E. J. Jory, "Associations of Actors in Rome," *Hermes* 98 (1970): 224–253.

———, "The Literary Evidence for the Beginnings of Imperial Pantomime," *Bulletin of the Institute for Classical Studies* 28 (1981): 147–161.

O. Navarre, "Pantomimus," in *Dictionnaire des antiquités grecques et romaines.* Vol. IV, pt. 1. Eds. Charles Daremberg and Edmund Saglio (Graz, Germany: Akademische Druck und Verlagsanstalt, 1962–1963): 316–318.

Charlotte Rouché, *Performers and Partisans at Aphrodisias in the Roman and Late Roman Periods* (London, England: Society for the Promotion of Roman Studies, 1993).

Louis Séchan, "Saltatio," in *Dictionnaire des antiquités grecques et romaines.* Vol. IV, pt 1. Eds. Charles Daremberg and Edmund Saglio (Graz, Germany: Akademische Druck und Verlaganstalt, 1962–1963): 1049–1054.

SIGNIFICANT PEOPLE
in Dance

ARION

c. 650 B.C.E.–c. 590 B.C.E.

Musician
Choreographer

THE FAME OF ARION. Arion was a master of *mousike*—dancing, poetry, and music—whose major period of activity was in the last half of the seventh century B.C.E. His fame has lived on, although none of his poetry has survived. He was a native of Methymna, a city-state on the island of Lesbos off the west coast of Turkey, but he spent much of his life at Corinth, where his patron was the tyrant Periander. During Periander's forty-year reign, Corinth was a brilliant center of art and culture, and among the artists attracted to his court was Arion.

ARION AND THE DITHYRAMB. The dithyramb was a choral hymn, accompanied with dance, that was sung in honor of the god of wine Dionysus, and exactly what the music and dance were like before Arion is unknown. Arion's contribution was to give the dithyrambic choir a fresh organization. He was responsible for setting the number of choristers at fifty, and he himself composed dithyrambs and taught choirs in Corinth to perform them. Oxen were prizes given to the winning choirs, and the sacrifice of the prize oxen was part of the festival. From Corinth, the dithyramb was brought to Athens where its development is connected with an equally shadowy figure, Lasus of Hermione who was born around 548–547 B.C.E. Aristotle claimed that Greek tragic drama developed from the dithyramb.

ARION AND THE DOLPHIN. Arion was almost more famous for his adventure with a dolphin than for his contributions to dance and music. The story goes that he took a sabbatical from Periander's court and made a tour of the Greek cities in Italy and Sicily, where he made a great deal of money. When it was time to return to Greece, he chose a Corinthian vessel for the voyage because he trusted the Corinthians more than any others.

The sailors knew that he had a good deal of money, however, and they plotted to take it and throw Arion overboard. Arion begged them to take his money but spare his life, and when he could not persuade them, he asked to be allowed to stand on the ship's poop and sing one last song before he died. The sailors agreed, and Arion put on his costume that he wore when he performed and sang a song, and then leaped into the sea, where a dolphin picked him up and carried him on its back to land. Once he got there, he made his way, still in his costume, to Periander's court. Later, the sailors arrived back in Corinth and reported to Periander that Arion was still safe and sound in Italy. They got an unpleasant shock when Periander confronted them with Arion. It was said that Arion was given a helping hand by the god Apollo, who was the god of the lyre and to whom dolphins were sacred. The Greeks believed that Apollo helped musicians in distress, and saw to it that Arion's would-be murderers were punished. After this account of Arion, there is no further reference other than a mention of his death around 590 B.C.E.

SOURCES

Lillian B. Lawler, *The Dance of the Ancient Greek Theatre* (Iowa City: University of Iowa Press, 1964).

Sir Arthur Pickard-Cambridge, *Dithyramb, Tragedy and Comedy.* 2nd ed. Rev. by T. B. L. Webster (Oxford, England: Clarendon Press, 1962).

Emmet Robbins, "Arion," in *Der Neue Pauly: Enzylopädie der Antike.* Eds. Hubert Cancik and Helmut Scheider (Weimar/Stuttgart, Germany: Metzler, 1996): 1083–1084.

Richard A. S. Seaford, "Arion," in *Oxford Classical Dictionary.* 3rd ed. (Oxford, England: Oxford University Press, 1996): 158.

BATHYLLUS AND PYLADES

Mid-first century B.C.E.–Early first century C.E.

Pantomime dancers

INTRODUCTION OF THE PANTOMIME. The introduction of the pantomime into Rome is credited to two dancers, Bathyllus and Pylades. Bathyllus was a native of Alexandria in Egypt and nothing is known about his early life. Somehow he became the slave of Maecenas, the minister of public relations for the Roman emperor Augustus (r. 27 B.C.E.–14 C.E.), the nephew and heir of Julius Caesar. Maecenas freed him and became his patron. Pylades who came from Cilicia in Asia Minor, was an ex-slave of the emperor Augustus himself. The two dancers were rivals, and their fans often clashed in street riots, so much so that Augustus banished Pylades from Rome for a short period. Both men had students, and one student of Pylades, Hylas, became his master's rival. Bathyllus was famous for his comic pantomimes, whereas Pylades specialized in serious or tragic themes taken from Greek myth.

THE NEW PANTOMIME. Information about Bathyllus and Pylades is sparse, but it is clear that they introduced into Italy a new kind of dance which combined features from the dance of the Old Comedy of classical Greece known as the *kordax,* the more dignified dance of tragedy known as the *emmeleia,* and the dance of the satyr play called the *sikinnis.* In fact, Pylades wrote a treatise on dancing. Bathyllus' performances were more light-hearted. One ancient author compared his dance to the *hyporchema,* which was a lively choral song and dance, although the similarity was with the spirit and joyousness of the *hyporchema* as there were no choral dances in pantomime. Bathyllus is also supposed to have introduced the *Memphian* dance, which involved matching every muscle in the dancer's body to the rhythm of the music, and dealt with serious themes. One ancient source mentioned performances of tragedy by Bathyllus and comedy by Pylades, and so they may have poached on each other's territory occasionally. The date of death for either Bathyllus or Pylades is not known, though in 2 B.C.E., Pylades produced and financed a festival, but did not give a performance himself because he was too old. Bathyllus was probably older than Pylades and so he had ceased dancing about the same time or earlier, though some dancers had very long careers on the stage.

SOURCES

E. J. Jory, "The Literary Evidence for the Beginnings of Imperial Patronage," *Bulletin of the Institute of Classical Studies* 28 (1981): 147–161.

Sir William Smith, *Dictionary of Greek and Roman Biography and Mythology.* Vol. 1 (London, England: Walton and Maberly, 1849–1858): 474.

MEMPHIUS

Mid-second century C.E.–Early third century C.E.

Pantomime artist

BACKGROUND. Memphius—also known as Apolaustus—was a famous pantomime artist in the reign of the emperor Marcus Aurelius (161–180 C.E.), and a great favorite of Lucius Verus, who was Marcus' co-emperor for the first seven and a half years of his reign. When

Verus returned from a campaign against the Parthians, he brought with him actors from Syria, one of whom was a slave, Agrippus, whom Verus and Marcus Aurelius freed. Thus Agrippus acquired the name "Lucius Aurelius" from his patrons, and in addition, he had two nicknames, his stage name "Apolaustus," and "Memphius" ("pantomime from Memphis"). Memphis in Egypt may have been where he first won fame as a pantomime artist, or it might refer to the kind of dance that he made his specialty, for there was a *Memphian* dance where the dancer moved every muscle in his body as he performed. The first dancer to introduce the Memphian dance to Rome was Bathyllus from Alexandria in Egypt, who belonged to the reign of the emperor Augustus (27 B.C.E.–14 C.E.). As for the name "Apolaustus," it was a favorite nickname for pantomime artists; in fact there already was an ex-slave named "Lucius Aelius Aurelius Apolaustus" who belonged to the imperial household before Memphius arrived in Rome. Presumably he also was a pantomime artist, and had the misfortune of being put to death by the emperor Commodus, the son of Marcus Aurelius, in 189 C.E. Memphius, however, was still alive in 199 C.E. when he is mentioned in an inscription.

PANTOMIME OF PYTHAGORAS. One pantomime which won Memphius fame was his exposition of the philosophy of Pythagoras in dance. Pythagoras was known for his theory of numbers, but in the second century C.E. he was best known for his doctrine of transmigration of souls. Since Memphius followed in the tradition of Bathyllus, whose performances were more light-hearted than those of Pylades, presumably Memphius' presentation of Pythagorean wisdom was not particularly serious.

CAREER AFTER LUCIUS VERUS. As long as Lucius Verus was still alive, Memphius was probably part of the entourage of actors, pantomime artists, and jugglers that belonged to his household. But Marcus Aurelius had no taste for Verus' pastimes, and Memphius must have forged a career of his own. He had his own *grex*—a troupe of musicians and supporting dancers—who performed in Rome and throughout Italy where every respectable town had its own theater. He was acclaimed as the "outstanding actor of his day." His death date is unknown but he was still performing at the end of the second century C.E.

SOURCES

E. J. Jory, "The Literary Evidence for the Beginnings of Imperial Patronage," *Bulletin of the Institute of Classical Studies* 28 (1981): 147–161.

P. R. C. Weaver, *Familia Caesaris* (Cambridge: Cambridge University Press, 1972).

THEODORA

c. 500 C.E.–548 C.E.

Pantomime artist
Empress

DAUGHTER OF A BEAR-KEEPER. The woman who would one day become empress of the Roman Empire was born as one of three daughters of the bear-keeper for the Green faction, the company which produced the chariot races and the amusements in the theaters of Constantinople. Her father died while Theodora and her sisters were still very young, and Theodora's mother quickly married again, anticipating that her new husband would take over her former husband's job. Her plan was thwarted, however, when the head ballet-master of the Green faction, who possessed the right to choose a new bear-keeper, was bribed into choosing another candidate. The change in fortunes left Theodora's little family destitute, but Theodora's mother was persistent in securing her young daughters' futures. She dressed them as suppliants and placed them before the section of seats in the Constantinople Hippodrome that belonged to the fans of the Greens and begged for compassion. Although the Greens paid no heed, the Blue fans did take pity on the little family and gave Theodora's stepfather the job of bear-keeper for their faction.

TOOK TO THE STAGE. As soon as they were old enough, Theodora and her sisters took to the stage. Her older sister, Comito, soon became a star, and Theodora' first role was as an attendant for Comito, carrying a little stool for her where Comito might rest briefly between dances. Theodora herself did not shine as a dancer. She did, however, make a name for herself as an interpreter of myths, and one that particularly pleased the audience was her pantomime of *Leda and the Swan*, which told the myth of how Leda, the mother of Helen of Troy, was raped as she took a bath by the god Zeus, who disguised himself as a swan. Like most actresses and dancers on the Roman stage, she practiced prostitution, and during this period of her life, she had an illegitimate daughter. One of her lovers, who had purchased a provincial governorship for himself, took her with him to his province in modern Libya. They soon quarreled, however, and when the governor discarded Theodora she was left to her own resources.

CONVERSION. Theodora made her way to Alexandria, which was full of refugees from religious persecution. At this time, the Christian church was split by a dispute over the nature of Christ. The Catholics held that Christ had both a human and a divine nature as set forth in the Chalcedonian Creed, whereas their op-

ponents believed that Christ's divine nature was dominant; some argued that it even subsumed Christ's human nature. When Justin I became emperor in 518 C.E., he initiated a persecution of the anti-Chalcedonians everywhere in the empire except Egypt, and hence the anti-Chalcedonians fled to Alexandria. Theodora came in contact with them there and was converted to their creed. She then made her way to Antioch, modern Antakya in Turkey, and there a dancer named Macedonia, belonging to the Blue faction's troupe, befriended her. Macedonia had a second career; in addition to being a dancer, she was a secret agent for Justinian, the emperor's nephew, and it was probably thanks to her that Theodora met Justinian. They fell in love, and even though it was illegal for an upper-class Roman to marry an actress, Justinian persuaded Emperor Justin to promulgate a law to allow the wedding to take place. Once Justin died in 527 C.E., Justinian and Theodora became emperor and empress.

EMPRESS. Theodora did not forget her old friends of the theater once she became empress. Dancing girls with names like Chrysomallo and Indaro were welcome in the palace. Justinian also passed a number of laws that made it easier for actors to give up their careers if they wished and to marry upper-class citizens. In fact, Theodora found suitable husbands for the daughters of some of her old friends. She was Justinian's partner in power, and in theological disputes she did not hesitate to intervene on behalf of the anti-Catholics. Justinian favored the Catholics but he had enormous respect for Theodora's intelligence. The Assyrian and Coptic churches in the Near East and Egypt hold Theodora in high regard, and reject the story that she was an ex-actress. Yet the evidence that she had a career as a dancer on the stage before she met Justinian seems to be sound. She died of cancer in 548 C.E.

SOURCES

Robert Browning, *Justinian and Theodora*. Rev. ed. (London, England: Thames and Hudson, 1987).

James Allan Evans, *The Empress Theodora: Partner of Justinian* (Austin: University of Texas Press, 2002).

Lynda Garland, *Byzantine Empresses: Women and Power in Byzantium A.D. 527–1205* (London, England: Routledge, 1999).

DOCUMENTARY SOURCES
in Dance

Aeschylus, *Suppliants* (462 B.C.E.)—The tragedy, the *Suppliants* by Aeschylus is the best surviving example of a drama that depends on the interpretative dancing of the chorus for its impact which in this instance, could have numbered as many as fifty instead of the usual fifteen members.

Apuleius, *Metamorphoses* (popularly known as "The Golden Ass," c. 180 C.E.)—The "Golden Ass," the only Latin novel to survive in its entirety, at Book 10.29–34, contains a description of a dance and pantomime production staged in Corinth.

Athenaeus, *Deipnosophistae* ("The Learned Men at a Banquet," c. 200 C.E.)—The *Deipnosophistae*, written in Greek by Athenaeus from Naucratis in Egypt, is an imaginary symposium where learned men discuss all manner of topics, and in both the first and fourteenth books, their topics include dancing. Athenaeus is a major source for modern knowledge of ancient dance.

Homer, *Iliad* (c. 750 B.C.E.)—The eighteenth book of Homer's *Iliad* contains an *ekphrasis*, or detailed description, of a scene from everyday life in Greece, in which is a word picture of young men and women dancing on a dancing floor like that which was made for Ariadne, daughter of King Minos, at Knossos in Minoan Crete.

Lucian of Samosata, *Peri Orcheseos* ("On the Dance," c. 165 C.E.)—Lucian, author of some eighty pieces, most of them in dialogue form, wrote a dialogue on pantomime dancing in which he imagines a fan of the pantomime winning over a Cynic philosopher who had condemned it.

Xenophon, *Anabasis* ("The Expedition into the Interior," c. 360 B.C.E.)—The Athenian, Xenophon, in his youth a disciple of Socrates, accompanied Prince Cyrus of Persia on his attempt to overthrow his older brother, King Artaxerxes II. The *Anabasis*, which describes Cyrus' ill-fated expedition and the return home of his force of ten thousand mercenaries, contains a description of folk dancing by the various ethnic groups that made up the force. Xenophon's *Symposium* is another source for ancient dance for it describes professional dancers who provided entertainment at a banquet which Socrates attended.

chapter three

FASHION

James Allan Evans

IMPORTANT EVENTS
in Fashion

c. 1700 B.C.E.
–c. 1450 B.C.E. In Minoan Crete of the Neopalatial Period frescoes show women wearing short jackets which left their breasts bare and a bell-shaped skirt falling from a girdle at the waist. Men, when not shown nude, wear a kind of short double-apron covering their genitalia.

c. 1200 B.C.E. The safety pin appears in Greece, which indicates that women are already wearing the *peplos* which is fastened at the shoulders by safety pins called *peronai*.

c. 600 B.C.E. Towards the end of the Early Archaic Period, the Ionian *chiton* becomes popular in Athens, displacing the simpler Dorian *chiton*, or *peplos*, which remains the standard women's dress in Sparta and other Dorian states.

594 B.C.E. Solon, the chief magistrate (in Greek *archon*) of Athens, creates a law that forbids women to wear more than three garments when attending funerals or festivals. This is an attempt to curb the overly elaborate fashions introduced into Athens along with the Ionian *chiton*.

490 B.C.E.
–479 B.C.E. Persia makes an abortive attempt to conquer Greece, and in the aftermath of the Persian War there is a shift in favor of simpler fashion and away from elaborate fashions associated with Persia.

In Athens, the *peplos* comes back in style.

c. 430 B.C.E. In Athens, Persian fashions come into favor again among wealthy citizens.

336 B.C.E. Macedonian king Alexander the Great begins his campaign which results in the conquest of the Persian Empire, opening up the Middle East to the Greeks and exposing them to Persian fashions.

330 B.C.E. The last king of Persia of the Archaemenid dynasty, Darius III Codomannus, is deposed and killed, and Alexander claims to be his successor. He begins to adopt Persian dress, which provokes an antagonistic reaction among his Macedonian troops who think that he is deserting the traditions of their homeland.

323 B.C.E. Alexander the Great dies at Babylon. His generals carve kingdoms out of his conquered territory, the capitals of which become leaders in fashion (Pella in the kingdom of Macedonia; Antioch and Seleucia-on-the-Tigris of the Seleucid kingdom, and Alexandria in the Ptolemaic kingdom of Egypt).

205 B.C.E. Publius Scipio the Younger, a rising general in the second war between Rome and Carthage, dons Greek clothing in preference to the Roman toga, thereby setting the style for members of the Roman ruling class who were attracted to Greek fashions.

189 B.C.E. Sometime after this date a luxury fabric called "Attalic" is marketed in Rome. The "Attalic" fabric is gold-embroidered cloth produced in workshops owned by Attalus II, king of Pergamum in Asia Minor, with needlework by Phrygian embroiderers who are famous for their skill in working with gold thread.

80 B.C.E.
–79 B.C.E. Julius Caesar, who will become Rome's most famous general and politician, is noted as being the "boy with loose clothes" by the dictator Sulla because Caesar wore a tunic with fringed wrist-length sleeves under his purple-striped toga and a loosely tied belt.

13 B.C.E. In Rome, the foundation stone is laid for the "Altar of Peace" erected by the

Roman Senate in the Campus Martius (Field of Mars). The south frieze of the altar shows the imperial family—save the emperor Augustus himself—in procession, and is an illustration of the new style of draping the Roman toga in the Augustan period.

37 C.E. –41 C.E. The emperor Gaius Caligula introduces fashions borrowed from oriental monarchies into the imperial court at Rome along with divine kingship.

c. 90 C.E. A portrait is sculpted of an unknown Roman woman, now in the Capitoline Museum in Rome, which shows an elaborate hairdo with the hair swept up high over her forehead in tight curls. The coiffeur is a wig which can be removed from the head and replaced with a wig of another style.

117 C.E. –138 C.E. The Roman emperor Hadrian who ruled during these years prefers Greek style, and is shown wearing a garment that looks very similar to the Greek *himation*, or overcloak.

284 C.E. –305 C.E. The emperor Diocletian institutes changes to the imperial office, and among other reforms, introduces elaborate, bejeweled costume for the imperial court.

324 C.E. The emperor Constantine designs the imperial insignia as a jeweled diadem, that is a cloth band encrusted with pearls tied around the head with a knot at the back and the ends dangling down.

547 C.E. The Church of San Vitale in Ravenna (Italy) with mosaics showing Justinian (emperor 527–565 C.E.) and Theodora (empress 527–548 C.E.) is dedicated. The mosaics give a vivid portrayal of the fashion of the imperial court in the sixth century, at a time when the Byzantine court was placing more emphasis on court ceremonial.

OVERVIEW
of Fashion

THE CLOTHES MAKE THE MAN. In the twenty-first century, fashions in clothing and hairstyles are temporary trends largely influenced by the media and fashion designers. Fashions can change quickly—usually with the introduction of seasonal clothing lines by designers—and make use of a variety of natural and synthetic fabrics. The presence of fashion trends, however, does not negate the reality that fashion can also be a highly individualized expression, with each person deciding on a personal level what clothes to wear. This modern concept of fashion stands in stark contrast to fashion in the world of the Greeks and Romans where there was little change in clothing trends, no fashion designers, and only a few fabrics available for use. Furthermore, clothing functioned as a societal tool to highlight the rigorous social and gender classifications of these ancient societies. One's clothing denoted a particular status in life rather than an expression of individuality; for example, women commonly dressed according to their marital status, with young girls donning outfits which differed from the clothing of married women. Even hairstyles provided tell-tale clues as to whether a woman was married or not, and the scandalous behavior of an adulteress or prostitute earned her an outfit that branded her as surely as Hester Prynne's scarlet letter 'A' in Nathaniel Hawthorne's novel *The Scarlet Letter* in nineteenth-century America. Men were no less exempt from such blatant labels with generals, politicians, soldiers, young boys, and slaves each wearing a distinctive outfit that marked their station.

FABRICS. Wool and linen were the primary fabrics from as far back as the Minoan/Mycenaean period; cotton also existed, though it did not come into common use until the Roman period. Hemp also was used for fabric in Thrace, in modern Bulgaria and north-east Greece, but in the rest of the Greco-Roman world, hemp was valued more for rope than for fabric. Greece had a silk industry of its own based on the island of Cos, which used fibers unravelled from the cocoons of a local moth, the *Pachypassa otus.* Its output was small, however, and probably inferior to silk from China, a luxury fabric that only the wealthy could afford. Greeks and Romans valued silk so highly that they sometimes unraveled silk cloth and re-wove it with linen thread so as to stretch its use. In the sixth century C.E. the Byzantine Empire under the emperor Justinian (527–565 C.E.) acquired silkworm eggs, which were smuggled out of China, and founded its own silk industry. Greeks and Romans also made use of leather and fur. Agamemnon, legendary leader of the Greek coalition in the Trojan War, was said to wear a lion's skin, and his brother Menelaus had a leopard's skin, which presumably would have been an import from Egypt. The vast majority of Greeks and Romans, however, had clothing made of wool and linen.

ATHLETIC APPAREL—OR THE LACK OF IT. In the heat of summer, Greek men probably wore as little as decency permitted, for unlike the civilizations of the Near East, Greek culture seems to have gloried in naked flesh. In gymnasiums, men stripped naked to exercise and wrestle (the very word *gymnos* means "nude" in Greek). In Sparta, a major city in Greece, the women likewise trained in the nude. Nudity had not always been in style; in early Greece, before the seventh century B.C.E., men wore loincloths, but legend has it that the style changed after a runner named Orsippos of Megara won his race at the Olympic Games after pulling off his loincloth in mid-race. Thereafter athletes competed naked at the Olympic Games and the practice spread to the rest of Greece.

STANDARD APPAREL IN GREECE AND ROME. The standard types of garments, both in Greece and Rome, had one characteristic in common: they required a minimum of sewing. While the Greeks' neighbors in Asia Minor, the Phrygians, were famous for their embroidery—particularly fine embroidery with gold thread—the Greeks themselves apparently did not emulate this specialized needlework. The Greek needle was much less refined than the modern needle; in fact, the Greek word for "needle"—*raphis*—is found infrequently in Greek writings, suggesting that needlework played a poor second to weaving among the domestic accomplishments of Greek women. The Greeks and Romans had buttons and ties, and they had safety pins called *peronai* in Greek and *fibulae* in Latin, and these sometimes took the form of elaborate brooches. The two common types of garment in Greece—the *chiton* (tunic) and the *himation* (cloak)—were both rectangular pieces of cloth which were draped over the body. The same was true of the Roman *toga*. The original meaning of the word "toga" seems to have been "coverlet," and in early Rome it was

simply a piece of woolen homespun cloth, worn during the day to keep the wearer warm, and taken off and used as a light blanket at night. The shape of the toga is a matter of dispute; some ancient authors called it a semi-circular piece of cloth, but it was probably closer to a semi-ellipse than a true semi-circle. It was originally a humble peasant dress, but it became the standard costume of a Roman citizen, and a number of variations developed. For instance, one style which the Romans borrowed from the Etruscans, neighbors they conquered in the third century B.C.E., was the short toga, decorated with rich embroidery and dyed purple or a multi-colored combination of purple, white, and scarlet. It was worn by the members of the ancient priestly college in Rome known as the Salii, the leaping priests of Mars, who celebrated the festivals of Mars in March and October with ritual dances. The costume of a Roman priest offering sacrifice to the gods was simply a toga with a cowl that covered the head. (Sacrifices performed *Romano ritu*, in the Roman fashion, required the head to be covered—*capite velato*—whereas those performed *Graeco ritu*, in the Greek fashion, left the head uncovered.) Roman senators and members of municipal councils in the cities of the empire wore togas when they transacted state business, and as long as there were municipal councils in the Roman Empire, there were still occasions when men wore togas. Dress in Rome denoted status. The toga with a broad purple stripe signaled that the wearer was a senator, whereas the narrow purple stripe showed that the wearer belonged to the class below the senatorial class known as the *equites*. This group began as Rome's equestrian order in the early days of the empire, from which came the Roman cavalry, but later it became simply a census group. For a married woman the proper costume was a *stola*—a shawl with which she could cover her head when she went outdoors, where it was improper to be seen with head uncovered. Persons inappropriately dressed would encounter the scorn of society and sometimes even legal penalties.

MILITARY DRESS. Military dress was practical and evolved as fighting styles changed from one-on-one battles to structured military formations. The warrior of ancient Greece, for example, was generally a foot soldier who fought as an individual for his own glory; the horsehair crest he wore on his helmet was a challenge to his enemy. This type of warrior gave way to the *hoplite*, a heavily armed infantryman with helmet, breastplate, greaves (which protected the lower legs), and a triangular metal plate called a *mitra* to protect his groin. The hoplite fought in a battle formation, eight rows deep, and standing foot-to-foot, with their round shields on the left arms and holding their spears in their right hands.

In camp, a hoplite wore a military cloak; the cloaks worn by the Spartan hoplites were red, the color of blood. The Roman soldier was also equipped for battle with helmet, chain mail (later replaced by a breastplate), an army boot called a *caliga* for his feet (hence the childhood nickname of the emperor Gaius, "Caligula" or "little boot"), and a cloak called a *sagum* which left his arms bare. The *sagum* was a practical garment; it was recommended for farm laborers in inclement weather by a Roman writer on agriculture named Columella. The Roman Army had workshops for arms and armor, and sometimes these state-owned and operated factories produced clothing for the troops as well.

ORNAMENTS AND COSMETICS. Although their clothing fashions changed little, the Greeks and Romans had a sense of style. The market for perfumes was lively, and hairstyles differed from place to place. Spartan hoplites wore their hair long and they groomed it carefully. Elsewhere, Greek men wore their hair short after reaching adulthood. After the time of Alexander the Great, who died in 323 B.C.E., Greek men shaved off their beards, and the fashion took hold in Rome in the third century B.C.E. Beards came back into style with the emperor Hadrian (117–135 C.E.). Lucius Verus, who was co-emperor briefly with Marcus Aurelius, was said to have used gold dust to give his beard a fashionable yellow sheen. The hairstyles of Roman women were often elaborate, and dyes were used to get the fashionable blonde color. Wigs hid bald heads or thinning hair, and a wig with hair supplied by a German woman from across the Rhine frontier was a safer way of becoming a blonde than using a strong dye which could damage the hair.

CHANGES IN LATE ANTIQUITY. As the empire moved from a period of invasions, plague, and short-lived emperors in the third century C.E. into the more stable fourth century, fashions, at least in the upper classes, grew more elaborate. By the end of the fourth century, Chinese silk became all the rage among the elite. The imperial court loved jewels, particularly pearls. Clothing marked status. The long embroidered robes of noblemen and noble ladies fitted their station in life, while the middle class was satisfied with costumes only slightly simpler. Priests of the Christian Church were distinguished by their vestments, typically adaptations of Roman garments. The robes of the nobles and the vestments of the priests were a far cry from the costume of the peasant who wore a type of *sagum* or a *cucullus*—a cape with a cowl to protect the head—or the barbarians, who wore trousers. Yet the toga retained its cachet as the correct dress of a *togatus*, or a Roman citizen. Archaeologists have found a sculptor's yard near Rome that was

still producing statues in the fourth century C.E. which were impeccably clad in togas, with sockets to attach the interchangeable portrait heads. The presence of such statues does not mean there was continued widespread use of the toga in this period; the Roman rank and file had long since abandoned the toga for more practical fashions, many borrowed from the so-called barbarian world.

TOPICS
in Fashion

FASHION IN THE MINOAN PERIOD

EVIDENCE. The history of Greek fashion extends all the way back to the Bronze Age to the Minoan culture on the island of Crete off the Greek mainland. Evidence for the clothing worn in Minoan Crete comes mainly from the frescoes that decorated the walls of the palaces, and from Minoan statuettes found on the island. The clothes and fabrics of this time period have long since disintegrated with time, although at the site of Mochlos in northeast Crete, a find of linen has been reported from a tomb dating to the Pre-Palatial Period (3500–1900 B.C.E.). It was probably an import from Egypt, but it does show that linen was known and used on Crete before the Minoan civilization burst upon the stage of history at the start of the second millenium B.C.E. Egypt also provides evidence for Minoan fashion. At Thebes, the capital of Egypt during the Eighteenth Dynasty, wall paintings from five tombs of high-ranking officials dating to the early years of the dynasty show foreigners from the Aegean area bringing tribute to the pharaoh. One of these tombs, dating to the mid-fifteenth century B.C.E. within the Neopalatial or "New Palace" period on Crete (1700–1450 B.C.E.), belonged to Rekhmire, a vizier (high executive officer) of the pharaoh Thutmose III, and in it, these Aegean people are labeled "Princes of the Land of Keftiu," that is, Crete. The artists who did these paintings of the envoys from Crete clearly made an effort to show their costumes accurately.

MEN'S CLOTHING. The basic garment for men was a loincloth tucked around the waist and held in place by a belt or girdle. The styles of loincloth varied with place and time; some styles seem to have been in fashion in particular regions. The loincloth might be worn as a kilt, hanging freely from the waist, or it might be tucked in under the groin, making it into something like a pair of shorts. In fact, by sewing the flaps of the loincloth, front and back, together under the groin, it evolves into a pair of shorts. This is a style found at Mycenae where a bronze dagger has been unearthed portraying a lion hunt on its blade, inlaid in gold. The scene shows men wearing shorts fastened under the groin. Above the waist, men normally wore nothing, as in Egypt. When cooler weather necessitated additional covering for warmth, there were furs and the skins of wild animals which could be worn as cloaks.

KILTS AND CODPIECES. A codpiece is defined as a flap appended to the front of tight breeches worn by men in the fifteenth and sixteenth centuries, but the term serves to describe a feature of men's dress in Minoan Crete. In early representations it is shown as a straight, narrow flap sometimes worn with a belt alone and no loincloth under it. In the Neo-Palatial Period (1700–1450 B.C.E.), it is commonly shown as a wide flap worn over a short, stiff kilt which was slit at the sides to expose the thighs and upturned at the back rather like a duck's tail. After 1500 B.C.E., however, the codpiece apparently went out of fashion to be replaced by long kilts, held up by a girdle or, as time went on, with a wide belt; sometimes a large, beaded tassel replaced the codpiece. The paintings of the "Keftiu" from the tomb of Rekhmire at Egyptian Thebes provide evidence for the change in style. The paintings show Cretans (inhabitants of the island of Crete) wearing long kilts without codpieces, but recent cleanings of these paintings revealed that the costume of the Cretans had been altered not long after the pictures were originally painted. The Cretans as they were originally depicted had short stiff kilts with codpieces. Scholars presume that the Egyptians altered the paintings after they became aware that fashions in Crete had changed to bring the costumes up-to-date.

WOMEN'S CLOTHING. In the Protopalatial Period (1900–1700 B.C.E.), women wore long skirts with girdles circling the waist twice and tied, with their ends hanging down in front. Bodices left the breasts bare and the costumes had collars which rose to a high peak at the back of the neck. In the early Protopalatial period women wore what look like cloaks made from a semi-circular swatch of what was probably woolen cloth, though scholars have suggested it might be leather. A sash was put around the waist and knotted in front. Holes were cut for the arms, the breasts were bare and at the back of the neck was a high collar. As time went on, skirts became more elaborate. In paintings, they are often shown with flounces, and when women appear in court ceremonies, their skirts display intricate woven patterns that required skillful weaving. Minoan women, if they could afford it, clearly gave a great deal of care to

their wardrobes. One feature of the dress of Minoan women from the Neopalatial period (1700–1450 B.C.E.) is an elaborate belt—sometimes padded, sometimes apparently made of metal—which covers the midriff where the bodice joins the skirt. There is also evidence for a patterned apron falling from the belt not only at the front but at the back as well. It looks, in fact, as if it was modeled on the loincloth worn by the men. In the last period of the Minoan civilization on Crete (after 1450 B.C.E.), and also in the Mycenaean civilization on the mainland which was heavily influenced by Minoan style, pictures show women wearing flounced floor-length skirts woven in elaborate patterns, and apparently cut so that the bottom of the skirt dips in the center, both in front and rear. It is not entirely clear if these representations accurately depict the clothing; it has been suggested that the artists who painted women wearing skirts of this sort were merely trying to show divided skirts, or alternatively that this was their way of portraying the movement of long skirts as women walked. There is no doubt, however, that Cretan women who took part in the life in the palaces wore elaborately woven costumes in bright colors—and no doubt they were expensive. Yet only a small percentage of women could have afforded court dress and it is difficult to determine what ordinary women wore since they were not typically the subjects of palace frescoes. There is, however, an ivory seal found at Knossos that shows a girl wearing a jumper hanging loosely without a belt from the shoulders to the knees. The skirt is short, but still appears to have stylish flounces. The seal is under some suspicion as a forgery, but if it is genuine it is evidence for short skirts among the ordinary women of Minoan Crete.

FOOTWEAR AND CAPS. The Minoans went barefoot in religious ceremonies and probably in their private houses, but when footwear was necessary, they had boots and sandals. The Greek word for "sandal" (*sandalon*) is of pre-Greek origin and may go back to Minoan times, before Greek-speakers reached Crete. Boots and sandals are often shown with upturned toes. As for headgear, the common type was a wide, flat cap for men, whereas women, at least in the Proto-Palatial period (before 1700 B.C.E.), are shown with high pointed hats like Phrygian caps which had high peaks folded over so that the peak pointed frontwards. After this period, there is evidence of a great variety of headgear for women, but much of this evidence comes from paintings showing religious ceremonies. It is a matter of conjecture whether women wore similar headgear in secular settings.

JEWELRY. Both men and women wore a variety of jewelry that included armlets, bracelets on the wrists,

Minoan woman or goddess called La Parisienne: fragment of a fresco from palace at Knossos, Crete. In the Heraklion Museum, Crete. © ROGER WOOD/CORBIS.

necklaces, anklets, and a great variety of earrings, using gold, silver, copper, bronze, and semi-precious stones. The jewelers were remarkably skillful. They had the technical expertise to make filigree work which requires hard soldering of small gold or silver wires. They also produced enormously delicate granulated work where minute grains of gold are soldered to a gold or silver backing. They had mastered the technique of inlaying with stones or paste, and making repousse work, where a design is embossed on a thin sheet of metal by pressure from behind, thus producing the design in relief on one side of the sheet and the same design beaten up from the underside on the other. French excavators discovered one of the most remarkable examples of the Minoan jewelers' craft at the tomb at Mallia on the northern coast of Crete and now in the Heraklion Museum. It is a pendant in the form of a bee, designed and executed with great skill.

FABRICS. As in classical Greece, the staple fabric in Minoan Crete was wool. A large portion of the written

Arts and Humanities Through the Eras: Ancient Greece and Rome (1200 B.C.E.–476 C.E.)

85

tablets found at Knossos record flocks of sheep, and they may have been kept for their wool. Minoans also used linen; they probably first imported it from Egypt, but may have produced their own linen at a later time. Mycenaean Greece, which borrowed its style from Minoan Crete, definitely produced linen, for the written texts from Pylos in southwest Greece, dating to about 1200 B.C.E., refer to growing flax in the region. Minoans wove fabric on upright looms of the type used in later Greece, and though no loom has survived—they were made of wood and all have long since rotted away—at one Minoan house at Ayia Varvara on Crete, a stone with two rectangular holes cut into it was found in the women's quarters; archaeologists suspect it may have held the upright posts of a loom. Primitive though these vertical looms seem to be, a look at the clothing of Minoan women shows that they could produce intricate designs.

DYES. Linen is difficult to dye, and so linen garments often were left white. Wool, however, takes pigments well, and vegetable dyes were commonly used to tint it. Minoans almost certainly imported the dried leaves of the henna plant from Egypt to make red dye, and the addition of natron (sodium carbonate)—another product from Egypt—turned the henna dye yellow. Alkanet, a deep red dye made from the roots of a variety of plants, was another way to color fabrics, as was a purple dye made from the shellfish known as the murex; heaps of crushed murex shells have been found at coastal sites on eastern Crete like Palaikastro and are good evidence of purple dye manufacture there in the Proto-Palatial and Neo-Palatial Periods.

PERFUMES. There is good documentary evidence for a perfume industry on Crete and on mainland Greece in the Bronze Age, prior to 1100 B.C.E. The palace at Pylos on the southwest coast of mainland Greece overlooking the Bay of Navarino, which was destroyed by fire suddenly about 1200 B.C.E., has yielded a cache of clay tablets written in "Linear B" script, which is an early form of Greek, and they give details about perfume manufacture carried on under the direction of the palace bureaucracy. "Linear B" is a label given this script by modern archaeologists to distinguish it from "Linear A" which is found on Crete and is not Greek. The Pylos tablets give the names of four perfume makers employed by the palace to make perfume. There is also evidence for perfume manufacture from Knossos on Crete and Mycenae on the mainland. Ancient peoples of this area made perfume by transferring scent to oil, most commonly olive oil. Although olive oil does not take a scent well, the boiling of aromatic leaves and heavy-scented flowers with the oil resulted in an acceptable result for the upper classes in the Minoan and Mycenaean world. It is likely that both men and women made use of perfumes.

SOURCES

Arthur Cotterell, *The Minoan World* (London, England: Michael Joseph, 1979).

Reynold Alleyne Higgins, *Minoan and Mycenaean Art* (London, England: Thames and Hudson, 1997).

Sinclair Hood, *The Minoans: Crete in the Bronze Age* (London, England: Thames and Hudson, 1971).

Bernice Jones, "Revealing Minoan Fashions," *Archaeology* 53 (2000): 36–41.

Cynthia Wright Shelmerdine, *The Perfume Industry of Mycenaean Pylos* (Göteberg, Germany: Paul Äströms Föring, 1985).

GARMENTS IN CLASSICAL GREECE

PROBLEMS WITH TERMS. The terms for Greek clothing types can be confusing, all the more so because the Greeks themselves sometimes used them carelessly. The carelessness is understandable, for every piece of clothing in ancient Greece, whether for men or women, consisted of a rectangle of cloth. The difference was in the size of the cloth and how it was draped over the body. To add to the confusion, Greek styles were adopted by the Romans. Rome's national costume was the toga, but in the third century B.C.E. Rome extended her rule to the Greek cities in what was called "Magna Graecia" (Great Greece) in southern Italy, and the more that the Romans learned of Greek culture, including fashion, the more they were fascinated by it. The Roman Publius Scipio Africanus, who was responsible for the defeat of Hannibal at the Battle of Zama in 202 B.C.E., was among the Roman leaders who adopted Greek fashion over the Roman toga. The confusion arises from the fact that the Romans adapted Greek fashion to their own, so it is not always easy to find exact Greek equivalents for Roman costumes. The toga, too, seems to have started its long history simply as a rectangular piece of cloth—the shape it had when it came off the loom.

DORIANS VERSUS IONIANS. The Dorians were Greeks who migrated into the Peloponnesos—that is, the area of Greece south of the Isthmus of Corinth—after 1150 B.C.E. when the Mycenaean civilization was foundering, and they founded a number of states, notably Sparta in southeast Greece, and Argos to the north of it. The Dorians favored physical fitness and simplicity in their everyday life, and Dorian fashions reflected

it. The Spartans in particular were famous for their austerity. The Dorians liked plain fashions that allowed the body free movement. The Greeks whom the Dorians displaced fled to Athens and from there, they set out for the western coastline of modern Turkey and the offshore islands, where they founded twelve cities which grew and prospered. This was Ionian Greece: twelve cities joined together in a loosely organized league, and though there were more Greek foundations on the coastline of Turkey and the islands than the twelve Ionian cities, it was Ionia that set the style. Ionian fashions reflected the affluent, comfortable, and luxurious life which the Ionians enjoyed, and though the Ionian cities lost their independence by the mid-sixth century B.C.E., they continued to thrive. The types of costume worn by both the Dorians and the Ionians were the same, but whereas the Dorians preferred simple styling and lack of embellishment, the Ionians favored more elaborate fashions and fine fabrics. In the fifth century B.C.E., however, the Ionian cities fell under the domination of Athens and they lost their preeminence as style setters.

GREEK CLOTHING TERMS. The basic item of clothing was the *chiton*, which was a tunic. If it was short, it might be called a *chitoniskos*, which means a "little tunic," and if it lacked sleeves, which was generally the case, it was called an *exomis*, which means a "sleeveless garment." There were some tunics with sleeves, which Romans with a conservative mindset considered a mark of oriental luxury, though in fact, Rome's greatest general and politician, Julius Caesar, wore one. The variety of terms becomes more confusing with the Dorian *chiton* which is, in fact, a *peplos* (a simple rectangle of cloth folded and hung from the shoulders). The epic poem *Iliad*, written by the Greek poet Homer, described the heroes who fought at Troy as wearing a cloak over the tunic which was called a *chlaina*, or sometimes a *pharos*; strictly speaking, they were not quite the same, for the *pharos* was a larger garment. In fact, Homer used the word *pharos* for any large piece of cloth, including a ship's sail or a funeral shroud. The *chlaina* seems to have been a general term for any heavy woolen cloak worn in cold weather. In the classical period, the word usually refers to the cloak called the *himation*, an outer garment worn by both men and women. The Romans used the Latin word *pallium* for *himation*, and regarded it as a peculiarly Greek costume, to such a degree that comedies staged in Roman theaters that were adapted from Greek plays were called *fabulae palliatae*—scenarios played in Greek dress. Another popular cloak was the *chlamys*. It was an oblong swatch of cloth that made almost a perfect square when it was doubled. The *peplos*, also called

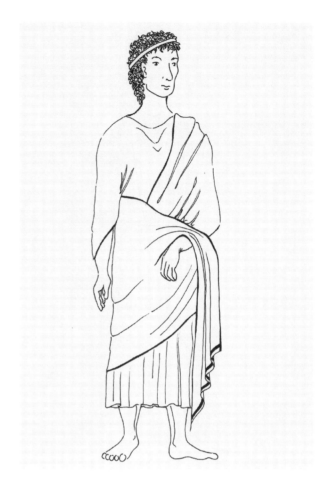

A man wearing a pallium. **CREATED BY CECILY EVANS. THE GALE GROUP.**

the Dorian *chiton*, was a rectangle of cloth folded over at the top and then doubled and draped over the body, and held in place with safety pins or brooches at the shoulders. The overfold or *apotygma* at the top of the garment could hang down as far as the waist. It was probably the earliest Greek dress for women, and it was capable of many variations.

THE CHITON. The Greek word *chiton* translates as *tunica* in Latin, from which the English word "tunic" is derived. It was a shirt worn directly over the body, sometimes as an undergarment. There is evidence of prototypes in the Minoan period, but it is in the sub-Mycenaean period (after 1200 B.C.E.), about the same time as the *perone* or safety pin appears in Greece, that men began wearing a short, sleeveless tunic recognizable as the *chiton* worn by the warriors in Homer's *Iliad*. The word *chiton* has Eastern origins, for it is related to a Semitic word that refers to linen cloth; this evidence suggests that the earliest chitons were linen garments, though later they are often woolen. Chitons

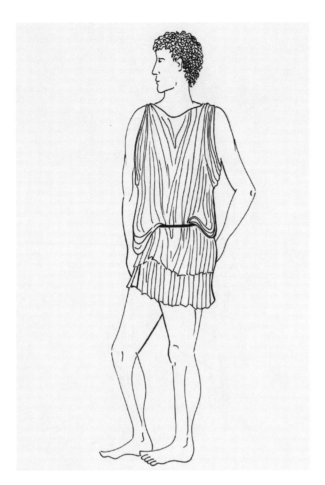

Man wearing a short chiton. **CREATED BY CECILY EVANS. THE GALE GROUP.**

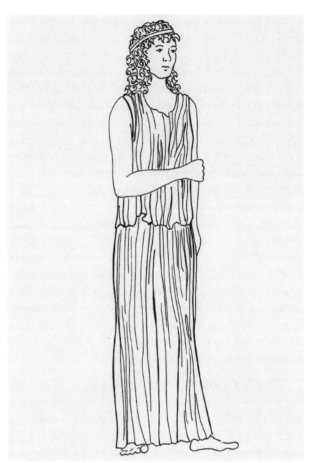

Woman wearing a long chiton. **CREATED BY CECILY EVANS. THE GALE GROUP.**

came in a great variety of styles. Young men and those regularly involved in physical activity preferred a short chiton which left the legs bare. If the skirt of the chiton was too long, the wearer pulled it up and let it hang over his belt in a fold known as a *kolpos*. A warrior wore a chiton as an undergarment beneath the cuirass (a piece of armor that protected his torso). A passage in *Iliad* illustrates the use of a chiton in a description of how the warrior goddess Athena put on her armor: first she took off her *peplos*, which was a woman's dress, and pulled on a chiton as an undergarment between her cuirass and her skin. Those individuals who are not as active, such as older men, men of high rank, and professional musicians, might wear a chiton long, reaching to the ankles, and over it they would wear a cloak such as the *chlaina* or the *pharos*. Both the short and the long chiton were prevalent all over the ancient Greek world.

THE IONIAN CHITON. About 600 B.C.E., the end of what art historians call the "Early Archaic Period," draped statues of women wearing chitons that reach the feet, leaving only the toes bare, began to appear. There are good early examples from Ionia, where several seated statues have been found lining the Sacred Way to the temple of Apollo at Didyma. The so-called *kore*-statues of young girls (in Greek: *korai*) found in Athens in the debris from the Persian sack of the Acropolis in 480 B.C.E. also provide models of the chitons worn by women in the Middle and Late Archaic periods. Made of fine linen, they fell in regular folds to the feet, and over them a woman would wear a shawl or a cloak like the *himation* or the *chlaina*. The evidence of the sculpture suggests that the Ionian chiton came into style in Athens about 600 B.C.E., replacing the *peplos* or Dorian chiton, as it was sometimes called. The historian Herodotus, writing in the second half of the fifth century B.C.E., explained the replacement of the peplos in Athens as the result of a violent incident, the accuracy of which cannot be verified. According to Herodotus, in the early seventh century B.C.E. the Athenians made an attack on the island of Aegina in the Saronic Gulf. It failed, and only one survivor of the Athenian expeditionary force re-

a PRIMARY SOURCE *document*

THE ADOPTION OF THE IONIAN CHITON

INTRODUCTION: Towards the end of the seventh century B.C.E. the ornate Ionian *chiton* came into fashion among Athenian women. Unlike the *peplos* or Dorian *chiton*, as it was sometimes called, the Ionian *chiton* did not need safety pins. According to Athenian tradition, the fashion changed following a gruesome incident involving the lone survivor of a disastrous Athenian military expedition against Athens' bitter rival, Aegina. When the man returned to Athens with the bad news, the widows of the lost soldiers killed him with the weapons most readily accessible to them: the pins in their clothing. Thereafter, the fashion for Athenian women changed to a style that did not require pins. The incident was reported by the historian Herodotus writing in the second half of the fifth century B.C.E.

The Argives and Aeginetans agree in this account, and the Athenians, too, admit that only one of their men returned to Attica alive: the only point of dispute is the occasion of his escape, the Argives saying that he got away after they had destroyed the rest of the Athenian force, the Athenians claiming that the whole thing was an act of God. Even the sole survivor soon came to a bad end; for when he reached Athens with a report of the disaster, the wives of the other men who had gone with him turned to Aegina, in grief and anger that he alone should have escaped, crowded round him and thrust the brooches, which they used for fastening their dresses, into his flesh, each one, as she struck, asking him where her husband was. So he perished, and the Athenians were more horrified at his fate than at the defeat of their troops in Aegina. The only way they could punish their women for the dreadful thing they had done was to make them adopt Ionian dress; previously Athenian women had worn Dorian dress, very similar to the fashion in Corinth; now they were made to change to linen tunics to prevent them from wearing brooches. Actually this kind of dress is not originally Ionian, but Carian, for in ancient times all the women in Greece wore the costume now known as Dorian. But the Argives and Aeginetans passed a law that in both their countries brooch-pins should be made half as long again as they used to be, and that brooches should be the principal things offered by women in the shrines of these two deities; also, nothing from Attica was to be taken to the temple, not even pottery, and thenceforward only drinking vessels made in the country should be used. From that time to the present day the women of Argos and Aegina have worn brooches with longer pins than in the past—all because of the quarrel with Athens.

SOURCE: Herodotus, *Histories.* Rev. ed. Trans. Aubrey de Sélincourt (London: Penguin Books, 1972): 309–310.

turned to Athens. Upon his return, the widows of the men lost at Aegina mobbed him and stabbed him with the safety pins from their Dorian chitons in grief and anger that he alone should have survived. The Athenians were so shocked by this murder that they passed a law forbidding women to wear the Dorian chitons which were fastened at the shoulders with safety pins, and instead ruled that they should wear the Ionian chiton, which was sewn and did not use the safety pins that could become lethal weapons. The Aeginetans continued to use safety pins, however, as did the Argives who had helped the Aeginetans defeat the Athenians; in fact, Herodotus claimed that they adopted safety pins with even longer shafts which were more lethal.

REACTION AGAINST DORIAN DRESS. Even if the incident really happened, it was probably not a singular event that prompted the change to Ionian style for women's clothing. The Aeginetans and the Argives were both Dorians, speaking the Dorian dialect of Greek, whereas the Athenians were Ionians and by adopting the fashions of the Ionian Greeks in Asia Minor whose cities were flourishing at this time, the women were making a political statement. Later, when Ionia was conquered by Persia after 546 B.C.E., the Athenians tended to look down on the Ionians because they were no longer free men and their sumptuous fashions seemed to signal a willingness to be subjects of the Persian king; in the Greek mind, anything Persian was associated with luxury and opulent living. But at the beginning of the seventh century B.C.E., Ionia was the cultural leader of Greece. Men in Athens wore Ionian chitons as well, and Thucydides, a younger contemporary of Herodotus, remarks that the older Athenians of his day still wore them. But the Persian Wars in the first quarter of the fifth century B.C.E. ushered in a taste for simpler fashions in Athens; in Dorian Greece, the Dorian chiton had never gone out of style. In the new postwar world, the elaborate Ionian chiton was considered a mark of oriental luxury and soft living. It suggested the Persian way of life.

FASHIONS IN CHITONS. The *peplos* came into style again in Athens after the Persian Wars, but it did not displace the chiton. In fact, chiton and peplos existed side by side throughout the fifth century B.C.E., borrowing features from each other. The *kandys*, a chiton

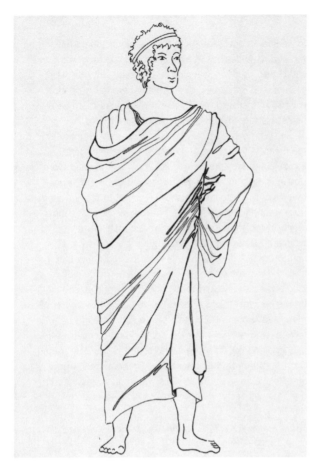

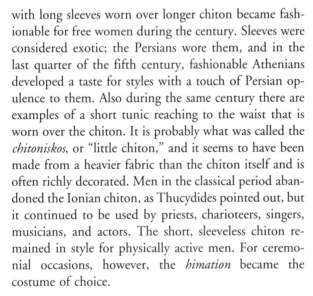

Man wearing a himation. CREATED BY CECILY EVANS. THE GALE GROUP.

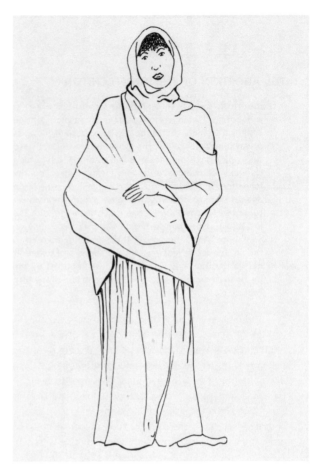

Woman wearing a himation. CREATED BY CECILY EVANS. THE GALE GROUP.

with long sleeves worn over longer chiton became fashionable for free women during the century. Sleeves were considered exotic; the Persians wore them, and in the last quarter of the fifth century, fashionable Athenians developed a taste for styles with a touch of Persian opulence to them. Also during the same century there are examples of a short tunic reaching to the waist that is worn over the chiton. It is probably what was called the *chitoniskos*, or "little chiton," and it seems to have been made from a heavier fabric than the chiton itself and is often richly decorated. Men in the classical period abandoned the Ionian chiton, as Thucydides pointed out, but it continued to be used by priests, charioteers, singers, musicians, and actors. The short, sleeveless chiton remained in style for physically active men. For ceremonial occasions, however, the *himation* became the costume of choice.

THE HIMATION. The *himation* was an essential outer garment for both women and men. It was simply an oblong woolen shawl of generous dimensions. There were various ways of draping it around the body. A

woman, for instance, might drape it under the right arm and pin or tie it at the left shoulder. In colder weather she could drape her upper body with it and draw it over the head like a cowl. Sometimes, however, she used a separate piece of cloth to cover her head, with one end falling down over the *himation*. A man threw his *himation* around his body from left to right, confining his arms; in fact, it was the mark of a gentleman not to extend an arm outside his himation. Wearing one's himation with grace was a mark of social standing in the community and it cannot always have been an easy achievement, for the himation was generally worn without fasteners like buttons or safety pins, and the wearer must have sometimes used his hands that were hidden by his himation to hold it in place. It was far too awkward a garment for a working man, who generally wore a chiton without sleeves called an *exomis*. In fact, wearing a himation signaled that the wearer did not have to do physical labor. Politicians and philosophers liked it, and in portrait sculpture, it had some of the same connotations as the Roman toga, which it somewhat re-

sembled. It showed that the wearer was not a member of the common people, and it was a fine garment to wear when delivering a lecture or a public speech.

THE PEPLOS. The peplos was a woman's costume consisting of an oblong swatch of woolen cloth. The cloth was first folded horizontally so that the top quarter was turned back, and then it was doubled by folding it from top to bottom. What resulted was a piece of cloth doubled over to form a square, with an overfold called an *apotygma* in Greek on the upper edge. It sheathed the body of the wearer, and was fastened at each shoulder by safety pins or buttons so that it hung free. On the right side, the peplos hung open, and one might catch glimpses of the woman's body as she moved. Young women in the Greek city of Sparta liked this style, but women elsewhere usually wore a belt or girdle at the waist to keep the side of the peplos closed and thereby preserve the wearer's modesty. The open side of the peplos might also be pinned together; in Homer's *Odyssey*, one of the suitors trying to win the favor of Penelope, Odysseus' wife, presented her with a peplos that had twelve gold pins. Since it needed only two pins, or at best four, to fasten it at the shoulders, presumably the rest were used to pin up the open side.

THE ORIGIN OF THE PEPLOS. The peplos was not a Mycenaean costume, and probably it arrived in Greece about the same time as the safety pin—that is, in the sub-Mycenaean period (after 1200 B.C.E.), after the citadels of the Mycenaean civilization had fallen and the great palaces destroyed. The Dorian newcomers may have brought the peplos with them, for they migrated into Greece in the sub-Mycenaean period, and so the name "Dorian chiton" which was sometimes applied to the peplos, may be justified. It was, however, worn in early Athens also until the end of the Early Archaic Period, about 600 B.C.E., when women switched to the Ionian chiton. With the reaction in Athens against frills and frippery after the Persian War, the peplos came back into fashion. In Sparta and the rest of Dorian Greece, the Ionian chiton never displaced the peplos. As the Greek language evolved, the word "peplos" acquired a wider meaning and applied to a variety of costumes. There was, however, one instance where the word "peplos" continued to mean a simple, old-fashioned piece of woolen cloth folded to form a woman's dress. Every four years, at the Great Panathenaea festival in Athens, the women of the city presented the goddess Athena with a new robe that they had woven. They used it to dress the ancient wooden statue of Athena *Polias*—that is, Athena, Guardian of the City—the most sacred cult statue in Athens, which was kept in the temple known

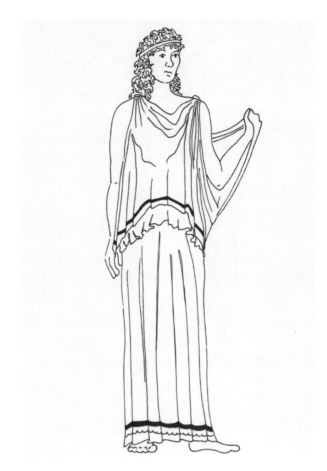

Woman wearing a peplos. CREATED BY CECILY EVANS. THE GALE GROUP.

as the Erechtheion. The robe was a peplos and the pattern did not change.

PEPLOS TYPES. Styles change with time and the peplos was no exception. From the classical period of the fifth century B.C.E. on, we must distinguish between the peplos worn without an undergarment, known as the *peplos endyma*, and the peplos worn over a chiton, the *peplos epiblema*. The girdle in early examples of the peplos simply encircled the waist, but with the skirt above it tucked up so as to form a loose fold. The *apotygma*, or overfold, which at first was short, grew in length until it reached the hips. In statues and relief sculptures of the fourth century B.C.E., the overfold is sometimes shown falling freely, but more often as time went on it was held in place by the girdle. The *peplos epiblema* that was worn over a chiton developed a number of variations. Sometimes the skirt came down to the ankles and only a glimpse of the chiton underneath can be seen at the bottom. Sometimes the peplos came down no further than the knees, and the chiton was shown covering the lower legs. Some

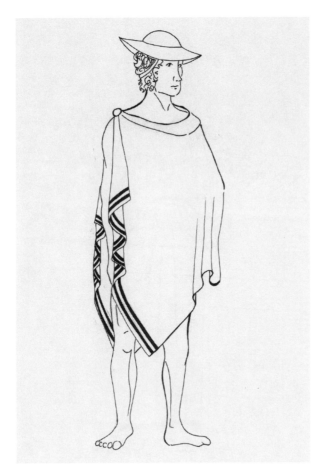

A man wearing a chlamys and on his head, the hat known as a causia. CREATED BY CECILY EVANS. THE GALE GROUP.

statuettes of Athena show her wearing a peplos with an overfold that has pleats of unequal length, and sometimes the peplos is shown pinned only at the right shoulder with the overfold pinned along the right arm to form a kind of short sleeve. It is hard to distinguish this kind of peplos from the Ionian himation. In fact, the Greek authors themselves used the terms for their clothes more indiscriminately as we move into the fourth century B.C.E.

THE CHLAMYS. The *chlamys* was a garment of non-Greek people in northern Greece, the Thessalians and the Macedonians. In fact, the chlamys, along with the *petasos* or *causia* (a hat with a brim), was the national costume of Macedonia. The distinctive items of costume worn by foreigners from the north when they are depicted on Greek monuments were the chlamys, the causia, the *alopekis* (a fox-skin cap), and the *embades* (boots that came part way up the calf of the leg). A Macedonian nobleman signaled his standing by wearing a purple chlamys and causia, and Alexander the Great, the king of Macedon who conquered the Persian Empire, made the

chlamys his customary dress. The chlamys was a swatch of cloth that was more or less rectangular with three straight sides and the fourth side concave. It was worn by putting it around the shoulders, straight edge up, and fastening it at the base of the neck, so that its folds fell down as far as the knees. The chlamys might also be fastened at the rear, leaving the wearer's back and buttocks bare. The two ends of the concave side formed points hanging down on either side, and were often compared to wings. Upon its introduction into Greece, it became the usual costume for horsemen. It appears on the Panathenaic frieze from the Parthenon in Athens, where young *ephebes* (youths undergoing their military training) are shown wearing it as they gallop in the wake of the procession or prepare to mount their horses. In the Greek city of Sparta, the chlamys became the costume of choice for the Spartiates, the military elite that ruled Laconia. It was not adopted by the Romans, but the Romans had a number of military cloaks which were similar, such as the *paludamentum*, the *abolla*, and the *sagum*. The *trabea* worn by the members of the equestrian order in Rome when they paraded on horseback in honor of Castor and Pollux seems to have been a similar garment. The chlamys, however, lasted into the Byzantine period. In the Church of San Vitale in Ravenna (Italy) there is a mosaic of the empress Theodora (527–548 C.E.) who is shown wearing a chlamys as part of her imperial regalia.

SOURCES

Ephraim David, "Dress in Spartan Society," *Ancient World* 19 (1989): 3–13.

Evelyn B. Harrison, "The Dress of the Archaic Greek *Korai*," in *New Perspectives in Early Greek Art.* Ed. Diana Buitron-Oliver (Washington, D.C: National Gallery of Art, 1991): 217–239.

Rolf Hurschmann, "Chlamys," in *Der Neue Pauly* (Stuttgart/Weimar, Germany: J. B. Metzler, 1997): 1133.

———, "Chiton," in *Der Neue Pauly* (Stuttgart/Weimar, Germany: J. B. Metzler, 1997): 1131–1132.

Marion Sichel, *Costume of the Classical World* (London, England: Batsford, 1980).

David J. Symons, *Costume of Ancient Greece* (London, England: Batsford, 1987).

SEE ALSO *Architecture: Greek Architecture*

THE TOGA

NATIONAL COSTUME OF ROME. The toga was the national costume of the Romans. The Roman people

were the *gens togata*—the "people that wear the toga." In his epic poem, the *Aeneid* the Roman poet Vergil used the term with pride to refer to the *populus Romanus*, that is, the "Roman People." Aliens—persons who were not Roman citizens—and Roman exiles were forbidden to wear it. It seems, however, that the law which forbade non-Romans to wear the toga was not universally enforced, for the provinces of Cisalpine Gaul and Transalpine Gaul were called, unofficially, *Gallia togata*—that is, "Gaul where the toga is worn"—which indicates that Romanized provincials sometimes wore the toga even before they received the citizenship. There was a tradition that the toga came to Rome from Etruria, the region of modern Tuscany in Italy which was inhabited by people the Romans called Etruscans and the Greeks *Tyrrhenoi*, who seem to have been immigrants from Asia Minor around 1000 B.C.E. Their underground tombs were decorated with wall paintings which show men wearing a short toga, though it is by no means the same as the Roman version of the same garment. The Roman toga probably began as a simple piece of woolen cloth which was worn with no undergarment and fastened in place with a safety pin, called in Latin a *fibula*. The name comes from the Latin verb, *tegere*, which means "to cover." The toga was a coverlet, used to cover a person's body by day and his or her bed at night. In the early period, women wore it as well as men. The Roman men even wore it to battle in the early days of Rome.

THE CINCTUS GABINUS. In some rituals which were connected with warfare—such as opening the Gates of Janus, which the Romans threw open whenever they embarked on a war—they girded up their togas in what was called the *cinctus Gabinus*. They took the corners of their togas, threw them over the left shoulder, wound it under the right arm and around the chest, thus making their togas into garments that did not impede their movement. The origin of this curious custom was explained by the story of the ancient enmity between Rome and the town of Gabii, which dated back to the time before the last Roman king was expelled in 510 B.C.E. The Romans used the *cinctus Gabinus* when they fought Gabii. The 193 centuries, or battalions, of the early Roman citizen army were divided into five classes according to wealth, and only the first class could afford full body armor. A Roman in the lowest class in those far-off days tied up his toga around his waist so that his arms were free to wield a weapon, and went into battle to fight as best he could. His toga gave him little protection, but it was better than nothing.

DEVELOPMENT. Gradually, the toga grew more elaborate, and its usage became more restricted. Women

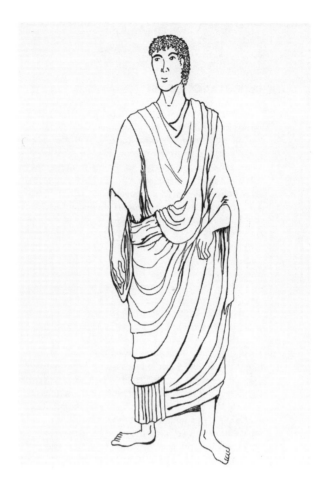

The toga of the type worn in the early first century C.E. **CREATED BY CECILY EVANS. THE GALE GROUP.**

replaced it with the *stola*, a long upper garment which became the conventional dress of a married woman. Soldiers gave it up for a more convenient cloak called the *sagum*. Even so, right up to the end of the republican period in the first century B.C.E. and even into the imperial period that followed it, togas were sometimes issued to Roman armies in winter camp. By that time, however, the toga had lost its military role and became a costume of peacetime and a symbol of citizenship. In Rome, a citizen was expected to wear his toga in public. The emperor Augustus (ruled 27 B.C.E.–14 C.E.) forbade citizens entry to the Roman Forum or to the circus if they were without togas. Outside, Rome, however, citizens quickly adopted foreign costumes which could be put on and taken off easily; the toga as it developed became so elaborate that a Roman needed help to put it on. Even in Rome itself, Greek fashions became increasingly popular in the first century C.E., and the toga was reserved more and more for official functions. Women abandoned it early, except for women who were courtesans or were found guilty of adultery. The *stola*

a PRIMARY SOURCE *document*

THE IMPORTANCE OF THE TOGA

INTRODUCTION: The toga was the national dress of the Roman citizen. In fact, Romans were sometimes called simply the "togati" (the "men who wear togas"), and when dramas about Roman citizens were produced in the theater, they were called *fabulae togatae*, as distinct from dramas involving Greek characters which were called *fabulae palliatae*. Roman senators wore togas when they transacted public business, as did the members of the municipal councils of other cities in the Roman Empire even in the fourth and fifth centuries C.E. The following passage from the Roman history of Livy, who lived in the reign of the emperor Augustus, illustrates the importance of wearing the toga to conduct public business. In 458 B.C.E., the Roman republic faced possible disaster. Rome's enemies, the Aequi, had cut off a consular army led by one of the consuls, Lucius Minucius. In this crisis, the Roman senate decided to appoint Lucius Quinctius Cincinnatus as dictator; the dictatorship in Rome was a six-month appointment that was made only in an emergency when the state was under threat and a strong leader was needed. Cincinnatus had a small farm across the Tiber from Rome, and he was working on his land when a deputation from the senate came to invite him to Rome. Prior to delivering the senate's invitation, the deputation asked Cincinnatus to put on his toga. Cincinnatus accepted the dictatorship, defeated the Aequi and, the crisis over, laid down the office after holding it for only fifteen days. Here Livy described the meeting of the deputation from the senate and Cincinnatus.

Now I would solicit the particular attention of those numerous people who imagine that money is everything in this world, and that rank and ability are inseparable from wealth: let them observe that Cincinnatus, the one man in whom Rome placed all her hope of survival, was at that moment working a little three-acre farm (now known as the Quinctian meadows) west of the Tiber, just opposite the spot where the shipyards are today. A mission from the city found him at work on the land—digging a ditch, maybe, or ploughing. Greetings were exchanged, and he was asked—with a prayer for God's blessing on himself and his country—to put on his toga and hear the Senate's instructions. This naturally surprised him, and asking if all were well, he told his wife Racilia to run to their cottage and fetch his toga. The toga was brought, and wiping the grimy sweat from his hands and face, he put it on; at once the envoys from the city saluted him, with congratulations, as Dictator, invited him to enter Rome, and informed him of the terrible danger of Minucius' army. A state vessel was waiting for him on the river, and on the city bank he was welcomed by his three sons who had come to meet him, then by other kinsmen and friends, and finally by nearly the whole body of senators.

SOURCE: Livy, *The Early History of Rome*. Trans. Aubrey de Sélincourt (Harmondsworth, England: Penguin Books, 1960): 213.

which married women wore was denied to them, for it was the mark of the respectable Roman *matrona*—a woman who was properly married.

RITE OF PASSAGE. In many cultures, a young man's transition from boyhood to manhood is marked by what is called a "rite of passage." In Rome, the rite of passage involved changing from the toga of adolescence to the toga of a man. A Roman youth of free birth wore the *toga praetexta*, a toga with a band of purple woven along the edge of the garment. Under it, he wore a tunic which had two purple woven stripes which extended from his shoulders to the hemline, and around his neck he wore a locket called a *bulla* which might be made of gold, silver, bronze, or even leather. When the youth came of age, he exchanged the *toga praetexta* for the *toga virilis*, the man's toga, which was all white, the natural color of the wool. In the early days of Rome, well down into the second century B.C.E., a youth gave up the *toga praetexta* at age sixteen. Later, the ceremony often took place at the end of the youth's fifteenth year. There were exceptions: the emperor Tiberius would not allow the future

emperor Caligula to assume the *toga virilis* until his twentieth year, and the future emperor Nero assumed it at age fourteen. The *toga praetexta* was also worn by important state officials, and the fact that children wore it as well was perhaps a recognition of the vulnerability and, at the same time, the importance of childhood. Children were as important to the future of the state as the men who held prestigious magistracies. The ceremony in which a young man gave up the *toga praetexta* usually took place during the festival of Bacchus known as the *Liberalia* on 16 March. The night before, the boy took off his *toga praetexta* and put on a white tunic to sleep in; this tunic was known as the *tunica recta* (the "straight tunic"), so-called because it was woven on the old-fashioned upright loom. The ceremony started the next morning with a sacrifice offered to the *Lares*, the household gods of the family. The boy dedicated his *toga praetexta* to the *Lares* and along with it, his *bulla*, the locket containing the amulet or charm which he wore around his neck as a boy to ward off evil influences and protect him in the vulnerable years of childhood. It was

rather like a modern good luck charm except that Roman society really did believe in the "Evil Eye" and assorted malign influences so hex signs to ward them off were more significant than good luck charms are in modern times. It also marked the wearer as the child of a freeborn Roman citizen. The young man then put on his new toga. It was the *toga pura*, which did not mean that it was "pure," but rather that it was not dyed, i.e. it was the natural color of the wool. This was the "toga of a man," the so-called *toga virile*. It signified that he was now an adult male. His family and friends escorted him in his new *toga virile* to the forum where they presented him to the Roman people, the *populus Romanus*, who would henceforth regard him as one of their members. The young man then went to the Capitoline Hill, and in the Temple of Jupiter he offered sacrifice to the gods of the state, the divine triad Jupiter, Juno, and Minerva. He was not yet of an age to begin a public career, but old enough to take an interest in public affairs and learn from his elders how to conduct the business of the state. He had crossed the divide between vulnerable youth and manhood.

TOGAS FOR GIRLS. Girls also wore the *toga praetexta*, but they gave it up at age twelve upon reaching puberty. From then on until marriage, girls wore a *palla*, or mantle. A girl over twelve is shown wearing a *palla* on the south relief of the "Altar of Peace" in Rome which the Roman senate commissioned in 13 B.C.E.; it can still be seen reconstructed in modern Rome, on the bank of the Tiber River. Unlike the toga, it was a rectangular swatch of cloth, but on the "Altar of Peace" it is shown folded over the girl's body in a manner so similar to a toga that it might be mistaken for one, except that its squared lower border gives it away.

THE SHAPE OF THE TOGA. The toga was simply a piece of cloth that was folded and wrapped around the body. In the early days of Rome, when the cloth was a piece of woolen homespun, it probably kept the shape that it had when it came off the loom: rectangular. The evidence from ancient authors, scanty though it is, indicates that the toga was a semi-circular piece of cloth with one straight edge, and when a purple stripe was woven along the edge—a wide one (*latus clavus*) for senators and a narrow one (*angustus clavus*) for members of the equestrian class—it could have been woven only along the straight edge. There have been many modern attempts to reproduce the sort of toga of the monuments and it seems likely that it was not a piece of cloth that was a true semi-circle, but rather that it was half an ellipse with one straight edge that was broad enough to allow the purple stripes to be woven parallel to it. Conservative though

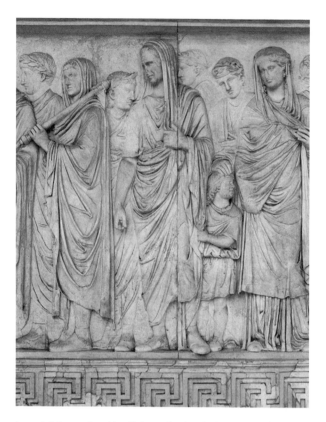

Imperial Procession (detail from the Ara Pacis Augustae), showing members of the imperial family in procession at the dedication of this altar which commemorates the pacification of Spain and Gaul by Emperor Augustus, begun 13, dedicated 9 B.C.E. © ARALDO DE LUCA/CORBIS. REPRODUCED BY PERMISSION.

the Romans were, the toga styles changed over time; the toga of the late empire bore a general resemblance to the toga of the Roman republic, but it was not the same garment. Yet stone-cutters in the late empire turned out toga-clad figures for official statues of emperors and public officials which were erected across the empire.

HOW THE TOGA WAS WORN. The toga of republican Rome, in its simplest form, was thrown over the left shoulder, drawn across the back and under the right arm and then thrown back again over the left shoulder so that there was an oblique fold across the chest. The right shoulder and arm were left unencumbered, but not bare, for a man would wear a tunic under his toga. There is a statue in the Archeological Museum in Florence, Italy, known as *Il Arringatore* (The Orator) which shows the kind of toga that might have been worn in the second century or the beginning of the first century B.C.E. The skirt does not reach the feet, and along its lower edge there is what seems to be a row of embroidery. The toga that Roman politicians Cicero or Julius Caesar might have worn in the last days of the Roman Republic,

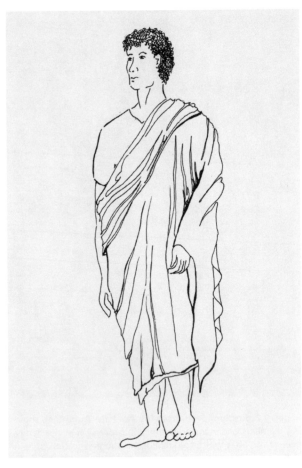

Man wearing short republican toga, c. 100 B.C.E. CREATED BY CE-CILY EVANS. THE GALE GROUP.

THE LACERNA. Since the toga gave poor protection against inclement weather, the Romans adopted a hoodless woolen outer cloak which was popular in the army: the *lacerna*. It was worn over the toga and was open at the side, leaving the arms free. The Romans fastened it with a brooch or buckle on the right shoulder so it could be tossed back over the shoulder. It was dark colored when it was used as a military cape, but when it was adopted as civilian dress, it was often made of bright colors and lighter cloth, particularly for upper-class men and women. In cold weather, the spectators in the amphitheater or theater who were wearing togas needed their *lacernae* to keep warm.

TYPES OF TOGA. Togas were made of wool—a light woolen fabric for summer and a heavier one for winter wear. Unless they were dyed, they remained the natural color of the wool, which was off-white, though given the absence of good laundry facilities, many of the togas worn in Rome must have been a rather dirty grey. It was important for a citizen who presented himself as a candidate for office to have a pure-white toga, and he would use chalk to give his toga the requisite color—hence, the Latin word for "candidate" (*candidatus*) came from the word for "white" (*candidus*). The *toga praetexta* worn by children and by state officials had a purple border. So did the togas worn by senators and men of the equestrian order. Senators had a wide purple border (the *latus clavis* or "laticlave") to mark their status, whereas men of the equestrian order, the so-called *equites* or "horsemen" whose minimum income requirement was less than half a senator's, had a narrow stripe. The *equites* by the second century B.C.E. were men of property who stayed away from a career in politics; they included in their ranks businessmen and tax farmers—that is, private entrepreneurs who contracted with the government to collect taxes. A variety of toga with stripes known as the *trabea* was worn by the *Flamen Dialis* and the *Flamen Martialis*, the high priests of Jupiter and of Mars, and also by the augurs, the priestly officials who took the auspices, but it is unclear how the stripes were arranged. A toga called the *trabea* was also worn by men of the equestrian order who paraded on horseback in the festival of Castor and Pollux (Rome's legendary founders) to commemorate the semi-mythical Battle of Lake Regillus. Their trabea, however, seems to have been a short mantle like the Greek chlamys. It was the distinctive costume of the equites, for when Roman theaters staged comedies where the characters were citizens of the equestrian order, they were known as *comoediae trabeatae*—comedies where the actors are costumed in *trabeae*. Dark-colored togas were worn as a sign of mourning. This type of toga was known as the *toga*

however, covered both shoulders. Under the Roman emperors, togas became elaborate with folds carefully arranged. The toga of the imperial period had two added features: an overfold of cloth called a *sinus* that ran diagonally across the chest, and a clump of drapery called an *umbo* that was a sort of decorative knot made by pulling up the folds on the left side in order to hold the drapery together. Apparel this elaborate cannot have been easy to put on or take off. The proper arrangement of the folds of the toga was a mark of elegance, and there were slaves trained to do the task, called *vestiplici* if they were male slaves, or *vestiplicae* if they were women. If a Roman magistrate was to officiate at a ceremony in imperial Rome where a toga must be worn, his slaves might have to sit up the night before to prepare the pleats and folds by squeezing them with tongs. The *sinus* in particular needed care, for in some portrayals of toga-clad figures it hangs loosely but elegantly across the chest and almost touches the ground. The toga which began as a practical piece of clothing ended up as an elaborate ceremonial costume.

...

pulla: the "dark-colored toga." A *pullum* was a garment dyed dark-grey. A toga known as the *toga picta*, or *trabea triumphalis*, was decorated with patterns and must have taken great skill to weave; it was worn in the period of the Roman Republic by generals returning from a victorious campaign who were granted the right of holding a triumph. The triumphant general paraded his spoils and captives through the streets of Rome, and finally made his way along the Sacred Road (*Via Sacra*) through the Roman Forum to the temple of Jupiter on the Capitoline Hill. In the rear of the procession came the general himself in a chariot, wearing a *toga picta*. The general did not actually own this toga, for these togas were kept among the treasures of Jupiter, and brought out only on special occasions. Under the Roman Empire, however, triumphs were reserved for the emperor, and the first emperor, Augustus, made the *toga picta* his official costume.

THE END OF THE TOGA. Juvenal, the Roman satirist who probably wrote in the first quarter of the second century C.E., wrote in his third satire that throughout most of Italy no man was seen in a toga until the day he died, when he was laid out in one. When shows were staged in the country theaters on holidays, everyone, magistrates included, wore a plain white tunic. Yet the toga remained the proper ceremonial garment until the fourth century C.E. as evidenced by developments from Roman sculpture. A relief sculpture of Marcus Aurelius, emperor from 161–180 C.E., which was re-used on the Arch of Constantine in Rome, shows a figure wearing a short toga which comes only to the knees; another panel of the same emperor, now in the Conservatori Museum in Rome, shows a person with a similar short toga, who is playing the reed pipe known as the *aulos*. It has been suggested that this short toga was the toga of the Roman common man, but the absence of such figures in art makes it difficult to come to a conclusion. Marcus Aurelius' predecessor, Hadrian, appears in one statue wearing a toga that resembled a Greek *himation*. Hadrian was a lover of Greek culture, which may account for his toga in the Greek style, but the fashion did not endure for long. In the third century C.E. a new style developed with a broad fold running from under the right arm across the chest and over the left shoulder, giving the appearance of a baldric, or sash running diagonally across the chest. This was the "banded toga" and a man needed the help of a valet to put it on. It was not a costume for everyday wear. Sometimes it seems that the bands were held in place with concealed stitching. Difficult though it might be to put on, the banded toga remained popular through the fourth century as ceremonial garb. As we reach the fifth century, a toga-clad statue of a consul in the Capitoline

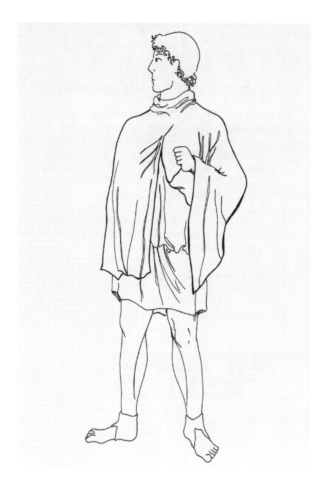

A man wearing a lacerna (a soldier's cloak). **CREATED BY CECILY EVANS. THE GALE GROUP.**

Museum in Rome shows the final stage of the toga's evolution. The statue dates to about 400 C.E., and it portrays a man wearing a tunic with short sleeves over a long-sleeved tunic. Over that he wears a toga with a long *sinus* in front, which the magistrate had to hold up with his left arm to prevent it dragging on the ground. This was clearly a purely ceremonial costume for it did not allow the wearer to move freely. By the time the toga reached the end of its long history, it had become unfitted for physical movement. Nonetheless it was not without an offspring. It mutated into the vestment of a Roman Catholic priest which is known as a *stola*—not to be confused with the costume of a Roman married woman which was known by the same name.

SOURCES

F. Courby, "Toga," in *Dictionnaire des antiquités grecques et romaines.* Ed Charles Victor Daremberg and Edmond Saglio (Paris: Hachette, 1877; reprint, Graz: Akademisch Druck und Verlagsanstalt, 1962): 347–353.

a PRIMARY SOURCE document

THE COSTUME OF THE EMPEROR AUGUSTUS

INTRODUCTION: The author known as John the Lydian lived in the reign of the emperor Justinian (527–565 C.E.), and worked in the imperial bureaucracy in Constantinople for forty years. Three of his works survive, the best known titled *De Magistratibus* (On the Offices of the State), *De Ostentis* (On Omens), and *De Mensibus* (On the Months) which collected information about the ancient Roman religious calendar and the various festivals which had their dates set by the calendar. In his *On the Offices of the State* he describes the costumes worn by various officials, and the passage below describes the dress of the emperor Augustus. John lived five centuries after Augustus' death, and no doubt he confused the costume of Augustus to some extent with the costumes of later emperors; the outer cloak of Augustus, for instance, was not made of silk, but silk was regularly used for the apparel of later emperors, and jewel-encrusted garments were a feature of imperial apparel in the later Roman Empire. John reports correctly that Augustus was high priest of Rome (*pontifex maximus*)—he became high priest in 12 B.C.E. after the death of the previous incumbent, and all his successors until the emperor Gratian (367–383 C.E.) held the office after him. The word *pontifex* does mean "bridge-builder"—John is correct on that score—and the reason is that when Rome was still pagan, it was believed that every river had a divine spirit of its own that would be offended if a priest failed to perform the prescribed rites when it was yoked by a bridge connecting its two banks.

In time of peace he [Augustus] used to wear the garb of a *pontifex*—the name stands for chief priest, connected with bridges—of purple reaching to the feet, priestly, ornamented with gold, and a cloak likewise of purple, which had pleats of gold at its extremities. He used to cover his head for the reasons which I gave in the treatise *On the Months* which I have written. For the wars he wore the *paludamenta*—these are scarlet mantles of double thickness spun from top-quality raw silk, caught up at the shoulders by a golden brooch inset with precious stones. We call this a *fibula* as Italians do, but people in the palace even nowadays speak of it, with a sort of special term, as a *cornucopia*. At festivals he would wear the *limbus*—this is a purple cloak which covers the body down to the feet, with a Meander pattern; on the shoulders it has a brilliant spray of *tabulamenta*—that is, material woven into piping—and a *paragauda* embroidered with the golden letter *gamma* [in other words a tunic with little figures like the Greek letter "gamma" embroidered on it]. From the border at the feet and the bottom end of the garment, on both sides these little figures trick out the tunic with gold to form a letter *gamma*. In the senate he would wear a mantle of purple (of course) and, at the edge of the border near the person who wore it, it was bedecked with squares outlined in pure gold—the court functionaries call these squares *segmenta*, meaning "gold embroidery on the hemline," whereas the man on the street calls embroideries of this sort on the mantles of private individuals *sementa*. This mantle is called *bracteolate* (covered with gold plaques), *gemosa* (encrusted with precious stones), and *lanceolate* (ornamented with embroidered spear-heads). He also wore the rest of the emperor's official regalia, concerning which I resume a detailed description to be excessive. …

SOURCE: John the Lydian, *De Magistratibus*, in *Bureaucracy in Traditional Society: Romano-Byzantine Bureaucracies Viewed from Within*. Trans. by T. F. Carney (Lawrence, Kans.: Coronado Press, 1971): 44. Text modified by James Allan Evans.

C. F. Ross, "The Reconstruction of the Later Toga," *American Journal of Archaeology* 15 (1911): 24–31.

Shelley Stone, "The Toga: From National to Ceremonial Costume," in *The World of Roman Costume*. Eds. Judith Sebesta and Larissa Bonfante (Madison, Wisc.: University of Wisconsin Press, 1994): 13–45.

Lillian W. Wilson, *The Roman Toga* (Baltimore, Md.: Johns Hopkins University Press, 1924).

THE TEXTILES OF THE GREEK AND ROMAN WORLD

WOOL. Sheep were all-purpose animals in the Greco-Roman world. They provided sheepskins which peasants used as cloaks, wool for cloth, mutton to supplement the Greek diet, and milk for making cheese. In ancient Greece and Rome, wool fabric had the added advantage that, unlike linen, it was easy to dye. In addition, wool in its natural state came in a variety of colors depending on the breed of sheep. Latin had words to describe the various hues: *albus* meant "white," *niger* "dark brown" or "black," *coracinus* "deep black," and *fuscus* "brown with a tinge of red." There was also a color of wool called *pullus* that came from sheep in south Italy, and also from Liguria, a region in the northwest of the peninsula. *Pullus* was evidently brownish-black, and it was a color associated with mourning. In the Po River valley in northern Italy, a breed of sheep was developed which produced a fine white wool that could be woven into a gossamer-like fabric. If a man or woman preferred an artificial color, however, there

a PRIMARY SOURCE document

THE MAKING OF LINEN

INTRODUCTION: The *Natural History* of Pliny the Elder, who died in the eruption of Mt. Vesuvius in 79 C.E., is the chief source for information on how linen thread was produced from flax. In the section of his *Natural History* from which this excerpt is taken, Pliny discussed various fabrics made from plants, including esparto grass, and—surprisingly—asbestos, which he thought was a plant found in the deserts of Egypt. Pliny thought that the best "linen" was made from it, but in second place was the fabric made from the fine flax grown in Elis in Greece. The passage below describes the processing of flax in order to extract the linen fiber.

With us the ripeness of flax is ascertained by two indications, the swelling of the seed or its assuming a yellowish color. It is then plucked up and tied together in little bundles each about the size of a handful, hung up in the sun to dry for one day with the roots turned upward, and then for five more days with the heads of the bundles turned inward towards each other so that the seed may fall in the middle. Linseed makes a potent medicine; it is also popular in a rustic porridge with an extremely sweet taste, made in Italy north of the Po, but now for a long time only used in sacrifices. When the wheat harvest is over the actual stalks of the flax are plunged in water that has been left to get warm in the sun, and a weight is put on them to press them down, as flax floats very readily. The outer coat becoming looser is a sign that they are completely soaked, and they are again dried in the sun, turned head downwards as before, and afterwards when thoroughly dry they are pounded on a stone with a tow-hammer. The part that was nearest the skin is called oakum—it is flax of an inferior quality, and mostly more fit for lampwicks; nevertheless this too is combed with iron spikes until all the outer skin is scraped off. The pith has several grades of whiteness and softness, and the discarded skin is useful for heating ovens and furnaces. There is an art of combing out and separating flax; it is a fair amount for fifteen … [here the text is defective] … to be carded out from fifty pounds' weight of bundles; and spinning flax is a respectable occupation even for men. Then it is polished in the thread a second time, after being soaked in water and repeatedly beaten out against a stone, and it is woven into fabric and then again beaten with clubs, as it is always better for rough treatment.

SOURCE: Pliny, *Natural History*. Books XVII–XIX. Vol. V. Trans. H. Rackham (Cambridge, Mass.: Harvard University Press, 1950): 431, 433.

were a large variety of dyes available; in Rome, legend claimed that Numa, the second king of Rome after Romulus, established the guild of dyers. The legend is not likely to be true, but certainly the guild had an ancient history.

LINEN. Linen was made from the domesticated flax plant which was developed early in the Mediterranean world from the wild flax for its fiber and the oil from its seeds. Linen was used in the Bronze Age, prior to 1100 B.C.E., both in the Minoan period on Crete and the Mycenaean period on the mainland. The tablets found in the so-called "Palace of Nestor" at Pylos in Greece show that flax was cultivated in the south-west Peloponnesos before 1200 B.C.E., and in the later classical period, Elis in the north-west Peloponnesos was well known for its fine linen. In the Hellenistic period after Alexander the Great, Egypt produced linen with a high reputation, but by the Roman period, the big centers of production had moved to Syria and Palestine. In the west, the linen of the Po Valley had a good reputation, as did the linen from the coastal areas of southeast Spain. Linen was used not only for dress, but also fishermen's nets, sails for ships, and the awnings in the theaters and amphitheaters that protected spectators from the sun; awnings were also made from cotton since it dried quickly, or a fabric that was half cotton, half linen was woven for use as canopies.

COTTON. Cotton was an imported fabric. It first appeared in India, where it has turned up on archaeological sites in the Indus River valley, dating to the early second millennium B.C.E. By the Hellenistic period, from the third to first centuries B.C.E., it had spread to Upper Egypt, Nubia, and Ethiopia, evidently following the trade route between east Africa and India. Greek and Roman authors seemed to think that cotton was grown on trees; the Roman poet Vergil in his *Georgics*, for instance, refers to the cotton trees of Nubia. Very likely this was not a mistake as many modern scholars believe. Cotton nowadays is grown on a bush with the botanical name *Gossipium herbaceum*, but there is also a cotton tree, *Gossipium arboretum*, and quite possibly it was the source of the cotton fiber that the Greeks and Romans knew.

SILK. True silk comes from the domesticated mulberry silkworm which extrudes a silk fiber to make its cocoon. In the reign of the emperor Justinian (527–565

a PRIMARY SOURCE *document*

THE UNUSUAL DRESS OF THE EMPEROR GAIUS CALIGULA

INTRODUCTION: Gaius Caligula, the great-grandson of the emperor Augustus, became emperor himself in 37 C.E., largely on the basis of his distinguished ancestry. In his four years as the emperor, he proved to be a terrible ruler, and was apparently mentally disturbed; he was assassinated before he could harm the empire. His general appearance was unfortunate: he was tall with a poor physique, spindling legs and a thin neck, and his body was very hairy except for his head which was almost completely bald. In place of the simplicity of dress which his two predecessors as emperors—Augustus and Tiberius—had favored, Caligula introduced elaborate styles which were considered borrowings from the orient and were associated, in Roman minds, with divine kingship. In fact, it has been argued that there was method in Caligula's madness; he was trying to introduce absolute monarchy with all its trappings and took his cues from royal courts such as Cleopatra's in Egypt. Three centuries later, Caligula's dress would not have been considered particularly odd in the imperial court. The passage below comes from the biographer of the first Caesars, Suetonius.

Caligula paid no attention to traditional or current fashions in his dress; ignoring male conventions and even human decencies. Often he made public appearances in a cloak covered with embroidery and encrusted with precious stones, a long-sleeved tunic and bracelets; or in silk (which men were forbidden by law to wear) or even in a woman's robe; and came shod sometimes with slippers, sometimes with buskins, sometimes with military boots, sometimes with women's shoes. Occasionally he affected a golden beard and carried Jupiter's thunderbolt, Neptune's trident, or Mercury's serpent-twined staff in his hand. He even dressed up as Venus and, long before his expedition, wore the uniform of a triumphant general, often embellished with the breastplate which he had stolen from Alexander the Great's tomb at Alexandria.

SOURCE: Suetonius, "Gaius Caligula," in *The Twelve Caesars*. Trans. Robert Graves (Harmondsworth, England: Penguin Books, 1957): 175.

C.E.) silkworm eggs were smuggled into the Roman Empire and became the foundation of the Byzantine silk industry. Prior to that development, all silk was imported. There have been finds of silk in Europe that date before Emperor Augustus, but silk was rare before the Augustan period when trade with India opened up. It was a luxury fabric; silk swatches were sometimes unraveled and the silk thread rewoven with fine linen in order to make it go twice as far and bring down the price. The emperor Caligula (37–41 C.E.) wore a silk toga, and the emperor Elagabalus (218–222 C.E.) insisted on a new silk garment every day. The historian Ammianus Marcellinus, a Greek writing in Latin at the end of the fourth century C.E., remarked that the wearing of silk—once confined to the imperial court—had become widespread among upper-class Romans. In 408 C.E., when the Visigothic chieftain Alaric was holding Rome to ransom, he demanded among other items, 4,000 silk tunics for his men. The chief trade route that brought silk into Mediterranean markets shipped it from China to Indian ports where Persian merchants bought it, carried it up to the head of the Persian Gulf, and then transported it by caravan to the ports of entry into the Roman Empire on the Euphrates River. The transit trade enriched Persia, which made the Roman imperial government unhappy, and it tried to develop alternative routes. The problem was not solved until the Byzantine Empire developed its own silk industry.

COAN SILK. Not all silk in the Greek world came from China. On the island of Cos—which is more famous for the great doctor Hippocrates of Cos who established a medical school there—there was a thriving silk industry which used silk from the cocoon of an indigenous moth. The chief ancient sources for information on this industry are Aristotle and Pliny the Elder, who agreed that the technique of extracting silk fiber from the cocoon of this moth was discovered by a woman named Pamphile. Both men and women wove Coan silk, which was unusual in Greece where weaving was considered women's work. But the output of the Coan silk industry cannot have been great, for Cos is a small island, and probably its silk was inferior to Chinese silk. China supplied a demand which Cos could not fill.

WEAVING. Women did the weaving in ancient Greece. The Greek historian Herodotus who visited Egypt in the mid-fifth century B.C.E. noticed that in Egypt men worked at looms, and he remarked on the difference between Egyptian and Greek custom. In Greece, the housewife was in charge of weaving cloth for the household. The Greek historian Xenophon commented on the importance of the wifely duty of weaving in his treatise on household management, *Oeconomicus.* In that work, he described a dialogue between his mentor, Socrates, and the wise Athenian

Ischomachus, during which Ischomachus highlighted the importance of his young wife being the preeminent weaver in the household. Not all weaving was done in the home, however. Fine fabrics in particular required professional weaving, and specialty firms existed in classical Athens as early as the later fifth century B.C.E. There is evidence of an establishment that specialized in the *chlamys* (a short cloak) and another whose specialty was the *chlanis*, which was a cloak for the upper body like the *chlaina*, but made of finer fabric. In Italy, the fine white woolen cloth produced in the north, in the Po Valley, called for skillful weaving, and factories established there used highly trained slaves for the weaving. From the first century C.E. well-to-do women had more to do with their spare time than to stand at the loom working alongside their female slaves, though the empress Livia, the third and last wife of Augustus, tried to set an example of the antique womanly virtue that her husband promoted by working at the loom. In the towns and cities of the Roman Empire in the Augustan Age, however, there were already shops that sold ready-made clothes both for freemen and slaves.

THE CREATION OF FABRIC. Despite evidence of ready-made clothes, the vast majority of people in ancient Greece and Rome had to make not only their own clothes, but their own yarns and fabrics as well. The process of making fabric was long and labor-intensive. After the shearing of the sheep in the spring, the women washed the wool and pulled apart the matted fibers with their fingers. Then they carded it, separating the fibers with a comb, and rubbed it until they produced a mass of tow, or combed wool, kneeling as they did so on a kind of terra-cotta kneeling pad and propping their feet on a stool called an *onos*, or donkey. At this point they dyed the wool unless the finished cloth was intended to be the natural color of the wool. The wool next had to be spun, but the spinning wheel had not yet been invented; the woman responsible for spinning, known as the spinster, used a distaff and spindle to twist the yarn. The spinster wound the tow on the distaff, pulled out a length of it and secured it to the spindle that she held in her left hand. A weight called a spindle whorl was tied to the bottom of the spindle. It held the length of tow taut and once the spindle was set spinning, it twisted tow into yarn. The spinster continued to feed tow from the distaff into the growing length of yarn until the spindle reached the floor. Then she wound the yarn around the spindle and the process started over again. Once she spun a full skein of thread, she took it off the spindle and placed it in the wool basket. The

a PRIMARY SOURCE *document*

COAN SILK

INTRODUCTION: Chinese silk was much prized, but it had to be imported at great expense until the reign of the emperor Justinian (527–565 C.E.) when silkworm eggs were smuggled into the Byzantine Empire, and the white mulberry tree (*Morus alba*)—the silkworm's food plant—was introduced about the same time. On the island of Cos, however, there was a caterpillar whose cocoon could be unraveled to yield a silk thread. Silk from Cos was famous for its lightness and transparency, though the production must have been small. The passage below is from Aristotle's *Historia Animalium* (Research Notes on Living Creatures). Pliny the Elder also describes the making of Coan silk in his *Natural History*, and both authors attribute the invention to a woman named Pamphile, the daughter of Plateus. It has also been suggested that Coan silk was known as far back as the Minoan period.

From one particular large grub, which has as it were horns, and in other respects differs from grubs in general, there comes, by a metamorphosis of the grub, first a caterpillar, then the cocoon, then the *necydalus*; and the creature passes through all these transformations within six months. A class of women unwind and reel off the cocoons of these creatures, and afterwards weave a fabric with the threads thus unwound; a Coan woman of the name of Pamphile, daughter of Plateus, being credited with the first invention of this fabric.

SOURCE: Aristotle, *Historia Animalium, Book V*. Vol. IV of *The Works of Aristotle*. Trans. D'arcy Wentworth Thompson (Oxford, England: Clarendon Press, 1910): 551b.

strength and the texture of the thread depended on the speed of the spindle as it turned. Once the yarn had been created, it could be woven into fabric on a loom. In ancient Greece there were two types of loom. One was a small, easily transportable loom used to produce girdles and relatively narrow swatches of cloth, and the weaver could sit as she worked at it. The other was the old-fashioned large, vertical loom used to weave the swatches of cloth that would become tunics or cloaks. This was the upright loom on which was woven the Roman *tunica recta* which a youth wore when he came of age and put on the "toga of a man" (*toga virilis*). The threads of the warp hung downwards from the top of the loom and were held taut by loom-weights. The weavers sang as they worked. Homer in the *Odyssey*

described the nymph Calypso, who kept Odysseus prisoner until the gods commanded her to let him return home to Ithaca, as a weaver who sang at her loom. The witch Circe from the same literary work also sang as she weaved. The drudgery of working a loom was not necessarily conducive to joyful songs, however. Weaving was hard work, and it is more than likely that the female slaves who toiled at the loom sang sad songs.

PATTERNED CLOTH. In 1972, a *kore*—that is a statue of a woman, fully clothed—and a *kouros*—a nude male figure—were excavated at a cemetery near Merenda outside Athens. On the base of the *kore* statue was an inscription which read, "Grave of Phrasikleia. I shall forever be called *kore*. The gods have given me this name instead of marriage." Phrasikleia had died before her marriage, and thus she would always be called a maiden (*kore*), never a married woman. More remarkable than this inscription, however, was the preserved original paint on the statue. Art historians knew that the Greeks painted their statues, but on those that have survived, the paint has disappeared or has faded almost to nothing. The paint on Phrasikleia's *chiton* shows swastikas, which were considered good-luck signs at this time, and rosettes on the front of it, and four-pointed stars and various flowers on the back. The predominant colors are red, black, and yellow. Clearly this was a patterned wedding dress in bright colors for a marriage that never happened. At one time, it was thought that Greek weavers with their warp-weighted looms could not produce patterned cloth; when Greek authors mentioned decorated robes, scholars assumed this to mean that they were embroidered—decoration had been sewn on *after* the fabric had been woven. But Phrasikleia's *chiton* proves that they were quite capable of making cloth with colorful patterns. The *peplos* which the women of Athens presented to Athena at every Great Panathenaea festival must have been a patterned weave of the same sort, and Athens was not the only place that regularly presented its guardian goddess with a new dress. In Elis in the northwest Peloponnesos, a *peplos* on which sixteen women had toiled was presented at regular intervals to Hera who was the guardian goddess of the state. Homer's *Iliad* related that Helen of Troy wove a battle scene in color in her spare time. Helen was no different from other Greek housewives in this one respect: she, too, was skilled at the loom.

DYE. Excavations at a Roman fort at Vindolanda, which is near Hadrian's Wall in Britain, have recovered various fragments of textiles and fifty of them were analyzed. The analysis revealed that eight of them had been dyed, and in all cases a red dye was used that came from the root of the madder plant (*Rubia tinctorum*). The Romans had various dyes, and madder red was one of the cheapest. Among the expensive dyes were the various shades of purple made from the murex shellfish. A cheaper, counterfeit purple could be obtained by combining madder red in the right proportions with indigo, which was imported from India. *Coccinus*, a brilliant scarlet made from the kermes, a scale insect, was in high demand as a luxury dye. It originated in Asia, but Spain also developed a lucrative kermes industry. Other dyes were a strong green with a blue tinge (*prasinus*), a fairly bright red (*russeus*), and dark blue (*venetus*). Dyes, however, were not much use without mordants to fix the colors. Ancient mordants included alum from wood ash or even human urine and natron—sodium carbonate, or washing soda, which was dug from natron pits in Egypt. To fix the color, dyers dipped the wool in the mordant before it was put in the dye vat and heated.

SOURCES

John Beckwith, "Textile Fragments from Classical Antiquity," *Illustrated London News* 224 (1954): 114–15.

John Ferguson, "China and Rome," in *Aufstieg und Niedergang der römischen Welt*, II–9–2. Ed. Hildegard Temporini and Wolfgang Haase (Berlin/New York: Walter de Gruyter, 1978): 581–603.

Reinhold Meyer, *A History of Purple as a Status Symbol in Antiquity* (Brussels, Belgium: Collection Latomus 116, 1970).

Judith Lynn Sebesta, "Tunica Ralla, Tunica Spissa: The Colors and Textiles of Roman Costume," in *The World of Roman Costume*. Eds. Judith Lynn Sebesta and Larissa Bonfante (Madison, Wisc.: University of Wisconsin Press, 1994): 65–76.

Beate Wagner-Hasel, "The Graces and Colour Weaving," in *Women's Dress in the Ancient Greek World*. Ed. Lloyd Llewellyn-Jones (London, England: Duckworth and the Classical Press of Wales, 2002): 17–32.

Jonathan P. Wild, "Linen," in *The Oxford Classical Dictionary*. 3rd ed. Eds. Simon Hornblower and Antony Spawforth (Oxford: Oxford University Press, 1999): 863.

DRESSING TO IMPRESS IN GREECE AND ROME

COLOR IN GREEK AND ROMAN APPAREL. A visitor to ancient Greece or Rome would have been impressed by the bright colors of the clothing that the people wore, particularly the women. On this point, the Greek and Roman art that has survived tends to give a false picture. The marble statues were originally painted

using wax-based paints, but it is very rare to find a statue now with traces of the original colors. The bronze statues have almost all disappeared long ago, melted down in the medieval period for their metal. The pictures on Greek vases of the sixth and fifth centuries B.C.E., when Athenian black-figured and red-figured vases were in style, present a record of changing fashions, but the vase painter was limited by the colors of his medium. In fact, Greek and Roman garments were far more colorful than most people realize. Weavers could produce elaborately patterned cloth. The *peplos* that was presented every four years to the goddess Athena at the Great Panathenaea festival was a masterpiece of design. It was woven by the women of Athens in a public building in the city where space was set aside for the loom, and the style of the garment did not change, but there was room for innovation in the pattern of the cloth.

THE EAST GREEKS. The Greeks always looked on the fashions of the Orient, particularly Persia, with admiration mixed with disapproval and contempt. On the one hand, the elaborate fashions associated with Persia signaled soft living and effeminacy; the Greek admiration for the well-muscled naked body was not to be found in Persia. On the other hand, Oriental fashions were enormously attractive for anyone who wanted his dress to signal his wealth and his cosmopolitan culture. East Greece—the Greek foundations in Asia Minor and Cyprus—was always an avenue for contact with the civilizations of the Orient. The collapse of the Mycenaean civilization had been followed by a period of migrations when three waves of migrants from Greece founded cities on the coastline of Asia Minor and the Dodecanese islands. The most important of these new foundations were made by Greeks speaking the Ionian dialect, and so East Greeks are often referred to as "Ionian," though there were also Aeolian and Dorian foundations, established by Greeks whose dialects were Aeolian or Dorian. These Ionian cities were cheek-by-jowl with the Lydian Empire, and the last Lydian king, Croesus, subdued those that were on the mainland while the cities on the offshore islands were protected by their fleets. In 546 B.C.E. Croesus in turn fell victim to a new empire builder, Cyrus, the founder of the Persian Empire. The Ionian cities that had belonged to the Lydian Empire fell under Persian control. Persia was not content with the Greek cities on the Asia Minor coastline. Little by little it took over the cities on the offshore islands, and from Asia, it moved into Europe and by 512 B.C.E. it controlled the region to the north of the Aegean Sea. Yet Persia's rule was relatively light. Ionian culture continued as before, and Ionian fashions, influenced by Lydia

a PRIMARY SOURCE *document*

THUCYDIDES ON ATHENIAN FASHIONS

INTRODUCTION: The Athenian historian Thucydides, who composed his *History of the Peloponnesian War* near the end the fifth century B.C.E., devoted a section in his introduction to the developments which had taken place in Greece in the Archaic Period (700–480 B.C.E.) and earlier, and he notes the change in fashion that had taken place in Greek clothing. He claims that the Athenians had taken the lead. It is more likely that it was the cities in Ionia that took the lead, but the surviving evidence does not allow us to contradict Thucydides with any confidence.

The Athenians were the first to give up the habit of carrying weapons and to adopt a way of living that was more relaxed and more luxurious. In fact, the elder men of the rich families who had these luxurious tastes only recently gave up wearing linen undergarments [chitons] and tying their hair behind their heads in a knot fastened with a clasp of golden grasshoppers: the same fashions spread to their kinsmen in Ionia, and lasted there among the old men for some time. It was the Spartans who first began to dress simply and in accordance with our modern taste, with the rich leading a life that was as much as possible like the life of the ordinary people. They, too, were the first to play games naked, to take off their clothes openly, and to rub themselves down with olive oil after their exercise. In ancient times, even at the Olympic Games, athletes used to wear coverings for their loins, and indeed this practice was still in existence not very many years ago. Even today, many foreigners, especially in Asia, wear these loincloths for boxing matches and wrestling bouts. Indeed, one could point to a number of other instances where the manners of the ancient Hellenic world are very similar to the manners of foreigners today.

SOURCE: Thucydides, "Introduction," in *History of the Peloponnesian War*. Trans. Rex Warner (Harmondsworth, England: Penguin Classics, 1954): 38–39.

and then by Persia, were elaborate and ornate. Ionia became a conduit for Persian style to pass to Greece, particularly to Athens, which the Ionians regarded as their mother city. In the first two decades of the fifth century B.C.E., Persia made an attempt to conquer Greece which resulted in Persia's defeat and her retreat from the region of the Aegean Sea. The elaborate fashions associated with the Orient went out of style in Athens which

a PRIMARY SOURCE document

NEW FASHIONS FROM PERSIA

INTRODUCTION: During the last quarter of the fifth century B.C.E., Persian fashions were on the rise in Athens, though not without the usual conflict between the old and new styles that mirrored the conflict between the old traditions and the new ways. In his play *The Wasps* (performed in 422 B.C.E.), Aristophanes highlights both of these conflicts in an exchange between a son and his father during which the son, Anticleon, attempts to convince his father, Procleon, to trade in his plain brown juryman's coat for the significantly fancier styles from Persia—in this case a *kaunakes* or a *persis*. The two men's clothes (as well as their names) in this instance also reflect their political convictions; Cleon was a political leader intensely disliked by the wealthy Athenians who wore the latest fashions, but the masses supported him.

Procleon: What is it you want me to do?

Anticleon: Take off that shabby old cloak and throw this gown over your shoulders.

Procleon: Lot of good having sons and bringing them up, if all they can do is try and suffocate you!

Anticleon: Come along, get it on, and don't talk so much.

Procleon: In the name of all the gods, what is this horrible thing?

Anticleon: It's a Persian gown: some people call it a full-waister.

Procleon: I thought it must be one of those goatskin things from the country.

Anticleon: You *would*. Now if you'd ever been to Sardis, you'd have known what it was; but it seems you don't.

Procleon: I most certainly don't. Looks to me like one of Morychus' fancy wrappings.

Anticleon: No, these are woven in Ecbatana.

Procleon: What from? Tripe?

Anticleon: Really, you're hopeless! Don't you realize that this is an extremely expensive Persian weave—why, at least sixty pounds of wool must have gone to the making of this.

SOURCE: Aristophanes, *The Wasps.* Trans. David Barrett (Harmondsworth, England: Penguin Books, 1964): 80–81.

opted for a more sober, austere appearance, though older, more conservative men continued to wear Ionic chitons with their many pleats and do up their hair with pins made in the shape of grasshoppers. Ionia won its independence from Persia after Xerxes' debacle in Greece, but then it fell under the domination of Athens. Ionia had the reputation of being a place where life was soft and easy, and the scientific view of the day held that soft living made men with soft muscles who were no good on the battlefield. Hard living made hard men, and as the Greeks saw it, it was the toughness of their foot soldiers and the free men who rowed their warships that won them victory over Persia. Simple clothing and toughness went hand in hand. The fact that Ionia won its freedom from Persia only to lose it the Athenian Empire seemed to prove that Ionia, with its love for Persian-style fripperies, was not fit to defend its liberty. The reaction against Persian fashion did not last, however. Active warfare between the Athenian Empire and Persia ended in 450 B.C.E., and peaceful contacts between Athens and Persia resumed.

PERSIAN FASHION IN ATHENS. By the last quarter of the fifth century, Athenians demonstrated a fondness for Persian styles again. New items of dress appear with telltale names. The fine wool cloak called a *syria* must have been inspired by Syrian fashion. These cloaks may even have been imports from Syria. There was a kind of women's shoes called *persikai*. One of Plato's dialogues refers to wealthy people who wore "Persian belts"; the dialogue is fictitious, but Plato imagines it taking place before 415 B.C.E., and it is probable that some rich Athenians of that time were wearing expensive belts probably imported from Persia. Another garment of the late fifth century B.C.E. was the *kaunakes*, also known as the *persis*—a name which betrays its origin. It seems to have been a heavy cloak with little woolen tufts. Chitons with sleeves—another Persian innovation—also appear. Vase paintings depict examples of the *chitoniskos cheiridotos*—that is, the short patterned chiton with sleeves—worn over a long chiton. The short chiton might have fringes at the bottom, and fringes were considered Lydian, or at least, oriental. Another Persian garment which the Greeks adopted was the *kandys*, an outer garment with sleeves, dyed purple, and fastened at the shoulders. The wearer used his *kandys* to keep his arms warm, even though the sleeves were too long to be of practical use and were sewn up at the end. In the Persian court, these sleeves served to protect the king from assassination since men with their arms in the long sleeves of their *kandys* could not wield an assassin's knife.

THE SYMBOLISM OF THE SLEEVE. Sleeves were not new to ancient Greece. Musicians wore long chitons with sleeves when they performed at public festivals, but the sumptuous costumes of musicians were not everyday dress. The policemen who patrolled the streets of Athens also wore tunics with sleeves and trousers, but these public servants were actually Scythian slaves owned by the state, and they wore their native costume. Sleeves were thought to be a peculiar mark of Persian fashion, but they won acceptance, for on the sculptured frieze from the Parthenon in Athens (carved in the 430s B.C.E.) some of the young horsemen in the parade are shown wearing short chitons with sleeves. It looks as if some well-to-do young Athenians had adopted the latest Persian-style fashions. Yet when sleeves reached Rome, they were considered effeminate. A passage in Vergil's epic, the *Aeneid,* demonstrates the prevailing Roman attitude towards this fashion. In the passage, a native Italian (representing the Romans) opposes a settlement of foreign Trojans in Italy by hurling insults at their leader, Aeneas; among the insults are derisive comments on their wearing of sleeves, which the Italian disparaged as unmanly. Aeneas had come from Troy, which was in Asia, and hence the Trojans were Asians and wore Persian costume. In the *Aeneid,* the Trojans have to abandon their Asian way of life before they win a place for themselves in Italy. It must not have been a complete abandonment, however, since Julius Caesar's biographer, Suetonius, reported that the purple-striped senatorial tunic which Julius Caesar wore under his toga had sleeves with fringes.

THE PARASOL. Parasols were known in the Myceneaean world but they drop out of the picture in the Dark Ages of Greece. They reappear on vase paintings in the later sixth century B.C.E. as part of a well-to-do woman's costume, though they were apparently not exclusively used by women. The lyric poet Anacreon, who enjoyed the patronage of a tyrant of Samos until Persia captured the island in 522 B.C.E., used his poetry to criticize a fellow named Artemon who wore gold earrings and held an ivory sun umbrella, "as ladylike as you please!" In Athens, the parasol became a status symbol for the freeborn woman. In Athens of the fifth century B.C.E. there was a sharp distinction between the citizens and the *metics*, or resident aliens. After the middle of the century, when the statesman Pericles passed a law that barred everyone from citizenship whose parents were not both Athenian citizens themselves, it was impossible for a metic to become a citizen. So the Athenian citizen body became an elite group that prevented outsiders from entering. The parasol marked the division. There was a law dating perhaps to about the same time as Pericles'

a PRIMARY SOURCE *document*

EFFEMINATE DRESS

INTRODUCTION: The Latin writer Aulus Gellius was a well-to-do Roman who received the standard education in rhetoric in Rome and then went to Athens to study philosophy. It was his custom to jot down notes of things that seemed worth remembering whenever he read a book in Latin or Greek, and during a winter that he spent at a country-place outside Athens, he began to assemble them into a collection which he later published as *Noctes Atticae* (Attic Nights). He wrote during the reigns of the emperor Antoninus Pius (138–161 C.E.) and his successor, Marcus Aurelius (161–180 C.E.). In the excerpt below, he relates the criticism of the second-century B.C.E. Roman Publius Scipio Africanus regarding the effeminate dress of his countryman Sulpicius Gallus, who wore long-sleeved tunics. Long sleeves were considered Persian finery, and not proper clothing for a tough virile Roman in the second century B.C.E.

For a man to wear tunics coming below the arms and as far as the wrists, and almost to the fingers, was considered unbecoming in Rome and all Latium. Such tunics our countrymen called by the Greek name *chiridotae* (long-sleeved), and they thought that for women—and only women—a long and full-flowing garment was not unbecoming to harm their arms and legs from view. But Roman men at first wore the toga by itself, without tunics; later they had close, short tunics ending below the shoulders, the kind that the Greeks call *exomides* (sleeveless). Habituated to this older fashion, Publius Africanus, son of Paulus, a man gifted with all worthy arts and every virtue, among many other things with which he reproached Publius Sulpicius Gallus, an effeminate man, included this also, that he wore tunics which covered his whole hands. Scipio's words are these: "For one who perfumes himself every day and dresses before a mirror, whose eyebrows are trimmed, who walks abroad with beard plucked out and thighs made smooth, who at banquets, though a young man, has reclined in a long-sleeved tunic on the inner side of the couch with a lover, who is fond not only of wine but of men—does anyone doubt that he does what wantons commonly do?"

SOURCE: Aulus Gellius, *The Attic Nights of Aulus Gellius.* Vol. 2 of 3 vols. Trans. John C. Rolfe (Cambridge, Mass.: Harvard University Press, 1927): 57, 59. Text modified by James Allan Evans.

citizenship law that required the daughters of metics to carry parasols and stools for the daughters of citizens in the Panathenaic procession. The parasol was not merely a shield from the sun; it was a status symbol.

PERSIAN FASHION IN ROME. "I detest Persian frippery, boy," wrote the poet Horace as the first line of one of his *Odes*. Horace claimed to like the simple life. He lived under the emperor Augustus and enjoyed the generous patronage of one of Augustus' ministers, Maecenas, so he expressed the official view about luxury in dress and in life generally. This view of Persian fashion was not merely a matter of taste, but a cunning example of propaganda reminiscent of the Greeks' abandonment of Persian fashion following their military conflicts with Persia. Augustus had begun his political career as the teen-aged great-nephew and adopted heir of the powerful Roman politician, Julius Caesar; following Caesar's assassination, Augustus had to defeat Mark Antony and Cleopatra, queen of Egypt, before he could become master of the empire. His propaganda portrayed Cleopatra as the paradigm of oriental luxury that extended to her clothes. Augustus presented himself as the champion of Roman traditions in clothes as in everything else. Yet Romans who could afford it liked rich dress. The longest fragment of a novel written by Petronius in the reign of the emperor Nero (54–68 B.C.E.) describes a banquet given by a wealthy former slave named Trimalchio who liked to show off his wealth. He made a grand entrance to the banquet chamber on a litter, wearing a bright scarlet cloak and a tasselled napkin with a broad purple stripe in imitation of the senatorial stripe around his neck that, as a freedman, he could not legally wear. He wore rings on his fingers and on his right arm was a gold armlet and another of ivory with a gleaming metal clasp. Clothes signaled a message, and the message of Trimalchio's costume was that he had "made it."

PERSIAN COSTUME IN THE LATE EMPIRE. By the time of the late Roman Empire, the costume of the imperial court under Diocletian (284–305 C.E.) and Constantine (324–337 C.E.) borrowed heavily from Persian fashion. Constantine began to wear a diadem decorated with pearls as a symbol of his autocratic power. Costume borrowed from the Persian court signaled the emperor's authority in late antiquity. Persia furnished a large share of the trappings of the imperial court as the Roman Empire evolved into the Byzantine Empire.

SOURCES

M. C. Miller, *Athens and Persia in the Fifth Century B.C.: A Study in Cultural Receptivity* (Cambridge: Cambridge University Press, 1997).

———, "The Parasol: An Oriental Status-Symbol in Late Archaic and Classical Athens," *Journal of Hellenic Studies* 112 (1992): 91–105.

G. M. A. Richter, "Greeks in Persia," *American Journal of Archaeology* 50 (1946): 16–30.

THE DRESS OF ROMAN WOMEN

A GIRL'S DRESS. Freeborn girls, that is, girls whose parents were not slaves, wore the same costume as freeborn boys: a toga worn over a tunic. The toga was the *toga praetexta* with a purple border that had to be made of wool. The purple border was, at least in origin, apotropaic—that is, it protected the wearer against the Evil Eye or other unseen dangers that might attack a child. She would wear her hair carefully combed, braided and tied with a single band of wool cloth called in Latin a *vitta*, or in English, a "fillet." The fillet was probably white and it signified purity. A boy would also wear a *bulla* or a locket, which contained an amulet—that is a charm which was worn to ward off evil spirits or miasmas that might infect him—but it seems that girls did not wear them. Few sculptures have survived of young Roman girls wearing the *toga praetexta* but those that have do not show bullas. However, a girl might wear a necklace of some sort which could have served the same purpose as an amulet. Once a girl reached puberty, she put off her *toga praetexta* and dedicated it to the goddess "Fortuna Virginalis"—Venus in her capacity as the guardian goddess of young maidens. This was the signal that she was now ready for marriage.

THE COSTUME OF THE ROMAN BRIDE. On the night before her wedding day, a bride put on the *tunica recta*, so called because it was woven on the ancient upright loom which weavers had abandoned for regular cloth manufacture. The rite of marriage demanded that a bride weave her tunic of white wool on the upright loom, as well as her hairnet, which was dyed yellowish-orange, the color of flame. On her wedding day, the fillets in her hair as well as her hairnet would signal her chastity, in Latin, her *pudor*. Around her tunic she put a belt made of the wool of a ewe—a female sheep. The belt was knotted in a knot that her husband would undo when they went to the marriage bed together. Then the bride put on the marriage veil that was dyed yellowish-red. It would protect her from evil spirits as she made the journey from her father's house to her husband's, or, in ritual terms, when she left the protection of the Lares (household gods) of her own family to the Lares of her husband. Her new husband gave her fire and wa-

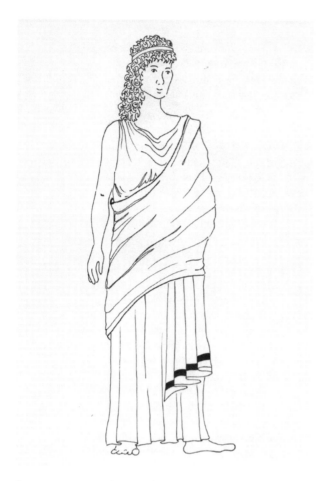

Roman woman wearing a stola. **CREATED BY CECILY EVANS. THE GALE GROUP.**

ter as she entered his house, and she placed a coin on the little altar of her husband's Lares that would be in a niche in a wall near the entrance. If she was moving to a new district of the city, she would place another coin on the altar of the Lar of the district, the *Lares compitales.*

THE MARRIED WOMAN. The standard dress of the Roman *matrona*—that is, a married woman—was the *stola.* It was a dress held to the shoulders by straps; it hung to the feet and resembled a modern slip, except that the skirt was fuller and fell in distinctive folds called *rugae.* Over her shoulders and covering her head was a cloak called a *palla.* Proper Roman women wore their head covered and the repercussions of neglecting this element of fashion could be severe. In the second century B.C.E. a Roman called Sulpicius Gallus who was consul in 166 B.C.E. divorced his wife because she had left the house with her head unveiled. A Roman woman's hair also signaled her status as a married woman; her hair should be carefully dressed and bound with fillets. The

stola and the fillets that tied up her hair would remain the costume of a chaste married woman throughout her life.

DISGRACED WOMEN. In the same way that clothing demonstrated the purity of the young Roman girl and the fidelity of the Roman wife, adulteresses and prostitutes also wore distinctive clothes. If a husband divorced his wife because she had an affair with another man, she would wear a plain white toga; she no longer had the right to wear a *stola.* The proper costume for a prostitute was also a toga. This particular way of branding impure women seems to have relaxed as time went on. Juvenal, the sour satirist of Roman life who lived in the second century C.E., claimed that a virtuous woman was hard to find in Rome of his day and yet nobody wore the toga.

THE WIDOW. If a woman's husband died, she took off her *stola* and replaced it with a *ricinium*, a word derived from the Latin verb meaning "to throw back." The *ricinium* was a shawl made of a square piece of cloth

a PRIMARY SOURCE *document*

ALLURING DRESS IN AUGUSTAN ROME

INTRODUCTION: Ovid's "Ars Amatoria" (The Art of Love), is a witty manual on the art of seduction, published in 2 B.C.E. In the passage below, Ovid instructs women how to dress their hair, as well as how to dress stylishly within a budget. Purple dye was expensive and highly prized, but there were other, cheaper dyes that were equally effective. He ends with a purely imaginary illustration taken from myth: Briseis, whom Achilles and Agamemnon quarreled over in Homer's *Iliad*, was a blonde who wore black, and the Trojan hero Hector's wife was a brunette and wore white.

By chic we're charmed; no rebel curl should show;
A finger's touch, and looks will come and go.
Not in one only mode may heads be dressed,
Consult your glass for what becomes you best.
A simply parting suits an oval face,
—Laodamia such coiffure did grace—
A round one needs a dainty cluster posed
Above the brow, that leaves the ears disclosed.
One o'er her shoulders should her tresses fling
Like tuneful Phoebus when he sweeps the string,
One braid her hair, as Dian's wont to do
When girt her startled quarry to pursue.
This head a lavish flow of hair demands,
That must be prisoned in restraining bands,
This one delights in combs of tortoiseshell,
That one affects a wave-like fall and swell.

No more the acorns on the oak you'll count
Or beasts on Alps or bees on Hybla's mount,
Than I can count the fashions that prevail,
While every day adds new ones to the tale. ...

What now of dress? Put rich brocades aside
And stuffs of Tyrian purple double-dyed.
Now that of cheaper colours there's no lack,
It's mad to bear one's fortune on one's back.
There's blue of skies, of skies without a stain,
No warm south-westers bringing threat of rain,
Gold that recalls the fleece whereon it's said
Phrixus and Helle from fierce Ino fled,
The green of waves, from waves that take its name
(Methinks such garments clothe the Naiads' shame).
Here's saffron too (in robes of saffron bright
The dewy Morning yokes her team of light),
Pale rose and Paphian myrtle swell the list,
Plumage of cranes, and purple amethyst,
Your chestnuts, Amaryllis, almonds too,
And wax to fabrics gives its name and hue.
Rich as earth's new-born flowers in balmy spring,
When vine-buds swell and winter's gloom takes wing,
So rich, nay richer, is the choice of dyes;
But all becomes not: let your choice be wise.
Black suits a blonde; Briseis favoured black,
Thus robed she trod her captor's bivouac.
White suits brunettes; Andromeda looked best
In white; in white Seriphos saw her dressed.

SOURCE: Ovid, "The Art of Love III," in *The Love Poems.* Trans. A. D. Melville (Oxford: Oxford University Press, 1990): 131–133.

which a woman folded and then threw back half of it apparently over her shoulder. Wearing it was a sign of mourning and thus it was probably dark-colored, made from wool that was naturally dark. The widow wore the *ricinium* for the year prescribed for mourning. She may have continued to wear it longer if she did not remarry, but this cannot be proven conclusively.

THE UNMARRIED WOMAN. Roman marriages were generally arranged. Fathers found proper husbands for their daughters. Romantic love sometimes upset their plans, and it is significant that the god who caused young men and women to fall in love was Cupid, the son of Venus, who shot poisoned arrows at his victims. In other words, romantic love was a poison that caused youths and maidens to neglect their duty to their families and seek improper unions. There were probably not a large number of unmarried women in ancient Rome. In Roman law, an unmarried woman and a widow were considered the same, but it is not clear that they dressed the

same. Neither is it clear what the appropriate costume was for a woman who was divorced for reasons other than adultery, particularly in an era when some Roman men married and divorced for political advantage. It is understood, however, that the costumes prescribed for women belonged to the customs of early Rome known as the *mos maiorum* by the Romans—the way of life of our ancestors. While the Romans revered the ways of their ancestors, they did not always adhere to them religiously, so the guidelines for what women in different stations of life should wear may not have been closely followed.

THE LATEST STYLE. Though fashions changed much more slowly in ancient Greece and Rome than nowadays, it was important to keep up to date. Well-to-do Roman women had their own dressmakers and hairdressers, who were generally slaves; if they did not satisfy the whims of their mistresses, they could be flogged. Evidence for hairstyles comes from portrait sculpture and

painting. In the sixth century B.C.E. in Greece, both young men and young girls had their hair done in elaborate coiffeurs, to judge from the so-called *kouros* and *kore* sculptures—that is, freestanding statues showing nude young men and clothed young women which were erected in the archaic period. The marcelling (crimping of the hair into rows of waves) and plaiting of their hair must have taken hours of primping. In the classical period hairstyles became simpler. In Rome in the Augustan period, the emperor Augustus set the style with short hair combed forward on his forehead, and his wife Livia is shown with her hair parted in the middle and marcelled. By the end of the first century tight curls piled up on top of the head was the fashion. Hair dyes turned brunettes blonde, which was the most fashionable color. Sometimes the results were disastrous; the Latin poet Ovid wrote a poem of commiseration to his girlfriend who had lost her hair as a result of using harsh hair dyes.

SOURCES

George M. A. Hanfmann, *Classical Sculpture* (Greenwich, Conn.: New York Graphic Society, 1967).

Mary G. Houston, *Ancient Greek, Roman and Byzantine Costume.* 2nd ed. (London, England: Adam and Charles Black, 1947).

Laetitia La Follette, "The Costume of the Roman Bride," in *The World of Roman Costume.* Eds. Judith Lynn Sebesta and Larissa Bonfante (Madison, Wisc.: University of Wisconsin Press, 1994): 54–64.

Judith Lynn Sebesta, "Symbolism in the Costume of Roman Women," in *The World of Roman Costume.* Eds. Judith Lynn Sebesta and Larissa Bonfante (Madison, Wisc.: University of Wisconsin Press, 1994): 46–53.

THE APPAREL OF THE SOLDIER

MILITARY ARMOR IN EARLY GREECE. Armor evolved over the long period of Greek and Roman history, but the requirements remained standard. Armor had to protect the soldier's body, it had to allow him free movement of his arms and legs and it had to please the eye. Some of the earliest examples of military garb are from the late Mycenaean period; a vase called the "Warrior Vase" shows soldiers marching in column. They wear helmets and short kilts with tassels leaving their legs bare, and they carry "Figure-8" shields—shields which are pinched in at the middle so that when the soldier held it in front of him to protect his body, he could still use his arms to ward off the enemy. The warriors described in Homer's *Iliad* who fought in the Trojan War wore similar armor, except that most of them were

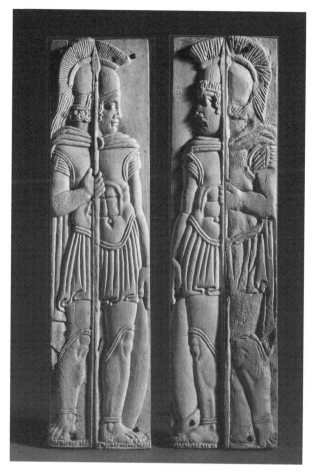

4th-century B.C.E. bone tablets with figures of soldiers in armor carrying shield and spear from a necropolis at Columbella just south of Palestrina outside Rome. THE ART ARCHIVE/MUSEO DI VILLA GIULIA ROME/DAGLI ORTI.

described as having round shields. Their armor allowed them to run in case the spears they threw at their enemies failed to hit the mark.

THE HOPLITE. As the Greek Dark Ages came to an end, the warrior of the sort found in Homer's *Iliad* gave way to a heavily-armed infantryman known as the hoplite. He wore a helmet, a metal corselet with metal shoulder pieces, and a triangular plate called a *mitra* to protect his groin. His legs below the knee were protected by greaves, which was armor shaped like the lower leg and fastened behind the calf. Under his corselet he wore a linen tunic and below his waist he had a kind of pleated leather kilt which gave his lower body some protection. He seems to have gone barefoot, for he is represented in art generally without shoes. He got his name "hoplite" from his large, round shield, called a *hoplon*. He fought in formation, drawn up in eight ranks, so that his shield on his left arm protected the right side of the hoplite beside him, while his own right side was protected by the

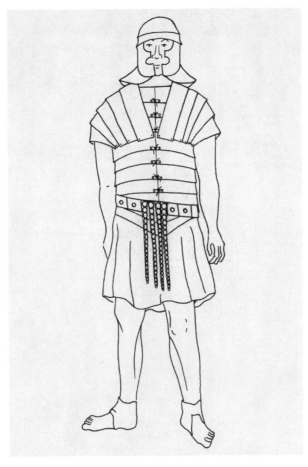

Roman soldier in armor of type known as "lorica segmentata" that was first introduced in the 1st century C.E. CREATED BY CECILY EVANS. THE GALE GROUP.

was the battle formation which Alexander used in the two great battles where he defeated the Persian king Darius Codomannus and conquered the Persian Empire.

THE ROMAN ARMY. The army that dominated the battlefields of the ancient world for the longest period was the army of Rome. In the early days of the Roman republic, it was a citizen army. A consul who set out on a campaign—Rome elected two consuls each year who served both as the principal magistrates of the state and as its commanders-in-chief—would conscript troops from the census list of those eligible to serve, who were owners of property. By the end of the second century B.C.E., Rome was in desperate need of more recruits, and a soldier named Marius, who would hold the consulship seven times during his life, opened the rank of the army to all volunteers. The next big change was made by the emperor Augustus who established a citizen army, made up of legionary soldiers who were citizens, and auxiliary troops who were not citizens and were paid somewhat less. We find their armor depicted on sculpture; Trajan's Column in Rome is particularly useful, for it shows the campaigns of the emperor Trajan in Dacia, modern Rumania. Sometimes fragments of a soldier's equipment are turned up by the archaeologist's spade, or found by accident.

MAIL ARMOR. Roman soldiers in the Republic wore chain mail shirts, and they were not phased out until the first century C.E. Mail was made by interlocking one iron ring with four others. Making a corselet of mail required a great deal of skill and patience, but once made, it needed little maintenance. The iron rings rubbing against each other kept the mail shirt clean. The small farmers who formed the backbone of Rome's armies in the early republic probably wore mail that they inherited from their fathers or grandfathers. Shirts of mail in republican times to the first century B.C.E. reached the mid-thigh; in the early imperial period from the time of the emperor Augustus (27 B.C.E.–14 C.E.), they came to just below the waist, but the soldier got added protection from leather strips called *pteruges* at the shoulders and around the hips. Chain mail left something to be desired, for though it shielded a man against the slash of a sword, it was poor protection against an arrow or the thrust of a dagger. The arrow did not need to pierce the armor to kill, for it could force the rings of the mail shirt into the wound, causing infection, and the results could be fatal.

SCALE ARMOR. Scale armor was made from bronze or iron plates of various sizes which were connected in rows and then overlapped like the tiles of a roof. The

hoplite on his other side. As long as the formation—known as a *phalanx*—remained unbroken, a hoplite army could avoid heavy casualties. It was a different matter if the *phalanx* broke. The hoplite was not a nimble soldier since running in full hoplite armor was not easy. Apparently when the Athenian hoplites defeated the Persians at the Battle of Marathon in 490 B.C.E., it was the first time that a hoplite army charged on the run. By the fourth century B.C.E., the Greeks discovered how effective the lightly-armed soldier called the "peltast" could be against hoplites, particularly in rough country which was ill-suited to hoplite tactics. The "peltast" carried a *pelte*, small, light shield of leather without a rim which did not impede his movements; if a hoplite had to run for his life, the best he could do was to throw away his shield and that was considered a great disgrace. Nonetheless Greek armies continued to use the *phalanx*. Philip II of Macedon (ruled 359–336 B.C.E.), the father of Alexander the Great, revamped it, making it larger and arming the troops with pikes about 13 feet long. This

finished product looked like fish scales—hence the name. It was cheaper to make than chain mail, and it gave better protection. Its disadvantage was that it was more difficult to put on and take off. In times of relative calm, the soldiers could rely on each other for help putting on their armor, but whenever a detachment was caught by a surprise attack, some of the troops might not succeed in putting on their armor in time to meet the onslaught of the enemy. Scale armor had been standard equipment for the Persian army long before Rome adopted it, for when Herodotus described in his *Histories* the army with which King Xerxes invaded Greece in 480 B.C.E., he reported that the Persian troops wore felt hats called tiaras, patterned tunics with sleeves, and coats of mail like fish scales. This type of armor remained popular in the East both in Parthia, Rome's enemy on the eastern frontier in the time of the emperor Augustus, and among the Sassanid Persians who took over the Parthian realm in the third century C.E. The Persians used cavalry with both riders and horses armed head-to-toe in scale armor, looking like medieval knights except that the horsemen rode without stirrups. The Romans were always quick to borrow good ideas, and adopted scale armor for themselves, both for infantry and heavy cavalry.

PLATE ARMOR (LORICA SEGMENTATA). A corselet made of metal strips—called in Latin a *lorica segmentata*—is the type most often associated with the Roman soldier. It is the armor of choice for movie directors who film cinematic epics about ancient Rome. It was invented in the early first century C.E. and one theory is that it was introduced after a military disaster of 9 C.E. when three Roman legions were annihilated in the Teutoberg Forest in Germany. Excavations at a site identified as the scene of the disaster, however, have uncovered fragments of an early form of *lorica segmentata*, which shows that some of the Roman legionary troops who lost their lives in the Teutoberg Forest were, in fact, wearing a corselet of metal strips. So the invention was not the result of the disaster, though its speedy adoption may have been. The cuirass protecting the chest and diaphragm had overlapping girth straps and curved shoulder plates that provided good protection. The disadvantage was its fastenings: the soldier held the armor on his body with hook and strap fasteners that were never entirely satisfactory. Moreover the soldier's sweat as he fought degraded the leather straps that held the metal plates in place, and the resulting damage might require expensive repairs. The initial cost of making this type of cuirass, however, was less than for chain mail or scale armor. It has been generally believed that the cuirass of metal strips attached to a leather backing became more or less standard for

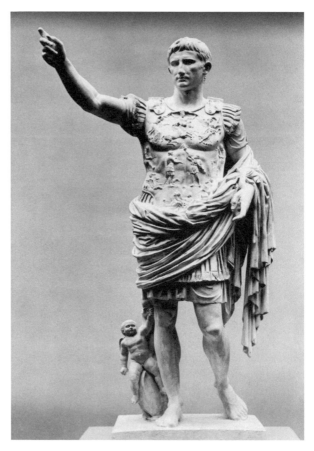

The Augustus of Primaporta, marble copy of a bronze sculpture of Caesar Augustus addressing his soldiers, holding out his right hand, wearing a breastplate with mythological and historic scenes in low relief, Roman, early empire, c. 20 B.C.E. © BETTMANN/CORBIS. REPRODUCED BY PERMISSION.

the Roman legionary soldier from the second quarter of the first century C.E. until the third century C.E. when it was abandoned. This theory is difficult to prove, however, on the evidence of the ancient monuments and of archaeology. The Column still standing in the center of Rome which depicts the campaigns of the emperor Trajan (98–117 C.E.) into Dacia (modern Rumania) shows legionary soldiers wearing the *lorica segmentata*. It seems to have been standard equipment for the regular troops, where as the auxiliary troops—non-citizens recruited from the Roman provinces—wore other types such as mail shirts. But most of the fittings for the *lorica segmentata* cuirasses which archaeologists have discovered are from Roman forts that were held by auxiliary troops, not by the Roman legions. Moreover, although the Column of Trajan in Rome shows the *lorica segmentata* as the standard armor of the legionary soldier, there is another monument commemorating Trajan's Dacian campaign—a *tropaeum* or "Victory Memorial" erected at Adamklissi in Rumania—and there both the Roman

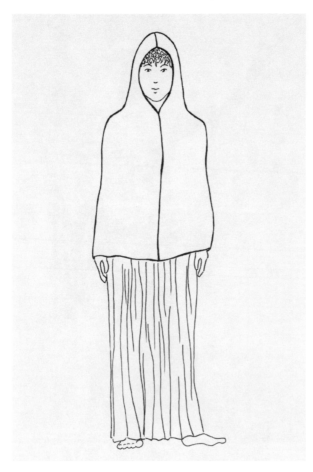

A man wearing a cucullus (a hooded outer garment). CREATED BY CECILY EVANS. THE GALE GROUP.

legionaries and the auxiliaries wear scale armor. The Adamklissi monument was sculpted by artists who were close to the battlefront and knew what both the Romans and the Dacians really wore in battle. The sculptors who carved the great spiral on Trajan's Column showing the Dacian campaign in a continuous frieze worked in Rome. They knew merely what the legionary soldier was supposed to wear—not what he did wear.

THE "MUSCLED CUIRASS." The "muscled cuirass" which encased the torso and showed the pectoral and stomach muscles underneath, was developed in the Hellenistic world, and the emperor Augustus made it a popular type for imperial sculpture. One of the most famous statues of Augustus, the Prima Porta statue, shows him in a warrior's uniform with a muscled cuirass that sculpted the musculature of his abdomen. Augustus is portrayed with the physique of an athlete—in fact, his body has the proportions which the classical sculptor Polycleitus used for his nude figures of athletes—and his breastplate follows the contours of the well-developed

pectoral and stomach muscles which the onlooker is to assume were underneath it. (In fact, Augustus did not have an athlete's physique; he was not an impressive physical specimen.) Statues of torsos encased in armor plate of this sort have been found all over the empire, often headless, for the heads were sculpted separately and fitted to the base of the neck. It was a favorite type for statues of emperors. In fact, archeologists have not found a single example of an actual Roman "muscled cuirass," though there are examples surviving from the Hellenistic period. This suggests that in the Roman period, the muscled cuirass was parade armor, more popular with sculptors than it was on the battlefield. The Roman sculptors show two types: one with a high waist which would be suitable for a horseback rider, and the other coming further down the hips with a curved extension at the bottom that would not be very suitable for a cavalryman. These cuirasses were fastened at the sides with hinges or rings that were tied together.

HELMETS. The helmet of the early Roman legionary soldier was an inverted hemispherical bowl with cheek pieces. Large numbers of these helmets were found in a region of northern Italy called Montefortino, and so nowadays it is called the *Montefortino* helmet. A cheaper alternative to the *Montefortino* was the *Coolus* type which had a neck guard to protect the back of the neck. Both types were borrowed from the Celts, with whom the Romans fought many battles from 387 B.C.E. when a horde of Celts sacked Rome, down to the end of the second century B.C.E. The Romans romanized them by adding crests, which at first were made of feathers fitted to a knob on the crown of the helmet, but by the end of the first century B.C.E. they were made of horsehair, either red or black. In the Civil War period of the first century B.C.E. new types of helmets appeared made of iron rather than bronze, with distinctive cheek guards, embossed eyebrows and ribbing at the rear of the helmet. The crest was no longer fixed to a knob but to a crest holder on top of the helmet. Crests were ornamental, and may have been worn into battle in the early imperial period, but the troops shown on Trajan's Column did not wear crests. The helmet continued to develop to give the wearer increased protection until by the third century C.E., the head was almost completely encased.

KEEPING WARM. Roman armies operated in varied climates, from the chilly wet weather at Hadrian's Wall in Britain to the Euphrates River in modern Iraq. Keeping cool in hot weather was a genuine problem. Troops clad in mail armor operating on the eastern frontier were known as *clibanarii*, a word which comes from *clibanus*, meaning "oven." In other words, in hot weather, mail-

clad troops baked. In colder climates, however, the soldier had a variety of cloaks to keep him warm. The sleeveless cloak of variable length called the *paenula* was made of heavy wool cloth, leather, or sometimes fur. It varied in length, and sometimes had a hood. It survives as the *chasuble*, a sleeveless vestment worn by priests who are saying Mass. Another item of clothing that was taken over as a vestment of the church was the *dalmatica*, so called because it was woven from the wool of sheep from Dalmatia (the eastern coast of the Adriatic Sea). It was a long tunic with long, wide sleeves which came into fashion in the second century C.E. The *cucullus* was a close-fitting cape with a peaked hood which extended to the waist. It gave protection against rain and cold. If it were open in front, it would have to be held together by a fastener of some sort, but if it was closed in front—as some of them were—it would have to be put on over the head, like a poncho. The *lacerna* was a cloak first worn by the troops which became popular among civilians because it was a practical overgarment for the toga. The *sagum* was a short military cloak of rough wool which Rome borrowed from the Gauls, and it became so popular with the soldiers that "putting on the *sagum*" was an idiom for going to war. It was probably no more than a rectangle of heavy cloth draped over the shoulders and tied under the chin. The *paludamentum* was a military cloak for the general. It was woven from purple wool, and though the size could vary, nine feet long and five feet wide is a good estimate of its size. When it is shown in sculpture, it is held at the right shoulder by a round brooch and then is thrown back so that the general's—or emperor's—muscled cuirass can be shown. It was a garment for parades, not for campaigning in the field.

KEEPING THE LEGS WARM. The opinion shared by both Greeks and Romans was that trousers were barbarian dress. The Gauls wore them. They were called *bracae* in Latin, a word related to the English word "breeches." Vergil in his *Aeneid* called them "the barbarian coverings of the legs." In the days of the Roman republic, the province of Transalpine Gaul—that is, Gaul beyond the Alps—had the unofficial name of "Gallia bracata": Gaul where the people wear trousers. On the other hand, Cisalpine Gaul—Gaul south of the Alps, that is, the Po Valley of Italy which had been colonized by Gauls in the fifth and fourth centuries B.C.E.—was "Gallia togata": the Gaul where togas were worn. If Roman soldiers disparaged trousers as barbaric, they did deign to wear stockings. At Vindolanda, one of the forts along Hadrian's Wall in the United Kingdom, a cache of Roman writing tablets contained a letter from a Ro-

man soldier thanking a friend or relative for the gift of a pair of socks and underpants. Socks, often brightly colored, were also worn by civilians. The emperor Augustus himself, who was not robust, liked warm stockings. In the fourth century C.E. paintings and mosaics show a new type of leg covering, which seems to be a strip of cloth wrapped around the lower legs like the puttees worn by soldiers in the First World War. Presumably the soldier also wore socks in his military boots. The Roman prejudice against trousers was not universal; the soldiers recruited from non-citizen provincials who served in the Roman forces for 25 years and received citizenship when they were discharged did apparently wear trousers.

SOURCES

Norma Goldman, "Reconstructing Roman Clothing," in *The World of Roman Costume.* Eds. Judith Lynn Sebesta and Larissa Bonfante (Madison, Wisc.: University of Wisconsin Press, 1994): 213–237.

Mary G. Houston, *Ancient Greek, Roman and Byzantine Costume and Decoration.* 2nd ed. (London, England: Adam and Charles Black, 1947).

A. H. Snodgrass, *Early Greek Armour and Weapons* (Edinburgh: Edinburgh University Press, 1964).

———, *Arms and Armour of the Greeks* (London, England: Thames and Hudson, 1967).

Graham Sumner, *Roman Army: Wars of the Empire* (London, England: Brassey's, 1997).

George R. Watson, *The Roman Soldier* (London, England: Thames and Hudson, 1969).

SIGNIFICANT PEOPLE
in Fashion

ALCIBIADES

c. 450 B.C.E.–404 B.C.E.

Politician

CREATING THE RIGHT IMPRESSION. Public figures in Greece often dressed to create an impression, and none more so than Alcibiades, the Athenian general who assumed the leadership of the extreme democrats in Athens in 420 B.C.E. and contributed as much as anyone to the Athenian defeat in the Peloponnesian War which ended in 404 B.C.E. with the surrender of Athens to Sparta and her allies. Alcibiades intended for his fashions and his

private life to attract notice as a member of the "smart set" in Athens, a group typically condemned by conservative Athenians as having no respect for principles or tradition. Plutarch (c. 46–later than 120 C.E.), in a short biography of Alcibiades, compared his shrewdness as a statesman with the profligacy of his private life.

> But with all these words and deeds, and with all this sagacity and eloquence, he mingled exorbitant luxury and wantonness, in his eating and drinking and dissolute living; wore long purple robes like a woman which dragged after him as he went through the market-place; caused the planks of his trireme to be cut away, so that he might lie more softly, his bed not being placed on the boards but upon girths.

Alcibiades took great care of his appearance; he refused to learn to play the *aulos*—the reed woodwind often mistakenly called a "flute"—because a person playing it had to screw up his face so much that it looked ugly. Alcibiades considered the lyre to be a far more becoming instrument, particularly since one could still talk and sing while playing the lyre.

Alcibiades promoted the ill-fated Athenian expedition against Sicily (415–413 B.C.E.) which ended in complete disaster. Alcibiades himself was recalled from Sicily in 415 B.C.E. to face a charge of sacrilege; not daring to face an Athenian court, he deserted to Sparta. Once there, he adopted the austere Spartan way of life, abandoning his expensive mantle of Milesian wool. He took cold baths and exercised regularly, naked, like the Spartans. Then when he wore out his welcome at Sparta, he transferred his services to Persia, and adopted Persian dress and the Persian way of life. Finally he answered a call from the sailors of the Athenian fleet to lead them and he became an Athenian general once again until his fleet suffered a defeat by Sparta. He was not personally responsible for the defeat, but nonetheless he lost his command and did not dare return to Athens. Athens surrendered in 404 B.C.E., and after the surrender, Alcibiades was assassinated at the instigation of Sparta out of the belief that Athens would never acquiesce in her defeat as long as Alcibiades was alive.

SOURCES

Edmund Bloedow, *Alcibiades Reexamined* (Wiesbaden, Germany: Franz Steiner, 1971).

Walter M. Ellis, *Alcibiades* (London, England: Routledge, 1989).

Donald Kagan, *The Fall of the Athenian Empire* (Ithaca, N.Y.: Cornell University Press, 1987).

———, *The Peace of Nicias and the Sicilian Expedition* (Ithaca, N.Y.: Cornell University Press, 1981).

CONSTANTIUS II

317 C.E.–361 C.E.

Roman emperor

DRESSING FOR THE IMPERIAL OFFICE. Roman emperors, from the first emperor Augustus (27 B.C.E.–14 C.E.) onwards, had always sought to maintain the dignity and prestige of their office with their dress and their deportment, but from the end of the third century C.E. their efforts to set themselves apart from ordinary citizens became more pronounced. One of the most striking descriptions of this period of an emperor on public display concerns Constantius II, who inherited the empire along with his two brothers, Constantine II and Constans, after the death of his father, Constantine I, in 337 C.E. Upon the deaths of his brothers in 340 and 350, respectively, he became ruler of the whole empire. In 357 C.E. Constantius II visited Rome for the first time, and his ceremonial entrance into the city is described vividly by the last great classical historian to write in Latin, Ammianus Marcellinus. The emperor rode, seated in a golden coach studded with precious stones. Before him were attendants with banners in the shape of dragons billowing in the wind, tied to the tips of golden, jewel-studded lances. On both sides of his coach were soldiers with shields, plumed helmets, and gleaming breastplates, and along with them in the parade were corps of cavalrymen wearing armor made of thin plates of steel that covered their bodies. Constantius II stared straight ahead, not acknowledging the cheers, though when he passed under a gateway he stooped slightly as if he were too tall to fit under it, thought he was, in fact, a rather short man. He did not spit or blow his nose; instead he remained motionless, even when his coach jolted over a bump in the road. He attempted to appear superhuman.

REFLECTS CHANGE IN STATUS. While the Roman Empire was still pagan, Roman emperors had been considered divine, and loyal subjects sacrificed to them. But after Constantine I, all the Roman emperors save one were Christian, and their relationship to the divine world had to change. The emperors became the deputies on earth of God in Heaven, and as such, they had to adopt a style and deportment that fitted this new Christian concept of the imperial office. The "advent" or ceremonial entrance of Constantius II into Rome in 357 C.E. is a vivid illustration of this new fashion in practice.

SOURCES

Ammianus Marcellinus, *The Later Roman Empire*. Trans. Walter Hamilton (Harmondsworth, England: Penguin Books, 1986): 100–101.

H. P. L'Orange, *The Roman Empire: Art Forms and Civic Life* (New York, Rizzoli, 1985).

DIOGENES

c. 400 B.C.E.–c. 325 B.C.E.

Philosopher

FASHION FOR A PHILOSOPHER. Philosophers did not always dress according to convention. Empedocles (c. 493–c. 433 B.C.E.)—best known for defining the four elements of earth, air, fire and water—wore sandals with soles of bronze. Socrates went barefoot in all weather. But the philosopher who made a cult of shunning all luxury was Diogenes of Sinope, who founded the Cynic school of philosophy (though some credited its foundation to a disciple of Socrates named Antisthenes, whom Diogenes considered his teacher). Diogenes was exiled from Sinope on the south shore of the Black Sea, some said because either he or his father was the city's mint master and minted coins that were adulterated with base metal. He came to Athens and soon made a reputation as a man who rejected all conventions. He maintained that a person would attain happiness by satisfying his needs in the simplest possible way.

INSULTED THOSE IN FINERY. There were various stories told about his rude remarks to persons dressed in finery whom he met. A young man who was splendidly attired asked him some questions, and Diogenes said he would not answer until he discovered if his questioner was a man or a woman. He told a man who gave himself airs because he was wearing a lion's skin not to disgrace the garb of nature. When he saw a youth dressing himself with care so as to look neat and handsome, he told him that if he was beautifying himself to impress men, he was to be pitied, and if for women, he was immoral. His rudeness earned him the nickname "dog" (in Greek, *kyon*), from which comes the word "cynic"; hence his followers were called "Cynics."

NOT A FORMAL SCHOOL. The Cynics were never organized into a formal school of philosophy, but like the "hippies" of the 1960s and the 1970s in America, every Cynic chose his own philosophy. The common thread amongst Cynics was a love of the simple life and disdain for fine clothes and all possessions. Although the Cynic sect faded out in the second and first centuries B.C.E., it revived in the first century C.E., and Rome was full of Cynic beggar philosophers whose shabby clothes proclaimed their calling. Like Diogenes, they exercised the right of free speech, and their open criticism of the emperors frequently earned them banishment from Rome.

SOURCES

Donald R. Dudley, *A History of Cynicism from Diogenes to the Sixth Century A.D.* (London, England: Bristol Classical Press, 1998).

Mark Edwards, "Cynics," in *Encyclopedia of Greece and the Hellenic Tradition.* Ed. Graham Speake (Chicago, Ill.: Fitzroy Dearborn, 2000): 426–427.

DOCUMENTARY SOURCES
in Fashion

Author unknown, *Periplus of the Erythraean Sea* (c. 100 C.E.)—The unknown author of this mariner's handbook was familiar with trade along the sea routes from the Red Sea ports to India, and among the commodities that came to the Roman Empire from the east were Indian cotton, raw silk, silk yarn and silk cloth and "mallow cloth" or jute, a rough fiber used nowadays for gunny sacks.

Herodotus, *The Histories* (c. 425 B.C.E.)—The main subject of *The Histories* is the Persian War of 480–479 B.C.E. when Persia attempted to invade Greece, but Herodotus tells why the Athenian women abandoned the Dorian *peplos* for the Ionian linen *chiton* in the last years of the sixth century B.C.E.—it was because the Athenian women used the safety-pins that fastened the *peplos* at the shoulders to stab a man to death.

Ovid, *The Art of Love* (c. 1 C.E.)—Ovid's manual in poetry of how to win the love of women contains a wealth of information about the fashions of Rome in the reign of the emperor Augustus.

Phaidimos, *Peplos Kore* (about 530 B.C.E.)—This statue of a girl dedicated in the sanctuary of Athena on the Acropolis of Athens and discovered when the Acropolis was excavated in the late nineteenth century, shows a simple Dorian *peplos* of the style worn by Athenian women in the mid-sixth century B.C.E.

Pliny the Elder (Gaius Plinius Secundus), *Natural History* (c. 79 C.E.)—This great ragbag of information was still being revised when Pliny died in the eruption of Mt. Vesuvius in 79 C.E. It contains a good deal of information about cloth-making and dying in Italy of the first century C.E.

Plutarch, *Life of Alexander the Great* (after 100 C.E.)—Plutarch's collection of biographies titled the *Parallel*

Lives includes a life of Alexander the Great that relates his attraction to Asian costumes—he did not go so far as to adopt trousers, a sleeved vest or the pointed cap called the "tiara," but he adopted other fashions from Persia, and this greatly displeased his fellow Macedonians.

Sculptor Unknown, *Kore* from Acropolis of Athens wearing Ionian *chiton* and over it, a *himation* (c. 510 B.C.E.)—This statue of a young girl was dedicated on the Acropolis of Athens near the end of the sixth century B.C.E. and her dress illustrates the change of fashion in the two decades or so since the *Peplos Kore* was dedicated. This girl wears a colorful linen *chiton* under a draped woolen *himation* with an edge which shows how skillfully cloth-makers could weave patterned material.

Tertullian (Quintus Septimius Florens Tertullianus), *De Pallio* ("On my Cloak"; 209 C.E.)—Tertullian, a doughty defender of Christianity, here writes in a light-hearted vein. He has been upbraided for abandoning his Roma toga for a *pallium*, a Greek cloak favored by philosophers and here he explains why.

Thucydides, *History of the Peloponnesian War* (c. 400 B.C.E.)—Thucydides' subject was the war between the Athenian empire and the Spartan alliance (431–404 B.C.E.) but he prefaces it with a discussion of the economic and social progress of Greece in the archaic period. Among the topics which he touches upon is "Fashion"; the Athenians, he claims, were the first to adopt luxurious "Ionian" linen garments whereas the Spartans used the simpler styles which in Thucydides' own day became the preferred fashion in Greece.

Titus Livius, *Ab urbe condita libri cxlii* ("History of Rome from its Foundation, 142 Books"; 39 B.C.E.—17 C.E.)—A passage of Livy's *History* (34.1) describes a demonstration in Rome by women for the repeal of a law passed twenty years before in the aftermath of the disastrous Roman defeat by Hannibal at Cannae which restricted expensive and luxurious fashions. The women continued to demonstrate until the law was repealed.

Vegetius (Flavius Vegetius Renatus), *De Re Militari* ("On the Military Arts"; c. 390 C.E.)—Vegetius' subject is the art and science of war, but one section of his first book deals with the history of arms and armor.

chapter four

4

LITERATURE

James Allan Evans

IMPORTANT EVENTS
in Literature

c. 725 B.C.E.
–c. 675 B.C.E. Homer's epic poems *Iliad* and *Odyssey* are written down.

c. 700 B.C.E. Hesiod writes the *Theogony* and the *Works and Days*.

c. 650 B.C.E. Archilochos of Paros wins a reputation for his iambic and elegiac poetry.

c. 620 B.C.E. The lyric poet Alcaeus of Lesbos is born.

c. 612 B.C.E. The poetess Sappho of Lesbos is born.

535 B.C.E. A dramatic competition is held in Athens for the first time.

534 B.C.E. Thespis of Icaria, the first tragedian to appear as an actor and take a solo role apart from the chorus, wins a prize for tragedy in the dramatic competition in Athens.

518 B.C.E. The lyric poet Pindar is born.

c. 493 B.C.E. The Athenian tragic poet Phrynichus produces *The Capture of Miletus* on the fall of Miletus to the Persians in 494 B.C.E. and is fined for reminding the Athenians too clearly of the misfortunes of their friends.

472 B.C.E. Aeschylus produces his play *The Persians*.

468 B.C.E. Sophocles wins his first victory in the writing of tragic plays, defeating Aeschylus.

467 B.C.E. Aeschylus produces his *Seven Against Thebes*, the last play of a trilogy on the Oedipus legend.

462 B.C.E. Aeschylus produces his play *Suppliants*.

458 B.C.E. Aeschylus produces his trilogy, the *Oresteia*, consisting of the *Agamemnon*, the *Choephoroe*, and the *Eumenides*, all of which have survived; a satyr play, the *Proteus*, is lost.

456 B.C.E. Aeschylus dies at Gela in Sicily.

455 B.C.E. Euripides makes his first appearance in a tragic contest with a set of three tragedies and one satyr play, placing third—that is, last.

c. 442 B.C.E. Sophocles produces his tragedy, the *Antigone*.

438 B.C.E. Euripides produces his play *Alcestis* which has a happy ending and is substituted for a satyr play in his tetralogy.

425 B.C.E. Aristophanes produces his play *Acharnians*, the earliest example of Old Comedy to survive.

405 B.C.E. Euripides dies only a few months after Sophocles.

322 B.C.E. The orator Demosthenes dies, taking poison to avoid capture by the Macedonians.

305 B.C.E. Callimachus is born. He will become a librarian at the great library at Alexandria and a poet typical of the Alexandrian school, writing for a small but well-educated group of readers.

293 B.C.E. Menander, the Athenian playwright who was the greatest master of New Comedy, dies before reaching the age of fifty.

c. 270 B.C.E. Gnaeus Naevius, author of the Latin epic *The War against Carthage* and the inventor of the Roman historical play, is born.

240 B.C.E. The first play, a Latin adaptation of a Greek tragedy by Livius Andronicus, is produced in Rome at the Harvest Festival (*ludi Romani*).

239 B.C.E. The Roman poet Quintus Ennius is born. He will write the *Annals*, eighteen books of epic poetry written in the dactylic hexameter borrowed from Greek epic poetry.

205 B.C.E. Plautus produces his play *Miles Gloriosus* in Rome.

166 B.C.E. Terence produces his first play, the *Andria* (Woman of Andros).

106 B.C.E. Rome's greatest orator, Marcus Tullius Cicero, is born in the Italian town of Arpinum (modern Arpino). In addition to his speeches, Cicero would write dialogues on philosophy, rhetoric and religion, and a large corpus of his private letters also survives.

c. 84 B.C.E. The poet Catullus is born at Verona.

70 B.C.E. Cicero prosecutes the politician Verres for maladministration in Sicily. After trial, Cicero publishes his speeches against Verres under the title *Verrine Orations*.

63 B.C.E. Cicero is consul and delivers his four Catiline orations, exposing the conspiracy of Catiline.

Vergil is born near Mantua in what was at that time the Roman province of Cisalpine Gaul.

59 B.C.E. The Roman historian Livy (Titus Livius) is born. He will write a history of Rome from its foundation.

44 B.C.E. –43 B.C.E. Cicero delivers fourteen speeches known as his "Philippics" attacking Mark Antony, Julius Caesar's adjutant who attempted to seize power after Caesar's assassination. His criticism of Mark Antony results in his execution at the end of 43 B.C.E.

43 B.C.E. Ovid is born at Sulmo, modern Sulmona about 90 miles (150 kilometers) east of Rome.

c. 42 B.C.E. Vergil joins the circle of Maecenas, the wealthy public relations minister of Julius Caesar's heir and adoptive son,

Octavian, who would become the emperor Augustus. At the urging of Maecenas he writes his *Georgics*, a didactic poem in four books on husbandry, between 37 and 29 B.C.E.

30 B.C.E. Horace publishes his *Epodes*, adapting the iambics of Archilochus to Latin.

23 B.C.E. Horace publishes the first three books of his *Carmina*, that is, his songs.

19 B.C.E. Vergil dies, leaving his epic poem the *Aeneid* unfinished. Nonetheless the *Aeneid* would become the national epic of the Roman Empire.

c. 13 B.C.E. Horace publishes the fourth book of his *Carmina*.

c. 17 C.E. Columella (Lucius Junius Moderatus Columella), the writer of a treatise on husbandry, is born.

37 C.E. Flavius Josephus is born. He will write the *Antiquities of the Jews* and the *Jewish War*, an account of the insurrection in Judaea which broke out in 66 B.C.E.

c. 56 C.E. The historian Cornelius Tacitus is born. He will write the *Annales*, covering the history of the Julio-Claudian emperors from Tiberius to Nero, and the *History* which continued it from the Year of the Four Emperors, 68 C.E.

c. 65 C.E. Pliny the Younger (Gaius Plinius Caecilius Secundus), nephew of Pliny the Elder, is born. He will write the *Letters of Pliny* and a panegyric (a formal oration) in praise of the emperor Trajan.

65 C.E. The epic poet Lucan is implicated in a conspiracy against the emperor Nero and forced to commit suicide.

c. 66 C.E. Petronius Arbiter, author of the Latin novel *Satyricon*, commits suicide after being accused on a trumped-up charge of treason against the emperor Nero.

79 C.E. Pliny the Elder, author of the *Natural History*, dies in the eruption of Mt. Vesuvius.

OVERVIEW
of Literature

KEY DATES. A general survey of literature in the world of ancient Greece and Rome takes us from the eighth century B.C.E. to the sixth century C.E., a span of nearly 1,400 years. Greek literature began with the development of the Greek alphabet in the eighth century B.C.E. that became the basis of the Latin alphabet still used by the romance languages. Greek literature then spawned Roman (Latin) literature as the Romans fell under the influence of Greek culture; the conventional date for the beginning of Latin literature is 240 B.C.E. when the Greek ex-slave Livius Andronicus translated the Greek poet Homer's *Odyssey* into Latin. The unofficial end of Greco-Roman literature can be linked to the closing of the Neoplatonic Academy in Athens in 529 C.E., which marks the end of Athens as a center for the teaching of Greek philosophy and the traditions of the pagan world. While this is a convenient marker for the end of the Greco-Roman literary tradition, the literary and philosophic traditions of the pre-Christian Greco-Roman world did not come to such an abrupt end. Moreover, the output of Christian literature in Greek and Latin was not affected by the closure of the Academy in Athens.

THE HEROIC AGE. In the years prior to 1100 B.C.E. there was a Bronze Age civilization in Greece which scholars labelled "Mycenaean" after its most important center, Mycenae, in the Argolid region south of the Isthmus of Corinth. The Mycenaeans were descended from Greek-speaking migrants who entered Greece shortly after 2000 B.C.E., but their civilization started to flower around 1600 B.C.E. thanks to contacts with Egypt, the Near East, and, in particular, with the "Minoan" civilization on Crete. Five hundred years later, this Mycenaean civilization came to an end, overwhelmed by unknown invaders who left a trail of destruction all over the eastern Mediterranean. Yet, as this civilization receded into the misty past, it left behind the literary heritage of an heroic age. The Greeks told stories of mythical heroes such as Heracles, the superman of Greek mythology; Jason and his Argonauts who sailed in quest of the Golden Fleece; and Oedipus, king of Thebes in central Greece who was fated to kill his own father and marry his mother. Greek literature began with oral bards who sang poems about the exploits of such heroes in the banquet halls of aristocrats, or at the religious festivals. The most famous of these myths was the tale of the Trojan war in which the Greeks laid siege to the city of Troy in order to reclaim the kidnapped wife of a Greek king. The epic tale of famous warriors and scheming gods told in Homer's *Iliad* and *Odyssey* may have been based on an actual event; the ruins of Troy have been found in the northwest corner of Asia Minor near the entrance to the Hellespont. The myth of Troy provided material for Greek poetry and drama throughout the great period of Greek literature.

HOMER AND EPIC POETRY. The written literature of Greece begins with Homer. We have no concrete information about his identity. The legend that he was blind might be true but it cannot be proved. The two epics attributed to him, the *Iliad* and the *Odyssey* both take their subject matter from the Trojan War myths, but they differ greatly in tone and temper. The *Iliad* describes how the hero Achilles made the quest for glory his all-important aim, while the *Odyssey* relates a story of survival as the Greek hero Odysseus endures a journey of ten years before returning home from the war. The Homeric poems were not unique in their subject matter. Other poets told stories of the heroes, and some fragments of their epics still exist. But out of the great crop of heroic poetry only the *Iliad* and *Odyssey* have survived complete. At the same time, there was another school of epic which catered to a less aristocratic audience, and its great representative was Hesiod.

OTHER POETIC FORMS. The epic soon had to share the limelight with other genres of poetry, such as elegiac, iambic, and personal and choral lyric. Elegiac poetry may first have been used for war poems, for its earliest masters wrote of the glory and horrors of warfare, but it became the favorite vehicle for expressions of love and pleasure thanks to an early master of elegy, Mimnermus of Colophon, the first hedonist in Western literature. The foremost master of iambic poetry was Archilochus of Paros, a lighthearted cynic who attacked the ideals of chivalry and heroism in battle. Lyric poetry dealt with personal feelings: political animosities, the pleasure of wine, and love. Alcaeus of Lesbos was a master of personal lyric, that is, songs meant to be sung at private gatherings of like-minded people; the greatest of the lyric artists, Sappho, also of Lesbos, wrote of love and marriage with an intensity which no later poet would match.

THE CHORAL ODE. Moving from the sixth into the fifth century B.C.E., two masters of a different type of lyric arose to popularity: Simonides of Ceos and Pindar. The first pioneered the *epinikion*, a victory ode sung by a choir in honor of a winner in one of the great athletic contests. Simonides was also famous for the epigrams he wrote for the monuments of the Greek warriors who died in the Persian Wars (490–479 B.C.E.), and recently a long papyrus fragment of his poem on the Battle of Plataea (479 B.C.E.) has been discovered. Pindar wrote a variety of poetry, but what has survived are his victory odes for the prize winners at the great athletic games. His style was elevated, with many allusions to Greek myths familiar to his listeners. Bacchylides, the third writer of choral lyrics who deserves mention, struck a different tone. His style was straightforward and simple. He marks the end of the great age of choral lyric.

DRAMA. The fifth century B.C.E. was the great age of drama, and the chief patron was Athens. There were two dramatic festivals, held in honor of Dionysus, the god of drama: the City Dionysia in March and the Lenaean festival in January. Comedies were presented on the second day of the festival, followed by three full days of tragedies—one day for each tragic poet who had been assigned a chorus by the archon, the chief magistrate of Athens. Each day three tragedies would be produced, followed by a burlesque called a satyr play, and at the end, the audience would judge which tragedian won. The costs of production were paid by wealthy citizens who were expected to defray them as their civic duty. The vast majority of these comedies and tragedies have been lost, but there is still a representative number by the playwrights whom the Greeks themselves judged the best: Aristophanes for comedy, and Aeschylus, Sophocles, and Euripides for tragedy. Tragedies continued to be written after the fifth century B.C.E. but the heyday of the genre was over, and with the conquest of Greece by Alexander the Great's father, Philip, the classical age of literature came to an end. A century after Aristophanes, a new dramatist, Menander, produced comedies in Athens that gave a new look to the stage. Menander's comedies took their plots from domestic life. The political lampoons and bawdy jokes of Aristophanic comedy disappeared; the "New Comedy" of Menander and his rivals belonged to a new political climate, when writers had to be more cautious about what they wrote.

THE WRITERS OF HISTORY. Herodotus, whose *Histories* were published about 425 B.C.E., was the first Western historian who did not merely record what events happened; he asked why they happened. His search for the reason why Persia invaded Greece led him to examine the mainsprings of Persian imperialism. Thucydides, a younger contemporary of Herodotus, chose to write on more current history: the great war between Athens and Sparta (431–404 B.C.E.), and he left his work unfinished. His history was an accurate year-by-year analysis of the war, and it is a splendid study of war psychosis. Time has been unkind to the successors of Herodotus and Thucydides, such as Theopompus and Ephorus who wrote in the fourth century B.C.E., and the historians who wrote about Alexander the Great, of whom there is only secondhand knowledge. In the second century B.C.E. Greece produced another great historian, Polybius, whose subject was the rise of Rome.

THE HELLENISTIC AGE. In the Hellenistic Age, after Alexander the Great's death, Alexander's generals founded kingdoms which self-consciously cultivated Greek culture. In Egypt, the Ptolemaic kings built a great library at their capital, Alexandria, and made it a center of literary culture. The writers and researchers who worked there wrote for a restricted audience, for the Greeks were a minority in Egypt and the Egyptians preferred their own native culture. The leading Alexandrian poet was Callimachus, who was greatly admired though his surviving poetry seems dry to modern readers. Two other Alexandrians wrote more engaging material; Apollonius of Rhodes and Theocritus. Apollonius wrote an epic poem on the quest of Jason for the Golden Fleece, which reads more like a romantic novel than a heroic epic. While Theocritus wrote many kinds of poetry, his fame rests on his bucolic idylls: pastoral poetry full of yearning for the countryside and the life lived there. The power of Greek culture influenced even the mighty Rome, which conquered the flourishing Greek cities in southern Italy and Sicily in the third century B.C.E. Contrary to most trends of war in which the conquered culture is subsumed into that of the conqueror, Greek culture became preeminent in Rome after Greece's defeat. The Latin poet Horace commented on this phenomenon in saying, "When Greece was captured, she took captive her rough conqueror." Latin literature begins with a Greek, Livius Andronicus. He came to Rome as a slave, was freed, and became a teacher, and then an actor and stage-manager. His translation of the *Odyssey* from Greek into the Roman language of Latin marks the beginning of Latin literature. The Roman ruling class fully embraced Greek literature, and there was soon a cultivated circle that learned to speak Greek and engaged Greek culture. The

Romans valued the Greek culture and language so much that the first Roman historians wrote in Greek rather than Latin.

THE BEGINNINGS OF LATIN LITERATURE. The Romans did not long shun their native language, quickly developing literature in Latin. A younger contemporary of Livius Andronicus, Plautus, translated and modified plays from the Greek "New Comedy" for Roman tastes. Ennius wrote an epic on the history of Rome, adapting the Homeric meter to Latin. The hard-boiled Roman statesman, Cato the Elder, wrote the first history of Rome in Latin in the second century B.C.E., and in the next century, there was a flowering of Latin literature: Julius Caesar described his conquests in unadorned prose, Cicero was famous both for his oratory and his philosophic works that introduced Greek ideas into a Latin context, and the poetry of Catullus marked a new wave when poets broke free of the conventions of the past. The Golden Age of Latin literature came with the next generation, under the emperor Augustus, whose minister of culture, Maecenas, gathered about him a circle of poets. He had an ulterior motive besides his support of culture: Augustus wanted literature to serve the interests of his new regime. He wanted his achievements celebrated in poetry, and the poet Vergil rose to the challenge. He did not write an epic on Augustus, but instead chose for his subject the Trojan hero, Aeneas, whom Augustus claimed as his ultimate ancestor. Although another Trojan hero, Hector, overshadows Aeneas in Homer's *Iliad*, Aeneas was the hero who survived the fall of Troy; long before Vergil wrote his *Aeneid*, the Romans had claimed him as the warrior who came to Latium and founded the royal line to which Rome's founder, Romulus, belonged. Vergil wove Greek and Latin mythology into the fabric of his great epic, and he added a new episode: a romance between Aeneas and Dido, queen of Carthage, which ends with Aeneas deserting Dido at the command of Jupiter, who has destined him to lay the foundation of the Roman Empire. Latin literature had a second great period in the first century B.C.E., with writers such as the historian Tacitus, the biographer Suetonius, the satirist Juvenal, and the novelist Petronius producing major works. Literary production continued, but the spark of genius did not reappear until the late empire, with the soldier-historian Ammianus Marcellinus and a crop of other authors in both Latin and Greek who continued to write in the classical tradition. At the same time there was a flowering of Christian literature in both languages: hymns, ecclesiastical histories, and chronicles which bring us to the threshold of the Middle Ages.

TOPICS
in Literature

THE AGE OF HOMERIC EPIC

THE EMERGENCE OF THE CITY-STATE. The word "city-state" is a translation of the Greek word *polis* from which we derive the word "politics." It was the political unit that arose out of the ruins of the Mycenaean world, and had a social and economic structure closer to that of Babylon and ancient Egypt than to the later world of classical Greece. The palaces where the Mycenaean *wanaktes*—a word meaning something like "god-kings"—had their seats were also bureaucratic centers where clerks kept records and dispatched memoranda to lower-ranking officials. Among them were the headmen of the various villages with the title *pa-si-reu*, a word that evolves into the classical Greek *basileus*, a king with a legitimate claim to the throne based on heredity and the favor of the gods. When the Mycenaean civilization was destroyed in the century of upheavals and migrations after 1200 B.C.E., the *wanaktes* and their palaces were swept away, and the need for writing disappeared along with them. Yet the *basileis* with their little domains endured, and once life in Greece became more secure again after 1000 B.C.E., these little baronies emerged as self-governing political units. It was in the halls of these little kings that bards improvised tales of the heroes that would eventually become the *Iliad* and the *Odyssey*.

THE WORLD OF HOMER. Homer's reputation as Greece's greatest epic poet rests on two famous works attributed to him: *Iliad* and *Odyssey*, which focus on a legendary war between Greece and Troy known as the "Trojan War" and its aftermath. While these works have been studied over centuries to modern times, details of the life of Homer are sketchy at best. Greek sculptors made portraits of him that can be easily recognized by their blind eyes and beetling brow, but they are imaginative creations rather than a true representation of his appearance. Several cities claimed to be his birthplace. The two with the best claims were Chios, one of the Dodecanese islands off the Turkish coast, and Smyrna, an important Greek settlement on the west coast of Asia Minor. Both were Ionian cities founded during the "Dark Ages" of Greece by refugees who were displaced by a wave of migrants into the Peloponnesos after the collapse of the Mycenaean world. Homer's dialect of Greek is mostly Ionic, though his Greek was not the Greek of the streets; it was "epic Greek," the language

used by epic poets. We do not know exactly when he lived. It is clear from the *Iliad* and *Odyssey* that the Trojan War took place long before they were written, in an age when men were mightier than in the contemporary world. Yet, since the *Iliad* and *Odyssey* were written down, it follows that Homer could write, or else dictated to someone who could. Thus we must date him *after* the Greeks borrowed the north Semitic alphabet from the Phoenicians and adapted it to their own use, adding vowels which the Phoenician alphabet lacked. When the adaptation occurred is much disputed, but the general consensus dates it not long after 800 B.C.E. So a Homer who knew how to write could have lived as early as the first half of the eighth century B.C.E., but hardly earlier. For the latest date, the *terminus ante quem* as it is called, a fragment of a vase found on the island of Ischia off the coast of Naples provides a clue. An inscription in verse on the vase fragment refers to a cup belonging to the hero Nestor which is described in the *Iliad*, and the vase is dated to before 700 B.C.E. Therefore, the epic must have been written before this vase was made. This date allows scholars to pinpoint the period between 725 and 675 B.C.E. as the time when the *Iliad* and the *Odyssey* were written down.

PERFORMANCE OF THE EPIC POET. The poems of Homer were composed in an age when oral bards sang poems to the accompaniment of the lyre, with the epic composed like music written in half and quarter notes; a long syllable equals a half note and a short syllable a quarter note. The stress accents found in medieval and modern poetry did not exist in this poetry, which was written to be sung, but there were pitch accents; almost every word had a pitch accent where the voice went up or down. The music of the lyre—an instrument with strings which the bard plucked as he sang—provided a melodic background. As he sang, dancers might perform to the music, but both the music and dance were subordinated to the spoken word. The poems of Homer must have started out as songs that were sung by bards but at some point they were committed to writing. Schoolboys learned them and committed portions of them to memory. They were recited at religious festivals. They had an influence on the language of Greece similar to the effect that the English translation of the King James Bible of 1611 had on the English language. The Homeric poems not only mark the beginning of Greek literature; their influence is felt in all aspects of Greek culture.

THE TROJAN WAR. The legend of the Trojan War probably has an historical basis, for there is archaeological evidence that around 1250 B.C.E. a fortified city came to a violent end on the site which Greek tradition identified as Troy. So there was once a war that ended with the capture of Troy, but the story relayed in Homer's telling of the Trojan War is an imaginative one that includes the involvement of the gods. In fact, the conflict begins with the gods when a beauty contest between the goddesses Athena, Hera, and Aphrodite takes an ugly turn. Having chosen a mortal prince from Troy named Paris to judge who was the most beautiful, each goddess attempts to bribe the young man to select her, and Paris chooses Aphrodite on the basis of her promise to give him the most beautiful woman in the world. Unfortunately, the most beautiful woman in the world, Helen, is already the wife of a Spartan (Greek) king named Menelaus, so Paris' abduction of her to Troy prompts the Greeks to muster a fleet in pursuit of her under the leadership of the high king of Greece, Agamemnon. The bloody conflict at Troy lasts ten years, and finally ends when the Greeks trick the Trojans into opening up the gates of the city to a large wooden horse concealing Greek warriors inside. These warriors then open the gates to the rest of the Greek army, allowing for the sacking of Troy. The Trojan warriors were slain and the women sold into slavery, though there were myths that some Trojans escaped; some aristocratic Roman families were to claim descent from Trojan heroes.

THE NOSTOI. The return home of the Greek victors after the war spawned a number of other myths of the type known as *nostoi*, the Greek word for "returns home." The most famous *nostos* was the tale of Odysseus, who spent ten years trying to reach his island of Ithaca, the subject of Homer's *Odyssey*. The Trojan War left a powerful imprint on the Greek imagination, perhaps because—if the date of 1250 B.C.E. is more or less correct—it was the last great venture of the Greek Bronze Age before the Myceneaean civilization fell. The myths about it were worked and reworked by Greek poets and dramatists. Not only the Trojan War itself, but the *nostoi* provided the raw material for the earliest Greek literature of Greece, and from Greece the tales of the Trojan War passed to Rome, where the family of the Iulii, which produced Julius Caesar, claimed descent from the Trojan hero Aeneas. Thus the Trojan War would contribute to the self-definition of both the Greeks and the Romans.

THE ILIAD. One of the reasons the *Iliad* has stood the test of time is that it is much more than a story about a war. In epic format, Homer provides keen psychological portraits of the heroes involved on both sides of the conflict. Central to the story is the figure of Achilles, the

leader of the Myrmidons and the greatest warrior on the Greek side. He is practically invincible on the battlefield because his immersion in the River Styx as a baby prevents him from being wounded anywhere on his body except for his heel—the one part that the water had not touched. He is the paradigm of the doomed hero who knows that death awaits him if he continues to fight at Troy, yet his desire for glory in battle consumes him. His status as Greece's best warrior sets him up for conflict with the army's leader, Agamemnon, and when the two have a dispute over the distribution of the spoils of war, Achilles allows the affront to his ego to negate his duty in battle and he refuses to fight against the Trojans. His decision has terrible consequences for both himself personally and the Greek military cause. Without Achilles in battle, the tide of the war turns in the Trojans' favor and several key leaders of the Greek side are wounded, including Agamemnon, Menelaus, and Odysseus. Achilles—though he will not return to battle himself—loans his armor to his friend Patroclus and allows him to lead the Myrmidons into battle, where Patroclus is killed by the Trojan hero, Hector. Once Achilles learns of Patroclus' death he returns to battle, and avenges Patroclus' death by killing Hector. He then buries his friend with funeral rites that are splendid, almost barbaric. Although Achilles is portrayed as a merciless warrior in battle, Homer humanizes him with a display of compassion when Hector's father, old King Priam, visits Achilles under cover of night to ransom the body of his son. Achilles is moved by pity, both for Priam and for his own father, Peleus, for his mother has warned him that if he returns to battle, his own death would soon follow Hector's. He accepts the ransom and sends Priam safely back to Troy and the *Iliad* ends with Hector's funeral. Throughout the story, Homer leaves no doubt that the Greek heroes are better warriors than the Trojans, and yet he is surprisingly sympathetic to Troy. The most sympathetic character in the story is the Trojan hero Hector. He is a great warrior but he does not love war. He fights to defend Troy, but he knows that Troy is doomed and his wife and son face a perilous future. Hector's last farewell to them is the most moving passage in the *Iliad*. He is hopelessly outclassed when he meets Achilles in their final duel; yet his honor as a warrior prevents him from retreating behind the city walls. This resolve to fight in the face of certain death is part of a general theme of the glory of battle that is present throughout the epic. The characters are judged on the basis of their fighting skills and their courage, and those who continue to fight even though they know the hard fate ahead of them (such as Hector and Achilles) are given the most accolades.

THE ODYSSEY. The *Odyssey* is the story of one of the Greek heroes at Troy, Odysseus, as he attempts to sail home from the war. A series of misfortunes turns the journey into a ten-year ordeal, and a combination of good fortune and craftiness saves him from several perilous situations. A tale of wandering that takes place over many years is not easy to relate, for it can lapse into a sprawling chronological account. To avoid that, Homer uses a "flashback" technique in which Odysseus relates most of his own story as a series of episodes, each episode relating some fresh peril he endured on his journey. When the story begins, Odysseus is near the end of his travels as he tells his story to an audience of Phaeacians who have given him temporary refuge in their land on his way home. His tales of encounters with fantastic creatures and his experiences in strange lands amaze them. Among his adventures, he outwitted the one-eyed giant, Polyphemus (the Cyclops); he sailed between the two monsters Scylla and Charybdis; he subdued the witch-goddess Circe; and he was the captive lover of the nymph Calypso for seven years. Although he had started home from Troy with a fleet of twelve ships, he alone reached Ithaca, his homeland. Each new adventure resulted in the loss of crew members. In the land of the Lotus-Eaters, some ate the fruit of the lotus plant that made them forget their home, and Odysseus had to force them back on his ships. Others were eaten by the giant Cyclops while captive in his cave. The cannibal Laestrygonians destroyed all his ships save only for Odysseus' own vessel. The witch Circe turned Odysseus' men into pigs, and Odysseus saved them only with the help of the god Hermes. Finally Odysseus was once again caught by a storm. Zeus struck his vessel with lightning and flung his men overboard, and Odysseus alone survived, clinging to the wreckage and drifting nine days at sea until he reached Calypso's island. Moved by his story, the Phaeacians return him to his kingdom of Ithaca where Odysseus discovers that suitors ambitious for the hand of his wife Penelope have overrun his manor house. Although Odysseus' long absence has led many to presume he is dead, Penelope has managed to keep her suitors at bay through a clever ruse; she promises to select a husband after she has finished weaving a burial shroud for Odysseus' father, Laertes, but every night she undoes her work of the day before. The suitors eventually discover the deception and increase pressure on her to choose one of them. It is at this point that Odysseus returns home, disguised as a beggar. Since she can no longer use the burial shroud as an excuse to put off marriage, Penelope has produced a new tryout for the suitors: she announces that she will choose as her husband whoever wins an archery contest with Odysseus' bow. Her choice will fall

on whoever can string the great bow and shoot an arrow through twelve axes. None of the suitors can so much as string the bow, much less shoot an arrow with it, but Odysseus easily accomplishes the feat, and then slaughters all the suitors. Penelope, however, is not yet completely convinced that Odysseus is her long-lost husband, and she puts him to one final test: she, orders a servant to move her marriage bed outside the bedroom for Odysseus to sleep on. Only Odysseus and Penelope know that the order is impossible to carry out since the bed is anchored to a tree stump; so when Odysseus reveals that he knows the secret of the bed, Penelope knows him to be her husband. Odysseus has regained his kingdom.

CUNNING OVER STRENGTH. While much of the *Iliad* focuses on the battle strength of warriors, the *Odyssey* exalts cunning over brute strength. Time and again, Odysseus is described as a crafty man, and he frequently escapes the dangerous passages of his journey by using his wits to overcome the superior strength of his adversaries. On more than one occasion he assumes a disguise or masks his identity to gain the upper hand, such as was the case in his confrontation with the suitors. The encounter with the Cyclops is a particularly good example of Odysseus' use of his wits to overcome a seemingly impossible situation; Odysseus and his men are trapped in the cave of the Cyclops Polyphemus, a one-eyed giant cannibal shepherd who was the son Poseidon, god of the sea. They face certain death since only Polyphemus can roll back the boulder blocking the entrance to the cave, which he does only to let his sheep out of the cave each morning and bring them back each night for safekeeping. Physically, Odysseus can do nothing, but he uses his wiles to get the giant drunk. When Polyphemus asks Odysseus his name, Odysseus replies that his name is "Noman." After the giant falls into a drunken sleep, the men put out his eye with a sharpened pole; he cries for help from the other Cyclopes, but they assume that a god must have caused his misfortune when he tells them that "Noman" ("No man") put out his eye. With Polyphemus at a disadvantage because of his blindness, Odysseus and his men make their escape from the cave by lashing themselves to the bellies of Polyphemus' sheep as he lets them out in the morning. The blind Cyclops runs his hand over the backs of the sheep to make sure no one is riding them to freedom, but he fails to perceive the men underneath. As Odysseus is pulling away in his ship, he cannot resist shouting back to the Cyclops his true name, which allows the giant to pray to his father Poseidon for vengeance on Odysseus. Poseidon sends a storm to blow the ships off-course and

Odysseus becomes subject to a curse: that he will not return home or, if he does, he will be long delayed, alone, and find trouble in his house.

TEMPTATION AND ENDURANCE. Odysseus' inability to resist revealing his identity to the Cyclops provides an example of another dominant theme of the work: the danger of temptation. Odysseus' pride at having outwitted the Cyclops tempts him to tell the Cyclops his name, though his men urge him to be cautious. In fact, when Odysseus found the Cyclops' cave, his men urged him to steal some cheeses and lambs and be off back to their ships, but Odysseus is tempted by a thirst for knowledge: he wants to see who owns this cave, and waits for the Cyclops to return home. In the Land of the Lotus-eaters, the temptation is to give up and forget about their goal of returning home, and Odysseus, no matter what he must endure, remains determined to return: he forces his men back onto their boats. When Odysseus sails past the reefs where the Sirens—half-women, half-bird creatures—sang their seductive songs that lured sailors to their deaths on the rocks, he saves his men from temptation by ordering them to plug their ears, while he himself, tempted by his thirst for knowledge, has himself tied to the mast, thereby allowing him to hear the Sirens' melody and survive. Following the Cyclops incident, Odysseus obtains from Aeolus, the lord of the winds, a magic bag that imprisons all the winds save the one that will waft his ships safely home, and he forbids his men to open it. Ithaca is already in sight when the crew, suspicious that Odysseus is keeping treasure from them in the sack, disobey orders and yield to the temptation to open the sack when Odysseus falls asleep. The winds are released, and a storm blows Odysseus back to the land of Aeolus, who refuses angrily to give him another sack. On the Isle of the Sun God, Hyperion, Odysseus' men are warned solemnly not to touch Hyperion's cattle, but they are driven by hunger, and yield to the temptation to slaughter some of them when Odysseus is away. Hyperion, the Sun God is so angry that he threatens to cease shining in the sky if Zeus does not avenge him, and Zeus agrees to destroy Odysseus' ship with a thunderbolt. Odysseus alone endures, never abandoning his goal of returning home.

THE EPIC CYCLE. There were other epics as well which filled in the story of the Trojan War. One, titled the *Cypria*, described how Paris abducted the wife of Menelaus, Helen, and brought her to Troy. It seems to have been composed almost as early as the *Iliad*, and some Greeks attributed it wrongly to Homer. Another titled the *Aethiopis* told how a king of Ethiopia named Memnon came to aid Troy and was killed by Achilles,

who in turn died from an arrow wound in his vulnerable heel. The *Little Iliad* and the *Sack of Troy* told how Troy fell, and there was a group of poems called the *Nostoi* (*The Returns*) which related the experiences of heroes other than Odysseus as they voyaged home from Troy. These poems survived into the second century C.E., for they were still being quoted by later authors, but they seem to have been lost in the upheavals of the third century C.E. There were epics as well which dealt with subjects other than Troy. One told the story of Oedipus of Thebes, who killed his father and married his mother, and there were several poems on Heracles. There were many other epics besides the *Iliad* and *Odyssey*, but those two poems were by far the most popular and were recited most often at religious festivals. One other poem, the *Margites* should be mentioned, too, for even as shrewd a critic as Aristotle thought that Homer wrote it. It was a mock epic, a burlesque which related the misfortunes of a stupid fellow named Margites. A surviving fragment relates his misadventures on his wedding night, and if Homer wrote it, he must have used it to give his audience some belly laughs after they had their fill of the Trojan legends. One short mock epic has survived, *The Battle of the Frogs and the Mice*, which describes in heroic style a battle between a corps of frogs and a regiment of mice. The banqueting halls of the aristocrats in the early city-states of Greece clearly enjoyed their comic moments.

SOURCES

Charles R. Beye, *Ancient Epic Poetry* (Ithaca, N.Y.; London, England: Cornell University Press, 1993).

Mark Edwards, *Homer; Poet of the Iliad* (Baltimore; London, England: Johns Hopkins University Press, 1989).

Moses Finley, *The World of Odysseus*. 2nd rev. ed. (Harmondsworth, England: Penguin Books, 1979).

Jasper Griffin, *Homer* (Bristol, England: Bristol Classical Press, 2001).

G. S. Kirk, *The Songs of Homer* (Cambridge, England: Cambridge University Press, 1962).

Joachim Latacz, *Homer; His Art and His World* (Ann Arbor: University of Michigan Press, 1996).

J. V. Luce, *Homer and the Heroic Age* (London, England: Thames and Hudson, 1975).

M. S. Silk, *Homer: The Iliad* (Cambridge, England: Cambridge University Press, 1987).

George Steiner and Robert Fagles, eds., *Homer: A Collection of Critical Essays* (Englewood Cliffs, N.J.: Prentice-Hall, 1962).

Michael Wood, *In Search of the Trojan War* (Berkeley: University of California Press, 1998).

THE BOEOTIAN SCHOOL OF EPIC

HESIOD. It is customary to speak of Homer and Hesiod in the same breath, but, in fact, the two poets lived in different worlds and produced markedly different poetry. Both belonged to eighth century B.C.E., but Hesiod reflected a different style of life. He grew up in the poor village of Ascra in Boeotia, a district of central Greece bordering on Athenian territory. The Athenians considered the Boeotians rather stupid, and, compared to Athens, Boeotia was a cultural backwater. Despite this reputation, about the same time as bards in Ionia were singing heroic lays about the Trojan War, poets in Boeotia were composing poetry on more down-to-earth subjects. There must have been a fair number of poets, but all that survives of their works are three poems attributed to Hesiod: the *Theogony*, the *Works and Days*, and a rather poor piece titled *The Shield of Heracles*, which few think is really Hesiod's composition.

THE THEOGONY. The *Theogony*, or *The Generations of the Gods*, is the first effort by a Greek to write a systematic theology. Hesiod begins by invoking the nine Muses who taught him the art of poetry while he was shepherding his flock on Mt. Helicon. The Muses, the daughters of Zeus who knew how to speak the truth when they wanted to, inspired him to sing of "things to come and things that were before."

"Hail, daughters of Zeus! Give me sweet song
To celebrate the holy race of gods
Who live forever, sons of starry Heaven
And Earth, and gloomy night, and salty Sea."

Dorothea Wender, trans., **Hesiod and Theognis (Penguin Classics): 26.**

Hesiod began with Chaos, the formless matter which was the earliest state of the universe, out of which appeared Earth and Tartarus, Night and Erebos, which in the *Theogony* was a mythical being. Earth produced *Ouranos* (Heaven), and from the sexual union of Earth and Heaven arose the race of Titans. The Titan Kronos, with the connivance of Mother Earth, castrated Heaven and thrust him up into the sky. But Kronos feared that his children would overthrow him just as he overthrew his father, and he swallowed the infants as his wife Rhea bore them. Rhea tricked him, however, by giving him a stone wrapped in swaddling clothes to swallow instead of her last-born child. When that child, who was Zeus, reached manhood, he overthrew Cronus and forced him to vomit up the children he had swallowed. Thus the generation of Zeus took control.

THE EASTERN CONNECTION. It is difficult to discern whether Hesiod was repeating traditional wisdom about the gods in his *Theogony* or whether it sprang from his own fertile brain. Certainly, the Near East had creation stories before Hesiod wrote; one that Hesiod might have known at second- or third-hand was the Babylonian Creation epic, the *Enuma elis* of which over 900 verses survive. The story of how Cronus castrated *Ouranos* has a parallel among the myths of the Hittites whose empire dominated central Asia Minor until the raids and invasions which ended the Mycenaean civilization after 1200 B.C.E. destroyed it as well; the Hittites, in turn, borrowed it from a people called the Hurrians, pre-Semitic inhabitants of Syria. The Hittite tale told that Kumarbi, the equivalent of Cronus, bit off the genitals of the Sky-God Anu. Folktale motifs can travel from culture to culture with surprising ease, but they change as they travel, and by the time the Near Eastern creation myths reached Boeotia, they had taken on a different complexion. Yet the cultural influence of the Near East was felt even in Hesiod's isolated little community. In the *Works and Days*, he tells the Near Eastern myth of the Ages of Man, but with a change to make it fit Greek common wisdom: the Oriental version has four ages corresponding to the four metals, Gold, Silver, Bronze and Iron, but Hesiod adds a fifth age before the Age of Iron—the heroic age—thus creating space in the history of mankind for the heroes who, as all Greeks knew, lived before the present age. It seems unlikely that Hesiod was the first Greek to use myths from the Near East, for Greek contacts with Syria go back to Mycenaean times. Yet much of the theology in the *Theogony* was Hesiod's own creation.

THE WORKS AND DAYS. In Hesiod's second poem, we hear the genuine voice of a peasant farmer. Hesiod's father had left Aeolian Cyme, fleeing from poverty, and had come to the town of Askra near Mt. Helicon, which Hesiod characterized as "harsh in winter, comfortless in summer, not really good at any time of year." Hesiod's brother Perses had cheated Hesiod in the division of their father's estate, and then had squandered his portion. He then attempted to acquire more of his brother's share by dishonest means, bribing the corrupt aristocrats who dispensed justice in the city-states. The *Works and Days* is Hesiod's advice to Perses. It tells him how to farm, when to marry, what sort of slaves to have, which days are lucky and so on. The sixth day of the month, for instance, was not a lucky time for girls to be born, but it was a good day for castrating kids and lambs, and for the birth of boys, though boys born on that day will be given to lies and flattery. Other admonitions included one always to wash one's hands before pouring libations to the gods, and another to wash one's hands in a stream before crossing it. This "wisdom literature" is typical of ancient Egypt, but the advice Hesiod gives is rooted in the soil of Boeotia. He had a strong sense of justice, and he had a message for crooked judges:

You lords, take notice of this punishment
The deathless gods are never far way;
They mark the crooked judges who grind down
Their fellow-men and do not fear the gods,
Three times ten thousand watchers-over-men,
Immortal, roam the fertile earth for Zeus,
Clothed in a mist, they visit every land
And keep a watch on law-suits and on crimes,
One of them is the virgin, born of Zeus,
Justice, revered by all the Olympian gods.

Dorothea Wender, trans., **Hesiod and Theognis** *(Penguin Classics): 66–67.*

Hesiod's suggestion that Zeus is the enforcer of fair play differs from Homer's amoral version of the god.

CORINNA. Boeotia continued to produce poets after Hesiod, though none wrote in the epic tradition. Nearly two centuries after Hesiod, one of the greatest Greek lyric poets, Pindar, was born there, near the chief Boeotian city of Thebes. An older contemporary of Pindar, a poetess named Corinna, wrote lyrical narrative poems on Boeotian subjects for a circle of women friends. A papyrus fragment from Egypt preserves substantial remains of two of her poems. In one she describes a contest in song between Mt. Helicon, or more precisely, the god Helicon, and Mt. Cithaeron. Helicon was Hesiod's mountain where the Muses appeared to him and taught him to sing, and Mt. Cithaeron was closer to Corinna's *polis* of Tanagra. The gods judge whether Hesiod's Helicon or Corinna's Cithaeron has sung the better poem.

The Muses told the high gods then
each to deposit his ballot stone
secretly in the gold gleaming
urns. Together the gods rose up.
Cithaeron won more of the votes.
At once Hermes, with a great cry,
announced him, how he had gained success
he longed for, and the blessed gods
with garlands crowned him, so that his heart
was happy.

Richmond Lattimore, **Greek Lyrics** *(University of Chicago Press): 52.*

Mt. Helicon was a sore loser. The poem may have been Corinna's declaration of independence from the Hesiodic epic school of poetry.

SOURCES

J. P. Barron and P. E. Easterling, "Hesiod," in *The Cambridge History of Classical Literature*. Eds. P. E. Easterling and B. M. W. Knox (Cambridge, England: Cambridge University Press, 1981): 92–105.

Robert Lamberton, *Hesiod* (New Haven, Conn.: Yale University Press, 1988).

Dorothea Wender, *Hesiod and Theognis* (Harmondsworth, England: Penguin Books, 1973).

THE AGE OF LYRIC POETRY

THE CHANGING GREEK WORLD. In the years after 700 B.C.E. the Greek world underwent social and economic change. The *poleis*, or city-states, now emerged fully from the so-called "Dark Ages" which had followed the collapse of the Mycenaean civilization. They began to send out colonies; about 770 B.C.E., the leading cities on the island of Euboea—Eretria and Chalcis—established a trading post on the island of Ischia off the coast of Naples. About twenty years later, Chalcis—her partnership with Eretria dissolved into enmity—planted a colony on the Italian mainland, at Cumae. It was the first of a host of colonies, and within the next two and a half centuries, Greek settlements—each of them a nascent city-state—appeared in Italy, Sicily, southern France, north-eastern Spain, as well as the north Aegean and the shore of the Black Sea. The eastern Mediterranean coast and Egypt were not open to colonization but even there the Greeks established a trading post at al-Mina in modern Lebanon; in Egypt, the pharaohs of the twenty-sixth dynasty allowed them to build a post at Naucratis at the mouth of the Nile. Egyptian culture came as a revelation to the Greeks; by the mid-seventh century B.C.E., Greek sculptors were carving nude male figures in poses borrowed from Egyptian sculpture. In the pottery workshops of Corinth, potters produced vases with oriental motifs taken from Asian metalwork, and their fine Protocorinthian ware found export markets all over the eastern Mediterranean as well as in Italy and Sicily. The *poleis* began to build freestanding temples; the earliest have an apse or semi-circular wall at the end, but by the latter part of the seventh century B.C.E., the canonical Greek temple-plan had been born. This was an age of revolution, in which the rule of the "lords," the injustice of which Hesiod had attacked, was swept away and replaced by dictatorships, which the Greeks called "tyrannies." It was against this background that the age of lyric poetry arose.

DEFINING LYRIC POETRY. Lyric poetry is poetry sung to the lyre, but that in itself was not a new development since epic poetry also had lyre accompaniment. The great lyric poets, beginning with Archilochus, belong to the exuberant seventh and sixth centuries when Greece moved from the "Dark Ages" to the great classical period of Greek culture. Lyric is commonly divided into three types of poetry: melic, elegiac, and iambic. Their boundaries are indistinct. "Melic" means "for song," and can include everything from party songs to choral cantatas. Elegies were sung, too, but they are defined by their meter, the elegiac couplet. Although it uses an iambic meter, poetry that is classified as iambic relates more to its subject matter which is ludicrous, abusive, or sometimes off-color. Not all lyric poetry was sung to the music of the lyre. Mimnermus of Colophon was accompanied by a girl playing the *aulos*, a remote ancestor of the oboe. Choral cantatas might be accompanied by both the *aulos* and the lyre, of which there were several models.

THE WAR POETS. Elegiac poetry is most often though to express emotions, such as love or sorrow, but there was a group of poets which used the elegiac couplet for patriotic themes. The seventh century B.C.E. was not a period of peace in the Greek world. In the so-called "Dark Ages" which followed the collapse of the Mycenaean civilization, Greeks had migrated to the west coast of Asia Minor and the offshore islands and founded settlements there, which flourished, but were always under threat from the non-Greeks in the interior of Asia Minor. One elegiac poet who used his talent to arouse the Greeks to defend themselves was Callinus of Ephesus. Ephesus was one of the twelve cities of Ionia, founded by Greeks speaking the Ionian dialect who fled from the ruins of the Mycenaean world first to Athens, and then from Athens across the Aegean Sea to Asia Minor. Ephesus' was in the forefront of Greek cultural development in the early to mid-seventh century. Yet it was a time of war. Anatolia, the plateau of central Asia Minor, was under attack by nomadic migrants, and the sole elegy of Callinus that has survived is an appeal for courage in the battle.

How long will you lie idle? When will you young men take courage? Don't our neighbors make you feel ashamed, so much at ease?

TYRTAEUS, SPARTA'S WAR POET. A generation later in Sparta across the Aegean Sea, Tyrtaeus used elegiac poetry for a similar purpose. The Spartan state had been founded by Dorian immigrants, the last of the migrants to arrive in Greece after the collapse of the Mycenaean world. They spoke their own dialect of Greek, though Dorian is not much closer to Ionic Greek than Spanish is to Italian. The Spartan immigrants conquered the natives of the Eurotas River valley and reduced them

to helots, serfs who worked the land and gave their overlords half their crop. Sparta prospered and its growing population of Spartiates, Sparta's landowning class, required more estates. To procure more land, Sparta conquered her neighbor to the west, Messenia, in the early seventh century and made the Messenians her helots. But towards the end of the seventh century, the Messenians rebelled. Tyrtaeus' poetry aroused the Spartan resolve to vanquish them. He recalled how Sparta had conquered Messenia in the first place, and reminded his listeners of the glory of battle.

… our sovereign Theopompus, whom the gods did love,
 through whom we took Messene's broad dance-
 grounds,
Messene good to plough, and good to plant for fruit.
 To conquer her they fought full nineteen years. …

For it is fine to die in the front line,
 a brave man fighting for his fatherland
and the most painful fate's to leave one's town
 and fertile farmlands for a beggar's life.

M. L. West, trans., Greek Lyric Poetry (Oxford, England: Oxford University Press, 1993): 23.

MIMNERMUS IN DEFENSE OF SMYRNA. The elegiac poet Mimnermus of Smyrna also wrote war poetry. Smyrna was one of the earliest Greek settlements in Asia Minor, but she was under attack by the neighboring empire of Lydia, and about 600 B.C.E. she lost the struggle and was destroyed. Mimnermus' patriotic efforts were unavailing.

ARCHILOCHUS. The Greeks themselves ranked Archilochus with Homer and Hesiod as the greatest poets of early Greece, but unfortunately little of his poetry has survived as evidence of his genius. He was the illegitimate offspring of a noble from Paros (an island in the Aegean Sea), and a slave from Thrace. He made his living as a mercenary soldier, but did not hold to the soldier's code of honor. In one of his poems he freely admitted his cowardice in a battle with a Thracian tribe called the Saians:

Some Saian sports my splendid shield:
 I had to leave it in a wood,
but saved my skin. Well, I don't care.
 I'll get another just as good.

M. L. West, trans., Greek Lyric Poetry (Oxford, England: Oxford University Press, 1993): 14.

Archilochus was famous for the invective with which he attacked his enemies, particularly Lycambes, who had two daughters, one of whom, Neobule, was the object of Archilochus' lust.

The lyric poet Sappho of Lesbos. THE LIBRARY OF CONGRESS.

I wish I had as sure a chance of fingering Neobule—
 the workman falling to his task—and pressing
 tum to tummy
and thighs to thighs. …

M. L. West, Greek Lyric Poetry, (Oxford, England: Oxford University Press, 1993): 6.

Lycambes did not fancy Archilochus as a son-in-law, and Archilochus' verse lampooned him and his two daughters so viciously that, according to the legend, they hanged themselves. Much of his surviving poetry reflects his observations on current events: bristling attacks on his enemies, banter with friends, mournful lyrics for men lost at sea, scorn for dandies. In his description of a good soldier—"A shortish sort of chap, who's bandy-looking round the shins,/he's my ideal, one full of guts, and steady on his pins"—he may have been describing himself.

THE CHORAL LYRIC. Choral lyric was poetry sung by choirs that danced as they sang, usually accompanied by a musician. Sparta, for all its emphasis on militarism in the seventh century B.C.E., was also a center of music and dancing. The first great composer and virtuoso on the type of lyre known as the *kithara*, Terpander of Lesbos, worked there, as did Alcman, who wrote choral works sung by choirs of girls. One long fragment of a choral song survives, preserved on a papyrus fragment found in Egypt. It is a *parthenion*, a song sung by young girls to the accompaniment of the

A LOVE POEM OF SAPPHO

INTRODUCTION: Sappho, who lived in the city of Mytilene on Lesbos, was famous for her short lyrics, written in well-articulated stanzas. The poem below expresses Sappho's longing for a girl who is leaving her group to get married. It is particularly famous both for its open expression of love from one woman to another, as well as its existence in both the original Greek and a Latin translation by the Roman poet Catullus.

Like the very gods in my sight is he who
sits where he can look in your eyes, who listens
close to you, to hear the soft voice, its sweetness
 murmur in love and
laughter, all for him. But it breaks my spirit;
underneath my breast all the heart is shaken.
Let me only glance where you are, the voice dies,
 I can say nothing,
but my lips are stricken to silence, under-
neath my skin the tenuous flame suffices;
nothing shows in front of my eyes, my ears are
 muted in thunder.
And the sweat breaks running upon me, fever
shakes my body, paler I turn than grass is;
I can feel that I have been changed, I feel that
 death has come near me.

SOURCE: Sappho of Lesbos, "Invocation to Aphrodite," in *Greek Lyrics*. 2nd ed. Trans. Richmond Lattimore (Chicago: University of Chicago Press, 1960): 39–40.

aulos—this one sung by a choir of ten. Choral lyric was also popular in the Greek cities of Sicily and southern Italy, where the first poet of note whose name we know was Stesichorus who came from Himera, not far from present-day Palermo. The most famous composer of choral lyric was Sappho of Lesbos, who is usually classified as a melic poet because her songs express personal feelings. A group of girls and unmarried women, it seems, met regularly with Sappho in a school, the "home of the disciples of the Muses," as Sappho called it in a fragment of her poetry that has survived—it may have been her own house—where they sang and learned to play musical instruments. Sometimes they sang in public at weddings and religious ceremonies; her group of students was called a *thiasos*, which means something like a "religious club." Sappho was a music teacher and choreographer, and her chorals often gave voice to her personal feelings.

POETRY AS THE PERSONAL VOICE. Poetry gave voice to the personal emotions—usually relating to love, politics and patriotism—of the lyric poets and their circles. For Sappho of Lesbos, it was love that was an all-consuming passion. She expressed her attachment to some of the girls she taught with an intensity that has made "lesbian" a byword for women who are homosexual lovers, although Sappho herself was married and had a daughter. Love between male youths and older, married men was accepted in Greek society, and Sappho merely represented the other side of the coin in expressing romantic attachments between women. The world of her contemporary, Alcaeus of Lesbos, was markedly different. He lived during a time of civil conflict on Lesbos, particularly in its leading *polis*, Mytilene, where tyrants challenged the rule of the aristocrats, and the aristocrats fought back. Alcaeus used to be best known for his political songs, his *Stasiotika*, as they were called from the Greek for "civil strife," *stasis*. They were songs of political commitment. The aristocrats formed political societies to defend their interests, and when they had their common meals, they sang songs such as Alcaeus wrote. In the last century, however, papyri have been found in the sands of Egypt with poems that show another side of Alcaeus' genius. He also wrote hymns to the gods, love poems, and poems on mythological themes. The individual voice of the poet can be heard in the works of Sappho and Alcaeus, but Mimnermus of Smyrna, too, whose war poems have already been noted, deserves a second mention as a poet of love. The editors at the great library at Alexandria in the Hellenistic Period made an anthology of his poetry titled the *Nanno* after the name of a courtesan. Mimnermus also looked on death with apprehension; dread of the ills of old age was another of his favorite themes.

POETRY IN AID OF POLITICS. The age of prose had not yet arrived, and when men expressed their political views in writing, they used poetry which they could recite at public gatherings. One political poet who belonged to the *polis* of Megara was Theognis. Megara is squeezed between Corinth on the south and Athens on the north, and in the last decades of the seventh century B.C.E., the winds of change that were toppling aristocratic governments elsewhere affected Megara, as well. Theognis was an aristocrat who apparently lost his land and became an exile. His poetry reflects a bitter cynicism about the state of society where good people can be plunged into poverty. Some of his elegies are addressed to a friend called Cyrnus, and they are not all political: some give advice, some reflect on the faithlessness of friends, and others are love poems. However, the

body of literature attributed to Theognis that has survived was not all written by him, and it projects a blurred image of Theognis himself. In a political poem attributed to him he says that no land on earth loves a tyrant, and in another non-political one, that he has no interest except high-class life and the culture of the intellect—so he wants to continue enjoying the lyre and dance and song. The social pressures that threatened the political power of the aristocratic landowners in Megara were felt as well in her larger neighbor, the city-state of Athens. There, too, the rival political factions recognized the danger of a tyranny if there were no reforms, and tried to forestall it. They turned to Solon, a poet, merchant, and aristocrat by pedigree if not by political inclination, and by common consent, he became sole ruler, or "archon," of Athens for a year in 594–593 B.C.E. with a mandate to make political and economic changes. He used poetry to defend his reforms, which were an effort to find a middle ground between the extremists on the left and on the right. He was no great poet, and he was not the originator of Athenian democracy, but two centuries later Athenians—particularly those whose politics were conservative—looked back at him as the founder of an ideal constitution.

THE AGE OF TYRANTS. The Age of Tyrants in archaic Greece was a transitional period between the early *polis* ruled by aristocrats whose power was based on the possession of land and long pedigrees, and the classical *polis* where government was more broadly based. Tyrants—in the modern world they would be called dictators—seized power by force and sometimes bequeathed it to their children and even grandchildren, and though the tyrannies left a bad reputation behind them, they were not all bad. Some tyrants were patrons of poetry. A tyrant of Corinth, Periander (ruled about 625–585 B.C.E.) gave profitable hospitality to a famous lyricist, Arion, but none of his work survives. Across the Aegean Sea at Samos, the tyrant Polycrates patronized Ibycus from Rhegium, modern Reggio on the toe of Italy, until he was unseated by the Persians in 522 B.C.E. The choral lyrics of Ibycus carried on the tradition of Stesichorus, but he was equally famous for his love poems. Anacreon, possibly the music teacher of Polycrates, also wrote well-crafted poetry: exquisite songs about the delights of wine and love. When Polycrates fell, Anacreon, along with Ibycus, moved to Athens, where Hipparchus, the younger brother of the tyrant Hippias, gathered about him a number of poets. Hippias was driven from Athens in 510 B.C.E., and as the Age of Tyrants came to an end so did their patronage of literature. One poet, Simonides of Ceos from the court of Hipparchus,

made the transition into the new period when professional poets would sell their services and make a living as literary entrepreneurs. He had a nephew named Bacchylides who would be equally entrepreneurial, if not the equal of his uncle in poetic inspiration.

SOURCES

William Barnstone, *Greek Lyric Poetry* (Bloomington, Ind.: Indiana University Press, 1967).

C. M. Bowra, *Greek Lyric Poetry. From Alcman to Simonides.* 2nd ed. (Oxford, England: Clarendon Press, 1961).

A. R. Burn, *The Lyric Age of Greece* (London, England: Arnold, 1960).

Paul Allen Miller, *Lyric Texts and Lyric Consciousness; The Birth of a Genre from Archaic Greece to Augustan Rome* (London, England; New York: Routledge, 1994).

David D. Mulroy, trans., *Early Greek Lyric Poetry* (Ann Arbor: University of Michigan Press, 1992).

D. L. Page, *Sappho and Alcaeus: An Introduction to the Study of Ancient Lesbian Poetry* (Oxford, England: Clarendon Press, 1955).

M. L. West, trans., *Greek Lyric Poetry* (Oxford, England; New York: Oxford University Press, 1993).

POETS FOR HIRE

THE END OF ARCHAIC GREECE. The Persian Wars, from 490 to 479 B.C.E. marked the end of the archaic age. The Persian Empire had been slowly pushing westwards. It captured the Greek cities on the western coast of Asia Minor shortly after 546 B.C.E. In 513 B.C.E. King Darius led a Persian army across the Bosporus into Europe and captured Thrace, the region south of the Danube River. But what turned Persia's attention to mainland Greece was the Ionian Revolt—a revolt of the Greek cities on the Asia Minor coast and the offshore islands which started in the Ionian city of Miletus in 500 and spread all along the coast and even to Cyprus. Athens sent the rebels help in the first year of the revolt and then withdrew it, but her one-year intervention was enough to rouse Persian resentment. A Persian expeditionary force landed on the plain of Marathon north of Athens in 490 B.C.E., planning to take Athens and establish a Persian bridgehead in Greece. But in a battle that gave Athens a new sense of pride and accomplishment, the Athenian citizen army defeated the Persian force. Ten years later, the Persians attacked again, this time with a great land and naval force, and once again the contribution of Athens to the alliance of Greek states that swore to resist Persia was crucial, for Athens had built a navy in the years after Marathon, and the

decisive battle that stopped the Persian onslaught was a naval victory fought off the island of Salamis within sight of Athens. Athens emerged from the Persian War as a center of power in the Greek world, strong enough to challenge the old dominant power, Sparta. In the next half-century, she would acquire an empire, and become the cultural center of Greece. The Persian War ushered in the classical period, which is considered the time when the Greek cultural achievement reached its height, and Athens led the way.

POETS OF THE PERSIAN WAR. The poets Simonides, Pindar, and Bacchylides all had one thing in common: their lives were bisected by the Persian Wars. This fact places them within the transitional period between the archaic and classical ages. Simonides was born early enough to enjoy the patronage of Hipparchus, who was the brother of Hippias, the tyrant of Athens. Hipparchus was assassinated in 514 B.C.E. Four years later, Hippias was driven into exile at the court of the Persian king Darius. Simonides wrote the epitaph for the 300 brave Spartans who died defending the Pass of Thermopylae against the Persians in 480 B.C.E.: "Stranger, report to the Spartans that here we lie, obedient to their commands." All three lived on into a different post-war world. There were still tyrants in Sicily, but in Greece itself the Age of the Tyrants passed on to be replaced in their patronage by the many wealthy Greeks willing to pay money for a poem, including hymns, dirges, songs sung in the service of Dionysus called *dithyrambs*, and the songs for choruses of girls called *partheneia*. One best-selling commodity was a praise poem in honor of a victory at one of the four great athletic contests of Greece. The victor or his friends would commission a *epinikion* (victory ode) which originally was a simple song of welcome, but Simonides developed it into an art form. The contract probably specified the length of the poem and what should be included. It might or might not require the poet to train the chorus to perform the ode. For his services, the poet charged a fee. Simonides in particular had a reputation for being expensive.

SIMONIDES. Simonides came from the little island of Ceos but he developed an international reputation as a poet, and used it to market himself. Only fragments of his work survive, but they include victory odes, chants that were called "paeans," dirges, epigrams, and various lyric poems. His subject matter was not limited to mythology, but also included the Persian War. He wrote a poem on the naval battle at Artemisium in 480 B.C.E., a defeat for the Greeks which they followed up later in the year with a great victory off the island of Salamis. The few surviving fragments of the poem indicate that it is a choral lyric. Recently a papyrus from Egypt has turned up an elegiac poem on the Battle of Plataea, where the Persian army was destroyed in 479 B.C.E. His dirges, or laments for the dead called *threnoi*, were also famous. Their simple pathos had no equal in Greek poetry, and more than four centuries later, the Roman poet Catullus used the phrase "sadder than the tears of Simonides" to describe his sorrow at a friend's coldness.

PINDAR. Pindar, born in 518 B.C.E. near Thebes in Boeotia, was one of the poets whose towering eminence was recognized by the Greeks in his lifetime, though he must be judged by the four books of his victory odes, plus fragments of his other poetry that have survived. He got his first commission at the age of twenty to write an ode in honor of Hippokleas of Thessaly, the winner in the boys' double footrace at the Pythian Games. He lived on, greatly honored, until his death around 438 B.C.E. His language is brilliant, and his allusions often obscure to the modern reader, although they were less so to his contemporaries. The structure of his victory odes is precise: first comes the naming in which the victor is named along with his home city and his patron; next comes the central feature which narrates a myth that in some way reflects on the victor's success; and then the conclusion returns to the victor and his community, which basks in his reflected glory. The ode was sung at a victory celebration for the athlete, but it is not clear how it was staged; perhaps a single choral leader sang the poem while the chorus danced behind him. Pindar was the greatest poet from Boeotia, which had already produced Hesiod and Pindar's older contemporary, Corinna. His reputation was such that in the following century Alexander the Great's destruction of Thebes spared only one house: the one which had belonged to Pindar.

BACCHYLIDES. Little more than the name of Bacchylides, the nephew of Simonides of Ceos, was known until 1896, when the British Museum acquired what remained of two papyrus rolls containing poems of Bacchylides, which had been found in a grave. One roll contained victory odes, the other six dithyrambs. He competed with Pindar for commissions, apparently not without success. In 476 B.C.E., both he and Pindar wrote victory odes for Hiero, tyrant of Syracuse in Sicily, for a victory at Olympia in the horse race, but in 468 B.C.E. when Hiero won a victory in the chariot race at Olympia, he commissioned Bacchylides for the victory ode and passed over Pindar. Bacchylides' surviving dithyrambs have some of the quality of ballads, for they relate episodes excerpted from Greek mythology with twists to the plot that probably come from Bacchylides' own imagination. Their charm lies in his skill as a narrator.

He gives the impression of a capable rather than a great poet, who practiced his craft competently, and the opinion of the ancient Greek critics that he was no equal of Pindar is not unfair.

SOURCES

D. S. Carne-Ross, *Pindar* (New Haven, Conn.: Yale University Press, 1985).

Greek Lyrics. 2nd rev. ed. Trans. Richmond Lattimore (Chicago: University of Chicago Press, 1960).

Gilbert Norwood, *Pindar* (Berkeley: University of California Press, 1945).

The Odes of Pindar. Trans. C. M. Bowra (London, England: Penguin, 1969).

The Odes of Pindar. Trans. Richmond Lattimore (Chicago: University of Chicago Press, 1947).

William H. Race, *Pindar* (Boston: Twayne Publishers, 1986).

HERODOTUS, THE FATHER OF HISTORY

EMERGENCE OF HISTORY. About 425 B.C.E., Herodotus published his *History* with the proem (introductory sentence):

> This is the publication of the research of Herodotus of Halicarnassus, which I have produced so that what men have done might not become dim with the passage of time, and that the great and marvelous achievements, some the doing of the Greeks, others done by the Persians, might not lack renown, and *in particular to show whose fault it was that they fought one another.* [Italics added.]

Herodotus states his subject at the beginning: the Persian Empire's invasion of the Greek city-states which began with the Persian takeover of the cities on the coast of Asia Minor and the offshore islands in the years following 546 B.C.E. and ending in 479 B.C.E. with the annihilation of the Persian army in the Battle of Plataea. Herodotus did not produce a mere chronicle of events as past historians had done, however. He had two purposes in mind. One was a purpose that he shared with the epic poets: to keep alive the memory of the heroic deeds and achievements of the men of old. The other was to examine the cause of the conflict, and cause could not be dissociated from blame. Who, or what was to blame for the great war between Persia and Greece? Finding the answer to that question would be the object of Herodotus' research, for his word for "research" was *historie*, which after Herodotus would acquire a new sense. *Historie*, as it was spelled in the Ionic dialect that

Herodotus used, or *historia* in the Greek spoken on the streets of Athens, would become the word for "history" in the modern sense. It would be a search for causes and developments, and not merely a record of facts.

BACKGROUND. Herodotus was born in Halicarnassus, modern Bodrum in Turkey, shortly before 480 B.C.E. Halicarnassus had been founded by settlers from the little Greek *polis* of Troezen in the Peloponnesos, and they were Dorians, speaking the Dorian dialect that they shared with Sparta. By Herodotus' day, the Ionic dialect had taken over, and in addition, Halicarnassus had a substantial population of Carians, non-Greeks from southwest Asia Minor who had been partially assimilated into Greek culture. The ruling dynasty of Halicarnassus was Carian, and in 480 B.C.E., when King Xerxes of Persia launched his invasion of Greece, the sovereign of Halicarnassus was Queen Artemisia, and when Xerxes conscripted naval contingents from his subject cities, Artemisia led Halicarnassus' fleet in person. Herodotus treats her with admiration in his *History*, but while he was still a young man, he was involved in a revolt against Artemisia's grandson, Lygdamis, along with his uncle, Panyassis, a poet who had tried to revive the epic and succeeded well enough to be ranked with Homer by some Greek critics. Panyassis lost his life, and Herodotus fled Halicarnassus. His exile turned him into an historian.

TRAVELS. Herodotus was now an alien wherever he went, for a Greek was born a citizen of a *polis*, and only under exceptional circumstances could he acquire a new citizenship. Eventually, when a new city called Thurii was founded in southern Italy, Herodotus was able to enroll on its citizenship list, and so ended his life as "Herodotus of Thurii," not "Herodotus of Halicarnassus." Probably the first sentence of his *History* identified him as "Herodotus of Thurii," but later editors amended it to "Herodotus of Halicarnassus." Regardless of the title of his origin, his *History* indicates that Herodotus was restless and traveled extensively. He visited Egypt at least once and interviewed Egyptian priests. He went to Babylon. He got as far north as the Ukraine where the Scythians lived and interviewed a Carian who was an agent for the Scythian king in the trade between the Greeks and the Scythians. He visited both Sparta and Athens, and some scholars believe that he became a friend of the leading Athenian politician of the time, Pericles, and tapped the traditions of Pericles' family for information; there is no hard evidence to support this theory, however. At some point he acquired a reputation as a *logios*, that is, an oral performer who did not chant poetry accompanied by music but recited prose. A late source which may

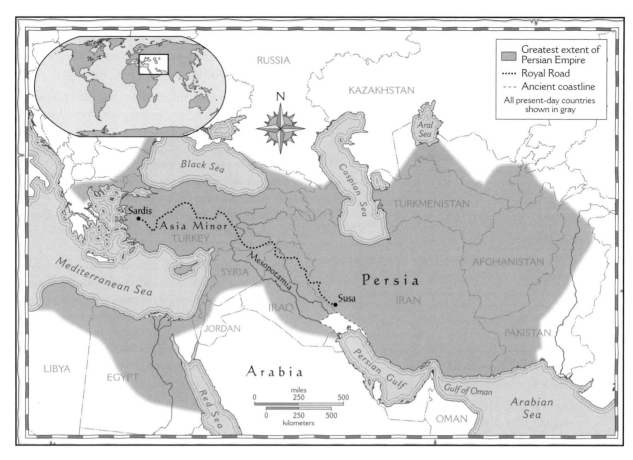

Map showing greatest extent of the Persian Empire. Herodotus chronicled the expansion of the Persian Empire and its conflicts with Greece in his *History*. XNR PRODUCTIONS, INC. THE GALE GROUP.

be trustworthy reports that Herodotus went to Olympia while the Olympic Games were in progress, and there set up his tent and gave recitations to all who would listen. There are stories of other visits to Greek cities, too. Athens liked his performance, and paid him handsomely, but he was not allowed to talk to the young men of Thebes in Boeotia. Thebes sided with the Persians in the Persian Wars and probably disliked being reminded of their lack of patriotism, and, in fact, Herodotus treated Thebes with a marked lack of sympathy in his *History*.

HERODOTUS' PLAN: THE PRELIMINARIES. The *History* is a long, sprawling work, full of digressions. Long after Herodotus' death, the scholars at the Alexandrian Library where the kings of Egypt supported a research institute, divided the *History* into nine books, named after the Nine Muses, but that is an artificial division, though a convenient one. Herodotus simply follows the course of Asian aggression upon the Greek world with the result that the subject of *History* becomes a study of imperialism and the resistance to oriental imperialism. The east was the home of a succession of em-

pires, culminating in the Persian Empire, whereas Greece was the home of free city-states. Herodotus began with the first Asian to subdue Greek cities and make them pay tribute: Croesus, king of Lydia. He conquered the Ionian cities on the western fringe of Asia Minor. He was in turn conquered by Cyrus, the founder of the Persian Empire, and all the Greek cities on the east side of the Aegean Sea—whether Ionian, Dorian or Aeolian—passed to Persian control. Then Herodotus followed the course of Persian expansion as Cyrus conquered Babylon, and his successor, Cambyses, took over Egypt. As the Persian juggernaut acquired new subjects, Herodotus digressed to describe what they were like. King Darius, who succeeded Cambyses, crossed the Bosporus into Europe, and the region between the Aegean Sea and the Danube fell under Persian dominion. So far, Persian expansion was driven by imperialism, but it was the Greeks themselves, specifically Athens, and Eretria on the island of Euboea, that provoked the Persian invasion of mainland Greece. At the start of the fifth century B.C.E. Ionia rebelled against the Persian yoke, and Athens and Eretria both sent assistance to the rebels. Darius took re-

venge in 490 B.C.E. by sending an expeditionary force across the Aegean Sea against Athens and Eretria. Eretria fell within a week, and the Persians then landed at Marathon north of Athens, intending to march on the city with their infantry and cavalry. The Athenians were outnumbered, but they adopted the daring tactic of lengthening their battle-line to match the Persian line by thinning its center and reinforcing its wings. They hoped to rout the Persian wings and then wheel in on the flanks of the Persian center, where it was vulnerable to attack. It was a desperate tactic: the Athenian center broke, but the Athenian wings swept aside the Persians facing them and closed in on the Persian flanks. After a stiff fight, the Persians fled. In spite of their fearsome reputation, they were not invincible, for the charge of the heavily-armed infantry—the hoplites—of Athens vanquished the Persian army, cavalry and all.

THE STRUGGLE FOR GREECE. Vengeance and counter-vengeance was a motive for action in history, as Herodotus saw it, but Darius died before exacting revenge on the Greeks for this defeat. The hawks in his court managed to persuade his son, Xerxes, to carry on his father's plans for Greece, although he is counseled against rash action by his uncle, Artabanus. At decisive moments like this, Herodotus often brought on a wise adviser, who almost invariably counseled against rash action. While initially heeding his uncle's advice, Xerxes decided to proceed with the invasion on the strength of a vision which appeared to him twice in a dream, telling him that he had to attack Greece or be brought low. Herodotus suggests in this that Persian imperialism had developed its own momentum, and no mere king could stop it without paying a heavy penalty. Xerxes conscripted a great army and navy and, crossing the Hellespont on pontoon bridges, made his way through northern Greece, while in Greece itself, under Sparta's leadership those states willing to resist joined in an alliance and planned for defense. They attempted to hold back the Persians at the Pass of Thermopylae, where the space between Mt. Kallidromos and the sea is so narrow that in places only a single cart could get through; at the same time, a Greek naval contingent tried to hold back the Persian fleet off Artemisium at the northern tip of the island of Euboea. But a traitor betrayed the Greeks defending Thermopylae and an elderly Spartan king, Leonidas, and his royal bodyguard of 300 hoplites died fighting there so that the rest of his army could get away. The Persians advanced, burning Athens. But the Athenian general Themistocles persuaded the Greek fleet to make a stand at the island of Salamis, and there the over-confident Persian navy was so badly mauled that it withdrew from the western Aegean Sea. Xerxes himself departed from Greece at the end of the campaigning season but he left behind a smaller but more efficient force under an able general, Mardonius, who captured Athens once again and burned it. But at Plataea in southern Boeotia, a Greek army commanded by the Spartan Pausanias, regent for Leonidas' underage son, utterly defeated Mardonius, and at the same time—some said on the same day—a Greek fleet destroyed a Persian fleet at Mycale on the coast of Ionia. Thus Persian imperialism reached its climax and began its long recession.

SEEKING A REASON. Herodotus states in his introduction that one of his aims was to show why the Greeks and Persians fought a war. Who or what was at fault? Herodotus never tells us explicitly the reason why, but he allows the reader to infer a great deal. Vengeance was a motive for historical action—one power wronged another and the power that is wronged seeks vengeance. Vengeance is a force that maintains limits and balance. If something harms the balance of nature, then something else will take vengeance and thereby restore the balance. Persia, by pushing the boundaries of its empire beyond Asia and aiming at world domination harmed the natural balance between the continents, and the two very different ways of life. But it is also clear that some force beyond the motive of vengeance pushed the Persian Empire into its ill-fated attempt to conquer Greece. Persia, under the rule of a despot, had adopted expansionism as a way of life, and when it invaded Greece, it encountered a people whose way of life embraced individual freedom. Two ways of life fought for dominance in the Persian War, as Herodotus saw it, and Greece's victory demonstrated the importance of liberty. If we seek themes in Herodotus' *History*, two stand out: that imperialism drives empires on to overexpansion, and that individual freedom makes braver soldiers than does despotic government.

SOURCES

Egbert J. Bakker, Irene J. F. de Jong, and Hans van Wees, *Brill's Companion to Herodotus* (Leiden, Netherlands: Brill, 2002).

Peter Derow and Robert Parker, eds., *Herodotus and His World: Essays from a Conference in Memory of George Forrest* (Oxford, England: Oxford University Press, 2003).

J. A. S. Evans, *Herodotus* (Boston: Twayne, 1982).

Stewart Flory, *The Archaic Smile of Herodotus* (Detroit: Wayne State University Press, 1987).

Charles W. Fornara, *Herodotus, An Interpretative Essay* (Oxford, England: Oxford University Press, 1971).

John Gould, *Herodotus* (New York: St. Martin's Press, 1989).

James S. Romm, *Herodotus* (New Haven, Conn.: Yale University Press, 1998).

THUCYDIDES

THE LONELY HISTORIAN. Thucydides occupies a lonely place in the pantheon of historians. He is regarded as one of the world's greatest, yet he had no followers to mimic his sort of history. His plan was to write an accurate history of the Peloponnesian War, the struggle that divided the Greek world at the end of fifth century B.C.E., stretching over the years 431 to 404 B.C.E. He intended to produce a "possession for all time" which future generations might consult if they found themselves in situations resembling the Peloponnesian War. Unlike Herodotus, he did not write with a pleasant, readable style. He was austere and distant, treating the war like a doctor observing a sick patient. This was the period when the medical school on the island of Cos, founded by the great diagnostician Hippocrates, was collecting descriptions of diseases so that doctors could make correct diagnoses, and Thucydides was influenced by the approach of this medical school. Among ancient Greek critics, Herodotus had a reputation—which he did not deserve—as a teller of tall tales, whereas Thucydides had the reputation of a truthful reporter of what actually happened, which he did not entirely deserve, either. His bias can be readily seen in his admiration of the Athenian democracy under Pericles, which was not truly a democracy, for Pericles dominated politics to such a degree that the democracy was really the rule of one man. The historian's admiration of Pericles did not extend to his successor, Cleon, the son of a leather-maker who was a favorite of the masses in the Athenian assembly. In reality, Cleon was a better administrator than Thucydides admits in his writings, but Thucydides favored Cleon's rival, Nicias, a conservative man who feared the gods but whose incompetence nearly brought Athens to her knees. For the most part, however, Thucydides played the part of an unprejudiced reporter very well.

THE PELOPONNESIAN WAR. The so-called Peloponnesian War, which lasted from 431 to 404 B.C.E., was fought between Athens on one side, which had built up an empire in the years following the Persian War, and Sparta, which headed an alliance of states centered in the Peloponnesos, the region of Greece south of the Isthmus of Corinth. There was a brief break after the first ten years of war, which are sometimes called the "Archi-

damian War" after the Spartan king Archidamus who commanded the Peloponnesian forces in the early years of the war. The Archidamian War ended with a peace treaty which was never accepted by some of Sparta's allies, and during the brief period when hostilities ceased, Athens launched an expedition against Sicily with the intention of extending her imperial reach there, and her expeditionary force was completely destroyed in 413 B.C.E. In the final years of the war Persia intervened, and supplied Sparta with a subsidy with which to build a Spartan fleet, and when the war ended with the surrender of Athens, Sparta and Persia divided the Athenian Empire between them. The slogan of Sparta and her allies when the war began was "Liberation for the Greeks"—that is, liberation from the Athenian Empire—but at the war's end, the slogan was forgotten.

THE DOWNFALL OF ATHENS. Thucydides began his history with the causes of the Peloponnesian War. The underlying cause was the fear which Sparta and her allies had of Athenian imperialism, though Thucydides pinpointed three immediate causes. First, Athens became embroiled in a struggle between Corinth, a member the Spartan alliance, and Corinth's former colony, Corcyra (Corfu, nowadays called Kerkyra), and Corinth appealed to her allies. Second, a tributary state of the Athenian Empire, Potidaea, rebelled against Athens and Corinth sent help to Potidaea. Finally, Athens placed an embargo on trade with her neighbor Megara, which was a Spartan ally. Pericles had a strategy to win the war for Athens that capitalized on her strength. Athens had a powerful fleet made up of galleys called *triremes,* rowed by well-trained crews of Athenian citizens. On land, however, she was no match for Sparta and her allies, and so when the Spartan-led army invaded Athenian territory, the Athenians evacuated their farms and took refuge behind their great city walls. Long walls fortified the road between Athens and her port of Piraeus so that Athens could access the sea and use her fleet to make commando raids on Peloponnesian territory. This would be a war of attrition—each side would try to wear the other down—and Pericles believed that Athens would last longer than Sparta. But an unexpected event upset his calculations. In the second year of the war, the Athenians were smitten by a plague described by Thucydides in clinical detail. Pericles himself took ill, recovered, but died shortly afterwards. The first ten years of war ended with a peace treaty in 421 B.C.E., but the result was to exchange a hot war for a cold one. Athens, ever ambitious to expand her empire, dispatched an expedition to the neutral territory of Sicily in 415 B.C.E., in the hopes of conquering its leading city, Syracuse. To Thucydides,

who was familiar with the plots of the tragedies staged in Athenian theater, the Sicilian expedition must have seemed like a protagonist's act of arrogance preceding his downfall in a tragic drama. The attempt to conquer Syracuse failed, and Athens lost all the ships and men she had dispatched to Sicily. The powerful prose of Thucydides' description of the last, desperate battle in the harbor of Syracuse provokes our emotions because it is outwardly unemotional. The Athenians, having lost their best warships and troops, were in desperate straits, bankrupt, and facing revolts in their empire, but they did not give up. For reasons unknown, when Thucydides reached 411 B.C.E. in his narrative, he broke off in mid-sentence and left his history unfinished. It may have been sudden death; he was reportedly drowned at sea. All that is certain is that he clearly knew that the war ended with the defeat of Athens, and he intended to finish the story.

CONTINUING THUCYDIDES. More than one author endeavored to continue Thucydides' work. Two historians, Theopompus and Cratinus, individually took up the story where Thucydides broke off, and they continued until 394 B.C.E., ten years past the year of Athens' defeat. Athens by 394 B.C.E. was about to rise again, and thus the tragic vision of Thucydides is given a happy ending. A scrap of papyrus discovered in 1906 at Oxyrhynchus in Egypt has some 900 lines of a continuation that was clearly written by an able historian, and many scholars attribute it to Cratinus. The lack of concrete evidence to support this supposition, however, forces the more generic authorship of "The Oxyrhynchus Historian," or the *Hellenica Oxyrhynchia*. The one continuation that we do have, the *Hellenica*, was written by Xenophon, a onetime disciple of the philosopher Socrates. The *Hellenica* of Xenophon took up Greek history where Thucydides left off and continued it to 362 B.C.E. None of those who continued the work of Thucydides, as far as we know, brought their histories to a close with the Athenians' capitulation to Sparta in 404 B.C.E.

SOURCES

Charles Norris Cochrane, *Thucydides and the Science of History* (London, England: Oxford University Press, 1929).

W. Robert Connor, *Thucydides* (Princeton, N.J.: Princeton University Press, 1984).

J. H. Finley, *Thucydides* (Cambridge, Mass.: Harvard University Press, 1942).

Simon Hornblower, *Thucydides* (London, England: Duckworth, 1987).

Jonathan Price, *Thucydides and Internal War* (Cambridge: Cambridge University Press, 2001).

HISTORY AFTER THUCYDIDES

XENOPHON. The fourth century had many historians, but only a small portion of their output remains. The author with the best survival record is Xenophon, an Athenian of good family and a member of Socrates' circle. Against Socrates' advice he joined a corps of Greek mercenaries in the army which Cyrus, the younger brother of the Persian king, mustered in 401 B.C.E. to usurp the throne. The expedition was a disaster, but Xenophon led them safely out to the Black Sea coast, and from there they dispersed to seek other employers. Xenophon himself took service with the Spartans. Athens exiled him shortly after Socrates' death—he would return to Athens only in 365 B.C.E.—and he lived on a estate granted him by Sparta for much of his banishment until the upheavals after Sparta's defeat at Leuctra in 372 B.C.E. forced him to move. He wrote on subjects ranging from the Spartan constitution to training horses, but he is best known for his memoirs of Socrates (the *Memorabilia*); his *Anabasis* or "March Up Country," which tells the story of the failed attempt of prince Cyrus, younger brother of King Artaxerxes II of Persia, to seize the Persian throne; and his *Hellenica*, which continues Thucydides' history to the Battle of Mantineia in 362 B.C.E. Xenophon is an easy author to read, and among his other claims to fame is his introduction of a new literary genre: the historical novel. His "Education of Cyrus" (*Cyropaedia*) is a fictional account of Cyrus the Great, the founder of the Persian Empire. It is a bad novel, full of moralizing and not much read nowadays, but it is a groundbreaking venture into historical romance.

THE LOST HISTORIANS. Many historians were writing in the fourth century B.C.E. but their works have not survived. We know them because they were quoted by later writers, or were used by later writers as sources for their own histories—or in some cases, because papyrus fragments have turned up in the sands of Egypt that contain remnants of their works. One of the most prominent was Theopompus of Chios, who wrote an exceedingly long history on Alexander the Great's father, Philip II of Macedon. It was innovative in that it focused on only one personality, whom Theopompus represented as the greatest man that Europe had produced. Another historian of high reputation was Ephorus of Kyme who produced what became the standard history of Greece: a universal history of Greece from the Dorian invasion to his own day. Some of what he wrote has survived at second hand because his history was used as a source by another universal historian who wrote in the first century B.C.E., Diodorus the Sicilian, and we still have Diodorus' history. Diodorus based his history of the world on other authors as well as Ephorus, but Ephorus was a favorite source for him to

Imaginative engraving of Xenophon, one of the modern sources for information on the life of Socrates. THE LIBRARY OF CONGRESS.

copy. Alexander the Great's conquests produced a body of historical writings, but none of it survived except as sources for the work of other Greek and Roman historians such as Plutarch and Arrian, both of whom wrote in Greek, and Curtius Rufus in Latin—all of these date to the period of the Roman Empire. Greece in the fourth century B.C.E. also developed a taste for local chronicles; the chronicles of Athens were known as *Atthides*, or "Chronicles of Attica," and two of its notable authors were Androtion and Philochorus. There is also an historian of the second century B.C.E., Polybius of Megalopolis (208–126 B.C.E.), who was exiled from Greece to Rome, where he wrote a history of Rome in forty books beginning with the first war between Rome and Carthage (265–241 B.C.E.). About a third of it survives. He is a major source for information on Rome's war with Hannibal. A dry writer, he is nonetheless reliable, and he was a shrewd observer of the rising power of Rome.

SOURCES

John K. Anderson, *Xenophon* (New York: Scribner, 1974).

William E. Higgins, *Xenophon the Athenian: The Problem of the Individual and the Society of the Polis* (Albany, N.Y.: State University of New York Press, 1977).

Gordon S. Shrimpton, *Theopompus the Historian,* (Montreal, Canada: McGill-Queens University Press, 1977).

Frank W. Walbank, *Polybius* (Berkeley: University of California Press, 1972).

———, *Polybius, Rome and the Hellenistic World: Essays and Reflections* (Cambridge: Cambridge University Press, 2002).

GREEK COMEDY

BEGINNINGS. The early history of comedy is unclear, remarked Aristotle in his *On the Art of Poetry*, because no one took it seriously. The *polis* of Megara which was sandwiched between Corinth and Athens claimed to have invented it, as did Sicily, which produced a writer of farces, Epicharmus, who was patronized by the tyrants of Syracuse Gelon (485–478 B.C.E.) and his successor Hiero (478–467 B.C.E.). Little of his work survives, though there is enough to make us regret its loss. He wrote burlesques of myths: one play called *Hebe's Wedding* was set in Olympus and parodied the marriage of Heracles to Hebe. Deified though he might be, Heracles was still portrayed much as he was in the comic theater: a muscle-bound lout who gobbled up his food, and drank until he was drunk. Another type of comedy that Epicharmus wrote dealt with contemporary life and introduced stock characters (that is, characters with trademark roles such as the clever slave, the boastful soldier, and the love-sick youth), and a third type that he wrote played with arguments between non-human abstractions—for instance, one seems to have hinged on a debate between women's logic and men's logic. The plays of Epicharmus had no chorus, unlike the comedies produced in Athens, though there was musical accompaniment. Farces were clearly popular in Sicily and "Magna Graecia," as the Greek settlements in southern Italy were called, for the local potters used scenes from the comic theater as vase paintings. These farces look forward to the New Comedy which would displace the Old Comedy of Aristophanes on the Athenian stage more than a century later.

ATHENIAN OLD COMEDY. Old Comedy was an Athenian theatrical development with topical allusions to Athenian politics, and its acceptance as an art form dates from either 488–487 or 487–486 B.C.E., when the archon—that is, the chief magistrate of Athens who gave his name to the year—was made responsible for providing a chorus for a day for five comedies to be produced at the City Dionysia festival each spring in the modern month of March. Shortly before 440 B.C.E. a day of comedies was included in the other great festival of

Dionysus where dramas were presented, the Lenaea festival in January. We also know that in the fourth century B.C.E. comedies were produced at the Rural Dionysia, which were festivals in the country districts of Athens called "demes," and it is likely that comedies were produced there earlier, too, given the physical evidence of theaters in some of these demes. Until the ascendance of Aristophanes there are only a few names and a handful of fragments from the comic poets of this era, including Cratinus—old, and notorious for his wine consumption, but still writing when Aristophanes began his career—and Eupolis, who was a worthy rival of Aristophanes and popular in his day, for he was often quoted. Other comic playwrights such as Crates, Pherecrates, Hermippus, Phrynichus, Teleclides, Ameipsias, Theopompus, and Plato—not to be confused with the philosopher Plato—are hardly more than names attached to titles of lost comedies. The eleven plays of Aristophanes are all that remains of Greek Old Comedy, and they owe their survival to the fact that Aristophanes became popular as assigned reading for Greek schoolboys of the second century C.E.

ARISTOPHANES' BACKGROUND. The approximate dates of Aristophanes' lifetime—450–385 B.C.E.—place him in one of the most turbulent periods of Athenian politics. He was a boy in the Periclean Age, when the politician Pericles dominated Athens. Pericles' authority was based on his dominance of the popular assembly, the *ekklesia*, where all male citizens could vote. As a well-connected, wealthy man, Pericles was able to dominate the assembly so long as he followed popular policies, which he did. He took an imperialist approach to Athens' neighbors, which led to the creation of an Athenian Empire profitable enough to finance a splendid building program in Athens. It also led to the Peloponnesian War with Sparta and her allies. Nine of Aristophanes' plays were written in wartime and they belong to the period that followed the death of Pericles in the autumn of 429 B.C.E. The great man proved irreplaceable and, under the stress of war, the fissures in the body politic of Athens began to appear.

THE FIRST PLAYS. Aristophanes' first comedy was *The Banqueters*, produced in 427 B.C.E., which won second prize at the City Dionysia, followed the next year by *The Babylonians*. Although *The Babylonians* won first prize, it also earned him the wrath of the politician Cleon, who successfully prosecuted him for anti-Athenian propaganda. The reason for the inflammatory nature of the work is lost in history since neither of these plays survived. His next play, the *Acharnians*, was produced at the Lenaea festival in January, 425 B.C.E. A year later at the

Bust of the Athenian comic poet Aristophanes. © BETTMANN/CORBIS.

same festival he produced the *Knights*, and in 423 B.C.E. he produced the *Clouds*, a burlesque of Socrates which only won third prize. Aristophanes was bitterly disappointed; the *Acharnians* and the *Knights* both won first prizes, and since the number of comedies had been reduced from five to three during the Peloponnesian War as an economic measure, that meant that the *Clouds* took last place. Aristophanes set about rewriting it, and at least some of the surviving text is from this second edition, which was never staged. In 422 B.C.E. his play the *Wasps* won second prize, and the next year, when Athens and Sparta signed a peace treaty, Aristophanes staged his comedy *Peace* and again won second prize.

FORMULA FOR OLD COMEDY. The structure of the comic play was already established by Aristophanes' heyday. First there was a *prologue* during which the leading character has a bright idea which gets the plot underway. Then comes the *parodos*: the entry of the chorus of 24 men wearing masks and fantastic costumes. Next is the *agon*: a debate between one character who supports the bright idea of the prologue, and an opponent who always loses. Then follows the *parabasis* where the chorus comes forward and sings to the spectators directly. The parabasis gave the comic poet an opportunity to

voice his views on the present state of affairs. Next comes the *episodes* where the bright idea is put into practice, sometimes with comic results, after which comes the *exodus*, which concludes the play on merry note: a marriage, or a banquet, or some happy occasion. This was not a hard-and-fast formula. The *Acharnians* has two episodes, the *Knights* three, and the *Clouds* two agons. The last two plays of Aristophanes lack a parabasis, but by the time they were produced, Old Comedy had given way to Middle Comedy, which did without the parabasis. It belonged to an age which preferred not to hear the personal views of comic poets.

THE ACHARNIANS. One of Aristophanes' first plays, *The Archarnian* is a play whose theme is the foolishness of war-mongering. The Acharnians of the title of this play were citizens of the deme (constituency) of Acharnae, war hawks who made their living making charcoal. The Peloponnesian War was beginning its sixth year when this play was produced. The citizens from the countryside were suffering great hardship, for they had to evacuate their farms when the Spartan allied force invaded Attica—as it did each year when the crops were ripe—and find shelter behind the walls of Athens. Pestilence aggravated their suffering; the great plague was at its most severe in the second year of the war but it lingered on for three more years. The setting of the *Acharnians* is the Pnyx in Athens where the people assembled for meetings of the *ekklesia*. Dicaeopolis, a decent citizen, recounts his woes as he waits for the assembly to convene. When it does, Amphitheus proposes peace negotiations with Sparta but is silenced. Disgusted, Dicaeopolis recruits Amphitheus to negotiate a private truce for him with Sparta, and he returns from Sparta to offer Dicaeopolis three possibilities: a truce for five, ten, or thirty years. Dicaeopolis chooses a thirty-year peace and exits. On comes the chorus of peace-hating Acharnians, searching for the man who dared conclude a truce with Sparta. When Dicaeopolis returns, they hurl stones at him, and to save himself, he runs to the house of the tragic poet Euripides, whose works were famous for their pitiable heroes. Euripides gives Dicaeopolis a tattered costume to wear, and with his Euripidean props, Dicaeopolis delivers a clever parody of a Euripidean speech in his defense, reviewing the causes of the war and absolving Sparta. The sympathies of the chorus are divided, and the war hawks call in an ally, Lamachus, a well-known hawk. Lamachus comes on stage, magnificent in full armor, but Dicaeopolis' arguments demolish him. Dicaeopolis proclaims the end of all war boycotts. The chorus then advances stage front and sings the parabasis directly to the audience, the subject of

which is the virtues of Aristophanes. Following two more episodes, Lamachus is ordered off to a battle, and the play concludes with Lamachus returning wounded from war, and Dicaeopolis returning drunk from a feast, with a courtesan on each arm. In the final scene, Dicaeopolis roisters and Lamachus groans, and the foolishness of war-mongering is made apparent to all.

THE KNIGHTS. The *Knights* was an attack on Cleon, the chief war hawk and the darling of the Athenian common man. The year before, the Athenians had defeated Sparta on Sphacteria, an island at the north end of the Bay of Navarino, where they had marooned a Spartan force, including 120 of their elite Spartiates, and forced it to surrender. Cleon was given the credit, which, in part, he deserved, though Aristophanes thought not. In the *Knights*, Demos is a good old man who is easily gulled, and his new slave, a tanner from Paphlagonia, has him under his thumb to the despair of two other slaves, Demosthenes and Nicias. Each character represented a real-life person: the Paphlagonian was Cleon, thinly-disguised; the two other slaves were the Athenian generals, Demosthenes and Nicias; and the old man Demos represented the Athenian people, for whom the Greek word was *demos*. Demosthenes and Nicias depose the Paphlagonian by putting forward an even greater rascal than he, a sausage seller who outbids the Paphlagonian for Demos' favor and is revealed as a statesman whose real name is Agoracritus, meaning "Choice of the Agora." In the exodus, Agoracritus announces that he has rejuvenated Demos into a young, vigorous, and highly-sexed man.

THE CLOUDS. The butt of Aristophanes' raillery in the *Clouds* is Socrates, who is portrayed in the play as the proprietor of a *phrontisterion*, a think-tank combined with a school for Athenian youth. The plot centers on Strepsiades, an elderly Athenian, and his ne'er-do-well son, Pheidippides. Pheidippides' passion for chariot racing has landed him deeply in debt, and Strepsiades is afraid that his son's creditors will pursue him. To avoid the creditors, he decides to enroll his son in Socrates' school that teaches debaters how to make weaker arguments appear the better. Pheidippides refuses to go, so Strepsiades enrolls himself. Socrates' attempt to teach poor old Strepsiades is a nice piece of buffoonery, but the upshot is that Strepsiades is expelled for stupidity and insists that his son enroll or leave home. Pheidippides is instructed by two teachers at the think-tank, Just Cause, who teaches the old-fashioned virtues, and Unjust Cause, who teaches how to find loopholes in the laws. They quarrel about the purposes of education. Unjust Cause wins on a technicality and takes over Phei-

dippides' training. He makes such splendid progress that he is able to justify beating his father. Strepsiades realizes that the new learning that Socrates represents has ruined his son and burns down Socrates' institute.

THE WASPS. A citizen in Athens had the right to a trial before his fellow citizens, and in practice that meant that he was tried before a large jury of from 100 plus one jurymen to 500 plus one, who listened to the arguments of both the plaintiff and the defendant and then voted on the verdict. A juryman's pay was small. Yet for elderly citizens, jury service was both a welcome income supplement and also entertainment. Yet because many took jury duty as entertainment, it was often seen by many as a useless system of judgement. In *Wasps,* a farce on the jury system, there is a clash of wills between the old man Philocleon (Cleon-lover) and his son Bdelycleon (Cleon-hater). The chorus of jurymen, who are costumed as hornets, summon Philocleon to join them at jury duty, but Bdelycleon has his father locked in the house. After an argument, Bdelycleon convinces his father that jurymen are only tools in the hands of self-seeking demagogues, and promises Philocleon that he will feed him and let him play at holding trials at home if he gives up his addiction to jury duty. Then in a parody of a court case, Philocleon tries the dog Labes for stealing cheese; Bdelycleon argues for the dog so well that Philocleon acquits it. When Philocleon realizes his error—he has never voted "Not Guilty" before—he swoons and is taken off stage. Two episodes follow: in the first, Bdelycleon, on his way to a banquet with Philocleon, instructs him how to behave like an Athenian gentleman; and in the second, Philocleon returns with a piper from the banquet, very drunk, and holding with one arm a nude girl. As Philocleon tries to make love to the girl, Bdelycleon manhandles him into his house.

THE PEACE. When the *Peace* was produced, Cleon was dead, as was the chief Spartan war hawk, Brasidas. Both had died in the same battle, at Amphipolis in northern Greece. For Athens the battle was disastrous, but in both Athens and Sparta, parties supporting peace were left in control, and during the year 421 B.C.E., a peace treaty was signed. In the *Peace*, an Athenian citizen Trygaeus flies to Heaven astride a dung-beetle where he learns that the Olympian gods have moved away in disgust at the warring Greeks and have left War and Tumult in charge of their palace. War has thrown Peace into a pit and piled stones on her. Trygaeus, with the help of a chorus of Greek farmers and laborers, frees Peace, along with Harvest and Diplomacy, two women whom Trygaeus brings with him when he returns to earth. Trygaeus prepares a wedding feast where a sooth-

sayer appears, prophesying that the war cannot be stopped. In the Exodus, there appears a group that is hard hit by the peace: manufacturers of armor, trumpet makers, and the like. They try to unload surplus arms and armor on Trygaeus, but he will have none of it. He drives them off and the feast begins.

THE BIRDS. The play the *Birds* is a good-natured spoof on the "castles in the air" that some Athenians were building as they imagined their triumph in taking over Sicily in the late fifth century B.C.E. The castles in the air would soon implode. In 415 B.C.E. Athens dispatched a great armada to Sicily, and two years later, the fleet was completely destroyed in a fruitless effort to take the city of Syracuse. When the *Birds* was produced, however, the Athenians still nursed hopes of winning an empire in Sicily that would make Athens the superpower in the Greek world. In the play, two Athenian adventurers, Pisthetaurus and Euelpides, convince birds to build a new city, to be called Cloudcuckooland, in the sky between Earth and Heaven. Cloudcuckooland cuts the gods off from the smoke rising from human sacrifices, and the gods are forced to seek a peace treaty with the birds. Pisthetaurus and Basileia (meaning "kingship") are to wed, and they exit the stage, flying off to Zeus' palace to take it over.

THE LYSISTRATA. In the year 411 B.C.E., following the disastrous Sicilian expedition, many of the wealthier, more conservative Athenians lost confidence in the Athenian democracy's conduct of the war. The *Lysistrata* is Aristophanes' plea for peace. Lysistrata is an Athenian housewife who is sick of war. Women in Athens were traditionally shut out of government, but Lysistrata's disgust with male bumbling causes her to lead a women's revolt to seize the Athenian government and end the war. The women agree to deny their husbands sex until they make peace, while at the same time making themselves as alluring as possible in order to set their husbands' hormones raging. They seize the Acropolis, where the Parthenon housed the state treasury. The revolution spreads to Sparta, where the women banish their husbands until peace is made. Finally in the third episode, envoys arrive from Sparta to sue for peace, and everyone calls on Lysistrata. She appears on stage bearing a statue of the goddess Reconciliation, and she makes a speech on the worth of women and the value of Panhellenism, when all the Greeks band together, rather than fight each other. The play ends with the Athenians and the Spartans feasting and dancing.

THESMOPHORIAZUSAE. *Thesmophoriazusae* (Women Celebrating the Thesmophoria) is a spoof on Euripides,

whose tragedies were controversial—he had the reputation of being a woman-hater because he did not idealize women in his plays. In the *Thesmophoriazusae*, the women of Athens have decided to put Euripides to death for his insults to the female sex. Euripides, along with his father-in-law, Mnesilochus, come to the tragic poet Agathon to ask for help. Agathon was famous in real-life for his effeminacy and for inventing plots for his plays rather than taking them from mythology. When Agathon consents to see his visitors, he appears lolling on his bed, surrounded by feminine toilet articles. He refuses to help but consents to lend Euripides some women's clothing so Mnesilochus can wear them when he meets the women at the Thesmophorion, the temple of Demeter where the women's religious festival known as the Thesmophoria is held. Finding them denouncing Euripides, he undertakes his defense, arguing that women are much worse than Euripides depicted them. He infuriates the women into attacking him, and then is exposed as a man by a well-known pederast, Clisthenes, who is also dressed as a woman. Then Euripides' himself attempts to save Mnesilochus, using various dramatic devices from his own plays, and finally he succeeds in rescuing his father-in-law with a tried-and-true method: he disguises himself as a procuress—that is, a female pimp—and comes on stage with two girls. They distract the policeman who is holding Mnesilochus, allowing Euripides to release Mnesilochus.

THE FROGS. In 405 B.C.E. the Peloponnesian War was nearing its end, but the radical democrats in Athens still did not want peace. The deaths of Sophocles and Euripides the year before lent a bittersweet tone to the *Frogs*. In the play the god Dionysus, patron of the Athenian stage, descends into the Underworld to bring back his favorite playwright, Euripides, for no tragedians still alive were as ingenious as he was. In the Underworld, there is a contest between Aeschylus, who was long dead, and Euripides, the new arrival in the Underworld. The worth of the poets is decided by bringing out a scale and putting a verse from one of the plays of each contestant into the balance and seeing which verse weighs more. Aeschylus wins in three trials, for his verses express weighty ideas whereas Euripides is an intellectual lightweight by comparison. When Dionysus decides in Aeschylus' favor, however, Euripides reminds him that it was to bring him back that Dionysus descended into the Underworld in the first place. Dionysus replies with a famous quotation from Euripides' tragedy the *Hippolytus* which struck the Athenians as the height of sophistry when it was first uttered on the stage: "My tongue has sworn. My heart remains unsworn." The play ends with a feast, and Hades, the Lord of Death, sends Aeschylus back to Athens with messages for some Athenian individuals who were still alive that he wanted to see them soon. The *Frogs* is the last surviving example of Old Comedy, and it is Aristophanes at his most brilliant.

THE ECCLESIAZUSAE. Following the conclusion of the Peloponnesian War, Old Comedy diminished in popularity. It had flourished under the freewheeling democracy of fifth-century Athens, but after the war, the political atmosphere changed even though the democracy was restored after a group of disgruntled right-wingers known as the "Thirty Tyrants" seized power and set up a short-lived oligarchic government. The *Ecclesiazusae* (Women in the Assembly, produced in 391 B.C.E.) and *Plutus* (388 B.C.E.), the last surviving play of Aristophanes, belong to Middle Comedy. Middle Comedy differs from Old Comedy in that the parabasis is omitted, the chorus is less important, and the pointed attacks on Athenian politicians are absent. The butt of Aristophanes' satire, *Ecclesiazusae*, is Plato's *Republic*. While it is unclear whether the *Republic* had been published at the time of the production of *Ecclesiazusae*, Plato's lectures had been propagating his ideas, and the idea of an ideal society without private property of the sort lampooned by Aristophanes in his play was familiar to Aristophanes' audience. In the play, the women of Athens, led by Praxagora, dress themselves in their husbands' clothing, go early to the *ekklesia*—that is, the assembly which held ultimate power in the Athenian democracy—and establish a new constitution in which everything is held in common, even women. The episodes that follow are commentaries on the new order. Praxagora's husband Blepyrus is delighted at his wife's initiative because he looks forward to a life of laziness. Another citizen wants to share in the benefits of the new order without contributing anything. A handsome young man wants to sleep with a lovely courtesan, but the law requires him to satisfy a couple old crones first who drag him off to enjoy his sexual prowess. The play ends with a communal feast. The moral of the play is that an ideal society needs ideal citizens to make it work, and none were to be found in Athens.

THE PLUTUS. One of the darker comedies of Aristophanes, *Plutus* reminded audiences that a certain amount of injustice may be necessary to make the economy function. In this play, a blind old man in rags comes on stage, followed by Chremylus and his slave, Cario. Chremylus has been told by the Delphic oracle to follow the first man he met after leaving the temple, and it turned out to be this blind old man. Chremylus and Cario ask the old man who he is, and reluctantly he tells them that he

is Plutus, the god of wealth whom Zeus, jealous as ever of mankind, has struck blind. Chremylus decides to cure Plutus of his blindness, and takes Plutus into his house. Chremylus' friend, Blepsidemus, agrees to help restore Plutus' sight in exchange for a share of the wealth granted by Plutus. They take him to the temple of Asclepius, the god of healing, but are interrupted by a horrifying woman, the goddess Poverty. She and Chremylus debate whether Poverty or Plutus, the god of wealth, benefits mankind more. Chremylus argues that if Plutus could see, he would reward only the good, and hence eventually everyone would become good. Poverty counters that if this happened, no one would want to work. Chremylus wins the argument, and a miraculous cure restores Plutus' sight. Then we see the results—good and bad— of giving rewards only to good and deserving persons. Not everyone is delighted with this new dispensation. A Just Man comes on stage. He is happy. An Informer enters. He is ruined. An old woman, dressed as a young girl, comes to tell Plutus that her gigolo has deserted her. Hermes arrives to report that humans are no longer making sacrifices and the gods are starving. A priest of Zeus reports that he is starving, too, and he deserts to the new god, Plutus. Then Plutus himself comes on stage, followed by the old woman that has lost her gigolo. She is assured that he will return to her. The play ends with a procession to the Acropolis to install Plutus and begin his reign.

MIDDLE COMEDY. Between Athens' defeat in the Peloponnesian War in 404 B.C.E. and 321 B.C.E.—the probable date when Menander produced his first comedy *Anger*—comedy underwent an enormous change. The audience became more solidly middle-class as the poor could no longer afford to go to the theater. The emphasis of the plays switched from politics to courtesans, food, and sex. The chorus merely provided interludes of song and dance instead of being part of the action. Though we have the names of some fifty authors, and the titles of over 700 comedies, no Middle Comedy survived, except for the last two plays of Aristophanes. The titles range from *The Birth of Aphrodite*, evidently a burlesque of mythology—send-ups of myths were popular in Middle Comedy—to *The Stolen Girl* which sounds like a situation comedy. Characters from the fringes of polite society appear again and again as stock characters: the professional courtesan who sometimes has a heart of gold, the clever slave, the braggart soldier, and the sponger who survives by truckling to rich friends. These are international character types with panhellenic appeal, meaning they could belong to any Greek city, not just Athens. In fact, many of the playwrights pro-

Imaginative portrait of Menander, the foremost playwright of the New Comedy. **THE LIBRARY OF CONGRESS.**

ducing Middle Comedy in Athens were not Athenian citizens.

THE UNEARTHING OF MENANDER. Until the beginning of the twentieth century the only known examples of New Comedy came from second-hand adaptations of Greek plays by the Roman playwrights Plautus and Terence for the Roman stage. These adaptations provided some flavor of the New Comedy playwrights Menander, Diphilus, Philemon, and Apollodorus. In 1905 a papyrus-codex—that is, a papyrus document bound like a modern book—was found in Egypt at Aphroditopolis, modern Kom Esqawh. It contains large parts of Menander's *Girl from Samos, The Rape of the Locks* and the *Arbitration*, plus fragments of two other plays. A little more than fifty years later, a papyrus containing the full text of the *Dyskolos* (The Man with a Bad Temper), more fragments of the *Girl from Samos*, and half of a play titled *The Shield* came to light Since then, other papyrus fragments have been discovered—one, as recently as 2003, yielding 200 lines of an unspecified play—but the *Dyskolos* is the only complete play to be discovered.

THE DYSKOLOS. The *Dyskolos* was first produced at the Lenaea festival in Athens in 316 B.C.E. It is an early play of Menander, a lightweight situation drama without the stock characters typical of New Comedy. In the play, Knemon, a misanthropic man, marries a widow with one son, Gorgias, by a previous marriage. They have a daughter, but Knemon's wife, unable to bear his bad temper, leaves him and he lives as a virtual hermit on his farm. Sostratus falls in love with the daughter and asks for her hand in marriage. Knemon refuses, but after he falls down a well and is rescued by Sostratus he becomes a changed man. He is reconciled with his wife and agrees to give his daughter to Sostratus to marry. In addition, he marries Gorgias to Sostratus' sister.

INFLUENCE OF NEW COMEDY. New Comedy set the style for Greek theater after Alexander the Great, from the third century B.C.E. onwards. Numerous theatrical festivals sprouted in cities everywhere, and troupes of professional actors traveled from place to place, staging their plays. From Greece, the New Comedy went to Rome where the playwrights Plautus and Terence crafted plays on the New Comedy model. While the Old Comedy plays of Aristophanes were tied to one place and one time, the New Comedy had universal appeal.

SOURCES

K. J. Dover, *Aristophanic Comedy* (London, England: B. T. Batsford, 1972).

R. L. Hunter, *The New Comedy of Greece and Rome* (Cambridge: Cambridge University Press, 1985).

Hans-Joachim Newiger, "War and Peace in the Comedy of Aristophanes," *Yale Classical Studies* 26 (1980): 219–237.

Gilbert Norwood, *Greek Comedy* (London, England: Methuen, 1931; reprint, New York: Hill and Wang, 1963).

F. H. Sandbach, *The Comic Theatre of Greece and Rome* (London, England: Chatto and Windus, 1977).

Dana Ferrin Sutton, *Ancient Comedy: The War of the Generations* (New York: Twayne Publishers, 1993).

Michael J. Walton and Peter Arnott, *Menander and the Making of Comedy* (Westfield, Conn.: Greenwood Press, 1996).

C. H. Whitman, *Aristophanes and the Comic Hero* (Cambridge, Mass.: Harvard University Press, 1964).

GREEK TRAGEDY

BEGINNINGS. The evidence for the origins of tragic drama is ambiguous. The name itself is odd, for *tragoidia* means the "song of the male goat," or perhaps a "song for a male goat" and attempts to explain its meaning have been ingenious but never quite successful. The Roman poet Horace, a contemporary of the emperor Augustus, thought that "tragedy" got its name because the prize for the best tragedy was a goat, but this is unlikely. One fact, however, is not disputed: tragedy was intimately connected with the cult of Dionysus, and Aristotle stated that it developed from the dithyramb, a choral song in honor of Dionysus. The great age of Greek tragedy began in Athens when the tyrant Pisistratus established the festival of the City Dionysia about 536 B.C.E. where dithyrambs were presented by amateur choristers. Pisistratus hoped to use the festival to raise the profile of Athens. After he died in 527 B.C.E., his sons Hippias—who succeeded him as tyrant—and Hipparchus—who became a quasi Minister of Culture—continued his policy until Hipparchus was assassinated and Hippias was ousted from power four years later in 510 B.C.E. At the City Dionysia of 534 B.C.E., or at least between 536 and 533, the chorus leader Thespis from the village of Icaria took a solo part in his dithyramb, thus introducing an actor who played a role in the story. Tragedy, as Aristotle pointed out, was the representation of an action worthy of attention, and once there was an actor, there could be an imitation of the action, though the chorus still sang the story line. We know almost nothing about Thespis except his father's name, Themon, and that he had a pupil named Phrynichus who lived well into the fifth century B.C.E. By then the great age of tragedy had arrived, dominated by Aeschylus, Sophocles, and Euripides.

AGE OF TRAGEDY. The great age of tragedy was short. It began with Thespis, but the first surviving tragedy is Aeschylus' *Persians*, performed in 472 B.C.E. It ends with the deaths of Sophocles and Euripides just before the Athenian defeat in the Peloponnesian War. Other surviving plays include seven plays of Aeschylus, seven of Sophocles plus a satyr play (the *Trackers*), and seventeen of Euripides plus a satyr play (the *Cyclops*). There is also the *Rhesus*, the shortest Greek tragedy we have, which may be by Euripides. Other tragedians whose work is now lost include Phrynichus, Choerilus and Pratinas—all of whom wrote before Aeschylus—and the sons of Phrynichus and Pratinas who belonged to the generation of Aeschylus and Sophocles. Aeschylus' son Euphorion also presented tragedies.

TRAGEDY BEFORE AESCHYLUS. Aeschylus was the first playwright to add a second speaking actor, and Sophocles added a third. Prior to Aeschylus, when there was only one actor, the chorus must have played a very important role in unfolding the plot of the drama. One

a PRIMARY SOURCE document

ARISTOTLE ON TRAGEDY AND COMEDY

INTRODUCTION: The eminent Greek philosopher Aristotle (384–322 B.C.E.) wrote on the subject of tragedy in his *Poetics,* along with a great many other subjects. In the excerpt below, he discusses the key components of tragedy.

Tragedy, then, is a representation of an action that is worth serious attention, complete in itself and of some amplitude; in language enriched by a variety of artistic devices appropriate to the several parts of the play; presented in the form of action, not narration; by means of pity and fear bringing about a purgation of such emotions. By language that is enriched I refer to language possessing rhythm, and music or song; and by artistic devices appropriate to the several parts I mean that some are produced by the medium of verse alone, and others again with the help of song.

Now since the representation is carried out by men performing the actions, it follows, in the first place, that spectacle is an essential part of tragedy, and secondly that there must be song and diction, these being the medium of representation. By diction I mean here the arrangement of the verses; song is a term whose sense is obvious to everyone.

In tragedy it is action that is imitated, and this action is brought about by agents who necessarily display certain distinctive qualities both of character and of thought, according to which we also define the nature of the actions. Thought and character are, then, the two natural causes of actions, and it is on them that all men depend for success or failure. The representation of the action is the plot of the tragedy; for the ordered arrangement of the incidents is what I mean by plot. Character, on the other hand, is what enables us to define the nature of the participants, and thought comes out in what they say when they are proving a point or expressing an opinion.

Necessarily, then, every tragedy has six constituents which will determine its quality. They are plot, character, diction, thought, spectacle and song. Of these, two represent the media in which the action is represented, one involves the manner of representation, and three are connected with the objects of the representation; beyond them nothing further is required.

SOURCE: Aristotle, "On the Art of Poetry," in *Classical Literary Criticism.* Trans. T. S. Dorsch (Harmondsworth, England: Penguin Classics, 1965): 38–39.

of Aeschylus' tragedies, the *Suppliants*, conforms to this pattern. At one time, scholars believed it was produced even before the Battle of Marathon in 490 B.C.E., where Aeschylus fought the Persian invaders as an infantryman on the Athenian battle line, but among the great cache of papyri discovered at Oxyrhynchus in Egypt there is a small fragment which upset the early date for the *Suppliants*. It now seems likely that it was produced at the City Dionysia of 462 B.C.E. The late date of *Suppliants* shows that Aeschylus did not feel the need to follow the newest fashions on stage.

THE PERSIANS. In 480 B.C.E. the Persian Empire launched a great invasion of Greece by land and sea, led by King Xerxes himself, and it ended in utter defeat. The turning point was the Greek victory at Salamis, and the Athenians had some right to claim the victory as theirs, for though the admiral of the allied Greek fleet was a Spartan, the Athenian navy was by far the largest contingent. *The Persians* is an imaginary portrayal of the impact of the Persian defeat on the Persians themselves. The play is set in the Persian capital of Susa and used a chorus of Persian councilors, magnificent in their costumes. Xerxes' mother, Atossa, reports a troubling dream

and receives comfort from the chorus. A messenger arrives with news of the defeat of the Persian fleet. His description of the naval battle at Salamis was masterful and must have made Athenian hearts swell with pride. Atossa takes offerings to the tomb of Darius, the wise old king who was Xerxes' father, and the ghost of Darius arises. He describes how the power and wealth of the Persian Empire has blinded the foolish Xerxes, and he utters prophecies of doom. Finally Xerxes comes onstage, his royal robes in tatters, and the drama ends with a lamentation sung antiphonally by Xerxes and the Chorus. This was patriotic drama of a high order, yet it does not disparage the Persians; except for Xerxes himself, all the Persian characters are dignified and noble. Yet the theme was a familiar one: man, blinded by his pride and his greatness, suffers an unexpected overthrow.

THE SEVEN AGAINST THEBES. The *Seven Against Thebes* was the last and only surviving play from a trilogy which dealt with the curse of the royal house of Thebes. The story provided Sophocles with the material for three great tragedies, the *Oedipus Tyrannus*, the *Antigone*, and the *Oedipus at Colonus*. According to the story, Laius, king of Thebes, is befriended in exile by

Imaginative portrait of the tragic poet Aeschylus. AP/WIDE WORLD PHOTOS. REPRODUCED BY PERMISSION.

Pelops, but falls in love with his benefactor's son, Chrysippus, and kidnaps him; the deed brings a curse upon Laius and his family in which his son is destined to kill him. In the lost second play of this trilogy, *Oedipus*, Laius is indeed killed by his son, Oedipus. The curse extends to Oedipus' own sons, Polynices and Eteocles, when they reach adulthood and agree to share the rule of Thebes between them, each reigning in alternate years. While Polynices rules for his year and resigns, Eteocles does not hold to the agreement, refusing to step down following his year of rule. To regain the throne, Polynices gathers an army led by seven heroes, one for each of the seven gates of Thebes, and lays siege to the city. It is at the start of this siege that *Seven Against Thebes* begins. The seven heroes in Polynices' army each lead an attack on their assigned gate, which are, in turn, defended by six champions selected by Eteocles; he himself defends the gate assaulted by his brother Polynices. While the subject matter of the play is action-packed and violent, the Greek audiences did not see any of the battle, which raged offstage, while onstage the chorus sang of the fearful curse that hangs over the royal house of Thebes. A messenger informs the audience of the result of the conflict; the city has been saved but Eteocles and Polynices killed each other, which causes the chorus to sing a lamentation. The message of the play is highly fatalistic, suggesting that nothing can avert a fate that is destined to be.

THE SUPPLIANT WOMEN. The *Suppliant Women* belongs to a trilogy of three tragedies which modern critics call the *Danaid Trilogy* for the sake of convenience. Only the first play of the trilogy, *Suppliant Women* survives, but we know the titles of the two plays that followed it: the *Egyptians* and the *Danaids* (the "Daughters of Danaus"). The myth on which the play is based was familiar to the Athenians: the fifty sons of Aegyptus (meaning "Egypt") force the fifty daughters of Aegyptus' brother Danaus (meaning "Greek") to marry them, and the daughters flee from Egypt with their father to seek refuge in Argos, their ancestral home. At the beginning of the play, the daughters are in Argos, pleading for sanctuary (thus, they are the "suppliant women" of the title) from Pelasgos, king of Argos. At the risk of war with Egypt, Pelasgos and the Argive people agree to give them sanctuary and defy the pursuing sons of Aegyptus. The fifty daughters act as the chorus in this play, although presumably represented by twelve singers, the standard size of tragic choruses. After thwarting the Egyptians, Danaus gives his daughters some fatherly counsel: be obedient to your father's instruction. The full weight of this advice is borne out in the last two plays of the trilogy, now lost, in which the sons of Aegyptus succeed in marrying the daughters of Danaus, and Danaus instructs his daughters to kill their husbands on their wedding nights. All of them do so except for Hypermestra, the one daughter who fell in love with her Egyptian husband Lynceus; she obeys the claims of love rather than her father. A fragment of the last play of the trilogy survives: a speech of Aphrodite, goddess of love, which praises love as the generative principle of the universe.

THE ORESTEIA. The *Oresteia* is the only complete surviving trilogy of Aeschylus, consisting of the *Agamemnon*, the *Libation Bearers*, and the *Eumenides*. The trilogy is about a blood feud coming under the rule of law. A hero of the Trojan War, Agamemnon, had sacrificed his own daughter prior to leaving for the war in order to secure favorable winds for the journey. This act sparked a chain reaction of revenge killings when Agamemnon is slain by his wife, Clytaemnestra, and her lover upon his return from Troy and his son Orestes then kills the murderous couple. Orestes is morally polluted by his matricide and is pursued by the Furies until he stands trial in Athens before the ancient Council of the Areopagus. The Council had only recently been stripped of most of its power when the *Oresteia* was produced, but still served

as a court for homicide cases. The Furies argue that Orestes must pay the penalty for matricide according to the law of blood feud. The gods become involved, with Athena presiding as a judge, and Apollo speaking for the defense. The jurors are evenly divided, so Athena casts the deciding vote. She rules that because the murder of a father outweighs the murder of a mother, Orestes was not in the wrong to punish his mother with death for killing his father. The decision implies the replacement of a matriarchal society by a patriarchal one, though whether or not that is the hidden meaning of this play can be endlessly debated. At any rate, the Furies are outraged, but Athena offers them a place in her city as kindly spirits, checking crime under her new dispensation. The Furies accept and become "Kindly Goddesses" under the new rule of law that replaces the law of an "eye for an eye and a tooth for a tooth."

PROMETHEUS BOUND. *Prometheus Bound* is considered to be Aeschylus' last play. The story re-tells the myth of Prometheus, a Titan who incurs the wrath of Zeus because he secretly gave the gift of fire to mortal men whom Zeus despised and would have replaced with a more perfect race if he had had his way. For his rebellion against Zeus, Prometheus was condemned to be eternally chained to a rock and to have his liver eaten by an eagle each day. Prometheus' immortality as a Titan assured the unending torture of his punishment since his liver would grow anew each day, only to be eaten again by the eagle. The drama ends with an earthquake—how the "special effects" department of the day accomplished it is a matter of conjecture—and Prometheus and his rock sink below ground while the chorus flees. Prometheus remains a man of principle in the face of overwhelming power. This ending cuts off the myth, but we know that the trilogy had two more plays and ended with peace between Zeus and Prometheus. The supremacy of Zeus is recognized, but so also is the right of human race to exist and live under the rule of law, free from violence.

SOPHOCLES. During his long life which stretched from about 496 to about 406 B.C.E., Sophocles wrote 123 dramas, of which seven survive along with an incomplete satyr play which was discovered on a papyrus. This abbreviated catalog of his work only hints at his development as a playwright. By all accounts, he was well born, handsome, and pious, and he took an active role in public life. He introduced the convention of a third actor in tragedy productions early in his career (previous tragedies had only two actors with a chorus), and Aeschylus soon followed his lead by including three actors in his *Oresteia*. Sophocles also introduced scenery of some

Imaginative portrait of Sophocles. © ARCHIVO ICONOGRAPHICO, S.A./CORBIS.

sort. The recurring theme of his tragedies is the suffering of men and women—sometimes suffering they bring on themselves by flaws in their characters, or suffering that results from being in the wrong place at the wrong time.

AJAX. The *Ajax,* which most scholars consider to be the earliest Sophoclean tragedy, centers on the legend of Ajax's suicide. According to Homer's *Iliad,* the hero Ajax was, after Achilles, the toughest warrior in the Greek army fighting at Troy. Following the death of Achilles, there is a contest to see who is the most valuable hero in the Greek army, and thus worthy to inherit his armor. Ajax loses the competition to fellow warrior Odysseus and goes mad with disappointment. In his madness, he attacks what he believes to be the Greek camp and at the start of the play is gloating over his supposed slaughter of Odysseus and two of the Greek champions, Agamemnon and Menelaus. When he recovers his sanity he realizes that instead of the Greek camp, he has attacked a flock of sheep, and he is so overcome by shame that he commits suicide. His death was dishonorable, and thus the issue arises of what sort of burial Ajax should have. His half-brother Teucer is determined to see him honorably buried, but Menelaus and Agamemnon for-

a PRIMARY SOURCE *document*

ANTIGONE'S SPEECH IN DEFENSE OF CONSCIENCE

INTRODUCTION: In Sophocles' tragedy, *Antigone*, there is a clash between the conscience of the individual and the demands of the state. The title character, Antigone, is on trial for burying her brother Polynices contrary to the decree of Creon, the king of Thebes, who ordered that he be left unburied because he led an invasion of Thebes. The burial rite, which could consist of as little as spreading some handfuls of earth on the corpse, allowed the dead person's ghost to enter the House of Hades. In war, there was regularly a truce after a battle to allow each side to bury its own dead. A dead soldier's family would be shocked and distressed if he was allowed to lie unburied. However, there was no such obligation to bury the enemy dead, and Creon regarded Polynices as an enemy. For Antigone, however, Polynices is her brother, regardless of what he has done, and her conscience demands that she bury him. In this speech, Antigone defies Creon, defending her right to obey her own conscience rather than the law of the state. From a modern perspective, Antigone's obedience to her conscience is admirable, but in ancient Greece her actions violate the treasured Greek maxims of "Nothing in excess" and "Moderation in all things." Both Antigone and Creon represent immoderate, inflexible viewpoints, and their immoderation leads to the destruction of Antigone; Creon's son, Haemon, who was betrothed to Antigone; and Creon's wife, who commits suicide. The play ends with Creon bowed down with grief.

Creon: Did you know the order forbidding such an act?

Antigone: I knew it, naturally. It was plain enough.

Creon: And yet you dared to contravene it?

Antigone: Yes.
That order did not come from God. Justice
That dwells with the gods below, knows no
such law.
I did not think your edicts strong enough
To overrule the unwritten unalterable laws
Of God and heaven, you being only a man.
They are not of yesterday or to-day, but
everlasting,
Though where they came from, none of us
can tell.
Guilty of their transgression before God
I cannot be, for any man on earth.
I knew that I should have to die, of course,
With or without your order. If it be soon,
So much the better. Living in daily torment
As I do, who would not be glad to die?
This punishment will not be any pain.
Only if I had let my mother's son
Lie there unburied, then I could not have
borne it.
This I can bear. Does that seem foolish to
you?
Or is it you that are foolish to judge me so?

SOURCE: Sophocles, *Antigone*, in *The Theban Plays*. Trans. E. F. Watling (Harmondsworth, England: The Penguin Classics, 1947): 138–139.

bid it, for it was Ajax's intention to slaughter them, even though he had not succeeded. The quarrel is settled when Odysseus successfully argues that grudges should be forgotten. There is a magnificent array of characters here: Ajax, completely absorbed in his own grievances; Menelaus and Agamemnon, both mean, small-minded men; and Odysseus, who allows his intelligence to override any rancor he might feel and realizes that statesmanship requires magnanimity. The *Ajax* demonstrates the worth of true statesmanship.

ANTIGONE. *Antigone* is a dark play with a troubling message. The attack on Thebes dramatized in Aeschylus' *Seven against Thebes* is over, and the two warring brothers, Polynices and Eteocles, are dead. Creon, the new king of Thebes, orders that Polynices remain unburied because he died as a traitor attacking his homeland. Polynices' sister, Antigone, disobeys, however, and gives Polynices' body formal interment—that is, she spreads earth on his corpse. She defies Creon in a magnificent speech, vindicating her

right to place divine laws above the man-made rules of a state. Creon condemns her to be shut up alive in a vault for her disobedience, but when the seer Teiresias warns him that the city is polluted by Polynices' unburied corpse, he reluctantly repents and goes to release Antigone. He is too late, however, as she has hanged herself. His son Haemon, who was betrothed to Antigone, kills himself, as does Creon's queen when she discovers what has happened. Creon leaves the stage a broken man. Two stubborn persons have clashed: the one, Creon, defending a state's right to enforce its laws, and the other, Antigone, defending the individual's right to follow her conscience. Both follow their agendas and both suffer, though Antigone achieves a degree of martyrdom. Yet there are no clear winners in this contest of wills, and the message of the play seems to be that one person's refusal to see another's point of view can bring calamity on both of them.

OEDIPUS TYRANNUS. In his *Oedipus Tyrannus* Sophocles returns to the myth of the curse that hung

over the royal house of Thebes, but the setting is a generation before *Antigone*. A plague has smitten Thebes and an oracle from Delphi reveals that the cause is moral pollution: the murderer of Laius who ruled Thebes before Oedipus is still unpunished. The Athenians in the audience knew from the myth on which the play is based that the murderer is Oedipus himself, a fact of which he is ignorant because he did not realize that the man he had killed, Laius, was his father. He compounded his crime by marrying Laius' widow, Jocasta, not knowing she was his own mother. In his ignorance, Oedipus calls on everyone to tell him what information they have about the crime and lays a curse on the killer and anyone who shelters him. He sends for the blind seer Teiresias for insight. Teiresias is at first unwilling to say what he knows, but Oedipus' badgering makes him angry and he tells Oedipus plainly enough that he is his father's murderer and his mother's husband. Oedipus does not believe him. He suspects that Teiresias is a tool of Creon, his wife's brother, who wants to depose him. Jocasta assures Oedipus that he need not fear oracles, citing as proof of their unreliability the fact that an oracle had warned Laius, her former husband, that his son would kill him. She, like Oedipus, bases her confidence on ignorance, for she believes that Laius was killed by robbers while on a journey. Jocasta's effort to reassure him has the opposite effect, for Oedipus had been told by the same Delphic oracle that he was fated to kill his father and marry his mother, and he now suspects the truth. This is what was called *peripeteia*—a thrust in one direction which results in the opposite of what was expected. Then Oedipus learns that the man he had presumed to be his father, Polybus of Corinth, has died—and not by Oedipus' hand; Oedipus is relieved, believing the oracle to be wrong. The truth is then revealed that Polybus was not actually his father, and that spurs Oedipus to discover the whole truth. His wife/mother Jocasta is actually the first to realize the awful truth and in horror, hangs herself. When Oedipus understands the horrible truth himself and sees Jocasta's lifeless body, he gouges out his eyes to shut out the light. The *Oedipus Tyrannus* is the most famous Greek tragedy for two reasons. First there is its structure: the action is compressed, one scene follows logically upon the scene that comes before it, and Sophocles' use of dramatic irony, for which he was famous, heightens the tension until we reach the final resolution. But the second reason for its fame is the multiple messages it projects. It appears to be a drama of fate; Oedipus is doomed to kill his father and marry his mother and though he takes steps to avoid his destiny, he cannot. But on the other hand it is Oedipus' determination to investigate Laius'

death and discover the cause of the plague which leads to the revelation of the awful truth, so he is inadvertently responsible for his own downfall. Finally this is a play that has attracted psychologists. Sigmund Freud, the father of modern psychology argued that it expressed a young male's subconscious desire to kill his father and take over as his mother's mate—a primitive longing that is suppressed because it is taboo in civilized society. Freud labelled this suppressed lust the "Oedipus Complex," although this psychological angle had probably not occurred to Sophocles when he wrote the play. Central to his drama is the horror with which Greeks regarded patricide and incest.

THREE LATER TRAGEDIES. The three tragedies titled the *Electra*, the *Women of Trachis*, and the *Philoctetes* do not build the same tension as Sophocles' masterpiece, but they are good pieces of theater. The *Electra* uses the same myth as Aeschylus' *Libation Bearers* but the general tenor is vastly different. Whereas Aeschylus' version shows Orestes' murder of his mother as a terrible crime in that he is pursued by the Furies, in the *Electra*, Orestes' matricide of Clytaemnestra is just recompense for her crime of murdering Agamemnon. The title character is Orestes' sister, and she lives a life consumed by thirst for revenge for she is devoted to her father's memory, and lives in hope that her brother Orestes will come home and kill Clytaemnestra and her lover. But Sophocles presents no great issues as Aeschylus did in his handling of the same myth. Sophocles' characters are ordinary people caught in an extraordinary situation. The *Women of Trachis* dramatizes the myth of Heracles' death. Heracles has captured the city of Oechalia, and his servant Lichas brings the captives from Oechalia to Heracles' home in Trachis, including Iole whose beauty is conspicuous. Heracles' wife, Deianeira, is a good woman by the standards of the day, but when Lichas blurts out that Iole is Heracles' new wife she believes that she is losing her husband's love. She sends Heracles a garment anointed with a love potion, not realizing that the love potion is poisonous. Heracles puts on the garment, and it burns into his flesh. Deianeira's son Hyllus curses her for having caused his father's death, and Deianeira hangs herself. Heracles is brought onstage, asleep, but soon awakes in horrible pain. He learns the truth about Deianeira from Hyllus and gives orders for his funeral pyre on Mt. Oeta. The *Philoctetes* centers on the conflict between two characters, Neoptolemus, the young, honorable son of Achilles, and the older and craftier Odysseus. The hero Philoctetes, who possesses the bow of Heracles, had been abandoned on a desert island by the Greek army on its way to Troy because he suffered

from an incurable ulcer, caused by a snakebite. The Greeks learn, however, that they cannot take Troy unless they possess the bow of Heracles, which Philoctetes owns. Neoptolemus and Odysseus travel to Philoctetes' island, and Neoptolemus reluctantly agrees to go along with a trick that Odysseus proposes to get the bow from Philoctetes and then abandon him again. But once Neoptolemus gets the bow, Philoctetes' despair moves him so greatly that he returns it over Odysseus' protests. The play concludes with an epiphany of Heracles who commands Philoctetes to sail to Troy where Asclepius will heal him. The ending is unusual for Sophocles for it involves a *deus ex machina*, that is, a god—in this case, Heracles—lowered in a basket on to the stage by a rope attached to a derrick crane to set matters right. Thus the resolution of the drama does not develop from the plot, but rather is brought about by divine intervention.

THE OEDIPUS AT COLONUS. The last and longest surviving play of Sophocles is about Oedipus' death and apotheosis—that is, his acceptance among the gods. It also is a play that requires four actors; Sophocles, who introduced the innovation of using three speaking actors early in his career, expands it here to include a fourth. Oedipus—now old, blind, and destitute, and cared for in his exile by his daughter, Antigone—reaches Colonus just outside Athens, Sophocles' own home village. He recognizes the precinct of the Venerable Goddesses there as the place where he is destined to die. His daughter Ismene arrives and tells him that his son Polynices is about to attack Thebes, and Creon wants Oedipus back, for he has been told that his presence in Thebes will save the city. Theseus, king of Athens, accepts Oedipus as an inhabitant of Athens. Creon arrives and tries to persuade Oedipus to come and live just outside the borders of Thebes and when Oedipus refuses, his attendants attempt to drag off Antigone and Ismene, only to be thwarted by Theseus. Then Polynices arrives and pleads for Oedipus' help. Oedipus listens to what he has to say, and replies with a solemn curse. A thunderclap warns Oedipus that his time is near. He sends for Theseus again and together they go offstage. A messenger arrives to report that Oedipus has vanished. Only Theseus knows what has happened and his knowledge is the preserve of the kings of Athens. This play was probably written only shortly before Sophocles' own death in 406 B.C.E.

EURIPIDES. For Euripides, the last of the triad of great classical tragedians, what was important in drama was character. He probed the deeper feelings of his heroes and heroines. Not for him were the great questions of fate, and the nature of justice. Instead he placed the persona of a hero or heroine under stress to explore how they would react. The fact that he often used heroines may have been the reason for his reputation as a woman-hater among contemporaries. In his greatest play, *Medea*, produced in 431 B.C.E., the first year of the Peloponnesian War, he shows a woman terribly wronged by her husband getting revenge. The myth was well known: the hero Jason had sailed to Colchis on a quest for the Golden Fleece, and got it only with the help of the Colchian princess, Medea, whom he takes with him to Greece. When the play opens, Jason and Medea have settled in Corinth. Jason has become a comfortable member of Corinthian society and his foreign wife, Medea, has become an embarrassment, especially now that Jason has an opportunity to marry the king's daughter. Jason, the complete egocentric, reasons with Medea that it is better for all concerned that he should discard her and make this advantageous marriage. Medea sees things differently. She destroys the king's daughter and the king along with her, then kills her children and departs in a fiery chariot sent by her grandfather, the Sun-God. The drama ends with supernatural intervention: the sort of conclusion that Euripides liked and for which he was criticized.

THE ALCESTIS. Eighteen dramas of Euripides survive, including one satyr play, the *Cyclops*, and one drama, the *Alcestis*, produced in 438 B.C.E. and which took the place of a satyr play as the fourth drama of a tetralogy. It is not a tragedy. Instead it points forward to the New Comedy which Menander wrote a century later when Euripides was the tragedian whose dramas were revived most frequently. The story of the *Alcestis* is a folktale with the following pattern: a man learns that he must die at a certain time unless someone else will die in his stead. In Euripides' play, Admetus, king of Pherae in Thessaly, who possesses all the conventional virtues, is the man who learns his doom, and tries to find someone to assume it. His parents refuse because they want to have the last years of their lives for themselves. His wife Alcestis, however, agrees to die in his place. Admetus accepts his wife's sacrifice, realizing after he has done so that he has been less than gallant. He is prepared to live on, however, forgetting all the virtuous resolutions he has made to salve his conscience. Alcestis is rescued from death by the hero Heracles, who wrestles with Thanatos, the god of death, to bring her back to life. The characters are brilliantly drawn, particularly Heracles, who is depicted as having a gargantuan appetite for food and drink. The later development of Heracles' character as a roisterer owes much to Euripides. The play ends happily, though a modern reader may

think that Admetus will have some explaining to do when he next talks to his wife.

THE CRUELTY OF PASSION. The *Hippolytus,* produced in 428 B.C.E., shows a woman stressed by passion and a man obsessed by virtue. Phaedra, the young wife of Theseus, falls desperately in love with her stepson, Hippolytus, whose love is the outdoor life and is not interested in sex. Phaedra's nurse offers to act as her go-between and proposition Hippolytus. Hippolytus reacts with disgust, and Phaedra, overcome with shame, kills herself, leaving a note for Theseus that accused Hippolytus of improper advances. Furiously jealous, Theseus invokes his father Poseidon to punish his son, and Poseidon sends a sea-monster that terrifies the horses of Hippolytus' chariot so that they bolt. Hippolytus is thrown from the chariot and mortally wounded. Theseus learns the truth of his son's innocence, and the two are reconciled just before Hippolytus dies. Phaedra is destroyed by her longing for sexual love, whereas what destroys Hippolytus is his obsession for chastity. The *Hecuba,* produced three years later than the *Hippolytus,* shows another woman under stress, this time because of the catastrophe of defeat. Troy has fallen, Hecuba, the wife of Troy's king, has been enslaved, and has seen her daughter Polyxena sacrificed to the ghost of Achilles. Now she learns of the murder of her last son, Polydorus, who had been entrusted to Priam's ally, the Thracian king Polymestor, to keep safe. Once Polymestor learns of Troy's fall, he kills Polydoros and casts his body into the sea. Calamity transforms Hecuba from a fallen queen into a bereaved mother thirsting for revenge. She makes a desperate appeal to the victor Agamemnon, and, having won his cooperation, she entices Polymestor into her tent, where she and her women kill his two sons before his eyes and blind him. The play ends with Polymestor relegated to a desert island, and the old queen departing to bury her dead.

WAR PROPAGANDA. The popularity of the Athenian theater stretched beyond Athens itself, even in the midst of the bitter Peloponnesian War, which divided Greece into two warring camps, each eager to justify itself. Many of Euripides' plays that were written during the war had a message for the two combatants, and Sparta and Delphi (a Spartan ally) tend to come off badly. It is stretching the truth to call these plays war propaganda, for Athens did not purposely mobilize her tragic poets to produce plays favorable to her aims. Nevertheless the *Andromache* does seem to have been inspired by some Spartan atrocity that took place in the early years of the war, and an ancient commentator in Euripides reports that it was not produced in Athens. The

Bust of the Athenian tragic poet Euripides. © GIANNI DAGLI ORTI/CORBIS.

question of where, then, the play was produced allows for two possibilities: one was Sparta's neighbor Argos, where Athens wanted to stir up anti-Spartan feeling; the other was the kingdom of Epirus in northwest Greece where there was a young king who had been educated in Athens. The plot deals with the aftermath of the Trojan War. When the spoils of Troy were divided, Hector's captive wife Andromache went to Achilles' son, Neoptolemus, also called Pyrrhus, whom the kings of Epirus claimed as their ancestor, and she goes home with him and bears him a son. When the play opens, the daughter of Menelaus and Helen, Hermione, has married Neoptolemus, and Andromache is no longer welcome in Neoptolemus' household. Menelaus, who is presented as a typical Spartan—cruel, faithless, and a blusterer into the bargain—wants to kill Andromache and her child in cold blood while Neoptolemus is absent in Delphi. She is saved by the intervention of Neoptolemus' aged grandfather, Peleus. Then crushing news arrives; Neoptolemus has been ambushed at Delphi and killed by a gang of armed men who acted under the orders of Orestes, another Spartan. The Delphians, whose partiality for Sparta in the Peloponnesian War was no secret, are shown as a treacherous lot in the *Andromache.* The *Children of Heracles* is even more clearly anti-Spartan. The Dorians claimed to be Heraclids—that is,

descendants of Heracles—and the Spartans were quintessentially Dorian. Heracles' children and his mother, Alcmena, take refuge from his old enemy Eurystheus at Marathon in Athenian territory. Eurystheus is captured and the vengeful Alcmena insists that he be put to death. Before he dies, he promises the Athenians that if they give him honorable burial, he will be their friend when the ungrateful descendants of the Heraclids—that is, the Dorians—invade, a clear reference to the Peloponnesian War when the Spartans led an invading army into Attica to destroy the crops in the early years of the war. The *Suppliants*, which is equally anti-Spartan, ends with an oath of Adrastus of Argos never to invade Athenian territory and to hinder any enemies who did. In 420 B.C.E., Athens and Argos negotiated an alliance, and the oath of Adrastus sounds like a reference to it. However, a few years later, in 415 B.C.E., when Euripides' *Trojan Women* was presented in March at the City Dionysia, on the eve of the departure of the disastrous Sicilian expedition, it is the brutality of war that weighed on Euripides. Only the year before, an Athenian force had taken the little island of Melos in the Aegean Sea and massacred the men and sold the women and children into slavery. The *Trojan Women* portrays the misery of the women captured when Troy fell, but Euripides takes one liberty with traditional mythology: he has Hecuba indict Helen so eloquently as a war criminal that Menelaus decides to execute her when he gets home to Sparta, even though the long war at Troy had been fought to return her to him, her rightful husband.

THE HERACLES. In the Renaissance this play was called the *Hercules Furens* ("The Madness of Heracles"). In the play, Lycus has made himself tyrant of Thebes and is about to kill Heracles' wife, Megara, and his children. Heracles arrives in the nick of time to save his family and kill Lycus. Then his enemy, the goddess Hera, inflicts Heracles with madness, and he kills his wife and children. When the fit of madness leaves him, he falls asleep, only to awaken to the news of what he has done. But Theseus, whom Heracles had rescued from Hades, comforts his friend and offers him asylum in Athens. There is no reliable date for this play, but 414 B.C.E., when the Athenians still had high hopes of their Sicilian expedition, is a good possibility.

HAPPY ENDINGS. Euripides did not always end his plays in tragedy. *Iphigeneia in Tauris*, the *Ion*, and *Helen* all have happy endings. The first exploits the myth of Agamemnon's daughter, Iphigeneia, whom Agamemnon sacrificed to the gods so that they would grant favorable winds for the Greek fleet to sail from Aulis against Troy. An alternative version of the myth had the goddess Artemis rescuing Iphigeneia at the last moment and carrying her to Tauris to be her priestess there. While in Tauris, she recognizes her brother, Orestes, and his friend, who are captives of the Taurians. She plots to save them from the Taurians, and does so with the goddess Athena's aid. The second nontragedy, the *Ion*, has a plot of the sort we find in the New Comedy in which a child conceived by rape is exposed to die only to be saved and reunited years later with the parents. In this play, Ion is the child of a rape perpetrated by the god Apollo on the wronged heroine, Creusa, the daughter of King Erechtheus of Athens. Fearing the wrath of her parents, Creusa secretly exposes Ion to the elements and leaves him to die, but Apollo takes the infant to his temple at Delphi, where he becomes a pious temple servant knowing little of the wicked outside world. When the play begins, Creusa and her husband Xuthus arrive at Delphi to consult the oracle regarding their inability to conceive a child, and their arrival at the temple in which Ion serves threatens to expose the truth about Ion's parentage. The oracle—to save Apollo's reputation—tries to foist Ion off on Xuthus, and Creusa, fearful for her own future with an unwanted stepson in her house (not realizing he is her actual son), tries to kill Ion. The plot is discovered and Ion and the Delphians are about the stone Creusa to death, when the aged priestess of Apollo who has reared Ion arrives with the cradle and clothes that he wore when she first received him, and Creusa recognizes them as belonging to her abandoned son. Everything is resolved with some help from Athena, who explains that she has come in Apollo's place because Apollo is too ashamed to own up to the rape of Creusa. Apollo is portrayed as an ordinary politician who has been caught in a sex scandal and tries what in modern times would be termed a "coverup." The message is that organized religion can claim no special privileges when it comes to moral standards. The *Helen* exploits an alternative myth about Helen of Troy that was invented by the Sicilian poet Stesichorus. Paris did not take Helen to Troy. Instead his ship was driven by contrary winds to Egypt where Helen remained and only an ectoplasmic facsimile of Helen went to Troy. On the way back home from the war at Troy, Menelaus is wrecked on the shores of Egypt and is amazed to find Helen living there. The facsimile that he took from Troy simply evaporates. This fantastic drama ends with Menelaus and Helen escaping from Egypt, where the king had the unpleasant custom of killing all Greeks who reached his shore. There is nothing tragic about the *Helen*. The myth that it relates is simply a nice story with comic elements.

Four Melodramas. With the *Electra*, produced about 413 B.C.E., and the *Orestes* (408 B.C.E.) Euripides turned to the familiar theme of vengeance for Agamemnon's murder. In the *Electra*, neither Electra nor Orestes are quite sane. Euripides' addition to the legend is Electra's marriage to a decent farmer; her mother Clytaemnestra has given her to a man of low standing to prevent her bearing children of a status high enough to embarrass the royal house of Mycenae. Despite her marriage, Electra remains a virgin. Electra and her brother Orestes plot the assassination of Clytaemnestra for killing their father, Agamemnon, and carry out the deed ruthlessly. Their mood then changes to hysterical remorse. But Castor and Polydeuces, brothers of Clytaemnestra and now divine beings themselves, appear and sort things out: Orestes is to go to Athens, his friend Pylades is to marry Electra, and as for the matricide, it can be blamed on Apollo. In the *Orestes* we have an array of unpleasant characters: Orestes, who is mad; Electra, whose only redeeming quality is her devotion to her brother; Menelaus; Helen; her daughter Hermione; old Tyndareus, who is Helen's father; and faithful Pylades. Electra and Orestes are condemned to death for killing Clytaemnestra but are granted the privilege of committing suicide instead. Thereupon they plot to kill Helen, who mysteriously disappears, and so they seize Hermione as a hostage to force Menelaus to intervene. Menelaus finds Orestes with a knife at Hermione's throat while Electra and Pylades set fire to the palace. Apollo intervenes and explains that everything has happened for the best. The *Phoenician Women* is a long play about the sons of Oedipus who died fighting each other at Thebes. Jocasta—who is still alive in spite of her suicide at the end of Sophocles' *Oedipus Tyrannus*—tries to stop the duel between Polynices and Eteocles but reaches them too late and kills herself over their corpses. *Iphigeneia at Aulis* was a play that Euripides never finished but someone supplied the missing parts and it was produced after his death. It tells the story of Iphigeneia's sacrifice and the text stops with a messenger arriving to report it. The characterization is splendid. Agamemnon is irresolute, and terribly distressed at the thought of sacrificing Iphigeneia to get favorable winds to sail to Troy, but his army is mad for battle. For Menelaus, what is important is getting on with the war. Clytaemnestra has brought Iphigeneia to Aulis because Agamemnon sent her a deceitful message that he wanted to marry her to Achilles. Achilles comes out of the plot as an honorable warrior. Angry at having his name misused, he is prepared to defend Iphigeneia. But then Iphigeneia herself volunteers to die as her patriotic duty, and Achilles departs, promising to defend her if she changes her mind.

The Bacchae. Either in 408 B.C.E. or early the following year, Euripides left Athens for the court of King Archelaus of Macedon and it was there that he produced the *Bacchae*, his last drama, and it is generally acknowledged as a masterpiece. The story comes from a legend of Thebes telling how Pentheus, the grandson of Cadmus, the founder of Thebes, resisted the coming of the god Dionysus (also known as Bacchus) and suffered for it. Dionysus himself explains the situation in the prologue to the play: he has returned to the city where he was born and his mother's sisters, including Pentheus' mother Agave, hesitated at first, but then were overcome by Bacchic frenzy and are now on Mt. Cithaeron, where he is on his way to join them. Then two old men, Cadmus and Teiresias, come on stage. They too are going to join Dionysus' votaries, and Pentheus fails to stop them. Then a servant arrives with a mysterious prisoner who is never identified, but when Pentheus shuts him up in the palace stables, the palaces collapses as if hit by an earthquake and the stranger emerges and faces Pentheus' threats with serene confidence. A messenger arrives with a report of the astonishing revelry of the women on the mountain, and the stranger persuades Pentheus to disguise himself and go and witness it. Soon after Pentheus leaves the stage, the news arrives that the women have caught him and torn him to pieces. Then Agave arrives, still under the spell of her frenzy and carrying what she thinks is a lion's head. It is actually the head of Pentheus. Cadmus brings her to her senses and she breaks into lamentations that Dionysus cuts short by reappearing and justifying his vengeance on unbelievers; much of his speech has been lost. The play has raised many questions. Did Euripides attack the religion of Dionysus or defend it? Who was the mysterious stranger whom Pentheus tried to imprison? One thing at least is certain: Euripides, whose attitude toward conventional religion was often marked with cynicism, here acknowledges its terrifying power. Pentheus' mother, Agave, who loses herself in the wild ecstasy of the Dionysiac cult becomes a tragic figure—a mother who has killed a son she loves. Dionysus himself does not hesitate to be ruthless if ruthlessness helps the spread of his religion. The message seems to be that mass religion is a force to be reckoned with.

SOURCES

J. A. S. Evans, "A Reading of Sophocles' *Ajax*," *Quaderni Urbinati di Cultura Classica* 33 (1991): 69–85.

John Ferguson, *A Companion to Greek Tragedy* (Austin: University of Texas Press, 1972).

H. D. F. Kitto, *Greek Tragedy: A Literary Study* (London, England: Methuen, 1939).

B. M. W. Knox, *Oedipus at Thebes* (New Haven, Conn.: Yale University Press, 1957).

Richmond Lattimore, *Story Patterns in Greek Tragedy* (Ann Arbor: University of Michigan Press, 1964).

A. Lesky, *Greek Tragic Poetry* (New Haven, Conn.: Yale University Press, 1983).

Gilbert Norwood, *Greek Tragedy*. 4th ed. (London, England: Methuen, 1948).

Jacqueline de Romilly, *La Tragédie Grecque* (Paris: Presses Universitaires de France, 1973).

Brian Vickers, *Towards Greek Tragedy* (London, England; New York: Longman, 1979).

THE ART OF PUBLIC SPEAKING IN GREECE

BEGINNINGS. Greece admired a good public speaker who could put forward his point of view effectively in an assembly of men, or conduct a case in the law courts. Tradition has it that public speaking as an art was cultivated first in Syracuse in Sicily in the years before the middle of the fifth century B.C.E. Syracuse had been ruled by tyrants and a great deal of litigation followed their overthrow, necessitating the oratorical skills of numerous people in court. The art reportedly first came as an import from Sicily into Athens in 527 B.C.E. While he was in Athens on a diplomatic visit, the rhetorical skills of Gorgias of Sicily captivated the Athenians. Gorgias went on to become a famous Sophist—that is, a teacher who taught the skills necessary for public speaking—and he was known for the high tuition fees he charged. Athenians were willing to pay the fees, however, because public speaking was a valuable skill in Athens, not only for a politician addressing the assembly, but in the courts as well, for neither the plaintiffs nor the defendants in trials could hire lawyers to speak for them. The best they could do was to hire a speechwriter, or a "logographer," as they were called. Speechwriting thus became a profitable profession—one that was particularly attractive for orators such as Lysias who were resident aliens in Athens and therefore could not themselves speak in the courts or the assembly. The pioneer speechwriter was the Sophist Antiphon, (c. 480–411 B.C.E.). Antiphon first gave advice to citizens who were entangled in litigation, but about 430 B.C.E. he began to write speeches for others to memorize and deliver. He spoke only once for himself. He was tried for treason in 411 B.C.E. and wrote out a speech in his own defense. His speech failed—Antiphon was executed—but he set a trend. After him orators would write down and publish speeches they delivered themselves in the courts or, more rarely, in the assem-

bly. Oratory was in full flower by the time Aristotle wrote a treatise on rhetoric, which he divided into three types: forensic, for the courts; deliberative, for delivering in the assembly; and epideictic, for a special occasion such as a funeral.

THE TEN ORATORS. In the great age of oratory from about 420 to 320 B.C.E., Athens saw or heard many orators and logographers, but only ten of these were selected for study by ancient scholars. Sometimes speeches by unknown orators have been preserved because it was thought—wrongly—that they were written by one of the Ten. Of the sixty speeches ascribed to the great orator Demosthenes, only about half of them are genuine. The Ten Orators were Antiphon and Andocides, whose careers belonged to the fifth century B.C.E.; Demosthenes and his rival Aeschines; Dinarchus and Lysias, both of them resident aliens in Athens; Isaeus whose forte seems to have been probate law for all eleven of his surviving speeches deal with inheritance; Lycurgus, better known as an Athenian statesman, who is represented by only one speech; Hyperides, who like Demosthenes opposed Philip of Macedon and his son Alexander the Great for which the Macedonians sentenced both him and Demosthenes to death in 322 B.C.E.; and Isocrates, who might have been unhappy to find himself included among the Ten Orators, for he considered himself a philosopher and an educator rather than a public speaker. Two of these stand out, both for their ability and reputation, and the number of their speeches that have survived.

ISOCRATES. The end of the Peloponnesian War in 404 B.C.E. was followed by political turmoil and Isocrates was apparently on the wrong side since he lost the family estate. Isocrates first tried logography as a way to make a living, but then turned to teaching, first on the island of Chios, and then, from not long before 387 B.C.E. until his death in 338 B.C.E. at the age of 98 in Athens, where students flocked to his school from all over the Greek world. His alumni included two important historians of the fourth century B.C.E., Ephorus and Theopompus. Greece in Isocrates' day was divided into warring camps; not only did the old powers of Athens, Sparta, and Thebes vie for hegemony, but there were new rising powers such as Thessaly and Macedon. Isocrates was not a public orator. His orations are really political pamphlets, but they reveal a consistent political aim. Isocrates advocated an alliance, or perhaps a federation of the states which would turn Greek energies from fighting each other within Greece to combating the Persian Empire, which had recovered control of the Greek cities in Asia Minor at the end of the Peloponnesian War. In his *Panegyricus*, dating to 380 B.C.E., he

advocated an alliance headed by the old enemies, Sparta and Athens, which would liberate the Asian Greek cities. In 346 B.C.E. Isocrates, now aged ninety, addressed an open letter to Philip of Macedon urging him to head a pan-Hellenic alliance which would attack Persia. In 339 B.C.E., he published his last long work, the *Panathenaicus*, an elaborate eulogy of Athens. Though he never mentions Philip by name, it seems clear that he still saw Philip as the champion of Greece. The following year, Philip defeated Athens and Thebes on the battlefield of Chaeronea, and Isocrates' last work is an epistle to Philip written after the battle, still urging a campaign against Persia.

DEMOSTHENES. Demosthenes is notable for two reasons. First, as an Athenian statesman he passionately opposed the imperialist ambitions of Philip II of Macedon, whose son, Alexander the Great, would continue his father's policies and transform the world of Greece with the conquest of Persia. For that reason, some historians have hailed Demosthenes as the courageous defender of Athenian freedom and democracy, while others have condemned him as a dead-end politician mired in the past. Second, he brought the art of oratory to new heights—a conclusion few would dispute. His masterpiece was his speech *On the Crown* in defense of Ctesiphon, one of his supporters who was charged with illegally proposing to honor Demosthenes. The combined armies of Athens and Thebes had been defeated in 338 B.C.E. at the Battle of Chaeronea, and it was the anti-Macedonian policies which Demosthenes urged upon the Athenians that led to the disaster. Yet two years after the defeat, Ctesiphon, one of Demosthenes' supporters put forward a motion in the assembly that Demosthenes be awarded a golden crown for his services at the upcoming festival of Dionysus. The time and place for the award violated the law, and Demosthenes' rival and bitter enemy Aeschines charged Ctesiphon for the proposal, as a way to attack his real enemy, Demosthenes. The case did not come to trial until 330 B.C.E. Demosthenes rose to address the jury after the jury had been listening all forenoon to Aeschines' argument that this extraordinary honor which Ctesiphon had proposed for Demosthenes could not be justified by a great service he had done the state, for the anti-Macedonian policy which he had promoted had ended in disaster. In a brilliant piece of sophistry, Demosthenes disregarded the legal questions and focused on slandering his accuser. He regaled the jury with a malicious caricature of Aeschines' parents, who were very ordinary folk, and finally he attacked Aeschines himself, suggesting that it was Aeschines who was really responsible for the disaster at the Battle of Chaeronea, which was a perversion of the truth. He ended with a prayer to the gods to keep the state safe. The speech is a brilliant example of making the worse argument appear the better. Demosthenes died following an anti-Macedonian uprising in Greece in 323 B.C.E. The tough old Macedonian general Antipater crushed the revolt in Athens, and Demosthenes tried to escape retribution by fleeing to the island of Calauria. He sought asylum in a temple, but he took poison when it was clear that Antipater's men intended to drag him from his sanctuary.

SOURCES

Charles D. Adams, *Demosthenes and His Influence* (New York: Cooper Square Publishers, 1963).

G. L. Cawkwell, "The Crowning of Demosthenes," *Classical Quarterly* 19 (1969): 163–180.

Isocrates. Vols. I-II. Trans. David C. Mirhady and Yun Lee Too (Austin: University of Texas Press, 2000).

David C. Mirhady, "Demosthenes as Advocate: The Private Speeches," in *Demosthenes, Statesman and Orator.* Ed. Ian Worthington (London, England; New York: Routledge, 2000): 181–204.

Raphael Sealey, *Demosthenes and His Time: A Study in Defeat* (New York: Oxford University Press, 1993).

GREEK LITERATURE AFTER ALEXANDER THE GREAT

A CHANGED WORLD. When Alexander the Great died in Babylon in 323 B.C.E. he left the Greek world irrevocably changed. The centers of Greek culture moved away from the old city-states of Greece to the capitals of the new Hellenistic kingdoms that were centers of wealth and power. Athens held its own in the field of culture, but it was an exception. Egypt emerged as a magnet for the Greeks. On Alexander's death, one of his shrewder generals, Ptolemy, secured Egypt as his province and established himself at Alexandria. Alexander's young son was killed in 310 B.C.E., and in 305 B.C.E., after there was no longer any pretense of unity in the empire Alexander had conquered, Ptolemy declared himself king. Ptolemy wanted to make Alexandria a hub of Greek culture, for the Greeks lived side-by-side with native Egyptians who had an ancient culture of their own, and there was remarkably little cross-fertilization. At some point before he died, Ptolemy started the Great Library of Alexandria, and his son, Ptolemy II Philadelphus, who ruled 285–247 B.C.E., continued the work. The kingdom of Pergamum, which was founded in Asia Minor in 263 B.C.E., also established a library, and Alexandria did not

THE
Great Library at Alexandria

The library at Alexandria, the capital of the kingdom founded by Ptolemy in Egypt, was a legendary institution in ancient times. Estimates of the size of its collection varied wildly—between 70,000 and 700,000 books—but any number within that range is impressive in a time when all books had to be copied by hand. Though it was not the first public library nor the only one, it was for about two centuries the most influential literary and scientific center in the Hellenistic Age.

Ptolemy I first founded the Museum (*Mouseion*) of Alexandria in 280 B.C.E. The English word "museum" is not an accurate translation of the Greek *mouseion*, which means a "home for the Muses" who were worshipped in the Museum of Alexandria. The Museum was part of the royal palace, and it was a gathering place for scholars, literary figures, scientists, and artists, with a common dining room and apparently living quarters. Attached to the Museum was the Great Library or Palace Library, which may also have been founded by Ptolemy I, but his son Ptolemy II can take credit for expanding the collection. Literary texts of the classical authors were edited there, and standard texts produced; one author who benefited from this scholarly work was Homer, whose *Iliad* and *Odyssey* were edited by the Alexandrian scholar Aristarchus of Samos, whose text is the one that has survived to modern times.

The question of what happened to the Library is a controversial one. Julius Caesar, who spent the winter of 48–47 B.C.E. in Alexandria with the young princess Cleopatra, got involved in the power struggle between her and her brother, and in the process books in the harbor region of the city were burned. Some scholars date the end of the Library to this time. But once Cleopatra became queen of Egypt, she continued to collect books; her lover Mark Antony gave her the collection from the old royal library of Pergamum which once was the second largest library in the Mediterranean world. Certainly the palace library continued to survive long into Roman times, and there is no reliable evidence for the date of its destruction. The emperors Caracalla (198–217 C.E.), Aurelian (270–275 C.E.) and Diocletian (284–305 C.E.) all did significant damage in Alexandria and some lay the blame on one or other of them for the library's downfall. A late legend says that the Arabs burned the collection when they captured Alexandria in 642 C.E. However, what destroyed the library was probably neglect. Papyrus scrolls grew old and brittle. In late antiquity, worn-out scrolls should have been replaced by *codices*—volumes bound like modern books—but there was no money to defray the costs. The greatest enemy of the collection in the old Palace Library was probably the natural decaying process.

look kindly on this rival; the Ptolemies cut off Pergamum's supplies of papyrus but Pergamum developed parchment as a substitute. Alexandria never surrendered its supremacy to the Pergamene library, which was neglected after Rome acquired Pergamum in 133 B.C.E., and terminated when Mark Antony gave its collection to Cleopatra, the last of the Ptolemies, for the Alexandrian library in the period 40–33 B.C.E. The dynastic capitals of Antioch in Syria and Pella in Macedon also boasted substantial libraries.

THE ALEXANDRIANS. Alexandria took the lead in literary development. It fostered a hothouse culture with no roots in the native Egyptian way of life. The literature produced there was not intended for the masses, for the masses did not speak Greek. There was some attempt at crossover between Greek and Egyptian traditions; an Egyptian priest, Manetho, in the reign of Ptolemy I wrote a history of Egypt in Greek, using Egyptian records, but it was not widely read. Alexandrian poetry was written for an elite Greek-speaking public, and it was meant to be read, not performed. Much learning was prized, and didactic poetry—that is, poetry written to instruct—was in vogue. One poet, Aratus of Soloi, enjoyed tremendous acclaim for writing a book on astronomy in verse. His information is all second-hand, for he was not an astronomer himself, and his work has little appeal for a modern reader. Another didactic poet of the same sort was Nicander of Colophon, who wrote a poetic work on venomous reptiles and insects, and another on poisons and their antidotes. Poets liked learned and obscure references. A good example is Lycophron, who belonged to the Pleias, a group of seven poets named after the Pleides constellation. Although none of the tragic dramas written by the Pleias survived, one poem by Lycophron, the *Alexandra*, did. It purports to be a long prophecy of Priam of Troy's daughter Alexandra, better known as Cassandra, who was fated to foresee the future and be disbelieved when she foretold it. Lycophron's Greek is peppered with words that are found nowhere else in surviving Greek literature.

GREEK POETIC INFLUENCE. Alexandria produced three poets who influenced Latin literature: Callimachus, Apollonius of Rhodes, and Theocritus. Callimachus was a librarian at the Alexandrian library and wrote a catalogue of books for it. He wrote a variety of poetry, in-

cluding six surviving hymns written in iambics in imitation of Hipponax of Colophon, who lived in the mid-sixth century B.C.E. He also wrote a poem titled the "Aitiai" (Origins), which sets forth the origins of a series of local customs, and a short narrative poem titled the "Hekale" which modern scholars have called an "epyllion" or "little epic"; the word is not found in antiquity. Callimachus believed that the long narrative poem was dead. There was no place for long epic poems anymore in the Hellenistic world. Apollonius was the second chief librarian at Alexandria, after Zenodotus, who was the first; if that information is accurate, it must have exacerbated his rivalry with Callimachus who seems to have been passed over for promotion in favor of a man who was about five years younger. Apollonius set out to prove Callimachus' stricture on epic poetry wrong, and wrote an epic in four books, the *Argonautica*, on the quest of Jason and the Argonauts for the Golden Fleece. It is not entirely successful. Jason is less than heroic. Medea, the princess of Colchis who helps Jason obtain the Golden Fleece, is the prototype of the romantic heroine who meets challenges that daunt men. She was to have many descendants in literature, including Dido in Vergil's *Aeneid*, and Scarlett O'Hara in Margaret Mitchell's *Gone with the Wind*. Theocritus has two claims to fame as a poet. First, he revived the mime as a poetic form. These were short dramatic dialogues on subjects taken from everyday life. The genre originated in Syracuse, which was Theocritus' hometown. Second, he was the inventor of pastoral poetry that purports to be poetry of the countryside—songs sung by shepherds as they watched their flocks. He wrote first in Syracuse, but he got little encouragement or patronage from the tyrant of Syracuse, Hiero II, and he moved to the island of Cos and then to Alexandria, which proved more profitable. His *Idylls* were short mimes that gave a snapshot of contemporary life. They are sometimes shepherds or herdsmen who converse or dispute—hence the name "pastoral" from the Latin word *pastor* for "shepherd"—or a girl who tries to recall her lover with a love charm, or two housewives of Alexandria who visit the royal palace that has been opened to the public for the festival of Adonis. He was to have a host of imitators both in ancient and modern times.

GREEK LITERATURE UNDER THE ROMAN EMPIRE. Greek authors continued to write after the Roman Empire conquered the eastern Mediterranean, though the Hellenistic kings who had patronized them no longer existed. The historian and geographer Strabo, of partly Asian descent, born about 63 B.C.E., wrote a work called *Historical Sketches* which is lost, and *Geography* which has survived. It describes the known world starting in the west with Gaul and Britain, moving eastwards until it reaches the Orient and India, and concluding with Africa. In historical writing, the Hellenistic age produced one historian of first rank, Polybius of Megalopolis, who was taken to Rome as a hostage in 167 B.C.E. He used his enforced stay to study Rome's language, customs, and history. He wrote a *Universal History* in forty books on the period 220–144 B.C.E. The first five books have survived complete, dealing with the Second Carthaginian War, when Rome encountered a general of genius, Hannibal. Of the remainder of Polybius' history we have only fragments. In the next century, another Greek, Dionysius of Halicarnassus, came to Rome about 30 B.C.E., taught rhetoric there some 22 years, and wrote a history of Rome called the *Roman Antiquities*. As might be expected, his history is rhetorical and not a great deal of use as a reliable source for Rome's past. In the reign of the emperor Augustus, another Greek, Diodorus of Sicily, attempted a universal history, beginning with the Trojan War and bringing his world history to 59 B.C.E. The writer who enjoyed the greatest fame in the modern world is Plutarch of Chaeronaea, born about 46 C.E. and living on until 120 C.E. He wrote a large number of essays collected under the general title, the *Moralia*, but his claim to fame is his *Parallel Lives*, which placed biographies of famous Greeks side-by-side with that of famous Romans. Plutarch had many admirers in the modern period. Among writers who have mined him for raw material was William Shakespeare, who used him for *Julius Caesar*, *Antony and Cleopatra*, and *Coriolanus*.

SOURCES

Luciano Canfora, *The Vanished Library* (London, England: Hutchinson Radius, 1989).

Andrew Erskine, "Culture and Power in Hellenistic Egypt: The Museum and Library of Alexandria," *Greece and Rome* 42 (1995): 38–48.

John Ferguson, *Callimachus* (Boston: Twayne Publishers, 1980).

C. B. R. Pelling, *Plutarch and History: Eighteen Studies* (London, England: Duckworth, 2002).

Thomas G. Rosenmeyer, *The Green Cabinet; Theocritus and the European Pastoral Lyric* (Berkeley: University of California Press, 1969).

Philip A. Stadter, *Plutarch and the Historical Tradition* (London, England; New York: Routledge, 1992).

ROMAN THEATER

BEGINNINGS. The Roman historian Livy, writing of the years 364–363 B.C.E., related that there was plague

in Rome. Since neither human remedies nor prayers to the gods abated the plague, the Romans introduced musical shows in the hopes of entertaining them. Etruscan dancers were brought in who danced to a piper's tune. Rome already had a comic tradition; at the harvest home festival or other occasions such as weddings "Fescennine songs" were sung: rough abusive verses chanted antiphonally in improvised repartee. On occasion they were composed in the native Latin meter known as "Saturnian"; the Saturnian line consisted of a group of seven syllables, followed by a group of six syllables with a break between them. No one thought crude jokes to be incompatible with solemn ceremonies; even a victorious general celebrating a triumph might hear his soldiers chant Fescennine verses as his procession made its way through the streets of Rome to the temple of Jupiter. One example chanted by Julius Caesar's soldiers chanted about their revered leader as he proceeded through the streets is translated as "City dwellers, lock up your wives / we're bringing in the bald lecher." Livy reports that the young Romans who saw the Etruscan dancers in the plague year began to imitate them and add improvised, bawdy repartee like Fescennine verses known as *satura*, or "medleys." There was much suggestive joking and mockery, but no plot worth mention. Fescennine verses were not the only influence, however. The Samnites in Campania between Rome and Naples, who spoke an Italic dialect called Oscan and hence are often known as Oscans, had a taste for slapstick farce with stock characters. When these were introduced into Rome they were called *Atellanae* after a town in Campania called Atella with which the Romans connected them. Like Punch and Judy shows, the characters were fixed by tradition. There was a clown named Maccus, a simple fellow named Pappus, a fat boy named Bucco, and the hunchback Dossenus. With their buffoonery and their exaggerated masks, they enjoyed a mass appeal that Latin adaptations of Greek plays never had.

GREEK INFLUENCE. The actual staging of dramatic productions in Rome of the sort popular in Greece began with Livius Andronicus, whose translation of Homer's *Odyssey* into Latin marks the beginning of Latin literature. He began to produce plays with plots. He produced a play translated from the Greek at the Roman Harvest Festival called the *Ludi Romani* in 240 B.C.E. which was a milestone in Roman theater for it seems to have been the first time a play was staged in Rome. He wrote more tragedy than comedy, and though he was no great literary figure, he was a pioneer as Rome's first playwright. Naevius, who came after him, was more at home with comedy than tragedy—not that he wrote original

plays, for all his comedies were taken from the Greek New Comedy. He did invent a new type of play which was not borrowed from Greece: the historical drama, or, in Latin, the *fabula praetexta*. The name came from the toga with a purple border called the *toga praetexta* worn by Roman magistrates, because the dramas dealt with figures of the Roman past. After Naevius, historical drama had a very modest success. Some plays dealt with the early history of Rome—Ennius wrote a *Rape of the Sabine Women*—and others with the victories of generals who were still alive or only recently dead. Ennius had a nephew, Pacuvius, born in 220 B.C.E., who arrived in Rome as a young man and made a name for himself both as a poet and a painter. His forte was tragedy on Greek subjects—*fabulae cothurnatae*, so-called from the special elevated boots called *cothurni* which tragic actors wore. We know the titles of thirty tragedies that he wrote, but none survive. The same fate awaited the plays of a more significant tragedian, Accius, who overlapped Pacuvius in 130 B.C.E. when each of them produced a drama: Pacuvius was eighty years old and at the end of his career, and Accius, aged thirty, was making his debut. With Accius, the popularity of the *fabula cothurnata* reached its height, and in later years, Romans looked back on the second half of the second century B.C.E. as the Golden Age of Tragedy. Only fragments of the plays survive, however.

ROMAN COMEDY. Roman comedy fared better. We have 27 comedies, more or less complete, all adaptations from Greek New Comedy. They are *fabulae palliatae*, that is, dramas with Greek characters who were costumed in a type of Greek cloak (*pallium*) much favored by Greek philosophers. Twenty-one of these comedies are by "Titus Maccius Plautus," about whom there is little reliable information. He supposedly came to Rome from Umbria where he was born, worked for a while in the theater business, tried his hand at trade, lost his money, and had to work at a mill where he used his spare time to write plays. He died in 184 B.C.E. The remaining eight are by Publius Terentius Afer, who was born in Carthage and brought as a boy slave to Rome by a senator who was so taken with the lad that he gave him a good education and freed him. Before he was 25, he produced six plays. He then left Rome for Greece, never to return. Various reports were told about his death, but they agree that he was carrying a large number of new plays in his baggage—translations from the Greek—that were lost with him.

PLAUTUS. It is impossible to judge how much Plautus adapted his Greek originals for Roman taste, but his plays ostensibly have Greek settings such as Athens or

Epidamnus. While they could be any city, much of the slapstick must come from the *Atellanae*, the popular Atellan farces. Plautus used the stock characters of the New Comedy but he put his own mark on them. His courtesans are not always sweet and alluring; in the *Truculentus* a ruthless courtesan brings her lovers to ruin. One favorite character type that Plautus developed brilliantly was the clever slave. He also reintroduced song into comedy. There had been songs in Old Comedy but they had fallen by the wayside. Plautus found that the Roman audience liked musical comedy and inserted songs more and more as time went on. The *Boastful Soldier,* which was an early play, has no songs; the *Brothers Menaechmus,* which is later, has five. His dialogue is racy but not dirty, for the Romans were still puritanical, and as the plots of Plautus' comedies unfolded onstage, many Romans must have reflected that such things happened in Greece but never in Rome, and found satisfaction in the sense of moral superiority.

THE BRAGGART SOLDIER. The "Braggart Soldier" of the title is a stock character, the mercenary soldier who is all bombast and self-advertisement. In this case, the soldier of the title has the mouth-filling name of Pyrgopolynices. A young Athenian, Pleusicles, is madly in love with a courtesan Philocomasium, but while he is away from Athens on official business, the soldier abducts her to Ephesus. Pleusicles' clever slave, Palaestrio, sets off to tell his master what happened, but he is captured by pirates. Coincidentally, they present him to Pyrgopolynices. Palaestrio gets a letter to Pleusicles summoning him to Ephesus. Pleusicles arrives and lodges at a friend of his father's, who lives next door to the soldier. The clever slave Palaestrio arranges an elaborate hoax to make the soldier believe the wife of a wealthy old gentleman has fallen desperately in love with him. The wife is actually a courtesan who plays the role that Palestrio has assigned her, and the old man is the friend of Pleusicles' father. The soldier readily gives up Philocomasium for his new love, but he is caught red-handed attempting adultery, given a sound beating, and threatened with castration. The old man relents when Pyrgopolynices swears never to seek revenge for the beating he received.

THE BROTHERS MENAECHMUS. *The Brothers Menaechmus* is a comedy of mistaken identities; it was adapted and elaborated by Shakespeare in his *Comedy of Errors.* Identical twins were born to a Sicilian merchant from Syracuse. One twin, Menaechmus, was kidnapped and his father died of grief. Thereupon the grandfather of the remaining twin renamed him Menaechmus to commemorate his lost brother. Thus we have Menaech-

mus I and Menaechmus II, identical siblings. Menaechmus I, the boy who had been kidnapped, was taken to Epidamnus by his abductor, who, it turned out, had no son, and so he adopted Menaechmus I and made him heir to his enormous fortune. When the play opens, Menaechmus II has come to Epidamnus in search of his twin; this is the sixth year he has been searching. Menaechmus I is having an affair with a courtesan, Erotium. Erotium mistakes Menaechmus II for Menaechmus I, and Menaechmus II goes along with the error; he has lunch with Erotium and enjoys her favors. The deception results in all manner of confusion so that when Menaechmus I returns to the stage he encounters a jealous wife, an irritated mistress, and a father-in-law who thinks he's insane. He escapes being dragged off to a doctor, a fate worse than death, by the intervention of Menaechmus II's slave. Finally the two Menaechmuses meet and sort things out. The drama comes with an assortment of stock characters: a parasite, an alluring courtesan, and a silly doctor. It is Plautus' only comedy of errors, and when Shakespeare adapted it, he doubled the scope for mistaken identities by having not one set of identical twins but two.

TERENCE. All six plays that Terence wrote have survived, which is a remarkable tribute to his staying power through the Middle Ages. His comedies did not have the popular appeal that Plautus' plays did, for they lacked his "comic power" as one ancient critic said. They were, however, well-constructed, polished dramas written in the sort of Latin that one could hold up to schoolboys as a model. His first play, the *Woman of Andros* (*Andria*) produced in 166 B.C.E., was based on two of Menander's plays, and uses stock characters with originality: there is the typical lovesick young man, but he wants to marry a young woman of good family, not a courtesan. The strict fathers are presented with sympathy, and the clever slave is more than a mere trickster. The plot is as follows: Simo has betrothed his son Pamphilus to Philumena, daughter of Chremes. But Pamphilus loves Glycerium, an orphan, whereas his friend Charinus wants to marry Philumena. The two fathers negotiate; the clever slave Davus orchestrates the action and everything is resolved when Glycerium turns out to be Chremes' daughter and also to have borne a child to Pamphilus. Pamphilus marries Glycerium and Charinus marries Philumena. The year after the *Woman of Andros,* Terence produced his *Mother-in-Law* but it failed at its first production. Then came the *Self-Punisher* and the *Eunuch* and in the same year as the *Eunuch,* the *Phormio.* His last play was the *Adelphi* (The Brothers) which many critics consider his best. In that play, there are two sets

of brothers. One set is elderly with contrasting characters: Micio who lives in Athens and is easy-going, and Demea, a farmer outside Athens who is frugal. Micio has no son of his own and adopts one of Demea's two sons. Thus we have a second set of brothers: one brought up virtuously by his father and the other indulgently by his adoptive father who is also his uncle. The plot centers about the attempt of Micio's adoptive son to kidnap a harp-playing girl for his virtuous brother. The plot is resolved when Demea is converted to a more indulgent attitude, his son keeps his harpist, and Micio's adoptive son gets married.

THEATER AFTER TERENCE. The accidents of survival make it appear that dramatic genius dried up after Terence. In fact, theater continued to be popular. While Terence was writing comedies that were purely Greek in everything except the language, other playwrights were putting Roman characters on stage. These were called *fabulae togatae*, that is, dramas in togas, in contrast to the *fabulae palliatae* where the characters wore Greek fashions. Their success was modest. Crowds were more attracted to mime and Atellan farce.

SOURCES

W. Geoffrey Arnott, *Menander, Plautus and Terence,* (Oxford, England: Clarendon Press, 1975).

W. Beare, *The Roman Stage. A Short History of Latin Drama in the Time of the Republic.* 3rd ed. (London, England: Methuen, 1964).

George E. Duckworth, *The Nature of Roman Comedy* (Princeton, N.J.: Princeton University Press, 1952).

Bruno Gentili, *Theatrical Performances in the Ancient World: Hellenistic and Early Roman Theatre* (Amsterdam: J. C. Gieben, 1979).

David Konstan, *Roman Comedy* (Ithaca, N.Y.; London, England: Cornell University Press, 1983).

Plautus, *Four Comedies: The Braggart Soldier, The Brothers Menaechmus, The Haunted House, The Pot of Gold.* Trans. Erich Segal (Oxford, England: Oxford University Press, 1996).

LATIN POETRY BEFORE THE AUGUSTAN AGE

LATIN EPIC POETRY. The Latin epic begins in 240 B.C.E. with Livius Andronicus, a Greek from Tarentum, modern Taranto on the south coast of Italy, which had been founded as the Greek colony of Taras and fell into Roman hands after Rome's war with Pyrrhus. Andronicus was brought to Rome as a slave and was acquired by a member of one of Rome's great Roman families, the Livii, who freed him because he tutored his owner's children so well. He continued to teach once he was a freedman and desired to develop a teaching model similar to that of the Greeks. Greek children learned from the Greek epic poet Homer, but Rome had nothing similar and so Andronicus translated one of Homer's most famous works, the *Odyssey*, into Latin, using the only rhythm native to Rome, the Saturnian verse. He became a professional poet and playwright, writing a hymn to the gods to win their favor during Rome's war with Hannibal. In recognition of his craft, Rome allowed him to found a guild of writers and actors with its headquarters in the temple of Minerva on the Aventime Hill. But he was best remembered for his translation of the *Odyssey* which was still a vital part of Roman education when the Augustan poet Horace was a boy in the mid-first century B.C.E.

NAEVIUS AND ENNIUS. The next step in the development of the Latin epic was taken by Gnaeus Naevius. He fought in Rome's first war against Carthage, which ended in 241 B.C.E., and he wrote a history of it in poetry. Like Andronicus, he used the Saturnian meter. His work is lost, but we do know that he traced the enmity of Rome and Carthage to their foundations, and brought in the story of Dido and Aeneas, as Vergil was to do later in his epic, the *Aeneid*. With Quintus Ennius, (239–169 B.C.E.) the Latin epic took a giant step forward. He came from a town in Calabria, and he knew Oscan, the language of the Samnites, as well as Latin and Greek, and he produced adaptations of Greek dramas for the Roman stage. His great work was his *Annales*, a poem on the history of Rome from the beginning. Unlike Naevius, he adapted the meter of Homer, the dactylic hexameter, to his verse. It was an important step as all later writers of Latin epic would follow his example and use hexameter verse.

TITUS LUCRETIUS CARUS. Lucretius (94–55 B.C.E.) stands apart as one of the finest didactic (from the Greek *didaskein*, "to teach") poets who ever wrote in any language. The early Greek Presocratic (before Socrates) philosophers had written in poetry, but poetry had given way to prose as a medium for philosophy even before Plato popularized the dialogue form. Didactic poetry was revived in Alexandria, but none of the poets working in the cultural hothouse surrounding the Alexandrian Library ever reached the height that Lucretius did. He was a convert to Epicureanism, which taught that all things are made up of atoms and void and that when human beings die, their atoms dissolve and there is no afterlife. Epicureanism did not deny that the gods existed, but it

LUCRETIUS AND THE ATOMIC THEORY

INTRODUCTION: Lucretius (c. 94–55 B.C.E.), a Roman poet, attempted to explain the atomic theory of the universe expounded by the Greek philosophers Democritus and Leucippus in his great poem *De Rerum Natura* (On the Nature of Things). The theory argued that since all matter is made of atoms and void, death is simply a dissolution of atoms, and no one need fear it. In the following passage he begins his explanation of creation with the principle that nothing can be created out of nothing. The translation into prose gives little hint of Lucretius' poetic genius, but it is a clear exposition of his ideas.

This dread and darkness of the mind cannot be dispelled by the sunbeams, the shining shafts of day, but only by an understanding of the outward form and inner workings of nature. In tackling this theme, our starting-point will be this principle: *Nothing can ever be created by divine power out of nothing*. The reason why all mortals are so gripped by fear is that they see all sorts of things happening on the earth and in the sky with no discernible cause, and these they attribute to the will of a god. Accordingly, when we have seen that nothing can be created out of nothing, we shall then have a clearer picture of the path ahead, the problem of how things are created and occasioned without the aid of the gods.

First then, if things were made out of nothing, any species could spring from any source and nothing would require seed. Men could arise from the sea and scaly fish from the earth, and birds could be hatched out of the sky. Cattle and other domestic animals and every kind of wild beast, multiplying indiscriminately, would occupy cultivated and wastelands alike. The same fruits would not grow constantly on the same trees, but they would keep changing: any tree might bear any fruit. If each species were not composed of its own generative bodies, why should each be born always of the same kind of mother?

SOURCE: Lucretius, "Matter and Space," in *On the Nature of the Universe*. Trans. R. E. Latham (Harmondsworth, England: Penguin Classics, 1951): 31–32.

relegated them to a region far removed from life on earth. The advantage of Epicureanism was that it removed all fear of death, or so Lucretius believed. Lucretius deserves honorable mention among the philosophers, but he also should be recognized as a great poet, for he wrote with verve and skill, and great passion for his subject. He describes matter and void, and the shapes and movements of the atoms in void, he explains how life and sensation came to exist and plants and animals evolved more or less by chance and then reproduced, and what the gods were, for they were also atoms and void, and he ends with a powerful description of a plague epidemic which breaks off suddenly; clearly the poem is unfinished and must have been published after Lucretius' death.

CATULLUS. Thanks to the fortunate discovery of a manuscript in the early fourteenth century, we have 116 poems of Gaius Valerius Catullus of varying lengths, and they reveal a poet of genius. He belonged to a new wave of poets in the first half of the first century B.C.E. who looked to writers in Alexandria for their inspiration. They followed in the footsteps of an unconventional poet named Laevius who, in the 90s B.C.E., wrote love poetry expressing personal feelings. The orator Cicero, who disdained them, called them the *neoteroi* (the newer writers or "the new wave"), and the name has stuck; modern critics call them the "neoterics." Catullus is the only one whose work has survived. His poems express his passionate love for a woman he called Lesbia and the emotional rollercoaster he endured as his love turned bitter. Shed of her alias, Lesbia was actually Clodia, a brilliant woman who was the sister of a political firebrand in Rome, Publius Clodius, and Catullus can only have been a minor figure in the group of influential powerbrokers she gathered about her. But Catullus wrote more than love poetry. Taking his cues from Callimachus and the Alexandrians, he tried his hand at an *epyllion*, or short epic, and he translated one of Callimachus' most famous poems, the *Lock of Berenice*. Sappho also influenced him; he translated a poem of hers imitating the Sapphic stanza. But it is his lyrics expressing his ill-fated love for Lesbia that have made him famous.

SOURCES

Cyril Bailey, "Lucretius," *Proceedings of the British Academy* 33 (1949): 143–160.

W. R. Johnson, *Lucretius and the Modern World* (London, England: Duckworth, 2000).

Duncan F. Kennedy, *Rethinking Reality: Lucretius and the Textualization of Nature* (Ann Arbor: University of Michigan Press, 2002).

Kenneth Quinn, *Catullus: An Interpretation* (London, England: Batsford, 1972).

T. P. Wiseman, *Catullus and His World: A Reappraisal* (Cambridge: Cambridge University Press, 1985).

LATIN PROSE WRITERS BEFORE THE AUGUSTAN AGE

WRITERS BEFORE CICERO. Roman historical traditions shaped the Roman people; from early times, the *pontifex maximus* (high priest) of Rome kept a record on a whitewashed board of the magistrates for each year and any notable events. The first true historian of Rome, Fabius Pictor, wrote in Greek rather than Latin. His history, written during the desperate war with Hannibal the Carthaginian, was intended to encourage pro-Roman sympathies in Greece. Marcius Porcius Cato (234–149 B.C.E.) was the first author and statesman who made a point of using Latin in his writing. He was a considerable orator, and in his old age he wrote a history titled the *Origines* on the origins not only of Rome but neighboring towns as well. All that survives of his writing is a treatise on agriculture that leaves the impression that he was a hard-boiled but pious farmer. After him, there is no prose author of note until Cicero and Julius Caesar in the middle decades of the first century B.C.E.

MARCUS TULLIUS CICERO. The facts of Cicero's life can be given briefly. He was born in 106 B.C.E. in the small town of Arpinum (modern Arpino). At age sixteen he was attached to a well-known barrister of the day, Quintus Mucius Scaevola, to win his *entrée* into the Roman legal industry. At eighteen he began his compulsory military service. He served under the father of Julius Caesar's rival, Pompey, which he always thought gave him a special link with Pompey. For the next few years he studied rhetoric and philosophy in Rome and made his court debut in 81 B.C.E. This was the period of Sulla's dictatorship, and Cicero made himself a marked man by successfully defending a man who had incurred the enmity of one of Sulla's minions, Chrysogonus. Cicero thought it prudent to retire to Greece for further study following this case and only returned to Rome after Sulla's death in 78 B.C.E. His first great triumph in court was in 70 B.C.E. when he impeached Gaius Verres for his corrupt governorship of Sicily. Verres went into voluntary exile before he was sentenced, and the Sicilian provincials who were his victims got no restitution. To win the case, Cicero had defeated the best lawyer of the day, Hortensius, and his reputation was made. He rose to be consul in 63 B.C.E. even though he was a "new man"—that is, no one in his family had been consul before—and during his year in office, he suppressed the conspiracy of Catiline and put the conspirators to death without trial, which was illegal. For that he was exiled in 58 B.C.E. and was allowed to return only after he made it clear that he would not make waves for

the political triumvirate of Pompey, Crassus, and Julius Caesar who were manipulating politics behind the scenes at this time. When Caesar started the civil war in 49 B.C.E. by crossing the Rubicon River which marked the boundary between his province of Cisalpine Gaul and Italy, Cicero, after some hesitation, joined the senatorial group led by Pompey, who were Caesar's enemies. After the defeat of Pompey's army during the next year at the battle of Pharsalus, Cicero returned to Italy. He was not one of the conspirators who murdered Caesar on the Ides of March (15 March) 44 B.C.E., but there is little doubt that he approved, and in the immediate aftermath, he tried to arouse the senate to suppress Mark Antony's efforts to take over. He thought—wrongly—that he could use Julius Caesar's grandnephew Octavian, whom Caesar had adopted in his will, against Mark Antony, and then discard him when he was no longer necessary. Events turned out otherwise; Octavian joined Antony and another of Caesar's officers, Lepidus, in a second triumvirate of power brokers, and when this second triumvirate drew up its list of enemies to be proscribed in November, 43 B.C.E., Antony insisted that Cicero be included. He was killed by Antony's troops and his head nailed to the rostra, or speaker's platform in the Roman Forum where Cicero had often spoken.

CICERO'S LETTERS. The sheer bulk of Cicero's works is impressive. He bequeathed to posterity private letters, public speeches—some delivered in the law courts, others in the senate or before a public assembly—treatises on rhetoric, and dialogues on philosophy that had an enormous influence even though he was not, by any means, an original philosopher. His letters were written to his friends and family members, including his younger brother Quintus and his close friend and confidante, Titus Pomponius Atticus, a wealthy businessman and financier who stayed out of politics and survived the civil wars. The letters reveal the private Cicero, who differed from his public persona. Lawyers at this time in ancient Rome did not charge their clients fees, for the pretence was maintained that lawyers were above such considerations. They did, however, expect gifts and legacies from their clients, and Cicero's income was such that he could maintain a large number of country villas, although his lifestyle was not particularly extravagant for men of his class by the standards of the day. Cicero's letters give a rare glimpse of the private life of a Roman statesman as the Roman republic slid into civil war.

CICERO'S SPEECHES. Of Cicero's orations delivered in the Roman senate or public forums, his most famous are his four speeches against Catiline and his *Philippics*,

speeches attacking Mark Antony, of which the first was delivered in the senate on 2 September, 44 B.C.E. and the second—his most famous—actually published as a pamphlet though it was in the form of a speech. The Catilinarian orations were delivered in the year of Cicero's consulship, 63 B.C.E. How serious a threat Catiline was to constitutional government is a matter for dispute—certainly Cicero exaggerated. Cicero's speeches delivered in the law courts throw a lurid light on Roman public life. His *Verrine Orations* against the corrupt governor of Sicily, Verres, who was tried in 70 B.C.E., were published after the case; they had not actually been delivered in court, for Verres went into voluntary exile first. Another great speech on behalf of a thuggish gang leader, Milo, in 52 B.C.E. was not delivered in court either. Cicero lost the case, but made up for it by publishing the version he would have given, but failed to do so because he was unnerved by Pompey's soldiers ringing the court. Other speeches give splendid vignettes of Roman life. One, "In Defense of Cluentius," is a murder case in an Italian town. Another, "In Defense of Caelius" throws a sidelight on Catullus' love affair with Lesbia, for Caelius was an ex-lover of Clodia, who seems to have been the Lesbia of Catullus in real-life. Caelius had had an affair with Clodia, and when he abandoned her, she charged him with an attempt to poison her. Cicero's defense of Caelius gives him a chance to dwell on the *demi-monde* of Rome, and Clodia's private life in particular.

RHETORICAL AND PHILOSOPHICAL TREATISES.

Cicero was an eclectic philosopher who wrote philosophic dialogues during a period of his life when the alliance of the power brokers Caesar, Pompey, and Crassus, known as the First Triumvirate, sidelined him from politics. Of his works on rhetoric, his *Brutus* is interesting for its discussion of the development of oratory in Greece and Rome, which leads up to a description of his own development. Cicero followed it with his *Orator*, which makes the case that the true orator must be a master of all styles: the simple, the somewhat florid, and the grand. Cicero is a major source for modern knowledge of oratory in the Roman republic.

OTHER NOTABLE WRITERS OF PROSE.

Gaius Julius Caesar is better known as a world conqueror, but he was also an author. His claim to fame in the latter arena is his *Commentaries on the Gallic War* and *Civil War*. His Latin style is unlike any other writer's, except for his imitators. He was writing a "commentary," not a "history" of his conquest of Gaul and the civil war that followed it; a "commentary" purported to be a first draft which would later be fitted out with literary adornments. Cae-

Cicero, profile portrait, engraving. **PUBLIC DOMAIN.**

sar was writing for propaganda purposes, but he reads like a good war correspondent. His bias is apparent but not blatantly so. One of his officers, Aulus Hirtius, added an eighth book to the *Gallic War* and continued Caesar's *Civil War* with a work in a style that copies Caesar's, the *Alexandrine War*. It is the source for the affair between the young Cleopatra of Egypt and Julius Caesar. Another supporter of Caesar with a more eloquent style was Sallust (Gaius Sallustius Crispus) who wrote a *History*, now lost, monographs on the Conspiracy of Catiline in 63 B.C.E., and the war with Jugurtha in north Africa at the end of the second century B.C.E. which was won by Marius, Caesar's uncle by marriage. In the second of these, Marius comes off very well. In his monograph on Catiline's Conspiracy, Cicero's role pales beside those of Julius Caesar and Cato the Younger. Cicero is portrayed as a decent but lightweight politician, but Cato represents the severe righteousness of an extreme right-wing statesman while Caesar has the makings of a beneficent ruler. Finally, there was an extraordinarily productive writer, Marcus Terentius Varro, of whose many works only one survives complete: a dialogue on buying and running a farm. Another writer worthy of mention is Cornelius Nepos, whose *Book about Excellent Leaders of Foreign*

Peoples—22 of them, all Greeks except for two Carthaginians and one Persian—was written in straightforward but rather dull Latin prose.

SOURCES

Samuel W. Crompton, *Julius Caesar* (Philadelphia: Chelsea House, 2003).

Anthony Everitt, *Cicero: A Turbulent Life* (London, England: John Murray, 2001).

Elizabeth Rawson, *Cicero: A Portrait.* Rev. ed. (Ithaca: N.Y.: Cornell University Press, 1983).

David Stockton, *Cicero: A Political Biography* (London, England: Oxford University Press, 1971).

Sir Ronald Syme, *Sallust* (Berkeley: University of California Press, 2002).

Kathryn Welch and Anton Powell, ed., *Julius Caesar as Artful Reporter: The War Commentaries as Political Instruments* (London, England: Duckworth, 1998).

THE GOLDEN AGE OF LATIN LITERATURE UNDER AUGUSTUS

NEW CLIMATE OF OPINION. The civil war—which started when Julius Caesar crossed the Rubicon River in 49 B.C.E. and ended when Caesar's heir, Octavian, defeated Mark Antony and Cleopatra at the Battle of Actium in 31 B.C.E.—ended the era of literature of the late republic and started the Augustan Age. The poet Horace fought as a staff officer (tribune) in the army of Brutus and Cassius, but he was no diehard defender of the Roman republic. He returned to Italy after the defeat of Brutus and Cassius at Philippi in 42 B.C.E., and made his peace with the new regime. The poet Tibullus personally had no taste for war, as he tells us in two poems which celebrate the victories of his patron Messala, and Propertius preferred to write about the love of his life whom he called Cynthia—her real name was Hostia and she was a beautiful courtesan—but since he belonged to the circle of writers who were supported by Augustus' unofficial minister of propaganda, Maecenas, he was called upon to eulogize Augustus' exploits and excused himself as gracefully as he could. Vergil, the greatest of the Augustan writers, had no hankering for the old Roman republic, having seen first-hand how it misruled the provinces, for he was born in one. Ovid was born the year after Julius Caesar was murdered and never knew the free-wheeling days of the republic when writers could write what they pleased, but he learned that an author under the principate—as Augustus' regime was called—failed at his peril to respect certain limits to his freedom. When Ovid was about fifty years old, Augustus exiled him to Tomis on the Black Sea in modern Rumania. Augustus' successor, Tiberius, did not recall him and he died there. The reasons for his exile are obscure, but one of them may have been a playful poem he wrote titled *The Art of Love* which is a witty poetic instruction manual on how to seduce women.

VERGIL'S ECLOGUES. A group of minor poems have survived which have been considered Vergil's early works, and one of them, the *Culex* (*The Gnat*) is an epyllion worthy of Vergil. The poem describes how a shepherd is wakened from a nap by a mosquito, which he kills only to discover that a venomous snake is about to strike him; the mosquito had sacrificed its life to warn him in time. Some scholars accept the *Culex* as Vergilian, but the earliest works that are certainly written by him are his *Bucolics* (Poems of the Countryside), otherwise known as his *Eclogues* (Select Poems). There are ten of them, and two—the first and the ninth—have been thought to be autobiographic, for they deal with the land confiscations after the Battle of Philippi, when Octavian expropriated land in the region of Cremona and Mantua to settle demobilized soldiers. Vergil's family estate was expropriated and the first *Eclogue* tells how a freedman, Tityrus, had his little farm restored to him. There are problems with this interpretation, and it is more probable that Vergil's intent in both his first and ninth *Eclogues* was to make known the disruption and injustice caused by the land expropriations. The fourth poem, the so-called "Messianic" *Eclogue* hails the expected birth of a child who will usher in a new age. The identity of this child has been much disputed, and later Christian commentators interpreted the poem as a prophecy of Christ's birth. It could be a child expected by Octavian; when *Eclogue* Four was written in 40 B.C.E. he was still married to his second wife Scribonia by whom he had his only child, a daughter Julia. But if so, the child whose birth Vergil foretold was never born. In the *Eclogues*, the influence of Theocritus is clear, but it was Vergil who invented Arcadia—not the Arcadia in central Greece but an imaginary Arcadia where shepherds and cowherds sang and loved and lived a life far removed from the turmoil of the city. In the literary tradition of Europe, it was Vergil, not Theocritus, who invented pastoral poetry.

THE GEORGICS. The *Georgics* (On Land Cultivation) is a didactic poem written at the behest of Maecenas who gathered about him a cluster of writers and tried to harness their talents for the benefit of Octavian. Restoring agriculture in Italy after civil war was a vital concern, and though the *Georgics* is the most polished verse that Vergil ever produced, it is propaganda. It also brought didactic poetry to a new height. The subject of

the first book is the crops and the signs for good and bad weather. The second discusses vineyards and olive orchards, the third stockbreeding, the last beekeeping. Vergil worked on the poem for seven years and somehow manages to make plain passages about plowing, planting, and beekeeping interesting.

ROME'S NATIONAL EPIC. Augustus wanted a heroic poem, an epic that could be compared without apology to the Greek poet Homer, whose *Iliad* and *Odyssey* overshadowed the works of Roman poets. Of the prominent Roman poets of the day, only Vergil answered the call, producing the *Aeneid*. It has been justly admired from its own time to the present day. Even while it was being written, the poet Propertius wrote that "something greater than the *Iliad* is being created"—a favorable review even before the publication date. It soon became the national epic of Rome, the Latin answer to Homer. It tells the story of the Trojan hero Aeneas, who escaped from the sack of Troy and arrived in Italy, bringing with him his household gods and winning a space in Latium for himself and his descendants. The Romans were familiar with the myth. Aeneas' son Ascanius founded Alba Longa, the royal houses of which spawned Romulus, founder of Rome. Old Roman families called themselves "Trojan-born," which was the equivalent of claiming ancestors that came over on the *Mayflower*. Julius Caesar's family, the Iulii, made the claim, and the emperor Augustus was Caesar's great-nephew and his adoptive son. Julian tradition told that Aeneas had a son, Iulus, who was the first ascendant of the family. Vergil identifies Iulus with Ascanius by claiming that Iulus was Ascanius' other name. Thus Augustus was a descendant of Aeneas, and the story of Aeneas shed a glow of legitimacy over the emperor and his dynasty. Aeneas' struggle to establish his Trojans in Latium paralleled Augustus' struggle to bring peace and prosperity to the empire after the generation of civil war that destroyed the old Roman republic.

THE AENEID. For the first half of the *Aeneid*, Vergil took Homer's *Odyssey* as his model and the *Iliad* for the second half, purposely inviting comparisons. For instance, the character of Aeneas is a warrior from the Trojan War who must endure a long and troubled journey following the end of the war, much like the character of Odysseus from the *Odyssey*. Unlike Odysseus, however, Aeneas is actually fleeing his home, having fought on the side of the Trojans. With a ship full of survivors, including his son and his father, he flees Troy for Italy, where it is his destiny to found Rome. The reality of his destiny does not procure for him an easy passage, however; a tempest tosses Aeneas' little fleet up on the shores

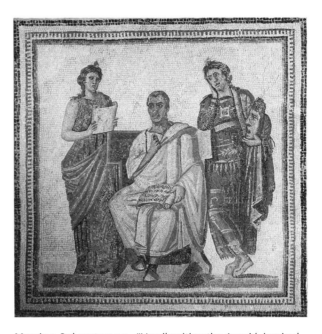

Mosaic c. 3rd century C.E., "Vergil writing the Aeneid, inspired by two muses," in the Bardo Museum in Tunis, Tunisia. Clio, the muse of storytelling, holding a manuscript, is on Vergil's left, and Melpomene, the muse of tragedy, holding a mask, is on the right. © ROGER WOOD/CORBIS.

of Carthage, which has just been founded by queen Dido. Dido welcomes Aeneas and his Trojans and gives them a royal banquet, which parallels Odysseus' landing on the shore of Phaeacia and his welcome by the Phaeacian king and queen. As with the banquet scene in the *Odyssey*, Vergil related what had happened previous to the Trojans' landing at Carthage as a "flashback" sequence in which Aeneas relates to the Carthaginians the fall of Troy, including the famous story of how the Greeks finally penetrated the city walls. The Greeks had built a large wooden horse, left it outside the city gates, and then pretended to depart for home. The Trojans were told by a Greek pretending to be an escaped slave that the horse was a gift from the gods and if they took it within the city walls, their city would never be taken. Tricked by his story, the Trojans did indeed take the horse into their city, not knowing that contained in its hollow belly was a group of Greek soldiers waiting for nightfall to open the gates for the Greek forces outside. That night the Greek forces came out of hiding and sacked the city. So famous is this tale that the "Trojan Horse" has become an enduring symbol for trickery and duplicity. The Trojans fought with the courage of despair, but when resistance proved futile, Aeneas followed the orders of the gods to leave. The story of how he hoisted his crippled father Anchises on to his shoulder and escaped from Troy was already famous in Rome.

VERGIL'S PROCLAMATION OF ROME'S MISSION

INTRODUCTION: Literature in ancient Rome often served the purpose of the state as propaganda. In 30 B.C.E, the Roman poet Vergil began his epic work *The Aeneid* in response to the emperor Augustus' call for a poem to glorify his regime that could be compared without embarrassment with the works of the Greek poet Homer: the *Iliad* and the *Odyssey*. Using those texts as models, Vergil related the story of the founding of Rome, using the Trojan hero Aeneas as its legendary founder. Although still unfinished at the time of Vergil's death in 19 B.C.E., the work became Rome's national epic, glorifying the Roman Empire's establishment by the "blood, sweat and tears" of Rome's ancestors. In Book 6 of *The Aeneid*, Vergil relates the story of the descent of Aeneas into the Underworld where he meets the ghost of his father Anchises who shows him the souls of Romans yet to be born. As Anchises concludes this pageant of Rome's history, he proclaims the unique mission of the Roman Empire in the following lines.

Others, I do not doubt it, will beat bronze into figures that breathe more softly. Others will draw living likenesses out of marble. Others will plead cases better or describe with their rod the courses of the stars across the sky and predict their risings. Your task, Roman, and do not forget it, will be to govern the peoples of the world with your empire. These will be your arts—and to impose a settled pattern upon peace, to pardon the defeated and war down the proud.

SOURCE: Vergil, *The Aeneid*. Book 6. Trans. David West (London: Penguin Classics, 1990): 159.

Aeneas got away safely with his father, his little son Ascanius, and his household gods, but his wife Creusa was lost. Aeneas returned to Troy to seek her, but her ghost told him to be on his way—a new home awaited him in Italy. Like Odysseus, Aeneas endured hardship and loss during his journey by sea; he lost his father in Sicily, and a storm blew them onto the shore of Carthage in Africa. As with Odysseus and the Phaeacians, Dido and her people are moved by the sad tale of Aeneas and the Trojans, and the two peoples appear prepared to settle down together. Dido and Aeneas begin an affair, but the gods perceive the romance as a threat to Aeneas' destiny and order him to leave Carthage for Italy; the plot develop-

ment closely resembles the gods' ordering of the nymph Calypso to release her lover, Odysseus, so he can return home. Neither of these powerful female characters wanted to let go of their lovers, and Dido stages a dramatic suicide at Aeneas' departure by building a funeral pyre for herself out of Aeneas' discarded possessions and killing herself in its fires. Dido's death is evidence of a Roman belief that romantic love was a poison which disrupted betrothals and family alliances; in Rome, marriage was a business deal worked out by the parents of the bride and groom, and among well-born Romans it involved property. Love induced irrational behavior and led to unsuitable marriages. Aeneas' rejection of his lover is also evidence of the Roman emphasis on duty over emotional ties; Aeneas is devoted to duty—the usual epithet that Vergil applies to him is *pius* which means more than its English derivative "pious." It means god-fearing, dutiful, and even compassionate.

DESTINY IN ITALY. While Aeneas did not lose nearly as many fellow travelers as Odysseus, he is forced to leave behind the women of his party in Sicily after the travel-weary women set fire to the ships in an attempt to prevent their leaving the island. Thus the Trojan settlers in Italy will be men only, which means that they will have to find Italian women for their mates. Aeneas is aware that their settlement in Italy will necessitate another war similar to the Trojan War, but he sees it as his destiny to be on the winning side this time when he visits the Underworld and sees the ghosts of the future builders of Rome. The last six books describe the fight in Italy between the native Rutulians and the immigrant Trojans, and Vergil switches his narrative model to the *Iliad*. Aeneas arrives at the future site of Rome, and there meets King Latinus who has been told by an oracle to marry his daughter Lavinia to someone who is not a native of the country. Although the king is amenable to Lavinia's marriage to Aeneas, the queen, Amata, is not; she favors the prince of the Rutulians, Turnus, and the rivalry between Turnus and Aeneas sparks a war between the two peoples. After much bloodshed, the war is decided by hand-to-hand combat between the two suitors in which Aeneas kills Turnus.

ASSESSMENT OF A GREAT POEM. Vergil's *Aeneid* became the national epic of the Roman Empire. The poet drew from various literary influences for his creation, particularly Homer. Vergil also drew upon the *Argonautica* of the Hellenistic poet Apollonius of Rhodes. Vergil's Dido owes something to Apollonius' Medea. Vergil was conversant with Alexandrian poetry; his *Eclogues* draw their inspiration from Theocritus and the *Aeneid* also draws inspiration from Alexandria even

though its model was Homer. Finally there was Ennius, Rome's first epic poet to use the dactylic hexameter from whom Vergil borrowed heavily for his knowledge of primitive Italy. The *Aeneid* no doubt celebrates the Roman Empire, Augustus' contribution to it, and the courage and self-sacrificing toil of Rome's founders. Yet he also pities the people trampled underfoot by Rome's growth to power. Turnus and Dido both engage our sympathies, whereas Aeneas can be remarkably brutal, and his epithet *pius* (dutiful) is a trifle chilling. In the end, it is clear that the Trojans will be assimilated. Aeneas has brought his gods from Troy and plans them to be the gods of Rome, but the god Jupiter makes it clear that he will decide what gods the Romans will worship. Aeneas, who is an Asian immigrant, will start the historical process that results in the Roman Empire, but he will lose his native culture, and his descendants will be purely Italian.

HORACE. Quintus Horatius Flaccus was the son of an ex-slave who saw to it that his son received a good education in Rome and then managed to send him to Athens. These were the heady days after Julius Caesar's assassination, and Horace was caught up in the enthusiasm among the Romans studying in Athens for the republican cause and joined the army raised by Marcus Brutus, the assassin of Julius Caesar. The defeat of Brutus and Cassius at Philippi understandably quenched his enthusiasm, so he returned to Italy, got a low-paying clerical post in the government, and began writing. Some of his *Epodes*, belong to this period. They got their name from their meter which the Greek lyric poet Archilochus had invented, for almost all of them have a long line followed by a shorter one, for which the technical name was an *epoide* (after-song). Sometime before the Battle of Actium he was introduced to Octavian's minister in charge of molding public opinion, Maecenas, and his poverty-stricken days came to an end. It was Maecenas who suggested that he put together a collection of his *Epodes*. About 35 B.C.E. he brought out a collection of satires, or as he titled them, *sermones* which can be translated not inaccurately as "chitchat." He was also experimenting with something new: an attempt to use the meters of the Lesbian poets Alcaeus and Sappho. Although the poet Catullus had tried his hand at the Sapphic stanza, Horace could claim to be original because his subject matter was his own. The first three books of his *Odes*—or as he called them, his *carmina* (songs)—took seven years to compose, and they were published about 23 B.C.E. He followed them up with his *Epistles*, so called because they purport to be versified letters to various recipients. He addressed one to his farm man-

ager,' for Maecenas had given him a farm in Sabine country not far from Rome. Horace advised his manager to be content with what he had. The emperor Augustus, who liked Horace and wrote him frequently, urged him to write more in praise of the imperial house, and in response he added a fourth book to his *Odes* and also produced a long hymn for the Secular Games of 17 B.C.E. The Games were not "secular" in the modern sense, for the word comes from the Latin *saeculum*, meaning "century," so "Centennial Celebrations" might be a better way of describing the festivities of that year. The hymn is called the *Carmen Saeculare* and it is not Horace at his best. Horace wrote another long poem which is famous: the third book of his *Epistles* which is taken up entirely with his *Ars Poetica* (The Art of Poetry). It is a nice example of didactic poetry but its content is not original, for Horace followed a treatise written by a Hellenistic author, Neoptolemus of Parion.

PROPERTIUS, TIBULLUS, AND SULPICIA. Propertius, Tibullus, and Sulpicia all wrote love poems addressed to specific individuals whom they claim as objects of their devotion. Propertius addressed his poems to Cynthia and Tibullus to Delia. Sulpicia was a woman and the lover whom she addressed is a man, but otherwise she follows the conventions of this genre of poetry. Propertius belonged to Maecenas' circle, but Tibullus had another patron, Messalla. Both wrote in elegiac couplets that had been used for centuries in Greek literature and brought into Latin in the Augustan age. The pioneer of the genre was a friend of Vergil, Gaius Cornelius Gallus, who wrote four books of elegies to a mime actress whom he calls Lycoris; in real life, her name was Cytheris and she had a number of lovers, including Mark Antony. Gallus became prefect of Egypt, where he proved too independent for Augustus' regime; the Roman senate tried and condemned him, and he committed suicide. His political disgrace eclipsed his poetry. Tibullus left two books of elegies. In the first he addresses Delia, and in the second, a woman he called Nemesis. In Messalla's circle there was also a poetess, Sulpicia, probably Messalla's niece, who wrote six short poems addressed to a man whom she calls Cerinthus. They are little gems of frank passion. A more productive poet than either of these was Sextus Propertius, whose love was a woman he calls Cynthia. Maecenas noticed his little book of 22 elegies titled *Cynthia* and took him into his circle. Like the other poets in Maecenas' stable, Propertius was urged to help popularize the principate (the constitutional settlement of Augustus), but his heart was really with love poetry. Propertius is the most interesting of these writers of love elegies if we take the vicissitudes of his love-affair at face

a PRIMARY SOURCE *document*

HORACE ON PATRIOTISM

INTRODUCTION: Horace (65–8 B.C.E.) owed the comfortable life that he led to his patron, Maecenas, whose gifts to him included a small estate outside Rome—his "Sabine Farm" made famous by his poetry. But Maecenas was a friend and close advisor of the emperor Augustus, and in return for his generosity Maecenas—and Augustus, too—expected Horace to support the aims of the empire, one of which was to rekindle patriotism and morality among the Romans. This excerpt is from one of Horace's *Odes* written to please his patron. Some phrases from it are famous, such as *dulce et decorum est pro patria mori* ("Sweet and fitting it is to die for your fatherland" or, as the translation printed below expresses it, "The glorious and the decent way of dying is for one's country"), which has been inscribed on countless cenotaphs for the war dead. Equally famous is the metaphor that concludes the poem, that Vengeance or Punishment, though she be lame, seldom gives up her pursuit of a man.

Disciplined in the school of hard campaigning,
Let the young Roman study how to bear
Rigorous difficulties without complaining,
And camp with danger in the open air,

And with his horse and lance become the scourge of
Wild Parthians. From the ramparts of the town
Of the warring king, the princess on the verge of
Womanhood with her mother shall look down

And sigh "Ah, royal lover, still a stranger
To battle, do not recklessly excite
That lion, savage to touch, whom murderous anger
Drives headlong through the thickest fight."

The glorious and the decent way of dying
Is for one's country. Run, and death will seize
You no less surely. The young coward, flying,
Gets his quietus in the back and knees.

Unconscious of mere loss of votes and shining
With honours that the mob's breath cannot dim,
True worth is not found raising or resigning
The fasces at the breeze of popular whim.

For those who do not merit death, exploring
Ways barred to ordinary men, true worth
Opens a path to heaven and spurns on soaring
Pinions the trite crowds and the clogging earth.

Trusty discretion too shall be rewarded
Duly. I will not suffer a tell-tale
Of Ceres' sacred mysteries to be boarded
Under my roof or let my frail boat sail

With him, for slighted, often God confuses
The innocent with evil-doer's fate.
Yet Vengeance, with one lame foot, seldom loses
Track of the outlaw, though she sets off late.

SOURCE: Horace, *Odes*. Book III. Trans. James Michie (New York: Modern Library, 2002): 119, 121.

value. But we must not be too quick to infer autobiographical details from their poetry, for they were writing within well-defined conventions. Sincerity was not considered a virtue in Latin poetry, and when a poet claims to be dying of love, he may be expressing only a conventional emotion that was demanded by his art form. Sulpicia's poetry differs only in one way: usually women were the object of male desire in elegiac love poetry, but Sulpicia presents herself as a woman who desires a partner as much as any man does.

OVID. Ovid was truly a man of letters. Sophisticated and technically brilliant, he wrote poetry effortlessly. Although not wealthy, he was sufficiently well-to-do to dispense with a patron and he remained outside the circles of Maecenas and Messalla. He began as an elegiac poet of love. His collection known as the *Amores* (Love Affairs) follows the examples of Tibullus and Propertius, for they tell of romantic encounters, but whereas the loves of those two writers probably existed, Ovid's lover, Corinna, probably did not exist outside literature. While

he was writing the *Amores* he was working on a more ambitious work, the *Heroides* (Heroines), letters in verse by women of mythology addressed to their husbands or lovers. Among others, he imagines Dido writing to Aeneas, Ariadne writing Theseus from Naxos where he had abandoned her, and Medea writing Jason after she has learned of his plans to jilt her and marry the king of Corinth's daughter. Ovid then turned to didactic poetry, but his subject was not a respectable one like agriculture. Ovid wrote the *Art of Love* in three books, the first two instructing men in the art of seduction and the third showing women who planned to be courtesans how to make the most profit from their husbands. He followed this up with a fourth book, the *Remedium Amoris*, on how to fall out of love. Ovid's greatest work is undoubtedly his *Metamorphoses* (Changes of Shape). No one believed in the ancient legends anymore, but they were still subject matter for literature, and Ovid decided to string them together on the common theme of changes of shape. He retells myths that told how heroes and heroines changed their shapes, like Actaeon who was

changed into a stag, or Alkyone who was changed into the halcyon bird. The resulting epic is a tapestry of myth, told with wit and all the tricks that an author versed in rhetoric could muster. Then came his exile. Augustus relegated him to Tomis, modern Costanza in Rumania, for reasons unknown. He burned his *Metamorphoses*, but fortunately copies were already in circulation and so it survived, though unfinished. Exile did not break Ovid, though he never saw his beloved Rome again. He wrote five books of *Tristia* (Poems of Sorrow)—the first book was complete before he reached Tomis. He continued these with his *Letters from Pontus*; "Pontus" was the name for the Black Sea. He wrote *Ibis*, an attack on an imaginary figure which was probably written as a psychological release, and a poem on the fish in the Black Sea. The major work of his exile was the *Fasti*, a versified Roman calendar of religious festivals. Ovid finished the first six months of the year and may have hoped that his interest in Roman religion would soften Augustus' heart. If that was his intent, he must have been disappointed in the result. Ovid died in exile.

LIVY. The Augustan age had one prose writer of distinction, Titus Livius, known in English by the name Livy, who wrote a history of Rome from its foundation to his own day in 142 books. He was the type of historian who wrote to edify his readers, and the characters of his history were either heroes or villains. The most wholesome outcome of knowing history, he told his readers, was to have examples of every type of conduct so that a person could choose models to imitate with foreknowledge of what the results of their choices would be. He was not a careful researcher, but he had historians to consult who have been lost long ago, and that gives his work real value for the historian of the Roman republic. His history extends to the Roman triumph over the last king of Macedon, Perseus, in 167 B.C.E. His style is smooth and his characterization vivid, but his panorama of the Roman past is not an example of historical accuracy.

SOURCES

William S. Anderson, *The Art of the Aeneid* (Englewood Cliffs, N.J.: Prentice-Hall, 1969).

David Armstrong, *Horace* (New Haven, Conn.: Yale University Press, 1989).

D. Thomas Benediktson, *Propertius: A Modernist Poet of Antiquity* (Carbondale, Ill.: Southern Illinois University Press, 1989).

Harold Bloom, ed., *Vergil* (New York: Chelsea House, 1986).

Francis Cairns, *Tibullus: A Hellenistic Poet at Rome* (Cambridge: Cambridge University Press, 1979).

T. A. Dorey, ed., *Livy* (London, England: Routledge and Kegan Paul, 1971).

Jasper Griffin, *Vergil* (Bristol, England: Bristol Classical Press, 2001).

W. R. Johnson, *Darkness Visible: A Study of Vergil's Aeneid* (Berkeley: University of California Press, 1976).

W. R. Johnson, "The Figure of Laertes," in *Vergil at 2000; Commemorative Essays on the Poet and His Influence*. Ed. John D. Bernard (New York: AMS Press, 1986), 85–105.

Sara Mack, *Ovid* (New Haven, Conn.: Yale University Press, 1988).

Alexander G. McKay, *Vergil's Italy* (New York: Graphic Society, 1970).

Niall Rudd, ed., *Horace 2000: Essays for the Millenium* (Ann Arbor, Mich.: University of Michigan Press, 1993).

David R. Slavitt, *Vergil* (New Haven, Conn.: Yale University Press, 1991).

———, trans., *Propertius in Love: The Eclogues* (Berkeley: University of California Press, 2002).

J. P. Sullivan, *Propertius: A Critical Introduction* (Cambridge: Cambridge University Press, 1976).

LATIN LITERATURE OF THE SILVER AGE

WRITERS BEFORE THE DEATH OF NERO. The name "Silver Age Latin" as applied to the literature that follows the "Golden Age" under Augustus reflects the judgement of generations of scholars. Writers of the Silver Age valued rhetorical skill and literary ornaments, and produced a style that was quite unlike ordinary human speech. Contemporary writers in Greek moved in the other direction; they were Atticists, that is, they revived the style and even the dialect of the best classical authors of Greece. Their example did not rub off on their Latin counterparts. Still, the sheer bulk of their writing is impressive. One poet, Marcus Manilius, wrote a didactic poem in five books on astrology. Calpurnius Siculus wrote pastoral poetry that was heavily dependent on Vergil's *Eclogues*. An ex-soldier, Velleius Paterculus, who served under the future emperor Tiberius, wrote a history of Rome in two books, and when he comes to his own period, he is a good historical source. Valerius Maximus collected nine books of sayings and anecdotes under the title *Notable Doings and Sayings*, and Phaedrus versified Aesop's fable.

SENECA. Lucius Annaeus Seneca's family came from Roman Spain, and his father was a rhetorician known as Seneca the Elder to distinguish him from his son. The reputation of the elder Seneca stems from a collection written in his old age of anecdotes about rhetoricians he had known. The younger Seneca is known for his philosophic treatises—he was a Stoic who failed to practice

what he preached—four prose works—one of which is a funny but cruel essay on the distaste with which the gods received the dead emperor Claudius when he entered their company after being decreed divine by the Roman senate—and nine tragedies. The tragedies were based on Greek originals except for the *Thyestes*, which told how the father of Agamemnon and Menelaus, Atreus, fed Thyestes his own children. The work allowed Seneca to give free rein to his love for blood and gore. He reworked Euripides' *Medea* and made Medea into a bloodthirsty witch. His *Phaedra* reworks Euripides' *Hippolytus* and gives Phaedra nymphomanic tendencies and makes Hippolytus a woman-hater. It is generally agreed that these plays were intended for public readings before select audiences, not for production in large theaters for the masses, whose taste was for interpretative dancing and mimes. Seneca's plays appealed only to the educated elite who were familiar with the Golden Age of tragedy in Athens of the fifth century B.C.E.

COLUMELLA. Lucius Junius Columella, like Seneca, came from Spain, but his interests were very different. After a career in the Roman army, he acquired an estate in Latium outside Rome, and devoted himself to agriculture. His *De Re Rustica* (On Husbandry) is a treatise on scientific farming. It gives a picture of the countryside of central Italy in his own day, with its growing number of country houses for wealthy Romans, and its absentee landowners. His cure for the decline of farming in Italy was hard work, personal supervision, and mastery of the science of agriculture.

GAIUS PETRONIUS. The novel as a literary form was becoming popular in Greece in the early imperial period, and Petronius chose to use it for what he called the *Saturae*—the "Mixed Bag" of writing. It is now known as the *Satyricon*. It is picaresque novel (relating to the adventures of rovers) but instead of the hero and heroine of the Greek novels who have a series of wild adventures as they roved from place to place, Petronius has a rascal named Encolpius and a cheeky boy named Giton. Only fragments remain, but one sizeable portion, describing a banquet given by a wealthy ex-slave named Trimalchio, is a masterpiece. The banquet was an orgy of feeding, and Trimalchio takes vulgarity to astonishing heights. Petronius was a favorite of the emperor Nero and invented revels for that pleasure-loving emperor until court intrigue destroyed him and he committed suicide with elegance and irony, as befitted a man of his talents.

MARCUS ANNAEUS LUCANUS. The fame of Lucan, who was Seneca the Younger's nephew, rests on one work: his epic poem on the civil war between Caesar and the senatorial party led by Pompey. Its name, the *Pharsalia*, comes from the decisive battle fought in Greece at Pharsalus, modern Farsala in Thessaly, where Pompey's army was defeated. Lucan's style is somewhat artificial but he is a smooth versifier. His sympathies were with Pompey and the republican form of government that Pompey defended. All of this fitted the popularized Stoic philosopher of the day that looked back with nostalgia at the republic which died in the civil war. Lucan died young. He was implicated in a plot against Nero, and died by bleeding to death, reciting some of his own verses on death by bleeding as he breathed his last.

PERSIUS. Little is known about Aulus Persius Flaccus, except that he left a collection of six satires and died young. The first was on the decay of literary taste, the second on the vanity of riches, the third on idleness, the fourth on self-knowledge, the fifth on true liberty, and the sixth on how to use wealth properly. His poetry is crammed with allusions to contemporary life. His fourth satire, for instance, urges a popular statesman named Alcibiades to examine his soul and pay no attention to public adulation. There was an Alcibiades who was an Athenian politician of the fifth century B.C.E., but perhaps the "Alcibiades" whom Persius has in mind is the emperor Nero. Persius' style is not easy to read. He is not for the beginning Latin student. But his small output reveals an interesting talent.

THE SILVER AGE AFTER THE EMPEROR NERO. Whatever the emperor Nero's faults may have been, he was an aesthete who was sensitive to culture, and his death in 68 C.E. did not improve the lot of the literary artist. The Flavian dynasty—the emperors Vespasian, Titus, and Domitian who replaced the Julio-Claudian clan to which the emperors from Augustus to Nero belonged—was from Sabine peasant stock. The Flavians were sensitive about their lack of background, and Domitian in particular was a menacing presence who inspired fear. With Nerva, Trajan, Hadrian, Antoninus Pius, and Marcus Aurelius (who died in 180 B.C.E.) there was greater freedom, but there was a comfortable mediocrity about the age, and it was not until the fourth century C.E. that there was a renewed outburst of literary talent. Still, the period did not lack for writers. Silius Italicus was one such figure; his primary position was as an informer under Nero, passing on information about potential enemies of the regime, although he later cleaned up his reputation by earning praise for his administration of the province of Asia. He wrote an epic titled the *Punica* on Rome's wars with Carthage, which were called the "Punic Wars" after the Latin word for Carthaginian: *Poenus*. The meters are correct but as poetry it is second-rate. He likes to put his learning on display, and the result is more tire-

some than impressive. Papinius Statius who wrote under Domitian whom he was careful to flatter, left five books of *Silvae*—miscellaneous poems on various subjects—and two epics, the second unfinished. The first epic was *Thebaid* and covered the legends of Thebes: how Oedipus killed his father, how his sons fought over the throne and killed each other, and how Creon succeeded to the throne. The poem reflects the taste of the day for romanticism through the inclusion of slaughter, exaggerated passions, and high-flown sentiment. The second epic, the *Achilleis* retells the myth of how Achilles' mother Thetis tried to save her son from being conscripted to fight in the Trojan War by dressing him as a woman and hiding him among girls at the court of the king of Scyrus. Statius wrote 1127 lines on this subject, but he died before he could write more. Valerius Flaccus wrote an epic on the legend of Jason and the Golden Fleece, taking as his model the *Argonautica* of Apollonius of Rhodes. Quintilian, the son and grandson of rhetoricians, is known for his *Education of an Orator*. His perfect orator was Cicero, and he concluded that all developments since Cicero's day had brought oratory downhill. Martial was a master of the epigram: the short poem that ends with a sharp, stinging quip. He took his subjects from contemporary life, throwing an interesting sidelight on it. Suetonius, secretary to the emperor Hadrian, wrote biographies in straightforward Latin, and one collection has survived entire: his *Lives of the Twelve Caesars* from Julius Caesar to Domitian. A little later than Suetonius, another author wrote the only novel in either Greek or Latin worthy of comparison with Petronius' *Satyricon*: Apuleius, whose tale, *Metamorphosis*, better known as *The Golden Ass*, tells how the hero Lucius dabbled in magic and managed to transform himself into a donkey. We have another work of Apuleius, too, for he married a wealthy widow and her relatives brought him to trial on a charge of winning her affections by magic. Apuleius' *Apology* is the speech he gave in his own defense before a court in Sabratha, in modern Libya. Of all the authors belonging to these somewhat tarnished last years of the Silver Age, there are three that should detain us: Juvenal, Pliny the Younger, and the historian Tacitus, for they were first-rate practitioners of their genre of literature.

JUVENAL. Juvenal was a bitter man. Life in Rome had not treated him well, to judge from his poetry, and after the emperor Domitian died and the pall of fear lifted, Juvenal wrote satires—sixteen of them—attacking the wickedness of contemporary life. He disliked women, all immigrants from the east—especially Jews, with Greeks a close second—avarice, the miserly rich, and the horrors of living in the shoddily built apartment houses of Rome. He attacked scoundrels by name, though he only picked on already-dead scoundrels to avoid retribution. He is the source of the aphorism that the Roman mob cared only about bread and circuses. He accepted the dictum of the Stoic philosophers that all transgressions were equal and hence he indicted the emperor Nero both for murdering his mother and for writing bad poetry as if they were sins of equal magnitude. He was himself a good poet who wrote vigorous hexameter lines.

PLINY THE YOUNGER. The reputation of Gaius Plinius Caecilius Secundus—the full name of Pliny the Younger—might have been overwhelmed by that of his uncle, Pliny the Elder, an encyclopedia writer who died in the eruption of Mt. Vesuvius in 79 C.E., except that the only surviving work of the elder Pliny is his *Natural History*, which is a mine of information but not casual reading. Pliny the Younger is known for his collection of pleasant letters written, ostensibly, to various contemporaries, including the historian Tacitus to whom he addressed an eyewitness account of the eruption of Vesuvius. The last book of his collected letters is correspondence between him and the emperor Trajan, for Trajan sent Pliny to the province of Bithynia in Asia Minor about 110 C.E. to correct maladministration there. Among the matters for consultation with Trajan was a cell of Christians whom he found. Pliny wanted to know the legal status of Christianity and Trajan replied that it was outlawed, though he warned against any witch hunt. For historians of Christianity, this is an important morsel of evidence; it defines the attitude of the Roman state towards Christianity in the second century C.E.

TACITUS. Cornelius Tacitus wrote five works: a dialogue on orators, evidently his first; a biography of his father-in-law, Agricola; an essay on Germany, the *Germania*; and his two greatest works, his *Histories* and his *Annals*. The first is a discussion of orators of the past, giving top marks to Cicero. Agricola governed Roman Britain under Domitian and hence Tacitus' biography adds significantly to knowledge about Britain in the years after its conquest under the emperor Claudius. The *Histories* begin with the turbulence after Nero's death when there were four emperors in the year 68 C.E., and it breaks off two years later. The rest is lost. The *Annals* also survives in mutilated condition; Tacitus begins with the emperor Tiberius, but the reign of Caligula is lost. Even so, Tacitus' account of Claudius and Nero is splendid. Tacitus knew firsthand the misery of Rome under the tyrant Domitian and when he describes these early emperors, he sees them as forerunners of Domitian. His powers of description were superb, and he is the last great Latin historian until the fourth century C.E. when

Ammianus Marcellinus takes Tacitus as his model and produces a history which compares well with any other in Latin, though Ammianus was a Greek and presumably Latin was his second language.

SOURCES

Frederick Abel, *Lucan* (Ithaca, N.Y.: Cornell University Press, 1976).

Philip B. Corbett, *Petronius* (New York: Twayne, 1970).

M. D. Grant, "Plautus and Seneca. Acting in Nero's Rome," *Greece and Rome* 46 (1999): 27–53.

G. O. Hutchinson, *Latin Literature from Seneca to Juvenal* (Oxford, England: Clarendon Press, 1993).

Ronald Mellor, *Tacitus* (London, England: Routledge, 1993).

Anna Lydia Motto, *Seneca* (New York: Twayne, 1973).

Victoria Rimell, *Petronius and the Anatomy of Fiction* (Cambridge: Cambridge University Press, 2002).

GREEK LITERATURE OF THE IMPERIAL AGE

CHANGED CONDITIONS. When Queen Cleopatra of Egypt committed suicide in 30 B.C.E., the last independent Hellenistic monarchy disappeared and all the eastern Mediterranean was under Roman rule. In place of the Hellenistic kings there were Roman governors whose language of administration was Latin. Yet Roman rule was light. On the local level, cities governed the people. Every Roman province contained a number of cities, some of them very old, some dating back to a foundation by a Hellenistic king or even Alexander the Great himself. Alexandria in Egypt was not the only city that Alexander founded; the Middle East was dotted with cities with the name "Alexandria" which claimed Alexander as founder. The Roman governor made his headquarters in the most important city in his province, and he was chiefly interested in law and order, and seeing to it that taxes were paid; but within limits, the cities were left to govern themselves. The governors cultivated the local elites and kept the loyalty of the well-to-do property owners, who were glad of the protection of an empire that safeguarded their economic interests, but at the same time they looked back with pride at the Golden Age of Greece and its great literary achievements. The literature of Greece under the Roman Empire reflected this vision: pride in the past, and support for the Roman Empire, or at least acquiescence to it. Rome would not tolerate anything that smacked of sedition.

CLASSICISM. The taste of the new imperial age ushered in by the emperor Augustus was classical. That is,

it looked back to the classical period of Greece (480–330 B.C.E.) for its models. The taste is reflected both in the visual arts of the Roman Empire and the literary taste. Dionysius of Halicarnassus, a Greek teacher of rhetoric who settled in Rome about 30 B.C.E., expressed the same view in the various treatises on literary style which he produced; his *On Ancient Orators* defends the Athenian or "Attic" style of oratory exemplified by Demosthenes and rejects the ornate "Asiatic" style which replaced the Attic style in the Hellenistic period. We find the same taste for the past in the essays of two important essayists of the period, Plutarch and Lucian.

PLUTARCH. Plutarch (c. 40–c. 120 C.E.) is best known for his *Parallel Lives*: paired biographical essays of Greeks and Romans where Plutarch puts the life of a famous Greek side-by-side with a Roman whose career was in some ways similar, and follows each pair with a comparison. As well as his *Parallel Lives* we have a great collection of essays grouped under the title *Moralia*— "Moral Essays" where the adjective "moral" means "based on general observation of people." Their subjects range far and wide: religion, music, philosophy, superstition (which Plutarch hated), love, and divine justice. He was typical of Greeks who were happy to cooperate with their Roman rulers, but were still proud Greeks. Lucian, (c. 117–after 180 C.E.), born in Samosata, now the village of Samsat in Syria, tried a legal career before turning to lecturing, travelling widely over the empire giving public lectures. When he was about forty, he settled in Athens and wrote satirical essays which laughed at the lives and beliefs of conventional Greeks and Romans. Then, as old age began to close in on him, he accepted a job on the staff of the governor of Egypt, thereby joining the "Establishment" that had been the butt of his humor. His favorite literary forms were dialogues and epistles; the first was borrowed from the theater and also from the dialogues of Plato, and the epistle pretended to be a letter addressed to someone: thus his essay on a charlatan, Alexander of Abonoteichos, takes the form of a letter addressed to one Celsus. Alexander invented a religion centered on a god named Glycon who was incarnate in a large, tame snake that was fitted with an artificial head with a speaking tube so that the snake could give prophecies and answer questions, rather like the Wizard of Oz. Lucian ends his epistle with the hope that it may help the general reader by shattering his illusions and confirming any sensible ideas he might have.

LUCIAN. Lucian was educated under a system heavily influenced by a literary movement known as the "Second Sophistic." It taught that an author should model his content and style on the best Greek authors of the

past, and the most obvious way to do this was to use many quotations and allusions to these authors. It also placed great value on rhetorical exercises, and the chief "Sophists" of the movement were orators who gave declamations, often before large audiences that thronged to hear them perform in theaters or music halls (called "odeons") or other public buildings. The movement got its designation "Second Sophistic" from its memorialist, Philostratus, who belonged to a literary family on the island of Lemnos. Philostratus gave the literary renaissance that he chronicled in his *Lives of the Sophists* the name "Second Sophistic." Philostratus' "Sophists" were polished, cultivated orators who were to be distinguished from the sophists of the classical period in the fifth and fourth centuries B.C.E. They were men like Dio of Prusa, nicknamed *Chrysostomos* ("Golden-Mouthed") who lived about 40–110 C.E., Aelius Aristides (117–189 B.C.E.), and Maximus of Tyre (c. 125–185 C.E.). Their repertory of speeches celebrated both the power and the beneficence of Rome, and at the same time the glorious past of Greece. Nowadays their sociological content is more interesting than their literary excellence. Aelius Aristides, for instance, wrote a panegyric in praise of Rome that shared its power with the ruling classes among the subject peoples that it ruled by granting them Roman citizenship as a reward for cooperation. Aristides gives us a window into the psychology of Greece under Roman rule.

THE NOVEL. Writing romantic novels did not begin with the "Second Sophistic" but this was the period of its great development. In fact, Dio of Prusa included a novella in one of his orations. The other novels we have are *Chaereas and Callirhoe* by Chariton, *An Ephesian Tale* by Xenophon, *Leucippe and Clitophon* by Achilles Tatius, *Daphnis and Chloe* by Longus, and the *Aethiopica* of Heliodorus. The authors are only names to us. The plots are full of voyages and adventures with pirates, shipwrecks, and premature burials, and the characters live in a world where everything is governed by chance, but apart from that, they show considerable variation. Chariton's romance, which could date as early as the first century B.C.E. is a historical novel; Chariton places it after the Athenian expedition to Sicily (415–434 B.C.E.) which took place in the Peloponnesian War and ended in disaster at Syracuse. His heroine Callirhoe is the daughter of Hermocrates, the Syracusan leader of the resistance against Athens. *Daphnis and Chloe* is the story of a shepherd, Daphnis, and his love, Chloe, who, like characters in a Greek New Comedy, turn out to be children of well-to-do parents. There are religious overtones to these novels. Xenophon's *Ephesian Tale* celebrates the cult of Artemis of Ephesus and Heliodorus celebrates the

cult of the Sun-God, known in Rome as *Sol Invictus*. In this respect they resemble Apuleius' Latin novel known as *The Golden Ass* which is a better novel than any of them. It need not surprise us that some of the Christian apocryphal gospels as well as stories of Christian saints borrow features from the novel.

THE ACCEPTANCE OF ROMAN RULE. The underlying theme of the historians who wrote in Greek was acceptance of Roman rule, and recognition of the benefits that it brought to its subjects. The same Dionysius of Halicarnassus who wrote *On Ancient Orators* also wrote a history of early Rome titled *Roman Antiquities* which covered the period from Rome's beginnings to where Polybius began his history with Rome's first war with Carthage (265–241 B.C.E.). His aim was to celebrate Rome's empire and also to prove a special relationship between Greece and Rome by proving that Rome's origin was Greek. Flavius Josephus (37–100 C.E.), a Jew who took part in the rebellion of Judaea against Rome that broke out in 66 C.E. but went over to the Roman side in 67 C.E., wrote the history of the revolt in his *Jewish War*, a work in seven books written in the tradition of the great classical historians Herodotus and Thucydides. His aims in writing, he tells the reader, were to remind the victors in the war of the valor of the men they conquered, and also to console the Jews who were vanquished and urge them to reflect on their failed revolt. Josephus wrote one other major work, his *Antiquities of the Jews* on Jewish history, as well as a tract titled *Against Apion* which is a reply to an anti-Semitic tract written by someone called Apion who is otherwise unknown. Josephus accepted Roman rule, but he remained proud of his Jewish heritage. The Egyptian Appian, who was born at the end of the first century C.E. emphasized the benefits of Roman rule in his Roman history. He was not an original researcher—he was a civil servant dabbling in history—but his organization was an effort at a new approach. He wrote a history of Rome's conquests, people by people and region by region. He did not completely abandon the annalistic technique whereby the historian presents the pageant of the past year by year, but he made an effort to deal with Rome's wars of conquest as separate military operations.

ARRIAN. Arrian, or Flavius Arrianus, to give him his full name, was a governor of Cappadocia in Asia Minor under the emperor Hadrian (117–138 C.E.) where he defeated an invasion by an Iranian tribe known as the Alans in 134 C.E. He was a disciple of the philosopher Epictetus, and like Xenophon with Socrates, he preserved his teachings. His major work that survives is his *Anabasis* which borrows its title from Xenophon's *Anaba-*

sis ("The March Up Country"), but Arrian's "March" is the story of Alexander the Great's conquest of the Persian Empire (334–323 B.C.E.). He based his history on the memoir written by Ptolemy, Alexander's general who became king of Egypt and founded the Ptolemaic dynasty that ended with the suicide of Cleopatra in 30 B.C.E., supplementing Ptolemy when necessary with the memoir of Aristobulus who had been a Greek technician with Alexander's army. Arrian's account is a sober narrative, and a valuable source for the military campaign of Alexander, for the historians contemporary with him have survived only in fragments.

CASSIUS DIO. Cassius Dio deserves special notice, for he is an important source for Roman history. He was born in Iznik in modern Turkey, ancient Nicaea, the son of a consul, in 163 or 164 C.E., and he himself would become a consul and a provincial governor under the emperor Septimius Severus (193–211 C.E.). He started to write in the reign of Caracalla (211–217 C.E.), one of the most odious emperors of Rome. His history, starting with Rome's beginning and continuing to 229 B.C.E. was a tremendous work that took ten years to prepare and twelve to write. Part of it has survived, and for the missing portions, we have digests written by later writers in the Byzantine period. For the reign of Augustus, the first emperor of Rome (27 B.C.E.–14 C.E.), the account of Cassius Dio is the fullest that we have.

THE CHRISTIAN WRITERS. Although still in its infancy in the first century C.E., Christianity began to produce its own literature almost as soon as its founder, Jesus, was crucified in 33 C.E. The earliest writings were letters exchanged between the disciples of Jesus and converts that were later compiled as the New Testament of the Bible. As the persecution of the Christian church intensified, other writings commemorated martyrdoms. One of the earliest examples is a group of seven letters composed by Bishop Ignatius of Antioch who, in his old age, was taken to Rome to be put to death sometime in the reign of the emperor Trajan (98–117 C.E.). Guarded by ten Roman soldiers, whom he describes in one letter as "ten leopards," he travelled across modern Turkey to Smyrna (modern Izmir), where he composed letters to the Christian communities nearby, and from there he proceeded to the Hellespont where he embarked on a ship for Rome. The custodian of Ignatius' letters was the bishop of Smyrna, Polycarp, who was burned to death at the age of 86 in the arena at Smyrna in 156 C.E.; the story of his martyrdom survives in Greek, Latin, Syriac, and Coptic versions. Apologies, that is, defenses of the Christian faith appear in the second century C.E.; one of the first, notable for its conciliatory tone, was by Justin

the Martyr, who was born in Shechem (modern Nablus in Israel). His apologies are lucid explanations of Christianity for the non-Christian; his *First Apology*, written about 150 C.E. is addressed to the emperor Antoninus Pius, and his *Dialogue with Trypho* reports a discussion with a Jewish rabbi which ends on a note of mutual tolerance and respect. By the third century C.E. Christian theology was borrowing from the Greek philosophers. The most brilliant theologian of the period was Origen (185–254 C.E.), who learned philosophy in Alexandria where a fellow pupil was Plotinus, the founder of Neo-Platonism, the mystical interpretation of Plato which was to be the last great school of pagan philosophy. After teaching for a period in Alexandria, Origen moved to Caesarea in Palestine where he produced, among other works, the first critical edition of the Old Testament. During the brief but violent persecution of the Christians under the emperor Decius (249–251 C.E.), Origen was tortured, and never recovered from the ordeal. Later Christian churchmen decided that Origen had married Greek philosophy a little too closely with Christianity, and judged him heretical. The same fate befell the greatest of the Latin theologians, Tertullian, who was born in Carthage in North Africa about 155 C.E., converted to Christianity about age forty, and then abandoned Catholicism for the heresy of Montanism, which was founded by a Christian in Phrygia (in western Turkey) who claimed to have a new revelation vouchsafed him by the Holy Spirit. Tertullian wrote over thirty treatises on all aspects of life, from women's fashions to sports in the arena. But the great age of Latin theology came in the fourth and fifth centuries C.E., after the empire became Christian, with men such as St. Augustine and St. Jerome.

SOURCES

G. Bowersock, ed., *Approaches to the Second Sophistic* (Philadelphia, Pa.: American Philological Association, 1974).

H. Chadwick, *Early Christian Thought and the Classical Tradition* (Oxford, England: Oxford University Press, 1966).

Thomas Haegg, *The Novel in Antiquity* (Oxford, England: Oxford University Press, 1983).

C. P. Jones, *Culture and Society in Lucian* (Cambridge, Mass.: Harvard University Press, 1986).

———, *Plutarch and Rome* (Oxford, England: Oxford University Press, 1971).

George Kennedy, *The Art of Rhetoric in the Roman Empire* (Princeton, N.J.: Princeton University Press, 1972).

B. E. Perry, *The Ancient Romances: A Literary-Historical Account of Their Origins* (Berkeley: University of California Press, 1967).

D. A. Russell, *Plutarch* (London, England: Duckworth, 1973).

SIGNIFICANT PEOPLE
in Literature

AESCHYLUS

c. 525 B.C.E.–c. 456 B.C.E.

Poet

EARLY YEARS. The tragic poet Aeschylus was born in Eleusis—now a suburb of Athens—in 525 or 524 B.C.E. and died at Gela in Sicily 68 years later. The dates of his life place him squarely in the formative period of the golden age of Greek classical culture. When he was born, Athens was ruled by a tyrant named Hippias, but following Hippias' exile in 510 B.C.E., Athens opted for a constitutional government in which political power was vested in a popular assembly where all citizens could vote. Aeschylus' formative period therefore coincided with Athens' development as a democracy. Aeschylus presented his first tragedies in the seventieth Olympiad—that is, the period between the seventieth and seventy-first Olympic Games, which puts the date between 499 and 496 B.C.E. In 490 B.C.E. Aeschylus fought at Marathon where the Athenians defeated a Persian expeditionary force that landed there, and he lost a brother in the battle. Ten years later, Aeschylus was in the thick of the naval battle off the island of Salamis where the allied Greeks defeated the Persian fleet. These experiences with the Persians in battle inspired his production of *The Persians* in 472 B.C.E. as the second of a trilogy of tragedies; the first was titled *Phineus* and the third *Glaucus Potnieus*. There was no apparent connection between the three dramas, and the satyr play which was the last play in Aeschylus' production—*Prometheus the Firebearer*—must have been a burlesque of the myth that told how Prometheus gave fire to mankind. *The Persians* differed from the other plays by Aeschylus produced on the same day because its subject was taken from contemporary history, and it was a patriotic tribute to the courage of Athens.

AESCHYLUS AND SICILY. A few years after Salamis, Aeschylus left Athens for Sicily, where the tyrant of Syracuse, Hiero, had founded a new city, Aetna, and wanted Aeschylus to celebrate the foundation with a drama. Aeschylus' play, *The Women of Aetna*, does not seem to have been a regular tragedy so much as a pageant honoring the new city; a couple surviving scraps of papyrus provide an inkling of what it was like. Aeschylus was

back in Athens again in 468 B.C.E. when he took part in the tragic contest and was defeated by a new tragic poet, Sophocles, who made his debut this year. The following year Aeschylus won with a trilogy on the tragic figure of Oedipus, who was fated to kill his father and marry his mother. One of these tragedies survives: the *Seven Against Thebes*, which chronicles the conflict between Oedipus' sons. In 458 B.C.E. he produced his masterpiece, the *Oresteia*, the only complete trilogy to survive, consisting of three tragedies: the *Agamemnon*, the *Libation-Bearers*, and the *Furies*. Shortly afterwards, he left Athens again for Sicily for reasons unknown. He may have been out of sympathy with some of the political developments in Athens. In any case, he died at Gela in Sicily around 456 B.C.E. According to legend, Aeschylus died when an eagle flying overhead mistook his bald head for a rock and dropped a tortoise on him to break the shell. The story is not quite credible but it supplies a piquant ending for a great tragedian. The epitaph on his monument at Gela which, according to tradition, he wrote himself, mentioned with pride that he fought in the battle of Marathon against the Persians, but omits any reference to his success as tragic poet.

SOURCES

D. J. Conacher, *Aeschylus: The Earlier Plays and Related Studies* (Toronto, Canada: University of Toronto Press, 1996).

Michael Gagarin, *Aeschylean Drama* (Berkeley: University of California Press, 1976).

John Herington, *Aeschylus* (New Haven, Conn.: Yale University Press, 1986).

Shirley Darcus Sullivan, *Aeschylus' Use of Psychological Terminology: Traditional and New* (Montreal, Canada: McGill-Queen's University Press, 1997).

CATO

234 B.C.E.–149 B.C.E.

Historian

POLITICS. Cato was the author of the first surviving Latin prose work, and the first Roman historian to write a history of Rome in Latin. He was born at Tusculum near modern Frascati in the hills around Rome in 234 B.C.E., and spent his early years on a small farm in the country where he worked in the fields alongside the farm laborers. At seventeen, he joined the Roman army and served in the long war against the Carthaginian Hannibal which Rome did not win until 202 B.C.E. He settled in Rome about 208 B.C.E. and began his political career four years later, reaching the coveted post of consul in 195

B.C.E. He remained in many ways a small-town Italian, loyal to his native customs and shocked at the "philhellenism"—passion and imitation of everything Greek—that infected the circle centered around Scipio Africanus, the conqueror of Hannibal, and his brother Lucius Scipio. The Scipionic circle admired Greek culture and wanted to introduce it into Rome. In Cato's eyes, the Greek way of life meant abandoning the frugality, self-discipline, and honesty that made up the Roman ideal. In 187 B.C.E. Cato managed to destroy Scipio Africanus' political career and won election as censor in 184 B.C.E. He continued to dominate Roman politics until his death three years before the final destruction of Carthage, which Cato advocated strenuously in his last years.

CATO'S WRITINGS. What survives of Cato's writing is an essay *On Agriculture* which sets forth precepts for good farming. Cato was a man who feared the gods, but he was hard-fisted and unsentimental. For instance, he advised getting rid of old slaves who could no longer do their share of work. This is the oldest surviving Latin prose. Cato also wrote a history of Rome, the *Origines*, which he began writing about 172 B.C.E. It dealt not only with the early history of Rome but also with the origins of neighboring Italian towns—hence its title "Origins." Earlier Romans wrote histories of Rome, beginning with Fabius Pictor who wrote his history in Greek for Greek readers, but Cato was the first to write in Latin. He was also famous in his day as an orator. There is some irony to the fact that it was Cato who brought the epic poet Ennius to Rome where he became a prime mover in introducing Greek culture, and in fact, Cato in his old age, did start to study Greek himself.

SOURCES

A. Astin, *Cato the Censor* (Oxford, England: Clarendon Press, 1978).

Elizabeth Rawson, *Intellectual Life in the Late Roman Republic* (London, England: Duckworth, 1985).

THUCYDIDES

c. 460 B.C.E.–c. 400 B.C.E.

Historian

ONE OF GREECE'S GREATEST HISTORIANS. Thucydides, who wrote a history of the Peloponnesian War between the two power blocs led by Athens and by Sparta (431–404 B.C.E.), is considered by most scholars to be the greatest historian that Greece produced, though some would give first place to his earlier contemporary, Herodotus. Yet we are not well-infomed about his life.

What we know about him comes from the sparse autobiographical scraps he includes in his *History* and a brief, unreliable *Life* written by someone called Marcellinus. From these sources we can infer a birthdate and date of his death, which was probably sudden and unexpected, for his *History* breaks off in mid-sentence in the winter of 411 B.C.E. He belonged to the upper crust in Athens, and his family had an interest in a mine in Thrace which brought him a regular income. When plague smote Athens in 430 B.C.E. he took ill, but recovered and used the experience to write a clinical description of the disease. In 424 B.C.E., he was elected one of the ten generals whom the Athenians chose each year, and thanks in part to his failure of leadership, the strategic city of Amphipolis in northern Greece fell to Sparta. He was exiled from Athens for his nonsuccess, and remained in exile until the war between Athens and Sparta ended. Though his exile removed him from Athens, it gave him a better opportunity to collect information from the rest of Greece. His standards for source evaluation were high—if he did not witness an event himself, he sought reliable eyewitnesses. He lived to see the end of the war, but he left his work unfinished, and parts of it unrevised. The circumstances of his death are unknown. He was, however, buried in the family vault of the Athenian statesman Cimon who was Pericles' conservative rival at the start of Pericles' career. Despite his familial association with the anti-Periclean camp, he became a supporter of Pericles in his mature years because he admired his ability to hold the radical elements of the Athenian democracy in check.

WROTE ON THE PELOPONNESIAN WAR. Thucydides states in the introduction to his *History* that he realized at the start of the Peloponnesian War that it would be the greatest war that Greece had ever known, surpassing the Trojan War and the war against Persia. Both the adversaries were at the height of their power, and before the war ended, it involved both Sicily and Persia. Yet the war was to prove that unexpected events could upset the best plans. The plague that smote Athens in 430 B.C.E. sapped her strength. The great Athenian leader, Pericles, took ill, and though he survived the immediate onset of the plague, he died of its aftereffects in 429 B.C.E. Thucydides recognized his death as a turning point in Athens' fortunes, for none of the politicians who followed him enjoyed the broad measure of support that he did. In fact, there is a subtle anti-democratic bias in Thucydides' *History*; he clearly doubted the ability of a government to conduct war wisely when an assembly of all the citizens made the decisions, as was the case in Athens. Yet he admired the indomitable spirit of Athens.

After the Athenians suffered a disastrous loss of their entire expeditionary force in Sicily in 413 B.C.E. in their campaign to conquer Syracuse (modern Siracosa), they still fought on, and might still have won if Persia had not supplied Sparta with the funds to build a fleet. Thucydides clearly intended to finish the story, but his *History* ends abruptly in 411 B.C.E. Various reasons have been suggested to explain why the *History* is incomplete, but the most likely one is that he died suddenly. Someone took the unfinished work and published it after Thucydides' death. It is a profound study of war and the effect of the stress of war upon civil society. There are also overtones of tragedy to it. Like a protagonist (chief player) in a Greek tragedy, the Athenian democracy entered the war, overconfident, and was brought low by a number of ill-considered moves. Yet the workings of fate also lurked behind the defeat of Athens. Not even the best-laid plans could have foreseen the plague and the death of Pericles.

SOURCES

W. R. Connor, *Thucydides* (Princeton, N.J.: Princeton University Press, 1984).

Simon Hornblower, *Thucydides* (Baltimore: Johns Hopkins University Press, 1987).

Clifford Orwin, *The Humanity of Thucydides* (Princeton, N.J.: Princeton University Press, 1994).

Dennis Proctor, *The Experience of Thucydides* (Warminster, England: Aris and Phillips, 1980).

A. G. Woodhead, *Thucydides and the Nature of Power* (Cambridge, Mass.: Harvard University Press, 1970).

VERGIL

70 B.C.E.–19 B.C.E.

Poet

THE MAKING OF THE POET. Vergil was born in 70 B.C.E. at Andes, probably modern Pietole, in the valley of the River Po in northern Italy. Vergil was born a provincial, for at the time of his birth, the Po Valley was still the province of Cisalpine Gaul (that is, Gaul south of the Alps) which included the whole region as far south as the Rubicon River. Roman citizenship was extended to Vergil's native region only in 49 B.C.E. Seven years later, Cisalpine Gaul was incorporated into Italy. His father was a small landowner who made money by bee-keeping, and was able to send his son to Cremona, then to Milan and finally Rome to learn rhetoric and train as a lawyer, but he appeared only once in court and decided that it was not for him. Instead he went to Naples and joined a school of philosophy run by the Epicurean, Siro. He may already have been writing poetry, for there is a group of poems—fourteen of them short and five longer works—attributed to him from this time period, but modern students of Vergil doubt that he was the author.

THE ECLOGUES AND THE GEORGICS. In 42 B.C.E., disaster struck Vergil's family. Troops were demobilized after Caesar's assassins were defeated at the Battle of Philippi and in order to find land for settling them, farms in the Po Valley were confiscated, among them the landholdings of Vergil's family. They may have been restored, however, since the first of Vergil's pastoral poems known as the *Eclogues*, a conversation between the shepherds Meliboeus and Tityrus—speaking, perhaps for Vergil himself—refers to a restoration. Vergil's didactic poem on the art of husbandry, the *Georgics*—the title comes from the Greek word for farming—was written between 36 and 29 B.C.E. in honor of Vergil's patron and friend, Maecenas, but it loses no opportunity to praise the emperor Augustus. Vergil, who had been born a provincial, felt no nostalgia for the old Roman republic which had misgoverned the Roman provinces and he appreciated the achievement of Augustus who sought to establish law, order, and good government in Italy and the empire.

THE AENEID. Augustus wanted an epic in praise of himself, and Vergil undertook the task. He chose the Trojan hero Aeneas as his subject, for the Julian family to which Augustus belonged claimed Aeneas as its forebear. Vergil spent the last ten years of his life writing the *Aeneid*. In 19 B.C.E. he set out for Greece, intending to spend three years traveling in Greece and Asia and completing the *Aeneid*, and to immerse himself in philosophy for the remainder of his life. But in Athens he met the emperor Augustus and was persuaded to return to Italy with him. He fell ill on the journey and was brought back to Italy only to die in Brundisium (modern Brundisi), the favorite harbor for ships crossing the Adriatic Sea from Greece. Vergil had asked his literary executors Varius and Tucca to burn his unfinished *Aeneid* but Augustus ordered them to ignore this instruction and instead to publish the poem in its unfinished state. In places, the poem shows some lack of finish, but time has vindicated Augustus' command. The *Aeneid* became the national epic of the Roman Empire. The character of Aeneas, a Trojan warrior who fought against the Greeks in the legendary Trojan War, escapes from Troy after it is sacked; he endures many hardships in a journey which eventually takes him to pre-Roman Italy, where he lays the foundation for the future greatness of Rome. The

fact that Vergil highlights Aeneas' "foreignness" in the work is curious; he began writing the *Aeneid* only a year after the Battle of Actium, portrayed in Augustus' propaganda as a victory of Italian values over the effete east, represented by Cleopatra. Yet Aeneas is an Asian himself, and the epic ends with his pitiless slaying of Turnus, the leader of the Italian resistance to his invasion. Yet the final settlement, which is approved by Jupiter, ordains that the Asian Trojans will be assimilated. They will give up their language and adopt Latin, and even the gods of Rome will bear Jupiter's mark of approval. They will not be Trojan gods. Aeneas and his Trojan followers do not found a new Troy in Italy. Instead they set an example of assimilation to the idea of Rome for the various nationalities that will later make up the Roman citizen body.

SOURCES

John D. Bernard, ed., *Vergil at 2000; Commemorative Essays on the Poet and His Influence* (New York: AMS Press, 1986).

W. A. Camps, *An Introduction to Vergil's "Aeneid"* (Oxford, England: Oxford University Press, 1969).

K. W. Gransden, *Vergil's Iliad; An Essay on Epic Narrative* (Cambridge: Cambridge University Press, 1984).

M. C. J. Putnam, *The Poetry of the Aeneid* (Cambridge, Mass.: Harvard University Press, 1965).

———, *Vergil's Pastoral Art* (Princeton, N.J.: Princeton University Press, 1970).

DOCUMENTARY SOURCES
in Literature

Aeschylus, *Oresteia* (525–456 B.C.E.)—The *Oresteia* is made up of three tragic plays: the *Agamemnon*, the *Choephoroe* and the *Eumenides*. It is the only complete trilogy of Greek tragedies to survive from antiquity, and its theme is vengeance and counter-vengeance concerning a blood feud within the family of Agamemnon.

Alcaeus of Lesbos (c. 620–after 580 B.C.E.)—Alcaeus was a lyric poet who wrote songs generally for solo performance: drinking-songs, hymns to the gods, love lyrics, and poems on contemporary politics. Only fragments of his works survive.

Apollonius Rhodius, *The Argonautica* (c. 260–247 B.C.E.)—This work is an epic poem on the story of Jason and his quest for the Golden Fleece, written in a period when long epics were out of style.

Aristophanes, *The Clouds* (423 B.C.E.)—Written in the "Old Comedy" style of playwriting, *The Clouds* avoids the political themes of other Athenian plays and instead satirizes Socrates and the education that he offered the Athenian youth.

Cornelius Tacitus, *Histories* (after 96 C.E., *Annals* (after 115 C.E.)—The *Histories* and the *Annals* together, when complete, covered the history of the first century C.E. from the perspective of a Roman who thought that liberty had perished along with the republic which Julius Caesar overthrew.

Demosthenes, *On the Crown* (330 B.C.E.)—This speech was delivered in a court of law as Demosthenes' defense of his anti-Macedonian political policies of the previous 25 years. Written down and published, it is considered to be the masterpiece of the greatest Athenian orator of the fourth century B.C.E.

Euripides, *Medea* (431 B.C.E.)—This tragic play is famous for its psychological insight in its portrayal of a woman who has suffered wrong.

Herodotus of Halicarnassus, *The Histories* (c. 425 B.C.E.)—This work of history, covering the rise of the Persian Empire and its clash with Greece in 480–479 B.C.E., earned Herodotus the title "Father of History."

Hesiod, *Works and Days* (c. 700 B.C.E.)—Hesiod's *Works and Days* gives insight into the life of a small farmer in early Greece.

Homer, the *Iliad* (c. 700 B.C.E.)—This epic centering on an incident in the Trojan War represents the culmination of the epic oral tradition in Greece. Also attributed to Homer was the *Odyssey*, the tale of how the hero Odysseus returned home after the Trojan War.

Petronius Arbiter, *Satyricon* (c. 60–65 B.C.E.)—An elegant voluptuary at the emperor Nero's court, Petronius wrote a long novel which is unique in Latin literature—nothing like it exists in Greek literature—which recounts the adventures of three young rascals in southern Italy. Fragments survive, including a long description of a feast given by a rich freedman, Trimalchio.

Pindar, *Epinician Odes* ("Victory Odes") (518–438 B.C.E.)—These lyric poems, written to commemorate athletic victories at the Olympian, Pythian, Nemean or Isthmian Games, are the only ones to have survived complete from the many Pindar wrote.

Publius Vergilius Maro, *Aeneid* (30–19 B.C.E.)—Generally considered Rome's greatest poet, Vergil's masterpiece is the *Aeneid*, which tells the story of how the Trojan

hero Aeneas escaped from Troy, landed in Italy, and founded the royal line that would eventually produce Romulus and Remus, the founders of Rome.

Quintus Ennius, *The Annals* (c. 170 B.C.E.)—Playwright, satirist and epic poet, Ennius introduced the Greek meter used by Homer, the dactylic hexameter into Latin in his epic, *Annals* which told the history of Rome in verse up to 171 B.C.E., the year before his death.

Quintus Horatius Flaccus (Horace), *Epodes* (41–31 B.C.E.)—Sappho was the head of a *thiasos* (sisterhood) which honored Aphrodite and the nine Muses. One complete poem and fragments of others now survive of the seven books of her collected poems.

Sophocles, *Oedipus the King* (c. 429–425 B.C.E.)—This tragic play was considered by Aristotle to be a model Greek tragedy.

Thucydides, *History of the Peloponnesian War* (c. 400 B.C.E.)—This clinical account of the war between the Athenian Empire and the Spartan coalition (431–404 B.C.E.) broke off in mid-sentence in the year 411, probably interrupted by Thucydides' death.

Titus Livius, *History of Rome from its Foundation* (c. 28 B.C.E.–17 C.E.)—Livy's *History*, composed in 142 books, is a monumental work covering the rise of Rome from its foundation to 9 B.C.E. when the emperor Augustus' stepson, Drusus, died. Only thirty-five books have survived.

Titus Lucretius Carus, *The Nature of Things* (65–55 B.C.E.)—This unfinished epic poem expounded the theory that the universe is made up of atoms and void, and therefore men and women do not need to fear death, for it is only a dissolution of the atoms that make up the human body and soul.

Arts and Humanities Through the Eras: Ancient Greece and Rome (1200 B.C.E.–476 C.E.)

179

chapter five

MUSIC

Nancy Sultan

IMPORTANT EVENTS
in Music

c. 2800 B.C.E. –c. 1100 B.C.E.
During the Aegean Bronze Age, musicians and musical instruments are depicted in frescoes, on vases and seal stones, and in sculpture. Fragments of lyres, pipes, percussion instruments, and triton horns survive from this period.

c. 2200 B.C.E.
Figurines from the Cycladic Islands depict Bronze-Age Aegean musicians holding the frame harp, the *aulos* (reed pipe), and the *syrinx* (pan-pipe).

c. 1490 B.C.E.
A Bronze-Age painted sarcophagus from Ayia Triada, Crete, illustrates musicians playing the *phorminx* (lyre) and *aulos* during a ritual sacrifice.

c. 1100 B.C.E.
A miniature bronze votive *kithara* (lyre) from the Sanctuary of Apollo at Amyklai (near Sparta) is the earliest representation of the type that would become popular in the classical period (480–323 B.C.E.).

c. 800 B.C.E. –c. 700 B.C.E.
During the Early Archaic Period, the Homeric epics *Iliad* and *Odyssey*, the Homeric Hymns, and the poet Hesiod describe musicians, instruments, and musical contexts. Phemios and Demodokos, two of Homer's *aoidoi* (professional bards), perform at the palaces of Odysseus and the Phaiakians in the *Odyssey*.

c. 750 B.C.E. –c. 550 B.C.E.
Greeks colonize southern Italy and eastern Sicily; musicians, poets, and composers bring Greek musical culture to Syracuse and other cities in Magna Graecia.

c. 676 B.C.E. –c. 673 B.C.E.
Music schools are established in Sparta by Terpander of Lesbos and Thaletas of Gortyn.

The virtuoso composer and *kitharode* Terpander wins the musical competition at the first Karneia festival of Apollo and four successive victories at the Pythian Games.

c. 654 B.C.E. –c. 611 B.C.E.
Lyric poet Alcman lives in Sparta and composes his *Partheneia* ("Maiden's Dance").

The island of Lesbos becomes a second music center.

c. 628 B.C.E. –c. 625 B.C.E.
Arion of Lesbos teaches the Corinthian choirs to perform the dithyramb (male choral dance), which he invented. The tragic chorus is said to have developed from his type of dithyramb.

c. 612 B.C.E.
The most famous female poet, Sappho, is born on Lesbos. At her hometown of Mytilene she composes lyrical songs, usually monodies and choral dances, and is the leader of a circle of girls and young women; the *barbitos* (a low-pitched lyre) and other instruments accompany the music.

c. 632 B.C.E. –c. 556 B.C.E.
The composer Stesichorus (born Teisias) sets up the first tragic chorus and is known for his use of the *Harmateios nomos* ("Chariot melody") and the *Nomos of Athena* in the Phrygian mode, which tells the story of the birth of Athena in full armor from the head of Zeus.

c. 625 B.C.E. –c. 585 B.C.E.
The dithyramb (male choral dance) is invented by kitharode Arion of Lesbos during the time of the tyrant Periander at Corinth.

c. 600 B.C.E. –c. 500 B.C.E.
Tyrants reform festivals, and attract talented musicians to their cities: at Corinth, Periander supports Arion, who creates the dithyramb; at Sicyon, Cleisthenes ends performances of rhapsodes and paves the way for classical tragedy; and Pisistratus institutes the festival of the City Dionysia in Athens,

a central feature of which are dithyrambic, tragic, and comic contests.

Thespis produces the first tragedy in Athens by adding a speaker to interact with the chorus.

Under Hipparchus, Pisistratus' son, the poets Anacreon, Lasus of Hermione, and Simonides flourish. Hipparchus develops the rhapsodes' competition at the Great Panathenaea into an organized serial performance of the entire *Iliad* and *Odyssey*.

586 B.C.E. New contests for *aulodes* and *auletes* are added at the Pythian Games. The *aulode* Echembrotus of Arcadia wins a bronze tripod cauldron.

The *aulete* (piper) Sakadas of Argos wins a prize at the music contest at the Pythian Games. He will win prizes at the next two Games, and become known for his *Pythikos nomos* ("Pythian Composition") in which he interprets the defeat of the serpent Pytho by Apollo at Delphi.

Argos becomes a center of musical excellence.

574 B.C.E. Pythocritus of Sicyon wins six Pythian
−554 B.C.E. victories on the aulos.

c. 560 B.C.E. The philosopher, mathematician, and scientist Pythagoras is born. He later founds a school at Croton where he and his followers study acoustical and musical phenomena.

566 B.C.E. The Panathenaea festival at Athens is reorganized on a grander scale and includes music competitions for rhapsodes, kitharodes, aulodes, and auletes.

558 B.C.E. Unaccompanied kithara-playing is added to the Pythian music competition. Agelaus of Tegea is the first victor.

c. 520 B.C.E. The east-Greek poet Anacreon's pres-
−c. 460 B.C.E. ence in Athens prompts a series of vase-paintings that depict Ionian influence

in Athenian music. In one image a singer holds a *barbitos* (an Ionian-style lyre) with Anacreon's name on it.

518 B.C.E. The poet Pindar, the most celebrated of all lyric poets of ancient Greece, is born near Thebes in Boeotia (d. 438). He is most famous for his epinikian odes composed for victors at the four athletic games: Pythian, Nemean, Isthmian, and Olympic.

c. 508 B.C.E. Lasus introduces the dithyrambic competition in Athens.

c. 500 B.C.E. Democratic Athens is the center of all
−c. 400 B.C.E. intellectual and cultural activity in Greece. In this city, tragedians Aeschylus, Phrynichus, Sophocles, Euripides, and Agathon produce their dramas in the theater of Dionysus during the City Dionysia; comic playwright Aristophanes lampoons Athenian politics and culture; and poets Lasus, Simonides, Bacchylides, Pindar, Melanippides, Timotheus, Philoxenus, and Cinesias compose dithyrambs for Athenian choruses and so-called "New Music."

478 B.C.E. Hieron, tyrant of Syracuse in Sicily,
−467 B.C.E. makes his city a haven for artists, poets, and musicians from all over Greece. His hospitality toward Pindar is so appreciated that the poet composes a eulogy for him.

c. 475 B.C.E. The first concert hall in the Western world—the Odeion—is commissioned by the Athenian statesman Themistocles for musical contests held during the Great Panathenaea. It stands in the Athenian marketplace.

474 B.C.E. Hieron defeats the Etruscans at Cumae and begins his rule at Syracuse, during which time he entertains Aeschylus, Pindar, and other Greek artists and musicians.

c. 470 B.C.E. The Etruscans build the so-called "Tomb of the Leopards" and "Tomb of the Triclinium" in Tarquinia, northern Italy, and paint the walls with a

funerary banquet scene featuring men and women dancing to the music of the *aulos* (reed pipe) and a six-stringed *chelys* (tortoise-shell) lyre.

c. 450 B.C.E. Several different forms of harp begin to appear in Athenian vase-paintings, although it was a familiar instrument to Anacreon before this time.

c. 435 B.C.E. The noted dithyrambist Philoxenus of Cythera is born. His most famous work will be the *Cyclops* (also called *Polyphemus and Galatea*).

443 B.C.E. –c. 430 B.C.E. Damon, one of the greatest intellects of his time, publishes an essay in which he argues that musical modes and rhythms are intimately connected with ethical qualities, and the state should concern itself with the regulation of music and music education. His ideas influence Plato's and Aristotle's attitudes regarding the *ethos* of music in their discussion of music education.

c. 427 B.C.E. The philosopher Plato is born. He will discuss the character and role of music in many of his works, most notably in the *Timaeus, Republic,* and *Laws.*

c. 420 B.C.E. The musician Timotheus of Miletus beats his teacher, the eminent Phrynis, in a music competition. Several hundred lines of his kitharodic composition *Persians* survive, along with an epilogue containing prayers to Apollo and a manifesto praising his own talent and originality.

416 B.C.E. The tragedian and composer Agathon wins first place in the dramatic contest at the Lenaea in Athens. He is later satirized by Aristophanes in his *Thesmophoriazousae* but treated with much affection in Plato's *Symposium.*

410 B.C.E. –360 B.C.E. The witty kitharist Stratonicus of Athens is active, along with a host of other virtuoso performers whose showmanship captivates audiences, including Chrysogonus, hired to pipe the rowing stroke for the naval general Alcibiades' crew;

the aulete Pronomus of Thebes, shown on a vase (in the Museo Nazionale in Naples) playing before a crowd of actors, wearing an ornate robe and a garland on his head; and Antigeneidas, another aulete from Thebes, described by the writer Apuleius as a "honey-sweet melodizer of every word and a practiced player of every mode" (*Flor.* 4).

402 B.C.E. Kitharodes, the most popular with the crowds, win the largest prizes at major competitions; the list of prizes includes: a gold crown weighing 85 drachmas, a crown worth 1,000 silver drachmas, and 500 drachmas in cash; other kitharode prizes are worth 700, 600, 400, and 300 drachmas, respectively. There are two prizes for aulodes (300 and 100 drachmas) and three for kitharists.

c. 400 B.C.E. –c. 300 B.C.E. Alexander the Great's five-day wedding celebration in Susa features entertainment by a rhapsode, three psilokitharists, two kitharodes, two aulodes, five auletes (who played the Terpandrean *Pythikos nomos*) and then accompanied choruses, three tragic and three comic actors, and a harpist.

392 B.C.E. –388 B.C.E. Aristophanes produces his last surviving comedies *Ecclesiazusae* (Women in the Assembly) and *Plutus* (Wealth), in which the part of the chorus has been much reduced and is no longer written by the playwright; instead of choral lyrics, the word "KHOROU" ("interlude by chorus") appears. Solo song and piping continue as central musical elements in the play.

343 B.C.E. Aristotle discusses the character and purpose of music in his *Politics* and *Problems.* The music theorist Aristoxenus becomes one of his prize pupils.

c. 333 B.C.E. Aristoxenus is a pupil of Aristotle in Athens and writes many books and essays, the most influential of which are the *Harmonika stoikheia* (Harmonic Elements) and *Rhythmika stoikheia* (Rhythmic Elements).

319 B.C.E. The boy's chorus of the Cecropid tribe wins the dithyramb contest at the Great Dionysia in Athens with a rendition of Timotheus' composition *Elpenor*.

316 B.C.E. *Dyskolos* (Grouch), the one complete surviving play of comic writer Menander, is produced; it features four choral interludes indicated by the word "KHOROU" between the five acts. At line 879 a stage direction "the aulos-player plays" and a change in rhythm indicates additional musical content.

311 B.C.E. Roman censor Appius Claudius Caecus deprives the Etruscan artists' guild (*collegium*) the right to dine at the public expense in the Temple of Jupiter after performing at the religious festivals; they protest by marching out of Rome to Tibur (eighteen miles away), and eventually win back their free dinners.

c. 300 B.C.E. –c. 200 B.C.E. New dramatic and musical competitions are added to the Nemean and Isthmian Games.

Kitharode Nicocles of Tarentum records his victories at the Pythian and Isthmian Games, Great Panathenaea, the Lenaea (in a dithyramb), the Hecatomboia, the Helieia, and royal festivals in Macedonia and Alexandria.

Artists come together in several cities in Greece, Alexandria, and Sicily to form professional organizations known as *technitai Dionysou* (Artists of Dionysus), which formed guilds (*koina*, or later *synodoi*). They provide musicians, composers, conductors, and teachers for religious festivals and secular events.

290 B.C.E. –280 The *technitai* ("artists guild") forms in Athens to produce shows in various cities. The rival Isthmian-Nemean guild is established in the north-east Peloponnese; both establish relations with Delphi.

c. 270 B.C.E. Ktesibios of Alexandria invents the pneumatic pump and the water-organ (Greek *hydraulis*).

235 B.C.E. A major artists' guild appears in Teos, which serves Ionia and the Hellespont.

211 B.C.E. The Isthmian-Nemean guild is invited to participate in several festivals, including the festival of the Muses at Thespiae, at Thebes, on the island of Delos, and around the Peloponnese.

205 B.C.E. Kitharode Pylades of Megalopolis performs Timotheus' *Persians* at the Nemean Games.

c. 200 B.C.E. –c. 100 B.C.E. New music is performed alongside revivals of old standards and selections from fifth-century tragic poets, especially Euripides.

c. 194 B.C.E. Satyrus of Samos, a famous aulete, wins the prize, and gives an encore performance selected from Euripides' tragedy *Bacchae*.

191 B.C.E. Plautus produces his comedy *Pseudolus* (The Cheat), which, like many of his other plays, integrates polymetric *cantica* (solo songs) accompanied by different types of *tibiae* (reed pipe) and instrumental pipe music into the plot, along with musical interludes between scenes.

170 B.C.E. –150 B.C.E. Menecles, an envoy from Teos, performs works of Timotheus and Polyidus at Knossos and Priansos, Crete.

163 B.C.E. Terence produces his comedy *Heautontimoroumenos* (The Self-Tormentor), the structure of which depends completely on musical accompaniment by a *tibicen* (reed player).

127 B.C.E. –97 B.C.E. Members of the Athenian guild participate in the Pythaid religious pilgrimage from Athens to Delphi. The group consists of epic and dramatic poets, rhapsodes, actors, instrumentalists, singers, and, in 127, a large choir to sing the paean to Apollo; the notated music of the paeans composed for this occasion by kitharist Limenius and singer Athenaeus is inscribed on the wall of the Treasury of the Athenians.

118 B.C.E. The Delphians honor two musicians from Arcadia who trained boys' choruses to perform bits from the "old poets."

90 B.C.E. A Cretan organist named Antipatros awes his audience at Delphi; he is awarded prizes at the Pythian Games and earns civic honors for himself and his descendants.

c. 27 B.C.E. The Roman architect Vitruvius dies. In Book Five of his work *De architectura* he discusses acoustics in relation to the design of the theater auditorium, and translates the works of Greek music theorist Aristoxenus into Latin, explaining the system of *harmonia* (tetrachord system) to his Roman readers.

26 B.C.E. –19 B.C.E. Vergil composes his epic for Augustus, the *Aeneid*, in which he describes a type of Phrygian *aulos* and other musical instruments and contexts.

22 B.C.E. Pilas of Cilicia introduces pantomime in Rome, which consists of re-creations in performance by solo dancers of scenes from myth and history; musical accompaniment is provided by a chorus and orchestra of pipes, lyres, and percussion instruments.

17 B.C.E. The Latin poet Horace's *Carmen Saeculare* is performed by a choir of 27 girls and 27 boys; commissioned by the emperor Augustus for Rome's Centennial Games, it is the only known poem of Horace's to have been set to music.

54 C.E. Nero, a seventeen-year old art enthusiast who sings, acts, and plays the *kithara* and the organ, becomes emperor of Rome.

79 C.E. Vesuvius erupts and buries Pompeii and Herculaneum, preserving a number of frescoes with musical scenes.

c. 100 C.E. The Roman orator Quintilian dies. In his work *Institutio oratoria*, he discusses music as part of his instructions on how to properly train an orator.

117 C.E. Hadrian becomes emperor of Rome after the death of Trajan. A very cultured man who was heavily influenced by Greek ideals, he employed a Cretan *kitharode* named Mesomedes to compose hymns; several fragments with musical notation survive in medieval manuscripts.

c. 127 C.E. –148 C.E. Astronomer and mathematician Claudius Ptolemy is writing in Alexandria. Among his many books is the *Harmonika*, a systematic treatment of the mathematical theory of harmony.

c. 200 C.E. –c. 300 C.E. Gladiators fight to the accompaniment of an organist, trumpeters, and hornblowers. The organ also is used in religious festivals.

c. 250 C.E. –c. 350 C.E. Two important music theorists are publishing their works: Aristides Quintilianus, *De musica* (Greek title *peri mousikes*); and Gaudentius, *Harmonica introductio* (Greek *Harmonike eisagoge*).

c. 300 C.E. Alypius, a younger contemporary of Aristides Quintilianus, compiles his *Introductio musica*, which contains the most complete record of the notational symbols.

384 C.E. The emperor Carinus organizes a concert in Rome with a hundred trumpet players, a hundred horn players, and two hundred *tibicens* (reed-pipe players).

387 C.E. –389 C.E. Augustine, Latin philosopher and distinguished church father, writes *De musica*, in which he discusses meter and versification. Ten years later he ponders the ethics of music in church in his autobiographical *Confessions* (397–400), asking whether the worshipper should be moved by the singing, or the song itself.

OVERVIEW
of Music

THE ROOT OF WESTERN MUSIC. The modern word "music," and indeed most of the terms and concepts associated with music—melody, harmony, symphony, orchestra, chorus, ode, hymn, paean, and rhythm, for example—are Greek. Western music is rooted in the Greek concept of *mousike techne*, "the craft of the Muses." The term *mousike* referred to poetry and dance as well as music, thus all three are linked in Greek culture. Although the Greeks themselves were influenced by Near Eastern, Anatolian, and Egyptian musical traditions, it is the poets, philosophers, and theorists of Greece whose musical writings had the most profound influence on later cultures; the Romans followed the lead of the Greeks, as did the early Christians.

VITAL PART OF ANCIENT LIFE. Art and archaeological evidence, literature, theoretical writings, and a few surviving fragments of musical compositions all demonstrate that music was a vital part of public, private, sacred, and secular life in ancient Greece and Rome. Choral dance and song, theatrical and solo performance, and musical competitions filled the calendar year. Ordinary men and women sang as they performed their everyday chores of weaving, making wine, or harvesting grain; professional bards and virtuosos performed for a living to small groups at parties as well as to large audiences at festivals. Music was, however, not solely for entertainment. Because of its connection with the gods, especially the Muses—goddesses who, according to the Archaic Greek poets Homer and Hesiod, legitimize and validate the truth of myths—music itself was considered divine; it played a central role in Greek and Roman religion, which can best be described as polytheistic, employing a combination of myth (sacred storytelling) and ceremonial rituals. Music was an integral part of all important ceremonial rites of passage in Greek and Roman culture: birth, coming of age, wedding, death, and funeral.

EARLY DEVELOPMENT. Music was already very much a part of social and religious life in prehistoric Greece. As early as the third millennium B.C.E., musicians playing instruments such as the harp, the *aulos* (double-reed pipe), and the *syrinx* (a type of flute) are depicted in art, most notably marble and ivory figurines found in graves. By the second millennium, the so-called Mycenaean Period, many of the instruments that were popular later in Greek and Roman history—the *phorminx* (lyre), *sistrum* (rattle), and *triton* (trumpet)—had already made their appearance. Singers and musical instruments again appear in the two most important poems of the eighth century B.C.E., Homer's *Iliad* and *Odyssey*. These heroic epics provided the musical link between the Mycenean and the Archaic period of Greece, for the professional bards described in the poems still sung to the accompaniment of the *phorminx*. A century later, the lyric poets Terpander and Archilochus sung Homeric poetry to a more elaborate lyre—the *kithara*—and other solo performers—the *rhapsodoi*—recited the poems at festivals without any musical accompaniment at all.

MUSIC EDUCATION. Music education came to be considered by the Greek and Roman writers as essential for civilized people as mathematics and athletics. The earliest music schools are said to have been established in the town of Sparta in southern Greece sometime between the eighth and seventh centuries B.C.E. by the musicians Terpander of Lesbos, Thaletas of Gortyn, and Sacadas of Argos. Terpander, perhaps the most famous *kitharode* (kithara-player), organized and won the first major music competition in Sparta; he is one of the earliest known musical masters, credited also with adding strings to the *kithara*, composing, and perfecting composition and performance techniques for a variety of instruments. He is also said to have invented the categories of *nomoi* (tunes, melodies, laws, customs) used by poets to classify types of songs in a singer's repertory and to refer to specific melodic compositions, either for a particular instrument (kitharodic), a composer (the Terpandrean), or even a deity. The word *nomos* was originally used to refer to unique melodies or types of tunes attached to a particular region or village; each *nomos* thus maintained unique characteristics.

CENTERS FOR MUSIC. Between the seventh to the sixth centuries B.C.E., the island of Lesbos, near the coast of ancient Asia Minor (now Turkey), became another center of music and poetry in Greece. The poets from Lesbos, most notably Alcaeus and Sappho, were influenced by melodic forms from Lydia and Phrygia in the East, and their musical compositions had an Eastern flavor. Together with the *dithyramb*, a ritual choral dance in honor of Dionysus, solo virtuoso playing and

accompaniment to song or recitation was occurring with ever-increasing popularity. By the fifth century B.C.E., the democratic city of Athens was the most powerful *polis* (city-state) in Greece, and had become the center of Greek intellectual and cultural life. During the classical period (480–323 B.C.E.) in Greek history, competitions formed a part of the Olympian, Nemean, Pythian (at Delphi), and Isthmian (near Corinth) festivals, and poets, including the renowned poet Pindar, composed *epinikia* for the victors—elaborate lyric poems of praise—to be sung by a chorus with musical accompaniment. The playwrights Aeschylus, Sophocles, and Euripides produced their dramas, or *tragoidia* (tragedies), in the amphitheater of Dionysus at the foot of the Acropolis as part of the City Festival of Dionysus. Music, especially choral dance and song, played a central role in the tradition of Greek theater, which included not only tragedy, but also comedy and "satyr plays" (satire); indeed the words for "tragedy" and "comedy"—*tragoidos* and *komoidos*—both contain the word for "song," *oidos*.

INNOVATIONS. New types of musical genres and innovations continued to emerge in the fourth and third centuries B.C.E. Especially popular were performances by solo virtuosos—*rhapsodoi* and *tragodoi*—who sang or recited Homeric epic, lyric, or dramatic poetry, often to the musical accompaniment of a band. Perhaps the most important contribution to music in the late third century was the invention of the *hydraulis* (water-organ) by the engineer Ktesibios. Originally designed as a mechanical water pump, the *hydraulis* became a popular musical instrument in Rome and later in the Christian church. The modern pipe organ derives from this early mechanical hydraulic machine.

ROMAN MUSIC. The Romans, ever practical, were not very original when it came to music. Aside from some indigenous Etruscan ritual songs and musical instruments, the Romans generally looked to the Greeks for instruction and inspiration. It is safe to say that once Greece becomes part of the Roman Empire in the third century B.C.E., it becomes difficult to distinguish Greek from Roman musical expression. Roman musical instruments, such as the popular *tibia* (a version of the Greek *aulos*), the *fistula* (pan-pipe), and even the true flute, were variations on Greek instrument types. The Greek *kithara* remained the most popular instrument in Rome, and was enlarged in size. As in Greece, military music played a central role in Roman life. A wide variety of wind instruments blared in marching bands: *kerata* (cow horns), *salpinges* (ivory or bronze trumpets), *cornu* (circular horn), and *tuba* (brass tuba). Although the Romans adopted, and then adapted, Greek forms of epic, lyric, tragedy, and comedy, very little is known about the role that music played in their versions. The comedies of Plautus and Terence in the second century B.C.E. featured a spoken, rather than sung version of the Greek chorus, and included the *canticum*, a scene enacted in sing-song manner to the accompaniment of the tibia. Mime and pantomime were invented and added to the repertoire in the Roman Period, around the first century B.C.E., and the Roman architect and engineer Vitruvius improved the acoustics in theaters with his theory of sound waves.

MUSIC AND PHILOSOPHY. In Greek and Roman religion, the myths of heroes and gods not only featured music and musical competitions, but also explained the origin of certain melodies, rhythms, and instruments. The Greeks and Romans believed that music had an effect on moral behavior, and writings from the time period demonstrate a concern that certain types of music might lead young people down the wrong path. The gods Apollo and Dionysus (Roman Bacchus) represented complementary aspects of the human psyche, and thus were especially important in the philosophy of music education. Early Greek philosophers and theorists—especially Damon, Plato, and Aristotle—carefully examined the aesthetic, ethical, and moral qualities of different types of melodies and rhythms. The mathematician Pythagoras (c. 560–470 B.C.E.), who also studied melodies and rhythms, is said to have invented what is now called "acoustic theory" in teaching that the same numerical laws that governed the universe also governed music and, by extension, the soul.

MUSIC COMPOSITION. There are countless references to music, musicians, and musical forms in Greek and Roman literature and art. Between 23 and 51 actual notated musical compositions survive, depending on the definition of "composition." They exist on papyri, on stone, and in manuscripts. Many are fragmentary, and most date from the relatively late periods between the third century B.C.E. and the fourth century C.E. The texts include hymns and paeans to divinities, lines of poetry and drama, and choral song. It is difficult, but not impossible, to read these compositions. Sometime in the fifth century B.C.E., the Greeks developed the science of acoustic theory, the tetrachord scale system, and musical terminology, which served as the foundations for the composition, performance, and the study of music in later periods. Although very little of what modern scholars would call "music theory" proper has survived, a few theoretical works assist in interpreting the surviving fragments. These theoretical treatises and handbooks span a period of about 800 years, from the earliest—Aristox-

enus (c. 375–320 B.C.E.)—to the latest—Alypius (c. 450 C.E.). These works explain and describe musical systems, genres of melody, tunings, *tonoi* (scales), and rhythm, and discuss various philosophical problems in music, such as ethics, and the proper use of music in education. The application of these in composition and performance may be unclear, but the surviving ancient theoretical corpus (especially the Aristoxenian tradition) does a remarkable job of constructing discrete categories for dissecting the phenomena of music, categories still used to some extent in modern musical analysis.

MUSICAL NOTATION. Ancient Greek and Roman music was composed and transmitted aurally, without the need for writing, but a standard alphabetic form of musical notation was in limited use by the mid-third century B.C.E. In the surviving musical examples, these notation symbols are placed over the words of the song, probably to indicate the melody, but sometimes they are interspersed between passages of text, to indicate a passage for instruments. There are also a few notated passages without any text. Most of the modern knowledge about notation is found in the tables of Alypius, a music theorist of the late fourth or fifth century C.E. who wrote down the names of all the notes and notation symbols for the two-octave scale, or "Greater Perfect System" in fifteen *tonoi* ("keys"). Notation was clearly used by professionals only. Music was primarily an oral tradition even into the latest periods, passed on from grandparent to child, master to pupil. In the same way that Gregorian Chant was derived from an oral tradition, and remained primarily that through the medieval period, Greek and Roman music thrived for centuries without the aid of written notation or theory.

CONNECTION TO POETRY. Ancient Greek music was primarily monophonic—melody without harmony or counterpoint. By the seventh century B.C.E., composers such as Archilochus were employing heterophony (instrumental or singer embellishment), modulation, mixed rhythms, and combining text with music. It is probable that music was improvised, not thoroughly composed. The Greeks used the word *melos* for a simple "song," either vocal or instrumental, while the Romans used *carmina*; in its "perfect form," the *teleion melos*, ancient Greek and Roman music was always associated with poetry and dancing. The melody and rhythm of the music was intimately connected with the rhythm of the poetic meter.

UNDERSTANDING MUSIC FROM SURVIVING EVIDENCE. Taken together, the theoretical writings, literary and artistic representation, and archaeological evidence provide a reliable, if imperfect, understanding of music in Greek and Roman life. Musicologists have used the tables of Alypius and other theorists to transcribe surviving compositions into Western notation; ethnographers and acoustic scientists have reconstructed instruments based on surviving artifacts, descriptions in literature, and images in art; and recordings have been made of surviving compositions using these instruments, all in an attempt to recreate the sound of Greek and Roman music.

TOPICS
in Music

MUSICAL INSTRUMENTS

THE VOICE. The human voice was the first and the most central of musical instruments in Greek and Roman life. Ordinary people sang while they plowed fields, harvested grain, worked wool, made wine, and tended children. There were drinking songs, hymns to the gods and heroes, laments, and wedding songs. Victors at the athletic games were awarded a song of praise; paeans rallied troops for battle. Singers competed for prizes in solo and choral song. One of the earliest depictions of singing is found on a Bronze-Age black steatite vase from Crete, dating to the second millennium B.C.E.: a group of three singers, heads thrown back and mouths open in song, march together with a group of harvesters; a *sistrum* (shaker) player keeps the beat. The first surviving reference to singing in literature comes from the *Odyssey* where the goddess Circe sang in a sweet voice as she worked at her loom. Singers were commonly portrayed on Greek vase-paintings from the sixth century B.C.E.; some paintings represent the sound emitting from the mouth in the form of little "o's." Epic lyric poetry was sung or recited, often to the accompaniment of musical instruments, and the few examples of surviving written music show that the poetry that would be sung was important enough to be written down even if the piece was for a solo instrument. Language itself glorified the voice as an important instrument as well. In his work *De Anima*, the philosopher Aristotle distinguished *phone* ("voice") from *psophos* ("sound") by noting that only animals with souls have a true voice. The Greek adjective *ligys*, or *ligyros*, was most often applied to the voice when it was tuneful, clean, and pure, like a nightingale.

STRINGS. Chordophones (stringed instruments) were the most basic and arguably the most important of

Drawing of a figure playing the lyre. CREATED BY CECILY EVANS.
THE GALE GROUP.

the musical instruments in ancient Greece. They included four types of lyre, a variety of harps, psalteria (zithers), and, after the fourth century B.C.E., a lute-like instrument called the *pandouros*. The Romans preferred the wind instruments, but the lyre appeared in Etruscan art and continued to be popular with soloists throughout the Roman period. Ancient scholars and lexicographers, such as Pollux and Athenaeus (second century C.E.), listed and discussed the different types of lyres and harps, providing important information about their construction, tuning, and usage. In music education, Plato, Aristotle, and the later music theorists advocated the use of simple, traditional tunes on the lyre.

THE LYRE. Musicians used the lyre to accompany the singing of sacred hymns, as well as epic and lyric poetry, and it became the preferred instrument of solo virtuoso performers. People of all ages played the lyre for their own personal pleasure, in musical contests, at ritual ceremonies such as weddings and funerals, and at parties and festivals. In Greek myth the lyre was asso-

ciated with the Muses, Hermes, Apollo, Dionysus, and Orpheus. According to the *Homeric Hymn to Hermes*, the god Hermes fashioned the first lyre from the shell of a *chelys* (tortoise). Archaeology shows that the earliest lyres appeared in ancient Palestine and Sumeria in the third millennium B.C.E., and most likely entered Greece through trade with the Mycenaeans during the Bronze Age. Earliest depictions of the Greek lyre in action come from Mycenaean Greek settlements of the second millennium, where archaeologists have found painted frescoes and sculptures depicting lyre players and women's circle dances. Lyre-players appear on Mycenaean engraved rings and seals. The Greek word for "lyre"—*lura*—refers to the family of chordophones with strings of equal length. There are four main types of lyre: the *chelys*, *barbitos*, *phorminx*, and *kithara*, each having its own particular shape, size, tuning, and social function. Basic construction consisted of a soundbox (tortoise shell or wood), to which arms and a crossbar were attached; gut strings were attached by a knot to the chordotonon (a small board on the bottom of the sound-box), passed over the bridge, and were attached to the crossbar at the top of the instrument. The number of strings varied from five to nine, with seven being the norm from the Archaic Period onward. The player could stand, sit, or walk while strumming or plucking the strings with a bone plectrum (pick). A lyre-strap helped the musician to hold the instrument in place against the chest.

TYPES OF LYRES. The chelys and the barbitos were small and lightweight; their bowl-shaped soundboxes did not amplify sound with much volume. They were played by amateur musicians, used for music lessons, and were preferred by the lyric poets such as Sappho for smaller, indoor group performances. Although the ancients attribute the invention of the barbitos to the Greek musician and poet Terpander, it is not a Greek word and most likely came to Greece from Asia Minor. The most accomplished musicians desired bigger wooden-soundbox lyres: the phorminx and the kithara. There are numerous literary and artistic references to these being more professional instruments. In Homer's *Odyssey*, two *aoidoi* (professional bards) named Demodokos and Phemios perform songs of the epic cycle to the accompaniment of the phorminx before an audience eager to applaud "that song which is the latest to circulate among men." In the *Iliad*, the Achaean fighter Achilles sat in his tent singing "the glory of heroes" as he strummed a beautiful phorminx "made by an artist, with a silver bridge and a clear lovely tone" (9.185–188). Vase paintings often showed the phorminx with a decorative eye

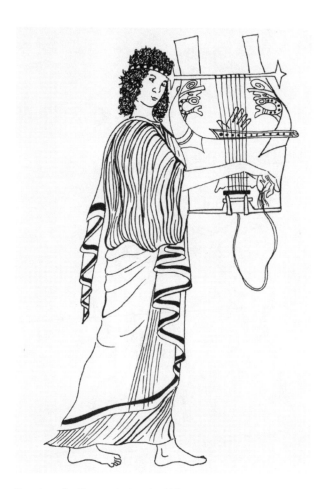

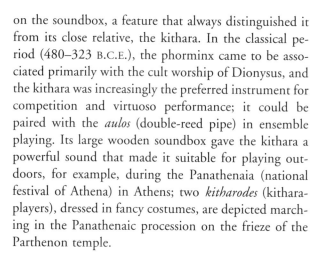

Drawing of a figure playing the kithara. CREATED BY CECILY EVANS. THE GALE GROUP.

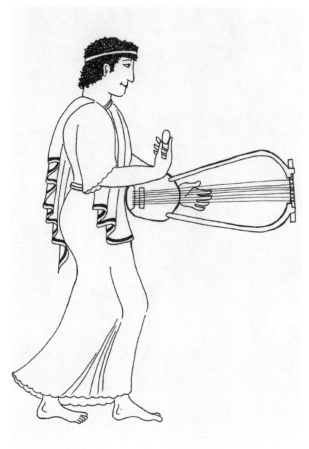

Drawing of a figure playing the barbitos. CREATED BY CECILY EVANS. THE GALE GROUP.

on the soundbox, a feature that always distinguished it from its close relative, the kithara. In the classical period (480–323 B.C.E.), the phorminx came to be associated primarily with the cult worship of Dionysus, and the kithara was increasingly the preferred instrument for competition and virtuoso performance; it could be paired with the *aulos* (double-reed pipe) in ensemble playing. Its large wooden soundbox gave the kithara a powerful sound that made it suitable for playing outdoors, for example, during the Panathenaia (national festival of Athena) in Athens; two *kitharodes* (kithara-players), dressed in fancy costumes, are depicted marching in the Panathenaic procession on the frieze of the Parthenon temple.

KITHARODES. The names of several famous Greek kitharodes are known. Terpander was one of the earliest and best-known composers and performers on the instrument in the Archaic Period, while Philoxenus of Kythera and Timotheus of Miletus were the most famous in the classical period (480–323 B.C.E.). Timo-

theus claimed to have invented "eleven-stroke meters and rhythms"; this may mean that he added strings in order to embellish the melody of a song with intricate rhythmic ornamentation. Fame had its downside, however; great kitharodes were sometimes lampooned in Athenian comedies. Two famous kitharodes in Greek myth are Orpheus and Thamyris, both from Thrace. Orpheus was said to have charmed even the rocks with his playing, and Thamyris boasted that he played better than the Muses. Both died violently, but were compensated with cult worship after death. Orpheus gained the gift of prophecy, while a special type of kithara was named after Thamyris.

THE HARP. The harp, an instrument that was used by the Sumerians and the Egyptians in the fourth millennium B.C.E., first appeared in the Greek world during the Bronze Age about a thousand years later; a number of marble figurines from tombs in the Cycladic Islands represent the triangular harp in the arms of seated male musicians; no strings are indicated in the

Arts and Humanities Through the Eras: Ancient Greece and Rome (1200 B.C.E.–476 C.E.)

191

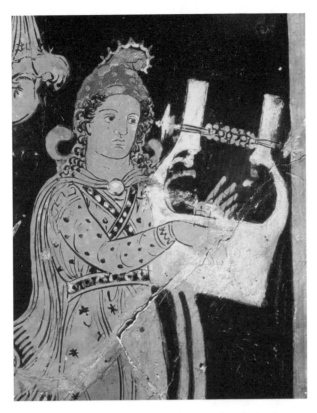

Detail of a red-figure Apulian vase from southern Italy, show-ing Apollo playing the kithara. THE ART ARCHIVE/BIBLIOTHÈQUE DES ARTS DÉCORATIFS PARIS/DAGLI ORTI.

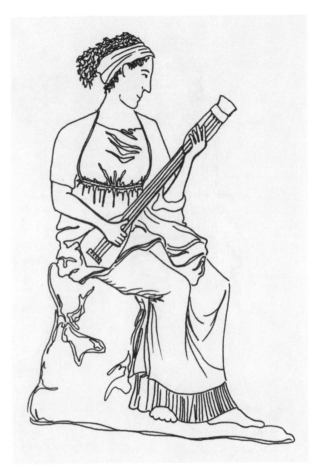

Drawing of a figure playing the lute. CREATED BY CECILY EVANS. THE GALE GROUP.

statues, but a contemporary seal impression shows four. Later versions had twenty to forty strings, and were thus called "many-stringed" instruments. Harps varied in size, and appear in three basic shapes: arched, triangular, and C-shaped. Among the many names for the instru-ment are: *pektis, trigonon, psalterion, magadis,* and *sam-byke.* The harp falls into the category of a psalter because it was normally played with the fingers of both hands without the aid of a plectrum (pick). The frame was of wood, and a soundbox was located at the base. Strings of unequal length were stretched from the base to the top of the harp, following the curve of the frame, and tuning pegs were either located on the base or at the top, depending on the type of harp. The Bronze-Age Greek harper figurines were all male, but by the fifth century B.C.E. harps—especially the trigonon, sambyke, pektis, and magadis—were most often de-scribed as women's instruments; they were shown in vase-paintings as being played exclusively by women, generally in the context of a wedding or a *symposium* (men's drinking party) together in ensemble with the aulos and the chelys. Since it was associated primarily with the feminine, and especially sensual or erotic en-tertainment, Plato did not consider the harp to be an appropriate instrument for educational purposes. Professional women harpists—known as *psaltriai* or *sambykai*—scandalized conservative Romans when they first played there.

THE LUTE. There was limited use for the lute in Greece and Rome, although the instrument was known in Mesopotamia as early as the third millennium B.C.E., and in Egypt soon thereafter. The name *pandouros* ("lute") may derive from the Sumerian *pan-tur* ("little bow"). In both Egypt and the Mediterranean, the lute was another instrument primarily played by women. It is not known in Greece before the Alexandrian Period of the mid-fourth century B.C.E., when the pandouros appears in the arms of a group of female terracotta fig-urines. The instrument is also held by one of the Muses in a well-known pedestal relief sculpture on a temple to the goddess Leto built in the same century. The fourth-century comic poet Anaxilas alludes to a lute in his play *The Lyre-Maker.* It is possible that the instrument, which resembles a small guitar or a banjo, came into Greece

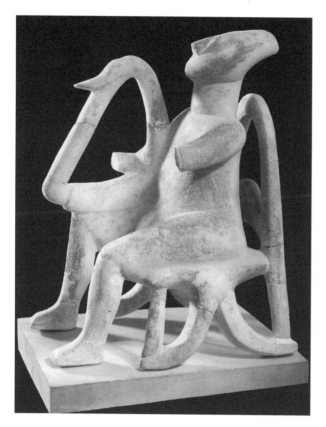

Greek Cycladic marble figure of a harpist from 2500 B.C.E. THE ART ARCHIVE/NATIONAL ARCHEOLOGICAL MUSEUM ATHENS/DAGLI ORTI.

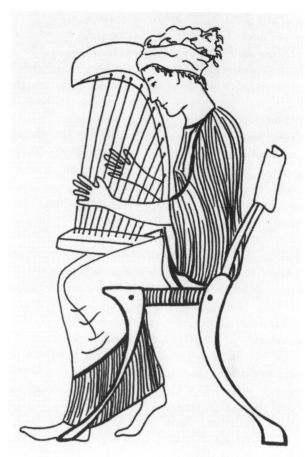

Drawing of a figure playing the harp. CREATED BY CECILY EVANS. THE GALE GROUP.

during Alexander the Great's military campaigns in Persia. Constructed of wood, the pandouros consisted of a pear or triangular-shaped soundbox from which projected a fretted neck of varying length. A cord around the shoulders served as a lute-strap. Gut strings were stretched from the bottom of the soundbox to the tuning pegs on the head. The players could either sit or stand, and strummed with their right hand while fretting with their left. The number of strings varied from one to four. The theorist Pollux included the pandouros with the *trichordos* ("three-stringed") lyres, and it is likely that this very simple chordophone was also used by the Pythagoreans for acoustic research.

WINDS. The wind instruments—reeds, pipes, horns, and flutes—were important in ancient Greek and Roman music from the earliest periods, especially the double-reed instrument known as the *aulos*. In fact, the aulos appears more often in vase paintings and fresco art than any other instrument, despite the opinion of Plato and Aristotle that the instrument was not appropriate for education. Wind instruments were used in a variety of contexts: *salpinges* ("brass trumpets") and *kerata*

("horns") accompanied military processions as well as public spectacle. The Roman cavalry thundered to the sound of the *lituus* ("trumpet"); brass ensembles featured the *cornu* ("horn") and the *bucina* ("tuba"). Triton-shells were used as trumpets (or, perhaps, megaphones) by ordinary people and children; they were often imitated in stone or faience. The aulos was used to accompany small and large groups of singers during religious festivals, banquets, and parties, and could be played while dancing. The aulos was essential during the ecstatic cult worship of the gods Dionysus (Roman Bacchus) and Cybele; it is often shown being played by satyrs and silenes (over-sexed woodland creatures associated with the ecstatic cult of Dionysus), and Aristotle commented that the aulos could arouse wild and dangerous passion. Pan-pipes (Greek *syringes*, Roman *fistula*) were played by shepherds and herdsmen. Along with iconographical and literary evidence, a good number of actual wind instruments have been recovered by archaeologists, so that scholars have a good idea of how many of them were manufactured, tuned, and played.

THE AULOS. The aulos was not a flute, but a single- or double-reed instrument, comparable to the oboe. Thinner than an oboe and often much longer, the aulos was usually played in pairs, one held in each hand. It commonly consisted of five parts: the *glotta* (mouthpiece), in which a reed of varying materials was housed; a three-part resonator consisting of two bulb- or oval-shaped resonators called the *holmos* and the *hupholmion*; the *bombyx* (main resonator), constructed in sections; and the *trupemata* (finger-holes). The pipe could be made of reed, ivory, bone, wood, or metal, and could be straight or have a curved bell. In vase-paintings from the sixth century B.C.E., the instrument was frequently shown strapped to the musician's face with a *phorbeia* ("halter"). The aulos (plural, *auloi*) was carried in a *sybene* ("bag"), and the reeds in a *glottokomeion* ("reed-carrier"), when not in use. In the classical period (480–323 B.C.E.) the aulos normally had five finger-holes, with one located on the bottom of the pipe for the thumb. In later Greek and Roman auloi, the holes could be covered by rotatable bands. The theorist Aristoxenus listed five sizes of auloi from highest to lowest in pitch: *parthenikoi* ("for girls," soprano), *paidikoi* ("for boys," treble), *kitharisterioi* ("for lyre-players," tenor), *teleioi* ("complete," baritone), and *hyperteleioi* ("more complete," bass).

ORIGINS OF THE AULOS. The writer Pollux noted a number of so-called "ethnic species" of auloi coming from Phrygia, Libya, Egypt, Thebes, and Scythia, each with its own peculiarities. The Greeks desired to claim the aulos as their own instrument and not a foreign import, thus some myths credit Athena with creating the aulos, or its music, while other stories say that a virtuoso player named Pronomos of Thebes (late fifth century B.C.E.) invented the two-pipe arrangement. In fact, the aulos was played in pairs in Mesopotamia, Babylonia, and Egypt from the third–second millenia B.C.E. and is attested in early Bronze-Age Aegean art. The earliest example of an *aulete* (aulos-player) in Greece is a marble figurine from the Cycladic island of Keros (c. 2200 B.C.E.). Myth and history are intertwined regarding the invention of the aulos. Two Greek myths, often re-told well into the fifth century B.C.E., credit the Phrygian satyr Marsyas or the goddess Athena with inventing the instrument. Pollux places the origin of the aulos in Phrygia, noting that there was a Phrygian type of aulos, the *elymos aulos*, used in the celebration of the Phyrgian goddess Cybele. Plutarch (first century C.E.) related a famous and often illustrated Greek myth of the Phrygian satyr Marsyas, whose father Hyagnis was said to have invented both the aulos and the first tune for it: "The Great

Mother's aulos tune" (a reference to the goddess Cybele). Hyagnis taught the tune to his impish son, who in turn taught a certain real-life musician named Olympos. Pindar (fifth century B.C.E.) claimed in his twelfth *Pythian* ode that Athena created the *pamphonon melos* ("all-sounding song") of the aulos "in order to imitate the shrieking cry of the Gorgon." In his *De cohibenda ira*, Plutarch gives another account of the story in which Marsyas, watching Athena play the aulos, ridiculed the way her cheeks puffed out when she blew notes; the goddess, mortified, threw the instrument away. Marsyas then invented the *phorbeia* ("cheek-halter") to control the movement of the mouth and cheek. In yet another version, Athena, displeased with the aulos, passed the instrument on to Apollo.

THE AULOS IN PERFORMANCE. Numerous artistic and literary references show the aulos being used. On the famous painted Bronze-Age sarcophagus from Ayia Triada from Crete (c. 1490 B.C.E.), a male aulete plays during the occasion of an animal sacrifice; a phorminx player performs on the opposite side. Auloi are again paired with the phorminx in the *Odyssey* on Achilles' shield, accompanying dancing at a wedding. The aulos was often played in ensemble with lyres and harps. It accompanied the *dithyramb* (choral dance) and most other types of choral and lyric performance. Deemed appropriate for both happy and sad occasions, the aulos was played at funerals. Auloi were the instruments that accompanied dancing and singing during the Eastern ecstatic worship of Dionysus, Cybele, and Orpheus. Prostitute women auletes entertained men at drinking-parties, and the instrument is often depicted in erotic scenes on vase-paintings.

THE SOUND OF THE AULOS. There were three basic modal systems, or scales, associated with the aulos: Dorian, Lydian, and Phyrgian, but several dozen types were categorized by pitch range. Accomplished auletes could play an impressive array of scales and pitches by employing techniques such as half-holing, cross-fingering, and over-blowing; by playing two auloi at once, the aulete could combine scales. Different tones and timbres were also accomplished by adjusting the tonguing of the reed and embouchure (lip position) on the mouthpiece. Different writers described the sound of the aulos as screeching, buzzing, sweet-breathed, pure-toned, wailing, enticing, orgiastic, and lamenting. Plato and Aristotle considered complex melodies employing more than one mode or scale to be disruptive to the soul; Plato banned the aulos from his ideal city in the *Republic* because it was a "pan-harmonic" instrument.

THE ROMAN TIBIA. The Roman *tibia* (plural *tibiae*) was a pipe of reed or bone, equivalent to the Greek au-

los. The Roman writer Varro said the same thing about the tibia as the Greek philosophers did about the aulos: its tones were complex, and could have an ecstatic affect on the soul. As in Greece, the reed pipe was played during the worship of deities such as Cybele, Bacchus (Greek Dionysus), and Isis, all of whom are connected with fertility, fecundity, and rebirth. The tibia was also used to accompany different kinds of solo theatrical performance, such as mime, pantomime, and farce, often in ensemble with lyres and percussion. Solo *tibicen* ("tibia-players") would introduce tragedies, and according to Cicero, the audience could often identify a drama by the first few notes. The tibia is ubiquitous in Roman mosaics and paintings depicting scenes from Roman comedy. Tibicen would play instrumental pieces or accompany songs between the acts. The tibia was indespensible in the comedies of Terence and Plautus as the accompaniment to certain polymetric scenes of dialogue called *cantica*; the playwrights would direct the tibia to play, or to be silent, depending on the desired effect in the scene, and the tibicen would engage sometimes in the action. Stage directions in the comedies of Terence indicate which type of tibia were required: *tibiae pares* ("pipes of equal length"), *tibiae impares* ("pipes of unequal length," probably an octave difference), and *tibiae sarranae* ("Phoenician tibiae"). The tibia musician who composed for Terence may have also served as musical director.

THE FLUTE AND PAN-PIPE. The aulos has often been translated as "flute," but this is incorrect. The true flute has no reed, and is played by blowing transversely across the blow-hole while holding the instrument horizontally to the side. Most types of auloi were reed instruments played in pairs and held in front of the musician, like an oboe or bassoon. One type of aulos, however, might have been played like the modern flute: the *plagiaulos* (Greek) or *obliqua tibia* (Latin). Like the other auloi, the plagiaulos was not Greek in origin, but came from Lydia, Phrygia, or, according to Pollux and Athenaeus (late second century C.E.), Libyia. The flute is rare, and does not appear in Greece before the third century B.C.E. Two surviving plagiauloi are housed in the British Museum; both feature a small bust of a bacchante (worshipper of Bacchus) on one end. Both the plagiaulos and the *syrinx* ("pan-pipes") were pastoral instruments, played by shepherds and herdsmen for simple enjoyment. There are more artistic and literary references to the syrinx then there are to the flute. While there are no surviving Bronze-Age examples of the syrinx, it is depicted in the *Iliad* (eighth century B.C.E.) on the shield of Achilles, in the hands of happy shepherds. The so-called "François Vase" (circa 575 B.C.E.) features a Muse

a PRIMARY SOURCE *document*

A PIPERS' STRIKE IN ANCIENT ROME

INTRODUCTION: The *tibicines* were musicians in Rome who played the *tibia*, originally a pipe made of bone with three or four finger-holes; as time went on, it became a double-pipe reed instrument like the Greek *aulos*. The guild of tibicines held a festival every year on the Ides of June (15 June) when they wore masks and fancy dress—sometimes women's clothing. The festival commemorated a strike of the tibicines in 311 B.C.E., which is described in the following passage of Livy. The story shows how important a role that the guild of pipe-players had in Roman sacrificial rites.

I should have omitted an episode of the same year as being scarcely worth mentioning did it not seem to concern religious duties. The pipe-players (*tibicines*) were angry at having been forbidden by the last censors to hold their feast in the temple of Jupiter, according to ancient custom, and marched off to Tibur in a body, with the result that there was no one in the city to play the pipes at sacrifices. The Senate was seized with pious misgivings about the incident, and sent delegates to Tibur to request the citizens to do their best to return the men to Rome. The Tiburtines courteously promised to do so and first summoned the pipers to their senate-house and urged them to return to Rome. Then, when they found that persuasion achieved nothing, they dealt with the men by a ruse nicely in tune with their nature. On a public holiday various citizens invited parties of pipers to their homes on the pretext of celebrating the feast with music, and sent them to sleep by plying them with wine, for which men of their kind are generally greedy. In that condition they dumped them, heavily asleep, in cart and carried them off to Rome. The carts were left in the Forum and the pipers knew nothing until daylight surprised them there, still very drunk. The people quickly gathered round them and prevailed on them to stay. They were given permission on three days a year to roam the city in fancy dress, making music and enjoying the license which is now customary, and those of them who played pipes at sacrifices had their right to hold a feast in the temple restored.

SOURCE: Livy, *Rome and Italy*. Books VI–X of *The History of Rome from its Foundation*. Trans. Betty Radice (Harmondsworth, England: Penguin, 1982): 259.

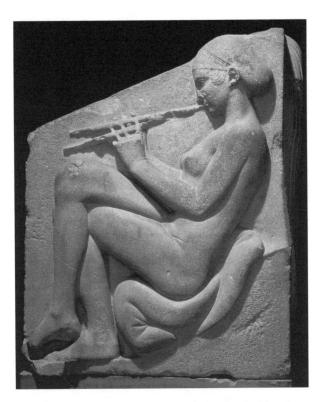

A Greek relief sculpture of a woman playing the double aulos, on the Ludovisi throne, from about 450 B.C.E. THE ART ARCHIVE/MUSEO NAZIONALE TERME ROME/DAGLI ORTI.

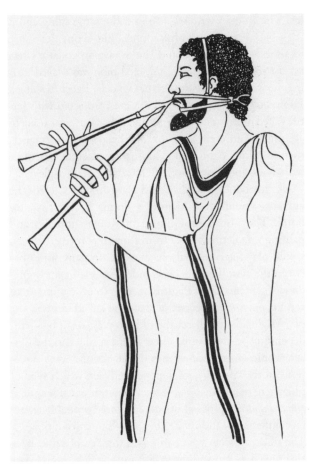

Drawing of a figure playing the double-aulos. CREATED BY CECILY EVANS. THE GALE GROUP.

playing the syrinx at the mythical wedding of Peleus and Thetis, but the instrument is most widely associated with pastoral poetry of the third century B.C.E. Although Plato bans the aulos from his ideal state in *The Republic*, he allows herdsmen in the country to have their simple *syringes*. In Greek myth, the god Hermes is credited with inventing the syrinx; it is the instrument commonly associated with Hermes' son, Pan, god of shepherds—hence the term "pan-pipe." Later writers suggest other origins, including Pollux who associates it with the Celts and unnamed "islanders in the ocean." The term *syrinx* (Latin *fistula*) was used to designate both a single-pipe whistle and also a group of five to seven equal-length pipes, tied together, and plugged with wax at graduated intervals to form a scale. The musician holds the instrument upright beneath the mouth and blows across the pipes as one would a bottle. Later versions include a rank of different-length pipes tied together, or pipes with holes bored into them to effect the desired pitch.

THE ORGAN. The idea behind the syrinx—that scales could be created by blowing air across the opening of pipes—was expanded by Greek engineers in Egypt during the Hellenistic Period (fourth century B.C.E.). Athenaeus, writing in the late second century C.E., cred-

its an Alexandrian mechanic named Ktesibios with the invention of the *hydraulis* ("water organ"), which used a hydraulic pump to create a continuous supply of air to ranks of pipes. The Roman architect Vitruvius (late first century B.C.E.) later described how "stops" were used to close off air from entire rows of pipes in order to alter the pitch. Hero of Alexandria, an engineer writing 100 years later, explained in detail how the hydraulic machine of Ktesibios worked in his book *Pneumatika*. A complex mechanical organ, the hydraulis was not commonly played, but there is an inscription from the sanctuary of Apollo at Delphi that praises the *hydraulist* Antipatros for winning a musical competition in 90 B.C.E.

THE TRUMPET. Several different types of horns were played by the Greeks and Romans. The ivory or more often bronze *salpinx* ("trumpet") was primarily a battle instrument, used to send signals; it also appeared in ritual and ceremonial contexts, especially in the Roman period, where it was called a *tuba* and often made of brass or iron. The blast of the trumpet was used to

Roman water organ found at Aquincum, Hungary. COURTESY OF
THE AQUINCUMI MUZEUM.

call people to assembly and start races. Most writers claim
the salpinx to be of Etruscan (Italian) origin, but the in-
strument is comparable to both Mesopotamian and
Egyptian trumpets. It consisted of a long, thin, tube,
which could be straight or curved, with a funnel or
orchid-shaped bell at the end. The *glotta* ("mouthpiece")
was made of bone. In his *De Musica*, the Roman theo-
rist Aristides Quintilianus (third–fourth century C.E.)
described the salpinx as a "warlike and terrifying instru-
ment" that the Roman army employed to move troops
by playing "codes through music." Human and divine
salpinges (players of the salpinx) were frequently depicted
in vase paintings; on a fifth-century B.C.E. cup by the
painter Epiktetos, a saytr holds a salpinx in one hand, a
shield in his right, and plays while running; a *phorbeia*
("halter," also used by dancing auletes) holds the mouth-
piece to his lips.

HORNS. Animal and sea-shell horns were commonly
used throughout the Mediterranean and the Near East

from the earliest periods. In Greek myth, triton and
conch shell horns were the instruments played by sea
deities such as Nereids and Tritons. The *keras* ("cow-
horn"), often baked to produce a clearer tone, was used
together with the much louder salpinx to signal troops
in battle. In Rome, military horns and trumpets, in-
cluding the tuba, *bucina* (shaped like a bull-horn), and
the circular *cornu* were featured in concerts given by large
choral groups and orchestras.

PERCUSSION. Percussion instruments included the
sistrum ("rattle"), *krotala* ("castenets"), *kumbala* ("finger-
cymbals"), *tympanon* ("drum"), *kymbalon* ("cymbal"),
and the *kroupalon* (Latin *scabellum*), a wooden or metal
tap worn on a shoe used to keep time. The *rhombos*
("bull-roarer") could be classified as either a percussion
or a wind instrument. It consisted of a piece of wood at-
tached to a string, which made a rumbling sound when
whirled above the head. Sistra—metal or clay-and-wood
rattles—were popular in Egypt and throughout the
Mediterranean. They appeared in Bronze-Age art of
the second millennium B.C.E., and many actual sistra
survive—over twenty were found at Pompeii. Evidence
shows that percussion instruments—notably large, one-
sided drums (*rhoptra* and *tympana*) and perhaps
clappers—were used by the Parthians, ancient people of
Iran and Afghanistan, to terrify the enemy in battle. In
Greece and Rome, percussion instruments were rather
used predominately by women to accent rhythm of
dance and poetic meter in the cult worship of Diony-
sus, Cybele, Pan, and Aphrodite, deities associated with
fertility, fecundity, and sexuality. Women devotees of
Dionysus, called *maenads*, are frequently depicted in
vase-paintings dancing while striking small hand-held
tympana with their palms. In his comedy *Lysistrata*, the
fifth-century B.C.E. playwright Aristophanes suggested
that women playing the tympana during the worship of
Pan and Aphrodite could create quite a ruckus. Women
also played the *krotala*, a pair of bar-shaped wooden or
metal clappers, hinged at one end, and played with each
hand, like castenets; a commonly depicted duet includes
a female krotala-player and a male aulete, both dancing
wildly. Krotala are also depicted as being played by satyrs,
over-sexed mythical creatures associated with Dionysus.
Kumbala (finger-cymbals) are also associated principally
with female worshippers of Dionysus. These are small,
round clappers made of wood, shell, or clay, which pro-
duced a higher tone than krotala. Many examples can
be found in museums. A pair of kumbala from the fifth
or fourth century B.C.E. in the British Museum is in-
scribed with the owner's name. The sistrum (rattle or
shaker) was also a woman's instrument. A ladder-shaped

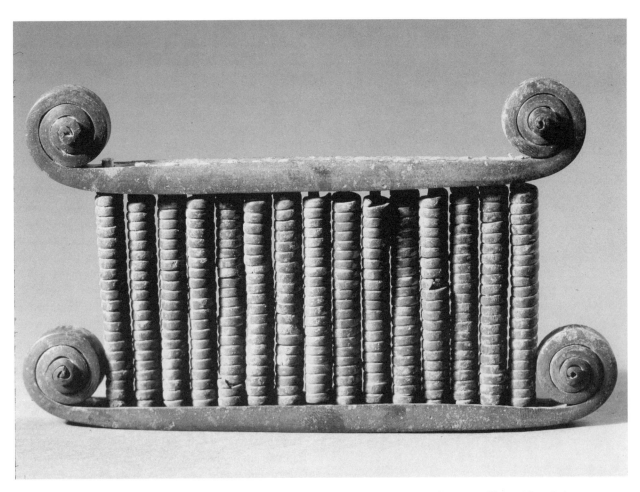

Greek bronze sistrum (musical instrument), 6th century B.C.E. from the Macchiabate necropolis, Francavilla Maritima, Italy. THE ART ARCHIVE/MUSEO DELLA SIBARITIDE SIBARI/DAGLI ORTI.

wooden version, labelled by Pollux as a *psithyra*, is regularly depicted hanging on the wall in a woman's room or in a woman's hands in Greek vase-paintings from Apulia in southern Italy.

SOURCES

Giovanni Comotti, *Music in Greek and Roman Culture.* Trans. Rosaria V. Munson (Baltimore, Md.: The Johns Hopkins University Press, 1989, originally published in Italian, 1979).

John G. Landels, *Music in Ancient Greece and Rome* (London: Routlege, 1999).

Martha Maas and Jane Snyder, *Stringed Instruments of Ancient Greece* (New Haven, Conn.: Yale University Press, 1989).

Thomas J. Mathiesen, *Apollo's Lyre: Greek Music and Music Theory in Antiquity and the Middle Ages* (Lincoln: University of Nebraska Press, 1999).

Martin West, *Ancient Greek Music* (Oxford: Clarendon Press, 1994).

MUSIC IN GREEK LIFE

INTEGRATED INTO EVERY PART OF SOCIETY. Music was undeniably prevalent in all parts of Greek society. It was featured prominently in weddings, funerals, and other social events, during military campaigns, and most notably during festivals. Music was appropriate for all situations, whether they were family or community events. Once a musical performance had begun, it was common for neighbors, friends, and even strangers passing by to take part in some of the activities that included music. Music was also the central entertainment at *symposia*, private drinking parties held after dinner in the men's area of the house. Almost all types of these musical events have been preserved, either in the artwork or literature that has survived from the era, giving clues to modern scholars about the scope of music in Greek life.

EPIC POETRY. One of the earliest examples of music being performed in public was when it accompanied the performance of epic poetry. The eighth-century

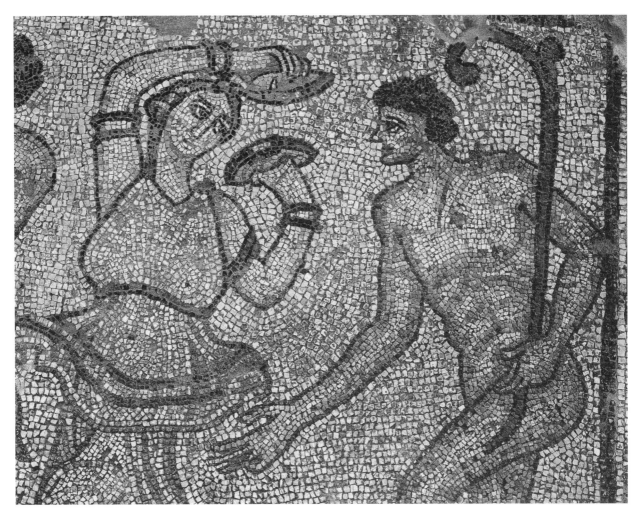

A mosaic showing dancers from a villa found in Argos, Greece, 4th–5th century C.E. The woman plays the cymbals. THE ART ARCHIVE/ARCHAEOLGICAL MUSEUM ARGOS/DAGLI ORTI.

B.C.E. Homeric epics *Iliad* and *Odyssey* are the earliest written examples of myths performed in poetic form; they represent a tradition reaching back at least to the second millennium B.C.E. Originally sung to the accompaniment of the *phorminx* (lyre), the Homeric epic was composed in stichic form, meaning that many lines were repeated in the same meter. In the case of Homeric epic, this meter was dactylic hexameter, which consisted of a combination of the dactyl (– ∪ ∪) and spondee (– –). The melody was simple and conservative. In antiquity the transmission of epic poetry was accomplished through oral rather than written means; the poet trained his pupil, and they traveled from city to city, singing in music competitions and at the homes of patrons, always tailoring their performance to their audience.

PERFORMANCE OF EPIC POETRY. The epics themselves include many references to their own performance style: Demodokos and Phemios, two *aoidoi* (professional bards), sing and play selections of epic poetry before large audiences at banquets in the royal courts of kings Odysseus and Nestor. In the *Odyssey* Book Two, Odysseus' son Telemachus praises Phemios for delivering the "newest song to circulate." Amateur musicians would also attempt a few lines of epic, as the poem illustrates: the Achaean warrior Achilles, on a break from battle, plays his phorminx and sings "the glorious deeds of fighting heroes" for his friend Patroclus in Book Nine of the *Iliad*. From the sixth century forward, epic poetry was performed by *rhapsodes*, professional bards who recited selections of Homeric poetry at music competitions during religious celebrations, such as the Epidaurus festival of Asclepius, the god of healing who appeared as a mortal doctor in the *Iliad*. In Athens, during the Great Panathenaea held every four years in honor of Athena,

a PRIMARY SOURCE *document*

ODYSSEUS PRAISES SONG

INTRODUCTION: The earliest literary allusions to music are found in the *Iliad* and *The Odyssey*, the eighth century B.C.E. Archaic epic poems attributed to Homer. The subject of these poems—the Trojan War and its aftermath—refer back to a much earlier time: the Aegean Bronze Age (Mycenean Period) of the second millennium, when *aoidoi* (bards) entertained at the courts of ancient princes with songs of heroes, accompanied by the *phorminx* (a type of lyre). In this excerpt from *The Odyssey* Book Nine, the hero Odysseus praises as "the crown of life" the good food and songs of the bard Demodokos, provided for his pleasure by his host, Alcinous, king of Phaiaicia.

Odysseus, the great teller of tales, launched out on
 his story:
"Alcinous, majesty shining among your island
 people,
what a fine thing it is to listen to such a bard
as we have here—the man sings like a god.
The crown of life, I'd say. There's nothing better
than when deep joy holds sway throughout the
 realm
and banqueters up and down the palace sit in ranks,
enthralled to hear the bard, and before them all, the
 tables
heaped with bread and meats, and drawing wine
 from a mixing-bowl
the steward makes his rounds and keeps the
 winecups flowing.
This, to my mind, is the best that life can offer.

SOURCE: Homer, *The Odyssey*. Trans. Robert Fagles (New York: Penguin, 1997): 211.

groups of rhapsodes were organized to perform the complete *Iliad* and *Odyssey*.

MUSIC IN THE MILITARY. Another early use for music was its necessity on the battlefield. The *aulete* (piper) was an essential timekeeper for rowers on Greek warships and for soldiers on the march. Bards and musicians entertained sailors and infantrymen while on campaign, keeping their spirits up. Marching songs were played on the *salpinx* ("trumpet"), which was also used to signal and direct troop movement in battle. The paean was sung during battle to rally troops, as the playwright Aeschylus wrote in his tragedy *The Persians*: "O Children of Greece, come! Free the fatherland, free your children, your wives, the shrines of your ancestral gods, the tombs of your ancestors! Now the struggle is for all!" The Spartans, noted for their military prowess, used several different types of marching song and rhythms which, according to Plutarch in his *Instituta Laconica*, made the soldiers brave and fearless of death. The seventh-century B.C.E. poet Tyrtaeus used one of the marching meters known as the *embateria* when he urged the Spartan troops to march on, shield and spear in hand, with no thought for their lives, sparing no one.

EPINIKIAN POETRY. Athletic contests were held every four years during the Olympian, Pythian (at Delphi), Nemean, and Isthmian Funeral Games, during which music was often heard and was often used as a prize of sorts. Modern Olympic games descended from such celebratory festivals, which featured many of the same events, including boxing, running, wrestling, horse racing, and pentathlon. Athletes from all over Greece would participate, and the victor of a competition was rewarded with prizes. After the competition, a grand homecoming celebration was held for the winners, and an elaborate poem, known as the *epinikion*, would be composed and performed especially for the individual. The poet, who was paid handsomely, extolled the victor and his family, and contextualized his accomplishment by comparing his effort to the struggle of a mythic hero or god. The poem could be performed again on the anniversary of a victory. Epinikia were composed for choral performance and, as the poems themselves reflect, were enhanced with dance accompanied by the *phorminx* (lyre) or *aulos* (reed). The best-preserved epinikian poems of the late sixth–early fifth centuries B.C.E. are those of Pindar, from Boeotia. Four books of Pindar's epinikia—one for each of the major Games—survive; many can be assigned to specific festivals and victors. Pindar's first Pythian Ode was composed for a certain Hieron of Aetna, winner of the chariot race in 470 B.C.E. Pindar also wrote poems for war heroes and musicians; his twelfth Pythian Ode, written for Midas of Acragas on the occasion of back-to-back victories on the aulos, contains a reference to the invention of a "many-headed" melody for the aulos by the goddess Athena. Pindar was well respected in antiquity for his brilliant use of imagery and metaphor, lyric meter, and musicality. Dionysius of Halicarnassus, a first-century B.C.E. theorist, praised Pindar's "archaic and austere" beauty, and the range of his modal systems.

PUBLIC FESTIVALS. Much like the Olympics, music was used in numerous other festivals, and many festivals had musical competitions that replaced the athletic competitions that were familiar to Olympians. The ear-

liest evidence that music was part of public festivals in Greek life comes from the Bronze-Age settlement of Ayia Triada on the island of Crete (c. 1490 B.C.E.); a fresco and a stone sarcophagus depict musicians playing the phorminx and the aulos during a procession and a ritual sacrifice. Public festivals in honor of the gods filled the Greek calendar, and each region of Greece had its own particular ceremonial traditions; these came at yearly or longer intervals, and could last from one to seven days. Choral and solo songs, dance, and poetry were central parts of all festival events. The three main features of public religious festivals were the procession, the animal sacrifice, and the feast. The *prosodion* ("processional hymn") was sung to the accompaniment of the aulos while people paraded to altars and temples; when they arrived at their destination, the prosodion was sung to the *kithara* (type of lyre). Larger, more important celebrations, such as the City Dionysia and the Great Panathenaea at Athens, the Pythian festival at Delphi, and the Karneia at Sparta, included dramatic, poetic, and/or musical competitions.

CHORAL SONG. The festival procession generally included the *dithyramb*, a male choral dance with musical accompaniment, *hymnoi* ("hymns"), and the *paean* (a song of exhortation sung and shouted by men and boys in unison). Originally associated with the ecstatic worship of Dionysus, the god of "altered consciousness," the dithyramb was passionate and tumultuous, a revelry that celebrated masculine sexual power and fecundity. The seventh-century B.C.E. poet Archilochus proclaimed that he knew how to lead the dithyramb, the beautiful song of lord Dionysus, when infused with wine. Later, the dithyramb became institutionalized, and the City Dionysia in Athens featured organized performances by close to two dozen dithyrambic choruses of fifty men and boys each; dressed in costume, often crowned with ivy, they sang and danced under the direction of the *khoregos* (teacher, or leader of the chorus) to the accompaniment of the aulos. The names of a number of *khoregoi* (dithyrambic poets) and *auletes* (double-reed players) were inscribed on monuments. Pindar, Simonides, and Bacchylides, poets of the early fifth century B.C.E., were famous composers of dithyrambic choral song; the historian Herodotus named Arion as the person who first categorized the dithyrambs in Corinth, and after the fifth century B.C.E., Timotheus of Miletus and Philoxenus were credited with adding more complex rhythms and melodies to the dithyramb through modulation and modification of the aulos.

HYMNS. Often during the beginning and end of festivals, *hymnoi* were sung as a sign of thanks for prosper-

ity. *Hymnoi* ("hymns") were songs of praise to gods. These could be brief accolades to gods during a procession or short introductions to paeans or epic poems. Hymns were composed by the lyric poets Archilochus, Alcaeus, Sappho, Pindar, and Bacchylides in the sixth–fifth centuries B.C.E., but the earliest hymns were part of an oral tradition. The Homeric Hymns—so named because they were composed in the same meter, dactylic hexameter, as the epic poems of Homer—were a literary genre performed by professional bards during a religious festival. These were long, elaborate, and detailed biographies of divinities that explained the particular god's origin, sphere of influence in society, and sites of worship. Thirty-three are preserved. The Homeric Hymn to Hermes includes a description of how the god invented the first lyre out of a *chelys* ("tortoise shell"). Aphrodite's Hymn relates how the goddess fell in love with the mortal hero Anchises, and bore his son—the Trojan prince Aeneas—whose descendents would later found Rome. One of the longest and most elaborate of the Homeric Hymns is the Hymn to Demeter, the goddess of grain and agriculture. Her hymn describes how Demeter's daughter, Kore, came to be known as Persephone, the wife of Hades, god of the Underworld; the story in the hymn contains many symbols and cryptic references to the popular mystery cult of Demeter, which was held in a large sanctuary in the town of Eleusis, near Athens.

THE PAEAN. The paean, a versatile form of song that could be sung on a variety of public and private occasions, was especially important during the festivals of the gods Apollo and Artemis, twin children of Leto. Many paeans were composed by musicians and poets to honor Apollo as the Oracle of Delphi. Two were inscribed on the wall of the Treasury of the Athenians at Delphi, complete with musical notation. Dating to the second century B.C.E., the 33 preserved lines of the first paean praise the glory of Apollo with sacrifice and music of the *kithara* (lyre) and the *lotus* (a type of reed pipe), and relates the myth of how Apollo became the prophet of Delphi by slaying Python, the serpent who guarded the prophetic tripod. Paeans also served as a holy song performed by soloists or choruses during the Panathenaea, a great festival of Athena held every four years in Athens; the Hyakinthia at Sparta; and other festivals honoring the major divinities. They could also function as a prayer of deliverance or thanksgiving.

GIRLS' CHORAL SONGS. Men were not the only ones to perform at festivals. Girls received training in choral music and dance from a young age; before the seventh century B.C.E., this was the only "formal" edu-

a PRIMARY SOURCE *document*

THE INVENTION OF THE LYRE

INTRODUCTION: The anonymous "Homeric Hymns," devotional songs in honor of a divinity, were performed as preludes to the recitation or singing of the Homeric epics, usually as part of a contest during a religious festival. "Hymn to the God Hermes" describes the birth of this trickster god, and relates several of his many powers and accomplishments; his first feat soon after birth is to invent the lyre from a tortoise-shell (*chelys*); he then sings a song while striking the lyre with a plectron, improvising "such as young men do at the time of feasts when they taught and mock each other" (presumably in musical competitions). The chelys-lyre must have been introduced into Greece during the Bronze Age; it is depicted in art from the second millennium B.C.E.

Of Hermes sing, O Muse, the son of Zeus and Maia,
lord of Kyllene and Arcadia abounding with sheep,
helpful messenger of the immortals, whom Maia bore,
the fair-tressed and revered nymph, when she mingled in
 love
with Zeus. ...
Born at dawn, by midday he played his lyre,
and at evening he stole the cattle of far-shooting Apollo ...
for Hermes was the first to make a singer of a tortoise,
which met him at the gates of the courtyard,

grazing on the lush grass near the dwelling
and dragging its straddling feet; and the helpful son of
 Zeus
laughed when he saw it and straightway he said:
"... if you die, your singing could be beautiful."
Thus he spoke and with both hands he raised it up
and ran back into his abode, carrying the lovely toy.
There he tossed it upside down and with a chisel of gray
 iron
he scooped out the life of the mountain-turtle. ...
He cut measured stalks of reed and fastened them on
by piercing through the back the shell of the tortoise;
and skillfully he stretched oxhide round the shell
and on it he fixed two arms joined by a crosspiece
from which he stretched seven harmonious strings of
 sheep-gut.
And when it was finished, he held up the lovely toy
and with the plectron struck it tunefully, and under his
 hand
the lyre rang awesome. The god sang to it beautifully,
as on the lyre he tried improvisations, such as young men
 do
at the time of feasts when they taunt and mock each
 other.

SOURCE: Homer, *The Homeric Hymn to Hermes*, in *The Homeric Hymns*. Trans. Apostolos N. Athanassakis (Baltimore: Johns Hopkins University Press, 1976): 31–32.

cation open to girls. From the fifth century onwards, vase-paintings show women teaching girls to dance or play an instrument. Many vase-paintings depict girls and young women dressed in long, modest costumes, holding hands while dancing together in a line or a circle. Choruses of girls and women performed at family occasions such as weddings, but were also a feature of public festivals. Many famous poets, including Pindar, Simonides, and Bacchylides, composed *partheneia* ("maiden's choral dances") for public performance. In one of the best preserved of the *partheneia*, composed by seventh-century B.C.E. Spartan poet Alcman, two girls are singled out as the most charming and lovely leaders of ten girls dancing to honor the Dawn Goddess. Choruses of young women joined men in singing paeans and dancing on the Acropolis all night at the beginning of the Panathenaea. At Thebes, girls danced at night during the worship of the Mother of the Gods.

MUSIC COMPETITIONS. Four major Funeral Games—multi-day festivals held to commemorate a region's ancestral king—provided opportunities for athletes as well as musicians to compete for prizes. From

the end of the eighth century B.C.E. musicians arrived from all over the Mediterranean to participate in festival contests. Instrumental competitions were instituted in the first quarter of the sixth century; competitors included instrumentalists on the concert lyre (*kitharists*) and the double-reed pipe (*auletes*); poets, who performed to accompaniment (*kitharodes* and *aulodes*); and the *rhapsode*, a professional bard who performed selections from the *Iliad*, the *Odyssey*, and other epic poetry, introduced by a hymn. Vase-paintings depict these competitors standing on a small stage before a judge.

THE VICTORS. In his poem *Works and Days*, Hesiod, a shepherd-poet roughly contemporary with Homer (c. 700 B.C.E.), described how he won a tripod with handles, which he dedicated to the Muses, for his performance of a hymn at the Games of Amphidamas in Chalcis (654–652 B.C.E.). The names of many winners are known, some of them women: a kitharode named Polygnota of Thebes won a crown and 500 drachmas for her performance during the Pythian Games, according to a second-century B.C.E. inscription from Delphi. Two among the male victors stand out: Terpander of Lesbos

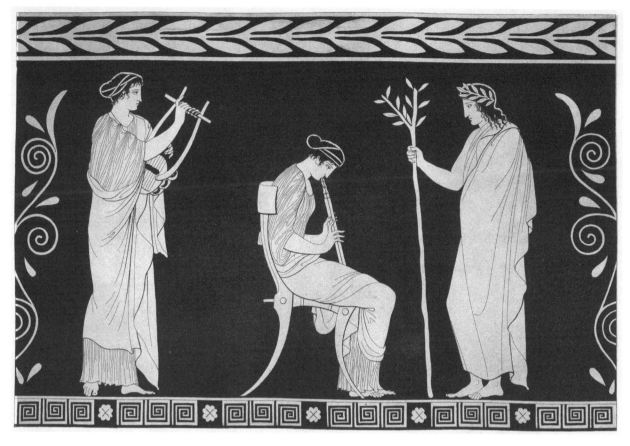

An engraving copied from a Greek red-figure vase shows a musical competition. A standing woman tunes her lyre, and a seated woman plays the double aulos. THE ART ARCHIVE/BIBLIOTHÈQUE DES ARTS DÉCORATIFS PARIS/DAGLI ORTI.

and Timotheus of Miletos. Terpander was a celebrated musician of the early Archaic Period (seventh century B.C.E.), and was maligned in a comedy by Phercrates for singing too many notes. It is said that while Terpander increased the number of strings on the kithara to seven, Timotheus added four more; an anecdote relates that Timotheus was exiled from Sparta for using too many strings on his kithara during the music competition at the Karnean Festival there.

GREEK THEATER. The festival of the Great Dionysia, held in Athens in March, was the most important dramatic competition in Greece. Instituted in the mid-sixth century B.C.E. by Peisistratus, the festival lasted five days and featured three tragedies, three satyr plays, five comedies, and two dithyrambs. The Dionysia honored the god Dionysus as *Eleutherios* ("The Liberator"), and the plays were performed in the large, open-air theater dedicated to the god at the foot of the Acropolis. Here, tragedians, of whom the most famous are Aeschylus, Sophocles, and Euripides, and comic playwrights—Aristophanes is the best known—produced their spectacular and timeless productions before thou-

sands of spectators; adaptations and revivals of these plays continue to be staged today. The tragedies were serious re-enactments of well-known myths, such as the murder of Agamemnon, commander of the Achaean forces at Troy, by his deceitful wife Clytemnestra, or the downfall of the Theban hero Oedipus, who unwittingly killed his father and married his mother. The playwright was free, within reason, to interpret these myths through plot and action, which combined spoken dialogue between two to three actors, and choral song. All the parts were played by men or boys. The earliest surviving tragedy, produced by Aeschylus in 472 B.C.E., is unique in not drawing its plot from a myth; it treats an historical event: the bloody sea battle that had occurred at Salamis only eight years before between the Greek and Persian fleets.

THE CHORUS. The most important musical element of Greek tragedy and comedy was the chorus. Aristotle, in the *Poetics*, states that tragedy evolved from the *dithyramb*, the young men's choral dance originally performed in honor of Dionysus. He adds that the tragic chorus employed melody, rhythm, and meter in combi-

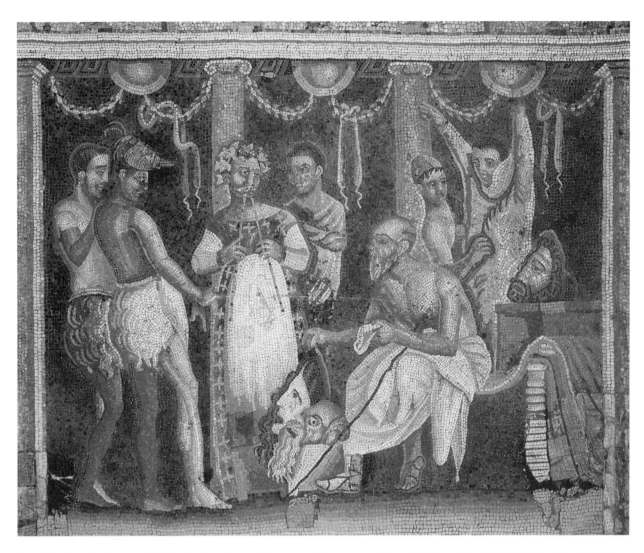

An aulos player backstage with Greek actors, from a Roman mosaic. THE ART ARCHIVE/ARCHAEOLOGICAL MUSEUM NAPLES/DAGLI ORTI.

nations composed by the tragedian, who also choreographed and trained the chorus. Each playwright entering the competition was assigned a chorus of twelve to fifteen teenage boys, and a *khoregos* ("chorus-leader"). The boys were citizens of Athens, until the fourth century B.C.E., when professional singer-dancers were chosen. Aristotle explained that choral performance consisted of three basic parts: the *parados* (entrance song); the *stasimon*, sung while standing in the orchestra (literally "dancing place"); and the *kommos*, an antiphonal lament exchanged between the chorus and the actors. Musical accompaniment was provided by an *aulete*, a player of the double-reed pipe. In the classical period (480–323 B.C.E.), the chorus was assigned a character role; they played the part of elder statesmen, old men, slave-women, sailors, even supernatural beings, and shared in the action of the plot. Their function was to provide background for the story, interpret the action of the plot for the audience, and provide

a moralizing element. Like the actors, the choral members wore masks, and their musical performance was enhanced by the use of dance and gesture.

MUSIC IN COMEDY. In the fifth century B.C.E. "Old Comedy" of Aristophanes, the chorus was 24 in number—twice the size of the tragic chorus. The group played the part of humans, but also birds, frogs, clouds, and other whimsical characters whose primary purpose was to entertain. Vase-painters illustrated the fantastic costumes of these choruses. Contemporary popular music, such as love songs, were part of the repertory, sung and danced to the accompaniment of the aulete. Several of Aristophanes' comedies featured a *parabasis*, during which the chorus would step forward and address the audience directly, speaking on behalf of the playwright. A musical celebration, often comic, marked the end of many comedies. Aristophanes' play *Wasps* ended

with a type of ribald can-can danced by men, called the *kordax*. In his last surviving comedies, produced at the beginning of the fourth century, the role of the chorus was reduced. The poetry of the choral odes apparently were no longer written by the poet and included in the text; the word KHOROU ("Choral Song") was simply written in near the end of the play or between acts to indicate the performance of a song that was not necessarily connected with the story of the play. Aristotle referred negatively to the use of such interludes, which he called *embolima*. In the "New Comedy" of the fourth century—of which only one entire play, Menander's *Dyskolos*, survives—no choral odes were written; instead, the word "KHOROU" occurs between the acts. The play itself, like the tragedies and comedies before it, does refer to music and the performances of the aulete, which confirms that music was always part of Greek theater in one form or another.

MUSICAL INNOVATIONS OF THE PLAYWRIGHTS. Thanks to a comedy by Aristophanes called *Frogs*, it is possible to know a bit about how the poetry and music of the great tragedians of the fifth century B.C.E. was perceived by other artists. In the late fifth century, when *Frogs* was produced, the great playwrights Aeschylus, Sophocles, and Euripides were all deceased; in the play, the god Dionysus goes to the Underworld to fetch the best of the three back to earth. A contest is arranged, during which Aeschylus and Euripides ridicule each other's language, meter, and music. Euripides labels Aeschylus as repetitive and monotonous, while Aeschylus charges Euripides with employing the base songs of prostitutes, foreign music, laments, and dance-hall music. Aeschylus boasts that his musical style fits his lofty, heroic subject matter; Euripides brags that his realism makes the audience think. In the end of the play, Aeschylus wins the contest, but leaves his Underworld throne to Sophocles, whom Aristophanes chose not to mock (perhaps because he had only just died). In his comedy *Peace*, Aristophanes praised the songs of Sophocles, which contained a variety of modes and more complex rhythms than those of Aeschylus.

THE "MODERN" PLAYWRIGHTS. The most innovative poets of the classical tragedians were Euripides and Agathon. The music of Euripides was so popular abroad that it was said to have saved the lives of some Athenian sailors and prisoners of war: Plutarch related that when the Athenian forces were defeated at Syracuse by the Sicilians, their captors freed anyone who could sing any songs of Euripides. Unlike their predecessors, Euripides and Agathon employed the chromatic genus of scale, which resulted in more notes and a wider range.

a PRIMARY SOURCE *document*

SAVED FOR THE SAKE OF EURIPIDES' HYMNS

INTRODUCTION: One source for the popularity of Euripides' plays is an anecdote related by Plutarch (second century C.E.) in his biography of the Athenian commander Nicias, who had led a fateful military expedition against the city of Syracuse, Sicily, between 415–413 B.C.E. The Athenians were defeated by the Syracusans in 413; Nicias was killed, and the Athenian prisoners were held in a stone quarry; some of them survived, Plutarch said, by entertaining their Sicilian captors with snatches of Euripides.

Most of the Athenians perished in the stone quarries of disease and evil fare. … Some were also saved for the sake of Euripides. For the Sicilians, it would seem, more than any other Hellenes outside the home land, had a yearning fondness for his poetry. They were forever learning by hear the little specimens and morsels of It which visitors brought them from time to time, and imparting them to one another with fond delight. In the present case, at any rate, they say that many Athenians who reached home in safety greeted Euripides with affectionate hears, and recounted to him, some that they had been set free from slavery for rehearsing what they remembered of his works; and some that when they were roaming about after the final battle they had received food and drink for singing some of his choral hymns. Surely, then, one need not wonder at the story that the Caunians, when a vessel of theirs would have put in at the harbour of Syracuse to escape pursuit by pirates, were not admitted at first, but kept outside, until, on being asked if they knew any songs of Euripides, they declared that they did indeed, and were for this reason suffered to bring their vessel safely in.

SOURCE: *Plutarch's Lives*. Vol. III. Trans. Bernadette Perrin (Cambridge, Mass.: Harvard University Press, 1967): 307, 309.

Although other playwrights sometimes used women's ritual laments in their choral odes, no one made better use of this genre of song than Euripides. Almost every one of his plays contains a lament, considered to be one of the most powerful and effective of the performance genres. It is telling that of all the music composed by the major playwrights, only Euripides' survives, on two scraps of papyrus dating from the early third century B.C.E. The first comes from his play *Orestes*, originally

a PRIMARY SOURCE *document*

ORESTES

INTRODUCTION: One of the most famous of a group of musical fragments found written on mummy papyri is the so-called Vienna G 2315, which contains seven lines of a choral ode from the tragedy *Orestes* by Euripides. The myth of Orestes—the Argive prince who murdered his mother Clytemnestra to avenge the death of his father, King Agamemnon, whom Clytemnestra and her lover Aegisthus had killed—belonged to the Homeric tradition and was retold in several tragedies. The surviving fragment captures lines 338–344 of an ode sung by the chorus in the role of Argive maidens, who have seen Orestes, covered in his mother's blood, driven mad by the Furies, divine avengers of matricide. The chorus describes the horror of the murder and its aftermath. If this piece represents the actual music composed by Euripides over 100 years prior to the date of the papyrus (still an open question), it is among the earliest authentic examples of ancient Greek music. The center lines of text only are preserved; both vocal and instrumental notation are present, as well as rhythmic and time signs that reveal an expressive dochmiac beat (UUU–U–). The notes indicate the enharmonic or chromatic Lydian scale, mixed with one diatonic. If this fragment does not represent the actual music of Euripides, it is very much in his style: ancient writers remarked on Euripides' use of the chromatic genera of scale, his varied textual rhythms, reduplication of syllables, and repetition of words for emotional effect, all of which are present in the fragment.

Song from Euripides' *Orestes*

TEXT OF THE PAPYRUS VIENNA G2315 FROM EURIPIDES' *ORESTES*

⌊κατολοφυρομαι⌋ 339

]⊓̅ Ρ C Ρ̇ Φ Π [

1 ⌊κατολο⌋φυρομαι ˩ ματεροc⌊αιμαcαc⌋ 339–338

]Ζ̣ ι Ζ Ε Δ̣[

2 ⌊οcαναβ⌋α̣κ̣χ̣ευει ˩ ομεγα⌊cολβοcου⌋ 338–340

] ⊓̅ Ρ C ι̇ Ζ [

3 ⌊μονιμο⌋cεμβροτοιc ˩ ανα⌊δελαιφοc⌋ 340–341

] C Ρ ⊓̅ C Ρ ˩ Φ̇ C–[

4 ⌊ωωcτι⌋ c̣α̣κ̣ατουθ ο α⌊c⌋τινα⌊ξαcδαι⌋ 342

]Φ̇ Π Ρ ⊓̅ ?[

5 ⌊μωων⌋κατεκλυcεν ⌐⊐δ⌊εινων⌋ 343

] ι̇ Ζ [

6 ⌊πονωω⌋ν⌐ ⊏ι⌐⊐ ωωcποντ⌊ουουλα⌋ 343

] Ρ̣ Ċ Ρ Ζ ⊓̅ Φ [

7 ⌊βροιcολεθριοι⌋ ˩ ⌊cι̣ε̣ν̣κ⌊υμαcιν⌋ 344

[continued]

TRANSLATION FROM THE GREEK TEXT

...I grieve...

1 I grieve...your mother's blood
2 which drives you raving mad/Great prosperity
3–4 Is not secure among mortals/like a sail
4–5 of a swift, light, ship some divine power, shaking,
6 inundated by the terrible works of the sea
7 in furious destructive waves...

produced at the Great Dionysia in 408 B.C.E., and the second from *Iphigenia at Aulis*. Despite the fragmentary condition of the examples, it is possible to recognize Euripides' style: the use of chromatic lines, alteration of poetic meter, and reduplication of syllables. Agathon, the youngest of the playwrights, won his first competition in 416 B.C.E. when Euripides was sixty; he is credited with introducing new dithyrambic modes and the performance choral music that was not connected to the subject of the tragedy. The music of both Agathon and Euripides was influenced by "modern" tendencies toward multiple notes, complex scales, and modulation, their melodic complexity described as *anatretos* ("bored-through like an ant-hill"). The choral poet Melanippides of Melos, writing at the end of the fifth century, was considered a pioneer of "modern" music in his use of many-noted *anabolai*, instrumental preludes to a dithyrambic performance. By the fourth century, the *embolima* ("interlude") replaced the traditional choral ode in tragedy, as it did in comedy. The tragedian would no longer write his own choral odes as an integral part of the plot and action.

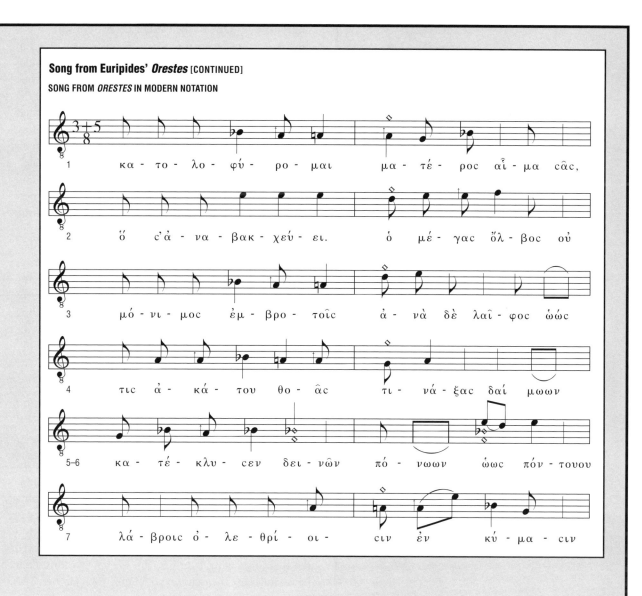

Song from Euripides' *Orestes* [CONTINUED]

SONG FROM *ORESTES* IN MODERN NOTATION

COMPETITIONS AFTER THE CLASSICAL PERIOD. Agathon was, for all points and purposes, the last of the great classical tragedians. From the fourth century forward, solo arias and "star performances" became the most popular, and the *tragodos*, a virtuoso performer, would sing and mime new material or selections from the great tragedies of the fifth century to instrumental accompaniment. Musical compositions were now being written down for professional use, and a few texts have survived (two of them being perhaps the fragments of Euripides mentioned above). More musical competitions were added to existing festivals, and the number of festivals increased, as inscriptions attest. In 279 B.C.E. a new festival called the *Soteria* was established at Delphi, in gratitude to Apollo "The Savior" for his divine help in defeating the Galatians, who had attacked Apollo's sanctuary there. Royal festivals were now held in Macedonia, northern Greece, and Alexandria, in Egypt. Professional guilds, established at the beginning of the fourth century B.C.E., were now sending their musicians, poets, and actors from all over Greece to these competitions. The rise of the virtuoso singer and instrumen-

a PRIMARY SOURCE document

PLATO ON MUSICAL INNOVATION

INTRODUCTION: In Plato's *Republic* Book Three, Socrates argues that certain types of *harmonia* (system of scales) and rhythms are more appropriate than others for lyric poetry and song; too much "sweet, soft, and plaintive tunes" will corrupt the soul and make men weak. He also warns against innovations in music that are "counter to the established order"; simple melodies and tunes are best for the purposes of moral education.

When someone gives music an opportunity to charm his soul with the flute and to pour those sweet, soft, and plaintive tunes we mentioned through his ear, as through a funnel, when he spends his whole life humming them and delighting in them, then, at first whatever spirit he has is softened just as iron is tempered, and from being hard and useless, it is made useful. But if he keeps at it unrelentingly and is beguiled by the music, after a time his spirit is melted and dissolved until it vanishes, and the very sinews of his soul are cut out and he becomes "a feeble warrior." ...

To put it briefly, those in charge must cling to education and see that it isn't corrupted without their noticing it, guarding it against everything. Above all, they must guard as carefully as they can against any innovation in music and poetry or in physical training that is counter to the established order.

SOURCE: Plato, *The Republic*. Trans. G. M. A. Grube (Indianapolis, Ind.: Hackett, 1992): 87, 89.

merrymaking. One of the earliest descriptions of a wedding march appears as a scene on Achilles' new shield in *Iliad* Book Eighteen; the bride is carried on a mule-drawn wagon through the town by torchlight while young men whirl and dance to the aulos and the phorminx, and the *hymenaeum* ("wedding song") rings loud. The *hymenaeum* was sung during the wedding proper; it was strophic, and often contained a refrain calling upon the god of marriage: "Hymen, Hymenaie!" The song wished the couple harmony, prosperity, and love. Another wedding song, the *epithalamion*, was performed by a group of unmarried men and women at the door of the wedding chamber. This bittersweet song signaled the transition from child to adult, virgin to married person. Some of the same themes and metaphors featured in the epithalamion—marriage as a journey, the danger of separation from parents—also appeared in funerary laments. In one of her many poignant wedding songs, Sappho of Lesbos wrote a dialogue between the bride and her virginity:

Bride: Maidenhood, maidenhood, where have you gone and left me?
Maidenhood: No more will I come back to you, no more will I come back.

FUNERALS. Funerary scenes depicted on vases from the ninth century B.C.E. forward indicate that large, public funerals were expected for important people, and music was an important element. For nine days mourning took place privately, in the house, but on the tenth day the public burial would occur. Whenever the body was conveyed to or from the house, the mourners followed the bier, displaying their grief by weeping, tearing their hair, scratching their faces, and rending their clothes. The most important public funeral rite was the lament, performed over the body by kinswomen and professional mourners. The two terms commonly used in literary texts for "ritual lament"—*threnos* and *goos*—both represented vocalizations that combined inarticulate cries with swaying movements and antiphonal poetic song, often described in tragedy and poetry as "un-lyred" and "un-danced" hymns, in reference to their sobriety. Vase-paintings show auletes performing at funerals, and later writers such as Josephus and Cicero refer to the hiring of up to ten professional auletes for large funerals. The *goos* may have been a more private, informal and extempore lament. In Homeric epic the word *threnos* was used for the formal laments by goddesses for dead heroes; it could also refer to the lament of professional mourners. In Athenian tragedy, the threnos was delivered during the *kommos*, an antiphonal song of lament between the actors and the chorus. The earliest literary lament occurs

talist was alarming to more than a few people. In the *Republic* and the *Laws*, Plato argued that the sound of complex rhythms and melodies are harmful to the soul, in the way that "new" musical styles over the years like jazz, rock, and most recently, hip-hop and rap music have been considered a threat to social harmony and stability. Plato and other writers complained that music with "too many notes" was vulgar and/or womanish.

WEDDINGS. While music was often used at very large social events, it was also used for smaller, personal purposes as well. A popular subject for painters, poets, and playwrights, the wedding was a time for paeans, choral song and dance, women's ululation, and music of the lyre and the pipe. The wedding procession of the bride to the groom's house was an occasion for grand

a PRIMARY SOURCE *document*

GRAVE STELE OF SEIKILOS

INTRODUCTION: A grave stele (tombstone) dating to the second century C.E. was unearthed in Tralleis, Turkey, during the building of a railway sometime in the late 1800s. The artifact was first published by Sir William Ramsay in 1883, but the public was largely unaware of the object until it was purchased by the National Museum in Copenhagen, and made public in a 1967 lecture by J. Raasted. It is now on display in the National Museum in Copenhagen. The column is inscribed with thirteen lines of Greek text, in-cluding an epitaph and an epigram with musical notation. After the little song, the owner signed his name "Seikilos, Son of Euter." The last line, "He lives," may indicate that Seikilos made the monument during his lifetime. Musical notation, in the diatonic Iastian *tonos* (scale) according to the tables of Alypius, is inscribed over the words to the epigram: one note for each syllable, with the exception of a few words that carry a short melisma of two or three notes over a syllable. The meter of the song is iambic dimeter, and rhythmical marks present above the vocal notation clarify the duration of notes. The well-balanced melody confirms patterns of composition described later by theorists Cleonides and Aristides Quintilianus.

Seikilos Funeral Epitaph

TEXT OF THE SEIKILOS FUNERAL EPITAPH

1 εικωνηλιθος
2 ειμι·τιθησιμε
3 σεικιλοσενθα
4 μνημησαθανατου
5 σημαπολυχρονιον

6 ο σονζηςφαινου
7 μηδενολωσςυ
8 λυπουπροσολι-
9 γονεστιτοζην
10 τοτελοσοχρο-
11 νοσαπαιτει

12 σεικιλοσευτερ(που)
13 ζη [

TRANSLATION FROM THE GREEK TEXT

Epitaph

1 I am a stone image.
2–3 Seikilos put me here
4–5 A mark of eternal remembrance for all time

Epigram with musical notation

6 "As long as you live, shine;
7–8 Do not be sad at all.
9 Life is for a little while;
10–11 Time demands its toll."

Signature

12 Seikilos, Son of Euterpes
13 He lives

SONG FROM THE SEIKILOS EPITAPH IN MODERN NOTATION

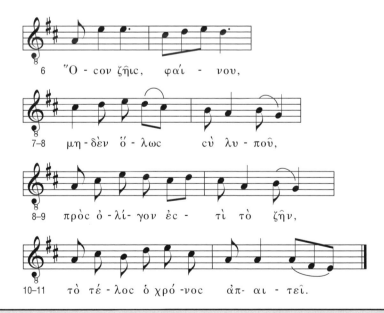

6 ῞Ο - σον ζῆις, φαί - νου,

7–8 μη - δὲν ὅ - λως σὺ λυ - ποῦ,

8–9 πρὸς ὀ - λί - γον ἐς - τὶ τὸ ζῆν,

10–11 τὸ τέ - λος ὁ χρό - νος ἀπ - αι - τεῖ.

Arts and Humanities Through the Eras: Ancient Greece and Rome (1200 B.C.E.–476 C.E.)

209

in Book Twenty-Four of the *Iliad*, when the Trojan prince Hector is mourned by three kinswomen: his mother Hecuba, wife Andromache, and sister-in-law Helen. No music or dancing is indicated, but the poetry of the laments is very powerful in using the discourse of grief to praise and to blame. So effective were laments in raising the level of emotion in the crowd that the sixth-century B.C.E. Athenian lawgiver Solon banned women's public performance of the threnos, and many fifth-century B.C.E. texts indicate that the practice of women's laments was perceived as politically threatening. Plato was adamantly opposed to women's public laments, calling them irrational feminine expressions of grief; in the *Laws*, he states that the ideal lawgiver would prohibit public outcries at funeral processions. In later periods, an epigram—a simple, often plaintive or melancholy verse—might be inscribed on the tombstone. The only surviving funerary epigram with musical notation was found inscribed on the grave monument of a certain Seikilos, dating to the first century C.E.

THE SYMPOSIUM. The *symposion* (literally a "drinking together") was an important social gathering for Athenian aristocrats from the fifth century B.C.E. forward. The party took place in the men's quarter of a private home; the wife and children remained upstairs. The guests, reclining on couches, ate, drank diluted wine out of large cups, conversed about silly or even serious matters, played games, and caroused. The entertainment was often provided by professional actors or singers and *hetairai*, high-class prostitutes who could sing, dance, and play the aulos. The guests themselves might play the lyre and sing their own renditions of well-studied lyric and elegiac poets of a century before: Alcaeus, Anacron, Stesichorus, Archilochus, and Theognis, to name but a few. *Skolia* ("drinking songs") were satirical ditties, freely constructed, sung under the influence of wine by any guest who was handed a myrtle branch in turn. The skolia of the poet Anacreon were quite popular; he was considered one of the best of the Ionian (East-Greek) poets of the late sixth century. Athenaeus, in his *Deipnosophistae* (second–third century C.E.), listed 25 skolia and discussed their style. The symposium was a popular subject for vase-painters, who filled their scenes with fantasy mixed with reality. In his *Symposium*, Plato staged a philosophic dialogue during a drinking party. In an unlikely scenario, the characters decided not to drink wine to excess and to let the piper go home so that they could have a serious philosophical discussion on the "Nature of Love." It might have been a boring night, had Socrates' friend Alcibiades not crashed the party and brought some raucous merriment to the evening.

SOURCES

Thomas J. Mathiesen, *Apollo's Lyre: Greek Music and Music Theory in Antiquity and the Middle Ages* (Lincoln: University of Nebraska Press, 1999).

A. Pickard-Cambridge, *Dithyramb, Tragedy and Comedy*. Rev. T. B. L. Webster. 2nd ed. (Oxford: Clarendon Press, 1962).

———, *Dramatic Festivals of Athens*. Rev. John Gould and D. M. Lewis. 2nd ed. (Oxford: Clarendon Press, 1968).

Martin West, *Ancient Greek Music* (Oxford: Clarendon Press, 1994).

Women's Life in Greece and Rome: A Source Book in Translation. Ed. and trans. Mary Lefkowitz and Maureen Fant. 2nd ed. (Baltimore, Md.: The Johns Hopkins University Press, 1992).

MUSIC EDUCATION

METHODS OF TRAINING. Formal music education is known in Athens from the beginning of the fifth century B.C.E. Before this, people interested in learning to sing or play an instrument could study informally under someone else, or even teach themselves. A professional bard would train a talented pupil in return for lodging, food, and clothes. Repertoire and technique were passed down orally and by rote; it is unlikely that there was any tradition of teaching pupils how to read music. The large choral groups, which performed at public festivals, did require organized training by a chorus-leader (*khoregos*), who may also have taught participants to read the poetry. From the seventh to sixth centuries B.C.E., there were active music centers at Sparta, where Alcman composed his *partheneia* (girls' choral dances), and on the island of Lesbos, where Sappho set up choruses for girls. In Sparta, part of a young boy's military training included learning how to dance and sing paeans while wearing armor.

SCHOOLS. Instruction in music and letters generally took place in the teacher's home, but professional music schools were established in the late eighth to seventh centuries B.C.E. by Terpander and Thaletas at Sparta. After the fourth century B.C.E., professional training was offered by a Guild or Academy school, where students from all over the Greek world would study choral and instrumental composition. Girls and boys both received an education, and some girls became professional musicians. Many vase-paintings from Athens depict a typical day in school, which included music, letters, mathematics, and physical education. A famous cup, painted by Douris in the early fifth century, illustrates this in particularly fine detail: a *kitharistes*

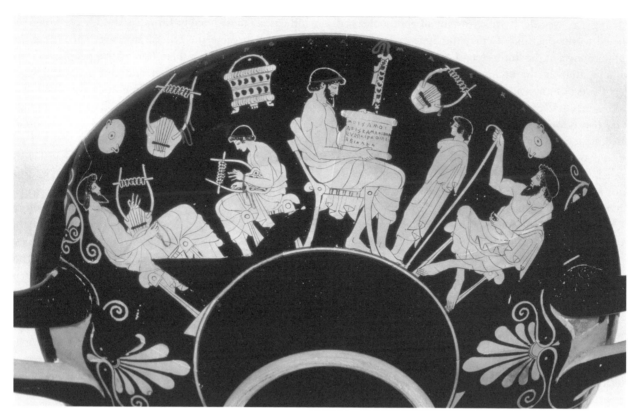

A red-figure kylix in Berlin by the Douris painter showing a music school. 5th century B.C.E. **ART RESOURCE.**

("lyre-teacher") is facing his student; both hold the *chelys* (tortoise-shell lyre). Other lyres hang on the wall above their heads. To their right, a seated *grammatistes* ("grammar-teacher") holds a scroll with verse written on it, which his pupil recites while standing stiffly at attention. A bearded *paidagogos*, a slave in charge of the boys, watches the lessons. On the other side of the cup, one student prepares to sing while his teacher plays the *aulos* (double-reed pipe); nearby, another teacher writes on a wax tablet for his pupil.

THE EFFECT OF MUSIC. Greek philosophers, theorists, and even the poets themselves generally agreed that music had a profound effect on a person's character, and for that reason the types of music taught in school should be carefully chosen. As a rule, simple traditional styles were preferred by educators—complex, foreign (not Greek), styles were not. The lyre, associated with Apollo and Orpheus, was favored over the pipe, which accompanied wild ecstatic worship of Dionysus. Homeric poetry or selections of tragic choral odes were preferable to other genres of songs. Pythagoras, a mathematician of the late sixth–early fifth centuries B.C.E., believed that sounds and rhythms, which are ordered by numbers, exemplified and corresponded to the harmony

of the cosmos. This is further explained through the Greek word for music theory, *harmonics*, which contains the Indo-European root -*ar*, meaning "to join, fit together, be in synchrony." According to Pythagoras, the consonances of a fourth, fifth, and octave were models of harmony. His inquiries into the science of sound and relative numbers began what would later be known as "acoustic theory."

ETHOS. The music teacher Damon, building on the ideas of Pythagoras a generation later, taught that each musical genre had its own character, or *ethos*, which affects human thought and behavior. For boys, rhythms and melodic forms should be chosen for their masculine qualities; girls should learn music that taught modesty and restraint. The chromatic genera of scales were considered effeminate, while the enharmonic promoted courage and manliness. Damon's focus on the ethical qualities of music in turn influenced those who followed, including Plato, Aristotle, and the Roman writer Varo. All of these writers exhibit a conservative desire to label, categorize, select, and even censor certain types of melodic forms. In the *Laws* and *Republic*, Plato considered only two *harmoniai* (modal scales) acceptable for the purposes of education: the Dorian and Phrygian. Aristotle was a bit more lenient, admitting that all types of music have

their place, even the baser sorts. Not all philosophers adhered to the doctrine of *ethos*; the Stoic and Epicurean philosophers of the third–second centuries B.C.E., for example, attacked the notion that music had any permanent effect on the soul. Philodemus, an Epicurean, wrote a treatise entitled *On Music* in which he argued that poetry had power, but music itself was simply pleasurable. Despite those who would contradict the Pythagorean notion that music was linked to cosmic harmony and therefore had the ability to influence the soul, the idea would not go away. After the first century C.E. the doctrine of ethos was adopted and adapted by Ptolemy and Aristides Quintilianus (third–fourth century C.E.), who supported earlier arguments that traditional, rational, masculine melodic forms must be used for education, but others could be used for different purposes.

GUILDS. Professional guilds of artists and musicians, known as the *Dionysou Technitai* (Artisans of Dionysus), were created in Athens and in Teos (north-west Asia Minor, now Turkey) by the beginning of the third century B.C.E. In his *Deipnosophistae*, the lexicographer Athenaeus included solo instrumentalists such as kitharists and auletes, as well as poets, actors, singers, and composers as members of guilds operating under a group of officers headed by a priest of Dionysus. They provided performers, directors, and composers for any occasion, and handled payment contracts. In this way, the *Dionysou Technitai* was comparable to a musician's union. Such guilds also functioned as schools offering training in singing, musical instrument instruction, and lessons in the writing of rhythm and melody. The guild schools may have kept a library of written compositions, but none have survived.

SOURCES

Giovanni Comotti, *Music in Greek and Roman Culture*. Trans. Rosaria V. Munson (Baltimore, Md.: The Johns Hopkins University Press, 1989, originally published in Italian, 1979).

John G. Landels, *Music in Ancient Greece and Rome* (London: Routlege, 1999).

Thomas J. Mathiesen, *Apollo's Lyre: Greek Music and Music Theory in Antiquity and the Middle Ages* (Lincoln: University of Nebraska Press, 1999).

Martin West, *Ancient Greek Music* (Oxford: Clarendon Press, 1994).

MUSIC IN ROMAN LIFE

PRODUCT OF MANY INFLUENCES. The surviving evidence indicates that Roman musical culture was not unique and new, but rather a product of many external influences, most notably Etruscan and Greek. Long before Latin became the official language, and Rome the seat of a great empire, there were native peoples in Italy who spoke their own—as yet undeciphered—languages and, no doubt, enjoyed their own musical traditions; virtually nothing is known about them. The Greeks interacted with many of these cultures and exerted a profound influence. Imported Greek pottery, some of which dates as early as 1000 B.C.E., has been found by archaeologists in the northern regions of Etruria, Latium, and Umbria, along the Tiber River in central Italy, and in Campania in the south. During the course of the eighth century B.C.E., Greeks emigrated in large numbers to southern Italy and Sicily, where they founded permanent colonies. Greek musicians, composers, actors, and poets who had been living and working in Italy eventually found their way to Rome, where their musical ideas, traditions, and practices were accepted by most, if not all the citizens. The native Italian traditions were not completely supplanted by the Greek, but they are not well understood; only a few fragments of early Latin *carmina* (songs, poems) from Rome and Latium survive; these were monodic or choral, and included ritual song (e.g. *Carmen Fratrum*), epic-historical poetry (*Carmen convivialia*)—which were accompanied by the *tibia* (the Latin version of the Greek *aulos*)—triumphal songs (*carmina triumphalia*), and funeral laments (*neniae*). The Romans enjoyed musical concerts, solo performances, and theatrical productions that were, for the most part, versions of Greek or native Italian genres. With few exceptions, the Romans adopted Etruscan, Near Eastern, and Greek lyres, double-reed pipes, and percussion instruments. In fact, after Rome conquered Greece and brought the entire country into the empire in the second half of the second century B.C.E., the pervasive Hellenizing (Greek) presence provoked some heavy criticism from Latin writers and even lawmakers; Juvenal and Cicero both condemned the excessive Hellenizing of Roman culture, and Roman censors issued edicts limiting the performances of Greek virtuosi and the use of Greek instruments.

THE ETRUSCAN HERITAGE. The Etruscans were a people who dominated the area of Etruria and Latium in northern Italy before Rome emerged as the central power. Archaeologists have discovered a large number of imported Greek vases in Etruscan tombs, proving that they had a thriving trade with the Greeks from at least the fifth century B.C.E., perhaps earlier. The fresco art in some of the tombs also indicates Greek influence. One grave, the so-called Tomb of the Leopards in Tarquinia, contains a fresco depicting two musicians. One plays the *tibia* (double-reed pipe) known in Greece as the *aulos*;

the other plays a lyre that resembles the Greek *chelys* (tortoise-shell lyre). Even after Roman rule was firmly established, the Etruscans had much influence on Roman religious practices and the music involved. Many, if not most, of the state musicians hired to play for Roman religious and other state festivals were Etruscans who belonged to a *collegium* ("artist guild") in Rome.

ETRUSCAN INSTRUMENTS. The Etruscans played instruments that were comparable to Greek versions, but also others which seem to be unique to them, and they paired instruments that were not played together in Greece. In a relief on a bronze Etruscan *situla* ("bucket") dating to the late sixth century B.C.E. a musician playing an unusual m-shaped harp (or lyre) is paired with a player of the *fistula* ("pan-pipes"); the two musicians, both wearing wide-brimmed hats, sit facing each other in a formal concert pose. In Greece, the pan-pipe (*syrinx*) was rather a pastoral instrument used primarily by shepherds or for outdoor revels. If an illustration on an Etruscan cinerary urn dating to the late second century B.C.E. can be trusted, the Etruscan *obliqua tibia* was a pipe that may have been played more like a flute than an oboe, comparable to the mysterious Greek *plagiaulos*. The player in the scene on the urn seems to hold the tibia horizontally out to his right like a modern flautist; the placement of his lips transversely across the mouthpiece on the top of the pipe and his cross-fingering of the holes suggests that the instrument was more like a flute than a reed. This type of pipe was shown in Roman art well past the third century C.E. Curved horns used by the Etruscans and later adopted by the Romans include the *lituus*, *bucina*, and *cornu*, and were more comparable to the Greek *tuba*, a straight trumpet, than the Greek *salpinx*. Both the salpinx and the tuba were referred to as "Etruscan" by Greek and Latin writers, but the Greek salpinx was almost exclusively a military instrument, whereas the Etruscans and Romans also played their trumpets and horns in concerts, sometimes in ensemble with the *tibia* ("pipe") and *kithara* ("lyre").

GREEK INFLUENCE. The Greek influence in Italy did not begin with the Etruscans in the north, but in the south, as early as the late eighth century B.C.E., when large numbers of Dorian Greeks moving west from the Peloponnese colonized southern Italy and eastern Sicily. Many Italian and Sicilian Greeks became very wealthy in their new land, especially those living in the Sicilian city of Syracuse. Unlike Athens, which by the fifth century B.C.E. had established a democracy, the political system of Syracuse was a type of monarchy called a "tyranny." These tyrants took power by force, but once established, they could be very generous to the Greek artisans, musicians, and poets whom they admired; the fifth-century B.C.E. Greek poet Pindar and playwright Aeschylus were among those who received lavish hospitality at the court of the tyrant Hieron in Syracuse. The largest cities in Italy and Sicily boasted open-air theaters comparable to the most majestic amphitheaters in Greece (such as Epidauros). Greek influence on Roman culture became more evident after the First Punic War, during the course of the third century B.C.E., when contact between the Roman people and the Greeks in southern Italy increased. Musical instruments that were popular in Greece—pipes, lyres, horns, rattles—were also played in Rome, albeit in different forms and combinations. The Romans imitated Greek literary and dramatic forms; they adopted and adapted Greek architecture. Wealthy Latins hired Greek teachers and doctors. Greek gods and heroes of myth received Latin names, but were worshipped in comparable ways. By the time the Roman army took Corinth in 146 B.C.E. and brought the whole country of Greece into their empire, the Roman people had already long been captured by Greek culture.

ROMAN THEATER. As in Greece, dramatic dance and song in ancient Italy were central to the various rites and rituals performed to appease or praise the gods. Many early dances were improvised, and accompanied by the tibia—the most popular wind instrument for dancers in both Italy and Greece. The Latin historian Livy related that in 364 B.C.E. Etruscan *ludiones* ("pantomimists") were called upon to save Rome from a plague by dancing to a special melody played by a *tibicen* ("piper"). The Romans adapted this Etruscan dance and added a rhythmically varied song; the new compositions were called *saturae* (satire). Scenes on vases from Apulia, a region on the coast of southern Italy, show that a popular form of entertainment in the Greek colonies in Italy after the mid-fourth century B.C.E. was the travelling troupe of tragic jesters called *phlyakes*, who performed satires and burlesque on a portable stage, with music provided by an *aulete* ("piper"). The Romans adopted Greek forms of epic, lyric, tragedy, and comedy, and music continued to play an important role, although very little is known about its melodies or characteristics. No musical compositions from Roman theater survive. In the third century, Roman theatrical productions favored revivals of fifth- and fourth-century B.C.E. Greek playwrights, especially Euripides, Aristophanes, and New Comedy writers Menander and Philemon; the first writer/composer with a Roman name—Livius Andronicus—was actually a Greek slave brought from Tarentum to Rome and later freed. His Latin successors included the playwrights Ennius, Plautus, Terence, and others, who flourished into the second

century B.C.E. These Roman writers translated Greek original plays into Latin, and enjoyed a good deal of poetic license, changing names, mixing scenes, and rearranging the plots in a technique known as *contaminatio;* they also sometimes turned spoken dialogue from the Greek original into song.

ROMAN COMEDY. The comedies of Plautus (250–184 B.C.E.) and Terence (a generation later) were among the most popular in Rome at least until the end of the first century B.C.E. Their plays, like those of their Greek predecessors Menander and Aristophanes, were full of ribald and often obscene humor. Male actors played all the parts—even the "girlfriends" in the bawdy love stories. Roman comedy featured the *canticum,* a scene enacted in sing-song manner to the accompaniment of the tibia which would alternate with the *deverbia* (recited portions). Choral song, which was so central to Greek tragedy, probably played less of a role in Roman theater; the orchestra space, used by the chorus in Greek theater as the dancing place, served as an area for reserved seating in Rome. Solo virtuosity was highly prized in Rome, and the tibicen often introduced a tragic or comic performance with an easily recognizable tune composed specifically for that show. The tibicen also interacted with the actors and the audience during a performance. Production data has survived that lists the names of actors, dates of production, and the name of the festivals, along with some information about the original music composed for the plays. Different kinds of tibia were assigned to each actor in a comedy: "equal pipes" were designated for the "Girl from Andros," while the character of "Phormio" required "unequal pipes" (possibly an octave apart).

OTHER THEATRICAL FORMS. After Terence and his generation of playwrights, comedy and tragedy became less prominent in Rome, but a new theater of Pompeii was opened in 55 B.C.E., and the old plays were performed during the Funeral Games for Julius Caesar after his assassination in 44 B.C.E. Mime and pantomime, developed from Etruscan forms, were popular in the Roman repertoire around the first century B.C.E.; the mime was a re-enactment of real or mythical stories performed using speech, dance, and movement, sometimes with the accompaniment of the tibia. Pantomimes might include choral and orchestral music using a variety of instruments: tibiae and other types of pipes, kitharae (lyres), cymbals, and a percussion instrument played with the foot called the *scabella.* Solo comic and tragic actors— *comoedi* and *tragoedi*—were in big demand; the comic Roscius and dramatic actor Aesopus were celebrities in Rome. Suetonius, the biographer of the first twelve Roman emperors, related that the cruel and perverted emperor Nero was, ironically, an accomplished *kitharode* who also performed in costume, on stage, along with the professional actors.

LATIN POETRY. While the verses of the famous first-century B.C.E. Latin poets Catullus and Horace contain many allusions to music and the musical instruments of the Greek poets, there is no evidence to suggest that Latin lyric was actually performed to the accompaniment of the lyre, as Greek lyric poetry was. Horace did compose a publicly performed poem in Sapphic meter for chorus, to be sung by two groups of 27 girls and boys. Commissioned by the emperor Augustus for the Centennial Games in 17 B.C.E., no evidence for the music survives. The Latin poet Vergil, working under the patronage of the emperor Augustus, composed the Roman national epic the *Aeneid* using the same meter as Homer— dactylic hexameter—and employing the themes of the *Iliad* and *Odyssey,* yet this poem was not sung, nor was it performed to the accompaniment of the lyre, as Homeric epic had been in the Archaic Period.

ROMAN FEMALE POETS AND MUSICIANS. With few exceptions, there were no Latin female poets comparable to Sappho or Nossis of Greece. Male poets, such as Propertius and Ovid, mentioned the names of Roman female writers in their works, but the actual poems of only one Latin woman—Sulpicia (31 B.C.E.–14 C.E.)— survive. Six of Sulpicia's elegies exist, totalling only forty lines. She was probably the niece of her patron, Marcus Valerius Messalla Corvinus, a historian who also supported other elegiac poets, including Ovid and Tibullus. Although Sulpicia used to good effect the stylistics common during the reign of Augustus—couplets, alliteration, and assonance—she did not allude to music in her poetry, and her poems were meant to be recited, not sung. Some Roman women studied music seriously from an early age, and made a name for themselves as professional dancers, singers, and *kitharists* (lyre-players); girls as young as nine or ten might perform in public, as Phoebe Vocontia did, in Rome. According to her tombstone (imperial period), Phoebe was an *emboliaria,* a performer during the interludes in the theater. "Learned in all the arts," she died at age twelve. Another inscription on a tomb dating to the imperial period reads: "To the gods of the dead. Gaius Cornelius Neritus made this for himself and for Auxesis the kitharist, the best wife." Female performers were paid a living wage for their craft. A papyrus from Philadelphia in Egypt dating to 206 C.E. records that a castanet-dancer by the name of Isidora was offered the following payment for a six-day wedding-gig at a gentleman's home: thirty-six drachmas per day, four

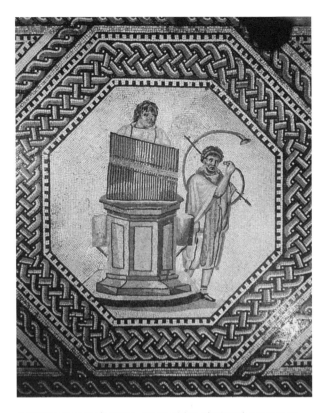

A Roman mosaic showing one musician playing the water organ and another playing the curved trumpet known as the "cornu." THE GRANGER COLLECTION.

a PRIMARY SOURCE *document*

DOMITIAN AND THE FESTIVAL FOR CAPITOLINE JUPITER

INTRODUCTION: According to the biographer Suetonius, Domitian, son of the emperor Vespasian, began his reign in 81 C.E. by promoting festivals and religious celebrations; he also erected many public buildings, including the Colosseum, where he staged spectacles; he may have been popular with the people, but the senate grew to despise him, and he was assassinated in 96 C.E.

Domitian presented many extravagant entertainments in the Colosseum and the Circus ... In honour of Capitoline Jupiter he founded a festival of music, horsemanship, and gymnastics, to be held every five years, and awarded far more prizes than is customary nowadays. The festival included Latin and Greek public-speaking contests, competitions for choral singing to the lyre and for lyre-playing alone, besides the usual solo singing to lyre accompaniment. ... When presiding at these functions he wore buskins, a purple Greek robe, and a gold crown engraved with the images of Jupiter, Juno, and Minerva.

SOURCE: Suetonius, *The Twelve Caesars*. Trans. Robert Graves (Harmondsworth, England: Penguin, 1978): 297–298.

artabas of grain, and twenty double loaves of bread. In addition, the writer offered to keep all her cloaks and gold jewelry safe, and to provide two donkeys for her round-trip journey. According to Roman law, the social status of actors and actresses was low, although female actresses were admired nonetheless. The actress Bassilla, called "the tenth Muse" by her admirers, "won fame in many towns and cities for her various accomplishments in plays, mimes, choruses, and dances," according to her third-century C.E. epitaph from the theater at Aquileia.

MUSIC AND THE EMPERORS. A rich and diverse musical climate existed in Rome during the imperial period; talented actors, instrumentalists, singers, and dancers poured into the city from all corners of the empire, including Egypt, Syria, and Spain. The emperors enjoyed musical entertainment while they dined, and many were fine musicians themselves. Theatrical performances in the amphitheaters were well-attended throughout the imperial period. During the time of Nero, the mechanical *syrinx* (water-organ) gained in popularity. This early pipe organ, said to have been invented in the third century B.C.E. by Ktesibios in Alexandria, Egypt, was loud; it was designed for use in Roman am-

phitheaters, where it could be heard in the back rows. A mosaic from a Roman villa in Germany dating to the third century C.E., shows a pipe-organ with about 29 pipes set upon an altar-shaped wooden base. Despite a lack of detail in the illustration, it appears that the instrument could have played a complete two-octave scale in several different keys. Nero, who spoke Greek and learned to play the kithara from a Greek virtuoso named Terpnos, instituted and participated in musical competitions. The emperor Vespasian hired Terpnos, another kitharode named Diodorus, and the tragoedus Apollinaris to perform at the reopening of the theater of Marcellus. Hadrian, a talented musician, was the patron of the Cretan kitharode Mesomedes; fourteen or fifteen poems by Mesomedes survive, several with musical notation. Large concert performances by choral groups and orchestras were a feature of both secular occasions and religious festivals. Horns such as the tuba, lituus, bucina, and cornu—normally used in the military—were played in ensembles. Rome was host to a number of foreign religious cults; the music associated with these contained

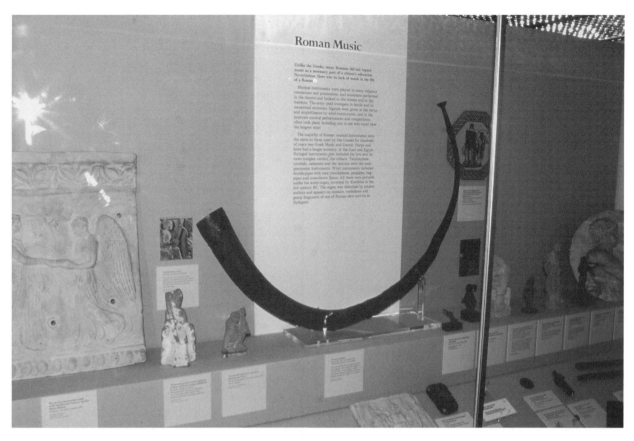

Roman cornu, a curved trumpet. PHOTOGRAPH BY HECTOR WILLIAMS. © HECTOR WILLIAMS.

foreign melodies. During the worship of Cybele and Bacchus, music of the Phrygian *elymoi* (reed pipes of unequal length, one of which featured a curved bell at the end) joined with melodies and dances from Egypt.

MILITARY MUSIC. As in Greece, military music played a central role in Roman life. A wide variety of wind instruments blared in marching bands and were used for signalling military maneuvers in battle: *kerata* (cow horns), the *salpinx* and *lituus* (ivory or bronze trumpets), *cornu* (circular horn), and *tuba* (brass tuba). The Etruscans employed these horns as early as the fourth century B.C.E., and they remained popular for more than 500 years—well into the late imperial period (fourth century C.E.). A bonafide *lituus* was found by archaeologists in the town of Caera (modern Cervetri) not too far from Rome. It consists of a 63 inch-long tube with no keys or valves; it would have been blown a bit like a bugle but had a lower tone. The *bucina* and *cornu*, originally cow horns but the latter crafted of bronze or other lightweight metal, curved around the player like a modern sousaphone. The *tuba*, a straight trumpet with a flared bell, had a higher and more striking tone than the *lituus*. Horns such as these, which were used by the Greeks ex-clusively as military instruments, were also played in concerts, at weddings, and in funeral processions by the Etruscans and Romans.

SOURCES

Giovanni Comotti, *Music in Greek and Roman Culture.* Trans. Rosaria V. Munson (Baltimore, Md.: The Johns Hopkins University Press, 1989, originally published in Italian, 1979).

John G. Landels, *Music in Ancient Greece and Rome* (London: Routlege, 1999).

Timothy Moore, "Music & Structure in Roman Comedy," in *American Journal of Philology* 119.2 (1998): 245–273.

Women's Life in Greece and Rome: A Source Book in Translation. Ed. and trans. Mary Lefkowitz and Maureen Fant. 2nd ed. (Baltimore, Md.: The Johns Hopkins University Press, 1992).

WOMEN IN ANCIENT MUSIC

WOMEN IN SOCIETY. Ancient Greece and Rome were patriarchal societies; men dominated the social and

political sphere. Women's lives were bound to the men in their families and to a system of government that denied women an equal voice in public life. The general rule that women should neither be seen nor heard was enforced into the Christian era and beyond. Most of what is known about Greek and Roman women in music comes not from the women themselves, but from the men who wrote about them, and the male artists who depicted them in vase- and wall-painting. Only if a woman gained enough of a reputation (good or bad) to warrant attention was her name made known. The family was considered the most important unit in ancient Greece and Rome, and women were the center of family life; they played an important role in family religion, and presided over all rites of passage from birth to death. The ceremonies connected with these rites gave women an opportunity to sing, dance, and play music in public. Women also participated in the large state religious festivals, and some became professional poets and musicians. Despite the scant evidence for women writers, poets, and musicians, there is enough to indicate that women did make names for themselves in music, while amateurs enjoyed playing for their own pleasure.

PARTICIPATION. In the Greek Bronze Age, Greek women must have sang and probably played instruments, but they are not represented doing so. Mycenaean art of the second millennium B.C.E. depicts only men playing the *phorminx* ("lyre") and the *aulos* ("double-reed pipe"). As a rule, men and women led separate lives in ancient Greece and Rome. Women normally stayed close to home and tended to domestic affairs, while the men spent time working at their profession or in the public gathering places of the city. Even the private homes were divided into male and female spaces. A vase from a grave in Italy shows a group of women dancing and playing a variety of instruments for each other in the privacy of their quarters. They also entertained each other and listened to music while working wool, baking bread, or nursing children. *Hetairai*, often highly educated and musically trained prostitute-musicians, entertained men at *symposia* (drinking parties). Some religious rites and ceremonies were open only to women, especially those connected with fertility, and evidence shows that both Greek and Roman women sang and played musical instruments during these rites.

INSTRUMENTS FOR WOMEN. Although both men and women could be professional musicians, certain instruments were thought to be more appropriate for one gender or the other. Since men marched in military parades and moved about more freely in public generally, the horns and the larger lyres were appropriate to them.

a PRIMARY SOURCE *document*

JUST ONE OF THE GIRLS

INTRODUCTION: In his *Life of Caesar*, the writer Plutarch (second century C.E.) related a humorous story in which a young man named Clodius tried to sneak into the women's sacred rite of the *Bona Dea* (Good Goddess—associated with Dionysus) by dressing as a female lyre-player.

Rome, 62 B.C.E.: Publius Clodius was in love with Julius Caesar's wife Pompeia, but a close watch was kept on the women's apartment, and Aurelia, Caesar's mother, made it difficult for the lovers to meet. During the festival of the 'Good Goddess', it is customary for the men to leave the house; the wife takes over and decorates for the festival. Most of the rites are celebrated at night, and with great amounts of festivity in the revels and music as well. The evening when Pompeia was celebrating this ritual, Clodius snuck into the house dressed like a young woman lyre-player. As he was walking around he met one of Aurelia's attendants, who asked him to play with her, as one woman might with another. When he refused, she dragged him before the others, asked who he was, and where he came from. His voice gave him away, and Aurelia, calling a halt to the rites, had Clodius thrown out of the house. Clodius was duly indicted by the senate for sacrilege, but later acquitted. Caesar immediately divorced Pompeia, saying that a wife of his "must be above suspicion."

SOURCE: Plutarch, *Life of Caesar*, in *Women's Life in Greece and Rome: A Sourcebook in Translation*. Eds. M. Lefkowitz and M. Fant (Baltimore, Md.: Johns Hopkins University Press, 1982): 292–293.

Women and girls played the smaller lyres, the harp, and the *aulos* (reed pipe). The wife of Ktesibios, the inventor of the organ, may have given concerts on it. *Hetairai* were hired to play the aulos and *chelys* (a type of lyre) at men's drinking parties, while *psaltriai* (literally "pluckers") played the harp at parties for women; certain melodies and instruments, such as the aulos, lute, and chelys, were associated with erotic love. The *barbitos* (another type of lyre), the *pektis* (a type of harp), and the Lydian harp were popular instruments for women, and after the fourth century B.C.E., the lute-like *trichordos* or *pandouros* appeared in the arms of women. The *tympanos* (drum), *kymbala* (cymbals), and other percussion instruments were most often played by female worshippers

of Dionysus, the Great Mother, and other deities connected to fertility and fecundity.

FEMALE POETS. It was the job of the *pythia*, priestess of Apollo at the Oracle in Delphi, to interpret the divine prophecy of Apollo for the pilgrim, and she did so by chanting the god's words in hexameter verse. While this chanting is not proper poetry, it is one indicator that women had a powerful poetic voice in ancient Greece, even though Homer's professional bards were men, not women. Between the sixth and the third centuries B.C.E., however, some of the most famous female poets and musicians make their entrance. None came from Athens, perhaps because women's lives were much more restricted there than in other places. All were highly educated and well-to-do. Sappho, born around 612 B.C.E. on the island of Lesbos, is the most famous of a group of women poets whose work survives: Korinna, Erinna, Nossis, and Anyte. Sappho's poetry was autobiographical, personal, and often erotic. She wrote passionately about the power of Aphrodite, the Muses, and the Graces. She was an innovative poet, setting the rhythms of her native Aeolic dialect of Greek to new melodies; her form of lyric monody (solo singing), which has been called by scholars the "Sapphic stanza," was meant to be sung to musical accompaniment. Sappho is depicted in vase-painting holding the *barbitos*, and she mentions lyre and harp-playing in her poetry. In addition to monody, Sappho also wrote compositions for choral performance. Fragments of her *partheneia* (maiden-songs) and *epithalamia* (wedding-songs) survive, albeit without musical notation. Her choral works were performed by separate groups of dancing young men and women. Admired not only by her contemporary male poets, but generations of poets coming after, Sappho was a vivid portrayer of women's emotions:

Once again that loosener of limbs, Love,
bittersweet and inescapable, crawling thing,
seizes me.

Very little is known about the other Greek women poets and only small fragments of their poems survive. The traveler Pausanias (second century C.E.) reported that Korinna of Boeotia beat Pindar—a very important male lyric poet of the fifth century B.C.E.—more than once in poetry competitions. Praxilla, another fifth century poet, was famous for her *scolia* ("drinking-songs"). Of Roman women poets almost nothing is known, despite the fact that in Rome women's social status was better than in Greece. Sulpicia (first century B.C.E.) was the only Latin female poet whose work survives to any degree, because it was included in a book of poems by Tibullus, a male friend.

TYPES OF MUSIC FOR WOMEN. In his *Republic* and *Laws*, the philosopher Plato prescribed different melodies and rhythms to men and women according to the nature of each gender. Specifically, men should make "masculine" music, and women, music that is "orderly and moderate." Plato and Aristotle wrote that both girls and boys should be taught *mousike*, the broad term for "music" that included song, dance, and instrument playing. Plato recommended three years of training on the lyre beginning at age thirteen. These philosophers insisted that there were two types of women musicians: respectable and shameful. In the fourth century B.C.E., education was more available to women than it had been in earlier times, and now a sharp distinction was made between the unsavory *hetairai* (prostitute-musicians) and other female musicians who had been taught by reputable music teachers from a very young age and were paid to perform concert music during public festivals. An inscription from 186 B.C.E. recognized Polygnota, a Theban, for her *kithara* performance and recitations during the Pythian Games in honor of the god Apollo at Delphi. It notes that she received a crown and 500 drachmas in payment. Roman female musicians also performed during religious festivals. In Rome and many parts of the Roman Empire, female musicians, singers, and dancers performed every November during the three-day festival of the goddess Isis, who had a temple in Rome despite being an Egyptian deity. The performance involved actors playing the parts of Isis and Nephthys in the mystery plays celebrating the death and resurrection of Osiris. In Roman Egypt, female entertainers were paid quite handsomely. A third-century C.E. papyrus from Philadelphia in Egypt contains a letter in which the services of three castanet-dancers were requested, presumably for a wedding feast. Payment was set at 36 drachmas per day, plus four artabas of grain and twenty double loaves of bread.

WOMEN'S RITUAL LAMENTS. In ancient Greece, women generally did not have a public platform in which to express their opinions and sentiments. Ritual lamentation—public mourning for the dead during a funeral—provided women a protected medium to address publicly issues of social importance. Ritual laments were performed by an inner circle of women close to the body of the deceased, and combined weeping and wailing with poetic song and stylized movement. During a ritual lament, women were free to say whatever they felt, no matter how explosive or threatening; in the epic poem the *Aeneid* by the Roman poet Vergil, the mother of a dead soldier criticizes the war so vehemently in her lament that the men are ordered to drag her away be-

HELEN'S RITUAL LAMENT

INTRODUCTION: The musically gifted tragic playwright Euripides was especially attracted to women's melodic forms, most notably the ritual lament. In his play *Helen*, produced in 412 B.C.E., Euripides captured vividly the power of the musicality of the lament form, with its antiphonal response ("songs to answer songs"), its melancholic sound ("lyre-less elegy"), and the combination of weeping with song ("choirs to sing with my wailings").

Helen: Stricken as I am with great griefs and troubles, what lament shall I find to rival them? Or to what music shall I turn, with tears or wailing or mourning? Aiai! Come Sirens, youthful winged maidens, virgin daughters of the earth, come to join my laments with the Libyan *lōtos* or the syrinx or the phorminx, with tears to accompany my sorrowful misfortunes. And may Persephone send griefs to answer griefs, songs to answer songs, choirs to sing with my wailings, all stained with blood, so that with my tears she may receive a paean for the dead, to grace the halls of night.

Chorus: On the twisted green grass by the dark blue water I was spreading clothes, purple with sea-dye, to dry upon shoots of reeds in the golden rays of the sun. There I heard the sound, when my mistress cried out pitifully, a lyre-less elegy, moaning with groans—for whatever reason it may be—like a woodland nymph uttering a nomos of flight in the mountains, with wails in the rocky hollows lamenting her coupling with Pan.

SOURCE: Euripides, *Helen*, in *Greek Musical Writings I: The Musician and His Art*. Ed. Andrew Barker (Cambridge: Cambridge University Press, 1984): 67–68.

physical and psychological pain. In Greek tragedy, ritual laments were often called "lyre-less" or "undanced" to illustrate their harsh discordance and lack of joy. Euripides, an accomplished composer and playwright of the fifth century B.C.E., often wrote laments into his plays. In his musical tragedy *Helen*, the queen of Sparta laments her role in the destruction of Troy, wishing that the Sirens could accompany her mourning with the Libyan harp, the syrinx, with lyres, and with tears of their own to match her own "suffering for suffering, care for care, antiphonal chorus to match" the lament (164–166). The so-called Berlin Papyrus (second or third century C.E.) preserves a notated fragment of a dramatic vocal lament on the death of the hero Ajax that appears to be set at the register of the female voice. Traditionally in Greek and Roman theater men played all the roles, but this fragment suggests that a female singer, perhaps playing the role of Ajax's grieving wife Tecmessa, performed the lament. The Dorian mode, the same melodic system used by the lyric poets, in love songs, and in paeans, was commonly used for formal laments.

SOURCES

Diane Rayor, *Sappho's Lyre: Archaic Lyric and Women Poets of Ancient Greece* (Berkeley and Los Angeles: University of California Press, 1991).

Jane McIntosh Snyder, *The Woman and the Lyre: Women Writers in Classical Greece and Rome* (Carbondale: Southern Illinois University Press, 1989).

Nancy Sultan, "Private Speech, Public Pain: The Power of Women's Laments in Ancient Greek Poetry and Tragedy," in *Rediscovering the Muses: Women's Musical Traditions*. Ed. Kimberly Marshall (Boston, Mass.: Northeastern University Press, 1993): 92–110.

Diane Touliatos, "The Traditional Role of Greek Women in Music from Antiquity to the End of the Byzantine Empire," in *Rediscovering the Muses: Women's Musical Traditions*. Ed. Kimberly Marshall (Boston, Mass.: Northeastern University Press, 1993): 111–123.

Women's Life in Greece and Rome: A Source Book in Translation. Ed. and trans. Mary Lefkowitz and Maureen Fant. 2nd ed. (Baltimore, Md.: The Johns Hopkins University Press, 1992).

fore she disheartens the troops. There were three categories of laments: the *threnos*, the *goos*, and the *kommos*. The *threnos* was a composed dirge performed, for example, by goddesses in Homeric epic and formal laments of a female chorus in Greek drama. The *goos*, a more frequent term, referred to the improvised discordant weeping performed by kinswomen and close friends of the deceased. The *kommos* was specific to tragedy. Aristotle in his *Poetics* defined the kommos as an antiphonal song of lament between an actor and the female chorus, which was one of the most visually compelling exhibitions of

MUSIC THEORY

OVERVIEW OF SOURCES. The study of ancient Greek and Roman music depends on a wide variety of sources: iconographic, literary, and archaeological. Musical scenes, depicted in vase-paintings and frescos, in sculptural decoration and figurines, and on coins and gems, provide one piece of the puzzle. An iconographic

a PRIMARY SOURCE *document*

CRITICIZING THE HARMONIKOI

INTRODUCTION: Aristoxenus criticized earlier authors, whom he called *Harmonikoi* (Harmonicists), for paying too much attention to mathematical ratios in their determination of scales and intervals; he argued that these should be judged by sense-perception. The trained ear, he claimed, detects the unique functional quality of sounds; in his view, the dynamic context of music must be judged empirically, not by measuring sizes of intervals or naming notes.

The essence and order of harmony depend not upon any of the properties of instruments ... neither the *auloi* nor any other instrument will supply a foundation for the principles of harmony. There is a certain marvellous order which belongs to the nature of harmony in general; in this order every instrument, to the best of its ability, participates under the direction of that faculty of sense-perception on which they, as well as everything else in music, finally depend. To suppose, because one sees day by day the finger-holes the same and the strings at the same tension, that one will find in these harmony with its permanence and eternally immutable order—this is sheer folly. For as there is no harmony in the strings save that which the cunning of the hand confers upon them, so is there none in the finger-holes save what has been introduced by the same agency. That no instrument is self-tuned, and that the harmonizing of it is the prerogative of the sense-perception is obvious, and requires no proof.

SOURCE: Aristoxenus, *The Harmonics of Aristoxenus.* Trans. H. S. Macran (Oxford: Clarendon, 1902): 187–198. Reprinted in *Source Readings in Music History: Antiquity and the Middle Ages.* Ed. Oliver Strunk (New York: W. W. Norton, 1965): 31–32.

sic played in society and culture. The archaeological discovery of actual musical compositions, carved into stone or written on papyrus manuscripts, and bonafide musical instruments recovered from excavated settlements and graves can confirm or contradict what has been deduced from written and iconographical sources. Finally, comparative studies of the musical traditions of other cultures that either influenced or were influenced by Greece and Rome have contributed much to the overall understanding of ancient Greek and Roman music.

WRITTEN SOURCES. The earliest written sources on music are descriptions of musical instruments, performances, and musical forms in the epics of Homer (eighth century B.C.E.); in the poetry of Sappho, Alcaeus, Alcman, Pindar, and others (seventh–fifth centuries B.C.E.); and in Athenian tragedy and comedy composed during the fifth century B.C.E. by Aeschylus, Sophocles, Euripides, and Aristophanes. Historians, mythographers, and scholars writing after the fifth century ascribed the invention of musical instruments and melodic forms to divinities or to innovative musicians, composers, and singers. During the late sixth–early fourth centuries, the philosophical schools of Pythagoras, Plato, and Aristotle were established; they influenced all later scientific and theoretical thought about music. The best application of Aristotelian science to music is the work of Aristoxenus. Born in Calabria, Italy, around 370 B.C.E., Aristoxenus studied in Athens with the Pythagorean school and was the star pupil of Aristotle. Aristoxenus is said to have written 453 essays on various subjects, but the majority of his writing has survived only in bits and pieces quoted by other authors. Two substantial theoretical works on music by Aristoxenus—*Harmonika* and *Rhythmika*—highly influenced later theorists. The mathematical approach to harmony of the Pythagoreans is best preserved in a fourth-century B.C.E. anonymous treatise sometimes (erroneously) attributed to Euclid, known as the *Sectio canonis* ("Division of the Kanon"). The title referred to the Pythagorean method of using a *kanon* ("ruler") to mathematically measure pitches of notes based on string length. The Alexandrian astronomer Claudius Ptolemy supported this approach to acoustics in his *Harmonika*. In the first century C.E., the Roman architect Vitruvius contributed to acoustical science by applying the principle of sound waves to the design of a theater auditorium. Vitruvius translated the *Harmonika* of Aristoxenus into Latin, apologizing to his readers for the lack of Latin equivalents for many of the Greek technical terms used in music theory. Much information about musical life is also found in many non-theoretical works: Athenaeus of Crete (c. 200 C.E.) wrote a dialogue on the Greek *sym-*

image may show the placement of a musician's hands or mouth on an instrument, and the number of strings on a lyre, or holes in a pipe; the relative size of an instrument and the material used to construct it may, in some cases, be reasonably determined by examining an image; a guess—but no more than that—can then be made regarding pitch, tone, and volume. Images may show which instruments are played in ensemble, by whom, and on what occasion. Ancient poets, historians, lexicographers, philosophers, and theorists—most of them Greek—add much more to modern understanding of the scientific principles of music and the role that mu-

posium called the *Deipnosophistai*, in which he named, described, and defined 25 *skolia* (drinking songs), along with their performance techniques; his contemporary, a lexicographer named Pollux, compiled technical terms, discussed the species of *aulos* (reed pipe) and types of horn (especially the *salpinx*), and described the Greek theater and structure of comedy in his lexicon, the *Onomasticon*.

ARISTOXENUS AND HIS FOLLOWERS. The *Harmonika* and *Rhythmika* of Aristoxenus were two of the most influential treatises on music. Especially important were his discussions and explanations of intervals, tetrachords, and the systems of *harmoniai*. He identified elements of melody and the three genera of tetrachord: diatonic, enharmonic, and chromatic. A number of important philosophical, theoretical, and historical works composed between the second and the fifth centuries C.E. restate and expand on the work of Aristoxenus, including Cleonides' *Harmonica introductio*, Ps.-Plutarch's *De musica*, Gaudentius' *Harmonika*, Alypius' *Introductio musica*, and Aristides Quintilianus' *De musica*. These works provide valuable explanations of the Greek musical system, including notation, melody, rhythm, scales, modulation, consonance and dissonance, and scientific problems of acoustics. Later, during the Byzantine Period (tenth–twelfth centuries C.E.), material on music based on the earlier work of Aristoxenus and Aristides was transmitted in manuscripts. One important such collection is the so-called *Anonymus Bellermanni*, published by F. Bellermann in 1841 C.E., which contains the sole surviving description of rhythmic notation.

SCALE AND TUNING. As early as the seventh century B.C.E. accomplished *kitharodes* and *aulodes* (musicians who sing while playing their instruments) were teaching others to play and sing; they must have developed a vocabulary of terms to explain technique, and demonstrated techniques on their instruments. Their students learned by imitation and practice. From the fifth century B.C.E. to the fourth century C.E. (and even later), the Greeks used the term *harmonikoi* to designate the teachers, scientists, and philosophers whom they considered knowledgeable about music theory; the study of the basic building blocks of music (notes, intervals, scales, genera, *tonoi*, modulation, melodic patterns) was known as "Harmonics." The word *harmonia* was originally used in Homeric poetry to mean "joint, connection," so the modern word "harmony" is literally a "fitting together" of notes. The earliest use of *harmonia* as a specific musical term occurs in a poetic fragment of Lasus of Hermione, an innovative *kitharode* (a singer-lyre-player) working as a professional composer in Athens in the late sixth–early fifth centuries B.C.E. The line reads: "I sing of Demeter

a PRIMARY SOURCE *document*

ARISTOTLE ON MUSIC

INTRODUCTION: In Books VII and VIII of the *Politics* Aristotle considered the construction of the ideal state with special focus on education and the arts. He argued Plato's notion that music is more than amusement; it affects the soul. Since young people (and mankind, generally) are encouraged to imitate what they see and hear, the character and quality of all melodies and musical styles must be carefully examined before they are selected for educational purposes.

There is the natural distinction between the modes, which cause different reactions in the hearers, who are not all moved in the same way with respect to each. For example, men are inclined to be mournful and solemn when they listen to that which is called Mixo-Lydian; but they are in a more relaxed frame of mind when they listen to others, for example the looser modes. A particularly equable feeling, midway between these, is produced, I think, only by the Dorian mode, while the Phrygian puts men into a frenzy of excitement.

...Music has indeed the power to induce a certain character of soul, and if it can do that, then clearly it must be applied to education, and the young must be educated in it.

SOURCE: Aristotle, *The Politics*. Trans. T. A. Sinclair (Harmondsworth, England: Penguin, 1981): 466.

and of Kore, wife of Klymenos, intoning the sweet hymn on the low-roaring Aeolian *harmonia*." By the time of Lasus, a *harmonia* came to represent an entire complex, including text, rhythm and meter, tuning, scale, and melody, associated with a specific geographical region: Aeolian, Phrygian, Dorian, Lydian, Ionian.

CHARACTER OF HARMONIAI. The precise nature of the regional (or tribal) harmonia is not known. Plato, in the *Republic*, defines the character of two varieties of the Lydian harmonia as "mournful," the Ionian and Lydian generally as "good for drinking parties," the Dorian as "manly," and the Phrygian as "inspiring enthusiasm." In the *Politics*, Aristotle—who was sometimes at odds with his teacher Plato on the character of the various *harmoniai*—agreed that the Dorian was the "most grave, and most suitable for education"; he described the Lydian as "suitable for young children," but was of the opinion

a PRIMARY SOURCE *document*

ALYPIAN NOTATION TABLES

INTRODUCTION: The musical notation used for the fifteen trans-
position scales, or *tonoi* (literally "position of the voice"),
are preserved in the notational tables included by the the-
orist Alypius in his *Introductio musicae* (fourth–fifth cen-

tury C.E.). It was his intention to represent the fifteen *tonoi*
extending over the range of three octaves and a tone,
complete with vocal and instrumental notation in each of
the three genera of scale: diatonic, chromatic, and en-
harmonic. In the composite table below, the ethnic names
of the *tonoi* are listed along the left side, in low and high
forms. At the top, are the names of the notes, and their
tetrachord position. The musical staff represents the con-
ventional approximation of the pitches in each scale.

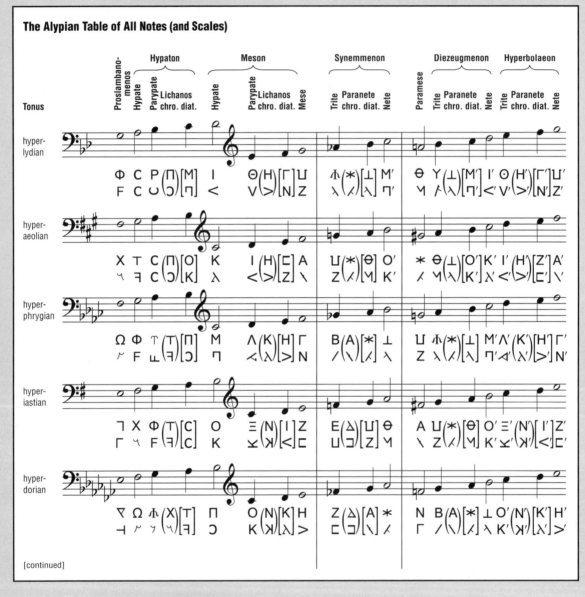

[continued]

that the Phrygian harmonia, played on the aulos during
the ecstatic worship of Dionysus, was too emotional for
use in school. Certain harmonia, such as the so-called
"tense Lydian," were more suitable for women, while the

"slack" Ionian and Lydian were softer and easier to sing.
The Greek poets sometimes expressed a preference for one
or the other of the harmonia. The fifth-century poet Pin-
dar praised the Dorian as being the most dignified, and

The Alypian Table of All Notes (and Scales) [CONTINUED]

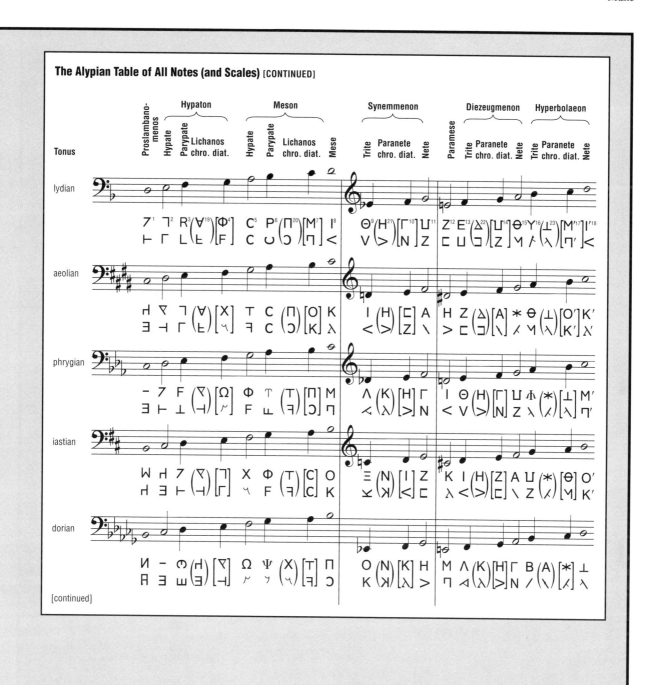

[continued]

used the Lydian in several of his *epinikian* odes (praising athletes). Composers of the *dithyramb* (choral dance), such as Alcman, employed the Phrygian. The Mixolydian and Dorian were used in tragedy. Perhaps the clearest de-

finition of the harmoniai is to be found in the third–fourth century C.E. work *De musica*, by theorist Aristides Quintilianus. He listed the notes of six *harmoniai*, adding that there were other tetrachordal divisions

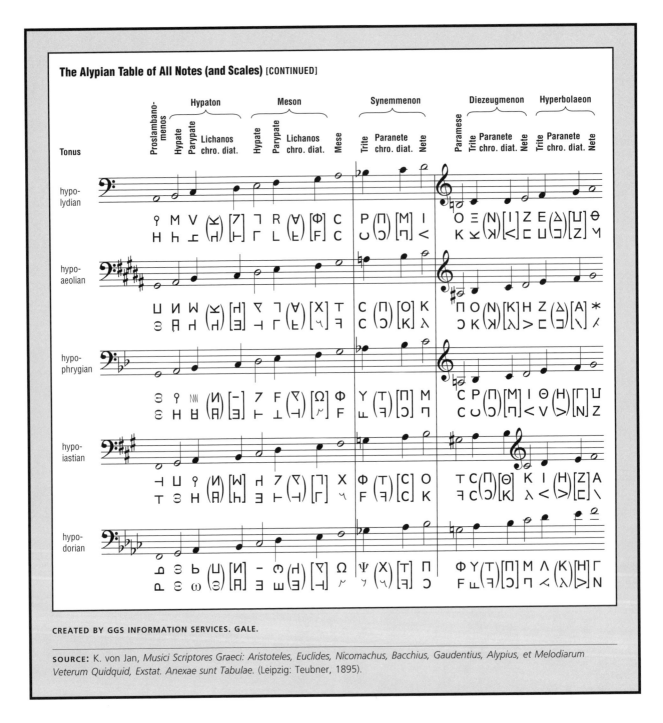

The Alypian Table of All Notes (and Scales) [CONTINUED]

CREATED BY GGS INFORMATION SERVICES. GALE.

SOURCE: K. von Jan, *Musici Scriptores Graeci: Aristoteles, Euclides, Nicomachus, Bacchius, Gaudentius, Alypius, et Melodiarum Veterum Quidquid, Exstat. Anexae sunt Tabulae.* (Leipzig: Teubner, 1895).

used by "the most ancient people" (likely referring to the fifth century B.C.E.): 'Tense' Lydian and Ionian (spanning less than an octave); Phrygian, Lydian, and Mixolydian (spanning an octave); and Dorian (spanning an octave and a tone). He explained that each of these harmoniai had its own particular set of intervallic relationships, forming the so-called "Octave Species."

THE PERFECT SYSTEMS. The tetrachord—four contiguous notes forming a perfect fourth—was the basic

building block of the ancient Greek musical scale. A connected series of conjunct or disjunct tetrachords formed the so-called *systema teleion* ("perfect system"), first mentioned by Aristoxenus, but defined and explained in the handbooks of Aristides Quintilianus, Cleonides, and other theorists. A conjunct tetrachord is formed when the last note of one tetrachord coincides with the first note of the next; disjunction occurs when two tetrachords are separated by the interval of a tone. Two conjunct tetrachords constitute the *heptachordon* (seven-note system).

Since a fourth plus a tone equalled a fifth, a pair of disjunct tetrachords was, in effect, a fourth and a fifth, making up an octave. A pair of conjunct tetrachords, with an additional tone at either top or bottom, likewise made up an octave (a fourth plus a fifth, or vice versa). The steps within the tetrachords were all either larger or smaller than a tone. The names of the eight notes of the octave refer to the seven strings on the lyre, plus one—the lowest—added later: *hypate* ("the principal") was the farthest from the player's body, *parhypate* ("next to *hypate*"), *lichanos* ("touched by the index finger"), *mese* (the "middle"), *paramese* ("next to *mese*"), *trite* (the "third" from the highest), *paranete* ("next to *nete*"), and *nete* (the "last").

THE GREATER AND LESSER PERFECT SYSTEMS.

Two "perfect systems" were described by the theorists. According to Aristides, the *systema teleion elatton* ("lesser perfect system") consisted of three conjunct tetrachords plus the *proslambanomenos*, an "added lowest tone" before the *hypate*. Four conjunct tetrachords separated by a tone of disjunction, plus the *proslambanomenos*, constituted the *systema teleion meizon* ("greater perfect system"). Played together in succession, the two perfect systems were called the *systema teleion ametabolon* ("perfect immutable system"). Despite a number of theoretical treatises and handbooks that describe and explain the theory of these systems, their application in performance and the sound of the music resulting from their use remains unclear.

TRANSPOSITION KEYS.

Aristoxenus used the terms *tonoi* to refer to "positions of the voice." Later, Cleonides defined *tonos* or *tropos* as note, an interval, a position of the voice, and pitch. Difficulties arise because writers did not always distinguish *tonos* from *harmonia*; Aristoxenus said that the *harmonikoi* were already associating the "octave-species" with the *harmoniai*, and Ptolemy applied the term *tonoi* to the "octave species," which were explained as "transposition keys" used to solve the problem of different vocal ranges in choral groups. Cleonides attributed thirteen tonoi to Aristoxenus; Aristides Quintilianus observed that the "younger theorists" added two additional *tonoi*, for a total of fifteen, which were preserved in the notational tables of Alypius. The *tonoi* were manifested in three genera: diatonic, chromatic, and enharmonic; each *tonos* began on a pitch that was a semitone apart from the next, and was built using a series of tetrachords (four contiguous notes forming a perfect fourth). The five middle *tonoi* carried the same regional names as the *harmoniai*: Lydian, Aeolian, Phrygian, Iastian, and Dorian. The highest five tonoi carried the prefix *hyper* (e.g. Hyperlydian), the five lower, *hypo* (e.g. Hypodorian).

METER AND RHYTHM.

In English, meter (or accentuation) is determined by the stress placed on a syllable. In the tongue-twister "Péter píper pícked a péck of píckled péppers" correct pronunciation requires that the stress be placed on the first syllable of every word; this stress dictates the rhythm of the line, and any deviation would ruin the beat. Ancient Greek meter was not based on stress, but on pitch; a rise in the musical pitch of the voice determined the meter. Ancient scholars devised a system of written accents to explain the pronunciation: the *oxytone* ("acute") accent signified the raising of a pitch, the *barytone* ("grave") marked a lowered or canceled pitch (used exclusively at the end of a word), and the *perispomenon* ("circumflex") indicated a combination of up and down pitches on one syllable. The metrical patterns of Greek and Latin song and speech were based on long and short syllables. The ancient metricians explained that the value of one long syllable (–) equaled two shorts (∪ ∪). In many poetic meters these two quantities were interchangeable. Aristotle, Aristoxenus, and other writers on rhythm assigned proportional ratios of long and short syllables to each unit (called a "foot"): – ∪ ∪ (dactyl) = 1:1; – – (spondee) = 1:1; ∪ – (iambus) = 1:2; – ∪ ∪ ∪ (paeon) = 2:3; and so forth. The 2:1 ratio predominated, and variations were few. Time was kept by tapping the foot: "up" or "lift" was denoted by the word *arsis*, while "down" or "step" was called *thesis*. Each measure (or "foot") of poetry was divided into "up" and "down" segments. Ancient songwriters were bound to the metrical types available to them, and until the middle of the fifth century, the meter simply dictated the rhythm of the verse. From the time of Timotheus of Miletus (c. 450–360 B.C.E.) was the elegiac couplet, a stanza composed of a dactylic hexameter followed by – ∪∪ – ∪∪ – | – ∪∪ – ∪∪ – ‖. Iambic (∪ –) was generally combined into the so-called metron ∪ – ∪ – seen in many variants. A common pattern was the iambic trimeter ∪ – ∪ – ∪ – ∪ – ∪ – ∪ –; the first iambic formed the thesis (down-beat), and the second, the arsis (up-beat). Many variations on this rhythm existed, and it was popular in spoken verse as well as lyric poetry, tragedy, and comedy. If the first two note-values of the metron were transposed (– ∪∪–), a so-called choriamb was created. The opposite of iambic is the "tripping" rhythm trochaic (– ∪ – ∪) which, when played in sequence, always ended its metron with a rest (– ∪ – ×). The paeonic rhythms (– ∪– or – ∪∪∪ or ∪∪∪∪∪)—also called Cretic—played in quintuple time, were used in serious hymns and war chants, as well as light music of dances; they were favored by certain lyric poets and tragedians. The comic playwright Aristophanes frequently employed the paeonic, which could be alternated

with trochaic meters. Among the fragments of ancient Greek musical compositions that survive, two Delphic paeans dating to the second century B.C.E. reveal extensive musical notation almost entirely in paeonic rhythm. The latest extant example of the use of paeonic rhythm is a poem by the composer Mesomedes (patronized by the emperor Hadrian), which shows three new ways of combining the longs and shorts. Thus, the paeonic rhythm evolved from two variants in the seventh century B.C.E. to seven by the second century C.E. The five-syllable Dochmiac (∪– – ∪–) was a diverse and irregular patterned rhythm, and may have been a combination of iambic, anapestic, and paeonic forms. There is no evidence of its use before the fifth century, but it was popular in tragedy, especially in highly charged scenes in Euripides' plays, where it comprised long strings of many short notes in succession. The Ionic rhythm (∪∪— ∪∪—), first used by the lyric poets Sappho and Alcaeus of Lesbos in the sixth century B.C.E., continued to be popular in all song genres from the tragic chorus to hymns and love songs. Many variations of this rhythm were possible. The so-called Aeolic meter was commonly used by Sappho and Alcaeus, and by other poets between the sixth–fourth centuries B.C.E. This rhythm is characterized by the coexistence of single and paired short notes beginning with a free or undefined series of shorts or longs: the most common was ×× – ∪ ∪ – ∪ –.

MELODY. A thorough treatment by Aristoxenus on melody has not survived, but in his *Harmonika*, he made a distinction between the melody of speech and that of music; melodic speech was based on word-accents, while musical melody moved by definite intervals of greater pitch variation. Very early traditional vocal melodies were simple, constrained by the pattern of long and short syllables in the meter of the verse, and the small number of strings on the lyre or holes in the pipe. Modulation (moving from one key to another) and heterophony (when strings of the lyre sound one melody while the singer sings another) were not commonly practiced. This began to change in the seventh century B.C.E., when poets, such as Archilochus, introduced the combination of differing genera of rhythms, the mixture of spoken text with instrumental accompaniment and singing, and an instrumental accompaniment that did not follow the melodic line in unison. By the middle of the fifth century B.C.E., virtuoso composers and performers expanded and modified their instruments and performance techniques: more strings were added to the lyre, vocal range widened, and use of the chromatic genus of scale added more notes. Melodic ornamentation and melisma (two or more notes sung to a single syllable) occurred on important words

(like the names of mythical gods or heroes), and words of songs no longer matched the melody note-for-note. In the *Laws*, Plato criticized both melodic and rhythmic heterophony as too complex and unsettling to be used in music education. Some Latin writers, such as Cicero, also maligned the melodic complexity of "modern" music, and pined for the old, simple tunes of yore. Nevertheless, the florid style continued to be popular throughout the Roman period, as musical compositions preserved on papyri from the second and third centuries C.E. attest.

FORM OF MELODY. Aristides Quintilianus wrote that before a lyre-player began a song, he would select a register of the voice, decide upon the structure of the scale, the genus, and the key, and consider the style of melody. Two terms were used for "melody, song, composition" in Greek: *melos* and *nomos*. The Greeks defined *melos* simply as "tune," but more completely as an art form that comprised notes, melody, rhythm, and text. The term *nomos* (law, custom) was used by poets generally to label a type of song or melodic composition—from the song of birds to the songs in a musician's repertoire. Professional musicians and theorists used the term *nomos* more narrowly to identify: (1) a specific melody used for an occasion (e.g. a sacrifice or a funeral); (2) a composition for the kithara (lyre) or aulos (reed pipe); (3) a song for a divinity; (4) a type of ethnic song or melody (e.g. Aeolian); (5) a song named for a composer (e.g. Terpandrean); or, (6) a class of song-types, such as lullaby, choral song, etc. The oldest *nomos*, the so-called *kitharodikos*, was a solo song for the lyre-player, said to have been invented by Terpander in the seventh century B.C.E. One of the more famous was the instrumental *nomos Pythikos* ("Pythic Composition") composed for the aulos in the early sixth century, either by Timosthenes or Sacadas; the first-century C.E. writer Strabo described this piece as a *melos* which narrated the mythic battle between Apollo and the serpent Pytho in five distinct parts, or movements. The composition itself does not survive, but according to Strabo it was performed by an orchestra of winds and lyres, each movement employing a different type of melody and rhythm to illustrate the story through music.

ACOUSTICS. The science of acoustics began in the late sixth century B.C.E. with Pythagoras and his followers. They developed mathematical theories about the laws and principles governing the universe, and extended those to music and the concept of the soul. The primary interests of the Pythagoreans were metaphysical and cosmological, but they were intrigued by the problem of defining musical pitch and the relationship between intervals, which they tried to gauge using a monochord—a single string stretched over a board—and other devices.

The Pythagoreans held that there was a mathematical relationship between lengths of vibrating string and harmonious sounds, which could be measured using a ruler. According to ancient theorists, the first to apply mathematical principles to musical sound were Hippasus of Metapontum, a Pythagorean, or his contemporary, Lasus of Hermione, a virtuoso kitharode, instructor of dithyrambic choruses, and theorist. They were said to have discovered the 2:1 ratio between two sounds at the interval of the octave, 3:2 between interval of the fifth, and 4:3 between the interval of a fourth; Hippasus demonstrated this phenomenon using bronze discs of equal diameter, but different thicknesses, while Lasus, filling vessels with different amounts of liquid, struck them. The consonances of a fourth, fifth, and octave became models of *harmonia*, the "fitting together" of two sounds. A contemporary of Plato, the eminent Pythagorean mathematician Archytas (most of whose own work is lost), noted that a sound can only be produced by an impact of two bodies in motion. Sound, he said, was always created this way, but it was not always audible. He explained that the differences of pitch between sounds depended on the force and speed of the impact. Archytas divided the tetrachord system into harmonic ratios in an attempt to determine which numbers are concordant and why. Another work that is reminiscent of Archytas' acoustic theory, but goes further, is a short anonymous treatise called the *Sectio canonis* ("Division of the Monochord"), sometimes erroneously attributed to Euclid. The author of this treatise adds to Archytas' idea that force and speed determine pitch by supposing that some movements are more closely-packed, causing notes of higher pitch, while other notes are more widely spaced, creating notes of lower pitch. The quantification of pitch is perhaps the most advanced of the Pythagorean contributions to acoustic theory. No school of thought on acoustics was beyond criticism, however. Aristotle's pupil Aristoxenus (fourth century B.C.E.), whose interest in music was more philosophical than scientific, claimed that mathematical calculation of the relationship between sounds and the measure of intervals was not sufficient to explain musical phenomena or to indicate the characteristics of musical composition. He emphasized in his *Harmonika* that in order to understand music, the listener needs ear, intellect, and memory; for him, sense perception was vital to judging dynamic musical phenomena. Claudius Ptolemy (second century C.E.), who clearly inclined towards Pythagorean mathematics in his explanations, examined critically both the Pythagorean and Aristoxenian definitions of tuning systems, sound, pitch, and consonance in his *Harmonika*, noting the strengths and weaknesses of each approach. One of antiquity's finest astronomers, Ptolemy took a scientific approach to the study of music, and held—as did the Pythagoreans—that the principles of harmonic order were mathematical. The Romans, who were ambitious construction engineers, were aided by the application of Greek acoustic theory in the design of their theater auditoria. Vitruvius, a late first-century B.C.E. Roman architect who translated the work of the Greek theorists into Latin, showed an impressive understanding of acoustics when he described a system of resonators that would improve the sound quality in the small and large theater auditorium. He also discussed the importance of using the right materials: wooden structures resonated sound waves more readily than marble or concrete, which did not vibrate in sympathy; he therefore recommended that bronze jars be added to stone-built auditora to improve the acoustics.

MUSICAL NOTATION. The system of musical notation that was standard for professional use by the mid-third century B.C.E. and seen in all the extant compositions from the earliest (third century B.C.E.) to the latest (third century C.E.) is best represented in the tables of Alypius (fourth–fifth centuries C.E.). He originally mapped each of the fifteen *tonoi* (transposition keys or modes) over three octaves and a tone and in three genera—diatonic, chromatic, and enharmonic—showing the separate and distinct alphabetic symbols used for vocal (*leksis*) and instrumental (*krousis*) music. The enharmonic tables are incomplete, and essentially duplicate the chromatic symbols. Vocal notation employed the 24 letters of the standard Ionic Greek alphabet, with some letters altered and inverted. In the fragments the notation always appears above the text. Instrumental notation matched or was derived from letters in sixth–fifth century B.C.E. local Greek scripts, and appears to have been in use before vocal notation. Some rhythmic values were defined using additional signs; the sole surviving description of rhythmic notation, found in the Byzantine *Anonymus Bellermanni* treatise, includes five types of signs: duration, ligation, articulation, division, and rest. Aristoxenus mentioned the existence of musical and metrical notation in his *Harmonika*, but scoffs at its use. He remarked that simply having the ability to notate a meter or melody did not prove a person's ability to understand its nature. Aristoxenus insisted that notation could not be the goal of harmonic science, and evidence shows that the tradition of music in ancient Greece and Rome remained oral, not written, regardless of the existence of a notational system.

THE MUSICAL DOCUMENTS. Music in ancient Greece and Rome was an oral tradition; songs, melodies,



and even complex compositions were learned by ear. Aristoxenus believed that notation was unimportant, and went so far as to dismiss it as useless for the understanding of music. Although a system of notation was well-established by the third century B.C.E., it was used only by a handful of professionals for a very long time; the Roman orator Quintilian (first century C.E.) omitted notation from his list of recommended readings for music education. Yet, a number of notated compositions survive in medieval manuscripts, papyri, and in stone inscriptions. Although a few pieces were already known and transcribed in the sixteenth century, most of the surviving music was not known or studied prior to the nineteenth century. Today, a respectable corpus of approximately sixty genuine fragments has so far been compiled; newly discovered notated pieces are being published on a regular basis. In the most recent century, a number of papyri have been recovered from mummy cartonnage dating to the Ptolemaic period in Egypt (third–second century B.C.E.) that contain snatches of notated music. The extant collection of fragments, which date from the fifth century B.C.E. to the fourth century C.E., is conveniently transcribed and explained (but not translated) in the *Documents of Ancient Greek Music,* edited by Egert Pöhlmann and Martin L. West. The corpus contains four fragments from the classical period (480–323 B.C.E.), fifteen of the late classical to early Hellenistic periods, three Late Hellenistic inscriptions from sanctuaries, and 39 fragments from the Roman period.

TYPES OF DOCUMENTS. Numerous different types of documents exist that show modern scholars different facets of the musical world. From the fifth century B.C.E., examples include a broken clay knee-guard for sewing, located in the Eleusis Museum, which was decorated with a painting of Amazons, one of whom was blowing a trumpet (Greek letters were painted between her body and the trumpet to imitate the sound of the trumpet-call.); remarks on the melody of Euripides, with an example from his tragedy *Orestes,* in the work *De compositione verborum* by Dionysius of Halicarnassus; and two papyrus fragments with notated music of Euripides' *Orestes* and *Iphigeneia in Aulis.* Late fifth century–third century B.C.E. compositions include fragments on papyri of unknown tragedy, and a hexameter hymn inscribed in stone discovered in the precinct of the healing god Asclepius at Epidauros. Examples from the second century B.C.E. include two substantial paeans (to Athenaios and Limenios), inscribed on the south outer wall to the Athenian Treasury at Delphi, and the so-called "Hymn to the Carian god Sinuri" in two block fragments, published in 1945 C.E., but now missing. The last, and largest, group of extant musical documents comes from the Roman period: the grave stele of

Seikilos; several compositions by the emperor Hadrian's court musician Mesomedes of Crete; six Lydian instrumental pieces; a number of excerpts from tragedies and other hymns or paeans, lyric, and instrumental pieces of unknown origin; a selection from Menander's comedy *Perikeiromene* with some curious notation; and a Christian hymn to the Trinity, written around the end of the third century C.E. on the back of a list of grain deliveries from the first half of the century. Two examples of notated music provide a general idea of the type of fragments available for study in the collection: seven lines from the tragedy *Orestes* by Euripides (presented on a papyrus of the third century B.C.E.); and an epigram on the grave stele of Seikilos (second century C.E.).

SOURCES

Andrew Barker, ed., *Greek Musical Writings* (Cambridge: Cambridge University Press, 1984–1989).

Giovanni Comotti, *Music in Greek and Roman Culture.* Trans. Rosaria V. Munson (Baltimore, Md.: The Johns Hopkins University Press, 1989, originally published in Italian, 1979).

A. M. Devine and L. D. Stephens, *The Prosody of Greek Speech* (New York: Oxford, 1994).

Documents of Ancient Greek Music. Ed. and transcribed with commentary by Egert Pöhlmann and Martin L. West (Oxford: Clarendon Press, 2001).

John G. Landels, *Music in Ancient Greece and Rome* (London: Routlege, 1999).

Thomas J. Mathiesen, *Apollo's Lyre: Greek Music and Music Theory in Antiquity and the Middle Ages* (Lincoln: University of Nebraska Press, 1999).

———, "Greek Music Theory," in *The Cambridge History of Western Music Theory.* Ed. Thomas Christensen (Cambridge: Cambridge University Press, 2002): 109–135.

Martin West, *Ancient Greek Music* (Oxford: Clarendon Press, 1994).

SIGNIFICANT PEOPLE
in Music

ARISTOXENUS
c. 370 B.C.E.–c. 304 B.C.E.

Philosopher
Music theorist

MOST IMPORTANT FIGURE IN MUSIC THEORY. Known in antiquity as *o mousikos* ("the Musician"), Aris-

toxenus was born in Calabria, at Tarentum, Italy, around 370 B.C.E., and died in Athens around 304 B.C.E. He was the son of Mnesias, a musician from Tarentum, and studied music first with his father, and later with Lamprus of Erythrai in Mantineia, and the Pythagorean philosopher Xenophilus of Chalkis. Finally, he came to the Lyceum in Athens, and became a star pupil of Aristotle. According to the Byzantine lexicographer Suda, Aristoxenus was expecting to be named Aristotle's successor at the Lyceum, and was angry when his colleague Theophrastus was chosen instead. A prolific writer, Aristoxenus was said to have produced 453 essays and books on music, philosophy, history, and education. Unfortunately, nearly all of his works are lost, though some useful fragments are preserved in Plutarch, Athenaeus, and others.

THEORIES. Details of Aristoxenus' theoretical explanations of intervals, tetrachords, and the *sustema* (systems) of scales are found in the later works of Cleonides, Aristides Quintilianus, Gaudentius, and Bacchius. The Roman architect Vitruvius translated his works into Latin. The two most substantial and influential of Aristoxenus' books on music are *Harmonika stoikheia* (Harmonic Elements) and *Rhythmika stoikheia* (Elements of Rhythm). His explanation of *tonoi* (keys) influenced all later thought; he taught that all melodic scales are constructed of tetrachords (four contiguous notes forming a perfect fourth), which are either conjunct or disjunct, and if disjunct separated by a tone. His primary interest was to account for every kind of modulation, which he determined constituted a note, interval, or tetrachord common to two keys. He regarded the fourth and the fifth, not the octave, as the primary intervallic or scalar components of music and music theory.

SOURCES

Andrew Barker, ed., *Greek Musical Writings* (Cambridge: Cambridge University Press, 1984–1989).

Thomas J. Mathiesen, *Apollo's Lyre: Greek Music and Music Theory in Antiquity and the Middle Ages* (Lincoln: University of Nebraska Press, 1999).

Martin West, *Ancient Greek Music* (Oxford: Clarendon Press, 1994).

PINDAR

c. 518 B.C.E.–c. 443 B.C.E.

Poet

COMPOSER OF VICTORY ODES. The poet Pindar was born in Thebes around 518 B.C.E., but traveled widely and was well-connected; he was hosted by, and wrote a number of poems for, Hieron, tyrant of Syracuse, in Sicily, whom he considered a champion of Greek civilization. He was also friendly with various aristocratic families on the island of Aigina, near Athens, and wrote eleven odes for Aiginetan athletic victors. Roughly contemporary with the tragedian Aeschylus, Pindar was a prolific poet; he composed choral odes, hymns, paeans, dithyrambs, processionals, *partheneia* (maiden-songs), laments, and more, all intended for public performance; only his *epinikian*, or victory, odes have survived almost intact. These odes commemorated the victory of competitors in the four major athletic games held regularly in Greece: the Olympian, at Pisa in Elis, sacred to Zeus; the Pythian, at Pytho (Delphi), sacred to Apollo; the Isthmian, at the Isthmus of Corinth, sacred to Poseidon; and the Nemean, at Nemea in the Peloponnese, sacred to Zeus. These festivals are also known as Funeral Games, because each celebrates the life of a mythological hero considered by the locals of the region as their ancient king.

FORM OF THE ODES. When a victory was won, the winner (or his family, or a wealthy friend) commissioned Pindar to write an ode to be performed for the winner by a chorus of men or boys, trained to sing and dance, some time after the event. The contract stipulated that certain details about the victor be included; thus the odes often include specific allusions to the winner, his family, and his ancestors. Certain particulars must be included: the victor's name, type of competition and place with some allusion to the divinity associated with that area, and one or more myths of heroes that elevated the victor to heroic status himself. Despite the required elements, many passages in Pindar's poems seem personal and moralizing. The poetic structure consisted of triads of two identical stanzas, called "strophe" and "antistrophe." A few odes, called "monostrophic," contain no triads, but a series of identical stanzas. The poems were not always sung by the whole chorus; solo parts could be performed by chorus leaders, accompanied by the *kithara* and *phorminx* (types of lyres) and the *auloi* (reed pipes). Though the melodies are lost, Pindar often referred to his own music in his poems, mentioning specific melodies and modes by name; in his only surviving ode written for a victorious musician—Pythian Twelve—Pindar credits Athena with the invention of the composition played by the victor, Midas, on the *aulos*. He employed a wide variety of complex meters, which give a sense of his rhythms. He praised his art frequently in his poems, referring to his hymns as "honey-voiced," his odes as "a mix of pale honey with milk, and a liquid shining is on the mixture, a draught of song blown on Aeolian *auloi*."

SOURCES

Andrew Barker, ed., *Greek Musical Writings* (Cambridge: Cambridge University Press, 1984–1989).

Richmond Lattimore, *The Odes of Pindar.* 2nd ed. (Chicago, Ill.: University of Chicago Press, 1976).

Gregory Nagy, *Pindar's Homer: The Lyric Possession of an Epic Past* (Baltimore, Md.: Johns Hopkins University Press, 1994).

M. L. West, trans., *Greek Lyric Poetry: The Poems and Fragments of the Greek Iambic, Elegiac and Melic Poets (Excluding Pindar and Bacchylides) Down to 450 B.C.* (Oxford: Oxford University Press, 1999).

CLAUDIUS PTOLEMY

c. 108 C.E.–c. 165 C.E.

Mathematician
Music theorist
Astronomer

CRITIQUED CURRENT THEORIES. The *Harmonika* of Claudius Ptolemy is considered to be second only to Aristoxenus in importance to the understanding of Greek music theory. A well-respected geographer, astronomer, and mathematician, Ptolemy was born at Pelusium, Egypt, around 108 C.E., and died near Alexandria around 165 C.E. The lexicographer Suda says that he lived during the reign of the emperor Marcus Aurelius (161–180 C.E.); he worked in the cities Canopus and Alexandria, writing many scientific books; he is one of the founders of the field of astronomy. In the three books of the *Harmonika,* Ptolemy employed Pythagorean mathematical concepts in his explanation of tuning systems, sound, pitch, and consonance, but he carefully critiqued both the Pythagorean and Aristoxenian definitions, noting the strengths and weaknesses of each approach. He agreed with the Aristoxenian principle that the purpose of keys is to bring the different segments of the "Greater Perfect System" (different species of octave, each with its own particular character) into the most comfortable vocal register. He regarded the pitches forming the interval of an octave as homophones, and therefore functionally identical.

DEVELOPED OWN THEORIES. In Book II, Ptolemy developed his own theory of the *tonoi* (keys or scales), restructuring them to demonstrate his belief that the only perfect scale was one that contained all the species of the basic consonances. Thus, for Ptolemy, the octave was not a perfect scale, as "previous scholars" had asserted. Ptolemy's book is full of impressive theoretical details (he must have had access to the great library at Alexandria); yet, the metaphysical view of music, expounded

by both the Pythagoreans and the followers of Aristotle, is evident; the book's overall design treats music as a model for higher universal order and understanding.

SOURCES

Andrew Barker, ed., *Greek Musical Writings* (Cambridge: Cambridge University Press, 1984–1989).

Thomas J. Mathiesen, *Apollo's Lyre: Greek Music and Music Theory in Antiquity and the Middle Ages* (Lincoln: University of Nebraska Press, 1999).

Martin West, *Ancient Greek Music* (Oxford: Clarendon Press, 1994).

PYTHAGORAS

c. 580 B.C.E.–c. 500 B.C.E.

Philosopher
Scientist
Mathematician

STUDIED MATHEMATICS, SCIENCE, AND PHILOSOPHY. Pythagoras, son of Mnesarchus, was born in Samos in the mid-sixth century B.C.E., and was said to have died as a refugee in Metapontum, Italy. One of the most influential figures in Greek intellectual history, Pythagoras was both a philosopher of religion and a scientist, yet very little is known about the man himself; there are no written records. It is therefore impossible to tell how much of the Pythagorean tradition in mathematics, music, and science can be traced back to the man himself and his early followers, called Pythagoreans. As a philosopher, Pythagoras is said to have introduced the "doctrine of transmigration of souls"; as a mathematician, Pythagoras is credited with, among other discoveries, the "Pythagorean Theorem" in geometry.

DISCOVERED MUSICAL CONSONANCES. He also discovered the musical consonances, represented by the mathematical ratios of 2:1, 3:2, and 4:3 (the octave, perfect fifth, and perfect fourth). According to Pythagoras, the consonances of a fourth, fifth, and octave were models of *harmonia* (harmony); sounds and rhythms, which were ordered by numbers, exemplified and corresponded to the fitting-together (harmony) of the cosmos. Thus, the ratios, which were displayed in the *tetractys* (an equilateral triangle composed of ten dots), carried religious, as well as scientific, significance for early followers. The scientific application of Pythagorean mathematics appears early, in the *Sectio Canonis* (Division of the Canon), dating to fourth–third century B.C.E., and the acoustic notions of the Pythagoreans—that the same numerical laws that governed the universe also governed music and, by

extension, the soul—profoundly influenced Plato, Aristotle, and the later Greek and Latin music theorists. The treatment of Pythagorean theories of consonance and harmonics in the *Manuale harmonices* of Nicomachus (fl. 100–150 C.E.) and the *Harmonika* of Claudius Ptolemy (fl. 127–148 C.E.) represents the persistence of the Pythagorean tradition in later Greek music theory.

SOURCES

Andrew Barker, ed., *Greek Musical Writings* (Cambridge: Cambridge University Press, 1984–1989).

Walter Burkert, *Lore and Science in Ancient Pythagoreanism.* Trans. Edwin L. Minar Jr. (Cambridge: Harvard University Press, 1972).

Charles H. Kahn, *Pythagoras and the Pythagoreans: A Brief History* (Indianapolis, Ind.: Hackett, 2001).

Thomas J. Mathiesen, *Apollo's Lyre: Greek Music and Music Theory in Antiquity and the Middle Ages* (Lincoln: University of Nebraska Press, 1999).

SAPPHO

c. 625 B.C.E.–c. 570 B.C.E.

Lyric poet

LEADER IN MUSIC FOR YOUNG WOMEN. Sappho was one of the most important lyric poets of the Archaic Period (sixth century B.C.E.). Little is known about her life, and only a small portion of her large output of work survives. She was born at Mytilene (or Eresus) on the island of Lesbos around 625 B.C.E. The ancient historian Strabo said that she was a contemporary of Alcaeus, another well-respected poet from Lesbos; a vase-painting, dating to about 480, depicts the two poets standing together, both holding the *barbitos* (low-pitched lyre) in their hands. The names of Sappho's family are known; she was married to wealthy Cercolas of Andros, and had a daughter, Cleis. Her family may have led a dangerously active political life, because Sappho mentioned exile in one of her poems, and a marble inscription reported that she spent her exile in Sicily sometime between 604–596. Over the centuries Sappho has been described as a school leader, chorus organizer, and a leader of a *thiasos* (a group of young women devoted to Aphrodite and the Muses), but the evidence for these occupations is scant. The most important information about Sappho comes from her poetry. She wrote choral poetry as well as monodic songs, and *epithalamia* ("wedding songs"). The subject of her poetry was young women; she wrote for them, and about them, in often erotic style, describing women's desires, passions, loves, and anguish. Like many other lyric poets, Sappho composed choruses for young girls, *parthenoi,*

and most likely trained her chorus and accompanied them on the lyre during their public performance. Her work was considered so valuable that the Alexandrians made collection of her poems in nine books, which survived through most of the Hellenistic and Roman periods; parts were still directly known in Byzantium in the twelfth century C.E. In the books, her poems are arranged by meter. She composed in dactylic pentameter, hexameter, mixed meter, and a type of meter that is named for her: the Sapphic stanza. The fragments of her poems reveal language that is witty, passionate, and melodious; "Fragment One," Sappho's only complete poem, was admired by Dionysius of Halicarnassus for her melodic use of vowels and consonants, sense of euphony, and charm. Other readers emphasized the atmosphere of magic and incantation, the exotic settings, and the musicality of her lyrics.

SOURCES

Elaine Fantham, Helene Foley, eds., et al., *Women in the Classical World* (New York and Oxford: Oxford University Press, 1994).

André Lardinois, "Subject and Circumstances in Sappho's Poetry," in *Transactions of the American Philological Association* 124 (1994): 57–84.

Diane Rayor, *Sappho's Lyre: Archaic Lyric and Women Poets of Ancient Greece* (Berkeley: University of California Press, 1991).

Jane McIntosh Snyder, *The Woman and the Lyre: Women Writers in Classical Greece and Rome* (Carbondale: Southern Illinois University Press, 1989).

Eva Stehle Stigers, "Sappho's Private World," in *Reflections of Women in Antiquity.* Ed. Helene Foley (New York: Gordon and Breach, 1981): 45–61.

DOCUMENTARY SOURCES
in Music

Alypius, *Introductio musica* (Introduction to Music; fourth–fifth century C.E.)—This treatise on music theory, in three books, contains interesting material not found elsewhere, some of which may go back to the school of Damon. Based partly on Aristoxenus, and influenced by the Pythagoreans and Neo-Platonists, it contains some unique rhythmic and harmonic doctrines.

Aristotle, *Politics, Poetics,* and *Problems* (c. 384–322 B.C.E.)—In these philosophical works, Aristotle analyzes the role of music in a civilized community, including the nature and function of different musical and poetic

forms and the production, perception, and properties of sound.

Aristoxenus, *Harmonika stoikheia* (Harmonic Elements); 375/360–320 B.C.E.)—This treatise was one of the most influential theoretical works on music in antiquity, known only today through a series of fragments and excerpts. It focused on the tetrachord system, *tonoi* (scales), and intervals, and formed the basis for the later technical "Aristoxenian" theorists.

Athenaeus, *Deipnosophistae* (The Learned Banquet; c. 192 C.E.)—The only extant work of this author describes, in fifteen books, the variety of the symposium (banquet) form, and includes a classification of drinking songs (*skolia*), and other types of musical entertainment.

Augustine, *De musica* (On Music; 387–389 C.E.)—In this work, the early Christian theologian follows the Pythagorean and Platonic traditions in applying the theory of ratios to verses of Latin poetry to argue that numbers and ratios allow the mind to transcend the sensual reality of sound, and rise to a knowledge of rational truth.

Bacchius Geron, *Eisagoge tekhnes mousikes* (Introduction to the Art of Music; third–fourth century C.E.)—This small but complex Aristoxenian handbook on music presents theory through a series of simple questions and answers.

Cleonides, *Eisagoge harmonike* (Introduction to Harmonics; second century C.E.)—This is the clearest and most concise summary of the technical details of Aristoxenus' *Harmonika*.

Nicomachus of Gerasa, *Harmonikon enkhiridion* (Manual of Harmonics; fl. 100–150 C.E.)—This Pythagorean approach to harmonic theory uses material drawn from Aristoxenus and attempts to link the foundations of musical harmony to the principles of the universe. It is the only handbook of harmonics to have survived complete from the period between the *Sectio Canonis* and Ptolemy.

Plato, *Republic*, *Laws*, and *Timaeus* (c. 429–347 B.C.E.)—In these philosophical dialogues, Plato discusses the character (*ethos*) of music, and its role in moral education; he also deals with the Pythagorean analysis of musical structures, and the mathematical science of harmonics.

Plutarch [Pseudo], *De musica* (On Music; c. 50–120 C.E.)—Attributed to Plutarch, but generally agreed not to be written by him (hence, *pseudo*), this work, stylistically modeled on Plato's *Symposium*, is a useful compilation of writings on music from the fourth and fifth centuries B.C.E., notably the writings of Plato, Aristotle, and Aristoxenus.

Claudius Ptolemy, *Harmonika* (Harmonics; fl. 127–148 C.E.)—This treatise is one of the most valuable systematic treatments of the mathematical theory of harmony, in three books; it includes a critical review and analysis of the Pythagorean and Aristoxenian theoretical models.

Sectio Canonis (Divison of the Canon; fourth–third century B.C.E.)—This anonymous treatise, once erroneously attributed to Euclid, applies Pythagorean mathematics to many musical topics.

Theon of Smyrna, *ton kata to mathematikon khresimon eis ten Platonos anagnosin* (On Mathematics Useful for the Understanding of Plato; fl. 115–140 C.E.)—This one surviving treatise is a type of Platonic handbook in three major sections: on arithmetic, on music, and on astronomy, which provides a summary of the Pythagorean and neo-Platonic harmonic theory.

PHILOSOPHY

James Allan Evans

IMPORTANT EVENTS
in Philosophy

585 B.C.E. Greek natural philosophy begins with Thales of Miletus who held that water was the underlying substance of everything in the world.

c. 546 B.C.E. Anaximander of Miletus (born 610 B.C.E.) writes the first Greek treatise in prose, setting forth his view that the origin of all things was the "Boundless" or the "Infinite" which he considered divine. He also speculates that the underlying substance of everything is air which becomes fire when rarefied and earth when condensed.

545 B.C.E. Greek philosopher Xenophanes of Colophon goes into exile and eventually settles in Elea, modern Velia, in southern Italy. He is the precursor of the Eleatic school of philosophy.

532 B.C.E. Polycrates becomes tyrant (dictator) of Samos; to escape his tyranny, Pythagoras leaves Samos and emigrates to Croton in southern Italy where he founds a society that is both a scientific school and a religious community.

c. 515 B.C.E. Parmenides of Elea, a rigorous logician who argued that the real universe is without beginning or end, is born.

c. 500 B.C.E. Heraclitus of Ephesus envisions the universe as a conflict of opposites which an eternal Justice holds in check. He develops a theory that Eternal Fire gave rise to all things.

c. 493 B.C.E. Empedocles of Acragas in Sicily who
–c. 433 B.C.E. lives in this period posits a universe in the shape of a sphere within which are four "roots," or elements: fire, air, water, and earth. He believes that Love brings these elements together in an unending cycle in order to create, whereas Strife drives them apart in order to destroy.

c. 490 B.C.E. Zeno of Elea, a pupil and friend of Parmenides, is born. He will become famous for the riddles he uses to refute the theories of opponents of the Eleatic School, as the followers of Parmenides are called.

c. 480 B.C.E. Anaxagoras of Clazomenae comes to Athens where he remains for thirty years. He is the first philosopher to reside in Athens, beginning a long philosophic tradition in the city.

c. 460 B.C.E. Democritus of Abdera, who lives in this
–c. 370 B.C.E. period, puts forward the Atomic Theory which he adopts from his lesser-known master, Leucippus of Miletus.

427 B.C.E. The philosopher Plato is born in Athens.

c. 400 B.C.E. Diogenes of Sinope, also known as the "dog" (*kyon*), is born. He will become the founder of the Cynic sect.

399 B.C.E. Socrates is condemned to death on a charge of impiety by a court in Athens.

388 B.C.E. Plato meets the Pythagorean philoso-
–387 B.C.E. pher Archytas, ruler of Tarentum, and Dioynysius I, the tyrant of Syracuse. He also befriends Dionysius' brother-in-law, Dion.

c. 386 B.C.E. Plato founds the Academy in Athens where he is to teach for the rest of his life.

367 B.C.E. Dionysius I dies, and his successor, Dion, invites Plato to Syracuse to instruct the young Dionysius II in philosophy and the art of ruling.

366 B.C.E. Plato is an uneasy guest of Dionysius
–365 B.C.E. II, who exiles Dion and allows Plato to leave only after he promises to return.

361 B.C.E.
–360 B.C.E.
Plato yields to a pressing invitation from Dionysius II to return to Syracuse, but Dionysius' interest in philosophy proves a passing fancy and after a year he allows Plato to return home.

357 B.C.E.
Dion, whom Dionysius II had driven into exile, returns with an armed force, ousts Dionysius II, and takes control of the government of Syracuse.

354 B.C.E.
Dion is assassinated. Dion's friends appeal to Plato and in response he writes his "Seventh Letter," advising them on how to frame a new constitution for Syracuse.

347 B.C.E.
Plato dies and his nephew Speusippus succeeds him as head of the Academy.

Aristotle leaves the Academy, perhaps out of disappointment that he did not succeed Plato, and goes to live at Assos in the Troad (the region around Troy) under the protection of Hermias of Atarneus who had taken advantage of the weakness of the Persian Empire to carve out a little independent kingdom for himself.

345 B.C.E.
Hermias is captured and killed by the Persians. Aristotle leaves Assos for Mytilene on Lesbos where he carries on research in biology.

342 B.C.E.
Aristotle undertakes the education of Alexander, the son and heir of Philip II, king of Macedon.

335 B.C.E.
Aristotle returns to Athens, where he leases buildings outside the city and founds his school, the Lyceum.

c. 325 B.C.E.
Diogenes of Sinope, the founder of the Cynic School, dies and is succeeded by Crates as the chief Cynic.

323 B.C.E.
Alexander the Great dies in Babylon, and when news of his death reaches Athens, there is a violent outbreak of anti-Macedonian sentiment. Aristotle whose friendship with Alexander, his former pupil, is well known, finds himself under attack.

322 B.C.E.
Aristotle leaves Athens for Chalcis on the island of Euboea to escape a charge of impiety that is brought against him, and he dies there in the fall of the year. He leaves his papers to Theophrastus who succeeds him as head of the Lyceum.

c. 317 B.C.E.
Zeno of Citium in Cyprus comes to Athens and attaches himself to the Cynic philosopher Crates, Diogenes' successor.

306 B.C.E.
Epicurus moves to Athens and buys a house and a garden, where he founds a school known as the *kepos* (the "Garden"); he lives there for the rest of his life and expounds Epicurean doctrine.

301 B.C.E.
Zeno of Citium begins to give lectures at the *stoa poikile* (Painted Stoa) in Athens, thus founding the school of philosophy known as Stoicism.

c. 269 B.C.E.
The Academy founded by Plato enters a new phase, the "New Academy," under Arcesilaus, who interprets Platonism as scepticism and argues that since true knowledge is impossible, the best course is to suspend judgement.

c. 144 B.C.E.
The Stoic philosopher Panaetius comes to Rome and joins the circle of Roman *philhellenes* (lovers of all things Greek) gathered about Publius Scipio Aemilianus. He introduces the philosophy of Stoicism into Rome where it becomes the philosophy of choice for the Roman upper classes.

129 B.C.E.
Panaetius becomes the head of the Stoa in Athens, initiating the development of the school known as the "Middle Stoa."

54 B.C.E.
Marcus Tullius Cicero in Rome produces his *De Republica* (On the State), which proposes a constitution for a well-governed state.

52 B.C.E. Cicero starts to write his *De Legibus* (On the Laws), in which he discusses the Stoic idea of divinely sanctioned law based on reason.

45 B.C.E. Cicero begins to produce a series of books on philosophy, covering subjects such as perception, immortality, the problem of pain, the possibility of divination, determinism and the concrete application of moral principles.

c. 5 B.C.E. Lucius Annaeus Seneca, author of several philosophic dialogues including the incomplete *De vita beata* (On the Happy Life) which expounds the Stoic theory of happiness, is born.

c. 55 C.E. The Stoic philosopher Epictetus is born. His *Discourses* and *Enchiridion* (Handbook) will be two of the primary sources for information on Stoicism in modern times due to the fact that most other Stoic writings did not survive.

161 C.E. Roman emperor Marcus Aurelius ascends to power. His work, the *Medita-*

tions, is the last great surviving statement of Stoic philosophy.

204 C.E. Plotinus, founder of Neoplatonism, is born in Egypt.

c. 250 C.E. The Neoplatonic philosopher Iamblichus is born. He will subordinate philosophy into theurgy ("god-working"), which sought to connect the philosopher with divine power by oracles, magic, and mysticism.

270 C.E. Plotinus, who is suffering from a disfiguring disease which is probably leprosy, dies in Rome.

412 C.E. Proclus, who will become *diadochos* (head and Plato's successor) of the Neoplatonic Academy in Athens, is born. The school will develop a pagan theology based on the philosophy of Plotinus and Plato under Proclus' leadership.

529 C.E. The emperor Justinian closes down the Neoplatonic Academy in Athens as part of his policy of suppressing paganism.

OVERVIEW
of Philosophy

SCANT EVIDENCE. Greek philosophy has survived only in tantalizing fragments. The works of only one philosopher, Plato, have survived in their entirety. Much of Aristotle has been lost, and the scientific and philosophic treatises that have survived were not written for publication. Socrates who lived in Athens in the fifth century B.C.E., wrote nothing, although he gave Greek philosophy a new direction. Modern knowledge of him is dependent on two very different disciples, Plato and Xenophon, and a burlesque of his teachings by the comic poet, Aristophanes. The works of the philosophers before Socrates, the so-called "Presocratics" who speculated about the nature of the universe, are all lost. They are known by reputation, and by fragments of what they wrote, which are mostly quotations by later writers. One late writer in particular, Diogenes Laertius, wrote a work that is indispensable to modern knowledge of ancient Greek philosophy: *A History of Philosophy, or on the Lives, Opinions and Maxims of Famous Philosophers*, dating to the third century C.E. This work, plus the surviving fragments from the actual writings, provide enough information to recreate the thought of these Greek thinkers with some confidence and to demonstrate their importance. They began the long progression of speculation and philosophic thought that was continued in medieval and modern Europe as well as the world of Islam, and has now become the dominant intellectual tradition everywhere. In reconstructing the thought-world of the Greek philosophers, however, there is a strong temptation to "fill in the blanks" in such a way as to render their ideas too modern. Ancient criticism of the conventional Greek religion, for instance, should not be interpreted in such a way as to suggest that the author was irreligious or an atheist. They belonged to the background of their own day, and this was particularly true when they approached favorite subjects of speculation, such as the nature of the ideal state, and the character and education of the ideal ruler. Yet the contribution of Greek thought has been enormous: in the history of science it made the first steps towards the modern scientific method, and in the fields of ethics and politics it is the underpinning of modern speculation.

THE BEGINNINGS IN IONIA. Greek philosophy began with speculation in the region of Ionia about the nature of the physical world. Miletus, located on the south-west coastline of modern Turkey, was the most important of the Ionian cities and it was there that Thales—an engineer, astronomer, mathematician, and a statesman, as well as a natural philosopher—had the intuition that a single substance underlay everything in the world that can be perceived with the senses. His hypothesis was that this substance was water. His disciple, Anaximander, suggested instead that it was something that he called the *apeiron*—the "Infinite" (or "Indefinite")—a substance without boundaries. His follower, Anaximenes, in turn suggested that the underlying substance was *aer* (air), but with substance and weight. There was no place for traditional Greek religion in the theories of these Milesian thinkers, though it would be inaccurate to call them atheists. There is no denying, however, that their ideas challenged traditional religion with its anthropomorphic gods such as Zeus and his wife Hera, because they pinpointed natural causes for the physical world. A poet named Xenophanes from Colophon, a city neighboring Miletus asserted that the gods of the poets Homer and Hesiod were unsatisfactory as explanations of how creation happened. There is, he asserted, one supreme deity who never moves but who knows all and controls everything without effort by his thought.

THE PROBLEM OF CHANGE. Heraclitus of Ephesus, who was prominent around 500 B.C.E., continued in the footsteps of the Milesians. His underlying substance was not water or air, but fire. All things in the world, he argued, come into being in exchange for fire, in the same way as one buys goods in exchange for gold coin. The cause of movement in the world is the conflict of opposites that is controlled by eternal Justice. Conflict, therefore, is a creative force by which everything is constantly changing. The result of this constant state of impermanence is the only knowledge that matters—in fact, the only knowledge that is possible—is self-knowledge. Wisdom consists of comprehending the *logos*, by which Heraclitus seems to mean the rationale that underlies nature.

THE RUTHLESS LOGIC OF PARMENIDES. The Milesians and their followers all assumed that the universe was made of matter. Matter was the stuff from which everything was made. Thales' hypothesis was that this stuff was water, and Anaximenes suggested a substance like air, but whatever it was, it had weight and substance. Even the fire of Heraclitus was matter. It

remained for Parmenides to point out the logical consequences of this assumption. Parmenides, who lived in the Greek colony of Elea (modern Velia) in southern Italy in the first half of the fifth century B.C.E., argued that everything is matter. He believed there could be no movement in the universe, for an object that moves must have empty space into which it can move, and there was no empty space. "What exists," he pointed out, is all matter, and "what does not exist" is nothing. There is no such thing as "nothing" so space containing nothing cannot exist. Parmenides founded the Eleatic School on this theory, and argued that the perceived movement in the universe was a deception of human senses. According to Parmenides, no true knowledge can be gained from sensory perception.

THE ATOMIC THEORY. The challenge of Parmenides never received a completely satisfactory answer. One philosopher, Empedocles, argued that there were four elements—air, earth, fire, and water—that moved through each other through pores like the holes in sponges, always impelled by the alternating forces of Desire and Hate, that is, attraction and repulsion. But two thinkers developed another hypothesis that sounds almost modern. Leucippus and his follower Democritus argued that the universe was made up of atoms and void. The atoms were tiny particles of matter, like our molecules, which moved about in a void like the specks of dust (or "motes") that can be seen moving in a sunbeam. Atoms had a skin like velcro, and so when they collided, they stuck together, thus forming the objects that we see about us. Trees, animals, even people, were all made of tightly packed atoms. Yet the atomic theory could remain only an hypothesis. There was no way of proving it, and "void," which was nothingness, continued to seem illogical to many philosophers.

THE SOPHISTS. The Sophists mark a new departure in Greek philosophy. They were itinerant teachers who appeared upon the scene to meet a demand for higher education. Education had been an aristocratic preserve in archaic Greece—a young man of good family learned the rudiments of reading and writing. He learned and sometimes memorized the poems of the epic poet Homer, and might also learn how to play the lyre and perhaps some basic arithmetic. In the fifth century B.C.E. this education expanded to include speech making, particularly before the law courts and public assemblies. The itinerant teachers claimed to be able to impart that type of knowledge, and the art of "sophistry" came to be centered in Athens. Although none of the early Sophists were from that city, most of them spent some time there and gave lectures for which they charged fees. In their teachings and speeches, the Sophists turned philosophy from an examination of the workings of the physical universe to issues of ethics and behavior, including the nature of goodness and justice.

SOCRATES. The Sophists provided the intellectual matrix which produced Socrates in Athens in the fifth century B.C.E. Socrates was born in Athens; his father was a stonecutter and his mother a midwife. He was sufficiently well-to-do, allowing him to fight in the Athenian army as a *hoplite*—a heavily-armed infantryman who had to have the wherewithal to supply his own armor. He was at first attracted to the theories of Anaxagoras, a philosopher who continued in the Milesian tradition, arguing that the source of creation was *Nous* ("Mind" or "Intelligence"), but Socrates soon found Anaxagoras' theories unsatisfying because they could not be applied to everyday life. Socrates turned to ethical questions. He could be seen almost everyday in the public places in Athens, walking barefoot and conversing with people he encountered. He accosted Athenians who thought they knew how to define what was right or wrong, and cross-examined them. The conversations ended often with Socrates' interlocutor discomfited and annoyed. Yet Socrates attracted large numbers of followers who appreciated his sharp mind. Sometimes they were only ambitious young men who wanted to improve their skill at argument, but among them were genuine disciples, and much of modern knowledge about Socrates comes from two of them: Plato and Xenophon. Xenophon was a voluminous writer who wrote a memoir on Socrates called the *Memorabilia* which provides valuable information about Socrates' everyday life. Plato was a great philosopher in his own right, and in his many works Socrates acted as the spokesman for Plato's ideas.

PLATO. Socrates was put to death in 399 B.C.E. on charges of atheism and corrupting the young, and after his execution, many of his disciples—Plato among them—left Athens for the safety of the neighboring state of Megara. Plato did not stay there long. He traveled, did a couple stints of service in the Athenian army, and wrote his early dialogues. In 390 B.C.E. he visited southern Italy and then Sicily, where he met the powerful tyrant of Syracuse, Dionysius I, who soon tired of him and sent him back to Athens. Once there, he founded a school on the outskirts of Athens in a park sacred to the hero Academus, from whom the "Academy" got its name. It was intended as a school for statesmen, for Plato was deeply concerned about good government where true justice can exist, and his best-known work is his *Republic*, an ideal utopia where government is in the hands of "Guardians" who are trained in philosophy. On

Plato's death, his nephew Speusippus assumed the headship of the Academy, and it continued to be an intellectual force, though it wandered from Plato's teachings as time went on and became skeptical about the possibility of men acquiring true knowledge. Among the students at the Academy was a young man from Macedonia, Aristotle, who studied there for twenty years. He left when Plato died, and did not return to Athens until 335 B.C.E. During his absence from Athens, he lived for a period at the court of the Philip II, king of Macedonia, and he tutored Philip's son, Alexander, who would a few years later change the course of Greek history by conquering the Persian Empire and pushing his victorious army as far as India. Philip was assassinated in 336 B.C.E.; Alexander became king in his stead, and Aristotle returned to Athens to found the Lyceum.

THE LYCEUM. The Lyceum was a research institute, a product of Aristotle's wide-ranging mind. His interests included everything from the dialogues he wrote while a student at the Academy to his groundbreaking treatise on animals—a product of his biology research conducted after his departure from Athens. In the Lyceum he gave lectures, both to his students and to the public, and his surviving works seem to have been notes that he used to prepare his lectures. Those most admired nowadays are his *Ethics* and his *Metaphysics*. In the latter he analyzes the theories of the philosophers who came before him, and he is an important source for modern knowledge of the Presocratics. As much as Aristotle admired Plato, he disagreed fundamentally with him, particularly on the question of perception. Aristotle believed that the senses could provide reliable information about the world.

EPICUREANS. After Alexander the Great's conquests, two great philosophers settled in Athens and attracted students. One was Epicurus, who bought a house with a garden in which he formed a community with his students, both male and female. The aim of the Epicureans was happiness—not sensuous enjoyment, but a happiness based on contentment with one's situation. The watchword of the Epicureans was *lathe biosas*, which means "Live without attracting notice," and the "Garden," as Epicurus' school was called, was a retreat from the vicissitudes of life. Fear of death was banished, for Epicurus borrowed the atomic theory and used it to show that the body and soul were both made of atoms which would dissolve upon death. There was no afterlife and hence no reason to fear any tortures in the Underworld.

STOICISM. Stoicism was the philosophical belief that combined the philosophies of the Cynics—those who valued all things natural—and the Academics—those who saw wisdom and knowledge as the key to a perfect society. Stocisim heavily favored the natural world, wanting to enjoy all the things that life had to offer, but believed that this natural world must be tempered by a rational mind. The Stoics believed that institutions such as government, religion, and law were unnecessary if everyone in a society could reach complete rationality (which the Stoics believed should be the goal of every society). Stoicism's founder, Zeno of Citium, lectured in the *stoa poikile* (Painted Stoa) which stood at the southern edge of the marketplace of Athens, and it was from this spot that Stoicism derived its name. In the second century B.C.E. Stoicism became the dominant philosophy of the Hellenistic world and the Roman Empire. In 144 B.C.E. the Stoic Panaetius came to Rome and joined the Scipionic circle, a group of Roman philhellenes who gathered about the statesman Scipio Aemilianus. These Roman aristocrats became enamored of Stoic doctrines, and Stoicism became the philosophy of choice of the Roman elite. The last great surviving Stoic work is the *Meditations* of Marcus Aurelius, the philosopher-emperor who died in 180 C.E.

CICERO. The Romans never took philosophy very seriously. Young men might have dabbled in it as part of their education, but once they entered the workaday world, they turned to more practical matters. Typical was Seneca the Younger (c. 3 B.C.E.–65 C.E., the emperor Nero's tutor whom Nero forced to commit suicide when he outgrew his tutelage; on his essays he advocated the precepts of Stoicism and in his own life followed none of them. Still, Rome produced one exceptional student of philosophy: Marcus Tullius Cicero. Cicero (106–42 B.C.E.) was a man of many talents. He was a lawyer and a statesman as well as an accomplished orator, the greatest that Rome produced. He often wrote on political science and rhetoric, and also tried his hand at poetry, but was not as successful. Near the end of his life, beginning in March of 45 B.C.E., he produced a remarkable series of books on various aspects of philosophy. These included works on immortality, perception, Stoic logic, the problem of pain, the possibility of divination, and others. He wrote partly for self-comfort, for his beloved daughter Tullia had just died. He was not an original philosopher, and he tended to pick and choose his philosophies—that is to say, he was an eclectic. If he had any preference, it was for the Sceptics, who denied the possibility of knowledge, though Cicero leaned towards the branch of Scepticism that allowed likelihood, meaning that there were likely or probable truths. Yet most of all, Cicero shows the attitude of a well-read Roman towards philosophy. It was a personal thing, a comfort in time of stress.

THE NEOPLATONISTS. The last progeny of Greek philosophy was the Neoplatonic School, founded by an Egyptian, Plotinus, who moved to Rome in the middle of the third century C.E. His starting point was Plato, who had written in his *Republic* of what he called the "Good." For Plotinus, the "Good" was the "One," and between the "One" and the world of material objects there were three levels of reality: the world-intelligence, the world-soul, and nature. With Plotinus, philosophy began to move into the field of theology, and his followers went even further. Neoplatonism rejuvenated the Academy in Athens that claimed to go back to Plato's Academy, and in this Neoplatonic Academy, pagan philosophy made its last stand. It was closed down by imperial decree in 529 C.E.

TOPICS
in Philosophy

BEGINNINGS OF GREEK PHILOSOPHY

MILETUS. Greek philosophy began in a city-state on the coast of south-west Turkey: Miletus, which claimed that it was founded by a city on Crete called Milatos—probably Mallia on the north coast of Crete—in the Minoan period. If so, the Minoan foundation did not survive the catastrophe that overtook the Bronze Age civilization about 1200 B.C.E., and Miletus was refounded by Ionian Greeks during the age of migrations in the eleventh century B.C.E. The city prospered, and civic life was as turbulent as it was in most city-states in the Early Archaic Period of the seventh and early sixth centuries B.C.E. Around 600 B.C.E., Miletus' independence was threatened by her neighbor, the Lydian Empire. The city of Lydia was ruled by a strongman—a "tyrant" as the Greeks called such men—named Thrasybulus, and he led the resistance to Alyattes, king of Lydia, who harried the Milesians for eleven years. In the end Alyattes made peace and alliance with them but soon had to turn his attention to his eastern frontier where he faced the aggressive empire of the Medes who had destroyed the Assyrian Empire with some help from Babylon and were now expanding into Asia Minor. In 585 or 584 B.C.E., the Lydian and Median armies met at the frontier of Lydia, the Halys River which flows into the Black Sea. Just as they were on the verge of battle, there was an eclipse of the sun. A young man from Miletus, Thales, who was there among the Milesian allies supporting Alyattes, was said to have foretold the eclipse. Modern scholars find this story hard to believe, but it is clear that this man would be the founder of Greek natural philosophy—that is, speculation about nature and the natural causes of what occurs in the cosmos.

THALES, ANAXIMANDER, AND ANAXIMENES. Thales believed that everything in the world is made of matter which might take various forms, be it solid, liquid or gas. The one matter that he knew could appear in all these forms was water. If heat was applied to ice, it became water, and heat applied to water produced steam that in turn could condense and return to water. Thales' disciple Anaximander carried Thales' speculation a step further. He suggested that the substance underlying all natural phenomena was not water but rather something that he called the *apeiron*—the "Infinite" (or "Indefinite")—matter that had no boundary. He argued that the world was a cylinder with a flat top that provided men with living space. It floated freely in space, equally distant from all things, and thus without any need of support. Anaximander's thoughts were daring and almost modern, but his follower Anaximenes abandoned his concept of the *apeiron* and suggested instead that the primary substance of the universe was *aer*—the Greek word for "air." It is clear that Anaximenes' *aer* is more than mere "air," however. Rather, it is a kind of mist out of which denser substances are formed by condensation, much as felt can be made from wool by the process of felting. For Anaximenes, *aer* was a material substance. Unlike the *apeiron* of Anaximander, it could be defined, and later natural philosophers who argued that the universe was constructed of matter looked back on Anaximenes as the last great thinker of the Milesian School who brought the speculation that Thales began to its natural conclusion.

SOURCES

G. B. Burch, "Anaximander the First Metaphysician," *Review of Metaphysics* 3 (1949–1950): 137–160.

Dirk Couprie, Robert Hahn, and Gerard Naddaf, *Anaximander in Context: New Studies in the Origins of Greek Philosophy* (Albany, N.Y.: State University of New York Press, 2003).

Hans George Gadamer, *The Beginning of Knowledge.* Trans. Rod Coltman (New York: Continuum, 2003).

Charles H. Kahn, *Anaximander and the Origins of Greek Cosmology* (New York: Columbia University Press, 1960).

Patricia O'Grady, *Thales of Miletus: The Beginnings of Western Science and Philosophy* (Aldershot, Hants: Ashgate, 2002).

PYTHAGORAS AND THE PYTHAGOREANS

THE LIFE OF PYTHAGORAS. Pythagoras, perhaps best known for his theorem on triangle angles and

lengths, left behind him a great reputation as not only a mathematician, but also as a philosopher and cult figure. Yet he is an indistinct personality, veiled in the shadows of legends that grew up around him. He was born on the island of Samos off the coast of modern Turkey in the first half of the sixth century B.C.E. and he was the son of an engraver of gemstones. In 532 B.C.E. a Samian named Polycrates seized control of the government of Samos and established himself as a tyrant. Polycrates maintained a splendid court and ruled like a pirate king, living on the fringe of the Persian Empire which would eventually, around 517 B.C.E., overthrow him, but during his heyday no cargo ship in the southern Aegean Sea was safe from his marauding warships. Pythagoras, it is reported, left Samos to escape Polycrates' dissolute court, and emigrated to southern Italy, to the Greek city of Croton, modern Crotone. The Greeks had founded a number of colonies in the region: not only Croton, but also Sybaris, Locri, Metapontum, and Rhegium. These colonies battled each other for the rich farmland of the area; when Pythagoras reached Croton, it had just suffered a defeat at the hands of its smaller neighbor, Locri. The rich Crotoniates, humiliated by their defeat, were ready for Pythagoras' austere teachings. He gathered about him a brotherhood of Pythagoreans who were both scientists and mystics with secret doctrines and curious taboos; Pythagoreans wore white clothes to worship the gods and avoided eating beans, to name only two of the taboos that governed their lives. The Pythagorean circle soon dominated the aristocratic ruling class in Croton. The Pythagorean brotherhood became a force in the politics of the Greek cities in southern Italy until there was a violent reaction against their high-handed oligarchic rule that aroused strong resentment. Pythagoreans were massacred, and Pythagoras himself had to flee. He went to neighboring Metapontum where he died in exile. Pythagoreans remained active in southern Italy, continuing their scientific inquiries. It was a Pythagorean in the first half of the fourth century B.C.E., Archytas of Tarentum, who was recognized in the Greek world as the founder of mechanics, the branch of physics that deals with motion.

THE RELIGIOUS TEACHINGS OF PYTHAGORAS. Pythagoras introduced a new vision of the fate of human beings after death: the doctrine of metempsychosis, or the transmigration of the soul from one body to another. The traditional religion of the Greeks which is reflected in the *Iliad* and *Odyssey* of Homer taught that humans differed from the gods in that human life was short, whereas the gods never died. Pythagoras taught that the soul was reborn after death and went through

a PRIMARY SOURCE *document*

ARISTOTLE ON THE PYTHAGOREANS

INTRODUCTION: Aristotle in his *Metaphysics* gives a summary of the doctrines of the philosophers who were active before his time. When he reaches the Pythagoreans, he emphasizes their fascination with mathematics, which seemed to hold the key to the secrets of the universe. He describes their researches as follows.

At the same time and even earlier (as the discoverers of the Atomic Theory, Leucippus and Democritus) were working, the so-called Pythagoreans applied themselves to mathematics, and were the first to develop this science; and through studying it they came to believe that its principles are the principles of everything. And since *numbers* are by nature first among these principles, and they fancied that they could detect in numbers, to a greater extent than in fire and earth and water, many analogues of what is and comes into being—such and such a property of number being *justice*, and such and such *soul* or *mind*, another *opportunity*, and similarly, more or less, with all the rest—and since they saw further that the properties and ratios of the musical scales are based on numbers, and since it seemed clear that all other things have their whole nature modeled upon numbers, and that numbers are the ultimate things in the whole physical universe, they assumed the elements of numbers to be the elements of everything, and the whole universe to be a proportion or number.

SOURCE: Aristotle, *Metaphysics, Books I–IX*. Book I. Trans. Hugh Tredennick (Cambridge, Mass.: Harvard University Press, 1996): 33.

a cycle of rebirths until it attained the immortality that hitherto only the gods enjoyed. The details of Pythagoras' original doctrine cannot be recovered now, for later philosophers added their own insights. The question of whether there was a set number of rebirths that the soul had to experience before it reached a blessed state was answered by the poet Pindar, for instance, who wrote that if a soul avoided injustice for three lives, it would attain a marvelous existence in the Isles of the Blessed. Philosophers differed on whether the transmigrating soul was the same soul that governed a person's sentience and activity during his lifetime; Plato thought it was, but the philosopher Empedocles thought that it was not the *psyche* (soul) that transmigrated but the *daimon* (spirit). The

doctrine of transmigration that Pythagoras taught his followers pioneered a new field of speculation about life after death. Not everyone was impressed. Pythagoras' contemporary, the poet and philosopher Xenophanes, mocked the doctrine with a story in which Pythagoras urges a man to stop beating his dog, recognizing in the dog's yelps of pain the soul of a dead friend.

THE COSMOLOGY OF PYTHAGORAS. Pythagoras' theory of the nature of the universe—his cosmology—was influenced by the Milesian philosophers, Anaximander and Anaximenes. Anaximander's "Infinite" and Anaximenes' "Limitless Air" corresponded to what Pythagoras called the "Dark," which is cold, dense, without light, and without boundaries. Yet "Light" also exists, the opposite of the limitless "Dark," and it has form and thus it has limits, for without limits, matter is by definition formless. Portions of the limitless "Dark" are attracted to the "Light" where they receive form and limit. The Pythagoreans conceived of the "Light" as a living, breathing thing, and from the portions of the "Dark" which "Light" breathes in, the celestial bodies are formed. The celestial bodies numbered ten, and they revolved from east to west around a central fire. The sun reflects light from the central fire and thus provides Earth with light and warmth. Thus the cosmos consists of the central fire, Earth, the moon, the sun, Mercury, Venus, Mars, Jupiter, Saturn, and counter-earth which seems to serve no other purpose than to make the number of heavenly bodies total ten, which the Pythagoreans considered a sacred number. At the very limit of the cosmos were the fixed stars. Except for these fixed stars, the heavenly bodies moved around the central fire, and since moving objects can produce sound, Pythagoras assumed that *harmonia* existed in the universe. *Harmonia* was the word for the octave-system of music he developed according to mathematical ratios. Hence, arose the Pythagorean theory of the "music of the spheres," though it is not at all certain that Pythagoras himself thought of the heavenly bodies as spheres.

THE NEOPYTHAGOREANS. Pythagoras came to be regarded as the archetypal philosopher by the end of the fourth century B.C.E., and the followers of Plato and Aristotle absorbed many of his ideas. But his reputation was such that there appeared forged documents attributed to him from the third century B.C.E. onwards, and their numbers grew in the first century B.C.E. when a sect which modern scholars call the "Neopythagoreans" was founded. Neopythagorean doctrine owes more to Plato than Pythagoras. The Neopythagoreans built up a cult around Pythagoras so that he became a legendary semi-divine sage whom the pagans in the Christian era put forward as a rival for Christ. It is not always easy to separate the Neopythagorean sage from the semi-legendary but nonetheless historical figure of Pythagoras.

SOURCES

Jonathan Barnes, *The Presocratic Philosophers, I* (London, England; Boston: Routledge and Kegan Paul, 1979).

Walter Burkert, *Lore and Science in Ancient Pythagoreanism.* Trans. Edward L. Minar, Jr. (Cambridge, Mass.: Harvard University Press, 1972).

Kurt von Fritz, *Pythagorean Politics in Southern Italy: An Analysis of the Sources* (New York: Columbia University Press, 1940).

Peter Gorman, *Pythagoras: A Life* (London, England: Routledge and Kegan Paul, 1979).

Carl A. Huffman, "The Pythagorean Tradition," in *The Cambridge Companion to Early Greek Philosophy*. Ed. A. A. Long (Cambridge: Cambridge University Press, 1999): 66–87.

Milton C. Nahm, ed., *Selections from Greek Philosophy* (New York: F. S. Crofts, 1947).

J. A. Philip, *Pythagoras and Early Pythagoreanism* (Toronto, Canada: University of Toronto Press, 1966).

Richard Wallace, "Pythagoras," in *Encyclopedia of Greece and the Hellenic Tradition* (London, England: Fitzroy Dearborn, 2000): 1426–1428.

XENOPHANES, HERACLITUS, AND PARMENIDES

XENOPHANES OF COLOPHON. Xenophanes was one of the first philosophers to promote monotheism in Greece, and was the founder of Eleatic philosophy—the belief that above everything in the world there is an unchanging, everlasting "One." He did not define this "One" in his own writings, but many of his later followers, such as Plato and Aristotle, would attempt to steer this concept towards a belief in one God, contrary to the Greek belief of many different gods. Xenophanes was a native of Colophon, a city on the western fringe of Asia Minor, which he left when it was conquered by Persia about 546 B.C.E. He would spend the rest of his life traveling the Greek world. He had a close connection with Elea, modern Velia in southwest Italy, which was founded by Ionian Greeks fleeing the Persian conquest. Xenophanes was an accomplished writer whose influence was immense in the intellectual world of the western Greeks, among the Greek cities in Sicily and southern Italy. He criticized Homer and Hesiod for their portrayal of the gods. They were wrong, Xenophanes asserted, to show the gods in human form with human

a PRIMARY SOURCE document

HERACLITUS THE MISANTHROPE

INTRODUCTION: Heraclitus of Ephesus, famous as the site of the great Temple of Artemis which was considered one of the "Seven Wonders of the Ancient World," was famous for his disdain of the masses and his cryptic utterances about the nature of the universe. He was a descendant of Androcles, the founder of Ephesus and as such inherited the title *basileus* (king), which denoted a civic priesthood rather than a political office, but he rejected it. Diogenes Laertius, writing in the third century C.E., preserves stories about him which illustrate his contempt for his fellow Ephesians as well as the thinkers and the poets—including Homer—who were his predecessors or his contemporaries.

Heraclitus was possessed of a haughty and arrogant character, as is clear from his writings, where he says, "Great learning does not make for intelligence; if it did, it would have instructed Hesiod, and Pythagoras, and likewise Xenophanes and Hecataeus. For the only piece of real wisdom is to know the *logos* (the intelligence that sustains human laws) which will by itself govern everything on every occasion. He used to say, too, that Homer ought to be expelled from the contest (for wisdom) and Archilochus as well. He also used to say, "It is more necessary to extinguish arrogance than to put out fire." Another of his sayings was, "People should defend their law as much as their city walls." He also upbraided the Eph-

esians for having banished his companion, Hermodorus, saying, "The Ephesians deserve to have all their young men put to death and those who are adolescents exiled from the city, for they have banished Hermodorus, the best man among them, saying, 'Let no one of us be outstanding, and if there be such a person, let him go to another city and another person.'"

When he was requested to make laws for the Ephesians, he refused, because the city was already immersed in a thoroughly bad constitution. He withdrew to the temple of Artemis with his children and began to play dice, and when the Ephesians all flocked around him, he said, "You wretches! What are you gaping at? Isn't better to do this than to meddle in public affairs in your company?"

Finally he became a complete misanthrope, and spent his time roaming the mountainsides, living off plants and grasses, and as a result, he developed dropsy (a build-up of fluid in the cells of the body). So he returned to the city and asked the doctors a riddle: could they produce a dry season after wet weather? But they did not understand him, and so he shut himself up in a cow stable, and covered himself with manure, hoping to make the excess of fluid evaporate from him by the warmth this produced. But this treatment did him no good, and he died, having lived for seventy years.

SOURCE: Diogenes Laertius, "Heraclitus of Ephesus," in *The Lives and Opinions of Eminent Philosophers*. Trans. C. D. Yonge (London: Henry G. Bohn, 1853): 376–377.

faults, though it was natural to do so; oxen and lions, if they had hands, would draw their gods as oxen and lions. Xenophanes taught instead that there was a single supreme divine being who, without moving, controlled the universe through his intellect. Xenophanes had a gift for observation that not all Greek intellectuals shared. He found seashells and fossilized sea-creatures in rocks and inferred that there was once a time when the sea covered the land, and hence the earth must have been subject to periods of flooding and drying out. He may even have written a treatise on the subject.

THE ETERNAL FIRE OF HERACLITUS. Heraclitus of Ephesus was inspired by Xenophanes' idea of an everlasting unchanging "One," but like many philosophers of his time did not think this "One" was a being or a person, but was instead a basic material that was transformed in some way into other kinds of material. Thales of Miletus had pinpointed water as that basic material and Anaximenes had thought it was air; Heraclitus chose fire. Fire, he claimed, was an infinite mass which was

eternal—no divine power created it—and it was kindled and extinguished according to fixed measures. The kindling and quenching of fire maintained the world order. Heraclitus came to this conclusion after observing how flames, flickering in constant motion, transformed wood into ashes and smoke, and yet the fire maintained its own identity as fire. Once it was quenched, it could be rekindled. Like fire, Heraclitus' universe was subject to constant change. Everything was in constant motion. One famous saying of Heraclitus was that a person cannot step twice into the same river, for new water is constantly being carried past him by the flow of the stream, and hence the river is never entirely the same from one minute to the next. Yet, like fire, the river itself continues to exist.

THE UNITY OF OPPOSITES. Heraclitus' teachings were notoriously obscure, but he was identified in the ancient world with a number of doctrines. One doctrine maintained that the world was in a state of continual flux; his saying, "Everything flows," made the universe

akin to a moving stream. He also believed in the unity of opposites: things that seem to be opposites are actually aspects of the same thing. This unity is demonstrated in the seeming opposites of "heat" and "cold" which are interdependent: "cold" is the absence of "heat." Once the continual flux that never ceases in the world removes "heat," we have "cold." "What is cool becomes warm and what is warm becomes cool," Heraclitus wrote. So the young and the old are aspects of the same, and so are the living and the dead, for the one becomes the other. One of Heraclitus' axioms reads, "The road up and the road down are the same"—meaning there is a single road with two-way traffic. It is the tension between opposites that allows living things to exist, just as the string of a lyre will sound the correct note when it is placed under the right degree of tension by drawing it in opposite directions. This interaction of opposites, which Heraclitus identified as strife, is a creative force, and this belief probably explains one strange assertion of his: "War is the father of all and king of all." Everything is created and passes away through strife between opposing forces. The world is a mass of conflicting tensions but, at the same time, these contrary forces are bound together by a strict unity. The strife between them results in a sort of balance which Heraclitus identified as justice, and justice maintains order—hence Heraclitus asserted that the sun would keep its allotted course in the heavens, for otherwise the Furies, the agents of Justice, would punish it. The unity of opposites is the central feature of the *logos* that Heraclitus proclaimed.

THE LOGOS. Many of Heraclitus's views on the *logos* are attributed to his study of Xenophanes. *Logos* is a word with many meanings. It means "word"—not "word" in the strictly grammatical sense, but rather "word" as a vehicle expressing thought, and so it comes to mean the thought itself. It is the wisdom of the mind expressed in speech. For Heraclitus, the word *logos* seems to have expressed the Intelligence that directs the manifold changes in the world. It was both willing and unwilling to be called Zeus, according to one of Heraclitus' cryptic utterances. The *logos* that Heraclitus proclaimed would continue to haunt philosophy and theology as well. In the early Christian era, some thinkers considered Heraclitus a Christian before his time because of his emphasis on *logos*, a Christian synonym for Jesus Christ derived from the opening verse of the Gospel of St. John: "In the Beginning was the *Logos* (the Word) and the *Logos* was with God and the *Logos* was God." In the Roman period, the Stoic philosophers embraced Heraclitus because his doctrine of eternal fire that was alternatively kindled and quenched seemed to fit their

belief that the world passed through cycles, each of which ended in fiery destruction. Yet Heraclitus was neither a proto-Stoic nor a proto-Christian, though his eccentric lifestyle and his oracular utterances mark him out as almost as much a religious teacher as a natural scientist.

PARMENIDES OF ELEA. While Xenophanes and Heraclitus furthered the idea of the everlasting element that underrides all things, it was Parmenides, born in Elea about 515 B.C.E., who brought the line of speculation that began with Thales and Anaximander to its logical conclusion. All the Ionian philosophers who speculated about nature took for granted that there was a primary substance such as water, air, or fire that could take different forms. They left no place for nothingness. The Greeks had no symbol for "zero." "Nothing" was something that could not be defined or expressed; the opposite of "that which exists" is "that which does not exist." Parmenides pointed out the consequences of this line of thought. In the first place, "that which exists" cannot have been created for if it were, it would have to be created out of either something or nothing. Nothing does not exist and so "that which exists" cannot not have been created out of it. Nor can it have been created out of something, for the only "something" is "that which exists." Nor can anything else besides "what exists" be created, for there is no empty space where such creation could take place. Parmenides refuted all accounts of creation with a simple principle that could not be contradicted: "Out of nothing there is nothing created."

THE UNIVERSE OF PARMENIDES. Thus for Parmenides "that which exists" is matter that is continuous and indivisible, and therefore the universe must be a continuous, indivisible *plenum*, that is, a space filled with matter. The plenum cannot move, for if it did, it would have to move into empty space—a vacuum, the opposite of a plenum—and empty space is "nothingness," which does not exist. The plenum must be finite, with definite boundaries, and spherical, for matter cannot have direction, and that can be true only in a sphere. Within the plenum there can be no movement, for if an object moves, then there must be some empty space into which it can move, and there is no empty space. So the evidence of our eyes that tells us that things in the world that we see *do* move must be an illusion. The messages that our senses send to our brain about the nature of the world must be wrong. The alternative would be to believe that the underlying assumption of all the philosophers from Thales to Heraclitus—that the world of the senses was made from some basic matter such as water, air, or even the "boundless" of Anaximander— had to be wrong.

ZENO'S RIDDLES. Zeno, born around 495 B.C.E. was a favorite of Parmenides, and he made it his business to drive home the logical conclusion of the Eleatic school of philosophy that motion was a mere illusion. The paradoxes by which he drove home the logic of the Eleatics were famous. One was the paradox of the arrow that is shot from a bow. The arrow must either be moving in the place where it is or where it is not, and it cannot be moving in the place where it is, or it would not be there. Nor can it be moving in a place where it is not, for it is not there. Therefore the moving arrow is stationary. To put it another way, the apparent motion of the arrow is like a moving picture, which is actually a succession of still pictures that are fed rapidly through a projector and produce the illusion of motion. In fact, at every point in its trajectory, the arrow is actually at rest and what is at rest at every point is not moving. Zeno used this deduction as proof that Parmenides was right: there is no motion. The Greek philosophers had no solution to this paradox, and the modern world had to wait until Sir Isaac Newton discovered differential calculus before Zeno's error could be discovered. Another famous paradox proposed by Zeno was that of Achilles, a legendary Greek hero, and the Tortoise. Achilles and a tortoise run a race, and the tortoise has a head start. Achilles cannot overtake the tortoise, for when he reaches the point where the tortoise started, it has already moved on to further point, and when Achilles reaches that point, the tortoise has already moved further on, and so on through an infinite series which has no end. There is no final term to this infinite series and so Achilles can never pass through the final term. Yet here, Zeno's logic ultimately proved itself faulty, for it is a fair question to ask why, if there is no final term, does Achilles need to pass through it? It cannot be necessary for Achilles to pass through a non-existent final term to overtake the tortoise. Yet the relentless logic of the Eleatic philosophers was hard to counter.

MELISSUS OF SAMOS. One of the major flaws in the universe of Parmenides was the idea of a plenum with a finite boundary. If there was nothing whatsoever beyond the boundary, what happened if a person went to the outer edge of the universe, kicked a hole through its skin, and thrust his foot into nothingness, which does not exist? Melissus of Samos, who lived in the mid-fifth century B.C.E. and was the last member of the Eleatic School, attempted an answer. He defended the basic doctrine of the Eleatics, but proposed a plenum without a finite boundary, so that the universe was infinite. So no one could kick a hole through the boundary of the universe, for there was no boundary. Yet there was still no place

for movement. Melissus had to deny that the senses could yield us true knowledge, for the intelligence that our eyes report to our brains indicates that there are bodies in motion in the world about us. The Eleatics denied real existence to the "phenomena"—that is, to the objects that appear to us as actual—and any thinker who wanted to save the phenomena had to devise an argument that countered their uncompromising logic.

SOURCES

Jonathan Barnes, *The Presocratic Philosophers* (London, England: Routledge and Kegan Paul, 1982).

Harold F. Cherniss, *Aristotle's Criticism of Presocratic Philosophy* (New York: Octagon Books, 1964).

Patricia Curd, *The Legacy of Parmenides: Eleatic Monism and Later Presocratic Thought* (Princeton, N.J.: Princeton University Press, 1997).

Kathleen Freeman, *Pre-Socratic Philosophers* (Oxford, England: Blackwell, 1949).

H. D. P. Lee, *Zeno of Elea: A Text with Translation and Notes* (Cambridge: Cambridge University Press, 1936).

Richard D. McKirahan, Jr., *Philosophy Before Socrates; An Introduction with Texts and Commentary* (Indianapolis, Ind.: Hackett Publishing, 1994).

———, "Zeno," in *The Cambridge Companion to Early Greek Philosophy*. Ed. A. A. Long (Cambridge: Cambridge University Press, 1999): 134–158.

T. M. Robinson, *Heraclitus: Fragments* (Toronto, Canada: University of Toronto Press, 1987).

Gregory Vlastos, "Zeno of Elea," in *Studies in Greek Philosophy*. Ed. Daniel W. Graham (Princeton, N.J.: Princeton University Press, 1996): 241–263.

Philip Wheelwright, *Heraclitus* (New York: Atheneum, 1964).

EMPEDOCLES, ANAXAGORAS, AND THE ATOMISTS

THE IDEA OF FOUR ELEMENTS. Empedocles attempted to find an escape from the logical conclusions of the Eleatic philosophers. Born in the early fifth century B.C.E. in Sicily, Empedocles took on many roles before becoming a philosopher. For a short time he was a politician, and then he turned his attention to educating people on the topics of medicine and religion. When he embarked on his own study of philosophy, he held two very important views. First, he abandoned the accepted belief that all philosophers had held since Thales: that all matter was derived from a single underlying substance. Instead he theorized that the world, as it is known, is due to the mixing and separation of four elements: earth, air,

fire, and water, which Empedocles called "roots." Second, he accounted for the blending and the separation of the elements by theorizing the existence of two different forces that blend and separate called Love and Strife—attraction and repulsion. The first caused the elements to blend together and created the physical world, whereas Strife forced the elements apart and caused destruction.

LOVE AND STRIFE. Empedocles compared the blending of the elements to what a painter does when he mixes his basic colors: by combining his colors, he produces new tints. So in the universe, which Empedocles, like Parmenides, imagined as a sphere, the elements are mixed together by the attractive force of Love in their proper ratios to form concrete objects; human bones, for instance, were two parts water, four parts fire, and two parts earth. This blending of the elements results in genesis and growth in the world of the senses, whereas the separation of the elements results in death, destruction, and decay. Strife is on the outside of the sphere but in due time it penetrates it, driving Love towards the center of the sphere. Gradually the four elements separate from each other. Death and decay occurs. Then the opposite process begins: Love, which has been driven into the center of the sphere, begins to expand, driving out Strife. This never-ending cycle is like the flux and reflux of blood from the heart, or the action of breathing air into the lungs and then expelling it. All the objects that can be seen are unstable compounds. Blending the elements brings about genesis and the creation of new things, and the dissolution of the mixture of elements brings about their decay.

THE PROBLEM OF MOTION. Empedocles still had to explain how this blending of the elements took place. The process implies movement, and Empedocles accepted Parmenides' concept of a sphere as a plenum in which there was no movement for lack of space in which to move. Empedocles explained that there were "pores" in the elements that allowed them to move together and coalesce. The Greek for "pores" is *poroi*, passageways, like the holes in a sponge. These "pores" provided passageways so that the elements could move into each other and create unstable compounds, and then move apart and destroy them as the endless cycle of cosmic change.

ANAXAGORAS OF CLAZOMENAE. Anaxagoras, a contemporary of Empedocles, took up Empedocles' theory of blending elements and completed it by describing what caused motion in these elements. Anaxagoras, born in Clazomenae in the early fifth century B.C.E., was a man of privilege from a wealthy background. He gave up a good deal of his possessions and lands to study sci-

ence and philosophy, to the point that he left Clazomenae after 470 B.C.E. and settled in Athens. He stayed there for some forty years until he was driven into exile on a charge of impiety. Much like Empedocles, Anaxagoras asserted that the Greeks were wrong to speak of genesis and destruction; instead they should call genesis a "blending together," and destruction "decomposition." Empedocles spoke of "elements" whereas Anaxagoras spoke of "seeds." His "seeds," however, were not the same as Empedocles' "roots." Rather, they were themselves compounds, each with a fixed shape, color, and taste, and each containing a fixed number of *dynameis*—the word means "powers" or "capabilities." The ration of *dynameis* within each seed is a fixed amount, and they tend to exist in pair of opposites, such as hot *dynameis* coupled with cold ones, heavy with light ones, and moist with dry ones. A stone is made up of seeds with more heavy *dynameis* than light ones and more dry than moist ones—hence its solidity. Every seed has a portion of everything within it, no matter how minutely it may be divided.

THE POWER OF "MIND." Anaxagoras realized that his theory of "seeds" was incomplete. He still needed a source of motion that allowed this blending and uncoupling of the "seeds." Anaxagoras, however went a step beyond Empedocles and created a force called the *Nous* (Mind), which served as the source of knowledge for the human intelligence. It was not an incorporeal force, however, but a kind of unmixed fluid that did not have portions of other things in it. It coupled the "seeds" and uncoupled them by setting them in rotation. That is, "Mind" established a kind of vortex which began in the center of the "seed" and then spread further and further, evidently somewhat like the ripples that a stone thrown into a tranquil lake produces on the surface of the water. Anaxagoras did not expand further on his concept of the *Nous*, and this left future philosophers dissatisfied with the theory. Although initially attracted to Anaxagoras' philosophy in his youth, Socrates complained that Anaxagoras thought of "Mind" simply as a mechanical device to get motion started in his universe, and once that was done, he had no further use for it.

SOURCES

Felix M. Cleve, *The Philosophy of Anaxagoras* (The Hague, Netherlands: Nijhoff, 1973).

Daniel E. Gershenson and Daniel E. Greenberg, *Anaxagoras and the Birth of Physics* (New York: Blaisdell, 1964).

———, *Anaxagoras and the Birth of the Scientific Method* (New York: Blaisdell, 1964).

Denis O'Brien, "Empedocles Revisited," *Ancient Philosophy* 15 (1995): 403–470.

——, "The Relation of Anaxagoras and Empedocles," *Journal of Hellenic Studies* 88 (1968): 93–114.

Gregory Vlastos, "Physical Theory in Anaxagoras," in *Studies in Greek Philosophy*. Ed. Daniel W. Graham (Princeton, N.J.: Princeton University Press, 1996): 303–327.

Leonard Woodbury, "Anaxagoras and Athens," *Phoenix* 35 (1981): 295–315.

THE ATOMIC THEORY

ESCAPING THE LOGIC OF THE ELEATIC SCHOOL.

Both Empedocles and Anaxagoras attempted to evade the ruthless logic of Parmenides and the Eleatic School of philosophers who argued that there are two opposites, "that which exists," which is matter, and "that which does not exist," which obviously does not exist. Since the world is composed of matter which does exist, it fills all the available space. Thus there can be no motion, for motion implies that there is empty space into which an object in motion can move, and there is no empty space. Parmenides' follower, Zeno, proved to his own satisfaction that an arrow in flight only appears to move. In actuality, at any given point in its apparent flight, it is at rest. To escape from this logic, someone had to produce a theory to prove that empty space was not the same thing as the Eleatic's "that which does not exist." The philosopher who provided the necessary leap of imagination to get over this Eleatic idea was Leucippus of Miletus, the same city that fathered Thales, Anaximander, and Anaximenes who had started the long tradition of Greek speculation about the nature of the universe. Unlike his predecessors, he is a shadowy figure, overshadowed by his more famous follower Democritus to such an extent that some Greeks even denied his existence. He was recognized, however, by such philosopher greats as Aristotle, who headed the school known as the Lyceum in Athens of the fourth century B.C.E., and his successor Theophrastus. Both men referred to Leucippus as the author of a work on the atomic theory titled the *Great World System*, although other philosophers—notably Epicurus (342–271 B.C.E.) and his followers—attributed this theory to Leucippus' pupil, Democritus of Abdera. Although Democritus was a prolific writer, none of his works survive to the present day.

THE ATOMS OF LEUCIPPUS AND DEMOCRITUS.

Leucippus and Democritus conceived of particles of matter called "atoms" which moved through space like the flecks of dust that can be seen moving in a sunbeam. Some were large, some small, and some might be smooth and round and others might have an irregular shape. The atoms moved through void. Parmenides had argued that the universe was a plenum filled with matter, and there was nothing else, but Leucippus and Democritus argued that the opposite of a plenum—a vacuum—also existed. Each atom, however, which was so small as to be invisible, was itself a plenum, and could not be split. Atoms were *atoma somata* (bodies that cannot be divided). The atoms were perpetually spinning, like the "seeds" of Anaxagoras, and as they collided some stuck together while others were forced apart. Small, perfect atoms gravitated towards the outside of the universe and formed the dome of the sky, whereas heavier atoms gravitated towards the center and formed earth. The concept of weight and its opposite, lightness, was something the Greeks did not understand, for the force of gravity had not yet been defined. Leucippus explained that weight resulted from the size of the atoms and their combinations, but neither he nor Democritus seemed to have thought weight very important and they never committed the error that Aristotle made later, of arguing for the existence of absolute weight. Epicurus later assigned different weights to the atoms, and argued that the heavier atoms moved at a different speed than the lighter ones. For Leucippus and Democritus, weight was a relative thing and the atoms moved at random. But they collided, and from their collisions they formed the groups of atoms that make up every object in this world, including human beings. The atomists saw an analogy in the letters of the alphabet. Each letter is a separate symbol with its own form, but when arranged together in various ways they form words. So the various arrangements of the atoms form different objects in the same way as the different arrangements of letters make different words. It was taken for granted that the atoms would always keep moving unless something intervened to make them stop.

THE PROBLEM OF THE SOUL.

The atomic theory of Leucippus and Democritus assumed that the soul, too, was made up of atoms and void. Soul atoms were round and very mobile, and the atomists argued that there was also a fiery quality about them. Fire-atoms exist in the universe, but had no influence on how material things move; men breathed them into their bodies, at which point they formed an aggregate of fiery atoms known as the soul, and on death, it dissolved. This theory hearkened back to the old Greek belief that the soul—the *psyche*—was the breath of life which departed from the body at death. According to the atomic theory, the soul that is composed of atoms leaves the body when the last breath is drawn and returns to mingle with the fire-atoms of the universe. There is no place in this theory for any

belief in the immortality of the soul. Yet the soul that is within every living person endows him with his intellect and his senses and even governs the motion of his limbs. The senses allow humans to see, hear, and taste, for objects project images of themselves as emanations, and these are received by the soul. Animals apparently did not have souls of this sort, though they, too, breathed in air and exhaled it, and in fact, the concept of the soul according to the atomic theory seems to involve a good deal of inconsistency.

DEMOCRITUS THE MORALIST. Democritus wrote on a remarkable number of subjects, including mathematics, and among them was a theory of ethics which he fitted to his atomic philosophy. One treatise titled *On Cheerfulness* began with a warning against restless activity. Freedom from disturbance, he wrote, is what brings about human happiness. Cheerfulness is the ultimate good and it is a state in which the soul lives tranquilly, without being disturbed by any fear or superstition. Here we find a new conception of life for a person, not as a part of a social order such as a city, but rather as an individual. Human happiness was the sum total of all feelings that give pleasure—not just vulgar pleasures, though Democritus did not rule them out, but also pleasures in the beautiful. His thoughts about the gods are difficult to discern; one surviving fragment of his writings refers to them as providers to mankind of all that is good, and another fragment mentions them as images that approach human beings to impart knowledge of the future and of the divine. On morals, he was no relativist. As far as he was concerned, there was one standard of morality for everyone:

> The same things are good and true for all mankind, but some men take delight in some things and others in others.

SOURCES

Paul Cartledge, *Democritus* (London, England: Routledge, 1999).

Marshall Clagett, *Greek Science in Antiquity* (London, England: Abelard-Schuman, 1957).

Thomas Cole, *Democritus and the Sources of Greek Anthropology.* American Philological Association Monograph, no. 25 (Cleveland: Press of Case Western Reserve University, 1967).

George N. Vlahakis, "Atomism," in *Encyclopedia of Greece and the Hellenic Tradition.* Vol. 2. Ed. Graham Speake (London, England: Fitzroy Dearborn, 2000): 201–202.

Gregory Vlastos, "Ethics and Physics in Democritus," in *Studies in Greek Philosophy.* Ed. Daniel W. Graham (Princeton, N.J.: Princeton University Press, 1996): 328–350.

THE SOPHISTS

A SHIFT IN EMPHASIS. The scientific philosophers, from Thales to Democritus, had done their best to understand the nature of the world with remarkable achievement. The intuition of Leucippus and Democritus—that the universe was created of atoms and void—was a remarkable one, but the Greeks lacked the scientific equipment to make it anything more than an hypothesis. In the classical period (480–323 B.C.E.), philosophy sought new areas of speculation. In Athens, Socrates was a pivotal figure, so much so that the natural philosophers, from Thales to Democritus, are lumped together under the label, "Presocratics." Yet the way for Socrates was prepared by a group of thinkers and teachers called Sophists. The Greek word *sophistes*, from which the word "sophist" is derived, means a "master of one's craft," and it has a secondary meaning of "one who is expert in practical wisdom." Experts in classical Greece always suffered from a degree of prejudice—the American slang word "egghead" is a good translation of *sophistes*. But it was not until the fourth century B.C.E. that the word "sophist" carried distinct overtones of disdain, and Socrates' disciple, the philosopher Plato, must bear much of the responsibility for that development. Plato was at pains to show that Socrates was not a Sophist, though some of his contemporaries clearly thought that he was. Socrates had disciples, but Plato claimed that he never charged tuition fees whereas the Sophists did.

THE DEMAND FOR HIGHER EDUCATION. The Sophists appeared at a time when the old aristocratic prejudices of archaic Greece were breaking down all over the Greek world. The age of the Sophists seems to have begun outside Athens, and it gave rise to a cadre of international experts who, like the lyric poets in archaic Greece, roved from city to city in search of students willing to pay the tuition fees they charged. In the aristocratic thought-world of archaic Greece, *arete*, a word which combines the meanings of "virtue" and "valor," was an innate quality. So far as there was an educational program, it consisted of poetry—particularly the poems of Homer—music, training in arms, and following the examples of one's elders. This sort of education was incomplete in classical Greece, however, where individuals needed to be skilled in presenting cases in court; in the public assemblies, competence in public speaking paid dividends. The Sophists claimed to be able to teach the skills necessary for success. They asserted that they could make their disciples proficient in rhetoric and the verbal skills to make a weak case appear stronger than it really was. From teaching men how to be good at something like rhetoric, the claim to teach men goodness it-

self required no great leap of the imagination. One of the learned men who approached these broader questions was Protagoras, the first Sophist to charge tuition fees, who came from Abdera in northern Greece not far from the border with modern Turkey. He was an itinerant teacher who spent most of his life traveling; he visited Sicily and he came to Athens at least twice. During one of these times in Athens he was threatened by a conservative Athenian named Pythodorus with a charge of impiety, and he made a timely departure. His books were publicly burned, but Protagoras' reputation outside Athens no doubt resulted in the survival of copies of his books elsewhere in the Greek world.

THE TEACHINGS OF PROTAGORAS. Conservative pious Athenians had good reason to be shocked by Protagoras' books, which he presented during public readings. An early work titled *On the Gods*, which was his first book to be read in public, began with the memorable sentence:

> Of the gods, I can know nothing, neither that they are nor that they are not, nor how they are shaped if at all. Many things prevent such knowledge—the uncertainty of the question and the shortness of human life.

With these few words, Protagoras turned his back on the gods to whom the Greeks sacrificed all over the Greek world, though it cannot be said for certain that he was an out-and-out atheist. His outline for the proper education of a politician was laid out in a book titled *Truth, or Refutations* which began with a sentence that became famous as the summary of his philosophy:

> Man [or "a man"] is the measure of all things, of things that are, that they are, and of things that are not, that they are not.

In the context of its time, this passage may have been a protest against the Eleatic school of philosophy, particularly Parmenides, who argued that existence as men perceive it is not at all what it actually is. Protagoras' rejoinder to the Eleatics was that as things exist *for me*, that is what they are for me, and as they exist for you, that is what they are for you. In other words, each person has a right to trust his own senses. Yet there is little doubt that Protagoras carried over this relativist view into judgments of value as well. The inference was that there was no such thing as absolute justice or absolute goodness; rather they were matters of personal judgment. Thus Protagoras held that one could argue equally well for or against any proposition; whether or not the proposition had some merit was of no consequence since all opinions were equally true. Some opinions, however, could be better than others even if they were not more

a PRIMARY SOURCE *document*

PROTAGORAS: THE FIRST PROFESSIONAL TEACHER

INTRODUCTION: Protagoras of Abdera (circa 485–circa 415 B.C.E.) was the first professional sophist to offer instruction for a fee, and he died a wealthy man. He was clearly a man of recognized integrity who was generally respected, for when Athens founded the colony of Thurii on the Gulf of Taranto in Italy in 444 B.C.E., the Athenian statesman Pericles appointed him to draw up a code of laws for the new foundation. He upheld a doctrine of relativism—the sentence that introduced a work of his, "Man is the measure of all things" was famous and was taken to mean that every person has his own criterion for what is good and true. Thus truth existed in the eye of the beholder and everything could be true for in the opinion of someone. The following selections comes from the *Lives* of the ancient philosophers, a compilation by Diogenes Laertius who probably lived in the first half of the third century C.E.

Protagoras was the first person to declare that in every subject for debate, there were two sides which were the exact opposite of each other, and he used to use this debating procedure in his arguments, being the first person to do so. He started a book of his with this introductory sentence:

> Man is the measure of all things, of the existence of things that are and the non-existence of things that are not.

He used to say, too, that the soul was merely sensory perception, as Plato says in the *Theaetetus*, and that everything was true. Also, he introduces another of his treatises this way:

> Concerning the gods, I cannot know for certain if they exist or if they do not. For there are many things that prevent one from knowing, especially the uncertainty of the subject and the shortness of human life.

Because of this sentence that began his treatise, he was banished by the Athenians, who burned his books in the market-place.

SOURCE: Diogenes Laertius, "The Life of Protagoras," in *The Lives and Opinions of Eminent Philosophers*. Trans. C. D. Yonge (London: Henry Bohn, 1853): 397–398. Text modified by James Allan Evans.

true; that, at least, is what Plato suggested in his dialogue, the *Theaetetus*, as Protagoras' meaning, and it is very close to that of a modern pragmatist.

GORGIAS OF LEONTINI. Like Protagoras, Gorgias of Leontini found the conclusions of the Eleatic philosophers impossible to accept. But unlike Protagoras, whose reaction was to affirm that it was right for every person to decide for himself what was true, Gorgias maintained that there was no truth at all. Gorgias was from the Sicilian city of Leontini and he came to Athens in 427 B.C.E. as an envoy for his native city. His skill at public speaking made a great impression on the Athenian public. He introduced Athens to methods of persuasion that had been developed in Sicily, and his influence on Athenian literature and prose style was enormous. During his time in Athens he studied and presented his own brand of philosophy. One of his works *On Nature, or What Does Not Exist*, attempted to show that there is nothing; even if there is something, we cannot know it, and even if we could know it, we cannot communicate our knowledge to anyone else. This sort of nihilism would seem to lead to the conclusion that there is no right or wrong, but Gorgias did not go so far. Others did, however; in the first book of Plato's *Republic*, an Athenian named Thrasymachus maintains that there is no "Right" at all, and what we call "Right" is only what is advantageous for the more powerful person who can force weaker persons to accept it as lawful and binding simply because he is more powerful. Thrasymachus was a teacher of rhetoric in Athens when Gorgias visited Athens, and though the *Republic* of Plato was written more than a generation later, Plato probably reported accurately the conclusions that some of Gorgias' disciples drew from his teachings.

PRODICUS OF CEOS AND HIPPIAS OF ELIS. Prodicus was a contemporary with Democritus and Gorgias, and was a disciple of Protagoras. Originally from Iulis on the island of Ceos, he was a popular public servant who eventually was sent to Athens as an ambassador. After a time, he also took up the study of philosophy and soon had opened his own school of Rhetoric. By the late fifth century B.C.E., he was giving expensive lecture-courses which seem to have emphasized linguistics. His particular specialization was the exact meaning of synonyms. His studies in religion focused on the personalization of natural objects as the creation for the need for organized religion, that man needed to understand how nature related to him personally and not how he worked in conjunction with nature. This defied many of the ideas that man was the center of the universe and that all things were created by the gods to serve man. Many of these ideas were noted in his most famous work *The Choice of Heracles*, a work that is no longer available but is often cited by later philosophers. Prodicus was put to death for his ideas on religion and was accused of corrupting the youth of Athens. Another contemporary Sophist was Hippias, who belonged to a school of teachers that believed that the educated man was master of everything. Once he visited the Olympic Games wearing a purple cloak, and boasted that he made everything he wore, including the ring on his finger. He dabbled in all the recognized branches of learning—grammar, rhetoric, geometry, mathematics, and music—and he also tried his hand at literature: epic poetry, tragedy, chronicles, and so on. He made profitable lecture tours, traveling from city to city; in one of the Platonic dialogues he boasts to Socrates that he had just given a very successful series of lectures in Sparta, where his subject was genealogies, which was one of the few categories of learning that were to Spartan taste. One of his works was a list of the victors at the Olympic Games, starting in 776 B.C.E. Hippias' work is lost but it served as one source for a later list drawn up in the early third century C.E., and it is the basis for the chronology of archaic Greece.

SOURCES

The Greek Sophists. Trans. John Dillon and Tania Gergel (London, England: Penguin, 2003).

Eric Havelock, *Preface to Plato* (Cambridge, Mass.: Belknap Press, 1963).

G. B. Kerferd, *The Sophistic Movement* (Cambridge: Cambridge University Press, 1983).

Michael Nill, *Morality and Self-Interest in Protagoras, Antiphon and Democritus* (Leiden, Netherlands: Brill, 1985).

The Sophists and Their Legacy. Ed. G. B. Kerferd (Wisebaden, Germany: Franz Steiner, 1981).

Mario Untersteiner, *The Sophists.* Trans. Kathleen Freeman (New York: Philosophical Library, 1954).

Paul Woodruff, "Rhetoric and Relativism: Protagoras and Gorgias," in *The Cambridge Companion to Early Greek Philosophy.* Ed. A. A. Long (Cambridge, England: Cambridge University Press, 1999): 290–310.

SOCRATES

CONSTRUCTING SOCRATES. Often called the "father of philosophy," Socrates (470–399 B.C.E.) is known to modern readers only through the written works of other philosophers and historians. It is unclear whether Socrates himself ever wrote down any of his philosoph-

ical views, but it is certain that any of his works that were created have since been lost. Fortunately, a good deal was written about Socrates both before and after his death. The main source of the philosophical viewpoints of Socrates comes from his disciple Plato, who first recorded the dialogues of Socrates and later used the persona of Socrates in his writing to promote his own philosophy. Three of Plato's most famous dialogues—the *Apology*, the *Crito* and the *Phaedo*—recreate Socrates' last days before he was put to death on charges of impiety and corrupting the young. All three works focus on different areas of philosophy: the *Phaedo* discuss death, life, and the morality of suicide; the *Apology* constructs a defense of philosophy in general and an attack on the Sophists' way of thinking; and the *Crito* focuses on justice and issues of good versus evil even in the face of injustice. In Plato's earlier dialogues, such as the *Apology* and the *Euthyphro*, Socrates appears as a personality in his own right, but in later works, such as the *Republic*—Plato's dialogue that has had the greatest influence of anything he wrote—Socrates has become a spokesman for Plato's own philosophy. Yet the personality of Socrates recognized by modern scholars as most authentic is Socrates as portrayed by Plato. Numerous other accounts of Socrates—such as the comical character Socrates in Aristophanes' play *Clouds* and the day-to-day advisor that appears in the works of the historian Xenophon—survive, yet these accounts are considered to be minor sources in comparison to Plato.

THE IDENTITY OF SOCRATES. Socrates was probably born in Athens in the spring of 468 B.C.E., and he lived there all his life. He was reportedly the son of a stonemason and a midwife, and he had three sons of his own—two of whom were still small children at the time of his death. His wife Xanthippe was famously ill-tempered; stories about Socrates, recorded in the works of Xenophon, include episodes of public fights between the two which often included acts of violence. (Despite the marital discord, Plato's dialogue the *Phaedo* describes a tearful Xanthippe leaving Socrates' prison cell the day before his death in 399 B.C.E., indicating the presence of genuine feelings between the two.) Socrates was a contemporary of the Sophists, and talked and argued with many of them, but the Sophists were itinerant teachers who charged tuition fees, whereas Socrates never left Athens and did not charge his disciples tuition. He originally was attracted to the doctrine of Anaxagoras, and tradition made him a pupil of Anaxagoras' disciple, Archelaus, who kept a school in Athens; after Archelaus left Athens, Socrates probably took over as headmaster of the school. For the last twenty or 25 years of his life,

Marble bust of Socrates. © GIANNI DAGLI ORTI/CORBIS. REPRODUCED BY PERMISSION.

he was a familiar figure on the Athenian scene, always barefoot, discussing and debating the important questions of philosophy.

SOCRATES' MISSION. Socrates' mission in life was to expose the lack of wisdom in the world, a purpose that had its origins in a statement by the oracle of Apollo at Delphi that there was no one wiser than Socrates. According to Plato's *Apology* Socrates did not believe the oracle, for he did not consider himself wise, so he began a quest to prove that the oracle was wrong. He encountered a man with a reputation for wisdom—Socrates did not name him—and after questioning him, he concluded that though many people, including the man himself, considered him wise, he really was not. He then examined another man who was considered wise, with the same result. He tried the politicians, then the poets and finally the skilled craftsmen, and concluded that though they might possess expertise in their own area, they were not truly wise, though they thought they were. These investigations did not make Socrates popular, as he readily admitted. Finally Socrates concluded that what the oracle meant was that he was not wise, for real wisdom belonged to God, but that he recognized his lack of wisdom and this self-recognition was what impressed the oracle. So Socrates made it his mission to seek out persons who thought they were wise and to prove to them

SOCRATES RECRUITS XENOPHON

INTRODUCTION: Philosophers in ancient Greece attracted disciples who desired to learn their ideas. Such was the popularity of some philosophers that they established schools to facilitate the teaching of their students, sometimes charging fees for their educational services. According to ancient sources, the eminent philosopher Socrates did not charge tuition fees to his disciples, although he did actively recruit promising young men. The following excerpt from *History of Philosophy, or On the Lives, Opinions and Apophthegms of Famous Philosophers* by Diogenes Laertius, who wrote in the first half of the third century C.E., provides a glimpse into the recruitment of Xenophon by Socrates as one of his disciples.

Xenophon, son of Gryllus, was an Athenian citizen and came from the "deme" (borough) of Erchia. He was a man of great decency, and handsome beyond anyone's imagination.

The story goes that Socrates encountered him in a narrow lane, and put his stick across it, barring him from getting past, and he asked him where men might find a market where foodstuffs necessary for life were sold. When Xenophon replied, Socrates asked him again where men could find goodness and virtue. Xenophon did not know, and so Socrates said, "Follow me, then, and find out." So from that time on, Xenophon became a disciple of Socrates.

Xenophon was the first person who took down dialogues as they occurred, and made them available to the public, calling them *Memorabilia*. He was also the first man to write a history of philosophers.

SOURCE: Diogenes Laertius, "Life of Xenophon," in *The Lives and Opinions of Eminent Philosophers*. Trans. C. D. Yonge (London: Henry G. Bohn, 1853): 75.

that they were not. It was a mission that made him many enemies.

WHAT DID SOCRATES BELIEVE? With the exception of the comic poet Aristophanes who mocked Socrates in his comedy, the *Clouds*, produced in 423 B.C.E., all the authors who wrote about Socrates did so after his death, and if he had any clear and coherent body of doctrine, we can discern it only dimly now. He was a traditonalist in religion insofar as he held that gods do exist and promote the welfare of mortals, and that they communicate their wishes by oracles, dreams, and other similar methods. On the other hand, he thought that all conventional beliefs needed rigorous examination, and hence he was a severe critic of Greek religion as it was practiced in the Athens that he knew. He claimed to possess a kind of inner self—a *daimonion* (spirit)—which guided him and warned him at times against an action he was contemplating, but nowhere do we have any explanation of what this *daimonion* was. He was a master of dialectic—that is, the art of investigating or debating the truth of general opinions—and his great contributions to dialectic were definition and inductive logic. He held that before any opinion can be debated, it has to be carefully defined so that there is a basis for argument. Then the argument can proceed by induction—that is, drawing general conclusions from particular facts or examples—and thus the definition can be tested and examined. Socrates was a masterful critic of irrational thought, but his philosophy is less clear since Plato used him as a mouthpiece for his own thought. It is impossible to distinguish between the philosophies of Socrates and Plato in Plato's writings. In Plato's *Seventh Letter*, so-called because it is the seventh in a collection of thirteen letters attributed him, he calls Socrates the wisest and most just man of his day, but the historical Socrates emerges from the mists of the past as a great personality and a master of rational argument rather than as the teacher of a philosophical system.

SOCRATES AS A REBEL. Socrates was a magnet for the bright, well-to-do young men of Athens who honed their debating techniques by matching their wits with his own. Some of these pupils used the skills they learned in ways that Socrates did not intend, however, and it led to serious charges against the philosopher. It cannot be denied that Socrates taught his Athenian disciples to question the basis of the democratic constitution of Athens. The underlying assumption of democracy as it was practiced in Athens was not that all men were born equal, but that every man was capable of performing the functions that public office required, provided that he was honest. It was not necessary to have professional training to hold a government post. Hence citizens were chosen by lot to hold important public offices; the chief exceptions were the ten generals who commanded the army and navy, who were elected each year. Socrates was fond of pointing out that a person would go to a cobbler skilled at shoemaking to have his shoes made, or to a doctor trained in medicine if he was ill, but if he wanted someone to hold high office in the state, he chose a man on the street. Socrates' logic was sound enough, but its inevitable conclusion was that cities should be governed by officials with training in government. That principle lay behind the work for which his disciple Plato is best

known, the *Republic*, which outlines an ideal constitution for a state where those that govern are trained in the art of governing. The same theme lay behind most of the speculation about the art of government in the ancient world after Socrates. Among philosophers, democracy had, at best, lukewarm defenders. It can be argued that Socrates was the intellectual great-grandfather of the totalitarian governments of the twentieth century, but it was the unintended consequence of his teaching.

THE EXECUTION OF SOCRATES. In 399 B.C.E., Socrates was brought to trial on a charge of heresy—not believing in the gods in which the other Greeks believed—and of corrupting the young. These charges against Socrates were less about morality and more likely the result of a political upheaval in Athens following Athens' defeat in the Peloponnesian War five years earlier. Socrates was known to associate with men who had seized power after the war and launched a reign of terror on Athens before the democratic process could be reinstated. Socrates was also a good friend of Alcibiades, a politician who many blamed for the loss of the Peloponnesian war. Socrates was arrested and tried before 501 jurymen and, like all Athenians arraigned before the lawcourts, he was given the opportunity to speak in his own defense; no defendant could hire a lawyer to speak for him. Socrates' defense is the basis of Plato's *Apology*, which may be an accurate reconstruction of what Socrates actually did say, for Plato witnessed the trial. Though Plato portrays Socrates as speaking eloquently and convincingly to the jury, he was found guilty and sentenced to death. He was confined to the state prison until the day came for him to drink the hemlock-juice, a poison made from a weed of the carrot family that the Athenians used to execute malefactors. His last words were a reminder to his friends that he owed the sacrifice of a rooster to Asclepius, the god of healing, implying, perhaps, that death was a cure for life.

THE INFLUENCE OF SOCRATES. Many of Greece's famous philosophers had their roots in Socrates. Antisthenes (c. 455–360 B.C.E.), considered the founder of the Cynic sect, was a devoted follower, and he in turn influenced Diogenes of Sinope, the most famous of the Cynics. Antisthenes taught that happiness was based on virtue, and virtue is based on knowledge and consequently can be taught. Aristippus of Cyrene, famous for his love of luxury, was a companion of Socrates. He was considered the forefather of the Cyrenaic school of philosophy that taught that the pleasures of the senses were the chief end of life. The Cyrenaics were to influence the Epicureans, one of the important schools of thought

a PRIMARY SOURCE *document*

SOCRATES' DOMESTIC LIFE

INTRODUCTION: Although revered as one of the greatest Greek philosophers, Socrates had a tempestuous domestic life with his wife Xanthippe, by whom he had a son named Lamprocles. Xanthippe seems to have found Socrates an exasperating husband, and she did not hesitate to voice her frustration with Socrates in public or to attack him physically. In the passage below, Diogenes Laertius, writing in the early third century C.E., describes scenes from Socrates' domestic life.

Socrates once said to Xanthippe, who scolded him and then threw a pot of water over him, "Didn't I say that Xanthippe was thundering just now, and there would soon be a downpour?"

When Alcibiades said to him, "Xanthippe's shrewish moods are intolerable!", he replied, "Yet I'm used to it, just as I would be if I were always hearing the screech of a pulley—and you yourself put up with the noise of geese honking." "Yes," replied Alcibiades, "but they bring me eggs and goslings." "Well, yes, so they do," replied Socrates, "and Xanthippe brings me children."

Once when Xanthippe assaulted him in the market-place and ripped off his cloak, his friends urged him to ward her off with his fists. "Yes, by Zeus," said he, "and while we are pummeling each other, you can all cry out, "Good jab, Socrates! Nice blow, Xanthippe!"

He used to say that a man should live with a recalcitrant woman in the same way as men handle violent-tempered horses, and when they have mastered them, managing every other sort of horse is effortless. "Thus," he said, "after managing Xanthippe, I will find it a simple matter to live with any other woman."

SOURCE: Diogenes Laertius, "Socrates," in *The Lives and Opinions of Eminent Philosophers*. Trans. C. D. Yonge (London: Henry G. Bohn, 1853): 70–71.

in the Greek world after Alexander the Great. Eucleides of Megara, another of Socrates' pupils, established a school of philosophy in Megara on the Isthmus of Corinth, between Athens and Corinth, where he tried to combine the teaching of Socrates on ethics with the doctrine of Parmenides on the nature of the universe. Greatest of all Socrates' pupils, however, was Plato whose

works had a lasting influence on the intellectual traditions of the world.

SOURCES

John Ferguson, *Socrates: A Sourcebook* (London, England: Macmillan, 1967).

Norman Gulley, *The Philosophy of Socrates* (New York: St. Martin's Press, 1968).

Eric A. Havelock, "The Socratic Self as It is Parodied in Aristophanes' *Clouds*," *Yale Classical Studies* 22 (1972): 1–18.

Mark L. McPherran, *The Religion of Socrates* (University Park: Pennsylvania State University Press, 1997).

Socrates: Critical Assessments. Ed. William J. Prior (London, England: Routledge, 1996).

Socrates, The Wisest and Most Just?. Ed. Meg Parker (Cambridge, England: Cambridge University Press, 1979).

I. F. Stone, *The Trial of Socrates* (Boston: Little Brown, 1988).

Leo Strauss, *Socrates and Aristophanes* (Chicago: University of Chicago Press, 1966).

A. E. Taylor, *Socrates* (Garden City, N.J.: Doubleday Anchor Books, 1952).

C. C. W. Taylor, *Socrates* (Oxford, England: Oxford University Press, 1998).

Gregory Vlastos, *Socrates: Ironist and Moral Philosopher* (Cambridge: Cambridge University Press; Ithaca, N.Y.: Cornell University Press, 1991).

PLATO

SOCRATES' DISCIPLE. Plato (429–347 B.C.E.) was not yet thirty years old when Socrates was put to death in 399 B.C.E., and though the date of their first meeting is unknown, Socrates must already have been a middle-aged man when the two first became acquainted. The meeting of the two changed Plato's life. He belonged to a distinguished Athenian family, and he was educated in music and gymnastics like other youths of his class. According to one tradition, he was a budding poet in his youth and had already written some tragedies, but he burned them all after he met Socrates. In the *Seventh Letter*, which he wrote in his old age, he reflected on the hopes of his youth. He planned to enter public life, and had an opportunity to do so in the immediate aftermath of the Peloponnesian War when a cadre of reformers overthrew the democratic constitution and took control. They were led by thirty men with absolute powers, some of them Plato's relatives—the leader of the "Thirty," Critias, was his mother's cousin—and they invited him to join them. Plato was at first favorably impressed: he

was young, and imagined that these reformers would establish a just state, but instead, they rapidly earned the title of the "Thirty Tyrants" by which they are known in the history books, and Plato soon realized that the democratic constitution which they had overthrown had been a very precious thing. One action in particular appalled him: the "Thirty Tyrants" tried to implicate Socrates in their crimes, but he refused and risked his life by doing so. When the "Thirty Tyrants" were overthrown, the restored democracy acted with restraint—Plato gave it credit for that—but "certain powerful persons" brought Socrates to trial on a charge of impiety. He was found guilty and put to death, and in the aftermath, many of Socrates' acquaintances, Plato among them, feared reprisals and fled from Athens to Eucleides in neighboring Megara. Plato did not stay there long. He served in the Athenian army in 395 and 394 B.C.E. and the rest of the time he spent traveling and writing. Giving dates to Plato's dialogues is no easy task, but it is generally agreed that his early dialogues belong to this period.

PLATO'S TRIP TO SICILY. It was probably in 388 B.C.E. that he visited southern Italy first, and then Sicily. In southern Italy he met the Pythagorean philosopher Archytas who had been elected ruler of Tarentum, modern Taranto. Thanks to Archytas, there was a revival of Pythagoreanism in southern Italy, and he made a deep impression on Plato. The two men became friends. From southern Italy Plato went to Syracuse in Sicily where Dionysius the Elder was at the height of his power. Dionysius had enjoyed a brilliant career; at the age of 25, he had been elected general of Syracuse with full authority at a time when Carthage seemed on the verge of conquering the whole island, and he had driven back the Carthaginians and made Syracuse one of the leading cities in the Greek world. Yet by the time Plato reached Syracuse, the brilliant young savior of Greek Sicily had become a tyrant, and Plato's portrayal of the typical tyrant found in his *Republic* owes a great deal to his experience with Dionysius. Dionysius had Plato removed by ship and put ashore on the island of Aegina that was at war with Athens at the time, and Plato might have been sold as a prisoner of war except that a friend from Cyrene ransomed him. During Plato's sojourn in Syracuse, he met Dionysius' brother-in-law, Dion, and was deeply impressed by him. In Dion, Plato recognized a man of similar ideals, and he believed he could be a potential ruler of an ideal state.

THE FOUNDING OF THE ACADEMY. Upon Plato's return to Athens, he founded his school known as the "Academy" because it occupied a park a half an hour's

walk outside the Dipylon, one of the city gates which was sacred to the guardian spirit Academus. There, under the sacred olive trees, Plato rented a gymnasium in which he started to teach, but he soon bought a parcel of land nearby which was given the name "Academy." Little is known about the actual teaching in the Academy, but there seems to have been a regular curriculum for the students who enrolled, and mathematics was an important part of it. One anecdote held that over the Academy's main gate was a sign that read: "No one shall enter who knows no geometry." The Academy was a magnet for the intelligentsia of Greece, among them pioneers in mathematics, the most important of whom was Eudoxus of Cnidus who arrived in 367 B.C.E. at the age of 23 and stayed to attend Plato's lectures. Aristotle arrived at the Academy at the age of seventeen and remained there for twenty years. It should always be remembered that the dialogues of Plato do not give us the full picture of Plato's thought. Some aspects he transmitted orally and never committed to writing, and among these subjects were his last words on the so-called "Theory of Forms." Thanks to the witness of Aristotle, we know that before he died, Plato lectured on one important aspect of Creation: how the ideal Forms were originally generated by the "One," which was a divine entity, or, put simply, God. He never committed this to writing, for he did not completely trust writing as a satisfactory mode of communication.

PLATO RETURNS TO SICILY. In 367 B.C.E., the tyrant of Syracuse, Dionysius the Elder, died and was succeeded by his son, Dionysius II. His father had allowed him no experience in politics, but he was a talented young man, eager to learn, and it seemed to his uncle Dion that here was an opportunity to apply Plato's political ideas to Syracuse. He wrote Plato, inviting him urgently to come, and in 366 B.C.E. Plato arrived to a gratifying welcome. The atmosphere soon changed, however, as court intrigues aroused Dionysius' suspicions of Dion, and he sent him into exile. He did not allow Plato to leave until 365 B.C.E. and then only after a promise from Plato to return. Four years later, he did return, urged by Dion, who hoped that Plato could persuade Dionysius to recall him, but this time things turned out worse than before, and Plato got permission to leave Syracuse only thanks to the intervention of his friend Archytas of Tarentum. Dion now prepared for war. In 357 B.C.E., he captured Syracuse, forced Dionysius out and ruled for four years himself. Well-meaning though he was, he was tactless and authoritarian, and in 354, he was assassinated by a former supporter. Dion's friends now appealed to Plato again, and Plato replied with two

Plato shown as a typical philosopher. THE LIBRARY OF CONGRESS.

letters, the *Seventh* and *Eighth* in a collection of thirteen that are attributed to Plato. These two are thought to be genuine, though suspicion hangs over the other eleven. Plato died at the age of 81, some seven years after Dion.

PLATO'S WRITINGS. All Plato's works (apart from the letters) are written as dialogues where he himself does not appear. The one possible exception is his last work, the *Laws,* where one of the interlocutors is an anonymous Athenian, who is almost certainly Plato himself. The result is that there is an elusive quality to Plato's thought, as if he was attempting to establish a mode of thinking as much as a systematic philosophy, and that is particularly true of his early dialogues. During his time as Socrates' disciple, he focused on issues of virtue and morality, and the importance of education and training, which interested Socrates himself in his last years. That seems clear from the dialogues that Plato produced in the aftermath of Socrates' death, which was the catalyst that prompted him to write. Then, having recovered from the immediate shock of Socrates' execution, Plato began to turn his attention to questions of law and government, writing his most famous text, the *Republic,* in response to his distaste for the sort of governments that he saw in contemporary

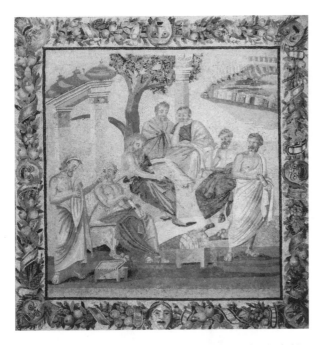

Roman mosaic of the 1st century C.E. called the "School of Philosophy" because it shows various famous philosophers in discussion. THE ART ARCHIVE/ARCHAEOLOGICAL MUSEUM NAPLES/DAGLI ORTI.

Greece. He also wrote on metaphysics, epistemology, and ethics during his study of philosophy, but it was the nature of the just society, governed according to the principles of philosophy, that continued to occupy him. His last work, left unfinished at his death in 347 B.C.E., was the *Laws* in which the topic returns to that of the *Republic*: the constitution of a truly just state.

THE EARLY PERIOD. The exact order in which Plato wrote his works is not known, and assigning dates is impossible, but the dialogues can be divided into three periods: early, middle, and late. The early writings deal mainly with the teachings of Socrates in the form of dialogues. The "dialogue" seems to have been a literary form that Plato invented, borrowing it from the theater, and he used it effectively to demolish preconceived notions. One of Socrates' main concerns is *arete*, the word that is always translated as "virtue," even though there is no word in English that is an exact translation: *arete* means "courage" and "excellence" quite as much as "moral virtue." The main doctrine that Socrates puts forward in almost all of the early dialogues is that this virtue is knowledge, and thus it can be taught. He does not say what knowledge is, but he does assert that no one willingly does wrong, and hence wrongdoing is a mark of ignorance. In a typical dialogue of this early period, Socrates poses a question in the form, "What is 'X'?" For instance, what is justice? When he is offered various examples of justice, he replies that he does not want examples, he wants to know what justice is, in and of itself. Since such questions typically cannot be answered in a satisfactory way the dialogues tend to conclude on a negative note. It is not until the dialogues of Plato's middle period—where Socrates becomes a mouthpiece for Plato's own thought—that an attempt is made to provide positive doctrine.

THE DIALOGUES OF THE MIDDLE PERIOD. The dialogues of the middle period include works like the *Phaedo*, the *Symposium*, and Plato's greatest work, the *Republic*, which describes a utopia ruled by right principles. In these works Plato's philosophy began to provide definite answers to the philosophical questions his master had pessimistically concluded were unanswerable. It is in these dialogues of Plato's middle period that the "Theory of Forms" is elaborated, most explicitly in the *Republic* and the *Phaedo*. In textbooks, the "Theory of Forms" is sometimes called the "Theory of Ideas" which is misleading, for the "Ideas" are not ideas in the modern sense; rather the word simply transliterates the Greek *idea* which means "form." Plato argued that these "Forms" are not mere intellectual concepts; they have an existence of their own. They are changeless and divine and among them, the form of the "Good" has a unique status. They exist separate from the things of the visible world that are imperfect copies of them, and knowledge of the "Forms" is therefore true knowledge and not mere opinion, which is fallible and changeable and easily influenced by persuasion. Thus true knowledge can exist. This is Plato's answer to Protagoras' dictum, "Man is the measure of all things," which taught that all things are relative. At the same time, his logic led him to the conclusion that the "Forms" are true reality; what we see in the visible world about us is only the appearance of reality.

THE FLAWS IN THE "THEORY OF FORMS." There were many bright students at the Academy, and they must have made Plato aware that his "Theory of Forms" was anything but watertight. The dialogue titled the *Parmenides* tests the theory. We cannot assign a date to it, but it is a later work, written some years after the *Republic* and the *Phaedo*, and it is a remarkable example of self-criticism. Plato imagines his half-brother Antiphon recalling a conversation that the young Socrates had once had with Parmenides and his follower Zeno. Plato pictures Parmenides, the founder of the Eleatic school of philosophy, as an old man when this imaginary conversation took place, but his logic was as ruthless as ever. Socrates expounds the theory that there are ideal "Forms" of justice, beauty, and goodness, which belonged to the

PLATO'S
Theory of Forms

The Dilemma of Knowledge

The "Theory of Forms" (in Greek *ideai*—hence the Theory of Forms is sometimes referred to as the "Theory of Ideas") was Plato's attempt to understand how knowledge exists. Heraclitus had claimed that the world was constantly changing. Everything is impermanent and hence it is impossible to know anything, since all things change even while one thinks about them. Parmenides had given another explanation: he taught that *what is* must be eternal and changeless and only *what is* can be known. The conclusion of both schools of thought was that the evidence of the senses was not reliable. Yet Plato's intuition told him that knowledge was possible. Socrates had been sure of it, for the world without the possibility of knowledge made only nonsense. The "Theory of Forms" was a way out of this dilemma and whether it was a conception of Socrates or one which Plato himself conceived, we cannot know. In the *Phaedo*, the dialogue which Plato sets in the prison where Socrates was awaiting death, Socrates, in his final hours before he drank the hemlock, discoursed on the immortality of the soul, and he refers to the "Theory of Forms" as an hypothesis with which his disciples were familiar. However the *Phaedo* was written long after Socrates' death, and probably Plato was attributing a theory of his own to his master.

Knowledge of the Forms

How does one recognize that a chair is a chair, even though many kinds of chairs exist? It is because the chairs which we see all partake of the ideal form of a chair which our souls recognize. How can we recognize Goodness? It is because an ideal form of "Goodness" exists which our souls recognize. These ideal forms are not mere conceptions. Plato would argue that they really did exist in an invisible world, the world from which the soul came and where it will return after it leaves the body at death. A soul knew the ideal chair before it was imprisoned in the body, and when a person sees a chair, he remembers the ideal form of the chair, and knows the chair in the visible world because it comprehends that it partakes of the form in the invisible world. Thus knowledge is a process of recollection.

The Forms as Causes

In the *Phaedo*, Plato explains that what makes an object beautiful is because of the presence in it, or the association with it of absolute Beauty—the form of Beauty that exists in the invisible world. Therefore it is the form of Beauty that makes things in the visible world beautiful, and therefore the Forms are the causes of existence. They make objects be what they are. Aristotle was to object that even if we assume that Forms exist, things which partake of these Forms cannot come into being unless there is something to impart motion. In fact, Aristotle could not accept Plato's view that Forms existed outside of the visible world. For him, form and the visible object that partook of the form could not be separated from each other. All substances consist of two parts, matter and form, Aristotle insisted. You cannot chop up a bronze statue into two parts, its bronze and its shape.

realm of true existence, though he is not prepared to assert that there are "Forms" of mud and dirt; he cannot say that absolutely everything has a "Form." Yet he defends the core of his theory: great things are great because they partake of the Form of Greatness, and beautiful things partake of the Form of Beauty, and so on. Parmenides objects. Does the beautiful object that we see partake of *all* the Form of Beauty or just part of it? If it partakes of only part of it, then the "Form" must be divisible, and if all of it, then the "Form" must be in many places at once. How does the object we see partake of a Form? If a beautiful object partakes of the Form of Beauty, then the object and the Form are similar and we must posit another Form that embraces the beautiful object and the Form of Beauty. Socrates suggests that the Forms are only thoughts or concepts, but Parmenides replies that concepts must be of something. There can be no concepts of nothing. Yet we cannot know the Forms, which are absolute, for our knowledge is not absolute, and if God's knowledge is absolute, then He cannot know us. The *Parmenides* concludes on an unsatisfactory note. Socrates does not abandon his "Theory of Forms" but Parmenides tells him that he needs more training in philosophy. Parmenides' objections are not always cogent, but the dialogue bearing his name seems to show that Plato knew what the weaknesses were in his hypothesis. For Plato, the Forms were timeless entities, which—since they are timeless—cannot have been created. At the Creation, God could create the world of appearances, but he could not create the timeless Forms, for they already existed. Both Plato and Parmenides could agree that the world that we see about us is the world of appearances, not reality. Yet it is fair to ask why, if an appearance really does appear, it is not part of reality? For if appearances do *not really* appear, why bother about them? As Aristotle was to realize, Plato's distinction

between the Forms—which are real—and appearances—which are not—was a stumbling block.

THE REPUBLIC. Plato wrote three dialogues on ideal constitutions: the *Republic*, the *Statesman*, and the *Laws*, his last work which he left unrevised. It is the *Republic* which is justly considered his greatest work, though its influence on the world of politics has not been entirely wholesome. The *Republic* has helped to form the intellectual background for many non-democratic governments, both communist and fascist. To understand Plato's notions of government, it is important to consider the actual types of government that a Greek such as Plato encountered in his contemporary world. Plato lists them in the eighth book of the *Republic*: Timarchy, Oligarchy, Democracy, and Tyranny. Timarchy (*timokrateia*) was a state where the ruling principle was love of honor. Plato used the example of Sparta, which had a constitution unique on mainland Greece. Plato admired the Spartan constitution, though he recognized some of its faults. The Spartan elite—the so-called "Spartiates"—were a military aristocracy who lived off a peasant population. Known as "helots," these serfs worked the land for their Spartiate masters, giving them half their produce. They were kept in subjection by brutal methods; Sparta had a secret police to root out any disaffection, and each year the Spartan magistrates formally declared war on the helots so that killing one of them was not murder but an act of war. The Spartiates themselves were a military caste that trained from early youth to excel in warfare. The Spartans were courageous and disciplined, and Plato admired them for it. Yet he also considered them to be slow-witted, greedy, and brutal to the underclasses. The word "oligarchy" comes from the Greeks words *oligoi* (few) and *arche* (rule), meaning to rule by a minority. In archaic Greece the minority had been aristocrats—that is, men of good family—but in Plato's time, the minority that controlled oligarchic governments was the wealthy. Plato distrusted the profit-motive and the influence of private wealth in politics. Plato used Athens as an example of a democratic government. Athens in Plato's day may have had as many as 300,000 residents, including men, women, slaves, and resident aliens who had little hope of acquiring citizenship, but the right to vote was restricted to male citizens. Sovereign power was vested in an assembly which was required to meet at least ten times a year, though meetings were often more frequent. At these assemblies any male citizen who attended could vote, but only a small minority did since attendance was difficult for citizens living in country villages. Plato had little respect for the system. The salient feature of democracy was liberty; individuals could do or say what they pleased, which gave society an attractive variety, but ultimately this freedom worked against social cohesion. When social cohesion failed, society disintegrated into class warfare between the rich and the poor. Finally there was tyranny, which was the personal rule of a dictator. A tyrant needed a private army for self-protection and had to eliminate all possible rivals. A tyrant, Plato argued, was essentially a criminal.

THE SOLUTION OF THE REPUBLIC. Having found fatal flaws in each of the existing governmental systems, Plato proposed his ideal constitution. According to Plato's system of government, the lawgiver whose task it was to establish this utopia set up three groups or classes. The first class, composed of "Guardians," was in charge of ruling and would have to be carefully educated and pass exacting tests before being accepted as Guardians. Once this class was selected by the lawgiver, it perpetuated itself by heredity, though occasionally an unsatisfactory son of a Guardian would have to be degraded. The next class was the "Auxiliaries" who carried out the duties of the military, police, and executive offices under orders from the Guardians. The third class was composed of the craftsmen, traders, and the like. Plato believed that men fitted to be shoemakers or carpenters should stick to their own trades and leave the ruling positions to those who had been specially trained for the task. To ensure that the Guardians carried out the lawgiver's intentions, they had to be carefully fitted for their duties by education in cultural pursuits and physical training. Plato recommended that the poems of Homer and Hesiod be banned due to the fact that their portrayal of the gods was often not edifying. He also believed that their writings made their readers fear death, which could undermine the Guardians' ability to die a fearless death in battle. Plato believed strongly in the power of the written word to influence behavior, and so suggested that the young should not read stories where the wicked are happy, or good men unhappy; he felt the poets to be too subversive, and recommended that they be banished. The other arts were not free of Plato's censorship either, however, as he outlawed any music that was too sorrowful or too joyous. Other recommendations for an ideal state included a balanced economic state in which the Guardians would be neither rich nor poor. They would live in simple houses on simple food, as if in an army camp, and they would hold their property in common. Plato argued that girls and boys should have the same education, and advocated complete equality of the sexes. Plato's advocacy of a strong state is most apparent in his structure of marriage and the family. He believed that marriages should be arranged for the good of the State by lot, although the rulers would actually

THE POSITION OF WOMEN IN PLATO'S IDEAL STATE

INTRODUCTION: In Plato's last work, *The Laws*, left unrevised at his death, Plato imagined three elderly gentlemen, a Cretan named Cleinias, a Spartan named Megillus, and an Athenian stranger—in effect, Plato himself—discussing the foundation of a new city on Crete. They turn to a practical discussion of what the laws and constitution of this new city should be. The Athenian eventually brings up the place of women. In Athens, women had no voice in government and no role in public life. The situation was somewhat different in Sparta and Crete, though nowhere was anything approaching equality of the sexes found. Plato's remarks, quoted below, are less than flattering to women, but they show recognition that women make up half of humanity and cannot be ignored and left outside the laws in an ideal society. It was a beginning, and in the Hellenistic period, beginning a couple generations after Plato's death, we find women taking a more active role in public life. The context of the excerpt below is this: the three gentlemen have decided that their new city shall have communal meals for male citizens, as was the case in Sparta, but the Athenian has an additional point to make about the position of women.

The blessings that a state enjoys are in direct proportion to the degree of law and order to be found in it, and the effects of good regulations in some fields are usually vitiated to the extent that things are controlled either incompetently or not at all in others. The point is relevant to the subject at hand. Thanks to some providential necessity, Cleinias and Megillus, you have a splendid and—as I was saying—astonishing institution: communal meals for men. But it is entirely wrong of you to have omitted from your legal code any provision for your women, so that the practice of communal meals for them has never got underway. On the contrary, half the human race, the female sex, the half which in any case is inclined to be secretive and crafty, because of its weakness—has been left to its own devices because of the misguided indulgence of the legislator. Because you neglected this sex, you gradually lost control of a great many things which would be in a far better state today if they had been regulated by law. You see, leaving women to do what they like is not just to lose *half* the battle (as it may seem); a woman's natural potential for virtue is inferior to a man's, so she's proportionately a greater danger, perhaps even twice as great.

SOURCE: Plato, *The Laws*. Trans. Trevor J. Saunders (London: Penguin, 1988): 262–263.

manipulate the lots in such a way as to ensure that the best sires beget the most children. The State would then remove the children from their parents at birth and, if healthy, they would be reared by the State so that no one could know the identities of his or her biological parents. Plato believed that this system would foster a community in which children regarded all their elders as their fathers and mothers. To make it all work, Plato was not averse to the state propagating certain falsehoods—"Noble Lies," as Plato called them—of which the most important was that God created three species of men: the men of gold, fitted to be Guardians; the men of silver, fit to be soldiers; and the common man of bronze and iron, fit for manual toil. Thus the bulwark of Plato's utopia was a lethal mixture of religious propaganda and political science, but in Plato's view, the result would be "justice," for everyone would have his proper slot in the political structure, and be satisfied with it.

PLATO'S LAST WORDS ON THE IDEAL STATE. Plato returned twice to the question of ideal government. In the *Statesman*, he repeated the view that government is a job for experts. He believed that the best government is rule by an expert, like the ideal lawgiver who laid out the constitution in his *Republic*, but if no such expert

could be found, then a law-abiding monarchy was the best alternative. In his last work, the *Laws*, Plato once again considered the question of what sort of government would rule a city best. It is a remarkably detailed work which shows that Plato's thought had evolved a good deal since he produced the *Republic*. For one thing, he placed much higher value now on the rule of law. He believed that complete obedience to the laws solves the problems of political strife. Another change is evident in that philosophy had been a vitally necessary ingredient in the *Republic*, but in the *Laws* philosophy yields pride of place to religion. Plato went so far as to suggest that atheists in the ideal state of the *Laws* should be converted or killed. This seems to represent a remarkable change of heart in Plato's old age.

THE IMMORTALITY OF THE SOUL. In the *Apology*, which is Plato's earliest dialogue, he muses on what happens after death. Plato determines that it will either be a dreamless sleep from which there is no awakening, or the soul will migrate to another place where one can meet with the great men of the past, such as Orpheus and Hesiod and Homer. Death is not to be feared. In the *Phaedo*, Plato imagines Socrates speaking to his friends on the last day of his life, and explaining what

happens at death. The soul separates from the body that has prevented it from acquiring true knowledge due to the body's constant interruptions and distractions from man's quest for Truth. Once the soul is free of the body, it can gain direct knowledge of all that is pure and un-contaminated, that is, the Truth. Thus like a man who chooses to follow a wife or children whom he loves into the next world in the hope of seeing them there, the true philosopher will gladly make the journey into the next world to discover Truth. The final book of the *Republic* ends with a vision of life after death: the so-called "Myth of Er." According to the myth, Er was apparently killed in battle, but ten days later, while he was on the funeral pyre, he revived and told an amazing tale. His soul had left his body and gone on a long journey. It had seen the righteous separated from the unrighteous who were condemned to punishment. The souls of the righteous then drew lots for the lives that they would live in their next life, and having made their choices, they traversed the desert plain of Amnesia and camped in the evening on the banks of Lethe, the stream of Forgetfulness. All were required to drink its water, and those who were im-prudent drank too much and forgot everything. Er, how-ever, was not allowed to drink, and his soul rejoined his body still remembering what it had seen. The *Phaedo* shows the soul anxious to leave behind the encumber-ing body to attain the Truth, and the "Myth of Er" tells how it must transmigrate from one life to another be-fore it can attain the Truth. Taken together, they pre-sent a picture of the immortal soul seeking to escape from the world of appearances, represented by the body, and reach the realm of real Goodness and Truth.

PLATO'S UNIVERSE. The *Timaeus*, one of Plato's last dialogues, was also one of his most influential dur-ing the medieval period, partly because the first 53 chap-ters were available in a Latin translation during the European "Dark Ages" and partly because it presents the-ology rather than philosophy and thus conformed to the mindset of the medieval world. Plato's construction of the universe rests on his basic premise that there are two orders of reality: that of true existence or "Being," in-habited by the "Forms"; and that of apparent reality, the world of "Becoming," the created world inhabited by the transient things perceived by our senses. The *Timaeus* describes how the world of "Becoming" came into exis-tence, through the character of Timaeus, a Pythagorean philosopher from southern Italy. In the dialogue, Timaeus describes the creation of the world as being sim-ilar to the creation of a model by a craftsman. Just as the craftsman works with a model, so the Creator, who is a divine craftsman, created the world of "Becoming" us-ing as his models the Forms that belong to the world of

"Being." His material was composed of the four ele-ments—earth, air, fire, and water—though later in the dialogue we learn that the Creator had found his mate-rial as a confused mass in the so-called "Receptacle of Being" and reduced it to form the geometrical shapes of the four elements. The universe itself was a geometrical construction: the planets move in rings around the earth. This concept of planetary movement proved influential to men of science centuries later. In the second century C.E. Claudius Ptolemaeus of Alexandria, better known as Ptolemy, refined the system using trigonometry. Then in the sixteenth century C.E., Nicolaus Copernicus (1473–1543) showed that the earth moved around the sun, but he retained the circles of the planets that Plato described. Then Johann Kepler (1571–1630) showed that the planets moved in ellipses, and Sir Isaac Newton (1642–1727) showed that they were not regular ellipses, and Plato's concept of a universe constructed according to the principles of geometry perished at last. The *Timaeus* survives as an interesting monument in the his-tory of science but nothing more.

SOURCES

Julia Annas, *Plato: A Very Short Introduction* (Oxford, Eng-land: Oxford University Press, 2003).

G. M. A. Grube, *Plato's Thought* (London, England: Methuen, 1935).

Robert W. Hall, *Plato* (London, England: Allen and Unwin, 1981).

R. M. Hare, *Plato* (Oxford, England: Oxford University Press, 1982).

M. S. Lane, *Plato's Progeny: How Socrates and Plato Still Captivate the Modern Mind* (London, England: Duck-worth, 2001).

Nikolas Pappas, *Routledge Philosophy Guidebook to Plato and the Republic* (New York: Routledge, 2003).

Plato as Author: The Rhetoric of Philosophy. Cincinnati Clas-sical Studies, series 2, no. 8. Ed. Ann N. Michelini (Leiden, Netherlands: Brill, 2003).

C. J. Rowe, *Plato* (Brighton, England: Harvester Press, 1984).

Sean Sayers, *Plato's "Republic": An Introduction* (Edinburgh: Edinburgh University Press, 1984).

Thomas Szlézak, *Reading Plato*. Trans. Graham Zanker (New York: Routledge, 1991).

ARISTOTLE

IMPORTANCE. Aristotle (384–322 B.C.E.) was a philosopher whose achievement has been fundamental to the subsequent development of Western philosophy.

No field of knowledge was beyond his purview, and for 2,000 years, his influence on European thought was supreme. It eventually became a straitjacket; from the start of the seventeenth century C.E., almost every new direction in the humanities and science had to start by overthrowing some Aristotelean doctrine, for after Aristotle, Europe never produced even his approximate equal until the Renaissance. Hence Aristotle's philosophy ultimately became unchallenged doctrine and his writings remained "holy writ" for a thousand years. That was not Aristotle's fault, however, but the fault of his disciples in the medieval period. In his own day, he set philosophy in a new direction. He learned from Plato, but he tempered Plato with common sense. He emphasized research and observation, and although he never developed the modern scientific experiment, he was groping in that direction. Politics was one of his interests, but he did not waste his time on utopias; rather he examined governments that actually existed in the Mediterranean world and analyzed how they functioned. His reality was not divided into "Being" and "Becoming" as Plato's was, the first of which was real and the second only apparently real. Instead the two realities were fused and thus one could gain knowledge by observation, for what one observed was real. This was a necessary step before philosophers could develop anything similar to the modern scientific method.

STUDENT OF PLATO. The acquisition of knowledge by observation may have been something that Aristotle learned from his father, who was the court physician of Amyntas II, king of Macedon, for by now, the medical fraternity had developed observation into a fine art in order to diagnose diseases. Physicians belonging to the medical fraternity of the Asclepiadae regularly taught their sons dissections, but Aristotle probably missed this training, for both his parents died while he was quite young. When he was about seventeen years old, he joined Plato's Academy. He spent almost twenty years there, but though he never ceased to show affection and respect for Plato, he became less and less comfortable with Plato's philosophy. Plato as he grew older placed increasing emphasis on mathematics and the trend continued at the Academy following his death. Aristotle, who must have suffered some natural disappointment at being passed over for the headship of the Academy, decided to leave it to conduct research in biology at Assos in the region of Troy. Following some time spent in Lesbos, he accepted the invitation—with a suitably generous salary attached—from King Philip II of Macedon to tutor his son, Alexander, who was fourteen years old. Alexander was under his tutelage for two years. Like Plato, Aristotle believed that there could be no good gov-

Modern engraving of the philosopher Aristotle. THE LIBRARY OF CONGRESS.

ernment until kings were philosophers or philosophers kings. Then in 336 B.C.E., Philip of Macedon was assassinated, and Alexander embarked on a series of military campaigns that would change the course of history in the Greek world. About a year later, Aristotle returned to Athens after an absence of about thirteen years and founded a school, the Lyceum.

ARISTOTLE'S WRITINGS. Approximately two-thirds of all of Aristotle's writings are lost. During his twenty years at Plato's Academy before Plato's death, Aristotle wrote dialogues, borrowing the literary form from Plato, and they were much admired in the ancient world. None have survived but it is possible to ascertain the subject matter of some of them. He wrote on rhetoric, the art of public speaking, where Aristotle probably pointed out the importance of logic. Although Aristotle had written a dialogue during his Academy days accepting Plato's views on the soul—that is, that it existed before birth and, after birth, it could recall the ideal forms from its previous life—his dialogue *On Philosophy*, most likely written after Aristotle left the Academy, dealt with the progress of mankind and indicated that Aristotle was already unhappy with Plato's Theory of Forms. Aristotle

also wrote collections of historical or scientific information, sometimes done in collaboration with students, or perhaps even done by students as assignments. One example from this group has survived: an essay on the Athenian constitution, a copy of which was unearthed in Egypt in 1890, copied on to the back of a tax register of the Roman period. One group of writings which did survive is composed of treatises which were never prepared for publication, possibly Aristotle's lecture notes. They show an enormous range of subjects, indicating that nothing was too great or small to arouse his interest.

THE ORGANIZATION OF KNOWLEDGE. Aristotle had an orderly mind and classified all knowledge into three categories: the productive, the practical, and the theoretical. Productive sciences have to do with making things, and their practitioners include engineers, farmers, artists, and the like. Practical sciences are concerned with how men act in various situations. They are the subject of Aristotle's treatises titled *Ethics* and *Politics*. Theoretical knowledge has as its goal the discovery of truth. This category includes theology, mathematics, and natural science with their various subdivisions.

ARISTOTLE ON CAUSE. In modern thinking, the causes of something that comes into existence are the factors—both the components and the agents—that are responsible for the thing being what it is. Aristotle's "cause" had a wider meaning; it can be translated as the "dimensions of reality." Aristotle looked at an object and asked "Why? How? What for? What's its material?", which broadened the philosophical discussion that began with the Milesian philosophers back in the sixth century B.C.E. That group concerned themselves only with the material. The underlying substance of the universe was water, according to Thales, and air, according to Anaximenes. Later the Pythagoreans concerned themselves with "why?"—that is, what is the pattern that makes a thing what it is? Aristotle took the discussion a step further in pointing out that "how?" is also important: who made the object what it is, and what for?, i.e. what was the purpose in making the object. Thus everything has four causes. There is the material cause: the stuff from which it is made. For that Aristotle had to find a new term, and the term he used was *hyle* which means "wood," but Aristotle used it for substance in general. There is the formal cause, which is the pattern. There is the efficient cause: the maker of the thing, whether it is a living thing like a dog or a person, or something inert like a table. The fourth cause is the final cause, which answers the question "what

for?" What is the purpose for which a thing is made? Let us take a chest of drawers as an example. The material cause is the wood from which it is made. The efficient cause is the carpenter who made it, and the formal cause is the pattern that the carpenter followed. Then there is the question "what for?"—the teleological question. The purpose of the chest of drawers is to store clothes. Apply the same logic to Bowser, the family dog. The material cause is the flesh from which Bowser is made. The formal cause is not a blueprint; rather it is a species, the sort of thing we find in nature. Bowser is classified by biologists as a dog. Then there is the efficient cause: Bowser was not manufactured, rather he was generated by parents of the same species as himself. Finally there is the teleological question. Aristotle believed that everything, even the stars, had a goal that, in theory at least, could be discovered. Bowser has an inner nature what directs him to grow from a puppy into a mature dog that will become a family pet. That is Bowser's goal. Aristotle applied these principles even to the universe where he asserted that the final cause is what he calls the "prime mover"—not a mechanical force, but an object of desire. It is "God," but though Aristotle often calls his prime mover "God" it is not really a religious God. It is a divine force that exercises a continual attraction for everything in the universe, and this magnetism of the "prime mover" is the reason for the movement that we can see of the constellations in the night sky. They continually seek the final perfection of the "prime mover" that will allow them to rest, and they will never attain it. Aristotle's "prime mover" is closer to "Mother Nature" than it is to any god of religion, whether pagan or non-pagan.

ARISTOTLE THE LOGICIAN. Aristotle was proud of his logic; in fact, he claimed to have produced a complete, perfect logic. Essentially he began with a proposition, which is a statement that is either true or false. If it is true, it refers either to a universal truth or a particular one, and similarly, if it is false, it must point either to a particular falsehood or a universal untruth. For instance, the sentence "All mammals are viviparous" is a general proposition. It means that all mammals reproduce through live births. Since Aristotle himself used letters instead of things to express propositions, we can express the sentence as "All X are Y." There are four types of these simple propositions: the universal affirmative ("All X are Y"), the universal negative ("All X are not Y"), the particular affirmative ("Some X are Y"), and the particular negative ("Some X are not Y"). These four types of propositions can be further subdivided into three modes: that X is always Y, that X is of necessity Y, and that X is possibly Y. Once a proposition is proven true,

ARISTOTLE as a Biologist

Much of the research which went into Aristotle's two monumental scientific works, the *Dissections* and the *History of Animals*, was done in the nearly thirteen years between the time he left Athens after Plato's death and his return. The *Dissections* has not survived. Its subject was the internal structure of animals, and may have consisted largely of diagrams. The *History of Animals* did survive, however, and is a pioneering study of animals, of their appearance, their methods of reproduction, their behavior, and habitat. It covers all living creatures from sheep and goats, to tortoises and crocodiles, octopods and oysters, and, of course, human beings. To modern researchers, Aristotle sometimes seems naive and pedantic. Modern biological textbooks do not bother to point out that humans have necks between their heads and their torsos, but Aristotle felt that if he was to be thorough that fact should be noted. His description of the European bison gives good grounds for suspicion that he had never seen one. He claims that when it was hunted, it defended itself kicking and discharging its excrement over a distance of eight yards and the excrement was so corrosive that it could burn the hair off the hunting hounds. Aristotle's observations are inexact—he did not usually measure or weigh his specimens, though there seems to have been some exceptions—and he did not discover the experimental method that is the basic procedure of modern science. He used second-hand information: for instance, he asked beekeepers about bees and fishers about fish, and for human anatomy, he relied on the expertise of the Greek medical profession. Yet research in biology was in its infancy, and Aristotle deserves respect as a pioneer.

it is possible to make a deduction using a form of argument called a "syllogism," from the Greek *sullogismos*. A syllogism is an argument whereby, if certain things are assumed as true, then something different from what is assumed can be deduced. An example would be, "All humans are mortal. John Doe is a human. Therefore John Doe is a mortal." The argument proceeds from a general proposition that is accepted as true, to a particular conclusion. Aristotle thought that he had discovered the key to deductive inference. Later philosophers developed Aristotle's logic into a separate field of its own, which it never was for Aristotle, and for better or worse, it became one of his most important legacies to our intellectual tradition.

ARISTOTLE'S ACHIEVEMENT. Before Aristotle, Greek philosophy had developed a profound distrust of the evidence of our senses. Parmenides and the Eleatic School were an extreme example. They held that the world perceived through the senses was not the real world. Heraclitus argued that constant change took place in the world. Plato held that the things seen in the visible world were only imperfect copies of ideal "Forms" in an invisible world. Aristotle's study of biology, however, must have quickly demonstrated to him that if a person was to acquire knowledge about plants and animals, he would have to trust his senses. If he was to do research, he would have to observe, and study the observations of others. There is a certain common sense about Aristotle's teachings. Aristotle continued to believe in the unity of knowledge, yet after him, researchers tended to specialize. Theophrastus, who succeeded him as head of the Lyceum, was a notable botanist. Aristoxenus, one of the most brilliant researchers at the Lyceum, wrote on music. Aristotle's Lyceum was the forebear of modern institutes for research and advanced study.

SOURCES

Jonathan Barnes, *Aristotle* (Oxford, England: Oxford University Press, 1982).

———, ed., *The Cambridge Companion to Aristotle* (Cambridge, England; New York: Cambridge University Press, 1995).

John Ferguson, *Aristotle* (New York: Twayne Publishers, 1972).

W. K. C. Guthrie, "Aristotle as an Historian of Philosophy," *Journal of Hellenic Studies* 77 (1957): 35–41.

Otfried Höffe, *Aristotle*. Trans. Christine Salazar (Albany, N.Y.: State University of New York Press, 2003).

W. Jaeger, *Aristotle: The History of His Development*. Trans. R. Robinson (Oxford, England: Oxford University Press, 1948).

Carlo Natali, *The Wisdom of Aristotle*. Trans. Gerald Parker (Albany, N.Y.: State University of New York Press, 2001).

Martha C. Nussbaum, "Aristotle," in *The Oxford Companion to Classical Civilization*. Ed. Simon Hornblower and Antony Spawforth (Oxford, England: Oxford University Press, 1998): 65–74.

Malcolm C. Wilson, *Aristotle's Theory of the Unity of Science* (Toronto, Canada: University of Toronto Press, 2000).

THE STOICS

SCANT HISTORICAL RECORD. In the six centuries between the death of Alexander the Great in 323 B.C.E. and the emperor Constantine (312–337 C.E.) the dominant philosophy that commanded the allegiance of thinking people was Stoicism—named for the *Stoa Poikile* (Painted Stoa) where Zeno of Citium first taught the philosophy. The early development of this philosophy was not preserved in written texts until about 100 C.E., when a disciple of the Stoic philosopher Epictetus, Arrian, wrote a memoir of his master's conversations with his students and published them as *Discourses.* Arrian was a Roman official and a soldier with literary tastes, and a man of his position may have had a slave trained in shorthand who could take notes while Epictetus and his students conversed. After Epictetus, the *Meditations* of the emperor Marcus Aurelius is the last expression of Stoic philosophy. The blanks in the historical record on Stoicism must be filled with second-hand reports of the earlier Stoics, the most important of these being the *Lives of the Eminent Philosophers* written by Diogenes Laertius. Without Diogenes' biography of Zeno of Citium, the founder of the Stoic school, and his successors Cleanthes and Chrysippus, it would be impossible to chart the beginnings of this school.

THE COSMOPOLITAN NATURE OF STOICISM. Diogenes the Cynic used to say that he was a *polites* (citizen) of the *kosmos* (world) which created the word "cosmopolitan." Philosophy was outgrowing the intellectual world of the *polis* (city-state) and the checklist of the native cities of the great Stoics proves the point. The founders of the School did not come from Athens, the seat of Greek philosophy. Zeno was a Hellenized Syrian who came from Citium, a city in Cyprus. His successor as head of the school was Cleanthes who came from Assos in the Troad, the region of northwest Asia Minor in the vicinity of Troy. He had been a boxer in his earlier career and when he came to Athens, he worked as a gardener while he attended the lectures at the *Stoa Poikile.* Chrysippus (c. 280–207 B.C.E.), the third head of the Stoic School, came either from Soli or from nearby Tarsus, both in the region of Asia Minor known as Cilicia. The next head of the school was Zeno from Tarsus; after him came Diogenes of Babylon followed by Antipater of Tarsus. After Antipater of Tarsus, Stoicism underwent a revision by the next successor, Panaetius of Rhodes, and a period of history in the philosophy known as the "Middle Stoa" began. This included a change from the rigid practices of the philosophy to a strong focus on humanism and social practice. Because of the revision, many of the prominent figures in Rome converted to

Marble bust of Zeno of Citium (335–263 B.C.E.), the founder of the Stoic school of philosophy. THE ART ARCHIVE/ARCHAEOLOGICAL MUSEUM VENICE/DAGLI ORTI.

Stocisim. Panaetius's writings would influence Cato the younger, the stubborn defender of the Roman republic against Julius Caesar; Marcus Brutus, who was one of Caesar's assassins; and Cicero, Caesar's contemporary, who was an eclectic philosopher, picking and choosing his doctrines from several schools. Cicero favored the scepticism of the Academy, but he also ascribed to some of the teachings of Stoicism. Finally in its last phase, Stoicism became the doctrine of the Roman upper classes under the empire, and in the first century C.E. the Roman aristocrats who were martyred for their resistance to the growing autocracy of the emperors all professed Stoicism.

STOIC PHYSICS. Zeno, the founder of Stoicism, divided knowledge into three divisions: natural philosophy, ethics, and logic. Stoic physical doctrine rejected the atomic theory of the Epicureans. "Nothing that is incorporeal exists" was the fundamental principle of Stoic physics, and hence there was no place for void. For the Stoics, matter was continuous and empty space did not exist within the finite universe, but only outside it. Everything, even the soul and God himself, was material. In determining what this material was, the Stoics

a PRIMARY SOURCE *document*

MARCUS AURELIUS ON THE SOUL

INTRODUCTION: Marcus Aurelius, Roman emperor from 161 to 180 C.E. succeeded Antoninus Pius (138–161 C.E.) whose reign had been long and peaceful. Marcus Aurelius' reign made up for it. He faced a revolt in the east by one of his generals, Avidius Cassius, which he survived. The empire was attacked by plague, probably smallpox although that is uncertain. But most unnerving of all, in 169 C.E. tribes known as the Marcomanni and the Quadi invaded across the Danube frontier of the empire and penetrated as far as northern Italy. Italy had known two centuries of peace, and the invasion was a shattering experience. Marcus Aurelius, who had had little experience in warfare, took command of the army and drove the invaders back. His little book, *Marcus Aurelius to Himself* which is usually known as the *Meditations,* was written on the battlefield, when Marcus, no longer a young man and suffering from tuberculosis, campaigned against the Marcomanni and the Quadi. The translation from which the passage excerpted below is taken is from a classic work by George Long, who dedicated his first edition of the *Meditations* to Robert E. Lee, Confederate commander in the American Civil War, whom Long regarded as another Marcus Aurelius. In the following passage, Marcus expounds the Stoic doctrine of the soul, which is part of the divine *logos* which permeates the world, and understands that all things pass away and are renewed in another cycle of history which will repeat what has happened before.

These are the properties of the rational soul: it sees itself, analyses itself, and makes itself such as it chooses, the fruit which it bears it enjoys itself —for the fruit of plants and that of animals which corresponds to fruits others enjoy—it obtains it own end, wherever the limit of life may be fixed. Not as in a dance and in a play and in such like things, where the whole action is incomplete, if anything cuts it short; but in every part, and wherever it may be stopped, it makes what has been set before it full and complete, so that it can say, I have what is my own. And further it traverses the whole universe, and the surrounding vacuum, and surveys its form, and it extends itself into the infinity of time, and embraces and comprehends the periodic renovation of all things, and it comprehends that those who come after us will see nothing new, nor have those before us have seen anything more, but in a manner, he who is forty years old, if he has any understanding at all, has seen by virtue of the uniformity that prevails all things which have been and all that will be. This, too, is the property of the rational soul, love of one's neighbor, and truth and modesty, and to value nothing more than itself, which is also the property of Law. Thus then, right reason differs not at all from the reason of justice.

SOURCE: Marcus Aurelius, *Meditations of Marcus Aurelius*. Book 11, Sec. 1. Trans. George Long (Chicago: Henry Regnery, 1956).

looked back to Heraclitus and argued that it was Fire. Fire was the *logos*, the divine reason. *Logos* pervades the universe as honey pervades a honeycomb, and the human soul was a portion of this *logos*. The primal fire which is the *logos* is God, and hence the soul proceeds into the body from God. Periodically the whole world turns to fire and there is a great conflagration that is not so much a destruction of the world as its apotheosis (elevation to divine status), for the world that is consumed by fire has become united with God. Then the fire goes out, and history begins a new cycle, repeating itself in exactly the same way as it unfolded before. History repeats itself in endless cycles.

THE THEORY OF KNOWLEDGE. According to Stoic doctrine, all knowledge reaches the mind through the senses. This view was in stark opposition to Plato's doctrine, that the senses were the source of illusion and error. There was no place for Plato's Theory of Forms in Stoic logic. For the Stoics, concepts have no reality outside the consciousness. They are merely ideas that the mind forms from the evidence with which the senses

have supplied it. Virtue is based on knowledge, but to possess knowledge, the conceptions of the mind must mesh with reality, and so the wise man is one who has an accurate grasp of the real world. The Stoics believed it was possible to accurately grasp the real world, and they tried to show how the mind can acquire conceptions that are based on reality.

THE VIRTUOUS LIFE. "Live in harmony with nature" was the watchword of the Stoics, that is, nature in a broad sense. The guiding principle of nature is the *logos*—that is, reason—which the Stoics identified with God. It manifests itself in both fate or divine necessity, and divine providence. Virtue consists of living in harmony with the guiding principle of nature—that is, the *logos*—and to be virtuous is the only good; the only evil is not to be virtuous. The Stoics, with some exceptions, admitted that a wise man might choose to avoid illness or death or seek self-preservation if he could do so and still act virtuously. Nonetheless, pain and discomfort should not affect his happiness, nor, for that matter, should their opposites, pleasure and good health. The

wise man will be indifferent to such things. Pleasure and favor will not influence him, and so he will be completely just. Nor will he consider pain and death evils, and so he will be absolutely courageous.

PERSONAL CONDUCT. Zeno defined emotion as an irrational movement of the soul, and so freedom from emotion is the mark of a wise man. A wise man is indifferent equally to fame and obscurity, and so he is devoid of conceit. Good men are not meddlesome; they decline to take any action that is outside the path of duty. Good men may drink wine, but they will refrain from drinking so much as to become intoxicated. The Stoics held that all sins were equal, for every falsehood is false, not more or less false than any other. If one man is a hundred miles from Rome and another man only five miles distant, they are both equally not in Rome. Good men are by nature sociable, and so they will not live in solitude. There should be no Stoic hermits. Finally, if a wise man has a good reason for it, he will commit suicide, or "make an exit" as the Stoics called it, either for the sake of his country or his friends, or because he is suffering great pain of incurable disease. Death as a Stoic was greatly admired in Rome where Cato the Younger became the paradigm of a Stoic martyr. Julius Caesar crossed the Rubicon River in 49 B.C.E. and drove the forces of the defenders of the republic—most of them upper-class Romans—out of Italy and defeated them at Pharsalia in northern Greece. Cato the Younger, an obstinate defender of republican ideals as he interpreted them, managed to rally the republican forces in north Africa, and in 46 B.C.E. Julius Caesar defeated them at Thapsus. Cato heard the news of the defeat at Utica near Carthage and committed suicide, refusing to survive the Roman republic. His suicide won him an acclaim which he had not enjoyed in his political career, for he was an unpleasant man and utterly uncompromising in politics. He became Cato Uticensis (Cato of Utica) who "made an exit" at Utica and thus became a martyr for republican freedom both in ancient Rome and in modern Europe. Seneca the Younger (c. 3 B.C.E.–65 C.E.), the emperor Nero's discarded tutor, made an equally edifying exit. He was accused, justly or unjustly, of being party to a conspiracy to murder Nero and put a new emperor on the throne. Nero decided that Seneca must die, and Seneca committed suicide. He was given no time to make a will, and so he told his family that he left them something far better than earthly wealth: the example of a virtuous life, and then, opening his veins, dictated his last words to his secretary as his life ebbed away. During his lifetime, Seneca had shown a remarkable

appetite for earthly wealth, but he died as a Stoic philosopher should.

SOURCES

Edward V. Arnold, *Roman Stoicism, Being Lectures on the History of Stoic Philosophy with Special Reference to its Development within the Roman Empire* (London, England: Routledge and Kegan Paul, 1911; reprint, New York: Humanities Press, 1958).

Jonathan Barnes, *Logic and the Imperial Stoa* (New York: Brill, 1997).

Lawrence C. Becker, *A New Stoicism* (Princeton, N.J.: Princeton University Press, 1999).

The Cambridge Companion to the Stoics. Ed. Brad Inwood (Cambridge: Cambridge University Press, 2003).

Marcia L. Colish, *The Stoic Tradition from Antiquity to the Early Middle Ages.* 2 vols. (Leiden, Netherlands: Brill, 1985).

Moses Hadas, *Essential Works of Stoicism* (New York: Bantam Books, 1961).

Brad Inwood, *Ethics and Human Action in Early Stoicism* (New York: Oxford University Press, 1985).

Margaret Reesor, *The Nature of Man in Early Stoic Philosophy* (London, England: Duckworth, 1989).

J. M. Rist, *Stoic Philosophy* (Cambridge: Cambridge University Press, 1969).

———, ed., *The Stoics* (Berkeley: University of California Press, 1978).

OTHER PHILOSOPHIES IN THE HELLENISTIC WORLD

PHILOSOPHY IN A CHANGED WORLD. Alexander the Great died in Babylon in 323 B.C.E., having radically changed the Greek world through a series of conquests that unified Greece and brought Persia into the Hellenistic world. The word "Hellenistic" comes from the Greek *hellenizein* which means "to speak Greek," and with the Greek language, to acquire a smattering of Greek culture. The Hellenistic world embraced regions that had been foreign to the Greeks of the classical period in the fifth century B.C.E. and it is significant that non-Greeks developed the dominant philosophy of the Hellenistic world and the Roman world after it: Stoicism. While the pre-Socratic philosophers had focused on abstract questions on the nature of goodness and aspects of society, the burning questions on the minds of the philosophers in this day and age focused more on how an individual should live in a world that had changed so dramatically within a generation and the achievement of personal happiness.

a PRIMARY SOURCE document

DIOGENES LAERTIUS ON THE SCHOLARCH ARCESILAUS

INTRODUCTION: About 265 B.C.E. Arcesilaus became scholarch or head of the Academy which Plato had founded. He brought new life to the Academy. There was some disagreement among later historians of philosophy in the ancient world about whether he could be called the founder of the "New Academy" or if he was the founder of the "Middle Academy" and his successor as scholarch, Carneades, was the founder of the "New" or "Third Academy." There was no doubt, however, that when Arcesilaus became scholarch, it marked a new stage in the development of the Academy. Arcesilaus employed scepticism—the view that true knowledge was impossible for humans to attain— as a weapon against the Stoics and Carneades continued the quarrel with the Stoics, particularly with their theological doctrines. Diogenes Laertius, writing in the early third century C.E. includes a life of Arcesilaus on his *Lives of the Eminent Philosophers,* and from it we learn some anecdotes about him.

Since he [Arcesilaus] suspended judgment on every question, he never, as it is reported, wrote so much as a single book. Yet others say that he was once observed detected correcting some passages in a work of his; and some assert that he published it. Others deny it, however, and claim that he threw it into the fire.

He appears to have been a great admirer of Plato and possessed all his writings. He also, according to some authorities, had a very high opinion of Pyrrho, [the sceptic philosopher]. ...

He was exceedingly fond of employing axioms, very concise in his diction, and when speaking he laid emphasis on each separate word. ...

He was so free from vanity that he used to counsel his students to transfer to other teachers, and once when a young man from Chios was dissatisfied with his Academy but preferred the school of Hieronymus, whom I have already mentioned, he himself took him and introduced him to that philosopher, advising him to continue to conduct himself regularly. There is a very witty saying of his recorded. When someone asked him once why people left other schools to join the Epicureans, but no one left the Epicureans to join other sects, he replied, "People sometimes make eunuchs out of men, but no one can ever make a man out of a eunuch."

SOURCE: Diogenes, "Arcesilaus," in *The Lives and Opinions of Eminent Philosophers.* Book 4, Sec.7–8, 10, 18. Trans C. D. Yonge (London: Henry G. Bohn, 1853).

THE ACADEMY AND THE LYCEUM. Plato's Academy continued in this new era, though its reputation declined. Plato's nephew Speusippus became head after Plato's death, and he adhered to Plato's doctrines although he did not emulate Plato's temperament. He had a reputation as a man of violent passions; once, in a rage, he threw a puppy down a well. Xenocrates next took on the role of headmaster, and although he wrote an enormous number of works, none of them survived. In fact, none of the writings of Plato's successors survived. About 265 B.C.E. Arcesilaus, a pupil of Theophrastus, Aristotle's successor as head of the Lyceum, became head of the Academy, or *scholarch*, as the head was called, and began a new era: the so-called "New Academy," which became an opponent of Stoicism. The Stoics claimed that there was a kind of sense-perception that was convincing and irresistible, and that these senses conveyed truth. Arcesilaus retorted that wrong perceptions could be as convincing as right ones—it all depended on the circumstances—and from that argument, he went on to deny the possibility of any knowledge. The Academy became somewhat less dogmatic as time went on. Yet Arcesilaus' legacy was to make the Academy a center for logical scepticism.

SCEPTICS. Thanks to Arcesilaus, scepticism began to exercise considerable influence on Greek philosophy, but he was not the founder of the school. It was Pyrrho of Elis (c. 360–c. 270 B.C.E.) who taught that the aim of life was a serene mind, which can only be achieved if we understand our relation to the nature of things. But since we cannot know the nature of things, we should not trouble ourselves about matters we cannot understand. This doctrine is sometimes called "Pyrrhonism." It holds that we should refrain from making positive or negative judgments, and by maintaining a balance between "yes" and "no" in our judgment we can create balance in our soul.

THE CYNICS. The Cynics liked to claim descent from Antisthenes, who was one of Socrates' disciples, for that gave them a connection with the great master of classical philosophy, but the term "cynic" (doglike) was first applied to Diogenes of Sinope as a comment on the anti-social life he chose to live. He held that actions based on natural instincts and impulses could not be unnatural, and hence he refused to be bound by an social conventions. He believed a man should be free to say and do whatever he wanted—even to have

DIOGENES THE CYNIC

INTRODUCTION: Diogenes was famous for his wit and sharp, often tactless, remarks. When Alexander the Great stood beside him and said, "I am Alexander, the Great King," Diogenes replied, "I am Diogenes the dog." When he was asked why he was called a dog, he answered that it was because he fawned on those who gave him something and barked at those who gave him nothing, and bit them into the bargain. Diogenes Laertius recounts a great number of stories about Diogenes, not all of which can be true, but they illustrate the sort of man he was.

Plato defined man in this way: "Man is a two-footed, featherless animal," and he was greatly praised for his definition. However Diogenes plucked a rooster, and brought it into the Academy and said, "This is Plato's man." For that reason this addition was made to the definition, "with broad, flat fingernails." A man once asked him what was the proper time for supper, and he replied, "If you are a rich man, whenever you please. If you are a poor man, whenever you can." …

When Plato was lecturing on his Theory of Forms" and using the nouns "tableness" (for the ideal form of a table) and "cupness" (for the ideal form of a cup), Diogenes interrupted, "I, Plato, see a table and a cup, but I see no table or cupness." Plato replied, "That is natural enough, for you have eyes with which to contemplate a table and a cup, but you have no intellect with which to see tableness and cupness."

SOURCE: Diogenes, "Diogenes," in *The Lives and Opinions of Eminent Philosophers*. Book 6, Sec. 6. Trans C. D. Yonge (London: Henry G. Bohn, 1853).

sexual intercourse in public, if a natural impulse drove him in that direction. Antisthenes pointed to self-denial as the chief principle of a philosophic life, but Diogenes carried self-denial and the simple life to extremes. Legend has it that one day he saw a child drinking water by cupping it in his hands and raising them to his mouth, whereupon he threw away his own cup, saying that the child had outdone him in austerity. He was a street person—that is, he made his home on the streets, sleeping in porticoes and anywhere he could find shelter—and at one point, he made his home in a large storage jar called a *pithos*. Wealth and high rank did not impress him. There is a famous story, told by Plutarch in his *Life* of Alexander the Great, that Alexander came to visit him and found him basking in the sun. He asked if he could do anything for him. Diogenes asked him simply to stand aside, for he was blocking the sun. The story is probably apocryphal, but it does illustrate how little the Cynics were impressed by great men. One of Diogenes' early disciples was Crates of Thebes who was once the teacher of Zeno of Citium, the founder of the Stoic school of philosophy. Crates gave up a large fortune to follow the life of a beggar and a preacher, and though he was an ugly man, he won the heart of his pupil Hipparchia; she also gave up everything to marry him. Crates glorified his beggar's wallet, but that was precisely the weakness of the sect: they lived off others, thus saving their souls by using others who were too busy to save their own. Cynicism faded out gradually in the second and first centuries B.C.E., but in the first century C.E., it revived for reasons unknown. In the reign of the emperor Vespasian (69–79 B.C.E.) and his successors, there were swarms of Cynic philosophers in Rome and in the eastern provinces of the empire. Among the upper classes in Rome, resistance to the autocracy of the emperors was associated with Stoicism, but among the middle classes, it was voiced by the Cynics who always claimed the right to speak freely and frankly. They championed the principle that it was the duty of an ideal monarch to care for the welfare of his subjects; he should be like an idealized Hercules who used his great power for the good of his people, and they were fond of pointing out how far the actual conduct of the Roman emperors was from their ideal. The imperial government frequently lost patience with them and drove them from Rome.

THE CYRENAICS. The Cyrenaics were a short-lived school that was founded in Cyrene in north Africa by Aristippus, who was once a disciple of Socrates. They taught that the chief end of life was sensual pleasure. This philosophy was built on the belief that the mind feels two emotions, pleasure and pain; while the first is the primary goal of all living things, the latter is what every creature avoids. Pleasure for the Cyrenaics, however, was not merely the absence of pain or discomfort; rather it consisted of a number of particular pleasures, past, present and future: memories of past pleasures, enjoyment of the pleasures of the present, and anticipation of pleasure in the future. Aristippus, who is supposedly the founder of the school (though some scholars have doubted it), was a teacher of rhetoric in Athens who was famous for his pursuit of luxury. He

Imaginative drawing to Diogenes of Sinope, the founder of the Cynic School of Philosophy. © BETTMANN/CORBIS.

spent some time at the court of the tyrant of Syracuse in Sicily, Dionysius I, attracted there by the good food and the comfortable living. The chief importance of the Cyrenaics is that they influenced Epicureanism, which also taught that hedonism was the chief end of life, although the Epicureans were suspicious of the pleasures of the senses and sought pleasure by avoiding what might cause pain. The Cyrenaic school came to an end about 275 B.C.E.

SOURCES

R. Bracht Branham and Marie-Odile Goulet-Cazé, eds., *The Cynics: The Cynic Movement in Antiquity and Its Legacy* (Berkeley, Calif.: University of California Press, 1996).

Donald R. Dudley, *A History of Cynicism from Diogenes to the Sixth Century A.D.* (London, England: Methuen, 1937; reprint, New York: Gordon Press, 1974).

Ragnar Höistad, *Cynic Hero and Cynic King: Studies in the Cynic Conception of Man* (Uppsala: University of Uppsala Press, 1948).

Luis E. Navia, *Classical Cynicism: A Critical Study* (Westport, Conn.: Greenwood, 1996).

R. W. Sharples, *Stoics, Epicureans and Sceptics* (London, England: Routledge, 1996).

Voula Tsouna-McKirahan, *The Epistemology of the Cyrenaic School* (Cambridge: Cambridge University Press, 1998).

EPICURUS

FOUNDER OF EPICUREANISM. The English word "epicure," meaning a person who loves good food and drink, is taken from Epicurus and the Epicureans. It is a singular distortion, for the Epicureans believed that man should restrict his desires to those that spring from the natural appetites—gourmet food and fine wines not being among them. Epicurus (341–270 B.C.E.) was a hedonist in that he believed that the proper goal of all activity was pleasure, but he had an austere definition of it, in that his definition of pleasure was simply the absence of discomfort or pain. The Epicurean ate to rid himself of the discomfort of hunger and no more. According to this philosophy, he should guard himself against anguish at the death of a close friend by having no close friends. Insatiable desire for wealth, power, and fame can never be satisfied, and so they should be avoided. Epicurus himself, the founder of the Epicurean School, was born in Samos, but his parents were Athenian citizens and he himself was educated in Athens. While there, he studied under the tutelage of a disciple of Democritus and learned Democritus' atomic theory that he would later incorporate into his own philosophy. He taught philosophy at Mytilene on the island of Lesbos and in Lampsacus in northern Greece before returning to Athens, and it must have been in this period that he developed his view that pleasure was the chief end of life. It was not the avid pursuit of pleasure, but there was a fine line separating the Epicureans from the Cyrenaics, and the modern dictionary definition of "Epicurean" as a person who is fond of sensuous pleasure may be wrong but it is not entirely unjustified.

THE GARDEN. About 306 B.C.E. Epicurus moved to Athens and there bought a house with a garden as quarters for a school which he founded. There he was joined by his disciples who formed a community of philosophers in the "Garden," the name of his school. The disciples included women, for Epicurus was the first philosopher to admit women into an organized school. His community was known as a *thiasos* (company); it describes a band of persons such as worshipers of Dionysus who parade through the streets singing and dancing, but it also means a religious brotherhood. In his *thiasos*, Epicurus enjoyed a kind of adulation that approached worship. His birthday was celebrated as a festival. He was a voluminous writer, but all his major works are lost. Fortunately, Diogenes Laertius, writing in the early third century C.E., quotes four works by him: three of them letters to disciples and one, titled the *Chief Doctrines*, which is a collection of proverbs on ethical subjects, meant, evidently, to be committed to memory. Modern

Modern engraving of the Athenian philosopher Epicurus. THE LIBRARY OF CONGRESS.

knowledge of Epicureanism expanded in 1888 with the discovery of another collection of proverbs in the Vatican Library.

ATOMS AND VOID. Epicurus adapted the atomic theory of Democritus to the purposes of his philosophy. He actually cared very little about the theory itself but he needed a metaphysical background for his ethical doctrine, which taught that pleasure and avoidance of pain were the chief ends of life. He started from two simple points. First, nothing is created from nothing. That was an old principle of Greek philosophy, and it follows that the stuff from which the universe is made has always existed and will never pass away. The universe must also be infinite, for if it had a boundary, it would be possible to reach this boundary and puncture it. A dozen men thrusting their fists through the boundary of the universe could create a new boundary, and this process could be continued endlessly. Second, there are bodies in motion, as our eyes tell us that there is, for Epicurus was willing to trust the senses, and since there is motion, there must be empty space, that is, void, into which they

can move. Thus the existence of atoms and void could be taken as proved, and since the universe is infinite, the number of atoms must also be infinite.

CREATION. Epicurus explained the process of creation of objects as occurring when these atoms collided. He thought that the atoms had weight and were constantly falling. They could not fall at the same speed along parallel trajectories, however, or they would not naturally collide. So Epicurus taught that as the atoms fell, they would, purely at random, swerve to one side or the other. The swerve explained the collisions of atoms, which stuck together when they collided—they seem to have had velcro-like appendages—and group of atoms formed the objects that we see, both living and inert. The random nature of the swerve preserved free will in the universe, but it also left a great deal to chance. When an object passes away, the atoms disintegrate. Thus when an animal dies or a tree is cut down, the atoms that compose it will return to the infinite collection of atoms that move forever in a downward motion through the universe. Everything, including man, is atoms and void. Aristotle had claimed that everything that was created in nature had a purpose, or a "final cause." Epicurus could not accept that. Yet he had to accept the fact that the creative process in nature seemed to follow patterns: men and women, for instance, are not put together at random; they have heads, arms, and legs positioned where they should be on their bodies. Dogs all seem to belong to one species. To explain that phenomenon, Epicurus developed a rudimentary theory of evolution: in the remote past, the atoms did form human being and animals at random, so that once upon a time the world was inhabited by some odd and curious creatures, and a dog might have the claws of a cat, and a man might have the lower body of a horse, like the mythical centaurs. But by trial and error, nature discovered the creatures most able to survive in the competition for life, and these formed patterns of creation. This was a "survival-of-the-fittest" argument, a precursor of Charles Darwin's evolutionary theory.

THE GODS. The Epicureans denied divine providence, but they did not discard the gods. To be sure, Epicurus had mechanistic explanations for natural phenomena such as thunder, rainbows, and earthquakes, and he argued against the belief that there was some caring, benevolent deity that watched over the world. The manifold suffering in the world was proof of the falsity of any such notion. But the Epicurean system did leave space for the gods. They were blessed, happy beings who lived in a never-never land, the *intermundia*, to use the Latin term for it, which means the "space between the

a PRIMARY SOURCE *document*

THE MAXIMS OF EPICURUS

INTRODUCTION: Diogenes Laertius ends his biography of Epicurus with four authentic documents, three of them letters to disciples in which, among other things, he presents purely mechanistic explanations for various natural occurrences. For example, earthquakes may be the result of wind penetrating the interior of the earth or it may be caused by the earth itself being bombarded by particles from the outside, and since earth's own atoms are in constant motion, it is prone to general vibration. In any case, earthquakes were not caused by the will of the gods. The last document is a set of Epicurus's maxims to guide a person seeking a happy life. Ten of them are quoted below.

What is happy and imperishable suffers no trouble itself, nor does it cause trouble to anything. So it is not subject to feelings either of anger or of partiality, for these feelings exist only in what is weak.

Death is nothing to us, for that which is dissolved has no feeling whatsoever, and that which has no feeling means nothing to us.

A person cannot have a pleasant life unless he lives prudently, honorably and justly, nor can he live prudently, honorably and justly without a pleasant life. A person cannot possibly have a pleasant life unless he happens to live prudently, honorably and justly.

No pleasure is intrinsically bad, but what causes pleasure is accompanied by many things that disturb pleasure.

Vast power and great wealth may, up to a certain point, grant us security as far as individual men are concerned, but the security of men as a whole depends on the tranquility of their souls and their freedom from ambition.

Of all the things that wisdom provides for the happiness of a whole life, the most important by far is acquiring friends.

Natural justice is an agreement among men about what actions are suitable. Its aim is to prevent men from injuring one another, or to be injured.

Justice has no independent existence: it results from mutual contracts, and we find it in force wherever there is a mutual agreement to guard against doing injury or sustaining it.

Injustice is not intrinsically bad: people regard it as evil only because it is accompanied by the fear that they will not escape the officials who are appointed to punish evil actions.

The happiest men are those who have reached the point where they have nothing to fear from those who surround them.

SOURCE: Diogenes, "Epicurus," *The Lives of the Eminent Philosophers*. Book 10, Sec. 31. Trans. C. D. Yonge (London: Henry G. Bohn, 1853).

worlds." They lived happy lives in a perpetual state of *ataraxia* (tranquillity). They did not worry about the wretchedness of human society, which could only disturb their tranquillity. They were ethical ideals, for they had achieved the *ataraxia* which was the aim of the Epicurean philosopher. There was no need to fear their wrath.

GAINING KNOWLEDGE. Epicurus' atomic theory explained vision. Every object, he argued, threw off *eidola* (images), which were actually thin films of atoms which traveled through the air to our eyes. An image that struck the eyes affected the soul-atoms there, which transmitted the image to the mind. The whole process was to be understood in terms of the movement of atoms that are arranged and rearranged into patterns. All sensations were true, but Epicurus admitted that some images could be distorted. A favorite example was an oar partly in and partly out of the water that appears to be bent. Epicurus explained the distortion by claiming that the atoms of the *eidola* emitted by the oar collided with other atoms on their way to the eye, and thus transmitted a distorted image to the eye which in turn transmitted it to the mind. The mind, however, which is made up of very small atoms, can sort things out. The mind stores concepts—Epicurus refers to them as presuppositions—of what objects such as oars look like, which it has gained from experience. If a person makes the mistake of believing that the oar really is bent, it is because that person assumed too soon that the image that has reached the eyes is accurate. It follows that a person can accept the evidence received by the eyes so long as the objects that are seen are clearly visible. Senses can provide a person with accurate information.

THE FEAR OF DEATH. The aim of life was pleasure—the satisfaction of desires—though Epicurus never went as far as the Cyrenaics who held that sensual pleasure was the aim of life. Fear of death was one thing that could disturb the life of *ataraxia*, and yet there was no reason for such fear. Death was a dissolution of the atoms. The mind, which was also made up of atoms, did

not survive death. There was no need to fear tortures in the Underworld, or any of the travails that, according to myth, the souls of men suffered in the House of Hades. Epicurus and his followers assumed that it was the life after death that men feared, and by eliminating the afterlife, they removed a source of stress. They did not address the fact that what many persons fear is the act of dying itself.

EPICUREANISM IN ROME. The philosophy that appealed to the Roman upper classes was Stoicism, not Epicureanism. Rome did produce one enthusiast for Epicurus' philosophy, however: Titus Lucretius Carus, about who little is known. He probably lived from 94–55 B.C.E. He produced one long poem, divided into six books, the *De Rerum Natura* (On the Nature of Things), which is a splendid exposition of the physical theories of Epicurus. He explains the atomic theory of Epicurus, and in his third book, he applies it to the human soul, which is mortal. In fact the third book ends with a hymn to the mortality of the soul and the foolishness of humans who fear death. The poem was left unfinished. The Roman statesman, orator, and philosopher Cicero knew it, for he refers to it in a letter dated to 54 B.C.E., which he sent to his brother Quintus in terms that would lead us to believe that both his brother and himself had read it. Cicero himself leaned towards the scepticism which Arcesilaus had preached in the New Academy in Athens. It is also true that a center of Epicurean study developed in the region of Naples in the first century B.C.E.; a house excavated in the city of Herculaneum, which had been destroyed in 79 C.E. by the eruption of Mt. Vesuvius, contained charred rolls of papyrus apparently containing Epicurean works, most of them by the Epicurean philosopher Philodemus of Gadara (c. 110–c. 40 B.C.E.) who had a villa at Herculaneum. Now known as the Villa of the Papyri, the house must have been a gathering place for Epicureans in the early first century C.E. after Philodemus' death.

SOURCES

Cyril Bailey, *The Greek Atomists and Epicurus* (Oxford, England: Clarendon Press, 1928).

Benjamin Farrington, *The Faith of Epicurus* (London, England: Weidenfeld and Nicolson; New York: Basic Books, 1967).

Bernard Frische, *The Sculpted Word: Epicureanism and Philosophical Recruitment in Ancient Greece* (Berkeley: University of California Press, 1982).

Howard Jones, *The Epicurean Tradition* (London, England: Routledge, 1989).

Phillip Mitsis, *Epicurus' Ethical Theory* (Ithaca, N.Y.: Cornell University Press, 1988).

J. M. Rist, *Epicurus: An Introduction* (Cambridge: Cambridge University Press, 1972).

NEOPLATONISM

HISTORY. Neoplatonism is the modern name for the philosophy taught by Plotinus who came to Rome shortly after 234 C.E. and opened a school there. Plotinus' pupil, Porphyry, who published Plotinus' works after his death, was largely responsible for publicizing his philosophy and incidentally, antagonizing Christian leaders who were both attracted to and repelled by Plotinus' teachings. Porphyry in turn had a pupil named Iamblichus who founded a school in Syria. Iamblichus' works are all lost, but his philosophic ideas lived on in Athens, where Plato's old Academy was revitalized by Neoplatonism. The Neoplatonic Academy, which regarded itself as a direct descendant of the Academy that Plato founded, became a center for Neoplatonic doctrine until the emperor Justinian closed the school in 529 C.E., a move which marks the end of pagan philosophy. Thus Neoplatonism is the last product of the Greek philosophic tradition which went back to the Milesian philosophers in archaic Greece.

REMEMBERING PLATO. The philosophy of Plotinus harked back to Plato, though not to all of his writings. Plotinus paid no attention to Plato's early dialogues, choosing to draw from the dialogues of Plato's middle and late periods. Plato in his *Republic* referred to the "Being beyond Being" which is the Idea of the Good. The "Being beyond Being" re-emerges in Plotinus' conception of the "One," which is the principle of all being, and hence "beyond Being." It is infinite and, as such, it has no attributes. It simply transcends any description or knowledge. But while the goal of Plato's philosophy was the achievement of knowledge of the divine being, Plotinus went a step further and posited that the goal should be an actual union with the divine being. For Plotinus, the "One" is all things and yet none of them. It is formless, but it possesses a kind of true beauty, for it is the power that produces all that is beautiful. The "One" produces offspring, and its greatest offspring, second only to itself, is Intellect. Soul has the same relation to Intellect as Intellect has to the "One." It is the source of all that lives and, as such, it must be immortal. Soul is the principle of motion. Capable of moving itself, it is the cause of movement in the world, and it is the source of life for all bodies that have souls within them. Soul, therefore, rules nature. So between the "One" and the material world there are three descending grades of reality: "Intelligence," that is, the *nous* (world-mind); the *psyche* (world-soul); and *physis* (nature).

THE DESIRE OF THE SOUL. The soul's desire is to attain union with the "One," and to do that, it must itself become simple and formless. The soul must discard all awareness of intelligible realities. The union of the Soul with the "One" cannot be described. It is like the return of a wanderer to his native land. To attain this union, a person must free his soul from all outward things and turn completely within himself, rid his mind even of ideal forms and forget himself and thus come within sight of the "One." The Soul loves God and wants to be one with him. This was not a philosophy for a person who took an active role in public life. Plato had founded his Academy as a school of future statesmen, but the world had changed since the fourth century B.C.E., and Plotinus' philosophers withdrew and sought salvation in contemplation.

THE FINAL DEVELOPMENT. Porphyry's pupil, Iamblichus (c. 250–c. 325 C.E.), after studies in Rome, returned home to Syria and founded his own school there. His ideas survive, though most of his writings do not, and what is remarkable about them is that he explicitly subordinated philosophy to *theurgy*, the art of communicating with God by oracles, mysticism and magic. Iamblichus imported a great many religious ideas from the East, particularly from Egypt, into Neoplatonism. In the fifth century C.E. the Neoplatonic Academy acquired new life under a *scholarch* (headmaster) named Proclus (412–484 C.E.). Proclus was born in Constantinople and came to Athens as a young man to study philosophy. He stayed to become the head of the Academy. Professors taught in their homes—the park-like setting where Plato himself had taught had long since disappeared—and the remains of Proclus' house have been discovered. It was below the Acropolis, where Proclus had a good view of the Parthenon, the temple of Athena. When the gold-and-ivory cult statue of Athena was removed from the Parthenon, Proclus had a dream in which Athena appeared to him and told him that now she was ousted from her temple, she would have to make her home with him. Proclus enjoyed Athena's favor, it was said. He and his disciples were also devotees of the Sun God, to whom they offered daily prayers. Life in the Neoplatonic Academy was almost that of a pagan monastery. In 529 C.E., the emperor Justinian closed it down, and the long tradition came to an end.

SOURCES

The Cambridge Companion to Plotinus. Ed. Lloyd P. Gerson (Cambridge: Cambridge University Press, 1996).

Kevin Corrigan, *Reading Plotinus: A Practical Introduction to Neoplatonism* (West Bend, Ind.: Purdue University Press, 2002).

L. E. Goodman, ed., *Neoplatonism and Jewish Thought* (Albany, N.Y.: State University Press of New York, 1992).

John Gregory, *The Neoplatonists: A Reader* (London, England: Routledge, 1999).

A. C. Lloyd, *The Anatomy of Neoplatonism* (Oxford, England: Clarendon Press, 1990).

J. M. Rist, *Plotinus: The Road to Reality* (Cambridge: Cambridge University Press, 1967).

Lucas Siorvanes, "Neoplatonism," in *Encyclopedia of Greece and the Hellenic Tradition.* Ed. Graham Speake (London, England: Fitzroy Dearborn, 2000): 1143–1145.

R. T. Wallis, *Neoplatonism* (London, England: Duckworth, 1995).

SIGNIFICANT PEOPLE
in Philosophy

ARISTOTLE

384 B.C.E.–322 B.C.E.

Philosopher
Teacher
Biologist

EARLY DEVELOPMENT. Aristotle was born in 384 B.C.E. in Stagira, Chalcidice, the projection of land that forms the eastern edge of the Thermaic Gulf in the northern Aegean Sea. His father Nicomachus was the court physician of King Amyntas II, the father of Philip II of Macedon who would eventually make Macedon the dominant power in Greece. Aristotle may have spent part of his boyhood at the Macedonian court at Pella, and acquired his interest in physical science in his father's surgery. At age seventeen, he travelled to Athens and entered Plato's Academy where he remained until Plato's death in 348 or 347 B.C.E., first as a student, then as a teacher and research associate. When Plato died, Aristotle left Athens, perhaps because he was disappointed at not being named Plato's successor as head of the Academy. In any case, the new head, Speusippus, represented the trend of later Platonic thought to make philosophy into a branch of mathematics, for which Aristotle had no sympathy. Aristotle went to the court of Hermias, a former student at the Academy who extended his hospitality to a small circle of philosophers, and Aristotle married his niece. Hermeias was a eunuch and a tyrant who ruled Atarneus and Assos in the Troad (the region around ancient Troy), on the fringe of the Persian

Empire; in 341 B.C.E. he was betrayed to the Persians who captured him, tortured him and put him to death. In his memory, Aristotle wrote a hymn to virtue. The execution of Hermias may account for Artistotle's prejudice against the Persians which is apparent in his treatise, the *Politics*.

FOUNDED THE LYCEUM. Aristotle himself moved to Lesbos, and it is during his stay at Assos and Lesbos that he did much of his research into the natural sciences which laid the foundation for the modern study of biology. Then about 343 B.C.E. Philip II of Macedon asked him to come to Pella as tutor to his son Alexander. The appointment ended when Philip appointed Alexander regent in 340, and Aristotle probably went back to Stagira. The year after Philip's death in 336 B.C.E., Aristotle returned to Athens and leased some buildings—as a non-citizen he could not buy property—and founded a school where he gave lectures and collected books and artifacts to illustrate his lectures, especially his lectures on zoology. The school was in a grove sacred to Apollo Lyceius and the Muses, and it took the name, the Lyceum, from Apollo Lyceius. The buildings which Aristotle rented there included a courtyard with a colonnade called a *peripatos* where Aristotle loved to walk with his students, and from it, the Aristoteleans got the name "Peripatetics" by which they were known in later centuries. There Aristotle built a library and a museum; Alexander the Great is supposed to have given him a grant of 800 talents—a enormous sum by the standards of the day—to fund the collection and ordered information to be sent to him about any new species discovered in the course of his conquests. When Alexander died in 323 B.C.E. Athens was swept up in a wave of anti-Macedonian feeling, and Aristotle's close connections with Macedon put him in danger. He prudently withdrew to Chalcis on the island of Euboea where his family had an estate, and he died there less than a year later.

RESEARCH LOST. Much of Aristotle's work is lost. As a young research associate at Plato's Academy, he wrote a number of dialogues that were much admired for their style, but none survive. He also produced memoranda and collections of materials for treatises. At the Lyceum, he organized large-scale research; he assigned his students the task of producing research essays on the constitutions of 158 Greek states and of these one survives: a papyrus found in Egypt at the end of the nineteenth century contains most of the *Athenaion Politeia* (The Constitution of Athens), which is probably one of these research essays. Aristotle's surviving works include the scientific and philosophic treatises, perhaps about one-third of his total output.

DIVERGED FROM PLATO Aristotle began as a student of Plato but he soon diverged from his master. He could not accept Plato's Theory of Forms, which held that physical objects in the world such as chairs, horses, and men are imitations of perfect realities which exist separate from the human sphere, and among these perfect realities were abstractions such as pure Goodness and pure Beauty. For Aristotle, these "Forms" did not exist apart from the substances from which they were formed. He pointed out that if the substances did not exist, the Forms could not exist. Thus a horse is recognizable, for instance, because a number of horses exist and their characteristics are known. This is true of all species, whether plants or animals or even types of government, and thus by collecting data about them, and classifying them, real knowledge can be acquired. Aristotle would have said that a political scientist who wanted to acquire skill in the art of governing should not formulate constitutions for imaginary utopias, but rather should imagine the actual constitutions of states in the Mediterranean world.

ACHIEVEMENT IN DEDUCTIVE LOGIC. One of Aristotle's major achievements was in the field of deductive logic—the process of reasoning from a premise to a logical conclusion, or from a known principle to one that is unknown. Aristotle no doubt spent a great deal of thought perfecting his logic, and he was proud of the results, but for him it was always a means to an end, and the end was a solution to the old problem: how can anyone know anything for certain? Aristotle always regarded his logic as a tool that he might use to separate wrong arguments from sound ones. His logic was taken up with enthusiasm by the medieval philosophers who used it to make rigorously accurate deductions from one or more first principles that were taken as self-evidently true. The problem with this method of reasoning was that the first principle really must be true; otherwise the deduction would be wrong. However, Aristotle, unlike the medieval philosophers that came centuries after him, did not himself accept first principles as true without examining them carefully.

THE LYCEUM AFTER HIS DEATH. After Aristotle died in 322 B.C.E., Theophrastus became the head of the Lyceum and it flourished under his leadership. Theophrastus himself carried on research in botany; Eudemus of Rhodes wrote on the researches into science, including arithmetic, geometry and theology; and the brilliant researcher Aristoxenus wrote on music—parts of his works on harmonics and rhythm have survived. After Theophrastus' death, a series of lesser philosophers became heads, or "scholarchs," as they were called, but the Lyceum was increasingly overshadowed by rival

schools. It probably ceased to exist after the sack of Athens by the Roman general Sulla in 86 B.C.E. Although the school did not survive, Aristotle's influence did, particularly after the publication if an edition of his works by Andronicus of Rhodes in 40 B.C.E.

SOURCES

Jonathan Barnes, *Aristotle* (Oxford, England: Oxford University Press, 1982).

John Ferguson, *Aristotle* (New York: Twayne, 1972).

William David Ross, *Aristotle* (London, England: Methuen, 1949).

EPICTETUS

c. 55 C.E.–c. 135 C.E.

Philosopher
Teacher

SOURCE OF STOICISM. Given the small number of surviving writing by the early Stoics, the works of Epictetus take on a particular importance as a major source of modern knowledge of Stoicism. He wrote nothing himself, but he was fortunate enough to have as a student Flavius Arrianus, or Arrian as he is usually known. Arrian was a Roman citizen who served as governor of the province of Cappadocia in Asia Minor under the emperor Hadrian (117–135 C.E.). He transcribed the *Discourses* of Epictetus, which seem to have been conversations between Epictetus and his students after the formal lectures were over for the day. It is hard to believe that they are an actual stenographic record of what Epictetus said, though it is not impossible, for a man of standing such as Arrian might well have had at his disposal a slave trained in shorthand. There is one shred of evidence that would indicate that the *Discourses* do represent the actual words of Epictetus; another work of Arrian—a history of Alexander the Great—differs markedly in literary style from that of Epictetus' *Discourses,* indicating that two different authors are responsible.

FROM SLAVE TO PHILOSOPHER. Epictetus was born in Hierapolis (modern Pamukkale in Turkey) and as a boy he went to Rome as a slave where he was purchased by a secretary of the emperor Nero named Epaphroditus. Epaphroditus was himself an ex-slave who had gained his freedom and rose through the ranks of the imperial civil service until he became the official in charge of receiving petitions for his master, the emperor Nero. There were stories told that he treated Epictetus cruelly; he did, however, allow him to attend the lec-

tures of the Stoic philosopher Musonius Rufus. During his mid-twenties, shortly after the suicide of Nero in 68 C.E., Epictetus was manumitted, thereby becoming a freedman. It was then that Epictetus began his own lecturing and philosophizing, much of it focusing on the Stoic philosophy. About 89 C.E. the emperor Domitian expelled the philosophers from Rome, including Epictetus who migrated to Nicopolis in north-west Greece, an area that attracted many upper-class Romans including Arrian. Although there were originally eight books of Epictetus' *Discourses,* only four survived to record the philosopher's thoughts for posterity. A manual of personal conduct for the adherent to Stoic doctrine, the *Enchiridion,* also survived, giving readers a synopsis of the key themes of Epictetus' teaching.

SOURCES

A. A. Long, *Epictetus: A Stoic and Socratic Guide to Life* (Oxford, England: Oxford University Press, 2002).

William O. Stephens, "Epictetus on How the Stoic Sage Loves," *Oxford Studies in Ancient Philosophy* 14 (1996): 193–210.

EPICURUS

341 B.C.E.–270 B.C.E.

Philosopher

EPICURUS' LIFE. Epicurus was born in Samos in 341 B.C.E., but his father and mother were both Athenian citizens so he suffered none of the disadvantages of resident aliens in Athens who could not, for instance, own property in Athens. Epicurus fulfilled his military service in Athens just after the death of Alexander the Great in 323 B.C.E. and then rejoined his family who had by then settled in the city of Colophon, an Ionian city in Asia Minor. It was there he probably learned about the theory of atoms and void proposed by Leucippus and Democritus. At age 32, he moved to the city of Mytilene on the island of Lesbos, where he set up a school and began his career as a teacher; from Mytilene he moved to Lampsacus on the Hellespont, where he also set up a school and began to acquire pupils and loyal friends. The intellectual center of the Greek world was in Athens, however, so he moved there in 306 B.C.E. He purchased a house with a garden, where he set up a school known as "The Garden." Apart from some visits to Asia Minor, he remained in Athens until his death.

EPICUREAN PHILOSOPHY. For many Greeks, the Garden provided an escape. The expanded world that resulted from Alexander the Great's conquests had

become a bewildering place. Epicurus' students retired to his Garden where they attempted to live a life of *ataraxia*: freedom from stress and worry. Though the adjective "epicurean" has come to mean "fond of sensuous pleasure," Epicurus himself and his followers were not epicurean in that sense. They were abstemious: a small cup of light wine was enough for a day, otherwise Epicurus taught that happiness was the aim of his ethical system, and happiness meant pleasure. Pleasure was the one true good, but not the sensual pleasure of the Cyrenaic School with which the Epicureans were sometimes confused by their enemies. Rather it was intellectual pleasure, and freedom from stress, desire, need, and, above all, pain.

EPICURUS' DEATH AND LEGACY. As it turned out, Epicurus' death was exceedingly agonizing, and he bore the pain with fortitude. He suffered from a kidney stone, and he failed to pass it in his urine. After some two weeks of excruciating pain, he had a warm bath prepared for him in a bronze tub, asked for a cup of pure wine and drank it, and stepped into the tub. As he rested there, he urged his friends to remember his teachings, and so he died. Unlike the Stoics, the Epicureans never influenced the world to any great extent, but on the other hand, Epicurean teachings did not die out despite being much reviled, particularly by the Christians who disagreed with the Epicurean position that the cosmos was the result of accident and there was no divine plan.

SOURCES

Cyril Bailey, *The Greek Atomists and Epicurus* (Oxford, England: Clarendon Press, 1928).

Benjamin Farrington, *The Faith of Epicurus* (New York: Basic Books, 1967).

A. A. Long and D. N. Sedley, *The Hellenistic Philosophers* (Cambridge: Cambridge University Press, 1987).

J. M. Rist, *Epicurus: An Introduction* (Cambridge: Cambridge University Press, 1972).

PLATO

427 B.C.E.–347 B.C.E.

Philosopher

DISTINGUISHED FAMILY. Plato, one of Greece's most famous philosophers, was born in Athens in 427 B.C.E. to an old distinguished family. His father, Ariston, was a conservative man of property and established family lineage, and his mother, Perictione, counted among her ancestors Solon, the Athenian statesman who reformed the government in 594 B.C.E. and gave it what

conservatives called the "ancestral constitution" of Athens. Plato himself claimed in two of his dialogues that the tale of Atlantis, a lost continent submerged beneath the sea, was passed down to his family from Solon, who learned it in Egypt. Ariston passed away while Plato was still a child, and his mother married a close friend of Pericles, Athens' powerful statesman. Thus, Plato had close connections to the powerful elite of Athens even as a young child.

DISCIPLE OF SOCRATES. Despite his political connections, Plato's most influential relationship was no doubt the one he shared with the philosopher Socrates. Plato must have been quite young when he met Socrates and it was the turning point of his life. Engrossed by Socrates' relentless pursuit of ethical questions, Plato became Socrates' most famous disciple, and it is through Plato's writings that most of the modern knowledge about Socrates is derived. Not everyone was so enamored of Socrates, however; the philosopher's penchant for confronting the citizens of Athens with their own foolishness had earned him many enemies, and the hostility he aroused contributed to his condemnation and death penalty on charges of impiety and corrupting the young in 399 B.C.E. For Plato, Socrates' condemnation resulted in his disillusionment with politics as he saw them practiced in the Greek world. He became convinced that the only cure for bad government lay in philosophy, and there could be no good government until true philosophers gained political power, or politicians become true philosophers. He himself explained how he came to this conclusion in his personal testament expressed in the *Seventh Letter*, which he wrote in his old age, and this belief permeates his most famous work, the *Republic*, as well as his last work, the *Laws*, left unrevised at his death in 347 B.C.E.

PLATO'S TRAVELS. Plato traveled widely for about a decade after Socrates' death. He visited southern Italy in the year 388 B.C.E. where he encountered the Pythagoreans; at Tarentum a Pythagorean philosopher and distinguished mathematician, Archytas, had been elected governor and provided an example of a philosopher in power. Plato's fascination with mathematics owed something to Archytas' influence. From Italy, he went to the court of the tyrant Dionysius I in Sicily, and got to know Dionysius' brother-in-in law, who was excited by Plato's political ideas. But Plato offended Dionysius somehow and returned to Athens. There he set up the Academy about 386 B.C.E. where he taught for the rest of his life, except for two brief periods (in 367 B.C.E. and again in 361 B.C.E.) when he returned to Sicily to train Dionysius I's successor, Dionysius II.

PLATO'S ACADEMY. The aim of the Academy was to train statesmen. Many members of the Academy took an active part in the political life of the Greek states. The Academy was not the first such institution in Athens, but it does have a claim as the first university in Europe. When the Roman general Sulla sacked Athens in 88 B.C.E., the Academy was a casualty, and there is no evidence of activity in the Academy in the centuries that followed. Individual Platonists, however, held classes in their houses and Athens retained a reputation as a center of philosophy. In the fifth century C.E., however, the Academy was refounded as a center for Neoplatonism, which mixed mysticism with Platonic philosophy, and this Neoplatonic Academy claimed direct descent from Plato's Academy, a claim that was clearly bogus. Yet it became paganism's last intellectual stronghold, and in 529 B.C.E., the emperor Justinian closed it down as part of his campaign against the remnants of paganism.

SOURCES

Plato's Epistles (The Library of Liberal Arts). Trans. Glen R. Morrow (Indianapolis, Ind.: Bobbs-Merrill, 1962).

Paul Shorey, *What Plato Said* (Chicago: University of Chicago Press, 1933).

A. E. Taylor, *Plato, The Man and His Work* (London, England: Methuen, 1960).

PLOTINUS

c. 205 C.E.–270 C.E.

Philosopher

STUDIED FOR MANY YEARS. The philosopher Plotinus is best known as the founder of Neoplatonism—the study, interpretation, and progression of the work of the Greek philosopher Plato. Plotinus, like many philosophers who studied Plato, was not born in Greece, but in Lycopolis, Egypt, around 205 C.E. Not much is known about his early life other then he had an early thirst for knowledge that prompted him to leave Egypt in his twenties in order to learn more. At the age of 28 he returned to Egypt, this time to Alexandria, in search of a contemporary philosopher by the name of Ammonius Saccas. He attended lectures given by Saccas and eventually became a personal student of the philosopher. It was Saccas that introduced Plotinus to Plato, as well as to Persian and Indian philosophy, both of which would heavily influence his later interpretations of Plato. After eleven years as a student of Saccas, he felt the need to travel again, and his newfound love of Asian philos-

ophy led him to join up with a Roman military expedition to Persia in 243. Unfortunately, Plotinus never made it to Persia, for the leader of the expedition, Roman emperor Gordian III, was lynched by his own troops and the expedition was abandoned. It took Plotinus two years to return from the expedition, and his next recorded appearance was in Rome in 245. By this time Plotinus was forty years old, and was ready to embark on his philosophical career.

LECTURED IN ROME. Plotinus's first lectures did not relate to Plato directly but instead focused on the teachings of his old mentor Ammonius. According to a biography written by Plotinus's student Porphyry, Plotinus spoke all over Rome about Eastern philosophies in relation to Plato's work, but did not put down on paper any of his theories or interpretations for close to ten years. However, by 263, Plotinus had moved on to the direct study and interpretation of Plato's work and had written 21 treatises on philosophical issues. These writings, along with 33 other treatises which he would write over the last seven years of his life, would make up his most famous compilation of work, the *Enneads*. The 54 treatises in the *Enneads* cover a wide variety of subjects and were later arranged by Porphyry in the following order: *Ennead* I dealt with issues of ethics; *Enneads* II and III looked into natural philosophy and cosmology; *Ennead* IV delved heavily into psychology; *Ennead* V concerned itself with epistemological issues, especially those of the intellect; and *Ennead* VI covered a variety of topics from numbers to the issue of a higher being above the intellect. These writings are not so much musings on these topics as they are responses to questions that Plotinus received during his lectures about different areas of Plato's philosophy.

SUFFERED AILMENT IN LATER YEARS. During his later years, Plotinus also heavily studied the works of Aristotle, another pupil of Plato. While most of Plotinus's written work is original, many of his lecturers and many of the positions from which he starts his writings were taken directly from Aristotle's interpretation of Plato's work. By 268, Plotinus had retired from lecturing and his writing also seemed to stop completely. This has been attributed to an ailment he suffered, possibly leprosy, which disfigured him. It is unclear whether it was this ailment or simply old age that caused Plotinus's death in 270 at the age of 66. His final words that were reported were, "Try to bring back the God within you to the Divine in the universe." The *Enneads* which Porphyry edited were published thirty years after his death, and they are the main surviving work that produced Neoplatonism centuries later.

SOURCES

John Gregory, *The Neoplatonists* (London, England: Routledge, 1999).

J. M. Rist, *Plotinus: The Road to Reality* (Cambridge: Cambridge University Press, 1967).

Andrew Smith, "Plotinus," in *Encyclopedia of Greece and the Hellenic Tradition.* Ed. Graham Speake (London, England: Fitzroy Dearborn, 2000): 1339–1340.

THALES

c. 625 B.C.E.–c. 547 B.C.E.

Philosopher
Mathematician
Astronomer

THE FOUNDER OF GREEK PHILOSOPHY. The Greeks looked upon Thales as the founder of Greek philosophy and the first man to attempt to provide a scientific explanation for the origin of the world. He was born in Miletus on the south-west coast of Asia Minor around 625 B.C.E. and in his youth he was an avid traveler. As Hieronymus of Rhodes indicates in his report, Thales measured the pyramids by their shadow, having observed the time when a person's shadow is equal to the person's height. It wasn't long after his trip to Egypt that Thales went to Greece to further his study of geometry. It was in Greece that he began to lecture on natural sciences and philosophy and he founded one of the first Greek schools of philosophy the Ionian School, also called the Milesian school.

LEGEND OF ECLIPSE PREDICTION. Thales was said to have predicted an eclipse of the sun which has traditionally been dated to 585 or 584 B.C.E. and if this report is true, it would provide the one certain date in his life. Whether he actually predicted the eclipse or not is a matter of dispute. At one time scholars believed that he used astronomical observations borrowed from Babylon to make his prediction, but it is now known that at this time, the Babylonians had no theory for predicting solar eclipses that Thales could have used. Moreover, the story goes that the eclipse that Thales predicted took place just as the Medes and the Lydians were about to fight a battle at the Halys River in Asia Minor, and the Milesians were present as allies of Lydia. The eclipse caused the Medes and Lydians to break off the battle. The story implies that the eclipse took place during daylight hours, and there was no solar eclipse at a suitable hour in 585 or 584 B.C.E., though on 21 September 582, there was a partial eclipse, three-quarters total at 10 and this may have

been the eclipse which Thales was said to have foretold. Clearly Thales' prediction was a legend, but it is evidence of his reputation as an astronomer was among the Greeks.

ANECDOTES ABOUT THALES. There were a number of similar stories told of Thales' activities as engineer, mathematician, and astronomer, as well as a philosopher. When his critics derided his wisdom as impractical, he used his astronomical knowledge to predict a superabundant crop of olives, and made a fortune by cornering the market in olive presses. Another story which presented him as an absent-minded intellectual told that while he was stargazing, he fell into a well, and a servant girl who found him laughed at him because he failed to notice what was at his feet as he examined the heavens. He discovered that two triangles were equal if two angles and one side were equal and he evidently used this theorem to measure the distance of ships out at sea. He was credited with a book on navigation titled the *Nautical Star Guide,* but it is doubtful if he was the author of this work. Most scholars think that Thales wrote nothing.

CONTRIBUTION TO NATURAL PHILOSOPHY. Thales argued that the material constituent of all things is water. The earth, he claimed, floats on water, and he used this theory to explain why earthquakes occurred. He rejected the explanation that they took place when a god such as Poseidon shook the earth. It is possible that he derived his theory from Near Eastern mythological explanations of creation, for Babylonian descriptions of the world order spoke of the "waters under the earth." Yet Thales' doctrine did not turn to supernatural or mystical explanations in order to understand natural phenomena. Instead of elaborating stories of how the universe came into existence, as Hesiod did in his *Theogony* which proposed a theological explanation for how the world arose from chaos, Thales posed a new question—"What is the universe?—and his answer was a theory based on observation of the real world. As such he paved the way for the development of modern natural science.

HELPED CROESUS DURING WAR WITH PERSIA. When Thales was an old man, the Lydian kingdom, then ruled by Croesus, whose wealth was proverbial, was threatened by a new enemy, Cyrus, king of Persia, who had overthrown the last king of the Medes in 550 B.C.E. Croesus, whose sister had married the last king of the Medes, wondered if he should attack Persia before it grew too strong, and he consulted the oracle of Apollo at Delphi. The oracle gave the ambiguous answer, "If Croesus crosses the Halys River, a great em-

pire will fall." Croesus imagined the prophecy was favorable and launched an attack, not realizing that his empire was the one destined to fall. Thales accompanied him, and another legend told that he helped the Lydians cross the Halys River by diverting part of the stream into another channel. Croesus was defeated, and in 547 or 546 B.C.E. his capital of Sardis fell to Cyrus. The Ionian cities that had been subject to Croesus wondered what to do, and Thales proposed that they should form a federal state and present a united front to Persia. But Cyrus split the Ionian resistance by offering Miletus a favorable alliance and leaving the conquest of the rest of Ionia to one of his generals. Following this event, Thales passed from the historical records until his death around 547 B.C.E.

SOURCES

Robert S. Brumbaugh, *The Philosophers of Greece* (New York: Thomas Y. Crowell, 1964).

John Burnet, *Greek Philosophy; Thales to Plato* (London, England: Macmillan, 1950).

James Longrigg, "Thales," in *Dictionary of Scientific Biography.* Vol. XIII. Ed. Charles Coulson Gillespie (New York: Charles Scribers Sons, 1976): 295–298.

Erwin Schrödinger, *Nature and the Greeks* (Cambridge: Cambridge University Press, 1954).

ZENO OF CITIUM

335 B.C.E.–263 B.C.E.

Philosopher

EARLY YEARS Like many people in Citium, Zeno was most likely Phoenician, a sect of Middle Eastern people who were known for their sea trading. Zeno himself was a merchant in his younger years, traveling often to numerous ports around the Mediterranean Sea. Over the years Zeno began to gather philosophical books from Athens, Greece (both from his own travels and from his father's travels as a merchant), and by his mid-twenties he sold what cargo he had left and settled permanently in Athens.

BEGAN TEACHING AT THE PAINTED STOA. Zeno was influenced heavily in his early philosophical education by two very different schools of thought. He often attended lectures by Polemon, a follower of the Academics, who were considered very traditional philosophers and used Plato's teachings as their core beliefs. He also was known to follow the teachings of Crates the Cynic, a well-known teacher of Cynicism. Cynicism was the exact opposite of the Academic philosophy, rejecting all

conventions of society and instead pointing towards a life focused on nature and base needs. By the time Zeno began his own lecturing around 300 B.C.E., he had begun to combine these two schools of thought into a new philosophy. Zeno, like many other philosophy teachers at the time, taught in public locations that were accessible to any person who might wander by. It was well known that Zeno's favorite place to teach was in front of the "Stoa Poikile" (Painted Stoa), a central colonnade on the north side of the agora in Athens. Zeno became so well known for lecturing on philosophy in this spot that his new brand of philosophy was soon named Stoicism. Over time Zeno began to develop a large following that included Antigonus Gonatas, the king of Macedonia who would come to Athens often just to hear Zeno teach. While Zeno was invited numerous times to become the royal philosopher in Macedonia, he declined, not wanting to leave Athens, the seat of philosophy during his lifetime.

STOICISM. Zeno's philosophical core beliefs grew out of the idea of corruption and rationalism. In his most famous and controversial work, the *Republic,* Zeno chastised society and other philosophies for needing to set up binding institutions such as government, law, and religion. In the *Republic* Zeno first breaks down society by all of its ills, and then reconstructs it by describing a new form of society. In this society, members rely completely on rational thinking as a way of life. In this "Utopian" view of the world, there is no need for any sort of government, economic system, nor institutions such as religion. Instead the rational thinking human would only do what is best not only for himself or herself, but for the society at large. This line of thinking allowed Zeno to promote many "radical" ideas for his time period such as equality between the sexes, homosexuality, and shared responsibility for successes and failures. While many of Zeno's followers saw the possibility of a world where only moral and ethical choices were made, many of Zeno's contemporaries saw Stoicism as the path toward moral depravity. The philosophy was rejected not only by the Academics, but also by the Cynics who felt that it did not give in completely to all of the natural ways of the world (for much of what Zeno outlined in the *Republic* was an orderly society where no one was offended by actions because all actions were deemed right or wrong by rationalism).

LIVED A SIMPLE LIFE. While most of Zeno's time was spent teaching at the Stoa, he was well known throughout Athens as a person who was of high class and who was highly connected, an unusual status for someone who was not born an Athenian. He was also

perceived as one who enjoyed simple but expensive things. It was well known that he was not a heavy drinker, often turning down invitations to symposia (traditional Greek drinking parties), but that he always drank a little wine of the best stock when taking his meals. He ate loaves of bread with only the freshest honey and could often be found lounging in the sun eating freshly picked green figs. According to the works of some of his later followers, such as Diogenes Laertius, who wrote a biography on Zeno, Zeno was the perfect example of Stoicism; he used his rational mind to enjoy only the best of those things that nature could provide. Unfortunately, Laertius's writing is one of the few records that scholars have of Zeno and his own writings. There are no known surviving copies of the *Republic* nor of any of Zeno's other supposed philosophical writings. Much has been taken from later Stoic writing by followers of Zeno, but it is often difficult to attribute what was originally part of Zeno's Stoicism and what was added later by other philosophers. While Zeno was a student and teacher of rational thinking, he committed suicide, something his own teachings would have looked at as irrational, at the age of 72 after injuring himself severely in a fall.

SOURCES:

Andrew Erskine, *The Hellenistic Stoa: Political Thought and Action* (New York: Cornell University Press, 1990).

George E. Karamanolis, "Zeno of Citium," in *Encyclopedia of Greece and the Hellenic Tradition.* Ed. Graham Speake (London, England: Fitzroy Dearborn, 2000): 1750–1751.

F. H. Sandbach, *The Stoics* (New York: Norton, 1975).

DOCUMENTARY SOURCES
in Philosophy

Aristotle, *Metaphysics* (335 B.C.E.)—This work contains an examination of earlier philosophers as well as Aristotle's own account of how the universe was created.

Diogenes Laertius, *Lives of the Eminent Philosophers* (early third century C.E.)—This collection of biographies of the Greek philosophers is one of the major sources for modern knowledge of ancient philosophy.

Epictetus, *Discourses* (100 C.E.)—This record of the exchanges between the Stoic philosopher Epictetus and his students is one of the few sources available on Stoicism.

Marcus Aurelius, *The Meditations* (c. 175 C.E.)—This last great statement of Stoic philosophy was written by the emperor Marcus Aurelius as he campaigned on the German frontier against the Quadi and the Marcomanni in the 170s.

Plato, *The Republic* (c. 429–347 B.C.E.)—Plato's most famous work is one of the best surviving studies of ancient Greek government systems. It also succinctly captures Plato's philosophical views on the flaws of government and the necessity of philosophy.

Plotinus, *The Enneads* (c. 290 C.E.)—This collection of Plotinus' writings, edited and published by Plotinus' pupil Porphyry about twenty years after Plotinus' death in 270 C.E., is the most complete expression of Neoplatonic views.

Titus Lucretius Carus, *The Nature of Things* (65–55 B.C.E.)—The Roman philosopher expounded the Epicurean atomic theory in this long poem comprising six books.

chapter seven

RELIGION

James Allan Evans

IMPORTANT EVENTS
in Religion

c. 3500 B.C.E. –c. 1100 B.C.E. Greece passes through the Bronze Age; bronze, an alloy of copper and tin, is used for weapons, tools, and cooking utensils.

c. 3500 B.C.E. –c. 1900 B.C.E. On Crete, now in the Pre-Palatial Period, family tombs are built with adjoining dancing floors, suggesting that dancing is part of the funeral rites.

Gods are worshipped in sacred caves.

c. 1950 B.C.E. Greek-speaking migrants invade Greece, displacing earlier peoples known in Greek tradition as the "Leleges" and the "Pelasgoi." The pre-Greek language is unknown but Greek place-names ending in *–inthos* and *–ssos* or *–ttos*, such as *Korinthos* (Corinth), or *Knossos* (Cnossus), are thought to belong to this pre-Greek language.

c. 1900 B.C.E. On Crete during what is known as the Proto-Palatial or "Old Palace Period," "peak sanctuaries" are built on mountain tops, and human burials are made in great jars called *pithoi*, though Pre-Palatial tombs also continue to be used.

1700 B.C.E. The palaces on Crete are destroyed, probably by an earthquake.

c. 1700 B.C.E. –c. 1450 B.C.E. This is the Neo-Palatial or New Palace period, when the palaces are rebuilt, all of them constructed around rectangular central courts which had a ceremonial function. Seven palace sites have been identified thus far, as well as five other sites with mansions like small palaces but lacking the central court.

c. 1600 B.C.E. On mainland Greece, a dynasty at Mycenae buries its dead in "shaft graves" with costly gifts of gold and amber, and bronze weapons.

c. 1500 B.C.E. –c. 1200 B.C.E. "Tholos" tombs resembling old-fashioned beehives, roofed with a false vault without a keystone, are constructed in many regions of mainland Greece, the best of them at Mycenae. Princes build palaces not only at Mycenae but also Thebes, Pylos overlooking the Bay of Navarino, Tiryns, Volos and elsewhere.

c. 1450 B.C.E. The palaces on Crete are destroyed by fire, and are rebuilt only at Knossos.

c. 1450 B.C.E. –c. 1350 B.C.E. In the "Post-Palatial Period," the Knossos palace is reinhabited, and modern archaeologists will later find in its ruins clay tablets written in "Linear B"—an early form of Greek—which reveal the names of gods worshipped by the classical Greeks.

c. 1350 B.C.E. There is destruction at Knossos, but the palace continues to be at least partially in use for another two and a half centuries.

c. 1200 B.C.E. The palace at Pylos on mainland Greece is burned, apparently by raiders, and the "Linear B" tablets discovered in 1939 in its ruins show that the gods of classical Greece—with the exception of Aphrodite—are known in the Mycenaean world.

c. 1150 B.C.E. The citadel at Mycenae falls to invaders who are part of a general folk migration that causes widespread destruction in the eastern Mediterranean. The *wanaktes*, or semi-divine kings who lived in the palaces at Mycenae and at other Bronze Age sites, disappear, and their role as intermediaries between gods and mortals ceases.

776 B.C.E. The first recorded Olympic Games festival is held at Olympia in honor of Zeus Olympios.

c. 770 B.C.E. The period of Greek colonial expansion begins with a settlement on the island of Ischia near Naples, and for the next two and a half centuries Greek states sponsor colonies along the Mediterranean and Black Sea coasts, and export their religion to these new cities.

c. 725 B.C.E. –c. 675 B.C.E. The epic poem *Iliad* is put into writing, followed by the *Odyssey* not much later. The Homeric concept of the gods becomes dominant.

c. 715 B.C.E. –c. 673 B.C.E. The legendary King Numa draws up the Roman religious calendar and establishes an order of Vestal Virgins, the priestesses of Vesta, the Roman goddess of the hearth.

c. 700 B.C.E. Hesiod writes the *Theogony*, which recounts the generations of the gods, and the *Works and Days*, which describes the Five Ages of Man: the ages of gold, silver, bronze, the age of heroes, and finally the age of iron.

c. 700 B.C.E. –600 B.C.E. The normal type of Greek temple, usually raised on a three-stepped platform with gable roof, replaces earlier, primitive structures.

c. 625 B.C.E. –510 B.C.E. An Etruscan ruling family from Tarquinii takes over Rome and introduces the Etruscan divine triad, *Tinia, Uni* and *Menrva*, which supersedes the earlier Italic triad of Mars, Jupiter, and Quirinus.

c. 600 B.C.E. At Olympia, a temple is built to Hera and Zeus using wood for the columns and mud brick for the walls. It is the earliest temple to have left substantial remains.

590 B.C.E. The "First Sacred War" results in the destruction of Delphi's neighbor, Krisa, which had sought to annex Delphi, and Delphi becomes a small independent state deriving its income and its importance from Apollo's oracle.

582 B.C.E. The Pythian Games are organized at Delphi, and athletic, musical and poetry contests are held every four years in honor of Apollo.

566 B.C.E. In Athens, the old annual Panathenaea festival in honor of Athena *Polias* is reorganized so that a Great Panathenaea is held every fourth year which is open to competitors from all Greece. In other years, the annual Panathenaea continues as the "Lesser Panathenaea."

c. 560 B.C.E. On the acropolis of Athens, the earliest temple is built on the site later occupied by the Parthenon. It is dedicated to Athena *Polias*, the "Guardian of the City," and houses the ancient wooden cult statue of the goddess.

548 B.C.E. The temple of Apollo at Delphi burns down and is rebuilt over the next forty years with subscriptions from across Greece.

546 B.C.E. –528 B.C.E. Peisistratus, dictator of Athens, purifies Delos by removing all graves within sight of the sanctuary of Artemis and Apollo.

c. 530 B.C.E. In Italy, the Etruscans—whose earlier sanctuaries had been caves, lakes, or mountaintops—begin to build temples with wide porches intended, possibly, as places to stand and observe the heavens for portents, that is, signs such as the flight of birds in a particular quarter of the sky that might signal some future happening.

509 B.C.E. In Rome, the temple of Jupiter *Optimus Maximus* on the Capitoline Hill is dedicated.

480 B.C.E. –479 B.C.E. The Persians invade central Greece, destroying the temples, including those in Athens. Delphi is spared.

399 B.C.E. Socrates is sentenced to death in Athens on a charge of introducing strange gods and corrupting the youth.

324 B.C.E. A decree of Alexander the Great is proclaimed at the Olympic Games,

demanding that the Greek states recognize him as a god.

c. 317 B.C.E. Zeno of Citium on Cyprus comes to Athens and founds the Stoic school of philosophy, important not only for its philosophical doctrines but for its theology and cosmology.

306 B.C.E. In Athens, Epicurus founds the Epicurean school of philosophy which teaches that all beings are made up of atoms and void, including the gods, who live a blessed life in the space between the worlds (the *intermundia*) and are indifferent to mankind.

290 B.C.E. Ptolemy I, *Soter* (the Savior), one of
–285 B.C.E. Alexander the Great's generals who had carved out a kingdom for himself in Egypt after Alexander's death, introduces divine worship for the dead Alexander.

283 B.C.E. Ptolemy I *Soter* dies and his son and successor Ptolemy II proclaims him a god.

279 B.C.E. On the death of Ptolemy I's widow, the two are proclaimed "Savior Gods" and a religious festival, the *Ptolemaika*, is established to honor them.

c. 272 B.C.E. King Ptolemy II of Egypt proclaims himself and his queen Arsinoe, who is also his sister, the "Brother-Sister Loving Gods."

205 B.C.E. The Romans, distressed at their failure to defeat Hannibal, consult the Sibylline Books and are instructed to introduce the religious cult of Cybele, the Great Mother, from Asia Minor into Rome.

186 B.C.E. The Roman Senate decrees that the rites of Bacchus (Dionysus) be suppressed in Rome and in Italy.

100 B.C.E. The worship of the Egyptian goddess
–90 B.C.E. Isis is introduced into Italy.

44 B.C.E. Julius Caesar is assassinated on the Ides of March (15 March) and is deified by decree of the senate.

12 B.C.E. The emperor Augustus becomes *pontifex maximus* (high priest) of Rome, and all succeeding emperors until Gratian (367–383 C.E.) continue to hold this priesthood.

64 C.E. The emperor Nero persecutes the Christians in an attempt to divert blame from himself for a fire which had burned two-thirds of the city of Rome.

66 C.E. In Judaea, a revolt rages against Rome,
–72 C.E. led by the Zealots, a Jewish nationalist party, and when Jerusalem is captured in 70, the Jewish Temple is burned, possibly by accident.

132 C.E. The Jewish nationalist leader, Simon Bar-Kochba, leads a revolt in Judaea, and once it is suppressed, Jews are banned from Jerusalem and its immediate vicinity.

312 C.E. Constantine wins control of the western Roman Empire by defeating his rival Maxentius in a battle at the Milvian Bridge outside the walls of Rome, and is converted to Christianity.

324 C.E. Constantine wins control of all the Roman Empire and founds a new capital, Constantinople, on the site of the Greek city of Byzantium.

341 C.E. The emperor Constantius II bans pagan sacrifices, a repetition of a ban issued by his father Constantine I.

391 C.E. Visiting temples or paying them reverence is prohibited, and sacrifices are banned again.

OVERVIEW
of Religion

THE MEANING OF RELIGION. There is no word in the vocabulary of ancient Greek for the modern word "religion." Latin, the language of ancient Rome, does have a term for it, from which the English word "religion" is derived, but the Latin *religio* does not have quite the same meaning. For the Romans, "religio" meant "the fear of the gods" or "reverence for the divine," and its secondary meaning was "scruples of conscience." These facts are important to remember in the study of ancient Greek and Roman religion. Greco-Roman religion did not demand acceptance of a creed or theological dogma. What the gods expected of their worshippers was homage, awe, and even fear. Religion, in the broadest sense of the term, was a factor in the cultures of ancient Greece and Rome as far back as one can delve into their prehistory, and its aim, as much as can be discerned, was always to control the great crises of human life: birth, death, and the circumstances that influenced them such as war, pestilence, and famine.

PRIMITIVE RELIGION. It is difficult, if not impossible, to comprehend the mind of primitive human beings, who were dependent on hunting, fishing, and gathering wild fruits and seeds. It is apparent, however, that they were aware that their own well-being was intimately connected with the abundance of the wild beasts that supplied them with meat, and they attempted to control the hunt through religion. One of the earliest deities modern scholars recognize in the Greek world was a goddess called the "Mistress of the Wild Animals," the *Potnia Theron*, who is depicted as a woman, fully clothed, and flanked on either side by wild beasts which she seems to be protecting. In classical Greece, the *Potnia Theron* was Artemis, a virgin goddess who presided over the hunt as well as well as pregnancy and childbirth. Her earliest precursor was a prehistoric goddess belonging to the Old Stone Age, stretching back into the last Ice Age when a glacier stretched down over northern Europe, and humans lived by hunting and gathering. Once men and women began to domesticate animals and cultivate the

wild grasses which were the ancestors of our barley and wheat, they became even more aware of an environment that was beyond human control. Life began to revolve around an agricultural cycle, with sowing and harvesting seasons, a rutting season when rams bred ewes, and another season when the young lambs were born. Abundant crops depended upon rainfall at the right season of the year and so these humans began to concern themselves with rudimentary theological questions to control these factors. What deities controlled the rain, or presided over the grape harvest? Could their favor be won? How could they be made to notice an ordinary mortal who sought their help? Giving the gods worship that pleased them demanded knowledge of ritual. The Greeks were not as great sticklers for correct ritual formulas as the Romans, who believed that if a mistake was made in the ritual of a sacrifice, the sacrifice had to be begun again. Still, for the Greeks, too, a correct approach to the gods was necessary if their favor was to be won.

THE PRIESTS. Neither in Greece nor Rome was there any special class of priests. This is in marked contrast to Egypt and the Near East. Priests in Egypt were professionals who shaved their heads and wore white linen, and ancient Israel had a priestly tribe known as the Levites. The priests in Greece and Rome, however, were ordinary citizens. A Roman who officiated as a priest at an altar wore his toga, a gown made of a single piece of cloth which was considered the everyday dress of a Roman citizen in peacetime. The only difference was that the Roman priest pulled up the cowl of his toga so that his head was covered as he sacrificed, whereas the Greeks, in contrast, sacrificed bareheaded. There might be priesthoods that were hereditary within certain families. In Athens, for instance, the priestess of Athena *Polias* (Athena who protects the city) had to belong to the House of the Eteoboutadai, and in the sacred mysteries celebrated at Eleusis, now a suburb of modern Athens, the families of the Eumolpidai and the Kerykes had an hereditary right to certain priesthoods. Most priests in Athens, however, were appointed annually and sometimes they were even chosen by lot. Customs differed from city to city; in some places, priesthoods were sold to the highest bidder. But nowhere was there a priestly class set apart from the ordinary citizens.

THE HOLY DAYS. No day was set aside each week for worship, as Shabbat is for Jews, Friday for Moslems, and Sunday for Christians. Congregations never gathered for services inside Greek or Roman temples. Instead, worshippers celebrated religious festivals: the feast days of the gods. In Athens the principal festivals numbered 32—some celebrated every month, others only

annually—but if the monthly and the annual festivals are combined, they total 120 festival days every year. No other Greek state, to the knowledge of modern-day scholars, had as many, but everywhere, festivals were important. There would be sacrifices at festivals, and sometimes athletic competitions; in two of the festivals in Athens there were dramatic performances of tragedies and comedies. Festivals were also a time for feasting, for the sacrificial animals were eaten by the worshippers. Only the inedible parts were burned on the altars as offerings to the gods.

THE LIMITS OF TOLERANCE. To modern eyes, Greco-Roman religion seems disorganized. Yet the disorganization had one virtue. Since there were so many gods and goddesses, and no fixed theology, the Greeks and Romans lacked any concept of orthodoxy. It follows that there could be no heresy, for if the Greeks and Romans had no idea of what correct belief was, how could a worshiper deviate from it? Yet religion was embedded in society and the Greeks and Romans would not have understood the modern concept of division between church and state. They had no dogma, but they believed in maintaining the traditional beliefs, taboos, and rituals that their ancestors had accepted. Impiety was a crime, and if men who committed impious deeds such as robbing temples or slaying suppliants who sought refuge at the altars of the gods were not punished by their fellow men, then the gods would see to it that they paid a penalty. Out-and-out atheism was not acceptable. If anyone denied the existence of the gods, that person could endanger the whole society, for the gods would be angered by the atheist's blasphemy and seek vengeance, which could take the form of an earthquake or plague. The atheist's neighbors would also suffer, innocent though they might be. Thus it was unsafe to tolerate atheism. The world of the Greeks and Romans was tolerant if compared to medieval or early modern Europe, but their tolerance was not based on principle and there were limits to it.

THE LONGEVITY OF GRECO-ROMAN PAGANISM. The history of Greek and Roman paganism spanned a period of more than two thousand years, from its beginnings in the prehistoric period to the fourth century C.E. when the Greco-Roman world abandoned it. For the Minoan period on Crete, and the Mycenaean Age on the mainland, scholars are dependent on mythology and the evidence of archaeology, but it is clear that these Bronze Age civilizations were the matrix of Greek religion. In the "Dark Ages" that followed them, central authority collapsed, and taking its place were several hundred little independent or semi-independent communities—*poleis* or "city-states," as they are referred to—each with its own religious traditions. It was in them that the religion of classical Greece developed. Memories of the Mycenaean age shaped Greek mythology, which told stories of gods mingling with men, even appearing on earth to fight beside mortal warriors, and the bards who performed at festivals or in the banquet halls of great aristocrats articulated religious concepts as they retold the traditional myths. They could not help doing so, for the gods were embedded in Greek mythology. The Greek poets, particularly Homer who was popular all over Greece, shaped popular belief in a family of gods who controlled the forces with which mortals had to contend. Their headquarters was on Mt. Olympus where they had a good view of the world beneath.

THE DOMINANCE OF THE OLYMPIANS. The Olympians maintained their grip on Greek hearts and minds throughout the sixth and fifth centuries B.C.E. Some intellectuals grew skeptical as time wore on, however. In Athens, Socrates pointed out that the Olympian gods could hardly be seen as role models. Anyone who looked for a connection between ethics and religion turned aside from the Olympians with disgust. Yet the majority of Greeks in the classical period lived in rural villages and the speculations of philosophers did not reach them. Temples continued to be built and religious festivals drew crowds as great as ever. The classical period of Greek history came to an end with Alexander the Great's conquests, and in the Hellenistic age that followed religious attitudes changed.

RELIGION IN THE HELLENISTIC AGE. One reason for the change was that Greeks emigrated in great numbers to the new kingdoms which Alexander the Great's generals carved out for themselves from Alexander's conquests, and they came in contact with foreign gods and religious cults that were even more ancient than their own. For another, the Hellenistic kings declared themselves divine and expected worship—and there was some logic to their self-proclaimed divinity, since gods were venerated for their power to do their worshippers good or evil, and certainly kings had that power. Then, too, the Hellenistic period was the great age of the philosophic schools, and there was no clear division between religion and philosophy. One philosopher, Epicurus, taught that the gods were made up of atoms and void, and cared nothing for mankind. Last but not least, there was the coming of Rome.

THE ROMAN ENCOUNTER WITH GREEK RELIGION. The Roman Empire began with a small, Latin-

speaking city on the Tiber River in Italy, and the first tutors of the Romans in religious matters were Rome's powerful neighbors, the Etruscans. The Etruscans brought to Rome the great divine triad of Jupiter, Juno, and Minerva whose temple on the Capitoline Hill became the focal point of Roman religion. Then the Romans encountered Greek beliefs and fell under their influence. Jupiter was identified with Zeus, Juno with Hera, and Minerva with Athena. More foreign contacts followed: as Rome's empire expanded, the Romans encountered a multitude of foreign gods from the east, whose cults immigrated to Italy. Rome's conquests brought a flood of slaves into Italy, and their gods came with them.

THE ROMAN REACTION. There was a reaction to this dilution of Roman theology. Augustus, the first Roman emperor, attempted to emphasize Italian religious traditions. He made himself master of the Roman world by defeating Mark Antony and Cleopatra, queen of Egypt, and his propagandists presented this war as a struggle against effete orientalism. He took over the office of high priest of Rome, as did his successors, and on his death, he was proclaimed a god. Yet for the most part, Rome remained tolerant of other religions. Judaism was accepted, and even accorded special rights, though the Roman could not understand Jewish monotheism. Christianity, however, the Romans could not accept. They considered it atheist and anti-Roman, and they outlawed it. The persecution of Christians were sporadic and served only to create a Christian tradition of martyrdom. Rather than hindering conversion to Christianity, the persecutions aided in the dissemination of the faith.

THE END OF PAGANISM. It is customary to speak of the failure of paganism as if the gods lost their grip on the hearts and minds of the people, but paganism did not die a natural death. Christianity had the advantage of a well-organized clergy and a highly-developed theology which usurped the place which philosophy once held in the pagan world. After the conversion of Constantine, the first Christian emperor, in 312 C.E. the church not only became wealthy, but the state took over the task of crushing paganism. The state suppressed pagan sacrifices, which was a severe blow, for sacrifices were central to pagan festivals. By the end of the fourth century C.E. paganism was facing defeat, but it still persisted for more than a hundred years; an appropriate end-date to Greco-Roman paganism would probably be the year 529 C.E. when the emperor Justinian closed the Neoplatonic Academy in Athens which was paganism's last intellectual stronghold.

THE RELIGION OF MINOAN CRETE DURING THE BRONZE AGE

EARLY EVIDENCE. The earliest Greek agriculturists are found in the north; at Nea Nikomedeia, north-west of Thessaloniki, there was a settlement of farmers as early as 6500 B.C.E. But it is further south, on Crete and on the Cyclades, the archipelago in the Aegean Sea grouped around the island of Delos, that one can find the first signs of civilization—a society complete with political structure, distinctive art forms, and religious rites. Islanders in the Cyclades were forging daggers and spearheads of copper by 2750 B.C.E. The white island marble provided the raw material for a distinctive Cycladic sculpture that was geometric with flat planes, almost two-dimensional. One favorite subject was a harpist sitting on a chair and playing his instrument, perhaps for the dead in the afterlife. The most common subject is a nude woman with her arms folded over her stomach. She is probably a deity, very likely a goddess whose concern was pregnancy and childbirth.

THE PREPALATIAL PERIOD ON CRETE. Crete follows a different pattern, even though there was interaction with the Cyclades islands. Bronze, an alloy of copper and tin, appears in Crete about 2700 B.C.E. probably introduced by immigrants from Asia Minor, where tin was mined. The immigrants were not numerous and quickly intermarried with the native Cretans. By 2500 B.C.E. monumental tombs appear, first in the fertile Mesarà plain in the southern part of central Crete where five of them have been found, circular in shape with entrances facing east. How they were roofed is uncertain for none have been found intact, but it is clear that they were burial places for entire clans over several generations. Paved dancing floors laid out next to the tombs indicate that these were places where the community gathered for religious rites; dancing in burial grounds renewed the will to live, and affirmed family solidarity in the face of death.

SACRED CAVES IN THE PREPALATIAL PERIOD There is another clue to contemporary religious belief: sacred caves which were places of worship. On the hill above Amnisos on the north coast of Crete is a cave sacred to Eileithyia, the goddess of childbirth, which received worshippers as early as the New Stone Age, and continued in use until the Roman period. The earliest dedications that the pilgrims left behind were idols with

CHRONOLOGY
of the Bronze Age

Our knowledge of the religion of the prehistoric Bronze Age in Greece is dependent on archaeological excavations which have taken place within the last century and a half. The pioneer was Heinrich Schliemann, an amateur archaeologist from Germany who, in 1870, discovered the site of Troy that was made famous by the legend of the Trojan War. Four years later, he revealed the rich remains of an ancient kingdom at Mycenae. The Bronze Age civilization on mainland Greece that is now known from investigations at many archeological sites is called "Mycenaean" after Schliemann's discovery at Mycenae. Archaeologists now prefer the label "Helladic," since it is evident that Mycenaean culture was widespread in "Hellas," that is, Greece.

In 1899, the British archaeologist Sir Arthur Evans began excavating at Knossos on the island of Crete and found the foundations of a great sprawling structure which he believed was the legendary Palace of Minos where a king of Crete named Minos kept the Minotaur, a monster that was half-man, half-bull. Evans labeled this civilization "Minoan" after Minos, and he worked out a chronology for its development. He divided it into three phases: Early, Middle and Late Minoan, each of which is subdivided into three sub-phases denoted by Roman numerals. These divisions suit the site of Knossos well enough, but they are an awkward fit for the other palaces that have since been found on the island, and an easier sequence of periods has been worked out by the Greek archaeologist Nicholas Platon. It begins with the Pre-Palatial period before any palaces were built, corresponding to Early Minoan and Middle Minoan I (3500–1900 B.C.E.), then the Proto-Palatial period (Middle Minoan IB–Middle Minoan II—1900–1700 B.C.E.), then the Neo-Palatial Period (Middle Minoan III–Late Minoan I—1700–1450 B.C.E.), and finally Postpalatial.

All dates in prehistory that are based on archeological finds are approximate and some will no doubt be revised in the future. Platon's chronological system, however, gives a better development sequence than the old labels of Early, Middle, and Late Minoan.

large hips and plump buttocks, handmade pottery, and stone or bone tools. Eileithyia is a goddess known in the classical period, when she is closely associated with the Olympian goddess Artemis, and the fact that her cult persisted here is a remarkable example of continuity. Two other cave sanctuaries on Crete were important enough to survive as cult sites long after the Minoan civilization came to an end. One, in the mountains south of Malia, was—according to one tradition—the cave of Dicte where Zeus was born. His father, the Titan Cronus, learned from an oracle that his son would overthrow the rule of the Titans, and so he swallowed the infants which his wife, Rhea, bore, until at last she managed to give birth to Zeus deep in the cave of Dicte. A roughly-built altar, set against the cave wall, was found in the upper part of the cave, and it was within a sacred precinct which is marked off by a barrier. The Minoan worshipers who climbed up to this cave left offerings behind to win divine favor, for bronze weapons were found embedded in the stalactites of the cave, and other votives were discovered in a pool which is at the lowest point of the cave. The other cave is situated on Mt. Ida, and it is also connected with the infant Zeus, who was supposedly brought there and suckled by the nymph Amalthea who took the form of a goat. Around his cradle danced young warriors called *Kouretes*, leaping high into the air and beating their shields to drive away the evil spirits who might betray the child-god's presence. The cave was used from the end of the New Stone Age, but it seems to have reached the height of its importance as a cult center in the Early Palace period. The latest offerings were terracotta lamps left there in Roman times. Roman visitors—tourists, perhaps, motivated by a mixture of curiosity and piety—were still climbing up to this cave after Crete had become a province of the Roman Empire.

THE AWAKENING OF CIVILIZATION. Quite suddenly, about 1900 B.C.E., palaces were built at a number of sites on the island. The first to be discovered was at Knossos about three and a half miles south of Heraklion, the capital of present-day Crete, where the British archaeologist Sir Arthur Evans began to excavate in 1899. Within three years he had uncovered a great sprawling building with a maze of rooms which he called the "Palace of Minos" after the legendary King Minos who lived at Knossos, according to Greek myth. He labeled the civilization that he had found "Minoan." Since then, similar "palaces" have been unearthed at six other sites on Crete: Phaistos directly south of Knossos, Malia along the northern coast, Gournia overlooking the Bay of Pseira, Galatas near Khania to the west of the island, and to the east, Petras and Kato Zakros. All were built around central courts roughly twice as long as they are

wide. At other sites archaeologists have found the remains of great mansions, but they lack the central courts which seem to be the characteristic mark of a palace. Palaces imply kings, perhaps priest-kings, and the legend of King Minos shows that the Greek storytellers of a later age believed that a king once ruled at Knossos, where there was the largest palace on Crete and the only one that continued to be inhabited after the others were deserted. Except in the last phase of the Knossos palace's existence, however, there is no archaeological evidence that kings inhabited these palaces. They seem to have had two main functions. One was the storage of foodstuffs, the other was religious ritual.

PEAK SANCTUARIES. The sudden appearance of these palaces on Crete postdates—though only by a brief period—a new religious development. At the very end of the Prepalatial period, "peak sanctuaries" appear, built on mountain tops. One example that can be easily visited is on Mount Juktas above the modern town of Arkhanes, where remains of a sprawling Minoan mansion—though without a central court—have been found. Just below the summit of Mount Juktas, a stepped altar was built across a natural cleft in the rock. There were two construction phases, the first dating to the Old Palace period, and the second to the New Palace period. The offerings and the remains of sacrifices found there show that worshipers frequented this shrine from before the palaces were built until after 1100 B.C.E. The only physical evidence that shows what peak sanctuaries looked like is a *rhyton*, that is a vessel for pouring ritual libations, decorated with a low relief of a peak sanctuary. The facade was divided into three sections. There was a great central gateway adorned with multiple spirals, and on either side, smaller wings, their eaves embellished with "horns of consecration"—stylized bulls' horns with some religious significance. The temple is shown built over a cleft in the rock, and—if allowances are made for the artist's ignorance of perspective—it rises above two altars decorated with more "horns of consecration." On the roof of the temple rest some *agrimi*, the Cretan wild goats which still survive on the island in limited numbers. They may be sacrificial victims, quietly awaiting their fate. The temple is situated on a rocky mountain top which the artist has indicated by a schematic sketch.

THE ORIENTAL CONNECTION. Peak sanctuaries have a connection to the Near East. The Canaanite gods, like the gods of Mt. Olympus worshiped by the classical Greeks, lived on mountain peaks. Texts found at the Canaanite site of Ugarit, modern Ras Shamra near the Mediterranean coast of Syria, tell of the storm god Baal

going up the "Northern Mountain" to attend the assembly of the gods. Canaanite hilltop altars were the "high places" mentioned in the Old Testament, where the Canaanites propitiated Baal, who sent the rain and ruled the thunder and lightning. This is not to say that the Minoans worshiped Canaanite gods, but the evidence for Canaanite influence is strong. For instance, a statuette of a woman, probably a priestess, handling snakes was found at Knossos, a reminder of the Canaanite goddess Asherah, the Lady of the Serpent and Mother of the gods and all creatures. Though mountaintop gods were worshiped in Canaan, no peak sanctuary like those found on Crete has been found in the Levant except at one site in northern Israel where a hilltop shrine with a stepped altar has been discovered. It dates to the nineteenth century B.C.E. that is, the early Old Palace period on Crete. Later research may turn up more evidence for parallels between Canaan and Crete but for the time being caution must be taken: the Minoans were not Canaanites.

THE ROLE OF THE PALACES. Evidence for the religious rites that went on in the palaces is almost entirely dependent on archaeology. At Knossos, clay tablets with writing in "Linear B" have been unearthed, dating perhaps as early as 1450 B.C.E. though many scholars date them later. "Linear B" was deciphered by Michael Ventris in 1952 and shown to be an early form of Greek. "Linear B" has been found at a number of Bronze Age sites in mainland Greece, but on Crete, it has been found only at Knossos. It was preceded on Crete by an earlier linear script that is labeled "Linear A," and it has been found not only at Knossos but at other places on the island as well; a particularly large cache was discovered at the site known as *Hagia Triada* (Holy Trinity), so-called from a church nearby, for its ancient name is unknown. "Linear A" has not been deciphered, nor has the hieroglyphic script that was used on Crete before "Linear A" became common. Therefore, the clues these documents might provide as to what early Minoan religion was like are inaccessible. The study of pre-Greek words that have survived as place names or the names of gods, however, has provided a few tantalizing clues. For instance, a goddess with the pre-Greek name of Britomartis survived into the classical period; she is probably the same goddess as Aphaia, who had a temple on the island of Aigina, a short boat ride south from Piraeus, the port of Athens. Britomartis seems to have been a Minoan word meaning "sweet virgin."

THE DOUBLE-AX. The archaeological evidence— wall-paintings, statuettes, votive offerings—raises as many questions as it answers. Double-axes have a religious

significance of some sort, for scholars find them in connection with shrines that they seem to mark as holy places. They come in various sizes, made of bronze, bone, or ivory. Some are highly ornate. They seem to be symbols of power, but they are never associated with a male figure. It is always a woman—probably a goddess—who wields the ax, swinging it above her head with two raised arms. The axes can have had no practical purpose, for their blades are too thin and fragile to chop wood or even slit the throat of a sacrificial animal. In Asia Minor double-axes are found symbolizing thunder-bolts, but they are associated with a male god, and it would be hard to show a connection between them and the Minoan double-ax. Yet the double-ax has left behind one tantalizing folk-memory: there is a rarely-used word in classical Greek, *labrys* meaning a "battle-ax" or a "double-ax," which seems to be connected with the word *labyrinthos*, a building with a maze of corridors from which it was almost impossible to extricate oneself. The myth of King Minos of Crete told that he built a *labyrinthos* to house a monster called the Minotaur, which was half-man, half-bull. Greek words ending in *–inthos* betray a non-Greek origin, and it is tempting to believe that the "labyrinth" of the Minos–myth was the sprawling palace at Knossos with its multitude of rooms and winding hallways, and that *labyrinthos* means something like the "House of the Double-Ax."

THE LONG-HORNED BULLS. The word "Minotaur" means simply the "bull of Minos," and whatever the monster may have been, it is clear that long-horned bulls had a special place in Minoan religious rites. Terracotta figurines of bulls were left as votive offerings in holy places. *Rhytons*, which are vessels for pouring libations, were frequently made in the shape of bulls' heads. Stylized bull horns, called "horns of consecration" are found in sacred contexts and have some unexplained religious significance. One fresco from Knossos depicts a bull charging with a flying gallop, both front and rear legs extended to show that the beast is traveling at speed, and toreadors, both male and female, are shown vaulting over his back. This kind of bull-fight, if that is what it was, is too risky to be mere sport. The toreadors are pitting their skill and athleticism against the power and speed of the bull, and those that lost the contest—as some must have done—would perish, impaled on the bull's horns, sacrificing their lives for the good of the community. The toreadors represented the strength and courage of the youthful hero who faces death unflinching, for he knows that the passing years will soon slow his reflexes, and someday he will fail to leap clear of the bull's deadly charge.

SHRINES. Two miniature frescos which depict religious ceremonies were found in fragments just west of the north entrance hallway of the Knossos palace, where they had probably fallen from an upper floor. One shows a scene set in the countryside, where a fence surrounds a precinct with a sacred tree and a small building, possibly a shrine. It is probably a holy space consecrated to a matriarchal goddess, for Minoan gold rings often have engravings of a goddess seated under a tree or in front of a shrine, receiving worshippers. The second fresco shows a scene in the central court of the palace. Against one wall there is the familiar Minoan shrine with tripartite facade, and double axes attached to it. A crowd has gathered there to watch a ceremony that included dancing. From this it is possible to infer that the central courts of the palaces were places where crowds gathered for religious ceremonies.

WHAT THE MYTHS TELL US. Greek mythology connected Minoan Crete with the cycle of myths which centered around the Athenian hero, Theseus, a prince of Athens. Each year the king of Crete, Minos, required Athens to send him twelve adolescent boys and twelve young girls to be fed to the Minotaur who lived in the labyrinth at Knossos. Theseus volunteered as one of the youths destined for this sacrifice, but once he reached Knossos, he won the heart of Minos' daughter, Ariadne, who provided him with a sword to defend himself, and a spool of woolen thread to mark his path when he entered the labyrinth so that he could retrace his footsteps. Theseus slew the Minotaur, escaped from the labyrinth and fled Crete, taking with him Ariadne, whom he soon abandoned. The youths destined as food for the Minotaur sounds like an indistinct memory of a cannibalistic rite, and students of Greek religion often wonder if there is any evidence of cannibalism or human sacrifice on Crete. Sir Arthur Evans did, in fact, discover a cache of children's bones in the palace of Minos at Knossos that showed what looked like knife marks, which might be evidence of cannibalism, and at a Minoan shrine discovered in 1979 at Anemóspilia near Phourni, an altar was found in one of the rooms with the bones of a young man still on it. Two other skeletons were found nearby. The shrine was destroyed by the great earthquake which brought the Old Palace Period on Crete to an end, and the excavators concluded that the youth on the altar had been sacrificed just before the earthquake, perhaps in an effort to avert it.

THE MINOTAUR. The figure of the Minotaur also has possible connections to Minoan religion. He sounds like a therioanthropic god, that is, a god that is half-man, half-beast, and therioanthropic figures do appear on Mi-

noan seals used to make impressions on clay. Another possibility is that the Minotaur was really the priest-king of Knossos, who wore a bull's head mask as part of the sacrificial ritual. Masks made from real bull skulls have been unearthed in sanctuaries on Cyprus, and terracotta figurines wearing such masks have also been found. It seems likely that the myth of Theseus and the Minotaur reflects a dim recollection of human sacrifice to a god that was half-man, half-bull, since there is sound evidence that human sacrifices did take place. The evidence for cannibalism, on the other hand, is shaky.

THE EVIDENCE FOR GREEK GODS. In the last phase of habitation in the palace at Knossos—but not elsewhere—clay tablets with "Linear B" writing were found, which indicates that there, at least, Greek-speaking invaders took over. "Linear B" has yielded the names of all the Olympian gods which are most familiar in classical Greek literature, except for Aphrodite, the goddess of love-making. One "Linear B" tablet from Knossos assigns an offering of honey to the Cave of Eilytheia at Amnisos, showing that the Greek-speaking immigrants adopted this ancient shrine. Another "Linear B" tablet from Knossos mentions the *Potnia*, that is, the Mistress, of the Labyrinth. But what does the tablet mean by the word "labyrinth"? Can it mean the same as the English word "labyrinth"? Or does it mean something like the "Holy House of the Double-Ax"?

THE SINGULARITY OF CRETAN RELIGION. Long after the Greek-speakers had taken over Crete, Cretan religion retained some unique features that marked it as different from the rest of Greece. The god Zeus, the king of the Olympian gods, was immortal in the rest of Greece. But the Cretans believed not only that their Zeus was born in the Cave of Dicte, but also that he died and was reborn. The Cretan Zeus seems to have been the result of a merger of the Olympian Zeus of the Greeks with an earlier vegetation god, who died and was reborn with the changes of the seasons. The importance of bulls in Minoan religious life may also be reflected in the fact that the Zeus of the Greeks was also associated with the bull, as was his brother, Poseidon, the god of the sea. On Crete, the religion of the Olympian gods overlaid an earlier religion, which seems to have had Asian and perhaps also some Egyptian connections.

SOURCES

Robert Drews, *The Coming of the Greeks; Indo-European Conquests in the Aegean and the Near East* (Princeton, N.J.: Princeton University Press, 1988).

Reynold Alleyne Higgins, *The Archaeology of Minoan Crete* (London, England: Bodley Head, 1973).

Nanno Marinatos, *Minoan Sacrificial Ritual: Cult Practices and Symbolism* (Stockholm, Sweden: Göteborg, 1986).

Nicolas Platon, *Crete* (London, England: Frederick Muller Ltd., 1966).

THE EARLY GREEKS ON MAINLAND GREECE

THE DISCOVERY OF THE MYCENAEANS. On the mainland, our study of religion has more guideposts than in Minoan Crete, for classical Greece inherited a wealth of mythology which told of a Greek Bronze Age society where Mycenae was the dominant kingdom, and the other kings owed a sort of allegiance to the high king of Mycenae. This was Greece's age of heroes, which continued to haunt the imaginations of the Greeks and inspire their poets. There is another reason, too, why the label "Mycenaean" is attached to this prehistoric civilization. Mycenae was the site that revealed it to the modern world in 1874, when the pioneer German archaeologist, Heinrich Schliemann, fresh from his discovery of ancient Troy four years earlier, started excavating inside the main gate of the Mycenaean citadel, and uncovered a circle of graves with rich burials. Archaeologists have discovered many more Bronze Age sites in Greece since then, but the term "Mycenaean" is still applied to the whole civilization.

THE MYCENAEAN GOLDEN AGE. The great age of Mycenaean civilization was between 1400 B.C.E. and 1200 B.C.E., after the Minoan civilization had fallen victim to some sort of disaster, and only the palace at Knossos continued to be inhabited. These last inhabitants of the Knossos palace wrote in the same "Linear B" script that the Mycenaeans used, which was deciphered in 1952 and shown to be an early form of Greek. Hence there is good reason to think that Greek-speaking Mycenaeans took over the Knossos palace in its final years. There is good archaeological evidence to show that the Mycenaean Greeks ranged far and wide. They carried on trade with Sicily, Italy, and even Sardinia in the west, and with the Levant in the east, until they fell victim to a general upheaval in the eastern Mediterranean that took place about 1200 B.C.E. and left evidence of folk migration and violent destruction throughout the region.

THE MYCENAEAN TEMPLE. It was once thought that the Mycenaeans built no temples and religious life was centered in their palaces, which Mycenaean barons built in imitation of the palaces on Crete. This was not the case, however. A temple has been recently discovered at Mycenae that is connected to the palace on the

acropolis by a processional way leading down to a building that was clearly used for religious rites. In front of the entrance was an altar and a table for offerings—limestone blocks with dowel-holes for table-legs are all that survive, but the interpretation is likely. Near it was a circular enclosure filled with ash. This forecourt gives on to two rooms, one of which, the front room, has a great horseshoe-shaped altar made of clay, and beside it was a stone block, possibly intended for slaughtering sacrificial victims. A stairway from the forecourt leads down to a second courtyard where there is a round altar with the remains of many sacrifices, and next to it is a subterranean building that has been called the "House of Idols." The idols, up to sixty centimeters—almost two feet—tall, are both male and female, and some have painted mask-like features that grimace horribly. They are hollowed underneath so that poles could be fitted to them for carrying in procession. Close to the "House of Idols" was another house, so-called the "House of the Frescoes" from the fresco in the main room showing two goddesses—or perhaps a god and a goddess—on either side of a column, and a woman, either a priestess or a goddess, holding ears of grain. This complex was clearly a place of worship, but it is unlike any classical Greek temple.

THE EVIDENCE OF THE "LINEAR B" TABLETS. The "Linear B" tablets found at Mycenaean sites reveal that all the Olympian gods that the later Greeks worshipped were known in the Mycenaean world, except for Aphrodite who seems not yet to have reached Greece. At Pylos, where the largest cache of "Linear B" tablets was found, Poseidon, the god of the sea, seems to have been more important than Zeus. In addition there is a goddess whose name is the feminine form of "Poseidon"—a "Mrs. Poseidon." Similarly for Zeus: there is a goddess named *Diwija* who is "Mrs. Zeus," and these goddesses had their own places of worship. Men played a greater role in religious rites than they did in Minoan Crete, where priestesses dominated. But at Pylos, a *ijereu* is mentioned frequently; in classical Greek the word is *hiereus* and it designates a man who holds an official position as a priest.

THE END OF THE MYCENAEAN KINGS. Raiders destroyed Pylos about 1200 B.C.E. and the other Mycenaean palaces did not last much longer. The kings who ruled in these palaces disappeared with them. The word for "king" was *wanax*. In classical Greek, which loses the *w*-sound, the word becomes *anax* and it is used to address a god, not a mortal king whose title was *basileus*. That fact may suggest that there were god-kings in the Mycenaean world, but there is no good evidence to support that theory. The Mycenaean *wanax* prayed to the gods in a spirit of give-and-take: he made offerings to the gods and expected the gods to be grateful and show their gratitude by keeping the kingdom from harm. He was an intermediary between the gods and mortal men, and in that sense, he was semi-divine. In the end, this religious system failed to protect this culture. The little Mycenaean realms fell victim to raiders who came, plundered and burned, and then left—there is no evidence for new immigration immediately on the heels of raiders—and the shock to the religious mentality of the age must have been as great as the trauma that the political structure suffered.

SOURCES

Bernard C. Dietrich, *The Origins of Greek Religion* (Berlin; New York: de Gruyter, 1974).

S. Marinatos, *Crete and Mycenae* (London, England: Thames and Hudson, 1960).

William A. McDonald and Carol G. Thomas, *Progress into the Past: The Rediscovery of Mycenaean Civilization.* 2nd ed. (Bloomington, Ind.: Indiana University Press, 1990).

Nancy K. Sandars, *The Sea-Peoples* (London, England: Thames and Hudson, 1978).

THE DARK AGES

THE BEGINNINGS OF THE POLIS. In the Dark Ages that followed the end of the Mycenaean world, Greece sank back into illiteracy. "Linear B" writing had been only a tool for keeping records in the little bureaucracies in the Mycenaean palaces, and once the palaces were destroyed, and records were no longer kept, "Linear B" died out. Central authority collapsed, and once stability reappeared in the Greek world, some 700 little independent states called *poleis* (translated rather inadequately as "city-states") are found—each a little urban center with a market, surrounded by its territory where the citizens had their farms and pastures. The urban center was the seat of government and the market was intended both for commerce and as a gathering-place for the citizens to discuss matters of common concern. Since life in the "Dark Ages" was insecure, the preferred site for an urban center was around an acropolis—the word means simply "high city," or "city on a mount"—which was a defensible hill, able to provide a place of refuge. Of the hundreds of *poleis*, modern scholars are familiar with only a few of the largest, such as Athens, Sparta, Corinth, and Thebes, and these were not the most typical. They revered the same pantheon of gods; yet each

a PRIMARY SOURCE document

THE FESTIVAL OF APOLLO AND ARTEMIS

INTRODUCTION: The "Homeric Hymns" were composed by the *Homeridai*, a guild of *rhapsodes* (bards who recited poetry in the epic tradition, sometimes composed by themselves) who performed at religious festivals. The festival of Apollo and Artemis at Delos was celebrated by the Ionians; there were twelve cities founded by Ionian Greeks on the coastline of Asia Minor and the Dodecanese islands, including such famous places as Miletus, Ephesus, Chios, and Samos. The following excerpt comes from a Homeric Hymn that celebrates the festival at Delos. The bard gives us his "signature" at the end of the hymn: he is a blind man living in Chios, which led some Greeks to speculate that the bard was Homer himself, who, according to legend, was blind.

Phoebus [Apollo], you get your greatest pleasure from Delos, where the Ionians in their long robes gather with their children and their esteemed wives; and they commemorate you and delight you with their boxing, dancing and song whenever they hold their competitions. Anyone who chances on a gathering of the Ionians would say they were a deathless people who do not grow old; for he would see how graceful they all are, and he would rejoice in his heart as he watched the men and the well-girdled women and their fast ships and their many pos-

sessions. Besides, there is a great marvel here whose glory will never perish: the Delian maidens, the servants of the Far-shooter. For they sing praises to Apollo first, and then Leto and Artemis the shooter of arrows, and then they recall the men and women of old, and sing songs about them, enchanting the tribes of men. They know how to represent the voices of all men, and the beat of their music. One would say those men themselves were speaking, so realistic is their lovely song.

But come, Apollo and Artemis, give your blessing; and [maidens] farewell to all of you. Remember me in times to come, when a stranger from among the men who haunt the earth, who has seen and suffered much, comes and asks: "Who do you think, girls, is the sweetest of the singers who frequent you here? Who delights you most?" With one voice, all you who stand about me, give him answer: "The blind man who lives in rocky Chios; all his songs are the best and will be, too, in time to come." And I shall carry your fame with me as I go about the world, visiting the well-sited cities of humankind. And they will be persuaded, for it is the truth. For my part, I shall not cease hymning Apollo of the silver bow, the son of fair-tressed Leto.

SOURCE: Homer, "The Delian Festival," in *The Penguin Book of Greek Verse* (Harmondsworth, Middlesex, England: Penguin Books, 1971): 120–122. Translated by James Allan Evans.

had its own favorites, and sometimes even its own versions of the myths about their favorite gods. Moreover, within the *poleis*, there were great families; Corinth, for instance, was dominated by one extended family called the Bacchiadae, who elected one of their members king. Elsewhere there were various family alliances called *phratries*, each of which might have its own patron god. What gave the religion of the "Dark Ages" whatever unity it had was the common memory of the Mycenaean world and the mythology that arose from it.

THE IMPORTANCE OF ORAL TRADITION. The oral culture of the Greek world remained lively. Oral bards sang their poems at religious festivals or in the banqueting halls of the great aristocratic families, and they related stories of a time when gods walked the earth and fought beside their favored warriors on the battlefield. It was the poets who gave shape to the Greek ideas about their gods. They imagined deities in human form, though in the standard epithets that were applied to them there seems to be a folk memory of an early time when some of them were theriomorphic gods. Athena was called "owl-eyed" and her special bird was the owl,

which may recall an early, primitive belief that the owl incorporated her spirit. An owl gliding to its perch on silent wings, for example, was Athena manifesting herself. Hera was called "ox-eyed," perhaps for the same reason. The gods' association with animal totems aside, the poets made their gods in the likeness of man, and they thought of them as a divine version of an aristocratic clan, whose members had all the human failings. There was this important difference: the gods were immortal. They were safe from the fear of death, and thus they could afford to be more irresponsible than mere humans.

THE IMPORTANCE OF HOMER. Two poets in particular can be singled out for their role in shaping religious concepts. The first is Homer, whom legend said was a blind poet who composed the two epic poems, the *Iliad* and the *Odyssey*, as well as the *Homeric Hymns* which were sung at religious festivals. Whether a poet named Homer ever existed or not is much debated, but it is the least consequential of the many questions which this body of literature raises. What is important is that the Greeks at a later time looked back on these poems as the literature that gave shape to their concept of the

gods. Both the *Iliad* and the *Odyssey* take their subject matter from the most famous myth that Greece inherited from the Mycenaean world: the story of the siege of Troy. According to the myth, a Trojan prince, Paris, also known as Alexander, abducted Helen, the beautiful wife of the king of Sparta, Menelaus. A Greek coalition led by Menelaus' brother, Agamemnon, king of Mycenae, sailed to Troy in pursuit of Helen and captured the city after a ten-year siege. Archaeology shows that a city on the site of Troy did stand siege and was destroyed at about the date that the Greeks assigned to the Trojan War, and so the Trojan War-myth must have a kernel of truth to it. But the oral bards who performed in the halls of warrior aristocrats in the "Dark Ages" developed a Trojan myth that mingled the human realm with the divine. Homer, who may have been the poet who first put the *Iliad* and the *Odyssey* into writing, belonged to this bardic tradition. His tales of the gods helped form the Greek conception of them as immortal beings that are powerful but not omnipotent, and capable of doing mortals good or evil according to their whims of the moment. They answered a human's prayers if they were well disposed. They had their favorites, they carried grudges, and they loved to receive honors. When they appeared to humans in divine epiphanies, they were always tall, handsome, and sweet smelling. They were super-human, but they were also unreliable creatures and not to be trusted. They had both the vices and virtues of mortal men, but since they could not die, their lives were untouched by tragedy as were the lives of humans.

THE CONTRIBUTION OF HESIOD. The other poet who helped shape the Greek religious beliefs was Hesiod, author of the *Theogony* which is a creation myth, and the *Works and Days* which describes a farmer's life and sets it in a world where the relationship with the divine element was important. The fifth-century historian Herodotus—the first European author to write history that was more than a chronicle of facts—relates that it was Homer and Hesiod who described the gods for the Greeks and gave them all their appropriate titles, functions, and powers, and he suggested the poets lived sometime before 800 B.C.E. That date may not be far wrong, for some scholars think that by that time the Greeks had already learned to write again, having borrowed their alphabet from the Phoenicians. Once the texts of Homer and Hesiod were written down, they gave whatever standard form there was to Greek religion.

OTHER WRITERS. The gods of Homer were never canonical, and later writers were free to develop their own concepts that fitted the intellectual currents of the day. Greek story-tellers presented gods that were envi-

ous divine powers, and the tragic poets—the greatest of whom were Aeschylus, Sophocles and Euripides—took up the theme: the standard subject matter of tragedy was a human who became too great or too lucky, and aroused the jealousy of the gods who struck him down. Greek philosophers freely criticized the conduct of the Homeric gods and even began to point out in the fifth century B.C.E. that there was no way of demonstrating the actual existence of the gods or, if they did exist, what they looked like. Yet worship of the gods was deeply embedded in Greek society. It was sustained by ancient custom, and the Greeks revered the way of life that their ancestors had bequeathed to them.

SOURCES

V. R. d'A. Desborough, *The Greek Dark Ages* (London, England: Ernest Benn, 1972).

W. K. C. Guthrie, *In the Beginning: Some Greek Views on the Origin of Life and the Early State of Man* (London, England: Methuen, 1957).

A. M. Snodgrass, *The Dark Age of Greece* (Edinburgh: University of Edinburgh Press, 1971).

Carol G. Thomas, *Myth Becomes History: Pre-Classical Greece* (Claremont, Calif.: Regina Books, 1993).

H. S. Versnel, "What Did Ancient Man See When He Saw a God? Some Reflections on Greco-Roman Antiquity," in *Effigies Dei*. Ed. D. van der Plas (Leiden, Netherlands: Brill, 1987): 42–55.

THE GODS OF OLYMPUS

THE DIVINE BEINGS OF GREECE. If a modern observer could tour the cities and villages of ancient Greece, he would be astonished at the multitude of gods and goddesses that the Greeks worshipped. They would include some gods whom he recognized, such as Zeus, the king of the gods, or Athena, whose ruined temple in Athens, the Parthenon, has appeared in countless tourist brochures. But many of them would be unfamiliar. There were woodland nymphs, female spirits of nature who might kidnap mortals whom they fancied. There were river gods who could cause floods if they were angered. A god called Pan, half man and half goat, lived in the woods, and could instill irrational terror in men or beasts, which was called 'panic' after him. To make matters more confusing, sometimes the Greeks referred to "Pan" in the plural, as if he was free of the mortal constraints of singular and plural. If the observer went to the little island of Aegina which is a short distance south from Athens, he might see a well-preserved temple built in the early fifth century B.C.E. that was dedicated to a goddess named Aphaea. She is possibly the

a PRIMARY SOURCE *document*

A GUIDEBOOK TO GREECE IN THE SECOND CENTURY C.E.

INTRODUCTION: Pausanias traveled through south and central Greece in the second century C.E. and wrote an account of his travels. His work does not seem to have been widely read in his own time, but it did survive to give us a picture of Greece when it was a province of the Roman Empire. Depopulation was emptying the countryside and yet every square mile had holy springs, sacred precincts, shrines, temples—sometimes ruined—or tombs associated with the religion, mythology, and early history of Greece. This excerpt is from his description of Laconia (or Lacedaemon—both names were used), which was the territory of Sparta just as Attica was the territory of the city of Athens. Therapne, the place first mentioned in the excerpt, was where Menelaus and his wife Helen of Troy were supposedly buried.

The spring at Therapne called Messeis is something I myself have seen. Other Laconians have maintained the modern Polydeucia rather than the spring at Therapne is the ancient Messeis; the Polydeucia is on the right of the road to Therapne, both the spring itself and Polydeuces' sanctuary.

Not far from Therapne is what they call the *Phoibaion* with a shrine to the Dioscuri (Castor and Polydeuces) inside it; this is where the fully-grown boys sacrifice to the war-god. Not far away is a sanctuary of Poseidon called the "Earth-holder." If you go on beyond it towards Taygetos you come to a place called "Grinding-ground"; they say that Myles the son of Lelex who first invented the mill-stone ground with it in this grinding-ground. They have a shrine here to Taygetes' son, the divine hero Lacedaemon. From here if you cross the river Phellia and go to Amyclae straight towards the sea, you come to where the Laconian city of Pharis used to be, but if you turn off to the right from the river Phellia, your road will take you to Mount Taygetos. In the plain is the sacred enclosure of Messapean Zeus; they say it got this title from a man who was the god's priest. From here as you come away from Taygetos you come to a place where the city of Bryseai once stood. A temple of Dionysus still survives there with a statue in the open air; only women are allowed to see the statue inside the temple; and all the ceremonies of sacrifice are performed in secret by women.

SOURCE: Pausanias, *Guide to Greece*. Vol. 2. Trans. Peter Levi (Harmondsworth, England: Penguin Classics, 1971): 72–73.

Minoan goddess called Britomartis, surviving on Aegina with a changed name. Her temple was in the countryside, high on a hill in the center of the island, and there the islanders gathered for her festivals to pray, offer sacrifices, and enjoy the festivities of a "holy day."

THE DEMIGODS. To add to the modern observer's bewilderment, there were the demigods or "half-gods." They were the heroes, and they played a role similar to Christian saints. They were mortals, many—but not all—of whom belonged to the Age of Heroes. What made them demigods was that they won great renown in their lifetimes, and hence received worship after death, for their power did not perish along with their mortal bodies. No temples were built for them, but they did have shrines where worshipers could venerate them with prayers and sacrifice. They did not dwell with the Olympian gods; instead they subsisted with the ghosts of the dead in the Underworld. If they were heroes of mythology, they might be the sons of gods, or more rarely, of goddesses. Great families boasted of pedigrees which went back to a demigod who might have divine ancestry, and the sacrifices they offered their semi-divine ancestor reinforced family solidarity. Our visitor might even have found some heroes that were nameless: if they

ever had names, they were lost in the mists of time. One clan in Athens offered yearly sacrifice to a demigod known simply as the "hero beside the salt-pans."

THE GREAT MAN AS HERO. Some of these heroes were historical figures who lived within the time-frame of mortal men. They were men who had once wielded power and used it to perform memorable deeds. If a person founded a colony in Italy or the Ukraine, for example, the colony he founded would honor him after his death as a *Heros Ktistes*, that is, the "founder hero." He would often be buried in the marketplace, where a shrine would be built for him, and sacrifices offered. Great gods were no longer born in historical times, but new heroes could always be created; all that was needed was a resolution passed by a city, clan, or religious group to give a deceased person heroic honors.

THE LOGIC OF PAGAN WORSHIP. Although the gods and heroes of the Greeks, and their cults may seem like a chaotic hodgepodge to the modern observer, there was an underlying logic to Greek worship. Gods and heroes were powerful supernatural beings whom men feared and supplicated to win their favor and avert evils, such as shipwreck, earthquake, or the drought that parched the crops. Gods had sacred places which they

a PRIMARY SOURCE *document*

THE PESSIMISM OF THE OLYMPIAN RELIGION

INTRODUCTION: The gods did what they wanted to do, and humans were helpless before them. Fate likewise dogged the footsteps of every man as an inescapable force. The following excerpt is a deeply pessimistic expression of an enduring religious belief among the classical Greeks that humans were playthings of the gods. Even if man were lucky enough to avoid angering the gods, old age or disease was sure to finish him off. The passage quoted below was written by Simonides of Amorgos, a little-known poet who probably lived in the seventh century B.C.E.

My child, Zeus the deep-thundering holds the ends
 of all
actions in his own hands, disposes as he will
of everything. We who are human have no minds,
but live, from day to day, like beasts and nothing
 know
of what God plans to make happen to each of us.
But hope and self-persuasion keep us all alive
in our unprofitable desires. Some watch the day
for what it brings, and some the turn of years, and
 none
so downcast he will not believe that time to come
will make him virtuous, rich, all his heart's desire.
But other things begin to happen first; old age,
which no one wants, gets one before he makes his
 goal.
Painful diseases wear down some; others are killed
in battle, and death takes them under the dark
 earth.

SOURCE: Simonides of Amorgos, "The Vanity of Human Wishes," in *Greek Lyrics*. 2d ed. Trans. Richmond Lattimore (Chicago: University of Chicago Press, 1960): 11–12.

DIVINE POLITICS. The worshipper also had to remember that gods and goddesses had special interests—like cabinet ministers who preside over government departments—and it was important to address the correct department. The goddess Hera took an interest in women in childbirth, Hephaestus was a patron of blacksmiths, and Poseidon controlled the sea and the terrifying earthquakes. Prayers and sacrifices were most effective when they were directed to the right god, for however much a god might favor a suppliant, he would hesitate to trespass upon another god's department.

GREEK THEOLOGY. The Greeks had no equivalent of the Bible, the Torah, or the Koran to give coherence to their religion. So far as they had any formal theology at all, they owed it to their poets, particularly the epic poets Homer and Hesiod, who produced the earliest surviving Greek literature. Almost everything that has been written about Homer is subject to controversy, including his very existence, but there can be no doubt that the Homeric poems shaped Greek conceptions of their gods and goddesses. In his *Iliad*, Homer presents them as a large extended family dwelling on Mount Olympus, the highest mountain in Greece, from which they viewed the world below like spectators at a football game. They were immortal: they could not die and did not grow old; they had no need to worry about disease, famine, or the other ills that beset mankind; they had *ichor* rather than blood in their veins; and their food was ambrosia. Beyond these distinctions, they lived lives similar to the lives of earth-bound humans. They had the same family disputes and felt the same passions. They were not, however, bound by the same social constraints as human beings; if a mortal man had dared to rape women with the same licentiousness as the gods, the brothers or male relatives of the victims would have hunted him down. Gods were powerful but not omnipotent; even Zeus, the most powerful of them all, could not change the decrees of Fate. Twelve members of the Olympian family were dominant. Homer knew of more than twelve gods on Mt. Olympus, but twelve great gods formed a sort of inner circle, and that number was never to increase. After Homer, twelve remained the canonical number. Later Greeks added Dionysus, the god of wine, and dropped Hestia, the goddess of the hearth, thus maintaining the number twelve.

HESIOD'S GENERATIONS OF THE GODS. Hesiod's contribution was the myth of the creation of the world out of chaos, and the birth of the gods, which he described in his *Theogony*. The main components of the myth were borrowed from the Near East. As more and more clay tablets from the ancient Near East are deci-

particularly liked, and if a worshipper wanted his prayer to be heard he would be wise to go to a place that was dear to the god whose favor he was seeking and there make his prayer or sacrifice. Gods did not always hear prayers, for they had their own lives to lead and had neither time nor inclination to listen to all the mortals beseeching their help. But if a suppliant went to a precinct sacred to a god, where there might be a temple housing his image, then the chances were good that the god would pay attention. Gods could not ignore their images, for the image captured a god's likeness, and with it, a share of the divine potency.

phered, it has become increasingly clear that Greek religious ideas owe a great debt to the East. We know now that Hesiod's *Theogony* adapts a story that is found first among the Hurrians, a people in northern Mesopotamia, who passed it on to the Greeks via the Hittites in Asia Minor, and the Phoenicians in what is now Lebanon. Hesiod's tale relates that the great gods of Olympus were preceded by three earlier generations. First there was Chaos, and out of it, *Ouranos* (Heaven) and *Gaia* (Earth) were formed. Ouranos, who was male, covered Gaia, and from their union came the generation of the Titans. The rule of the Titans ended when Cronus, the youngest of the children of Ouranos and Gaia, attacked his father, castrated him, and thrust him up into the sky. Ouranos has been separated from Gaia by the atmosphere of the world above ever since. Cronus, fearing that his offspring would overthrow him in turn, swallowed the infants whom his wife Rhea bore. His children were immortal, and so did not die, but as long as they were imprisoned in Cronus' stomach, they could do their father no harm. Rhea grew angry at the fate of her children, however, and instead of giving Cronus her last child, Zeus, to devour, she handed him a stone wrapped in swaddling clothes, and Cronus swallowed it instead. Zeus was brought up secretly on Crete in a cave high on Mt. Ida. Once he was fully grown, he forced Cronus to regurgitate his brothers and sisters, and after terrible battles—first with the Titans and then with a race of Giants and other monsters—he established the rule of the Twelve Olympians. Yet just as the Titans were overthrown, the Twelve Olympians in their turn might suffer the same doom. The gods were always wary of rivals.

THE TWELVE OLYMPIANS. The circle of the twelve great gods of Mt. Olympus consisted of Zeus, the king of the gods, his siblings—Hera, Poseidon, Hestia, and Demeter—and his children—Pallas Athena, Apollo and Artemis, Aphrodite, Ares, Hephaestus, and Hermes. Dionysus was added to the Twelve later, and Hestia dropped. One member of Zeus' family was not included: Hades, the dark lord of the Underworld. He was Zeus' brother, but he lived in a sunless realm, ruling over the weightless ghosts of the dead.

ZEUS, THE SKY-GOD. Zeus, the king of the gods, was the god of the sky and the weather. He sent the rain that made the crops grow. Homer called him the "cloud-gatherer," for when the clouds gathered in the sky and lightning flashed the Greeks imagined that they were seeing a manifestation of Zeus' power. He was by far the strongest of the gods, stronger than all the others, who dared not revolt against his rule, much as they might grumble about it. His favorite creature was the eagle, the

most lordly of birds, and his preferred weapon of war was the thunderbolt, which was his exclusive property. Other gods had their preferred weapons as well: Poseidon the trident, Apollo the bow and arrow, and Hephaestus fire, but none of these were as terrible as the thunderbolt. Zeus' enemies, the Titans and the Giants, were utterly overwhelmed by it when he hurled it against them, and mere mortals were powerless in the face of it. The lightning that flashed across the sky was Zeus revealing himself, and wherever it struck the earth, a sanctuary would be set up to "Zeus Descending," for there Zeus had touched the earth and left his mark.

THE PROMISCUOUS GOD. Zeus had a wife, Hera, but he was not a faithful husband. He was a god of extraordinary sexual prowess, for he was a fertility god. It was he who made the earth fruitful and saw to it that the seasons came and went in due order. Greek mythology had many tales about his scandalous escapades. He seduced an extraordinary number of both goddesses and mortal women, and his seductions rarely involved mutual consent. One myth related that he saw Leda, the mother of Helen of Troy, taking a bath in a pool and transformed himself into a swan in order to rape her. Another myth relayed Zeus' seduction of Danaë, who had been imprisoned by her father in a bronze chamber after an oracle told him that a son born to his daughter would kill him. While the chamber had barred mortal men access to Danaë, Zeus worked around this barrier by transforming himself into a shower of gold that penetrated the bronze chamber, and thus he sired her son who did, eventually, kill her father, as the oracle foretold. Zeus was also the father of Heracles, the strongman of Greek legends, and the tale of how he impregnated Heracles' mother Alcmene is an example both of craftiness and a lack of conventional morality. Zeus disguised himself as Amphitryon and slept with his wife, Alcmene, while Amphitryon was away at war. Then, shortly afterwards, the real Amphitryon returned and slept with his wife, who was surprised at his ardor, for she believed that they had slept together only a short while before. From the coupling of Zeus and Alcmene, Heracles was born, while his twin, Iphitus, was fathered by Amphitryon.

ZEUS, THE SIRE OF GODS. It is not surprising, therefore, that Zeus had a great many offspring, both mortal and immortal. He sired both Apollo and Artemis by the Titaness, Leto. He begot Hermes by Maia, one of the Pleiades, the seven daughters of the Titan Atlas, whom Zeus set as a constellation among the stars. He fathered Dionysus by a mortal woman, Semele, the daughter of Cadmus, king of Thebes. His sister Demeter bore him

Persephone, the queen of the Underworld whom Hades took as his partner. Hera's children by him were Ares, the god of war, and, according to some accounts, Hera and Zeus were father and mother of Hephaestus, the god of smiths and craftsmen. Zeus deserved his title as father of gods and men. Even those gods who were not sired by him addressed him as "Father," and rose to their feet when he came into their presence.

THE JUSTICE OF ZEUS. Zeus was a god of impartial judgment. He was the guardian of conventional morality among mankind even if he did not set an example of it himself. As time went on, he became connected with the principle of justice. Justice, wrote Hesiod, was a daughter of Zeus who reported all deceit and perfidy to him. Yet powerful though Zeus was, he never tried to overturn the decrees of Fate, for he knew that to challenge Fate would be unwise. Every mortal person had his *moira* (portion of life), marked off by boundaries which even Zeus did not transgress, for respect for limits was the basis of ethical behavior. The most distressing of these limits was death, which no mortal could evade. A myth described how a mortal named Sisyphus tried to cheat death and overstep his *moira*, and the judgment of Zeus was severe. In the Underworld Sisyphus was condemned forever to roll a heavy stone to the top of a steep hill, only to be overcome by exhaustion as he neared the top so that the stone rolled back down the hill and he had to start again.

ZEUS, THE PANHELLENIC GOD. Zeus was a god whom all the Greeks revered. One of his epithets was *Panhellenios*, which means "god of all the Hellenes," for the Greeks in their own language called themselves "Hellenes." Zeus had no city that he favored above all others. His most famous festival was the Olympic Games that were held every four years at his greatest sanctuary, Olympia, situated in south-west Greece within boundaries of Elis, but in the countryside, away from the urban center of the state. It was a panhellenic festival. Athletes from all over the Greek world gathered there every four years to participate in the contests, and while the games were being held, there was a universal truce: states at war with each other ceased hostilities until the games were finished. All Greeks were welcome to compete, but non-Greeks were not eligible. A victor won only a wreath made of the wild olive for his prize, but the honor and glory that he received in his home city was enormous.

HERA THE MISTRESS: QUEEN OF THE GODS. Zeus' wife was Hera, whose name means "mistress." She was the queen of the gods, and she had two city-states she especially loved. One was Argos, south of Corinth, where she had a sanctuary so venerable that one of her most common titles was "Argive Hera." It was built, not in the urban center of Argos, but some distance away in the countryside. Her other favorite place was the island of Samos where a temple was built for her as early as 800 B.C.E. In fact, she seems to have been one of the first, if not the first, of the Greek deities to have temple buildings erected for her cult. At Olympia, for instance, before the great temple of Zeus was built, a temple was erected for her, and it was so ancient that the walls were made of mud brick and the columns were originally hewn out of wood with stone replacements as the wood columns rotted.

THE JEALOUS WIFE. Hera was a goddess of weddings and a patron of married women. She looked after the recurrent cycle of pregnancy and birth—and often infant death—which Greek women experienced. Hera's own marriage with Zeus was no model of connubial bliss, for she saw through the deceptions and infidelities of her randy husband. She reacted with jealousy and anger, and since she could not curb Zeus, she pursued his paramours with unrelenting rage. When the Titaness, Leto, was in labor with Apollo and Artemis—both sired by Zeus—Hera prevented Eileithyia, goddess of childbirth, from going to assist Leto, and consequently Leto's labor lasted nine days. The other gods eventually took pity and offered Eileithyia a great bribe to attend the birth without Hera's knowledge. Her enmity for Heracles, the son of Zeus, was implacable. While he was still an infant, she sent two great serpents to destroy him, but he grabbed them with his fists and strangled them. Once Heracles became a man, Hera deranged his mind, and in a blind rage he killed his wife, Megara, and his children. Another target of Hera's jealousy was Io, a priestess at Hera's sanctuary at Argos who attracted Zeus' lustful eye. Hera persecuted her, first turning her into a heifer and then sending a gadfly that tormented her so much that she fled across the sea to Egypt. In Homer's *Iliad*, Hera plays the role of a quarrelsome partner of Zeus, railing against his infidelity. But she is always careful not to rouse him to violence, for Zeus had no compunction about wife-beating.

HERA'S CHILDREN. Hera had children of her own. One was the god of war, Ares, sired by Zeus. The blacksmith god Hephaestus was also Hera's son; one story related that, angered at Zeus' constant infidelities, she bore him miraculously without male sperm. Hera also had two daughters who were not included among the twelve Olympians: Hebe and Eileithyia. Hebe, whose name means "youth and health," was a goddess of healthful well-being. She served as cupbearer of the Olympian

gods until Zeus fell in love with a handsome Trojan boy named Ganymede and snatched him up to Olympus where he usurped Hebe's place as cupbearer. After Heracles was admitted into the company of the gods, Hebe became his wife. Eileithyia, the divine midwife, was an ancient goddess who was worshipped in Minoan Crete, and when she was brought into the Olympian regime, she became Hera's daughter, which must have been a demotion. It demonstrates the disorganization of the Greek religion when Homer speaks of more than one daughter of Hera bearing the name Eileithyia, as if she was a sisterhood of midwives.

POSEIDON, RULER OF THE SEA. Poseidon, the god of the sea and earthquake, was the brother of Zeus. Homer refers to a myth that was derived ultimately from an ancient Akkadian epic from Mesopotamia, titled the *Atrahasis*, that after the Olympian gods overthrew the rule of the Titans, the three brothers—Zeus, Poseidon, and Hades—drew lots to decide which portion of the universe each would rule. Hades won the Underworld, Zeus the clouds and the high clear sky, while Poseidon got the sea. The earth, however, was to be common to all three, and whenever Zeus became too autocratic and tried to extend his dominion beyond his proper boundaries, Poseidon complained, though he knew better than to revolt. He ruled the tempests, and sailors and fishermen feared him. If his anger was roused against an unlucky mariner, he was relentless, as the hero Odysseus discovered as he made his voyage home from Troy. Poseidon lived in an underwater palace with his wife, Amphitrite, the daughter of Ocean, and their children were the Tritons, sea monsters with fishtails that could make venturing on the sea dangerous. At the same time, he was the Earth Shaker, the Lord of the Earthquake who could smash rocks with a single blow of his trident. When earthquakes struck, the Greeks would invoke Poseidon and sing his paean, which was a hymn giving thanks for deliverance from evil. He had no city which he could call his own—though he did contest Athens with Athena and lost narrowly—but he did have one famous sanctuary at the Isthmus of Corinth, where every two years the Isthmian Games were held in his honor.

PALLAS ATHENA, PATRON OF ATHENS. Athena, or Pallas Athena, was the patron deity of Athens, so much so that when an Athenian referred simply to "the goddess," it was Athena whom he meant. The derivation of her second name, "Pallas," is uncertain, but mythology had at least two tales that explained it. One told that Pallas was a Giant, and in the battle between the gods and the Giants Athena killed and flayed him and covered her own body with his skin for protection. An alternative tale

related that Pallas was a goddess who was Athena's playmate when they were both young. They were both skilled warriors, and once when they were sparring, Pallas was about to strike Athena when Zeus intervened and thrust his shield in front of her. Startled, Pallas was thrown off her guard, and Athena's next blow accidentally killed her. Athena mourned her death and took her name. This tale belongs to a common type of myth where one god slays another, sometimes by accident and then assumes his name, and these myths are generally interpreted to mean that the killer god has taken over his victim's cult and co-opted his worshippers. If this interpretation of Pallas' death is right, it may mean that Athena co-opted the cult of an earlier warrior goddess who did not belong to the charmed circle of the Olympians, and the name "Pallas Athena" reflects the merger.

A GODDESS OF INTELLIGENCE, RESOURCEFULNESS AND WARFARE. Athena was the daughter of Zeus and Metis. The word *metis* means simply "wisdom" or "cunning," but in the myth of Athena's birth Metis is a female divinity. While Metis was pregnant, Zeus learned that her son was destined by fate to overthrow his father. Hoping to eliminate this threat, he swallowed Metis with her unborn child. Thus Zeus literally incorporated wisdom in his own body. One day he had a splitting headache, and called on Hephaestus to help. Hephaestus cured the migraine by taking an ax and splitting Zeus' head open. Out stepped the warrior goddess, Athena, in full armor. She was a goddess of battle, and Greek art always depicted her wearing a helmet. She delighted in the clamor of combat. When she favored a soldier, she stood beside him in the fight and gave him courage. In particular she loved a warrior who was not merely strong and brave, but intelligent and crafty as well. The hero Odysseus was a special favorite of hers, for on his long journey home after the destruction of Troy, he survived by his wits, whereas all his men perished. Her shield was called an aegis, and whenever she raised it in battle, it struck panic into her enemies. In art her aegis is shown sometimes as a shield, sometimes as a short cloak; whichever it was, it had in its center the head of a Gorgon, a fearsome monster-woman with snakes instead of hair fringing her head, and a face that was believed to turn those who looked on it into stone. The Gorgon's head was an apotropaic device, that is, a symbol supposed to ward off the evil eye.

A GODDESS OF DOMESTIC CRAFTS. Athena was a goddess of domestic crafts as well as warfare. She was a patron of the spinners and weavers of wool, and she was proud of her skill and jealous of rivals. There is a myth that tells how she punished a mortal woman named

Apollo, life-size painted terracotta acroterium figure from the ridgepole of an Etruscan temple, c. 510 B.C.E., found at Veii, Italy. © ARCHIVO ICONOGRAFICO, S.A./CORBIS. REPRODUCED BY PERMISSION.

Arachne who boasted she could weave a better fabric than Athena. Athena challenged her to a contest, and when Arachne lost, Athena turned her into a spider and let her weave her webs to her heart's content. She was also a patron of carpenters and skilled workmen, and it was she who gave Greece the olive tree: not the wild olive but the domesticated olive which yields olive oil, one of the staples of the Greek diet.

THE VIRGIN GUARDIAN OF ATHENS. Athena was a virgin—in Greek, a *parthenos*—and in her city of Athens, her great temple which still overlooks the city is called the Parthenon, the Virgin's Temple. Athens was a city she loved, and she won it after a contest with Poseidon, who coveted it for himself. A mark can still be seen on the rock of the Acropolis, the Athenian citadel, which Poseidon supposedly made when he struck it with his trident and created a salt-water well as a gift to Athens. When Athena planted an olive tree beside the well as her gift, Poseidon challenged her to a fight, but

Zeus intervened and set up a court to arbitrate the quarrel. By a majority of one, the court decided that Athena had given Athens the better gift, and Athens became her city. The Athenians continued to reverence the mark on their Acropolis that Poseidon made, however, and never built over it. Instead they left it open to the sky. When the temple known as the Erechtheion was erected and its north porch stretched out over the mark, they left a hole in the pavement of the porch so that the mark was left uncovered, and in the porch roof directly above it a small area was left unroofed. In fact, the mark was probably caused by lightning striking the earth.

ERECHTHEUS AND ATHENA. Athena became the stepmother of the ancestral king of Athens, Erechtheus, who was one of the divinities worshipped in the Erechtheion. How Athena, a virgin goddess, became a stepmother was explained by an ancient myth. Hephaestus desired Athena and once tried to rape her. Athena easily fought him off, and all Hephaestus managed to do was to ejaculate semen on to her thigh. In disgust, Athena wiped it off with a piece of wool (Greek *erion*) and hurled it to the ground. When the semen fell on Mother Earth, she conceived and gave birth to Erechtheus. Athena pitied the infant and, taking him up, reared him in her temple. Homer refers to the story in his *Iliad*. Athens, he reports, was the realm of Erechtheus whom Athena settled in her temple, and there the Athenians worshipped him with sacrifices of bulls and goats.

APOLLO, GOD OF PESTILENCE. Apollo, the "Far-Darter" was the master of the bow and arrow, and hence his epithet, the "Far-Darter," which means that the shafts from his bow travelled a great distance. Yet though he was an archer god, he was not a patron of hunters; his sister Artemis filled that role. Apollo's arrows were not for killing wild beasts; instead they brought disease. The first book of the *Iliad* presents a vivid picture of him striding down from Mt. Olympus to the Greek camp outside Troy, with the arrows in his quiver rattling as he walked. When he reached the Greek ships, he knelt on one knee, drew back his bowstring and aimed his shafts into the Greek camp. First the dogs and the beasts of burden died of the pestilence; then men perished, and the smoke rose from their funeral pyres day and night.

HOLY PLACES. Apollo's chief sanctuaries were at Delos and at Delphi. Delos is a small, waterless Greek island in the center of the archipelago in the Aegean Sea known as the Cyclades. Greek myth related that Delos alone dared offer a haven to Apollo's mother, Leto, who was driven from place to place by Hera's anger, and she gave birth to Apollo and his sister Artemis as she stood clutching a palm tree for support. Thus Delos became a

holy island, sacred to both Apollo and Artemis. Delphi in central Greece, however, was the greatest center of Apollo's cult. Apollo's oracle there had a reputation for truth which was perhaps undeserved, for when questions were put to it, the replies were famous for their ambiguity. Yet it was thought that if one was clever enough to interpret the real meaning of an oracle, it would prove to be a truthful prophecy. It was no fault of Apollo if his responses were misunderstood. As time went on and the Greeks became more skeptical, belief in oracles faded, but Apollo's sanctuary at Delphi remained a sacred place, and it was filled with rich dedications made over the years by his worshippers.

THE PYTHIAN GAMES. Delphi was also the site of the Pythian Games, which were held every four years, and were second only to the Olympian Games in prestige. They included music and poetry competitions as well as athletic contests, for Apollo was a patron of music and poetry as well as athletics. His favorite instrument was the lyre, a stringed instrument with a hollow shell or box to amplify the sound. First prize at the Pythian Games was a laurel wreath, and the laurel, for which the Greek word is *daphne*, had a close association with Apollo, which was explained by a myth. Daphne was the lovely young daughter of a river god, with whom Apollo fell in love. She fled from him, however, and just as he was about to catch her, she prayed for help and was turned into the tree that bears her name. Thus the laurel became a tree that Apollo particularly loved, for it was the maiden he desired and lost.

APOLLO'S COMBAT WITH THE DRAGON PYTHO. Apollo won Delphi for himself by fighting and killing the creature that occupied it before him. Before Apollo arrived, Delphi was a hallowed place belonging to a dragon known as Pytho. Apollo fought the dragon and slew it, leaving the carcass to rot (Greek *python*). Murder, however, was an evil deed that made the murderer unclean in the sight of gods and men. Spilling blood left Apollo polluted, and before he could return to the society of the gods, he had to be cleansed of the pollution. He was banished to northern Greece, to a valley near the foot of Mt. Olympus known as the Vale of Tempe, and there he had to undergo a ritual that purified him and allowed his return. To commemorate his combat with the dragon, there was a religious rite called the *Strepteria* that was held at Delphi every eight years. A youth was led to a hut called Pytho's palace, which was built near Apollo's temple. The hut was set on fire, and the youth departed, apparently for exile at Tempe, and then he made his return in a procession along a sacred pathway known as the Pythian Way. The youth impersonated Apollo, who was always shown in art as a well-proportioned,

muscular young man wearing his hair unshorn, like a Greek youth who had not yet reached adulthood. As for the dragon Pytho, his sanctuary which Apollo made his own became the most important oracular shrine in Greece, and the title of the priestess who uttered the sacred oracles, the Pythia, recalled Pytho's name.

ARTEMIS, PATRONESS OF WILD BEASTS. Artemis, like her brother Apollo, was born on the island of Delos, and had a temple there which predated Apollo's. Artemis' temple was in the center of the sanctuary, whereas the Apollo temple was off to one side; the positioning of the temples has led students of religion to suspect that Artemis was an early, primitive deity on Delos whom Apollo joined only later, in spite of the myth which related that they were twins. Her cult seems to fit a primordial era, when people survived by killing the beasts of the forest, and were anxious not only that their hunts should be successful, but that the creatures they hunted should increase and multiply, and thus provide them with more prey. In Homer's *Iliad*, Artemis is called the "Mistress of the Animals," the overseer of wild beasts. She was a goddess of hunters and hunting who killed the animals and birds of the forests, mountainsides, and marshes—she was sometimes called "Artemis *Limnatis*" or "Artemis of the Marshes"—and at the same time, she was concerned for their welfare. The endless cycle whereby living creatures were born and killed, or killed in order to survive and reproduce, fell under her authority.

THE GODDESS OF GIRLS BEFORE MARRIAGE. Like Athena, Artemis was a virgin, but whereas Athena was asexual, Artemis' virginity was connected with the purity of young girls before they are married. Her followers were the nymphs, and the word "nymph" could refer equally to a divinity of a stream or spring, or a young girl approaching marriage. Everywhere in Greece it was the custom for girls of marriageable age to dance and sing in choruses at festivals in honor of Artemis, and this was one place where young men could become acquainted with unmarried girls. There was a darker side to Artemis, however. Girls who failed to remain pure for whatever reason encountered her wrath. The nymph Kallisto, whom Artemis loved, was raped by Zeus and bore him a son, Arcas. Artemis in her anger turned Kallisto into a bear, and her own son Arcas hunted her down and killed her. In addition to overseeing the purity of unmarried girls, Artemis also presided over the birthing pangs of women. She could be a ruthless midwife, unlike Eileithyia who looked after the actual delivery of the infant from the mother's womb. Eileithyia was a gentle nurse whereas Artemis' interest was the reproduction of the species, and she made decisions involving the life and

death of pregnant mothers. In the *Iliad*, Hera rounds on Artemis at one point and exclaims angrily, "Zeus made you a lion against women, and lets you destroy women in their labor." It was Artemis who determined whether or not a woman would survive childbirth.

APHRODITE, GODDESS OF SEXUAL DESIRE. Aphrodite, the goddess of love and beauty, was worshipped all over Greece, but her most famous temples were at Corinth in Greece and on the island of Cyprus, at Paphos and at Amathus. In Homer's *Iliad*, she was the daughter of Zeus and a deity named Dione, whose name means "the *goddess* Zeus," or "Mrs. Zeus," so to speak. At an ancient oracle of Zeus at Dodona in northwest Greece, Dione was still recognized as Zeus' wife in classical times, long after Hera had replaced her elsewhere in the Greek imagination. The *Theogony* of Hesiod relates another tale, however. It tells that when Cronus cut off the genitals of his father Heaven, he tossed them into the sea and where they fell, the water foamed and frothed, until Aphrodite arose from the foam (Greek *aphros*), stark naked. She then floated on a scallop shell to Cythera, a favorite island of hers, though later she was thought to prefer Paphos on Cyprus. She was a late arrival among the gods of Greece, and her origins were Eastern. Her counterparts in Mesopotamia were the goddess Innana in ancient Sumer, and in Babylon, Ishtar. The Canaanite goddess Astarte who was worshipped in ancient Syria was Aphrodite in a different guise. Like these Eastern goddesses, Aphrodite presided over sexual desire, and prostitution was practiced at her temples. At Corinth in Greece she had a famous temple that housed prostitutes. While most myths about the couplings of gods and humans invariably involve male gods raping women, Aphrodite was one of the few to reverse the pattern. Aphrodite in disguise seduced a handsome young Trojan named Anchises, and became pregnant with Aeneas, whom the Romans would regard as their founder.

THE MYTH OF APHRODITE AND ADONIS. Like her Eastern counterparts, Aphrodite was coupled in mythology with a handsome young lover, who died young and descended into the Underworld. The youthful lover in Aphrodite's case was Adonis, and the myth of Aphrodite and Adonis is an adaptation of the tale of Astarte and Tammuz that was popular in ancient Syria. Both Tammuz and Adonis were young men who were loved by goddesses, and they died in the flower of their youth. Adonis, the story goes, was killed by a boar while he was hunting, and descended to the realm of the Dead. When Aphrodite tried to retrieve him, she found that Persephone, the queen of the Underworld, admired his beauty too much to release him. Zeus settled the dispute by decreeing that Adonis should spend half the year with Aphrodite, and half with Persephone. Thus he was a fertility god, whose death and resurrection marked the changing seasons of the agricultural year. In the fall, when Adonis descended into the Underworld, the seed was put into the ground and died, and then when the spring sun brought warmth to the earth, it quickened to new life and produced the harvest for the coming year.

HERMES THE DECEIVER. Hermes, the deceiver god, was the son of Zeus and Maia, the daughter of the Titan Atlas, and no sooner was he born than he showed his craftiness. On the first day of his life, he invented the lyre, stole cattle belonging to his brother Apollo, then lied when Apollo charged him with the theft, and it took the intervention of Zeus to reconcile the two. Hermes was not only a god of tricksters and thieves, but also the patron of merchants, for any purchaser of goods in Greece or Rome was wise to heed the caution, *caveat emptor*. "Let the buyer beware!"

THE DIVINE COURIER. Hermes' chief function in the pantheon of Homeric gods was as the divine courier who carried the messages of Zeus, and he often appears in art dressed like a traveler, wearing a broad-brimmed hat and stout sandals sometimes equipped with wings, and in his hand he carries a herald's staff. This staff was a rod of olivewood twined with two serpents, and it symbolized the sanctity of a herald, for it was a sacrilege to kill a herald. Hermes was also the god who guided the ghosts of the dead to the Underworld, and when this was his mission, he bore a magic wand that is not to be confused with the herald's staff. With it he herded the insubstantial shades to the River Styx where Charon ferried them across. Thus one of his epithets was *Psychopompos*, marshal of the souls of the dead.

THE GOD OF BOUNDARIES. Hermes was also a god of boundaries. In fact, guarding boundaries may have been his earliest function, for the word *herma* means a heap of stones piled up to mark a boundary. The heap of stones developed into a square pillar, and about 520 B.C.E. these stone pillars were introduced into Athens to mark midway points between the Athenian *agora*, or marketplace, and the many villages of Attica. As time went on, they came into general usage to mark off neighborhoods. The herm was an oblong shaft about five feet high, with the image of a bearded head on top, projections at the shoulders like two-by-fours, and a phallus half-way down the shaft. Herms were sacred. Anyone who mutilated them committed a sacrilege, and could be tried for it in a court of law. Hermes had one son, Pan, the god of the woods who was half-man, half-goat.

Both Hermes and Pan were connected with Arcadia, the wild mountainous area in the central Peloponnesos, and the identity of Pan's mother was lost in the mists of time, if it was ever known.

DEMETER, GODDESS OF THE RIPE GRAIN. Demeter, the sister of Zeus, was the personification of the ripened grain that was reaped at harvest time. The ancient Greeks themselves interpreted her name to mean "Mother Earth," but though the last two syllables of her name, *meter*, do mean "mother," modern linguists point out that the first syllable cannot mean "earth." Yet her connection with the grain harvest is clear. Mythology assigned her a son, Plutos, whose name means wealth, and the wealth of Plutos was the grain stored in the granaries.

DEMETER AND KORE Demeter was intimately connected with a goddess who was known simply as Kore, which is the Greek word for "girl," and the relationship between Demeter and "the girl" is so close that they were sometimes known simply as the "Two Goddesses." Kore did have a proper name, however. She was Persephone, daughter of Demeter and Zeus, and the wife of Hades, the king of the Underworld. According to the myth, Persephone was playing one day with other young girls of her age in a meadow near Enna in Sicily; when she stooped to pluck a flower, the earth opened and Hades arose in his chariot, seized her, and carried her off to his realm of darkness. Demeter heard her daughter's cry but did not see what had happened. She set out to look for her, traveling over land and sea, lighting her way with torches. When she reached Eleusis, which is nowadays a suburb of Athens, she paused to rest, and while she was sitting sadly outside the palace at Eleusis, the daughters of the king told her jokes and succeeded in making her laugh. To reward them, she founded the Eleusinian Mysteries at Eleusis that the Athenians celebrated every year. Still mourning the loss of her child, she would not allow the crops to grow until she found her daughter, and the whole race of men would have perished of hunger except that Zeus intervened. It was decided that Kore would spend half the year in the world of the Dead as queen of the Underworld, and half the year in the world above. While she was in the Underworld, the land lay barren, and when she returned to the land of the living, the crops grew and ripened. The death and rebirth of Kore, or Persephone, as she was known in her personification as queen of the Dead, marked the change of seasons from the barrenness of winter to the spring with its new growth.

THE CULT'S ORIGINS. It has been often noted that the death and rebirth of Kore does not quite fit the cycle of Greek agriculture, for Greek farmers planted their grain in the autumn; it sprouted and grew over the winter except for a brief period when the temperature fell to the freezing point, and the harvest ripened in late May or June. The barren season was therefore not winter but the hot, dry summer. The cult of Demeter and Kore seems to point to an early period of Greek prehistory, before the Greeks migrated into present-day Greece and were still living in a more northerly latitude. Central Europe has a cycle of seasons which fits the story of Kore better, for there the winter is the barren season, and the summer the time when the fields yield their harvests.

THE GOD DIONYSUS: THE OUTSIDER. Dionysus stands apart from the other Olympian gods. He seems to be an outsider, and at one time, scholars believed that he was a non-Greek god who was a relatively recent immigrant to Greece. Evidence from the Linear B clay tablets of Mycenaean Greece does contain the name of Dionysus, however. The tablets on which his name appears come from Pylos, overlooking the Bay of Navarino in southwest Greece, and from Khania in western Crete, and they date from 1250–1200 B.C.E. They give no inkling as to what Dionysiac worship was like in the Bronze Age, except that the one from Khania mentions offerings of honey to Zeus and to Dionysus. There is no mention of wine, with which Dionysus was particularly associated in the historical period.

THE GOD OF INTOXICATION AND ECSTASY. Dionysus was a god of wine and inebriation, but he had other associations which set him apart from other gods. His worship included ecstasy and ritual madness. That aspect of his cult in particular marked him as the opposite of Apollo, who appears as the god of self-control and self-knowledge. Apollo's favorite musical instrument was the lyre or *kithara*, a stringed instrument which was the ancestor of the guitar. The instrument of choice for Dionysus was the *aulos*, which was a reed instrument, the ancestor of the oboe, and it had a dominant, vibrant timbre much like modern bagpipes that appealed to deep-seated human emotions. The *skirl* (a shrill sound) of the *aulos* accompanied the chorus in theatrical productions, which were within the province of Dionysus, and the masks which were worn by actors on the stage became symbols of the Dionysiac cult. In art, they became a standard Dionysiac motif. Yet he was primarily a god of wine, which was supposed to have been his invention. When Dionysus is depicted on Greek vases, wine is his constant companion. He is often shown holding a grapevine in one hand, and a cup or some other vessel for wine in the other. Art historians have noticed that while Dionysus is often shown receiving wine, or

Arts and Humanities Through the Eras: Ancient Greece and Rome (1200 B.C.E.–476 C.E.)

303

a PRIMARY SOURCE *document*

A PARODY OF A MYTH

INTRODUCTION: The satirical essayist Lucian of Samosata, now the village of Samsat in Syria, belongs to the second century C.E., the period which Edward Gibbon, in his classic history, *The Decline and Fall of the Roman Empire,* calls the happiest period in the history of mankind. It was also a period when people took a great interest in new religions, and the old stories about the gods which were told by Homer and Hesiod were no longer taken seriously. Lucian was a failed lawyer who turned to the composition of satirical essays. In his new career, he won fame and, to a small degree, fortune as an author. Much of his writing makes fun of philosophy and religion, and in this excerpt he spoofs the myth of the god Dionysus' birth. According to the myth, Zeus saved his unborn son, Dionysus, from the flames that consumed the infant's mother Semele, and kept him sewn into his thigh until he was ready for birth. In this satirical dialogue, the god Poseidon drops by Zeus' palace for a visit and is told by Hermes the gatekeeper that Zeus cannot see him. In trying to discern the reason why Zeus will not see him, Poseidon first guesses that Zeus is in the middle of a sexual liaison, perhaps with his wife Hera, or a young man named Ganymede. Hermes informs him that he is wrong on both counts; Zeus is, in fact, not feeling well after giving birth to his own son.

Hermes: He mustn't be disturbed, I tell you. You've chosen a very awkward moment—you simply can't see him just now.

Poseidon: Why, is he in bed with Hera?

Hermes: No, it's something quite different.

Poseidon: Oh, I see what you mean. He's got Ganymede in there.

Hermes: No, it's not that either. The fact is, he's feeling rather unwell.

Poseidon: Why, Hermes, what a terrible thing! What's the matter with him?

Hermes: Well, I hardly like to tell you.

Poseidon: Oh, come on. I'm your uncle—you can tell me.

Hermes: All right then—he's just had a baby.

Poseidon: Had a baby? Him? Whoever by? Do you mean to say he's been a hermaphrodite all these years without our realizing? But there wasn't any sign of pregnancy—his stomach looked quite normal.

Hermes: You're quite right. That wasn't where he had it.

Poseidon: Oh, I see. He produced it like Athena, out of his head. It's a very prolific organ.

Hermes: No, he's been carrying this child of Semele's in his thigh.

Poseidon: What a splendid chap he is! He can produce babies from every part of his anatomy! But who, exactly, is Semele?

Hermes: A girl from Thebes, one of Cadmus' daughters. Zeus had an affair with her and got her in the family way.

Poseidon: What? And then had the baby instead of her?

SOURCE: Lucian, "Zeus Is Indisposed," in *Satirical Sketches.* Trans. Paul Turner (Harmondsworth, England: Penguin, 1961): 51–52.

pouring a libation of sacrificial wine, he is never shown actually drinking the wine. That may be only artistic convention, however, since intoxication had a central role in the worship of Dionysus.

THE FRENZY OF DIONYSIAC WORSHIP. Intoxication was a means to a state of rapture in which Dionysus' votaries, or worshipers, surrendered themselves utterly to his power and merged their identity with his. His most common cult name was *Bakchos,* which is a Lydian word—the Lydians were neighbors of the Greeks in Asia Minor—and when his worship penetrated Italy, he was commonly known by his cult name. His female devotees were called *Bakchai* (in Latin, *bacchantes*) or alternatively, maenads or *thyiades.* The Romans identified Dionysus, whom they called Bacchus, with an Italian god of fertility and wine called *Liber* (the Liberated/Lib-

erating One), who had a festival every March called the *Liberalia.* In Greek art Dionysus is often surrounded by a swarm of devotees who dance with utter abandon. What made his cult unique among the Olympians was the mass ecstasy and the frenzied exaltation that accompanied it. No other god threw aside the restraints of civilized society with such abandon.

BIRTH AND UPBRINGING. Dionysus' mother was Semele, daughter of the founder-king of Thebes, Cadmus. Zeus loved her, and then, when she was six months pregnant, he was tricked by Hera into destroying her. Resentful as ever at Zeus' philandering, Hera visited Semele disguised as an old woman and persuaded the naive young girl to ask her lover to show himself to her in his heavenly regalia. So Semele prevailed upon Zeus to take an oath by the River Styx to grant her whatever

she requested, and when he assented, she asked to see him garbed as the king of the gods. Zeus tried to dissuade her, but even gods dared not break oaths sworn by the Styx, and since Semele insisted, Zeus appeared before her carrying his thunderbolt. The lightning consumed her with its flame, but Zeus snatched the premature infant from Semele's womb, and Dionysus completed his gestation sewn up in Zeus' thigh until he was ready to be born again, which explains Dionysus' epithet, "Twice-born." Then Hermes carried him off to a faraway place called Nysa where maenads attended to him until he grew to manhood. Later mythographers elaborated this period of Dionysus' youth, telling a story of how he wandered as far east as India, but eventually returned to Greece, accompanied by a retinue of maenads and satyrs.

DIONYSIAC RITES. Dionysus' rites were called *orgia*: "orgies." The term could be used for any secret rites or mysteries, but its most usual meaning is the rite of Dionysus. In a Dionysiac *orgia*, women abandoned their homes and roamed over the mountainsides, dancing, swinging about torches and *thyrsoi*, which were light sticks of reed with large pine cones fixed on top and wreathed in fresh ivy. In their madness they might seize an animal or even a child, tear it apart, and eat it. How much of this is myth and how much is based on actuality is hard to say. One of Dionysus' epithets was *omophagos*, an adjective meaning "eating raw flesh," and in vase paintings Dionysus and his maenads are shown tearing apart animals with their bare hands and eating them raw. The last play written by the tragic poet Euripides, the *Bacchae* describes a characteristic Dionysiac experience in the words of a herdsman, who witnessed it. He and other herdsmen were pasturing their cattle on the mountain slopes and saw three groups of maenads, who had been dancing together, now sleeping quietly on the ground. On hearing the herd of cattle, they awoke, let down their hair, and wreathed their head with ivy and oak leaves. Then they began a wild dance and fell upon the cattle, tearing them limb from limb, and having had their fill of that, they swooped downhill on two villages which they plundered, snatching children from their houses. The villagers resisted, but the maenads hurled their *thyrsoi* at them and resistance was useless. They then returned to where they had started their wild rampage, their passion spent.

THE ORGIA IN GREECE. The rites described in the *Bacchae* were based on reality, for every two years a number of Greek cities held *orgia*. Athens was an exception, but maenads from Athens went to Delphi to celebrate the orgies there. They took place in mid-winter when it

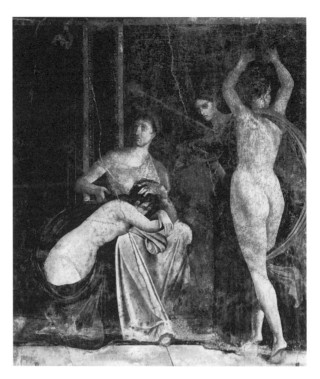

Detail of a wall painting from the Villa of the Mysteries, Pompeii, showing initiation into a religion of Dionysus. On the left, a girl, naked to the waist, is being lashed by a winged figure not shown in this photo, and on the right, the girl is performing a wild dance. **PUBLIC DOMAIN.**

was believed that Apollo left Delphi, and for three months the shrine belonged to Dionysus. Thebes, between Athens and Delphi, was the center of maenadism from which professional maenads were exported to other cities to organize the biennial orgies. Athens did not celebrate Dionysiac orgies, but she had five festivals that were dedicated chiefly to him. In two of these—the Lenaean festival in January and the City Dionysia in March—tragedies and comedies were presented. Another festival, the three-day long Anthesteria, was a time for merrymaking. The new wine was broached on the first day; the second was a day of competitive drinking, and on the third, the spirits of the dead were free to return above ground and wander among the living, for Dionysus was also connected to death and the afterlife. At the end of the day, the shades were dismissed with the ritual cry, "Get out, ghosts, the Anthesteria is over!"

WELCOME AND RESISTANCE. The spread of Dionysus' worship into Greece met resistance: Homer in the *Iliad* recalls that the herdsman Lycurgus drove the maenads pell-mell down the slope of Mt. Nysa with his ox goad, and as punishment, Zeus struck him blind. King Pentheus of Thebes, where Dionysus was born, tried to suppress his worship when Dionysus returned there, but

could not prevent the Theban women from swarming off into the mountains and surrendering to mass ecstasy. There are various other myths of resistance to the coming of Dionysus as well, and this has led scholars to think that he was a late immigrant to Greece. Many ancient Greeks speculated that Dionysus came from Thrace in northern Greece, and it is true that Macedonian and Thracian women were particularly devoted to his *orgia*. The alternative view was that Dionysus came from Phrygia in Asia Minor. The two views are not necessarily incompatible, for the Thracians and the Phrygians were related. There was also the suspicion, even before Dionysus' name appeared on Linear B tablets, that he might have a Cretan origin. His wife was Ariadne, the daughter of King Minos, who fled from Crete with Theseus after she helped him escape the Minotaur, and then was abandoned by him on the island of Naxos, where Dionysus came and rescued her. It is generally thought that Ariadne was a Minoan goddess, and now that there is evidence that Dionysus was known on Bronze Age Crete, there may be some significance to the union of the two. By Ariadne Dionysus had a son, Oenopion, who is sometimes shown as his attendant, pouring wine for him.

THE ROMANS ENCOUNTER BACCHUS. In 186 B.C.E. news came to the Roman senate that the rites of Dionysus, the Bacchanalia (so called after Dionysus' cult name), were being celebrated in Italy. It was reported that devotees of the rites met at night and took part in a ritual that included not only hard drinking but all kinds of sexual depravity. It was the social and political aspect of the Bacchanalia that disturbed the senate. They appeared to be a breeding ground for conspiracy. The senate issued a decree offering a reward for the arrest of any member of the Bacchus cult or even for the denunciation of anyone. It was reported that over 7,000 men and women were involved. Similar decrees went out to the Italian towns ordering the suppression of the cult. Bacchic sanctuaries were destroyed, and Bacchic ceremonies were outlawed in Rome and Italy. The Roman authorities were generally tolerant of foreign religions, but this is an instance of how fiercely they could react if they discerned a threat to the social order.

HEPHAESTUS, THE BLACKSMITH GOD. Hephaestus, the god of metal workers and craftsmen, was the son of Hera, but two stories provide two versions regarding the identity of his father. According to one, he was Zeus. According to the other, Hera, who was enraged at Zeus' infidelities, gave birth to Hephaestus by herself, without being inseminated by a male. He had a non-Greek name, and his favorite island was Lemnos; both facts arouse scholarly curiosity, for on Lemnos there was a non-Greek

people living as late as the sixth century B.C.E. He was deformed, with an immensely powerful torso and arms, and crippled legs, and it has been often pointed out that in early communities a lame man would turn to a specialized trade such as metal working, for his deformity barred him from the occupations of physically fit men, such as farming and fighting as a warrior. Hera wasted no motherly love on him, and a myth told how he took his revenge: he made her a splendid throne, which trapped her when she sat on it and held her until Dionysus reconciled him with his mother. A story that accounted for his deformity described how Zeus threw him out of Olympus when he tried to stop Zeus from beating his mother. He landed on the island of Lemnos and would have died, except that the Sintians who inhabited the island nursed him back to life. Another story related that Hera was so disgusted at his appearance that she threw him out of Olympus. Homer in the *Iliad* treats Hephaestus almost as a comic figure with his crippled legs and heavily-muscled torso, a powerful man hobbling about like a child learning to walk. The Greeks admired the well-proportioned masculine figure of the athlete or the warrior, and the ungainly physique assigned to Hephaestus by their mythology shows how little the Greeks esteemed their craftsmen. He did have a temple in Athens which he shared with Athena, and it still stands largely intact in the old blacksmiths' quarter overlooking the marketplace of the ancient city. It was built in the middle of the fifth century B.C.E., and it is the best preserved of all the ancient temples in Greece. Athena, like Hephaestus, was a patron of craftsmen. Except in Athens, there is little evidence for his worship. Yet the products of his smithy were universally admired as marvelous examples of the metal worker's craft. His inventions even included robots. He was also famously ugly, and there was more than a touch of mockery to the fact that his wife was Aphrodite. The goddess of love and beauty was paired with the only ugly Olympian.

ARES, THE HATEFUL GOD OF WAR. Ares, the son of Hera and Zeus, was the personification of battle. He was conceived as a warrior in full armor, and his attendants who harnessed his horses to his war chariot were named *Phobos* and *Deimos*, meaning "Fear" and "Terror." He represented war as a destructive force that spreads fire and rapine. He was an unpopular god; in Homer's *Iliad*, Zeus calls him the most hated of all the Olympians, and, for all his love of battle, he was not a markedly successful warrior. For instance, in the Trojan War where Ares championed the Trojans and Athena the Greeks, the two divinities once met in battle. Ares threw his spear at Athena who parried it, and then Athena hurled a stone at Ares and laid him low. That

was a typical example of the prowess of Ares. He represented everything that was odious in war, but the glory of victory did not belong to him. Victory, for which the Greek word was *niké* was reserved for Athena. On the south-west bastion of the Athenian Acropolis there still stands a small, exquisite temple dedicated to Athena *Niké*: Athena who brings victory. Ares did have one admirer; Aphrodite much preferred him to her crippled husband, Hephaestus.

THE GODDESS OF THE HEARTH. Hestia, who is found in early lists of the Twelve Olympians instead of Dionysus, was the goddess of the hearth. Every private house had a hearth, and so did the *prytaneion,* or town hall, of every city-state. The hearth was a sacred place, and any suppliant who sat there could claim the protection of his host. If the host rejected the suppliant on his hearth, he would offend Hestia's brother, Zeus. The sacred fire of Hestia continually burned in the *prytaneion* of every city, representing the vital essence of the community. Whenever a band of colonists set out to found a new city, they took with them a firebrand from Hestia's altar in their mother city, and with its flame, lit the fire of Hestia in the newly founded colony. She had no love affairs. She remained a virgin, and she was the mildest and most loved of all the Olympians.

CONSTITUENTS OF PANHELLENISM. The Olympian deities owed their preeminence to the Greek poets, and it was reinforced by the great panhellenic festivals, such as the Olympian Games which were open to all Greeks but not to foreigners. The Greeks had no political unity, but the worship of the Olympians gave them a common denominator. The Greek city-states fought innumerable wars; yet when the Olympic Games were held in honor of Zeus, there was a truce that all Greeks observed. Wars ceased until the Games were finished. Apollo's oracle at Delphi served a similar function, particularly after 590 B.C.E., when Delphi became a small independent state with the care of Apollo's cult its sole reason for existence. The oracle received visitors from all over the Greek world and answered their queries with cryptic utterances believed to be inspired by Apollo. Foreigners could consult Delphi as well, but it was as a holy place for all Greece that Delphi rose to preeminence.

SOURCES

E. R. Dodds, *The Greeks and the Irrational* (Berkeley: University of California Press, 1971).

W. K. C. Guthrie, *The Greeks and Their Gods* (London, England: Methuen, 1950).

Albert Henrichs, "Dionysus," in *The Oxford Classical Dictionary.* 3rd ed. Ed. Simon Hornblower and Antony

Spawforth (Oxford, England: Oxford University Press, 1999): 479–482.

Karl Kerényi, *Zeus and Hera; Archetypal Image of Father, Husband and Wife.* Trans. Christopher Holme (Princeton, N.J.: Princeton University Press, 1975).

Harold Newman and Jon O. Newman, *A Genealogical Chart of Greek Mythology* (Chapel Hill: University of North Carolina Press, 2003).

Walter F. Otto, *Dionysus, Myth and Cult.* Trans. Robert B. Palmer (Bloomington: Indiana University Press, 1965).

Jon Solomon, ed., *Apollo, Origins and Influence* (Tucson: University of Arizona Press, 1994).

Edward Tripp, *Collins Dictionary of Classical Mythology* (Glasgow: Harper Collins, 2002).

OTHER GODS BEYOND THE TWELVE

TOO MANY TO COUNT. In addition to the twelve most important gods, there were innumerable other gods in Greek mythology. Any list made of them would be very long and still be incomplete. Some were old deities whom the poets passed over as uninteresting, though they still attracted worshippers. Eileithyia, whose worship on Crete went back to the Stone Age, was still indispensable. Sea gods belonged to the periphery of Greek religion, though they also were very ancient. One of them, the Old Man of the Sea, is known under various names: Proteus, Phorkys, Nereus, or *Glaukos,* meaning "blue-green," the color of the sea. Anyone wanting his cooperation had to overpower him, which was difficult, for he could change from one form to another at the blink of an eye. Only Heracles, the strongman of mythology, had the muscular strength to capture him and then hold on to him.

THETIS, MOTHER OF ACHILLES. Thetis was a sea goddess, and her attendants were mermaids called Nereides, who were the daughters of the Old Man of the Sea. She had a sanctuary in Thessaly which the tragic poet Euripides made the setting of his drama *Andromache.* Myth relates that both Zeus and Poseidon desired Thetis, but when they learned from Prometheus that her son would be stronger than his father, they saw to it that she married a mortal, Peleus. She bore him a son, Achilles, whom she tried to make immortal by burning away his mortal element, but Peleus interrupted the ritual and she left him in a rage and returned to the sea. Another story relates that she tried to make Achilles invulnerable by lowering him into a magic well, but since she held him by one heel as she immersed him, the water could not cover that part of his body, and it remained unprotected. Achilles died from an arrow wound in his heel, and this

story gave rise to the modern phrase "Achilles' heel" to describe an area of vulnerability.

THE GOD PAN. Pan was an ancient god of fertility who was not completely anthropomorphic. He was half-man, half-goat, and his homeland was Arcadia, a mountainous region in the central Peloponnesos. He was worshipped in sacred caves, one of which has been found in Athens under the Acropolis. The finds from this cave show that Pan was worshiped there in Mycenaean times and then, after a long period of neglect, worship began again after 490 B.C.E. In that year, the Athenians defeated the Persians at the Battle of Marathon, and they believed that Pan helped them. Thereafter, the Athenians held an annual sacrifice and a torch-race in his honor.

THE SPIRITS OF RIVERS, MOUNTAINS, AND TREES. Rivers were gods, and they could take part in human life. The river god Achelous was Heracles' rival for Deianira, Heracles' last wife, and Heracles had to wrestle with him to win her. In the countryside and sometimes even the cities there were the nymphs who associated with Pan, and were like the fairies of European folklore. They embodied the divine essences of the mountains, woods, trees, and waters where they lived. The nymphs of the woods were the Alseides, the Napaeae, and the Dryades. The Hamadryades were tree-nymphs—the life spirit of the trees—and when a tree died, its Hamadryas died with it. The water nymphs were Naiads, Potameids, Creneids, and Hydriads. Like Pan, they were often worshipped in caves. They were usually kindly sprites who patronized springs of sweet water and danced with Artemis on the mountainsides, but they could be dangerous. When the nymphs fell in love with Hylas, a handsome boy whom Heracles loved, they dragged him down into a spring as he fetched water there, and he drowned. It was dangerous to be loved by a nymph.

CASTOR AND POLYDEUCES. The twin gods, Castor—the famous horseman—and his brother Polydeuces—equally famous as a boxer—were called the Dioscuri, or *Dios kouroi* in Greek, which means "the youths of Zeus," and there is a "Homeric Hymn" which hails them as the "sons of Zeus." Greek mythology had various versions of the Dioscuri-myth: the *Iliad* explains that they did not take part in the Trojan War because they were already dead, whereas the *Odyssey* explains that they are living and dead men on alternate days. This refers to a myth in which Polydeuces was the immortal son of Zeus who loved his mortal brother, Castor, so much that he agreed to share his immortality. Thus they spent alternate days alive and dead. Sparta was their homeland, where they were worshipped with a cult image consisting of two upright pieces of wood connected by two crossbeams. They represented the spirits of the young warriors who rode horses into battle, for though Castor was a more famous horseman than his brother, both were known as "riders on white steeds." Under the name of "Castor and Pollux" or sometimes simply the "Castores," their cult spread very early to Rome, where the Theoxenia festival was held every year on the Ides of July (15 July) in their honor, and the Roman cavalry performed a ceremonial parade. The parade supposedly commemorated the Battle of Lake Regillus in the early days of the Roman republic when it defeated an effort to restore the Etruscan kings, and Castor and Pollux aided the Romans. They had a temple in the Roman Forum near the spring of Juturna where the two gods were seen watering their horses after the battle.

THE MYSTERIOUS "MISTRESS." Near Lykosoura in Arcadia a goddess called simply "The Mistress" had a temple which she shared with Demeter. There is some indication that "The Mistress" was reared by one of the Titans, but little else is known about her. She is reminiscent of the title *Potnia* meaning "Mistress" found in the Mycenaean "Linear B" tablets, often in phrases such as the "Mistress of Horses" or the "Mistress of Wild Beasts." A goddess named *Potnia* without any further qualification was an important deity in Mycenaean Pylos. The name of Zeus' wife, Hera, is thought to mean "mistress": a powerful female deity whom the poets transformed into Zeus' shrewish wife, shoving aside Zeus' first wife, the colorless Dione.

NEMESIS. At Rhamnous outside Athens there was a temple to a puzzling deity called Nemesis. There was a myth that Zeus tried to rape her, and she turned herself into various non-human forms to escape him, particularly into various kinds of fish. The word *nemesis* means wrath aroused by any unjust deed, or righteous indignation. The goddess Nemesis presided over retribution, and her adversary was *hubris*, an act of arrogant violence. She preserved the social order by visiting retribution on those who would destroy it.

ASCLEPIUS, GOD OF HEALING. Asclepius, whose famous healing shrine at Epidaurus in the Peloponnesos attracted the sick from all over Greece, is a reminder of how blurred the distinction could become between a hero, who was mortal and descended to the Underworld when he died, and a god, who belonged to the world above. Homer in the *Iliad* referred to Asclepius as a "blameless physician" who was already dead at the time of the Trojan War, where his two sons served in the Greek camp as doctors. Yet at Epidaurus a temple was built for him which housed a cult statue made of gold

and ivory, and to the south of the temple was his great altar where sacrifices were made to him as a god. His festival at Epidaurus, held every four years, required a theater that could hold 14,000 spectators. It is now the best-preserved ancient theater in Greece.

THE BIRTH OF ASCLEPIUS. Ancient authors had no doubt that Asclepius' father was the god Apollo, but they differed on his mother. The most common version of the myth relates that Apollo impregnated Coronis, the daughter of Phlegyas in Thessaly. Thus Asclepius was of Thessalian origin, and the Asclepiads—Asclepius' priests on the island of Cos whose most famous member was the doctor Hippocrates who is still known for the "Hippocratic Oath"—maintained that Asclepius was born in Trikka, in Thessaly. Epidaurus, however, also claimed to be his birthplace. That version of the myth maintained that Coronis was unfaithful and slept with another man while she was pregnant with Asclepius, and a crow brought the news to Apollo. Apollo wrathfully cursed the crow, turning its color from white to black, and then he slew Coronis. As she lay on the funeral pyre, he snatched the infant Asclepius from her womb and gave it to the centaur Chiron to rear, who taught him the arts of healing. He grew up to be so skilled a doctor that he restored a dead man to life, and for that Zeus killed him with a thunderbolt, for restoring the gift of life was a prerogative of the gods. In fact, only Zeus could do it, and he refrained from the deed. Thus Asclepius went down into the Underworld to live with the heroes. As his cult expanded, the myth was adjusted accordingly. Zeus, it was said, brought Asclepius into the circle of Olympus and made him a god. Thus he could receive sacrifice as a god and not merely the sort of offerings that were made to the *chthonic* deities, or the earthbound heroes as they were called, for the Greek word for earth was *chthon*.

SPREAD OF THE HEALING CULT. The cult of Asclepius grew increasingly popular. In Pergamum, a Hellenistic kingdom in Asia Minor that was carved out of Alexander the Great's conquests, there was an immense shrine to Asclepius a short distance out of the city, and it included a theater that could seat 3,500. The Romans, who called him Aesculapius, brought him from Epidaurus to Rome after a plague in 293 B.C.E. Instructed by an oracle in the Sibylline Books, they brought a sacred snake incarnating the god to Rome, and as the ship bearing the snake up the Tiber River to Rome reached the island known today as the *Isola Tiberina*, it slithered ashore. A temple for Aesculapius was built there and to this day there is a hospital on this island, named after the physician apostle, St. Bartholemew. Early Christians found Aesculapius a difficult pagan god to extirpate, and at the *Isola Tiberina* their solution was to Christianize his sanctuary by substituting St. Bartholomew for him.

SOURCES

John Boardman, *The Great God Pan: The Survival of an Image.* The "Walter Neurath Memorial Lectures" (New York: Thames and Hudson, 1998).

Philippe Borgeaud, *The Cult of Pan in Ancient Greece.* Trans. Kathleen Atlass and James Redfield (Chicago: University of Chicago Press, 1988).

Harry Brewster, *The River Gods of Greece: Myth and Mountain Waters in the Hellenic World* (London, England: I. B. Tauris, 1997).

Jacques Désautels, *Dieux et mythes de la Grèce ancienne* (Quebec, Canada: Presses de l'Université Laval, 1988).

THE UNDERWORLD AND ITS INHABITANTS

GODS OF THE UNDERWORLD. The Underworld was the House of Hades, the world of the dead, ruled by Zeus' brother, Hades. The name "Hades" means the "Unseen One," and one of Hades' most prized possessions was his "Cap of Darkness" which made him invisible. The Greeks did not typically worship him; only at one place in Greece did he have a temple. In Elis there was a temple to Hades that was open only once a year, and only the priest was allowed to enter. In the land of the Thesprotians in northwest Greece, there was an oracle of the dead, sacred to Hades and Persephone, which is probably where Odysseus made his descent into the Underworld. By and large, the Greeks preferred not to talk about Hades.

PERSEPHONE AND HECATE. Hades' wife was Persephone, queen of the Underworld and the daughter of Demeter, and her close companion was Hecate, goddess of the witches. In the magical spells, sorcerer's rituals, and hymns that have survived from the Greco-Roman world, Hecate is one of the deities most often invoked. Her most common epithet was *phosphoros*, that is, "Bringer of Light," and she is sometimes shown bearing two torches. For the Romans, she was identical with Persephone, Selene the Moon Goddess, and Diana, and a witch might invoke any one of them with her magical formulas. The Romans called her by the epithet *Trivia*, for she preferred a place where three roads met for her place of worship. Before Hecate was demoted to an underworld goddess of the witches, she was an ancient, beneficent goddess whom Hesiod in his *Theogony* invokes with a hymn of praise. The Hecate of the *Theogony* was a Titaness, sister of Apollo's mother Leto. She was

a kindly goddess, favored by Zeus, and a patron of fishers and horsemen, and a friend of shepherds and herdsmen. When Hesiod wrote, Hecate was still a deity who had many devotees, particularly in the region of Greece known as Boeotia, which was Hesiod's homeland. Her development into a goddess of witches came later.

GEOGRAPHY OF THE UNDERWORLD. The Underworld was the abode of the souls of the dead, and it was a dismal place. Homer's *Odyssey* relates that Odysseus encountered the shade of Achilles there, who told him that he would rather be alive and the slave of a landless man than king of all the dead in the Underworld. In Hesiod's *Theogony*, the Underworld was Tartarus, the prison of the Titans who were overthrown by Zeus. Hades and Persephone had a palace there that was guarded by a fearsome watchdog that wagged its tail in welcome for all who entered, but would not let anyone exit. The river of the Underworld was the Styx, a stream dreaded even by the gods, for if a god swore an oath by the Styx, and then broke it, he would lie in a coma for a year and, once he recovered, would be shunned by the other gods for nine more years. Only in the tenth year could he rejoin their councils.

PLATO'S "MYTH OF ER." The geography of the Underworld developed further when Plato concluded his best-known dialogue, *The Republic*, with a parable called "The Myth of Er." The story related the experience of a warrior named Er, who recovered from near-death and told a strange story of his experience. His soul left his body and journeyed to a place where there were two chasms into the earth and, above them, two chasms in the sky. Between them sat judges who commanded the souls of the just to take the right-hand chasm in the sky, and the unjust to take the left-hand chasm into the earth. Some, who had been evil beyond redemption in their lives, were too wicked for even the left-hand chasm, and they were hurled into Tartarus. Those that ascended the path through the right-hand chasm reached a meadow where they saw the Three Fates, the daughters of Necessity, whose names were Lachesis, Clotho, and Atropos. There the souls of the dead chose lots for the new lives they would live. The soul of Agamemnon, who commanded the Greek alliance that destroyed Troy, chose to be an eagle. Odysseus' soul, however, chose to be an ordinary man who would live an uneventful life. These souls then made their way to the River Lethe, where they had to drink its water that brought forgetfulness. Those that drank too much forgot everything; those that drank no more than required continued to remember something of their pasts. Then, after they had drunk, a great earthquake swept up the souls to their rebirth.

THE UNDERWORLD OF VERGIL. The Roman poet Vergil, who wrote the national epic of the Roman Empire known as the *Aeneid* in the first century B.C.E., put his stamp on the popular conception of the Underworld. Vergil combined ideas inherited from Greco-Roman tradition to present an idea of the Underworld that would haunt the imagination of the European literary tradition. The hero Aeneas was guided by the Cumaean Sybil whose cave can still be seen at Cumae near Naples in Italy. He passed Disease, Hunger, and Poverty, and other scourges of mankind at the entrance gate, and War, Perverted Pleasures, and the Furies on the threshold. From there the road led to the river Acheron where the ferryman who ferried the souls across—a fierce old boatman named Charon—would accept only those souls whose bodies had been buried. The souls of those whose bones had not been properly laid to rest had to wander for a hundred years before they were allowed to cross Acheron, which was an alternative name for the Styx in Vergil's *Aeneid*. Aeneas was not dead, but he carried a talisman—a Golden Bough that he had broken off a magic tree—and Charon recognized it as a permit to cross, and ferried Aeneas and the Sibyl over the terrible river. As Aeneas disembarked on the opposite shore, the three-headed watchdog Cerberus lunged at him, but the Sibyl gave him a drugged honey-cake and he was soon asleep. Then he entered the region where the dead were judged by a court over which Minos presided, for Minos, the mythical king of Crete, had become a judge in the Underworld. There Aeneas saw the souls of children who had died young, and persons condemned on false charges, and the souls of those who had committed suicide. Finally he reached the place inhabited by dead warriors where he met the heroes who had perished at Troy. On his left was Tartarus with its triple wall, surrounded by a torrent of flame called the Phlegethon, and from it came fearful cries of anguish. The Sibyl explained that this was the abyss where the Titans lay imprisoned, and where great sinners were punished. Tartarus was Hell.

THE ELYSIAN FIELDS. Aeneas and the Sibyl pressed on until they came to a region of woodland and meadow where the souls of the righteous dwelled, enjoying athletic games or dancing to the music of the lyre played by the great musician, Orpheus himself. These were the Elysian Fields, reserved for those who lived just lives. There Aeneas met the ghost of his father Anchises, who was walking among the souls that were waiting to be reborn. Anchises greeted his son with joy. Aeneas expressed amazement at seeing souls buzzing about like bees in a meadow, and Anchises explained the phenomenon by saying that these were the souls that were owed a second

body by Fate. They would drink the water of Lethe and be reborn. Then, with a splendid literary flourish, Vergil imagines Anchises pointing out the builders of the Roman Empire who were still to be born, until he reaches his own patron, the emperor Augustus.

THE TITANS: PRISONERS IN THE UNDERWORLD. Hesiod's *Theogony* relates that the Titans were the offspring of Ouranos and Gaia, that is, Heaven and Earth, whose rule was overthrown by Zeus. After a terrible battle, they were imprisoned in Tartarus. The usual explanation is that the Titans were pre-Olympian gods who ruled before the Greeks arrived in Greece, and the battle between the Titans and the Olympians reflects in some way a half-forgotten struggle between the early inhabitants of the north-eastern Mediterranean region and the Greek immigrants. The Titans might have a Near Eastern origin. It has often been noted that one of them was named Iapetos, which reminds us of the name of one of Noah's sons, Japheth. But Iapetos had no connection with a flood, even though the Greeks—like the Hebrews—had a flood legend and perhaps both flood legends derived ultimately from the same source.

THE CONQUEST OF THE TITANS. Most of the Titans were consigned to Tartarus after their defeat by Zeus, where the laments of the damned could be heard day and night, as Vergil described them in his *Aeneid*. But legend related that some Titans fought with the Olympians rather than against them, and thus survived. Moreover, Cronus, the lord of the Titans, continued to receive worship. There was a festival called the "Kronia" held in his honor at various places in Greece. In Athens it was held in Hekatombaion, the first month of the Athenian calendar which began about mid-July. It was a harvest festival, a kind of harvest-home holiday when masters and slaves feasted together. The social norms of the class system were abandoned briefly, and everyone was equal. Among the Romans, Cronus was equated with Saturn, and his festival, the Saturnalia, was held during the Christian Christmas season. There was a Roman legend, reported in Vergil's *Aeneid*, that when Zeus overthrew Cronus, the defeated god fled to Italy. There he brought civilization to the natives, and his rule was remembered as a Golden Age that was ended by the arrival of new immigrants known as the Ausonians and the Sicanians. The Romans recognized Saturn as a Greek import, for whenever a priest made a sacrifice to him, he left his head uncovered in the Greek manner, whereas priests sacrificing to Roman deities covered their heads. The Saturnalia was a merry festival. Slaves were given temporary freedom to do what they liked. Presents were exchanged, particularly wax candles, or dolls or images made of pottery. A mock king, or "Lord of Misrule," might be chosen to preside over the merriment. For a brief period, the social order was overturned.

THE SATURNALIA AS NEW YEAR'S FESTIVAL. Once Christianity became the official religion of the Roman Empire, many of the Saturnalia customs were transferred to the New Year's Day festivities. The old Titan Cronus himself had a curious afterlife. Greek art depicted him with a pruning hook, for he was a god of the harvests. But the pronunciation of his name "Cronus" is very close to the Greek word for "time," which is *khronos*. So the old Titan became Father Time, his pruning-hook became a scythe, and he reappears in the iconography of the Western New Year's Day holiday as Father Time who is ushered out at midnight on the last day of December by the child who represents the New Year.

THE TITAN PROMETHEUS. The Titan Iapetos sired four sons: Atlas whom Zeus sentenced to bear the weight of the sky on his shoulders; Menoitios whom Zeus consigned to the Underworld for his arrogance; and two Titans who complemented each other, Prometheus, who always planned in advance, and Epimetheus who was the exact opposite. Students of folklore recognize Prometheus as a familiar figure: a trickster who could outwit gods and men. A deception that Prometheus played on the gods explained the Greek custom of burning the inedible parts of their sacrificial animals on the altars, and feasting on the more appetizing cuts themselves. A question once arose between the gods and mortals about which portions of the sacrificial animals each should get as their due. Prometheus butchered the sacrificial ox and divided it into two portions. In one portion he put the steaks and prime ribs, but he hid them in the stomach of the ox so that they looked unappetizing. In the other he put the bones, but he camouflaged them so that they seemed the better portion. Then he asked Zeus to choose, and Zeus chose the bones. Hesiod, who tells the story, explained that Zeus allowed himself to be tricked, for it would not do for an omniscient Zeus to be deceived. Yet Zeus was angry. In revenge he denied humans fire. But Prometheus, taking pity on mankind, stole fire from Zeus' altar on Olympus and soon Zeus was outraged to see smoke arising from human habitations. He chained Prometheus to a cliff-side, and sent an eagle every day to devour his liver. Because Prometheus' liver was immortal like the rest of his body, it grew back every night, and Prometheus' agony continued until Heracles released him from his chains.

THE CREATION OF HUMAN BEINGS. It was Prometheus who created humans. Using his skill as a

master craftsman, he fashioned human beings out of clay, and the Latin poet Horace added that he used bits and pieces of other animals as well. The Greeks added other creation myths, including the myth of the "Five Ages of Man" which Hesiod relates in his *Works and Days*. In that myth, Zeus created five races of mankind, and the fifth race were humans of the present day. Another myth told that Mother Earth gave birth to men and women. After the flood killed the entire human race except for Deucalion and his wife Pyrrha, Zeus granted them one wish. Deucalion asked that the human race might live again, and Zeus told them to throw stones over their heads. The stones Deucalion threw became men; those that Pyrrha threw became women.

THE ORPHICS AND THEIR CREATION MYTH.

A sect known as the "Orphics" had another theogony, sharply different from Hesiod's. The patron hero of the Orphics was the great musician Orpheus, whose wife Eurydice died of a snakebite. He descended into the Underworld to bring her back to life, charming his way past Cerberus, the watchdog of the Underworld, by playing music. Hades himself was so delighted that he allowed Eurydice to follow her husband to the world above, but on one condition: Orpheus was not to look back until they left the Underworld. But as he neared the exit of the Underworld, he could restrain himself no longer. He looked back and saw Eurydice, escorted by Hermes. She smiled at her husband and turned back to the Underworld, guided by Hermes. This death and near-resurrection myth attracted a cult following of converts who lived what they called the "Orphic life." Their creation myth told that in the beginning, there was a primordial power, either Time or Night. Out of it came an egg, which gave birth to *Phanes* (the Shining One). Phanes gave birth to *Ouranos* (Heaven) and *Gaia* (Earth), who reproduced by the sexual union. Their coition created Cronus and Rhea who copulated and produced the generation of Zeus, and so on by a repetition of murder and sexual acts until the cycle of violence arrived at the race of men. Mortals who opted for the pure Orphic life should refrain from all killing, including animal sacrifice, and attain reconciliation with the gods by a pure life. Hesiod's creation myth had described progress from chaos to the present-day Age of Iron which was unpleasant but relatively orderly. The Orphic myth described a process of human degeneration.

SOURCES

Marcel Detienne, *The Writing of Orpheus; Greek Myth in Cultural Contact*. Trans. Janet Lloyd (Baltimore, Md.: Johns Hopkins University Press, 2003).

Robert Garland, *The Greek Way of Death*. 2nd ed. (London, England: Bristol Classical Press, 2001).

Charles Penglase, *Greek Myths and Mesopotamian Parallels and Influences in the Homeric Hymns and Hesiod* (London, England; New York: Routledge, 1994).

HEROES AND DEMIGODS

THE AGE OF THE HEROES. The myth of the "Five Ages of Man" in Hesiod's *The Works and Days* was borrowed from the mythology of the Middle East. The Middle Eastern version, however, told of only four ages: a blessed Golden Age, followed by a lesser Silver Age which was in turn followed by a Bronze Age, and finally the age of the present day, the Age of Iron. The Greek adaptation inserted a fifth age between the Age of Bronze and the Age of Iron: the age of the heroes and of heroines. These were the men and women who peopled Greek mythology and lived within a mythological time frame. Some were warriors—such as Odysseus, Agamemnon, and Menelaus, who fought at Troy in the Trojan War—or movers-and-shakers of the mythic past, such as Helen of Troy. Theseus, who was the special hero of Athens, killed the Minotaur at Knossos on Crete, and then became king of Athens. He performed heroic deeds that rivalled the famous Twelve Labors of Heracles. Heracles, the superman of mythology, performed not only his Twelve Labors—incredible feats of strength done in penance for killing his family in a fit of insanity—but he was credited with various other deeds as well which only a man of incredible strength and virility could perform. The Dorian Greeks who settled in the Peloponnesos after the collapse of the Mycenaean kingdoms considered him their ancestor and called themselves *Herakleidai* or "offspring of Heracles." The kings of the Spartans, who were Dorians *par excellence*, had pedigrees that went back to Heracles.

SEMI-DIVINE. The heroes were not gods, though they might be called *hemitheoi* meaning "half-gods" or demigods. After death, they lived in the Underworld, not on Mt. Olympus, and as a general rule, no temples were built to heroes. Instead, the hero's tomb became a *heroon* or "hero-shrine," where the heroes were worshipped as if they were chthonian powers, that is, spirits of the earth, the nether world. Sacrificial animals with black hides were sacrificed to them after daylight had faded, at night or in the evening. The blood from the sacrificial victims was poured into a trench so that it would trickle down into the earth and feed the spirit, or shade, of the hero. A god would have a sacrifice made

to him on a high altar (*bomos*), whereas a hero had an *eskhara*, which was a low, round altar though—as is frequently the case in Greco-Roman religious practices—there were exceptions to the rule. Heroes were generally tied to a specific locality, for most of them had only one tomb. They were usually barely known outside the region where they were worshipped. Only the great international heroes such as Heracles, Theseus, Perseus, Jason and Medea, and the heroes of the Trojan War were famous all across Greece, and that was because there were innumerable myths told about them. Every storyteller felt free to embellish the old tales about them, and more than one place might claim to possess their bones. Heracles in particular had myths connecting him with localities all over the Mediterranean world, but he was a super-hero. Most heroes were hometown men, and their cults have puzzled historians of religion. There have been efforts to explain them as half-forgotten gods—"faded gods" is the term used, with the implication that gods can grow dim with time, rather like a slow-motion "fade-out" in a movie—or old vegetation gods, or simply men or women of the past who were remarkable for their great deeds, rather like Christian saints. One common explanation was that when a great man died, offerings were made at his tomb which developed over the course of time into a *heroon*. Thus a *heroon* on the site of a Mycenaean tomb showed that the memory of the Mycenaean warrior buried there lasted into the classical period. Archaeological evidence refutes this idea, however. The hero-shrines date from the eighth century B.C.E. Between about 750 B.C.E. and 700 B.C.E., tombs from the Mycenaean era which were discovered—probably accidentally in most cases—were given new importance as the burial places of heroes, and offerings were made there. The Greeks of the eighth century B.C.E. probably had no idea who the original occupants of these tombs were any more than scholars of the twenty-first century do, but they did know that their local hero should have had a burial somewhere in the vicinity of the Mycenaean tomb. So to whom else could the tomb belong? The logic was irrefutable. Thus a prehistoric tomb belonging to persons unknown, but suitably ancient, could become the site of a hero cult.

HERO CULTS AND THE RISE OF THE POLIS. The eighth century B.C.E. was the period when the *poleis* or city-states of Greece were developing and marking out their territories, and the hero-cults which arose at the same time were connected with this development. A legitimate *polis* had a hero, or perhaps more than one. The bones of a hero served to preserve and sanction a *polis* in much the same way as the relics of a saint might preserve a community in the Christian Middle Ages. The Greek historian Herodotus, whose *Histories* was published about 425 B.C.E., told how Sparta, which had been fighting the *polis* of Tegea in Arcadia for many years without success, consulted the oracle at Delphi and was told to bring home the bones of Orestes, the son of King Agamemnon, who commanded the Greek coalition in the Trojan War. When the Spartans asked where the bones of Orestes lay, the reply was that they were where two winds were blowing and iron smote iron. The Spartans were baffled and may not have been able to solve the riddle except that one day, a Spartan, taking advantage of a lull in the hostilities, visited a smithy in Tegea. The blacksmith there told him that when he was digging a well in his courtyard, he came across a huge coffin with a corpse inside. The great size of the bones showed that they belonged to the Age of Heroes, so the smith reburied them. His Spartan visitor reasoned that these must be the mortal remains of Orestes, for the two winds were the smith's bellows and the iron that smote iron was the smith's hammer striking his anvil. The Spartans tricked the smith into selling his courtyard and found the bones, and once these presumed relics of Orestes were in Sparta, she thereafter always had the better of her enemies until finally she managed to dominate the Peloponnesos.

THESEUS AND ATHENIAN POLITICS. The hero Theseus served Athens in a similar way. In his old age Theseus was banished from Athens, and went to the island of Skyros in the northern Aegean Sea. There the king of Skyros murdered him. About 475 B.C.E., the Athenian general Cimon, who was a shrewd politician as well as a good military officer, was campaigning in the area and on Skyros he unearthed huge bones. A cynic might suggest that they were dinosaur fossils and that Cimon did not find them entirely by accident. But their size seemed to prove that they belonged to the Age of Heroes, and it was easy to arrive at the conclusion that they had to belong to Theseus. Cimon carried them back to Athens, and his pious deed brought him more acclaim than any of the many victories he won. A *heroon* was built for Theseus in the marketplace of Athens. A festival was established for him, and the makers of myth—poets and dramatists—developed him into the founder-hero of the Athenian city-state and the patron of democracy.

THE HERO IN HISTORICAL TIME. Not all heroes belonged to the Heroic Age. Some were historical figures. Beginning in the mid-eighth century B.C.E., and for the next two and a half centuries, the Greeks planted colonies in the western Mediterranean region, and in the north Aegean and Black Sea area. Careful planning

usually went into the planting of colonies in new and often strange lands. An *oikistes*—the word has been anglicized as "oecist"—was appointed to head the colonial expedition. The oecist saw to it that a new home far away from the homeland of his colonists was established in an orderly fashion for them. When he died, a *heroon* would be built for him in the marketplace of the new city he had founded and sacrifices would be offered to his remains. Other great men might also be revered as heroes. At Olympia, where the Olympic Games were held, a *heroon* was built for King Philip II of Macedon, the father of Alexander the Great. The cult of heroes made it easy for the Greeks to believe that kings possessed a kind of divinity, and thus it need not surprise us to find divine kings who received worship in the Greek world after Alexander the Great's death. Within a couple generations of his death, the Hellenistic kings who had carved kingdoms for themselves out of Alexander's conquests, declared, first, the founders of their realms divine, and then themselves, too. From these divine kingships of the East, the idea passed to Rome. The Roman senate decreed that Julius Caesar became *divus* (divine) after he was assassinated in 44 B.C.E., as was the first emperor, *Imperator* Caesar Augustus, to give him his official name. Although the worship of dead emperors was an accepted practice, the worship of a living emperor met resistance within Rome itself; neither Augustus nor his successor Tiberius liked the idea, for Roman customs had no place for deified kings, and both Augustus and Tiberius were conservative in matters of religion. Yet outside Rome, the acceptance of living emperors as gods encountered little resistance and soon the cult of the emperors, living and dead, became an important instrument for legitimizing imperial rule.

NAMELESS DIVINE FORCES. The Greeks recognized another category of divine force as well which had the power to interfere in human affairs. These were the *daimones*—in singular form *daimon*—who were not worshipped with offerings as the heroes were. The English word "demon" comes from *daimon*, but while the Western concept of demons generally refers to unpleasant supernatural forces, the Greek *daimones* might be either malevolent or benign. They governed the impulses that moved men to action, or perhaps inaction. In the Hellenistic world after Alexander the Great, the *daimones* were often regarded as guardian spirits that looked after mortal men. They existed on the periphery of religious practices. They had no festivals or organized cults.

DEIFIED ABSTRACTIONS. Perhaps the logic which the Greeks applied to nameless forces called *daimones* also applied to personifications of abstract entities such as "Peace," "Wealth," or "Luck." In the fourth century B.C.E., the sculptor Kephisodotos made a statue for Athens of *Eirene* ("Peace") holding the infant "Wealth" in her arms. He treated *Eirene* as a goddess, the personification of the spirit of peace. The boundary between an abstract entity and a divinity was easy to cross. Thus it is clear that "Luck" or "Fortune"—in Greek, *tyche*—was treated as a goddess. In the Hellenistic world, when faith in the power of the Olympian deities grew more problematic, *tyche* became a popular goddess in whom cities might put their faith, and they erected statues showing her as a woman wearing a model of a city's fortification walls as her crown. In a society where "Fortune" seemed to play an increasingly important role, it was important for a city to cherish its *tyche*. If "Fortune" was in a good mood, she might forget to be blind, and bestow good luck on her city.

SOURCES

Carla Maria Antonacci, *An Archaeology of Ancestors: Tomb Cult and Hero Cult in Early Greece* (Lanham, Md.: Rowman and Littlefield, 1995).

Claude Calame, *Thésée et l'imaginaire athénien: légende et culte en Grèce antique* (Lausanne: Editions Payot, 1990).

Jennifer Larson, *Greek Heroine Cults* (Madison, Wisc.: University of Wisconsin Press, 1995).

Deborah Lyons, *Gender and Immortality: Heroines in Ancient Greek Myth and Cult* (Princeton, N.J.: Princeton University Press, 1987).

HERACLES, THE SUPER-HERO

A HERO WHO BECAME A GOD. Heroes belonged to the Underworld, and probably the earliest myths about Heracles consigned him there, too, after his death, for in most of Greece, the cult of Heracles was a hero-cult. But as the poets elaborated the Heracles-myth, it developed a happier ending. He was taken up to Mt. Olympus where he reconciled with his bitter enemy, Hera, and married her daughter, Hebe. In fact, the name "Heracles" means "The Glory of Hera," or "Glory through Hera," which seems to indicate that Hera was his patron. His name is at odds with the myth that portrayed him as a victim of Hera's jealousy because he was a son of Zeus by a mortal woman, Alcmene. Yet only at one place in Greece was Heracles worshipped as a god: on the island of Thasos, where he had a sanctuary; he received sacrifices both as a god, on a high altar, and on a low altar as a hero.

HERACLES' BIRTH. Heracles' mother, Alcmene, was the wife of Amphitryon, who traveled to Thebes with his wife after killing his father-in-law, Electryon, the ruler

of Mycenae. During a time when Amphitryon's military duties took him from Thebes, Zeus assumed Amphitryon's likeness and slept with the lovely Alcmene. Later the same night, Amphitryon arrived home and slept with Alcmene, too, who was amazed at his ardor since she thought he had slept with her only a few hours earlier. Alcmene gave birth to twins: Iphicles, who was Amphitryon's son, and Heracles, who was sired by Zeus.

HERA'S JEALOUSY. Hera was bitterly jealous. While Alcmene was in labor, Zeus prophesied that the next descendant of the hero Perseus to be born would rule Mycenae. Alcmene was the granddaughter of Perseus, the founder of the Perseid royal house of Mycenae. Hera heard the prophecy and delayed Heracles' birth. Alcmene remained in labor so long that Perseus' grandson, Eurystheus, was born first and consequently Heracles became Eurystheus' subject. Hera continued her persecution by sending two great serpents to destroy Heracles in his cradle, but he throttled them. Even after he grew up and married Megara, daughter of Creon, king of Thebes, Hera visited him with a fit of madness, and he killed Megara and their three sons. When he recovered his sanity, he consulted the Delphic oracle to learn what he should do to expiate his crime. He was told to submit himself to Eurystheus, king of Mycenae, who would assign him twelve labors. The number "twelve" is the canonical number, but there are variant accounts which assign him ten and have a somewhat different list of exploits.

THE FIRST SIX LABORS. The first labor was to slay a lion that terrorized Nemea. No weapon could pierce its hide, so Heracles strangled it, flayed it, and henceforth wore the skin himself. He then slew the Hydra, a many-headed reptile that lived in the swampland at Lerna. Next he captured a wild boar at Erymanthus and brought it back on his shoulders to Eurystheus, who was terrified at the sight of it. He then captured the Hind of Keryneia, and next killed the fierce birds that infested Stymphalus. The sixth labor was the cleansing of the stables of Augeas, who owned many cattle but had never cleaned their stables. Heracles flushed out the manure by diverting a local river through them.

THE LAST LABORS. Unlike the first group of labors which were all confined to the northern Peloponnesos, the next six took Heracles further afield. His seventh labor was to capture a wild bull from Crete. Heracles brought it back to Eurystheus and then let it go to continue its depredations. His eighth was to capture the man-eating horses of Diomedes, the king of the Thracian Bistones. Next he was assigned the task of bringing back the sash of Hippolyte, the queen of the Amazons, because

Eurystheus' daughter wanted it. The Amazons were warrior women, and though Hippolyte was quite willing to give Heracles her sash when she learned what his errand was, Hera stirred up trouble and there was a bloody battle between Heracles and the Amazons before he got the sash. The last three labors are variants of the theme of a mortal conquering death. The tenth was to capture the red cattle of Geryon, a triple-bodied monster who had a watchdog with two heads and lived beyond the western reaches of the Mediterranean. It was while he was performing this task that he passed through the Strait of Gibraltar and set up pillars on both sides of it, called the "Pillars of Heracles." There were various stories of how he made his way back to Greece with Geryon's cattle. One related that he spent a night on the site of Rome, where a local monster named Cacus tried to steal the cattle. Another told that the cattle stampeded and led Heracles into what is now the Ukraine, where he slept with a monster-woman and sired the Scythian people. Still another related that he borrowed the vessel of Helios, the Sun God, that Helios used every night after he set in the west to voyage underground back to the east where he would rise next. The eleventh labor took Heracles to the Underworld where he captured Cerberus, the three-headed watchdog of Hades. The final labor took him to the far west, to the world's end, where there grew a tree with golden apples that was guarded by a dragon in a garden belonging to the daughters of Hesperus. Heracles got them and brought them back to Eurystheus.

MORE CRIMES. The violence of Heracles is a recurrent theme. Having completed his labors, he committed another crime by murdering his half-brother Iphitus in another fit of madness. This crime was more than fratricide; it breached the laws of hospitality, for Iphitus was Heracles' guest when Heracles hurled him down from the walls of Tiryns. The pollution that resulted from this double crime caused him to contract a terrible disease, and he went to Delphi to ask for a cure. When the Pythia refused to prophesy for him, Heracles, in a rage, seized the tripod on which she sat and would have run off with it except that Apollo himself pursued him and wrestled with him for the tripod. The contest between god and hero ended with Zeus separating them by a thunderbolt. The oracle did speak at this point, and told Heracles that he must work as a slave for three years if he wanted to be purified.

FURTHER EXPLOITS. Thus Heracles served as a slave of Queen Omphale of the Lydians for three years and performed various exploits for her. After his three-year stint was complete, Heracles, now cured of his disease, had a number of other adventures, including the capture

of Troy and setting Priam, who was still a young man, on the Trojan throne. Heracles' last wife was Deianira, and to win her he had to wrestle with the river-god Achelous. While he was traveling home with his new wife, he reached a river where Nessos, a centaur (half-horse and half-man), carried people across for a fee. Heracles himself crossed without help, but he allowed Nessos to carry Deianira. As Nessos emerged from the river, he tried to rape her, but her screams reached Heracles, who shot Nessos with an arrow. As the centaur lay dying, he whispered to Deianira that she could make a love-potion by taking the sperm he had ejaculated and mixing it with blood from his wound. Deianira followed his instructions. The potion would prove to be Heracles' undoing.

HERACLES' DEATH. Heracles' career of war and homicide ended not on the battlefield but as the result of his wife's insecurity. The king of Oechalia, Eurytus, had offered his daughter, Iole, to whoever could defeat him and his sons at archery. Heracles won, but Eurytus refused to give him Iole because he remembered the fate of Heracles's first wife, Megara, whom Heracles had killed in a fit of insanity. Heracles nursed a grudge against Eurytus because of the broken promise, and he attacked Oechalia, killed Eurytus and his sons, and took Iole by force. He then sent a herald home to bring him a brightly-colored tunic to wear as he offered sacrifice before wedding Iole. When Deianira learned about Iole, she feared that she was losing Heracles' love, and so she smeared the love potion on the tunic. Heracles put it on, and as soon as it grew warm with the heat of his body, it burned into his flesh. He was brought home to Trachis in agony. When Deianira saw his suffering, she hanged herself. Heracles then instructed his elder son by Deianira, Hyllus, to marry Iole when he reached manhood, and he himself went to Mt. Oeta in Trachis where he had a funeral pyre built and climbed on it. Mt. Oeta is one of the earliest places in Greece where there is archaeological evidence of a cult of Heracles, and so if the story of Heracles' death is a later addition to the myth, as some have argued, it is an early addition. Poets and storytellers would later add the detail that, as the pyre burned, there was a clap of thunder, and as a cloud enveloped Heracles he was snatched up to Mt. Olympos.

HERACLES IN ITALY. The myth of Heracles came to Italy very early. He was popular among the Etruscans. In Rome, he received sacrifice at the *Ara Maxima* (The Greatest Altar) near the Cattle Market in Rome, and significantly, the sacrifice was "according to Greek rite," that is the priest left his head uncovered as he performed it. The Romans themselves found the rites of Heracles, whom they called Hercules, difficult to explain. Why was it a Greek rite? Why, too, were women barred from approaching Hercules' altar? There was a legend that before Rome was founded, there was a settlement of Greek colonists on the site, led by a king named Evander, and the worship of Hercules went back to his time. Like many Roman religious rituals, the forms of the rite remained unchanged over the centuries, but the reasons for them were forgotten.

THE SUFFERING HERO. One unexpected development of the Heracles-myth was its use as a paradigm of a great man who suffers for the good of mankind. The rationale was that he spent the best years of his life performing labors that rid Greece of monsters, or pushed back the boundaries of the known world. In the period after Alexander the Great when great Hellenistic kingdoms emerged in the lands Alexander had conquered, Heracles became a model king who labored during his life to make the world a better place and was rewarded with divine honors after his death. Under the Roman Empire, the myth continued to have its uses. In 285 C.E., the emperor Diocletian made much-needed reforms, among them taking a junior colleague as emperor. As director of the empire, he called himself "Iovius" after Jupiter, the Roman Zeus, and his junior colleague became "Herculius," who used his power in the service of his subjects. The myth lives on in comic-book heroes such as Superman and Spiderman: men who use their enormous strength to rid society of evils and make the world a better place.

SOURCES

G. Karl Galinsky, *The Herakles Theme* (Oxford, England: Oxford University Press, 1972).

A. Schachter, "Heracles," in *The Oxford Classical Dictionary.* 3rd ed. Ed. Simon Hornblower and Antony Spawforth (Oxford, England: Oxford University Press, 1999): 684–686.

Michael Simpson, trans., *The Gods and Heroes of the Greeks: The Library of Apollodorus* (Amherst, Mass.: University of Massachusetts Press, 1976).

Philip E. Slater, *The Glory of Hera* (Boston, Mass.: Beacon Press, 1968).

DISCOVERING THE WILL OF THE GODS: ORACLES AND DIVINATION

THE IMPORTANCE OF SEERS. It was vitally important not to offend the gods, but how could mortal men know what the gods wanted them to do, or learn what fate had in store for them? The gods might vouchsafe a sign that could be taken as an omen, good or bad. Reading divine signs and omens correctly required skill and

learning, and there were seers in ancient Greece who specialized in the art. It was important to watch the phases of the moon, and the meaning of an eclipse could test the limits of a seer's skill. There were seers that belonged to clans of hereditary soothsayers who could trace their ancestry back to some legendary vaticinator, or prophet, whose knowledge came from the gods, particularly Apollo who was the most important god of oracles. There was one such clan at Olympia, the Iamidae, or "Descendants of Iamus." Iamus was a son of Apollo and became a prophet because Apollo directed him to do so. The Iamidae continued to live at Olympia until well into the third century C.E.

COMMUNICATION BY DREAMS. A god might communciate by dreams. Dreams were a favorite method of Asclepius, the healing god. Patients who came to his sanctuary at Epidaurus slept in the hospice, and as they slept, the great harmless snakes that embodied the god's spirit would slither around and over them, and a dream would visit them and tell them what treatments the god prescribed. Asclepius' sanctuary was full of votive offerings by patients who left terracotta models of the parts of their body that had been healed, and the sick continued to seek Asclepius' help well into the Christian era.

TAKING THE AUSPICES IN GREECE. When sacrifices were made, the entrails of the sacrificial victim were examined carefully, with special attention given to the liver. Any abnormalities were noted, and their meaning interpreted by a seer skilled in the craft of haruspicy, that is, the art of interpreting signs and omens in entrails. Ill omens were taken seriously, as is illustrated by a story from Greek history. In 479 B.C.E., the Greeks were about to fight a battle against the Persians at Plataea, a little city-state that neighbored Athens. The Persians were advancing against the Spartan contingent and inflicting severe casualties with their barrage of arrows. The Spartans made the customary sacrifices before battle, but the auspices were not favorable. The Spartans waited, even though the Persian arrows took a deadly toll. The priests continued to slaughter sacrificial victims, but as long as the omens remained unfavorable the Spartans waited. At last the Spartan commander, Pausanias, turned his eyes towards a temple of Hera by the battlefield and in a loud voice prayed to her to save the Greeks from defeat. At that moment, the sacrifices yielded a favorable omen, the Spartans advanced against the Persians and, after a hard struggle, they won a complete victory.

AUGURIES IN ROME. Among the Romans, auguries and auspices—which were for practical purposes the same—were a fine art. The Roman augurs, who were Rome's official diviners, formed a committee called a *col-legium* which originally had three members but increased gradually to sixteen. Their duty was to observe signs, such as the flight of birds, and interpret them. They received reports of any unusual events, such the birth of a two-headed calf. On the Capitoline Hill the eating habits of a group of sacred chickens were open to interpretation by the augurs: if they refused to eat at all, that meant an ill-omened day. Roman armies on campaign took with them sacred chickens whose eating habits were carefully watched. It was a very good sign if they ate so as to drop a little food from their beaks. While it is not possible to know how seriously all the Romans took these signs, it is clear that they observed ritual meticulously. One story from their wars with Carthage seemed to prove that it was foolhardy to ignore auguries. In the First Carthaginian War, which cost Rome heavy casualties, a Roman fleet was about to engage a Carthaginian squadron when the sacred chickens aboard the Roman flagship would not eat. In disgust, the commander kicked them overboard, saying, "If you won't eat, then drink!" and joined battle. The Romans lost. The moral was that it was wise to pay attention to auguries. Auspices—from the Latin *auspicium* meaning "omen"—had some importance in the public life of early Rome. Certain magistrates were given the "Right of Auspices," and they played a role in elections or inauguration into office. The auspices would be taken for a governor who was going off to a province to administer it—that is, a magistrate with the "Right of Auspices" would examine the omens and interpret them. As the Roman Empire grew older, the practice fell by the wayside.

THE ORACLE OF ZEUS AT DODONA. The word "oracle" is used in two senses: it can be the place or the shrine where a god made his will known, or it can be the god's message itself. There were a number of famous oracles in the Greek world. The oldest was an oracle of Zeus and Dione at Dodona in northwest Greece. The cult center there was an oak tree growing in a sacred precinct or *temenos* surrounded by a low wall. Only in the fourth century B.C.E. was a simple stone temple built, and although later embellishments were added to the site, including a fine stone theater, Dodona remained a small place. A person who wanted to consult the oracle wrote a question on a lead tablet and submitted it. The priests then evidently divined the will of Zeus by interpreting the rustle of the oak leaves belonging to the sacred tree. Some lead tablets with questions written on them have survived, and to judge from them, many who consulted Zeus presented queries of the sort that a "Personal Advice" columnist in a newspaper might receive today.

THE ORACLE OF APOLLO AT DELPHI. The oracular god *par excellence* was Apollo who had several

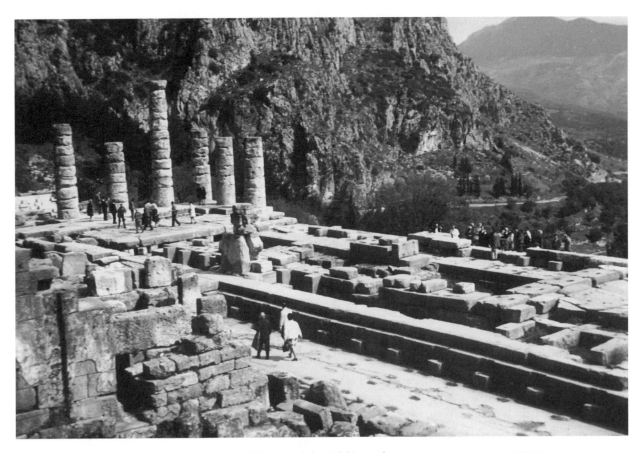

Ruins of the temple of Apollo at Delphi, Greece, which housed the Delphic oracle. **COURTESY OF JAMES ALLAN EVANS.**

renowned oracles, the most famous of which was at Delphi. There was a legend that a shepherd at Delphi noticed that if his flock approached a chasm in the rock, they began to leap about in a frenzy. He approached the chasm himself and found himself possessed by the spirit of prophecy. The Delphians, on learning of this phenomenon, chose a woman called the Pythia to prophesy for them all, and placed her on a tripod over the chasm. She fell into a trance-like state and uttered cryptic words. There was a real-life Pythia, a woman over fifty years old, who dressed as a young virgin to accentuate her purity. She gave her prophecies on only one day a month, except for the three winter months when it was believed that Apollo left Delphi and the god Dionysus took up residence instead. Originally, in fact, the Pythia gave oracles only one day each year, on Apollo's birthday, but the demand was such that she had to become more accessible. When the Pythia was not giving oracles, a consulter could get a reply to his query by drawing lots, and the method worked well enough, particularly if the answer that was needed was simply "yes" or "no." A mixture of black and white beans was placed in the bowl of Apollo's tripod. The Pythia would pick a bean at ran-

dom, and its color would give the answer. This was a cheap and easy way of consulting the oracle, and most private consultations seem to have been of this sort.

ORACLES FROM THE PYTHIA. On the appointed day when the Pythia herself was to give oracles, she washed herself at the Castalian spring which still flows at Delphi and purified herself in the smoke from laurel leaves and barley. She then went to the Temple of Apollo where the Delphian priests sacrificed a goat. The goat was expected to shiver before the sacrifice, thus indicating Apollo's willingness to use the Pythia as his medium. If the goat failed to shiver, the priests would sprinkle it with cold water and if it still did not shiver, they would accept the unfavorable omen and cancel the proceedings. If the sacrifice was successful, the Pythia would enter the temple and take her seat on a tripod—the tripod, which was a kettle with three legs used for boiling stews, was a sacred ritual vessel, used in sacrifices. She went into a trance and the answers she gave to the queries put to her were in a strange, unintelligible language that the priests interpreted. Most of the oracles that have been reported in literature were in polished hexameters, the meter used

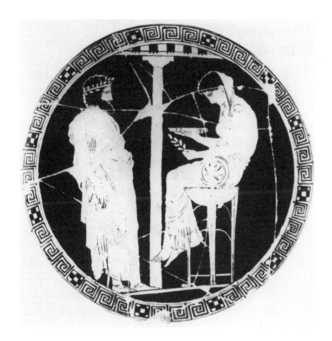

Greek red-figure vase painting showing Aegeus, king of Athens, and father of Theseus, consulting the Pythia at Delphi, shown seated on a tripod, giving an oracle. 5th century B.C.E. **FORTEAN PICTURE LIBRARY. REPRODUCED BY PERMISSION.**

The Cave of the Cumaean Sibyl, a cavern cut in the cliffside at Cumae, outside Naples, Italy. In Vergil's *Aeneid,* Aeneas encounters the Sibyl here. © MIMMO JODICE/CORBIS.

by the epic poets. The oracles that are considered most genuine, however, are in prose.

INTERPRETATION. The oracles were renowned for their ambiguity. Croesus, king of Lydia, whose memory survives in the saying "as rich as Croesus," asked the Pythia if he should attack the empire of Persia that was a threat on Lydia's eastern border. The oracle told him that if he attacked, a great empire would fall. Assuming that the oracle meant the Persian Empire, Croesus attacked, and discovered too late that the empire destined to be overthrown was his own. Yet the Delphic oracle could give fairly straightforward advice as well. Before a city-state sent out a colony, it consulted Delphi and often got good advice. The fact is that Delphi was a communications center, for it received visitors from all over the Greek world and beyond, and got reports from them. The priests at Delphi were well-informed, more so than most people in Greece in the days before modern methods of communication.

THE ORACLE OF THE "WOODEN WALL." The most famous Delphic oracle, and the longest to survive, is the response which the Pythia gave the Athenians when they consulted her on the eve of the Persian War. The Persian king, Xerxes, invaded Greece in 480 B.C.E. with an enormous army, and as the Athenians anxiously awaited the onslaught, they sent messengers to Delphi for an oracle. These envoys performed the preliminary rites, then entered the temple and squatted or sat before Pythia's tripod. Immediately the Pythia uttered a prophecy, which the priests relayed in good dactylic hexameters—the meter used by the epic poets—and its meaning was clear. Resistance to Persia was hopeless. The Athenians were dismayed, but a Delphian—probably a priest—advised them to approach the Pythia again, this time as suppliants carrying an olive branch. Two consultations on the same day were generally not allowed; however the Athenian messengers entered the temple again and asked for a more comforting prophecy, saying that otherwise they would remain in the temple until they were dead. The second oracle was hardly more cheerful than the first, but it held out a ray of hope. It said that Zeus had yielded to Athena's prayers to this extent: the Wooden Wall would save the Athenians, and it concluded by invoking the island of Salamis that would destroy the offspring of women either in the fall or the spring. When this second oracle was brought back to Athens, there was a great debate about its meaning. The *khresmologoi*—men skilled at expounding oracles—argued that it prophesied a defeat at Salamis. The politician Themistocles argued for a happier meaning by claiming that the Wooden Wall was the Athenian fleet, and the oracle's reference to Salamis presaged a victory there, for it called the island "Divine Salamis." As it turned out, the allied Greek navy did defeat the Persian

fleet at Salamis, which proved Themistocles right. Both Themistocles and Delphi gained prestige. Modern students of the ancient world are more cynical about Delphi's clairvoyance, suspecting that Delphi was really ready to collaborate with the Persians and made use of its prophetic reputation to weaken Greek resistance.

SIBYLS. At Delphi, there was a rock that was always left in its natural state as if surrounded by a taboo, and it was known as the Rock of the Sibyl. While there was no Sibyl at Delphi in the historical period, a legend told that Delphi was the seat of an oracle prior to Apollo's appropriation of the site for his own oracle. The earlier oracle was a Sibyl who sat on this rock and prophesied. The legend of the wandering of the Sibyl is a curious one. As time went on, the number of Sibyls multiplied. First there was only one, then two, then more until the legend knew ten Sibyls. They were all prophetesses, who uttered prophecies in states of ectasy. A famous sibyl lived at Cumae on the Italian coast near Naples, where the Greeks founded a colony about 750 B.C.E. The cave of the Cumaean Sibyl, cut into the living rock, is still to be seen there. Vergil, in his *Aeneid*, related that his hero Aeneas visited the Sibyl when he landed in Italy at Cumae. There was also a legend that the Cumaean Sibyl once sold a collection of her prophecies to an early king of Rome, Tarquin the Elder. Whatever the truth of the tale, Rome did have a collection of oracles called the Sibylline Books, written in Greek, which were consulted only on order of the Roman Senate. The books were lost when the Roman Capitol was burned in 83 B.C.E. during a period of civil war, but a new collection was put together to replace them and it still existed in the fourth century C.E. when they were consulted for the last time. Oracles lost their prestige as time went on and popular opinion became more cynical. Delphi was still consulted in the period of the Roman Empire, but no longer on questions of much importance. The last Delphic oracle that is recorded was given to an emissary of the last pagan emperor Julian (361–363 C.E.). It said,

> Tell the king, the cunningly-built hall has fallen in the dust, Phoebus (Apollo) no longer has a hut, a prophetic laurel, or a speaking stream. Even the talkative water has ceased to exist.

SOURCES

R. Flacelière, *Greek Oracles* (London, England: Elek Books, 1965).

Richard P. H. Greenfield, "Divination," in *Encyclopedia of Greece and the Hellenic Tradition.* Ed. Graham Speake (London, England: Fitzroy Publishers, 2000): 501–503.

Alan Walker, *Delphi* (Athens, Greece: Lycabettus Press, 1977).

WORSHIPPING THE GODS: SACRIFICES AND TEMPLES

TEMPLES. Gods were worshipped at holy places, precincts that were cut off from the surrounding region by a clear, well-defined boundary that was marked by boundary-stones. The Greek word for such a precinct was *temenos*, which is connected with the word that means "to cut." The most important structure in the *temenos* was the altar where sacrifice was made. Then in the eighth century B.C.E., the Greeks began to build houses for their gods and goddesses, and the familiar Greek temple made its appearance. The basic temple was a single rectangular room with a porch in front. It was a *megaron*, which was the name for the main room of an early Greek house with a hearth in its center, a hole in the roof to allow the smoke to escape, and in front of it a porch with a roof supported by a couple pillars. Later the Greeks elaborated the design by surrounding the *megaron* with a row of columns. Yet the temple remained a simple dwelling-place that housed the image of the god or goddess. The indispensable component for a sanctuary was not the temple, but the altar. Inside the sanctuary was the cult statue or statues, if the temple sheltered more than one god. Sheltering the god and protecting the property dedicated to him was the temple's prime purpose, for worshippers left votive offerings in the temples which ranged from painted wooden panels which were within the price range of a humble worshipper to offerings of gold or ivory. Few of these have survived: the wooden dedications have decayed and the dedications of gold and ivory were stolen long ago. Many terracotta votives have survived, however, for crockery is not subject to decay. At any healing shrine, archaeologists find models of legs, arms, women's breasts, or male testicles that were dedicated to the god, probably as thank offerings for healing a particular part of the human anatomy. The interior of a temple must sometimes have resembled an old curiosity shop. The votives might overflow the temple and be stored in separate buildings in the temple precinct called "treasuries," for the Greek word for treasury—*thesauros*—also meant "storehouse" or sometimes "granary." Sometimes the priests might houseclean by removing old dedications and giving them decent burial. When the stadium at Olympia was excavated, the excavators found many votive offerings of helmets, shields, and other pieces of armor that had been carefully buried in the embankments on either side of the track. The temple, evidently, had run out of space for them.

CULT STATUES. Some cult statues were magnificent. The statue made of gold and ivory which the sculptor

a PRIMARY SOURCE document

SOCRATES ON PRAYER AND SACRIFICE

INTRODUCTION: In Plato's dialogue titled *Euthyphro*, Plato imagines a conversation between his teacher Socrates and Euthyphro. While Euthyphro may or may not have been a real person, Plato presents him as a conventionally pious person who unfortunately models his own behavior on that of the gods; Euthyphro is prosecuting his own father for manslaughter and justifying his action with the example of Zeus, who put his father Cronus in chains for swallowing his children. Socrates and Euthyphro get into a conversation about the definition of true piety. Euthyphro attempts to define piety as what is dear to the gods, and Socrates shows by his relentless questioning that the definition is not so simple. The quotation below on the purpose of sacrifice comes from near the end of the dialogue, which concludes with Socrates and Euthyphro agreeing that they must discuss the matter again another day.

Socrates: Doesn't sacrifice consist of making presents to the gods, and prayer in making requests to them?

Euthyphro: Yes, indeed, Socrates.

Socrates: So on this view piety would be the science of asking and giving?

Euthyphro: You grasp my meaning perfectly, Socrates.

Socrates: You see, my friend, I am a passionate admirer of your wisdom and keep my attention fixed upon it, so that no word of yours will fall to the ground. But tell me, what is this form of service to the gods? Do you hold that it consists in asking from them and giving to them?

Euthyphro: Yes, I do.

Socrates: Then would not the right procedure in asking them be to ask for what we need from them?

Euthyphro: What else could it be?

Socrates: And similarly would not the right procedure in giving be to present them in return with what they actually need from us? Because surely it would be an incompetent use of presents to give a person things for which he has no need.

Euthyphro: Quite true, Socrates.

Socrates: So piety would seem, Euthyphro, to be a sort of art of commerce between gods and men.

Euthyphro: Yes, if you like it better to describe it so.

Socrates: I don't like it any better unless it is really true. But tell me, what benefit do the gods really get from the gifts they receive from us? What they give is obvious to anyone, for we have nothing good that they don't give us; but what benefit do they get from what they receive from us? Is our commerce with them so much to our advantage that we receive all our good things from them, while they receive none from us?

Euthyphro: But do you really imagine, Socrates, that the gods derive benefit from the things that they receive from us?

Socrates: Well, if not, whatever can these gifts of ours to the gods be, Euthyphro?

Euthyphro: Why, honor and esteem and—as I was saying just now—gratitude; what else do you suppose?

Socrates: So piety is what is gratifying to the gods, but not beneficial or dear to them?

Euthyphro: In my opinion it is supremely dear to them.

Socrates: Then apparently piety is once more what is dear to the gods.

SOURCE: Plato, *The Last Days of Socrates*. Trans. Hugh Tredennick (Harmondsworth, England: Penguin Books, 1969): 39–40.

Phidias made for the temple of Zeus at Olympia was a masterpiece, and after he completed it, he made an equally famous gold-and-ivory statue of Athena Parthenos for the Parthenon in Athens. Yet the most sacred image of Athena was not the gold-and-ivory image in the Parthenon, but an ancient olivewood statue of Athena *Polias* housed in the Erechtheion beside the Parthenon. Every four years, at the Great Panathenaea festival, the women of Athens gave this image a new saffron-dyed dress that they had woven. Wooden statues of this sort, known as *xoana*, were thought to have a divine origin. They were primitive images, roughly carved; in some cases a *xoanon* was not much more than a wooden post.

TEMPLE SITES. The temple sites were often determined by the preference of the god for a particular location. The preferred sites for temples sacred to Athena and Zeus were in the urban area: Athena on the acropolis and Zeus in the marketplace. Apollo had temples in the marketplace, too, but also sometimes by the seaside. Demeter's sanctuaries are often on a hillside near the city. Hera, Poseidon, and Dionysus preferred the countryside, and Artemis liked woods and marshy areas.

Wherever sanctuaries were sited, they were sacred places where violent acts were not permitted. Temples offered asylum to fugitives, and anyone who dragged a suppliant from a hallowed *temenos* would bring pollution upon himself and arouse the wrath of the gods.

FESTIVALS. The year was marked by religious festivals in honor of the various gods. They were holy days, important for both the cultural and the religious life of the community. Dancing, musical contests, athletic games, prayers, hymns, and processions all had a place in them. Greek worshippers did not kneel to pray or utter silent prayers. Instead, they stood and, raising their hands, invoked the god in a loud voice. A hymn was a form of prayer that was chanted: the worshipper addressed the god under his various names, recited his great deeds, and ended with a petition. Processions were parades that often took up the first day of the festivals. Religious custom dictated what the festival procession would be like and what route it would take. If the sanctuary of the god whose festival was being celebrated was outside the city, the worshippers would parade along the country road to the site. In one of Hera's favorite cities, the *polis* of Argos where the Hera sanctuary was several miles outside the city center, the priestess was carried there by ox-cart which apparently led a parade of worshippers.

SACRIFICE. The most important part of the festival was the sacrifice. Cattle were the most valued sacrificial victims, but the most common ones were sheep and goats, which were more within the price range of a middle-income Greek. Pigs were sacrificed to Demeter and Dionysus, dogs to Ares and Hekate, birds to Aphrodite, and cocks to Asclepius. A sacrifice to a god or goddess was made on an elevated altar called a *bomos* in front of the temple, and a sacrifice to a hero was made on a low, round altar called an *eschara*, but rules in Greek religion were rarely left unbroken. Sometimes a hero might have a high altar, but the blood from a victim sacrificed to a hero should still trickle down into the earth where it would nourish the bloodless ghost of the dead. Gods on Mt. Olympus needed no such nourishment. A priest or priestess officiated at the sacrifice. Generally, male deities had priests and female deities had priestesses, but one cannot count on consistency. Generally the inedible parts of the sacrificial animal were burned as offerings to the god, and the rest was eaten, or even sometimes sold in the market. The exception was the "holocaust," a sacrifice where the victim was totally consumed by sacrificial flames. The roster of festivals in Athens shows that only one month passed without massive slaughtering of beasts for sacrifice. There must have been many days when the city smelled

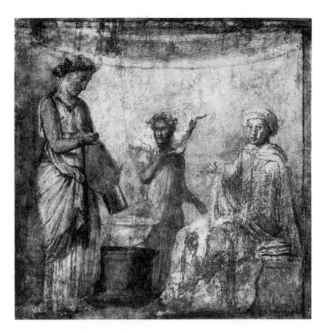

Wall painting from tablinum in the House of Livia on the Palatine Hill at Rome showing a Roman domestic sacrifice. End of 1st century B.C.E. **PUBLIC DOMAIN.**

like an abattoir, and resounded with the noises of the community drinking wine, eating meat, and making merry. For low-income Greeks, festival days might be the only times they ate meat.

THE WEALTH OF TEMPLES. Temples had an economic function which should not be overlooked. Sacrifices honored the gods, but they were also occasions for the distribution of food. Temples might also have to shelter asylum-seekers, sometimes in great numbers, whom it had to support. Archaeological excavations reveal that many temples had subsidiary buildings used for accommodation and cooking. Temples also served as depositories. Athens kept its state treasury in the back room of the Parthenon, and when she organized her archives, they were kept in the temple of the Mother of the Gods in the marketplace. Excavations of a temple at Selinunte in Sicily have yielded many clay seals used to seal documents written on papyrus. The papyrus has decayed, but the clay seals remain as mute evidence of the records that were once stored there. In Rome, a citizen might deposit his last will and testament in the Temple of Vesta where it was in the care of the Vestal Virgins. The god whose image was housed in the temple extended his protection over whatever was within his shrine. Some temples were wealthy and possessed large estates which they rented to leaseholders. They had other sources of income as well. An army that was victorious in battle would give the gods a small portion of the booty called "first fruits."

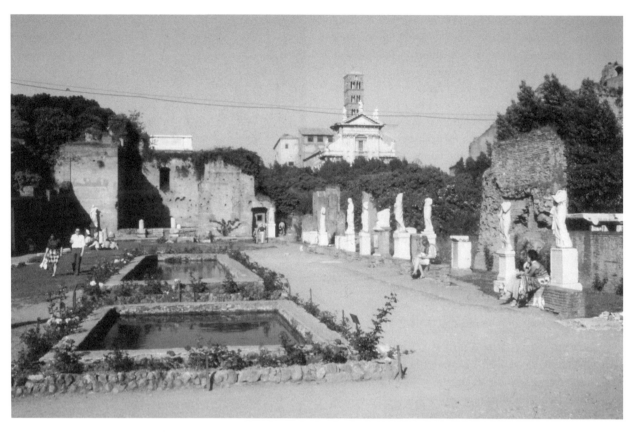

The Roman Forum, showing the foundations of the House of the Vestal Virgins in the foreground and beyond it, the round temple of Vesta. Rome, Italy. PHOTOGRAPH BY HECTOR WILLIAMS. © HECTOR WILLIAMS.

During the brief period in the fifth century B.C.E. when Athens ruled an empire, she consecrated one-sixtieth of the tribute that she received from the member states of her empire as "first fruits" to the goddess Athena. Temples made loans and functioned as a kind of reserve bank. Religious faith changed as time went on in the Greco-Roman world, but religious festivals continued to draw crowds. Mute evidence of their numbers is to be found in the theaters that were built at popular shrines for visitors to witness the drama of the ancient rituals. At Delphi, the theater overlooks the great temple of Apollo. Even at the lonely oracle of Zeus at Dodona there was a theater built, and it is the largest structure on the site. Faith in the Olympian gods was declining when these theaters were built but they still drew visitors and pilgrims. Religion also served to redistribute wealth. There was no income tax in the ancient world, and, in fact, the well-to-do resented paying any taxes at all. But while wealthy citizens did not like taxes, they were quite willing to make donations to the community. Rich citizens paid the bills for the great religious festivals, and the honor they received repaid their generosity. Thus Greco-Roman religion served an important economic function that cannot be overlooked.

SOURCES

Diskin Clay, "Heroes and Heroines," in *Encyclopedia of Greece and the Hellenic Tradition*. Ed. Graham Speake (London, England: Fitzroy and Dearborn Publishers, 2000): 742–744.

Tullia Linders and Brian Alroth, eds., *Economics of Cult in the Ancient World; Proceedings of the Uppsala Symposium 1990* (Stockholm, Sweden: Almqvist and Wiksell International, 1992).

Albert Schachter, "Festivals," in *Encyclopedia of Greece and the Hellenic Tradition*. Ed. Graham Speake (London, England: Fitzroy and Dearborn Publishers, 2000): 613–616.

Louise Bruit Zaidman and Pauline Schmitt Pantel, *Religion in the Greek City*. Trans. Paul Cartledge (Cambridge: Cambridge University Press, 1992).

THE RELIGION OF EARLY ROME

BACKGROUND. The Romans honored the religion of their ancestors, whom they referred to as "the greater ones"—in Latin, the *maiores*. While the Greeks and all peoples in the ancient world also honored their ancestors' religions, the Romans were excessively conservative.

They believed in superhuman divine beings as far back as surviving Roman history records exist, but at the same time, the Italian countryside that the Romans knew always remained the home of a multitude of little deities without human form. A grove of trees would be home to a god, as would a river or a stream or a spring. There was a host of small gods in charge of sowing the crops: the *deus Occitor* who looked after the harrowing, *deus Sterculinius* who looked after spreading manure on the fields, *Sarritor* who looked after hoeing, and *Messor* who looked after reaping, to name only a few of them. The priest of Ceres, the goddess of production, would invoke them all when he made sacrifice. Some of these unseen spirits were malevolent. Every 25 April, the *Robigalia* was held at a grove outside Rome to appease *Robigo*, who was the god—or goddess, for the Romans were not sure of *Robigo*'s gender—of grain rust, the fungus which plagued the farmers' crops. The guts of a dog were burned on *Robigo*'s altar and he was invited to stay away.

KEEPING THE GOOD WILL OF A SPIRIT. Suppose a landowner had a wooded area on his farm and wanted to thin the trees. Cato the Elder, the earliest Latin writer to produce a treatise on agriculture, instructs his readers first to sacrifice a pig, and then to repeat this prayer:

> Whether you who hold this grove sacred are a god or goddess, as it is proper to make you the sacrifice of a pig as a propitiative offering for disturbing this hallowed place, and hence, for these reasons whether I or someone designated by me carried out the sacrifice, provided that it be performed correctly, for this reason in sacrificing this pig, I pray in good faith that you be kindly and benevolent to me, my home, my family, and my children. For these reasons, accept the honor of the sacrifice of this pig as a propitiative offering.

It was not a sin to cut down trees. Roman religion was not greatly concerned with sin. Instead, the Romans regarded gods and goddesses as beings with rights and prerogatives, and one of them was the right not to be disturbed. If they were disturbed, they had to be propitiated. The prayer that Cato prescribed to appease the god of a grove that was about to be violated by a woodman's ax sounds like a legal proposition, and in a way, it was. Roman prayer always offered the god a bargain. If the god granted a petition, then the petitioner would do the god a service in return.

GODS OF THE HOUSEHOLD. Every Roman house had its guardian gods. The *Penates* were gods of the pantry, but they came to symbolize the household. The outer door of the house, the *ianua*, was in the care of the god Janus. Little guardian gods called *Lares* were re-

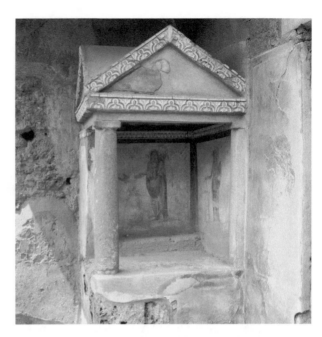

The lararium in a house at Pompeii, Italy. The painting on the back wall shows the "Genius" of the household. © MIMMO JODICE/CORBIS.

sponsible for the security and well-being of the household. A house would have a little shrine to its *Lar*—or its *Lares*, if there was more than one, as there often were—called the *lararium*. Once the Romans began to think of their gods in human forms, the *Lares* would be depicted as dancing figures wearing short tunics and carrying vessels for libations and saucers for offerings of salted meal. There were also *Lares* that protected a neighborhood, called the *Lares Compitales* and *Lares* that protected the whole city of Rome called the *Lares Publici* or the *Lares Praestites*, for the city was, in a sense, an extended family. There was a religious festival called the *Laralia*, held for the *Lares* on the first of May each year.

ANIMISM. Religion that recognizes formless supernatural spirits living in trees and rocks and streams is known as animism. The word derives from the Latin *anima*, meaning "soul," and animism assigns every stream or tree a soul or divine spirit, endowed with a right not to be disturbed without its consent. The Romans called this divine spirit a *numen*, a word with the basic meaning of nodding assent, and then by association it came to mean the divinity that nods assent or sometimes refuses it. At one time, scholars thought that at first Roman religion was purely animist, only later becoming more sophisticated as they came into contact with their neighbors—particularly the Greeks—and learned to make images of their gods in human forms. In fact, the Romans made images as far back as their earliest images

exist. Nonetheless, in primitive Italy there was a good deal of animistic belief. Animism explains, for instance, one ritual in early Rome that took place whenever the Romans embarked on a war. Before a general led his army out of the city, he first went to the Regia, which housed shields and spears sacred to Mars. He shook a sacred spear with the cry, "Mars, awake!" The *numen* of Mars, the spirit of war, was clearly somehow within the spear, and a good shaking roused it from its slumber. If a spear was seen to tremble of its own accord, that was a bad sign. It meant that the *numen* was apprehensive.

JANUS. The god of doors and gateways was Janus, and since to enter a house or a city, one must pass through a gate or door, Janus became a god of beginnings. Whenever a prayer was addressed to a list of gods, his name was mentioned first. There was a freestanding gateway in the Roman Forum, the "twin gate of Janus," which was opened to release the magic forces of battle whenever the Romans were at war, which they frequently were. The gateway represented Janus, but once the Romans began to portray their gods in human form, the symbol of Janus became a man with a double-faced head: one face looking forward and the other backwards. The first month of the year was named after him, and his festival was on New Year's Day.

SOURCES

Franz Altheim, *History of Roman Religion* (London, England: Methuen, 1938).

Georges Dumézil, *Archaic Roman Religion*. Trans. Philip Krapp (Baltimore, Md.: Johns Hopkins University Press, 1996).

W. Warde Fowler, *The Religious Experience of the Roman People, From the Earliest Times to the Age of Augustus* (London, England: Macmillan, 1922).

H. J. Rose, *Religion in Greece and Rome* (New York: Harper, 1959).

THE RELIGION OF THE ROMAN REPUBLIC

THE EARLY BEGINNINGS. Early Roman history and Roman mythology are so intertwined that it is impossible to separate the two. Legend described how Rome's first king, a son of Mars named Romulus, founded Rome in 753 B.C.E. He first asked the gods for divine approval, then laid out the sacred boundary—the so-called *pomerium* of his city—and built Rome's first temple to Jupiter *Feretrius*, that is, Jupiter the Striker, who smote Rome's enemies. Romulus' settlement was on one

of Rome's Seven Hills, the Palatine, and archaeologists have found early cuttings in the bedrock there that were left by a prehistoric settlement. Romulus himself may be fictitious, but the habitation on the Palatine Hill was not. The Romans evolved a legend long after Rome was established that told how it was founded. Its mother city was Alba Longa, a Latin town which was founded generations earlier by the son of the Trojan hero, Aeneas, who escaped from the destruction of Troy and came to Italy. Romulus and his twin brother, Remus, had a wicked great-uncle who had usurped the rule of Alba Longa from their grandfather, and, recognizing the two infants as a threat, he set them adrift on the Tiber River when it was in flood, fully expecting never to see them again. Their cradle floated ashore at the future site of Rome, however, and a she-wolf that had lost her whelps suckled them. A herdsman named Faustulus, who was the woodland god Faunus under a thin disguise, also cared for them until they developed into two husky young men. Upon reaching adulthood, they first disposed of their wicked great-uncle and restored their grandfather to the throne; they then journeyed to the Seven Hills of Rome to found a city. Remus was soon eliminated. He was killed either by Romulus himself or by one of his followers. Then Romulus attracted new settlers by offering asylum to men who were fleeing their native lands for some reason. He remedied the dearth of women by stealing them from a Sabine settlement on the Quirinal, another of Rome's Seven Hills. The Sabines, an Italic people on the fringes of Latium whose relations with the early Latins were more often hostile than not, were incensed by the abductions, but instead of fighting to the death, they united with the Romans to form a single community. Thus Rome from the beginning was a multicultural community, and archaeology lends credence to this theory, for the earliest burials found in the Roman Forum were both inhumation and cremation instead of either one type or the other, which one would expect if the population were homogeneous. Moreover, the union between the Romans and the Sabines may not have been a coalition of equals, for Romulus' successor was a Sabine, Numa Pompilius. Romulus himself vanished—snatched into Heaven, according to one legend, murdered according to another—and he was assimilated to the god Quirinus, a Sabine god who seems to have been the Sabine counterpart of Mars.

QUIRINUS. Quirinus is a colorless god. There were no myths told about him. He did have a festival that was held every 17 February, and *Quirites*, meaning the "Quirinus' people," was sometimes used as a synonym

THE Etruscans

Ancient Etruria was a little more than half the size of modern Tuscany in Italy, which takes its name from the Etruscans. On the west, its boundary was the Tyrrhenian Sea; on the south and south-east, it was the Tiber River; and on the north, the Arno River which flows through modern Florence. Most of the modern knowledge of the Etruscans comes from their tombs, which suggest that they were excessively religious with a gloomy view of the afterlife. Paintings, particularly from tombs of a later date when Etruscan power was declining, show terrifying demons which the dead would presumably encounter in the afterlife, and Etruscan ossuaries (depositaries for the bones of the dead) often have relief carvings showing the dead person, with face veiled, being escorted by a demon carrying a long-handled hammer, his face twisted into a wolfish grimace. The tombs show that the Etruscans spared no expense on funerals, and paintings from the heyday of Etruscan power show a people who loved banqueting, dancing, horse racing, and athletic contests. Women and men mingled freely, unlike in Rome where patriarchal power separated the two sexes.

In ancient Greece and Rome, it was generally believed that the Etruscans were immigrants from Asia Minor who arrived in Italy during the so-called "Dark Ages" (1100–800 B.C.E.), and there is a kernel of truth to this, for a people speaking a similar language lived on the island of Lemnos in the north Aegean Sea until near the end of the sixth century B.C.E. We find the cult of the Trojan hero Aeneas in Etruria, and the theory that the Etruscans were refugee Trojans has attracted some scholars, but it cannot be proved. They spoke an unknown language, but they wrote it using the Greek alphabet. They were also among the best customers for Greece's exports. The great majority of Greek vases that are in modern museums outside Greece itself came from Etruscan tombs.

Rome came under Etruscan domination in 625–600 B.C.E., and the largest Etruscan temple that was ever built was the Temple of Jupiter on the Capitoline Hill in Rome. Etruscan influence on early Rome is hard to measure. The Etruscans possessed sacred books on augury and divination, and Rome considered Etruria a source of knowledge in occult skills. As Rome's power grew, Etruria's faded, but Etruscan augury still commanded respect even into the Christian era.

for "the Roman people." He was a member of Rome's ancient triad of gods that consisted of *Diespiter* (Jupiter), meaning "the father god"; Mars, Jupiter's son; and Quirinus, who was the son of Mars, since Rome's founding myth told that Romulus' father was Mars. Rome's first emperor, *Imperator* Caesar Augustus (27 B.C.E.–14 C.E.), thought of taking the name "Romulus" as appropriate for his new status, and he rebuilt the temple of Quirinus in Rome. Romulus' fratricide was not forgotten, however, and Quirinus, the deified Romulus, was left in obscurity.

NUMA'S CALENDAR. Roman legend claimed King Numa as the founder figure of Roman religion. He gave Rome its twelve-month calendar to replace the ten-month calendar that began with March, the month of Mars, which Romulus' city had borrowed from Alba Longa. Numa's calendar fixed the dates for the religious festivals. Numa's successors are shadowy figures, but then Rome fell under Etruscan domination. The last three kings to rule Rome—Tarquin the Elder, Servius Tullius, and Tarquin the Proud—were Etruscans, and very likely historical figures.

THE ETRUSCANS. Roman legend veiled the uncomfortable fact that the Etruscan takeover was a conquest with a story that the first Tarquin left Tarquinii where he suffered discrimination because he was the son of a Greek, and came to Rome where he became a respected citizen and was chosen king by a popular vote. Tradition also told that Tarquin's name in Tarquinii was Lucumo, and in Etruscan cities, the *lucumo* was the chief magistrate. Tarquin, whose name was the Latinized form of a common Etruscan name, *tarcna*, probably came to Rome as a conqueror. With the Etruscans came their triad of gods—*Tinia* (the "Sky-Father"), *Uni*, and *Menrva*—who became Jupiter, Juno and Minerva. The Romans already had a divine triad of gods—Mars, Jupiter, and Quirinus—who were by no means forgotten. The new triad, however, took pride of place, and on the Capitoline Hill there arose a great temple with a grand portico to house them. This was the greatest temple in the whole Etruscan world, and it remained the largest temple in Rome until the fall of the Roman Republic. It had three rooms for its three divinities, but in the middle shrine, clothed in an embroidered tunic and a toga, sat a terracotta statue made by the Etruscan sculptor, Vulca of Veii. It portrayed Jupiter *Optimus Maximus*, that is, "Jupiter, the best and greatest god" who now absorbed the attributes of *Tinia*, the "Sky-Father." In fact, the Romans sometimes invoked him simply as

caelum, meaning "sky." The traditional date for its dedication was 509 B.C.E. A year before, the last Etruscan king had been expelled from Rome.

ETRUSCAN LEGACIES. The Romans owed two other rites to the Etruscans. One was the art of augury: how to divine the future by observing the flight of birds or examining the viscera of sacrificial animals. The Etruscans were experts at reading omens from the size, shape, color, and markings of the vital organs, particularly the liver and the gallbladder. One tool of the augur's craft has been found at Piacenza in Italy. It is a model liver made of bronze that is divided into forty sections labeled with the names of gods. There were Etruscan textbooks: Books on Lightning, Books on Ritual, Books on Fate, Books of the *Haruspices* (Soothsayers) on interpreting signs and portents, and Books on Animal Gods. Lightning was a significant foretoken. In which of the sixteen divisions of the heavens was it seen? The Etruscan Books on Lightning would have an answer. *Tinia* threw three kinds of thunderbolt, and eight other gods threw one kind each. If the omens were bad, what sort of expiation would avert disaster? Consulting the Books of Haruspices would be in order. The Romans were apt pupils, though they never took the occult sciences of the Etruscans quite as seriously as the Etruscans did themselves. The other Etruscan legacy was the Roman triumph. How much of the ritual was Etruscan is not known, but as time went on, the triumph developed into a parade where a victorious general entered Rome in a chariot and proceeded through the Roman Forum to the temple of Jupiter on the Capitoline Hill. Before him were paraded his prisoners and the spoils of his campaign. He wore the regalia of Jupiter Optimus Maximus, and his face was painted red. Behind him in his chariot stood a servant who repeated, "Remember that you are a man!" The triumph was an honor that generals in the Roman republic sought eagerly, and after the fall of the republic, it was reserved for emperors.

THE INFLUENCE OF THE GREEKS. Greek influence arrived early to Rome. A legend related that before Romulus founded his city, there was a Greek colony on the site of Rome. There were flourishing Greek cities in Sicily and southern Italy, and Rome was soon in contact. The result was that Rome's gods became identified with Greek gods. Mars and the Greek Ares were both war gods so they were equated even though they had little else in common. Aphrodite was identified with the Roman Venus, Artemis with Diana, Athena with Minerva, Hera with Juno, and Zeus with Jupiter. Hestia was Vesta and the Titan Kronos became Saturn. Apollo remained Apollo, and stayed on the sidelines until the em-

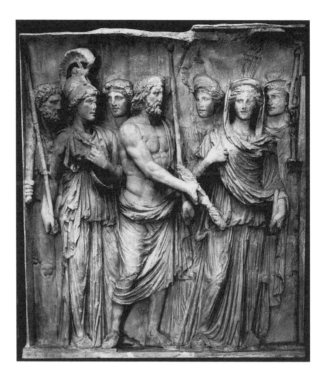

Arch of Trajan, detail showing Hercules, Minerva, Bacchus, Jupiter, Ceres, Juno, and Mercury, Beneventum, Italy, 114–117 C.E. ALINARI-ART REFERENCE/ART RESOURCE, NY. REPRODUCED BY PERMISSION.

peror Augustus endorsed his cult and built a great temple for Apollo on the Palatine Hill. Dionysus was known by his alternative Greek name, Bacchus, which does not appear in Greek usage before the fifth century B.C.E., and his festivities were called the Bacchanalia. Heracles became Hercules, and his worship was an early import from Greece. Sacrifices made to him at the *Ara Maxima* (the Greatest Altar) in Rome were according to the Greek rite: that is, the priest officiated with head uncovered, and not with head covered as was the Roman custom. These Greek immigrant gods brought their myths with them. Latin literature began when an ex-slave, Livius Andronicus, who was probably a Greek, produced Latin tragedies and comedies in Rome, based on Greek models and using Greek myths for subject matter. He also translated Homer's *Odyssey* into rough-and-ready Latin verse. Hera became Juno, Zeus Jupiter, and Athena Minerva, and the Romans were told titillating stories about their gods that were revelations. The Romans learned from Homer that Venus was married to Vulcan and had an affair with Mars. The discovery must have come as a shock to many of them.

THE PREEMINENCE OF GREECE. By the end of the third century B.C.E. there was a circle of Roman nobles who were so influenced by Greek culture that they

a PRIMARY SOURCE *document*

THE TABOOS SURROUNDING THE FLAMEN DIALIS AND HIS WIFE

INTRODUCTION: The word *flamen* seems to mean something like "priest" or "sacrificer," and there were fifteen of them, of whom the *flamines* for Jupiter, Mars, and Quirinus were the most important. They had to observe various taboos, and this excerpt from Aulus Gellius' *Attic Nights*, part of which is quoted below, reports the taboos that the Flamen Dialis (the priest of Jupiter) and his wife had to observe. It was not always easy to find candidates for the office. Julius Caesar considered it in his youth but thought better of it. Aulus Gellius, a Roman lawyer and litterateur who lived in the second century C.E., wrote a collection of table talk in twenty books titled the *Noctes Atticae*, which report a great assortment of information that he has gleaned from his reading. In this case, his source is Rome's first historian, Fabius Pictor, who lived in the last quarter of the third century B.C.E., and Gellius recalls—evidently from memory—what he has read.

These are the taboos that I recall from my reading. There is a religious ban against the Flamen Dialis riding a horse. Similarly there is a ban against his viewing the Ro-

man people armed and in battle order outside the city boundary of Rome. For that reason, the Flamen Dialis was elected consul very seldom, for the consuls are entrusted with high command in war. Likewise it is never lawful for him to swear an oath by Jupiter, and it is also unlawful for him to wear a ring, unless it is pierced and without a gem. It is not lawful for fire to be removed from the *Flaminia*, that is, the home of the Flamen Dialis, unless it is being taken to be used in sacrifice. If a prisoner in fetters enters the house, he must be released, and the fetters must be pulled up through the *impluvium*, [the opening in the roof above the main room of a Roman house, called the *atrium*] to the roof, and from there be dropped down on to the street. The cone-shaped cap he wears must have no knot on it, nor can there be a knot on his belt or on any other part of his clothing. If anyone who is being taken off to be flogged falls at his feet as a suppliant, it is a sin to flog him on that day. Only a freeborn man may cut the hair of the Flamen Dialis. Custom requires the Flamen neither to touch nor even utter the name of a female goat, or raw meat, ivy or beans.

SOURCE: Aulus Gellius, *Attic Nights*. 10.15. Translated by James Allan Evans.

preferred to speak Greek at home rather than Latin. Greek art was prized, and when Rome's empire expanded into the Greek world, the Romans found plenty of it to plunder. They also wanted copies of Greek sculpture for their houses and gardens, and Greece developed an export trade in replicas to meet the demand. Most of the masterpieces of Greek sculpture are known to us now through Roman copies, which were actually copies made by Greek craftsmen for the Roman trade. In the religious imagination of Rome, Roman gods began to look like their Greek counterparts. Modern cultural historians might consider this a degeneration of Roman culture, but it is unlikely that the Romans saw it that way. Roman culture changed constantly as a result of borrowing from a circle of contacts which expanded as Rome's imperial dominion grew, and many Romans thought the process strengthened rather than weakened Latin traditions. Not all Romans were so accepting of Greek culture, however. There was a reaction, and one figure associated with the reaction was the first Roman author to produce a work in Latin prose, Marcus Porcius Cato (234–149 B.C.E.). He authored the first history of Rome in the Latin language. It has not survived, but his treatise *On Agriculture* has, and it pays special attention to the traditional rites of the farmers who tilled the Italian countryside. Greek

culture might capture the imaginations of upper-class Romans, but ritual remained intensely conservative.

SOURCES

G. Barker and T. Rasmussen, *The Etruscans* (Oxford, England: Blackwell, 1998).

Alain Hus, *Les Étrusques* (Paris: Éditions du Seuil, 1959).

R. M. Ogilvie, *Early Rome and the Etruscans* (Glasgow: Fontana/Collins, 1976).

Robert E. A. Palmer, *Roman Religion and the Roman Empire* (Philadelphia: University of Pennsylvania Press, 1974).

THE WORSHIP OF THE ROMAN GODS

THE PRIESTHOODS. One remarkable feature of Roman religion was that the priests—who were all males except for the Vestal Virgins—were organized into a number of *collegia* and other small priestly groups, each with a special function to perform. There were four major *collegia*, a word usually inaccurately translated as "colleges," for they were actually clubs or associations. First there were the fifteen pontiffs, headed by the chief priest or *pontifex maximus* who was chosen by his colleagues in the early Roman republic. From the third

a PRIMARY SOURCE *document*

THE LUPERCALIA FESTIVAL

INTRODUCTION: The Lupercalia was a pagan festival celebrating Rome's legendary twin founders, Romulus and Remus. The name "Lupercalia" must be connected with the Latin word *lupus*, meaning "wolf," and suggests that this was at one time a primitive rite intended to keep flocks and herds safe from wolf packs. Whatever its origins, the festival became associated with the arrival of the legendary twin infants Romulus and Remus to Rome after their cradle—set adrift on the Tiber River by their wicked uncle—ran aground at the future site of the city. Almost two centuries after the emperor Constantine adopted Christianity as the religion of the Roman Empire, this pagan festival was still being celebrated. Every 15 February, people swept clean their houses and then went out to watch the Luperci run around the boundary of the city, starting at the Lupercal, the cave below the western corner of the Palatine Hill where a she-wolf supposedly suckled Romulus and Remus in their infancy. The festival began with the sacrifice of a goat (or goats) and a dog in the Lupercal, and then the Luperci—young men wearing only loin cloths—ran carrying strips of goathide from the sacrificial victims with which they lashed out at anyone in their way. Women often deliberately placed themselves within reach of the lash in the belief that a touch from it aided in fertility, pregnancy, and childbirth. The Roman poet Ovid described the Lupercalia in his unfinished work, the *Fasti*, which was a poetic commentary on the Roman calendar of festivals. In the excerpt below, he described the discovery of Romulus and Remus by the she-wolf.

The cradle drifts to a dark wood and gradually,
 As the river languishes, grounds in mud.
There was a tree: traces remain, and what is now called
 The Ruminal fig was Romulus fig.
A whelped she-wolf (marvel!) came to the abandoned
 twins.
 Who'd believe the boys weren't hurt by the beast?
Far from hurting, she even helps. A she-wolf suckles
 Those whom kindred hands were braced to kill.
She stopped, her tail caresses the delicate babes,
 And she shapes the two bodies with her tongue.
You could tell they were sons of Mars. They suck the
 teats
 Fearlessly, and feed on milk unmeant for them.
The wolf named the place, and the place the Luperci;
 The nurse was well rewarded for her milk.

SOURCE: Ovid, *Fasti*. Trans. A. J. Boyle and R. D. Woodard (London: Penguin Classics, 2000): 39.

century B.C.E., however, a pontiff would be elected by the Roman people and held office for life. The emperor Augustus became a pontiff early in his career, and as soon as the incumbent *pontifex maximus* died in 12 B.C.E., he took over the post. The college of pontiffs also included the *flamines* (priests), the *rex sacrorum* (the king of sacred rites), and the six Vestal Virgins. There were twelve minor *flamines* and three important ones: the *Flamen Dialis*, the *Flamen Martialis*, and the *Quirinalis*, that is, the priests of Jupiter, Mars, and Quirinus, the ancient divine triad of Rome. The *flamines* were surrounded by various taboos; the *Flamen Dialis*, for instance, could not be away from his own bed for more than two consecutive nights. Anyone hoping for military renown avoided the office, for no *Flamen Dialis* could lead an army on campaign. For a long period in the first century B.C.E., the office was vacant. The *rex sacrorum* took over the *sacral* duties of Rome's ancient kings—that is, their functions as priests of the state. Presumably, before the last king, Tarquin the Proud, was driven from Rome in 510 B.C.E., he headed the college of priests, and a "king of sacred rites" took over his sacerdotal functions. The presidency of the college, however, went to the *pontifex maximus*, and as a republican gesture the "king of sacred rites" was barred from all political offices. The second major college was the fifteen augurs who supervised all rituals concerned with the auspices. The third college had the mouth-filling name *quindecemviri sacris faciundis*, meaning "the fifteen-man committee for doing sacred things." Whenever the Roman senate felt that Rome's collection of oracles known as the Sibylline Books should be consulted, it was this group of priests who carried out the consultation. Finally there was a college that looked after one of the most characteristic institutions of later Rome, the *ludi* or the Games which were days filled with competitions and amusements for the public. They began with processions when the images of the gods were paraded through the streets; then there would be the shows: horse racing, to which there was later added animal fights and theater productions held in the presence of the gods, whose images would be seated among the spectators. These priests, called *epulones,* were not the business managers of the *ludi*; those were usually politicians on their way up the political ladder. Despite the political nature of the Games, the religious aspects of the Games were very important, and in 196 B.C.E. a three-man college of *epulones* was established to look after

a PRIMARY SOURCE *document*

THE REFORMS OF NUMA POMPILIUS

INTRODUCTION: After the death of Rome's founder, Romulus, the question of a successor arose, and the people elected Numa Pompilius from the Sabine town of Cures to rule over them. Numa was known as a man of peace who established Roman religion. Roman legend attributed to him the ancient rituals of Roman religion. The following excerpt is from Livy's history of Rome, which was written in the reign of the emperor Augustus; he thus was describing reforms that took place some seven centuries before his own time.

[Numa's] first act was to divide the year into twelve lunar months; and because twelve lunar months come a few days short of a full solar year, he inserted intercalary months, so that every twenty years the cycle should be completed, the days coming round again to correspond with the position of the sun from which they had started. Secondly, he fixed what came to be known as "lawful" and "unlawful" days—days, that is, when public business might, or might not, be transacted—as he foresaw that it would be convenient to have certain specified times when no measures should be brought before the people. Next he turned his attention to the appointment of priests; most of the religious ceremonies, especially those which are now in the hands of the Flamen Dialis, or the priest of Jupiter, he was in the habit of presiding over himself, but he foresaw that in a martial community like Rome, future kings were likely to resemble Romulus rather than himself and to be often, in consequence, away from home on active service, and for that reason appointed a Priest of Jupiter on a permanent basis, marking the importance of the office by the grant of special robes and the use of the royal curule chair. This step ensured that the religious duties attached to the royal office should never be allowed to lapse. At the same time two other priesthoods, to Mars and Quirinus, were created.

He further appointed virgin priestesses for the service of Vesta, a cult which originated in Alba and was therefore not foreign to Numa who brought it to Rome. The priestesses were paid out of public funds to enable them to devote their whole time to the temple service, and were invested with special sanctity by the imposition of various observances of which the chief was virginity. The twelve Salii, or Leaping Priests, in the service of Mars Gradivus, were also introduced by Numa; they were given the uniform of an embroidered tunic and bronze breastplate, and their special duty was to carry the *ancilia* or sacred shields, one of which was fabled to have fallen from heaven, as they moved through the city chanting their hymns to the triple beat of their ritual dance.

Numa's next act was to appoint as pontifex the senator Numa Marcius, son of Marcus. He gave him full written instructions for all religious observances, specifying for the various sacrifices the place, the time, and the nature of the victim, and how money was to be raised to meet the cost. He also gave the pontifex the right of decision in all other matters connected with both public and private observances, so that ordinary people might have someone to consult if they needed advice, and to prevent the confusion which might result from neglect of natural religious rites or the adoption of foreign ones. It was the further duty of the pontifex to teach the proper forms for the burial of the dead and the propitiation of the spirits of the departed, and to establish what portents manifested by lightning or other visible signs were to be recognized and acted upon. To elicit information on this subject from a divine source, Numa consecrated on the Aventine an altar to Jupiter Elicius, whom he consulted by augury as to what signs from heaven it should be proper to regard.

SOURCE: Livy, *The Early History of Rome: Books I–V of The History of Rome from its Foundations*. Book I. Trans. Aubrey de Sélincourt (Harmondsworth, England: Penguin Classics, 1971): 54–55.

them. In the first century B.C.E. their number was raised to seven. The *epulones* also looked after an odd ritual called a *lectisternium*, which the Roman senate decreed when menacing portents indicated that the gods should be appeased. The images of the gods were placed on the streets lying on pillows, and food of all kinds was set before them. Once fed, and presumably happy, the gods were returned to their sanctuaries. Actually, the *epulones* ate the food. Not for nothing did the word *epulones* mean "guests at a banquet." There were other priestly groups, too. The *fetial* priests looked after foreign relations. They determined that Rome's wars were "just

wars," and a fetial priest would perform a ritual before the Roman army crossed into the enemy's territory to make sure that the gods recognized that justice was on the Roman side. The *haruspices* specialized in the Etruscan lore of interpreting prodigies. Two ancient groups were connected with festivals: the *Salii*, priests of Mars who put on archaic armor with conical caps and shields shaped like the figure eight, and danced at various places in the city during the festivals of Mars in March and October; and the "Luperci," the runners in the Lupercalia festival. Finally there were the Arval Brethren, an ancient but obscure college during the Roman republic

that cared for the cult of an equally obscure goddess known as the Dea Dia. The emperor Augustus joined the Arval Brethren and adapted the college to the purposes of the imperial cult. The revived college inscribed its records on stone, and fragments of these inscriptions have survived, running from 21 B.C.E. to 304 C.E., with the result that historians are better informed about the Arval Brethren than any other college.

FESTIVALS. The dates of the great festivals were set out in the ritual calendar, which was first drawn up by the legendary King Numa, the successor of Romulus. Copies, inscribed on stone, survive, but almost all date from the reign of Emperor Augustus, and if Numa's calendar ever existed, it had undergone changes over time. Every month except September had festivals. Some lost their original meaning and acquired a new one. The shepherds' festival in April for the protection of their flocks known as the Parilia became a birthday festival for Rome. There were festivals for the dead—the Parentalia every February and the Lemuria in May—which were essentially family festivals. The Saturnalia in December was also a family festival, though it started with sacrifices at the temple of Saturn; the feasting when masters and slaves exchanged roles, and presents were given, all took place inside the household.

EMPEROR WORSHIP. Once Rome acquired divine emperors, the worship of the emperor was grafted on to the traditional religion. Temples to the emperors, living and dead, soon became the most prominent temples in Rome and in other great cities of the empire as well. The emperors not only became the high priests of Rome, but, as gods, they received sacrifices. In most of the provinces of the empire, a provincial assembly for the celebration of the imperial cult would meet every year in the chief city. It would hold a festival in honor of the emperor and it would discuss provincial business. If a governor was corrupt, for instance, it could arrange for him to be prosecuted in Rome. The cult of the emperors was not standardized, but it did provide a focus for provincial loyalty as well as a channel for complaints from the provinces to reach Rome.

JEWISH RESISTANCE. The Jews resisted the idea of making sacrifices to the emperors, and the civil authorities made an exception, though the emperor Caligula (37–41 B.C.E.) nearly provoked an uprising in Judaea by insisting that his image be placed in the Temple in Jerusalem. Caligula's assassination averted the crisis. The Jews were willing to offer prayers in their synagogues on the emperor's behalf, though they would not offer prayers *to* him. The Christians, however, were stubborn in their refusal to either pray to the emperor or for him.

SOURCES

Mary Beard, John North, and Simon Price, *Religions of Rome.* 2 vols. (Cambridge: Cambridge University Press, 1998).

Frederick C. Grant, *Ancient Roman Religion* (New York: Liberal Arts Press, 1957).

R. M. Ogilvie, *The Romans and Their Gods in the Age of Augustus* (London, England: Chatto and Windus; New York: Norton, 1969).

Ovid, *Fasti.* Trans. A. J. Boyle and R. D. Woodard (Harmondsworth, England: Penguin Books, 2000).

Howard H. Scullard, *Festivals and Ceremonies of the Roman Republic* (London, England: Thames and Hudson, 1981).

Jo-Ann Shelton, *As the Romans Did; A Sourcebook in Roman Social History.* 2nd ed. (New York: Oxford University Press, 1998).

Lily Ross Taylor, *The Divinity of the Roman Emperor* (Philadelphia: Porcupine Press, 1975).

IMMIGRANT RELIGIONS: THE ARRIVAL OF NEW CULTS FROM THE EAST

MULTICULTURAL ROME. By the first century C.E., Rome had a population of nearly a million people. It was huge by the standards even of the early modern world: in seventeenth-century Europe, only London, Paris, and Constantinople had populations above 400,000. It was also a magnet for immigrants from the empire, which by the mid-century stretched from Britain to the Middle East. Many came as slaves, who were then freed and as freedmen became Roman citizens. They brought their religious beliefs with them.

MAGIC. Along with the new cults there was an upsurge of interest in magic and astrology. The attraction of magic was that it purported to give mortals some control over life and death and the powers of the Underworld. The magician, with his handbooks of magic spells, gave the impression that he could make things work in a world where nothing seemed to work the way it once did. The authorities found it frightening. A *defixio*—an enchantment against an enemy, often only a thin leaflet of lead with a curse scratched on it, then folded, pierced with a nail and buried at a strategic location—could harness supernatural forces to do damage. What is striking about the enchantments that have survived is the range of divinities. All the Olympian gods appear, but as capricious, demonic powers. Apollo, the Olympian most often invoked, became a sun god. Babylonia, Egypt, and Judaea also contributed deities. Osiris and Isis from

a PRIMARY SOURCE *document*

THE IMPORTANCE OF MAGIC

INTRODUCTION: Magic was an important element of Greek and Roman religion. Greek mythology provides some information about it. For example, the Telchines who lived on the island of Rhodes were semi-divine little people like the gnomes of Europe and the leprechauns of Ireland, who were not only skilled metal-workers but also powerful magicians who had the Evil Eye. They hated the Olympian gods, and they cast spells on mortals. The Idaean Dactyls were also dwarfs who were wizards connected with Mt. Ida on Crete, though other traditions placed them in Phrygia. Magic, including astrology, was feared, and the Roman authorities tried to suppress it. Magic books that gave recipes for spells were burned, but some survived, and the sands of Egypt have yielded a large corpus of magical papyri. The document printed below is a spell for invisibility. The words that are in italics are written in Old Coptic, the language of the native Egyptians in the later Roman Empire. The rest of the document is in Greek. Where "NN" appears, the man casting the spell should insert his own name.

Tested spell for invisibility: A great work. Take an eye of an ape or of a corpse that has died a violent death and a plant of a peony [meaning the rose]. Rub these with oil of lily, and as you are rubbing them from right to left, say the spell as follows: "*I am Anubis, I am Osir-Phre, I am Osot Soronouier, I am Osiris whom Seth destroyed.* Rise up, infernal demon, IŌ ERBĒTH IŌ PHOBĒTH IŌ PAKERBĒTH IŌ APOMPS; whatever I, NN, order you to do, be obedient to me."

And if you wish to become invisible, rub just your face with the concoction, and you will be invisible for as long as you wish. And if you wish to be visible again, move from west to east and say this name, and you will be obvious and visible to all men.

SOURCE: *The Greek Magical Papyri in Translation, Including the Demotic Spells.* Ed. Hans Dieter Betz (Chicago: The University of Chicago Press, 1986): 9.

Egypt rubbed shoulders in the Underworld with Hermes and Aphrodite as did a god called Iao, who is the Jewish Yahweh. In the surviving enchantments, Iao is the god most often invoked. Part of magic's attraction was a wish to control destiny in a changing world, and to understand the life after death. While the worshippers of these gods were often immigrants who remained loyal to their ancestral religions, these new cults also made converts. Some Romans converted to several of them since, except for Judaism and Christianity, they were not exclusive.

CULT OF ISIS. The goddess Isis was an import from Egypt. In Egyptian myth she was the sister-wife of Osiris, who was slain by the evil god Seth and cut into many pieces so that he could not be mummified and enter the afterlife. Isis searched for the pieces and found them all but one. The secret of where it was hidden was revealed only when Isis' son, Horus, whom the Greeks called Harpocrates, forced Seth to reveal it. Then, at last, Osiris could be resurrected. In the afterlife, as Osorapis, he became the head of the panel of judges who judged the dead. When the Greeks came to Egypt, they identified Osiris as their god, Dionysus. The best-preserved temple of Isis in Italy is in Pompeii, which had just been rebuilt after it was destroyed by an earthquake in 62 C.E. and had not been in use long before all Pompeii was overwhelmed by the eruption of Mt. Vesuvius in 79 C.E. The temple at Pompeii had cells for her priests and a cistern for the Nile water; Isis was attended by Egyptian priests who shaved their heads and wore white linen garments, and her rituals used sacred water from the Nile river. The processions that marked her festivals were elaborate productions, with dances, penitent worshippers, and music. When the navigation season opened each spring, and the grain transports began to bring their cargoes from Egypt to Italy, Isis gave the ships her blessing in a festival called the *Ploiaphesia.*

CULT OF SERAPIS. The god Serapis was often coupled with Isis. His cult seems to have developed out of the cult of Osorapis, but it was encouraged by the Ptolemaic kings of Egypt who may have thought he would bridge the gulf between the religions of the Greeks and their Egyptian subjects. The great temple of Serapis at Alexandria was one of the wonders of the ancient world. Isis in Egyptian mythology was the mother of Horus, the hawk-headed god, but among the Greeks and Romans, Horus became Harpocrates, who is shown as a chubby infant with his hand in his mouth, and Serapis became his father. He is often shown being suckled by Isis and when Egypt was Christianized in the fourth century C.E., the Virgin Mary and the infant Jesus took over the iconography of Isis and Harpocrates.

MITHRAISM. Mithraism was an offshoot of Zoroastrianism, the national religion of Persia. Mithras was one of the angels in the forces of Ahura-Mazda, the god of light, in his battle with Ahriman, the god of evil. No

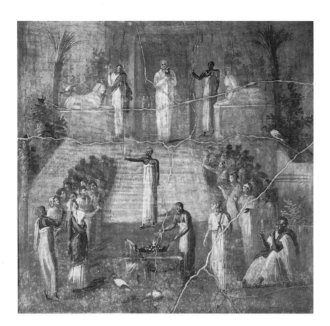

Wall painting from Pompeii showing priests celebrating the rites of the Egyptian goddess Isis. 1st century C.E. PUBLIC DO-MAIN.

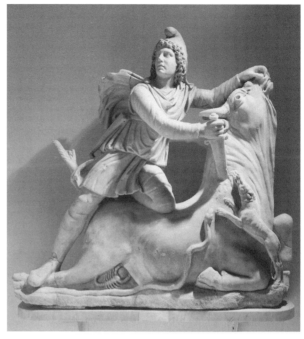

Sculpture from a Mithraeum (underground shrine of Mithras) showing Mithras slaying the bull from which all living things arose. 2nd century C.E. © ARCHIVO ICONOGRAFICO, S.A./CORBIS.

evidence of Mithraism has been found in ancient Iran, and possibly it was within the Roman Empire that Mithraism developed as a separate cult. Its ritual was secret and confined to men, and modern historians are ill informed about it, except that candidates for initiation underwent a series of ordeals. Initiates met in small oblong chapels with benches along the side-walls and, at the end, a painting or sculpture showing Mithras slaying a bull, for one duty that Mithras undertook was to capture and kill a mysterious bull. Mithraism was a militant religion with a special appeal for Roman soldiers. *Sol Invictus* was a natural associate of Mithras, for *Sol Invictus* was the "Invincible Sun," and Mithras was a god of light. In the third century *Sol Invictus* almost became Rome's national religion, for the emperor Aurelian (270–275 B.C.E.) was a devotee and built a great temple in Rome to *Sol Invictus*, which was dedicated on 25 December, the Sun's supposed birthday.

OTHER CULTS. There were other new cults as well. One that arrived early was the cult of Attis and the "Great Mother," Cybele. The Roman senate imported the cult towards the end of the third century B.C.E. and established a religious festival for it called the Megalensia. The rites of the Great Mother celebrated the death and resurrection of Attis, and they involved ecstatic rituals performed by priests called *galli* who had castrated themselves. The cult was kept under strict control in Rome for more than 200 years, but once it was allowed freedom, it began to win converts. One of

the rites attached to it was the *taurobolium* which appeared in Rome in the mid-second century C.E. and from there spread through the Western Empire, becoming particularly popular in Gaul. The recipient would climb down into a ditch and be bathed by the blood of a bull—or alternatively a ram—that was slaughtered above him.

JUDAISM. Among the immigrant religions was Judaism. There was already a Jewish community in Rome in the early first century B.C.E. and their numbers increased after the Roman general Pompey extended Rome's dominion into the eastern Mediterranean and returned home in 63 B.C.E. with a vast quantity of booty and slaves, among them Jews. Julius Caesar gave the Jews certain privileges, such as the right not be to summoned to court on Shabbat, and Judaism became a *religio licita*, that is, a "licensed religion," a cult that could claim protection under Roman law. There were soon synagogues in the major cities of the empire, and they attracted Gentile (non-Jew) attention. Persons called "God-fearers" were Gentiles with a sympathetic interest in Judaism who might come to synagogues to hear a good speaker and were made welcome. Some became converts, but that involved circumcison, which could be a dangerous procedure for an adult male before modern hygiene. The general Roman attitude to Judaism was ambivalent: Jews were considered clever in the art of healing the sick and

a PRIMARY SOURCE *document*

AN EPIPHANY OF ISIS

INTRODUCTION: Lucius Apuleius lived in the second century C.E. as part of a wealthy family at Madaura in Africa. His *Metamorphoses*—better known under the title *The Golden Ass*—is the only Latin novel that survives in its entirety. It tells the story of one Lucius whose curiosity about black magic led to his being transformed accidentally into a donkey, and as a donkey he undergoes a number of adventures. The novel reads like a light-hearted romp until the conclusion, when Lucius has a vision of the goddess Isis as he lies on the beach at Cenchreae, the port of Corinth. Isis restores Lucius to human form and he becomes a devotee. At the end of the story, Lucius shaves his head and becomes a priest of Isis. The following excerpt describes Isis as she rises from the sea.

I had scarcely closed my eyes before the apparition of a woman began to rise from the middle of the sea with so lovely a face that the gods themselves would have fallen down in adoration of it. First the head, then the whole shining body gradually emerged and stood before me poised on the surface of the waves. Yes, I will try to describe this transcendent vision, for though human speech is poor and limited, the Goddess herself will perhaps inspire me with poetic imagery sufficient to convey some slight inkling of what I saw.

Her long thick hair fell in tapering ringlets on her lovely neck, and was crowned with an intricate chaplet in which was woven every kind of flower. Just above her brow shone a round disc, like a mirror, or like the bright face of the moon, which told me who she was. Vipers rising from the left-hand and right-hand partings of her hair supported this disc, with ears of corn bristling beside them. Her many-colored robe was of finest linen; part was glistening white, part crocus-yellow, part glowing red and along the entire hem a woven border of flowers and fruit clung swaying in the breeze. But what caught and held my eye more than anything else was the deep black luster of her mantle. She wore it slung across her body from the right hip to the left shoulder, where it was caught in a knot resembling the boss of a shield; but part of it hung in innumerable folds, the tasselled fringe quivering. It was embroidered with glittering stars on the hem and everywhere else, and in the middle beamed a full and fiery moon.

In her right hand she held a bronze rattle, of the sort used to frighten away the God of the Sirocco; its narrow rim was curved like a sword-belt and three little rods, which sounded shrilly when she shook the handle, passed horizontally through it. A boat-shaped gold dish hung from her left hand, and along the upper-surface of the handle writhed an asp with puffed throat and head raised ready to strike. On her divine feet were slippers of palm leaves, the emblem of victory.

SOURCE: Lucius Apuleius, "The Goddess Isis Intervenes," in *The Transformations of Lucius Otherwise Known as The Golden Ass.* Trans. Robert Graves (Harmondsworth, England: Penguin Classics, 1950): 269–270.

also in magic, but their denial of all other gods except their own seemed unduly exclusive. Still, Judaism was one of the new religions which took an important place in Rome in the imperial period.

COMMONALITIES. All these cults had one thing in common: they accepted individuals as initiates and made them part of a special group. Most of them imparted some transcendental knowledge to their converts as part of their initiation, and for that reason they are commonly called "mystery religions." They did not all promise resurrection after death, but they did borrow from each other, and as time went on, they all developed an eschatology—that is, doctrines about the afterlife—of one sort or another. The greatest attraction seems to have been that, in a world that was increasingly chaotic—particularly in the third century B.C.E. when order broke down and the Roman Empire seemed unable to cope with new invaders that crossed its borders—these cults imparted a sense of belonging to a circle of like-minded persons.

SOURCES

Hans Dieter Betz, ed., *The Greek Magical Papyri in Translation* (Chicago: University of Chicago Press, 1986).

Walter Burkert, *Ancient Mystery Cults.* The Carl Newell Jackson Lectures (Cambridge, Mass.: Harvard University Press, 1987).

LeRoy A. Campbell, *Mithraic Iconography and Ideology* (Leiden, Netherlands: Brill, 1968).

John Ferguson, *An Illustrated Encyclopaedia of Mysticism and Mystery Religions* (London, England: Thames and Hudson, 1976).

Ramsay MacMullen, *Paganism in the Roman Empire* (New Haven, Conn.: Yale University Press, 1981).

F. Solmsen, *Isis Among the Greeks and Romans.* Martin Classical Lectures (Cambridge, Mass.: Harvard University Press, 1980).

R. E. Witt, *Isis in the Graeco-Roman World* (London, England: Thames and Hudson; Ithaca, N.Y.: Cornell University Press, 1971).

THE RISE OF CHRISTIANITY

CHRISTIANITY AS A JEWISH SECT. Christianity began with a group of Jews who followed the teachings of Jesus, a Jewish carpenter who attracted many followers during his three-year ministry which began in 30 C.E. Jesus' teachings regarding the Jewish law and his claim to be the "messiah" (the savior of the people) long-awaited by the Jews threatened the Jewish religious leaders, who managed to have him crucified by the Roman authorities in 33 C.E. on charges of heresy. Although the religion initially faltered after Jesus' death, reports that Jesus had risen from the dead bolstered the fledgling church in spite of its continued persecution by the Jewish religious leaders. The years following Jesus' crucifixion saw an increase in the number of "Christians"—so-called because they followed Jesus "the Christ." The religion was not without its growing pains, however. According to the *Acts of the Apostles* and the *Epistles* of St. Paul, there soon arose a division of opinion among the followers of Jesus. On the one hand, there was a conservative group centered in Jerusalem, led by James, the brother of Jesus. They clung to the Jewish law of Moses and insisted that all Gentile converts should be circumcised. The other group centered on Paul, a Jew of the diaspora, that is, the Jewish communities living outside Judaea. He had not known Jesus personally, but he had been converted to the new religion that he believed that Jesus had preached, and he was full of zeal. He wanted to reach out to the Gentiles, and he considered the dietary restrictions of Mosaic law and circumcision unimportant. Probably Paul and his followers would have lost the quarrel, except that a Jewish revolt intervened. A sect of Jewish nationalists in Judaea called the Zealots rose in rebellion in the final years of the emperor Nero's reign. The suppression of the revolt was delayed by Nero's dethronement and a year of civil war before Vespasian took over as emperor in 69 C.E.; the next year, Jerusalem was taken by an army led by Vespasian's son, Titus. The Temple was destroyed and its treasures taken to Rome as booty. The Jewish priesthood that had presided over the sacrifices at the Temple no longer had a center for their rituals. The future of Judaism lay with the synagogues and their rabbis, and a rabbinical school that was established at Yavna—later moved to Tiberias—in Judaea was actually encouraged by the Roman authorities. Judaism developed into a religion of the Talmud, which was the collection of writings that constituted Jewish civil and religious law. The Jewish-Christian community in Jerusalem that had opposed Paul had not supported the revolt, but still it was a casualty. It was dispersed, and many of its leaders were probably killed. Others fled, particularly to Alexandria.

PERSECUTION. The future of Christianity lay with the followers of Paul's teachings. They had not supported the Jewish revolt, and their lack of support was not forgotten. Christianity had spread rapidly, partly because Christian preachers were welcome in the synagogues of the Diaspora. That welcome began to grow thin, however, and by the reign of Nero (54–68 C.E.), the Roman authorities began to recognize the Christians as a sect separate from the Jews, and an unpopular one at that. In 64 C.E. more than two-thirds of Rome was destroyed in a great fire. Nero needed a scapegoat, and the Christians were unpopular; in some quarters they were blamed for setting the fire. In fact, many Christians at this point in history expected an imminent Second Coming of the risen Christ and may have imagined that the fire that consumed Rome was the opening scene in the destruction of an evil empire. The Christians suffered their first state persecution at this time, but there were more to follow. The persecutions were sporadic until the middle of the third century C.E. when the empire made a systematic attempt to wipe out Christianity. The emperor Decius (249–252 C.E.) faced a Gothic invasion, the first of many that the empire would suffer. The gods seemed to be angry with Rome, and Decius insisted that everyone sacrifice to them and present certificates to that effect. Had Decius lived longer, he would have done Christianity serious damage, but he was killed in battle, and the persecution slowed. At the beginning of the fourth century C.E. there was another determined persecution, but by then Christianity was too powerful to be wiped out.

THE ROMAN ATTITUDE TOWARD THE CHRISTIANS. In 111 C.E., a Roman named Pliny was governor of the province of Bithynia in Asia Minor, and encountered a cell of Christians. He wrote to the emperor Trajan to report how he had handled the case, and his letter has survived. As far as Pliny could ascertain, all the Christians did was to meet before dawn on a fixed day to chant verses antiphonally in honor of Christ "as if to a god" and to bind themselves by an oath, in Latin, a *sacramentum.* Then they would disperse and meet later to eat. Despite these innocuous proceedings, Pliny demanded that all of them make a little sacrifice before the emperor's image, and those that refused be put to death. Pliny sought of Trajan the legal basis for punishing the Christians, asking if Christianity was a crime *per se,* or whether it was the actions of Christians that were recognized as crimes by Roman law. Trajan's answer was brief. He approved of Pliny's actions. As for Pliny's question, the reply was simple. Christianity was a crime *per*

a PRIMARY SOURCE *document*

THE TRIAL OF THE SCILLITAN MARTYRS

INTRODUCTION: "The Acts of the Scillitan Martyrs" is a transcript of the trial of a group of Christians from the city of Scillium in the province of Africa Proconsularis, the capital of which was Carthage. Saturninus, the proconsul—that is, the former consul who was acting as governor of the province—presided. The date was the year when Calusian and Praesens held the consulship, 180 C.E. This was a time when the Roman government had outlawed the relatively new religion of Christianity because its followers did not recognize other religions, including the cult of emperor worship. Christians were given the opportunity to renounce their faith in court; those who did not do so were put to death.

On July 17, when Calusian and Praesens were consuls, the latter for the second time, Speratus, Nartzalus, Cittinus, Donata, Secunda and Vestia were arraigned at Carthage in the court.

Saturninus, the proconsul: If you come to your senses, you will gain the pardon of our Lord the emperor.

Speratus: We have never hurt anyone. We have never committed any crime. We have never libeled anyone. But when we were mistreated, we showed our thanks, because we reverence our own emperor.

Saturninus, the proconsul: We Romans are also a religious people. Our religion is very simple: we swear by the *genius* of our Lord the emperor and pray for his well-being. That is what you also ought to do.

Speratus: If you would only listen to me quietly, I would explain to you the mystery of simple belief.

Saturninus: If you are going to deride our sacred ceremonies, I shall not listen to you. Swear, instead, by the *genius* of our Lord the emperor.

Speratus: I do not recognize the kingdom of this world. Rather I serve the God whom no one has seen nor can see. I have committed no theft. I pay taxes on everything I buy. And this because I recognize my Lord, the king of kings, and emperor of all mankind.

Saturninus, the proconsul, then said to the others: "Cease to adhere to this belief."

Speratus: Any doctrine that teaches that we should commit murder or bear false witness—that would be evil.

Saturninus, the proconsul: [speaking to the others] Take no part in this business—it is madness.

Cittinus: The only one we fear is the Lord our God in Heaven.

Donata: Respect Caesar as Caesar, but fear God.

Vestia: I am a Christian.

Secunda: I want to be none other than what I am.

Saturninus, the proconsul, to Speratus: Will you persist in remaining a Christian?

Speratus: I am a Christian. (And all the rest agreed with him.)

Saturninus, the proconsul: Would you like some time to think this over?

Speratus: Where our duty is so clear there is nothing to think over.

Saturninus, the proconsul: What do you have as the documents in your case?

Speratus: The sacred writings, and the epistles of a saint named Paul.

Saturninus, the proconsul: You may have a thirty-day reprieve to think this over.

Speratus again said: I am a Christian. (And all the others were of the same mind.)

Saturninus, the proconsul, then read out the sentence from his tablets: Whereas Speratus, Nartzalus, Cittinus, Donata, Vestia, Secunda, and the others, have admitted that they live in accordance with the religious rites of the Christians, and whereas they have persevered in their stubbornness even when given the opportunity to return to the Roman religion, it is hereby decreed that they should die by the sword.

Speratus: Thank God!

Nartzalus: Today we shall be martyrs in heaven—thank God!

SOURCE: "The Acts of the Scillitan Martyrs," in *The Fathers of the Primitive Church.* Ed. Herbert A. Musurillo (Toronto: The New American Library of Canada, 1966): 150–152.

se. This decision to outlaw Christianity as a religion made it markedly different from Judaism, which suffered from Roman disdain but was always a legal religion. Christianity was considered dangerous for several reasons. For one thing, the Roman authorities saw Christianity as a secret society, and secret societies made them nervous. The empire was always afraid of subversion. For another, it is clear from early Christian writings that the Chris-

tians regarded the empire as evil. They looked forward to its final destruction and the Last Judgement. Then, too, there was misunderstanding at fault. There were rumors of horrific Christian rituals including cannibalism, and the liturgy of the Eucharist that professes to offer the body and blood of Christ to Christian worshippers must have nourished this misconception. Finally, unlike the ancient religion of Judaism, Christianity was a new sect, and it was founded by a man who had been crucified by the Romans on a charge of high treason. The Romans had reason to be apprehensive.

THE RETREAT OF PAGANISM. Rome's change of attitude towards Christianity began with the conversion of the emperor Constantine to Christianity in 312 C.E. In 313 C.E. he persuaded his co-ruler Licinius, who ruled the eastern portion of the empire, that freedom of religion should be extended to all. Licinius was not a Christian, but he wanted to maintain good relations with Constantine. The proportion of the empire that was Christian at the time of his conversion is a matter of conjecture, but it is generally agreed that it was a minority and perhaps a small minority at that. As Constantine began to favor the Christian church, however, new converts flocked to it. Constantine allowed pagans freedom of religion, but he banned sacrifices and thereby inflicted great damage on the pagan cults, for sacrifices were vitally important for them. He also helped himself to the wealth of the pagan temples. Constantine's new gold and silver coinage that helped stabilize the runaway inflation of earlier reigns used bullion from the pagan temples. The laws recorded in the Roman law codes mark paganism's retreat. Rome's machinery for enforcing its laws was always weak. There was no public prosecutor, and thus when a law appears in the law code, it should not be assumed that it was universally obeyed. If the law is repeated a number of times over a period of years, it can be assumed that there was widespread evasion. The ban on pagan sacrifice is a case in point. It was repeated again and again.

CHANGEOVER TO CHRISTIANITY. The changeover from a pagan to a Christian empire took up most of the fourth century C.E. On the coins that Constantine minted, three-quarters of the symbols shown belong not to Christianity but to *Sol Invictus*, the "Unconquerable Sun." Constantine, like his predecessors since the emperor Augustus, was *pontifex maximus*, that is high priest of Rome, and his successors continued to hold the post until Gratian (367–383 C.E.). The imperial cult did not die a sudden death. When Constantine received a request from a town in Italy to erect a temple to him, he gave permission, provided that they did not offer him sacrifices. In 356 Constantine's son, Constantius II, or-

a PRIMARY SOURCE document

THE ILLEGALITY OF CHRISTIANITY

INTRODUCTION: Pliny the Younger was a Roman litterateur and a gentleman of the governing class who was sent by the emperor Trajan to the province of Bithynia (in northwest Asia Minor) which had been misruled by its senatorial governors and needed someone to remedy the situation. Pliny arrived in Bithynia in 111 C.E. and died there two years later. Pliny's policy towards the early Christian church was harsh in accordance with Rome's suspicious attitude towards these radical believers who neither adhered to Roman pagan gods nor worshipped the emperor. He gave those persons admitting Christianity three chances to deny it, and if they persisted in their avowal, he ordered them executed. If they were Roman citizens, they had a right to a trial at Rome, and Pliny entered them on the list of persons to be sent to Rome to have their cases judged there. His efforts to elicit information about the Christian sect, however, revealed nothing that might endanger the state. Christianity seemed merely to be a "degenerate sort of cult carried to extravagant lengths." Therefore Pliny consulted the emperor Trajan to discover what course of action he should take regarding the Christian church and he received the following reply.

You have followed the right course of procedure, my dear Pliny, in your examination of the cases of persons charged with being Christians, for it is impossible to lay down a general rule to a fixed formula. These people are not to be hunted out; if they are brought before you and the charge against them is proved, they must be punished, but in the case of anyone who denies that he is a Christian, and makes it clear that he is not by offering prayers to our gods, he is to be pardoned as a result of his repentance however suspect his past conduct may be. But pamphlets circulated anonymously must play no part in any accusation. They create the worst sort of precedent and are quite out of keeping with the spirit of our age.

SOURCE: Pliny, *The Letters of the Younger Pliny*. Trans. Betty Radice (London, England: Penguin Books, 1969): 295.

dered all temples closed, but in 371 the emperor Valentinian ruled that everyone should be free to worship as he wished. The exceptions were astrologers, magicians, and Manichaeans—the last a sect on the fringes of Christianity which actually had its roots in Zoroastrianism, the national religion of Persia before the rise of Islam,

the doctrines of which envisaged an ongoing struggle in this world between the forces of Good and the dark forces of Evil. In 381, sacrifices were forbidden again, and again in 391 and 392, and in one of those years an event took place that dismayed the pagans who still clung to the old religion: the great temple of Serapis in Alexandria was destroyed by a Christian mob. The pagans expected the god to show his anger by refusing to let the Nile flood and water the fertile fields of Egypt, but the Nile flooded as usual. The pagans were disheartened at the impotence of their god. This was an example of a Christian tactic against paganism which had dramatic effect—demonstrating that the old gods could be flouted without fear of divine punishment.

SOURCES

Pierre Chuvin, *A Chronicle of the Last Pagans* (Cambridge, Mass.: Harvard University Press, 1990).

John Ferguson, *Jesus in the Tide of History: An Historical Survey* (London, England: Routledge and Kegan Paul, 1980).

Garth Fowden, "Bishops and Temples in the Eastern Roman Empire, 320–425," *Journal of Theological Studies* 29 (1978): 53–78.

Wayne A. Meeks, *The First Urban Christians; The Social World of the Apostle Paul* (New Haven, Conn.: Yale University Press, 1983).

Arnaldo Momigliano, *The Conflict between Paganism and Christianity in the Fourth Century* (Oxford, England: Oxford University Press, 1963).

Jacob Neusner, *Judaism in the Beginning of Christianity* (Philadelphia: Fortress Press, 1984).

Robert L. Wilken, *The Christians as the Romans Saw Them* (New Haven, Conn.: Yale University Press, 1984).

SIGNIFICANT PEOPLE
in Religion

CONSTANTINE

286 C.E.–337 C.E.

Emperor
Convert to Christianity

LEGITIMIZED CHRISTIANITY. Constantine I's long reign brought about a profound change between the Roman state and the Christian church. From being a persecuted sect, Christianity became the privileged religion of the Roman Empire. Constantine was, at first, a pagan, and worshipped *Sol Invictus*, that is, the "Invincible Sun." His sudden conversion to Christianity on the eve of the Battle of the Milvian Bridge in 312 C.E. does not seem to have resulted in a clean and immediate break with the Invincible Sun religion, but there can be no doubt that the conversion was genuine. He donated the Lateran Palace to the pope almost immediately after he made himself master of Rome. In 313 C.E. he met the eastern emperor, Licinius, in Milan and together they promulgated a decree ordering tolerance for all religions. Constantine soon made it clear, however, that paganism was out of favor. He probably banned pagan sacrifices; although a decree stating such that can be attributed to Constantine has not survived, one from his son, Constantius II, who banned sacrifices and referred to his ban as a repetition of his father's decree still exists. Sacrifice was at the heart of paganism, and by banning sacrifice Constantine struck the pagan cults a mortal blow.

CONSTANTINOPLE. In 324 C.E. Constantine united the eastern and western halves of the Roman Empire by overthrowing the eastern emperor, Licinius. He followed up his victory by founding a new capital at Byzantium on the Bosporus, the strait between the Sea of Marmora and the Black Sea. It was to be a New Rome, free from the pagan traditions and monuments of the old Rome on the Tiber River. It rapidly became known as the "City of Constantine," that is, "Constantinople." It would become the capital of the Byzantine Empire.

THE ROLE OF A CHRISTIAN EMPEROR. Emperors before Constantine had held the office of *pontifex maximus*, that is, high priest of Jupiter, Best and Greatest God, and they had also been gods themselves, receiving sacrifices in their temples. Constantine continued to hold the office of *pontifex maximus*, and he did not fully break with the custom of emperor worship; shortly after he conquered Italy he received a request from an Italian town to build a temple to him, and he consented, stipulating only that no sacrifices should be made to him. He eventually redefined the position of the emperor as the "friend" of the *Logos* of the Christian God, that is, the Divine Reason, rather than a god himself. He was God's vicar, that is, his representative on earth. Moreover, as God's vicar, the emperor was involved in defining orthodoxy and repressing heresy. In 325 C.E. he convened the first ecumenical council of the church at Nicaea to resolve the problem of the Arian heresy which held that Christ was a human being, and he was instrumental in formulating the Nicene Creed which set forth church dogma on the nature of Christ.

BAPTISM AND DEATH. In 337 C.E. Constantine died as he was planning a campaign against Persia. The end

seems to have come quickly; there was no lengthy illness. He was baptized virtually on his deathbed. It has sometimes been argued that this deathbed baptism shows that Constantine's adherence to Christianity was never strong, but deathbed baptisms were normal at this time, for it was believed that baptism wiped away sin; hence baptisms late in life allowed a sinner to enter Heaven with a spotless record. All the emperors after Constantine were Christian, save one: Julian the Apostate (361–363 C.E.), and his attempt to restore paganism was a failure.

SOURCES

H. A. Drake, *Constantine and the Bishops; The Politics of Intolerance* (Baltimore: Johns Hopkins University Press, 2000).

A. H. M. Jones, *Constantine and the Conversion of Europe* (Toronto, Canada: University of Toronto Press, 1978).

Ramsay MacMullen, *Constantine* (London, England: Croom Helm, 1987).

Ramsay MacMullen, *Christianizing the Roman Empire* (New Haven, Conn.: Yale University Press, 1984).

HOMER

c. 8th century B.C.E.–c. early 7th century B.C.E.

Poet

ILIAD AND ODYSSEY. The long epic poems, the *Iliad* and the *Odyssey* stand at the beginning of Greek literature, and the Greeks generally attributed them to a poet named Homer. Nothing can be said for certain about his identity. The years of his life are much disputed; guesses range from the time of the Trojan War, which was generally placed around 1200 B.C.E., up to 500 years after the Trojan War or about 700 B.C.E., which is a date most modern scholars can accept as the approximate period when he lived. It is generally agreed that he lived near the end of a bardic tradition, when oral poets who were generally illiterate performed at festivals or banquets. Yet at some point, the *Iliad* and the *Odyssey* took their present form and were written down, and it is at least possible that Homer was the poet responsible for producing the written text.

DEVELOPMENT OF RELIGION. Whoever Homer was, his importance to the development of Greek religion was enormous. The *Iliad* and *Odyssey* defined the gods and goddesses and gave them their attributes. The *Iliad* placed them on Mt. Olympus; the *Odyssey* was a little more vague about the exact location of their dwelling, but in both epics, the gods and goddesses lived high above the earth and looked down on mortals with detached interest. They represented no ethical ideal, but they were powerful and easily offended.

PERFORMANCE OF EPICS. The text of Homer was preserved by a company of bards called the *Homeridai* or "Sons of Homer," which did not necessarily imply that they were Homer's descendants, but rather professionals who continued to work in the Homeric tradition. Their responsibility was to recite the portions of the *Iliad* and *Odyssey* at festivals or public gatherings, accompanied by the lyre. Sometimes, before starting his performance, the bard would recite a prelude of his own composition, and some of these have survived as the so-called Homeric Hymns. These hymns are literary creations and not to be confused with the hymns that might be sung to a god as part of the sacrificial ritual, which invoked the god under his various names, recited his deeds, and ended with a prayer. The headquarters of the *Homeridai* was on the island of Chios, off the west coast of Asia Minor, and the author of one Homeric Hymn refers to himself as a blind poet from Chios. It was probably this little autobiographical detail that gave rise to the tradition that Homer himself was a blind poet from Chios.

HOMER AS EDUCATOR. The Greeks recognized Homer as the educator of all Greece. His poems were accepted everywhere as classics, and the education of a young Greek would include the memorization of long sections of the epics. We hear of Greeks who could recite all the *Iliad* and *Odyssey* by heart, for they had committed them to memory at school and could still recall them when they became adults. The Olympian gods as Homer represented them became accepted all over Greece, and gave Greek religion whatever unity it had. Moreover, Homer gave Greece a heroic ideal. The Achilles of Homer's *Iliad* became the splendid model of the heroic warrior who chose honor and valor over a long but uneventful life. If Homer provided the Greeks with an ethical paradigm, it was not the gods but the brave Achilles who died young but left behind him renown and glory.

SOURCES

C. M. Bowra, *Homer* (London, England: Duckworth; New York: Scribner, 1972).

Jenny Strauss Clay, *The Wrath of Athena: Gods and Men in the "Odyssey"* (Princeton, N.J.: Princeton University Press, 1983).

Jasper Griffin, *Homer on Life and Death* (Oxford, England: Oxford University Press, 1980).

G. S. Kirk, *Homer and the Oral Tradition* (Cambridge: Cambridge University Press, 1976).

NUMA POMPILIUS

715 B.C.E.–673 B.C.E.

Second king of Rome
Founder of Roman religion

THE CALENDAR OF NUMA. Numa Pompilius may never have existed, but the Romans looked back to him as the founder of their religion. According to Roman myth, Numa became the second king of Rome after Romulus was snatched up to Heaven to become the god Quirinus, or according to another version, murdered by the senators. He was credited with reforming the ritual calendar of Rome and establishing the priesthoods and the cult of Vesta. Before Numa, Rome had used a calendar of ten months, beginning with March, which it took over from Alba Longa, Romulus' native town in Latium. Numa drew up a lunar calendar of twelve months, with extra days inserted by the pontiffs to keep it congruent with the solar year. He fixed days which were lawful for business (*fasti*) and unlawful (*nefasti*), and he set the days for religious festivals.

THE ROMAN RITUAL CALENDAR. Numa's calendar may be mythical, but the Romans did have a ritual calendar. Broken inscriptions from Rome and vicinity have preserved fragments of more than forty copies of it. None are exactly the same, but all have roughly the same forty festivals marked in capital letters. While the person who drew up the calendar may not have been Numa, at least the calendar which the Romans thought was Numa's probably did exist.

THE CULT OF VESTA. Numa can hardly have founded the cult of Vesta. Her worship parallels the cult of Hestia in the Greek cities, and Roman legend remembered that Alba Longa also had a cult of Vesta. Vesta had a temple of her own in Rome, and she was attended by six Vestal Virgins, the only priestesses in the Roman priestly establishment. The priestesses of Vesta may show that Vesta's cult dates back to a time before Roman society became rigidly patriarchal. The remains of the Temple of Vesta in the Roman Forum and the House of the Vestal Virgins beside it can still be seen. Archaeologists have found votive offerings which were deposited in the forum temple as early as 575 B.C.E., and remains found in the House of the Vestals are even earlier. While these dates indicate that the cult of Vesta began *after* the death of Numa, Numa could have organized the cult of Vesta first in his own house, with his own unmarried daughters as Vesta's attendants. Only later did the Vesta cult move to its own temple after the Roman Forum was drained, and the number of Vestal priestesses became six. They had to remain virgins for the thirty-year term of their priesthood, and a Vestal who lost her virginity would be buried alive.

NUMA'S OTHER CONTRIBUTIONS. Numa was also credited with creating the *Flamen Dialis*, the priest of Jupiter, to take over some of his own ritual duties. He also created priests for Mars and Quirinus. He was also credited with building the Regia in the Roman Forum, which housed the armor sacred to Mars: one shield was said to have dropped from Heaven. The Regia was later the official headquarters of the *pontifex maximus*, or high priest of Rome, and in spite of the fact that the word "Regia" can be translated as "royal palace," it seems never to have been a residence. The first structure built on the site of the Regia was an open-air sanctuary. Another legend about Numa made him a disciple of the Greek philosopher Pythagoras of Samos, who had a group of followers in the Greek settlement of Croton on the Gulf of Taranto in Italy, and then in Metapontum after they were expelled from Croton. Chronology, however, gets in the way of the legend. Pythagoras emigrated from Samos to Croton about 530 B.C.E., long after Numa died.

SOURCES

A. K. Michels, *The Calendar of the Roman Republic* (Princeton, N.J.: Princeton University Press, 1967).

R. M. Ogilvie, *A Commentary on Livy Books 1–5* (Oxford, England: Oxford University Press).

Plutarch, "Life of Numa," in *Parallel Lives.* Rev. A. H. Clough (Boston: Little Brown, 1909).

ST. PAUL

64 C.E.

Christian missionary

BACKGROUND.

Meanwhile Saul was still breathing murderous threats against the disciples of the Lord. He went to the High Priest and applied for letters to the synagogues of Damascus authorizing him to arrest anyone he found, men or women, who followed the new way, and bring them to Jerusalem. While he was still on the road and nearing Damascus, suddenly a great light flashed from the sky all around him. He fell to the ground and heard a voice saying, "Saul, Saul, why do you persecute me?" "Tell me, Lord, who you are." The voice answered, "I am Jesus, whom you are persecuting."

Thus the *Acts of the Apostles* introduces us to Paul at the turning-point of his life: a sudden conversion which

transformed him from a Pharisee (a Jewish teacher of the law) into one of the major figures in the early Christian church.

PAUL THE PERSECUTOR. The future apostle was born in the Hellenistic city of Tarsus in modern Turkey. His father was a citizen of Rome, so he inherited the special status conferred on Rome's citizens, retaining both a Roman name, "Paulus," and a Hebrew name, "Saul." In addition to holding a privileged status in Roman society, Saul was part of the elite tribe of the Jews, the tribe of Benjamin, and was steeped in both Jewish culture and religion. Saul's schooling at Tarsus taught him a smattering of the Greek authors, but for the final stages of his education, his family must have moved to Jerusalem and placed him under the guidance of Gamaliel, the foremost rabbi of the first century C.E. Under Gamaliel, Saul trained to be a Pharisee, an elite teacher of Jewish law. He was also a tent-maker by trade.

PERSECUTION OF CHRISTIANS. Saul was extremely zealous in his religious vocation, and viewed the Christians as heretics for claiming that Jesus was the Son of God. The *Book of Acts* in the Bible records Saul's first known participation in the persecution of Christians: at the stoning of Stephen, a deacon of the Christian church, Saul is described as looking on in approval and holding the coats of Stephen's killers. Stephen's stoning apparently began a significant campaign by the temple priesthood to suppress Christianity, and Saul was at the forefront of the persecution, traveling to various cities and even making house-to-house searches for Christians to arrest. At the time of his vision of Jesus, he was on the road to Damascus with letters to the synagogues there from the high priest of the Temple, authorizing him to arrest any Jews he found neglecting the Law of Moses and accepting Jesus as the Messiah, in order to bring them to trial in Jerusalem.

CONVERSION. Saul's experience with Jesus described in the passage above convinced him that Jesus truly was the Son of God. The vision, however, had left him blind, and he had to be led to Damascus by his companions who had neither seen nor heard the vision Saul experienced. A second vision assured him that he would be healed of his blindness by a Christian named Ananias, who did indeed pray for Saul to be healed at the behest of a vision he had received. Ananias proved to be an important contact with the Christian church for Saul; he was able to convince a suspicious Damascus church that Saul's conversion was genuine, and Saul, now called "Paul," was accepted into their midst. Saul began to apply his knowledge of the Jewish holy text to prove that Jesus was the promised Messiah, and quickly became one of the most prominent preachers in the early church.

CHURCH LEADER. Paul embarked on an ambitious series of missionary campaigns, and was responsible for planting many churches in various cities. From Damascus he traveled to the Nabataean Kingdom of Arabia to make converts among the Arabs, and also went on a 14-year sojourn to Syria and Cilicia, preaching wherever he went. His letters to the churches he fostered compose a significant portion of the New Testament of the Bible, and his expositions of Christian theology in those letters are the basis for the modern church. So prominent was Paul in the church that he was considered to be an "apostle," even though that title was typically reserved for the members of Jesus' original twelve disciples. As a leader, Paul was a central figure in the theological debates that arose within the church; in particular, he advocated for the inclusion of Gentiles (non-Jews) into the church without forcing them to adhere to Jewish rites such as circumcision and the abstention from eating "unclean" foods. Paul argued that the church's continued fixation on Jewish law made them no different from those who did not believe Jesus was the messiah, and that they should be focusing on Jesus' teachings rather than the rites and laws of Jewish holy texts.

BREAK WITH JEWISH CHRISTIANS. Paul's position regarding the Gentile Christians eventually caused a permanent breach with some of the Jewish members of the church. Hard-line Jews, led by the apostle James (the brother of Jesus), pressured more moderate Jews like the apostle Peter to demand that Gentile converts adhere to Jewish law. When Peter sided with them, Paul publicly debated the issue with him and accused him of hypocrisy. The result was a break between Paul and the Jewish-Christian missionaries. Paul continued his mission work, and his travels took him through Asia Minor and across Europe, where he founded a church at Philippi in Macedonia and another in Thessaloniki. He visited Athens, Corinth, and Ephesus. Paul's message was not always well received in the cities he visited, and he was just as likely to be arrested, beaten, or threatened with death as he was to make converts.

PERSECUTION OF PAUL. Paul's troubles began when some Jews from Asia Minor recognized Paul in the Temple and incited the crowd to seize him. Roman troops intervened, saving his life, but they kept Paul under arrest. Paul was allowed to address the crowd in Hebrew, but this led to new riots, and Paul was taken into protective custody. At this point, fearing he might be flogged, Paul invoked his privilege as a Roman citizen, which protected him from flogging. Paul tried and failed

to defend himself before the Sanhedrin (the Jewish legal body), and Roman troops once again had to intervene. Some Jewish fanatics conspired to murder Paul, but Paul's nephew warned the Roman authorities and they removed him to Caesarea where he was kept under guard. There the Roman procurator of Judaea, Felix, kept Paul for two years without making a decision about him. When Felix's successor, Porcius Festus, arrived, the Jewish leaders renewed their case against Paul and asked Festus to transfer him to Jerusalem. Paul suspected that they were planning an ambush on the way and appealed to Caesar. The appeal saved Paul from possible murder, but it also meant that he had to present his case directly to Caesar.

DEATH AND AFTERMATH. Paul had a great deal of freedom in Rome. A soldier accompanied him, but he had his own lodging, and he contacted the Jewish community. He persuaded some as to the rightness of his ideas, but others remained skeptical. He probably died around 64 C.E. and so it is possible that he fell victim to the emperor Nero's persecution of the Christians in that year, though there is no independent evidence of that. If so, he died just before the event that would defeat his Jewish Christian opponents. In 70 C.E. the Romans, led by the future emperor Titus, destroyed the Temple in Jerusalem. The Jewish Christian church in Jerusalem was a casualty of this catastrophe, as was the Temple priesthood and the Sadducees who had dominated the priestly offices. The break between Judaism and Christianity was complete, and before the end of the century, relations between the two showed signs of hostility.

SOURCES

Hans Dieter Betz, "Paul," in *The Anchor Bible Dictionary.* Vol. 5. Ed. David Noel Freedman (New York; London, England: 1992): 186–201.

Wayne A. Meeks, *The First Urban Christians* (New Haven, Conn.: Yale University Press, 1983).

Arthur Darby Nock, *St. Paul* (New York: 1938).

SOCRATES

469 B.C.E.–399 B.C.E.

Philosopher
Teacher

IMPORTANCE TO GREEK RELIGION. Socrates is more important for his contribution to philosophy than religion. Nonetheless, he was important as a catalyst in Athenian intellectual life of the fifth century B.C.E., and the questioning of conventional attitudes which he helped to

initiate spilled over into religious thought. In 399 B.C.E. he was tried before a popular jury of 501 jurymen on a charge of not recognizing the gods whom the state recognized, introducing other new gods, and corrupting the young. There are two surviving accounts of his *Apology,* that is, his speech in his own defense: one by his disciple Plato and a second by another of his followers, Xenophon. They are quite different and neither has a great claim to accuracy. It is not clear what new gods Socrates introduced, and his accusers seem to have concentrated on the charge that Socrates corrupted the young.

QUESTIONED CONVENTIONAL VIEWS. It is true that Socrates questioned conventional views of Greek religion. In one of Plato's early dialogues, the *Euthyphro,* Socrates demonstrated that the Olympian gods could not be taken as models of morality or virtue. He himself, however, was scrupulous in his religious observances. His final words before his death were a reminder that he owed a cock to the god Asclepius. Apparently he had promised to sacrifice a cock at the temple of Asclepius on the south slope of the Athenian Acropolis, and he wanted his vow carried out.

THE TRIAL OF SOCRATES. Socrates was convicted at his trial by a vote of 281 out of 501 jurymen. His prosecutors suggested the death penalty, and Socrates then had a chance to suggest an alternative punishment. Socrates at first suggested facetiously that he be given meals at state expense for the rest of his life, but, at the urging of his friends, he suggested a modest fine. The jury was clearly annoyed by Socrates' attitude and opted for the death penalty by a greater majority than had found him guilty in the first place.

SOURCES

Thomas C. Brickhouse and Nicholas D. Smith, *The Trial and Execution of Socrates: Sources and Controversies* (Oxford, England: Oxford University Press, 2002).

Mark L. McPherron, *The Religion of Socrates* (University Park, Pa.: Pennsylvania University Press, 1996).

I. F. Stone, *The Trial of Socrates* (Boston: Little Brown, 1988).

DOCUMENTARY SOURCES
in Religion

Apuleius, *Metamophorses* (c. 160 C.E.)—The only complete Latin novel that survives, the *Metamorphorses* better known by its popular title *The Golden Ass,* tells the story of how Lucius, who is too interested in black

magic for his own good, is inadvertently changed into a donkey. It ends with an autobiographical account of how Lucius was transformed by the goddess Isis into a man again who stands for Apuleius himself, and is initiated into the cult of Isis who had saved him.

Cato the Elder (Marcus Porcius Cato "Censorius"), *De Agri Cultura* ("On Agriculture"; c. 160 B.C.E.)—Cato's handbook on how to farm for profit contains a great deal of information about Roman religion and superstition as well as the sacrificial rites which a farmer must know to keep the favor of the gods.

Cicero (Marcus Tullius Cicero), *De Natura Deorum* (c. 43 B.C.E.)—Cicero expounds the view of the gods held respectively by the Epicureans, Stoics and Academics (Platonists) and the work is followed by two appendices, the *On Divination* or "How to Interpret Portents" in two books and *On Fate* which shows the difference between determinism and fatalism.

Delphi, *Oracle of Apollo*—Delphi, on the slopes of Mt. Parnassus in central Greece, was the most famous oracular site in the Greek and Roman world. There the priestess of Apollo known as the Pythia, sitting on a tripod in the temple at Delphi, received questions on one day every month except for the three months of winter, and answered them with replies that were famous for their ambiguity.

Dodona, *Oracle of Zeus*—At Dodona in north-west Greece was an ancient oracle of Zeus, reputedly the oldest oracle in the Greek world, which was closed down only in 392 C.E. According to one account, the oracle spoke in the rustling of leaves on a sacred oak tree.

Hesiod, *Theogony* (c. 700 B.C.E.)—The *Theogony* attributed to Hesiod is a description of how the gods of Greece came into being. In the beginning there is Chaos, Heaven, which is male, and Earth which is female, separate from it; from their union is born the generation of the Titans and from the union of the Titans Cronus and Rhea is born the generation of the Olympian gods.

Homer, *The Iliad* (c. 700 B.C.E.)—Homer's epic poetry describes the Olympian gods and created the Greek concepts of what the gods were like, how they lived and what their relations were with mankind.

Marcus Minucius Felix, *Octavius* (c. 200 C.E.)—A dialogue written in Latin between a pagan, Caecilius, and a Christian, Octavius, with Minucius acting a referee. Though the dialogue ends with Caecilius becoming a Christian, he presents the case for paganism well and describes the wild rumors about the Christians that

were current among pagans, for instance that in their initiation ceremonies the initiate was made to kill a baby unintentionally and then everyone drank the baby's blood.

Ovid (Publius Ovidius Naso), *Fasti* (8–17 C.E.)—The *Fasti* is a poetical calendar of the Roman year which records festivals and religious rites for each month. It is an unfinished work, covering only the first six months of the year.

Pausanias, *Description of Greece* (c. 150 C.E.)—Pausanias' travel guide, based on his own journeys through Greece, pays especial attention to Greek religious sites such as Delphi and Olympia and fleshes out his account with descriptions of worship, superstitious customs, mythology and the like.

Pliny the Younger (Gaius Plinius Caecilius Secundus), *Epistulae* ("Letters"; 61 or 62–c. 114 C.E.)—Pliny's letters are small essays on current events and provide a valuable commentary on the history and society of Rome in the late first and early second centuries C.E. Two letters written towards the end of his life, one by Pliny himself addressed to the emperor Trajan, and the other Trajan's reply, deal with a cell of Christians which Pliny has discovered in the province of Bithynia which he is governing, and they show that the imperial authorities regarded Christianity at this time as an outlaw religion.

St. Augustine, *De civitate Dei contra paganos* ("Against the Pagans: The City of God"; 413–426 C.E.)—St. Augustine's most careful refutation of pagan thought, this work urges Christians to look beyond the turmoil of the Roman world and fix their gaze on the City of God instead of the City of Rome. The work was written in the aftermath of the sack of Rome by the Visigoths in 410 C.E.

St. Luke (?), *Acts of the Apostles* (c. 100 C.E.)—The *Acts of the Apostles*, addressed to someone named Theophilus who was presumably a Roman official, and written by someone familiar with the travel diary of St. Luke which may be incorporated into the latter part of the narrative, describes the spread of Christianity from the crucifixion until thirty-two years later, when St. Paul has been under house arrest in Rome for two years, but is nonetheless free to preach and receive visitors.

Villa of the Mysteries: Pompeii (first century B.C.E.)—This suburban villa outside the walls of Pompeii, which began as a farmhouse in the third century B.C.E., developed into a luxurious villa and then declined to a farmhouse before its destruction in 79 C.E., has a wall painting along three sides of a front room, done in the first century B.C.E. which depicts the initiation of a woman into the mysteries of the god Dionysus.

IMPORTANT EVENTS
in Theater

c. 750 B.C.E. Homer composes the *Iliad* and *Odyssey* orally.

c. 600 B.C.E. The form of the tragic chorus and the first satyr verses are introduced in Athens.

566 B.C.E. Tragedies are first staged at the newly established City Dionysia in Athens.

c. 534 B.C.E. Thespis, the legendary actor who first stepped out of the chorus to sing alone, produces the first tragedy.

508 B.C.E. The Athenians establish a democratic constitution under Cleisthenes. The freedom of speech and personal rights the citizens gain under this new political system allows for the development of the intensely critical tragedies and Aristophanic political satire.

c. 502 B.C.E. The Athenians begin keeping records of victories at dramatic festivals.

490 B.C.E. The wars between Greece and Persia begin. The playwright Aeschylus fights at Marathon.

c. 486 B.C.E. Competitions for comedies are added at the City Dionysia.

484 B.C.E. The playwright Aeschylus wins his first victory at a dramatic festival.

472 B.C.E. Aeschylus produces a trilogy of plays containing *Persians*, the only extant tragedy not based on Greek mythology.

468 B.C.E. The playwright Sophocles enters a dramatic festival competition for the first time and wins the dramatic prize, beating Aeschylus.

467 B.C.E. Aeschylus produces his trilogy containing *Seven Against Thebes*.

c. 463 B.C.E. Aeschylus produces the trilogy containing *Suppliants*.

c. 459 B.C.E. –c. 450 B.C.E. Mynniskos, an actor in Aeschylean tragedy, comes to prominence.

458 B.C.E. Aeschylus produces the *Orestia* trilogy containing *Agamemnon*, *Libation Bearers*, and *Eumenides*, and wins first prize at a dramatic festival competition.

456 B.C.E. Aeschylus dies in Sicily.

455 B.C.E. The playwright Euripides enters a dramatic competition for the first time.

c. 449 B.C.E. Competitions for tragic actors are established at the City Dionysia.

c. 442 B.C.E. Euripides wins a dramatic competition for the first time.

c. 441 B.C.E. The playwright Sophocles produces the trilogies containing *Ajax* and *Women of Trachis*.

441 B.C.E. Sophocles produces the trilogy containing *Antigone*.

438 B.C.E. Euripides produces the trilogy containing *Alecestis*.

c. 435 B.C.E. –c. 430 B.C.E. Theatrical competitions, including contests for both tragic and comic actors, may have been introduced at the Lenaia festival.

431 B.C.E. The Peloponnesian War breaks out between Athens and Sparta. The war and the plague that followed its outbreak become subject material for several plays.

Euripides produces the trilogy containing *Medea*.

c. 430 B.C.E. Sophocles produces the trilogy containing *Oedipus the King*.

Euripides produces the trilogy containing *The Children of Heracles.*

428 B.C.E. The philosopher Plato is born.

Euripides produces the trilogy containing *Hippolytus* and wins first prize.

427 B.C.E. The playwright Aristophanes submits a comedy in competition for the first time at age eighteen.

c. 426 B.C.E. Euripides produces the trilogy containing *Andromache.*

c. 425 B.C.E. Aristophanes presents *Acharnians* for the first time.

c. 424 B.C.E. Euripides produces the trilogy containing *Hecuba.*

Aristophanes produces *Knights.*

423 B.C.E. Aristophanes produces *Clouds.*

c. 422 B.C.E. Euripides produces the trilogy containing *Suppliant Women.*

Aristophanes produces *Wasps.*

421 B.C.E. Aristophanes produces *Peace.*

c. 420 B.C.E. The tragic actors Hegelochos and Cal-
–c. 400 B.C.E. lipides are prominent.

c. 418 B.C.E. Euripides produces the trilogies con-
–c. 410 B.C.E. taining *Ion* and *Phoenician Women.*

c. 417 B.C.E. Euripides produces the trilogies containing *Electra* and *Madness of Heracles.*

416 B.C.E. The tragic playwright and actor Agathon wins first place at the City Dionysia, according to Plato's *Symposium*, the account of a party in honor of the playwright's victory.

c. 415 B.C.E. Euripides produces the trilogy containing *Trojan Women.*

c. 414 B.C.E. Euripides produces the trilogy containing *Iphigenia among the Taurians.*

Aristophanes produces *Birds.*

411 B.C.E. Aristophanes produces *Lysistrata* and *The Festival Goers.*

c. 409 B.C.E. Sophocles produces the trilogy containing *Philoctetes.*

c. 408 B.C.E. Euripides produces the trilogy containing *Orestes.*

c. 407 B.C.E. Sophocles writes *Oedipus at Colonus*, produced posthumously in 401 B.C.E.

c. 406 B.C.E. Euripides dies at court of King Archelaus
–c. 405 B.C.E. of Macedon. Sophocles honors him by dressing his chorus in mourning before the Dionysia.

405 B.C.E. Sophocles dies and is honored as a hero.

The Euripidian trilogy containing *Iphigenia at Aulis* and *Bacchae* is produced posthumously and wins first prize.

Aristophanes produces *Frogs.*

c. 392 B.C.E. Aristophanes produces *Women in the Assembly.*

c. 386 B.C.E. "Old Comedy" is listed as a category in the City Dionysia for the first time.

384 B.C.E. The philosopher Aristotle is born in Thessalonica. His *Poetics* defines and extensively discusses Greek tragedy.

382 B.C.E. Aristophanes produces *Wealth.*

c. 380 B.C.E. "Middle Comedy" is prevalent in many
–c. 320 B.C.E. dramatic competitions.

c. 350 B.C.E. Tragic actors Neoptolemus, Aristodemus, and Theodorus are prominent.

c. 330 B.C.E. Aristotle writes his *Poetics*, which defines and discusses Greek tragedy.

c. 321 B.C.E. "New Comedy" begins in Athens.

316 B.C.E. Menander produces *The Grouch*, his only complete extant play.

c. 310 B.C.E. Comic actor Parmenon becomes prominent.

c. 300 B.C.E. –c. 275 B.C.E.	The Artists of Dionysus, a performers' union and "religious" guild with its own priest, whose members were exempt from paying taxes and military service, is active.
	The poet Rhinthon of Tarentum, a Greek colony in southern Italy, composes scripts for *phlyax* plays, popular in the western Greek colonies.
291 B.C.E.	Comic playwright Menander dies.
c. 264 B.C.E.	The first gladiatorial show is performed in Rome.
c. 240 B.C.E.	Livius Andronicus translates one Greek tragedy and one Greek comedy for performance at the Roman Games.
236 B.C.E.	Naevius, a Roman playwright and poet, produces his first play.
c. 230 B.C.E. –c. 184 B.C.E.	Comic playwright Titus Maccius Plautus flourishes in Rome.
c. 220 B.C.E.	Pacuvius, a Roman tragic playwright and painter, is born in Brundisium, Calabria, in the "heel" of Italy.
207 B.C.E.	A Roman theatrical union is formed called the College of Scribes and Actors.
c. 204 B.C.E.	Livius Andronicus dies.
195 B.C.E.	The playwright Aristophanes of Byzantium becomes the head of the library at Alexandria, Egypt.
c. 173 B.C.E. –c. 172 B.C.E.	The first annual performance of mime occurs at the Roman festival Floralia.

	Roman actors Antipatros and Agathodorus perform at Delphi.
c. 170 B.C.E.	Accius, a Roman tragic playwright, is born in Pisaurum, Umbria, in central Italy.
c. 166 B.C.E. –c. 160 B.C.E.	Comic playwright Terence is active in Rome.
c. 100 B.C.E. –c. 50 B.C.E.	Roman actors Roscius and Claudius Aesopus are prominent.
69 B.C.E.	The comic actor Roscius is defended in court by Cicero on a charge of fraud.
55 B.C.E.	Pompey dedicates the first permanent, stone theater in Rome.
22 B.C.E.	The actors Pylades and Bathyllus introduce pantomime at Rome.
c. 4 B.C.E. –c. 65 C.E.	Seneca the Younger, philosopher and tragic playwright, serves in the court of Nero, who eventually forces him to commit suicide.
60 C.E.	Nero puts on the first "Neronian Games."
65 C.E.	Nero himself performs in the second Neronian Games.
c. 80 C.E.	Mime and pantomime performers form their own artistic union, the Parasites of Apollo.

OVERVIEW
of Theater

MYTHOLOGICAL ORIGINS. According to mythology, the theater in ancient Greece sprang from rituals that both honored and appeased the god Dionysus. Dionysus first taught the precious skill of viticulture, the cultivation of grapes for winemaking, to a man named Icarius. Icarius wore goatskins in honor of the god, who had been disguised as a goat in childhood to protect him from the wrath of Hera, queen of the gods. After Icarius served his newly made wine to some shepherds, they became ill from overindulgence and, believing that Icarius had poisoned them, killed him. In order to atone for their crime, they, too, donned the skins of goats and danced and sang around the fire to honor Dionysus and his pupil. From these songs and dances grew rituals of public performance, or so myth would have it. Human beings are fascinated by storytelling and the reenactments of human experience, and most likely always have been. That the Greeks developed this kind of myth about the origins of their theater tells us much about them. For the ancient Greeks, theater was more than entertainment, although it was that, too. It was a didactic institution that sought to analyze social and political change, human relationships, the existence of the divine, and the meaning of life in its deepest sense. For the fifth-century B.C.E. Athenian, drama was an educational and a religious experience as well as entertainment for the ancient Greeks.

AGE OF THE EPIC. The word "theater" derives from an ancient Greek verb that means "to see." But formal staged drama was not the first mode of public performance developed and enjoyed by the Greeks. After the great civilizations of the Minoans and Mycenaeans fell under mysterious but violent circumstances, and before Greece once again produced written literature, architecture, and art, there was a period of several hundred years now called the "Dark Ages." From the mists of these shadowy years arose a great poet, Homer, who wrote "epic" poetry—long, cadenced poems about great heroes and their struggles to retain their humanity in the face of warfare, loss, and isolation. These tales of the men who fought in the greatest war in human legend, the Trojan War, were composed orally and were memorized and presented by traveling bards called *rhapsodes* ("reciters of poetry"), who punctuated their performances with the beat of their long staffs. The stories of the Trojan War so captivated the ancient Greeks that they produced dozens of prequels and sequels and tangential episodes to fill in the gaps of and offer alternatives to the Homeric versions of the tales. These legends became the bulk of the material that tragedians later used as the basis for their dramas. Within the Homeric sagas, the poet tells us of the performance of "paeans" or songs of celebration and thanksgiving to the gods, especially Apollo.

COMPETITIONS. In cities and villages all over ancient Greece, large groups of men and boys formed choruses to perform the "dithyramb," an ecstatic song and dance to honor Dionysus that sprang from those first frenzied attempts of the shepherds to conciliate the angry god. Legend tells that a man named Thespis was the first to step out of the choral group to speak with his own voice, and thereby "invented" the individual actor in a staged drama. These dithyrambic choruses were also included in the structure of tragedy as it developed and became the heart of Greek drama. In the late sixth century B.C.E., the Athenians founded a democratic government and formalized the performance of tragedy by establishing theatrical festivals. During these festivals, religious processions and rituals blended with the day-long performances of dithyrambs, tragedies, satyr plays, and in later years, comedies, which were in themselves religious expressions. Classical drama combined spoken dialogue with monodies (odes for one voice), choral songs, and dances, which were accompanied by music. Competition was at the center of these festivals: playwrights submitted three tragedies (sometimes a trilogy organized and connected by a theme, sometimes not) followed by a light-hearted "satyr" play, a farcical stage show featuring the lecherous half-man/half-animal creatures who were the constant companions of Dionysus. The staging of these tragedies was undertaken by a *choregos*—a rich citizen who underwrote the cost of the production and oversaw auditions, rehearsals, and the equipage of the troupe. Three playwrights out of the dozens who were actively writing drama were chosen to perform their plays and were awarded first, second, and third prizes. Comic playwrights submitted one play for competition with their peers. Judges were selected from among the Athenian citizenry—adult males whose parents were both native Athenians. Actors in both tragedy and comedy wore masks, long robes, and elevated shoes in order to be seen and heard by the large crowds in the theater. There is

evidence that all classes of people attended performances at these dramatic festivals: citizen men and women, foreigners, slaves, and children. The philosopher Aristotle in the fourth century B.C.E. sought to codify tragedy in his *Poetics* according to his own experience and opinions of the theater.

COMEDY VERSUS TRAGEDY. Aeschylus is the earliest playwright whose works still survive. He served in the Athenian military and fought against the Persians during the early years of the fifth century B.C.E. when they sought to conquer Greece. His military experience heavily influenced his earliest extant tragedy, *The Persians*, the only surviving tragedy to use historical rather than mythological events for its plot. Aeschylus and most later tragedians like Sophocles and Euripides chose to dramatize the well-known tales from Greek mythology as a way of expressing their insights on such topics as the possibility of justice in a harsh world, the importance of honor, and the differences between divine and human law. Unlike the tragedies, the first comic plays are now categorized in a genre modern scholars call "Old Comedy." Comic playwrights like Aristophanes opted to stage political and social circumstances of the day and often portrayed famous people, like Socrates and the politician Cleon, in their uproarious and bawdy comedies (mostly in unflattering ways). Women were often featured as protagonists in both tragedy and comedy, despite the fact that in society, women were permitted very little freedom and would not usually have had much experience with public life. Male actors portrayed all the roles on the traditional stage, just as they did in Shakespeare's time.

THE GOLDEN AGE. The fifth century B.C.E., often known as the "Golden Age" of classical Athens, was bookended by two major wars. At the beginning of the century, the allied Greek forces fought off the invading Persians, and in the last thirty years of the century, the Athenians fought a drawn-out and devastating war with the Spartans, known as the Peloponnesian War. The Spartans were ultimately victorious in this war and annexed the democracy that the Athenians had enjoyed for over a century. This event signalled the end of Athenian ascendancy in the Mediterranean, and with it came a shift in the content of the theater. No longer possessed of such great freedom of speech, the comic playwrights abandoned their topical plays, which were often critical of the government and public figures. Instead, Aristophanes and the playwrights of the fourth century B.C.E., such as Menander, created gentle family-oriented comedies that featured stock roles: the grumpy father, the dissolute son, the dispossessed and vulnerable young girl, the nagging wife, and the nosy neighbor. These plays

were known as part of the style of "Middle Comedy." Although these plays also had a political message to deliver, it was conveyed by much more subtle means. The production of new tragedies slowed down considerably. A canon of tragic plays was established, and frequent revivals of fifth century B.C.E. dramas were popular.

RISE OF ROMAN THEATER. As Rome began to build slowly toward world dominance in the third and second centuries B.C.E., native Italic forms of literature and drama, like the Atellan farces and religious poetry, were supplemented by literature and drama influenced by the Greeks, who had had colonies in southern Italy for hundreds of years. The Romans were superior in military force and imperial ambition, but were in awe of the Greeks' achievements in architecture, art, poetry, dance, and theater, and they unashamedly copied the Greeks. Poets like Naevius wrote tragedies about Roman legend and myth, but these were not nearly as popular as the comedies adapted from the Hellenistic playwrights by Plautus and Terence. While these comic plays retained the ostensibly Greek settings and many of the more familiar stock characters of "Middle Comedy" (400–200 B.C.E.), the "New Comedy" of Plautus and Terence enlivened the dated dramas of the previous century or two with purely Roman expressions, situations, and humor. Plautus was among the most popular and successful playwrights in history, and his plays continued to be revived and performed for hundreds of years after his death. Under the empire established by Augustus in 27 B.C.E., theater in various forms continued to flourish. The poet Ovid, who was exiled in eight C.E., is known to have written tragedies on classical themes, but unfortunately none of these survive. The emperor Nero fancied himself an actor and often appeared on stage in revivals and newer drama. Seneca, a Stoic philosopher and confidante of Nero, also wrote tragedies using some of the most lurid and disturbing classical myths. Today we cannot know whether Senecan drama was intended to be performed on the stage or merely to be read aloud as entertainment (and perhaps edification) in the royal court. Other forms of theater, like mime and pantomime shows, remained popular throughout the Roman Empire. More extreme forms of public spectacle, like gladiatorial combats, wild beast fights, dangerous chariot races, and executions grew ever more lavish and gruesome.

LEGACY. The theater of the ancient Greeks and Romans has continued to enthrall the Western world. It influenced the development of new art forms like opera, which combines dramatic storytelling with grand music and dance. The architecture and brilliant acoustics of ancient theaters shape the way many modern theaters are

designed. The themes of ancient Greek tragedy—like the struggle for power in the family and in the outside world, the harshness of unjust laws, the search for meaning amidst catastrophe, and the soaring heroism of the human spirit—remain as pertinent and powerful today as they ever were.

TOPICS
in Theater

ORIGINS OF GREEK THEATER

PERFORMANCE CULTURE. The ancient Greeks had a love of pageantry and formalized ritual that permeated their entire society. The poet Homer composed long ballads orally, narratives of great warriors and great human themes. Wandering *rhapsodes* ("recitors of poetry") memorized these poems and performed them for audiences at banquets and festivals that were public performances in and of themselves. Religious rituals involving all aspects of what we now call drama were performed publicly as well: weddings, funerals, celebrations to honor the gods, and victories in performative competitions of all kinds. Most of the formal elements of theater—people acting out specific roles, appropriate costumes, a set order of events, as well as audience expectation and participation—already existed in the religious rituals the Greeks had been performing for hundreds of years. For the Greeks, performance was an integral part of all aspects of their life. Athenian democracy involved the entire adult male population, and at several meetings a month on the Pnyx, a hill standing opposite the Acropolis of the city, these men performed speeches in front of thousands to persuade or to inflame. To distill the origins of the "theater" from such a culture of performance is impossible, but at the same time it is easy to see how an art form that focused specifically on the performance of all Athenian customs, laws, rituals, government, and religion attained such heights. This art form was theater.

MYTHOLOGICAL ORIGINS. The theater festivals celebrated by the Athenians in the city and rural folk in outlying areas of Attica were all dedicated to the god Dionysus. One of the earliest performers in tragedy was said to have complained that the City Dionysia had nothing to do with Dionysus. In fact, it seems especially appropriate for formal rituals of performance to be dedicated to the mysterious god of wine, fertility, and agricultural growth. Though the name "Dionysus" can be

found in the earliest written form of ancient Greek, Linear B, there is a sense throughout the stories of this god in classical mythology that he was an outsider, a foreigner, essentially "un-Greek" in some fundamental way. Dionysus is related to gods from the Near East and Egypt, such as Osiris, but his presence in the Greek pantheon is no intrusion. While Apollo represented qualities the Athenians prized most—such as rational thought, ordered musical and poetic composition, and civic justice—the Greeks were also aware that human nature is two-fold. For every rational thought, there is an irrational desire. For every beautifully composed paean or song on the lyre, there is a wild and unformed song of pure, raw human emotion. In the Homeric Hymn to Dionysus, the god displays his unpredictable nature and demonstrates how he creates "enthusiasm," literally "the inspiration of the god," in his followers. The women who worship him, known as *maenads,* or "mad women," gave themselves up completely to the intoxicating power of the god, power that could bring ease and comfort from life's suffering but also brought the consequences of inhibition. An individual could become another person entirely through Dionysiac worship—a person could behave and "act" as another character. The half-man, half-animal creatures known as satyrs represent human nature at its most basic and uncivilized: the satyr lives to satisfy his primal urges for sex, wine, and food and has no thought for others. Thus the Athenians produced dramas written and staged according to ancient and well-defined guidelines, but expressive of the most terrifying aspects of the uncivilized human psyche: lust, betrayal, rage, incest, excruciating desire. The audiences who experienced these dramas were meant to undergo a *catharsis,* a cleansing of the soul. The very process of theatrical production was an essential ritual of life for the Athenians because it demonstrated the reintegration of the savage elements of human nature, represented by Dionysus and his retinue, with the civilized and ordered society defined by the tragic form.

HISTORICAL CONTEXT. The mighty thalassocracy, or "sea power," of the Minoans, based on Crete, gave way to the Mycenaeans on the Greek mainland in the mid-seventeenth century B.C.E. The Mycenaeans, whose name comes from the city of Mycenae, built huge palace complexes on the Greek mainland with thick protective walls and ruled through possession of land rather than number of ships. This civilization, from which monumental architecture, magnificent tombs filled with valuable grave gifts, and written documents remain, was wiped out by some kind of catastrophic event around 1100 B.C.E. Greece then entered a period in which there was a widespread deterioration of material culture and

no new cultural production at all. Beginning in the ninth and eighth centuries B.C.E., there was a migration from the mainland of Greece to lands in Asia Minor, the islands in the Mediterranean, and Sicily and the southern parts of Italy. During this period of regrowth, poets and artists once again began to create, including the poet known to modern scholars as Homer, who composed two massive epic poems about the Trojan War, which he presented as a cosmic event from Mycenaean times. Other poets composed hymns to various gods in Homeric style. As the Greeks began to trade with merchants from around the Mediterranean, they came into contact with the Phoenicians, a literate Semitic people with a functional system of writing. The Greeks began to adapt this Phoenician alphabet to the Greek language, and literacy spread once more, this time from outlying areas into the mainland. The Greeks began to write down songs previously transmitted orally, and they developed games and competitions, more occasions for the production of art and poetry. The various poetic genres took shape: epic, wedding songs, dirges, choral odes, and poetry for victorious athletes, musicians, and performers. In the sixth century B.C.E., under the rule of Pisistratus, the Athenians began to develop the democratic civilization that modern governments admire and emulate. To celebrate their monumental achievements both in conquest and in culture, they established dramatic festivals and began a building program to demonstrate their supremacy to the world. Although they were almost constantly embroiled in warfare during the century of their greatest accomplishments, they used the strife and suffering that war brings to strengthen their patriotism and their artistic expression, until their patriotism turned to megalomania and their attempts to bring peace inspired instead greed and merciless colonialism.

THE DEVELOPMENT OF THE DITHYRAMB. The first performers of songs in praise of Dionysus were said to have been his closest followers, the satyrs. The satyrs played pipes, and the maenads banged on timbrels (tambourine-like drums) in the production of Dionysiac music. Unlike the sober and ordered melodies dedicated to the god Apollo, Dionysiac songs expressed the emotional need to be free from social constraints and conscious rationality. From these earliest musical and verbal expressions of divine ecstasy (literally "a standing outside of oneself") inspired by Dionysus arose a form of lyric poetry called the *dithyramb*. This word is not Greek and is of unknown origin, but the poetic form became the primary way for a chorus composed of fifty men and boys to praise Dionysus. Arion of Corinth is credited with the development of the dithyramb as an established poetic genre in the seventh century B.C.E., and a poet named

Lasus brought it to Athens. The Athenians embraced it and began including it as part of their dramatic competitions in 509 B.C.E. According to Aristotle in his *Poetics* (fourth century B.C.E.), a poet named Thespis was part of a chorus performing a dithyramb when he decided to step out in front of the chorus and speak lines of his own, thereby "inventing" the actor and the form of tragedy as a whole. In English, a "thespian" is an actor on the stage. Thespis was commonly held as the winner of the first dramatic competition at the City Dionysia around 534 B.C.E. The word "tragedy" is derived from two Greek words meaning "goat-song," another reference to the earliest forms of Dionysian worship. The goat was sacred to Dionysus because he had been disguised as a goat when he was a child to protect him from the jealous anger of his stepmother Hera. The dithyramb thus became the center of Greek tragedy, which was built upon the foundation of a chorus who sang and danced in between solo songs (monodies) and exchanges of dialogue between characters on the stage.

SOURCES

P. E. Easterling, ed., *The Cambridge Companion to Greek Tragedy* (Cambridge and New York: Cambridge University Press, 1997).

David Wiles, *Tragedy in Athens: Performance Space and Theatrical Meaning* (Cambridge and New York: Cambridge University Press, 1997).

John J. Winkler and Froma I. Zeitlin, eds., *Nothing to Do with Dionysus?: Athenian Drama in Its Social Context* (Princeton, N.J.: Princeton University Press, 1989).

FESTIVALS AND THEATERS

THE FRAGMENTS OF THEATRICAL CREATION. Athens was not the only place where plays were written or performed, but after the establishment of the City Dionysia, where formal competitions of drama were held beginning in the late sixth century B.C.E., it was the center of dramatic production. Unfortunately, only a tiny portion of the theatrical output of this time survived. The names Choerilus, Pratinas, and Phrynichus, the first tragic playwright to include female characters in his dramas, in addition to Thespis as predecessors of Aeschylus are known, but all of their works are lost. Of the eighty or ninety plays Aeschylus wrote, only six survive. (The authorship of a possible seventh, the *Prometheus Bound*, is hotly contested; it has been attributed to Aeschylus but also to his son Euphorion, another tragedian.) Sophocles, in his remarkably productive career, wrote some 130 plays, of which only seven are accessible to modern readers. Ion of Chios and Achaeus of Eretria

THE QUEEN IS THE KING

INTRODUCTION: Aeschylus' *Oresteia*, "The Orestes Saga," is the only extant dramatic trilogy remaining from antiquity. It was the venerable tragedian's last production before his death in 458 B.C.E. The satyr play, a farcical and lewd lampoon called *Proteus* which accompanied the trilogy, is lost, however. In these three majestic and powerful dramas, the curse on the house of Atreus, which began with the child-murder and cannibalism of their ancestor Pelops, is finally ended by the young Orestes, the troubled son of Agamemnon and Clytemnestra. Queen Clytemnestra, with her lover, her husband's cousin Aigisthus, has been ruling Argos while Agamemnon was away at the Trojan War, and she is not willing to become submissive to Agamemnon's power again after his return. She is also furious that Agamemnon sacrificed their daughter and came home with a slave-woman, Cassandra, in tow. In this speech, at the end of the first play of the trilogy, *Agamemnon*, Clytemnestra gloats over the dead bodies of Agamemnon and Cassandra, both of whom she has murdered with her "man-slaying axe." In this passage, the extraordinary imagery and the denseness of Aeschylus' rich poetic voice are on stunning display.

Clytemnestra: Since I said many things before to suit my own needs, I am not ashamed now to say just the opposite. For how could one person, planning hateful things for hated enemies who only seemed to be loved ones, build a fence around the nets of suffering so high that no one could jump over it? I had been thinking for a long time about this match to settle an old grudge, and it was a long time coming, but in time it finally came: I stand here where I struck them down, over the deeds I accomplished. In this way I did it, and I will not deny any of it— my husband did not escape nor did he ward off his doom. I threw a boundless net, like a net used to catch fish, around him, a dreadful mass of a garment. I struck him two times, and with two cries his limbs fell lax, and while he lay there in a heap, I struck him a third time as an offering to Zeus of the Underworld, the redeemer of the dead. And as he fell he released his spirit. Then he breathed out a sharp clot of blood and he sprayed me with a dark mist of bloody dew as I rejoiced just as much as the growing grain rejoices in the god-given sparkling rain when the buds are sprouting. That's the way things are, you elders of the Argives, so rejoice, if you would rejoice. I myself exult in my triumph! If it were appropriate to pour libations over the body, then these things would have been done justly, more than justly. Agamemnon filled the drinking cup of this house with so many curses and evils that he drank it dry when he came home.

Chorus: We are horror-struck at your tongue, at your harsh mouth, that glories like that over your husband!

Clytemnestra: You are treating me like I am some dim-witted woman! My heart has no fear, and I am speaking to those who know it well. Whether you want to praise me for what I did or censure me, it's all the same to me. Here is Agamemnon, my husband, a corpse, the act of this right hand, the act of a just craftsman. And that's the way it is.

SOURCE: Aeschylus, *Agamemnon*, in *Aeschyli Septem Quae Supersunt Tragoedias*. Ed. Denys Page (Oxford: Clarendon Press, 1972): lines 1372–1406. Translated by Lisa Rengo George.

were his contemporaries. Euripides, the youngest of the three great tragedians whose works have survived, produced 92 plays, but only 19 of these made it to modern times. The titles of several other tragedies are known and some fragments from them exist. The names of other playwrights are also known, such as Critias, Plato's uncle and the leader of the notorious "Thirty Tyrants" who controlled Athens briefly after the Peloponnesian War, and Agathon, the host and one of the central figures of Plato's *Symposium*, whose victory at the Lenaia in 416 B.C.E. was the reason for the party.

DRAMATIC FESTIVALS. The most important theatrical festivals in Attica during the sixth and fifth centuries B.C.E. were the City or Great Dionysia, the Rural Dionysia, and the Lenaia. The Great Dionysia was held every year in the month of Elaphebolion, corresponding to March in the modern calendar. Pisistratus either founded or expanded the City Dionysia around 536 B.C.E. by introducing the cult of Dionysus of Eleutherae to the celebration. The Rural Dionysia took place in the month of Poseidon (December), and the Lenaia in the month of Gamelion, or January (in Ionian Greece, the month was known as Lenaion). A special archon (an elected Athenian official) oversaw all aspects of dramatic production at the Dionysia. This archon selected the three tragedians who would present a trilogy of tragedies, not necessarily connected by theme, along with a satyr play, a lighthearted farcical drama, during the days of competition. There were five days allotted for dramatic and choral competition except during the Peloponnesian War, when it

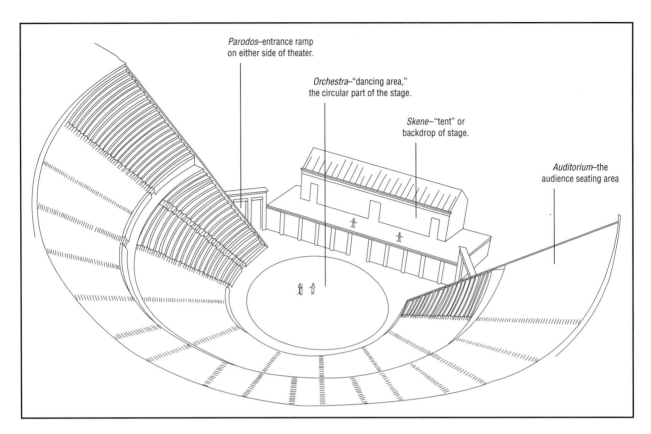

Parodos–entrance ramp on either side of theater.

Orchestra–"dancing area," the circular part of the stage.

Skene–"tent" or backdrop of stage.

Auditorium–the audience seating area

Illustration of a Greek theater. **CREATED BY GGS INFORMATION SERVICES. GALE.**

was cut back to three days. On the first three days, a tragic trilogy and satyr play were performed, followed by a comedy (beginning in 486 B.C.E.). On the final two days, choral dithyrambs were followed by a comedy. In his *Laws*, Plato suggests that the playwrights read portions of their dramas to the archon who based his choice on these mini-performances. The archon was also responsible for lining up a *choregos* for each production. The *choregos* was a wealthy Athenian citizen who paid for the outfitting and rehearsal of the chorus—the *polis* or city-state of Athens supported the dramatic poets and the leading actors. Playwrights were known to act in their own dramas—Sophocles is said to have stopped acting when his voice became too weak—but as the festivals developed, professional actors were hired. Later, in 449 B.C.E., competitions were held for actors as well as dramatists. Before the theatrical productions proper began, a *proagon* or "pre-contest" was held in which the playwrights appeared with the casts of their plays to explain the sources and themes of their dramas. In a time before theatrical placards or programs, it would have been most useful to have some guidance along these lines from the playwright himself. Athens was divided into ten *phylai* or tribes, and one man was chosen as a judge from each one of the ten. The ivy wreath be-

stowed upon the first-prize winner signified the admiration and adulation of the entire Athenian populace.

THE ENACTMENT OF THE DIONYSIAC FESTIVAL. The City Dionysia began with a lengthy procession that reenacted the original journey of Dionysus from Eleutherae to Athens. The Athenians maintained an image of Dionysus within the ancient temple precinct of the god on the south slope of the Acropolis, where a permanent theater was constructed under Pisistratus in the sixth century B.C.E. A few days before the festival procession, this image was taken to a temple of Dionysus outside the city, and during the opening festivities, the Athenians carried it by torchlight back to its rightful home. The *choregoi* marched in fancy costume along with citizens who carried large phalluses, which signified the agricultural aspects of the god's character, to the temple precinct. There the ten generals, elected officials of the city, performed sacrifices and libations. Following the *proagon*, the five days of competition began.

THE STRUCTURE OF THEATRICAL SPACE. The space for performance and the manner of performance were well-defined by the time tragedy reached its peak in Athens in the fifth century B.C.E. The structure of the Greek theater actually influenced the way actors per-

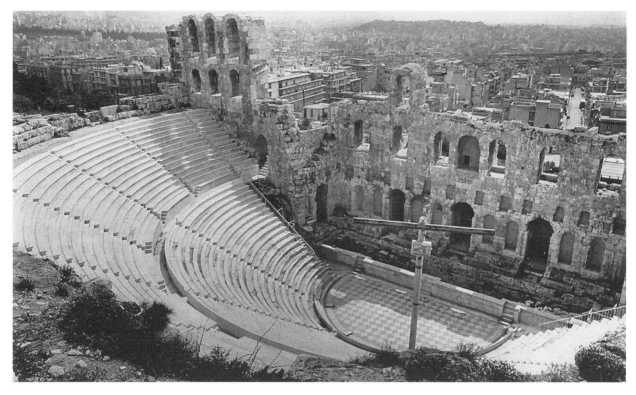

A view of the Odeon of Herodes Atticus on the south-west slope of the Acropolis in Athens. The seats have been replaced in the modern period. AP/WIDE WORLD PHOTOS, INC. REPRODUCED BY PERMISSION.

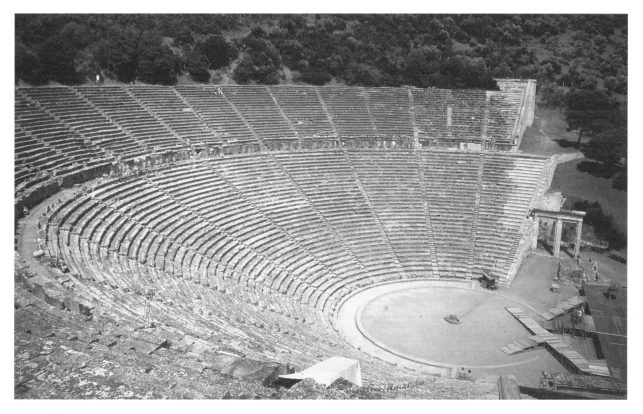

View of the Greek theater at Epidaurus, the sanctuary of Asclepius. 4th century B.C.E. PHOTOGRAPH BY HECTOR WILLIAMS. © HECTOR WILLIAMS.

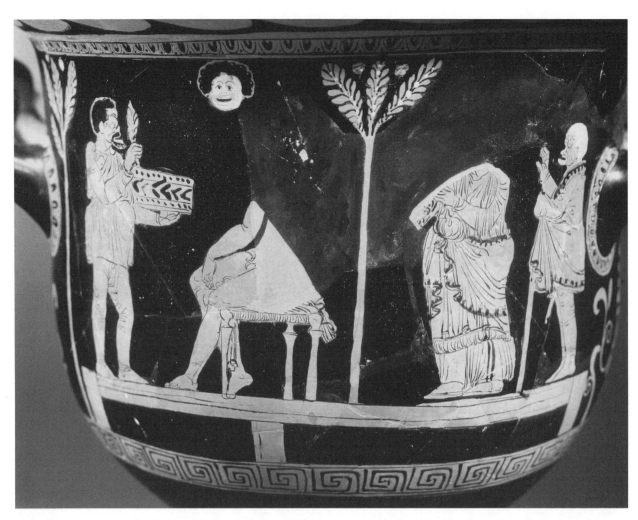

Actor making man's head disappear in illusion, red-figure crater, 375–350 B.C.E. **THE ART ARCHIVE/MUSEO NAZIONALE TARANTO/DAGLI ORTI.**

formed the dramas. Originally, the performance space was probably little more than a flat semi-circular area where the chorus performed the dithyramb, next to a sloping hillside where spectators could sit with an unobstructed view of the show. The flat area for choral performance was called the *orchestra*, which derives from a Greek word for "dance" rather than the production of music. At the back of the orchestral space stood an altar to Dionysus, for whom the dithyramb was sung. On either side of the orchestra was a path, called a *parodos*. Both spectators and actors used these entranceways to enter and exit the theatrical space. As first one and then two and more actors were added, the *skene*, meaning simply "tent," was added on a small platform behind the orchestra. This simple hut served as a dressing and waiting room for the actors as well as the primary stage setting of the drama, whether a palace, temple, cave, or tomb was required. The *skene* soon transformed into a permanent building with a number of doors, which would open into the performance space. The *skene* could be painted to convey more vividly the location of the drama. Inside the *skene* was housed an important piece of equipment called the *ekkyklema*, a platform on runners that could be rolled out of the *skene* at critical moments, such as when the display of dead or dying characters murdered off stage was necessary. A crane-like device, called the *mechane*, was employed to display gods in the heavens or humans hovering above the stage, as when Medea makes her escape in Helios' chariot at the end of Euripides' *Medea*. The Latin phrase *deus ex machina*, literally "god from the machine," refers to the appearance of a god via the *mechane* who offers a divine solution to the human entanglements in the drama. Seating was erected in the hollowed out hillside for up to some 15,000 spectators at the Theater of Dionysus, with wooden benches for the common folk and specially reserved stone chairs for important officials. The acoustics of such an arrangement are excellent, and some of Greece's best pre-

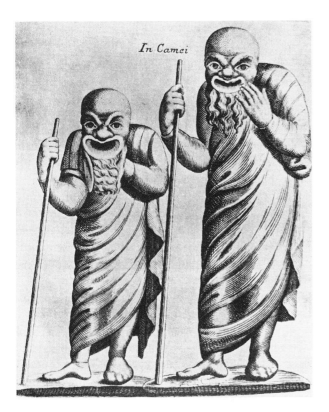

Ancient Greek actors wearing masks and dressing as old men, "In Camei" written on image, copper engraving from antique cameo. © BETTMANN/CORBIS. REPRODUCED BY PERMISSION.

served ancient theaters, such as the one at Epidaurus south of Athens, remain in use for modern performances. All theatrical performances took place in daylight, beginning at dawn and running until dusk. The thousands of theater-goers would have been perfectly visible to their neighbors, and would have had to eat, drink, talk to each other, and move around during the lengthy shows. This level of audience visibility would have created a much different atmosphere than the typically hushed and darkened theater in which modern viewers commonly watch dramatic spectacles.

ELEMENTS OF PERFORMANCE. Because the structure of the Greek theater remained static, acting style conformed to the theatrical space and exploited its most attractive features. All actors were male, and some men and boys seem to have specialized in performing female roles although most would have had to play roles of both genders. Because there were only two and sometimes three actors, each would have had to take multiple roles. This was more easily accomplished by the use of theatrical masks and costumes that covered the body completely. The mask had a wig attached to it and a large opening at the mouth, perhaps to amplify the voice. The actors also wore a common lace-up boot called a

cothurnos, to which high platforms were added in the Hellenistic period to provide greater visibility. Thus, acting style could not be subtle. No facial expressions or small gestures could be seen by the audience, and stage whispers or low voices would not have been heard. It must also be remembered that ancient theater was more like opera than a modern stage play, since the chorus and actors sang many of their parts, accompanied by dance, and even spoken dialogue was constructed in complex poetic rhythms called "meters" that influenced the method of delivery. Actors employed large gestures that became iconic. An actor's skills were expressed by the emotive qualities of his voice, and his rhetorical techniques, the same ones orators used in the government assembly and public forums. The plots of most tragedies were taken from the stories now known as "mythology." In fact, Plato in his *Republic* called Homer "the first tragic poet," not only because his subject matter was revisited in tragedy but because of the many dramatic interactions between major characters in the epic. Only a few plays that are known were not based on myth—Aeschylus' *Persians*, reflecting his experiences in the Persian War and produced in 472 B.C.E., is one of them.

SOURCES

P. E. Easterling and Edith Hall, eds., *Greek and Roman Actors: Aspects of an Ancient Profession* (Cambridge and New York: Cambridge University Press, 1997).

Arthur Pickard-Cambridge, *The Dramatic Festivals of Athens* (London: Oxford University Press, 1968).

Oliver Taplin, *Greek Tragedy in Action* (Berkeley and Los Angeles: University of California Press, 1978).

Peter Wilson, *The Athenian Institution of the Khoregia: The Chorus, the City, and the Stage* (Cambridge and New York: Cambridge University Press, 2000).

TYPES OF GREEK DRAMA

TRAGEDY TAKES SHAPE. During the sixth century B.C.E., as Greece awoke from the dark years of illiteracy and cultural deterioration, tragedy as a dramatic form began to take shape. In a performance space that consisted of a central location, known as the *skene* ("tent"), a half-circle called the "orchestra" in front for the chorus, and entrances on either side, tragic drama was first performed. In *Poetics* Aristotle describes how Thespis added an actor to the chorus who would deliver a prologue relating the content of the play and speeches separate from the choral songs. Aeschylus is said to have added a second actor, thereby allowing an exchange of dialogue between two characters, despite the fact that in

some of his surviving plays, the main actor, or "protagonist," still speaks primarily to the chorus. Aeschylus' younger contemporary, Sophocles, added a third actor and painted scenery and expanded the chorus from twelve men to fifteen. The movement of the tragic form can thus be seen as the growth of choral song and dance to a series of choral songs relating to spoken interludes of dialogic narration of a story delivered by two or even three actors. The Greek word for actor is *hypocrites*, meaning "interpreter" or "responder," which suggests that the actor's earliest role may have been to explicate the cryptic and elusive odes performed by the chorus. In its fully developed form, tragedy followed a generic form. There were two basic styles of communication in a tragedy: the choral ode in poetic meter with musical accompaniment; and spoken dialogue, also in meter, but without music. An actor could perform a solo song, or monody, set to music. Exchanges between an actor and the chorus were also written in special meters. A tragedy usually began with a prologue, spoken by one or two actors, which described the setting and the circumstances of the play. The chorus then entered, singing and dancing, and it remained in the orchestra for the entire drama. Then a series of "episodes," sometimes culminating in a central *agon*, or debate between irrevocably opposed sides, followed. The chorus divided the episodes with songs called *stasima* (the plural of *stasimon*, meaning "standing in one place"). Sometimes the choral songs were obscure and had only the most arcane connections to the plot of the play, but at other times the chorus sang plaintively about the troubles that swirled around them or rejoiced, ironically, in the peace and happiness that can be foreseen, but which will not materialize. After the last *stasimon* came the *exodus* or final scene and exit, during which the action of the drama was summed up or its results were delineated. Some standard features of tragedy, which appear in some but not all of surviving tragedies, and sometimes in altered forms, are as follows: a chorus of powerless individuals (the elderly, foreigners, women, even slaves); violent action that takes place offstage and is described in detail by a hurried minor character, perhaps a messenger or household member; and a number of silent supernumeraries on stage, such as heralds, guards, servants, children, and other non-speaking roles as necessary.

TRAGIC PLOTS. Most tragedies drew on a fund of shared lore that bound Greek-speaking peoples together. We refer to these stories as "myths" and "legends." Stories of the creation of the cosmos and the battles for control of it; the Olympian gods and the formation of their cults; the many children of the gods, both mortal and immortal; and their numerous tales of daring and adventure, love and conquest, great journeys, the Trojan war and its aftermath all resurfaced in tragedy as settings for the great fifth century B.C.E. tragedians to dramatize the problems facing their city and the eternal questions of human life. The heroes of mythology were called upon to face danger and repel threats by dint of physical force and mental acuity: they literally voyaged to the ends of the earth and even into the Underworld itself to face down monsters and restore order to their society. In comparison, the heroes of tragedy must still confront danger and take perilous journeys, but these are often represented by the internal struggles of the hero as he or she ruthlessly seeks the truth and determines to find answers. The tragic hero, like the hero of myth, takes the ills of his or her society, often represented by the family unit, upon himself and works tirelessly to bring resolution. Human beings must face the horrors of life: the cruelty of divine will; the greed, lust, and brutality of human interaction; the desire for revenge or power; and the senseless suffering people undergo and inflict on each other. In most tragedies, a terrible deed or event is the catalyst, and we watch as the characters face ultimate catastrophe or, in attempting to thwart it, create new misfortune for themselves. Tragedies did not depend on suspense, since audiences knew well the plots of the stories treated by the playwrights. The excitement and power of the tragedy lay instead in the manner in which the story unfolded, the language employed, and the inevitable realizations of the characters. The Athenian audience would also have felt very deeply the associations the playwright drew between the adversity of the noble family on the stage and their own pressing issues. When Sophocles' audience was presented with the specter of the plague threatening Thebes at the beginning of *Oedipus the King*, they would have shuddered in acknowledgment, since a horrendous plague struck Athens at the beginning of the Peloponnesian War, during the time period this tragedy would have been performed. Matters of individual rights, tyranny, the possibility of justice, and the right way to live were the subjects treated by Athens' philosophers, politicians, and historians as well as their playwrights. For the ancient Greeks, divisions of genre were not that strict: tragedy was meant to educate, to pose difficult questions, and to offer potential solutions as well as to entertain.

THE SATYR PLAY. After an audience at the Great Dionysia had experienced several hours of the intense performance of tragedies, they were eased back into daily reality by means of a "satyr play," a coarse and farcical play that followed the formula of tragedy. The same play-

a PRIMARY SOURCE *document*

THE OEDIPUS COMPLEX

INTRODUCTION: Sophocles presented the trilogy that contained *Oedipus the King* in 430 B.C.E. when Athens was in the throes of a devastating plague. In the second year of the Peloponnesian War against Sparta, all the residents of rural Attica around the city of Athens were forced to abandon their homes and farms and to crowd into the city. The poor sanitation allowed this plague to spread quickly and thousands died. It is no coincidence, therefore, that Sophocles presents the ancient city of Thebes in his play as overwhelmed by plague as well. Many scholars consider *Oedipus the King* to be nearly perfect in its structure, its dramatic irony, and its presentation of the tragic hero, whose very strengths—his relentless pursuit of truth and justice, his strength of will, and his refusal to compromise—bring about his tragic downfall. Oedipus was left to die on a hillside as a baby because of a prophecy that foretold he would kill his father and marry his mother. In this scene, Oedipus confronts the servant who rescued him and the messenger who raised him, and finally realizes the awful truth: *he* is the cause of the plague—his father's murderer and his mother's husband!

Messenger: Come on now, do you recognize a certain child you gave me to raise as my own son?

Servant: What? Why are you asking about that?

Messenger: This man here is the one, friend, who was a young child then.

Servant: May ruin destroy you! Why won't you be quiet?

Oedipus: Ah, don't rebuke him, old man, since your words need to be upbraided more than his do.

Servant: What am I doing wrong, best of masters?

Oedipus: You are not acknowledging the child, the one he inquires about.

Servant: He doesn't know what he's talking about. He's on the wrong track.

Oedipus: If you won't talk as a favor, then you will talk while in pain!

Servant: Please, by the gods, don't hurt an old man like me.

Oedipus: Will someone pull his arms behind his back?

Servant: Oh no, don't! What do you want to find out?

Oedipus: Did you give the child to this man who is asking questions?

Servant: Yes, I did. I wish I had died on that very day.

Oedipus: You will get there unless you tell the truth.

Servant: Things will be much worse if I do talk.

Oedipus: It seems that this man is looking for a delay.

Servant: Not, I, sir, I just said that I gave him the child a long time ago.

Oedipus: Where did you get this child? In your household or from somewhere else?

Servant: It didn't belong to me—I got it from someone else.

Oedipus: From which one of these citizens and from what household?

Servant: Oh by the gods, master, please don't ask me any more.

Oedipus: You will die if I have to ask you this again!

Servant: He was one of the household of Laius.

Oedipus: A slave, or a relative of his?

Servant: Ah! I am about to say a dreadful thing!

Oedipus: And I'm about to hear something dreadful. But it must be heard.

Servant: He was said to be Laius' child. Really, Jocasta inside could tell best what the situation is.

Oedipus: Did she give him to you?

Servant: Yes, my lord.

Oedipus: Why?

Servant: So I could kill him.

Oedipus: The wretched woman who bore him?

Servant: She was afraid of the evil prophecy.

Oedipus: What prophecy?

Servant: That the child would kill his own father.

Oedipus: How did you happen to give him to this old man?

Servant: I pitied the baby, master, and I thought he would carry him away to another land, where he himself was from. But he saved him for the worst fate. If you are the man he's talking about, you were born cursed.

Oedipus: AH! Oh my god! Everything is clear now! O light of day, I am looking at you now for the last time!

SOURCE: Sophocles, *Oedipus the King*, in *Sophoclis Fabulae*. Ed. A. C. Pearson (Oxford: Clarendon Press, 1924): lines 1142–1185. Translated by Lisa Rengo George.

Arts and Humanities Through the Eras: Ancient Greece and Rome (1200 B.C.E.–476 C.E.)

359

wright who produced the tragic trilogy also produced this satyr drama, which may have echoed some of the themes raised in his tragedies. Aristotle believed that satyr drama was the genesis of tragedy, although others think that satyric drama arose as a separate theatrical form. The playwright Pratinas, a predecessor of Aeschylus, turned this ancient cult performance consisting of a group of satyrs who sang and danced in honor of their patron into a dramatic form, with a chorus comprised of actors dressed as men with horse ears and tails led by Silenus, the chief satyr. In the fourth century B.C.E., artists began to represent satyrs as half-goats rather than half-horses. The standard costume for the actors in a satyr play would have been quite obscene from a modern perspective: over a typical bodysuit, they wore short, rough pants with a very large and erect penis attached in front and a horsetail attached behind. Masks portrayed the "ugly" facial features of the uncivilized man-beast: balding, rounded foreheads with snub noses, pointy ears, and black hair and beards. Silenus, as their leader, wore a similar mask with older features and white hair. Although Pratinas wrote over thirty satyr plays, none survive. There are very few examples of this genre: Euripides' *Cyclops*, essentially the same story Homer tells in the *Odyssey* about Odysseus' encounter with the Cyclops Polyphemus (with the addition of a chorus of satyrs), is the only complete satyr play to survive. Fragments from Aeschylus' *Net-Men* and Sophocles' *Trackers* also survive.

ORIGINS OF GREEK COMEDY. In ancient Greece, a *komos* was a drunken parade of carousing revelers who staggered through the streets of their town dancing and singing bawdy and insulting songs. The same form can be seen in the Dionysiac processions that began the theatrical festivals. This familiar kind of inebriated group behavior gradually took shape as a genuine dramatic form, which followed many of the elements of the tragic genre: a chorus, a limited number of speaking parts for actors, the same theatrical structure, and the same modes of production. Comedy, however, as a latecomer to the dramatic competitions, had several unique characteristics as well. The level of invective and insult in comedy is related to the similarly-themed poetics of authors like Hipponax and Archilochus, who flourished during the seventh and sixth centuries B.C.E. during the diaspora from the mainland, as well as to the types of verbally abusive songs sung at the Eleusinian Mysteries, the secretive cult worship of the goddess Demeter, centered at Eleusis, a town south of Athens. Comedy was introduced to the City Dionysia around 487 B.C.E. and was performed after the tragic trilogy and the satyr play. At this time a comic poet named Magnes was on the rise, and for some time he alone remained prominent in the genre,

winning a total of eleven first prizes at the City Dionysia. Magnes was particularly well known for the wonderful musical accompaniments to his plays as well as for his imitations of barnyard animals. In the middle of the century, other comedic poets began to gain prominence: Cratinus, held to be a great drinker; Crates, whom Aristotle said invented actual plots for his comedies rather than producing a series of caricatures; Pherecrates; and Eupolis. Aristophanes is the only comic playwright whose works have survived. Modern scholars know more than 32 titles of his plays, and eleven of them have survived along with some fragments. It is clear from the writings of Aristotle and other historians that playwrights did not write in both the comic and tragic genre.

THE STRUCTURE OF OLD COMEDY. Modern scholars must rely on the plays of Aristophanes to determine the structure of ancient Greek comedy also known as "Old Comedy"—those plays written and produced between the mid-sixth century and late fifth century B.C.E. Most of Aristophanes' plays begin with a prologue spoken by an actor or the playwright himself. In the prologue the author could air grievances, talk about his audience or the government, and describe the circumstances of the comedy to follow. Next the 24-man comic chorus—rather than the twelve- or fifteen-man tragic chorus—entered singing and dancing, often dressed in wild and fantastical costumes. The chorus introduced the audience to the comedy proper and outlined the setting for the play. The chorus usually took sides, either for or against the hero of the play. The *agon*, as in a tragedy, was the centerpiece of the play, in which the two opposing sides argued for their cases, with additions by the chorus. The first speaker in the debate was almost always the loser. The word *parabasis* means "a stepping aside," and was the time in the play when the chorus, after the actors had exited the stage, held the theatrical space alone and, performing a special song and dance unconnected to the rest of the plot, addressed the audience directly. After this, a series of scenes called "episodes" took place, which illustrated the results of the central debate. Finally, the play ended with a rowdy celebration of marriage or reconciliation.

FREEDOM OF SPEECH AND OBSCENITY IN OLD COMEDY. Just as the masks worn by comic actors were grotesquely exaggerated, and their costumes were excessively padded with comically enlarged genitalia, so also were the types of humor, both physical and verbal, garish and vulgar. Athenian democracy guaranteed liberty to its citizens (adult males only), which included freedom of speech (*parrhesia* in ancient Greek). This freedom to speak one's mind, whether in a public assembly or in a private

a PRIMARY SOURCE *document*

ARISTOTLE'S LECTURE NOTES

INTRODUCTION: Aristotle most likely wrote down his analytical work *Poetics* sometime in the 340s B.C.E.—at any rate, he apparently used this work as notes for teaching in his own school, the Lyceum, which he founded in 335 B.C.E. This collection of "lecture notes" is a unique set of writings; the earliest extant work that treats poetic writing as an art and employs a distinct set of theory and criticism in its analysis. Aristotle set out to define the genres of poetry; in essence, to propose "laws" about its structure and purpose. Poetry was of paramount significance in ancient Greek culture, and who better to tackle it scientifically than the great pupil of Plato and teacher of Alexander the Great? Aristotle may sometimes seem hostile to drama, but his observations have influenced the way all scholars since his time have seen, read, and examined the ancient art of stagecraft. In *Poetics* V–IX, Aristotle describes the origins of comedy and tragedy, and lays out his theory that a successful tragedy must have a beginning, middle, and end in the course of a single day. In addition, he discusses types of plots and other integral elements of ancient epic and drama.

Comedy, as we said, is mimesis of baser but not wholly vicious characters: rather the laughable is one category of the shameful. For the laughable comprises any fault or mark of shame which involves no pain or destruction: most obviously, the laughable mask is something ugly and twisted, but not painfully. Now, tragedy's stages of development, and those responsible for them, have been remembered, but comedy's early history was forgotten because no serious interest was taken in it …

Epic matches tragedy to the extent of being mimesis of elevated matters in metrical language; but they differ in that epic has an unchanging meter and is in narrative mode. They also differ in length: tragedy tends so far as possible to stay within a single revolution of the sun, or close to it, while epic is unlimited in time span …

Let us next discuss the required qualities of the structure of events, since this is the principal and most important factor in tragedy. We have stipulated that tragedy is mimesis of an action that is complete, whole, and of magnitude (for one can have a whole which lacks magnitude). A whole is that which has a beginning, middle, and end. A beginning is that which does not itself follow necessarily from something else, but after which a further event or process naturally occurs. At end, by contrast, is that which itself naturally occurs, whether necessarily or usually, after a preceding event, but need not be followed by anything else. A middle is that which both follows a preceding event and has further consequences. Well-constructed plots, therefore, should neither begin nor end at an arbitrary point, but should make use of the patterns stated. … To state the definition plainly: the size which permits a transformation to occur, in a probable or necessary sequence of events, from adversity to prosperity or prosperity to adversity, is a sufficient limit of magnitude

A plot is not unified, as some think, if built around an individual. Any entity has innumerable features, not all of which cohere into a unity; likewise, an individual performs many actions which yield no unitary action. …

It is also evident from what has been said that it is not the poet's function to relate actual events, but the *kinds* of things that might occur and are possible in terms of probability and necessity. … In comedy the point has by now become obvious: the poets construct the plot on the basis of probability, and only supply arbitrary names … But in tragedy they adhere to actual names. The reason is that the possible seems plausible …

SOURCE: Aristotle, *Poetics*. Trans. Stephen Halliwell (Cambridge, Mass.: Harvard University Press, 1995): 45–47; 55–63.

gathering, naturally applied to Athenian playwrights as well. Therefore, the comic poets like Aristophanes were perfectly free to criticize or mock any aspect of their city-state: public figures, wars, laws, treaties, citizens' rights, intellectual movements—all could be, and frequently were, treated in satiric form on the comic stage. Even the gods and religious rituals could be parodied, though Aristophanes never presents the gods with serious skepticism. Excretive humor and obscenity were rampant in Old Comedy as well. Aristophanic comedy is all-inclusive and included elements that every level of the *demos* (the citizen population) could enjoy, from highest political satire to the most juvenile jokes about flatulence and bodily functions.

ROLE OF WOMEN. In ancient Greece, wealthy women led lives that would be considered restrictive by modern standards. It is likely that women in poorer families had more freedom, but unfortunately there is not much information about the lives of the poor. The vast majority of evidence about the lives of women in antiquity comes from sources, objects, and monuments created by men, from a male perspective. Young girls of noble heritage were educated mostly at home, in the arts of housekeeping, weaving, and food preparation and preservation. Young women remained in their fathers' households until their marriage, usually at the age of fourteen or so. Married women must have spent con-

a PRIMARY SOURCE *document*

SPEAKING ILL OF THE DEAD

INTRODUCTION: The Athenian demagogue Cleon, who ruled Athens for six years after the death of Pericles during the Peloponnesian War, was one of the comic playwright Aristophanes' worst enemies. Aristophanes criticized Cleon in his first play, *Babylonians*, for his brutal decision to kill all the adult males on Mytilene after Athens conquered that island in 427 B.C.E. Cleon responded by attempting unsuccessfully to prosecute Aristophanes for treason. Aristophanes continued to mock Cleon, even after the ruler's death in 422 B.C.E. In his play *Peace* (421 B.C.E.), the Athenians are awaiting a peace treaty with the Spartans. The comic hero Trygaios, who is starving because of the food shortage in Athens during the war, decides to emulate the mythological hero Bellerophon, who rode the winged horse Pegasus. Instead of a fantastical horse, however, Trygaios uses a fattened dung-beetle for his journey to Mt. Olympus. When he arrives at Zeus' palace, Hermes informs him that the gods have moved out because of the war, and that War himself is in charge and has imprisoned Peace in a cave. The following excerpt highlights the metatheatrical aspects of Aristophanes' comedies. "Metatheater" involves the display of knowledge by the actors during a performance that they are in fact merely performing a play with an audience.

House-slave: So now some smart-aleck youth in the audience will ask, "What's going on? What's the dung-beetle for? And an Ionian sitting beside him will say, "I suspect that it alludes to Cleon, since he eats excrement [in Hades]. ..."

Hermes: (describing how corrupt politicians manipulated the events of the war) The city, pale and crouching in terror, would happily eat up whatever anyone slandered to it [a pun based on the similarity of the ancient Greek words "toss" and "slander"]. When your allies saw the blows that were being administered to them, they stuffed with gold the mouths of the perpetrators of these acts and made them rich as a result. But meanwhile you did not notice that Greece was being turned into a desert. And the man who did this was the tanner (Cleon).

Trygaios: Stop, Lord Hermes, stop, don't speak, but let that man be where he is down below. That man is no longer ours but yours [Hermes is the usher of the dead]. Anything you might say about him— that he is a crook, when he lived, and a blabbermouth and an extortionist and a troublemaker and a peace disturber—all this you will now say of one of your own.

SOURCE: Aristophanes, *Peace*, in *The Context of Ancient Drama*. Eds. Eric Csapo and William J. Slater (Ann Arbor: University of Michigan Press, 1994): 182.

siderable amounts of time in the *oikos* or private family space, and lived in special secluded areas. This does not mean that women were never permitted to go about in public: women were active participants in religious rituals, and they undoubtedly visited friends and family, shopped for food and household necessities, and attended public events. But women did not have public lives as men did. Therefore, it is somewhat surprising that female characters are featured so prominently in Greek tragedy and occupy center stage in some of Aristophanes' comedies. In order to understand this, it must be remembered that the creative setting of the theater was itself sacred space, within the temple precinct of Dionysus, and the performances reflected and commented upon Greek culture by artistically depicting events that could occur in real life. Tragedies borrowed their subject matter from mythology and utilized the family unit, at least in part, as a microcosm for the functioning city-state. Since women were central to family life, they could represent certain values on stage that women in society may not have been allowed to articulate. For instance, Antigone in Sophocles' play of the same name represents a strict religious view and upholds the duties of individual families rather than the laws of the state, in direct opposition to her uncle Creon, the male head not only of her own family but also of the state itself. In Euripides' play, Medea, a foreigner and suspected witch, eloquently expresses the hardship she has suffered at the hands of Jason, a Greek hero, and even gets away with multiple murders, including the killing of her own children. On the comic stage, the line between fantasy and reality is blurred, sometimes even non-existent. The requirements of the stage necessitated that all female roles be played by male actors. Aristophanes enjoyed playing with this convention by having male characters disguise themselves as women, as in the *Women at the Thesmophoria*, and by having female characters, already being played by men, disguise themselves as men to attend a political gathering in *Assembly-Goers*. Just as in tragedy, women were an accepted part of the *polis*, and could express political and social discontent through their behavior. In *Lysistrata*, the women of Athens and Sparta, in despair about the length of the Peloponnesian War and the absence of the menfolk, de-

a PRIMARY SOURCE *document*

MEDEA, SERIAL KILLER

INTRODUCTION: The life of Euripides, the youngest of the three greatest Athenian tragedians, spanned most of the fifth century B.C.E., a period of unequalled cultural production in literature, drama, art and architecture, and politics. Euripides was often accused of focusing on marginalized characters—women, foreigners, slaves—in his tragedies, to the exclusion of the noble people tragedy was supposed to portray as didactic examples to the Athenian people. But as a result of this, we can see Athenian attitudes and cultural problems of concern to the democracy, such as in his masterpiece, *Medea*. The story was part of mythology: the hero Jason must capture the Golden Fleece from the distant kingdom of Colchis on the Black Sea in order to regain his rightful kingship in Iolcos. In Colchis, the beautiful daughter of the king, Medea, is charmed by Aphrodite into falling in love with the dashing young hero, and she assists him in his quest. In some versions, she murders her own younger brother and chops his body into pieces, which she throws overboard as the Argonauts make their escape from Colchis. In this play, Euripides seems to ask the question, "What would happen to Medea, a spooky foreign woman, supposedly possessed of eerie magical powers, once she returned with her Greek husband to Greece?" During the fifth century in Athens, no Athenian citizen was allowed to marry a foreigner—if he did so, the marriage was not considered legal in Athens. In the following scene, the end of the play, Medea has killed the king of Corinth and his daughter, to whom Jason was betrothed, as well as her own children with Jason, as revenge for being cast out unceremoniously from Jason's life. Medea is speaking to Jason from the chariot of the Sun, provided for her escape, with the dead bodies of her children on board.

Jason: But may the Fury (a horrid female monster who pursues people who kill family members) and murderous Justice destroy you because of what you did to the children!

Medea: (gloating savagely) Which god or divine being will hear you, you oath-breaker and liar?

Jason: Oh my god, you disgusting child-murderer!

Medea: Go home and bury your "legal wife" [i.e. the king's daughter].

Jason: I'm going, deprived of both my children.

Medea: Don't grieve yet—wait until you're old.

Jason: O dearest children!

Medea: Dearest to their mother, not to you!

Jason: And you murdered them!

Medea: I did it to hurt you.

Jason: Ah, the pain! Oh wretched me, I long to kiss the soft mouths of my children!

Medea: *Now* you speak to them, *now* you show them affection—not so long ago you pushed them away.

Jason: In the name of the gods, allow me to touch just once more the gentle faces of my sons.

Medea: No! Your plea is cast on the wind!

Jason: O Zeus, do you hear these things, how I am driven away, how much I suffer at the hands of this horrible child-killing lioness? But no matter what, as much as it is possible and I am able, I will grieve for these things and I will call on the gods, making the divinities my witnesses, that after slaughtering my children, you are preventing me from touching their skin, and from giving their bodies a proper burial, bodies which I, their father, should never have had to see destroyed by you.

Chorus: Zeus, master of many gods on Olympus, the gods bring to pass many things unexpectedly! Justice was not done, but instead a god found the means of the unjust! In this way, this situation has been resolved.

SOURCE: Euripides, *Medea*, in *Euripidis Fabulae*. Ed. Gilbert Murray (Oxford: Clarendon Press, 1902): lines 1386–1425. Translated by Lisa Rengo George.

clare a sex strike in order to hasten a resolution to the conflict. The fantastical element of comedy can make allowances for such an event as a metaphor for the Athenians' dissatisfaction with their political leadership.

MIDDLE COMEDY. After the Peloponnesian War ended in 404 B.C.E., the zenith of Athenian creativity passed as well. As first the Spartans and then the Macedonians gained ascendancy, Athens continued its cultural production but on a lesser scale. A canon of tragedies was established and revivals of these plays were performed, but no new tragedies were written. As Athenian democracy faded, so did its civic freedoms, and the comic poets were compelled to tone down the overtly political content in their plays. This period defined the transition from "Old" Comedy to "Middle" Comedy, a term possibly coined by Aristophanes of Byzantium, the librarian at Alexandria, to describe the comedies created between 404 and 321 B.C.E. Some scholars have seen the beginnings of Middle

a PRIMARY SOURCE *document*

MURDER AND THE COMIC EVOLUTION

INTRODUCTION: Platonius was a late Hellenistic writer who, in his work *On the Differences of the Comedies*, set out to explain the evolution of ancient Greek comedy from "Old" to "Middle" to "New" by relying on the questionable theory that the Athenian general Alcibiades had murdered the comic poet Eupolis because of slander, and thereby created the widespread threat of prosecution among poets. Platonius aimed at explicating the particular differences during the three periods—the evolution from the political toward the domestic, the decline in caustic satire, and the loss of the chorus. Platonius owes a debt in his explanation to Aristotle's *Nichomachean Ethics.*

It is good to indicate the reasons why Old Comedy has a certain form peculiar to itself, and Middle Comedy is different from it. In the times of Aristophanes, Cratiunus, and Eupolis, democracy ruled in Athens and the people held all the power, being itself the autocrat and master of its political affairs. Since everyone had freedom of speech, the writers of comedy had license to mock generals, judges who gave bad judgments, and also any of the citizens who were either greedy or behaved wantonly. For when the people heard the comedians vigorously insulting such persons, as I said, they exempted them from terror of reprisal. We know that the people by nature have been opposed to the rich since time immemorial and that it rejoices in their discomfiture. So in the time of the comedy of Aristophanes, Cratinus, and Eupolis, some poets were pitiless against those who erred, but for the rest, when democracy was driven back by those who wanted to set up a tyranny in Athens and an oligarchy was established and the power of the people had gone over to a few men and the oligarchy was in charge, terror seized the poets: it was not possible to mock anyone openly when the offended parties could demand justice from the poets. And so we know that Eupolis, upon producing the *Baptai*, was drowned in the sea

by the man against whom he launched [the play] (i.e. Alcibiades). Because of this they grew more wary of mockery and the *choregoi* began to grow scarce, for the Athenians no longer had the will to elect *choregoi*, who defrayed the expenses of the choreuts [chorus members]. … Since the *choregoi* were no longer being elected and the choreuts had no sustenance, the choral odes were taken out of comedy and the character of the plots changed. … These are the plots of Old Comedy: to censure some generals and judges who do not judge rightly and make money through injustice and have taken up a wicked way of life. Middle Comedy gave up that sort of plot, and proceeded to mock the stories told by the poets, because such things as mocking Homer for saying something or some tragic poet or other are not liable to prosecution. Even in Old Comedy one can find dramas of the same sort as those produced in the end when the oligarchy had consolidated its power. … For such are the plots in Middle Comedy. Placing in their comedies certain myths that were told by earlier authors, they mocked them as badly told and they rejected *parabaseis* [choral entrance songs] as there were no choruses because of the lack of *choregoi*. They did not even bring on stage masks made the same way as in Old Comedy: in Old Comedy the masks resembled the people ridiculed in the comedy, so that, even before the actors said anything, the identity of the ridiculed person was obvious from the likeness of the mask's appearance; in Middle and New Comedy they deliberately constructed the masks with greater comic distortion since they were afraid of the Macedonians and the terror that was attached to them, and so that the appearance of the mask would not coincide by some chance with the features of some Macedonian ruler and the poet incur a penalty because he was thought to have acted deliberately. At any rate, we see the shape of the brows on the masks of Menander's comedy and how the mouth is distorted and not of human proportion.

SOURCE: Platonius, *On the Differences of the Comedies*, in *The Context of Ancient Drama*. Eds. Eric Csapo and William J. Slater (Ann Arbor: University of Michigan Press, 1994): 172–173.

Comedy in the romantic tragedies of Euripides, like *Ion* and *Helen*, and in the later comedies of Aristophanes, including the *Assembly-Goers* and *Wealth*. The material becomes less inherently political and much more broadly-based. The role of the chorus is diminished substantially; the *parabasis* is completely absent, and only occasional songs meant for the chorus are indicated. Most of the names of authors and fragments of so-called Middle Comedy that survive come from the work of one author: the *Educated Dinner-Party*, written by Athenaeus

around 200 C.E., and no complete examples of Middle Comedy exist after Aristophanes. Hence assumptions must be made about the content of Middle Comedy based on the comments of ancient scholars and the titles and fragmentary remains, but even these extrapolations are telling. Although the political subject matter may be less explicit and the obscenity and scatological humor less evident, there still seems to have been a wider range of plot-types in Middle Comedy than there came to be in the last stage of ancient comedy known as "New" Comedy. Play-

wrights still wrote political plays parodying public officials and intellectuals like Plato and the Pythagoreans. Mythological lampoons were still popular, especially when figures from mythology were placed in more contemporary settings. The riotous celebratory feasts featured at the end of many Old Comedy plays are found in Middle and New Comedy as well, and the theme of *anagnorisis* ("recognition") figured prominently in many Middle comedies. This type of "recognition" plot often involved a child separated from his or her parents at birth (sometimes by exposure), who is later recognized by the real parents by means of tokens, specific knowledge, or the child's name. Contemporary mores, characteristics, and manners were also satirized, according to some of the references to figures like the "criticizer," "lyre-player," "shoemaker," and the "lover of Thebes." Plays about daily family life (romantic entanglements, debts, conflicts between generations) as well as more alarming themes (such as scam artists, illegitimate children, and rapes) were popular in the New Comedy of Greece and later Rome; they are also recognizable in Middle Comedy, as were stock figures like the sycophant, the prostitute and the pimp, the crabby cook, the boastful soldier, grumpy old men, and amorous young men. Athenaeus mentions nearly sixty playwrights and over 800 plays belonging to the period of Middle Comedy; some of the most well-known authors were Alexis, Eubulus, and Anaxandrides.

NEW COMEDY. The period of "New" Comedy began in the fourth century B.C.E. but its peak was in the mid-third century B.C.E. The names of more than eighty playwrights who were writing in the late fourth and third centuries B.C.E. and an assortment of fragments survive, but many of them are unidentifiable. The best-known names of this era are Menander, Diphilus, Philemon, Posidippus, and Apollodorus. Although much of their work was lost during the Byzantine era (seventh–eighth centuries C.E.) because their Greek was considered inferior, in twentieth-century excavations in Egypt, archaeologists uncovered several significant fragments, and one nearly complete play of Menander, to whom the Roman playwrights Plautus and Terence were indebted for many of their "adapted" plots. Plautus also named Diphilus and Philemon as sources for some of his plays. The themes of New Comedy are recognizable from Middle Comedy: the plots focus on family life and its daily complications, and include many of the stock characters that were fixed by the playwrights of Middle Comedy. The chorus, whose role was already diminishing in Middle Comedy, was reduced to providing musical intervals between the five acts of the play. New Comedy was originally written and performed in Athens, and its focus is the law and mores of Athens, particularly in regards to citizenship and marriage

laws. One could not become a naturalized Athenian citizen: both parents had to be proven Athenian citizens in order to pass the privileges and duties of citizenship on to their children. New Comedy often addressed social problems like casual rape and resultant pregnancy, children separated from their parents and lost, and love between citizens and "foreigners," all of which ultimately arrived at the question of legal marriage. Lost children and victimized young women had to be revealed as real Athenian citizens by means of the "recognition" plot, possession of mementos, and other devices, in order to resolve the plot happily with a celebration of marriage. The topics treated in the comedies had broad enough appeal, however, that the plays were popular all over the Greek world despite their Athenian focus. In addition to plots about love, New Comedy treated fundamental social conflicts— between parents and children, rich and poor, neighbors, and city and rural folks. Menander was especially aware of problems of bigotry, misunderstanding, and lack of tolerance, as can been seen from the subjects found in surviving fragments. New Comedy remained popular for hundreds of years, as Plautus and Terence continued the tradition in their plays, which borrowed the Athenian plots but translated them into Roman plays.

SOURCES

K. J. Dover, *Aristophanic Comedy* (Berkeley and Los Angeles: University of California Press, 1972).

Helene Foley, *Female Acts in Greek Tragedy* (Princeton, N.J.: Princeton University Press, 2001).

Susan Lape, *Reproducing Athens: Menander's Comedy, Democratic Culture, and the Hellenistic City* (Princeton, N.J.: Princeton University Press, 2004).

Arthur Pickard-Cambridge, *The Theatre of Dionysus in Athens* (Oxford: Oxford University Press, 1946).

Richard Seaford, *Reciprocity and Ritual* (Oxford: Oxford University Press, 1994).

Erich Segal, *Roman Laughter: The Comedy of Plautus.* 2nd ed. (Oxford and New York: Oxford University Press, 1987).

Oliver Taplin, *Comic Angels* (Oxford: Oxford University Press, 1993).

George Thomson, *Aeschylus and Athens: A Study in the Social Origins of Drama* (London: Lawrence & Wishart, 1967).

Jennifer Wise, *Dionysus Writes: The Invention of Theatre in Ancient Greece* (Ithaca, N.Y.: Cornell University Press, 1998).

THE BEGINNING OF ROMAN THEATER

GREEK INFLUENCES. The period between the death of Alexander the Great of Macedon (323 B.C.E.) and the beginnings of the Roman Empire (31 B.C.E.) is known to scholars as the Hellenistic era. Even though Athens had undergone a major political downfall, its cultural production remained steady, and its influence on first the Etruscans, from the region of Etruria in northern Italy, and later the Romans is incalculable. The Greeks continued to be highly invested in theater and its performance. Around 300 B.C.E., an actor's union, called the Artists of Dionysus, was established throughout Greece and other Hellenistic sovereignties, a sign of the continuing attraction of the presentation of Greek tragic and comic drama. This powerful guild functioned as a religious organization that was politically independent, with its own priests and sanctuaries (of the god Dionysus) as well as their own elected officials. This was the last era that actors would enjoy such privilege and protection, since performers of all kinds were eventually disenfranchised under Roman law. The Greeks had colonies in southern Italy and Sicily since Homer's time, and they built many permanent performance spaces based on Greek prototypes. Syracuse on Sicily had a theater dating from the fifth century B.C.E., and many other archaeological remains have been excavated throughout the area of colonization. Acting troupes toured the region often, and revivals of ancient plays by authors like Euripides and Aristophanes were popular. In the western colonies, another tradition developed as well: the *phlyax* play, a farcical genre in which tales from myth and everyday life were performed on a special type of stage, with grotesque masks and obscenely padded costumes recalling those worn in Old Comedy, and perhaps involving extemporization and lewd action. A number of vases from this region and era survive depicting the performance of *phlyakes*, and it is from these that most of the modern knowledge about the genre comes. Beginning in the third century B.C.E., a poet named Rhinthon from Tarentum began to write *phlyax* plays as well. The stage consisted of a raised wooden platform covered by a roof and decorated with painted scenery, altars, porches, and other elements necessary for the depiction of the play. It is quite likely that the Romans were influenced far more by these bawdy farces than they were by the performances of "high" drama like tragedy and Old Comedy, but both kinds of theater were well established in Italy.

ETRUSCAN INFLUENCES. The Etruscans, an indigenous people from the north of Italy who had power over Rome until the late sixth century B.C.E., seem to have been aware of Greek drama to a greater extent than the early Romans were. There is much artistic evidence for Etruscan shows, since various performers like musicians, dancers, actors wearing masks, and tumblers, as well as audiences, are found in wall paintings. Etruscan vases from the late sixth century B.C.E. depict performers dressed as satyrs, leading scholars to posit that satyr drama, which was developing in Athens during this period, was the form of theater that most affected the Etruscans, since the satyr play combined coarse farce with a religious element. The Roman historian Livy (59 B.C.E.–17 C.E.) reported that the Etruscans were the first to introduce enacted performance to the Romans in the mid-fourth century B.C.E. Livy, however, was obsessed with identifying "firsts" in Roman history, as evidenced even by the title of his work, *From the Foundation of the City*, and as a result may have exaggerated a bit. The satyr play would probably have appealed to the Romans more than other types of formal drama due to native rituals relating to the harvest that included satirical and vulgar jokes, songs and dances, and good-natured abuse and mockery. Whether the Etruscans were truly the first to introduce acted shows to the Romans or not, their influence was prevalent not only in the lively arts but also in the way the Romans structured their society and government.

ITALIAN INFLUENCES. Existing primary sources for early forms of Italian performance are the historian Livy and the Augustan poet Horace (65–8 B.C.E.). Horace traced the development of "Fescennine" poetry to early harvest or wedding celebrations involving sacrifices, libations, and an exchange of playful insults, which Horace says degenerated into cruelty and abusive slander (it was a common lament in Latin letters that society had deteriorated since the innocent days of the early Republic). The term "Fescennine" may derive from the Etruscan town of Fescenna, apparently a place known for these verses, or from the Latin word *fascinum*, having to do with the phallus. This agricultural ritual recalls the legendary origins of Greek drama from lascivious songs and dances, and parades of phallic representations, in honor of Dionysus. Fescennine verses may have developed into an early kind of dramatic performance involving improvisation, rude humor, and rustic music. There was another type of farcical performance already developing in the region of Atella, Campania, called the *Atellanae* or "Atellan farces." The peoples of this region spoke Oscan, an Italic language, and so Latin speakers were unable to understand any of the dialogue in these lampoons, although the mimetic gestures of the actors would have been clear enough. In fact, most Atellan farce lacked extensive dialogue anyway, and relied more on crude physical comedy and charade. The character types

depended on a dominant emotion or quality like anger or stupidity or appetite for food or sex, and stock types carried the same names in every farce: Pappus the old man; Bucco the boaster; Maccus the buffoon. Scholars have suggested the famous Roman comedian Titus Maccus or Maccius Plautus took his familial (middle) name from this last character. The Romans also had a performance tradition of the *satura*, a mixture of genres and content, the precise nature of which remained a mystery even to ancient scholars. One ancient commentator derived the name *satura* from "satyr," and described the genre as a musical medley written for the pipes and involving the same kind of shameless dialogue and stage action as Greek satyr plays. The Romans derived their own genre of "satire" from this term, and perhaps from the performative tradition as well. Hence, there were a multitude of dramatic influences for the development of the Roman theater, and these influences shed light on why the Romans may have preferred comedy and "light" musical drama such as mime and pantomime to "heavier" dramatic genres, like tragedy and politically driven satire.

SOURCES

Richard C. Beacham, *The Roman Theater and Its Audience* (London: Routledge, 1991).

Gian Conte, *Latin Literature: A History* (Baltimore, Md.: Johns Hopkins University Press, 1994).

E. J. Kenney, ed., *The Cambridge History of Classical Literature II: Latin Literature* (Cambridge: Cambridge University Press, 1982).

ROMAN THEATERS, PLAYWRIGHTS, AND ACTORS

STRUCTURE OF THE ROMAN THEATER. The Romans did not construct a permanent theater until Pompey sponsored one in 55 B.C.E. Instead, as the Roman architect, engineer, and writer Vitruvius (last half of first century B.C.E.) described, the Romans built temporary wooden structures as performance spaces, and continued to do so even after the advent of permanent theaters. There may have been several political reasons for this. Conservatives argued that theater promoted immoral behavior and fought to prevent the building of permanent structures. As class divisions and personal sponsorship of occasions for performance arose, such as the annual *Ludi Romani* ("Roman Games"), circuses and other spectacles, and funeral celebrations for the wealthy and notable, the building of provisional theater spaces allowed for luxury seating and elaborate decorative elements.

There was also a fear of seditious behavior, again due to the growing divide between the aristocracy and the *plebs* or common people, and permanent theaters provided a made-to-order space for public assemblies and mass communication. As needed for festivals and other celebrations, theaters could be erected in public spaces like the Forum, the Campus Martius, or the Circus. These wooden edifices affected the development of the Roman theater as much as the theatrical influences of the Greeks, Etruscans, and early Roman displays and rituals. The ephemeral nature of these wooden theaters allowed the Romans to modify the buildings as needed rather than blindly follow the Greek and Hellenistic models, resulting in a performance space that diverged in distinct ways from its Greek predecessors. Theaters in *Magna Graecia* and on Sicily seem to have followed models from Greece, as might be expected: built into a hillside for ready-made tiered seating, for the most part with a raised stage, an orchestra dividing the acting platform from the spectators, and side entrances. There were also the *phlyax* stages depicted on painted vases—elevated and covered platforms with scenery and accouterments added as needed for individual plays. No remains of the temporary wooden theaters survive, but based on the stage directions implicit in the comedies of Plautus and Terence as well as Pompeian wall paintings and references to the stage in other works, modern scholars can postulate what these Roman performance spaces might have looked like. There was a raised stage with a roofed structure at the rear and usually a public byway running in the front of the stage building. No space for a chorus was necessary. This building could be adapted to suit specific plays, with an altar in front to serve as a temple, or rocks in front of a cave, or a separation between two citizens' homes. The stage building probably had at least three doors and an off-stage back alley to allow for unseen action and to accommodate the frenetic entrances and exits required in a chaotic comedy. Roman audiences included all strata of society, from aristocrats in special and secluded seats to common folk and slaves. Some playwrights lamented the short attention spans of their spectators, who could easily lose interest in a performance if sidetracked by a high-energy display of physical skill or combat.

ACTING TROUPES. Even though Roman theaters were not permanent until 55 B.C.E. actors were amassed into solid unions and groups by the late third century, something that did not occur until late in the history of Greek theater. In 207 B.C.E., Livius Andronicus—who produced the first plays adapted from Greek originals at the *Ludi Romani* in 240 B.C.E.—oversaw the

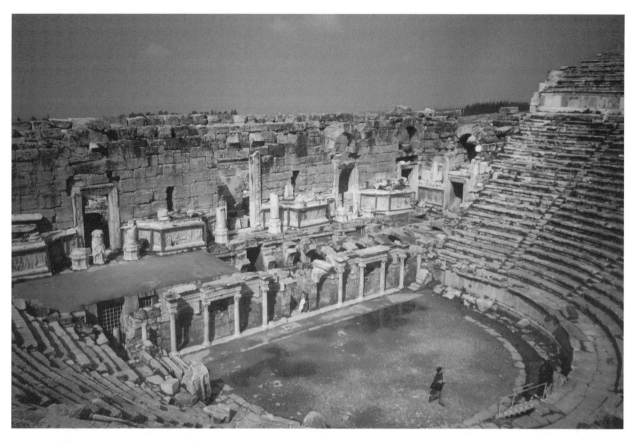

Roman theater at Hierapolis in Turkey, built in 2nd century C.E. and restored by the emperor Septimius Severus (193–211 C.E.) and again by Constantius II (337–361 C.E.). **COURTESY OF JAMES ALLAN EVANS.**

establishment of the first performers' union in Rome, called the *Collegium Scribarum Histrionumque*, or the Association of Theatrical Authors and Actors. This union was probably modeled closely on the "Artists of Dionysus," the theatrical association formed in Greece in the third century B.C.E., which was treated as a religious organization exempt from political or military service. This Roman union was associated with the goddess Minerva (Athena in the Greek pantheon), whose temple on the Aventine Hill housed their headquarters. It seems that early on in Roman theatrical history, actors and writers of drama may have had a certain amount of respectability in society that was lost altogether later on. The legal status of actors has been a subject of much debate among scholars. They may have been slaves owned by the company manager, foreigners, freedmen, or even freeborn Romans. At any rate, in the later Republic and Roman Empire, all stage performers, along with gladiators and workers in the sex industry, were deprived of civil rights and designated by the term *infamia*, which indicated legal disenfranchisement. The Romans may have had a *choragus* who supported an acting troupe, much like the *choregia* system in fifth-century B.C.E. Athens (the dif-

ferent spelling comes from the Doric-dialect spoken in the Greek colonies of southern Italy). The magistrates who organized the Roman Games and other opportunities for performance may also have assumed financial responsibilities for some of the dramatic shows held at the annual festival. Many troupes had a *dominus gregis* or "company manager," an actor-director who staged the dramas in conjunction with the playwright himself. Lucius Ambivius Turpio acted in and directed many of the Roman comic playwright Terence's plays in the 160s B.C.E. In the Greek tradition, Roman actors on the formal stage of tragedy and comedy were probably all male, and wore masks and costumes suitable for their roles. The obscene costumes of Old Comedy were long gone, however.

FAMOUS ROMAN ACTORS. Although the Romans did not hold full-fledged dramatic competitions as in Greece, there is some evidence that individual actors may have participated in contests with prizes. One of the most famous actors in the first century B.C.E. was Quintus Roscius Gallus. Roscius was born to an equestrian family in Latium and was a close friend of Cicero, who de-

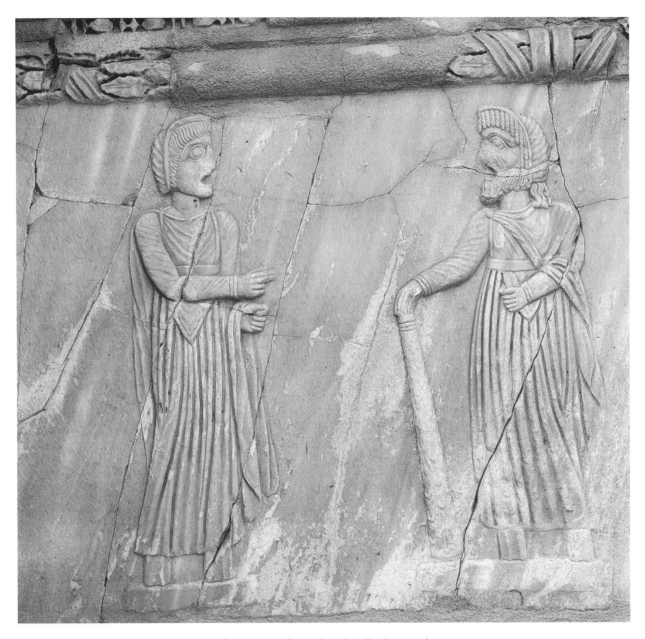

Roman stone relief of actors wearing masks from Sabrata (in modern day Libya), post 4th-century B.C.E. **THE ART ARCHIVE.**

fended Roscius in court on a charge of business fraud around 69 B.C.E. It seems that women were allowed to perform in mimes, and various other productions, such as pantomime, private parties, and festivals. Some famous mime actresses are known, like Lycoris, the stage name of Volumnia Cytheris, who was the mistress of some of Rome's most prominent citizens in the first century B.C.E. Toward the end of the Roman Empire, women were known to perform in revivals of Roman comedy as well as in mimes and other skits, sometimes wearing scandalously scanty clothes. Theodora, a sixth-century C.E. mime actress in the eastern Roman Empire,

was described as an especially outrageous and lewd woman by her contemporary Procopius in his *Secret History*. She was raised by theater folk, became a prostitute early in her life (it was a common conceit that mime actresses were also prostitutes), and was something like a modern-day "performance artist"; she paraded through the streets of Constantinople wearing see-through clothing and allowed birds to eat seeds nestled between her thighs. When she married the emperor Justinian in 525 C.E. and became empress of the Eastern Empire, it caused a terrific scandal.

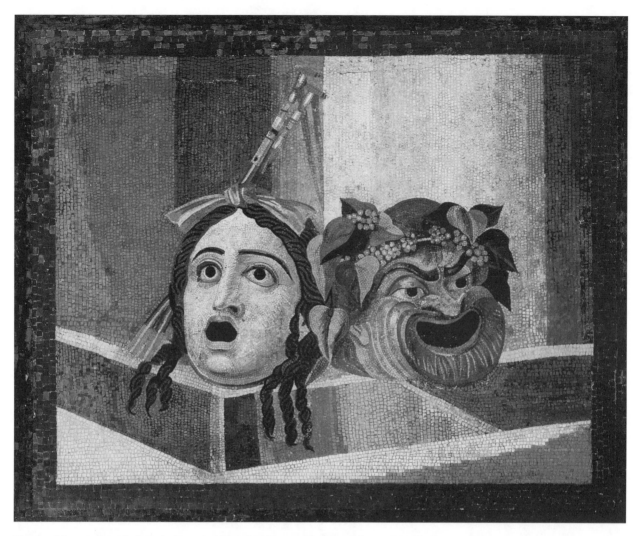

Mosaic of Roman theatrical masks from the Villa of Hadrian at Tivoli, outside Rome. 2nd century C.E. THE ART ARCHIVE/MUSEO CAPI-TOLINO ROME/DAGLI ORTI.

PLAUTUS AND TERENCE. Even though playwrights often took a backseat to actors and other spectacles that occurred in Roman theaters, two Roman playwrights that were known throughout the Roman Empire were Plautus and Terence. Titus Maccius Plautus, a comic playwright perhaps originally from Umbria, was the first to make Greek New Comedy a truly Roman genre. His career stretched from the late third to the early second centuries B.C.E., but his legacy and popularity lasted much longer. Playwrights after Plautus' time could ensure the success of a comedy by attaching the name of Plautus to it, and eventually the number of plays attributed to him grew to more than 130 titles. In the first century B.C.E. the Roman scholar Varro limited that number to 21, and most of these still survive. Plautus freely admitted to borrowing titles, plots, and character-types from his Greek New Comedy predecessors, particularly from Diphilus, Philemon, and Menander, but

he gleefully modified these plays to suit his Roman audience. Plautus referred to his method of adaptation from Greek originals as *vortere barbare* ("to turn into another language"), but the adverb *barbare* also has the connotation of "barbarically, inelegantly, roughly." Plautus took the themes of New Comedy—concerns about marriage, family, citizenship, and disputes—and turned them upside down, relying on the influence of Atellan farce and bawdy harvest rituals as much as on his Greek forerunners. Whereas many Greek New Comedies seem to have ended with a marriage, Plautus overwhelmingly preferred to end with a wild debauch, often in the house of a prostitute. Young men, with the help of their cunning slaves, regularly thwarted their mean-spirited parents and ended up not with the proper and respectable young female citizens, but instead with the prostitutes they have been patronizing. Those who had authority in Roman society or those who exploited the weak—such

a PRIMARY SOURCE document

SASSY SISTERS

INTRODUCTION: Titus Maccius Plautus was Rome's favorite comic playwright. He flourished during the late third and early second centuries B.C.E. in Rome, though he may originally have come from Umbria. Plautus freely adapted plots from his Greek New Comedy predecessors for his Roman revels, but since there is very little extant of Greek New Comedy, it is not often that we can compare Plautus' riotous shows with those of his models. In his play *Two Sisters Named Bacchis*, however, we actually have a significant portion of the Menandrian original, called *Double Dealer*, which allows us to make an educated guess about the changes Plautus may have included in his adaptation. Plautus amplifies the roles of the marginalized—the female prostitutes and the clever slave—and employs the double-plot technique, often seen in Terence, in this madcap play. The comedy is about two sisters, both prostitutes, who are trying to avoid extended service to a pompous soldier, while a clever slave named Chrysalus ("Goldie") schemes to assist his young master in his relationship with one of the Bacchis sisters while at the same time trying to forestall his old master's lust for the same girl. In this scene, one of the young men tries to resist the wiles of Bacchis I, but at last gives in to her charms. In this scene we can see something of Plautus' love of alliteration, puns, and double entendre (many do not translate from Latin).

Pistoclerus: I'm more afraid of your allure than of being lured to the bed itself. You are an evil creature. A lurking lair is not appropriate for this young man, woman. ... Why am I, a young man, afraid, you ask? To enter into a wrestling arena of this sort, where one sweats into debts? Where I should take up debt instead of a discus, disgrace instead of a race?

Bacchis I: You talk beautifully!

Pistoclerus: Where I would take up a turtledove instead of a sword [both slang words for penis], and where someone would put a drinking cup in my hand instead of a boxing glove, a ladies' chamber pot instead of a helmet, a braided wreath instead of military decorations, dice instead of a spear, a soft cloak instead of a breastplate, where I'd be given a bed instead of a horse, and would lie down with a whore instead of a shield? Get away from me, away!

Bacchis I: You are much too rough.

Pistoclerus: I am to myself.

Bacchis I: So make yourself super-soft. ... Go on then. By Pollux I don't care, except for your sake. He [the blowhard soldier] will certainly carry her [Bacchis II] off; you don't have to be with me, if it's not what you want.

Pistoclerus: Am I nothing at all, then, can't I control myself?

Bacchis I: What is it you're afraid of?

Pistoclerus: It's nothing, just nonsense. Woman, I put myself in your power. I am yours, command me.

Bacchis I: You're sweet. Now, this is what I want you to do.

SOURCE: Plautus, *Bacchides*, in *T. Macci Plauti Comeoediae*. Ed. W. M. Lindsay (Oxford: Clarendon Press, 1903): lines 55–56; 65–73; 91–93. Translated by Lisa Rengo George.

as fathers, money-lenders, and pimps—were the villains, while the underdogs—those who held little power or social status such as the young man still under his father's control, the slave, and the prostitute—were empowered and made comic heroes. Plautus frequently employed many themes that can be traced back to Old and Middle Comedy, such as "recognition" dramas, amatory misadventures, and long-lost children. Plautus' "comedies in Greek dress" could lampoon Roman mores and present a reversal of social structure because they were part of a festival atmosphere, and the fact that they were ostensibly set in Greece (despite the use of purely Roman legal and idiomatic language) helped to displace any sense of Roman impropriety. Plautus' brand of comic chaos remained unfailingly popular for hundreds of years. Even Shakespeare used one of Plautus' comedies

of recognition, *The Twin Brothers Named Menaechmus*, as the source for his *Comedy of Errors* and inspired the Broadway musical and film *A Funny Thing Happened on the Way to the Forum*. Terence, on the other hand, did not aim for such mass appeal, nor did he receive it. A former slave from Africa, Terence rose socially to enter the elite "Scipionic Circle," as the friends and clients of Scipio Africanus (c. 185–129 B.C.E.) were called. The Scipio family was fond of Greek culture, and they stood in opposition to conservatives like Cato the Elder, who promoted traditional Roman values and perceived Hellenism as a bad influence. Terence adapted four of his six plays (all of which survive) from Menander, and overtly adhered much more closely to the form and language of his originals than Plautus did. Terence, too, was aiming to please an audience of elite philhellenes and in

that he may have succeeded, but he certainly failed to please the masses as Plautus did. He complains bitterly in some of his prologues that his Roman audiences were frequently distracted by displays of spectacle, such as gladiatorial fights and acrobats. Terence was also criticized for *contaminatio*—combining plot elements and characters from more than one play to create something new. The tensions surrounding Terentian drama reflect the contemporary concerns about the possible infestation of Greek culture and its ability to defile Roman purity during a time when Rome had just vanquished Greece and was inundated with Greek art and culture. Terence's tendency to celebrate and honor his Greek originals as works of art in their own right made him less admired than his older contemporary Plautus. Nevertheless, Terence's talent was considerable: his language is fluid and elegant and his philosophical interest in the human condition lends a global appeal to his plays.

SOURCES

Margarete Bieber, *The History of the Greek and Roman Theatre* (Princeton, N.J.: Princeton University Press, 1961).

John Evans, *The Empress Theodora: Partner of Justinian* (Austin: University of Texas Press, 2002).

Charles Garton, *Personal Aspects of the Roman Theatre* (Toronto: Hakkert, 1972).

Timothy J. Moore, *The Theater of Plautus: Playing to the Audience* (Austin: University of Texas Press, 1998).

John Wright, *Dancing in Chains: The Stylistic Unity of the Comoedia Palliata* (Rome: American Academy in Rome, Papers and Monographs, 1974).

OTHER TYPES OF ROMAN THEATER

MIME AND PANTOMIME. Mime was a genre of theatrical performance lying outside the formal boundaries of tragedy and comedy. It originated in Greece, where it probably began as the informal performance of imitative gestures, impressions, dances, and songs. Mime actors did not wear masks or shoes, and performed mimetically, as the name of the genre implies, improvising the expression of simple but ribald plots from mythology or daily events through gestures, dance, and facial expressions, accompanied by music. In Greece, mime performers were included in the same class as acrobats, much lower socially than the state-sponsored actors, directors, and producers of tragedy, comedy, and the dithyramb. In Rome, performances of mime were at first connected to the *Floralia*, a raucous and bawdy festival for the goddess Flora, which was established in the late third century B.C.E. Flora was a goddess of bloom-

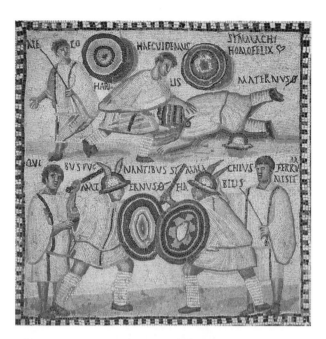

4th-century C.E. mosaic depicting gladiators in an amphitheater scene. THE ART ARCHIVE/ARCHAEOLOGICAL MUSEUM MADRID/DAGLI ORTI.

ing plants and was thought to be suspiciously Greek by conservative Roman traditionalists. The Floralia was patronized by prostitutes: in fact, *mima* or "mime actress" was a euphemism for a prostitute, and women in mimes often displayed their bodies provocatively. Sulla, the Roman dictator in the early part of the first century B.C.E., elevated the status of mime by socializing with mime performers. Mime eventually became a literary genre in the first century B.C.E., written by such authors as Laberius and Publius Syrus, a former slave who was freed because of his talent in the genre of mime. Historical sources relate that Julius Caesar asked Publius Syrus to compete in the Roman Games of 46 B.C.E., and he challenged his fellow producers of mime to a contest of improvisation, of which Caesar declared him the winner. Roman mime was known for its inclusion of proverbial expressions and pithy moral teachings (despite its reputation for indecency), which were excerpted and collected by Seneca the Elder, among others. This genre reached its peak of popularity in the last years of the Roman Republic, but continued to be enjoyed throughout the remainder of the Roman Empire. A connected genre, "pantomime," meaning "one who mimes everything," became popular in the Roman Empire. It was brought to Rome from the Hellenistic east in 22 B.C.E. by the actors Pylades, who was said to have a more dramatic tragic style, and Bathyllus, who preferred comic themes. A single, silent performer who wore a mask and loose clothing to permit free movement, accompanied by mu-

a PRIMARY SOURCE document

THE YAWNING ACTOR

INTRODUCTION: Lucian was a prolific author, critic, satirist, and essayist in the second century C.E. The influences of Attic Comedy, Plato and Cynical philosophy are apparent in his many writings. In *On Dancing*, written around 150 C.E., Lucian defends the genre of pantomime at the expense of traditional drama, and in the process provides us with a fascinatingly detailed (albeit biased) description of the tragic theater of his day. Lucian gives us the impression that for him, at least, old-fashioned and traditional dramas were out of style, and the freer and more balletic genre of pantomime outstripped tragedy and comedy in popularity.

What a repulsive and at the same time frightful spectacle is a man tricked out to disproportionate stature, mounted on high clogs, wearing a mask that reaches above his head with a mouth set in a vast yawn as if he meant to swallow up the spectators. I forbear to speak of pads for the breast and pads for the paunch, detachable fat that he puts on so that the grotesqueness of his height won't be more obvious for his skinniness. Then too inside all this you have the man himself bawling and bending over backward and forward, sometimes even chanting his iambics (tragic verse) and—most disgraceful of all—melodically singing the [reports of the] disastrous events and making himself answerable for his voice alone since the poets who lived so long ago prescribed everything else ... (Lucian then contrasts the pantomime). The dancer's mask is most beautiful and suited to the drama that forms the theme; its mouth is not wide open as in tragedy and comedy, but closed, for he has many people who do the shouting for him.

SOURCE: Lucian, *On Dancing*, in *The Context of Ancient Drama*. Eds. Eric Csapo and William J. Slater (Ann Arbor: University of Michigan Press, 1994): 182.

sicians and singers, acted out pantomime, and sometimes an actor spoke while the pantomime described the action physically. Prominent authors like Lucian (39–65 C.E.), an epic poet, wrote lyrics for pantomime, and because of its greater demands on the performer, was deemed to be of higher status than mime. Pantomime remained fashionable in both the Roman and Eastern Roman empires well into the sixth century C.E.

GLADIATORIAL GAMES AND OTHER SPECTACLES. Scholars posit that fights between armed opponents at Etruscan funerals were the origin of the Roman gladiatorial combats, dating from the third century B.C.E. Whatever the source, the gladiator became a truly Roman figure, who could earn wealth, admiration from the ladies, and even freedom if successful in the amphitheater. Candidates for Roman office often funded gladiatorial contests as they did performances of other Roman entertainments, like theater, mime, and acrobatic shows, in order to gain popularity among the masses and win votes. Their original connection to funerals was superseded quickly by the desire of politicians and officials to appease the often rowdy and fickle Roman population. Gladiators probably fought in the Roman Forum before permanent amphitheaters were constructed beginning in the early Roman Empire. The most famous amphitheater in Rome is the Colosseum, whose remains still stand. The building of this massive and complex structure was undertaken during the reign of Emperor Vespasian and finished up under Titus in 80 C.E. The amphitheater has an extensive basement with waiting areas for gladiators, criminals about to be executed, and others unlucky enough to be sent out to face danger and death in the arena, as well as holding pens for wild animals, like lions and tigers, for beast-fights and brutal executions of criminals, slaves, and other undesirables. There were many amphitheaters all over the Roman Empire, as the Romans eagerly exported their favorite entertainments to the furthest reaches of their colonies. As the Roman lust for larger and more elaborate spectacles grew, officials sponsored contests featuring thousands of gladiators and victims. There were four types of gladiator. The Thracian used a round shield and curved dagger. Both the Samnite—dressed to resemble a warrior from the Oscan town of Samnium—and the *murmillo*—identifiable by a fish on his crest—were armed with a long shield, helmet with a visor, and sword. The *retiarius* ("net-man") had little body armor and relied on agility and speed with his net and trident. Most gladiators were slaves, prisoners of war, or criminals who were pressed into service. Free citizens could also sell themselves to a keeper of a gladiatorial team. The combats were often gruesome affairs, resulting in amputated limbs, horrendous wounds, and death. Not all Romans relished these bloody exhibitions: the great Roman statesman Cicero bemoaned the popularity of these brutal entertainments. The poet Juvenal (first–second century C.E.) was disgusted when a dog ran past with a human hand in its mouth after a night of gladiatorial combats. Other types of popular public

a PRIMARY SOURCE *document*

AN UNHOLY FEAST

INTRODUCTION: Lucius Annaeus Seneca the Younger most likely composed his tragedies while serving as an adviser to Nero in the mid-first century C.E. Seneca's tragedies are a puzzle to modern scholars: when exactly were they written, and for what purpose? Are they meant to teach Stoic principles, despite their grotesque violence, or were they merely meant to entertain the callous court of a maniacal emperor? At any rate, they are the only extant Roman tragedies and as such provide us with a glimpse of the continuing tradition of the tragic genre. In his play *Thyestes*, Seneca retells the gory tale of the sons of Pelops, Thyestes and Atreus, who are doomed to repeat the gruesome familial pattern of cannibalism and revenge. Thyestes has seduced his brother's wife, and in a horrible act of vengeance Atreus has killed his nephews and cooked them to serve to his brother in an ironic "reconciliation" banquet for his brother.

Thyestes (after finishing his grim meal and discovering its source): This is what shamed the gods, this drove the day against its dawn. Wretched me, what noises shall I make, what laments? What words will be enough for me? I recognize the severed heads, the hands cut off, the feet ripped from broken legs! This is what the ravenous father could not gulp down. My sons' guts are rolling around inside me, and my crime concealed in my stomach struggles without a way out and searches madly for an escape. Brother, give me your sword that is clotted with my own blood. With its blade, the path to freedom may be provided for my children. You refuse to give me the sword? Then may my chest echo, beaten by resounding blows! Hold back your hand, you miserable son of a bitch—let's show mercy to the ghosts of the dead. Who in the world has ever seen such a horrible crime? What Heniochian [a notoriously savage nation] who lives on a jagged cliff of Mt. Caucasus, what Procrustes [an unusually sadistic fellow], who causes fear among the Cecropians? Look at me, a father who crushes his sons, and is in turn crushed by them. Is there no limit to evil?

Atreus: There ought to be a limit to evil when you do evil, but not when you repay it. Even this [gesturing at the bloody body parts of the children] is not enough for me. I should have poured their hot blood right from their wounds down your throat, so that you could drink their gore while they were still alive! My words of rage were lost in my rush. I stabbed them with a deep thrust of my blade, I slaughtered them at the altars, I placated the sacred hearth with their blood as an offering. I carved up their lifeless corpses and I tore them to pieces, immersing some parts in boiling pots: others I set to drip over slow fires. I tore off their limbs and muscles while they were still breathing, and I watched their livers pierced on a thin spit, still quivering, and I myself fed the flames. Their father could have done all these things better—my pain has fallen for no purpose. He ripped apart his sons with an unholy mouth, without knowing it, and without them knowing it!

SOURCE: Seneca, *Thyestes*, in *Tragedies*. Ed. Frank J. Miller (London and Cambridge, Mass.: Harvard University Press, 1968). Translated by Lisa Rengo George.

spectacle, most involving a high level of risk, were wild-beast hunts, executions, chariot-racing, athletic competitions, military triumphal processions, numerous religious holidays and festivals, and religious rituals.

NERO AND SENECA. One era of the Roman Empire deserves special mention here. When Nero became emperor in 54 C.E. he introduced a new level of interest in the performing arts. He had been tutored by Seneca the Elder and fancied himself as a talented artist, author, musician, and actor. He developed his own version of Greek games called "The Neronia," instituted in 60 C.E., and he himself performed in the second year of the games. Nero often traveled to Greece to perform in games and to give recitals of music and drama. His refusal to heed the traditional laws of Rome, which forbade members of the upper classes to perform on the public stage, out-

raged many Romans. Seneca, son of Seneca the Elder, became one of Nero's advisers. He had been a senator and held other political offices, but was renowned for his skills as a public speaker and author. He amassed a great fortune while serving under Nero, but his position in the emperor's court also meant that he had to accept the emperor's unsavory and cruel methods, including several assassinations, while at the same time espousing moral values. His works are comprised of several philosophical and didactic treatises, a book on natural science, a comedy parodying the emperor Claudius, and nine tragedies based on Greek mythology. These plays were modeled explicitly on Greek tragedies: they were written in tragic meters and in episodic form, and they included choral songs and dances. His style has often been called "Euripidean" since he explored the psychology of his characters, portrayed individuals as blameless victims

of fate or the gods, and focused on some of the most gruesome and shocking events portrayed in myth. At the same time, his treatment of themes and characters is so exaggerated it may have been intended as parody. Scholars have argued for centuries about whether Senecan drama was meant to be staged or only recited in private performances or public acting contests. Some have pointed out that the plays would have been impossible to stage realistically, since they portrayed murders, funeral pyres, animal sacrifices, and other scenes of ferocious violence—events that always took place off stage and were only described during the course of a Greek tragedy. Others have argued that the unstageable events could have been performed mimetically, or that the dramas were not intended to be staged as a whole, since many individual scenes are performable. Still others have suggested that Seneca wrote these gory dramas only to be read as an evening's entertainment at court or to provide "set pieces" for Nero and others to perform at recitals or in contests. Not surprisingly, Seneca's plays featured beautifully written speeches with fine rhetorical turns, extensive descriptive passages, moralizing and pithy epigrams, or short sayings. Senecan drama had great influence on theater in the Renaissance and in Tudor and Jacobean England.

SOURCES

Bettina Bergmann and Christine Kondoleon, eds., *The Art of Ancient Spectacle* (Washington, D.C.: National Gallery of Art; New Haven, Conn.: distributed by Yale University Press, 1999).

Pat Easterling and Edith Hall, eds., *Greek and Roman Actors* (Cambridge: Cambridge University Press, 2002).

Anna Motto and John Clark, *Senecan Tragedy* (Amsterdam: Adolf M. Hakkert, 1988).

Ruth Scodel, ed., *Theater and Society in the Classical World* (Ann Arbor: University of Michigan Press, 1993).

SIGNIFICANT PEOPLE
in Theater

ARISTOPHANES

c. 445 B.C.E.–c. 385 B.C.E.

Comic playwright

FAMOUS COMEDIAN. Unfortunately, there are very few details about the life of Aristophanes other then the fact that he was born around 445 B.C.E. He began writing for the comic stage as a very young man, and submitted his first play, *Banqueters*, to the competition at the City Dionysia in 427 B.C.E. when he was only eighteen years old. The titles of 54 of his comedies are known, but unfortunately only eleven of those plays exist today. In fact, Aristophanes is the only Greek comic playwright of the fifth century B.C.E. whose works have survived even in part from this time period. Yet through literary sources, it is clear that Aristophanes was not the only comedic playwright at the time; his most famous contemporaries were Eupolis and Cratinus. Yet Aristophanes' inventive use of language and his inimitable poetic style won the admiration not only of the Athenian public (except the outraged officials) but, later, of Plato. Aristophanes is one of the guests at Plato's fictional *Symposium* and gives a memorable speech about the origins of love.

WORKS. Of the surviving plays of Aristophanes it is known that three won first prizes at the City Dionysia. Yet he won many other awards for his plays as well. His known plays include: *Acharnians* (first prize at the Lenaia, 425 B.C.E.); *Clouds* (last place at the City Dionysia, in 423 B.C.E., later revised); *Birds* (second prize at the City Dionysia, 414 B.C.E.); *Lysistrata* and *The Festival Goers* (the first at the Lenaia, the second at the City Dionysia, 411 B.C.E.); *Frogs* (first prize at the Lenaia, 405 B.C.E.); and *Women in the Assembly* (perhaps 392 B.C.E.). Aristophanes was often threatened with prosecution by the statesman Cleon, whom he mocked frequently in his comedies. Comedy in fifth century B.C.E. Athens was quite different from what comedy is to modern audiences. Comedies were topical satires that derided important political and intellectual movements and figures of the day. Famous targets included Cleon, a rich politician and successor of Pericles; Euripides, the famous tragedian; and Socrates, already infamous as a philosopher and teacher, who is identified with the Sophists (itinerant professors of philosophy and rhetoric) whom Aristophanes despised. Even the gods could appear on stage in ridiculous settings. Though he was an intellectual himself, Aristophanes was not averse to including extremely crude (and crowd-pleasing) humor in his plays, which abound in sexual and scatological references. Aristophanes employed outrageous costumes and scenery in some of his fantasies, such as *Birds*, in which actors dressed as animals, wore padded costumes with genitalia protruding from beneath short tunics, and grotesque masks in a fictional utopia called "Cloud Cuckoo Land." Many of the heroes of his plays are common people who want solutions to problems in their

daily lives and who are mystified by the machinations of politicians and diplomats.

SHIFTED TO MIDDLE COMEDY. There was a shift in Aristophanes' comic sensibilities as the political climate changed due to the Peloponnesian Wars with Sparta (431–404 B.C.E.). His early plays followed a rigid dramatic structure involving a strong chorus crucial to the action that gradually loosened as the playwright defined his own style. After Athens lost the war to Sparta, however, his plays lost their topicality and became less specific to Athens, and the chorus—formerly of prime importance—became largely extraneous to the plot. These plays are now designated as "Middle Comedy," as opposed to the "Old Comedy" defined by his earlier style, and influenced fourth and third century B.C.E. Greek playwrights like Menander, and later the Romans Plautus and Terence.

SOURCES

E. Csapo and W. J. Slater, *The Context of Ancient Drama* (Ann Arbor, Mich.: The University of Michigan Press, 1995).

K. J. Dover, *Aristophanic Comedy* (Berkeley and Los Angeles: University of California Press, 1972).

M. C. Howatson, ed., *The Oxford Companion to Classical Literature* (Oxford and New York: Oxford University Press, 1989).

Douglas M. MacDowell, *Aristophanes and Athens* (Oxford and New York: Oxford University Press, 1995).

EURIPIDES

c. 480s B.C.E.–c. 405 B.C.E.

Tragic playwright

GIVING VOICE TO THE UNHEARD. There are more than twice as many surviving plays of Euripides than of either Aeschylus or Sophocles (eighteen as compared with six or seven apiece of the others). There is also a parodic portrayal of the playwright in Aristophanes' *Frogs* and a fanciful biography of him written in the third century B.C.E. which relied on details from the playwright's own works as well as various other spurious sources. Even so, it is difficult to discern the facts of the playwright's life, and ultimately there is as little known about him as about most famous people from antiquity. Euripides was born to a wealthy family in the Athenian deme of Phyla, though there were stories that he came from modest origins as well, most likely because he often portrayed humble people in his plays. The tale that he isolated himself

in a cave at Salamis to write his plays probably more reflects his lack of interest in politics or public life than an actual physical isolation. He first competed at the City Dionysia in 455 B.C.E. He won fewer first prizes—only four—than did Aeschylus or Sophocles during his career, but the story that he fled Athens for Macedon in disgust at his lack of popularity is undoubtedly false. Nevertheless, he did die at the court of King Archelaus of Macedon in approximately 406 B.C.E.; the story has it that he was torn to pieces by the king's guard dogs, which echoes his propensity in tragedies to include unusually violent deaths for his characters, such as the demise of King Pentheus in *Bacchants*, who is ripped apart by a raving band of maenads led by his own mother. Euripides had three sons, one of whom, also named Euripides, may have produced some of his tragedies after his death

WORKS. Eighteen of Euripides' plays survive. (A nineteenth, the *Rhesus*, is of doubtful authorship.) The plays securely attributed to Euripides include: *Medea* (last place in 431 B.C.E.); *Electra* (417 B.C.E.); *Trojan Women* (second prize in 415 B.C.E.); *Bacchants* and *Iphigenia at Aulis* (first-prize winners produced together posthumously in 405 B.C.E.); and a satyr play, *Cyclops* (date unknown). In addition, there are substantial fragments of eleven others, including *Oedipus*, *Cretans*, and *Archelaus*, written for his patron in Macedon. Euripidean drama focuses on individual characters and their personal circumstances, the paradoxical nature of human life and its vicissitudes, and the internal struggle that the tragic hero undergoes. As a consequence, the structure of his plays sometimes follows a predetermined plot to its foreseeable, if regrettable, outcome; at other times, his plays swerve as unpredictably as his characters do. Euripides featured characters who commit the most extreme acts humans are capable of—incest, rape, betrayal, murder—and allowed them to stand up for themselves. He sometimes drew criticism for portraying women who defended roles that were contrary to Athenian values, like Agave in *The Bacchants*, who glories in her newfound bloodlust, and Medea in the play that bears her name. He often added startling innovations to familiar stories from myth. Some of his tragedies, like *Ion*, include elements more familiar to Middle and New Comedy: a son born out of wedlock is eventually recognized and reunited with his parents with the help of the gods. The amazing variety of Euripidean plots, from the very bleak *Trojan Women*, portraying women who must face a future as the sexual slaves of the men who killed their families, to the almost lighthearted *Helen*, which chronicles the awkward reunion of Helen and Menelaus after the Trojan War, ultimately de-

fies categorization. Euripides was criticized in his own time for portraying ordinary people as they were instead of noble denizens of a tragic past, but he often seems like the most "modern" playwright. His plays were among the most popular in later revivals.

SOURCES

E. Csapo and W. J. Slater, *The Context of Ancient Drama* (Ann Arbor, Mich.: The University of Michigan Press, 1995).

M. C. Howatson, ed., *The Oxford Companion to Classical Literature* (Oxford and New York: Oxford University Press, 1989).

Laura McClure, *Spoken Like a Woman: Speech and Gender in Athenian Drama* (Princeton, N.J.: Princeton University Press, 1999).

LIVIUS ANDRONICUS

c. 280 B.C.E.–c. 204 B.C.E.

Playwright
Translator

THE ORIGINATOR OF LATIN POETRY. Little is known about the early life of Livius Andronicus, who was born around 280 B.C.E. He likely came to Rome as a teacher of Greek and Latin sometime in the mid-third century B.C.E. in the household of one Livius Salinator, from whom he took the family name "Livius" after being freed. His exact region of origin is not known, though his last name "Andronicus" sounds Greek, and he may have been born in the Greek colony of Tarentum in southern Italy. This area was known to the early Romans as *Magna Graecia* or "Greater Greece," because it, as well as the island of Sicily, had been colonized by the Greeks since at least the eighth century B.C.E. He is credited as the first to create Latin poetry when he began translating Homer's *Odyssey* into Latin using a native Italic poetic meter. He also began producing plays for and acting on the Roman stage, influenced by the Greek theater in southern Italy, Greek-influenced Etruscan performances, and the early native forms of spectacle, like the Fescennine verses at harvest times, the Atellan farces of the Oscans in Campania, and the Italians' love of music, dance, and religious ritual.

WROTE IN BOTH GENRES. His first production took place in 240 B.C.E., during an especially grand celebration of the annual Roman Games to celebrate Rome's victory over Carthage in the First Punic War (264–241 B.C.E.). Unlike Greek playwrights, who wrote in only one genre, Livius Andronicus wrote both tragedies and comedies in the Greek style, of which seven titles and fewer than seventy fragments have survived. His tragedies often centered around the events of the Trojan War, such as *Achilles, Aegisthus, Ajax with a Whip, The Trojan Horse,* and *Hermione,* but he wrote on other mythological stories as well, including *Andromeda, Danae,* and *Tereus.* One of the few comedies that survived to modern times is entitled *The Little Sword.* In 207 B.C.E., he received state honors for his work, the first time that the Romans honored literary achievement. In that same year, the professional actors' and scribes' union (the *collegium scribarum histrionumque*) was officially recognized, and space was provided for them in a temple on the Aventine Hill. Under the influence of Livius, and due to the popularity of his plays, the old Roman *saturae* (sketches accompanied by music that were originally performed) gradually became a purely literary genre in favor of the Greek-inspired drama Livius brought to his adopted city.

SOURCES

Gian Biagio Conte, *Latin Literature: A History* (Baltimore, Md.: Johns Hopkins University Press, 1994).

M. C. Howatson, ed., *The Oxford Companion to Classical Literature* (Oxford and New York: Oxford University Press, 1989).

E. J. Kenney, ed., *The Cambridge History of Classical Literature II: Latin Literature* (Cambridge: Cambridge University Press, 1982).

E. H. Warmington, ed., *The Remains of Old Latin, Volume I* (Cambridge, Mass.: Harvard University Press, 1959–1961).

LYCORIS

c. 70 B.C.E.–Late 1st century B.C.E.

Mime actress
Prostitute

MIME AND MISTRESS. "Lycoris" was the pseudonym of Volumnia Cytheris, a freed slave, perhaps originally a Greek, who became a famous mime performer and prostitute. Lycoris was the mistress of some of Rome's most famous men in the Republican era: Cornelius Gallus, poet and colleague of Catullus and first prefect of Egypt; Brutus, a well-known conspirator in the assassination of Julius Caesar in 44 B.C.E.; and Marcus Antonius, lover of Cleopatra and the unsuccessful opponent of Augustus in the war for control of Rome in 31 B.C.E. She is mentioned in the poetry of Ovid, Vergil, and the fragments of Gallus's works, and unflatteringly in Cicero's letters. It is commonly believed that

Roman actors on the "legitimate" stage were all male, and that respectable women were forbidden to act on the stage, but women were permitted to perform in the less reputable genre of mime and pantomime. All performers of Roman theater and spectacle were legally *infamis* ("disreputable"), and Lycoris, a woman, former slave, and a foreigner as well, lived on the margins of society even though she had connections to powerful political figures. There is no mention of Lycoris after the early 40s B.C.E.

SOURCES

W. Beare, *The Roman Stage* (London: Methuen, 1964).

Augusto Fraschetti, ed., *Roman Women*. Trans. Linda Lappin (Chicago and London: University of Chicago Press, 2001).

A. Wallace-Hadrill, *Patronage in Roman Society* (London and New York: Routledge, 1990).

MENANDER

342 B.C.E.–c. 292 B.C.E.

Comic playwright

THE MASTER OF NEW COMEDY. Menander was born in 342 B.C.E., a native Athenian who may have had family connections to the Greek theater of which he became such an integral part. Some sources relay that he was the nephew of the well-known Middle Comedy playwright Alexis, none of whose works survive. Ancient references also tell that Menander studied with the philosopher Theophrastus, Aristotle's successor as the head of the Peripatetic school of philosophy at Athens. He served in the military with Epicurus, another philosopher whose doctrine, Epicureanism, involved the pursuit of wisdom and happiness by relying on human perception rather than religious belief. These associations may account for much of the philosophical content of Menander's plays. Nearly 100 titles of plays are attributed to Menander, but very little of his writing survives today. Most of the manuscripts of his plays were lost during the seventh and eighth centuries C.E. because the Byzantines thought their style of Greek was substandard compared to that of the fifth-century B.C.E. dramatists. Fortunately, several substantial portions, including a few plays more or less in their entirety, were discovered during twentieth century C.E. excavations in Egypt. More of Menander's works may have survived because he was a master of the genre of New Comedy: his plots, which focused on family life and its daily complications, displayed gentle comic flare, timeless social commentary, and impeccable timing. The

plays had such widespread appeal, in fact, that the Roman playwrights Plautus and Terence frequently "borrowed" from him in creating their own comedies.

WORKS. A nearly complete manuscript of *The Grouch* exists, which was first performed in 317 B.C.E. and won first prize at the City Dionysia in Athens. Large portions and fragments of varying size and quality have survived as well. *The Grouch*, which in many ways seems to be a typical New Comedy, features a misanthropic old man named Knemon who, after his wife leaves him, withdraws with his daughter to an isolated farm outside Athens. The god Pan announces that he wants to help Knemon's daughter by setting up a marriage between her and Sostratos, the son of a wealthy farmer. After a series of comic mix-ups and mishaps that focus on the lovestruck Sostratos' attempts to prove himself worthy to the crabby Knemon, Knemon realizes the benefits of living in society, accepts Sostratos as his son-in-law, and reunites with his wife. Although Menander and his colleagues had a political agenda invested in the laws of Athens, it was much less obvious than their predecessors. Their plays are far less topical and specific to Athens than those of their predecessors in Old and Middle Comedy. Menander in particular seems to have been especially sensitive to widespread social problems and family issues like rape, illegitimate children, citizenship and marriage, prejudice, and intolerance. Menander was an especially adroit playwright, who was aware of dramatic nuance and who used the genre and versification of New Comedy to explore human psychology, political concerns, and societal dilemmas. The Roman playwrights Plautus and Terence openly acknowledged their debt to Menander and other Greek New Comic playwrights in the prologues and plots of their "adapted" plays. Menander drowned while he was swimming in the Piraeus, Athens' harbor, around 292 B.C.E.

SOURCES

Sander M. Goldberg, *The Making of Menander's Comedy* (Berkeley and Los Angeles: University of California Press, 1980).

A. W. Gomme and F. H. Sandbach, *Menander: A Commentary* (Oxford: Oxford University Press, 1973).

Susan Lape, *Reproducing Athens: Menander's Comedy, Democratic Culture, and the Hellenistic City* (Princeton, N.J.; Oxford: Princeton University Press, 2004).

Netta Zagagi, *The Comedy of Menander: Convention, Variation, and Originality* (Bloomington and Indianapolis: Indiana University Press, 1995).

GNAEUS NAEVIUS

c. 270 B.C.E.–c. 200 B.C.E.

Playwright
Translator

FIRST ROMAN PLAYWRIGHT. Naevius was most likely born in Rome around 280 B.C.E., despite a later reference to his possible Campanian origins. His family name is known from historical records as a plebeian rather than noble name and he was certainly a Roman citizen, not a freedman like his contemporary Livius Andronicus. He served in the Roman army during the first Punic War (264–241 B.C.E.) and began writing for the stage afterward, with his first production in Rome in 235 B.C.E. He did not act in his own plays like Livius, but he did originate a uniquely Roman form of drama: the *fabula praetexta*, historical tragedies about Roman subjects rather than Greek mythology. One, called *Clastidium*, recounted a Roman victory in that city in 222 B.C.E.; another, *Romulus*, told the story of Rome's legendary founder. He also wrote comedies, based on Greek originals (called *fabula palliata* after the Greek *pallium*, or outer garment) and Roman originals (*togata* after Roman clothing). In a style that harked back to Greek Old Comedy and very much contrary to New Comic practice, Naevius often attacked famous Romans, like Scipio Africanus and the noble Caecilius Metellus family. He was even jailed for a time because of his assaults on the upper class, which Plautus alludes to in one of his comedies. He may have been best known for his epic poem "The Punic War," the first real Roman epic in native Italic meter. This sweeping national poem, which went back to Rome's connection to the Trojan Aeneas, was a powerful influence on later writers of Roman epic like Ennius and Vergil. Naevius' younger contemporaries Pacuvius and Accius continued to write in the genres Naevius established or developed, but Roman tragedy as a dramatic form did not endure past Naevius' time. Plautus and Terence carried on writing comedies "in Greek dress," and in the first century C.E., Seneca wrote tragedies based on or inspired by Greek originals.

SOURCES

Gian Conte, *Latin Literature: A History* (Baltimore, Md.: Johns Hopkins University Press, 1994).

M. C. Howatson, ed., *The Oxford Companion to Classical Literature* (Oxford and New York: Oxford University Press, 1989).

E. J. Kenney, ed., *The Cambridge History of Classical Literature II: Latin Literature* (Cambridge: Cambridge University Press, 1982).

E. H. Warmington, ed., *The Remains of Old Latin, Volume II* (Cambridge, Mass.: Harvard University Press, 1959–1961).

NERO

37 C.E.–c. 68 C.E.

Roman emperor
Performer

A TROUBLED EMPEROR IN A TROUBLED TIME. Nero was born Lucius Domitius Ahenobarbus in December 37 C.E. to Agrippina the Younger and G. Domitius Ahenobarbus. His mother was the daughter of Germanicus Julius Caesar, grandson of the emperor Augustus and brother of the emperor Claudius. His father was a cruel and much vilified former soldier who swindled and killed for fun. His family was banished by the emperor Caligula in 39 C.E., and his father died soon afterward. When Claudius became emperor in 41 C.E., he restored Agrippina's civil rights and her estates, which had been confiscated by Caligula. Seneca the Elder, an historian and orator, tutored the young Nero. His uncle Claudius adopted him in 50 C.E., making him heir to the throne. Agrippina murdered Claudius in 54 C.E., and Nero became emperor. His dominating mother held the empire's reins at first, but gradually the impressionable Nero fell under the influence of his advisers, and she was removed from the emperor's palace in 55 C.E. Nero murdered his mother in 59 C.E. Never very stable, he allowed his advisers to run the government while he slid into debauchery, excess, and madness. He was married three times, and had numerous affairs with both men and women, and, according to some rumors, even his mother.

PUBLIC PERFORMANCES. Nero adored spectacle and the arts, and spent a lot of time in Greece, the cradle of culture for the Romans, where he regularly competed in games. He once staged a triumph for himself, but instead of displaying the spoils of conquered nations, he was preceded by a display of the trophies and proclamations of his victories in singing and lyre playing in Greek. He fancied himself as a gifted author and performer on the stage, and often compelled the citizenry to listen to him declaim and sing excerpts from drama for hours in locked theaters. Citizens were said to have faked serious illness in order to be carried out of the theater. In 60 C.E. he established the Neronia, contests modeled on Greek games in which noblemen vied in declamation and music. He underwent grueling rituals to strengthen himself for performing in public, such as lying with heavy weights on his chest, purges and

extreme diets, and drinking a concoction made of dried boar's feces to repair sore muscles. He surrounded himself with flatterers who encouraged his delusions. The famous fire in 64 C.E., in which Nero was famed to have "fiddled while Rome burned," serves as an example of the extent of his megalomania and the urban turmoil in Rome during his reign. He was so serious about himself as one of the world's most talented performers that the writer Suetonius relays that his dying words were "I die as such a great artist."

SOURCES

Matthew Bunson, *A Dictionary of the Roman Empire* (New York and Oxford: Oxford University Press, 1991).

Miriam Griffin, *Nero: The End of a Dynasty* (New Haven, Conn.; London: Yale University Press, 1984).

Suetonius, *The Twelve Caesars*. Trans. Robert Graves (East Rutherford, N.J.: Penguin, 2003).

Tacitus, *The Annals*. Trans. Michael Grant (New York: Viking Press, 1956).

TITUS MACCIUS PLAUTUS

c. 250 B.C.E.–c. 184 B.C.E.

Comic playwright

FROM SLAVE TO KING OF COMEDY. Because Plautus was the most popular playwright in Roman history, there are many biographical details about him from many sources. It is ultimately impossible to determine which are true, or even partly true, and which are wholly false. In any case, the stories about Plautus bestow on him a colorful life, with a dramatic rise from slavery to comic sovereign. It is said that he was born in Sarsina, Umbria, around 250 B.C.E., and was a native speaker of his regional Italic language, Umbrian. "Plotus" is the Umbrian spelling of his *cognomen*, or last name, which may have meant "flat-footed" or "big-eared," both perfect for a comedian. This name would have been Romanized as "Plautus." "Plautus" also connotes "applause" (the modern English word comes from a Latin root), and therefore is a clever last name for a famous playwright, whose livelihood depended on his popularity with his audience. His gentilician or family name, Maccius or Maccus (the manuscripts are unclear), was very probably made up as a joke on the Roman nobility with prestigious family names like Julius and Claudius. There was a typical character named "Maccus," a clown, in the native Italic dramatic genre known as Atellan farce. Though Plautus was born a free citizen, his popular biography told that he was a slave who had been a performer in Atellan farce and mime, and who then came to Rome as a freedman and rose to greatness on the comic stage.

LIBRARY OF WORK. In the second century B.C.E. over 130 titles of plays were attributed to Plautus. Certainly he was a prolific author, but part of this overwhelming number of attributions may be a result of his name itself: any play said to be written by the great Plautus would certainly have attracted more audience members. At the end of the century, the Library of Alexandria began to collect manuscripts and put together reliable editions of the best known authors, and in the first century, one of the foremost scholars in Rome, Varro, made what he considered a definitive list of 21 plays that could accurately be called Plautine. These plays are the ones that have been recognized by modern scholars, mostly complete with some fragmentation. The chronology of the plays is uncertain and has been a source of scholarly debate for hundreds of years. Because New Comedy focused on general social situations and avoided most topical references, allusions to historical events are few and often hard to assess. The titles of Plautus' best-known plays are as follows: *Casina*, the name of a household maidservant (c. 186 B.C.E.); *The Twin Sisters Named Bacchis*; *The Twin Brothers Named Menaechmus*; *The Boastful Soldier*; and *Pseudolus*, the clever slave of the play (c. 191 B.C.E.).

THEMES AND STYLES. From these plays, much can be garnered about Plautine style, characterization, and staging. Plautus often presented as his comic heroes not members of the nobility or figures of authority but the lowliest and least powerful elements of society: slaves, foreigners, prostitutes, young men without resources. Since Plautus unabashedly "adapted" plots from his Greek New Comedy predecessors, many of the same characters that were established in that genre can be seen: the grouchy old man, the nagging wife, the nosy neighbor, the shrewd prostitute, the dissolute son, the victimized young woman. Plautus made these characters his own, however, by changing them from Greek comic stereotypes to real denizens of Rome, who used Roman idioms and legal terms and thought like Romans. In this way, Plautus could satirize aspects of his own ultraconservative society by presenting all his characters as "Greek," thereby absolving them of their debauched morals and behavior, and allowing his Roman audience to enjoy the reversal of heroic status. One scholar has compared the comedies of Plautus to the celebration of the Saturnalia, a festival in which masters and servants changed places for the day. Plautus' Latin is the only example of literary Latin in the late third and early second centuries B.C.E. His latinity is deceptively fluid and id-

iomatic; it is also highly stylized, uses a great number of anachronisms and other oddities, and follows a complicated metrical schema. Plautus' play *Twin Brothers Named Menaechmus* was the basis for Shakespeare's *A Comedy of Errors.*

SOURCES

W. S. Anderson, *Barbarian Play: Plautus' Roman Comedy* (Toronto; Buffalo; London: University of Toronto, 1993).

Richard C. Beacham, *The Roman Theater and Its Audience* (London: Routledge, 1991).

Gian Biagio Conte, *Latin Literature: A History* (Baltimore and London: The Johns Hopkins University Press, 1994).

E. J. Kenney, ed., *The Cambridge History of Classical Literature II: Latin Literature* (Cambridge: Cambridge University Press, 1982).

QUINTUS ROSCIUS GALLUS

c. 120 B.C.E.–c. 62 B.C.E.

Actor

ROME'S MOST FAMOUS ACTOR. Quintus Roscius Gallus was one of the most famous actors in ancient Rome. In fact, his name continued to be used to describe a brilliant actor until the nineteenth century C.E.—as modern critics might use "an Olivier" to designate an especially gifted actor. His *cognomen* ("last name") Gallus usually denoted someone who was a freedman (the son of a former slave), but Roscius was born to a prosperous family in Latium, what is now the area south of Rome. Most of the biographical information about him comes from the great Roman statesman Cicero, who defended Roscius in court on a charge of business fraud in 69 B.C.E. or thereabouts. He was extremely handsome with a slight squint, and was especially renowned for his *venustas* ("grace of movement"). He may have tutored Cicero in the art of elocution when Cicero was a young student, but he was aristocratic enough to be part of the inner circle of Sulla, the Roman dictator, who made him a knight in 81 B.C.E. Roscius preferred acting in comedies to tragedies, perhaps because comic roles required more physicality, but he was known for his tragic performances as well. As the great actor grew older, he slowed down his movements and was renowned for his "old man" voice.

SOURCES

Cicero, "In Defense of Roscius the Comic Actor," in *On Oratory and Orators.* Trans. J. S. Watson (Carbondale, Ill.: Southern Illinois University Press, 1986).

Pat Easterling and Edith Hall, eds., *Greek and Roman Actors* (Cambridge: Cambridge University Press, 2002).

Charles Garton, *Personal Aspects of the Roman Theatre* (Toronto: Hakkert, 1972).

SENECA THE YOUNGER

c. 4 B.C.E.–65 C.E.

Statesman
Author

TUTOR TO NERO. Lucius Annaeus Seneca, the "Younger," was born in the Roman colony of Spain just before the turn of the first millennium. His father, Seneca the "Elder," was a famous orator who wrote treatises on rhetoric for his sons, which were later used as school texts. Seneca the Younger was born around 4 B.C.E. and educated in Rome from an early age. He pursued a political career as a young man and, in addition to being a lawyer, held the offices of quaestor and praetor before becoming a senator. When Nero became emperor in 54 C.E., Seneca became one of his most influential political advisers, and thanks largely to him and another adviser, Burrus, the Roman state proceeded smoothly for the next eight years. As Nero's behavior became more erratic and violent, Seneca was increasingly compelled to overlook the emperor's barbarity until, after Burrus died in 62 C.E., he was allowed to retire from court. He set out to write works of philosophy, but was incriminated in a political conspiracy and was forced to kill himself in 65 C.E.

WORKS. Seneca wrote prolifically and his corpus included works on morals, philosophy, and ethics in addition to poetry and drama. He became known in particular for the tragedies in Greek style he composed in the first century C.E., such as *Medea, Phaedra,* and *Thyestes.* Seneca was indebted to the great Greek tragedians Aeschylus, Sophocles, and Euripides for the treatment of his subject matter and in some elements of his style, but overall Senecan tragedy is a unique amalgam of moralizing, gore, and hyperbolic rhetoric. Seneca's rhetorical training is apparent in the frequent, impassioned speeches of his characters, and his focus is on the power of language rather than of actions. Some have suggested that Seneca taught Stoicism through his tragedies, since many of them feature the destructive power of unrestrained emotion, a Stoic precept. This is unlikely, however, since evil often triumphs over rationality in his plays in a distinctly un-Stoic manner. His tragedies are richly drawn with extraordinarily vivid characters. His plays are filled with suspense, madness, and horror, which kept them in the theatrical limelight far past Seneca's own time. It is un-

clear whether Seneca intended for his tragedies to be staged completely or whether he wrote them for other purposes. Seneca had a widespread influence on authors of the Italian Renaissance and Jacobean England.

SOURCES

Gian Biagio Conte, *"Latin Literature: A History* (Baltimore and London: Johns Hopkins University Press, 1994).

Miriam Griffin, *Seneca: A Philosopher in Politics* (Oxford: Oxford University Press, 1976).

Anna Motto and John Clark, *Senecan Tragedy* (Amsterdam: Hakkert, 1988).

R. J. Tarrant, "Senecan Drama and Its Antecedents," in *Harvard Studies in Classical Philology* (1978): 213–263.

SOPHOCLES

c. 496 B.C.E.–c. 405 B.C.E.

Tragic playwright

ROLE IN GOVERNMENT AND RELIGION. In his play *Oedipus at Colonus*, Athens' most prize-winning tragic playwright paid tribute to his native village Colonus, just outside of Athens, where he was born sometime around 496 B.C.E. He was the son of Sophilus and had connections to the most important political figures of his day, from Cimon until his ostracism in 461 B.C.E. and Pericles afterward. Sophocles served as a treasurer of Athens and as a *strategos* or general, one of the highest elected offices in the state, though his contemporary Ion of Chios reported that he had no particular talent at politics. He was also called upon to serve as a state adviser after the catastrophic Athenian defeat at Syracuse in 413 B.C.E. Ancient sources report that he was a cult priest and worshipper of Asclepius, the son of Apollo and healer, and after his death he was honored with his own hero cult under the name "Dexion."

WORKS. His career as a tragic poet was long and impressive. He is credited with three important theatrical innovations: the addition of a third actor, painting of the *skene*, and the increase of the chorus from twelve men to fifteen. He is said to have written over 120 plays, with twenty first-place prizes and no last-place showings in any dramatic competition. He competed for the first time in 468 B.C.E., perhaps against Aeschylus, and won. His last competition was in 406 B.C.E., when he dressed his chorus in mourning for the death of Euripides during the introduction to his trilogy at that year's celebration of the Dionysia. Of his many titles, only seven plays remain, and the dates for most are uncertain. His most famous plays and their probable dates are: *Antigone* (c. 441 B.C.E.);

Oedipus the King (between c. 436–426 B.C.E.); and *Oedipus at Colonus* (won first prize posthumously in 401 B.C.E.). He is renowned for his three Theban plays about the fortunes of Oedipus and Thebes, but those dramas were not written together in one single trilogy; rather, they were produced in trilogies over the course of forty years.

THEMES. Sophoclean heroes can be characterized by an arrogant inflexibility that must be broken before the truth—another vital element to Sophoclean drama—can be found. The characters in Sophocles' plays are also haunted by their responsibilities to the dead: the character Oedipus must uncover the murderer of the former king of Thebes; Antigone must bury her dead brother against the edict of her uncle; Ajax is tortured by his failure to possess the dead Achilles' weapons. Part of Sophocles' particular dramatic flair revolved around his use of a talismanic item or action: the solving of the Sphinx' riddle, the bow of Philoctetes, Deineira's magic potion. Sophocles is also renowned for his use of the theme of dramatic recognition, his characters' exquisitely well-timed entrances and exits, and the naturalistic language he intersperses with high-flown and abstract poetic flourishes. Some of the greatest actors of later periods, such as Polus and Theodorus, often appeared in Sophocles' plays, which were regularly revived. Sophocles died at about age ninety around 405 B.C.E., the same year his younger contemporary Euripides died.

SOURCES

P. E. Easterling, ed., *The Cambridge Companion to Greek Tragedy* (Cambridge and New York: Cambridge University Press, 1997).

Helene Foley, *Female Acts in Greek Tragedy* (Princeton, N.J.: Princeton University Press, 2001).

M. C. Howatson, ed., *The Oxford Companion to Classical Literature* (Oxford and New York: Oxford University Press, 1989).

Alan H. Somerstein, *Greek Drama and Dramatists* (London and New York: Routledge, 2002).

TERENCE

c. 193 B.C.E.–c. 159 B.C.E.

Comic playwright

HELLENIST AND HUMANIST. The Roman biographer and historian Suetonius in the first century C.E. wrote the life of Terence, and some of that biography was preserved by Aelius Donatus, a medieval commentator on the playwright's work. Even so, as with all ancient biography, it is impossible to determine the

authenticity of all the details. He was born in Carthage around 193 B.C.E., which accounts for his *cognomen* (last name) "Afer," meaning "African." He may have come to Rome as the slave of one Terentius Lucanus, from whom he took his family name, Terence. Despite his humble and unpromising entrée into Rome, he became closely associated with the house of Scipio, one of Rome's premier families. Some contemporaries suggested that Scipio Aemilianus or Gaius Laelius, two members of that elite circle, composed Terence's plays themselves. The playwright refutes these and other allegations in the prologues to his six plays. At any rate, the Scipionic circle held wide influence culturally; they were philhellenes, or lovers of all things Greek, and with their Greek conquests they brought also a renewed passion for Greek art, drama, and culture. This trend is illustrated by Terence's corpus. Like fellow playwright Plautus, Terence used the plots and titles of Greek New Comedies for his comedic drama, relying on Menander for four of his six plays. He followed his precursors more closely than Plautus did, but his talents were distinctly different from his forerunner in Roman comedy. All six of his plays survive and include: *Mother-in-Law*, *Eunuch*, and *Brothers*. This last play was commissioned for the funeral of Lucius Aemilius Paulus, the father of Scipio Aemilianus, in 160 B.C.E. While Plautus aimed and succeeded at entertaining the Roman masses in vast numbers, Terence's more tightly constructed and less riotous plays seem to be geared toward a more sophisticated group of theatergoers, people who recognized the constraints of the genre and sought something beyond its boundaries. Terence adhered strictly to the generic conventions, but used them to express a new interest in humanism and the personal. A famous line from *Self-Torturer* states that "I am human, and I don't think anything human is foreign to me." Terence also celebrated the artistic achievement of Greece and followed his models more closely in order to showcase his predecessors' talents. Using primarily Menander as a model, he wrote plays in refined Latin on the Menandrian themes of the importance of friendship, the resolution of family conflicts that reflected social issues, and the making of good citizens. He also offered some important innovations to the structure of theater: Terence used a double-plot structure and strove for on-stage realism, more suspense and less irony, and the universal quality of gentle humor found in Greek New Comedy. In one of his most exciting plays, *Eunuch*, a young man who lusts for an innocent young woman (the slave of a prostitute) poses as a eunuch to gain access to her chamber, while in another plot, a soldier is in love with this same prostitute and competes with another client for her attention. In the end, the slave-girl

is found to be the daughter of a citizen and so can be legally married to her rapist, which passed as a happy ending in New Comedy. Terence's humanism was not necessarily popular with the public, however, as the playwright himself relays in prologues that make no attempt to be integrated into the plays themselves. At the first performance of *Mother-in-Law* in 165 B.C.E., Terence's audience was distracted by an acrobatic display; at a second performance in 160 B.C.E., they left in droves to watch gladiators fighting. At a third production later that same year, his audience, or most of it, finally stayed until the end of the play. Terence died at a very young age, either 24 or 34, while on a voyage to Greece. Dying while journeying to the cultural center of the world was especially poetic—the same story is also told of Vergil's death in 19 B.C.E.

SOURCES

Richard C. Beacham, *The Roman Theater and Its Audience* (London: Routledge, 1991).

Gian Conte, *Latin Literature: A History* (Baltimore and London: The Johns Hopkins University Press, 1994).

George E. Duckworth, *The Nature of Roman Comedy: A Study in Popular Entertainment* (Princeton, N.J.: Princeton University Press, 1952).

E. J. Kenney, ed., *The Cambridge History of Classical Literature II: Latin Literature* (Cambridge: Cambridge University Press, 1982).

DOCUMENTARY SOURCES
in Theater

Aeschylus, *Oresteia* (458 B.C.E.), and other tragedies—This trilogy is the only surviving trilogy from the fifth century B.C.E.

Aristophanes, *Acharnians* (c. 425 B.C.E.)—Aristophanes' first play introduced the comedic genius of the young playwright. The plot of this Old Comedy revolves around a simple man who defies the Athenian government and makes a separate peace with the Spartans during the Peloponnesian War.

Aristotle, *Poetics* (c. 340 B.C.E.)—Aristotle's treatise is the first to treat poetic composition of all kinds as art, making Aristotle the first literary critic and theorist.

Cicero (Marcus Tullius), *In Defense of Roscius the Comic Actor* (c. 69 B.C.E.)—In this speech, Cicero defends the comic actor Roscius against a charge of fraud and in

the process reveals important information about the profession of acting in the first century B.C.E.

Euripides, *Medea* (431 B.C.E.)—One of the more famous of Euripides' plays, *Medea* highlights the playwright's penchant for depicting society's victims—women, outcasts, the abused—and his ability to explore the interiority of characters in a new way. In this play, Medea—a foreigner, outsider, woman, and witch—is allowed to wreak vengeance on her callous Greek husband Jason, and is rescued in the end by a *deus ex machina*.

Homer, *Iliad* and *Odyssey* (c. 750 B.C.E.)—Homer's epics were the source of Greek dramatic form and much of its subject matter.

Livy (Titus Livius), *From the Foundations of the City* (c. 25 B.C.E.)—This complete history of Rome (not surviving in its entirety) from its founding in the eighth century to 9 B.C.E. in 142 books includes many anecdotes about Roman theater from its beginning until the beginning of the empire.

Ovid (Publius Naso), *Metamorphoses* (c. 5 C.E.)—This extremely creative and playful Roman "anti-epic" focuses on the many transformations that take place in Greek mythology, and is one of the most valuable sources of ancient myth.

Plautus (Titus Maccius), *Pseudolus* (c. 191 B.C.E.)—The comedies of Rome's most popular playwright gleefully borrow plots and settings from Greek New Comedy but turn the material into brilliant and purely Roman plays. Plautus' *Pseudolus* is representative in many ways of his values; the eponymous clever slave outwits his master and assists his young master's quest for love, with no thought of his own gain.

Seneca (Lucius Annaeus) The Younger, *Thyestes* (c. 60 C.E.)—Seneca's work, heavily indebted to the Athenian tragic playwrights, are the only extant attempts from Rome to create new tragedies since the days of Naevius, Accius and Pacuvius in the third and second centuries B.C.E. In *Thyestes*, Seneca displays all of his prodigious rhetorical talent as well as his fondness for the grotesque, as Atreus, the title character's brother, serves up a stew made from Thyestes' own children as revenge for his brother's adultery with his wife.

Sophocles, *Oedipus the King* (c. 430 B.C.E.)—Sophocles is most famous for three of his plays about the Oedipus story, and his extant tragedies feature strong but stubborn heroes whose greatest qualities often ironically bring about their downfalls. Sophocles' most famous tragic hero, Oedipus, tries desperately to outwit Fate and avoid killing his father and marrying his own mother, while ironically moving inexorably toward the fulfillment of the oracle that prophesied his downfall. This play is often considered one of the most perfect examples of a Greek tragedy, in its characterizations, structure, language, and ultimate moral lesson.

Terence (Publius Afer), *Eunuch* (c. 160 B.C.E.)—This sophisticated playwright's comedies paid tribute to the artistry of Greek New Comedy during a time when a conservative movement fought to eradicate Hellenistic influences from Rome culture. In this play, he uses his trademark double-plot structure to demonstrate how a personal catastrophe, like rape, can in the end be resolved and can even lead to civic justice and order.

Vitruvius, *On Architecture* (first century B.C.E.)—The only architectural work to survive from ancient Rome, it provides modern readers with valuable information about Roman engineering, building practices, and theater design.

VISUAL ARTS

James Allan Evans

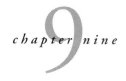

IMPORTANT EVENTS
in Visual Arts

c. 3000 B.C.E.–c. 2000 B.C.E. Early Cycladic art develops in the Cyclades archipelago, the islands that circle Delos and neighboring islands, excluding Crete.

c. 3000 B.C.E.–c. 1950 B.C.E. Pottery is handmade during the Prepalatial period on Crete, before the development of the Minoan civilization.

2600 B.C.E.–2400 B.C.E. Fine handmade vases with mottled decoration, called "Vasiliki-Ware" from the place of their discovery, appear on Crete. They appear to imitate vessels made from stone found in Egypt.

2500 B.C.E.–2200 B.C.E. On the Cyclades Islands, this period known as Early Cycladic II is the heyday of Cycladic sculptors, who produce magnificent abstract figures. Most of them are schematic representations of women, but there are also abstractions of seated harpists, standing pipers playing pipes, and warriors.

c. 2000 B.C.E. The period known as "Middle Helladic" begins in mainland Greece, corresponding to the Middle Minoan Period on Crete. Wheel-made pottery appears, though on the mainland it does not yet become widespread.

c. 1950 B.C.E. A new type of pottery, grey "Minyan Ware," appears on mainland Greece. Minyan Ware has a burnished surface and is decorated with geometric designs either incised on the surface before the pot is fired, or applied in a flat dark color on a pale slip.

1950 B.C.E. During the Proto-Palatial or Old Palace

–1700 B.C.E. period in Minoan Crete, pottery is made using the potter's wheel.

c. 1650 B.C.E. Minoan artists are at work in Avaris (modern Tell el Dab'a), the capital of the Hyksos kings in Egypt, producing frescoes in a palace which predates the eruption of the Thira volcano.

1628 B.C.E. The volcano on Thira, the southernmost of the Cyclades Islands, erupts. Volcanic ash buries the Minoan settlement at Akrotiri, preserving wall paintings that will be discovered almost intact in modern times.

c. 1600 B.C.E. Towards the end of the Middle Helladic period on the mainland, gray Minyan ware is superseded by pottery with polychrome geometric designs, owing their inspiration to Crete and perhaps the Cyclades Islands.

1550 B.C.E.–1500 B.C.E. A new style of pottery emerges on Crete, with patterns favoring spirals and depictions of plants.

1500 B.C.E. The "Marine Style" of pottery appears on Crete, with designs of fish, octopods, and argonauts. This is the last Minoan style before the catastrophe of 1450 B.C.E.

1450 B.C.E.–1350 B.C.E. During the Post-Palatial period, there appears a style of pottery known as "Palace Style" which lacks the spontaneity of the earlier "Marine Style."

1400 B.C.E.–1200 B.C.E. In this period, designated "Late Helladic IIIA and B," Mycenaean pottery is exported far and wide over the Mediterranean area to Sicily, Italy, Egypt, and Asia Minor.

c. 1200 B.C.E.–1100 B.C.E. In the Late Helladic IIIC period after the collapse of the Mycenaean palaces, the so-called "Granary Style" pottery appears, decorated with a few wavy lines and festoons on the belly and neck of the vase. This style will develop into the Protogeometric style.

c. 1050 B.C.E. Early Geometric (Protogeometric) vases appear—vases painted with geometric

designs such as circles, spirals, and concentric rings.

c. 900 B.C.E. –c. 700 B.C.E. In the fully-developed Geometric period, geometric designs spread over the vases that the potters produce and a new repertory of patterns appears.

700 B.C.E. –600 B.C.E. The influence of Asian art is at its height, so much so that art historians have dubbed this the "Orientalizing Period."

Monumental architecture and sculpture revives.

700 B.C.E. Athenian potters have by now adopted the black-figure technique showing figures in silhouette, which had already been practiced in Corinth for a century.

c. 675 B.C.E. –c. 650 B.C.E. The earliest Greek style of sculpture, the so-called Daedalic style, appears.

The Nikandre statue, an over life-sized statue of a woman in Daedalic style, is dedicated to Artemis at Delos by Nikandre of Naxos about this time.

c. 650 B.C.E. –c. 550 B.C.E. Corinthian pottery dominates the export market in Italy and Sicily.

c. 650 B.C.E. The first Daedalic-style *kouros* statues appear. The style depicts nude male figures standing stiffly with one foot thrust forward like contemporary Egyptian statues.

620 B.C.E. –580 B.C.E. The so-called Sunium *kouros* is carved for the temple of Poseidon at Sunium. The ten-foot tall statue is the best-preserved of several over life-sized *kouroi* found there.

c. 550 B.C.E. Athenian pottery begins to dominate the export market in Sicily and Italy, displacing Corinthian pottery.

c. 530 B.C.E. Athenian potters begin to produce vases in red-figure style.

c. 480 B.C.E. –445 B.C.E. The Greek sculptor Myron produces his masterpieces during these years.

478 B.C.E. To commemorate a victory in the chariot races in the Pythian Games of either this year or four years later in 474 by Polyzalus, tyrant of Gela in Sicily, the bronze charioteer now in the Delphi Museum was erected as part of a chariot group.

465 B.C.E. –456 B.C.E. The Athenian sculptor Phidias is working on his great bronze statue of Athena Polias, later known as Athena Promachos, which stood over nine meters (30 feet) on the Acropolis of Athens.

c. 452 B.C.E. The earliest work of the sculptor Polyclitus of Argos dates to this time.

447 B.C.E. –438 B.C.E. Phidias is working on his statue of Athena made of gold and ivory which stands 12.7 meters (41.67 feet) high in the Parthenon on the Athenian Acropolis.

c. 437 B.C.E. Phidias goes to Olympia to work on the gold-and-ivory cult statue of Zeus for the Temple of Zeus.

405 B.C.E. The Spartans defeat the Athenians at Aegospotami in northern Greece, destroying the Athenian fleet. The Spartan memorial that Polyclitus of Argos designed for this victory is the last known work of Polyclitus.

372 B.C.E. The sculptor Lysippus of Sicyon makes his first statue that can be dated for a victor in the Olympic Games of this year.

c. 364 B.C.E. Praxiteles sculpts the first female nude, the *Aphrodite of Cnidus.*

323 B.C.E. –c. 240 B.C.E. In the Early Hellenistic Period of Greek sculpture, sculptors continue with the traditions of late classical sculpture as exemplified by Lysippus and Praxiteles.

280 B.C.E. A bronze portrait statue of Demosthenes by Polyeuctus, which is erected in the marketplace of Athens a generation after the orator's death, portrays him realistically, without any attempt at idealism.

272 B.C.E. The Romans capture Taras, Roman Tarentum on the south coast of Italy, and take some of its art as plunder, thus introducing Romans to Greek masterpieces.

240 B.C.E. –c. 150 B.C.E. In the "High Hellenistic Period," a "Baroque" style of sculpture is developed which is full of violent motion and physical energy.

211 B.C.E. The Roman general Marcellus, having captured Syracuse in Sicily the previous year, takes Greek works of art to Rome as spoils, thereby starting a craze for Greek sculpture and painting in Rome.

c. 190 B.C.E. The *Nike* of Samothrace, a sculpture now in the Louvre in Paris, showing a Winged Victory alighting on the prow of a warship, is erected at Samothrace, an island in the northern Aegean Sea.

c. 175 B.C.E. The Great Altar of Zeus, the most famous ensemble of High Hellenistic "Baroque," is erected in Pergamum, modern Bergama in Turkey.

168 B.C.E. Aemilius Paullus, having defeated the last king of Macedon, Perseus, takes a huge number of statues and paintings to display at his triumph in Rome.

c. 150 B.C.E. –31 B.C.E. In the Late Hellenistic Period sculptors return to the styles of the classical period.

150 B.C.E. –125 B.C.E. The sculptor Alexandros of Antioch-on-the-Meander River sculpts the *Venus di Milo*, a statue of Aphrodite holding the apple which Paris had awarded her as a beauty prize, which according to myth was the cause of the Trojan War.

146 B.C.E. Lucius Mummius sacks Corinth and ships cartloads of major and minor arts to Rome.

133 B.C.E. The last king of Pergamum, Attalus III, dies, and leaves his kingdom to Rome in his will. Pergamum ceases to be a Greek artistic center but Pergamene traditions continue on Rhodes.

9 B.C.E. The Altar of Peace is dedicated in Rome.

64 C.E. A great fire in Rome ruins half the city, and the emperor Nero seizes the opportunity to build his extravagant "Golden House" in the center of the city that was cleared of buildings by the fire.

79 C.E. The eruption of the volcano of Mt. Vesuvius overwhelms Pompeii, Herculaneum, Stabiae, and Oplontis, thus preserving houses and public buildings along with wall paintings and statuary.

81 C.E. The emperor Titus dies and after his death, the Arch of Titus is erected in Rome by his successor, Domitian, to commemorate the victories of Vespasian and Titus in the Judaean War which ended with the sack of Jerusalem.

113 C.E. The Column of Trajan in Rome, carved in less than four years by an unknown master sculptor and his workshop, is dedicated in Rome to commemorate the emperor Trajan's conquest of Dacia (modern Rumania).

129 C.E. Antinous, a youth who was a favorite of the emperor Hadrian, is drowned in the Nile River, and Hadrian expresses his grief by deifying Antinous and erecting statues of him which represent a last flowering of the classical male nude as an artistic type.

180 C.E. –196 C.E. The Column of Marcus Aurelius is built in Rome with marble from quarries at Luni to commemorate his campaigns of 168–176 C.E.

203 C.E. The Arch of Septimius Severus is erected in the Roman Forum, spanning the "Sacred Way" at the foot of the Capitoline Hill. The arch commemorates the victories of Severus and his sons Caracalla and Geta over the Parthians (195 C.E.) and the Osroeni (197 C.E.).

305 C.E. The Arch of Galerius is erected in Salonika in northern Greece to celebrate

the victory of Galerius over the Persians. Reliefs show scenes of the campaign: one shows Diocletian, Augustus of the East, and Galerius, his Caesar, offering sacrifice, and another shows the surrender of an eastern town.

315 C.E. The Arch of Constantine is erected in Rome to commemorate his victory over Maxentius at the Milvian Bridge in 311 C.E. It is decorated with sculptural fragments from earlier monuments.

330 C.E. The emperor Constantine dedicates his "New Rome," Constantinople, which is to be the capital of a Christian empire. Large numbers of works of art are taken from Greece to adorn the new capital, including Phidias' "Athena Promachos" and his "Zeus" from the Temple of Zeus at Olympia.

c. 390 C.E. The emperor Theodosius I erects an Egyptian obelisk originally from the temple of Amon at Karnak in the Hippodrome at Constantinople, and has a base made for it decorated with reliefs, one of which shows Theodosius surrounded by his court. Figures are all frontal and of equal height, except for the taller figure of the emperor in the center.

c. 425 C.E. The so-called Mausoleum of Galla Placidia is built at Ravenna in Italy, and its interior is decorated with a rich group of early Christian mosaics, including one showing Christ as the Good Shepherd in the lunette above the entrance, still done in the three-dimensional, naturalistic style of the classical tradition.

504 C.E. The Church of Sant' Apollinare Nuovo is dedicated in Ravenna, with mosaics that move away from the naturalistic style of the classical tradition and use gold as the background color.

OVERVIEW
of Visual Arts

PERIODS OF DEVELOPMENT. The history of ancient Greek art falls neatly into five periods. It begins in the prehistoric Bronze Age, when a civilization flourished on the island of Crete in the second millennium B.C.E., which has the modern label "Minoan." Its artistic traditions were carried on in mainland Greece via the Mycenaean civilization. This civilization flourished until 1200 B.C.E., when it fell victim to raiders and new migrants into Greece, thereby entering a "Dark Age" (1150–700 B.C.E.). Archaeology is gradually making this period less dark, however, for the ceramics of this age continue to shed light on the development of artistic tradition. By the ninth century B.C.E. a new period of Greek art emerged known as "Geometric" after the geometric designs such as triangles, circles, and spirals that decorate the pottery. "Geometric" developed by natural stages into the Early Archaic Period (700–550 B.C.E.), when the first sculptured human figures appear. The Late Archaic Period (550–480 B.C.E.) is the great age of Athenian vase-painting, when pottery from Athenian workshops found buyers all over the Mediterranean world. Then, in the classical period (480–330 B.C.E.) Athens set the standard for the visual arts of Greece. Alexander the Great's conquest of the Persian Empire ushered in the next period, the Hellenistic Age (330–30 B.C.E.), which takes its name from the Greek word *hellenizein*, meaning "to adopt Greek culture and language." It was an era in the ancient world when Greek culture spread over the eastern Mediterranean region, submerging other, more ancient cultures in Egypt and the Near East. The centers of culture moved from Greece itself to new cities such as Alexandria in Egypt and Antioch in Syria and many others scattered throughout Asia Minor and the Near East. Egypt, the last Hellenistic kingdom, fell to Rome in 30 B.C.E. and what followed was the period of Roman imperial art, though in the eastern Mediterranean the traditions of the Hellenistic Age lived on until late antiquity (284–632 C.E.).

THE MINOAN AND MYCENAEAN WORLD. The art of the Minoans is known solely through archaeological finds, beginning with the excavation of the so-called "Palace of Minos" at Knossos in Crete by British archaeologists in 1900 C.E. The finds at Knossos were rapidly supplemented by finds made by Italian excavators at Phaistos in the south-central region of the island, and by the French at Mallia close to the north coast. At all these sites, sprawling palaces were discovered, built around central courtyards, and the rooms decorated with frescoes provided a glimpse of Minoan artistic tradition. These palaces began to be built about 2000–1900 B.C.E.; they were destroyed by some disaster, probably a great earthquake, about 1700 B.C.E. and then overtaken by another disaster about 1450 B.C.E., after which only the palace at Knossos was reinhabited. The best-preserved examples of Minoan wall painting were discovered at Akrotiri on the volcanic island of Thira, where an eruption in 1628 B.C.E. buried the outpost. On mainland Greece, a prehistoric civilization also flourished, called Mycenaean after the earliest site excavated, Mycenae, where a sprawling, poorly preserved palace was discovered. The Mycenaeans carried on the traditions of Minoan art despite differences of culture in other areas, such as language.

THE GEOMETRIC AGE. The Mycenaean civilization began to decline around 1200 B.C.E. when raiders began to invade the area. Over the course of the next century, they overran the rule of the Mycenaean kings and destroyed the palaces. By 1000 B.C.E., some stability had returned to the Greek world, and in the city-states which took the place of the old Mycenaean palace-based monarchies a new type of art emerged that art historians label "geometric." Athens provides the best evidence for the development of geometric art, for in the Kerameikos cemetery there, in the potters' quarter of the ancient city, a continuous series of burials have been excavated, from the end of the Mycenaean civilization down to the classical period. About 1000 B.C.E., vase painters in Athens ceased to imitate Mycenaean prototypes and turned to abstract patterns. They decorated the necks, shoulders, and bases of their vases with continuous bands and concentric circles. Athens seems to have taken the lead, but the new style spread rapidly throughout Greece and the islands. As the style developed from Early Geometric (Protogeometric) to mature Geometric, the early simplicity disappeared, and painters covered the whole surface of their vases with geometric forms: triangles, diamond-shaped figures, squares, checker-board patterns, and the so-called "Greek key" pattern, a continuous square-cornered meander. By the eighth century B.C.E., animal figures appear, to be fol-

lowed by human figures not much later. The vase paintings began to show scenes; the most common are scenes of funerals, for many of the greatest surviving vases were intended as monuments for the graves of wealthy men. They held food and drink offerings for the dead and some had holes pierced in the bottom so that drink offerings could flow down into the earth and feed the corpse buried beneath. Then about 700 B.C.E. artistic patterns borrowed from the East appeared: lions, panthers, sphinxes, and griffins. This "orientalizing style" began on Cyprus, and developed in the Greek cities of Asia Minor which came into contact with the art of the Assyrian Empire through the mediation of the Syrians, Phoenicians, and Lydians. The Greeks borrowed the Assyrian way of portraying the human body, as well as the Assyrian technique and style, but their themes were Greek, taken from Greek legends. In 668 B.C.E. Assyria conquered Egypt, but she failed to hold it. By 650 B.C.E., Egypt was in revolt, and Greek mercenaries were helping rebel leader Psammetichos. Greeks visited Egypt as soldiers and traders, and what they saw was a revelation. Egypt would teach Greece the potential of free-standing sculpture.

SCULPTURE. Sculptors began to experiment with free-standing human figures in the middle of the seventh century B.C.E. Males are nude, women fully clothed, and both face the onlooker like the Egyptian statues which served as the inspiration for the Greek craftsmen. But by the end of the Archaic Period, sculptors learned how to model the muscles of the body and to show figures that were no longer strictly frontal. The names of famous classical sculptors survived, including Myron, Phidias, and Polyclitus, but their masterpieces did not. Art historians are dependent on Roman copies of these works. Wealthy Romans were passionate collectors of Greek art, and in Greece an industry developed for manufacturing copies for the Roman market. Yet it is rare that a statue has survived with its original color, for statues were painted; in addition to coloring the eyes, lips, and hair, painters decorated the clothing of female statues with bright patterns. The white marble statues displayed in museums have drained Greek art of its color. Even so, marble sculpture has fared better than bronze statues of ancient Greece. Most of them were melted down in the Middle Ages for their metal. Underwater finds, however, have brought a number of bronze masterpieces to light; the best of them is a splendid, life-size figure of Zeus hurling a thunderbolt which is now in the National Museum of Greece in Athens.

GREEK PAINTING. The evidence for early Greek painting for the archaic and classical periods comes mostly from Greek vases. In the mid-sixth century B.C.E. Athenian potters developed a style known as "black-figure" because the figures were shown in black glaze, with details etched with a pointed instrument, while the background was left the natural burnt siena color of the Athenian clay. Some artists signed their vases with their names, but many are anonymous. "Black-figure" gave way in the last quarter of the sixth century B.C.E. to "red-figure," where the background is in black glaze and the figures are the natural color of the clay. These vases provide only a tantalizing glimpse of the painters' art in Greece. Ancient authors wrote descriptions of lost paintings and the names of the great fifth-century B.C.E. painters such as Polygnotus, considered the first great painter; or Zeuxis, famous for his realism; or Apelles in the next century who was the favorite painter of Alexander the Great. Macedonian tombs, which are underground chambers with walls decorated with murals, give some idea of what painting was like in the fourth and third centuries B.C.E.; since the great painter Apelles of Epehesus was active in Macedon in his early years, the murals may reflect his influence. In the Roman period, the cities destroyed by the eruption of Mt. Vesuvius in 79 C.E.—Pompeii, Herculaneum, Oplontis, and Stabiae—had wall-paintings and mosaics, some of which probably tried to reproduce the great masterpieces. One house in Pompeii, the House of the Dancing Faun, has a splendid mosaic showing Alexander the Great defeating King Darius III of Persia at the Battle of Issus in 333 B.C.E. It reproduces some ancient masterpiece, and there have been attempts to conjecture who the artist was—perhaps Philoxenus of Eretria, or a woman artist, Helena from Egypt, both of whom painted a "Battle of Issus." The Christian churches of the fifth and sixth centuries C.E. also preserve mosaics which continue the traditions of ancient painting.

THE HELLENISTIC AGE. New centers of Greek art appeared in the period after Alexander the Great unified Greece and conquered the Persians and Egyptians. Greece itself, particularly Athens, remained a center of art in the expanded Hellenistic world, although other centers developed. In the early Hellenistic period, sculptors carried on the artistic traditions of the fourth century B.C.E. Following the example of Praxiteles, they portrayed female nudes in seductive poses, and following Lysippus' example, they showed male nudes as active figures. Then, from the mid-third century B.C.E., the Hellenistic Age developed a taste for the baroque. One notable center for the baroque style was Pergamum (modern Bergama in north-west Turkey), where the Great Altar of Zeus, erected about 175 B.C.E., was

adorned with a frieze showing the familiar subject of the Battle of Gods and Giants, where the combatants are in violent motion, with muscles taut and straining. Draperies swirl, figures writhe in anguish. As the eastern Mediterranean slipped under Roman domination, Hellenistic taste returned to its classical roots, though the baroque school continued to flourish at Rhodes which produced a masterpiece dating to the early first century C.E.: a statue group showing the Trojan priest Laocoon and his sons struggling with the two serpents that came out of the sea and attacked them when Laocoon urged his countrymen not to bring the Trojan Horse within the walls of Troy. The statue group illustrates an incident in Rome's national epic, the *Aeneid*, which describes the death of Laocoon in vivid detail.

ROMAN IMPERIAL ART. The Roman Empire preferred to take its models from the classical period, not the Hellenistic world. Roman emperors, for instance, were shown with the muscular, well-developed bodies of the male nudes sculpted by Polyclitus, who was famous for his athletes who were more powerfully built than the nudes of the Athenian sculptor Myron in the fifth century B.C.E. or Praxiteles in the following century. The emperors wear Roman armor with breastplates that emphasize the musculature of their chests, but beneath their armor, we see the proportions prescribed by Polyclitus. Roman portraits are a distinctive breed. Greece had produced portraits since the fifth century B.C.E. and sought to combine realism with idealism. The Roman taste for portraits was simply realistic, often brutally so. That is particularly true of those portraits that date to the republican period, before 30 B.C.E. In the first and second centuries C.E. Roman artists looked to classical Greece for inspiration and portraits show a tendency to idealize, though the individuality of the subject is always all-important. Imperial portraits in the late third century C.E. are again brutally realistic, but as we edge into the fourth century the spirit of imperial portraiture changes. The emperors are shown as men of power, not of this world. The robes of imperial office, which are rich and ornate, bear the same message. Art of this time period reflect the end of an era, when the pagan world and its culture were dying.

EARLY CHRISTIAN ART. The earliest Christian art is found in the catacombs which were great subterranean passage-ways with cubbyholes (*loculi*) placed one above another like shelves for the bodies of the dead. The catacombs in Rome are estimated to run from sixty to ninety miles and they date from the second to the fourth centuries C.E. The paintings found there are rough work which use the designs and techniques of contemporary

pagan work: what is different is the choice of subject. The Christian artists liked subjects from the Jewish scriptures: Jonah and the whale, Adam and Eve, the Sacrifice of Isaac, and Daniel in the lions' den, for instance. When Jesus appears, he is shown either as a youthful teacher or as the Good Shepherd tending his flock and even carrying a lamb. Only after the Roman Empire became Christian in the fourth century C.E. are there depictions of Jesus with a halo, wearing a purple robe. The picture of Christ as a mature, bearded man, which eventually displaced the picture of the youthful Christ, was developed only in the fifth century C.E. Christian subjects also appear on Christian sarcophagi, many of which have survived, for the Christians rejected cremation of the dead; pagans likewise favored burial over cremation in the third century C.E. Sarcophagi had common themes—standard scenes from the life of Christ—for the marble cutters turned them out with the sculptural decoration roughed out, and only after the sarcophagus was purchased would they finish them to the specifications of their customers. One scene from the life of Christ which did not occur in early Christian art, however, was the Crucifixion. It was unknown in Christian art before the fifth century C.E. and remained fairly rare for some time afterwards. The Resurrection, that is Christ's victory over death, engaged the imaginations of the first Christian artists rather than His death itself.

TOPICS
in Visual Arts

POTTERY IN THE BRONZE AGE

EARLY DEVELOPMENTS. Pottery first appeared in the Greek peninsula about 6000 B.C.E., introduced, perhaps, by immigrants from the Near East where pottery was made as early as 8000 B.C.E. The first pots were coarse, gray, handmade ware with simple decorations made by scratching linear designs on them, but in the mid-Neolithic period (5000–4000 B.C.E.) there is evidence of potters in southern Greece using slips, or washes of specially-prepared clay painted on the pot before firing in order to produce a lustrous finish. Pottery was still made by hand, as it would continue to be during both the Early Helladic Period (3000–2000 B.C.E.) on mainland Greece, and the Early Minoan Period which corresponds to it on Crete. Yet on Crete, a change took place once the island entered the Early Minoan Period. The quality of pottery on Crete improved. One type of pot-

tery found on Crete during the Early Minoan period hints at connections with Egypt; the "Vasiliki-ware," so-called from the site of Vasilike on Crete where it was first discovered, apparently imitated vessels made from fine veined stone of the sort found in Egypt. Vasiliki-ware is decorated with patches of paint which is then fired to different shades of red, yellow, and dark brown, producing a mottled effect. Typical shapes are the goblet and a jug with a long spout. By the end of the Early Minoan period (2000 B.C.E.), however, this mottled decoration found on Vasiliki-ware had been abandoned. Contemporary ware on the mainland at the end of Early Helladic is typically plain and dark in color, though pots with patterns have also been found that feature interlocking triangles, winding lines, and chevron. The potter's wheel also made its appearance on mainland Greece before the end of the Early Helladic Period, though it was not much used there until after 1600 B.C.E. By 2000 B.C.E., when the Middle Minoan period began on Crete and Middle Helladic on the mainland, Crete and mainland Greece apparently went their separate ways.

THE PROTOPALATIAL PERIOD ON CRETE. The early years of Middle Helladic on the mainland Greece were marked by a new migration into the Greek peninsula, and it is generally agreed that these new immigrants spoke Greek, and were thus the first wave of Greek-speakers to reach Greece. They brought with them a type of ware which archaeologists call "Minyan Ware," either gray or beige in color and without decoration. For the next three centuries or more, mainland Greece became a backwater. On Crete, however, the Middle Minoan period ushered in a brilliant age, the Protopalatial or Old Palace Period, when great sprawling palaces were built at a number of sites, chief of them Knossos just south of Iraklion, the capital of modern Crete; Phaestos, due south of Knossos; and Mallia on the northern coast of the island. The potter's wheel was generally used. Potters in the Old Palace Period threw their clay on the horizontal surface of a disk and molded it with their hands as the disk spun around, turned by the potter's helper. The result was a more symmetrical pot of a finer texture and the best of these can stand comparison with the best oriental porcelain.

KAMARES WARE. The most distinctive pottery of the period is "Kamares Ware" which took its name from a cave sanctuary on the slopes of Mt. Ida near the village of Kamares where the first examples of the style were found in the 1890s. Kamares Ware is egg-shell thin and polychrome, that is, it is decorated with designs in several colors: creamy white and reddish-brown against a black background is the favorite color combination. One

example, from the palace at Phaistos in south-central Crete, shows a large fish and what appears to be a fish-net on the belly of the vase, and beneath it are spirals, concentric circles and wavy lines, perhaps representing the sea. The development of Kamares Ware was interrupted by a catastrophe about 1700 B.C.E. in which the palaces of the Old Palace Period were destroyed. When the palaces were rebuilt, the Kamares-type vases continued to be made, though they lacked the vivacity of the earlier examples.

VASE-PAINTING IN THE NEOPALATIAL PERIOD. By 1600 B.C.E. vase-painters began to experiment with designs in dark paint on light backgrounds, the opposite of the Kamares-style where the background was dark. Vase-painters moved towards a new style, with themes taken from nature; a number of vases show illustrations of papyrus plants which the Minoans must have seen in Egypt, for no papyrus grows on Crete. Then, by 1500 B.C.E. the last Minoan pottery style before the great catastrophe of 1450 B.C.E. evolved: the so-called "Marine Style." In this style, vases were decorated with life-like paintings of sea-creatures: fish, octopods, and the mollusk with octopus-like tentacles known as "argonauts." There is nothing stiff or ornate about the Marine Style. Fish, dolphins, and cephalopods were depicted as they appear in real life, and the style betrays familiarity with marine life. Then about 1450 B.C.E. catastrophe overwhelmed all the palaces and only the Knossos palace was rebuilt and reinhabited, apparently by Mycenaean Greeks, for their language is Greek. At Knossos in this period, the last pottery style of Bronze-Age Crete emerged: the so-called "Palace Style," associated with the palace at Knossos. The cheerful spontaneity of the Marine Style disappeared, and was replaced by a style that aimed at grandeur. Formalism replaced naturalism. The taste is Mycenaean, for at Mycenae on the mainland natural motifs were stylized into symmetrical and often heraldic patterns.

MYCENAEAN VASES. By the late 1400s B.C.E., Greek-speakers from mainland Greece had probably invaded Crete, and more and more in the later centuries Minoan pottery and the Mycenaean ware from the mainland converged and became standardized. From a technical point of view, Mycenaean vases are often very fine work, with clean shapes and stylized decoration that re-uses motifs from Crete. For two centuries after 1400 B.C.E. Mycenaean pottery found markets all over the Mediterranean world. It has been found in Italy, Sicily, Asia Minor, and Egypt. However, with the end of the Mycenaean civilization around 1200 B.C.E., the world became an unsettled place, and the change is reflected

in the pottery. The last styles from the aftermath of the Mycenaean collapse—the period from 1200–1100 B.C.E. which archaeologists call Late Helladic IIIC—belong to the "Close Style" and the "Granary Style," both modern labels. The Close Style has decoration distributed in close rows of concentric half-circles, triangles, and the like over the body of the vase and sometimes there are motifs of fish and birds. One group that has been found has stylized octopods as decoration. Granary Style got its name because a cache of "Granary Style" vases were found at Mycenae in a store-room for grain inside the "Lion Gate" there, and they can be securely dated. Their decoration is simple: wavy lines and festoons on the belly and neck of the pot. "Granary Style" is recognizably sub-Mycenaean. It is the art of the dying Mycenaean civilization which still influenced potters, though the palaces where the god-kings used to rule had been destroyed and the well-to-do customers who used to buy Mycenaean pottery had vanished. Granary Style or "sub-Mycenaean" developed naturally into the Protogeometric style, whereas the Close Style did not survive the final phase of the Mycenaean world.

SOURCES

Philip P. Betancourt, *A History of Minoan Pottery* (Princeton, N.J.: Princeton University Press, 1985).

Oliver P. T. K. Dickinson, *The Aegean Bronze Age* (Cambridge: Cambridge University Press, 1994).

J. Lesley Fitton, *Minoans* (London, England: British Museum Press, 2002).

Roland Hampe and Erika Simon, *The Birth of Greek Art. From the Mycenaean to the Archaic Period* (Oxford, England: Oxford University Press, 1981).

Reynold A. Higgins, *Minoan and Mycenaean Art* (London, England: Thames and Hudson, 1981).

Sinclair Hood, *The Arts in Prehistoric Greece* (New Haven, Conn.: Yale University Press, 1978).

A. D. Lacy, *Greek Pottery in the Bronze Age* (London, England: Methuen, 1967).

Penelope Mountjoy, *Mycenaean Pottery: An Introduction* (Oxford, England: Oxford University Committee for Archaeology, 1993).

THE EARLY POTTERY OF GREECE

THE IMPORTANCE OF ATHENS. Athens was relatively unimportant in the Mycenaean period, but after the collapse of the Mycenaean world, it dominated the Geometric Period that followed. Sites from the century following 1200 B.C.E. show destruction by fire all over Greece and, for that matter, the Aegean world, but Athens

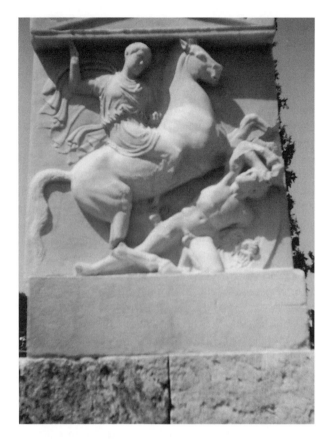

Funeral monument for Dexileos, a 20-year old Athenian cavalryman killed in action at Corinth in 394 B.C.E., from the Kerameikos Cemetery in Athens. **COURTESY OF JAMES ALLAN EVANS.**

survived. Athenian traditions told that Athens was attacked by the Dorians—a group of Greek people speaking the Dorian dialect—and in the struggle, the last king of Athens, Codrus, sacrificed his life to save the city. Athens and her territory, Attica, remained unconquered and offered a refuge for other dispossessed Greeks. The evidence of Athenian pottery during this period is particularly important, for not only is it the only evidence for the visual arts during the "Dark Ages" that followed Mycenae's collapse, but it contributes a major body of evidence about the period's history. In the *Kerameikos* cemetery—that is, the cemetery in the Potters' Quarter in Athens—there is an unbroken series of burials from the end of the Mycenaean age into the classical period, and the pottery found in these burials allows scholars to document pottery decoration from sub-Mycenaean to Geometric.

MOVEMENT FROM SUB-MYCENAEAN TO GEOMETRIC. The sub-Mycenaean pottery from the immediate aftermath of the catastrophe ending the Bronze-Age civilization is similar to the Granary Style found at Mycenae. It bears signs of culture shock, as the potters adjusted to the collapse of the civilization they once knew.

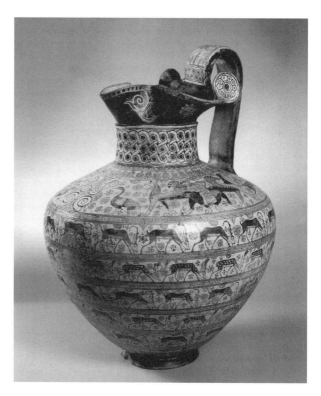

Rhodian oinochoe (wine jug), 7th-century B.C.E., belonging to the "Orientalizing Period." THE ART ARCHIVE/MUSEE DU LOUVRE PARIS/DAGLI ORTI.

Geometric amphora from Athens, c. 760 B.C.E., showing the "lying-in-state" of the dead. © WOLFGANG KAEHLER/CORBIS.

Simple Mycenaean patterns remembered from the past are repeated as if by rote. By about 1050 B.C.E., however, a new spirit emerged with a generation that never knew the Mycenaean world at first hand. The first stages of a new style of pottery appear which is labelled "Protogeometric" or "Early Geometric." Vases were made once again on the fast wheel and fired at higher temperatures. The feature that gave the style its name, "Protogeometric," is the type of decoration that the potters used on their ware: lines, circles, and, as time went on, intricate geometric patterns. Protogeometric artists employed a black background with light-ground stripes around the neck or the belly of the vase, or alternatively, a light background with geometric designs such as concentric circles, wavy lines, or checker-board patterns. The vase painters used compasses to draw concentric half-circles. The technique of producing the fine black gloss from the Bronze Age was not forgotten; it is used to cover more of the surface of the vase.

GEOMETRIC POTTERY. About 850 B.C.E., the pottery artists moved into the so-called Middle Geometric

Period with new and more complex geometric designs. Vases have bands of zigzags, triangle-patterns and meander designs that cover the whole surface of the vase. The patterns used by the Middle Geometric artist seem to owe their inspiration to basket weaving. During this period, the most dramatic change occurred with the introduction of figures, first of animals and then suddenly around 770 B.C.E., human figures. The spirit of these new vases is still geometric as the figures are still marshaled in orderly rows. But there is an effort to depict a scene. In one large vase made in Athens about 750 B.C.E., a central band across the belly of the vase shows a woman's corpse laid out on a bier, and on either side, rows of women with their hands clasped over their heads in a ritual gesture of mourning. The rest of the vase is completely filled with geometric patterns marshaled in concentric circles. This vase, which stands about one and a half meters (five feet) high, was a grave marker, placed on top of a woman's grave and partially buried. Another vase made in Athens about the same time shows a war galley with rows of oarsmen. A man is about to embark, and as he does, he turns and clasps a woman standing behind him by the wrist. The man is portrayed with a very slender waist and heavily-muscled thighs, and he grasps the woman's wrist as if he is trying to drag her

Arts and Humanities Through the Eras: Ancient Greece and Rome (1200 B.C.E.–476 C.E.)

395

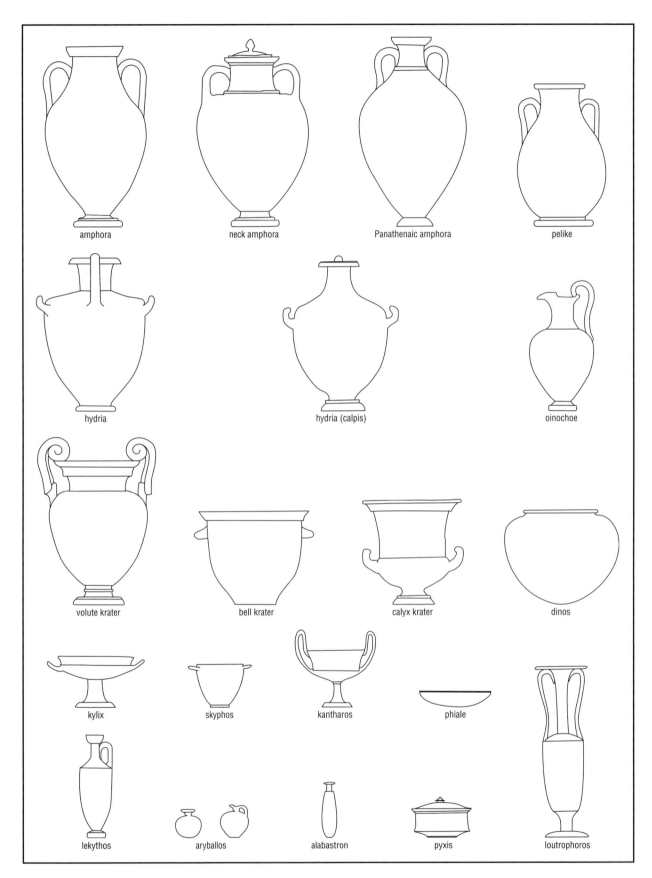

Various ancient vase shapes. CREATED BY GGS INFORMATION SERVICES. GALE.

with him into the ship. Clearly the vase is telling a story, perhaps from Greek mythology, as one of the first examples of narrative art.

CORINTHIAN POTTERY. Vases ornamented with geometric figures were popular among Athenian potters, but this was not the case everywhere in Greece. In Corinth, the potters preferred linear designs coupled with fine craftsmanship, using the local buff-colored clay that is still found there. A new style of vase painting appeared in the early seventh century B.C.E., at the same time as Corinth became a major exporter of pottery to Sicily and Italy: the Corinthian potters began to decorate their vases with figures and motifs that show Eastern influence. The images were more frequently done in outline rather than in silhouette as had been the case in Geometric, but the artists also started to experiment with a new technique they borrowed from metalworking; they made images in solid black paint and drew in details by graving the surface of the paint with a sharp stylus so that the buff clay beneath it became visible. By about 720 B.C.E., this technique developed into the Corinthian black-figure style, with images in solid black, and details engraved with incised lines. Parts of the figures were sometimes highlighted with purplish-red paint. The subjects that the vase paintings depicted were geared to the taste of the market. Battle scenes reflected a time of civil strife in many of the Greek city-states as the old aristocracies which had once dominated the government faced a changed political situation that they would no longer control. There were also many oriental motifs, such as friezes of animals such as wild boars, wild goats, dogs, lions, and griffins, marshaled in rows, that reflected the growing commerce with the Near East. The inspiration was Asian, particularly from Mesopotamia. The Corinthian potters aimed to please their markets, and Corinthian pottery in this period reached Syria, Asia Minor, and Egypt, where the Greeks had a trading center at Naucratis on the Nile Delta. In Sicily and southern Italy, Corinth was the major player in the pottery export market until the middle of the sixth century B.C.E., when products from Athens suddenly became popular. Yet the Corinthian potters did not retreat from the market in Italy and Sicily without a struggle. There is a remarkable *krater*, or mixing-bowl for wine—the Greeks drank their wine mixed with water—found at Cerveteri in Italy north of Rome, which was the old Etruscan city of Caere. It shows how the Corinthian potters tried to adapt their art to counter the new taste for Athenian pottery in the Etruscan market. A tinge of red ochre had been added to the buff Corinthian clay to make it look more like Athenian clay. There is a familiar frieze of animals, lions, and antelopes in black and dark purple. But on the belly of the vase, the artist attempted a polychrome effect: a married couple is shown setting out on a chariot, with attendants and well-wishers standing around. Men are done in black-figure and a white wash is used for the flesh of women—that is by now conventional—but the horses are also white, and the cloaks of both the men and the women are purple. This is an example of innovative vase painting, but it did not secure the Etruscan market for Corinth.

SOURCES

Ekrem Akurgal, *The Art of Greece: Its Origin in the Mediterranean and the Near East.* Trans. Wayne Dynes (New York: Crown Publishers, 1968).

Paolo Enrico Arias, *A History of One Thousand Years of Greek Vase-Painting* (New York: H. N. Abrams, 1962).

John Boardman, *Early Greek Vase-Painting: Eleventh to Sixth Centuries B.C.: A Handbook* (London, England: Thames and Hudson, 1998).

J. Nicholas Coldstream, *Geometric Greece* (New York: St. Martin's Press, 1977).

Vincent R. D. Desborough, *Protogeometric Pottery* (Oxford, England: Clarendon Press, 1952).

Jeffrey M. Hurwitt, *Art and Culture of Early Greece, 1100–480 B.C.* (Ithaca, N.Y.: Cornell University Press, 1965).

Dietrich Von Bothmer, *Greek Vase-Painting* (New York: Metropolitan Musem of Art, 1987).

Dyfri Williams, *Greek Vases* (London, England: British Museum Press, 1985).

THE DOMINANCE OF ATHENS

EARLY BLACK-FIGURE POTTERY. In the last quarter of the seventh century B.C.E. the Athenian pottery industry adopted the black-figure technique from Corinth, and perfected it. It would be a mistake to think of Corinth and Athens as the only centers of vase painting, for Sparta produced vases of considerable merit at this time, as did Chalcis on the island of Euboea, the cities of East Greece in Asia Minor, and the Dodecanese Islands. Nonetheless, by 550 B.C.E. Athens overtook its Corinthian rival, and its vases became the dominant imports in the western Mediterranean pottery market. Many of the vase painters who produced the masterpieces of Athenian black-figure ware can be recognized by their individual styles as well as their signatures on their work. The first black-figure artist to have a recognizable style to modern scholars is the "Nessos Painter," an anonymous artist so named because his best-known vase depicts on its neck Heracles fighting the centaur

Nessos. On the belly of the vase he used a stock scene: the three dread sisters with black wings called the Gorgons, galloping in pursuit of Perseus who had just lopped off the head of one of them, Medusa. Any Greek would recognize the myth; the fact that the Gorgons' quarry, Perseus, is omitted from the scene did not matter. After the "Nessos Painter" the next group of painters with recognizable styles all still betray an artistic debt to the Corinthian pottery industry. Then about 580 B.C.E. an artist signed his name: Sophilos. It appears on four vases, three as the vase painter and one as the potter.

THE DEVELOPMENT OF VASE DECORATION. Unlike the early painters who scattered ornaments over the whole surface of the vase, painters in sixth century B.C.E. confined them to definite areas, such as the neck, shoulder, and handles, or they served as frames for figured scenes. Moreover, ornaments were reduced to a limited number of standard motifs, such as the meander pattern, the lotus, palmette, ivy and laurel wreaths, scrolls, tongues, and horizontal bands. The figured scenes showed illustrations from mythology, but as time went on the scenes from everyday life became more popular. Youths are shown exercising, riding, arming for battle, or reclining at banquets and listening to music. Women are shown at household tasks. The figures were at first two-dimensional silhouettes, but after 550 B.C.E. artists experimented with three-quarter views. By 500 B.C.E. three-quarter views were completely mastered; drapery is shown with flowing lines and artists were trying linear perspective. One of the treasures of the Florence Archaeological Museum in Italy is a black-figure masterpiece, called the François Vase after its finder, Alessandro François, who discovered it in 1845 in an Etruscan tomb at Vulci in Italy. It is a volute *krater*—a new shape—signed by the potter Ergotimos and the painter Kleitias. It shows scenes from mythology. In a horizontal band under the rim, Peleus and Meleager face an enormous boar. They are identified by their names, so that the viewer is left in no doubt that this is the Calydonian Boar Hunt. Beneath it are friezes showing other scenes from Greek myth, with the figures carefully labelled. This *krater*, which was used to mix wine, evidently served as a conversation piece whenever its Etruscan owner gave a banquet. With vases such as these, by about the mid-sixth century B.C.E. Athenian potters were driving their Corinthian rivals out of the markets in the western Mediterranean.

IMPORTANT ARTISTS. Among those artists working in the mid-sixth century B.C.E. was one who called himself "the Lydian," evidently an immigrant from the kingdom of Lydia in western Asia Minor. There was another who signed "Amasis," a Greek form of the Egyptian name "Ahmose," whose signature appears on eight surviving vases. His black-figure vases are particularly fine, but even greater than he was Exekias. His great masterpiece is in the Vatican Museum. He signed it "Exekias decorated and made me," indicating he was both a potter and a painter. On one side he showed Castor and Polydeuces welcomed home, on the other Achilles and Ajax playing a board game. Both heroes wear splendidly embroidered cloaks which Exekias drew with exquisite detail. Achilles wears a helmet; Ajax's helmet rests on his shield behind him. Both bend intently over the board, but Ajax bends lower. His shoulders are slumped, whereas Achilles has shoulders squared and back comparatively straight. Through the body language of the figures, Exekias subtly conveys the message that Ajax is losing the game. Another Exekias vase, a *kylix*, or drinking-cup, shows the god Dionysus reclining on a ship, its mast sprouting vines while dolphins surround the boat. The painting illustrates one of Dionysus' adventures in which he was captured by pirates, who failed to reverence the god; because of their impiety a grapevine sprouted from the mast and the sailors leaped overboard in terror, becoming dolphins as they did so.

THE SELLING OF ATHENIAN VASES. The majority of Athenian vases in modern museums outside Greece itself come from Etruscan tombs in Italy. For the Etruscans, fine Athenian vases were the equivalent of Wedgewood and Royal Doulton china in modern times. Excavations of Etruscan tombs still yield Athenian vases, but the great age of their collection was the eighteenth century. During that century Etruscan tombs were looted for their antiquities, and the Athenian vases that were found were called "Etruscan urns" because it was thought that they were made in Etruria. One pottery workshop in Athens, belonging to an inventive potter named Nikosthenes, made a distinctive type of *amphora* (an ancient Greek vase with a large oval body, narrow cylindrical neck, and two handles that rise almost to the mouth of the vase) with an angular body and broad, flat handles which was made to appeal to Etruscan taste, for the shape mimics Etruscan *bucchero*-ware: black glaze pottery without decoration which was manufactured in Etruria. Various vase painters worked for Nikosthenes, including "the Lydian." There is a curious pattern to the find-spots of his vases. The Etruscans at Caere (modern Cerveteri) apparently liked his *amphora*-type since almost every surviving example is from there. His other types of pottery come mostly from Vulci. It looks as if Nikosthenes targeted these two particular Etruscan markets.

THE Potters' Art

Greek vases were an important export of Greece, and they are found all over the Mediterranean world, but particularly in Italy and Sicily, where Corinthian pottery dominated the markets until about 550 B.C.E. when exports from Athens came into vogue. Most of the Greek vases on museums outside Greece itself were discovered in Italy, particularly in Etruscan tombs. Ancient Etruria, which comprised the region of modern Tuscany in Italy, was the homeland of the Etruscans, a mysterious people who spoke a language unrelated to Latin or any Italic dialect, were probably immigrants from Asia Minor who developed a unique civilization that influenced early Rome, and they carried on a lively trade with Greece. Many of our best examples of Athenian black-figure and red-figure pottery were found in Etruscan tombs. Greek vases were the equivalent of Royal Doulton and Meissen china nowadays. On some of them, both the potters who made them and the artists who decorated them signed their names. They took pride in their work.

The Technique of Making a Vase

Both Corinth and Athens had clay deposits of high quality. The clay of Corinth was buff-colored, whereas the Athenian clay was a burnt siena. The first step in making a vase, after the clay was dug from its bed, was to levigate it. Levigation is the process of removing natural impurities from the clay, and it was done by mixing the clay with water and letting the impurities sink to the bottom. The process was repeated until the clay was pure enough for pottery-making. Then the clay was kneaded like dough to remove air bubbles and make it flexible. This process is called "wedging" the clay. Then the clay was placed on the potter's wheel, a rotating horizontal disk which the potter's apprentice turned by hand while the potter pulled the clay into the desired shape with his fingers. The body of the pot, the foot and the spout, if there was one, were all made separately, and the handles were shaped by a different method and attached to the pot. A slip made of liquefied clay was applied to the joints to hold them together.

The Role of the Vase Painter

Sometimes the potter was also the vase painter, but frequently the painter was a specialist employed by a potter. They might sign their names on the vases that they decorated, which is how we know them, but who they were, and whether they were slave or free we cannot say. Students of Greek vase paintings still use terms such as "black glaze" and "paint," but in fact, the Greek vase painters used neither glaze nor paints. Instead they drew their designs using slips of finely-sifted clay, some of which might contain pigments from metal. Then followed a three-stage firing process. In the first stage, which was the oxidizing phase, the kiln was heated to about 800 degrees Celsius and air was allowed free access. Both the pot and the slip turned red. In the second, reducing phase, the supply of oxygen into the kiln was shut off, and both pot and slip turned black, and the areas covered by the slip became partly vitrified. In the final, reoxydizing phase, oxygen was allowed in again, and the kiln was allowed to cool. The result was that the surface areas of the pot that were covered by the smooth slip, now partly vitrified, remained black whereas the coarser surface areas not covered by the slip absorbed oxygen once again and turned red. If the slip was applied too thinly, there might be a red spot in a black area, and this happened not infrequently. This was the technique used for both black-figure and the later red-figure vases which were produced in Athenian potteries. Corinthian potters were fond of a reddish-purple color, which they got by mixing a little red iron oxide into the slip. White could be produced by a slip of very fine white clay, which was not affected by the reducing process.

RED-FIGURE POTTERY. A rival of Nikosthenes was a potter who signed his vases "Andokides," and apparently an anonymous employee in his workshop pioneered red-figure vase painting about 530 B.C.E. If not the first red-figure artist, the Andokides painter was the first to show the potential of the technique. The black-figure technique showed figures in silhouette with details incised in the black glaze with a sharp instrument, while the background was left the natural color of the reddish clay found in Attica (the territory under control of Athens). Red-figure reversed the method: the background was black glaze and the figures were the color of the red Attic clay, with details painted with a fine brush. Some of the early productions were "bilinguals"—red-figure on one side and black-figure on the other. One "bilingual" *amphora* was painted by the Andokides Painter in red-figure on one side, and by the Lysippides Painter in black-figure on the other. Other painters followed the lead on this new trend, including a painter named "Epiktetos," who worked in the potteries of both Andokides and Nikosthenes, and a group known to modern scholars as the "Pioneers" composed of Euphronios, Phintias, Euthymides, and a few others who seem to have belonged to a close-knit guild of painters.

Arts and Humanities Through the Eras: Ancient Greece and Rome (1200 B.C.E.–476 C.E.)

399

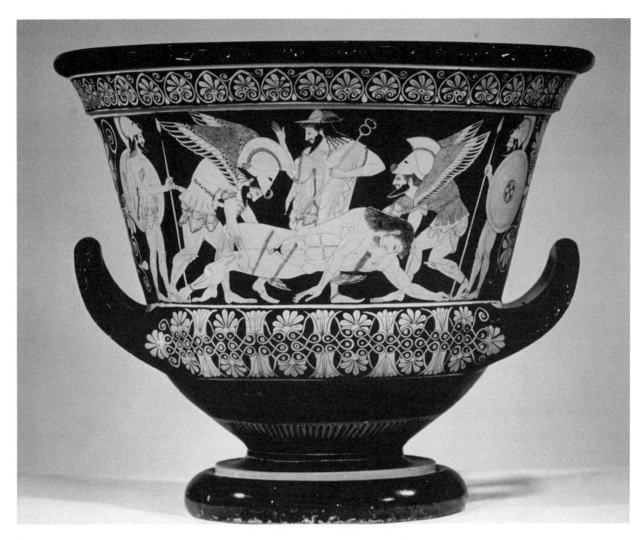

Red-figure calyx crater, late 6th century B.C.E. © BETTMANN/CORBIS. REPRODUCED BY CORBIS CORPORATION.

By the last years of the sixth century B.C.E., red-figure vases dominated the market, and red-figure ware continued to be made until near the end of the fourth century B.C.E. Black-figure production never disappeared, however. In the Panathenaic Games held each year in Athens, the first prize for the contestants was an amphora filled with olive oil, and the amphora was always decorated in black-figure technique, even long after black-figure had gone out of style.

THE RED-FIGURE VASE PAINTERS. Like the black-figure artists, red-figure vase painters are mostly anonymous. Buyers seem to have been interested in the potter's workshop that manufactured the vase more than in the artist who painted it. Euphronios, who was active in the years 520–470 B.C.E. was both a potter and a painter; he signed twelve surviving vases as a potter and six as a painter. In his old age he seems to have concentrated on pottery production and employed other vase painters,

some of them the finest artists of the period. One artist who worked in Euphronios' pottery was Douris, who signed his name on 39 vases that have survived, two of which he also potted. Douris worked in the first half of the fifth century B.C.E., and if the number of his surviving works is any indication, he must have been enormously productive. The survival rate for Greek vases is probably no more than an average 0.5 percent of an artist's work, and if that calculation holds true in the case of Douris, he must have produced some 78,000 vases during his productive life. His specialty was red-figure cups, but he worked in other media as well, including white-ground painting, which was a favorite decoration for *lekythoi*, oil flasks which were buried with the dead.

WHITE-GROUND VASES. In the fifth century B.C.E., the Athenian Empire reached the height of its prosperity, and Athenian artists made their mark on the art world. Great artists such as Polygnotus produced narra-

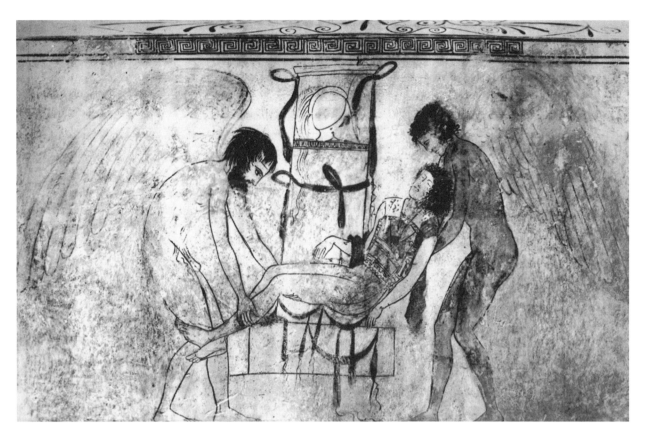

The Daimons Sleep (Hypnos) and Death (Thanatos) carrying the body of a warrior, grave stele behind, detail of an Attic white-ground lekythos attributed to the Thanatos Painter, c. 440 B.C.E. **PUBLIC DOMAIN.**

tive paintings, and they influenced the vase painters. A new spirit can be detected in the years 475–450 B.C.E.; artists decorated large vases with ambitious combat scenes of, for instance, Greeks fighting Amazons, that are set in hilly landscapes where the artists tried to produce an illusion of depth by placing more distant figures at a higher level than those in the foreground. The great murals that inspired these painters have not survived, but descriptions of these works by ancient authors provide a record of them for modern scholars. Yet the skill of the painter's brushwork can be seen on white-ground vases of the fifth century B.C.E. On these, the artist covered the background with a wash of fine white clay, and then painted his figures on the white surface in the same way as he would paint on a wooden panel. The finish is not as durable as red-figure, and thus it was particularly popular for the oil-flasks that were buried with the dead. The paintings on them are often domestic scenes, but there is a cosmetics jar (a *pyxis*) in the Metropolitan Museum in New York that shows the "Judgment of Paris" in which Paris, the young Trojan prince, is visited by the god Hermes. Greeks, who knew their mythology very well, would have known what was taking place: Hermes was bringing Paris a message that he was to judge which

of the three goddesses—Hera, Athena, and Aphrodite—was the most beautiful. Paris seems youthful and innocent, the picture of naivety, and yet he was about to start the Trojan War.

THE END OF THE RED-FIGURE PERIOD. The workshops in the Kerameikos—the potters' quarter of Athens—continued to produce red-figure vases in the fourth century B.C.E., though the disintegration of the Athenian Empire meant that there were no more protected markets, and local potters in Italy and Sicily began to offer serious competition. One place where Athenian pottery still found eager customers, it seems, was in the Ukraine, and one fourth-century fashion in pottery is known as the "Kerch Style" after the city on the Black Sea where numerous fourth-century vases imported from Athens have been found. The vases discovered at Kerch improved on the basic red-figure technique by picking out details in color, especially white, yellow, and gold. Among those who were producing Kerch Style pottery was the last notable red-figure artist in Athens: the so-called Marsyas Painter, who is named for a vase of his in Berlin which depicts the flaying of Marsyas, the satyr who had lost a musical contest with

Apollo. He embellished his vases with gilding, raised relief, and colors such as pink, blue, white, and green. Yet as the Athens-based workshops declined, production of red-figure vases in old Athenian markets in Italy increased. The customers were not only the Greeks who lived in the colonies planted during the great period of colonization from the mid-eight century to the end of the sixth century B.C.E. but also the native Samnite peoples who were now encroaching on the Greek cities, driven by a sharp increase in their population. They, too, liked Greek vases. About 400 B.C.E., the Greek colony of Poseidonia (now Paestum on the western shore of Italy south of Naples) had been taken over by the Samnites who denied the Greek inhabitants the right to use their own language except for one day a year, but nonetheless the pottery workshops of Poseidonia remained active. Two of their vase painters are known, Python and Assteas, who signed their names in Greek. They took the subjects for their paintings from the theater and Greek myth. Some of their scenes taken from the comic theater show performers wearing padded costumes and grotesque masks, acting on a wooden stage. These represent a type of comedy called phlyax-plays—the word *phlyax* means a comic parody of Greek tragedy invented by a comedian named Rhinthon. They were evidently very popular in southern Italy, and the vases give a hint of what the plays of the Athenian comic poet Aristophanes may have looked like when they were staged in Athens.

SOURCES

P. E. Arias, *A History of One Thousand Years of Greek Vase Painting* (New York: H. N. Abrams, 1962).

John Boardman, *Athenian Black Figure Vases* (London, England: Thames and Hudson, 1991).

———, *Athenian Red-Figure Vases: The Archaic Period: A Handbook* (London, England: Thames and Hudson, 1991).

———, *Athenian Red-Figure Vases: The Classical Period: A Handbook* (London: Thames and Hudson, 1989).

———, *The History of Greek Vases: Potters, Painters and Pictures* (London, England: Thames and Hudson, 2001).

R. M. Cook, *Greek Painted Pottery* (London, England: Methuen, 1972).

Arthur Lane, *Greek Pottery*. 3rd ed. (London, England: Faber, 1973).

Susan B. Matheson, *Polygnotos and Vase-Painting in Classical Athens* (Madison, Wisc.: University of Wisconsin Press, 1995).

Richard T. Neer, *Style and Politics in Athenian Vase-Painting: The Craft of Democracy, ca. 530–460 B.C.* (New York: Cambridge University Press, 2002).

Martin Robertson, *The Art of Vase-Painting in Classical Athens* (Cambridge: Cambridge University Press, 1994).

Brian A. Sparkes, *The Red and the Black: Studies in Greek Pottery* (London, England: Routledge, 1996).

Dyfri Williams, *Greek Vases* (London, England: British Museum Publications, 1985).

HELLENISTIC AND ROMAN POTTERY

MEGARIAN BOWLS AND TERRA SIGILLATA. During his brief lifetime, the Macedonian king Alexander the Great (356–323 B.C.E.) brought mainland Greece under his control and also conquered Persia and Egypt to form a "Hellenistic" kingdom composed of diverse peoples. Not surprisingly, the pottery from the period after Alexander the Great shows many diverse cultural influences. One type of pottery, however, became enormously popular in the Hellenistic period and, after 30 B.C.E., in Italy. From Italy its popularity spread to Roman Gaul and from there to Germany and Roman Britain. Its precursors were the "Megarian bowls" in Greece, tableware made in molds which seems to have had no particular connection with Megara, a Greek city on the Isthmus of Corinth. No later than the early third century, Athenian potters were producing crockery with relief ornaments which imitated the designs on metal vessels which were too expensive for most people. These so-called "Megarian bowls" were the forerunners of red-gloss *terra sigillata*, also known as "Samian Ware," though it has no connection with the island of Samos. *Terra sigillata* means "earthenware decorated with figures," which describes the pottery well, for on the exterior of the dish there are relief designs and figures which are imprinted from the mold. The place where this type of pottery may actually have been invented was the kingdom of Pergamum in Asia Minor, and the date was probably the mid-second century B.C.E. It was perhaps there that the black-ground ware inherited from Athens was modified into bronze or dark red gloss, which was its distinctive color.

THE POPULARITY OF TERRA SIGILLATA. Terra sigillata was pottery that could be easily mass-produced: clay was put in a mold, and the interior of the vessel scooped out using a fast wheel, and then the vessel was fired. With its smooth, red glossy surface, it was serviceable tableware and relatively cheap. Yet it was elegant and artistic, for it copied designs from silverware, and it must have appealed to customers for whom silverware was beyond their means. It brought style to the tables of the common man. As the first half of the first century C.E. wore on, production of terra sigillata in Ar-

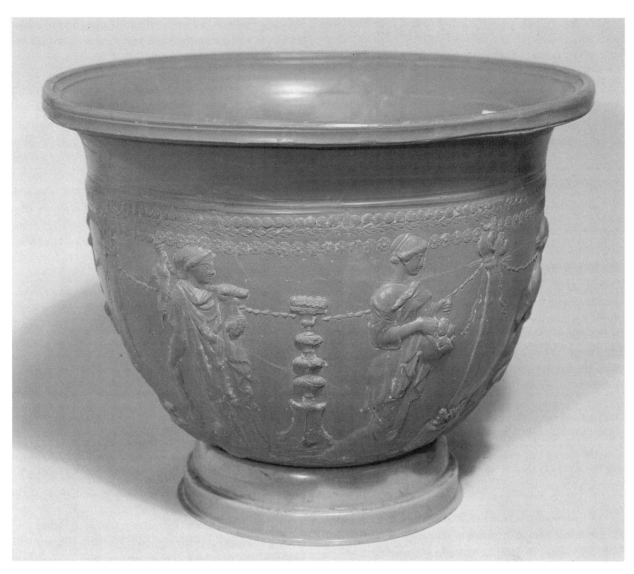

Arretine ware bowl from Capua, Italy, with reliefs of the seasons. An example of "terra sigillata." THE ART ARCHIVE/BRITISH MU-SEUM/HARPER COLLINS PUBLISHERS.

retium in Italy declined as potters migrated to Roman Gaul. The Roman army was also a factor in this "hollowing-out" of pottery manufacture in Italy. The legionary soldiers liked the sort of pottery that they knew in Italy or the Romanized provinces where they were recruited, and exports from Italy to the regions along the Rhine and Danube Rivers, and Roman Britain, where the military units were concentrated, were common. The corps of craftsmen attached to the army who knew how to make bricks and roof tiles for military use would also turn their hands to making pottery in the Roman style.

THE DECLINE OF TERRA SIGILLATA. From the end of the first century C.E. the common ware that came into fashion was "Red Slip" pottery, once called "African Red Slip" since the center of production seemed to be in North Africa. It is now clear that not only Roman Africa but also Asia Minor manufactured and exported Red Slip ware all over the Mediterranean. Land transportation may have been exorbitantly expensive, but transportation by sea, though slow, was very cheap. Yet though Red Slip ware displaced terra sigillata as the common table crockery of the Roman Empire, it shared a common origin and it was recognizably Roman. It continued in use until the seventh century C.E.

SOURCES

R. J. Charleston, *Roman Pottery* (London, England: Faber, 1997).

Kevin T. Greene, "pottery, Roman," in *The Oxford Companion to Classical Civilization.* Ed. Simon Hornblower

and Antony Spawforth (Oxford, England; New York: Oxford University Press, 1998): 569–570.

John W. Hayes, *Handbook of Mediterranean Roman Pottery* (Norman: University of Oklahoma Press, 1997).

Catherine Johns, *Arretine and Samian Pottery* (London, England: British Museum Press, 1971).

Susan I. Rotroff, *The Athenian Agora: Results of the Excavations Conducted by the American School of Classical Studies. Vol. XXIX: Hellenistic Pottery; Athenian and Imported Wheel-Made Table Ware and Related Material* (Princeton, N.J.: American School of Classical Studies, 1997).

SCULPTURE IN ARCHAIC GREECE

THE DAEDALIC STYLE. By the mid-seventh century B.C.E. Greek sculptors were experimenting in free-standing figures, influenced, no doubt, by their discovery of the art and architecture of ancient Egypt earlier in the century. Once the Assyrians were driven out of Egypt, the pharaohs of the Twenty-Sixth Dynasty cultivated close relations with Greece and allowed the Greeks to build a trading station at Naucratis on one of the mouths of the Nile River. The Greeks themselves attributed many of their early efforts at sculpture to the legendary craftsman Daedalus, whose name means "Cunning Worker," and hence modern art historians apply the label "Daedalic" to the earliest Greek sculptures. An early example comes from the sanctuary of Apollo and Artemis on the island of Delos, and it must be one of the first made. It is made of the white marble from the island of Naxos, which was the stone of choice for early sculptors until the quarries on the neighboring island of Paros were opened. The statue is of a woman wearing a wig and the garment known as the *peplos*, shaped awkwardly from an oblong piece of marble. She faces the onlooker, her arms hanging by her sides. On her skirt there is a verse inscription disclosing that this statue was dedicated to Artemis by Nikandre of Naxos, whose father, brother, and husband are also named. Nikandre's statue is the first of many. One, a statuette of solid bronze from Apollo's other great sanctuary at Delphi from the mid-seventh century B.C.E., shows a boy naked except for his wig and a belt at his midriff. He stands stiffly at attention, except that the left leg is slightly forward, the right leg slightly back. Except for the Daedalic wig and the belt, this is the stance of the later *kouroi*, that is, statues of naked youths.

THE KOUROI. The word *kouros* (plural: *kouroi*) means "boy" or "youth," and it is a term that describes the archaic statues of nude youths produced from about 650 B.C.E. until the last quarter of the sixth century and the early years of the fifth, when they lost their archaic features and became the male nudes of the classical period. Some 200 known examples of *kouroi* survived to modern times, although most of them are badly damaged and in fragments. The *kouroi* began to appear about the mid-seventh century B.C.E. One of the earliest examples, dating to about 600 B.C.E., is the "Metropolitan *Kouros*," now in the Metropolitan Museum in New York. It is rigidly frontal; the statue has a front, two sides, and a rear—four independent faces that preserve the four sides of the marble block from which it was carved. A comparison between it and an Egyptian statue of a standing male figure reveals the source of the Greek sculptor's inspiration. The Egyptian figure and the Metropolitan *kouros* have the same proportions. In both, the arms hang at the sides, and the left leg is thrust forward. Yet there are differences: the Egyptian figure wears a skirt held up by a belt whereas the Metropolitan *kouros* is entirely nude; and unlike the Egyptian sculptor, the Greek artist did not try to give the face any individuality. The lips are drawn back at the corners into what has come to be known as the "archaic smile." Not much later than the Metropolitan *kouros*, about 580 B.C.E., two *kouroi* of Cleobis and Biton were erected at Delphi. According to the historian Herodotus, Cleobis and Biton were the two sons of the priestess of Hera at Argos who dragged their mother's ox-cart from the city of Argos to the sanctuary of Hera in the countryside. For this act of piety, their mother prayed to the goddess to confer on them whatever reward was best for mortal men. The two youths then lay down to rest after their exertion and never awoke again, proving that, for men, death at the height of their renown is the best reward. The *kouroi* of Cleobis and Biton show them as two sturdy youths with well-developed pectoral muscles, smiling the "archaic smile" and staring with large eyes into the distance. These were two athletic young men who died at their physical peak and the sculptor tried to convey in stone the ideal they represented. They are dwarfed, however, by the contemporary "Sunium *kouros*," the best preserved of several over life-size *kouroi* found at Sounion, the eastern tip of Attica, where there was a sanctuary of the god of the sea, Poseidon. Over three meters (9.84 feet) high, it stood with its giant companions overlooking the treacherous waters off Cape Sounion, perhaps commemorating men lost at sea. Slightly later, belonging to the second quarter of the sixth century B.C.E., is a *kouros* found at Tenea south of Corinth, a small place whose inhabitants claimed to be captive Trojans whom the Greeks settled there. The sculptor of the Tenean *kouros* had observed the male anatomy carefully; the shoulders, pectorals, stomach muscles, and thighs are well-shaped and well

a PRIMARY SOURCE *document*

DAEDALUS THE SKILLFUL CRAFTSMAN

INTRODUCTION: Daedalus, whose name means "skillful worker" (the Greek adjective for "well-wrought" or "intricately made" is *daidalos*) was connected in Greek myth with the legendary king of Crete, Minos. It was said that he built a great labyrinth for Minos as a lair for the Minotaur, a monster that was half-man, half-bull. There was also a tale that Daedalus escaped from Crete by making wings for himself and flying away to Italy or Sicily. There is, however, another set of legends that seem to place Daedalus in the period after the fall of the Bronze Age civilization, and attribute the beginnings of Greek sculpture to him. The Greek traveler, Pausanias, who toured Greece in the second century C.E. and wrote an account of what he saw that has been enormously useful to archeologists, remarked on several works attributed to Daedalus which he encountered. A passage from Pausanias is quoted below. The reference to the relief sculpture in "white stone" (marble), which Daedalus made of the "Dancing Floor" of Ariadne, is a reference to a dancing floor designed by Daedalus that Homer describes in his epic, the *Iliad*. The passage is quoted in the chapter on "Dance" in this volume.

Of the works of Daedalus, there are two in Boeotia—the Heracles in Thebes and the Trophonius in Lebadeia. There are two other wooden images in Crete, that of Britomartis in Olus and the Athena at Cnossos. The Cnossians also have the "Dance of Ariadne," of which Homer made mention in the *Iliad*, a relief executed in white stone. And the Delians possess a wooden image of Aphrodite, not very large, which over the years has lost its right hand. It is finished at the bottom with a square base instead of feet. I believe that this is the statue which Ariadne received from Daedalus, and that when she followed Theseus, she carried away the image from her home. And the Delians relate that, when Theseus got rid of her, he set up the image of the goddess to Apollo at Delos.

SOURCE: Pausanias, *Pausanias*, Book IX, in *The Art of Greece, 1400-31 B.C.: Sources and Documents*. Ed. J. J. Pollitt (Englewood Cliffs, N.J.: Prentice-Hall, 1965): 7.

coordinated. The pose remains the same: left leg slightly forward, right leg drawn slightly back and arms hanging loosely at the sides. Yet there is a new plasticity to the modelling of the body that signals a leap forward.

THE KORAI. The female figures dating to the same period as the kouroi are called *korai* (singular: *kore*). Males are shown nude and women clothed, the convention that will not be breached until the fourth century B.C.E. Sometime in the sixth century, a person whose name was Cheramyes dedicated a kore at the great temple of Hera on the island of Samos. The kore is now headless, but the body is intact except for the left arm. It is basically a cylindrical figure. A long tunic or *chiton* drapes the body, falling in tiny pleats from the waist to the toes which peep out from under it, and she wears a cloak that once veiled her hair. It falls over her shoulders, covering her right arm completely, and it is drawn diagonally across her breasts. Under her clothes the contours of her body are visible; her breasts are full and her stomach bulges slightly below her belt. Unlike the nude kouroi, the korai were clothed, and this required the sculptors to portray garments which were originally painted to reproduce the patterns on the clothes that the korai wore—usually a chiton and over it a cloak known as a *himation*. The Acropolis of Athens in the late sixth and early fifth centuries must have been full of *kouroi* and *korai* which were dedicated there. In the course of

the Persian Wars, the Persians captured the city in 480, and again in 479 B.C.E., laying the whole area waste and leaving the shattered remains of these statues on the ground. The Athenians buried the decimated statues reverently, and they remained in their graves until archaeologists, clearing the Acropolis in the 1880s, stumbled on an amazing collection of archaic sculpture, including a cache of korai from the century before the Persian Wars. They stand, facing forward, left foot thrust slightly forward as if they were dancing. The treatment varies, but in the standard pose the kore's left hand pulls the skirt of her chiton across her legs, sometimes so tightly that the legs can be seen beneath it, and over it she wears a himation, a wrap that is slung over the right shoulder and hangs diagonally across her bosom and under her left arm. The reason for their burial is unclear, although the statues did commemorate an untimely death on occasion. They were, however, erected all across Greece in the archaic period.

"RIPE ARCHAIC" SCULPTURE. "Ripe Archaic" is a convenient label for the style of sculpture from the period dating from about the second quarter of the sixth century to the time of the Persian Wars (490–479 B.C.E.). This is also the period when Greek craftsmen learned how to make hollow bronze statues using the so-called "Lost Wax" technique. In this technique, a model of the figure was made of wax over a clay core, then a

CASTING
Bronze Statues by the "Lost Wax" Method

The Technical Difficulty

The earliest bronze figures that we have from Greece are small statuettes cast of solid bronze. Bronze in ancient Greece was an alloy of copper and tin and it was expensive. Making a life-size statue in bronze would be costly, to say nothing of its weight. In the sixth century B.C.E., Greek sculptors learned how to cast hollow bronze statues using the "lost wax" method, which they learned from Egypt. Greek authors such as the historian Herodotus in the fifth century B.C.E., Pliny the Elder in the first century C.E., and Pausanias in the second century, whose guidebook to Greece is a mine of information for the archaeologist, attribute the introduction of bronze casting by the "lost wax" process to Rhoikos and Theodoros who worked for the tyrant of Samos, Polycrates, who became tyrant about 540 and died about 522 B.C.E. Whether that is true or not, hollow bronze statues appear around the middle of the sixth century B.C.E.

The Technique

First, the sculptor made a clay core. He then inserted metal pins, known as chaplets, into the clay core, covered it with wax and carved it to form a model of his statue. Then he covered his wax model with clay and allowed the clay to become completely dry, thus forming a mold. The next step was to place the mold in a casting pit and heat it so that the wax melted and ran out, leaving a space between the clay core and the mold. The chaplets which had been inserted into the core held it firm within the clay mold. Next bronze was melted in a furnace constructed alongside the casting pit and poured into the space between the clay core and the mold, using a clay funnel. The bronze was allowed to cool and harden, the mold was broken away—it would probably not be used again— and the bronze statue would emerge. The clay core could then be removed. Or it might not—in 1959, a bronze Apollo, dating to about 525 B.C.E., was found in Piraeus, the port of Athens, which was part of a lost consignment of bronze statues intended for shipment to Rome in the first century B.C.E., and it was cast using the "lost wax" process, but the core had not been removed. Nor had the iron chaplets which held the core in place.

Finishing the Statue

Once the statue was removed from its mold, the sculptor would finish it. Most statues were far too large to be cast at the same time. The head, the legs, and the arms were usually cast separately and then were fitted together only after they had emerged from their molds. The Delphic Charioteer in the Museum at Delphi in Greece, which commemorated a victory at the Pythian Games in either 478 or 474 B.C.E., is a case in point. Its skirt, upper torso, both arms and head, as well as the side-curls on the head, were all cast separately. The left arm is now lost and so we can see how it was originally attached. The sculptor then inset the eyes using colored glass, and smoothed off any imperfections. He then oiled and polished his statue, and it was ready to be erected.

mold was made from the wax model; the wax was then melted out and replaced by molten bronze and finally, after the bronze had cooled, the mold was removed. Before the discovery of this technique, large bronze statues could be made only by hammering bronze plates over a wooden core, in the same way as bronze armor continued to be made. Most of the bronze statues of the ancient world disappeared long ago, melted down in many cases for their metal, and so it is easy to forget that all the great sculptors of Greece worked in bronze. Only one bronze *kouros*, dating to about 525 B.C.E., survived, discovered in 1959 in Piraeus, the port city of Athens. It is the exception, however; the *kouroi* and *korai* that still exist are generally of marble. The type changed very little. *Kouroi* and *korai* still face the viewer head-on as if their movements were constrained by the block of marble from which they were sculpted, and they still wear their archaic smiles which make them look a little smug.

Yet the sculptor's chisel was surer, as the sculptors became more skilled at representing the anatomy of the male body. A *kouros* found intact at Tenea, a village south of Corinth, illustrates what the type was like at the beginning of the "Ripe Archaic" period. The *kouros* still smiles at the viewer with the corners of his lips pulled back in an archaic smile. His arms hang by his sides and his left leg is thrust forward in the familiar pose that was borrowed from Egypt, but his torso is modeled with skill. The sculptor paid close attention to the pectoral and stomach muscles. Yet a comparison between the *kouros* from Tenea with one made a generation later, the Anavysos *kouros*, shows the great strides forward in just a short time. Sometime after 540 B.C.E., at Anavysos in the countryside outside Athens, a *kouros*-statue was erected on the grave of a young man named Kroisos (Croesus) who had died in battle. The Anavysos *kouros* is intact; in fact, some of the original paint on it sur-

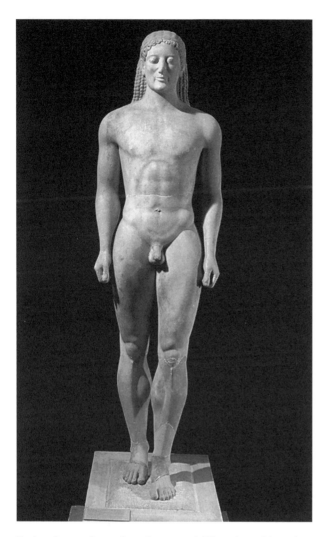

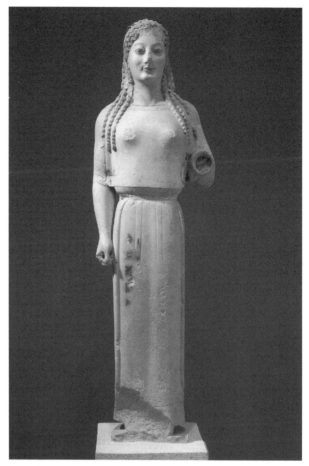

The "Peplos Kore," a girl wearing the garment known as a "peplos," found on the Acropolis in Athens with some of its original paint intact, c. 530 B.C.E. THE ART ARCHIVE/ACROPOLIS MUSEUM ATHENS/DAGLI ORTI.

Kroisos, kouros figure from Anavysos, full length marble sculpture of nude young man walking, funerary monument/portrait of a young man who died in battle, c. 530 B.C.E. © GIANNI DAGLI ORTI/CORBIS. REPRODUCED BY PERMISSION.

vives. It is not a portrait of *Kroisos*, but it is somehow intended to represent the spirit and life-force of the dead warrior. The lips still smile the "archaic smile," and the kouros stands, hands hanging at his sides with his left leg still thrust slightly forward and the right leg pulled slightly back. The traditional pose of the kouros-statue is unchanged, yet the spirit is different: the sculptor had observed the musculature of the male body carefully and attempted to reproduce it accurately. Kroisos was evidently a powerfully-built young man, unlike the lithe youth that the *kouros* from Tenea represented, and the sculptor tried to convey an impression of his physical power in the statue that marked his grave.

THE KORAI IN THE "RIPE ARCHAIC" PERIOD. The *korai* demanded stone carving that was even more proficient, for these were statues wearing clothing that had

to be recreated in stone. The fashions of the day were elaborate and the garments that the *korai* wear reflect it. The garments were originally brightly painted and on a few of them that have escaped weathering some of the pigment has survived. One of these, dating to 530–515 B.C.E. which is now in the Acropolis Museum in Athens, shows a young woman with an elaborate coiffure and long braids hanging down over her shoulders. She wears a mantle with heavy folds that contrast with the soft, crinkly folds of the tunic (*chiton*) beneath it. The color is well-preserved; the tunic is dark and the mantle has a pattern on a white background and a dark fringe along its edges. Another almost contemporary statue, also in the Acropolis Museum, is the so-called *peplos kore*, so-called because she is wearing a simple *peplos* with an over-fold that falls down as far as her waist. Her right arm hangs by her side, and she may have held something in her left hand, though the left forearm is broken off. The simplicity of her dress is more apparent than real for the

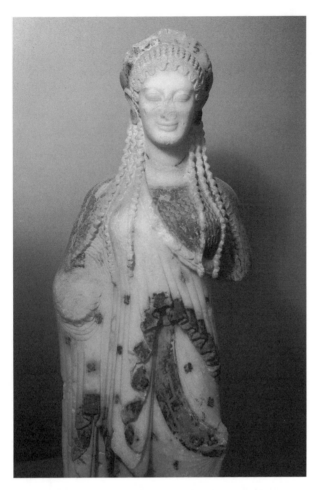

Marble statue of a "kore" from the Athenian Acropolis, dressed in an ornate Ionian "chiton" under an Ionian-style "himation," c. 510 B.C.E. THE ART ARCHIVE/ACROPOLIS MUSEUM ATHENS/HARPER COLLINS PUBLISHERS.

fabric was originally brightly patterned. Only a few remnants of the paint survive, but enough to suggest what the statue must have once looked like. Her hair hangs down her back in multiple braids; three are slung over each shoulder. She has a lively face with almond-shaped eyes and pupils picked out in paint.

SCULPTURE IN RELIEF. Relief sculpture appeared as decoration for monumental temples about the middle of the seventh century B.C.E., the colonial period of Greece, when various city-states in both mainland Greece and East Greece on the western fringe of Asia Minor sent out colonies to Sicily, Italy, southern France, and the north-east coast of Spain, as well as to the northern Aegean region and the shore of the Black Sea. The earliest Greek temples were one-roomed structures, entered through a porch at one end, with a place for burnt sacrifices in the middle. This style developed into a long narrow room with the entrance-porch at the east end,

and the cult statue facing it at the other end. The earliest examples of cult statues were what the Greeks called *xoana*: primitive statues of wood, hardly more than wooden posts with some human features carved roughly on them. The sacrificial pit was moved to an open-air altar, often outside the east door. The Doric temple evolved from this style in the Peloponnesos, while in East Greece the Ionic temple developed; the first use of relief sculpture decorated both of these temple types. At each end of the temple there was a triangular gable called a "pediment," surrounded by cornices, leaving a recessed triangular space called the "tympanum" in which sculpture could be placed. On Doric temples, a frieze of triglyphs and metopes appeared below the pediment. The *triglyphs* were plaques carved with two vertical channels separated by three moldings, one over each column and one in the space between. The *metopes* were the empty spaces between the triglyphs, and they could be filled with relief sculpture. Some of the earliest examples of metope-sculpture comes from the Greek colonies in Sicily and Italy. One, which comes from a ruined temple at Selinunte (ancient Selinus) in western Sicily shows the hero Perseus cutting off the head of the Gorgon, Medusa, a monster who could turn anyone who looked at her face into stone. The relief tells a story familiar to Greeks, who believed that Perseus was not a mythical hero but a man who actually lived in an earlier era when gods walked the earth; the Gorgon's head was also a well-known terror-symbol that struck fear into men's hearts. Both Perseus who holds his sword at Medusa's throat, and Medusa, whose head is being severed, confront the onlooker, their facial expressions unmoved. From a small mid-sixth-century B.C.E. temple built to Hera at the mouth of the Sele River in Italy comes a remarkable series of 36 metopes, some of which are only roughed out and left incomplete. The finishing of the relief sculptures was evidently done after the metopes were in place, and the builders of this temple never got around to it. Some of the best metopes show the Labors of Heracles or events from the Trojan War.

SCULPTURE IN AN AGE OF TYRANNY. The sixth century B.C.E. was a period in Athenian history when Athens moved from aristocratic government to tyranny and finally to democracy, though democracy was not fully in place until the fifth century B.C.E. In 560 B.C.E., Pisistratus, an outsider in Athenian politics who belonged to neither of the main political factions, staged a *coup d'état* and seized power, but he did not last long. The two main factions forgot their bickering long enough to unite against him, and he was expelled. Yet once he was gone, the factions returned to their rivalry, and the leader of the weaker faction made Pisistratus his

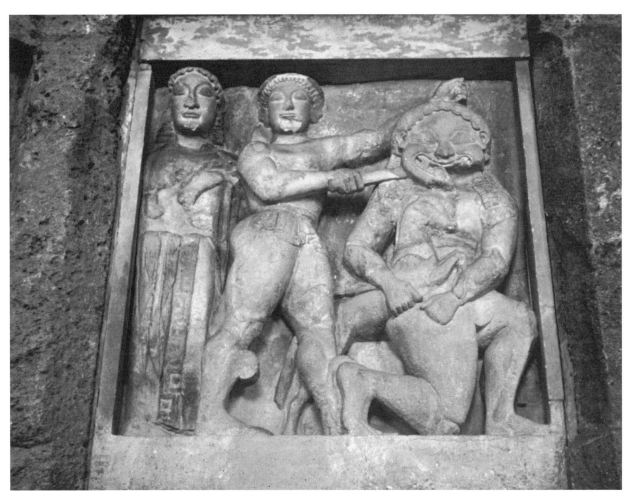

Frieze of Perseus Slaying the Gorgon from Temple C in Selinus, Sicily (c. 540 B.C.E.). COURTESY OF JAMES ALLAN EVANS.

ally and brought him back. He was soon driven out again, but he made a third attempt, backed by armed force, and this time it took only one battle to scatter his enemies. He remained tyrant of Athens from 546 to 527 B.C.E., and his son Hippias carried on as tyrant until 510. After the tyrants were gone, the Athenians of a later generation looked back on the tyranny as a time of oppression, although in actuality both Pisistratus and Hippias kept their iron fists well camouflaged in velvet gloves. They allowed the Athenian constitution to function and only manipulated from behind the scenes. Likewise during this time period Athens prospered and new temples arose on the Acropolis. Some of the sculpture that adorned their pediments was found among the debris left when the Persians sacked Athens in 480 B.C.E. One group portrays the three-headed serpent Typhon; the long serpentine coils must have filled the corners of the tympanum, and Typhon's three torsos filled the space under the central peak. His three faces still have blue beards and moustaches, and the lips are curved into

the familiar archaic smile. One other sculpture that belonged to the time when Pisistratus was trying to secure his hold on power is a variation of the *kouros*-type: a statue of a man bearing a calf on his shoulders, and its inscribed base reveals that it was dedicated by Rhonbos. Whoever he was, Rhonbos is almost certainly the man whom the sculpture represents, and he is shown bringing a calf for sacrifice. Over his shoulders, he wears a thin cloak; the paint which once set it off from his naked flesh has long disappeared. His upper body, the muscles of his arms, and the calf slung over his shoulders are realistically modeled, though the modeling of his lower body is more stiff, and his legs are broken off at the knees. His face, which is bearded, smiles the "archaic smile." Rhonbos' statue was erected about 560 B.C.E., the year when Pisistratus first seized power and held it briefly. Perhaps Rhonbos erected this statue to commemorate his thank-offering to Athena for delivering Athens from the tyrant. He did not yet know that the tyrant would return.

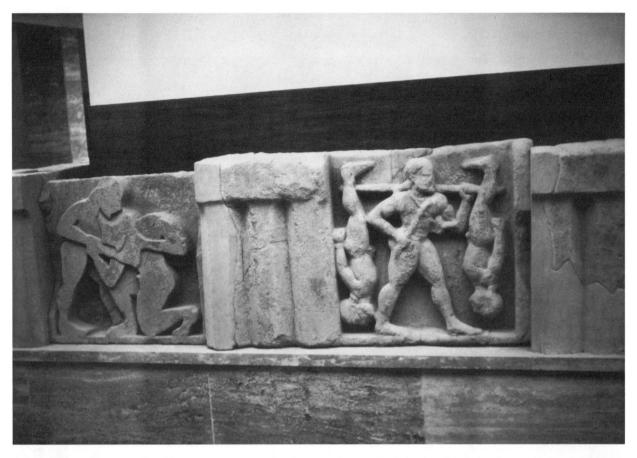

Carved metopes from a small mid-6th-century B.C.E. temple of Hera at the mouth of the river Sele in southern Italy, showing exploits of Heracles. COURTESY OF JAMES ALLAN EVANS.

SOURCES

John Boardman, *Greek Sculpture: The Archaic Period. A Handbook* (London, England: Thames and Hudson, 1985).

C. G. Boulter, ed., *Greek Art: Archaic into Classical; A Symposium held at the University of Cincinnati, 2–3 April 1982* (Leiden, Netherlands: Brill, 1985).

Catherine M. Keesling, *The Votive Statues of the Athenian Acropolis* (Cambridge: Cambridge University Press, 2003).

Carol G. Mattusch, "Molds for an Archaic Bronze Statue from the Athenian Agora," *Archaeology* 30 (1977): 326–332.

Sarah P. Morris, *Daidalos and the Origins of Greek Art* (Princeton, N.J.: Princeton University Press, 1992).

Robin Osborne, *Archaic and Classical Greek Art* (Oxford, England: Oxford University Press, 1998).

Humfrey Payne and Gerard Mackworth-Young, *Archaic Marble Sculpture from the Acropolis: A Photographic Catalogue.* 2nd ed. (London, England: Cresset Press, 1950).

Gisela M. A. Richter, *Kouroi: Archaic Greek Youths; A Study of the Development of the Kouros Type in Greek Sculpture.* 3rd ed. (London, England; New York: Phaidon, 1970).

Brunilde S. Ridgway, *The Archaic Style in Greek Sculpture.* 2nd ed. (Chicago: Ares, 1993).

SCULPTURE OF THE CLASSICAL PERIOD

THE EARLY CLASSICAL PERIOD. About 480 B.C.E., just before the Persians under King Xerxes sacked Athens, someone dedicated a *kouros* (a Greek male nude statue) on the Acropolis which has been labelled the "Critian Boy" because of the resemblance of its head to a statue group by two sculptors, Critias and Nesiotes, erected a few years after the Persian invasion had been defeated. The Critian Boy faces the onlooker like earlier *kouroi*, but he stands relaxed, his weight on one leg, his head inclined. His body is skillfully modeled. It is that of an athletic youth aged eighteen or nineteen. There is no vestige left of the "archaic smile," typical of earlier statues, indicating its stylistic alignment with sculpture from the classical period. The sculptors who produced

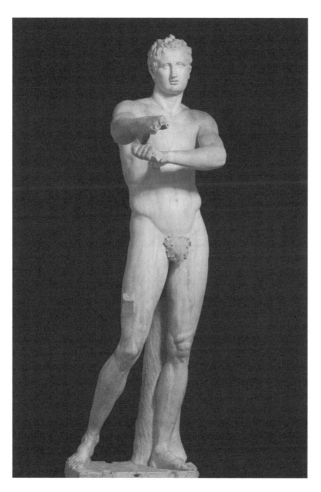

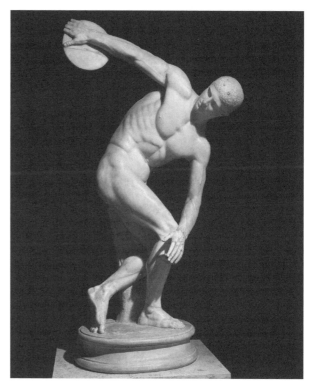

"Discobolus" or "Discus-thrower," a Roman copy of a famous statue by Myron, early 5th century B.C.E. © GIANNI DAGLI/COR-BIS. REPRODUCED BY PERMISSION.

The Apoxyomenos (athlete scraping himself after exercise): a Roman copy of a famous bronze statue by Lysippus. ART RESOURCE.

the *kouroi* and *korai* (female versions of the *kouroi*, only clothed) are generally nameless, though one battered *kore* bears the signature of the sculptor Antenor. The preferred medium of the great sculptors of the classical period was bronze, although copies of the sculptures were done in marble for Roman customers. It is these copies which survived antiquity, since most of the bronze statues were melted down for scrap metal during in the Middle Ages. Unfortunately, marble cannot reproduce bronze exactly because it is a heavier, more inflexible medium, and the sculptor working in marble must distribute the weight of his statue evenly or it will not be stable. Therefore, the copies do not reveal the evolution of sculpture in the classical period from the stiffness of the archaic period, a development made possible by the more flexible medium of bronze. The bronze *kouros* found in Piraeus which dates to about 525 B.C.E. is already less stiff than contemporary marble kouroi; its head is slightly inclined and its forearms stretch out towards the onlooker. The "Discus-Thrower" of the sculptor My-

ron whose career began just after 480 B.C.E. shows a naked youth in the act of throwing a discus. Though the original is lost, the survival of several Roman copies reveal that the statue is an action figure, a type developed by early classical bronze-workers. It is still two-dimensional; the onlooker can view it from the figure's right side or from the rear. Other viewpoints are an unsatisfactory jumble of lines. The original in bronze was balanced, though it has been argued that Myron altered the natural stance of a youth about to throw a discus in order to give the statue stability. The copyist, however, introduced a strut to stabilize the figure.

THE BRONZE ORIGINALS. While it is fortunate that Myron's work was preserved in good marble copies of his "Discus-Thrower" and his statue group of Athena and Marsyas, there are no surviving Roman copies of the work of the other two outstanding sculptors of the period, Pythagoras and Calamis, that can be attributed to them with any certainty. Despite the widespread destruction of bronze works during the Middle Ages, some bronze originals of the early classical period did manage to survive. One is the Delphic Charioteer found at Delphi, where it was preserved by a landslide. Of the chariot, horses, and groom that were part of the statue group,

a PRIMARY SOURCE *document*

PLINY THE ELDER ON THE SCULPTOR, MYRON

INTRODUCTION: Myron is best known nowadays for his *Diskobolos,* or "Discus-Thrower," which depicts a young athlete crouching down to throw the discus. The bronze original is lost, but it survives in copies, of which the finest and best-preserved is the so-called Lancelotti *Diskobolos* in the National Museum in Rome. A second statue group survives, portraying the myth of Athena and Marsyas: Athena invented the reed pipe known in Greek as the *aulos,* but threw it away because it distorted her mouth when she played it, and made her look ugly. The satyr Marsyas picked up the pipe that had been discarded and learned to play it. He became so proud of his skill that he challenged Apollo to a musical contest, and when he lost, he was flayed for his impertinence, for gods took offense when they were challenged by lesser beings. In the ancient world, Myron was particularly famous for his statue of a heifer that was so life-like that, according to one report, it aroused the lust of a concupiscent bull. The passage quoted below comes from the *Natural History* of Pliny the Elder, a Roman man of learning who died in the eruption of Mt. Vesuvius in 79 C.E. His *Natural History* touched on the visual arts among other topics, and it is a major source of our knowledge about ancient art. Pliny's remark that many short verses or epigrams were written in praise of Myron's heifer is true. The *Greek Anthology,* which is the title given to two collections of ancient Greek poetry made in the Byzantine period, preserves thirty-six epigrams on Myron's famous heifer.

Myron, who was born at Eleutherae [on the border of Attica as the territory of Athens was called] and was a pupil of Ageladas, was most renowned for his statue of a heifer, a work which is praised in well-known verses—for many people gain their reputations through someone else's inventiveness rather than their own. He also made a dog, a Discus-thrower, a Perseus and the sea monster, a Satyr marveling at the flutes, and an Athena, as well as contestants in the *pentathlon* at Delphi, pankratiasts, and a Heracles which is now in the round temple of Pompey the Great in the Circus Maximus. He also made a monument to a cicada and a locust, as Erinna indicates in her poem. He also made an Apollo which was carried off by the Triumvir [Mark] Antony but restored again by the divine Augustus after being warned in a dream. Myron seems to have been the first to extend the representation of reality; he used more compositional patterns in his art than Polyclitus and had a more complex system of symmetry; he, too, however, though very attentive as far as the bodies were concerned, failed to express a sense of inner animation; moreover he did not render the hair and the pubes any more perfectly than the rude art of an earlier period had.

SOURCE: Pliny, *Natural History,* in *The Art of Greece, 1400–31 B.C.: Sources and Documents.* Ed. J. J. Pollitt (Englewood Cliffs, N.J.: Prentice-Hall, 1965): 61–62.

only fragments remain. Another is a bronze statue of Zeus hurling a thunderbolt that is now in the National Museum of Greece in Athens. It was found in the waters off Artemisium at the north tip of the island of Euboea in the Aegean Sea. Zeus strides forward, his right arm raised to hurl the thunderbolt. The sculptor is unknown, but Ageladas of Sicyon, a famous artist who taught both Myron and Phidias, is known to have sculpted a Zeus hurling the thunderbolt. If the Zeus in the National Museum is not his, it may at least have served as the inspiration for it. The sea off southern Italy at Riace Marina also yielded two Greek bronze statues in 1972. They are dated to shortly before 450 B.C.E. Both are nudes and both portray bearded warriors; one has the remains of a shield on his right arm, and the other originally wore a helmet which has mostly disappeared. On the first, the eyes are of ivory and glass paste, the teeth—visible between his parted lips—are inlaid silver. His lips, his nipples, and his eyelashes are of copper, precast and inserted into the mold when the statue was made. The warrior that once had a helmet also has copper for his nipples, lips, and eyelashes, and his one surviving eye is made of marble and glass paste. Both statues were made by the "lost-wax" technique (in which a mold is made from a wax model over a clay core; then the wax is melted out and replaced by molten bronze) and, when found, they still had their clay cores, though these are now removed. Both are about six and a half feet tall, the helmeted one slightly shorter than the other. Better than any other bronze statues that have survived, these powerfully built warriors provide a clue as to what Greek bronzes in the early classical period must have looked like.

THE HIGH CLASSICAL PERIOD. By the middle of the fifth century B.C.E., Greece had fully recovered from the ravages of the war with Persia. After the Persian invasion was repelled, Persia remained a powerful enemy, and the Greek states in Asia and northern Greece still felt threatened. They willingly joined an alliance under Athenian leadership to continue the fight and make sure that Persia could not launch a counter-offensive. The center of the alliance was on the island of Delos, sacred to Apollo and Artemis, and there the treasury of what

was called the "Delian League" was kept, and all members of the alliance contributed to it according to an assessment drawn up by Athens. But more and more the Delian League developed into an Athenian Empire. In 454 B.C.E. the treasury was moved from Delos to Athens, and in mid-century the campaigns which the Delian League had once launched annually against Persian territory came to an end; there may even have been a peace treaty signed at last, though that is a matter of debate. Yet Athens decreed that the yearly tribute to the Delian League treasury should still be paid and used the money not only to maintain the most powerful fleet in Greece, but also to finance a building program in Athens. On the Athenian Acropolis, a splendid temple to the goddess Athena Parthenos was built that was larger than the temple of Zeus at Olympia, and unlike the temple at Olympia which was built of limestone, the Parthenon was built of marble from the Athenian quarries on Mt. Pentele. The architect of the temple was Ictinus, but the artist who oversaw the project and made the great gold-and-ivory statue of Athena to stand inside it was Phidias. It was probably Phidias, too, who drew up the designs for the sculpture that decorated the temple: the sculptures that filled the pediments at the east and west ends, the relief sculptures that filled the metopes, and the frieze that ran around the whole of the cella—inner room of a Greek sanctuary or temple—wall inside the colonnade. An examination of the relief sculpture of the frieze shows that it was done by several hands. The same was probably true of the other sculptures, but much has been lost. In 1687, during one of the wars between the Venetians and the Turks, the Turkish garrison on the Acropolis was being besieged by the Venetians and a Venetian cannon lobbed a shell into the Parthenon. The Turks were using the Parthenon as a powder magazine, and the shell ignited an explosion that blew out the center of the temple. The pedimental sculptures affected by the explosion as well as some undamaged specimens were taken to England in the early nineteenth century before the Greek War of Independence by Lord Elgin, British ambassador to the Ottoman Empire which still ruled Greece. They are now in the British Museum and known as the "Elgin Marbles." There is no agreement about what the pediments of the Parthenon looked like before the explosion of 1687, for most of the sculpture is lost. The frieze is thought to represent the Panathenaic procession that was part of the festival of the Great Panathenaea, but even that is not completely certain. Also uncertain is what part Phidias played in carving the sculptures that do survive, if any, but at least it can be said with confidence that he was the presiding genius who drew up the designs that other stone carvers executed. Phidias' activity extended

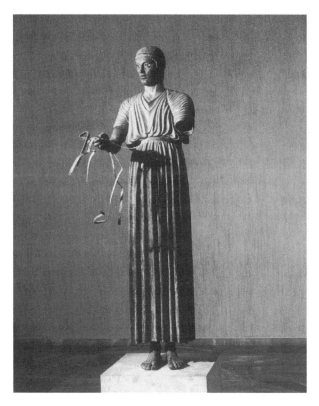

Bronze statue of a charioteer dressed in a long tunic, found at Delphi, dedicated by Polyzalus, tyrant of Gela in Sicily, to commemorate his victory in the chariot race at the Pythian Games in 478 or 474 B.C.E. © DAVID LEES/CORBIS.

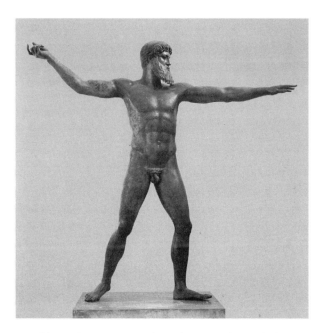

Over life-size bronze statue of Zeus hurling a thunderbolt, or possibly Poseidon throwing his trident, recovered off the coast at Cape Artemisium at the north tip of the island of Euboea, Greece, c. 460 B.C.E. THE ART ARCHIVE/NATIONAL ARCHAEOLOGICAL MUSEUM ATHENS/DAGLI ORTI.

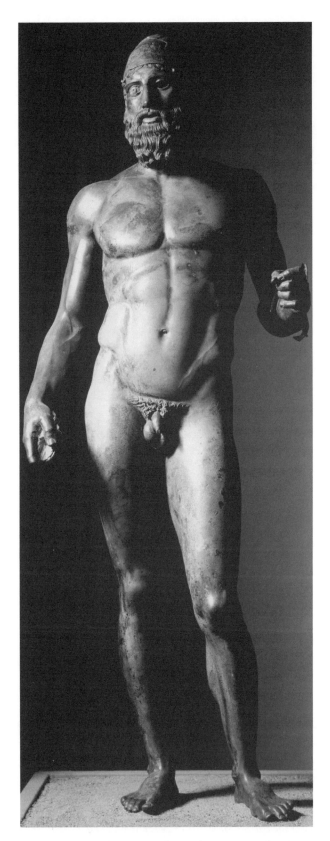

The Riace Warrior, a Greek bronze statue created c. 460–450 B.C.E., found in the sea off the coast of southern Italy at Riace Marina. © ARCHIVO ICONOGRAFIO, S.A./CORBIS.

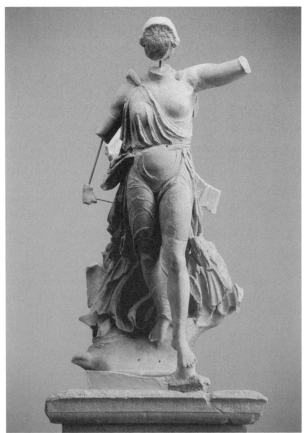

Front view of Nike of Paionios of Mende sculpture by Paionios. © ARCHIVO ICONOGRAFICO, S.A./CORBIS.

beyond Athens. In fact, he spent his last years in exile. From Athens he went to Olympia and made the gold-and-ivory statue of Zeus there; Olympia is also the site of the discovery of his workshop and the terracotta molds used to fashion the gold drapery of the statue, which was not pure gold as at Athens but gold inlaid with glass.

THE ARGIVE STYLE. Although Athens was the dominant center of art and literature in Greece from the mid-fifth century B.C.E. on, one other center retained its artistic independence: Argos and its neighbor Sicyon. While the Parthenon was being built in Athens, in Argos the workshop of the sculptor Polyclitus was perfecting its own idea of what the proper proportions of a male nude should be. Polyclitus also made statues of deities, and though he was primarily a bronze-caster, he made a chryselephantine statue of Hera for her temple at her holy site in the Argive countryside. Chryselephantine statues (from the Greek *khrysos* meaning "gold" and *elephantinos* meaning "ivory") were made of gold and ivory: the drapery was made of gold and the flesh of ivory, and the statue was supported on a wooden frame. They were considered the pinnacle of Greek sculpture. Polyclitus,

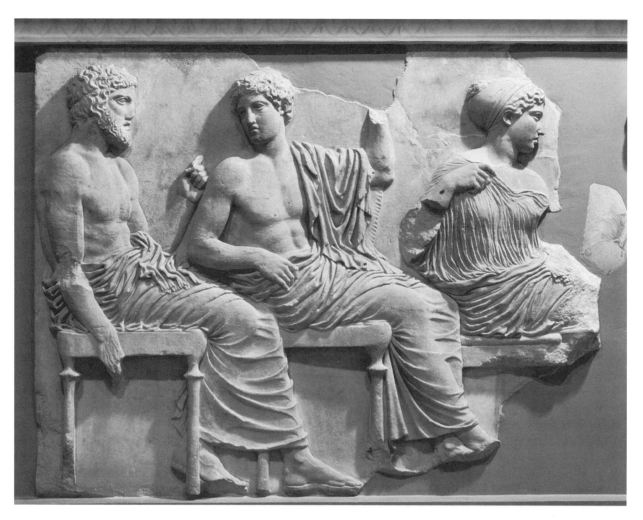

Poseidon, Apollo, and Artemis (left to right), marble relief sculpture fragment from the Parthenon east frieze, c. 445–438 B.C.E. © GI-ANNI DAGLI ORTI/CORBIS. REPRODUCED BY PERMISSION.

however, was especially known in the ancient world for his bronze statues of athletes, two of which survive as good Roman copies: the *Doryphoros* or "Spear-bearer," and the *Diadoumenos*, a youth adjusting his *diadema* or headband. These male nudes form the climax of the long development towards naturalistic form. Both statues portray arrested motion: the Spear-bearer, for instance, is in the midst of a step forward, with all his weight on his right leg and the musculature of his torso responds to the movement of the body. The right hip that supports the Spear-bearer's weight is slightly raised, and the left hip droops while the left shoulder is tensed and slightly raised to compensate for the weight of the spear that the Spear-bearer holds in his left hand. In these two nudes, Polyclitus achieved a balanced, harmonious, and naturalistic whole. He was particularly interested in proportion; in fact, he wrote a book on the proper proportions of the body titled the *Canon*. Polyclitus' *Canon* would be recycled in the Roman Empire for imperial statuary.

Statues from this era showed the emperors as military leaders wearing armor, but under the armor their physiques adhered closely to the proportions which Polyclitus set forth.

WIND-BLOWN DRAPERY. In the late fifth century B.C.E. sculptors turned their artistic energy to exploiting the wind-blown style of drapery which the sculptors of the Parthenon pediments had developed. Figures were portrayed as having cloaks blown by the wind. The drapery sometimes appears almost transparent as the wind presses it against the body, showing the anatomy underneath. The style stressed both elegance and technical virtuosity. One example of this style was found at Olympia, an original sculpture by the little-known sculptor Paionius of Mende, who carved a figure of *Nike* (the goddess of Victory) for a victory monument dating to about 420 B.C.E., erected by the Messenians at Naupactus to commemorate a defeat they had inflicted on

a PRIMARY SOURCE *document*

PHIDIAS' GOLD AND IVORY STATUE OF ZEUS AT OLYMPIA

INTRODUCTION: After Phidias finished his great statue of Athena for the Parthenon in Athens, he went to Elis which had the site of the Olympic Games within its territory, and there he made another great statue of gold and ivory for the new Temple of Zeus. The remains of Phidias' workshop have been discovered at Olympia—among the finds was a cup bearing Phidias' name—and the pottery found in the workshop can be securely dated to the late 430s and 420s B.C.E. This settles an old debate among archaeologists whether Phidias sculpted the statue of Athena Parthenos in Athens before or after he sculpted the statue of Zeus at Olympia. It is clear now that the making of Zeus came second. The passage quoted below comes from the *Geography* of Strabo (64 B.C.E.–circa 21 C.E.). Strabo visited Greece which he describes in books eight to ten of his *Geography*, and in the following excerpt he describes the impression which Phidias' statue of Zeus at Olympia made on him more than four centuries after it was made.

The greatest [of the offerings in the temple of Zeus at Olympia] was the image of Zeus, which Phidias, the son of Charmides, made of ivory, and which is of such great size that, though the temple is indeed one of the largest, the artist seems to have failed to take into account the question of proportion; for although he represented the god as seated, he almost touches the peak of the roof, and thus gives the impression that, if he were to stand upright, he would take the roof off the temple. Some authors have written down the measurements of the statue, and Callimachus mentioned it in one of his iambic poems. Panainos the painter, Phidias' own brother and his co-worker, was a great help to him in the decoration of the statue, especially the drapery, with colors. There are a good number of quite marvelous paintings on display around the sanctuary which are the work of that artist. And they recount this tradition about Phidias: when Panainos asked him what model he intended to employ in making the image of Zeus, he replied that it was the model provided by Homer in the following lines:

> Thus spoke the son of Cronus and nodded his dark brow and the ambrosial locks flowed down from the lord's immortal head, and he made great Olympus quake.

SOURCE: Strabo, *Geography*, in *The Art of Greece, 1400–31 B.C.: Sources and Documents*. Ed. J. J. Pollitt (Englewood Cliffs, N.J.: Prentice-Hall, 1965): 73.

the Spartans. Messenia was a region west of Sparta that the Spartans had subjugated in the early archaic period, reducing the Messenians to serfdom; the Messenians who erected this monument had escaped from the Spartan yoke and had been settled on the Gulf of Corinth at Naupactus by Athens. To mark the victory, they erected this victory monument at Olympia where all the Greeks who came to the Olympic Games could see it. The *Nike* of Paionius stood on a high triangular base some 9.14 meters (thirty feet) high before the front end of the Temple of Zeus. To viewers below, it looked as if the *Nike* was alighting on the pillar as the air swirled around her, pressing her *chiton* (tunic) against her body, while her *himation* (outer cloak) billowed out around her. The *himation* is now largely broken away, but it is still possible to appreciate the technical virtuosity which this statue displays. Battered though it is, this is a masterpiece of the "flying drapery style."

SCOPAS OF PAROS. Early fourth-century sculpture retained the artistic conceptions of the fifth. Figures stand with the same easy balance, their facial expressions have the same calm serenity, and the drapery is transparent though it is often combined with heavier, agitated folds. The fourth century did develop its own style, however, in introducing a more human quality. Poses became more sinuous, drapery was more naturalistic, and a dreamy gentleness appeared in the faces. Three sculptors dominated the period: Scopas of Paros, Praxiteles of Athens, and Lysippus of Sicyon. Of Scopas little remains to form a judgement of his art. He worked on three important monuments of the first half and middle of the fourth century B.C.E.: the temple of Athena Alea at Tegea, the temple of Artemis at Ephesus, and the great Mausoleum of Halicarnassus (modern Bodrum in Turkey). From the pediment of the temple at Tegea, some battered heads survive and they are arresting, with deep-set eyes that gaze upwards and furrowed brows. While they cannot be attributed with certainty to Scopas, he was the architect of the temple and these sculptures must have been approved by him at the very least. The sculptural remains from Halicarnassus and Ephesus add little to modern knowledge of Scopas although Roman copies do exist of one famous free-standing sculpture of Scopas, the so-called *Pothos* ("Yearning"). The statue is of a youth standing with crossed legs, leaning on a pillar, with a goose at his feet. He stands with raised

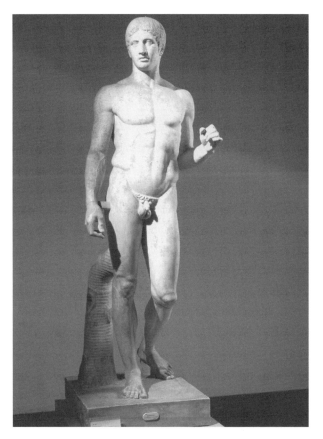

Copy of the "Doryphorus," or "Spear-bearer" from Greek original by Polyclitus of Argos, found at Pompeii. THE ART ARCHIVE/ARCHAEOLOGICAL MUSEUM NAPLES/DAGLI ORTI.

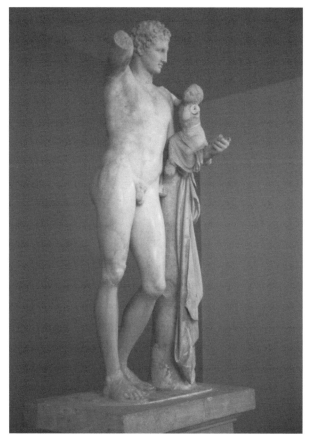

Statue of Hermes carrying the infant Dionysus, by Praxiteles. PHOTOGRAPH BY HECTOR WILLIAMS. © HECTOR WILLIAMS.

head, looking upwards with a melting gaze. The upward gaze seems to have been a mark of Scopas' sculpture.

PRAXITELES. The most famous work of Praxiteles was his statue of Aphrodite which he made about 370 B.C.E. for the Dorian city of Cnidus. It was extravagantly admired in its own day for its beauty and its daring, for it showed Aphrodite naked, one hand shielding her pudenda from the onlooker's gaze, and the other resting on a water jar (*loutrophoros*) with a towel draped over it—Aphrodite has been surprised as she was preparing for her bath, it appears. Many Roman copies of the statue have survived. The best example is in the Vatican Museum in Rome but even though it is a competent replica, it gives little idea of the statue's original appearance, when its paint was fresh. At Cnidus it was placed in an open shrine where it could be viewed from all sides. It is the first of a whole series of female figures, some nude, some partially clad, the most famous of which is the *Venus di Milo*, the Aphrodite found on the island of Melos which is now in the Louvre museum in Paris. Praxiteles worked in bronze, but he was at his best working in marble, which he knew how to polish to a finish that

represents the softness of female flesh. He was also a master of the tender gaze. A statue by Praxiteles was discovered during the archaeological excavations at Olympia, and though there has been a long debate as to whether it is a genuine Praxiteles or a later but very fine copy, the reasons for rejecting it as genuine are not convincing. This statue shows the god Hermes holding the infant Dionysus. Hermes holds the child with his left arm, and with his right he dangles a bunch of grapes. The right arm is broken, but other depictions of the statue show that Hermes is teasing Dionysus with a bunch of grapes and Dionysus recognizes his special fruit, infant though he is. Hermes' head is particularly fine, and the finish of the marble and the impressionistic method used to portray Hermes' hair are all marks of Praxiteles' style.

LYSIPPUS. Lysippus of Sicyon, who was active not long after 370 and was still at work in 312 B.C.E., marked the period of transition to the Hellenistic Age. When he was born, the city-states of Greece were squabbling in the aftermath of the Peloponnesian War that had ended in 404 B.C.E. with the defeat of Athens. When he died,

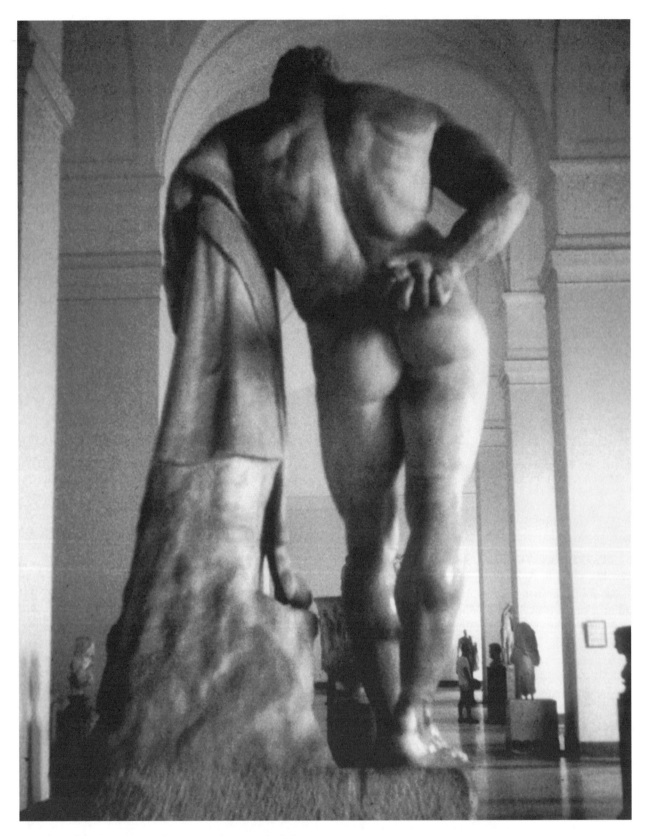

Rear view of the Farnese Heracles, a copy of a statue by Lysippus. COURTESY OF JAMES ALLAN EVANS.

Arts and Humanities Through the Eras: Ancient Greece and Rome (1200 B.C.E.–476 C.E.)

a PRIMARY SOURCE *document*

POLYCLITUS AND THE ARGIVE STYLE

INTRODUCTION: Polyclitus was a native of Argos, and a younger contemporary of Phidias. Thanks to him, the Peloponnesian tradition of sculpture, centered in Argos and its neighbor Sicyon, maintained its artistic independence from Athens in the fifth century B.C.E. when Athens became the cultural leader of Greece and absorbed the other local sculptural traditions. Like both Myron and Phidias, he is supposed to have been a pupil of Ageladas of Argos who was active in the 470s. The period of Polyclitus' activity as a sculptor stretched over the whole of the second half of the fifth century B.C.E. In the excerpt from Pliny the Elder's *Natural History* quoted below, Pliny makes two errors. First, the "Canon" which set out Polyclitus' prescription for the proportions of the male nude figure was not a separate statue. It was the *Doryphoros* or "Spearbearer," a muscular youth carrying a spear over his shoulder. It expressed what Polyclitus thought were the perfect proportions for the young man's body, and he drove home his point with a treatise on the subject titled the "Canon." Second, Polyclitus came from Argos, not Sicyon, but Sicyon, next door to Argos, succeeded Argos as the center for sculpture in the Peloponnesos in the fourth century B.C.E., and Pliny's error is understandable.

When Pliny quotes the opinion of the learned Roman Marcus Terentius Varro (116–27 B.C.E.) that Polyclitus' statues were "square," he probably means that they were squarely-built, which is more or less true.

Polyclitus of Sicyon, a disciple of Ageladas made a *Diadoumenos*, a soft-looking youth which is famous for having cost one hundred talents; and a *Doryphoros* [spear bearer], a virile looking boy. He also made a statue which artists call the "Canon" and from which they derive the basic forms of their art, as if from some kind of law; thus he alone of men is deemed to have rendered art itself a work of art. He also made a man scraping himself with a strigil, and a nude figure attacking with a javelin, and two boys, also nude, playing with knucklebones, who are called the *astragalizontes* [dice players] and are now in the Emperor Titus' atrium—a work that which, some claim, there is none more perfect. ... It was strictly his invention to have his statues throw their weight on one leg; Varro says, however, that they are "square" and almost all composed after the same pattern.

SOURCE: Pliny, *Natural History*, Book XXXIV, in *The Art of Greece, 1400-31 B.C.: Sources and Documents*. Ed. J. J. Pollitt (Englewood Cliffs, N.J.: Prentice-Hall, 1965): 88–89.

the Hellenistic Age had already begun, and Lysippus pioneered the new sculptural style. His workshop in Sicyon produced hundreds of statues—he is supposed to have turned out 1,500 works—but one was particularly famous: his *Apoxyomenos* or "Athlete Scraping Himself," referring to the process by which athletes removed the residue of the olive oil they rubbed on themselves prior to exercise. The *Apoxyomenos* broke with the tradition established by the *Canon* of Polyclitus that the head should be one-eighth the total height of the statue; the head of the *Apoxyomenos* is one-ninth the total height. Nor is the *Apoxyomenos* a "square" statue like Polyclitus' "Spear-bearer." Lysippus' statue constantly draws the viewer's eyes around the figure, for he has given it no clearly defined front, unlike the defined front and back approach of Polyclitus. The *Apoxyomenos* represents a figure in motion, caught in the act of shifting its weight from one leg to the other. Lysippus had absorbed what Polyclitus had to teach him, and moved forward.

THE FARNESE HERACLES. Heracles was a subject of interest to Lysippus. Lysippus did a miniature sculpture of the famous Greek hero that was much copied, showing Heracles sitting on a table, somewhat drunk and looking a little flabby. His most famous Heracles-figure, however, is the "Farnese Heracles" in the Naples Museum,

so called because it was once part of the collection belonging to the Farnese family in Rome. It is a marble copy of a bronze original by Lysippus, and the copyist has signed his name: Glycon of Athens. There is reason to suspect that the copy by Glycon gave Heracles a more exaggerated physique than the original to please his Roman customers, for there is a copy of the same statue in the Louvre in Paris where Heracles' muscles are less overwhelming, though he still has the appearance of a body builder. He is shown resting after completing the last of his legendary Twelve Labors: fetching the golden apples from the Garden of the Hesperides. He leans on his club, his gaze tilted down and towards the left. He is weary; his labor has exhausted him, for he is clearly no longer a young man. His face expresses utter fatigue. His right arm is tucked behind his back, and his right hand holds the three golden apples. Like the *Apoxyomenos*, the "Farnese Heracles" prompts the viewer to circle around it, and only upon seeing the apples is it possible to comprehend the cause of Heracles' fatigue. This is a good example of three-dimensional sculpture, a style that Lysippus pioneered.

SOURCES

John Boardman, *Greek Sculpture: The Classical Period* (London, England: Thames and Hudson, 1987).

———, *The Parthenon and Its Sculpture* (Austin: The University of Texas Press, 1985).

Rhys Carpenter, *The Esthetic Basis of Greek Art in the Fifth and Fourth Centuries* (Bloomington, Ind.: Indiana University Press, 1959).

———, *Greek Sculpture: A Critical Review* (Chicago: University of Chicago Press, 1960).

A. W. Lawrence, *Greek and Roman Sculpture*. Rev. ed. (London, England: Jonathan Cape, 1972).

Gisela M. A. Richter, *The Sculpture and Sculptors of the Greeks.* 4th ed. (New Haven, Conn.: Yale University Press, 1970).

Brunilde S. Ridgway, *Fifth-Century Style in Greek Sculpture* (Princeton, N.J.: Princeton University Press, 1981).

———, *Fourth-Century Styles in Greek Sculpture* (Madison, Wisc.: University of Wisconsin Press, 1997).

Brian A. Sparkes, "Greek Bronzes," *Greece and Rome* 34 (1987): 154–165.

THE HELLENISTIC PERIOD

BACKGROUND. The Hellenistic period spans the years from the death of Alexander the Great in 323 to 30 B.C.E., when Rome annexed the last independent Hellenistic kingdom, Egypt, which was ruled by a royal dynasty that was descended from one of Alexander's generals, Ptolemy. The year 30 B.C.E. does not mark a sharp break in the artistic tradition. Athens maintained its reputation as a center for the visual arts, but it was now only one of many. The world of the Greek artist expanded enormously. This period of artistic development was ushered in by Alexander's favorite sculptor Lysippus of Sicyon. He was not the first to portray figures in motion, but he was the first to make them fully three-dimensional. Yet there is a rational organization to their composition which Lysippus inherited from the classical age and passed on to his successors. Sculptors were fond of using a "pyramidal design," so-called because a pyramid can be drawn around the figures, enclosing them. Hardly less influential than Lysippus was Praxiteles, whose nude Aphrodite of Cnidus set the style for the female nude, a type which sculptors throughout the Hellenistic period exploited with even more flair and ingenuity than their classical predecessors had lavished on the male nude. Then about 240 B.C.E. a new style burst upon the artistic scene. The impression it conveys is almost baroque—to borrow a label that is applied to the grandly ornate art of southern Europe in the period 1550–1750 C.E. The Hellenistic "baroque" loved struggling figures in violent action, with muscles straining and bulging, and faces contorted with desperate striving or

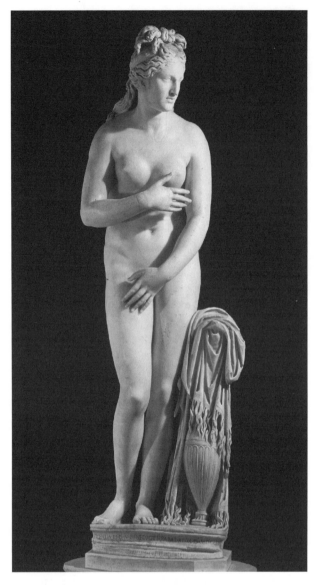

The Capitoline Venus in the Capitoline Museum in Rome. THE ART ARCHIVE/MUSEO CAPITOLINO ROME/DAGLI ORTI.

bitter anguish. The Roman presence, however, began to exert influence. In 197 B.C.E. Rome defeated Philip V, king of Macedon, and in 167 she dethroned the last king of Macedon, Perseus. By 146, Greece had become the Roman province of Achaea. The creative fire that had informed the visual arts of the Hellenistic period began to burn low following this domination by the Romans. Late Hellenistic sculpture returned to the styles of the classical Greece of the fifth century B.C.E., perhaps an artistic expression of the yearning for Greece's heyday. From the late second century B.C.E. on, a group of sculptors known as "Neo-Attic School" specialized in producing reliefs based on classical designs. Sculptors became increasingly satisfied to recall and imitate the

past. It was safe, unadventurous art, and it was what the market wanted. The baroque style continued into the first century C.E., but it was the taste and preferences of the market that dictated style. The sculptors catered to the tastes of their patrons, who were more and more the Romans, the new masters of the Mediterranean world, and the preference of the Augustan Age (27 B.C.E.–14 C.E.) was for Neo-Attic.

THE POPULARITY OF THE FEMALE NUDE. Praxiteles' famous Aphrodite of Cnidus set the style for the female nude and there were many variations on the theme. The subject is always Aphrodite, goddess of love and sexual desire. One variation, by an unknown sculptor, showed her either untying her sandal or putting it on again after taking a swim. Another famous nude, the Capitoline Venus, is simply a variation of the famous Aphrodite of Cnidus by Praxiteles. It exists in more than 100 copies, of which the best is in the Capitoline Museum in Rome. It shows Aphrodite naked; there is a tall water-jug called a *loutrophoros* beside her with a towel draped over it, and so she has presumably just taken a bath. Evidently she has been surprised, for one arm tries to hide her breasts and with her other arm she shields her pudenda. In spite of the enormous popularity of this statue, both the original statue and its creator are lost. One other experiment with the female nude in a different pose became a favorite ornament of the gardens and courtyards of great Roman houses, to judge from the number of Roman copies that have survived. The sculptor of the original, Doidalsas of Bithynia, worked in the mid-third century B.C.E., and the statue for which he is known shows a naked Aphrodite washing herself. She is shown in a crouching position, glancing over her right shoulder. Many copies have turned up in the region of Naples in Italy, which was dotted with villas in the heyday of the Roman Empire.

THE PARTIALLY-CLOTHED FEMALE NUDE. Both Praxiteles and Lysippus have a claim to be the first to produce a partially-clothed female nude. In 1651, in France, a statue of Aphrodite, without her arms, was found in an old cistern at Arles. The "Venus of Arles," as she is known, is now in the Louvre with arms restored by order of King Louis XIV. The statue shows Aphrodite with her garment slipping down over her hips far enough to give a glimpse of her groin. Her head turns to the left in a pose similar to the Hermes of Praxiteles found at Olympia, and the creator of this copy's original may have been a work of Praxiteles, too. The claim of Lysippus is based on the Aphrodite of Capua, a Roman copy found in the ruins of the Roman amphitheater in Capua north of Naples and now in the Naples Museum. Praxiteles,

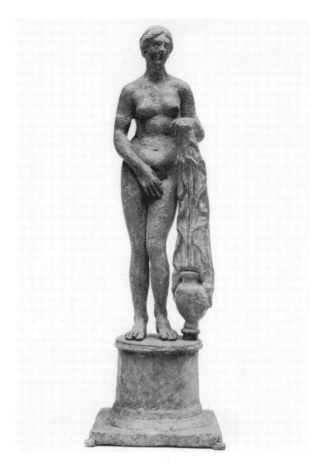

Aphrodite of Cnidus. REUNION DES MUSEES NATIONAUX/ART RESOURCE, NY.

Scopas, and Lysippus have all been suggested as the sculptor of the original, but Lysippus is the favorite. The most famous partially-clothed Aphrodite, however, is the *Venus di Milo*, now in the Louvre. It was found in 1820 on the island of Melos, one of the Cyclades archipelago, by a young French naval officer and a Greek farmer. Her arms are lost, but a hand holding an apple was found as well as the statue base, which identifies the sculptor. The first four letters of his name cannot be read with certainty, for the inscription is mutilated, but he was probably Alexandros of Antioch-on-the-Meander River in Asia Minor, to be distinguished from the more famous Antioch-on-the-Orontes River in Syria. The apple must be the "Apple of Discord" that started the legendary Trojan War. According to the myth, the goddess *Eris* (Discord) had not been invited to the wedding of Peleus and Thetis, the parents of Achilles, and avenged the slight by hurling a golden apple inscribed "For the fairest" among the guests. The goddesses Athena, Hera, and Aphrodite all claimed it, and they entreated the young Trojan prince, Paris, to judge which of them was the most beautiful and therefore the rightful owner of the apple.

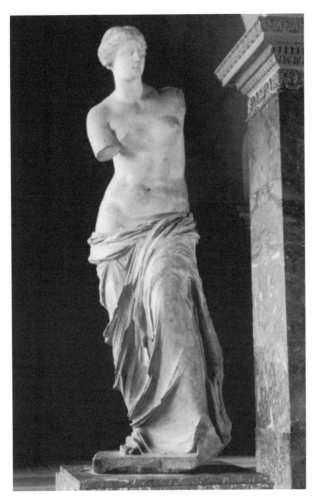

Venus de Milo, statue of Aphrodite found on the island of Melos in Greece, c. 100 B.C.E. AP/WIDE WORLD PHOTOS. REPRODUCED BY PERMISSION.

Samothrace, now in the Louvre in Paris, depicts the goddess Victory at the very moment when she alights on the bow of a ship. She was found in 1863 in the Sanctuary of the Great Gods on Samothrace in the northern Aegean Sea, and she was dedicated probably between 180 and 160 B.C.E. to commemorate a naval victory. The artist sculpted the Victory in the pure white marble from the quarries on the island of Paros, but for the prow of the ship he chose grey marble from Rhodes. The wind swirls round her as she alights, filling her wings like great sails, and blowing back her cloak so that it ripples around her body in great folds. Another military victory was celebrated with the Victory Monument of Attalus of Pergamum. In the first half of the third century B.C.E., Greece was menaced by Gallic invaders, who moved into Asia Minor where they pillaged and marauded, threatening the newly founded principality of Pergamum (modern Bergama in Turkey). Pergamum at first tried to buy them off, but reversed this policy in 241 B.C.E. when Attalus I became ruler of Pergamum. He refused any more payments to the Gauls and when they attacked, defeated them soundly. After the victory he took the title of king and set up a monument to commemorate his triumph. Although the original is long gone, there are some Roman copies. One shows a Gallic warrior in the act of killing himself after his defeat. With his right arm he thrusts his sword into the base of his throat, while with his left he holds the limp body of his wife whom he has already slain. Another shows a Gaul in the throes of death. He has sunk to the ground, but still props himself up with one arm. These tall, hard-muscled Gallic warriors would not be mistaken for Greeks. The sculptors have captured a difference between their nude male bodies and typical Greek physiques. Another monument that Attalus set up to advertise his triumph showed the same taste for the exotic. It showed battles against Gauls, Giants, Amazons, and Persians. Copies of the figures show what they looked like: a Persian lies dead, a Gaul is dying, a wounded Amazon slips from her horse. Attalus had the monument placed on the Athenian Acropolis, for though Athens no longer was a great power, it was still recognized as the cultural heartland of the Greek world.

Alexandros' statue portrays Paris' choice, Aphrodite, at the moment of her victory. One lost arm was outstretched and her hand held the apple, and her other hand probably held up her garment which is about to slip off her hips. There is more than a hint of suggestiveness to her pose. Yet the softness of her flesh and the subtle curves of her body have been masterfully rendered, and she is justly famous, though she is not a masterpiece of the classical period of Greek sculpture as art historians proclaimed a century ago. She was probably carved between 150 and 125 B.C.E.

HIGH HELLENISTIC "BAROQUE." About 240 B.C.E. sculptors began to portray figures in motion as statues radiated exuberant energy. Men portrayed in violent actions have muscles that ripple and swell. The new style was particularly conducive to the victory monuments that were erected to commemorate some military triumph. The famous Winged Victory of

THE GREAT ALTAR OF PERGAMUM. The superlative masterpiece of the baroque style is the frieze on the podium of the Great Altar built at Pergamum, erected about 165 B.C.E., and now partially reconstructed in the Berlin Museum. The frieze portrays the Battle of the Gods and Giants from Greek mythology which told how the supremacy of the Olympian gods was challenged by a race of vast creatures like Tityus whose immense mass covered

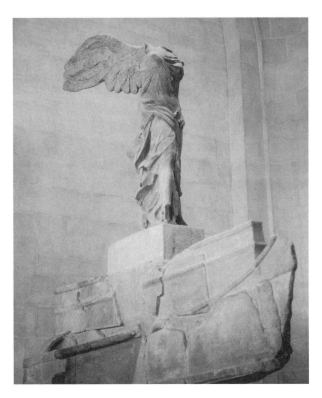

Nike (Victory) of Samothrace, showing her landing on the prow of a warship, found at Samothrace, early second century B.C.E. © PAUL ALMASY/CORBIS.

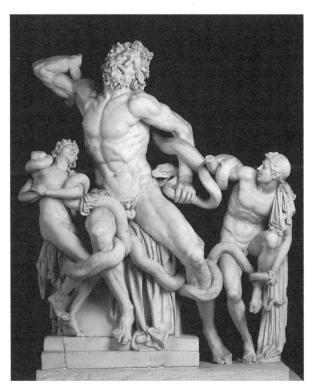

The Laocoon Group, Greek sculpture illustrating an episode from Vergil's *Aeneid*, Book II, Laocoon and his two sons wrestling with snakes. © ARALDO DE LUCA/CORBIS. REPRODUCED BY PERMISSION.

nine acres when he lay stretched out on the plain, and Enceladus whom all of Mt. Etna was needed to hold down. About one hundred over-life size figures carved in high relief are shown in violent struggle. Muscles strain and bulge, cloaks swirl, faces portray anguish. A dog bites a giant as he sinks to the ground, reminding the viewer of one of the greatest horrors of war, that the dead on the battlefield might be left unburied for dogs to devour. The central part of the west side, which the visitor would see first upon approaching the monument, shows Zeus and Athena in the thick of the fight. Zeus' cloak has slipped from his shoulder, revealing a heavily muscled torso, and on his left, Athena hurls a giant to the ground, his eyes turned heavenwards in mute appeal. The relief gives the general impression of a new, vigorous approach to sculpture, but a closer look reveals reminiscences of the classical past. The mute appeal on the face of the dying giant whom Athena kills is borrowed from Scopas. The relief on the central west side of Zeus and Athena reverses the composition used on the west pediment of the Parthenon, but the derivation is clear. The "Baroque" artists, like the other sculptors of the Hellenistic period, build upon the techniques and traditions of the classical past.

THE LAOCOON GROUP. The last king of Pergamum, Attalus III, willed his kingdom to Rome when he died in 133 B.C.E., and Pergamum became the Roman province of Asia, which was a notable example of Roman misrule in the following century. However, the High Hellenistic "Baroque" had another center of excellence: the island of Rhodes, where the style of the Great Altar frieze at Pergamum continued to flourish. The Laocoon Group, now in the Vatican Museum, dates from the early first century C.E. and is a good example of late Rhodian work. It is narrative art, and the story that it relates comes from Vergil's poem, the *Aeneid*, the national epic of the Roman Empire which described how the city of Troy supposedly fell to the Greeks. In the story, the siege of Troy by the Greeks had lasted ten long years, and, unable to penetrate the city walls, the Greeks devised a scheme to trick the Trojans into letting them into the city. They constructed a large wooden horse and hid a group of Greek warriors in its belly. They then left it at the city gates, supposedly as an offering to the gods, and pretended to depart, as if they had given up the siege. The Trojans, thinking that the siege was over at last, decided to bring the horse within the city walls as part of a celebration. The Trojan priest Laocoon was the lone voice

of warning against bringing the horse into the city, rightly fearing that it was a trap set by the Greeks to gain access to Troy. As Laocoon made his case to his fellow Trojans, however, two great serpents emerged from the sea and wound their coils around him and his two sons. The Trojans took Laocoon's horrible death as a token of divine anger, and decided to bring the horse into their city, thus sealing their doom. The statue group shows Laocoon and his sons struggling in vain against the serpents, one of which sinks its fangs into Laocoon's thigh. Laocoon's face expresses anguish and despair. He is losing the struggle and he knows it. One of his sons is already dead; the other is still fighting to disentangle himself. The coils of the serpents bind the three figures together into an artistic whole. The statue group was found above the ruins of the Golden House of Nero in 1506, and among the spectators who witnessed the excavation was the great Michelangelo. Unfortunately we cannot be certain that this statue group is an original rather than a copy. According to the Roman historian Pliny the Elder who described this statue, the original was made by three Rhodian sculptors—Hagesandrus, Polydorus, and Athanadorus—from a single block of marble whereas the existing Laocoon is made of seven or eight pieces fitted together. That would seem to indicate that the "Laocoon Group" in the Vatican Museum is a copy, but Pliny is not infallible, and whether it is a copy or not, it is a masterpiece of the baroque style.

THE SCULPTURES FROM SPERLONGA. In 1957, at Sperlonga on the west coast of Italy some sixty miles south of Rome, a cave was found that once belonged to a villa of the emperor Tiberius (14–37 C.E.). What was remarkable about the cave were the statues found there. An inscription was found that gives the names of the sculptors: Hagesandrus, Polydorus, and Athanadorus—the Rhodian sculptors who carved the Laocoon group. The find dates these sculptors firmly in the early first century C.E.; they had previously been dated at least a century earlier. The sculptures show incidents from Homer's *Odyssey*; one group shows the blinding of the Cyclops Polyphemus, another shows the monster Scylla attacking Odysseus' ship. This is theatrical sculpture in the best traditions of High Hellenistic Baroque. The face of Odysseus bears an expression of apprehension mixed with resolve; as a portrayal of feeling it is comparable to Laocoon's face and is utterly different from the calm, unemotional expressions found in the classical sculpture of the fifth century B.C.E. The creative fire of the Hellenistic artistic tradition may have been burning low by the first century C.E., but the finds at Sperlonga show that it could still produce a masterpiece.

THE LATE HELLENISTIC PERIOD: A RETURN TO ATTIC STYLE. By the second half of the second century B.C.E., it was clear that there was no hope for Greek independence. In 146 B.C.E., Greece became the Roman province of Achaea. In 133 B.C.E., Pergamum fell under Roman rule. Huge numbers of Greek works of art were taken as spoils of war to Rome, and along with Greece's subjection to Roman rule there seems to be a decline in artistic creativity. Rome provided a market for copies of Greek masterpieces that adorned the houses and country villas of the wealthy classes, and sculptors honed their skills by making replicas. Many Greek sculptors went to Rome to find work, making it increasingly hard to disentangle Greek from Roman sculpture. The lack of development is not due altogether to a failure of inspiration, but rather to the fact that Greek artists, who now saw their world subject to a foreign empire, salved their pride by looking backwards to the heyday of Greece. The same feeling can also be detected in the Greek literature of the period. It is these classicizing Greek masters of the Late Hellenistic period who provide the artistic vocabulary for the Rome of the emperor Augustus.

THE "NEO-ATTIC" IDIOM. The hallmark of this Late Hellenistic style known as "Neo-Attic" is its recycling of the idioms of the classical period—the century when Athens dominated the artistic world of Greece. It was the poses, the modeling, and the features of Attic (that is, Athenian, for Attica was the territory of Athens) sculpture that made up these idioms. The *Venus di Milo* is a successful example of Neo-Attic style. No single part of her is original, but the sculptor Alexandros combined his various borrowings into a harmonious whole. Much less successful is a statue group of Orestes and Electra that apparently once adorned the Roman meat market in Pozzuoli, ancient Puteoli on the western outskirts of Naples. Orestes is a standard male nude of the fourth century B.C.E., and his sister Electra, standing beside him with an arm over his shoulder, is a standard clothed female figure with transparent drapery of the last quarter of the fifth century B.C.E. It is an uninspired work, which shows how perfunctory "Neo-Attic" style could become when art was treated as mere decoration.

SOURCES

Margarete Bieber, *The Sculpture of the Hellenistic Age.* Rev. ed. (New York: Columbia University Press, 1961).

Richard Brilliant, *My Laocoon: Alternative Claims in the Interpretation of Artworks* (Berkeley: University of California Press, 2000).

Greg Curtis, *Disarmed: The Story of the Venus di Milo* (New York: Alfred A. Knopf, 2003).

G. Dickens, *Hellenistic Sculpture* (Oxford, England: Oxford University Press, 1920).

Christine Mitchell Havelock, *Hellenistic Art; The Art of the Classical World from the Death of Alexander the Great to the Battle of Actium* (Greenwich, Conn.: New York Graphic Society, 1968).

A. W. Lawrence, *Later Greek Sculpture and Its Influence on East and West* (New York: Hacker Books, 1969).

Brunilde Sisimondo Ridgway, *Hellenistic Sculpture: The Styles of ca. 331–200 B.C.* (Madison, Wisc.: University of Wisconsin Press, 1990).

R. R. R. Smith, *Hellenistic Sculpture: A Handbook* (London, England: Thames and Hudson, 1991).

ROMAN SCULPTURE

THE ETRUSCAN INFLUENCE. Roman sculpture has its roots in Etruria, an ancient country north of Rome. According to tradition, the Etruscans were immigrants from Asia Minor who migrated to Italy, perhaps during the general meltdown at the end of the Bronze Age, in the years following 1200 B.C.E. Once they arrived, they established themselves as a ruling class that exploited the resources of one of the richest regions of Italy. Etruria was an important export market for Greek vases, and Greek artisans worked in its cities for Etruscan patrons. One such colony of Greek craftsmen existed in Caere (modern Cerveteri, north of Rome), where there is still a large Etruscan necropolis. The paintings in the Etruscan underground tombs at Tarquinia were probably done by Greek artisans, though the taste is Etruscan. Rome's last three kings were Etruscan; the last of them, Tarquin the Proud, who was expelled in 510 B.C.E., built a great temple for the triad of gods, Jupiter, Minerva, and Juno on the Capitoline Hill in Etruscan style. As a model for all future Roman temples, it stood on a raised podium and was decorated with painted terracotta moldings. The cult statue of Jupiter was made of terracotta by an Etruscan sculptor from Veii named Vulca. A surviving terracotta statue from the school of Vulca was found in the ruins of Veii and now stands in the Villa Giulia museum in Rome. The so-called Apollo of Veii originally looked down from the ridgepole of an Etruscan temple. It has the "archaic smile" of the Greek *kouroi* (nude male statues), but it has little of the quiet serenity of archaic Greek sculpture.

EARLY SCULPTURE IN ROME. Etruscan influence continued in Rome after the Etruscan kings were driven

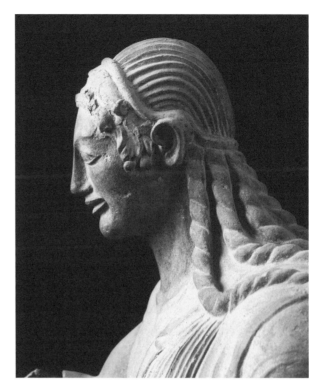

The Apollo of Veii, the head shown in profile of this terracotta Etruscan statue found at Veii. © ARALDO DE LUCA/CORBIS. REPRODUCED BY PERMISSION.

out, and Etruscan sculptors continued to work there. One monument that survived from this early period is a bronze she-wolf of about 500 B.C.E. In the Renaissance period, two infants were added, suckling her teats. The addition clearly identified this wolf with the legendary wolf that suckled Rome's legendary founders, Romulus and Remus, as infants, but it is not clear whether the original statue should be connected with the legend or not. The Etruscan influence on Rome faded, however, as Rome's conquests brought Greece into the empire. A turning point came in 211 B.C.E. while Rome was fighting a desperate war with the Carthaginians who were led by a general of genius, Hannibal. That year the city of Syracuse, which had sided with the Carthaginians, fell to Marcellus, the proconsul commanding the Roman army that was operating in Sicily. Syracuse was a great Greek city filled with works of art, and a share of the art travelled back to Rome as spoils of war. They made a strong impression on the Roman elite, who clamored for more Greek art. In the second century B.C.E., when Rome conquered Greece, there was ample opportunity for more looting. In 146 B.C.E. Rome destroyed Corinth, and the commander, Lucius Mummius, sent shiploads of art works to Rome, saying as he did so that if these cargoes were lost at sea, there were more where they came

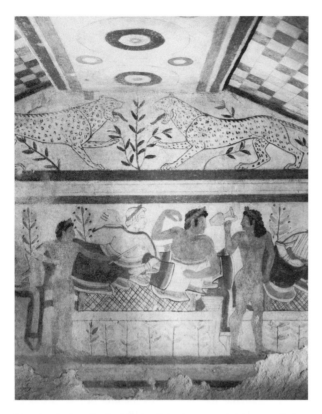

Mural paintings in the Tomb of the Leopards in Etruscan, Italy, detail showing banquet scene with young musicians and/or servants, heraldic leopards and geometric patterned ceilings above. © ARCHIVO ICONOGRAFICO, S.A./CORBIS. REPRODUCED BY PERMISSION.

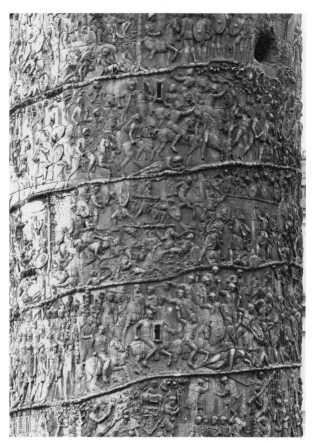

Column of Trajan in Rome: detail showing his wars against the Dacians in modern Romania. The sculpture in low relief spirals around the column. ALINARI-ART REFERENCE/ART RESOURCE, NY. REPRODUCED BY PERMISSION.

from. Yet the number of masterpieces was limited, and so a flourishing industry arose in Greece of copying sculptures in marble for the Roman market. The skill of the copyists varied, and though the sculptors knew how to make exact replicas, it is clear that they sometimes varied the originals. Yet without these Roman copies modern understanding of Greek sculpture would be greatly diminished.

AUGUSTAN CLASSICISM. The emperor Augustus (r. 27 B.C.E.–14 C.E.), the heir of Julius Caesar, made himself master of the Roman world only after a hard-fought civil war. First he had to suppress Caesar's assassins, Brutus and Cassius, who had mustered armies in the east. He destroyed them in a battle fought in 42 B.C.E. at Philippi in northern Greece. Then he had to suppress a more dangerous rival, Mark Antony, defeating him at the Battle of Actium in 31 B.C.E. After finally achieving peace, Augustus was determined to give the empire a capital worthy of its position as mistress of the Mediterranean world. He turned to the art of classical Greece to accomplish this goal. His artists revived the *Canon* of Polyclitus, a classical treatise on the proper proportions

for sculpture, in creating statues of Augustus. Indeed, a comparison between the so-called "Prima Porta" statue of Augustus, found at the villa of his wife Livia a short distance north of Rome, with the *Doryphoros* (Spearbearer) of Polyclitus reveals some startling similarities. The statues have the same tilt of the head, and the same treatment of the hair. While Augustus has some individual features, such as his high cheekbones and the hint of resolution to his brow, his physique adheres to the proportions which Polyclitus set forth in his *Canon.* The statue is a copy of an original statue of the emperor conceived about 27 B.C.E., the year that the senate conferred on him the title "Augustus," meaning "the revered one." The statue of Caesar Augustus is an idealized version of the man as a celebration of his new title. Augustus harnessed the art of Greece for his political purposes. The aesthetic value of the "Prima Porta" Augustus cannot have greatly interested the sculptor who carved it or Augustus' wife Livia, who was probably the person that commissioned it, for its rear is only roughly finished. Af-

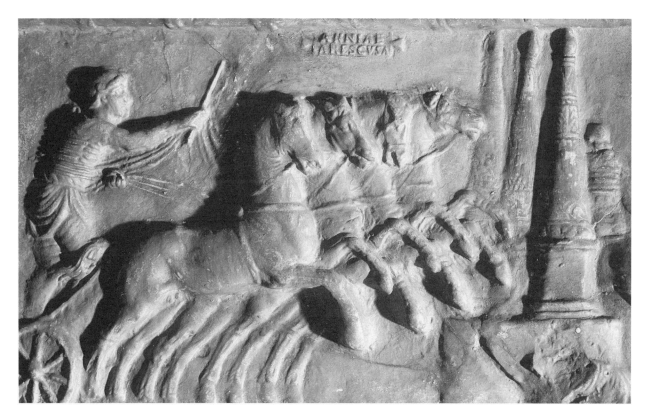

Roman terracotta relief showing a four-horse chariot race in a Hippodrome. THE ART ARCHIVE/MUSEO DELLA CIVILTA ROMANA ROME/DAGLI ORTI.

ter all, no one could see it, for the statue was intended to stand against a wall.

THE ALTAR OF PEACE. In 9 B.C.E., the Roman senate dedicated the *Ara Pacis* (Altar of Peace) on the *Campus Martius* (Field of Mars) in Rome to commemorate the safe return of Caesar Augustus from his campaigns in Gaul and Spain. It was a modest monument, reproducing the proportions of the Altar of the Twelve Gods which stood in the marketplace of Athens. It was adorned with reliefs, which are the most important features that survive of Augustan sculpture. Some of the reliefs portray the sacrifice that took place at the ceremony of dedication on 30 January 9 B.C.E. The panels on the north and south of the altar show a procession of the imperial family and court; the portraits are sufficiently realistic that most can be identified. On the east and west sides there are panels representing mythological scenes. One shows Aeneas, whom Augustus claimed as an ancestor, making sacrifice. But the most arresting of all is a panel on the outside of the altar enclosure that shows a goddess holding two infants. Various fruits are on her lap, and a child offers her one in his small hand. At her feet a cow rests, and a sheep grazes. The identity of the goddess is unknown. Some scholars believe her to represent

"Peace," while others claim she is "Mother Earth," or perhaps Venus, the mother of Aeneas and hence the progenitor of the Julian family. Whatever her identity, she adheres to the artistic traditions of classical Greece. Her *stola*, the proper dress of a Roman matron, clings to her body, revealing her breasts and even her navel underneath. It reproduces the transparent drapery of Greek sculpture of the 420s B.C.E., such as the Flying Victory of Painonius of Mende, except that in the *Ara Pacis* relief there is no wind. Yet the message is clear enough. The goddess, whoever she is, is bringing the fruits of peace, and of law and order, to the Roman Empire. This, proclaims the relief, was the achievement of Caesar Augustus.

HISTORICAL RELIEFS. In one category of relief sculpture, the Romans could claim a degree of originality: the relief that narrated an historical event. The Arch of Titus in the Roman Forum commemorates the suppression of the revolt in Judaea that broke out in 66 C.E. Titus, who took over command of the Roman forces in Judaea from his father Vespasian, captured Jerusalem and then returned to Rome with his spoils to celebrate a Roman Triumph. In the triumphal ceremony, the victorious general paraded his captives and his spoils

Relief sculpture from the Altar of Peace in Rome, with the goddess Peace shown as Mother Earth, surrounded by symbols of the abundance that peace brings. COURTESY OF JAMES ALLAN EVANS.

through the streets of Rome, through the Roman Forum along the "Sacred Way" and up to the temple of Jupiter on the Capitoline Hill where he laid down his command. Inside the arch there are two great panels which portray the triumph: one shows the exhibition of the spoils, which include the seven-branched candlestick from the Temple in Jerusalem, and the other shows Titus himself in his triumphal chariot. There are two other great monuments in Rome that use continuous narration: the columns of Trajan and of Marcus Aurelius. Trajan, emperor from 98–117 C.E., added Dacia (modern Rumania) to the empire, and his column shows the campaigns that he waged to conquer Dacia. The story unfolds in a spiral scroll that runs from the bottom to the top of the column, where there perched a statue of the emperor himself. The episodes run into each other without obvious breaks. The column of Marcus Aurelius (161–180 C.E.) takes its inspiration from the column of Trajan. The "continuous narrative" frieze spirals up the column, but there is less attention to the factual recording of details. The nature of Marcus Aurelius' campaigns may account for the difference. Trajan's military operations resulted in an addition to the empire, whereas Mar-

cus Aurelius was fighting to hold back barbarian attacks across the Roman frontier. The emphasis of his relief sculpture is more on the hardships and cruelty of war.

THE APPEARANCE OF THE FRONTAL POSE. In the third century C.E., the frontal pose appeared in sculpture as a way of emphasizing the isolation of the emperor. Frontal poses were borrowed from Middle Eastern art; the first examples that we have come from the site of Dura-Europus on the Euphrates River, which was destroyed and abandoned in 257 C.E. Naturalism in sculpture was in full retreat in the third century, and the tendency became more marked in the fourth century. The base of an Egyptian obelisk erected by the emperor Theodosius I (379–395 C.E.) in the Hippodrome at Constantinople is a dramatic illustration of the portrayal of the emperor in the art of late antiquity. Theodosius and the imperial family sit in the imperial loge in the Hippodrome. On either side are senators and court officials. All face the onlooker. Below the imperial loge are various barbarians, recognizable by their dress. They kneel and offer tribute. Even as the empire was growing more ramshackle, the message of Roman sculpture in-

sisted that the emperor was the fount of Roman peace and prosperity.

SOURCES

Richard Brilliant, *Visual Narratives: Storytelling in Etruscan and Roman Art* (Ithaca, N.Y.: Cornell University Press, 1984).

Peter Brown, *The World of Late Antiquity, from Marcus Aurelius to Muhammad* (London, England: Thames and Hudson, 1971).

Glenys Davies, "Roman Sculpture," in *The Oxford Companion to Classical Civilization.* Ed. Simon Hornblower and Antony Spawforth (Oxford, England; New York: Oxford University Press, 1998): 651–653.

Niels Hannestad, *Roman Art and Imperial Policy* (Aarhus: Aarhus University Press, 1986).

Diana E. Kleiner, *Roman Sculpture* (New Haven, Conn.: Yale University Press, 1992).

Hans Peter L'Orange, *The Roman Empire: Art Forms and Civic Life* (New York: Rizzoli, 1985).

Nigel J. Spivey, *Etruscan Art* (London, England: Thames and Hudson, 1997).

Eugénie Strong, *Roman Sculpture from Augustus to Constantine* (London, England: Duckworth, 1907).

Paul Zanker, *The Power of Images in the Age of Augustus.* Trans. Alan Shapiro (Ann Arbor, Mich.: University of Michigan Press, 1988).

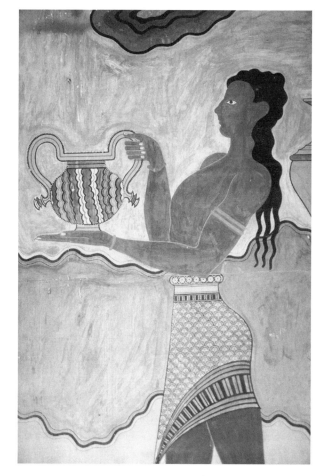

"Man Carrying a Vessel in a Procession," Minoan wall painting, c. 1400 B.C.E. © WOLFGANG KAEHLER/CORBIS. REPRODUCED BY PERMISSION.

GREEK PAINTING

WALL PAINTING IN THE MINOAN PERIOD. Greek wall painting has its roots in the prehistoric civilization on the island of Crete during what is known as the Minoan Period. The excavations of Sir Arthur Evans at Knossos on Crete at the start of the twentieth century revealed not only a great, sprawling palace, but they also turned up fragments of wall paintings. Reconstructing them was a painstaking process, but the results can be seen in the Heraklion Museum on Crete. The most impressive of the murals that Evans found was one that showed toreadors leaping over the back of a charging bull. Since then, fragments of frescos have been found at other sites on Crete and some of the Cyclades Islands as well. Also in the early 1900s, a house belonging to a Minoan settler was uncovered on the island of Melos, and among the finds was a naturalistic painting of flying fish. In the 1980s, Austrian archaeologists discovered a palatial complex at Tell el-Daba (ancient Avaris in Egypt), which was the capital of the Hyksos who invaded Egypt in the period between the Middle and New Kingdom and were driven out by the founder of the New Kingdom, the pharaoh Ahmose. In it were fragments of Minoan mural paintings, including one showing bull-leapers against a background that shows a maze. The most startling finds, however, have emerged since 1967 from Akrotiri on the island of Thera, where a Minoan town was buried by the eruption of the Thera volcano that preserved houses to their second and even their third story. The eruption is dated by scientists to 1628 B.C.E., for it must have spewed enough ash and pumice into the atmosphere to block the rays of the sun, producing abnormally low temperatures for a year or two. By examining tree rings for signs of retarded growth and ice cores from Greenland for layers of peak acidity, the date can be pinpointed with a degree of confidence, even though the pottery found at Akrotiri would indicate a date about a generation later. Akrotiri produced the earliest surviving Minoan paintings, as well as those that are best preserved.

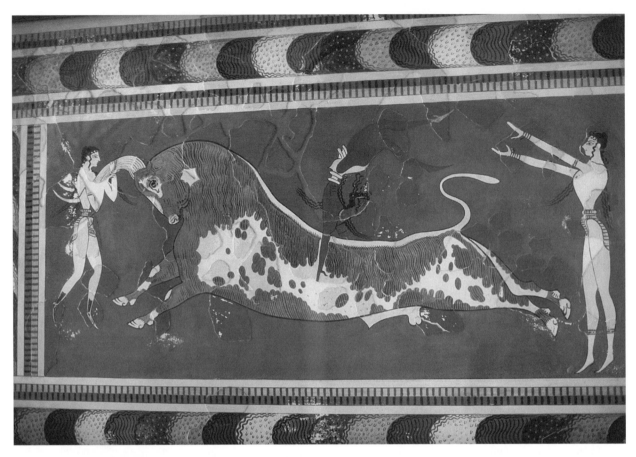

Toreador Fresco, from the Minoan Palace at Knossos, Crete, c. 1500 B.C.E. A young man somersaults over the back of a charging bull while a girl in front grasps his horns and another girl stands with arms outstretched at his rear. © WOLFGANG KAEHLER/CORBIS. REPRODUCED BY PERMISSION.

THREE CLASSES OF MINOAN MURALS. Minoan wall paintings—known also as frescoes—fall into three major classes, yet due to their often overlapping styles, it is often difficult to establish any direct line of development between the classes. The first class deals with the world of nature. These frescoes show flowers and other plants, animals, birds, and sea creatures. Human figures are usually not present. The second class shows human figures of both men and women, on a large scale. Female figures seem to predominate, and they are dressed in the fashions of the Knossos court, but it is not always clear whether they are priestesses or ordinary women dressed for a festival. The third group is the miniature frescoes that feature small human figures in a landscape or architectural setting. Assigning dates to these frescoes is not easy, and without dates it is hard to trace any development. Obviously the paintings found at Akrotiri must date before the eruption of the volcano that buried the Minoan town, but elsewhere dates are much less approximate. The famous fresco showing a life-size charging bull and toreadors is part of a stucco relief of charging bulls from the north entrance of the palace at Knossos and is assumed to have been created relatively late in the Minoan period. Yet it is a thoroughly Minoan painting belonging to the second class, even if it belongs to the years shortly before the palace was taken over by Greek-speaking invaders from the Greek mainland.

THE PAINTINGS FROM AKROTIRI. The finds at Akrotiri have added immensely to modern knowledge of Minoan painting. Not only are the paintings well preserved, but they are securely dated before the eruption of the Thera volcano, during the New Palace period on Crete. There are examples of all three classes of painting. The world of nature is represented by a mural in a house labelled the "House of the Ladies" which shows papyrus plants. Since papyrus does not grow on Thera or Crete, the presence of the plant in Minoan art indicates Egyptian influence. A fresco from a shrine portraying a garden with stylized rocks and naturalistic lilies is another example. The second class is represented by a mural of two boys boxing, and another of a naked

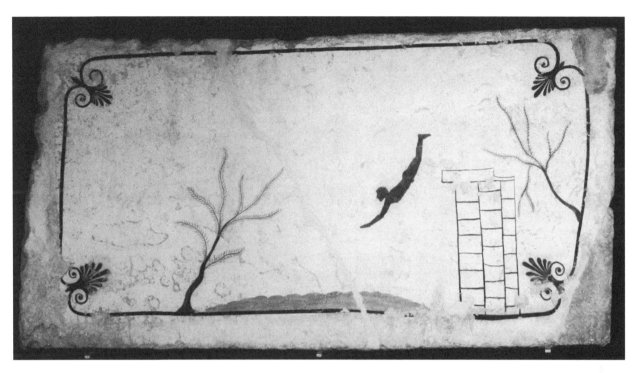

A panel from a Greek tomb found at Paestum, Italy, c. 480 B.C.E., showing a young man diving, perhaps symbolizing his departure from life to the realm of the dead in the Underworld. © VANNI ARCHIVE/CORBIS.

fisherman holding his catch of fish in both his hands. The Miniature Style is represented by a remarkable fresco of a ship from the so-called "West House" at Akrotiri. It is a frieze about 43 centimeters (seventeen inches) high running around the top of at least three walls of a room. It shows a flotilla of ships being paddled between two ports. It seems to be an example of narrative art, perhaps of a naval campaign, but it is impossible to know for sure.

MYCENAEAN PAINTING. On mainland Greece the Mycenaean civilization, a Greek-speaking peoples, flourished between 1600 and 1200 B.C.E. Mycenaean wall painting is a continuation of Minoan painting, but it is not easy to attach dates to the surviving evidence. Recent excavations at Thebes in central Greece, the city of the legendary King Oedipus, have revealed remains of two successive palaces, and in the earlier of the two, archaeologists found fragments of a fresco showing a procession of women dated to the fourteenth century B.C.E. At Mycenae, houses outside the citadel walls yielded fragments of frescoes that might be dated equally early. But nothing on the mainland is as early as the frescoes found on the island of Thera. Most of what has been found dates to the last century of the Mycenaean civilization.

FAVORITE SUBJECTS. A procession of women, life-sized and wearing the typical Minoan dress consisting of a tight bodice, bare breasts, and flounced skirt, is one of the most common themes of Mycenaean murals. Each woman bears an offering, and they move from left to right, making their way probably towards a goddess. There are also battle scenes; at Pylos there were enigmatic battle scenes showing duels between Mycenaeans equipped with short swords, daggers, and helmets made from the tusks of boars, and adversaries wearing animal skins knotted over the shoulder. A painted mural at Mycenae showing scenes of battle ran around the four walls of the main room of the Mycenaean palace, the "megaron," with a hearth in the middle. There were also hunting scenes, including one of a boar hunt from the palace at Tiryns, where the boar is portrayed running in a flying gallop, pursued by hunting dogs that leap on his back. A shield fresco showing figure-eight shields was found at Tiryns, better preserved than the similar figure-eight shield fresco found at Knossos by Sir Arthur Evans. On the whole, the subjects of the paintings seem to reflect a more martial society than on Crete; hunt-scenes and battle-scenes were apparently more attractive. Other murals do indicate the presence of varied interests, however. The Throne Room in the palace at Pylos had a mural of a black man playing a lyre. From a house at Mycenae built after 1400 B.C.E. outside the citadel,

a PRIMARY SOURCE *document*

THE "PAINTED STOA" IN ATHENS

INTRODUCTION: The "Painted Stoa" was a colonnade on the south side of the Athenian marketplace which got its name because it displayed on its back wall four paintings, one of the Battle of Oenoë by an unknown artist, and the others by Polygnotus, Micon, and Panainus. The pictures were not painted directly on the wall, but on wooden panels affixed to it, which could be removed. Pausanias, the Greek traveler of the second century C.E., visited Athens and left the following description of them.

This stoa contains first a scene with the Athenians drawn up against the Lacedaemonians at Oenoë in the territory of Argos. The painting does not show the climax of the struggle, nor has the action gotten to the point where there is already a display of valorous deeds, but rather the battle is just beginning and they are still in the process of coming to grips. On the middle wall the Athenians and Theseus are shown fighting the Amazons [painted by Micon]. Among these women alone, it would seem, defeats did not rob them of their recklessness in the face of danger, since Themiscyras was seized by Heracles, and later, their army, which they sent to Athens, was destroyed but in spite of all that they came to Troy to fight against the Athenians and all the other Greeks as

well. After the Amazons come the Greeks who have taken Troy, and also the kings who have gathered together on account of the outrageous act of Ajax against Cassandra [painted by Polygnotus]. The painting includes Ajax himself and also Cassandra and other captive women. The final part of the painting represents those who fought at Marathon [painted by Mikon and Panainus]. The Boeotians who inhabit Plataea and the Attic force are coming to grips with the barbarians. In this section, the struggle is an equal match. In the center of the battle, however, the barbarians are fleeing and pushing one another into the marsh, and at the borders of the painting there are Phoenician ships and Greeks slaying those of the barbarians who are climbing into them. Here too there is a portrait of the hero Marathon, after whom the plain is named. Theseus is represented as rising out of the earth, and Athena and Heracles are also here. For Heracles was decreed to be a god first by the Marathonians, as they themselves say. Of the combatants the most conspicuous in the painting are Callimachus who was chosen by the Athenians to be the supreme commander, and, of the other generals, Miltiades, and also the hero who is named Echettos.

SOURCE: Pausanias, *Pausanias*, Book I, 15, 1, in *The Art of Greece, 1400-31 B.C.: Sources and Documents*. Ed. J. J. Pollitt (Englewood Cliffs, N.J.: Prentice-Hall, 1965): 108.

fresco fragments depict toreadors and bulls. This fresco may have been painted by a Minoan artist who had emigrated from Crete to mainland Greece, and it does not prove that bull-leaping was a sport that was popular in the Mycenaean world, though it does indicate some interest in it. When the Mycenaean palaces fell at the start of the Greek Dark Ages in 1100 B.C.E., the art of fresco painting perished with them.

THE REVIVAL OF GREEK PAINTING. Painting revived in the early archaic period of Greece, but except for vase painting the evidence is mostly literary. Only one well-preserved example of painting dating earlier than 600 B.C.E. survived: a terracotta plaque from a temple at Thermon in north-west Greece which portrays the hero Perseus fleeing with the head of the Gorgon, Medusa, under his arm. The Etruscan tomb paintings found in Italy seem to have been done by Greeks for Etruscan customers, however; they are therefore the products of Greek journeymen who traveled to Etruria (modern Tuscany north of Rome) to find work as early as the start of the sixth century B.C.E. A painted wooden votive plaque has been discovered in Greece, at Pitsa near

Corinth, which dates about 530 B.C.E. It shows a family making sacrifice. A man is apparently pouring wine on the altar, and a boy wearing a garland has brought up a sheep to be sacrificed, while two flautists and a lyre-player supply music and two women look on, holding laurel branches in their hands. It is a colorful composition, rather like the polychrome vases which Corinthian potters were producing at the time. The next evidence dates to about 470 B.C.E.: a painted tomb from Poseidonia, a Greek colony in Italy south of Naples, now known as Paestum. It is a small tomb with paintings of banqueters reclining on couches along the sides of the interior, and on the ceiling a picture of a youth diving from a high scaffolding. The painting was not meant for public viewing and it is impossible to interpret its message. In the history of the visual arts, it is important because Greek painting on media other than pottery is exceedingly rare.

THE GREAT PAINTERS: POLYGNOTUS AND MICON. For the works of the great Greek painters, modern scholarship must rely on descriptions from ancient authors. The painter who introduced portrayals of per-

sons in three-quarters view was Cimon from Cleonae, which is between Corinth and Argos in Greece. Polygnotus of Thasos, who was brought to Athens by the Athenian general and statesman Cimon who dominated Athenian political life in the late 470s and 460s B.C.E., introduced more innovations. He was the first to paint faces with the mouth open, showing the teeth, and the first to paint women with transparent drapery. He lived in the period when painters were discovering the laws of perspective. The tradition is that painted scenery for productions in the theater was invented by the tragic poet Sophocles, but his older rival Aeschylus was the first to have scenery that had perspective, developed by the painter Agatharchus. Other painters of the period were Micon, who collaborated with Polygnotus, and Panainos, the brother of the great sculptor Phidias. There was one monument where all three of them collaborated: the *Stoa Poikile* (The Painted Colonnade) on the south side of the Athenian marketplace, where the philosopher Zeno, founder of the Stoic School of philosophy, would give his lectures years later. There were four painted panels in the stoa affixed to the back wall. One depicted the Battle of Oenoë between the Athenians and the Spartans that was evidently an important battle although historians are uncertain what it was or why it took place. Another was a painting from mythology showing a battle between the Athenians and the Amazons, warrior women who attacked Athens and were defeated by King Theseus. A third showed a scene from the legendary Trojan War in which the Greek leaders are meeting to decide how to punish Ajax the Less for his rape of the priestess Cassandra. Finally a fourth painting evidently shows a sequence of actions related to the Battle of Marathon where the Athenians defeated the Persians: first the struggle itself, then the flight of the Persians, and finally the Persians trying to embark on their ships to leave. Panainos painted the Battle of Marathon with Micon's collaboration; Micon painted the battle of the Athenians and the Amazons; and Polygnotus' contribution was the painting of the Judgement of Ajax. The greatest masterpiece of Polygnotus, however, was found at Delphi in the *Lesche* or club house of the Cnidians. One part of it depicted the sack of Troy, and another part the descent of the hero Odysseus into the Underworld. We have a detailed description of it by Pausanias, the Greek traveler of the second century C.E. who toured Greece and wrote a guidebook describing what he saw.

THE SUCCESSORS OF POLYGNOTUS. The balancing of light and shade—what modern artists call *chiaroscuro*—was pioneered by a little-known artist Apollodorus of Athens in the late fourth century B.C.E., but the artist who exploited it was Zeuxis in the early third

a PRIMARY SOURCE *document*

THE BEGINNINGS OF PERSPECTIVE

INTRODUCTION: When a modern artist wants to paint in perspective, he draws a horizon line and on the horizon he makes a vanishing point. Then lines that are parallel in real life are drawn so that they intersect at the vanishing point. Greek painters seem first to have discovered the need for something like a vanishing point when they produced painted scenery for theatrical productions. A casual reference in a treatise on architecture and engineering by Vitruvius Pollio, a Roman architect and engineer who worked under the emperor Augustus (27 B.C.E.–14 C.E.), indicates that the first painter to try to show depth by making lines converge on a central point was a craftsman named Agatharcus who produced scenery for the tragedies of Aeschylus (525–456 B.C.E.) in Athens. Democritus and Anaxagoras, who wrote treatises that are lost on perspective, were both philosophers in the fifth century B.C.E.

First there was Agatharcus in Athens who painted scenery for Aeschylus who was producing a tragedy, and wrote a commentary about it. This resulted in Democritus and Anaxagoras writing on the same subject and showing how, once a central point is drawn in a definite location, the sight lines should have a natural relation to the central point and the spread of the visual rays from it, so that painted scenery can portray, by this sleight of hand, a faithful representation of how buildings appear, and though everything is drawn on a vertical flat plane, some parts look as if they have withdrawn into the background and other parts to be positioned in the foreground.

SOURCE: Vitruvius, *The Ten Books on Architecture*. Trans. Morris Hicky Morgan (New York: Dover, 1960): 198. Text modified by James Allan Evans.

century B.C.E., who was famous for his illusionist effects. One of his paintings was The Centaur Family which shows a female centaur stretched out on the grass, suckling her two infant centaurs, while the male centaur, who is portrayed as a shaggy beast, leans over them laughing. Zeuxis' contemporary, Parrhasius of Ephesus, took a different approach. He was a careful draftsman, the acknowledged master of contour line. He is best known for his picture of Theseus that adorned the Capitol in Rome years after his death. His other works, besides the obscene subjects with which he supposedly amused

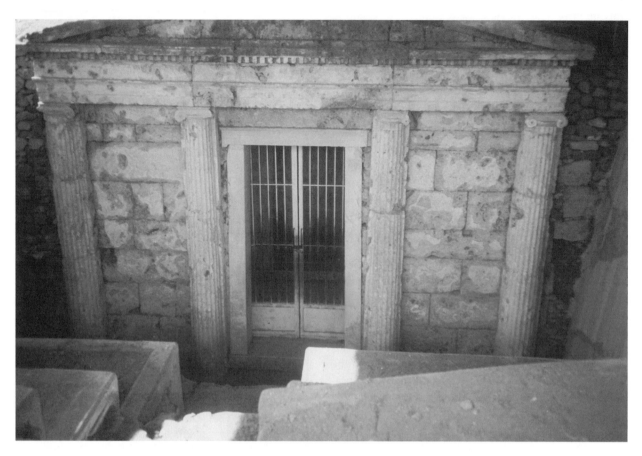

An underground Macedonian tomb from Vergina in Greece, identified as Aegae, the ancient capital of Macedon where the Macedonian kings were buried. **COURTESY OF JAMES ALLAN EVANS.**

himself in his leisure time, are chiefly mythological groups. A picture of the Demos, the personified People of Athens, is among his most famous of these works. In the fourth century B.C.E. Pausias of Sicyon, who was known for the garlands of flowers that he introduced into his murals, also became famous as a master of paintings in the encaustic technique, mixing his pigments in hot wax and applying the wax with a small spatula. He learned the technique from Pamphilus of Sicyon, who was also the teacher of the great Apelles, the favorite painter of Alexander the Great. With Apelles, Greek painting evidently reached its height in the late fourth century B.C.E. One painting of his was particularly famous: it showed the birth of the goddess Aphrodite, rising from the foam of the sea. A similar painting discovered on the wall of a house in Pompeii may have been an attempt to copy Apelles' masterpiece, or at the very least had its inspiration in Apelles' work. Unfortunately, the journeyman wall painter who made the mural did not do a good job.

MACEDONIAN TOMBS. The masterpieces of Greek painting are lost, though sometimes archaeologists uncover bits of evidence that intrigue the imagination. Macedon, an ancient country in northern Greece, has yielded a number of underground tombs from the fourth and third centuries B.C.E. at various sites, the most famous of which are the royal tombs at Vergina, the ancient capital of Macedon. There a tomb has been identified, rightly or wrongly, as the burial place of Philip II of Macedon, father of Alexander the Great. In one, dating probably to the third century B.C.E. garlands and floral designs are reminiscent of the work of Pausias. Pausias' own works are lost but his influence may be reflected in these tombs.

SOURCES

K. W. Arafat, "Greek Painting," in *The Oxford Companion to Classical Civilization.* Ed. Simon Hornblower and Antony Spawforth (Oxford, England: Oxford University Press, 1998): 516–518.

Vincent J. Bruno, *Form and Color in Greek Painting* (New York: Norton, 1977).

Christos Doumas, *Hellenistic Painting Techniques: The Evidence of the Delos Fragments* (Leiden, Netherlands: Brill, 1985).

————, *The Wall-Paintings of Thera*. Trans. Alex Doumas (Athens, Greece: Thera Foundation, 1992).

Reynold Higgins, *Minoan and Mycenaean Art* (London, England: Thames and Hudson, 1981).

Sara A. Immerwahr, *Aegean Painting in the Bronze Age* (University Park; London, England: Pennsylvania State University Press, 1990).

Spyridon Marinatos, *Life and Art in Prehistoric Thera*. The Albert Reckitt Lecture, British Academy (Oxford, England: Oxford University Press, 1972).

Susan B. Matheson, *Polygnotos and Vase-Painting in Classical Athens* (Madison, Wisc.: University of Wisconsin Press, 1995).

Friedrich Matz, *The Art of Crete and Early Greece: The Prelude to Greek Art*. Trans. Ann E. Keep (New York: Crown Publishers, 1963).

Paolo Moreno. *Pittura greca da Polignoto ad Apelle* (Milan: A. Mondadori, 1987).

Lyvia Morgan, *The Miniature Wall-Paintings of Thera: A Study in Aegean Culture and Iconography* (Cambridge: Cambridge University Press, 1988).

Martin Robertson, *Greek Painting* (New York: Rizzoli, 1979).

H. Alan Shapiro, *Myth into Art: Poet and Painter in Classical Greece* (London, England: Routledge, 1994).

ROMAN PAINTING

THE DESTRUCTION OF POMPEII. On 24 August 79 C.E., the volcano of Mt. Vesuvius, which was thought to be extinct, reawakened and blew up, spewing a mushroom-shaped cloud into the air to the amazement and terror of the onlookers. The eruption would claim the life of Pliny the Elder who is one of the major sources for information about Greek and Roman art. When the eruption was over, the cities of Pompeii, Herculaneum, Stabiae, and Oplontis had been sealed in ash and lava. Pompeii and Stabiae were covered in easily removable ash and pumice, but Herculaneum, directly beneath the volcano, was covered with mud and lava that hardened as it cooled, making it impossible to remove without pick-axes and pneumatic drills. While the eruption was a terrible tragedy in the ancient world, it was a boon for modern art historians, for the lava preserved the wall decorations of the houses and the mosaics on their floors for modern excavators to discover. While wall-paintings from other sites are only isolated finds, the art from Pompeii and Herculaneum show the changes in Roman taste over three centuries. Even though Pompeii, a town of some twenty thousand inhabitants, was already past the peak of its prosperity when it was buried under the ash from Mt. Vesuvius, and so did not attract the Roman Empire's best painters, its houses present a vivid record of changing fashions. Towards the end of the nineteenth century, the German scholar August Mau divided the wall paintings of Pompeii into four styles: first, second, third, and fourth, in chronological order. Fourth style was in vogue when the eruption of Mt. Vesuvius abruptly ended the life of the little city.

FIRST STYLE. First Style tried to produce in painted stucco the appearance of a wall covered with panels of marble or with blocks of masonry, for which reason it is also sometimes called "Masonry Style." The largest house in Pompeii, the House of the Dancing Faun, which was built in the second century B.C.E., had first-style wall decoration: plaster that faked marble panels, all painted a bright red. Herculaneum has a well-preserved example of this style in a house built in the late second century B.C.E.: the so-called "Samnite House." The plaster is shaped into panels which were painted using the *al fresco* technique in which the pigment is applied to the plaster while it is still damp. The inspiration for the style is the marble-paneled walls in the Hellenistic palaces and public buildings in royal capitals such as Alexandria and Antioch. First Style counterfeits the marble panels in plaster, and since the painter had more colors at his command than did the marble-cutter, the effect of First Style could be more garish than the real thing, an example of which can still be seen in the Pantheon in Rome where the marble panels on the wall are still in place.

SECOND STYLE. Second Style came into fashion after 80 B.C.E. though it never pushed First Style completely aside. Second-style painting was illusionist, meaning it tried to create the illusion that the spectator was looking beyond the confines of the wall to a world outside it of gardens and fantastic architecture. One splendid example was found in the villa of Livia, the wife of the emperor Augustus, at Prima Porta just north of Rome. There a vaulted, partly underground room was painted on all sides with a panorama of a garden, complete with trees bearing fruit and birds. With this illusion the walls of the room no longer confine the space. The artist suggests depth to his painting by a kind of atmospheric perspective: the trees and plants in the foreground are painted precisely but as objects recede into the distance, they become increasingly blurred. If the artist working in Second Style wanted to open up the wall and show landscapes beyond it receding into the distance, he had to use perspective to give depth to his

Arts and Humanities Through the Eras: Ancient Greece and Rome (1200 B.C.E.–476 C.E.)

435

a PRIMARY SOURCE *document*

VITRUVIUS ON CONTEMPORARY ROMAN WALL PAINTING

INTRODUCTION: Vitruvius, who wrote a treatise of ten books on architecture in the latter part of the reign of the emperor Augustus (27 B.C.E.–14 C.E.) has some derogatory remarks to make about the wall-painting fashion of his own day, which, from his description, was Third Style. In the passage quoted below, he begins with a reference to First Style or "Masonry Style," and then progresses to Second Style, which, as he reports, took some of its inspiration from the scenery in theatrical productions. He approves of paintings taken from mythology, and many examples of these have been found in Pompeii. Two of the best examples, however, come not from Pompeii but from a house excavated on the Esquiline Hill, one of the Seven Hills of Rome. It shows landscape scenes taken from Homer's *Odyssey*, copied, like most such wall paintings, from lost masterpieces. The originals of the wall paintings from the Esquiline would have dated to about 150 B.C.E. Note that Vitruvius, whose language was Latin, refers to Odysseus by his Latin name, "Ulysses."

The ancients, who introduced well-finished wall surfaces, began by representing different varieties of marble slabs in different positions, and then cornices and blocks of yellow ochre arranged in various ways. Afterwards they made such progress as to represent the forms of buildings, and of columns, and projecting and overhanging pediments; in their open rooms, such as exedrae, (rooms or outdoor conversation areas) on account of their size, they depicted the façades of scenes in the tragic, comic, and satyric style; and their walks, on account of the great length, they decorated with various landscapes, copying the characteristics of particular locations. In these paintings, they show harbors, promontories, seashores, rivers, fountains, straits, temples, groves of trees, mountains, flocks and shepherds. In some places there are also pictures designed in the grand style, with representations of gods or episodes from myths portrayed in detail, or the battles at Troy, or the wanderings of Ulysses, with landscape backgrounds, and other subjects reproduced on similar principles from real life.

But those subjects which were copied from real life that exists around us are scorned in these modern days of bad taste. We have now fresco paintings of monstrosities rather than truthful paintings of tangible things. For instance, reeds are put in the place of columns, fluted accessories with curled leaves and volutes instead of pediments, candelabra supporting representations of shrines, and on top of their pediments numerous tender stalks and volutes growing up from the roots and having human figures seated on them without rhyme nor reason. Sometimes there are stalks with only half-length figures, some have human heads, others the heads of animals.

Such things do not exist and cannot exist, and never have existed. Thus this is the new taste that has caused bad judges of substandard art to prevail over true artistic excellence.

SOURCE: Vitruvius, "The Decadence of Fresco Painting," in *The Ten Books of Architecture*. Trans. Morris Hicky Morgan (New York: Dover, 1969): 210–211. Text modified by James Allan Evans.

painting. Greek scenery designers for the theater had been the first to use perspective in the first half of the fifth century B.C.E., and its general rules were well known. A fine example of Second Style was found in the villa of Publius Fannius Synistor, otherwise unknown, at Boscoreale near Pompeii which dates to the middle of the first century B.C.E. The frescoes were removed from the walls and taken to the Metropolitan Museum in New York shortly after the villa was discovered, and they are part of a reconstructed *cubiculum*, or Roman bedroom, there. The wall paintings create the illusion that the onlooker can walk through the bedroom walls into a cityscape with porticoes, arches, and temples; one view shows a charming *tempietto*, a small, round shrine which seems to be set in a courtyard surrounded by porticos. Roman taste changed a few years after the villa of Publius Fannius Synistor, as evidenced by the construction of another villa belonging to Agrippa Postumus which was decorated in Third Style about 10 B.C.E.

THE ELEGANT THIRD STYLE. As the landscapes of Second Style went out of fashion, they were replaced by mural designs that emphasized the wall instead of dissolving it into a vista beyond. The artist painted his wall in a solid, dark color such as black, and instead of the architectural elements of Second Style, he framed his space with thin, spidery columns holding up insubstantial canopies—architectural forms that never existed in real life. In the middle of his space he composed a picture enclosed within a frame, like a painting hanging on a wall. Or he sometimes substituted a motif borrowed from Egyptian art. Third Style was elegant and exquisite, but it was also oppressive.

FOURTH STYLE. Illusionism returned with the Fourth Style, which became popular in Pompeii about 62 C.E., when Pompeii was shaken by an earthquake and houses needing their damaged wall paintings restored no doubt opted for the latest style. The emperor Nero, who was building his *Domus Aurea* (Golden House) in the heart of Rome following the devastation of a great fire that broke out in the summer of 64 C.E., used Fourth Style to decorate the rooms of his extravagant new villa. Walls were painted a creamy white with landscapes appearing as framed pictures in the center of a large subdivision of the white wall. There are also architectural vistas, but they are dream cityscapes: columned facades, sometimes fragments of buildings, none of them belonging to the world of reality. The painters of these architectural follies may have been influenced by the painted scenery that they saw in contemporary theater. Some of the framed paintings show scenes from mythology: one, from Pompeii, now in the Naples Museum, shows Aeneas, wounded in one leg, being tended by Iapyx, master of the healing art, while Venus appears in the background, bringing with her a medicinal herb. The scene comes from the final book of Vergil's epic, the *Aeneid*, and it is evidence that the Romans had illustrated books containing such pictures. The *codex*, or bound book, would not appear until the second century C.E., but the picture of the wounded Aeneas from Pompeii is the sort of illustration that might have been found on a parchment scroll containing the last book of the *Aeneid*.

THE AFTERMATH. Campania, the region of Italy around Naples which includes the cities destroyed by the eruption of Mt. Vesuvius, has no examples of wall paintings after 79 C.E. The murals after that date which have survived come from Rome or the imperial provinces, and they show less taste for fantastic ornamentation and an increase in simpler, more realistic designs, done on white, red, or yellow backgrounds. In the Roman province of Britain, a town house of the second century C.E. found at Verulamium (modern St. Albans) yields evidence of a mural with painted panels with two candelabra on a red background, and in the center, a blue dove on a perch. On the ceiling, there were ears of wheat painted in a lattice-work design on a purple background. The third century C.E. had a penchant for scenes on a large scale, most of them illustrations of ancient myths. The third century was a period when the Roman Empire seemed on the verge of disintegration, and yet it was also a time when there were new departures in artistic taste. In the eastern provinces, the retreat from naturalism that we find in medieval art, where two-dimensional figures stare directly at the viewer, was already underway.

DURA-EUROPOS: A POMPEII OF THE THIRD CENTURY C.E. In 256 C.E., a Roman garrison town on the Euphrates River in modern Iraq, called Europos by the Greeks and Dura by the Romans, fell to the Persians. The eastern frontier of the Roman Empire had become a dangerous place, for the Persians under a new dynasty, the Sassanids, had overthrown Rome's old foe, the Parthian Empire, in 224 C.E. They were more aggressive than the Parthians had ever been for they dreamed of restoring the Old Persian Empire that Alexander the Great had overthrown. Dura-Europos was discovered during World War I, and in 1931 excavations got underway under the auspices of Yale University. The wall paintings that were found made art historians rethink their notions about the retreat from naturalism in the late Roman Empire that had hitherto been associated with the rise of Christianity. There was a Jewish synagogue with scenes from the Old Testament, dating to about 200 C.E. These came as a surprise, for Judaism took the Second Commandment banning "graven images" very seriously, as did early Christianity, but by the start of the third century C.E., the veto for both religions had broken down. There was a Christian "house church," built about 240 C.E., for before Christianity became a legal religion, Christian congregations met in ordinary houses which were adapted for worship; we know that there were at least forty such "house churches" in Rome by 258 C.E. At one end of the baptistery room in the Dura "house church," set in a vaulted niche, there was a font shaped like a sarcophagus, and on the back wall of the niche was a painting showing Christ as the Good Shepherd, carrying a sheep on his shoulders, and beside him, Adam and Eve. This was clearly an example of wall painting as a mode of instruction: Adam and Eve represented the old Adam who sinned, and Christ, the new Adam, redeemed the victims of original sin. The synagogue paintings were also art serving to instruct, and since they date before the "house church" was built, the Christians probably borrowed the idea of using art for religious education from the Jews. One synagogue painting shows the prophet Samuel anointing David as the future king of Israel while his six older brothers look on. Samuel towers over David and his brothers who are all the same height, though David's status is marked by the purple toga that he wears like a Roman emperor. The figures face the onlooker, fixing him with an intense gaze, and they seem to float in air. This frontality and weightlessness is even more pronounced in the sacrificial scenes that were painted and carved in the Temple of the Palmyrene Gods in Dura. By contrast, the art in the Christian baptistery has not quite abandoned the classical tradition. The "Christ the Good Shepherd"

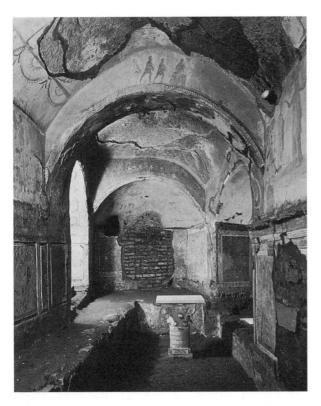

Greek chapel of the catacomb of Priscilla, an example of early Christian art in Rome, Italy, c. 230–240 C.E. © ARCHIVO ICONO-GRAFICO, S.A./CORBIS. REPRODUCED BY PERMISSION.

figure recalls a classical type; among the archaic sculpture found on the Athenian Acropolis there is an example, the dedication of Rhonbos showing a man carrying a lamb on his shoulders. The Dura finds make it clear that the features associated with early medieval art—two-dimensional, weightless figures in frontal poses—developed independently of Christianity, and that their inspiration came from the Middle East.

EARLY CHRISTIAN ART. Apart from the "house church" at Dura-Europos, examples of early Christian art come from the catacombs: underground cemeteries hewn from the rock-like tunnels for mines. The catacombs were not solely Christian—the Jewish catacombs in Rome antedate the Christian ones—nor are they only in Rome: there are also catacombs in Naples, Syracuse in Sicily, and Alexandria. Christians, like Jews, did not cremate their dead, which was the prevailing custom in the pagan world until the later second century C.E., and the catacombs provided burial places that a Christian of modest means could afford. Most of the catacomb burials are later than 313 C.E. when Christianity was made legal by the so-called "Edict of Milan," and so the old romantic notion of persecuted Christian believers gathering secretly for worship in the

catacombs must be abandoned. The dead were placed in niches (*loculi*) stacked one above the other like shelves lining the underground galleries, and in various places small rooms (*cubicula*) cut out of the rock served as funerary chapels. The paintings in the *loculi* and particularly in the *cubicula* are our earliest examples of Christian art. The style is similar to contemporary pagan art, though there is a charming naivete about the pictures. They are narrative art but they have an educational purpose: they give instruction in the Christian faith. Christ is usually shown either as a teacher or as the Good Shepherd, caring for his flock of sheep. In the early drawings he is depicted as a young man and beardless; he might pass for a young pagan god. The figure of Christ as a mature man with a full beard developed only later in Constantinople in the fifth century, and perhaps it reflects the impression made by Phidias' great gold-and-ivory statue of Zeus at Olympia when it was taken to Constantinople after the temple was closed by imperial decree in 391. The catacomb paintings were executed by journeymen painters who worked quickly in poor light, surrounded by decaying corpses, and they are not great art. They borrow heavily from the classical tradition. Yet their general aim was instruction in Christian piety, and though occasionally figures from classical mythology appear if they can be linked in some way with Christian teaching, the subjects are usually stories that convey a message from the Old and New Testaments.

SOURCES

John R. Clarke, *The Houses of Roman Italy, 100 B.C.–A.D. 250* (Berkeley: University of California Press, 1991).

André Grabar, *Early Christian Art from the Rise of Christianity to the Death of Theodosius.* Trans. Stuart Gilbert and James Emmons (London, England: Thames and Hudson, 1967).

Michael Grant, *Cities of Vesuvius: Pompeii and Herculaneum* (Harmondsworth, England: Penguin, 1976).

Philippe Heuzé, *Pompéi, ou, Le bonheur de peindre* (Paris: De Boccard, 1990).

Phyllis W. Lehman, *Roman Wall Paintings from Boscoreale in the Metropolitan Museum of Art* (Cambridge, Mass.: Harvard University Press, 1953).

Roger Ling, *Roman Painting* (Cambridge: Cambridge University Press, 1991).

———, *Romano-British Wall Painting* (Aylesbury: Shire, 1985).

Amedeo Maiuri, *Roman Painting* (Geneva: Skira, 1953).

August Mau, *Pompeii: Its Life and Art.* Trans. Frances Kelsey (New Rochelle, N.Y.: Caratzas Brothers, 1982).

Frank G. J. M. Müller, *The Wall Paintings from the Oecus of the Villa of Publius Fannius Synistor in Boscoreale* (Amsterdam: J. C. Gieben, 1994).

Ann Perkins, *The Art of Dura-Europos* (Oxford, England: Clarendon Press, 1973).

D. Talbot Rice, *The Beginnings of Christian Art* (London, England: Hodder and Stoughton, 1957).

Silvia Rozenberg, *Enchanted Landscapes: Wall Paintings from the Roman Era* (London, England: Thames and Hudson, 1994).

W. F. Volbach, *Early Christian Art* (London, England: Thames and Hudson, 1961).

PORTRAITS

IDEALISM AND REALISM. In modern society, photographic equipment makes it easy to capture images of one's self and one's family in portraits, and the ease with which such pictures can be created tends to devalue their significance. The absence of such technology in the Greek and Roman world, however, made the creation of portraits a very important and significant act that was generally done for a motive beyond the capturing of an image. In the sixth century B.C.E., victorious athletes in Greece were commemorated with portrait statues which presented an idealized picture of vigorous youth, though there was a degree of realism as well. Idealism was the hallmark of Greek portraiture because the motive of the portrait artist was not to portray an exact likeness—warts and all—but rather an impression of a real individual as an exemplar of vigor, intellectual power, or heroic virtue or the like. This motivation did not quite hold true for the Romans, however, as portraiture had a practical purpose. A Roman kept *imagines*—images usually of wax—in the atrium or living room of his house as the visible record of his ancestors and of his own social status. They were exact likenesses, and they set the standard for Roman portraiture. Early Roman portraiture can be realistic to the point of homeliness. However, once Rome was ruled by emperors, from the time of Augustus (27 B.C.E.–14 C.E.) onwards, imperial portraiture was used to convey a message of power. Yet the Roman portrait, whether of an emperor or an ordinary citizen, always portrayed an individual with a distinctive appearance, and this taste for realism survived even into the early Byzantine period.

PORTRAITURE IN CLASSICAL GREECE. A bust of the Athenian statesman Pericles, the architect of the Athenian Empire, has survived in a Roman copy. The original was a bronze statue by the sculptor Cresilas, erected in Athens after Pericles' death in 429 B.C.E. The date is important, for there was a prejudice against portraits of living men. The great Phidias who made the gold-and-ivory statue of Athena Parthenos for the Parthenon, smuggled a likeness of Pericles into his design for the shield of Athena and was apparently driven into exile for it. While the original is lost, the marble bust is a good copy and shows an idealized Pericles. Any blemishes he may have had were removed and the helmet he always wore hid his peaked skull. The helmet also marked him as a general, for during his years of power he was elected year after year to the influential Board of Ten Generals. Without the helmet, this portrait of Pericles would pass for the image of a god. Portraits in fifth-century Greece were intended to flatter, although this was not the case in the following century. No original portrait from the fourth century B.C.E. survived, but to judge from Roman copies representing Plato, it seems that the aim of the sculptor was to portray him not so much as an individual as a typical philosopher. Pliny the Elder reported that the Sicyonian school of sculpture experimented with realism and that Lysistratus, the brother of the famous Lysippus of Sicyon, made a likeness from an actual face. Lysistratus was probably the first artist to ask his subject to sit for his portrait so he could sculpt what he saw, whether it was flattering or not. Pliny's evidence has been disbelieved by some art historians, but there is evidence of a greater taste for individualism in portrait sculpture in the Hellenistic world, though it is far from the uncompromising realism found in Egypt and later in Rome.

PORTRAITURE IN THE HELLENISTIC WORLD. In the Hellenistic world after Alexander the Great's death in 323 B.C.E., there were two rival traditions in portraiture. One carried on the classical tradition. Like Cresilas's portrait of Pericles, it sought to idealize. Alexander the Great's portraits are a case in point. Alexander had his favorite artists: Lysippus for sculpture, Apelles for painting, and the gem cutter Pyrgoteles for his seal engravings. It is likely that the many sculptures depicting Alexander take their inspiration from portraits that he himself approved. They show Alexander with his head bent slightly to the left, directing his gaze above the spectator as if he were looking into the distance, or perhaps a distant future, and they emphasize Alexander's physical beauty and youth. The portrait is of an individual, but in 324 B.C.E. Alexander demanded that the city-states recognize him officially as a god, and his portraits have a god-like quality about them. About 280 B.C.E. a statue in Athens by the sculptor Polyeuctus of the orator Demosthenes made no effort to idealize Demosthenes, and art historians have pointed to it as a landmark in the development of realistic portraiture. This asser-

Arts and Humanities Through the Eras: Ancient Greece and Rome (1200 B.C.E.–476 C.E.)

439

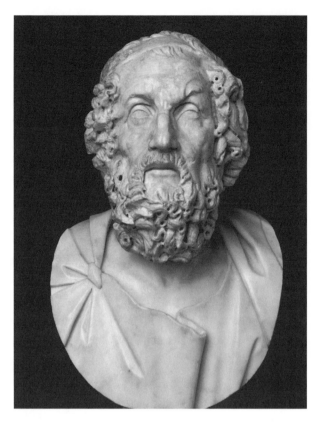

Bust of Homer, showing balding head, full beard and beetling brows which were typical of his portraits. © ARALDO DE LUCA/CORBIS.

tion must be tempered, however, with the reality that the statue was made some forty years after Demosthenes' death by an artist who probably never saw Demosthenes in his lifetime. Even so, he showed Demosthenes as he should have looked, not as he did. The statue of Demosthenes has the body of an old man, slightly stooped, and he clasps his hands nervously in front of him; his face is lined and his expression is sober, almost melancholy, as if he was apprehensive of the future, reflecting, perhaps, Athens' approaching defeat by Macedon.

PORTRAITS OF THE IMAGINATION. While it cannot be determined how true to life the portrait of Demosthenes is, it is reasonably certain that portraits were produced in this period which were not true to life at all; they portray real individuals, but they are purely imaginary. This is a period in the history of portrait art when sculptors produced "portraits" of authors who were long-since dead, which could be set up in libraries. Homer's portrait is a case in point. No one knew what Homer actually looked like, but the portrait sculptor started with some preconceived notions: Homer was a dignified old man of genius, and he was blind. The finished portrait fits the conception. Yet what was remark-

able about it is its individualism. This portrait was not simply the portrayal of a poet-type; it depicts an individual, and copies of it are immediately recognizable. Homer's hairline is receding and he wears a fillet or headband which partly disguises it. The lines on his forehead suggest great intellectual power. He wears a full beard, denoting maturity, and his eyes are arresting under his beetling brows. This portrait was an imaginative creation, but it was one that the Greeks could accept as a representation of what Homer actually looked like.

ROMAN PORTRAITURE. Romans kept *imagines* (portraits) of their distinguished ancestors in the main rooms of their houses. They were usually made of wax from death-masks of the departed ancestor, and when a Roman died, these *imagines* were carried in the funeral procession so that a Roman was buried in the presence of his ancestors. His genealogy was put on public display, and the longer it was, the better it was for his social and political standing. If any such *imagines* existed in the houses buried by the ash and lava from Mt. Vesuvius in 79 C.E. they were unfortunately melted by the heat. A fourth-style wall painting from a Pompeian house has yielded a wedding portrait, however. It shows a man and a woman, the man holding a scroll and the woman a stylus and a writing tablet known as a *pugillaris*, two small thin wooden boards hinged at one side so that they could be folded over and their inner surfaces covered with a layer of wax on which a message could be written. The scroll, stylus, and pugillaris are all stage setting: they are intended to portray the man and wife as an educated couple who read books and wrote letters. The faces of the man and woman are photographic likenesses, done with such startling realism that we could recognize them if we met them on the street. The man transfixes us with his gaze; the woman gazes off to one side with a look of infinite sadness. There must have been many portraits like this in the Roman Empire. From the second and first centuries B.C.E. a number of Roman portraits depict their subjects with uncompromising realism. The wrinkles and other blemishes that come with advancing age are clearly marks of honor. This attitude towards portrait art owes little to Greece. Rather it draws its inspiration from the *imagines* of the ancestors, which Romans kept in their houses. This realistic tradition continued into the first century C.E. and, in fact, never died. Yet by the mid-first century C.E., the completely uncompromising realism of the earlier age was no longer in fashion. Many Romans no longer displayed masks of their ancestors in the atriums. The historian Pliny the Elder makes a grumpy complaint in his *Natural History* about the new custom of decorating rooms with pictures of athletes

from the gymnasium or the arena rather than family portraits. An imposing array of family portraits went along with lengthy genealogies, and the demographic changes in the Roman Empire from the first century C.E. onwards resulted in persons with very short genealogies rising to power and wealth. The portrait artist could pick and choose from the styles of the past, and eclecticism was the vogue.

THE IMPERIAL PORTRAITS OF AUGUSTUS. The emperor Augustus (r. 27 B.C.E.–14 C.E.), who restored peace to Italy after a half-century of civil war and political turmoil, was very conscious of the fact that his reign was a new beginning for the Roman Empire. His portraits reflected this new era by seeking inspiration in classical Greece, the age before the Hellenistic monarchies, when the city-states (Sparta excepted) were little republics. He adapted the art of classical Greece to Roman uses. One famous statue of Augustus that was found at the villa of his wife Livia at Prima Porta just north of Rome shows him in full armor, with one arm raised in the gesture of an army commander addressing his troops. The body beneath the armor conforms to the *Canon* of Polyclitus which outlined proportions for sculpture in the classical period. Augustus, who in real life did not have an impressive physique, had his statue conform to the proportions of Polyclitus' *Diadoumenos*, a muscular youth adjusting his headband. The face of the Prima Porta statue is easily recognized because it has the high cheekbones and hairstyle of Augustus. Augustus was shown in two other ways as well. He was portrayed as a priest, wearing a toga with a cowl, for Roman priests covered their heads when they sacrificed to the gods. He was also shown as a youth: a young man who was leading in a new age. Augustus' portraits never aged, nor did those of his wife, Livia, though her hairstyles changed with the fashion. Like the famous portrait of Pericles by Cresilas, the portraits of Augustus showed him as no ordinary man.

CHANGING FASHIONS. Portrait styles changed in 69 C.E. with the ascension of Vespasian as the new emperor. He had none of the aristocratic background of the previous dynasty, the Julio-Claudian family that became extinct with the suicide of the emperor Nero in 68 C.E., and though he was sensitive about the peasant origins of his family, known as the Flavians, he was wise enough to know that he should make a clean break with the Julio-Claudians. His portraits therefore returned to the realist tradition of Roman republican portraiture. They show him with receding hairline and the leathery skin of an old soldier who knows what life in the military camps is like. His portraits were numerous; this was a

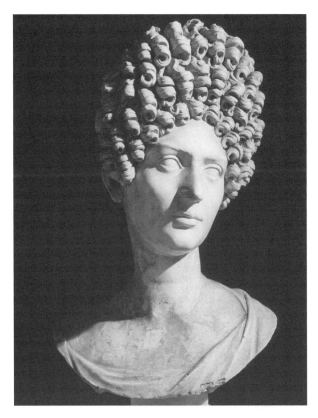

Bust of Roman woman with hairstyle typical of the Flavian period (69–96 C.E.). THE ART ARCHIVE/MUSEO DELLA CIVILTA ROMANA ROME/DAGLI ORTI.

great age of portraiture when people of all ages, not just old men, had portrait sculptures made. One marble bust of a woman of the Flavian period, which is now in the Capitoline Museum in Rome, should be noted as an example of Flavian style, even if it is not an imperial portrait. The face and the long neck are modelled softly, and the sculptor managed to portray the texture of the skin by the polish of the marble. The woman's coiffure is a mass of tight curls piled up above her forehead. The sculptor used a drill rather than a chisel to sculpt the curls, a trend that became more common as sculptors used the drill more and more, particularly for hair and beards. The surprising element of this particular bust is that the coiffure is, in fact, a wig. It can be lifted off the bust and replaced by another. In an age when hairstyles changed, this was an efficient way of keeping the bust up to date.

IMPERIAL PORTRAITURE IN TROUBLED TIMES. With the reign of Marcus Aurelius (161–180 C.E.) the long period of peace that the empire had enjoyed came abruptly to an end. There were grim times ahead, and imperial portraiture conveyed a new message of suffering and sadness. A relief sculpture of Marcus Aurelius

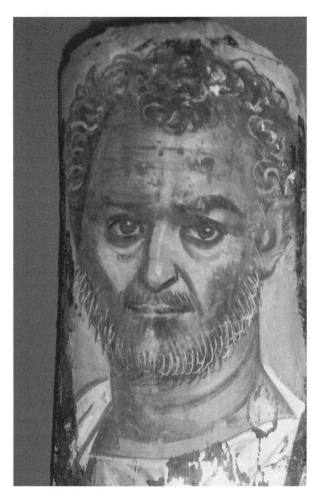

A mummy portrait from the Fayum province, Egypt, c. 200 C.E. Portraits of this type were placed over the face of the mummy. **PHOTOGRAPH BY HECTOR WILLIAMS. © HECTOR WILLIAMS.**

alism increased to the point of brutalism. The emperors are shown as tough and effective rather than handsome.

THE LOSS OF INDIVIDUALITY. A great political change occurred at the end of the third century C.E. In 284 C.E. a soldier from Illyria named Diocles was elected emperor by the Roman army. He immediately changed his name to Diocletian and chose a colleague, a fellow soldier named Maximian, to share the imperial office. A few years later, he chose two more junior colleagues, naming them "Caesars." So the empire was ruled by a committee of emperors, two bearing the title "Augustus" with one of them, Diocletian, senior to the other, and two with the title of "Caesar." This tetrarchy (the rule of four men) lasted until 305 C.E., when Diocletian retired and persuaded his colleague, Maximian, to retire as well. At San Marco Cathedral in Venice there is a remarkable group portrait of the tetrarchs that captures the spirit of the new age. It is made of porphyry, a hard reddish granite from Egypt which, because of its dark crimson color, was considered particularly fitting for representing emperors. The tetrarchs are each shown embracing another with one arm; with the other arm each grasps his sword. They have larger, cubical heads on squat, shapeless bodies. This sculpture group represents the tetrarchy as an office rather than a group of individuals. The sculptural form is less important than the message it conveys. The same spirit, too, informs a colossal portrait of the first Christian emperor, Constantine, who united the Roman Empire under his rule in 323 C.E. and founded a new capital, Constantinople, the next year. The portrait, which is in Rome in the *Palazzo dei Conservatori*, is over two and a half meters (8.2 feet) tall, and it is what remains of a seated statue, over nine meters (30 feet) in height, that has a core of brick, a wooden torso covered with bronze, and head and limbs of marble. The face is a mask. Enormous eyes are set into the broad planes of the face. The eyes stare beyond the onlooker as if their gaze is fixed on Heaven where resides the ultimate authority. This is an image of power and Christian faith, and the message that it conveys almost overwhelms the human individualism of the portrait.

PAINTED PORTRAITS. Few of the imperial portraits survived to modern times, except for marble sculptures. While portraits were also painted on wood in hot, colored wax, only one such rendering exists today: a portrait of the family of the emperor Septimius Severus (193–211 C.E.). These wooden portraits were sent to the far corners of the empire and set up in public places when a new emperor ascended the throne. The best examples of portraits come from Roman Egypt. They are mummy portraits painted on wooden panels and placed

that once adorned a lost imperial arch shows him bearded after the style of the emperor Hadrian (r. 117–138 C.E.) who had worn a beard to hide scars on his face. Marcus' face is that of a care-worn man. His eyes are incised rather than merely painted, creating a melancholy effect that no doubt was a window to his soul. The sense of sadness is even greater in the portrait of a short-lived emperor, Decius (r. 249–251 C.E.), in the Capitoline Museum in Rome. He is balding and what is left of his hair is clipped short. The sculptor made no effort to flatter. His gaze is fixed upwards, as if he hoped for help from above. If so, the help failed to arrive, for Decius died in a disastrous defeat at the hands of the Goths. After 268 C.E., when the empire began to revive under a succession of emperors from Illyria (modern Croatia and Serbia), first Claudius Gothicus (r. 268–270 C.E.) and then Aurelian (r. 270–275 C.E.), the emperors are shown as men of action with several days' growth of beard. Re-

a PRIMARY SOURCE *document*

WOMEN PAINTERS

INTRODUCTION: Two wall-paintings from Pompeii show women artists at work. One shows a woman painting a statue, the other a woman seated at her easel. Most of the ancient painters, men as well as women, are only names to us, and they would not have been known at all except that Pliny the Elder mentions them in his *Natural History*. Pliny garnered his information from earlier sources, and in one of these sources, Marcus Terentius Varro (116–27 B.C.E.), he found a reference to a woman who worked as a portrait painter in Rome, sometimes painting with a brush and sometimes using the encaustic technique. Her name was Iaia, and she came from Cyzicus in north-west Asia Minor. Pliny compares her to Sopolis and Dionysius. We know nothing of Sopolis; Dionysius was a portrait artist who painted only men.

Iaia, who came from Cyzicus and remained unmarried all her life, worked at Rome when Varro was a young man and she painted portraits on ivory, of women mostly, sometimes using a brush and sometimes a spatula (for applying molten colored wax). She painted a large picture of an old woman which is at Naples, and also she painted a portrait of herself using a mirror. No artist worked more swiftly than she; yet the excellence of her art was such that her paintings sold for far more than those of the most celebrated artists of her day, Sopolis and Dionysius, whose works fill our art galleries.

SOURCE: Pliny, *Natural History*. Book 35. Chapter 147. Translated by James Allan Evans.

over the face of the corpse that is then wrapped in long bands of white linen. The portrait painters used the encaustic technique, mixing their pigments with hot wax and then applying them to the smooth surface of the wooden panel. The dry climate of Egypt has preserved the wood and the colors have not faded. The faces show the man or woman in the prime of life. They were probably painted some years before the time of death. There are no side-views or three-quarters views; the pose is always frontal, and the eyes transfix the viewer with a sober, almost melancholy gaze, conveying a sense of spirituality. Their eyes are windows to their souls. Hundreds of these portraits have been found in the Fayum province of Egypt west of the Nile River, and they date mostly from the second and third centuries C.E. They show how portrait painting developed in the Roman Empire in the years following the eruption of Mt. Vesuvius in 79 C.E. It is interesting to compare them with imperial portraits of the same period. The medium is different and these portraits from the Fayum portray ordinary people, not emperors. Yet one can detect a similarity in spirit. Both suggest that the everyday life with its troubles and turmoil is not all there is to life.

FORERUNNERS OF THE ART OF ILLUMINATION.
The troubled third century produced another type of portrait: miniatures on glass set against a gold-leaf background. One exquisite example has survived which bears the signature of the artist: Boumeris. He is otherwise unknown. His portrait group shows a mother and two children, a girl and a boy, painted on a glass roundel (a round object) four inches (10.16 centimeters) in diameter. The portrait, dating to about 230 C.E., shows the mother and her children full-face and unsmiling. Another example, which is unsigned, shows a man painted in a roundel 2.7 inches (6.86 centimeters) in diameter. This is exquisite work, and only the well-to-do could afford portraits such as this one. They are, however, forerunners of the art of illuminating texts and paintings printed on vellum which is one of the glories of art in the Middle Ages.

SOURCES

Euphrosyne Doxiadis, *The Mysterious Fayum Portraits: Faces from Ancient Egypt* (London, England: Thames and Hudson; New York: Abrams, 1996).

Ludwig Goldscheider, *Roman Portraits* (Oxford, England: Phaidon, 1945).

Christine M. Havelock, *Hellenistic Art. The Art of the Classical World from the Death of Alexander the Great to the Battle of Actium* (Greenwich, Conn.: New York Graphic Society, 1968).

R. P. Hinks, *Greek and Roman Portrait Sculpture*. 2nd ed. (London, England: British Museum Publications, 1976).

Sabine G. MacCormick, *Art and Ceremonial in the Later Roman Empire* (Berkeley: University of California Press, 1980).

Gisella M. A. Richter, *The Portraits of the Greeks*. Rev. R. R. R. Smith (Oxford, England: Phaidon, 1984).

Moses S. Slaughter, *Roman Portraits* (Freeport, N.Y.: Books for Libraries Press, 1969).

MOSAICS

BEGINNINGS. The beginnings of Greek mosaic art occurred before the middle of the fourth century B.C.E., and all the early examples are pebble mosaics, in which pebbles of different colors are laid in mortar. In Olynthus, a Greek city on the northern coast of the Aegean Sea, there are some fine pebble mosaics in the dining rooms of private houses which were built in the last quarter of the fifth century B.C.E., though the mosaics may not have been laid at the time of construction. However, in 348 B.C.E., King Philip II of Macedon destroyed Olynthus, so the mosaics cannot be dated later than that. They show scenes taken from mythology; one scene shows Dionysus, the god of wine, riding a chariot pulled by leopards and surrounded by a following of maenads and satyrs. The pebbles used are white and black. White figures are shown against a black background, and art historians have pointed out the similarity to red-figure vase painting in which the figures are red against a black background. From these beginnings, the technique developed rapidly.

THE PELLA MOSAICS. Pella, the capital of Macedon which was rebuilt on a grand scale by Alexander the Great's father, Philip, has yielded mosaics that mark the high development of pebble mosaic. In addition to black-and-white patterns, there are now mosaics using colored pebbles, though the range of colors is still limited. The basic pattern of white figures against a dark background remains unchanged, but details are modeled using small pebbles that are packed tightly together, while fine strips of terracotta and lead mark the contour lines with the figures, and there is skillful use of colored pebbles. One mosaic from Pella shows a lion hunt with white pebbles for the body of the lion, grey and pale blue to set off muscles and shadows, brown and yellow for the hair, and strips of lead or terracotta to mark the contour lines. Another mosaic from Pella shows two young hunters, both wearing the cloak known as the *chlamys* but otherwise naked, hunting a stag. The mosaic craftsman used different shades of pebbles for the bodies of the two hunters, and for their hair he used yellow pebbles. The tongue of the stag is shown in red. The craftsman's skill is extraordinary.

TESSELLATED MOSAICS. The art of the mosaic did not come into its own until mosaicists began to use bits of marble and stone cut, more or less, into cubes and fitted closely together in a bed of mortar. These small pieces of marble or colored stone were called *tesseras*, and the mosaics made from them were called *opus tessallatum.* Tesseras had a range of colors which pebbles lacked,

and if they were cut into tiny pieces and set together closely enough, the mosaic could give the impression of a painting. This new technique sometimes went by the Latin name of *opus vermiculatum,* and probably began in Alexandria, the capital of the Ptolemaic kingdom of Egypt, but it was embraced enthusiastically by the kingdom of Pergamum. It was the fashion to use *opus vermiculatum* to make what were called *emblemata* (singular: *emblema*)—panels imitating paintings—which the mosaicist could make in his workshop and then insert into the floor of a room, in its center, and surround it with coarser mosaic work. Mosaic artists were not so much creative artists, however, as they were humble craftsmen who executed designs given to them, and ancient literature mentions the name of only one of them: Sosus, who worked at Pergamum. He was known for a famous mosaic that was often imitated. It portrayed a floor with the appearance of being littered with the leavings of a banquet that the banqueters have thrown on it. The central panel, or *emblema,* shows doves sitting on a bowl, drinking from it and preening themselves. The motif was often repeated, with modifications. There are examples of the motif from Pompeii and Herculaneum, and there is a particularly fine example from the emperor Hadrian's villa at Tivoli outside Rome, which is so well done with tiny tesseras that art historians have wondered if it could be Sosus' original. Though ancient literature mentions only one great mosaic artist, some of the mosaics themselves bear signatures. Someone called Gnosis, for instance, signed the pebble mosaic of the stag hunt from Pella. The mosaic craftsmen were proud of their art.

MOSAICS FOR THE MIDDLE CLASSES. By the second century B.C.E., mosaic floors were no longer the preserve of princes. They were the decorative flooring of middle-class homes. Evidence for their ubiquity comes from the houses found on the island of Delos in the southern Aegean Sea. For a period between 166 and 69 B.C.E., there was an economic boom on Delos, for Rome had made her a free port, and she rapidly developed as a trading center, particularly for the slave trade. The private houses found there belonged to traders and merchants who settled there during the boom. Mosaics are to be found in every room of these houses, not just in the dining room. This was the sort of mosaic art which the Romans encountered when they came to Greece. In fact, among the merchants living on Delos were a group from Italy, and some of the houses there with elegant mosaics may have belonged to them. When archaeologists excavated Pompeii and Herculaneum, cities buried

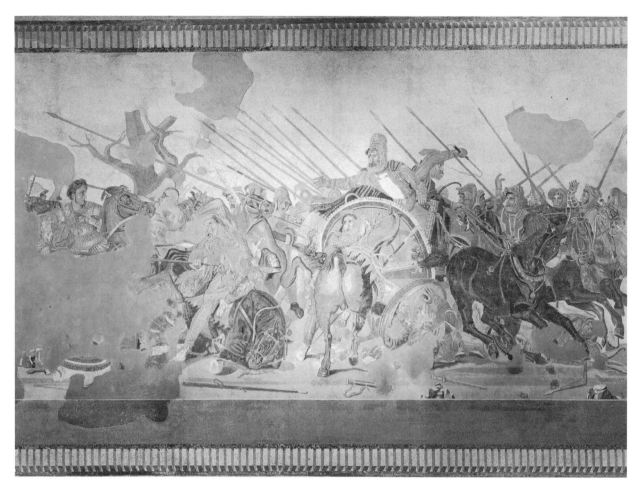

Mosaic from the House of the Faun in Pompeii, showing the Battle of Issus between Alexander the Great and Darius III of Persia. Copied from a Hellenistic painting by an unknown artist probably of the third century B.C.E. **THE ART ARCHIVE/ARCHAEOLOGICAL MUSEUM NAPLES/DAGLI ORTI.**

by the eruption of Mt. Vesuvius in 79 C.E., it is not surprising that they found a rich collection of mosaics.

THE MOSAICS OF POMPEII. The House of the Dancing Faun, so called because of a dancing faun in the middle of its atrium or main room, is the largest house in Pompeii, taking up a whole city block. When it was excavated in 1831, it turned out to be a treasure trove of mosaics. Mosaic subjects include a lion, three doves pulling a necklace from a casket that was an adaptation of Sosus' famous mosaic, and a cat attacking a hen. On the floor of a room off the atrium is one of the greatest mosaics to survive. It reproduces a painting of the Battle of Issus where Alexander the Great met the king of Persia, Darius III, for the first time and defeated him. The painting that the mosaicist copied must have been famous, and art historians have made various guesses as to what it was and who executed it. A painter named Philoxenus of Eretria is known to have painted

a "Battle of Issus," and so did a female painter, Helena of Egypt. There have been suggestions, too, that the painter was the great Apelles himself. The painting depicts the moment when Darius flees from the battlefield. Alexander charges from the left, thrusting his long lance towards Darius. Darius is masterfully executed; he turns toward Alexander with panic in his face, while his charioteer lashes the horses. In the middle of the picture, the painter has shown a horse from the rear, which a Persian rider is trying to pull out of the way of the deadly Macedonian charge. The original painting was done with the four-color palette favored by fourth-century artists who created their colors by mixing red, yellow, white and black pigments, but the craftsman who made his mosaic did not have that luxury: he had only tiny tesseras of different colors at his disposal and he had to juxtapose them with infinite care to get the right effect. It is estimated that one and a half million tesseras were used to produce this mosaic. It is likely that this mosaic was

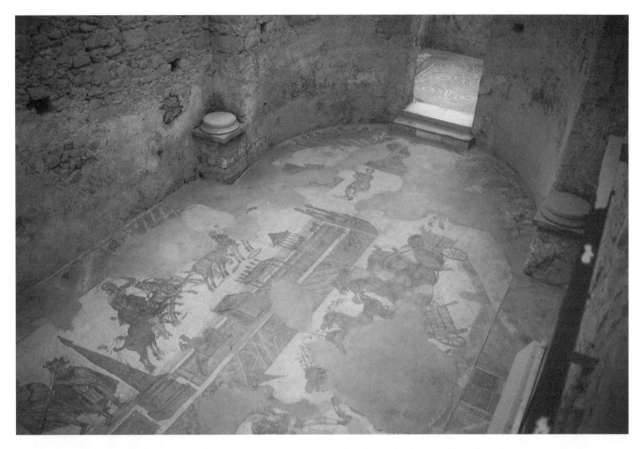

Mosaic from a Roman villa found at Piazza Armerina Sicily, c. 300 C.E., showing a chariot race in a Hippodrome. **PHOTOGRAPH BY HECTOR WILLIAMS. © HECTOR WILLIAMS.**

not actually made in Pompeii, but was shipped from somewhere in the eastern Mediterranean in several sections and reassembled in Pompeii. It may have been prefabricated for a Roman customer by a mosaic workshop in the Hellenistic east, but more likely it was a mosaic that had already been laid in the east and was lifted and shipped to Italy in sections where it was reassembled. Probably it came to Italy as plunder from the east. A close examination of the mosaic supports this argument, for it is possible to find mistakes made in reassembling it such as incomplete figures. Mosaics were among the works of art that the Roman armies looted when they operated in Greece in the second and first centuries B.C.E., but not all mosaics from the east came to Italy as spoils of war. Some were made for paying customers in Italy. This was probably true of two mosaics found in Pompeii in the so-called House of Menander, showing scenes from the comedies the playwright Menander. Each is signed by Dioscurides from Samos off the southwest coast of Turkey, and each is set in a marble tray so it could be transported easily.

MOSAICS IN ROMAN ITALY. The mosaics of Roman Italy from the latter part of the first century to the third favor silhouette designs. There is an example from Pompeii itself, from the "House of the Tragic Poet," which has a silhouette mosaic in black and white in the vestibule showing a snarling dog straining at his leash, and the words "CAVE CANEM"—"Beware the dog!". It is, however, in Ostia Antica ("Old Ostia") that the best black-and-white mosaics are found. Ostia, situated at the mouth of the Tiber River, was an unsatisfactory port, but the emperor Claudius (r. 41–54 C.E.) attempted to improve it and make it possible for grain ships to unload their cargoes there. His harbor works soon silted up, however, and the commercial buildings and baths in Old Ostia were deserted as business moved to a new port built by the emperor Trajan north of the Tiber river mouth. The "Baths of Neptune" in Ostia still have a well-preserved black-and-white mosaic showing Neptune driving his sea-horses across a floor filled with marine creatures. The figures are distributed freely over the floor; the old Hellenistic practice still found at Pompeii of placing a framed picture, or *emblema*, in the center of

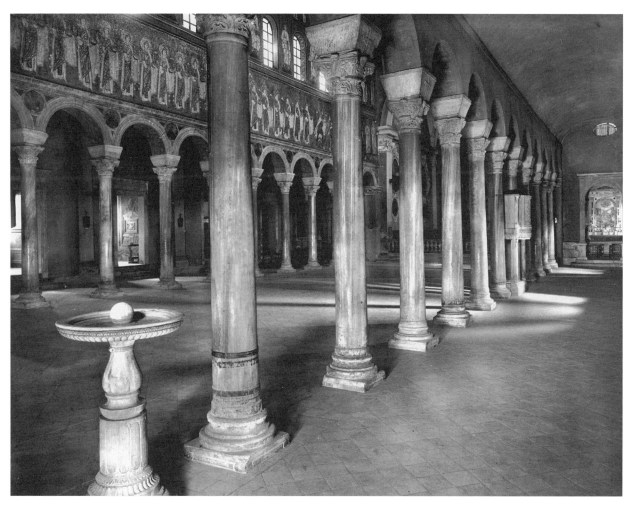

Lateral view of the colonnaded nave of the Church of S. Apollinare Nuovo with its mosaics, procession of female saints bearing offerings visible along left side, Ravenna, Italy, c. 504 C.E. **ALINARI-ART REFERENCE/ART RESOURCE, NY. REPRODUCED BY PERMISSION.**

the floor had been abandoned. Mosaics of this black-and-white style remained popular in Italy until the third century when color crept back in.

THE ROMAN PROVINCES. The black silhouette mosaics of the sort found in Ostia were never very popular in the western Roman provinces and they were not at all popular in the Roman East, where the traditions of Hellenistic mosaics were strong. The exception was Greece, which had suffered greatly in the civil wars of the first century B.C.E. The market for mosaics collapsed during this time, and mosaic workshops in Greece went out of business. When the market recovered in the second century C.E., the mosaic artists looked to Italy for their inspiration. Elsewhere, the provinces developed their own traditions. Excavations at Antioch, the capital of Roman Syria (modern Antakya in Turkey), in the 1930s revealed a splendid group of mosaics which were unaffected by styles in Italy. The mosaic artists of Anti-

och loved color; the black-and-white mosaics of Italy had no appeal. Scenes from mythology were still as popular as they were in the Hellenistic period when they were used as *emblemata* framed in the center of mosaic floors. The chief difference is that the *emblemata* became larger, so that they took over much of the floor space, and the framing around them became narrower and less important. Roman Africa also developed its own style. Few mosaics have been found in country villas there, though that may be an accident of archaeology, for not many country villa ruins have been explored in Roman Africa. The town houses, however, have yielded an astonishing array of mosaics. Polychrome mosaics were particularly popular. One favorite pattern was the "floral style," where vine or ivy tendrils and flowers were arranged in geometric patterns. One fine example from El Djem in Tunisia, belonging to the second half of the third century C.E., shows grapevines growing out of urns in each corner and spreading over the whole floor. In the

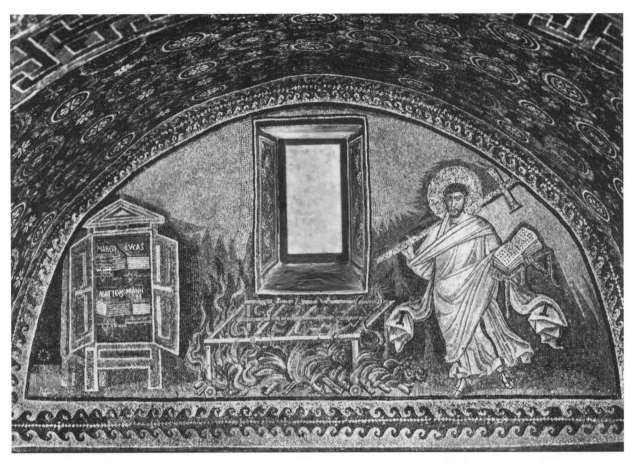

Mosaic from the Tomb of Galla Placidia, Ravenna, Italy, dating to about 425 C.E., showing the martyrdom of St. Lawrence who was roasted on a gridiron. MAUSOLEUM OF GALLA PLACIDIA AT RAVENNA, ITALY.

center there is a small picture framed in a hexagon which shows old Silenus, the perpetually intoxicated follower of the wine god, Dionysus, sprawled on a couch, playing with children. Another popular type of mosaic shows scenes distributed freely over the surface of the floor as they were in the Italian black-and-white mosaics. From the mid-second century C.E. an increasing number of scenes were taken from the amphitheater. Such scenes show wild-beast hunts where gladiators armed with spears faced savage beasts like leopards and bears, or criminals being thrown to them to be torn apart in the Roman arena. The expense of producing these duels between gladiators and wild beasts was heavy, and the mosaics sometimes commemorate the generosity of wealthy citizens who paid the bill out of their own pockets.

THE MOSAICS FROM PIAZZA ARMERINA. One of the most extensive African-style mosaics was found not in Africa but in central Sicily, at Piazza Armerina. The villa at Piazza Armerina is a vast, sprawling structure which seems to be a great hunting lodge built at the end of the third or the beginning of the fourth century C.E.

Some scholars conjecture that it was built for the use of the emperor Maximian, the colleague of Diocletian from 286 to 305 C.E., who retired without enthusiasm when Diocletian did and presumably sought peace and quiet there. The floors are covered with polychrome mosaics in the style of Roman Africa. Experts generally agree that the mosaic craftsmen who made them came from Carthage, on the edge of modern Tunis. Some show the fauna that was fodder for the amphitheaters—including lions, tigers, elephants, and ostriches—being caught and shipped, presumably to Rome, while others depict the amusements in the arenas and the hippodromes. One mosaic shows a chariot race, with the charioteers competing under their colors which indicated their teams: the Reds, Whites, Blues, and Greens. Another mosaic shows scantily-clad girls playing a kind of water polo, for one of the popular spectacles called for the orchestras of theaters to be made water-tight and then filled with water so that girls wearing bikini-type bathing suits could put on a water show.

WALL MOSAICS. Sometime about the middle of the first century C.E. Romans began to put mosaics on their walls. The owner of one up-to-date house in Herculaneum, the so-called House of the Neptune and Amphitrite Mosaic, had wall mosaics installed not long before Herculaneum was buried by the eruption of Mt. Vesuvius. In Pompeii, a house owner used mosaic to decorate a small fountain. Mosaics were particularly suitable for areas that were damp, such as ornamental fountains and public baths, where painted plaster would quickly mildew. Most of the wall mosaics of ancient Rome were destroyed when the buildings they once decorated were ruined, and the best wall mosaics belong to Christian churches. There are splendid examples in Ravenna, the last capital of the Western Roman Empire before the last emperor was dethroned in 476 C.E. The little mausoleum of Galla Placidia, the sister of the incapable emperor Honorius (395–423 C.E.) who provided what imperial rule there was for the Roman Empire in the middle of the fifth century, has its interior walls covered with mosaics. One portrays St. Lawrence approaching the hot griddle where he would suffer martyrdom, his flesh roasted while he was still alive, and another, in the lunette above the entrance, shows a popular Christian design: Christ the Good Shepherd looking after his sheep. Christ sits in a naturalistic landscape that extends to a background beneath a blue sky. The mosaic belongs to the classical artistic tradition, which was still strong at Ravenna when the mausoleum was built about 425 C.E. Yet its days were numbered. As the sixth century began, the Church of Sant' Apollinare Nuovo was being built in Ravenna, and its mosaics belong to world of Byzantine art. A mosaic of the "Miracle of the Loaves and Fishes" shows Christ wearing imperial robes, facing the onlooker, dominating the center of the picture while on either side are two disciples. The background is gold, symbolizing the splendor of Heaven. Henceforth gold became the background of choice for mosaics.

THE LAST OF THE RAVENNA MOSAICS. At Ravenna, there are two famous mosaics which mark the transition from the artistic traditions of the classical world to the new world of Byzantine art. In the Church of San Vitale, which was dedicated in 547 C.E., there are mosaics on the walls on either side of the chancel, one of which shows the great emperor Justinian and his entourage about to enter the church for the dedication ceremony; on the other wall is the empress Theodora, the ex-actress whom Justinian married, standing in the courtyard of the Church of San Vitale, surrounded by her attendants. The mosaic dates to 547 or shortly before, and was probably made in Constantinople; the next year, in 548 C.E.,

Theodora died of cancer. The figures are in procession, filing into the church, and they are not shown in profile; instead they face the viewer and gaze at him. Theodora's eyes are particularly arresting. Yet the figures are still to some degree three-dimensional and the portraits of the emperor and empress show them as real individuals. The classical tradition in art is fading but its influence is not yet dead.

SOURCES

M. E. Blake, "Mosaics of the Late Empire in Rome and Vicinity," *Memoirs of the American Academy in Rome* 17 (1940): 81–130.

———, "Roman Mosaics of the Second Century in Italy," *Memoirs of the American Academy in Rome* 13 (1936): 67–214.

Philippe Bruneau, *Le mosaique antique* (Paris, France: Presses de l'Université, Paris-Sorbonne, 1987).

Sheila Campbell, *The Mosaics of Antioch* (Toronto, Canada: Pontifical Institute of Medieval Studies, 1988).

J. R. Clarke, *Roman Black-and-White Figured Mosaics* (New York: New York University Press, 1979).

K. M. D. Dunbabin, "Mosaics," in *The Oxford Companion to Classical Civilization*. Ed. Simon Hornblower and Antony Spawforth (Oxford, England: Oxford University Press, 1998): 475–477.

———, *Mosaics of the Greek and Roman World* (Cambridge: Cambridge University Press, 1999).

Roger Ling, *Ancient Mosaics* (Princeton, N.J.: Princeton University Press, 1998).

———, "Mosaics in Roman Britain: Discoveries since 1945," *Britannia* 28 (1997): 259–295.

UNESCO, *Tunisia: ancient mosaics* (Greenwich, Conn.: New York Graphic Society, 1962).

SIGNIFICANT PEOPLE
in Visual Arts

APELLES

c. 370 B.C.E.–Early third century B.C.E.

Painter

GREECE'S GREATEST PAINTER. Apelles was probably the greatest artist in the Greek world, though all that survives are descriptions of his works. He gained fame as the portrait artist of choice to some of the most powerful men in the ancient world, including Philip of Mace-

don, Alexander the Great, and Ptolemy I in Egypt. He placed great emphasis on precise line drawing, and every day he made a point of practicing it to maintain his skill. He also used a transparent varnish to preserve his paintings. The exact formula of the varnish is not known, but the word that the historian Pliny the Elder used for it was *atramentum* (black lacquer) which indicates that it darkened his colors and probably softened them.

TRAINING. Apelles was born either on the island of Cos, or on the Asia Minor mainland at Colopohon around 370 B.C.E. He was thus an Ionian Greek and he trained first with Ephorus of Ephesus who belonged to the Ionian School of artists. He then moved to the Greek mainland to study with the celebrated artist Pamphilus, who headed a school at Sicyon, the western neighbor of Corinth. Pamphilus was famous for charging high tuition fees, but his school had some famous alumni, including the sculptor Lysippus, who became Alexander the Great's sculptor of choice. Apelles learned to combine the precision of the Sicyonian style with the elegance that he had learned in Ionia, and about 340 B.C.E., his reputation was such that he was invited to the court of Philip II, king of Macedonia, where he painted portraits and won the admiration of the young Alexander, Philip's son.

ALEXANDER'S FAVORITE PORTRAIT ARTIST. Alexander was the subject of Apelles' most famous portraits, and Apelles helped to create the image of Alexander as a superhuman hero, ruler of the inhabited world. Alexander recognized the value of art in creating an image, and he entrusted his representation to only three artists: Apelles, Lysippus, and the engraver Pyrgoteles. The most famous of the portraits was Apelles' depiction of Alexander as the god Zeus holding a thunderbolt, *Alexander as Zeus Keraunophoros*, a painting that aimed to support Alexander's claim to deity. Another painting of Alexander showed him with the Victory Goddess, *Nike*, and another with strong allegorical overtones showed Alexander in a triumphal chariot along with the personification of war, *Polemos*, whose hands are bound. Both these paintings were later taken to Rome where they were displayed in the Forum of Augustus and later repainted so that Alexander's features in the paintings were replaced by those of Augustus himself by order of the emperor Claudius (r. 42–54 C.E.).

APHRODITE ANADYOMENE. One of Apelles' most famous works was *Aphrodite Anadyomene* (Aphrodite Arising) which showed Aphrodite arising from the sea where she was born, and wringing her hair. According to one story, the model for the work was Alexander's mistress, with whom Apelles fell in love during a previous portrait sitting. When Alexander discovered Apelles'

feelings, he gave his mistress to Apelles. If the anecdotes from ancient writers about Apelles' relationship with Alexander can be believed, Apelles was able to take liberties with Alexander that others could not. Both Pliny the Elder and Aelian noted instances when Apelles directly insulted Alexander's understanding of art and apparently suffered no consequences for his cheekiness. Apelles also did a self-portrait, the first self-portrait known from the ancient world.

PAINTER TO THE KINGS. When Alexander died in 323 B.C.E., Apelles painted portraits of his successors, including Antiogonus *Monopthalmus* (One-Eyed), who was blind in one eye. According to a description of this portrait, Apelles painted it in such a way as to show only the good eye, suggesting that he introduced a three-quarters view. Apelles then travelled to Alexandria in Egypt, where he worked in the court of King Ptolemy I. His career nearly came to an abrupt end there when he was implicated in a plot against Ptolemy, but he managed to clear his name and regain the favor of the king. Some scholars suggested that his famous allegorical painting, *Calumny*, described by the second-century C.E. satirist Lucian, was part of Apelles' argument for his innocence. The fifteenth-century Florentine artist Sandro Botticelli (1445–1510) recreated this work from Lucian's description, and it now hangs in the Uffizi Gallery in Florence.

DEATH. Apelles died on the island of Cos, while copying his famous *Aphodite Anadyomene*. The painting was later taken to Rome. While the exact date of his death is unknown, it was probably early in the third century B.C.E.

SOURCES

Vincent J. Bruno, *Form and Color in Greek Painting* (New York: Norton, 1977).

E. H. Gombrich, *The Heritage of Apelles: Studies in the Art of the Renaissance* (Ithaca, N.Y.: Cornell University Press, 1976).

Andrew Sherwood, "Apelles," in *Encyclopedia of Greece and the Classical Tradition*. Ed. Graham Speake (London, England: Fitzroy Dearborn, 2000): 99–101.

EXEKIAS

c. 570 B.C.E.–After 530 B.C.E.

Potter
Vase painter

KNOWN BY HIS VASES. The Greek artist Exekias represents black-figure vase painting at its height, a distinction he shares with a contemporary known as the Amasis-painter. Although the time period in which he

flourished places him in Athens during the rule of the tyrant Pisistratus, the only other biographical details about him come from his vases. His signature appears on two vases as both potter and painter, and on eleven others as the potter. Other vases are attributed to him on stylistic grounds and thus a total of about forty of his pieces survive. Exekias' career as a potter seems to have begun before he tried his hand at vase decoration. Scholars guess that he was probably born in the 570s B.C.E., and while the date of his death is unknown he seems not to have been active after 530 B.C.E.

REMARKABLE SKILL. Exekias is remarkable for the quality of his draftsmanship and his skill as a potter. He may have invented the type of vase known as the calyx crater, for he decorated the earliest surviving calyx crater. But it is his skill as a vase painter that is most impressive. His masterpiece is a black-figure amphora in the Vatican Museum showing Achilles and Ajax playing a board game, Achilles wearing his helmet and Ajax, bareheaded, bending intently over the board. After Exekias, this scene is repeated by later vase painters about 150 times. It refers to some incident in the Trojan War myth, but it is not mentioned in any of the classical literature that has survived. The Trojan War, however, seems to have been a favorite subject for Exekias. One vase shows Ajax lifting up the corpse of Achilles who has just been slain by the arrow of Paris. Another vase of his shows Ajax committing suicide: all alone he plants a sword upright in the sand and falls on it. Exekias has only one surviving scene from the sack of Troy. It shows Aeneas rescuing his father Anchises; Exekias managed to portray the haggard face of old Anchises with remarkable skill.

OTHER SUBJECTS. Exekias was also interested in other subjects. One splendid drinking-cup shows the god Dionysus in a boat that is sprouting a grapevine from its mast, while dolphins swim round about. The myth is well known: pirates kidnapped Dionysus who turned them into dolphins as punishment. Exekias also did a fine black-figure hydria—a small water jar with three handles and a small neck—showing Heracles wrestling with the Nemean lion. Heracles seems to have been a favorite hero in Athens of the sixth century B.C.E., though in the next century, he was supplanted to a large extent by Theseus who was made into an Athenian counterpart of Heracles. Heracles was too intimately connected with the hated Sparta whose kings claimed to be his descendants. Exekias did a scene from the Theseus-myth but the vase is broken and its scene cannot be reconstructed. Another of Exekias' amphoras shows Theseus' two sons, Demophon and Akamas, walking their horses. This, as far as we know, is the first time they appear in Athenian art.

SOURCES

John Boardman, "Exekias," *American Journal of Archaeology* 82 (1978): 11–25.

———, *Athenian Black-Figure Vases: A Handbook* (London, England: Thames and Hudson, 1991).

Eleni Zimi, "Execias," in *Encyclopedia of Greece and the Hellenic Tradition*. Ed. Graham Speake (London, England: Fitzroy Dearborn, 2000): 597–598.

LYSIPPUS

c. 390 B.C.E.–After 316 B.C.E.

Sculptor

PRODUCTIVE CAREER. The sculptor Lysippus was born in Sicyon, a small city-state west of Corinth in Greece near the beginning of the fourth century B.C.E. He was active as early as 370 B.C.E., as an inscription found at Delphi makes clear, and according to another inscription, he made a portrait of King Seleucus, one of Alexander the Great's successors who laid claim to Alexander's conquests in the Near East in 312 B.C.E. He was extraordinarily productive. His workshop turned out literally hundreds of bronze statues. None survive, but a few copies sculpted in marble still exist. The most famous is his *Apoxyomenos* (Scraper) in the Vatican Museum, which portrays a naked athlete scraping himself. Athletes rubbed themselves down with olive oil before exercising and then, after exercise, scraped off the oil and sweat with a scraper called a *strigil.*

ROYAL SCULPTOR. It is clear that Lysippus' career was closely associated with the Macedonian royal house. Philip II, king of Macedon who ruled from 359–336 B.C.E., employed him first, and then he became the court sculptor of Alexander the Great (r. 336–323 B.C.E.). It is reported that Alexander would allow only Lysippus to sculpt portraits of him. This may not be literally true, but it was probably Lysippus who was responsible for the portrait-type of Alexander which shows him as if divinely inspired, his eyes looking upwards and his hair windswept. Another favorite subject of his was Heracles, whom the royal house of Macedon claimed as an ancestor. He was greatly praised for two colossal statues of Heracles, both made of bronze. One was a seated figure of Heracles made for the Greek city of Taras, Roman Tarentum (modern Taranto) on the southern coast of Italy, where it once stood on the acropolis. It was taken to Rome in 209 B.C.E. and displayed on the Capitoline Hill. Libanius, an author of the fourth century C.E., described the second as Heracles leaning heavily on his club which was draped with his lions' skin. There are about

25 Roman copies of it: the largest was found in the Baths of Caracalla in Rome and is now in the Naples Museum. The statue of Heracles in Naples bears the signature of a sculptor named Glycon, an Athenian sculptor of the second century C.E. who was a copyist. Another copy in Florence states that it is a work of Lysippus. It probably belongs to Lysippus' old age, for it looks forward to the High Hellenistic period with its taste for statues with superhuman bodies; Heracles is shown resting after his exertions with bulging muscles and stretched tendons.

CAPTURED MOVEMENT IN SCULPTURE. Outside Lysippus' house in Sicyon stood a statue that the sculptor made for himself, titled *Kairos* which can mean "due measure" and "proportion" or "opportunity"—the right time to do something. It has been taken as Lysippus' manifesto, just as the "Spear-bearer" of Polyclitus represented Polyclitus' *Canon*, his statement of the proper proportions of the naked male body. The *Kairos* showed that Lysippus had moved far beyond Polyclitus. Modern knowledge of the statue comes from reproductions on reliefs and gems. It showed a youth with wings on his shoulders and his ankles, running on tiptoe, with his one hand balancing a set of scales on the edge of a razor and with the other adjusting the scales. This is an allegorical representation and it refers to the saying taken from the historian Herodotus: "Our affairs are on the razor's edge," meaning, "This is the time for decision, and time will not wait." Lysippus represented rapid motion frozen in bronze. In Lysippus' *Apoxyomenos* too, the muscles of the left leg seem to carry the weight of the body, yet the shoulders and torso swing to the right. Lysippus caught the athlete at the moment when he is shifting his weight from one leg to the other thereby successfully sculpting motion. This innovation in sculpture was further developed in the Hellenistic Age when sculptors depicted subjects frozen in a moment of restless or violent motion.

SOURCES

Erik Sjoqvist, *Lysippus*, Semple Lectures Series (Cincinnati: University of Cincinnati, 1966).

A. F. Stewart, *Greek Sculpture: An Exploration* (New Haven, Conn.: Yale University Press, 1990).

———, "Lysippan Studies I: The Only Creator of Beauty," *American Journal of Archaeology* 82 (1978): 163–171.

PHIDIAS

c. 490 B.C.E.–c. 417 B.C.E.

Sculptor

THE GREATEST GREEK SCULPTOR. Phidias was not only the most important sculptor produced by the artistic center of Athens but the most important artist of the fifth century B.C.E. He is responsible for two of the most impressive cult statues produced in Greece—the *Athena Parthenos* and the *Zeus* at Olympia—and, according to ancient sources, was in charge of the creation of the Parthenon, Greece's most recognizable structure. His skill as a sculptor in a number of mediums, including bronze and marble as well as the combination of gold, ivory, and wood used in his chryselephantine statues, made him an extremely versatile artist whose work inspired generations of artists after him. It was largely due to his reputation that Athens became the trendsetter for Greek sculpture. Although none of his works survived to modern times, his art was immortalized in the descriptions of ancient writers, engraved on coins of the day, and copied by lesser artists.

FIRST MAJOR WORK. The "Attic Style" which developed in Athens during the period of Phidias' dominance absorbed the other regional styles in Greece with the exception of the Peloponnesos where the city of Argos maintained its reputation in bronze casting and its independent artistic traditions. Phidias himself was a product of the workshops of Argos; according to tradition he had been trained by Hegias and Ageladas, who also trained Myron. His first large commission seems to have been at Delphi, where Athens commissioned a monument to honor its victory over the Persians at the battle of Marathon in 490 B.C.E. The monument dates to some 25 years after the battle, during the political heyday of Cimon, the son of Miltiades who was the architect of the victory at Marathon. Of the sixteen bronze statues on the monument, which included depictions of gods, heroes of Athenian tribes, and Miltiades himself, thirteen were by Phidias.

EARLY ATHENA STATUES. Besides his *Athena Parthenos*, Phidias produced several other cult statues of the goddess. He sculpted his *Athena Areia* to celebrate another Greek military victory, although ancient writers disagreed as to which one. The drapery of her clothes was gold-covered while her flesh was crafted in ivory, a composite technique that was a hallmark of his style. Sometime around 450 B.C.E. he sculpted the famous bronze statue of *Athena Polias*, later known as *Athena Promachos* (Athena who fights in the forefront of the battle), which is estimated to have been around seven and a half meters (25 feet) tall. It stood in the Acropolis of Athens where it could be seen by nearby ships. Both of these Athenas are depicted as warriors, and contrast with a more peaceful presentation of the goddess in his bronze of Athena known as the *Athena Lemnia*, produced about the same time. It was probably dedicated by a group of

Athenians who were going to the island of Lemnos as military colonists to secure Athens' hold on the island. A Roman copy of the *Athena Lemnia* was found. Its head—now in Bologna, Italy—and the body—now in Dresden, Germany—fit together to give modern scholars an idea of what the original statue looked like.

ATHENA PARTHENOS. While these statues earned Phidias praise, his reputation was built on his creation of the chryselephantine statues *Athena Parthenos* for the Parthenon, and *Zeus* for the Temple of Zeus in Olympia, neither of which survived. A chryselephantine statue (from the Greek *khrysos* meaning "gold" and *elephantinos* meaning "ivory") is a statue made of gold and ivory: the drapery is made of gold and the flesh of ivory, and the statue is supported on a wooden frame. In 448 B.C.E. Athens decided to build the Parthenon which still stands on the Acropolis of the modern city of Athens. Phidias, who had connections with Pericles, the leading Athenian statesman of the day, was put in charge of the sculpture on the building. Scholars disagree on Phidias' contribution to the project. It is clear from an examination of all the Parthenon marbles that a number of sculptors were at work, but Phidias may have been responsible for the overall design. There is no doubt, however, that the great chryselephantine statue of *Athena Parthenos* that stood inside the temple was by Phidias. She stood more than twelve meters (40 feet) high, and over a ton of gold went into making her clothes. Her robe, however, was made of pieces of gold that could be removed easily and melted down if financial stringency made it necessary. *Athena Parthenos* literally carried a large share of the Athenian treasury on her back.

ZEUS AT OLYMPIA. There is some question as to when Phidias worked on his famous *Zeus* at Olympia. Some scholars argued that it was actually completed before he started work on the Parthenon, sometime around 448 B.C.E. There is evidence, however, that Phidias was charged with impiety in Athens sometime around 432 B.C.E., possibly because he included a representation of both himself and Pericles on Athena's cult statue. The resulting trial may have forced Phidias' departure to Elis, where he kept a workshop and created the *Zeus*. The later date is further supported by the style of a piece of black-glaze pottery which reads "I belong to Phidias" on the bottom discovered in the remains of this workshop. At the time of Phidias' arrival to Elis, the temple of Zeus at Olympia had already been built but still lacked a statue. The seated statue Phidias created was even larger than the *Athena Parthenos*, so large, in fact, that one ancient observer noted that were *Zeus* to rise from his seated position, he would unroof the temple.

UNCERTAIN ENDS. The fates of Phidias' monumental works are unknown, as is the death of their creator. His statue of *Athena* in the Parthenon was destroyed by fire in the second century C.E., but was restored by the emperor Hadrian. It was removed by imperial decree, probably to Constantinople, in the fifth century C.E. The *Zeus* of Olympia was also taken to Constantinople at which point it disappeared from history.

SOURCES

John Boardman, *Greek Sculpture, The Classical Period* (London, England: Thames and Hudson, 1985).

Richard Neudecker, "Pheidias," in *Der Neue Pauly.* Vol. 9 (Stuttgart, Germany: J. B. Metzler: 2000): cols. 760–763.

POLYGNOTUS

c. 500 B.C.E.–c. 440 B.C.E.

Painter

INNOVATIONS IN PAINTING. Polygnotus, a Greek painter who introduced several innovations to his craft, was born on the island of Thasos in the northern Aegean Sea although he lived in Athens during the first half of the fifth century B.C.E. He was the son of a painter of Thasos, Aglaophon, and adhered to the familiar pattern of a son following his father's trade. The historian Pliny the Elder, writing in the first century C.E., credited Polygnotus with being the first to paint women with transparent garments revealing the body beneath them, and to show them with multicolored headdresses. He treated the faces and mouths of his human figures in a freer, more naturalistic manner than his predecessors. The famous Greek philosopher Aristotle praised Polygnotus' ability to represent the characters of his human figures. His effort to represent space and depth in his pictures was also an innovation. Polygnotus was not satisfied with placing all his figures in the foreground, on the baseline of the picture, as was typical in pictures of the time. Instead he tried to represent depth in his paintings by placing figures that were more distant on a higher level than that which were nearer to the viewer. There is evidence of similar experiments in red-figure vase painting about the time that Polygnotus was active, indicating his influence on that medium.

WORKS. Since none of his paintings survived, knowledge of his works comes entirely from descriptions of them by later writers. The Greek writer Pausanias who wrote an account of his travels in Greece in the second century C.E. mentioned a painting by Polygnotus in the picture gallery in the north wing of the Propylaea, the

monumental entrance to the Athenian Acropolis. He also saw Polygnotus' picture of an episode in the sack of Troy in the *Stoa Poikile* ("Painted Porch") in the Athenian marketplace. It was painted on wooden panels attached to the wall of the porch, the foundations of which have recently been uncovered, and must date soon after 460 B.C.E. His work on the Stoa may have been the reason that Athens conferred citizenship on him in an era when Athens rarely gave aliens such an honor. His most famous works were at Delphi, however, where he did paintings of the Sack of Troy and of the Underworld—that is, the world of the dead—in the *Lesche*, or club house of the Cnidians, built by the city-state of Cnidus sometime between 458 and 447 B.C.E. The foundations of the *Lesche* survive, and Pausanias provided a detailed description of Polygnotus' paintings there.

SOURCES

Robert B. Kebric, *The Paintings in the Cnidian Lesche at Delphi and Their Historical Context* (Leiden, Netherlands: Brill, 1983).

E. G. Pemberton, "The Beginning of Monumental Painting in Mainland Greece," in *Studia Pompeiana et classica*. Ed. Robert I. Curtis (New Rochelle, N.Y.: Caratzas, 1988): 181–197.

Eleni Zimi, "Polygnotus," in *Encyclopedia of Greece and the Hellenic Tradition*. Vol. 2. (London, England: Fitzroy Dearborn, 2000): 1383–1384.

PRAXITELES

c. 400 B.C.E.–Before 326 B.C.E.

Sculptor

LEADING GREEK SCULPTOR. Praxiteles of Athens was the leading Greek sculptor of the fourth century B.C.E. and introduced several innovations to the medium that significantly influenced Hellenistic sculpture. He more than likely belonged to a family of sculptors; his own sons, Cephisodotus and Timarchus, followed in his footsteps, and the fact that he named his first son Cephisodotus indicates that his own father was also Cephisodotus (given names skipped a generation). Praxiteles' father is likely the Cephisodotus who carved a famous statue of *Eirene* (Peace) and *Ploutos* (Wealth) which was set up in the marketplace in Athens in the 370s, perhaps after 374 B.C.E. when Athens made peace with Sparta. The statue betrays some of the characteristics for which Praxiteles would be famous, including a humanizing of the gods that is a departure from the more formal representations of the gods in the fifth century B.C.E.

Eirene is shown as a goddess carrying the infant boy Ploutos on her left arm. Cephisodotus managed to portray the psychological interaction between the goddess and the child: the goddess looks tenderly at him, and he stretches out his hand to her in a gesture of trust. On the immediate level this is a portrayal of a mother and child; only after a moment's thought does the onlooker realize that this is an allegorical sculpture.

PRAXITELEAN CURVE. The same tenderness is evident in the one genuine statue of Praxiteles that has survived, his *Hermes and the Infant Dionysus* found in the temple of Hera at Olympia in 1877. While it is unclear whether the statue is the original or a copy, Praxiteles' distinctive style is obvious. Instead of the defined muscles of the previous century's statuary, Praxiteles created statues with softer, more fluid lines, and composed his statues along a languid 'S-curve' that became known as the "Praxitelean curve." His *Apollo Sauroctonus* also illustrates the dreamy quality of Praxiteles' work. The statue of the god Apollo as a young boy has him leaning against a tree trunk, on the verge of killing a lizard with an arrow. Roman copies of the work in both bronze and marble highlight Praxiteles' ability to portray the gods as emotional beings.

APHRODITE OF CNIDUS. Praxiteles worked both in bronze and marble, but marble seems to have been his most successful medium. Marble was the material for his most famous statue, the *Aphrodite of Cnidus*, that brought tourists to Cnidus, anxious to view the statue. It was the first statue to show a woman naked, and its appeal was perhaps more erotic than artistic. The goddess is shown as if she was surprised by an intruder while she was bathing. One hand shields her pudenda from view, but there is a slight smile on her lips and a hint of welcome to her expression. The statue was exhibited at Cnidus so that it could be viewed from all angles, and it was the first of many female nudes that Greek sculptors would produce.

LEGACY. Altogether seventy works have been associated with Praxiteles, though some may be by members of his workshop. He died sometime before 326 B.C.E., leaving his sons to carry on his style. The Praxitelean school became enormously influential in early Hellenistic sculpture as other sculptors sought to emulate the delicacy of expression and fluid lines he introduced in his works.

SOURCES

A. Ajootian, "Praxiteles," in *Personal Styles in Greek Sculpture*. Ed. Olga Palagia and J. J. Pollitt (Cambridge: Cambridge University Press, 1996): 91–119.

Rhys Carpenter, *Greek Sculpture: A Critical Review* (Chicago: University of Chicago Press, 1960).

Andrew Stewart, *Attika: Studies in Athenian Sculpture of the Hellenistic Age* (London, England: Society for the Promotion of Hellenic Studies, 1979).

———, *Greek Sculpture: An Exploration* (New Haven, Conn.: Yale University Press, 1990).

ZEUXIS

Fifth century B.C.E.–Fourth century B.C.E.

Painter

MASTER OF REALIST PAINTING. The Greek artist Zeuxis was born in the city of Heraclea in southern Italy sometime in the fifth century B.C.E. While still a young man, he travelled to Athens and built his reputation as one of Greece's best realist artists there. His style carried on the artistic innovation known as *skiagraphia* ("shading") developed by the little-known master Apollodorus of Athens. The technique modulated light and shade so as to imitate what the eye sees in nature, thus giving figures the appearance of weight and volume. Apollodorus remarked wryly in an epigram that Zeuxis robbed this artistic technique from his masters and made it his own. Regardless of the originality of his style, Zeuxis indeed was a master of it, and became very wealthy on commissions for his work. He even displayed his wealth at the Olympic Games one year by wearing garments into which his name had been woven with gold thread.

WORKS. None of Zeuxis' works survived to modern times, which means all that is known of his art comes from the descriptions of ancient writers. Aristophanes' comedy, the *Acharnians*, produced in 425 B.C.E., has a reference to his famous painting of the god of Love, Eros, wreathed in flowers. Another of his paintings was a renowned work of Zeus on his throne, with the other gods standing by, and another of the infant Heracles strangling the two serpents that Hera sent to kill him. The comic essayist Lucian of Samosata (second century C.E.) described a family of centaurs painted by Zeuxis— an unusual subject for a painting, but in keeping with Zeuxis' penchant for themes beyond the normal fare of gods, heroes, and wars. Lucian remarked that a copy of this work existed in Athens in his time, but the original had been stolen by the Roman general Sulla who sacked Athens in 86 B.C.E. and lost at sea during the journey to Rome. According to a legend, Zeuxis was so skilled at realist painting that birds attempted to eat the grapes he painted. Ever the perfectionist, Zeuxis was apparently disappointed that the boy he had painted with the grapes had not been sufficiently real to scare them off. His monochrome etchings on a white background were also notable, but what made his reputation was his skill at producing realistic figures in color.

SOURCES

Pierre Devambez, *Greek Painting* (New York: Viking, 1962).

J. J. Pollitt, *The Art of Greece, 1400–31 B.C.* (Englewood Cliffs, N.J.: Prentice-Hall, 1965).

Martin Robinson, *A Short History of Greek Painting* (Cambridge: Cambridge University Press, 1981).

DOCUMENTARY SOURCES
in Visual Arts

Anonymous, the "Critian Boy" (c. 480 B.C.E.)—The "Critian Boy" is a *kouros* that was dedicated on the Acropolis of Athens just before the Persian invasion of 480 B.C.E. It was damaged in the sack of Athens and buried after the Athenians recovered their city. The facial expression is sober but the "archaic smile" has disappeared, and the style of the "Critian Boy" dates it to the beginning of the early classical period. It gets its name from the resemblance of its head to the statue group of the "Tyrannicides" sculpted by Critias and Nesiotes in the decade after the Persian sack.

Anonymous, the "Zeus" from Artemisium (c. 470 B.C.E.)— This bronze statue, now in the National Museum of Greece in Athens, was found in the waters off Cape Artemisium, the northern tip of the island of Euboea. It shows Zeus striding forward like the "Tyrannicides" and hurling a thunderbolt. The thunderbolt is lost, and thus it is a matter of debate whether the statue portrays Zeus or Poseidon hurling his trident, but on the whole it seems more likely that it is Zeus. It is a rare survivor of a bronze statue from the early classical period. The sculptor is unknown, but one suggestion is that it was Ageladas, the teacher of the sculptor Myron.

The *Ara Pacis* of Augustus in Rome (9 B.C.E.)—The *Ara Pacis* ("Altar of Peace") is a modest altar similar in size to the "Altar of the Twelve Gods" in the marketplace of Athens. It was reconstructed on the banks of the Tiber shortly before the outbreak of World War II. Its sculpture speaks the language of Augustan propaganda; one famous relief shows "Mother Earth" with the blessings that peace brings: children brought up without fear, flocks and herds that multiply, and bountiful crops from the fields.

Critias and Nesiotes, *The Tyrannicides* (c. 475 B.C.E.)—In 514 B.C.E., Aristogeiton and Harmodius assassinated Hipparchus, the brother of the tyrant of Athens, Hippias, and though Hippias himself was not driven out

until four years later, thanks to the intervention of Sparta, the Athenians preferred to remember Harmodius and Aristogeiton as the heroes who delivered them from tyranny. To commemorate their deed, a statue group by the sculptor Antenor was erected in the Athenian marketplace shortly after Hippias was expelled, but the Persians took it as booty when they captured Athens, and the Athenians commissioned a replacement by Critias and Nesiotes. A good Roman copy was found in the villa of the emperor Hadrian at Tivoli outside Rome. The statue group, which shows the two men striding forward to attack Hipparchus, is a good example of early classical sculpture, comparable to the Zeus hurling a thunderbolt found off Cape Artemisium.

Lysippus, *Apoxyomenos* (c. 325 B.C.E.)—The *Apoxyomenos* or "Athlete Scraping Himself," marked a break with the sculptural tradition of Polyclitus of Argos. The *Apoxyomenos* is a three-dimensional figure with no clearly defined front or back. It looks forward to the art of the Hellenistic Age.

Myron, *The Discus-Thrower* (c. 455 B.C.E.)—Several Roman copies of *Discus-Thrower* by Myron survive, the best of which is in the Terme Museum in Rome. It shows an athlete in the act of hurling a discus, his head and body turned in a twisted, yet harmonious pose. The original statue was in bronze.

Phidias, *The Athena Parthenos* statue for the Parthenon (c. 440 B.C.E.)—Phidias was the most prominent Athenian artist in the mid-fifth century B.C.E. and his two most famous works in the ancient world were his cult-statues for the temple of Athena Parthenos in Athens and the temple of Zeus at Olympia. He was in charge of making the sculptures for the Parthenon, but how many of the surviving sculptures were carved by him is a matter of debate.

Polyclitus, *Doryphoros* (c. 440 B.C.E.)—Polyclitus' bronze *Doryphoros*, or "Youth Bearing a Spear," exemplifies the proportions of the male nude which he set forth in his *Canon*. A good Roman copy was found in the palaestra (gymnasium) at Pompeii, where it was buried by the eruption of Mt. Vesuvius in 79 C.E. The *Doryphoros* is a broad-shouldered youth who rests his weight on his right leg while his left is placed sideways and drawn back. The veins and muscles of his chest, abdomen, and biceps are all portrayed accurately.

Praxiteles, *Hermes with the Infant Dionysus* (c. 350 B.C.E.)—Praxiteles' *Hermes* was found at Olympia, in the Temple of Hera, where the Greek traveler Pausanias reported that he saw it in the second century C.E. Thus this statue is almost certainly an original by Praxiteles. Praxiteles was also famous for his nude *Aphrodite of Cnidus*, the first female nude which inspired many more, including the famous *Venus di Milo*.

GLOSSARY

Abacus: A flat, square-shaped slab forming the top of a column capital.

Academy: The school established by the philosopher Plato about 385 B.C.E. in the park and gymnasium on the outskirts of Athens sacred to the hero Academus, from whom the Academy took its name.

Acanthus: A plant known in English as brank-ursine, the leaves of which are used as a decorative motif on Corinthian capitals.

Acheron: A river in southern Epirus in north-west Greece which disappears underground at several points. It was therefore thought to flow into the Underworld and hence an Oracle of the Dead was situated on it.

Acropolis: The "high place" or citadel of a Greek city—an easily-defensible, fortified hill within the city walls. It was usually the oldest part of the city.

Adyton: An inner chamber at the rear of a temple.

Aegis: The shield of Zeus which flashes forth amazement and terror. The goddess Athena also has an aegis, which is shown in works of art not as a shield, but as a short cloak covered with scales, fringed at the bottom and with a Gorgoneion set in the center of it.

Aeolian: The dialect of Greek spoken by the Greeks of Aeolis. The dialect of Sappho and Alcaeus.

Aeolis: The territory of the northernmost group of Greek immigrants who migrated to the west coast of Asia Minor after the fall of the Mycenaean civilization. They mobbed from Thessaly and Boeotia to settle the region stretching southward from the entrance to the Hellespont, including the island of Lesbos.

Aer: Air. The Presocratic philosopher Anaximenes believed that the basic matter of the world was *aer*, a substance more like mist than pure air, that was transformed by expansion or contraction into water, earth and all other natural things.

Aetiological Myths: From the Greek word *aitia* meaning "the reason why." An aetiological myth tells why familiar objects or practices originated.

Agathos Daimon: The "Good Spirit" or the "Good Luck" of a household.

Agoge: The term used for the strict, militaristic education of Spartiate youths.

Agora: The marketplace of a city: both its commercial and administrative center.

Akroterion: (plural: *akroteria*) An ornament placed on the peak of the gable of a temple roof, or on the corners of the roof.

Alexandria: A port city of Egypt slightly to the west of the Canopic mouth of the Nile River. Here, where there was already an Egyptian village named Rhacotis, Alexander the Great founded a city named after himself on 7 April 331 B.C.E., which would become the capital of the Ptolemaic dynasty that ruled Egypt after Alexander's death, and one of the great cultural centers of the Hellenistic world.

Alexandrian Library: A great library in Alexandria probably founded by King Ptolemy I but greatly extended by Ptolemy II (308–246 B.C.E.). Estimates of the number of scrolls which it held range from 100,000 to 700,000.

Altar: A platform where sacrifices were made. If connected with a temple, it was outside the entrance, usually on the east side. In Christian churches, the altar was inside, generally at the east end of the church, and was where the bread and wine were offered and blessed as Jesus' body and blood during the sacrament of the Eucharist.

Ambo: The pulpit in a Christian basilica. A basilica would have two of them on either side of the church, one for reading the epistle and the other for reading the Gospel.

Ambulatio: A terrace where one might walk for exercise.

Amnisos: A Minoan harbour town on the northern shore of Crete, where a Minoan villa known as the "House of the Lilies" has been excavated. The Homeric hero Idomeneus is supposed to have set sail from Amnisos to fight in the Trojan War.

Amphictyony: A league of devotees of a religious sanctuary whose duty it was to protect and maintain the cult. The word derives from the Greek *amphiktiones* meaning "those who live in the vicinity." Important amphictyonies, however, like the Delphi amphictyony, had representatives from many parts of Greece.

Amphidromia: Literally "a running around." A religious ceremony marking the birth of a child where the father of the house carried the five-day-old infant around the ancestral hearth.

Amphiprostyle: With columns at the front and rear of the building, but not along the sides.

Amphora: A crockery container, normally two-handled, which was the standard storage pot of the ancient Mediterranean world. A type of amphora with a pointed end was used instead of barrels to transport olive oil, wine and other products. Another type, decorated and with a base, was used to keep wine and olive oil for domestic use, and sometimes an amphora filled with wine or olive oil served as a prize in athletic games—for instance, in the Panathenaic Games in Athens, the prize for the victors was an amphora of olive oil, always decorated in black-figure technique.

Anax: *See* Wanax.

Andron: A principal room in a Greek house, used as the dining room. It was part of the men's quarters in the house—the literal meaning is "belonging to men."

Aniconic: Without human features.

Anta: (plural: *antae*) The end of a wall, thickened often to form a pilaster. Columns *in antis* are columns at the end of a building between two antae.

Anthesteria: A flower festival (the Greek *anthos* means "flower") held in Athens on the 12th of the month Anthesterion in the Athenian calendar, roughly equivalent to the end of February and the beginning of March. The day before, on the 11th, the wine jars with the new wine were opened, and on the 12th, the wine was ceremonially blessed by the god of wine, Dionysus.

Antioch-on-the-Orontes: A city founded by Seleucus I in 300 B.C.E. on the Orontes River in Syria some fifteen miles from the sea. It became one of the capitals of the Seleucid Empire—the other was Seleucia-on-the-Tigris, founded in 312 B.C.E., which displaced Babylon as the major center for trade between east and west.

Antonine Age: Strictly speaking, the reigns of the Roman emperors Antoninus Pius (138–161 C.E.), Lucius Verus (161–169 C.E.), and Marcus Aurelius (161–180 C.E.). However the term is sometimes used to embrace the period from 96 to 180 C.E., when reigning emperors adopted their successors, thereby avoiding wars over the succession.

Aoidos: Singer, or bard, who performed, accompanied by the lyre, at festivals or private banquets.

Apeiron: Matter without any limit. According to the Presocratic philosopher Anaximander, the basic matter of the universe was vast, boundless substance where everything was mixed together, out of which the world as we know it emerged.

Apotheosis: The act of making a person into a god; deification.

Apotropaic: Designed to frighten away malignant spirits or ward off the evil eye.

Apse: The half-vaulted, semi-circular end of a building. A building with an apse at one end is called "apsidal."

Archaic: The term applied to the period of Greek culture from about 600 to 480 B.C.E.

Architrave: The course of masonry immediately above the column capitals, which supports the superstructure.

Archon: The highest public office in archaic Athens to which nine citizens were originally appointed and later chosen by lot from forty elected candidates, and after 487 B.C.E., from five hundred elected candidates.

Areopagus: The "Hill of Ares" (or Mars' Hill), a rocky outcropping which is directly opposite the entrance to the

Athenian acropolis. The ancient Council of the Areopagus, composed of ex-archons, met there.

Aristocracy: Rule by the *aristoi*—the "best people." The class of "best people" was usually defined by birth.

Arris: In the Doric order, the sharp ridge where the flutes of the column join.

Ashlar: A masonry style where the stones are cut and dressed into rectangular blocks and are laid in regular courses.

Atrium: The main room of a Roman house, with an aperture in the center of the roof for light, air and rain called the *compluvium* which had a catch basin directly under it called an *impluvium.* In Late Antiquity, the courtyard in front of a Christian basilica, with a fountain in the center where worshippers could wash, was called an atrium.

Attic: (1) The upper story of a Roman building. (2) On a Roman triumphal arch, a slab directly above the archway where an honorific inscription was carved.

Augur: In Rome, a member of a "college" or body of priests who predicted the future by observing and interpreting the path of lightning, the flight of birds, the feeding of sacred fowls and any unusual occurrences.

Augustan Age: The period when Rome was ruled by the emperor Augustus (27 B.C.E.–14 C.E.).

Augustus: A Latin adjective meaning "worthy of esteem and reverence." In 27 B.C.E., the Roman senate conferred the title "Augustus" on Octavian, the heir of Julius Caesar who had made himself master of the Roman Empire by defeating Mark Antony and Cleopatra at the Battle of Actium (31 B.C.E.), and henceforth the title was born by all emperors.

Aulos: Often mistranslated as "flute," the *aulos* was a reed-instrument which was an early ancestor of the modern oboe which was developed in the seventeenth century C.E. The double *aulos* had two pipes, and to assist the piper's breath control, he wore a leather band called a *phorbeia* like a halter around his head and over his mouth, with holes just large enough for the pipes to poke through.

Aurelian Wall of Rome: The Roman wall, most of which survives to this day, built by the emperors Aurelian (270–275 C.E.) and Probus (276–282 C.E.).

Auxilia: Units of the Roman army made up of non-Roman citizens recruited in the provinces of the Roman Empire. On Roman monuments they are shown wearing chain mail or scale armor rather than *lorica segmentata* which

seems to have been reserved for the Roman legions made up of Roman citizens. When the auxiliary trooper retired after twenty-five years of service, he would receive Roman citizenship — until 212 C.E. when the emperor Caracalla extended citizenship to almost of the inhabitants of the Roman Empire.

Balneum: A private bathroom in a Roman house, or a modest public bath, as distinct from the *thermae,* which were the great public baths, such as the Baths of Caracalla in Rome.

Barbitos: A type of lyre with long curved arms, favored by Greek courtesans. Also known as *barbiton.*

Bard: A poet, often illiterate, who improvised and recited narrative poetry of his own composition, usually with musical accompaniment.

Baroque: Characterized by curved, dynamic, elaborately-carved forms.

Basileus: In Homeric times, a local ruler like Odysseus or Menelaus, as distinct from the *wanax* or "high king" who seems to have been divine. In the city-states of Classical Greece, a magistrate with priestly functions was often called a *basileus*—one of the archons of Athens was called the "archon *basileus.*"

Basilica: A type of Roman hall built to house law-courts. The building type was adapted first by the Jews for synagogues, and after the conversion of Constantine I to Christianity, the type was used for the earliest Christian churches. A typical early basilical church faces west, with a narthex or oblong vestibule across the front end, and in the interior, a central hall (nave) with aisles on either side and an apse at the end wall.

Beehive tomb: A Mycenaean tomb with a false or corbelled vault, resembling an old-style beehive.

Bema: A rostrum or platform used by a speaker to address a crowd or preside over a meeting.

Black-figure Technique: A technique of decorating pottery whereby the figures were shown in black silhouette with incised detail, and the background was the natural reddish color of the clay.

Boeotia: The region in Greece northwest of Attica, where the chief city-state was Thebes.

Breastplate: Metal armor worn to protect the chest and midriff of a soldier.

Breccia: A composite rock made up of fragments of stone that have been compressed together. Also called "conglomerate" or "pudding stone."

Byzantium: A colony founded at the entrance to the Black Sea by the Greek city-state of Megara in 667 B.C.E. The city was refounded as Constantinople (dedicated in 330 C.E.) but the old name survived and hence the eastern Roman Empire which lasted until 1453 C.E. is known as the "Byzantine Empire."

Caldarium: The "hot room" of a Roman bath-house where hot water was available for bathing.

Caliga: A leather shoe, especially the leather boot worn by Roman soldiers.

Cantica: A passage in a Roman comedy which the actor sang, accompanied by a piper (*tibicen*).

Capital: The spreading element that caps a column, forming a transition between the vertical shaft of the column and the horizontal elements of the architrave.

Capitolium: The steep hill and the west side of the Roman Forum where the temple of Jupiter Optimus Maximus was built.

Cardinal virtues: The four cardinal virtues as listed in Plato's *Republic* are Justice, Wisdom or Prudence, Courage, and Self-Control.

Cardo: In a Roman town plan, the main north-south road which is bisected by the decumanus.

Caryatid: A figure of a woman used in architecture to support the entablature of a building in place of a column.

Catacombs: Underground graveyards excavated by Christians and Jews, found particularly at Rome but also in places like Naples and Syracuse where the geology was suitable for tunneling. They consisted of a network of tunnels lined with brackets for depositing the bodies of the dead.

Cavea: The seating area of a Greek or Roman theater.

Causia: Light-colored, broad-brimmed, felt hat of Macedonian origin worn to shield the wearer from the sun and the rain. In Rome, it was worn by poorer people as protection against the sun.

Cecrops: The mythical first king of Athens, often represented with a snake's tail.

Cella: The main room of a Greek temple where the cult statue was housed.

Centauromachy: Battle between the heroes known as the Lapiths and the centaurs, who gate-crashed the wedding of the king of the Lapiths, and tried to rape the women, but were driven out. The west pediment of the Temple of Zeus at Olympia shows a centauromachy.

Chamber Tomb: An irregularly shaped underground room used for burial, frequently approached by a corridor or *dromos*.

Charon: In Greek mythology, the old ferryman who conveyed the ghosts of the dead across the rivers of the Underworld. Greeks would put a coin in the mouth of a corpse as a fee for Charon.

Charun: An Etruscan demon with a fiendish face who carried a long-handled hammer and conducted the souls of the dead to the Underworld.

Chiaroscuro: The use of light and shade to give the effects of shape and mass in painting.

Chimaera: A mythical monster slain by the hero Bellerophon. It had the head and body of a lion, a snake for a tail, and a goat's head emerging from its back.

Chiton: A lightweight Greek garment made from a single piece of cloth, belted and with a buttoned sleeve. The Doric chiton was thigh or knee-length; the Ionic chiton was more elaborate and reached the ankles.

Chlamys: A short cloak fastened at the shoulder.

Chryselephantine: A statue constructed of gold and ivory; such statues usually had a wooden core.

Chthonic: Meaning "belonging to the earth," this adjective is applied to the gods of the Underworld.

Cipollino: A greyish marble with streaks of white or green favored by Roman builders.

Cithara: A large stringed instrument used in concerts, festivals and theaters. It was the ancestor of the guitar.

City Dionysia: A festival held each spring in Athens in honor of the god Dionysus, where tragedies and comedies as well as dithyrambs were presented.

Classical Period: The period of Greek cultural history from 479 B.C.E. when the Persian Empire's invasion of Greece was repulsed, to the death of Alexander the Great (323 B.C.E.).

Cnossos: The site of the Labyrinth of King Minos of Crete where he kept the legendary Minotaur. In 1900 C.E. Sir Arthur Evans discovered the remains of a great sprawling palace there and revealed the Minoan civilization of Bronze Age Crete.

Colonnade: A row of columns supporting an *entablature*.

Columbarium: A dovecote. The word was also used for a structure with little compartments built into the wall to receive the ashes of the dead after cremation.

Concrete: Roman concrete was made from lime mortar, volcanic sand, water and small stones. It was placed in wooden frames and left to dry with a facing of brick or stone or a marble revetment.

Conglomerate: *See* **Breccia.**

Contrapposto: A stance in which the body's weight is supported on one leg, so that a contrast is formed between the tension of one side and the relaxation of the other.

Corbeling: A system of supporting courses of masonry or wood by extending successive courses beyond the face of the wall. Thus a "corbeled" or false vault can be constructed by thrusting each course of a circular wall slightly closer to the center until it comes together at the peak.

Corinthian Order: A development of the Ionic order of architecture, but with a capital of stylized acanthus leaves.

Cornice: Horizontal molded projection above the frieze of a temple. Also called a "geison."

Cornu: A Roman bugle, or curved horn.

Cosmogony: A myth that accounts for the origin and nature of the world.

Crepidoma: The platform on which a Greek temple was built, consisting of the stereobate and the stylobate.

Crotalum: A castanet used to accompany dances, to accentuate the rhythm.

Cubiculum: A bedroom in a Roman house.

Cuirass: Metal armor worn to protect the chest and the back.

Cyclades: The southern islands of the Aegean Sea, especially Delos, Paros, Naxos, Siphnos, Melos and Thira, which is the southernmost.

Cycladic: The term applied to the prehistoric culture found on the Cyclades Islands, 3000–1550 B.C.E.

Cyclopean: Belonging to the mythical primitive giants called Cyclopes. The term is applied to the Bronze Age masonry fortifications made of huge, irregular blocks.

Dactyl: A "foot" (a group of syllables forming a metric unit in verse), consisting of one long syllable and two short syllables—the long syllable would be held twice as long as the short syllable, and hence when the verse was sung, the dactyl was the equivalent of a half note followed by two short notes.

Dactylic Hexameter: A line of poetry consisting of six dactyls or their equivalent. This was the meter used for epic poetry, such as the epics of Homer in Greek or Vergil's *Aeneid* in Latin.

Dado: The lower part of the wall of a room decorated differently from the upper part, often with colored marble or stucco.

Daedalic: From the legendary Minoan craftsman, Daedalus. The term is applied to a type of human figurine appearing about the end of the eighth century B.C.E., and belonging to the Orientalizing Period of Greek art, with the following traits: frontality (they face forward), rigidity, flatness, low brows, triangular faces, big noses and eyes and flat skulls.

Daimon: A spirit, or a manifestation of supernatural power. A man might have a good or an evil *daimon* which followed him through his life. Christianity impressed upon the word the meaning of "demon" which is now its common significance.

Dark Ages: A term applied nowadays to the period of Greek history (1100–900 B.C.E.) when Greece was illiterate.

Decumanus: In a Roman town plan, the main east-west road. The main street was called the "decumanus maximus."

Delphi: A small sacred city-state in central Greece north of the Corinthian Gulf, where the oracular shrine of Apollo was located on the slopes of Mt. Parnassus.

Delphic oracle: The oracle of Apollo at Delphi, where non-Greeks as well as Greeks could seek advice about the future. *See* **Oracle.**

Deme: A district or township. "Demes" were ancient townships of Attica which were distributed by Cleisthenes, the founder of the Athenian democratic constitution, into ten *phylai* or "tribes" that became the basic political units of Athenian government.

Demigod: A hero: a semi-divine person who still possessed some supernatural powers even though his soul (or "shade") was in the Underworld.

Demiourgos: The divine being in Plato's dialogue, the *Timaeus*, who creates the world out of pre-existing matter.

Dentil: Toothlike projection on an Ionic epistyle.

Deus ex machina: A "god (descending) by stage machinery" The term is used for a conclusion of a tangled plot of a tragedy which is resolved by the intervention of a god.

Diadem: A headband tied at the back of the head. Constantine I, the first Christian emperor, made a diadem encrusted with pearls the normal imperial head-dress.

Dialogue: A discourse consisting of question and answer on a political or philosophical subject. The most important source of the dialogue form was the conversations of Socrates, and the dialogue became the favorite medium of Plato for publishing his philosophic ideas.

Diazoma: A walkway dividing the upper tiers of seats from the lower in a Greek theater.

Didactic literature: Literature intended to teach or to inform the reader.

Didascalia: In Greece: the "teaching" of a play or dithyramb to the chorus that was to perform it by the poet or professional trainer who was employed for the task. The term is also used to refer to all aspects of the production of a play or a dithyramb.

Didascaliae: The plural form of "didascalia." In Greece it was used to refer to the records of performances, including the names of victorious tribes, poets, *choregi*, actors and auletes for each year and of the plays that were staged at the festivals in honor of Dionysus. In Rome, the term is used for the brief remarks that preface the plays of Terence, describing the first performances of the plays, mentioning the composer and the type of music, the Greek originals from which the plays were adapted, the date of the play and so on.

Dione: The word means "goddess" and it is the feminine form of "Zeus." At the oracular site of Dodona, Dione was worshipped as the consort of Zeus, and one version of the myth of Aphrodite's birth makes her the daughter of Dione. In the canon of the Olympian gods, however, it was Hera rather than Dione who was the wife of Zeus.

Dionysus: God of wine and of emotional religion. Greek myth made him the son of Zeus and the mortal Semele, a princess of Thebes.

Dithyramb: A type of narrative choral song accompanied by dance, originally associated with Dionysus. Aristotle claimed that tragedy originated with the dithyramb.

Dodona: The seat of an ancient oracle of Zeus in the mountains of Epirus in north-west Greece. The center of Zeus' cult at Dodona was a sacred oak tree and from the rustling of its leaves the will of Zeus was ascertained.

Dorian: (1) A dialect of Greek. (2) Greeks who spoke the Dorian dialect, who entered Greece in the so-called Dorian invasion which took place after the collapse of the Mycenaean civilization.

Doric: A type of architecture, characterized by fluted columns without bases, and triglyph and metope friezes.

Dromos: A passageway leading into a chamber tomb or a *tholos*.

Echinus: The lower member of a column capital.

Eileithyia: The Greek goddess of childbirth.

Ekkylema: In the Greek theater, a low trolley used to bring someone on stage such as a dying man or a corpse of a character who has been slain offstage.

Ekphrasis: A literary description of a work of visual art.

Eleatic School: The philosophy of the Eleatic School takes its name from Elea, modern Velia in southern Italy. The founder of the school was Parmenides of Elea.

Elegiac couplet: A verse in dactylic hexameter followed by a pentameter line (a line of five feet) with a caesura or pause in the middle. Roman poets of the Augustan Age associated elegiac poetry with sorrow, but probably early elegiac in Greece was simply poetry sung to the accompaniment of the *aulos*.

Eleusinian Limestone: A black limestone quarried at Eleusis west of Athens, which was used for decorative effect in marble buildings.

Elis: The state in the northwest Peloponnesus where Olympia, the site of the Olympic Games, was located.

Elysium: Elysium, or the Isles of the Blest, appears in the works of Homer and Hesiod as a place where certain favored heroes who were exempted from death were taken by the gods. It came to be regarded as a region of the Underworld reserved for persons who were righteous in their lifetimes.

Emmeleia: The dance associated with Greek tragedy.

Encaustic: A technique of painting using hot wax colored with various pigments.

Entablature: All parts of a building such as a temple above the columns.

Entasis: A cigar-like swelling of columns which is particularly pronounced in buildings of the archaic period, but is no longer found by the Hellenistic period.

Ephebe: A boy who has reached puberty, about eighteen to twenty years old.

Epic: A long, narrative poem written in dactylic hexameter meter.

Epigram: Originally a short verse inscription which the Greeks engraved on tombstones or votive offerings or even signposts. In the Hellenistic period, poets wrote artificial epigrams: short poems on persons long dead, or on famous works of art or on pet animals. The epi-

gram could also be used as a vehicle for invective. Latin epigrams were occasional poetry that could sometimes be humorous, and sometimes spiteful.

Epigraphy: The study of inscriptions.

Epiphany: The appearance of a god.

Epistle: A letter addressed to someone. As a literary form, the epistle could be used to expound philosophy or theology. The epistle was also used as a form of poetry: for instance, Ovid's *Heroides* is a collection of fictitious love letters written by famous heroines to their absent husbands or lovers.

Epistyle: Another term for "architrave."

Epitaphios: A funeral eulogy given, according to Athenian custom, at the memorial service held each year for the men who had fallen in battle.

Epithet: In epic poetry, an adjective applied to a hero, such as "Achilles, swift of foot." Divine epithets were surnames given to the gods, sometimes indicating some aspect of a god's activity, such as "Zeus, the cloud-gatherer," or in Rome, "Mars *Ultor*," that is, "Mars the Avenger." Sometimes the divine epithets are puzzling, such as "Owl-eyed Athena," or "Apollo *Lykeios*" which might mean "Apollo the Wolf-God" or "Apollo of Lycia" (Lycia was in south-west Asia Minor).

Epyllion: A type of narrative poem, popular in the Hellenistic period, where certain episodes, usually not the central ones, are taken from the context of old legends and carefully reshaped, while the remaining themes of the legend are left on the fringes of the narrative.

Erinyes: The "Furies." Snaky, winged creatures born of the earth who pursue mortals guilty of matricide and fratricide and drive them mad.

Eros: Sexual love or attraction. "Eros" (Latin: "Cupid") was the name of the child-god, son of Aphrodite, the goddess of love, who was depicted as a winged boy with a bow and poisoned arrows, with which he wounded men and women and infected them with sexual passion.

Etruria: The western part of central Italy, somewhat larger than modern Tuscany, inhabited by the Etruscans.

Etruscans: A people whose language has not yet been deciphered who emigrated from Asia Minor to Italy in the early Iron Age, established a number of cities in Etruria, and for a brief period, dominated early Rome.

Euripus: A long narrow fishpond placed in the center of a formal garden surrounded by a colonnade in a Roman villa.

Exodos: The "exit." In a Greek tragedy, it is the final section, after the last ode sung by the chorus.

Fabula palliata: A dramatic presentation on the Roman stage where the actors portrayed Greeks and wore Greek costumes, for example the plays of Plautus and Terence.

Fabula togata: A Roman drama, usually a comedy but sometimes historical, where the actors portrayed Roman citizens and wore togas on stage.

Familia: A Roman household, including father, wife, sons and daughters, domestics, slaves and freedmen.

Fauces: The entrance hallway into a Roman house.

Fayyum: The modern name for a province of Egypt in a depression in the desert west of the Nile which receives water from the Nile through a natural channel called the *Bahr Yousef* ("Canal of Joseph"). In the early Ptolemaic period, the agricultural area was extended and many settlers from the Greek world came there.

Fayyum portraits: Portraits from Egypt, painted on wood using the encaustic technique, which were placed over the face of a mummy in the Roman imperial period. They are realistic frontal portraits of the dead person who was mummified, and they are considered the artistic forerunners of later Byzantine icons.

Fibula: A brooch, or safety-pin.

Final Cause: In the philosophy of Aristotle, the purpose or end by which an event, a thing or a process can be explained.

Flavian Period: The period of Roman history when the Flavian dynasty ruled, the emperors Vespasian (69–79 C.E.), Titus (79–81 C.E.), and Domitian (81–96 C.E.).

Flora: The Roman goddess of flowers.

Floralia: The festival of Flora, held on 28 April. The festival had a reputation for licentiousness where mime actresses might appear in the nude.

Flutes: Shallow grooves that run vertically along the shaft of a column.

Foreshortening: An illusionistic trick that painters use to suggest depth on a flat surface by representing forms as shorter in length than they actually are.

Forum: Like the Greek *agora*, the commercial and administrative center of a Roman city.

Fresco: A type of wall painting where the paint is applied while the plaster is not yet dry.

Frieze: In architecture, a horizontal band with sculptural decoration.

Frigidarium: The cold room in a Roman bath where unheated water was available for bathing.

Fuller: A tradesman who "fulled" woolen cloth, cleaning it, thickening it and shrinking it with moisture, heat and pressure.

Gauls: Celts who migrated across central Europe into France and the British Isles in the sixth century B.C.E.; in Italy, they settled in the Po River valley which became known as Cisalpine Gaul. In 387 B.C.E. they sacked Rome and in 279 B.C.E. they invaded Greece, and from Greece moved to Asia Minor where they eventually settled in Galatia.

Geison: A cornice.

Geometric Style: A type of pottery decoration that develops from Protogeometric shortly after 900 B.C.E. with various designs such as cross-hatched and wavy-lined lozenges, squares, triangles, the meander motif arranged in concentric bands around the pot. In the eighth century B.C.E. stylized human and animal forms are introduced.

Geranos: The so-called "crane dance"—*geranos* is the Greek word for the bird called a "crane" in English—which was danced in chorus lines of young men and women in festivals on the island of Delos.

Glaze: Hard, glossy surface finish for pottery.

Gorgon: One of three hideous female monsters in mythology, with wings, large fangs and snakes for hair. The most famous of the three was Medusa whose face turned men who looked on it into stone.

Gorgoneion: The head of a Gorgon, shown full-face, with protruding tongue, serving as an apotropaic device.

Greaves: Armor worn by an infantryman to protect his lower legs.

Griffin: A legendary animal with the body of a lion and the wings and head of an eagle.

Gymnasium: A place for exercising. The gymnasium might also be a social center and a place for learning and listening to lectures on philosophy.

Gynaikeion: The portion of a Greek house which was reserved for women, either at the back of the house or on the second story. Men from outside the family would not normally enter the *gynaikeion*.

Gypsum: An easily-worked white or pinkish-buff limestone.

Hades: Lord of the Underworld, which was known as the "House of Hades." He presided over the souls of the Dead and was not counted among the Twelve Olympian Gods.

Hagia Triada: Site of a royal villa on Crete dating to the Late Minoan period where a cache of Linear A clay tablets was discovered.

Haruspices: Diviners of Etruscan origin who divined the future from portents such as the entrails of sacrificial animals or prodigies or meteorological phenomena such as lightning.

"Harvester Vase": A Minoan vase of black steatite, dating to about 1500 B.C.E., found at the site of Hagia Triada on Crete, about five inches high, showing in relief sculpture a group of harvesters or sowers, singing as they go to work, or as they return from the fields.

Helladic: The term used by archaeologists for the civilization of prehistoric Greece, 3000–1100 B.C.E. The Helladic period is divided into "Early Helladic" (3000–2000 B.C.E.), "Middle Helladic" (2000–1550 B.C.E.) and "Late Helladic" (1550–1100 B.C.E.). "Late Helladic" is otherwise known as the "Mycenaean Age."

Hellenistic: The term applied to the period between the death of Alexander the Great and the completion of Rome's conquest of the eastern Mediterranean with the annexation of Egypt (323–30 B.C.E.), when the Greek language and culture spread across the Near East.

Helots: The serfs in Sparta who farmed the estates of their Spartiate overlords and gave them half the produce.

Herculaneum: A town with a population of about 2,000 on the Gulf of Naples, which was buried by lava and mud from the eruption of Mt. Vesuvius in 79 C.E.

Heroon: The shrine of a hero, a dead man who was considered semi-divine and whose soul in the Underworld received offerings.

Hexastyle: A building with six columns along the front, or along the front and the back.

Himation: A garment consisting of a large rectangular piece of cloth that was draped over the body. The standard outer garment for Greek men by the sixth century B.C.E. and for women by the fourth century B.C.E.

Hippodamian: Belonging to Hippodamus, an architect and town-planner of the fifth century B.C.E.

Holocaust: A sacrifice where the victim was completely consumed by fire, as distinguished from the usual sacrifices where only the inedible parts of the sacrificial animal were burnt.

Hoplite: A heavily-armed footsoldier wearing helmet, cuirass, and greaves, and equipped with a round shield and spear for thrusting, who fought in a battle-line eight ranks deep. The hoplite was the standard heavy infantryman in Greece from the eighth century to the fourth century B.C.E.

Horns of Consecration: Stylized bull's horns, associated with Minoan shrines.

"House of the Faun": The largest house found in Pompeii, taking up a full city block, and dating from the second century B.C.E.

Hydraulis: The water-organ, invented by Ctesibius, an engineer in Alexandria in the third century B.C.E., which became popular in Rome as a domestic instrument and in amphitheaters as well because of its loud volume. By the fourth century C.E., organs worked with bellows had also been developed.

Hydria: A three-handled jar for holding water.

Hymettian Marble: A dark marble quarried at Mt. Hymettus outside Athens.

Hymn: Originally a song addressed to a god. However, hymns such as the *Homeric Hymns* were more literary than devotional and related a myth.

Hypocaust: Furnace in a Roman bath which not only heated the bath water but also the "caldarium" which had flues under the floor and sometimes in the walls where hot air and smoke from the furnace would be circulated.

Hypothesis: A conjecture or a supposition.

Iconography: The art of pictorial representation and illustration.

Inductive Logic: Inference from a finite number of particular cases to a further case or to a general conclusion. Thus if we know that twelve ducks reproduce by hatching eggs, we may conclude that a thirteenth duck will reproduce in the same way, or even reach the general conclusion that all ducks reproduce by hatching eggs.

Insula: Roman tenement house.

Ionia: The central part of the western coastline of Asia Minor and the offshore islands, settled by refugees from the Greek mainland displaced by the Dorians after the fall of the Mycenaean civilization.

Ionic Dialect: The dialect of Greek spoken in Ionia.

Ionic Order: An order of architecture, characterized by columns with bases, flutes on the columns but not with the sharp arrises we find on Doric columns, capitals with spiral volutes and lacking a triglyph and metope frieze.

Isthmian Games: A Greek athletic contest held every two years in honor of Poseidon at his sanctuary at the isthmus of Corinth. The prize was a crown of wild celery.

Judgement of Paris: The title given to the event which caused the Trojan War. The goddesses Hera, Athena, and Aphrodite appeared before the young Trojan prince Paris who had been banished from Troy to serve as a shepherd on the hillsides because of a prophecy that he would bring disaster on Troy. Paris was asked to judge which of the three goddess should get the golden apple offered by the old hag "Discord" to the most beautiful. Paris gave the apple to Aphrodite who had promised him the most beautiful woman in the world, Helen, wife of King Menelaus of Sparta, thus earning the hatred of Athena and Hera for Troy.

Jupiter Optimus Maximus: Jupiter, the Best and the Greatest. The chief god of Rome whose temple was built in the Capitolium, the steep hill on the west side of the Roman Forum. It was a tripartite temple, that is, with three cellas, with Jupiter occupying the central sanctuary, and on either side, sanctuaries for Minerva and for Juno.

Kantharos: A deep drinking-cup with high, vertical handles.

Keystone: The voussoir or wedge-shaped stone at the center of an arch at the top, which locks the arch together.

Kordax: The dance associated with Greek comedy.

Kore: A maiden. The term is applied to the archaic, fully-clothed statues of young women belonging to the archaic period.

Kotyle: A deep drinking-cup with small, horizontal handles.

Kouros: A youth. The term is applied to the archaic naked male figures found from about 650 B.C.E. to the time of the Persian War (480–479 B.C.E.) which marked graves, or served as dedications to a god.

Krater: A large mixing-bowl used to mix wine with water before drinking it.

Kylix: A shallow two-handled drinking-cup.

Lacedaemon: The southeastern region of the Peloponnesos which belonged to Sparta.

Laconia: Another term for "Lacedaemon."

Lares: Roman gods who gave protection against supernatural forces. The *Lar familiaris* (or in the plural, *Lares*

familiares) protected the family. There were also *Lares* that protected crossroads (*Lares compitales*).

Larnax: A casket or ossuary to hold the bones and other remains of a corpse after it was burned on the funeral pyre.

Late Antiquity: The period of the fourth and fifth centuries C.E.

Latona: The Roman name for Leto, the mother of Apollo and Diana.

Legion: The standard unit of the Roman army. It numbered five thousand foot-soldiers and a mounted bodyguard of one hundred and twenty men, if at full strength.

Lekythos: (plural: *lekythoi*) A tall flask with a single handle and a narrow neck for holding oil and unguents.

Lenaea: A festival in honor of Dionysus celebrated in January where dramatic performances were produced. Originally it seems that comedy was preferred to tragedy. The name comes from *lene*, meaning "maenad."

Libation: An offering to a god before eating or drinking. Before drinking wine, which was a part of a meal, a little of it was poured on the floor as an offering to the *Agathos Daimon* (Good Luck) to establish communion with him.

Light-Well: A small courtyard or an open shaft inside a building to let in light and air.

Linear A: A form of writing using a syllabic alphabet used in Minoan Crete. The language has not yet been deciphered.

Linear B: A form of writing using a syllabic alphabet used in the Mycenaean period for writing Greek.

Lintel: A horizontal beam bridging the top of a doorway or window in a wall.

Lions' Gate: The main gateway through the thirteenth century B.C.E. fortification wall at Mycenae, which has a relieving triangle above the massive lintel block and in the triangle, a relief sculpture, two lions with their heads missing, standing on an altar with a pillar between them which probably had some religious significance.

Lituus: A long-stemmed horn with a hook-shaped bell that was bent backwards. Used for military music in Rome.

Logographos: A writer of prose. In the fourth century B.C.E. the word designated a ghostwriter for speeches delivered by someone else.

Logos: A rational, logical account or explanation. For Heraclitus, the logos had the broader sense of a rational, ordering principle that remains constant in spite of all the apparent changes in the world.

Lorica segmentata: Articulated armor made of iron plates developed in the reign of the emperor Augustus (27 B.C.E.–14 C.E.). It was the body armor of Roman legionary soldiers—auxiliary troops are generally shown wearing chain mail or scale armor.

Loutrophoros: A tall vase for holding water.

Ludi Scaenici: Theatrical shows in Rome.

Lupercal: A grotto on the Palatine Hill in Rome sacred to Lupercus, identified with Pan.

Lupercalia: A festival held every February in Rome when *Luperci*, wearing only a girdle around their loins, ran around the city boundaries striking women whom they met in a ceremony supposed to make them fertile.

Luperci: Priests of Lupercus, identified with Lycean Pan (Pan the wolf-god) who was thought to keep the flocks and herds safe from wolves. At first these priests were chosen from young herdsmen but later young Romans of high rank might serve as *Luperci*.

Lustral Basin: A small, rectangular space generally thought to have a religious purpose, that is accessible from above by a short stairway.

Lyceum: The grove just outside Athens, sacred to Apollo Lyceius and the Muses, where Aristotle leased some buildings and founded a school in 335 B.C.E.

Lyre: Stringed instrument with a tortoise shell for a sound-box, or with a wooden sound-box shaped like a tortoise shell.

Lyric poetry: A term coined by critics in the Hellenistic period for early poetry intended to be sung accompanied by a stringed instrument or by the *aulos*, either separately or in combination. There were two types: choral lyric sung by a choir or solo lyric sung by an individual performer.

Macellum: A Roman market building for selling meat.

Maeander: A rectilinear, decorative motif that continuously winds backwards and forwards.

Maecenas: The wealthy unofficial "Minister of Public Relations and Propaganda" of the emperor Augustus who was the patron of the poets Vergil, Horace and Propertius as well as the pantomime, Bathyllus of Alexandria.

Maenads: Female followers of the god Dionysus. In art they are often depicted dancing ecstatically.

Magna Graecia: The term (Latin) means "Great Greece," and it is applied to the Greek settlements in southern Italy, and sometimes it includes Italy as well.

Mallia: Site of a Minoan palace on the north coast road of Crete, some twenty-five miles east of Herakleion. The ancient name is unknown.

Mausoleum of Galla Placidia: An oratory or place of prayer in Ravenna which, according to tradition which may be wrong, is the mausoleum of Galla Placidia, half-sister of the emperor Honorius and after Honorius' death, regent on behalf of her son. The interior has some splendid examples of mosaics of the fifth century C.E., including one showing Christ as the Good Shepherd, and another showing the martyrdom of St. Lawrence.

Megalensia: A procession and festival held in republican Rome in honor of Cybele the *Magna Mater* (Great Mother), where dramatic presentations were staged.

Megaron: The great hall of a Mycenaean palace with a hearth in the center, a vestibule and a porch with columns over the front entrance.

Mêkhanê: (in Latin *machina*) Part of the stage machinery of the Greek and Roman stage. The "machine" was a crane used for the entrances of actors playing gods who were lowered from Heaven, or for actors making exits to Heaven.

Metempsychosis: The rebirth of the soul in other bodies, a doctrine of the Pythagorean philosophers. Also called "Transmigration of Souls."

Metope: A slab, often blank but sometimes decorated with relief sculptures, between two triglyphs of a Doric frieze.

Mime: An imitative performance. Skits in archaic and classical Greece acted out with dialogue and sometimes song and dance presenting short scenes from daily life. In the Hellenistic period, authors such as Theocritus and Herondas wrote literary mimes, intended to be read or for semi-dramatic recitation. In Rome mime troupes produced extempore performances of improbable themes. Actors, who were both men and women, wore no masks. The mimes continued to be popular even after Bathyllus and Pylades introduced the much more elaborate pantomime in the Augustan Age.

Mimus: A mime actor. A mime actress was a "mima."

Minoan: The label applied to the culture of prehistoric Crete (3000–1100 B.C.E.), taken from the name of the legendary king Minos of Crete. The Minoan period is subdivided into "Early Minoan" (3000–2000 B.C.E.), "Middle Minoan" (2000–1550 B.C.E.), and "Late Minoan" (1550–1100 B.C.E.).

Molding: In architecture, a continuous decorative motif.

Monoidia: A song sung as a solo.

Mousike: "Arts belonging to the Muses," which include not only music in the modern sense of the word but dancing, poetry and literature in general.

Muses: Greek deities of cultural and intellectual pursuits.

Museum: A place connected with the arts of the Muses. The most famous Museum in the ancient world was a think-tank in Alexandria founded by Ptolemy, the first king of Egypt, which in its heyday housed about one hundred research scholars, supported by the Ptolemaic kings and later by Roman emperors. It should not be confused with the Alexandrian Library.

Mycenae: A Bronze Age citadel dominating the Argive plain in the Peloponnesus. Legend makes it the capital city of King Agamemnon, the commander of the Greek forces who fought in the Trojan War. Heinrich Schliemann's excavations at Mycenae in the 1870s first revealed the Bronze Age culture of Greece, and the term "Mycenaean" is often used for the civilization of the Late Helladic Period.

Naos: The main room of a Greek temple; the *cella*.

Naxian marble: A white marble quarried on the island of Naxos in the Aegean Sea.

Nemean Games: A Panhellenic athletic contest held at the sanctuary of Zeus of Nemea every two years. The prize was a crown of wild celery.

Neolithic Age: The "New Stone Age." Polished stone and flint are used for tools and weapons.

Nous: The divine mind that controls all events and processes in the universe according to the theory of Anaxagoras.

Numismatics: The study of coins.

Obelisk: A four-sided shaft, tapering towards the top, ending in a pyramidal point, which appeared in Egypt during the period of the Old Kingdom as a symbol of the sun-god Re. A number of Egyptian obelisks were brought to Rome by various emperors and erected there.

Obol: An iron spit used for toasting meat over a fire. The obol was also the smallest Greek unit of currency. Six obols equalled a "drachma" (meaning literally a "handful").

Obsidian: Black volcanic glass used in the Neolithic Period to make sharp blades.

Ode: A song, often choral. The term was used by the Latin poet Horace for his lyric poems written in meters borrowed from Sappho and Alcaeus.

Odeum: From the Greek, *Oideion.* A small theater or roofed hall for musical performances and competitions.

Oenochoe: Vase used for pouring liquids, usually wine.

Oikos: The household, a concept that included all family members, the husband, wife, and children, as well as slaves, animals and property.

Oligarchy: Rule by a select group.

Olympian Gods: The original list of the twelve Olympian gods consisted of Zeus, his wife Hera, Athena, Artemis, Apollo, Ares, Aphrodite, Hestia, Hephaestus, Poseidon, Demeter, Hermes and Hestia. Hestia, the goddess of the hearth, was soon displaced by Dionysus. In Latin literature, these gods were given Roman names: Zeus =Jupiter, Hera =Juno, Athena =Minerva, Artemis =Diana, Apollo remained Apollo, Hestia =Vesta, Hephaestus =Vulcan, Poseidon =Neptune, Demeter =Ceres, Hermes =Mercury and Dionysus =Bacchus.

Olympic Games: Panhellenic games held every four years, beginning in 776 B.C.E., in honor of Olympian Zeus, at his sanctuary between the rivers Alpheus and Cladeus in the territory of the city-state of Elis in the northwest Peloponnesus. The prizes were crowns of wild olive.

Omphalos: A sacred stone at Delphi marking the navel of the earth. Zeus was supposed to have sent two eagles to fly from the two ends of the earth and they met in the middle at Delphi.

Opisthodomus: The back porch of a Greek temple.

Opus caementicium: Roman masonry of undressed stone laid in concrete.

Opus incertum: A concrete wall faced with irregularly-shaped undressed blocks of small stones.

Opus reticulatum: A facing of a Roman concrete wall using diamond-shaped stones.

Opus sectile: Irregular slabs of colored marble embedded in concrete, used mainly for floors.

Opus signinum: Concrete floor with fragments of terracotta, stone or marble pounded into it before the concrete had set.

Opus spicatum: Roman brick flooring laid out in a herringbone pattern.

Oracle: The response of a god to a question put to him by a worshiper. Depending upon the context, the term might also mean an oracular shrine, or the body of priests that administered the shrine.

Orchestra: The level horseshoe-shaped area of the Greek theater between the seats of the auditorium and the stage building.

Orientalizing Period: In Greek cultural history, the seventh century B.C.E. when the influence of Asian artistic traditions was particularly strong.

Orthostate: An upright slab, higher than the other blocks of masonry, usually placed at the foot of a wall, or a course of masonry of such blocks.

Oscan: The Italic dialect spoken by the Sabellian peoples who lived in central and southern Italy.

Ossuary: A receptacle for the bones or ashes of the dead.

Paean: A hymn sung particularly to Apollo, but also to Zeus and Poseidon. It might be a hymn of thanksgiving, or it might have a military purpose—the Spartans and other Dorian Greeks sang paeans. Paeans might also be sung at banquets, after the libations were poured and before the feast began.

Palaeolithic Period: The "Old Stone Age," when roughly-shaped, unpolished stone and flint tools and weapons were used.

Palaestra: An exercise ground used for wrestling, boxing, ball-games and similar sports.

Palatine Hill: A flat-topped hill on the south side of the Roman Forum where the legendary founder of Rome founded his settlement in 753 B.C.E. Later the Roman emperors built their palaces there, with the result that the word *palatium* came to mean "palace."

Pallium: The Latin word for the Greek cloak known as the *himation.*

Palmette: A design consisting of leaves arranged like a palm shoot.

Pan: A woodland god native to Arcadia in the central Peloponnesus. Pan had a human body as far as the loins and goat's legs, horns and ears. In Athens he had a cave-shrine under the Acropolis and yearly sacrifices and a torch-race were held in his honor.

Panathenaea: An annual festival in Athens honoring Athena. Every four years the Panathenaea was opened to non-Athenians who were allowed to compete in the events—this festival was known as the "Greater Panathenaea." The prize for victors was always a black-figure amphora filled with olive oil.

Panhellenic: Encompassing all of Greece.

Panta rhei: A saying attributed to the philosopher Heraclitus, meaning "all things are in flux" or "everything flows."

It means that the world is in a constant state of change, like the water in a stream driven by the current.

Parabasis: The section of an Old Comedy where the chorus comes forward towards the audience and addresses it directly, speaking on behalf of the author.

Paradox: An apparently sound argument that leads to an unacceptable conclusion.

Parian marble: A pure white marble with flecks of mica quarried on the island of Paros in the Aegean Sea.

Parodos: The song which the chorus in a Greek classical drama sang as it made its entry into the orchestra of the theater.

Parthenia: Songs sung and danced by young, unmarried girls to the accompaniment of the *aulos.*

Parthians: An Iranian people who expanded their power over Mesopotamia and the Near East in the second century B.C.E. at the expense of the Seleucid Empire. The last Parthian king was overthrown in 227 C.E. by the Persians led by the Sassanid family from Persepolis.

Pediment: The triangular space formed by the gable at each end of a temple.

Pedimental Sculptures: Sculpted figures, carved either free-standing or in relief, which fill the tympanum, that is, the space of the pediment.

Peloponnesus: The region of the Greek mainland south of the Isthmus of Corinth.

Penates: Roman gods who guarded the family larder or food storehouse.

Pentelic marble: White marble from Mt. Pentelikon near Athens. It contains iron oxide and turns the color of honey over time when it is exposed to the air.

Peplophoros: (plural: *peplophoroi*) A woman who wore a peplos.

Peplos: A woman's garment consisting of a rectangular piece of cloth draped around the body and fastened with brooches at the shoulders.

Periblema: Greek clothing, such as the *himation,* designed to be wrapped around the body.

Perioikoi: "Those dwelling round about"; people ethically akin to the Spartiates but not full citizens who lived in separate communities in Laconia with a degree of self-government.

Peripatetic School: The Aristotelian school of philosophy. It took its name from the "Peripatos," the covered walking-place or courtyard which was one of the buildings which Aristotle leased at the Lyceum to found his school.

Peripteral: Surrounded by a row of columns.

Peristyle: A row of columns surrounding a building such as a temple.

Petasos: A man's hat made of felt, with a crown and a broad brim, giving protection from the sun.

Phaistos: Site of a Minoan palace in south-central Crete, destroyed about 1500 B.C.E.

Phlyax: (1) A type of comic drama with much buffoonery that was popular in south Italy, or (2) an actor who played in a *phlyax* drama.

Phorminx: An ancient stringed instrument strummed with a plectrum, which is mentioned in the poems of Homer.

Pilos: A felt cap.

Piscina: Fish-pool. The term was used for pools in Roman baths or swimming pools in palaestras, or of fish-tanks in private gardens.

Pithos: A massive, earthenware jar for storage.

Plataea: The little city-state on the southern fringe of Boeotia, on the north edge of Mt. Cithaeron, which maintained its independence from Thebes by becoming an ally of Athens, probably in 519 B.C.E.

Pnyx: The place in Athens where the assembly (*ekklesia*) met.

Polis: A "city-state," including the chief urban center which was the seat of government, and the agricultural region round about it which the *polis* ruled.

Politeia: The constitution of a *polis.*

Pompeii: A city with a population of about 20,000, near the Gulf of Naples on the river Sarno, which was buried by ash and debris from the eruption of Mt. Vesuvius in 79 C.E.

Poros: Term used in Greek archaeology for "tufa."

Porphyry: A hard, fine-grained dark-red or purplish rock quarried in Egypt, favored for portraits of Roman emperors.

Porticus: A colonnade; the Latin translation of the Greek "stoa."

Postern Gate: A small gate or door at the back of a building or a building complex.

Pozzolana: A fine volcanic sand that was used for quick-drying cement. *Pozzolana* cement will set under water and hence is suitable for constructing piers and moles.

Presocratic: A label given to the Greek philosophers who generally predated Socrates, who interested themselves in natural philosophy, that is, early science.

Prime Mover: God, in the philosophy of Aristotle, seen as the efficient and the final cause of the universe.

Principate: The term given to the government instituted by the emperor Augustus who entered into a agreement with the Roman senate in 27 B.C.E. whereby the senate would be responsible for governing those provinces of the empire which were peaceful, while those provinces where significant numbers of troops has to be posted would be ruled by Augustus himself who would appoint legates to govern them.

Proconnesian Marble: Marble from Proconnesus in northern Greece, much favored for marble sarcophagi in the later Roman Empire.

Pronaos: The front porch of a Greek temple.

Propylon: (plural: Propylaea) A monumental entrance to a *temenos*. The plural form is used if there is more than one door.

Prostas: A south-facing room off the courtyard of a Greek house that allowed for maximum exposure to the winter sun.

Prothesis: Lying in state and ritual mourning of a dead person, commonly depicted on Late Geometric pottery.

Protogeometric: A type of pottery dating to c. 1050–900 B.C.E. marked by simple decorations of bands and circles. The shapes of the pots mostly derive from the Mycenaean age.

Protome: Three-dimensional representation of the head and forepart of an animal, or head and upper part of a human body, usually as a decoration applied to a wall or other flat surface.

Province: The sphere of action of any Roman magistrate possessing *imperium* (the right to command an army) who exercised authority as a representative of Rome. The word came to be associated with Roman overseas possessions whose inhabitants paid tribute to Rome.

Prytaneion: The assembly hall of the ruling council of a Greek city-state.

Pseudo-Dipteral: In architecture, a building plan with a row of columns on all sides, but with unused space between the colonnade and the wall for a second row of columns.

Ptolemaic Dynasty: The royal family, descended from Ptolemy, son of Lagus, one of Alexander the Great's generals, who ruled Egypt until its last representative, Cleopatra VII, was dethroned in 30 B.C.E. and Egypt was annexed by Rome.

Pylos: According to Homer, the seat of the Homeric hero Nestor in the north-west Peloponnesus. In 1939, excavators at Ano Englianos above the Bay of Navarino revealed a Mycenaean palace, destroyed suddenly by fire about 1200 B.C.E., which has been called "Nestor's Palace."

Pyrrhic Dance. A war dance; the national dance of Sparta. In the Roman period, Pyrrhic dances were sometimes staged as spectacles in theaters and amphitheaters.

Pyxis: A cosmetic or jewelry box with a lid.

Quadriga: A sculpture of a chariot with two wheels drawn by four horses.

Quirites: Originally the citizens of the Sabine town of Cures, but once the Sabines and Romans united into one community the Romans began to call themselves "Romans and Quirites." Eventually the two terms became virtual synonyms.

Raking cornice: The slanting cornice at the top of the pediment of a temple, which forms the upper part of the gable. Also called a "raking geison."

Ravenna: The court of the western Roman emperors moved from Milan to Ravenna on the north-east coast of Italy at the beginning of the fifth century C.E., in the reign of Honorius (393–423 C.E.). The early Christian churches of the city provide us with our best examples of mosaic art in Late Antiquity.

Red-Figure Technique: A method of painting pottery which was the opposite of black-figure technique: the background was black with figures left the color of the clay. Contours and interior details were added with relief lines or dilute slip.

Register: In painting, a horizontal band or frieze decorated with ornament or figures.

Relieving Triangle: A triangular space left in the masonry above the lintel of a door to take some of the weight off the lintel block.

Repoussé: Metalwork decoration in relief, made by beating the metal from behind.

Revetment: A wall built to hold back earth. When the term is used in architecture, it means a facing of stone, brick or wood.

Rhyton: A drinking-horn, or a ritual pouring vessel sometimes in the shape of an animal head.

Ridge pole: The roof beam; the beam across the top of a ridge roof.

Roman Republican Period: The term given to the period of Roman history from the expulsion of the Etruscan kings in 510 B.C.E. to the civil war between Julius Caesar and the so-called "republicans" led by Pompey, which ended in 45 B.C.E. with Caesar's last victory at Munda in Spain.

Rostra: The speaker's platform in the Roman Forum, so called because it was decorated by the rams (*rostra*) of enemy warships captured by the Romans in an early naval battle. In English, the singular form "rostrum" is used to mean a speaker's platform.

Rubble: Rough stone-work.

Rural Dionysia: Festivals in honor of Dionysus held in many villages in Attica, where dramatic performances were staged, borrowed, in the classical period, from the City Dionysia or the Lenaea festivals.

Sabines: An Italic people who probably spoke Oscan who lived in villages north-east of Rome. Rome derived some of her religious rites from the Sabines.

Sacred Way: A processional road leading to a sanctuary. The most famous Sacred Way was the road leading through the Roman Forum to the temple of Jupiter Optimus Maximus on the hill known as the Capitolium.

Salpinx: A trumpet used in battle. A salpinx might also be used in some religious ceremonies.

Sanctuary: A sacred space defined by a boundary wall, with temple(s), altar(s), stoa(s), treasuries to store sacred objects, and other dependent buildings, where cult activities took place.

Sarcophagus: (plural: sarcophagi) A coffin made of stone, terracotta or wood.

Satura: *Satura* is translated from the Latin as "satire," but it is not satire in the English sense of the word. Rather it is a medley, that is, a poem of medium length that deals with a number of subjects often taken from everyday life. The Latin poet Horace claimed the *satura* as the one literary genre that was invented by the Romans.

Saturnine meter: The earliest meter used for Latin verse, which may have had an accentual rhythm. It was used by the early Latin poets Livius Andronicus and Naevius.

Satyrs: Spirits of wild life from the forests and hills, often shown as attendants of the god Dionysus. At least from the fourth century B.C.E. onwards, satyrs are usually shown as youthful, half-man, half-goat creatures.

Satyr play: A play with a chorus of satyrs which a tragic poet staged after the presentation of his tragic trilogy, parodying a tale from Greek mythology.

Scabellum: A foot-clapper which pipers used to mark the beat of the dance music that they were playing.

Seleucid Empire: The empire founded by one of Alexander the Great's generals, Seleucus I Nicator, which at his death in 280 B.C.E. stretched from Macedon to Iran. By the peace of Apamea in 188 B.C.E. Rome forced the Seleucid Empire to give up Asia Minor and thereafter the empire went into slow decline.

Shaft Grave: A grave for multiple burial, cut as a rectangular shaft in the rock. Two shaft-grave circles have been discovered at Mycenae.

Sikinnis: The dance associated with the satyr play.

Silenus: (plural: Sileni) Often confused with satyrs. However from the sixth century B.C.E. on, sileni are shown as shaggy, bearded men with horses' ears and sometimes horses' tails. Sileni were companions of Dionysus. In satyr plays sileni were treated as drunkards and cowards.

Sistrum: A musical instrument used in the cult of the Egyptian goddess Isis. It was a kind of rattle with a metallic sound like castanets.

Skene: The literal meaning is a tent, for in the earliest dramatic productions, a tent must have served as the dressing-room. In the developed Greek theater, the *skene* was the "scene-building" where there were dressing-rooms for the actors and storage space for props.

Skolion: A drinking-song.

Skyphos: A two-handled drinking cup, not as deep as the *kantharos* or *kotyle* but deeper than a *kylix*.

Slip: A coat of clay, of a different constitution from the clay of the pot itself, which is applied to cover the surface of the pot before firing. Also used to join together parts of a pot that are fired separately.

Soffit: The underside of a lintel, cornice or arch.

Sophist: A teacher of rhetoric and philosophy in classical Greece who gave instruction to pupils and charged tuition fees.

Spartiates: The warrior class that governed Sparta, educated from youth to be soldiers and supported by helots or serfs who worked their farms and gave them half the produce.

Spina: A low wall dividing a circus or hippodrome length-wise, so that the chariots could race down one side of the racecourse, turn and then race up the other side.

Stadium: The Greek *stadion* was 600 Greek feet (184.9 meters or 606.7 feet). This was exactly the length of the single-course foot race in the Olympic Games and thus this was the length of the Olympic stadium or race course. In the Roman period, stadiums acquired stone seats for spectators, though never at Olympia.

Stasimon: A "standing song." Any ode sung by the chorus of a Greek drama after the parodos.

Steatite: A soft stone made of compacted talc (magnesium silicate), sometimes called soapstone. In Minoan Crete it was used for carving vessels, such as the "Harvester Vase."

Stele: (plural: stelai) A vertical slab of stone with an inscription and often decorated, the normal use of which was as a grave marker.

Stereobate: The lower two steps of the three-stepped foundation of a stone temple.

Stirrup Jar: A vessel, normally globular in shape, with a small double handle like a stirrup and a thin spout, common in the Late Bronze Age.

Stoa: A long, rectangular colonnaded building of one or two stories found in marketplaces or sanctuaries. In Late Antiquity, the term may designate any building with a colonnade. The term, "The Stoa" was sometimes used to designate the Stoic School of Philosophy because the founder of the Stoic School, Zeno of Citium, lacking the wherewithal to lease a hall for his lectures, gave them in the *Stoa Poikilé* (Painted Stoa) in the Athenian *agora* (marketplace).

Stoa of Attalus: A stoa erected on the edge of the Athenian *agora* (marketplace) by King Attalus II of Pergamum (159–138 B.C.E.). It was reconstructed in 1953–1956 on its original foundations by the American School of Classical Studies in Athens and is now used as a museum.

Stoa Poikilé: The "Painted Stoa." A stoa on the north side of the Athenian *agora* erected about 460 B.C.E., which housed paintings by leading artists of the fifth century B.C.E., including Polygnotus and Micon.

Stola: Long, female garment worn by Roman married women, reaching from the neck to the ankles.

Stucco: Plaster used for coating walls.

Stylobate: The uppermost step of the three-stepped platform that formed the foundation of a temple. The columns stood on the stylobate.

Styx: One of nine rivers in the Underworld. If the gods took an oath by the River Styx, they feared to break it, for the punishment was terrible.

Symposium: An all-male drinking party in Greece where participants sang songs, recited poems and were entertained by musicians and dancers.

Syncretism: Identification of one god with another, as of Apollo and the Sun-god, Helios.

Syracuse: A Greek colony founded by Corinth on the east coast of Sicily in 734 B.C.E. With its magnificent harbor, Syracuse became the strongest and most prosperous Greek city in Sicily and a center of Greek culture.

Syrinx: Panpipes. A group of hollow reeds or pipes bound together and tuned by cutting the pipes to the proper length to produce a fully graduated musical scale. The syrinx was a favorite instrument of shepherds.

Syssitia: The dining clubs in Sparta where Spartiates who were club members ate their meals together.

Tablinum: A room in a Roman house opening on to the rear of the *atrium*.

Tanagra: The chief town of eastern Boeotia with a territory extending to the sea. It is best known for the so-called "Tanagra figurines," lively little Hellenistic terracotta figures of women and groups from daily life that are found in the graves at Tanagra.

Tartarus: The region of the Underworld where the souls of evil persons were subjected to terrible punishment.

Telamon: A male figure, used in place of a column, like a caryatid.

Temenos: A hallowed segment of land with defined boundaries which was consecrated to a god, where a temple and a altar for sacrifice might be built, though a *temenos* could exist with no structure on it.

Tepidarium: The warm room of a Roman bath-house where warm water was available for bathing.

Terpsichore: The Muse who presides over dancing.

Terracotta: Hard, brown-red earthenware, usually without a glaze, used for pots, statuettes, and ornamental facings on buildings.

Terra sigillata: Red-glazed table ware made in molds which imitates metal-ware with embossed decoration. It was the common table ware of the Roman Empire. Also known as "Samian Ware" and "Arretine Ware."

Tesserae: Small pieces of colored marble or glass used for making mosaics.

Tetrarchy: The type of imperial government introduced by the emperor Diocletian (284–305 C.E.) where he took a junior emperor, also called an Augustus, and in addition, each Augustus took a junior colleague called a Caesar.

Tetrastyle: With four columns at the front, or at the front and back.

Thalamos: Women's quarters of a Greek house.

Theogony: The origin of the gods, or the genealogy of the gods, that is, an account of their ancestry.

Theophany: A manifestation of a god to man by actually appearing on earth.

Thermae: Warm springs or warm baths. In Rome and other cities of the empire, great public buildings known as "Thermae" were constructed which not only served as public baths but also were cultural centers.

Thesmophoria: A women's festival celebrated everywhere in Greece in the autumn, intended to promote the fertility of the grain which had just been sown.

Tholos: A circular building, or a Mycenaean "beehive" tomb, circular in plan, roofed with a false vault.

Thymele: A place for sacrifice. In the Athenian theater, it was an altar-shaped platform in the middle of the orchestra where the leader of the chorus stood.

Tibia: In Rome, originally a pipe made of bone with three or four finger-holes; later a double-pipe reed instrument like the Greek *aulos* with two pipes made of silver, boxwood or ivory. It was a national ritual instrument of the Romans and its playing was intended to drown out any malevolent noises during the Roman sacrificial rites which were rigidly prescribed.

Tibiae pares: The Latin name for a double *aulos* with pipes of equal length that were evidently played in unison. Pipes of unequal length were evidently tuned to play in harmony. This was the instrument that provided the music for the plays of Plautus and Terence.

Tibicines: Tibia players, whose professional organization was one of the oldest in Rome.

Tiebeam: A piece of timber tying together rafters in a roof, or securing masonry in a wall.

Tiryns: Site of a Mycenaean citadel close by modern Navplion in Greece, dating to 1400–1200 B.C.E. Legend makes Heracles ruler of Tiryns.

Toga: The Roman national dress: an outer garment consisting of a single piece of cloth with one rounded edge which was wrapped around the body.

Toga candida: A white toga, made whiter by being rubbed with chalk, which was worn by a candidate for office.

Toga praetexta: A toga ornamented with a purple stripe, worn by free-born children, and by Roman magistrates.

Toga pulla: A dark-grey toga worn by mourners.

Toga pura: An unornamented toga worn by a youth who had laid aside his "toga praetexta" at a coming-of-age ceremony.

Torsion: In figural art, the turning or twisting of the human body.

Trabeated: A term in architecture for a post-and-beam building—one that depends on horizontal beams and vertical posts.

Tragedy: A poetic drama about the vicissitudes of a mythical hero, with an unhappy ending.

Tragic Trilogy: A set of three tragedies by a tragic poet that was presented on a single day of a dramatic festival such as the City Dionysia in Athens. The plots of the tragedies need not deal with the same theme.

Triclinium: The dining room in a Roman house. In later Roman houses, it becomes the chief reception room.

Triglyph: A slab with three grooves carved in it. In the frieze of a Doric temple, a triglyph was placed over each column and another between the columns. The slab between the triglyphs was called a "metope."

Trireme: The standard warship of the late Archaic and Classical periods of Greece. It was a galley with a ram at the bow, which was rowed by about 170 rowers arrayed in three banks of oars on each side.

Triumphal Arch: A monumental archway built usually to commemorate a victory.

Trompe-l'oeil: A French term for painting so true to life that it seems to be real. Examples of *trompe-l'oeil* painting have been found in Second Style wall painting from Pompeii, where the landscape painting gives the impression that the room opens on to a garden.

Tuba: A Roman straight war-trumpet, as distinguished from the *cornu* which was curved. Besides its military use, it was also used in religious festivals, public games, and funerals.

Tufa: A porous limestone. It underlies Rome and was ideal for tunneling catacombs.

Tunica: A tunic worn by the Romans as an undergarment.

Tyche: Chance, or luck. Sometimes "Tyche" is used almost with the meaning of "Providence."

Tympanum: The triangular space formed by the gable at each end of the temple. Also called a "pediment."

Verde antico: A green marble.

Vergina: Ancient Aegae, the capital of Macedon before it was moved to Pella in 399 B.C.E. Aegae remained the place where the kings of Macedon were buried, and in 1977 a Greek archeologist discovered there a tomb which he identified as that of Philip II, the father of Alexander the Great.

Villa: A country-house, or a farm in the Roman Empire.

Villa maritima: A seaside villa.

Villa of the Papyri: A suburban villa outside Herculaneum which was overwhelmed by the eruption of Mt. Vesuvius in 79 C.E. It took its name from a cache of carbonized papyri discovered there when it was excavated in 1752. It is the model for the Getty Museum in San Francisco.

Volute: A spiral carving on the face and back of an Ionic capital.

Voussoir: A wedge-shaped stone which forms part of an arch. The voussoir at the top of the arch is the keystone.

Wanax: A title meaning "lord," held by the dynasts who ruled from the palaces of the Mycenaean period. The first letter of the name, a *digamma* with the sound "w" became obsolete in classical Greek where the word was spelled *anax*, and the term was applied only to gods, or, in Homer's *Iliad*, to Agamemnon, high king of Mycenae.

Xoanon: Primitive, aniconic statue made of wood, usually an ancient cult statue in a temple.

Zakros: Site of a Minoan palace on the eastern shore of Crete, destroyed violently about 1500 B.C.E.

FURTHER REFERENCES

GENERAL

Ancient Greek Authors. Ed. Ward Briggs (Detroit: Gale, 1997).

Graeme Barker and Tom Rasmussen, *The Etruscans* (Malden, Mass.: Blackwell Publishers, 1988).

William Biers, *The Archaeology of Greece: An Introduction* (Ithaca, N.Y.: Cornell University Press, 1996).

Henry C. Boren, *Roman Society* (Lexington, Mass.: D. C. Heath, 1992).

Jacob Burckhart, *The Greeks and Greek Civilization.* Trans. Sheila Stern (New York: St. Martin's Press, 1998).

A. R. Burn, *The Pelican History of Greece* (Harmondsworth, England: Pelican, 1982).

Averil Cameron, *The Later Roman Empire, AD 284–430* (Cambridge, Mass.: Harvard University Press, 1993).

John Camp and Elizabeth Fisher, *The World of the Ancient Greeks* (London: Thames and Hudson, 2002).

Jérome Carcopino, *Daily Life in Ancient Rome.* Trans. E. O. Lorimer (Harmondsworth, England: Penguin Books, 1941).

Thomas H. Carpenter, *Art and Myth in Ancient Greece* (London and New York: Thames and Hudson, 1991).

Michael Crawford, *The Roman Republic* (Cambridge, Mass.: Harvard University Press, 1992).

John Kenyon Davies, *Democracy and Classical Greece* (Cambridge, Mass.: Harvard University Press, 1993).

Glanville Downey, *The Later Roman Empire* (New York: Holt, Rinehart and Winston, 1969).

J. Elsner, *Imperial Rome and Christian Triumph* (New York: Oxford University Press, 1998).

Michael Grant, *The Classical Greeks* (London: Weidenfeld and Nicolson, 1989).

———, *Greeks and Romans: A Social History* (London: Weidenfeld and Nicolson, 1992).

———, *The Rise of the Greeks* (New York: Scribners, 1987).

———, *The Routledge Atlas of Classical History* (London: Routledge, 1994).

Hugh Lloyd-Jones, *The Justice of Zeus* (Berkeley: University of California Press, 1983).

Oswyn Murray, *Early Greece* (Cambridge Mass.: Harvard University Press, 1993).

The Oxford History of Greece and the Hellenistic World. Ed. John Boardman, Jasper Griffin, and Oswyn Murray (Oxford: Oxford University Press, 1991).

The Oxford History of the Roman World. Ed. John Boardman, Jasper Griffin, and Oswyn Murray (Oxford: Oxford University Press, 2002).

G. M. Sargeaunt, *Classical Studies* (London: Chatto and Windus, 1929).

C. G. Starr, *Civilization and the Caesars: The Intellectual Revolution in the Roman Empire* (Ithaca, N.Y.: Cornell University Press, 1954).

F. W. Walbank, *The Hellenistic World* (Cambridge, Mass.: Harvard University Press, 1993).

Colin Wells, *The Roman Empire* (Cambridge, Mass.: Harvard University Press, 1992).

ARCHITECTURE AND DESIGN

A. Boëthius and J. B. Ward-Perkins, *Etruscan and Roman Architecture* (Harmondsworth, England: Penguin, 1970).

John M. Camp, *The Archaeology of Athens* (New Haven, Conn.: Yale University Press, 2001).

J. J. Coulton, *Ancient Greek Architects at Work* (Ithaca, N.Y.: Cornell University Press, 1982).

William Bell Dinsmoor, *The Architecture of Ancient Greece: An Account of Its Historic Development* (London: Batsford, 1975).

R. J. Hopper, *The Acropolis* (New York: Macmillan, 1971).

Arnold W. Lawrence and R. A. Tomlinson, *Greek Architecture* (New Haven, Conn.: Yale University Press, 1996).

William L. MacDonald, *The Architecture of the Roman Empire I: An Introduction* (New Haven, Conn.: Yale University Press, 1982).

———, *The Architecture of the Roman Empire II: An Urban Appraisal* (New Haven, Conn.: Yale University Press, 1986).

Roland Martin, *Greek Architecture: Architecture of Crete, Greece and the Greek World* (New York: Electa/Rizzoli, 1988).

Frank Sear, *Roman Architecture* (Ithaca, N.Y.: Cornell University Press, 1989).

H. A. Thompson, *The Athenian Agora: A Guide* (Athens: American School of Classical Studies, 1976).

John Travlos, *Pictorial Dictionary of Ancient Athens* (London: Thames and Hudson, 1971).

J. B. Ward-Perkins, *Roman Architecture* (New York: Abrams, 1977).

DANCE

E. Kerr Borthwick, "Trojan Leap and Pyrrhic Dance," in *Journal of Hellenic Studies* 87 (1967): 18–23.

Paola Ceccorelli, "Dancing the *Pyrrhiché* in Athens," in *Music and the Muses: The Culture of 'Mousiké' in the Classical Athenian City*. Ed. Penelope Murray (Oxford: Oxford University Press, 2004): 91–118.

Maurice Emmanuel, *The Antique Greek Dance, After Sculptured and Painted Figures* (London: John Lane, 1916).

Elaine Fantham, "Mime: The Missing Link in Roman Literary History," *Classical World* 82 (1989): 153–163.

Ruby Ginner, *Gateway to the Dance* (London: Newmann Neame, 1960).

Mary Anderson Johnstone, *The Dance in Etruria* (Florence, Italy: L. S. Olscki, 1956).

E. J. Jory, "The Pantomime Assistant," in *Ancient History in a Modern University*. Vol. 1. Ed. T. W. Hillard, R. Kearsley, C. E. V. Nixon, and A. M. Noble (Grand Rapids, Mich.: William B. Eerdmans, 1998): 217–221.

Lillian B. Lawler, *The Dance in Ancient Greece* (London: A. C. Black, 1964).

———, *The Dance in the Ancient Greek Theater* (Iowa City: University of Iowa Press, 1964).

Steven Lonsdale, *Animals and the Origins of Dance* (London: Thames and Hudson, 1981).

———, *Dance and Ritual Play in Greek Religion* (Baltimore: Johns Hopkins University Press, 1993).

Annette Lust, *From the Greek Mimes to Marcel Marceau and Beyond: Mimes, Actors, Pierrots and Clowns: A Chronicle of the Many Visages of Mime in the Theatre* (Lanham, Md.: Scarecrow Press, 2000).

F. G. Naerebout, *Attractive Performances: Ancient Greek Dance, Three Preliminary Studies* (Amsterdam: J. C. Gieben, 1997).

Theodore Petrides, *Greek Dance* (Athens: Lycabettus Press, 1980).

The Quest for Theseus. Ed. Anne G. Ward (New York: Praeger, 1970).

C. Sachs, *World History of the Dance* (New York: W. W. Norton, 1963).

T. B. L. Webster, *The Greek Chorus* (London: Methuen, 1970).

Victoria Wohl, "Dirty Dancing in Xenophon's *Symposium*," in *Music and the Muses: The Culture of 'Mousiké' in the Classical Athenian City*. Ed. Penelope Murray (Oxford: Oxford University Press, 2004): 337–364.

FASHION

Ethel B. Abrahams, *Greek Dress; A Study of the Costumes Worn in Ancient Greece, From Pre-Hellenic Times to the Hellenistic Age* (London: John Murray, 1908).

J. Anderson Black, Madge Garland, and Frances Kenneth, *A History of Fashion* (London: Orbis, 1980).

Larissa Bonfante, *Etruscan Dress* (Baltimore: Johns Hopkins Press, 1975).

Iris Brooke, *Costume in Greek Classic Drama* (London: Methuen, 1962).

Thomas Hope, *Costumes of the Greeks and Romans* (New York: Dover Publications, 1962).

Mary G. Houston, *Ancient Greek, Roman, and Byzantine Costumes and Decoration* (London: A. C. Black, 1931; reprint, New York: Dover, 2003).

Carl Kaehler, *A History of Costume* (London: G. G. Harrap, 1928).

Bernice R. Jones, "Revealing Minoan Fashions," *Archaelogy*, 53/3—May–June (2000): 36–41.

Lloyd Llewellyn-Jones and S. Blundell, eds., *Women's Dress in the Ancient Greek World* (London: Duckworth and the Classical Press of Wales, 2002).

Roman Military Equipment: The Accoutrements of War. Proceedings of the Third Roman Military Equipment Research Seminar. Ed. Sinclair Bell and Glenys Davies (Oxford: Archaeopress, 1987).

C. Vout, "The Myth of the Toga: Understanding the History of Roman Dress," *Greece and Rome* 43 (1996): 204–220.

Adele Coulin Weibel, *Two Thousand Years of Textiles: The Figured Textiles of Europe and the Near East* (New York: Pantheon, 1952).

LITERATURE

Piero Boitani, *The Shadow of Ulysses: Figures of a Myth.* Trans. Anita Weston (Oxford: Clarendon Press, 1994).

Susanna Morton Braund, *Latin Literature* (London: Routledge, 2002).

Gian Biagio Conte, *Latin Literature: A History.* Trans. Joseph Solodow. Rev. Don Fowler and Glen Most (Baltimore: Johns Hopkins University Press, 1994).

Albrecht Dihle, *A History of Greek Literature, From Homer to the Hellenistic Period.* Trans. Clare Krojzl (London: Routledge, 1994).

———, *Greek and Latin Literature of the Roman Empire, From Augustus to Justinian.* Trans. Manfred Malzohn (London: Routledge, 1994).

P. E. Easterling and B. M. W. Knox, eds., *The Cambridge History of Classical Literature.* Vol. I, *Greek Literature* (Cambridge: Cambridge University Press, 1981).

Moses Hadas, *A History of Latin Literature* (New York and London: Columbia University Press, 1952).

Gilbert Highet, *Poets in a Landscape* (London: Hamish Hamilton, 1957).

E. J. Kenney, ed., *The Cambridge History of Classical Literature.* Vol. II, *Latin Literature* (Cambridge: Cambridge University Press, 1982).

Richmond Lattimore, *The Poetry of Greek Tragedy* (Baltimore: Johns Hopkins University Press, 2003).

Albin Lesky, *A History of Greek Literature.* Trans. James Willis and Cornelis de Heer (London: Methuen, 1966).

Peter Levi, *A History of Greek Literature* (New York: Viking Penguin, 1985).

T. J. Luce, *The Greek Historians* (London: Routledge, 1997).

Arnaldo Momigliano, *The Development of Greek Biography* (Cambridge, Mass.: Harvard University Press, 1993).

Gregory Nagy, *Greek Mythology and Poetics* (Ithaca, N.Y.: Cornell University Press, 1992).

Barry B. Powell, *Writing and the Origins of Greek Literature* (Cambridge: Cambridge University Press, 2002).

Michael C. J. Putnam, *Virgil's Aeneid: Interpetation and Influence* (Chapel Hill, N.C.: University of North Carolina Press, 1995).

Elizabeth Rawson, *Intellectual Life in the Late Roman Republic* (Baltimore: Johns Hopkins University Press, 1985).

H. J. Rose, *A Handbook of Greek Literature from Homer to Lucian* (London: Methuen, 1951).

———, *A Handbook of Latin Literature from Earliest Times to the Death of St. Augustine* (London: Methuen, 1954).

Ruth Scodel, *Theater and Society in the Classical World* (Ann Arbor, Mich.: University of Michigan Press, 1993).

Michael von Albrecht, *A History of Roman Literature from Livius Andronicus to Boethius, with Special Regard for*

Its Influence on World Literature (Leiden, Netherlands: Brill, 1997).

David Wiles, *The Masks of Menander: Sign and Meaning in Greek and Roman Performance* (Cambridge: Cambridge University Press, 1991).

John J. Winkler and Froma Zeitlin, *Nothing to Do with Dionysos: Athenian Drama in its Social Context* (Princeton, N.J.: Princeton University Press, 1996).

T. P. Wiseman, *Roman Drama and Roman History* (Exeter, England: University of Exeter Press).

MUSIC

Warren D. Anderson, *Ethos and Education in Greek Music: The Evidence of Poetry and Philosophy* (Cambridge, Mass.: Harvard University Press, 1966).

————, *Music and Musicians in Ancient Greece* (Ithaca, N.Y.: Cornell University Press, 1994).

Giovanni Comotti, *Music in Greek and Roman Culture* (Baltimore: Johns Hopkins University Press, 1969).

Greek Musical Writings. Ed. Andrew Barker (Cambridge: Cambridge University Press, 1984).

W. A. Johnson, "Musical Evenings in the Early Empire," *Journal of Hellenic Studies* 120 (2000): 37–85.

John G. Landels, *Music in Ancient Greece and Rome* (London: Routledge, 1998).

Thomas J. Mathiesen, *Apollo's Lyre: Greek Music and Music Theory in Antiquity and the Middle Ages* (Lincoln, Neb.: University of Nebraska Press, 1999).

Solon Michaelides, *The Music of Ancient Greece: An Encyclopedia* (London: Faber, 1978).

Johannes Quasten, *Music and Worship in Pagan and Christian Antiquity.* Trans. Boniface Ramsey (Washington, D.C.: National Association of Pastoral Musicians, 1983).

Martin L. West, *Ancient Greek Music* (Oxford: Oxford University Press, 1994).

R. P. Winnington-Ingram, *Mode in Ancient Greek Music* (Cambridge: Cambridge University Press, 1936).

PHILOSOPHY

Arthur W. H. Adkins, *From the Many to the One: A Study of Personality and Views of Human Nature in the Context of*

Ancient Greek Society and Beliefs (Ithaca, N.Y.: Cornell University Press, 1970).

Ancient Women Philosophers: 600 B.C.–500 A.D. Ed. Mary Ellen Waithe (Dordrecht, Netherlands: M. Nijhoff, 1987).

Atoms, Pneuma and Tranquillity: Epicurean and Stoic Themes in European Thought. Ed. Margaret J. Osler (Cambridge: Cambridge University Press, 1991).

Jonathan Barnes, *Aristotle: A Very Short Introduction* (Oxford: Oxford University Press, 2000).

————, *Early Greek Philosophy* (Harmondsworth, England: Penguin Books, 2001).

————, *Logic and the Imperial Stoa* (New York: Brill, 1997).

The Blackwell Guide to Ancient Philosophy. Ed. Chrisopher Shields (Malden, Mass.: Blackwell, 2003).

The Cambridge Companion to Early Greek Philosophy. Ed. A. A. Long (Cambridge: Cambridge University Press, 1999).

The Cambridge Companion to Greek and Roman Philosophy. Ed. David Sedley (Cambridge: Cambridge University Press, 2003).

Janet Coleman, *A History of Political Thought from Ancient Greece to Early Christianity* (Oxford: Blackwell, 2000).

Will Durant, *The Story of Philosophy.* 2nd ed. (Garden City, N.Y.: Garden City Publishing Co., 1943).

Essays in the Philosophy of Socrates. Ed. Hugh H. Benson (New York: Oxford University Press, 1992).

From Myth to Reason? Studies in the Development of Greek Thought. Ed. Richard Buxton (Oxford: Oxford University Press, 1999).

From the Beginning to Plato. Ed. C. C. W. Taylor (London: Routledge, 1997).

B. A. G. Fuller, *History of Greek Philosophy.* 3 vols. (New York: Henry Holt, 1923–1931).

The Greeks and the Environment. Ed. Laura Westra and Thomas M. Robinson (Lanham Md.: Rowman and Littlefield, 1997).

G. S. Kirk, J. E. Raven, and M. Schofield, *The Presocratic Philosophers: A Critical History with a Selection of Texts* (Cambridge: Cambridge University Press, 1983).

A. A. Long, *Hellenistic Philosophers: Stoics, Epicureans, Sceptics* (New York: Scribners, 1974).

Luis E. Navia, *The Presocratic Philosophers: An Annotated Bibliography* (New York: Garland, 1993).

H. D. Rankin, *Sophists, Socratics, and Cynics* (Totowa, N.J.: Barnes and Noble, 1983).

Margaret Reesor, *The Nature of Man in Early Stoic Philosophy* (New York: St. Martin's Press, 1989).

Bertrand Russell, *A History of Western Philosophy* (New York: Simon and Schuster, 1960).

The Stoic and Epicurean Philosophers: The Complete Extant Writings of Epicurus, Epictetus, Lucretius and Marcus Aurelius. Ed. Whitney J. Oates (New York: Modern Library, 1940).

Gregory Vlastos, *Plato's Universe* (Seattle, Wash.: University of Washington, 1975).

———, *Socrates: Ironist and Moral Philosopher* (Ithaca, N.Y.: Cornell University Press, 1991).

Robin Waterfield, *The First Philosophers: The Presocratics and the Sophists* (Oxford: Oxford University Press, 2000).

RELIGION

Clifford Ando, ed., *Roman Religion* (Edinburgh: Edinburgh University Press, 2003).

Mary Beard and John North, eds., *Pagan Priests: Religion and Power in the Ancient World* (London: Duckworth, 1990).

Mary Beard, John North, Simon Price, *Religions of Rome* (Cambridge: Cambridge University Press, 1998).

G. W. Bowersock, *Hellenism in Late Antiquity* (Ann Arbor: University of Michigan Press, 1990).

Jan N. Bremmer, *Greek Religion* (Oxford: Oxford University Press, 1994; reprint, 1999).

Norman O. Brown, *Hermes the Thief: The Evolution of a Myth* (Great Barrington, Md.: Lindisfarne Press, 1990).

Walter Burkert, *Homo Necans; The Anthropology of Ancient Greek Sacrificial Ritual and Myth.* Trans. Peter Bing (Berkeley: University of California Press, 1983).

———, *Greek Religion, Archaic and Classical.* Trans. Paul Raffan (Oxford: Basil Blackwell, 1985).

Richard Buxton, ed., *Among the Gods: An Archaeological Exploration of Ancient Greek Religion* (London and New York: Routledge, 1989).

———, *Greek and Roman Religion: A Sourcebook* (Park Ridge, N.J.: Noyes Press, 1980).

———, *Oxford Readings in Greek Religion* (Oxford: Oxford University Press, 2000).

———, *The Religions of the Roman Empire* (London: Thames and Hudson; Ithaca, N.Y.: Cornell University Press, 1970).

Arthur B. Cook, *Zeus: A Study in Ancient Religion* (New York: Biblo and Tannen, 1964).

Etruscan Life and Afterlife; A Handbook of Etruscan Studies. Ed. Larissa Bonfante (Detroit: Wayne State University Press, 1986).

Denis Feeney, *Literature and Religion at Rome: Culture, Contexts and Beliefs* (Cambridge: Cambridge University Press, 1998).

Robert Garland, *The Greek Way of Death.* 2nd ed. (London: Bristol Classical Press, 2002).

Michael Grant, *Jesus: An Historian's Review of the Gospels* (New York: Scribner, 1977).

———, *Roman Myths* (Harmondsworth, England: Penguin, 1973).

———, *Saint Peter: A Biography* (New York: Scribner, 1995).

Paul Johnson, *A History of Christianity* (Harmondsworth, England: Peregrine Books, 1978).

Karl Kerényi, *Hermes, Guide of Souls: The Mythologies of the Masculine Source of Life.* Trans. Murray Stein (Dallas, Tex.: Spring Publications, 1986).

———, *Zeus and Hera; Archetypal Image of Father, Husband, and Wife.* Trans. Christopher Holme (Princeton, N.J.: Princeton University Press, 1975).

D. C. Kurtz and John Boardman, *Greek Burial Customs* (London: Thames and Hudson, 1971).

Margaret Littleton, *The Romans: Their Gods and Their Beliefs* (London: Orbis, 1984).

Martin Nilsson, *A History of Greek Religion.* Trans. F. J. Fielden (New York: Norton, 1964).

———, *Cults, Myths, Oracles, and Politics in Ancient Greece* (Lund, Sweden: P. Aströms Förlag, 1986).

———, *Greek Folk-Religion* (Philadelphia: University of Pennsylvania Press, 1978).

———, *Greek Piety.* Trans. H. J. Rose (London: Oxford University Press, 1948).

Arthur Darby Nock, *Conversion: The Old and the New in Religion from Alexander the Great to Augustine of Hippo* (London: Oxford University Press, 1933).

J. A. North, *Roman Religion* (Oxford: Oxford University Press, 2000).

Eric Orlin, *Temples, Religion, and Politics in the Roman Republic* (Leiden, Netherlands: Brill, 1997).

H. W. Parke, *Greek Oracles* (London: Hutchinson, 1967).

———, *Sibyls and Sibylline Prophecy in Classical Antiquity.* Ed. B. C. McGing (London: Routledge, 1988).

Simon Price, *Religions of the Ancient Greeks* (Cambridge: Cambridge University Press, 1999).

W. H. D. Rouse, *Gods, Heroes and Men in Ancient Greece* (New York: New American Library, 1957).

———, *Greek Votive Offerings; An Essay in the History of Greek Religion* (Cambridge: Cambridge University Press, 1902).

Joanne Stroud and Gail Thomas, eds., *The Olympians: Ancient Deities as Archetypes* (New York: Continuum, 1996).

J. C. Toynbee, *Death and Burial in the Roman World* (Ithaca, N.Y.: Cornell University Press, 1971).

Louise Bruit Zaidman and Pauline Schmitt Pantel, *Religion in the Greek City.* Trans. Paul Cartledge (Cambridge: Cambridge University Press, 1992).

THEATER

Peter Arnott, *An Introduction to the Greek Theatre* (Bloomington, Ind.: Indiana University Press, 1967).

———, *The Ancient Greek and Roman Theatre* (New York: Random House, 1971).

———, *Public and Performance in the Greek Theatre* (London: Routledge, 1991).

Clifford Ashby, *Classical Greek Theatre: New Views of an Old Subject* (Iowa City: University of Iowa Press, 1999).

H. C. Baldry, *The Greek Tragic Theatre* (London: Chatto and Windus, 1981).

Crossing the Stage: The Production, Performance, and Reception of Ancient Theatre. Ed. John Porter, Eric Csapo, C. W. Marshall, and Robert C. Ketterer. Vol. 10 of *Syllecta Classica* (Iowa City: University of Iowa Press, 1999).

Charles Garton, *Personal Aspects of the Roman Theatre* (Toronto: Hakkert, 1972).

Richard Green and Eric Handley, *Image of the Greek Theater* (Austin, Tex.: University of Texas Press, 1995).

Kenneth McLeish, *A Guide to Greek Theatre and Drama* (London: Methuen, 2003).

Rush Rehm, *Greek Tragic Theatre* (London: Routledge, 1992).

———, *Radical Theatre: Greek Tragedy and the Modern World* (London: Duckworth, 2002).

Niall W. Slater, *Plautus in Performance: The Theatre of the Mind* (Amsterdam: Harwood Academic, 2000).

J. Michael Walton, *Greek Theatre Practice* (London: Methuen Drama, 1991).

———, *Living Greek Theatre: A Handbook of Classical Performance and Modern Production* (Westport, Conn.: Greenwood Press, 1987).

T. B. L. Webster, *Greek Theatre Production* (London: Methuen, 1974).

David Wiles, *Greek Theatre Performance: An Introduction* (Cambridge: Cambridge University Press, 2000).

Jennifer Wise, *Dionysus Writes: The Invention of the Theatre in Ancient Greece* (Ithaca, N.Y.: Cornell University Press, 1998).

VISUAL ARTS

Bernard Andreae, *The Art of Rome* (New York: Abrams, 1977).

John Penrose Barron, *Greek Sculpture* (London: Studio Vista, 1965).

John Boardman, *Greek Art.* 4th ed. (London: Thames and Hudson, 1996).

Richard Brilliant, *The Arts of the Ancient Greeks* (New York: McGraw Hill, 1973).

Jean Charbonneaux, Roland Martin, and François Villard, *Archaic Greek Art* (New York: Braziller, 1971).

———, *Classical Greek Art* (New York: Braziller, 1972).

———, *Hellenistic Art* (New York: Braziller, 1973).

Mark D. Fullerton, *Greek Art* (Cambridge: Cambridge University Press, 2000).

A Handbook of Roman Art: A Comprehensive Survey of All the Arts of the Roman World. Ed. Martin Henig (Ithaca, N.Y.: Cornell University Press, 1987).

George M. A. Hanfmann, *Roman Art: A Modern Survey of the Art of Imperial Rome* (Greenwich, Conn.: New York Graphic Society, 1964).

Niels Hannestad, *Roman Art and Imperial Policy* (Aarhus, Denmark: Aarhus University Press, 1986).

Ernst Kjellberg and Gösta Säflund, *Greek and Roman Art, 3000 B.C. to A.D. 550* (London: Faber and Faber, 1968).

Walter S. Lowrie, *Art in the Early Church* (New York: Norton, 1969).

Paul MacKendrick, *The Greek Stones Speak: The Story of Archaeology in Greek Lands.* 2nd ed. (New York: Norton, 1981).

———, *The Mute Stones Speak: The Story of Archaeology in Italy.* 2nd ed. (New York: Norton, 1983).

John Griffiths Pedley, *Greek Art and Archaeology* (Englewood Cliffs, N.J.: Prentice-Hall, 1993).

J. J. Pollitt, *Art and Experience in Classical Greece* (London: Cambridge University Press, 1993).

Nancy H. Ramage and Andrew Ramage, *Roman Art: Romulus to Constantine* (Englewood Cliffs, N.J.: Prentice Hall, 1996).

Gisela M. A. Richter, *A Handbook of Greek Art* (New York: Capo Press, 1987).

Martin Robertson, *A History of Greek Art* (Cambridge: Cambridge University Press, 1975).

———, *A Shorter History of Greek Art* (Cambridge: Cambridge University Press, 1981).

Nigel J. Spivey, *Greek Art* (London: Phaidon, 1997).

James Stevenson, *The Catacombs: Rediscovered Monuments of Early Christianity* (London: Thames and Hudson, 1978).

Donald Strong, *Roman Art.* 2nd ed. (London: Penguin Books, 1990).

Mario Torelli, "The Frescoes of the Great Hall of the Villa at Boscoreale: Iconography and Politics," in *Myth, History and Culture in Republican Rome: Studies in Honor of T. P. Wiseman.* Ed. David Braund and Christopher Gill (Exeter, England: University of Exeter Press, 2003): 217–256.

Susan Walker, *Roman Art* (Cambridge, Mass.: Harvard University Press, 1991).

MEDIA AND ONLINE SOURCES

GENERAL

The Ancient City of Athens (http://www.indiana.edu/
~kglowack/athens/)—The Ancient City of Athens con-
tains links for the most important sites and monu-
ments, essays, an Internet tour of the city, teaching and
learning resources for students and teachers, and related
links. Take a "virtual" visit to Athens and see the set-
ting of history, culture, and literature come alive.

Atrium (http://web.idirect.com/~atrium/)—Atrium includes
"This Day in History," which provides the Roman date
and important events that occurred on any given day;
"The Ancient World on Television," a list of television
programs about antiquity on the History Channel, The
Learning Channel, PBS, and network series; Archaeol-
ogy's Top 100, and many other resources.

Diotima (http://www.stoa.org/diotima/)—Diotima, a store-
house of resources for the study of women and gender
in the ancient world, fulfills many functions. It contains
bibliographies from ancient gender and family courses
from institutions across the country as well as bibliogra-
phies and research guides to dozens of topics related to
the study of men and women, a refereed journal section
with essays published by leading scholars, a database for
biblical studies, and a catalog of imagery.

Perseus Digital Library (http://www.perseus.tufts.edu/)—
The Perseus Digital Library provided by Tufts Univer-
sity is a primary source for a wide range of materials,
including ancient texts and illustrations of objects and
monuments. There are a number of classical sites in-
cluded with extensive illustrations of the ruins and
monuments.

Providence College's page on Roman Art and Architecture
(http://www.providence.edu/dwc/romaarch.htm)—This
website is a critical list of other websites on Roman archi-
tecture with information on their content and comments
on their quality and characteristics.

Vroma (http://www.vroma.org/)—Vroma, a virtual commu-
nity for teaching and learning Classics, includes games,
photos, and interactive media. The website allows users
to become a Roman character and interact with other
characters in a virtual Rome circa 150 C.E.

Women's Life in Greece and Rome (http://www.stoa.org/
diotima/anthology/wlgr/)—This is the on-line searchable
version of *Women's Life in Greece and Rome. A Source
Book in Translation*, edited and translated by Mary R.
Lefkowitz and Maureen B. Fant, 2nd. ed. (Baltimore,
Md.: 1992). This is a useful compilation of primary
sources for the study of women in Ancient Gree and
Rome.

ARCHITECTURE AND VISUAL ARTS

The American School at Rome (http://www.aarome.org/
programs/classical.htm)—This site is useful for the
study of Roman art, history, and archaeology.

The American School of Classical Studies at Athens (http://
www.ascsa.edu.gr/)—This website is a principal resource
for research on the art, history, and archaeology of
Greece and the Greek world from pre-Hellenic times
to the present. Connected to it is the website of the
Athenian Agora Excavations (http://www.agathe.gr/)
that offers an opportunity to visit an excavation in

progress, the work that has been done, as well as the reconstrucion of the stoa carried out by the American School in Athens.

Classical Architecture at Loggia (http://www.loggia.com/designarts/architecture/classical.html)—This website is a particularly useful site for illustrations of Greek and Roman architecture. Often several views of a building and its situation in a context are included.

The Getty Museum Collections (http://www.getty.edu/art/collections/bio/a595-1.html)— This website from the Getty Museum in Los Angeles presents a biography of the Marsyas Painter, the last of the great Athenian vase painters working in the red-figure style. There is also an image of a work attributed to the Marsyas Painter.

The University of Colorado at Colorado Springs page on Greek Art and Architecture (http://harpy.uccs.edu/greek/greek.html)—The University of Colorado, Colorado Springs, sponsors this website on Greek architecture and art with many good links to other sites.

FASHION

Illustrated History of the Roman Empire (http://www.roman-empire.net/society/soc-dress.html)—The site contains pictures of Roman dress and brief descriptions, including short sections on footwear, hairstyles, and beards.

Metropolitan Museum of Art (http://www.metmuseum.org/collections/department.asp?dep=13)—This is a web page sponsored by the Metropolitan Museum in New York. It offers pictures of Greek vases and sculpture to illustrate various types of dress.

Roman Clothing I and II (http://www.vroma.org/~bmcmanus/clothing.html)—This site is recommended for its section on fashionable Roman hairstyles and jewelry. There are numerous connections to sites with illustrations.

MUSIC

Ancient Greek and Roman Music, Selected Bibliography (http://titan.iwu.edu/∼classics/music.html)— This website contains several citations for further research on Ancient Greek and Roman music.

Ancient Greek Music at the Austrian Academy of Sciences (http://www.oeaw.ac.at/kal/agm/)—This site contains all published fragments of Ancient Greek music which contain more than a few scattered notes. All of them are recorded under the use of tunings whose exact ratios

have been transmitted by ancient theoreticians (of the Pythagorean school, most of them cited by Ptolemaios). Instruments and speed are chosen by the author. The exact sound depends on the hard- and software used.

Music from Ancient Rome, Vol 1. Wind Instruments. Walter/Ravenstein, Natalia van Maioli, Luce Maioli, et al. (Amiata #1396, 1996)—This CD includes performances of primarily cultic music from Imperial Rome, based on the research of Synaulia and Walter Maioli, performed on reconstructions of ancient pipes, trumpets, and other aerophones. Includes notes.

Music from Ancient Rome, Vol 2: String Instruments. Performed by Synaulia (Amiata #1002, 2002)—This CD includes performances of primarily cultic music from Imperial Rome, based on the research of Synaulia and Walter Maioli, performed on reconstructions of ancient lyres. Includes notes.

Music of Ancient Greece. Christodoulos Halaris and instrumental ensemble, vocal soloists (Orata, 1994)—This CD includes Pindar's First Pythionic Hymn, a chorus from Euripedes' Orestes, a chant to Apollo, and a hymn to the Holy Trinity (based on ancient Greek musical theory). Includes 80 pp. booklet.

Music of the Ancient Greeks. De Organographia—Gayle Neuman, Philip Neuman, William Gavin. (Pandourion Records, PRCD 1001, 1997)—This CD features ancient Greek music from 500 B.C. to 300 A.D. performed on voice and copies of ancient Greek instruments including kithara, lyra, aulos, syrinx, seistron, tympanon, pandoura, trichordon, photinx, salpinx, kymbala, and others. Full listing of instrumentation and photos of ancient Greek instruments included.

Musique de la Grèce antique. Gregorio Paniagua and Atrium Musicae de Madrid (Harmonia Mundia, 1979)—This CD recreates the music for 22 of the extant fragments of ancient Greek music, performed on modern replicas of ancient instruments. Includes detailed liner notes.

Musiques de l'Antiquité Grecque. Annie Bélis and the Kérylos ensemble. (K617, 1996)—This CD includes performances of fifteen fragments of ancient Greek music, including four Mesomedes' songs and the Christian Hymn of Oxyrhynchus.

Oxyrhynchus Online (http://www.csad.ox.ac.uk/POxy/)— This online publication of the Oxyrhynchus Papyri from the excavations at Oxyrhynchus, Egypt, contains fragments of ancient Greek and Roman literature, music theory, and notated music.

Sappho de Mytilene. Angelique Ionatos and Nena Venetsanou (Paris: Tempo, A6168, 1991)—This CD includes poems

of Sappho sung in ancient and modern Greek by two female vocalists. The music is composed by Ionatos, and sounds very Greek (using both ancient and modern instruments). Modern Greek versions are by Nobel laureate Odysseus Elytis. $18.98 available from Ladyslipper.

The Thesaurus Musicarum Latinarum (TML) (http://www.music.indiana.edu/tml/start.html)—The Thesaurus Musicarum Latinarum (TML) is an evolving database of the entire corpus of Latin music theory written during the Middle Ages and the Renaissance.

The University of Michigan Papyrus Collection (http://www.lib.umich.edu/pap/)—This collection contains over 10,000 fragments. The website provides on-line public access to one of the largest collections of papyri in the world and, through the APIS search engine, to other papyrological resources. Musical documents are included in the collection.

ACKNOWLEDGMENTS

The editors wish to thank the copyright holders of the excerpted material included in this volume and the permissions managers of many book and magazine publishing companies for assisting us in securing reproduction rights. Following is a list of the copyright holders who have granted us permission to reproduce material in this volume of Arts and Humanities Through the Eras. Every effort has been made to trace copyrights, but if omissions have been made, please let us know.

COPYRIGHTED EXCERPTS IN ARTS AND HUMANITIES THROUGH THE ERAS: ANCIENT GREECE AND ROME WERE REPRODUCED FROM THE FOLLOWING BOOKS:

Anonymous. From "PGM I. 247–62," in *The Greek Magical Papyri in Translation, Including the Demotic Spells.* Edited by Hans Dieter Betz. The University of Chicago Press, 1986. © 1986 by The University of Chicago. All rights reserved. Reproduced by permission.—Apuleius, Lucius. From *The Golden Ass.* Translated by E. J. Kennedy. Penguin Books, 1950. Translation copyright © 1998 E. J. Kennedy. Reproduced by permission of Penguin Books Ltd.—Aristophanes. From "Peace," in *The Context of Ancient Drama.* Edited by Eric Csapo and William J. Slater. The University of Michigan Press, 1994. Copyright © by the University of Michigan, 1994. All rights reserved. Reproduced by permission.—Aristophanes. From *The Wasps The Poet and the Women the Frogs.* Translated by David Barrett. Penguin Books, 1964. Copyright © David Barrett, 1964. All rights reserved. Reproduced by permission of Penguin Books, Ltd.—Aristotle. From *Classical Literary Criticism.* Trans-

lated with an Introduction by T. S. Dorsch. Penguin Classics, 1965. Copyright © 1965 T. S. Dorsch. Reproduced by permission of Penguin Books, Ltd.—Aristotle. From *Metamorphosis, Books I–IX.* Translated by Hugh Tredennick. Cambridge, Mass: Harvard University Press, 1996. Copyright © 1996 by the President and Fellows of Harvard College. All rights reserved. Reproduced by permission of the publishers and the Trustees of the Loeb Classical Library.—Aristotle. From *Poetics.* Edited and translated by Stephen Halliwell. Cambridge, Mass: Harvard University Press, 1995. Copyright © 1995 by the President and Fellows of Harvard College. All rights reserved. The Loeb Classical Library (R) is a registered trademark of the President and Fellows of Harvard College. Reproduced by permission of the publishers and the Trustees of the Loeb Classical Library.—Aristotle. From *The Politics.* Translated by T. A. Sinclair, revised by Trevor J. Saunders. Penguin Books, 1981. Translation © 1962 the Estate of T. A. Sinclair. Revised translation copyright © Trevor J. Saunders, 1981. All rights reserved. Reproduced by permission of Penguin Books, Ltd.—Athanassakis, Apostolos N. From *The Homeric Hymns.* Johns Hopkins University Press, 1976. Copyright © 1976 by The Johns Hopkins University Press. All rights reserved. Reproduced by permission.—Euripides. From "Helen," in *Greek Musical Writing Vol. I: The Musician and his Art.* Edited by Andrew Barker. Cambridge University Press, 1984. © Cambridge University Press, 1984. Reprinted with the permission of Cambridge University Press.—Euripides. From *Ten Plays by Euripides.* Translated by Moses Hadas and John McLean. Bantam Books, 1985. Copyright 1936 by The Dial Press, Inc. Copyright

INDEX

Arts and Humanities Through the Eras: Ancient Greece and Rome (1200 B.C.E.–476 C.E.)

493

494

Arts and Humanities Through the Eras: Ancient Greece and Rome (1200 B.C.E.–476 C.E.)

Arts and Humanities Through the Eras: Ancient Greece and Rome (1200 B.C.E.–476 C.E.)

Bronze Age, 404–410
Daedalic style, 404–405
Egyptian influence, 404
Etruscan influence, 425
female nudes, *420–422*, 421–422
figures in motion, 422
frontal pose, 428
Hellenistic Baroque, 422–424
Lost Wax technique, 405–406
marble, 406, 411
market for, 425–426
Neo-Attic, 424
portraits, 439–442
relief sculpture, 408, *409, 410, 415*, 422–423, *427*, 427–428
Ripe Archaic, 405–408
Roman, 425–429
Roman copies of Greek sculpture, 425–426
Sperlonga, 424
wind-blown drapery, 415–416
Sculptures (statues)
Altar of Peace, 427, *428*
Aphrodite of Cnidus (Praxiteles), 417, 421, *421*
Apollo of Veii, *425*
Apoxyomenos (Lysippus), *411*
Arch of Titus, 427–428
Athlete Scraping Himself (Lysippus), 419
bronze charioteer, *413*
bronze Zeus, *413*
Capitoline Venus, *420*, 421
Column of Trajan, *426*
Diadoumenos, 415
Discus-thrower (Myron), 411, *411*
Doryphoros, 415
Farnese Heracles (Lysippus), *418*, 419
Great Altar of Pergamum, 422–423
Hermes holding the infant Dionysus (Praxiteles), 417, *417*
korai, 102, 405, 407–408, *407–408*
kouroi, 404–407
Laocoon Group, *423*, 423–424
Nike of Paionios, *414*, 415–416
Perseus slaying the Gorgon, *409*
"Prima Porta" Augustus, *111*, 112, 426–427
Riace Warrior, *414*
Spear-bearer (Polyclitus), *417*
Venus de Milo (Alexandros), 417, 421, *422*, 424
Venus of Arles, 421–422, *422*
Victory Monument of Attalus of Pergamum, 422
Winged Victory of Samothrace, 422, *423*

Second Sophistic, 172–173
Seers, 316–317
Seneca the Younger, 169–170, 374–375, **381–382**
Seven Against Thebes (Aeschylus), 145–146
Shrines, Minoan, 290
Sibyls, 310–311, *319, 320*
Silk, 99–100, 101
Simonides of Amorgos, 296
Simonides of Ceos, 132
Skolia, 210
Socrates, 248, 250–254, *251, 276*, **342**
Solon, 131
Sophists, 248–250
Sophocles, *147*, 147–150, 359, **382**
Soul, philosophy of, 247–248, 259–260, 265
Spartan civilization, 52–54, 61, 258
Spear-bearer (Polyclitus), *417*
Speechwriting, 154–155
Statius, Publius Papinius, 171
Stoa of Attalus, 22, *23*
Stoicism, 264–266, 275, 279
Stolas, 107, *107*
Strings (instruments), 189–193
Suetonius, **41**
Sulpicia, 167–168, 214
Suppliant Women (Aeschylus), 146
Symposium, 210
Symposium (Xenophon), 70

T

Tacitus, Cornelius, 171–172
Temple of Venus, *29*
Temples. *See also* Greek gods and goddesses
Apollo's Temple in Delphi, Greece, *60*
early examples, 13–14
Etruscan, 24–25
Greek, 320–323
Pantheon, 31, *33*
The Parthenon, 18–19, 413
relief sculpture, 408
Roman, 27–28, 30–31, *33*
Temple C, 408, *409*
Temple E, *16*
Temple of Aphaia at Aegina, 17
Temple of Apollo at Corinth, 15
Temple of Hera, *410*
Temple of Hera at Olympia, *14*, 14–15
Temple of Hera at Paestum, *15*
Temple of Nike, 20

Temple of Olympian Zeus, 20–21, *21*
Temple of Venus, *29*
Temple of Vesta, *322*
wealth of, 322
The Ten Books on Architecture (Vitruvius), 27, 433
Terence, 159–160, 370–371, **382–383**
Terra Sigillata, 402–403, *403*
Tetrachords, 224–225
Thales, 240, **278–279**
Theater, Greek, *204. See also* Plays
acting, *356, 357, 357*
bawdiness and obscenity in, 360–361
comedy, 360–365
costumes, 357, 360
dance and, 63–66
Dionysus, 144, 351–354
dramatic festivals, 353–354
music and, 203–208
origin of, 351–352
theaters, 354, *354–355*, 356–357
tragedy, 144–153, 158, 357–360 170
Theater, Roman, 157–160. *See also* Plays; Theaters
bawdiness in, 366–367
Etruscan influence on, 366
Greek influence on, 158, 366
Italian influence on, 366–367
mime, 372
music and, 195, 213–214
Theater at Epidaurus, 22
Theaters
Greek, 21–22, *22*, 354, *354–355*, 356–357
Roman, 32, 34–35, 367, *368*
Theocritus, 157
Theodora, **77–78**
Theognis, 130–131
Theogony (Hesiod), 126–127, 294, 296–297, 309–310
Theory of Forms, 256–257
Theory of universe, 260, 270
Theseus, 313
Theseus and the Minotaur, myth of, 50, 290
Thesmophoriazusae (Aristophanes), 141–142
Thespis, 58, 144
Thetis, 307–308
Tholos tombs, 11
Thucydides, 136–137, **176–177**
Tibia, 194–195
Tibicines, 195
Tibullus, 167
Timaeus (Plato), 260